McGill-Queen's/Beaverbrook Canadian Foundation Studies in Art History

SANDRA PAIKOWSKY and MARTHA LANGFORD, series editors

Recognizing the need for a better understanding of Canada's artistic culture both at home and abroad, the Beaverbrook Canadian Foundation, through its generous support, makes possible the publication of innovative books that advance our understanding of Canadian art and Canada's visual and material culture. This series supports and stimulates such scholarship through the publication of original and rigorous peer-reviewed books that make significant contributions to the subject. We welcome submissions from Canadian and international scholars for book-length projects on historical and contemporary Canadian art and visual and material culture, including Native and Inuit art, architecture, photography, craft, design, and museum studies. Studies by Canadian scholars on non-Canadian themes will also be considered.

The Practice of Her Profession
Florence Carlyle, Canadian Painter in the Age of Impressionism
Susan Butlin

Bringing Art to Life
A Biography of Alan Jarvis
Andrew Horrall

Picturing the Land
Narrating Territories in Canadian Landscape Art, 1500 to 1950
Marylin J. McKay

The Cultural Work of Photography in Canada
Edited by Carol Payne and Andrea Kunard

Newfoundland Modern
Architecture in the Smallwood Years, 1949–1972
Robert Mellin

The *Codex Canadensis* and the Writings of Louis Nicolas
The Natural History of the New World, Histoire Naturelle des Indes Occidentales
Edited and with an introduction by François-Marc Gagnon,
translation by Nancy Senior, modernization by Réal Ouellet

Vu des Etalons que Le

grand fût Envoyé auec soisante belles ?

La Nouuelle france ll y a plus de vent

fon sortis de fras de tres Beau cheuau

nous Lauons Vu

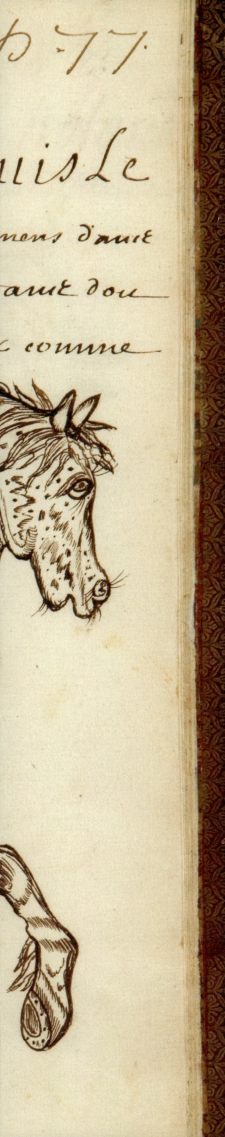

THE CODEX CANADENSIS

and the

Writings *of* Louis Nicolas

THE NATURAL HISTORY OF THE NEW WORLD

HISTOIRE NATURELLE DES INDES OCCIDENTALES

Edited and with an Introduction by François-Marc Gagnon
Translation by Nancy Senior
Modernization by Réal Ouellet

GILCREASE MUSEUM Tulsa, Oklahoma

and

MCGILL-QUEEN'S UNIVERSITY PRESS
Montreal & Kingston · London · Ithaca

ISBN 978-0-7735-3876-4

Legal deposit fourth quarter 2011
Bibliothèque nationale du Québec

Printed in Canada on acid-free paper that is 100% ancient forest free, processed chlorine free

This book has been published with the help of a grant from the Canadian Federation for the Humanities and Social Sciences, through the Aid to Scholarly Publications Program, using funds provided by the Social Sciences and Humanities Research Council of Canada. Funding has also been received from the Publishing Fund of the University of Saskatchewan and from Henry M. Reeves.

McGill-Queen's University Press acknowledges the support of the Canada Council for the Arts for our publishing program. We also acknowledge the financial support of the Government of Canada through the Canada Book Fund for our publishing activities.

Library and Archives Canada Cataloguing in Publication

Nicolas, Louis, fl. 1667–1675
The Codex canadensis and the writings of Louis Nicolas : The natural history of the New World = Histoire naturelle des Indes occidentales / edited and with an introduction by François-Marc Gagnon ; translation by Nancy Senior ; modernization by Réal Ouellet.

(McGill-Queen's/Beaverbrook Canadian Foundation studies in art history)
Includes bibliographical references and index.
Includes some text in French.
ISBN 978-0-7735-3876-4

1. Indians of North America—Canada—Pictorial works—Early works to 1800. 2. Natural history illustration—Canada—Early works to 1800. 3. Natural history—Canada—Pre-Linnean works. I. Gagnon, François-Marc, 1935- II. Senior, Nancy, 1941- III. Ouellet, Réal IV. Thomas Gilcrease Institute of American History and Art V. Title. VI. Title: Natural history of the New World. VII. Title: Histoire naturelle des Indes occidentales. VIII. Series: McGill-Queen's/Beaverbrook Canadian Foundation studies in art history

E78.C2N53 2011
971.004'9700222
C2011-905470-1E

Catalogage avant publication de Bibliothèque et Archives Canada

Nicolas, Louis, époque 1667–1675
The Codex canadensis and the writings of Louis Nicolas : The natural history of the New World = Histoire naturelle des Indes occidentales / edited and with an introduction by François-Marc Gagnon ; translation by Nancy Senior ; modernization by Réal Ouellet.

(McGill-Queen's/Beaverbrook Canadian Foundation studies in art history) Comprend des réf. bibliogr. et un index.
Comprend du texte en français.
ISBN 978-0-7735-3876-4

1. Indiens d'Amérique—Canada—Ouvrages illustrés—Ouvrages avant 1800. 2. Illustration en sciences naturelles—Canada—Ouvrages avant 1800. 3. Sciences naturelles—Canada—Ouvrages prélinnéens. I. Gagnon, François-Marc, 1935 - II. Senior, Nancy, 1941 - III. Ouellet, Réal IV. Thomas Gilcrease Institute of American History and Art V. Titre. VI. Titre: Natural history of the New World. VII. Titre: Histoire naturelle des Indes occidentales. VIII. Collection: McGill-Queen's/Beaverbrook Canadian Foundation studies in art history

E78.C2N53 2011
971.004'9700222
C2011-905470-1F

Designed and typeset by studio oneonone in Minion 10.2/14.5

CONTENTS

LIST OF ILLUSTRATIONS

We gratefully acknowledge the kindness of the Gilcrease Museum, Tulsa, Oklahoma, in granting the McGill-Queen's University Press permission to reproduce visual material from the work known as the *Codex Canadensis*, which is held in their collection as Codex Canadensis, accession #4726.7, Gilcrease Museum, Tulsa, OK.

The following figures are reproduced in the Introduction by François-Marc Gagnon. If the original source for an image is known, this is indicated. Complete references may be found in the Bibliography.

FOREWORD

The *Codex Canadensis* was two hundred and fifty years old when Thomas Gilcrease, founder of the Gilcrease Museum in Tulsa, Oklahoma, purchased it in 1949.[1] He had little idea of the manuscript's significance but he was fascinated by what it contained – 180 illustrations and descriptions of people, flora, and fauna in New France during the seventeenth century. He knew that pictorial representations of the western hemisphere during this period were rare and had seen nothing comparable on the open market during his decades of collecting. Gilcrease had already amassed a huge archival collection, including 100,000 pages of Spanish colonial records with rarities such as the earliest letter written from the western hemisphere (1512),[2] the earliest publication from the New World (1543),[3] and volumes of sixteenth-century documents on the exploration and conquests of North and South America as well as the inquisition in Mexico. Gilcrease had also collected many documents related to the founding of democracy in the United States. In 1950 he purchased the only known certified copy of the Declaration of Independence signed by Benjamin Franklin and Silas Dean.[4] He also assembled a massive amount of primary documentation related to Native American struggles to maintain their homelands in the nineteenth century.[5] Yet, given its subject matter, the *Codex Canadensis* remains a gem without compare in the Gilcrease collection.

Gilcrease saw the manuscript as a mystery, with layers of information yet to be revealed. He frequently pondered the illustrations, which vary from realistic to fanciful, and the terse descriptions, written in seventeenth-century French. The manuscript presents a number of diverse subjects: mammals, birds, fish, plants, and reptiles and insects. Interspersed among these easily recognizable images are imaginary creatures such as a unicorn and anomalous creatures that combine the attributes of disparate animals. In addition, there are portraits of Native Americans representing fifteen different nations, showing their dress, hairstyles, personal adornment, and tattoos. Accoutrements such as pipes, pipe bags, moccasins, snowshoes, clubs, birch bark megaphones, and a variety of canoes and shelters are also depicted.[6] In sum, the *Codex* ranks

as one of the most significant ethnographic documents of the early historic period in North America.

Prior to its purchase by Gilcrease, the manuscript, originally titled "Les Raretés des Indes," had remained largely unknown to the public. The gold armorial stamp on the manuscript's binding indicates that at one time it was in the royal library of Louis XIV. Only once, in 1930, did it surface long enough for a facsimile edition of one hundred copies to be produced by rare book seller Maurice Chamonal.[7] Chamonal's edition included a short essay by Baron Marc de Villiers, who gave the work the title *Codex Canadensis* and incorrectly attributed its authorship to Charles Bécart de Granville (1675–1703) in the erroneous belief that he was the only person in Quebec at that time who could have executed the two maps at the beginning of the manuscript. It was not until the 1960s, after Gilcrease's death, that French Canadian scholars traced the work to Louis Nicolas, a Jesuit missionary who was born in Aubenas, France, in 1634 and lived in Canada from 1664 to 1675.[8]

Gilcrease acquired the manuscript while his new museum was under construction. The museum represented the culmination of his life's work of amassing a collection that would tell the story of the Americas and would provide a venue where the collection could be shared with the world. It was an unlikely goal for the oldest of fourteen children, who, born in abject poverty, made and then spent a fortune realizing his dream.

His wealth had come about partly by accident and partly as the result of hard work and determination. In preparation for Oklahoma statehood in 1907, tribal land held in common was parceled out to individuals. As a member of the Muskogee Nation, Gilcrease received an allotment of 120 acres near Glenpool, twenty miles south of Tulsa. In 1905, it was discovered that his land was on top of one of the richest oil fields in the United States. Gilcrease unwittingly signed away the mineral rights for a fraction of their true value but, after a ten-year legal battle, he regained the rights to his property. In the process he also obtained a good education in oil drilling and leasing, and in 1920 he founded the Gilcrease Oil Company. The income from these ventures was sufficient to permit him to pursue other interests: he travelled extensively and became fascinated with art, artifacts, and archival records.

At first, he collected only as an avocation, but the more he collected, the more obsessed he became. With the acquisition of the Philip Gillette Cole Collection in 1947, Gilcrease realized that he had assembled the finest collection of western Americana in existence. However his wealth was exceeded only by his voracious appetite for collecting and by early 1950 he was deeply in debt. To prevent the collection from being sold, in August 1954 the residents of the City of Tulsa, in a public referendum and by a 3-to-1 majority, approved using public funds to pay off the debts of a private individual. In return, the city became the owner of the collection and the museum. (Gilcrease subsequently repaid the city in full from his oil revenues.)

Thomas Gilcrease spent his final years in the modest house that he had purchased in 1913, close to the collection that he had assembled. He passed away in 1962 at the age of seventy-two, leaving behind a legacy for future generations.

The *Codex Canadensis* has been characterized as "among the least well known early manuscripts describing or illustrating the natural history of North America."[9] Publication of this important volume will allow the *Codex Canadensis* to become better known and appreciated as a true international treasure.

DUANE H. KING
Executive Director, Gilcrease Museum

NOTES

1 Gilcrease purchased the *Codex Canadensis* from Henry Stevens, Son, and Stiles in 1949.

2 Diego Columbus in Hispaniola to Archbishop Cisneros, 1512

3 *Doctrina Christiana* was published in four volumes in 1543–44. They are believed to be the earliest extant copies of published material from the printing press that arrived in Mexico City in 1539.

4 Gilcrease purchased the Declaration of Independence (Cat. Number 4026.901, February 14, 1777) from rare book dealer Philip Rosenbach in 1950 along with Franklin's associated correspondence.

5 The collection includes eleven linear feet of the papers of Principal Chief John Ross (1790–1866), many of which are related to the forced removal of the Cherokee Nation to the Indian Territory in 1838–39.

6 Paula Hall, "Early Glimpses of New France," *Gilcrease Magazine of American History and Art* 13, no. 4 (winter 1991): 28–32.

7 *Les Raretés des Indes, "Codex Canadensis,"* (Paris: Léon Marotte, Librairie Maurice Chamonel, 1930; reprint Montreal: Bouton d'Or, 1974).

8 Anne-Marie Sioui, "Qui est l'auteur du Codex Canadensis?" *Recherches amérindiennes au Québec* 8, no. 4 (1979): 271–9.

9 Henry M. Reeves, François-Marc Gagnon, and C. Stuart Houston, "*Codex Canadiensis*, an Early Illustrated Manuscript of Canadian Natural History," *Archives of Natural History* 31, no. 1 (2004): 150–66.

ACKNOWLEDGMENTS

It is a great pleasure to acknowledge those who from far or near have contributed to the present work. The initial conception of this book goes back to the end of the nineteen-seventies, when one of us consulted Auguste Vachon at the Department of Iconography of what was then the Public Archives of Canada, who had reworked the modernization of the *Histoire naturelle des Indes Occidentales* done by E. Buron in 1903. At the time, ethnographer Marcel Moussette, then at Parks Canada, and Pierre Morisset of the Départment de Biologie, Université Laval, were also interested in the *Codex Canadensis*. We were already thinking of publishing the manuscript of the "Histoire naturelle" and the *Codex* together.

But the main impetus for moving the project forward really came from Saskatoon, where C. Stuart Houston, former professor at the School of Medicine, University of Saskatchewan, and now better known as an expert Canadian ornithologist, had become interested in the ornithology of the *Codex Canadensis* and the "Histoire naturelle des Indes Occidentales." He thought this manuscript should be published and translated into English. In parallel, wildlife biologist Henry M. Reeves, retired from the U.S. Fish and Wildlife Service in Washington D.C., was in contact with Sarah Erwin, curator of archival collections at the Thomas Gilcrease Institute in Tulsa, Oklahoma, where the *Codex Canadensis* is housed.

Previously I had assigned some of my MA students to the task. Very little had been known about the biography of Louis Nicolas before Guy Tremblay's research for his Master's thesis under the supervision of Father Lucien Campeau, S.J. Now the manager of Museum Services, Heritage Branch, in New Brunswick, Guy has kept in contact all these years. Another of my ex-students, Pierre-Simon Doyon, now a professor in the Département des arts, Université du Québec à Trois-Rivières, had devoted an important section of his PhD dissertation to Louis Nicolas's material on Canadian flora and has maintained his interest to this day. We highly recommend his useful website on botanical illustration: http://www.uqtr.ca/arts/histoire/botanique/.

For mammals and fish, the Master's thesis of Dorothée Sainte-Marie, then a student at the Département d'Histoire de l'art, Université de Montréal, was extremely helpful. Dorothée had contact at the time with zoologists and ichthyologists of the Université

de Montréal, who helped us identify these two categories of animals. She was fortunate to have met Professor Emeritus Pierre Dansereau; Ernest Rouleau, then the director of the Institut Botanique de Montréal; Vianney Legendre, a biologist at the Service d'aménagement et d'exploitation de la faune; and Etienne Magnin, Paul Pirlot, and Jean-Pierre Simon, all professors at the Département de sciences biologiques, Université de Montréal. They all took a great interest in her work and have thereby contributed indirectly to our own. More recently, Roch Samson of Parks Canada put us in touch with the historian Alain Bernard, author of the interesting *Étude sur la perception et l'exploitation du milieu marin, 16ᵉ au 18ᵉ siècle,* published by Parks Canada in 1998.

Professor Alain Asselin of the Département de phytologie, Faculté de l'agriculture et de l'alimentation, Université Laval, now retired, was of great help in the section on plants. He contributed not only his knowledge of the flora of Eastern Canada but his interest – wonderful in the present context – in the history of botany in North America. I must also acknowledge a dear Israeli art historian friend and botanist who saved me from a big mistake about the citrus in Europe before the time of Louis Nicolas.

The section on birds profited immensely from the expertise of two ornithologists: Canadian ornithological historian Jeff Harrison, and Michel Gosselin, collection manager at the Canadian Museum of Nature in Ottawa.

Because of Louis Nicolas's knowledge of native languages, especially Algonquian, on which he wrote a *Grammaire,* we needed specialists in linguistics also. Marthe Faribault of the Département de linquistique, Université de Montréal, helped us with the native names of plants; Anna Leighton, ethno-botanist and lecturer at the University of Saskatchewan, did the same from a more ethnological perspective; and John Bishop, then a PhD candidate in history at McGill University, was of great help in identifying the zoological names in the languages of the First Nations.

I am immeasurably grateful to my colleagues Professor Réal Ouellet from Laval University in Quebec and Professor Nancy Senior from the University of Saskatchewan in Saskatoon. I cannot thank them enough for their constant and unflagging support in this long enterprise, their competence in their respective fields, and their enthusiasm for the project. With impeccable care, Réal "read" transcribed the manuscript of the *Histoire naturelle* and put the text into modern French; and Nancy expertly and artfully translated it into perfect English, as well as transcribing and translating the captions of the *Codex Canadensis.* I want also to express my sincere thanks (and admiration) to the excellent team of editors and reviewers – Jonathan Crago, Joan McGilvray, Ryan Van Huijstee, and Jane McWhinney. Without their input, this project would not have seen the light of the day.

THE
CODEX CANADENSIS
and the Writings of Louis Nicolas

INTRODUCTION

Louis Nicolas's Depiction of the New World in Figures and Text

PART I
THE STORY OF THE *CODEX CANADENSIS*

The Thomas Gilcrease Institute of American History and Art in Tulsa, Oklahoma, possesses a magnificent album of pen drawings, some of which are painted with water colours. It is known as the *Codex Canadensis* because its illustrations are clearly devoted to the flora, fauna, and First Nations of Canada.

The history of this manuscript is somewhat obscure. We know nothing about it before 1930, when Maurice Chamonal, a famous Parisian bookseller of antique books known for his interest in Americana, published a fine facsimile entitled *Les Raretés des Indes*, with an introductory essay by Baron Marc de Villiers. This publication raises some questions. Did the manuscript belong to the baron? Was it from the "collection Valtat," as historian Charles de la Roncière suggested?[1] If so, could "Valtat" have been a reference to the fauvist painter Louis Valtat (born in Dieppe in 1869, died in Paris in 1952)? Perhaps it makes sense that a modern painter would have been touched by the naïveté of the *Codex* drawings. Did de la Roncière get the manuscript from Valtat? While this hypothesis cannot be confirmed, Robert Hollier has noted: "In 1930, in Paris, Charles de la Roncière had it in his hands. Not having the means to acquire it for the National Library, he had to resign himself to simply having some facsimiles made which he kept for himself, and letting the original be sold, against his will, to an American collection as it turned out."[2]

In 1934 the manuscript was listed as N° 328 in the catalogue of the Librairie Georges Andrieux (1883–1945), whose owner was an expert in French international trade.[3] It was bought at auction at the Hôtel Drouot, on 18 or 19 June 1934 by an unknown collector, apparently banking on its future value. Fifteen years later, in 1949, it was bought by Thomas Gilcrease from Henry Stevens, Son, and Stiles, a London auction house that had a branch in New York. Sued by his creditors, Gilcrease sold his collection for $2.3 million to the City of Tulsa, and in 1953 the Thomas Gilcrease Institute of American History and Art was founded. The *Codex* became one of the jewels of its collection.[4]

It seems likely that during the fifteen years between the sale at the Hôtel Drouot and the purchase by Thomas Gilcrease in 1949, the manuscript received its present impressive red Morocco-leather binding emblazoned with the arms of Louis XIV and decorated with fleur-de-lis motifs. This binding may have been added to give the impression that the *Codex* had belonged to the Royal Library, but no traces of its existence have been found in the catalogues of the Royal, the Imperial, or the National libraries.[5] One further clue seems to confirm that the binding is recent: there is a curious Anglicism on the back of the book, where we read *Rarety des Indies*, instead of the expected *Raretés des Indes*. Of course, the possibly recent origin of the binding does not mean that the manuscript itself is recent.

THE BÉCART DE GRANVILLE ATTRIBUTION

Neither signed nor dated, the manuscript that Baron Marc de Villiers called *Les Raretés des Indes* or the *Codex canadiensis*[6] raises many questions as to its date and authorship. When was it created, and by whom? The baron could not avoid these questions. He first tried to establish the date of the *Codex*. When this question was solved to his satisfaction, he proposed a possible author. He wrote as follows about the date: "The date of the drawings is not indicated; however, it is possible, for various reasons, to establish with a high degree of probability that they were produced during the year 1701."[7]

De Villiers's opinion is based on three sets of arguments, all of which are taken from the manuscript itself and thus are exclusively internal criticism. His first argument rests on facts given in the first three numbered pages of the manuscript, which contain the dedication. "First, since the dedication to Louis XIV also mentions the name of Philip V, the earliest the album could have been drawn is the end of 1700. Second, the manner in which the author speaks of the wars against Holland and Germany shows that the War of the Spanish Succession had not yet begun."[8]

The mention of Philip V comes from the caption on page 2 of the *Codex* (Pl. 11).

Couronne royalle de france appuyée sur deux globles et sur deux colonnes du plus ultra quy renverse les tours d'argent de castille relevées aujourdhuy par la même couronne de france dans la personne de philipe 5^eme fils de son Altesse royalle Monsey^r Le dauphin et petit fils de louis le grand [Royal Crown of France supported by two globes and two columns of the *plus ultra*, which overthrows the silver towers of Castile, re-established today by the same Crown of France in the person of Philip V, son of His Royal Highness the Crown Prince of France and grandson of Louis the Great].

De Villiers's mention of Holland and Germany is supported by the captions on the two other initial pages (Pls. I and III). The Netherlands are referred to on the first page:

Massue royalle de france, qui a Par la force de sa Couronne renversé presque toute la Hollande Représantée par ce Lion renversé qui est les amories de Hollande. Les serres du lion renversé quon voit dans cette page marquent les victoires de Louis Le grand devant qui toute la Hollande trembla dans les

guerres que le Roy avoit contre les Hollandais [Royal mace of France, which has
by the force of its Crown overthrown almost all Holland, represented by this
overturned lion which is the coat of arms of Holland. The claws of the over-
turned lion seen on this page mark the victories of Louis the Great, before
whom all Holland trembled in the wars that the King waged against the Dutch].

The third page speaks about Germany:

Eccusson de france qui porte un soleil si brillant quil éblouit les aigles d'Ale-
magne. En un mot cela veut dire que la france a bien battu laglemagne du tems
du grand Turene, qui a esté la terreur des Ennemis de Louis Le grand [Escut-
cheon of France, which bears a sun so brilliant that it dazzles the eagles of
Germany. In a word, this means that France thoroughly defeated Germany in the
time of the great Turenne, who was the terror of the enemies of Louis the Great].

As a well-trained historian, de Villiers wanted to establish his *terminus a quo* and his
terminus ad quem.

Since Philip V acceded to the throne of Spain in 1700 and the War of Succession
began in 1701, de Villiers was left with little latitude for dating the manuscript: late 1700
seemed the only logical date. He was also struck by the fact that, rather than mention-
ing the War of the Spanish Succession, which began in 1701, the author of the *Codex*
chose to speak of earlier battles with Holland and Germany.

The Dutch war was the so-called Guerre de Dévolution, Louis XIV's first war of
conquest. Marie-Thérèse of Austria, whom he had married in 1660, had renounced her
right to the Spanish succession in exchange for a dowry of 500,000 gold écus. Since this
dowry was never paid, Louis XIV used this default as a pretext to claim the rights of
the queen. When in 1665, at the death of Philip IV, Charles II, a son of his second
marriage, acceded to the throne, Louis XIV triggered a judicial battle by publishing a
Traité des Droits de la Reine. Basing his argument on an old Brabantine usage that stated
that only children of a first marriage had the right of inheritance from their father, he
claimed that the right of succession should fall to Marie-Thérèse, Philip IV's daughter
by his first marriage. While this legal battle was taking place, Louis's military advisors,
Marshall Turenne, the Marquis de Louvois, and the Marquis de Vauban, were prepar-
ing for a military offensive.

The Guerre de Dévolution itself was very short, beginning in 1667 and ending
the following year. After the ruinous and bellicose reign of Philip IV, Spain was unable
to defend far-off Holland, and France's victory was sealed by the Treaty of Aix-la-
Chapelle, signed in 1668.[9]

When the author of the *Codex* mentions the war with Germany and the "great
Turenne," he is referring to a slightly later period, since this war took place in 1673–74
and Turenne died in 1675 at Sasbach.[10]

The date of 1700 thus seems well established. I can only add one small remark to
de Villiers's expertise. It seems clear that the captions in the *Codex* were written *after*
the drawings were done, not at the same time. The captions – and this is true also of the
page and figure numbers – are written around the figures, filling the gaps between
them. There are cases where the writing overlaps the image but no cases of the images

INTRODUCTION: *Louis Nicolas's Depiction of the New World*

overlapping the writing. The drawings thus appear to have been completed before the captions and figure numbers were added. In other words, there was a time when the *Codex* was without captions or page and figure numbers.

In the case of one of the dedications (Pl. 11), this observation is of some consequence. If we compare the drawing with the text of the caption, it appears that the drawing illustrates only the *first part* of the caption – "Royal Crown of France supported on two globes and on two columns of the *plus ultra* which overthrows the silver towers of Castile" – since in the drawing, the towers of Castile are shown upside down. After 1700, when it is assumed that the captions were written, it was not possible to let this description stand: it was necessary to add, "re-established again today by the same crown of France in the person of Philip V."

If the drawings of the *Codex* were done before the captions, it is difficult to determine how much before.[11] It also raises the question of the drawings' authorship. Were they done by the same hand that wrote the captions? Before answering this question, let us finish our review of the de Villiers argument for the author and date of the *Codex*.

Giving 1700 as the probable date of the *Codex*, de Villiers proposed that it had been created by Bécart de Granville. The correspondence of Governor Louis-Hector de Callières and the intendant Bochart de Champigny tells us that in 1701 Mr de Granville was the only person in Canada able to draw a map.[12]

We know as well that Charles Bécart de Granville et de Fonville was born in Quebec in 1675 and died there in January 1703. In 1700 he succeeded his deceased brother as attorney general of the Provostship of Quebec.[13] Would his duties have allowed him enough time to draw maps and even to teach drawing in the colony? It seems that de Callière and de Champigny thought so, since they wrote the following to the Minister of the Marine on 18 October 1700:

> La grande facilité qu'il a pour le dessin, et l'offre qu'il fait pour l'enseigner, nous portent à supplier Sa Majesté de lui accorder quelque gratification annuelle pour procurer ce bien au pays où il se trouve seul capable de faire une carte, ce qui ne le détournera point de l'application qu'il doit donner à son emploi [His great facility in drawing and his offer to teach it, encourage us to beseech Your Majesty to grant him a yearly bonus, in order to obtain this service for the country, where he is the only one able to draw a map, and which will not distract him from his main occupation (that is, attorney general)].[14]

Evidently, this was a letter of recommendation and some exaggeration should be expected.

Despite these clues, however, the attribution of authorship to Bécart is not completely convincing. What if the *Codex* was completed not in Canada but in France?

LOUIS NICOLAS AS AUTHOR

Newly revealed facts have made it possible to dismiss Bécart de Granville as the *Codex*'s author, based on information about and from the manuscript titled "Histoire naturelle des Indes Occidentales,"[15] which has been the object of study for some time. Compris-

ing 196 folios, this manuscript is neither signed nor dated, except for the initials M.L.N.P. on folio 1. The history of this manuscript is better known than that of the *Codex*, however. On folio 197, the "Histoire naturelle" bears the *ex-libris* of Pierre Maridat, a jurist from Lyon and "seigneur de Servières." He had the manuscript of the "Histoire naturelle" in his possession until his death in 1689.

The indication "Oratoire 162" on folio 1 shows that after Maridat's death it belonged to the library of the Congrégation de l'Oratoire, a famous meeting place of the erudite during the eighteenth century. (Unfortunately, there is no mention of the manuscript in the catalogue of this library.) Later, after the Revolution and the dissolution of the Congrégation de l'Oratoire, the manuscript found its way to the Bibliothèque nationale de Paris, where it resides today.

From comments within the manuscript, is seems that the author of the "Histoire naturelle" had previously written a "Traitté des animaux à quatre pieds terrestres et amphibies, qui se trouvent dans les Indes occidentales, ou Amérique septentrionale,"[16] which can be considered to be a first draft of the "Histoire naturelle."

These manuscripts are relevant, because certain passages of the "Histoire naturelle" seem to refer the reader to illustrations, and one invariably finds these illustrations in the *Codex*. Could it be that these two manuscripts are related and that both can be attributed to the same author?

We have to be careful in our reading of the "Histoire naturelle." It is not always clear whether the author, in speaking of a *figure* or a *portrait*, is referring to a drawing or to a description in words. As a rule, *figure* seems to refer to a picture, a drawing, while *portrait* is more likely a description. For instance, the author devotes one section to the "great American wild ox which the barbarians call pichikiou" and affirms that he has "made here its portrait" (f. 87). Even though a "pichikiou" is depicted in the *Codex* (Pl. xxxv), one hesitates to translate *portrait* other than as a description in words, since he says "here," i.e., in the "Histoire naturelle." On the other hand, when starting his description of the moose with the words, "I think that to begin with, it would be good to provide a figure of this celebrated animal" (f. 91), he is probably referring to the drawing that appears in the *Codex* (Pl. xxxvi). But two pages later, when he concludes: "This is the portrait of the exterior of the moose," he probably means the word description that he has just provided.

The references to depictions of birds in the "Histoire naturelle" should be similarly interpreted. When the author says, "the bird that I represent here," he most likely means the "many-coloured porcupine bird" mentioned in the "Histoire naturelle" rather than the image in the *Codex* (Pl. xlii). The same remark can be made about the "anonymous bird," which is mentioned on the next folio and is also drawn in the *Codex*.

Of the "rainbow-coloured trout," the author declares: "This fish is made to be painted" (f. 183). Very nice, but did he do it? One thing is certain: the *Codex* has three representations of trout: the "common trout," "another species of trout," and "the big and great trout" (Pls. lxi and lxii). It is difficult to determine which of these the "Histoire naturelle" was referring to, since the author did not standardize his nomenclature.

There are instances, however, when he seems to make a clear distinction between a word description and a figure, presumably a drawing. For instance, this is what he declares toward the end of the "Histoire naturelle": "I will present [falconry] to you after the pages where I discuss the birds seen in the Indies. If, after all that, you would

like to go fishing, you will see many agreeable places that I will indicate, filled with every kind of fish not seen in Europe, whose names, figures, and portraits I will give you at the end of my natural history" (f. 128).

Concluding his description of the "lemon of Virginia," the author declares: "I provide a figure of it" (f. 11), and indeed one finds a drawing of it in the *Codex* (Pl. xxv). Of the caribou, he assures the reader: "the figure I made of this animal is perfectly true to life" (f. 81), and there is an image in the *Codex* (Pl. xxxiv). Sometimes, he distinguishes the verbal representation from the drawing, as for instance when he speaks of the muskrat "of which I gave a portrait by a figure, in which I think I have represented the animal as well as possible in a figure" (f. 109). The drawing of which he was so proud is probably the one found on Plate xxxviii of the *Codex*, with the caption: "Ouatchas ou rat musché [Outchas or muskrat]." Of the "sea horse" also, drawn in the *Codex* (Pl. xl), the author affirms: "Since this animal is well known … I will just give an exact representation [*la figure fort exacte*] of it" (f. 123), meaning a drawing.

One can again see an implicit reference to a drawing in the following notation about "the small and the large white fish." "The Latin and the French authors do not say a word about them, and do not give a picture [la figure] of them, not even Rondelet, who undertook to give us information about many fish, both saltwater and freshwater" (f. 177). The *Codex* shows both kinds of fish, (Pls. lix and lx). Finally, about the cod, he says: "I provide a very careful drawing of it [la figure fort recherchée], and since it is quite similar to a trout and since the drawing shows that it is very similar to those seen everywhere in France, there is no need to discuss it further" (f. 186). Such a figure can be seen on Plate lxiii of the *Codex*.

In all these instances, there is no clear indication of where one could see these drawings. But there are other mentions in which the author seems to refer to a specific group of drawings when he speaks of "my figures." On folio 122 of the "Histoire naturelle" he deals with a mythical animal that he describes as "an evil spirit known in the native tongue as Matchi Manitou or Michipichi," which is probably a walrus. Two things should be noticed about this case. First, the author clearly makes the distinction between a literary *portrait* and a drawn *figure*. "This animal, being monstruous, would be better known by the drawing [la figure] that I have made of it than by my inadequate description [ma description grossière]" (f. 122). Such a "monster" appears in the *Codex* (Pl. xxxix) with the caption: "misipichik or the Water God according to the Americans." But there is more. Being particularly proud of his drawing, the author mentions it again on folio 161: "They [the Natives] think [that the great god of the sea] is a huge monster that they call Michipichi, whose portrait I give in my figures [mes figures]." He now speaks of "his figures" as if they constitute a specific manuscript.[17]

Referring directly to a drawing about the fishing technique of the Indians, he says: "I gave a picture of the net in my figures" (f. 181). This indication is precious: it is one of the rare examples of a reference to the section devoted to the representation of Native people in the *Codex*.

But on one notable occasion, the author refers to something even more specific than "his figures." Speaking of the Inuit kayak, he says: "I have drawn it and given a description of it in my book of drawings [mon traité des figures]" (f. 122). One can see the kayak at the top of Plate xvii of the *Codex* with the caption, "canoe made of a marine tiger skin." The reader will have noticed the expression, "my book of drawings,"

as if the author were referring to a separate work in which all his drawings were collected – precisely as the *Codex* has been transmitted to us.

It seems, then, that if we can identify the "M.L.N.P." mentioned on folio 1 of the "Histoire naturelle" we will be on the right track to ascertaining the possible authorship of the *Codex*. And, as a matter of fact, there is one other instance where these initials can be found: in a *Grammaire algonquine*, known since about 1874, when the Canadian archivist Douglas Brymner, father of the celebrated landscape painter William Brymner, discovered it in the Bibliothèque nationale in Paris.[18] On the first page of the *Grammaire*, we read, in a hand different from the author's:

> Grammaire algonquine ou des Sauvages de l'Amérique septentrionalle, avec la Description du Pays, journaux de voyages, memoires, Remarques sur l'Histoire naturelle, etc, etc. Composé à ce qu'il paroist en 1672, 1673, 1674 par Louis Nicolas, Prêtre Missionnaire, natif de la ville d'Aubenas en Languedoc [Algonkian Grammar of the Natives of North America with the Description of their Country, diaries, memoirs, and notes on natural history, etc, etc. Composed, as it seems in 1672, 1673, 1674 by Louis Nicolas Missionary Priest, native of the city of Aubenas in Languedoc].

The author of this title page, whoever he may have been – an archivist, a priest, a collector? – was in fact deciphering the dedication that appears at the end of folio 6, clearly in the hand of the author, but full of abbreviations.

> Voilà le présent sauvage que vous fait Mon[seigneur] V[ostre] t[rès] o[béissant] s[erviteur] L[ouis] N[icolas] d[e] l[a] c[ompagnie] d[e] J[ésus] n[é] d[ans] l[a] v[ille] d'A[ubenas] en Vivarès[19] par Louis Nicolas, p[restre] missionnaire. [Here, My Lord, is the wild present that Louis Nicolas, your very obedient servant from the Company of Jesus, born in the city of Aubenas in the Vivarais, is offering to you. By Louis Nicolas, priest and missionary].

But how to explain that the initials L.N.M.P. have been replaced by M. L.N.P. in the "Histoire naturelle"? This question will be answered toward the end of this Introduction.

In summary, the indications of authorship of both the "Histoire naturelle" and the *Codex* are varied and strong. First, the author of the *Grammaire algonquine* is identified on the manuscript as "M.L.N.P." (the very initials we find on the "Histoire naturelle"), and later as "Louis Nicolas, P. Missionnaire," written in full. This author refers to his "histoire naturelle des simples, des arbres, des fruicts, des oiseaux, des poissons et des animeaux" – a phrase exactly descriptive of the "Histoire naturelle" and similar in wording to its subtitle. The "Histoire naturelle" in turn frequently mentions the author's "figures" and even speaks on one occasion of a "traité des figures." Since the textual correspondences and similarities in order of presentation between the "Histoire naturelle" and the *Codex* are far too numerous and too close to be accidental, this "traité des figures" can be none other than the *Codex*. And finally, according to the analysis of Germaine Warkentin, professor emeritus at the University of Toronto, the manuscripts of all three of these works are in the same handwriting.[20]

INTRODUCTION: *Louis Nicolas's Depiction of the New World*

So we can reasonably conclude that the *Codex*, the "Histoire naturelle," and the *Grammaire algonquine* were almost certainly all by the same author – Louis Nicolas, a Jesuit. The attribution to a priest is strengthened by the author's statement on folio 74 that his desire to send his tame bears to France was thwarted by his "compagnons missionnaires [fellow missionaries]." It is clear, by the way, that "M.L.N.P." cannot stand for Bécart de Granville!

LOUIS NICOLAS

Who, then, was Louis Nicolas?[21] The least we can say is that he was not your ordinary Jesuit. For instance, we learn from folio 73 of the "Histoire naturelle" that he succeeded in taming two bears and having them perform circus tricks on the ground of the Sillery residence of the Jesuits near Quebec. We are also told that his colleagues complained about it – which seems understandable!

Born in Aubenas in the Ardèche on 15 August 1634 and baptized on 4 September at the parish church of Saint Laurent,[22] Louis Nicolas entered the Company of Jesus on 16 September 1654 in Toulouse, a few months after his mother's death. The *Journal of the Jesuits* fixes his arrival in Canada as 25 May 1664. "Un vaisseau de Normandie conduit par le sieur Filis arriva le mesme jour ou estoit le P. Louys Nicolas de la province de Toulouse [A ship from Normandy under the captainship of Mr. Filis arrived the same day with F. Louis Nicolas from the Province of Toulouse on board]."[23]

The captain and the ship have been identified. Pierre Fillye, from Brest was the captain of the *Noir de Hollande*, which brought fifty-one new colonists – fifty men and one woman – to New France.[24] Nicolas never mentions the captain specifically. However, he speaks in his "Traitté des animaux à quatre pieds" of a journey he made with "un hollandois qui avoit esté a la pesche de la Baleine [a Dutchman who had been fishing whales]." He repeats the same information on folio 191 of the "Histoire naturelle": "I made a journey of close to 1,400 leagues with a Dutch captain who had just returned from whale fishing." On folio 80 he goes further, giving us his name as "the Dutch captain Pitre."

"Pitre" is probably a deformation of the Dutch Pieters. At the time, the French leased Dutch ships for commercial purposes and, since the Dutch insurers did not trust French captains, they insisted that a Dutch captain be on board while the ship was in French service. So it is quite possible that a Captain Pieters was with Captain Pierre Fillye on a ship called *Noir de Hollande*.

But things are not quite so simple. Nicolas mentions the name of another captain that he supposedly met at an earlier date. A passage on folio 59 of the "Histoire naturelle" reads as follows:

> Rabbits are not seen in the New World except on Bonaventure Island … Captain Poulet treated us to this game on his ship when we met him at anchor in Bonaventure Harbour on 15 May 1661.

That a Captain Poulet could have been at anchor at Bonaventure Island on 15 May 1661 is not impossible. We know from the *Journal des Jésuites* that Poulet was in Quebec on 22 August 1661. "Le 22. arriva le premier vaisseau, de Laurent Poulet, où estoit Mr.

Moret, prestre [On the 22nd, the first ship arrived, under Laurent Poulet, with Mr Moret, priest, on board]."

We hear again of Captain Poulet in the *Journal*, September 1661: "Le 1. partit Mons. le nouveau Gouverneur pour la visite de Montreal & des Trois Rivieres. Il en retourna le 19. & le mesme jour partit le vaisseau de Poulet, où estoit M. le Viconte d'Argenson, ancien gouverneur [On the 1st, Sir, the new governor went to visit Montreal and Trois-Rivières. He was back on the 19th, and Poulet's ship left that same day with Mr Viscount d'Argenson, the former governor]."[25] But how to explain that a young Jesuit could have made a trip to New France when still a student? Is it possible that his arrival in Quebec with Captain Fillye in 1664 was not his first trip in Canada? Or should we dismiss this suggestion as a pure invention?[26] But how then do we explain that on folio 82 Nicolas speaks of his "first trip to the Indies," as if there had been at least two. The possibility of two trips seems even more likely when we consider the context of this mention.

Nicolas speaks of a visit he made to "My Lord the Dauphin [Heir apparent] … on my way back from my first trip in the Indies." He gave the Dauphin a pair of snow-shoes, "done by the cleverest of the Montagnais women" and had a conversation "for more than two hours" with the young prince, "in the presence of my Lords the princes of Conti and la Rochesurion and all his court at Saint-Germain-en-Laye" (f. 82). This must have happened at a later date: the son of Louis XIV, born in 1661, even as preco-cious as he appears to have been, would not have been able to ask "the most beautiful questions in the world for more than two hours" in the year of his birth. The two princes mentioned were probably Louis-Armand de Bourbon, prince de Conti (1661–1685), and his younger brother, François-Louis de Bourbon, prince de La Roche sur Yon (1664–1709).

The only thing we know for certain about Nicolas in the year 1661 is that he was sent to Tournon to do a second philosophy course, as was the practice for Jesuits. We know also that on 4 December 1661 he wrote to Father Jean-Paul Oliva, the vicar gen-eral of the Company, about his long-standing desire to become a missionary in Canada. If he took part in this trip, let us say in the summer of 1661, the journey might have rekindled his desire to depart for Canada and would explain his request to the Vicar General. In this letter he mentions an encounter with Father Le Jeune.

> Iam vero cum a R.P. Paulo Le Jeune, missionum canadensium superiore dig-
> nissimo, acceperim aliquot e Societatis nostrae scholasticis illuc posse mitti
> ut philosophiae theologiaeque operam navantes Canadensium linguas perdis-
> cerent, operae pretium esse duxi hasce ad vestram Paternitatem literas scribere
> ut hanc a vestra Paternitate gratiam peterem [And since I have learnt from
> Rev. F. Paul Le Jeune, very praiseworthy Superior of the Canadian Missions,
> that it was possible to send some students from our Company to have them
> learn the languages of the Canadians, at the same times as their philosophy
> and theology, I thought I was authorized to write this letter to you Father and
> to ask you this grace].[27]

At the time, Father Le Jeune was no longer the Superior of the Canadian Mission, but he still held the position of procurator. Could the young student Nicolas have met him in Canada? It is not certain that Le Jeune was in Canada in 1660–61. The Abbé Auguste Gosselin thought so,[28] but Camille de Rochemonteix did not.[29] Léon Pouliot, basing

his opinion on the writings of Marie de l'Incarnation and other sources, agrees with Gosselin that a meeting in Canada was a possibility.[30]

If Nicolas had met Le Jeune in Canada during this first voyage, he might have discussed with him the project of returning there to learn the languages of the Natives. After all, it was not completely unthinkable that a young Jesuit could make a trip to New France during his studies.

Thirty years old when he arrived (for the second time?) in Canada, Nicolas had not yet finished his studies. He was sent immediately to the Sillery Residence to study theology and one of the native languages, as we learn from the *Catalogue*, the yearly list of Jesuits and their whereabouts kept by the Superior in France: "Pater Ludovic[us] Nicolas. In Residentia Silleriana. Studet linguae algonquinae et montanae [Father Louis Nicolas. At Sillery Residence. He is studying Algonquian and Montagnais]."[31] It is clear that the native languages interested Nicolas immensely. He seems, on the other hand, to have had less interest in theology: "Profectus in letteris et in theologia parvus [Proficient in letters, weak in theology]."[32]

While a student in Sillery, Nicolas was tempted to travel around the country. We find him at Trois-Rivières in 1665. The *Journal* notes that he came back from there on 13 October, "malade d'une fièvre continue [sick with fever]."[33] He was still in Sillery in 1666,[34] but on 25 November 1666 we find him again in Trois-Rivières, where he celebrated a marriage at the Church of the Immaculate Conception.[35] We also learn that a few days later he was sent into the Algonquian hinterland to fight alcoholism among these people:

> Le 4 [janvier 1667] on mande du Cap de la Magdeleine que le P. Louys Nicolas est allé pour deux ou 3 mois dans les terres avec les Algonquins, pour les tirer de l'occasion de l'yvrognerie, qui est plus grande que jamais [The 4th (of January 1667). They write us from Cap de la Madeleine that Father Louys Nicolas has gone for two or three months into the interior with the Algonquins, to remove them from the temptation of drunkenness, which is greater than ever].[36]

A possible reflection of this contact with the Algonquins is found in the *Codex*. On Plate XIX we are shown not only "a bark house in the Algonquin style" but also snow shoes, moccasins, and "a dog pulling a fish called *mame* or sturgeon," all of which Nicolas could have seen during the winter he spent with them in 1667.

Three different species of sturgeon are described on folio 185 of the "Histoire naturelle": the small one, the middle-sized one, and the big one. It is probably the last of these that is depicted in the *Codex* (Pl. XIX). Nicolas mentions also that the natives used this fish to make the glue with which they affixed stone points to their arrows.

Since he was gone "for two or three months" among the Algonquins, Nicolas was probably back in Quebec in March at the latest. What is certain is that on 29 May 1667, he was admitted to say his final vows.[37] He was then ready to do real missionary work. On 4 August of the same year, Father Claude Allouez came back from Chaquamegon, a site on the southwest bank of Lake Superior, to recruit a missionary and some workers for this distant mission.[38] The choice of Nicolas was well considered. In these regions they needed someone who, if not fluent in the Algonquian language, had at least some training in it. This was exactly the case with Louis Nicolas, future author of a *Grammaire algonquine*.

The *Journal* informs us of what happened: "Le 6. Le P. Allouez se rembarque avec nostre frere le Boesme, trois braves hommes & un jeune garçon. Il prendra le P. Nicolas à Monréal [6 (August) 1667. Father Allouez re-embarked, with our brother le Boesme, three worthy men, and a young lad; he will take on Father Nicolas at Montreal]."[39] These details are confirmed by the *Relation* of 1666–67, written by Father Jacques Bordier, Provincial of the Province of France, based on information given to him by Father Lemercier.

> Après avoir sejourné deux jours seulement, il fit telle diligence qu'il se mit en estat de partir de Montreal, avec une vingtaine de canots de Sauvages, avec lesquels il estoit descendu, et qui l'attendaient en cette Isle là, avec grande impatience. Son équipage estoit de sept personnes, le Père Louys Nicolas, avec luy, pour travailler conjoinctement à la conversion de ces peuples; & un de nos frères, avec quatre hommes pour s'employer sur les lieux à leur subsistance [After a stay of only two days, he was ready, so diligent had he been, that he was ready to start from Montreal with a score of canoes of Savages with whom he had made the descent, and who were waiting with great impatience for him on that Island. His party consisted of seven persons – Father Louys Nicolas and himself, to labour in unison for the conversion of those people; and one of our brethren, with four men, to be employed for their maintenance at the scene of action].[40]

The natives did not want to be overloaded – on such a trip, you carry on your back everything you bring with you. Undeterred, the missionaries decided to go anyway. Neither Allouez nor Nicolas was impressed by the "reasonable doubts" raised about their enterprise. In the end they were vindicated, as we learn from Marie de l'Incarnation, in a letter to her son, dated 1 September 1668:

> On croyait qu'il était mort avec le révérend Père Nicolas et un bon Frère, parce que l'on n'en avoit point entendu de nouvelles. L'on a appris depuis que ces barbares les reprirent dans leurs barques, mais sans provisions ni commodités. Enfin Dieu les a protégés et après des peines inconcevables, ils sont arrivés dans ces grands et vastes pays. De là, ils poussèrent vers les nations qu'ils avaient déjà en partie catéchisées, où ils ont gagné beaucoup d'âmes à Dieu [We believed that he was dead and with him the Reverend Father Nicolas and a good Brother (Louis de Boëme), because we had had no news. We have since been informed that the barbarians took them back in their barks, but without provisions or conveniences. In a word, God protected them and, after incredible difficulties, they arrived in those great, vast countries. Thence they pressed on toward the nations they had already partly catechized, where they gained many souls for God].[41]

It is probably to this trip that Nicolas alludes in the "Traitté des animaux à quatre pieds," when he wrote, for instance, on the subject of bears:

> Lorsque les Outaouaks estoient loges au fons du grand lac Tracy a 500 lieues de [folio 24v] Quebek sur la pointe de Chaquamoigoung ou ils avoient fait un

village, tout l'hyver, que je feus avec eux, J'en vis apporter de monstrueux [ours],
qu'ils alloient tirer à sept ou huit journées de la [When the Oreille nations were
living on the land at the end of the Tracy Sea, 500 leagues from Quebec City, at
Chagouamoigoung (Chaquamegon) where they had built a village, all through
the winter that I spent with these peoples I saw them bring huge bears that the
young men went to hunt seven or eight days from there]. (f. 24 v.)

What is more, in a section devoted to the moose, Nicolas mentions "le pere dalloués."[42]

Allouez and Nicolas reached Chaquamegon, their destination. Allouez then left
Nicolas at Chaquamegon and continued on alone up the Baie des Puants (Green Bay),
where he founded the Saint François-Xavier Mission. Nicolas was left in charge of
the Mission du Saint-Esprit at Chaquamegon. This site was an important commer-
cial centre, and many tribes visited it annually to exchange their products and get
arms and munitions from the whites. This traffic made it especially attractive to the
missionaries. Even though Chaquamegon was in "Outaouaks (Ottawa)" territory,
a part of the Northern Algonquin territory, contact with many other tribes was pos-
sible there.[43]

The Ottawa were the descendants of a group known to Champlain as "les Cheveux-
Relevés [the Standing Hair]." One "Sauvage de la nation outaouaks [man of the
Outaouak nation]," with his tobacco pouch, his pipe and his characteristic hairdo, is
represented in the *Codex* (Pl. vi). On his "*Carte generale du grand fleuve de S. Laurent
qui a esté decouvert plus de 900 lieues avant dans les terres des Indes Occidentales [Gen-
eral Map of the great Saint Lawrence River which has been explored more than 900 leagues
inland in the West Indies]*,"[44] Nicolas situated them, as "Cheveux relevez," on the shores
of Lake Huron ("la Mer Douce"), between the Hurons in the north and the Neutrals in
the south. Traditionally, or at least during the time of Champlain, the Cheveux Relevés
were concentrated more to the north on Manitoulin Island. It is there also that Father
François Du Creux situated them on his 1660 map as "*natio surrectorum capillorum.*"
They were allies of the French and the Huron. After the destruction of the Huron in
1648–49, the Iroquois turned against the Cheveux Relevés, who fled first to Green Bay
in Michigan. Later, driven away by the Sioux, whom they had unwisely attacked, they
ended up at Chaquamegon, where Father Nicolas found them.[45]

It was probably during the time of his stay at Chaquamegon that Nicolas met
Iscouakité, an Ottawa chief, who was a great enemy of the Iroquois and the Sioux.
Nicolas provides a portrait (Pl. xiv). The caption reads:

Portrait d'un Illustre borgne, ce Capitaine eut un œil crevé d'un coup de fleche.
Il a esté grand guerrier et la terreur de diverses nations du [voi]sinage de son
pais. Il hasrangue ses soldats au travers d'un tube d'escorce de bouleau. Il les
exorte a lescouter, Leur disant: *pissintaouik nikanissitik*, escoutes moy mes freres.
Il s'apelloit Iscouakité qui veut dire le tison allumé [Portrait of a famous one-
eyed man. This captain had one eye put out by an arrow. He was a great warrior
and was the terror of many surrounding nations. He is addressing his soldiers
through a birch bark tube. He urges them to pay attention to him, saying: *Piss-
intaouik Nikanissitik*,[46] Listen to me, my brothers. He was called Iscouakité,[47]
which means "burning fire-brand"].

Among the occasional visitors to Chaquamegon, Father Claude Dablon, in his *Relation*, mentions the Illinois and the Sioux.[48] It is notable that both are represented in the *Codex*. On Plate v we see a "Capitaine de la nation des Illinois … armé de sa pipe et de son dard [Captain of the Illinois Nation … equipped with his pipe and his spear]." Further along we find a a "Roy de la grande nation des Nadouessiouek … armé de sa massue de guerre qu'on nomme *pakamagan*. Il regne dans un grand Païs au deslà de la mer Vermeille [King of the great nation of the Nadouessiouek (Sioux) … armed with his war club, which is called a *pakamagan*. He reigns over a great country beyond the Vermilion Sea]" (Pl. viii). The Sioux mentioned here were the Eastern Dakota, who were then living in the present state of Minnesota, west of Lake Superior. Only after 1700 did they move even farther west.[49]

A letter from Father Allouez, then at the Mission of Saint François-Xavier at Green Bay on Lake Michigan, establishes that the Mascouten were another tribe that visited Chaquamegon.

> En cette Baye, en un lieu qu'ils appelent Oüestatinong, à vingt cinq lieuës de là, il y a une grande Nation nommée Outagami, & à une journée de celle-cy, il y en a deux autres, Oumami & Makskouteng: une partie de tous ces Peuples a eu connoissance de nostre Foy, à la pointe du saint Esprit, où je les ay instruits [On this Bay (Green Bay) in a place they call Ouestatinong, twenty-five leagues away, there is a large Nation named Outagami, and a day's journey from them there are two others, Oumami and Makskouteng. Of all these Peoples, a portion gained knowledge of our Faith at Pointe du Saint Esprit (Chaquamegon), where I instructed them].[50]

The Mascouten mentioned here by Father Allouez, who lived at the extreme south of Lake Michigan near the portage between the Kankakee and St Joseph rivers, were located even further away. They must have made quite an impression in Chaquamegon, since in the *Codex* (Pl. xii), Nicolas shows a "sauvage des Mascoutensak qui est la nation du feu … armé de son bouclier, de son dard, et de ses flèches [Mascouten, from the Nation of Fire … equipped with his shield, his spear, and his arrows]."

Finally, it is possible that the "portrait d'un homme de la nation des *Noupiming-dach-irinouek* [portrait of a man of the Nopeming Nation][51] (Pl. ix) was intended to show an example of a member of the Northern Nations who also wanted to do business at Chaquamegon. On the *General Map*, the Nopening are situated to the west of Lake Timiskaming, in Ojibwa territory. Were they Ojibwa? It is hard to know. It is probably better to consider them simply as Algonquin of the Middle Tier.[52]

The Indian iconography of the *Codex* is rich and complex. While we could not find any model for the portrait of le Borgne, it can be shown that three of the five *Codex* drawings just discussed were directly inspired by Du Creux's engravings of the *Historiae Canadensis seu Novae Franciae Libri Decem ad annum usque Christi* MDCLXIV *auctore Francisco Creuxio, E Societate Jesu*, 1664,[53] as if the author of the *Codex*, unsure of his drawing skill, wanted to lean, at least for the contours of his figures, on the engravings of Du Creux. The Sioux (*Codex* Pl. viii) is derived from Plate i in Du Creux (fig. 1); the Ottawa (*Codex*, Pl. vi), from Plate iv (fig. 2), and the Nopeming (*Codex*, Pl. ix) from Plate vi (fig. 3).

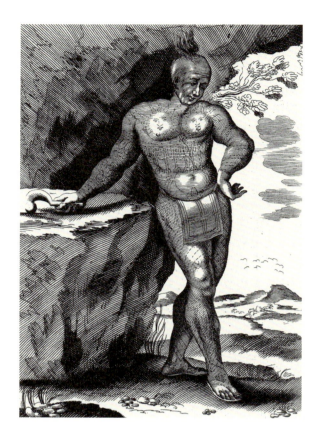

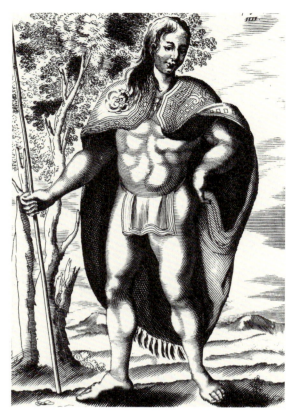

(*Clockwise*)
Fig. 1
Plate I in Du Creux, *Historiae Canadensis seu Novae Franciae Libri Decem*, 1664.

Fig 2
Plate IV in Du Creux, *Historiae Canadensis seu Novae Franciae Libri Decem*, 1664.

Fig 3
Plate VI in Du Creux, *Historiae Canadensis seu Novae Franciae Libri Decem*, 1664.

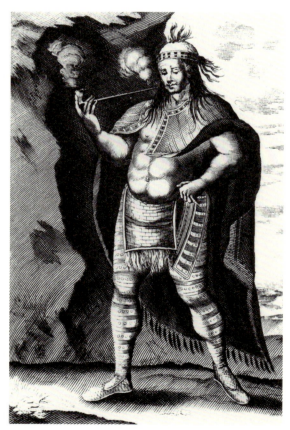

The upper body of the Sioux as represented in the *Codex* retains many details from the Du Creux engraving: the standing hairdo, the club in his right hand, the position of the left arm, and the tattoos representing the sun and the moon on his chest. But Nicolas added the fantastic pipe and the tobacco pouch. Curiously, the smoke coming from the Sioux's mouth corresponds to the branch in Du Creux's engraving.

The figure of the Ottawa is further from its model, since the *Codex* omits the spear and the cape, and adds a pipe and a pouch. In addition, a huge sun tattoo appears on the chest of that figure. One could say the same of the Nopeming, who is holding a tomahawk ("ouakacoua l'hache de guerre") instead of a pipe and does not wear a cape as does the corresponding figure in Du Creux's plate.

While the *Codex* bears witness to Nicolas's ethnographic interests at Chaquamegon, the *Jesuits Relations* are rather ambivalent about his "missionary" success.

> Les Pères Claude Allouez et Louys Nicolas ont passé par ces épreuves; et si les pénitences et les mortifications contribuent beaucoup à la conversion des âmes, on peut dire qu'ils mènent une vie plus austère que celle des plus grands pénitents de la Thébaïde; et ne cessent pas pourtant de s'employer infatigablement à leurs fonctions apostoliques [Fathers Claude Alloëz and Louys Nicolas passed through these trials; and if penances and mortifications contribute greatly to the conversion of Souls, it can be said that they lead a life more austere than that of the greatest Penitents of the Thebaid, and yet do not cease to occupy themselves indefatigably in their Apostolic functions].[54]

Perhaps, but the *Relations* say nothing about the conversions that these penances and mortifications should have led to. Not a year passed before Nicolas was back in Quebec. The very last line of the unfinished *Journal des Jésuites* reads: "*Le 21 juin 1668: Le père Nicolas &c.* [The 21st of June 1668: Father Nicolas etc.],"[55] probably to indicate the date of his return in Quebec. What happened? The *Relations* do not answer that question. A letter written by Marie de l'Incarnation dated 1 September 1668 gives us one hint.

> Le révérend Père Nicolas, nonobstant ses fatigues, est revenu sur ses pas pour amener ici une nation de sauvages qui n'avaient jamais vu d'Européens. Ils ont tous le nez percé avec quelques grains de poils de bêtes d'une belle couleur qui y sont pendus. Ils étaient très chargés de castors qui ont bien accommodé nos marchands. Ils ont été si satisfaits des Français qu'ils ont résolu de venir ici après leur traite avec eux. Les Outaouaks leur avaient fait entendre que les Français les feraient brûler s'ils passaient outre, mais ils ont reconnu depuis que ces barbares les entretenaient dans cette crainte afin d'avoir leur pelleterie pour rien et de les venir traiter eux-mêmes. Les Pères les ont désabusés, et c'est pour leur frayer le chemin et les retirer de la crainte où ils étaient [Despite his fatigue, the Reverend Father Nicolas retraced his steps to bring here a nation of Savages who had never seen Europeans. They all had their noses pierced, with bits of attractively coloured fur hanging from them. They were heavily laden with beaver, which very much suited our merchants. They were so well satisfied with the French that they are resolved to come here after trading with them. The Outaouak [Ottawas] gave them to understand that the French would burn them alive if they came down here, but they have now realized that those barbarians kept

them in that fear so they could have their pelts for nothing and come trade them themselves. The Fathers opened their eyes to the truth, and this was why Father Nicolas brought them down himself to clear the way and remove their fear].[56]

Marie de l'Incarnation was describing the Amikwa, also known as the Beaver Nation[57] or Nez-Percés, who were Northern Algonquians that the French met on the north shore of Lake Huron, opposite Manitoulin Island and west of Lake Nipissing,[58] as roughly indicated on the *General Map*. It is possible that during his stay in Chaquamegon, Nicolas found the time to visit their region. On folio 71 of the "Histoire naturelle" he mentions having seen bears "of extraordinary height and size … that were killed in the lake of the Nipissing." He adds: "We feasted upon them, all one hundred men that we were." Further, on folio 72, he is even more specific: "I observed everything I have just said when I was hunting this animal, particularly on the shores of a great island that is almost in the middle of the freshwater sea of the upper Algonquins which is 500 leagues around."

If he was at Lake Nipissing and then on Manitoulin Island, Nicolas was in Amikwa territory. We know from the *Relation par lettres de l'Amérique septentrionale*, 1709 and 1710, that the Amikwa cultivated corn on the islands of Lake Huron.

Les Amiquouë, autrement dit nation du Castor, sont en petit nombre. Ils habitent l'été le long des bords du Lac Huron, où ils vivent grassement de poisson. Ils font du desert dans les isles qui se trouvent dans ce lac, où ils sement du bled d'Inde qu'ils ne recueillent ordinairement qu'en vert; ils font provision l'automne de quantité de bluets qu'ils amassent pour l'hiver [The Amiquouë, also known as the Beaver nation, are few in number. In summer they live along the shores of Lake Huron, where they live richly on fish. They clear the land on the islands in the lake, where they sow Indian corn, which they usually harvest only in the green state. In the autumn they stock up large quantities of blueberries, which they gather for the winter].[59]

It is not surprising, then, that the *Codex* devotes an illustration to the Amikwa (Pl. XIII). "Homme de la nation des amikouek dont sa nation fournit plusieurs Milliers de castors pour la France" [Man of the Amikwa nation, which supplies many thousands of beavers to France]. Furthermore, an Amikwa canoe is depicted (Pl. XVII), a choice of image that is quite understandable, since the Amikwa lived from fishing and travelled between the islands of Lake Huron.

One can see from all this activity that Nicolas's performance was more commercial than missionary: it clearly had more to do with hunting than saving souls. Did his superiors disapprove of this? Some merchants, at least, would certainly have resented the Jesuits meddling in their business.

There is further information about Nicolas's performance: Guy Tremblay has found a relevant document written in Latin by Father Le Mercier to the General of the Jesuits in Rome, which sheds a very different light on the return of Nicolas to Quebec on 21 June 1668.

Scripserat mihi mense aprili huius anni P. Claudius Allouez P. Ludovicum Nicolas, quem illi as Outaouakos suos redeunti socium dederamus anno supe-

riori quemque recens ad nos procuratoris vice miserat, minus esse idoneum huic missioni propter incompositos mores, quoad exteriorem hominem, imprudentiam in rebus tractandis et praecipites et frequentes nimium iracundiae motus, quibus et Gallis et indigenis scandalo fuerat, ac proinde auctor erat ut hic hominem retineremus: quod cum ille subodoratus fuisset, tantam vis apud me lacrymarum effudit tantam prae se tulit de sibi objectis animi paenitudinem, tantam spem emendationis ostendit, tantum denique repetendae missionis suae desiderium ut omnes censuerimus unanimi consensum hortandum esse superiorem istius missionis ad illum uno adhuc saltem anno patienter sustinendum; ne ressipiscat proximo vere ad nos, immo etiam forte in Galliam, si ita ferat, remittendum [Father Claude Allouez wrote to me in April of this year about F. Louis Nicolas, that we had given him as companion last year, when he went back to the Ottawa, and that he has just now sent us as procurer, that he was not really proper for that mission because of his rough manners and behaviours, and also because of his lack of foresight in business and his frequent and sudden movements of wrath, that scandalize both the French and the Natives; and, because of this report by F. Allouez we have kept him in Quebec. When he suspected that this was the reason why he was not sent back to the mission, he shed so many tears in my presence and manifested such a regret of what he was accused of, and showed so much will to amend himself, and finally such a desire to go back to his mission that all of us have persuaded the Superior of this mission (Allouez) to be patient with him for one more year; and if he does not change, he will be able to send him back to us next Spring and even in France if necessary].[60]

Nicolas succeeded in convincing his colleagues in Quebec, and was back in Chaquamegon for another season. He spent the winter at Pointe du Saint-Esprit but was back in Quebec in the spring of 1669. Once again, according to Mother Marie de l'Incarnation, Nicolas was involved in business. "Les Révérends Pères d'Alois et Nicolas ont amené cette année six cens Outaouaks, qui ont apporté à nos Marchands une prodigieuse quantité de pelleterie [This year the Reverend Fathers d'Alois and Nicolas brought us six hundred Outaouaks, who brought our merchants a prodigious quantity of furs]."[61]

But, again, this is not the whole story. Another document reveals that Nicolas's repentence did not last long. A *Mémoire* written by Antoine Alet, secretary of Mr de Queylus, Superior of the Sulpicians,[62] describes Nicolas not only as a choleric man but also as a quite vain priest. Chief Kinonché complained that although he was the chief of a nation, he had been beaten with a stick by Nicolas; and that the young priest had boasted among the Indians that when they arrived in Montreal they would see how well he would be received, how respectfully the Sulpicians would treat him, asking him to say the high mass, and in what regal ornaments he would perform the holy sacrifice with all of them serving him. The Sulpicians learned about these boasts from Kinonché himself and decided to calm Nicolas down. "On résolut de ne point accorder au P. Nicolas de célébrer solemnellement, afin de lui ôter un si mauvais moyen que celui-là de se faire valoir parmi ces peuples [It was decided not to allow F. Nicolas to celebrate solemnly the high mass, in order to prevent him from using such bad means to get the respect of these peoples]."[63]

INTRODUCTION: *Louis Nicolas's Depiction of the New World*

Needless to say, Claude Allouez did not take Nicolas back with him to Chaquamegon the next fall. The priest who would replace him in September 1669 was Father Jacques Marquette. We know from the *Catalogue* that Nicolas was kept in Quebec at that time: "(Quebec) Pater Ludovic. Nicolas. Mission. Algonquinus [(Quebec) F. Louis Nicolas, missionary to the Algonquians]."

NICOLAS IN MOHAWK TERRITORY

The impression we are given is that Nicolas was doing penance in Quebec. Happily for him, a visit of Father Jean Pierron changed his fate. Pierron, a missionary who used his talent as a painter to convert the Indians,[64] came back from Tionnontoguen, in Iroquois territory, where he had spent fifteen months. Pierron, as the *Relations* say, was the creator of many "peintures spirituelles très dévotes qui ont puissamment servi à l'instruction [very devout spiritual paintings which have served powerfully for instruction]"[65] of the natives. He was proud of his achievements, and thought that if his superiors agreed to send missionaries to Iroquois country, they would convert many people. "Si les choses continuent dans l'estat où je les ay laissées, en partant pour aller faire un voyage à Québec; il y aura chez les Agniés de quoy occuper plusieurs fervens missionnaires [If things continue in the state in which I left them on setting out to go on a journey to Quebec, there will be work enough among the Agniés to occupy several fervent missionaries]."[66] Pierron's request was indeed honoured, and Father Thierry Beschefer and our Louis Nicolas went with Pierron.

The choice of Beschefer made sense. He, like Pierron, had been born in Champagne and they knew each other well. They had spent time together at Pont-à-Mousson in 1652–53 and in 1661. The choice of Nicolas seemed less well advised. After all, he was a *missionarius algonquinus* and did not know the language of the Iroquois. I have supposed elsewhere[67] that his talent in drawing could have interested Father Pierron … but, to confirm that possibility, we would have to be certain that Nicolas was the creator of the drawings of the *Codex*. Perhaps, more simply, his superiors were tired of hearing him complain and decided to send him off to do some field work.

Whatever the reason, the *Catalogue* mentions Nicolas at the Mission of the Martyrs in Mohawk territory: "1670. Martyr. Sanctorum Pater Ludovic. Nicolas." This mission was at Ossernenon, the present Auriesville, New York, not far from the Mohawk River. Was Nicolas more active there? We do not know. Father Claude Dablon, who wrote the *Relations* of 1671 and 1672 and devoted one chapter to the Mission of the Martyrs,[68] mentioned that Pierron baptized eighty-four children, seventy-four of whom died soon after baptism. He describes in greater detail the baptism of two pregnant women, but mentions neither Nicolas nor Beschefer.

The following year, the same Dablon reports that the mission among the Iroquois was served by seven missionaries,[69] but neither Nicolas nor Beschefer was listed among them. He mentions fathers Bruyas and Boniface, who had previously been with the Onneiout, known as "the haughtiest and least tractable of all Iroquois," among whom they had worked for four to five years. He does not mention anything about Nicolas and Beschefer. The only thing we know for sure according to the *Catalogue* is that in 1671 Nicolas was again in Quebec: "1671. (Quebec), Pater Ludovic. Nicolas." His stay with Pierron had lasted only one year. Why was he called back so early by his superior?

The "Histoire naturelle" gives one possible answer to that question. On a few occasions, Nicolas mentions a trip that he made with a few others to "Virginia." According to the *Great Map*, his "Virginia" was south of Lake Erie between "la Nouvelle Suède [New Sweden]" and "Andastogueha" on one hand, and the territory of the "Cinq Nations hiroquoises [the Five Iroquois Nations]" south of Lake Ontario. Not precisely the State of Virginia of today, obviously!

Apparently this trip was both difficult and dangerous, as this passage of the "Histoire naturelle" indicates:

> One day I was lost with a Frenchman in the woods and the great meadows of Virginia, where the grass was almost a quarter of a pike high. I was starving, along with my dear companion, who the day before I found the lemons, had fainted twice. We were starving, as we had hardly eaten anything for several days, and had spent the night beside a beaver dam sleeping on the ground, without covers and without food. The next day, dragging ourselves miserably through the woods to try to find our way again, we fortunately came into a great woods and then into meadows as far as the eye could see, which we had glimpsed from the top of a mountain. We found some of the lemons that I have described, with blackberries. We ate a large amount and gathered enough for several days. Our four comrades, who were lost in the other direction, went hunting green frogs, which tasted good, they assured us two days later, when we met again in the middle of the meadows and on the banks of the river Techiroquen in the midst of an army of Americans whom I had stopped by an impassioned speech asking the general to send thirty or forty of his soldiers to try to find my comrades who were lost and starving (f. 11).

Nicolas seems once again to have given in to his passion for travelling. The reader will remember that when he was still studying at Sillery, he was sent into the hinterland north of Trois-Rivières. He was brought back, sick, from this escapade. When in Chaquamegon, he found time to go bear hunting on Manitoulin Island. Now that he was among the Iroquois, he decided to visit "Virginia," again putting his life in danger. While it is true that he returned from all these expeditions with a wealth of information on the flora, the fauna, and the first inhabitants of the region, he seems to have made very few conversions.

The result is that the *Codex* is rich in information about the Iroquois people. A "Sauvage hyroquois de la Nation de gandouaguehaga en Virginie [An Iroquois of the Gandaouagué nation in Virginia]" is represented (Pl. XII). Nicolas added below the picture a rather long description of a ceremony that he had witnessed.

> Ce jeune homme a fait en ma presance son essay de guerre se faisant arracher des ongles, couper le bout du nés par ses camarades qui le menoient comme en triomphe autour du bourg voulant par la qu'on sceut qu'il souffroit genereusement tous les tourments que les ennemis de guerre luy fairoit souffrir en cas qu'il fut prix [This young man in my presence underwent his war test, by having some fingernails torn out, and the tip of his nose cut off by his friends, who led him as if in triumph around the village, to show that he would endure bravely all the tortures that war enemies would inflict on him if he were captured].

To what exactly was this "Gandaouaguehaga in Virginia" referring? On folio 37 of the "Histoire naturelle" we find mention of "a village of Virginia called Gandaouaghé." If this is the place he meant, Gandaougue-haga could refer to the inhabitants of Gandaouaghé, which is a well-known location. According to the *Relations of 1672–1673*, the Jesuits had established the Mission Saint-Pierre there. Father Bruyas described it in the following manner:

> C'est dans les deux bourgades les plus voisines de la Nouvelle Hollande et qui sont éloignées de Tionnontaguen d'environ cinq lieuës qu'il y a une seconde Mission établie, dont on a confié le soin depuis quatre ans au P. Boniface. On a donné à cette Mission le nom de Saint-Pierre, à cause que, depuis que les armes de sa Majesté ont assujetté les Iroquois inférieurs, ce fut Gandaouagué où la Foy fut plus constamment embrassée qu'en aucun autre pays d'Agnié [In the two villages that lie nearest to New Holland, which are situated at a distance of about five Leagues from Tionnotoguen, a second mission has been established, the care of which has for the past four years been conferred upon Father Boniface. To this mission the name of St. Peter has been given, because, after his majesty's arms had conquered the Lower Iroquois, it was at Gandaouagué that the faith was embraced with more constancy than in any other district of Agnié].[70]

Was it an important village?

> Il est vray que cette Eglise se trouve dans les deux plus petits bourgs qui soient dans tout le païs des Iroquois, et qu'une seule bourgade des Iroquois supérieurs est beaucoup plus grande et plus nombreuse que les deux dont je parle: mais aussy elle a l'avantage en quelque façon par-dessus les autres missions Iroquoises que la petite Tribu de Juda avoit sur toutes les autres tribus d'Israel qui estoient beaucoup plus grandes et plus peuplées que celle de Juda. *Notus in Judea Deus.* J'avoue qu'il [y] a encore beaucoup de desordres et que L'infidelité est aussi bien à Gandaouagué qu'ailleurs; c'est néanmoins dans ces deux petits bourgs qu'il y a le plus de fideles qui adorent Dieu en esprit et en vérité [It is true, this Church is located in the two smallest villages in the whole of Iroquois country; a single village of the upper Iroquois is larger and more populous than the two of which I speak. But, on the other hand it has, to a certain extent, the same advantages over the other Iroquois missions that the small tribe of Judah had over all the other tribes of Israel, who were much larger and more populous than that of Judah. *Notus in Judaea Deus.* I admit that considerable evil conduct and infidelity still prevail at Gandaouagué, as well as elsewhere; nevertheless, in these two small villages there are more faithful ones who worship God in spirit and in truth].[71]

Although not in Virginia, Gandaouagué was close to "la Nouvelle Hollande [New Holland]" and to the south of Mohawk territory. It could well have been one of the villages where Nicolas and F. Beschefer were together. Rev. William Martin Beauchamp[72] places Gandaouagué in 1677 to the east of Mohawk territory. At that time, all the villages had been displaced to the north of the Mohawk River. Gandaouagué would correspond

to the modern Fonda, on the west bank of Cayadutta Creek. All the other villages were more to the west; Tionnontoguen was ten miles further than Gandaouagué.

The *Codex* includes a "Sauvage de la nation des Onneiothehaga [Native from the Oneida Nation]" (Pl. x). The Oneida were neighbours of the Mohawk, to the west. The caption tells us: "il fume du tabac à l'honneur du Soleil qu'il adore comme son génie particulier [he is smoking tobacco in honour of the Sun, which he worships as his personal guardian spirit)."

On Plate xi, an Indian holding a huge snake is depicted:

> Cet Icy un depute du bourg de gannachiouavé pour Aller inviter au jeu les Mesieurs de gandaouagaahga. Ils tiennent que le serpent est Le dieu du feu. Ils l'invoquent le tenant en main en dansant et chantant [This is a representative sent by the village of Gannachiou-avé ready to invite the gentlemen of Gandaouaghaga to a game. They believe that the snake is the god of fire. They invoke the god by holding the snake in their hands while dancing and singing].

Marc de Villiers states that the village of Gannachiouavé was on the north shore of Lake Ontario.[73] It is evident that at the time of Father Nicolas the Iroquois had recently established themselves on the north of Lake Ontario, as can be seen on a map of c. 1680 attributed to the abbé Claude Bernou, where one reads: "Villages des Iroquois dont quantité s'habituent de ce costé depuis peu [Villages of the Iroquois, many of whom have settled recently on this side of the lake].[74]

As was the case for the iconography of the Chaquamegon Indians, two of the three Iroquois figures are derivative: the Oneida (*Codex*, Pl. x) comes from Du Creux (fig. 4) and the Iroquois of Gandaouagué (*Codex*, Pl. vii) also from Du Creux (fig. 5). Although the sources are clear, the images were somewhat modified when reused in the *Codex*.

The Oneida holds a double tobacco pouch instead of a quiver and a bow, and smokes his pipe "to honour the sun" rather than carrying a shield. The inhabitant of Gandaouagué holds an axe instead of a bow in his right hand and a pipe instead of an arrow in his left hand.

In addition, the *Codex* devotes a few drawings not only to types but also to the material culture of the Iroquois. On Plates xviii, xx, and xxi we learn first about the means of their transportation on water. Two types of canoes are represented: a "cannot a l'outaouaise [Ottawa canoe]" that Nicolas may have encountered at Chaquamegon, and a "cannot a l'Irocoise [Iroquois canoe]" with a sail, for crossing the Great Lakes.

Plate xx is replete with data. At least one of the figures is devoted to the Iroquois: a "cabane a l'hyroquoisse ou lon voit deux testes des ennemis qu'ils ont tué [Iroquois cabin with two heads of the enemies that they have killed]." This information is confirmed by the figure of an "Iroquois qui a tué deux ennemis [Iroquois who has killed two enemies]," which we can see on the right.

Elsewhere on the same page, the author depicts the forms of three different cabins: Huron, Killistinon, and Tissarouata. He includes also a drawing of the fire stick and a sketch of a "sauvage qui revient de la chasse chargé de paux de castors [native returning from the hunt carrying beaver skins]."

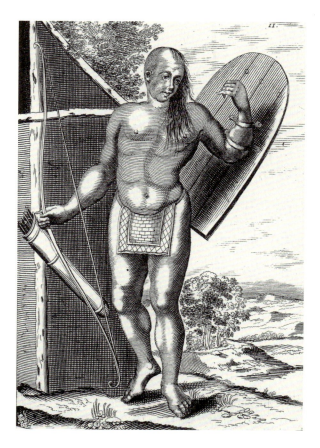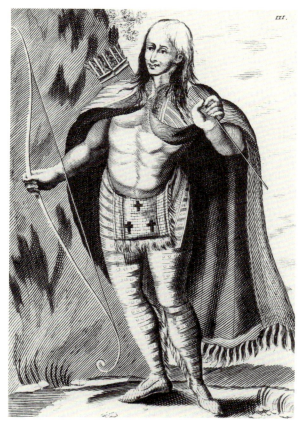

Fig. 4 (*Above left*)
Plate II in Du Creux,
*Historiae Canadensis
seu Novae Franciae Libri
Decem*, 1664.

Fig. 5 (*Above right*)
Plate III in Du Creux,
*Historiae Canadensis
seu Novae Franciae Libri
Decem*, 1664.

Equally interesting is Plate XXI, which is divided into three sections. In the top section, one sees a "sacrifice que ce sauvage fait a la lune [sacrifice that this man is making to the moon]." In the centre section to the right is a "cabane de peau ou lon voit une peau offerte ou sacrifiee a Agrikogé qui est le dieu de la guerre des ameriquains [cabin made of skin, where one sees a skin offered or sacrificed to Agrikogé, the-war god of the Americans]," as well as a "figure de la teste du dieu de la terre que ce sauvage va voir [*drawing* of the head of the earth god that this man is going to see]." Finally, in the bottom section we see a "mortier a piler le bled d'Inde [mortar for grinding corn]" and a "branle pour endormir les enfants [cradle to put children to sleep]."

The following page shows the "figure d'une femme prise a la guerre a qui on avoit arraché avec les dens toutes les ongles. Je lay veue brulé dans le bourg de Toniotogéahga durant six heures pandant lesquelles on lescorcha a petit feu elle fut mangée en partie par les Iroquois et par leurs chiens [a woman captured in war whose nails were all pulled out with teeth. I saw her burned in the village of Toniotogéhaga for six hours, during which she was slowly flayed. She was eaten partly by the Iroquois, and (partly) by their dogs]."[75]

Taken together, the *Codex* and the "Histoire naturelle" provide an extraordinary ethnology of the native populations visited by Nicolas. Nothing seems to have escaped his attention and he claims to have been a witness to everything he describes.

※ ※ ※

In 1671 Father Louis Nicolas was back in Quebec, and the following year, he was vicar at Sillery.[76] This was an easy task, which gave him a lot of leisure, and it was probably during this time that he began writing his *Grammaire algonquine*. It was not unusual for the Company to give free time to missionaries who showed some talent for languages so that they could write down what they knew. For instance, in 1670 Father Frémin relieved Father Garnier of his regular task, "afin qu'il puisse avoir le temps d'apprendre parfaitement la langue du pais, & d'en faire luy-meme des Regles, & un Dictionnaire, pour l'enseigner aux autres [in order that he may have time to learn the language of the country perfectly, and himself make rules for it and a dictionary, in order to teach the language to others]."[77]

AT SEPT-ÎLES

As busy as Father Nicolas may have been with writing his *Algonquian Grammar* during the period of 1672–74, in the spring of 1673 he was sent by his Superior to Sept-Îles, at the eastern end of New France. Did he have a mandate to open a mission or just to investigate conditions in this far-off region? The *Relation of 1673–1674* is not absolutely clear about this.

> Le P. Louis Nicolas a fait l'ouverture de cette Mission vers la fin du printemps. Ce n'est à proprement parler qu'un essai, car ce Père est allé surtout examiner comment on doit s'y prendre pour travailler efficacement au salut de ces peuples … Mais on a promis aux Sauvages que, le printemps prochain, il retournerait les voir pour les instruire entièrement [Father Louis Nicolas, about the end of the spring, began that Mission. It was, correctly speaking, only an attempt; for the Father went mainly to ascertain how he ought to go to work, in order to labour efficiently for the salvation of those peoples … he promised the Savages that the following spring he would return to them, so that he might fully instruct them].[78]

Like Chaquamegon, Sept-Îles was a post for trading with the whites (fig. 6).

The islands were "quite noted, on account of the gathering of Savages, who, after hunting in the forests on the mainland, return from time to time to a river quite near these islands, in order to trade with the French who are drawn there by commerce."[79]

It was probably on his way back from Sept-Îles, in June or July 1673, that Nicolas wrote his *Mémoire pour un missionnaire qui ira aux 7 isles q[u]e les sauvages appelent Manitounagouch ou bien mantounok* [*Memorandum for a Missionary who will go to the Seven Islands, which the Savages call Manitounagouch, or properly, Mantounok*].[80] In it he complains about not always remembering the names of the twenty-six natives he has baptized![81] Since he was at Cap-de-la-Madeleine as a procurator in autumn 1673,[82] it was probably there that he wrote his *Memorandum*.

This text is very short – only four pages long – but very informative. Nicolas reveals himself to be a good ethnographer who is able to distinguish the principal cultures of the region: the Montagnais Papinachois (Opâpinagwa), the Oumamiwek (Bersiamite), and the Inuit. He noticed that the Montagnais spoken there was different from the one

Fig. 6
Mission at Sept-Îles.
From A. Dragon,
*Trente robes noires
au Saguenay*, 253.

encountered around Tadoussac or in the Saguenay. He noted also that the natives around Sept-Îles had already had some conflicts with the whites and did not trust them.

As a good naturalist, he describes the fauna and the flora of the region: the sea birds, the seals, the cod, the salmon, the whales, and the absence of tall trees. He thought that the French could exploit the oil from the whales.

I see only one connection between this trip to Sept-Îles and an illustration in the *Codex* – the representation of an Inuit with a kayak on Plate XVII.

RETURN TO FRANCE

Nicolas was back in France in 1675. It seems that he left the Company in 1678, definitely not to go back to the laity, but probably to become a parish priest somewhere in France.[83] This reassignment provides an explanation for the change in his initials. When he wrote the *Grammaire algonquine* he was still a missionary (L.N.P.M., *Louis Nicolas prêtre missionnaire*). But after he left the Jesuits, he became M.L.N.P., *Messire Louis Nicolas prêtre* and it is in this later position that he signed a his "Histoire naturelle."

After that date, we lose track of him. We do not know exactly when he died. The date of 1682 proposed by J.-B.A. Allaire[84] and repeated by Dom Oury[85] is not based on any solid evidence, especially since Allaire does not seem to realize that Nicolas died in France. Nevertheless, this dating could be important – if Nicolas died in 1682, he could not be the author of the *Codex*. But then, who was the individual who claims that he was witness ("en ma presance") to the initiation of a young Iroquois warrior (Pl. VII)? Or who says "je l'ay veue" about a woman tortured by the inhabitants of Tionnon-toguen (Pl. XXII)?

CODEX CANADENSIS

PART II
THE TEXT AND THE IMAGES

THE *CODEX* AND THE "HISTOIRE NATURELLE DES INDES OCCIDENTALES"

Let us return to our two manuscripts, the *Codex* and the "Histoire naturelle." What exactly is their relationship? Could it be that one was intended to provide the illustrations for the other? Could it be that Nicolas, wanting to have his book printed, had prepared an album of illustrations to be given to a professional engraver who would have executed these illustrations at a later date? I thought so for a while.[86]

But recent paleographic considerations by Germaine Warkentin[87] have made me question this assumption. When we say that the author wanted to see his book in print, we also imply, of course, that he did not wish to see it remain in manuscript form. After all, printing had been known for well over a century; and who would not have wanted to have his book in print, possibly even illustrated? One document seems to give solid credence to this idea: Father Giovanni Paolo Oliva, general of the Jesuits in Rome, wrote on 28 July 1676 to Father Louis Nicolas, S.J., the presumed author of the "Histoire naturelle" and of the *Codex*. At that time, Nicolas was back in France and had consulted the general on a book he wanted to publish. His letter is lost, but the general's answer is known, and reads in part as follows:

> Iam vero quod ad librum quem cogitat dare in publicum, novit V.R. quae sint Societatis leges ut prius P. Provincialis eum tradat revisoribus secretis qui ad nos sua suffragia secreto mittant ubi accuratius expederint ... Unum praeterea meminisse debet V.R., severe sancitum esse a Sancta Congregatione ut ne quid de missionibus detur in publicum quod ipsamet non probaverit suo suffragio [About this book that Your Reverence wants to publish, you know what the rules of the Company are. The Provincial must first submit it to independent examiners, who will send us, under pledge of secrecy, their judgment, after having read it carefully ... Your Reverence must remember one thing: the Holy Congregation (of the Propaganda) orders us to never publish something about the missions without its approval].[88]

A few questions must be answered if we are to interpret this document correctly: Which book is the author referring to here? Is it possible that *dare in publicum* could mean anything other than "to print"? What was meant by *publicum*, the public, at the time? Do we find traces in the manuscript of the examination mentioned by Father Oliva?

Of the works attributed to Nicolas, the one that seems to have been more ready to be published and could be said to be "de missionibus,"[89] was his *Grammaire algonquine*,[90] which, although not about the missions, would at least have been more useful to missionaries than a treatise on natural history or an album of drawings.

Is it necessary, on the other hand, for us to assume that *dare in publicum* meant *imprimere*, "to print"? For instance, it was the practice at the time for a manuscript to circulate before it was given it to the printer or, as Descartes said, before "le mettre sous la presse [submitting it to the press]."[91] The idea was to take advantage of the opinions of friends or critics before committing a work to printed form. More impor-

27 INTRODUCTION: *Louis Nicolas's Depiction of the New World*

tant, however, as recent studies have shown, the manuscript tradition was not wiped out by the invention of printing but was maintained late into the seventeenth and the eighteenth century.

Finally, who constituted the public of the time? We assume that the general public is meant … but was that the case? Let us quote Descartes again, or rather a note from the librarian to the reader in the preface to the *Méditations*:

> Lorsque l'Auteur, après avoir conceu ces Meditations dans son esprit, resolut d'en faire part au public, ce fut autant par la crainte d'étouffer la voix de la verité, qu'à dessein de la soumettre à l'épreuve de tous les doctes [When the author, after having conceived those Meditations in his mind, decided to communicate them to the public, it was as much from fear of choking the voice of truth, as having them tested by the learned ones].[92]

In this case, the public seems to equal scholars. This is why the *Méditations* were first composed in Latin, "leur langue [their language]." The librarian explains that the book later went "des Universitez dans les Palais des Grands [from the universities to the palaces of the Nobles]," where "une personne d'une condition très éminente [a very eminent person]"[93] took it upon himself to translate it into French. Not really the general public, as one can see, even when the vernacular was used! So, even when printed, a book could have a rather limited circulation. Manuscript form was not seen as a less perfect form of publication. In fact, in certain cases, as when the work was destined for the king or for a very important personage, the manuscript form could be seen as a mark of respect, giving the recipient exclusive access to the text. In this context, it is very possible that the "Histoire naturelle" and the *Codex* were intended to remain in manuscript form.

But in the case of the "Histoire naturelle" the problem was complicated by the need to have the manuscript approved by examiners of the Holy Congregation before there was any question of having it circulated, let alone printed. The manuscript that we have has blue and red marks, which may well have been made by these very examiners.

Whether or not the "Histoire naturelle" was meant for print publication, then, it is very possible that the *Codex* was conceived as a "treatise" of its own, certainly related to the "Histoire naturelle" by its subject matter, but sufficiently independent to be considered more than simply illustrations to the "Histoire naturelle." As such, it would not have been unique – it could be compared, for instance, to the so-called Drake manuscript, Sir Francis Drake's account of daily life in the Indies, recently published in facsimile.[94]

There is one more argument in favour of this hypothesis. If one compares the order of presentation of the drawings of the *Codex* with the order of the subject matter in the "Histoire naturelle," certain discrepancies are apparent. For instance, the pages of the *Codex* devoted to the Natives, which come immediately after the three title pages, would have been more consistent with the order of the "Histoire naturelle" if they had been placed at the end of the *Codex*. At the beginning of the "Histoire naturelle" Nicolas announces that "it is a wonderful thing to see … great hills full of animals and several nations of men who, although not numerous, nevertheless have many rare things that can be said of their customs, their social organization, their religion, and their sacrifices, as I touched on them in my last books" (fs. 1–2). Nicolas's first project

was intended to comprise "18 books" (f. 4),[95] of which the last six were to deal with the Indians. "It is about time for me to finish my natural history and to begin my six final books on the state of more than one hundred nations that I encountered in the Indies and where we will see the thousands of curiosities of that vast country" (f. 196). These are the last words of the "Histoire naturelle" as it has come to us. It is clear, then, that Nicolas had planned the order of the books in the "Histoire naturelle" and could have adjusted the illustrations of the *Codex* to follow the order of presentation of the "Histoire naturelle" exactly, had he wished to do so. That he left them numbered as we see them now suggests that the *Codex* was intended to be an independent document.

There are other discrepancies between the *Codex* and the "Histoire naturelle." If one compares the order of presentation of the section on quadrupeds in the two documents, they agree broadly – but only broadly. For greater conformity between the two documents, one would have to reverse the order of Plates XXIX and XXX, and position Plate LXXIII between Plates XXIX and XXX on the one hand, and Plate LXXIV between Plates XXXI and XXXII on the other – a lot of changes to explain! As well, the animals on Plates LXXV–LXXIX at the end of the *Codex* – a lamb, a goat, a donkey, a bull, and a horse – are not even mentioned in the "Histoire naturelle." The "great bull of Denmark" seems a repetition of the *pichichiou* of Plate XXXV. It is also quite likely that the horse on Plate LXXVII was copied from an engraving. Once they are examined closely, these drawings have very little to do with Canadian fauna, leaving the impression that the author, at the end of his work, was filling in space.

The second section, devoted to amphibians, corresponds to the eighth book of the "Histoire naturelle." Here again the correspondence is not perfect as the *Codex* reverses the order of some pages (Plates XXXVII and XXXVIII). In the "Histoire naturelle," Nicolas starts with the water ferret and the muskrat, and goes on to the otter, the beaver, and so on – that is to say with the animals of Plate XXXVIII – and then continues with those on Plate XXXVII in the *Codex*.

The *Codex* devotes fourteen pages to birds – seventeen if we include Plates LXX, LXXI, and LXXII, which are found the end of the book. This section corresponds to the ninth, tenth, and eleventh books of the "Histoire naturelle" and would follow almost the same order, except that the pages devoted to the "American rooster" (Pl. LXXII) and the "Turkey" (Pl. LXX) would have been better situated after Plates XLVIII and LIV respectively. Furthermore, Plate LXXI, which shows a "beau pigeon des pais estrangés, semblable a celuy que noa fit sortir de La arche pour scavoir si les Eaux du deluge avoient diminué et qui revint avec une branche d'olivier qu'il portoit au bec [beautiful pigeon from the foreign countries similar to the one that Noah let go from the ark to check if the waters of the Flood had receded and which returned with an olive branch in its beak]," does not seem to correspond to anything in the "Histoire naturelle."

These discrepancies are not easily explained if one insists on making the *Codex* a mere annex to the "Histoire naturelle." They are less troubling if one considers the possibility of two different "treatises," related but relatively independent of one another.

Needless to say, such a conclusion re-opens the question of the authorship of the *Codex*. Are these drawings from the hand of Father Louis Nicolas himself? In "Histoire naturelle," from time to time, Nicolas interrupts his text to introduce a sketch, as for example the marks on the back of the chipmunk which "resemble the figure which I make here," the length of which are indicated by "the figure one sees here" (f. 50). As well, he draws the burrow of the muskrat (f. 55) and the manner in which the Indian

women "twist [the moose intestines] to cook them" (f. 99). These are very poor and schematic drawings. If they were the only specimens on which to base a decision, the drawings of the *Codex* could not be attributed to the same hand and might suggest that Nicolas used the services of a more professional artist to do the drawings of the *Codex*. Nevertheless, the fact that he refers so often and so directly to "*his*" figures" seems to indicate that if he was not the author of the drawings, having improved his skill at drawing in the meantime, they were done under his close supervision.

TO COMPARE

The seventeenth century saw a major transformation in natural history as a literary genre. Until then, the principal interest of ancient naturalists had been to find similarities between things, in the hope that these similarities would reveal their true utility to man.[96] But in the seventeenth century this utilitarian approach began to be criticized. The usefulness of nature was of much less interest to the *cognoscenti*, who now strove for a more objective view of the world around them, in the hope that it could be presented in a "tableau" where each thing could find its place, revealing the order to be found in nature. As a consequence, looking for similarities was less crucial and new treatises on natural history attempted to discourage the earlier mode of knowledge by analogy, mocking the authors who were still attached to it.

The present century is still under the spell of this objectivism. It is difficult to imagine a form of knowledge, or as Foucault calls it, an *épistémè*, in which objectivity played no role whatsoever. However, it is important to be aware of the earlier approaches to knowledge, if one wants to understand certain fundamental aspects of the "Histoire naturelle." Nicolas appears to have been attached to the old approach to natural history even if he was, from time to time, also attracted by the new.

According to sixteenth-century thought, the world was created for Man and revealed in its very polymorphism the many ways of Providence toward him. For instance, one could read on each herb the signs of its utility. The spots on the leaves of the *pulmonaria* (fig. 7) were in the shape of lungs, to tell us that this plant was useful to treat pulmonary diseases.[97] The yellow colour of the saffron was a sure sign that it could help biliousness.[98] Certain nuts had the same configuration as the brain: meaning they were undoubtedly useful for headaches or mental illness.[99]

The systematic development of comparisons of this kind, especially botanical, gave birth to the "doctrine of signatures," the "signatures" being the visible signs one could find on things to discover what their utility was. In addition to the many examples given by Foucault, Nicholas Culpeper (1616–1654) is a good example of a staunch supporter of this doctrine. His book *The English Physician* (1652), written in modern language and addressed to the general public, even looked for correspondences between plants and the signs of the zodiac, hoping to find the best time to collect the plants.[100] The description of things was as a function of their use, and their use was revealed through similarities. For the doctrine of signatures there is no such thing as Linnaean characteristics that enable us to the classify one plant with another. Instead there is only a network of comparisons, which, ever increasing with time, enables us to learn the plants' "secrets."

As long as such a view was maintained, it was impossible to have an objective system to represent things, either in writings or graphically. Why, for instance, describe or draw the root of a plant instead of its flower? Why its flower instead of its fruit, or the whole plant instead of its sexual organ as revealed by the microscope, as Linnaeus recommended? Such decisions were made in terms of what was seen to be important about the plant: in one case, it was the root which had curative powers; in another case, it was the fruit; in another case still, it was the leaves. In other words, there were no rules that should be applied to every case. It was more important to highlight similarities than to differentiate among things.

Nothing better reveals the traditional character of the "Histoire naturelle" than the poverty of the objective descriptions on the one hand, and the great place still given to analogies on the other. Let me illustrate these two characteristics in some detail.

The poverty of the descriptions is already noticeable in the first treatise about plants. Not only does Nicolas offer little description of individual plants but he is often satisfied to declare this one to be "particular" to a country, that one having been "transported" there, this one as being "similar to" or that one as "different from" a European one, without saying much more. Furthermore, he does not seem to worry much about this way of proceeding, since he writes as follows:

> Although several writers have dealt with the names of all the trees I have just described, I wanted to say a word about them, for I was certain that everything they had reported was different from everything that I had to say, and that although I have given the same names as they have to the simples and trees that I had to talk about, it was only to adapt myself as much as I could to the ideas that skilled botanists might form from reading the leading writers on this subject. (f. 43)

Fig. 7
Common Lungwort,
Pulmonaria officinalis
L. Drawing by Jessica
Darveau after K.N.
Sanecki, *The Complete
Book of Herbs*, 136.

Should we conclude from this statement that Nicolas will describe all the plants that he mentions? Not really. Even a plant for which he knows only the Indian name, such as the *outtagouara*, is not described in great detail. In fact in the treatise on simples, only the "milkweed" and the "lemon" are treated at length. In the treatise about grains, only maize is described in detail. The large trees seem to have been a little better treated, although less is said about their form than about "their uses and qualities, and most of their properties" (f. 28).

On the other hand, it is important to note that the "Histoire naturelle" makes extensive use of what Foucault calls "the great figures of similitude of the sixteenth century."[101] Knowledge of the similar through the similar, the Renaissance way of knowing, proceeded by rapprochement, comparison, and analogy. The mode of which the "Histoire naturelle" seems to be especially fond is *æmulatio*. The very subject matter of Nicolas's work explains it well, since its intention was to reveal the existence of flora, fauna, and human settlements characteristic of the New World and to compare them to those of the Ancient World. The two worlds are then constantly confronted, both as a whole and in details.

To begin with, in principle, the Old World is better than the New. First, it often smells better! "All these lands [in the New World] produce tulips of all colours, and double or single white pansies. They are similar to violets, but they have no fragrance,

INTRODUCTION: *Louis Nicolas's Depiction of the New World*

like almost all the other flowers native to the new world" (f. 13). Seeds brought from France lose their strength when they are sown in Canada. "The wheat that is sown in the Indies is not different from ours except that it is not quite so heavy and consequently not so good. It degenerates little by little, and is not so nourishing" (f. 13). One will not be surprised either if, under the pen of a Frenchman, the American vineyard produces only a wine "so coarse that it thickens like mustard" (f. 23).

The same applies to animals. The animals of the New World have less "spirit" than those of Europe. Even the Indians agreed when they were introduced to our hunting dogs.

> These men never grew tired of saying that our dogs have infinitely more wit than their own. "They are spirits," they said, "and ours are only stupid beasts. They only have enough sense to hunt beaver or moose. These people's dogs resemble their masters: they are extremely intelligent, they are skilful at everything like the people of the Great Wooden Canoe nation." That is how they refer to the French … "[In] truth, and in good faith, the Frenchmen have clever dogs." (f. 68)

Swedish otters are also more intelligent than their American counterparts. This may seem extraordinary, but Nicolas had his proof, as he states:

> It easily becomes well domesticated, but I have never seen as well trained or as intelligent as Swedish otters, which I am assured are so docile that when they are trained, the cooks of large houses only have to order them to go and catch a fish in the pond or castle reservoir and they immediately obey, bringing fish to the cooks as many times as they are asked. Western otters retain a wild mentality. They are not as skilled as Swedish otters and not as intelligent, yet it is true that when they are domesticated and trained they follow their masters everywhere and go fishing; but they bring nothing back, and eat all their catch (f. 113).

The starlings are no better. The "country" starlings in Paris can be so well trained that it is possible to make them speak "better than the best-raised parrots. Ours [in America] are barbarous, and no one tries teach them anything" (f. 135). The flora and the fauna of the New World are reflections of the flora and of the fauna of the Old World, but there is a loss when one passes from reality to the image, as in a tarnished mirror.

Examined in detail, however, the outcome of the rivalry between the Old and the New Worlds is not always clear. For instance, the "hawthorn" of America is declared to be "larger and much more beautiful than that in France, even its fruit, which, in this country, is as large as hazelnuts, so that the inhabitants give it the name of apple" (f. 4). On the other hand, even if "roses of all species" are found in New France, one cannot find "beautiful Damask roses with a hundred buds on each branch" (f. 5). While the meat of the "large rat … would taste better than rabbit if it were prepared in the French way," "young pigeons or chickens do not have a more delicate taste than these rats" (f. 53). The small hare that is found "in all regions of the West Indies … is not as good as the ordinary hares of France. It does not taste as good as ours, especially in winter." It is true, however, that in the spring it acquires "a new taste that is similar to

that of our hares" (f. 59). No need to multiply these examples. Nicolas's text is full of such comparisons, where the New World is shown in competition (*æmulatio*) with the Old World.

The other mode of similarity used by Nicolas is, of course, analogy. He constantly, even unrestrainedly, resorts to it. The seeds of the *noli me tangere* (the touch-me-not) are as much as "so many little darts" that the plant "sends ... against the one who has touched it" (f. 5). The "great beak" of the armed fish is "like a compass" that the fish uses to catch its prey. "It lives habitually on game birds which come in great flocks among the great reeds that I have mentioned. Our hunter or armed fish has only to close its compass quickly, I mean its long beak,which it keeps open to catch the bird that happens to pass through this trap" (f. 10).

Besides, the bear "puffs like a dragon, it froths at the mouth like a wild boar, it roars like a lion, and bellows like a bull. It imitates pigs" (f. 72). If one attempts to put it in a cage, "one can simultaneously hear a lion roaring, a bull bellowing, wolves howling and the raging of some furious wild boar that is snorting in anger and frothing with rage" (f. 76). What an orchestra!

The tail of the muskrat "perfectly resembles the file used to sharpen a pitsaw" (f. 112), and the beaver's has "the shape of a partisan halberd blunted into a rounded end" (f. 114). The beaver uses it "as a trowel" (f. 116). It is interesting to compare this description to the much more sober picture given by Father Charlevoix in 1744.

> Ce qu'il y a de plus remarquable dans la figure de cet Amphibie, c'est sa Queuë. Elle est presque ovale, large de quatre pouces dans sa racine, de cinq dans son milieu, & de trois dans son extrémité, je parle toujours des grands Castors. Elle est épaisse d'un pouce, & longue d'un pied ... Elle est couverte d'une Peau écail-leuse, dont les Écailles sont hexagons, sont d'une demie ligne d'épaisseur, sur trois ou quatre de longeur, & sont apuyées les unes sur les autres comme toutes celles des Poissons [What is more remarkable in the appearance of this amphi-bious animal is its tail. It is almost oval, four inches wide at its root, five in its middle, and three at its tip (I am still speaking of a large beaver). It is one inch thick, and one foot long ... It is covered with a scaly skin, in which each scale is in the shape of an hexagon, and is about half a line thick, three to four lines long, and they rest one on top of the other as in a fish].[102]

Charlevoix speaks the language of geometry, of numbers, of measures. His text is remarkably empty of analogies. From Nicolas to Charlevoix, the *épistémè* has changed. We have passed from similarities to representations, from the sixteenth to the seventeenth century.

Even rarer modes, such as *convenientia*, meaning unusual connections between places, and *sympathy*, or similitude among things that have no possible contact, are found in Nicolas's text. Lichens grow on rock; that is why a certain lichen is called "*tripe de roche* [which] is like a kind of foam or moss, like a simple called *oreille de Vénus*." In other words, there is a *convenientia* between rocks and lichens. One finds lichens only on rocks, and rocks are also the place of "little spiders" (f. 11). But here is an even more marvellous example. A moose antler "appears through a knob which grows at the same time that the antler is growing, like that of a mushroom that swells and hollows itself out little by little, until the fruit has reached its consistency and its perfect maturity,

INTRODUCTION: *Louis Nicolas's Depiction of the New World*

with the difference that one happens in several hours and in the other, only over several months" (f. 92). There is, then, a *convenientia* between moose antlers and mushrooms. They grow the same way. Grasshoppers "all have a pattern like a human face perfectly distinguished on their stomach" (f. 165).

Of *sympathy*, the "Histoire naturelle" gives at least one striking example. Nicolas writes: "I could not, in my opinion, end this treatise on fruits and bushes better than by what seems to me a very interesting remark about the sympathy existing between different objects" (f. 23). He then describes the juice of a tree that stains clothes "so surprisingly that there is no way to remove the spots, even if one washes and rewashes the clothing. But when the same tree produces new flowers, all the spots that soiled the clothing disappear gradually by themselves" (f. 24). Maybe one could see another example of sympathy in the following anecdote recounted by Nicolas.

> On one of those sad long days of fast, they [a group of Natives and a French man] finally killed a dog. The Frenchman, not content with the small portion he had been given, took the discarded dog liver without thinking, cooked it and ate it. He was told to throw it away, he was assured that it would harm him and that it would make his skin fall off, but his hunger was so urgent that he went voraciously on with his meal. His skin fell off several days later as he had been warned. He found that he had changed his skin like a snake. (f. 69)

One of the main consequences of this frequent use of comparison and similitude is to put the representation itself in peril. Words are used not to describe things but to indicate similarities between them. Moreover, words themselves are subject to the same attention as objects. Nicolas explains, for instance, that "this fruit [the strawberry] has been given this name [*outémin*], because of its heart shape" (f. 17). The same is true of the raspberry, which is called "blood fruit … because from this fruit comes a liquid that looks like blood." The blackberry, or "black raspberry," is called *makatemin*, since "*makaté* means black colour" in their language.

Conscious perhaps of giving too much importance to his research in lexicography, Nicolas adds: "But I am straying from my subject and acting as a grammarian and a historian rather than a naturalist as I claim to be" (f. 18).[103] This kind of aside is unique in the "Histoire naturelle." Most of the time, Nicolas does not express any particular uneasiness about his interest in words. Every time he finds an occasion, he indicates the *convenientia* of the word to the thing. For instance, of the cardinal flower, he affirms that "because of fine red colour it has been given the name cardinal" (f. 5). The same formula applies to the lady's-slipper: "Its form gave rise to its name" (f. 5);[104] for the same reason, the mullein (in Nicolas's text, *la dépiteuze* or spiteful plant) got its name because of "its yellow flower, which falls or detaches itself from time to time after the plant has been hit at the foot of the stalk with a switch" (f. 9); what is thought to be the crowberry (in French, the *fruit de la Trinité*) got "its name … from three seeds that grow out of three leaves on a very low bush" (f. 19); "the sumac (in French, *vinaigrier*) produces a very sour red fruit. When it is steeped in water, it reddens it and makes it sour, so it has the same effect as vinegar" (f. 22); "the *bois de plomb* [lead wood][105] resembles another kind of wood called *le pliant* [the bending wood] because it is impossible to break it except with cutting instruments"; thus lead wood is called by this

name "because of its weight" (f. 27); the "only particular quality" of the aspen (*tremble* in French) "is that it trembles at the least gentle breeze; for this reason it is called *tremble*" (f. 29); the wood of the American linden "is so white that the name *bois blanc* has been given to the tree" (f. 40); on the other hand, between the white cedar and the red one, "there is nevertheless a certain similarity, so that one must say that there is a great resemblance between the two and that consequently they have to be given the same name and are differentiated by colour" (f. 45).

The same applies to animals. The chipmunk (*suisse* in French) is so called "because of the variety of its hair, which is adorned with various beautiful colours like the uniforms of Swiss guards" (f. 49).[106] The woodchuck (*le siffleur* in Nicolas's text, that is, the "whistler") gives rise to a similar commentary: "The rarest thing about this animal is a whistling which is very much like the song of the nightingale. It is for this special quality that the name 'whistler' has been given to it" (f. 58).

It is clear, then, the driving force of Nicolas's thought is less the objective knowledge of the beings of the New World, than what he calls "curiosity."

> The desire for knowledge that we all have shows that curiosity is a certain stamp and a sort of divine character imprinted deeply in our souls which eternally leads us to advance in our knowledge. For this reason the eye, which in my opinion is the finest organ of our body,[107] is never satisfied with the various objects presented to it and which it surveys, although they are most delightful; it always tries to discover new things to advance unceasingly toward knowledge which it has not yet discovered. Thus great minds, aroused by curiosity, have marvelled at the smallest plants, which seemed to have nothing worthy of interest; they have zealously studied the differences, qualities and virtues of each thing, and have left us their writings. (f. 17)

The "curiosity" mentioned here has nothing to do with a kind of mania for the unknown or any form of indiscretion. To be "curious" in the seventeenth century meant to care for something. Curiosity is a form if not of solicitude at least of interest in something, the opposite of indifference about things.

The Abbé François de Marsy defined the *curieux en peinture* as a "man who collects with discrimination whatever is especially rare in drawings or pictures; these rarities are called curiosities … that is why Mr. Mariette was able to say that the name of Mr. Jubach will be remembered for a long time in curiosity, meaning among the curious."[108]

This definition of curiosity will also be found in Diderot's *Encyclopédie*: "*Curieux*. Adj. Subst. A *curieux, en peinture*, is a man who collects drawings, pictures, engravings, marbles, bronzes, medals, vases, etc. This inclination is called curiosity. Not all who are taken by it are connoisseurs; and this is what makes them often ridiculous, as people always are who speak about what they do not understand. However curiosity, this need to possess which is almost never without limits, and often upsets material well-being [*la fortune*]; & this is why it is dangerous."[109] In the nineteenth century, the "curious" was called an "amateur,"[110] and today is called a "collector."

For Nicolas, curiosity is a virtue, since it fosters the admiration one should have of the works of God. "[Nature] delights in having us marvel at her Master in countless different beautiful objects that we cannot know nor even understand other than

INTRODUCTION: *Louis Nicolas's Depiction of the New World*

by looking at them and examining them closely in the course of several repeated journeys, where it is necessary to study oneself, and to enjoy, or at least have the curiosity to look attentively at what one finds exceptional" (f. 46). Nicolas thinks that nothing is sadder than a traveller without curiosity, that is to say, one who is indifferent to the marvels he encounters.

> [Such a person] passes and passes again many times by the places where there are curious things and things worth noticing, without seeing them there; and it is quite useful to make these things known to the public, who remain ignorant because of the travellers who take no interest in anything as they pass by the places where there are beautiful things to see and know. This misfortune happens to a hundred thousand people who find voyages tedious and who think of nothing but their destination, at the end of which they are as learned as when they set out on great voyages, for what reason I do not know. These kinds of people are no more commendable for it nor learned. As for me, I have made a careful study and I took great pleasure in observing everything beautiful and curious that I was able to on my travels. (f. 47)

It is to the truly "curious" people, to all of those whom nature's marvels do not leave indifferent, that Nicolas addresses his book – first of all, to the king.

> I would have liked very much to have the three other species of squirrels that I have seen in the Indies. I am sure that his Majesty, who is moved by the noble desire to learn and to see everything that is beautiful, curious and rare in nature … would have been pleased to receive them, since they are all extremely interesting [curious] in their way, and very particular in their species, since they all have some things in common and some very different. (f. 52)

But not only to the king. Nicolas wanted to reach more humble readers, and often solicits their attention in the course of his text. For example he says: "With this rare shrub [i.e., lead wood] I will finish my account of shrubs in order to satisfy quickly readers who are curious about the special qualities of our large trees" (f. 26); "these rarities [walrus tooth and whalebone] are commonly seen in maritime towns, in the homes of collectors [the *curieux*] who amass everything rare that is brought back from foreign lands where these towns do business" (f. 80); "curious people will be glad to know almost all that can be told about this animal [the moose]" (f. 91); "The vanity of even the most curious ladies could be satisfied by buying beautiful bracelets made from the moose's four feet and as lustrous as the finest jet" (f. 105); "collectors [the curious] are content to have them [hummingbirds] in their studies" (f. 130); "If I say little about all these rare things … I will have done what has never been undertaken in these countries to satisfy the curious" (f. 170); "I finish my whole natural history with a description of eels. This is too rare a thing, and I end with this kind of fish to inspire in curious people a desire to go and see this marvel at the gates of Quebec … If by chance, their great curiosity leads them to follow all the routes that I have traced in my map and in my first six books, they will surely taste all the species about which I will speak" (f. 170); "I have already said elsewhere almost everything that I am going to say again here, so

as not to take anything away from the importance of this fine fish [the beluga], and so the curious reader does not have to have recourse to my earlier works" (f. 187).

The question remains: what exactly are the curious curious about? One could think that, by praising curiosity, Nicolas was advocating direct observation over bookish information. This is not the case. The empiricism that he defends is an empiricism of similarity. He can go on at great length to demonstrate the existence of an extraordinary sign. For instance, after having affirmed the immunity of the laurel to lightning, a common belief since antiquity,[111] he continues:

> I would not be surprised at that great marvel if all the bay trees that are in the world were as well marked as one of these trees (which I have seen and touched, and even taken a part of, which I still have), which was cut in the city of Montpellier, where the whole town came to see two fine natural black crosses in the middle of the trunk of the tree when it was by chance split in order to burn it. It is still kept in the house of Monsieur Forest, near the Citadel.[112] This bay tree was cut in a garden in the city, very near the Church Saint Pierre,[113] in sight of the Hospital. This is what I can say, having seen and touched it, as I said. (f. 25)

It would be hard to establish the validity of an observation any more strongly, but it is an observation that tells us nothing about the laurel itself. We are speaking here of one laurel in particular, and of one that deserves all this attention because of the extraordinary sign inscribed inside its trunk. Protected by the sign of the cross, this laurel was certainly never struck by lightning.

Art historian Svetlana Alpers has drawn attention to Cornelius Koning's engravings, after Pieter Saenredam's drawings, which, in a similar fashion, represent miraculous images found in the heart of an apple tree that grew on a farm in Haarlem. People thought that these images represented a Catholic priest, but Saenredam showed that they were merely shaped like a violin! In 1628, when these engravings were done, the Netherlands was still at war with Catholic Spain, so Saenredam's reading of the image was of great consequence at the time, showing that Catholics had the tendency to see miracles too easily everywhere.[114]

One finds in Nicolas the same need to authenticate an observation and the same amazement, this time in the case of two goldfinches.

> I have more than two or three thousand witnesses who will confirm that in the year 1676, for two to three months, they saw at the monastery of Saint Ruf[115] a wild male goldfinch, which was free and had never been domesticated, come into the rooms where there was another male goldfinch, domesticated, in a cage that it had never left. Its song had such a captivating charm for the wild goldfinch that there was no use pushing him out or hiding his beloved under covers. This little animal despaired, so to speak, until he found what he was looking for, and because he could not get into the cage, these two birds kissed each other by touching their beaks. This love lasted three to four months until one of the monks of the order that I mentioned gave these two birds to his General. I do not know whether the two birds left each other afterward. My pen cannot express how remarkable I found this. (f. 47)

This is a lot of witnesses for such a tiny incident! In fact, for Nicolas, however, this kind of event was not trivial. These goldfinches were important because of the similarity of their behaviour to that of human lovers. Nobody seems to have been troubled by the fact that the two birds were male!

It can thus be concluded that, although Nicolas is in favour of observation, he is more specifically looking for analogy.

<center>* * *</center>

Up to now, we have looked at the relationship of the text of the "Histoire naturelle" to the world, to reality. But there is another relationship, perhaps less apparent but no less important, that, as much as the idea of knowing by analogies, reveals the outmoded character of Nicolas's text. It is the relationship of the "Histoire naturelle" to ancient writings about nature – a relationship of a text to other texts, with the latter perceived as an equivalent to the world. Michel Foucault writes:

> For, in the treasure handed down to us by Antiquity, the value of language lay in the fact that it was the sign of things. There is no difference between the visible marks that God has stamped upon the surface of the earth, so that we may know its inner secrets, and the legible words that the Scriptures, or the sages of Antiquity, have set down in the books preserved for us by tradition. The relation to these texts is of the same nature as the relation to things: in both cases there are signs that must be discovered.[116]

The natural history of the sixteenth century was erudite, filled with Latin, Greek, and – among the more knowledgeable – even Hebrew quotations, and especially the opinions of of Aristotle and Pliny the Elder, which are always transmitted with respect. The apparently naïve character of the text of the "Histoire naturelle" should not mislead the reader here. Nicolas's erudition is formidable. The footnotes to the text provide citations for some of these hidden or overt quotations, whose sources were not always easy to find.

To increase the difficulty, some of these quotations are given as if they were personal observations. For instance, in the case of the bear, where such references are particularly numerous, the text starts with the following declaration: "As the bear is a well-known animal in Europe, I will not repeat what the great naturalist [Pliny] and others have written about it" (f. 71). This is a lie, of course. Even the "other" naturalists are not completely absent from his text. For instance, in the "Histoire naturelle" Nicolas writes that a root that is eaten before hibernation triggers the sleep of the bear in winter. To prove it, he tells us the story of a cowherd who ate this root and fell asleep. He does not give us the source of this story in the "Histoire naturelle" but he did in his "Traitté des animaux": "I don't know what to think about what Ulisse Aldrouan, quoting Gesner, relates on the food of the bear about to winter ... He says that in the neighbouring Swiss Alps, a certain cowherd saw from afar a great bear, scratching the earth and eating with great appetite a certain root. The bear having left the place, the cowherd went to the place where he had seen it eating, ate the same root and returning home had such a need to sleep that he could not resist it and felt asleep."[117] The same story occurs in the "Histoire naturelle" (f. 78). "Ulisse Aldrouan" is Ulysse Aldrovandi

(1522–1605), the famous Italian naturalist, and "Gesner" is Konrad Gesner (1516–1565), his no-less well-known contemporary.

So, even when he says otherwise, Nicolas refers constantly to the opinions of the ancients and of his contemporaries. If words are the equivalent of things, the observation of nature cannot contradict what has been written. If a contradiction seems apparent, one must defer judgment and pursue the enquiry.

One could object that Nicolas does not completely accept the ancient writings as he occasionally corrects Pliny when he is wrong. For instance, Pliny relates, without too much discrimination, an old story about the beaver: "Easdem partes sibi ipsi Pontici amputant fibri, periculo urgente, ob hoc se peti gnari: castoreum id vocant medici [The beavers of the Black Sea region practise self-amputation of the same organ (testes) when beset by danger, as they know they are hunted for the sake of its secretion, the medical name for which is beaver-oil (castoreum)]."[118] In fact, Pliny was only repeating a legend that was probably popular among Roman merchants as a way to boost the commercial value of castoreum.[119] Cicero already knew the story, since he referrs to it as commonplace, comparing his client Scaurus who fled from Sicily, leaving his wife in the hand of his enemies, to the beaver who cut off his testicles to save his own life.[120] Juvenal compares the beaver to his friend, the merchant Catullus, who during a storm threw all his goods overboard to save his life.[121] This legend was also repeated in the Middle Ages. The *Physiologus*, read with much respect at the time, even foresaw the case where the beaver, having already castrated himself, was once again pursued by the hunters. The clever animal would then raise itself on its hind legs and show its enemies that it had lost what they were after.[122] Solinus, in his *Collectanea Rerum Mirabilium*, summarizes what the ancients said about the beaver, both their dangerous bite and their cleverness at self-castration.[123] Isidore of Seville, finally, would sees in this performance the origin of the beaver's name, *castor*.[124]

It was easy for Nicolas to denounce this ridiculous story, saying: "It is not true to say … that the beaver, sensing himself chased by a hunter, tears off his testicles, so that the hunter will be content with that, and with the sweet smell that people wrongly suppose the beaver's testicles have, and with other uses for which they are sought" (f. 119). Charlevoix was of a similar opinion.

> Au reste c'est une folie, que de dire comme font encore quelques Auteurs, sur la foi des anciens Naturalistes, que quand le Castor se voit poursuivi, il se coupe ces prétendus Testicules, & les abandonne aux Chasseurs, pour mettre sa vie en sûreté. C'est de son Poil, dont il devroit alors se dépouiller, car au prix de sa Toison, le reste est presque compté pour rien. C'est néanmoins cette Fable, qui lui a fait donner le nom de Castor [Anyway, it is madness to claim, as some Authors still do, on the authority of the Ancient Naturalists, that when beaver sees itself pursued, it the cuts off its so-called testicles, leaves them to the hunter, and saves its life that way. It should rather give them its fur, since in comparison with its pelt, the rest is not worth much. It is nevertheless this legend that is at the origin of its name].[125]

It is tempting to conclude that, at least on this minor point, Nicolas was foreshadowing Charlevoix's critical approach and was not afraid to contradict even Pliny. In fact, it is not so simple. In the thirteenth century, Roger Bacon (c. 1214–1292) was already

calling this story a "horribile mendacium[a horrible lie]" and had rejected it as not factual.[126] Albertus Magnus was of the same opinion.[127] In fact, both Bacon and Albertus Magnus were referring to another passage in Pliny, in a completely different context. In book XXXII Pliny speaks of the pharmaceutical properties of the *castoreum* and does not repeat the stories of book VII:

> Amputari his [its testicles] ab ipsis, cum capiantur, negat Sextius diligentissimus medicinae, quin immo parvos esse substrictosque et adherentes spinae, nec adimi sine vita animalis posse [Sextius, a very careful inquirer into medical subjects, denies that the beaver itself bites off its own testes when it is being captured; he says that on the contrary these are small, tightly knit, attached to the spine, and not to be taken away without destroying the creature's life].[128]

In this case at least, it was possible to correct Pliny by referring to Pliny himself and thus save the principle of the correspondence of the world to the text of the ancients.

Nicolas relates another legend on the beaver which is not in Pliny. Its origin is more recent. He rejects it also:

> I do not agree with those who have written, based on false reports, that the beaver is captured by the tail, which freezes, they say, and sticks to the ice, and being stuck like this, the beaver can easily be taken by the hunter. Although this animal is quite stupid and awkward, it is not that stupid and is much too clever for that. And if there is any country on earth where that should happen, one would certainly see it in the Northern Indies. (f. 118)

In fact, the origin of this singular belief was probably medieval. But Albertus Magnus, who knew about it, was also critical and doubted its veracity.

> Non est verum quod numquam retrahat eam [its tail] ab aqua quia ex nimio frigore glacialis aquae retrahit eam ab aqua: et ideo falsum est quod hoc animal lutrem cogat ut aquam hyeme circa caudam suam moveat ne congeletur [It is not true that the beaver always keeps its tail in the water, since the animal withdraws it when the water freezes because of the extreme cold; it is then also false to affirm that in winter it wiggles its tail constantly to prevent it from freezing].[129]

At the time the beaver was classified as a fish, and it seems to have been generally accepted that at least one part of its body had always to be in water, as Thomas of Cantimpré, one of Albertus Magnus's sources, maintained.[130]

Nothing better illustrates the status of empirical observation as coextensive with the texts of the ancients than a passage by Nicolas on the existence of unicorns.

> I do not know what to say about the appalling error that has crept in even among many learned people who are otherwise very knowledgeable, but have seen nothing of the admirable things produced by nature because they have never lost sight of their parish church tower,[131] and who hardly know how to get

to the Place Maubert or the Place Royale without asking the way. I say that these people are stubborn to insist that there is no unicorn anywhere in the world. I would like to ask them if they believe in other things that they have not seen and that are much more extraordinary. They would say yes, they believe in them because authors they trust have reported them. And if I tell them that the same writers assert that there are unicorns, what will they say? Will they contradict themselves, claiming that they believe part of what is said by the authors they have read, and that they do not believe the other part? Where did they learn such discernment? Was it on the Pont-Neuf, where these scholars only cross in threes, adorned with furs and fine hats, carried in their chair or driven in a coach that has both sides plugged up to avoid draughts? Goodness me no, this sort of genius must not be believed. Faith must be put into a thousand excellent and courageous men who have suffered and seen rare things, at arms on land and sea, on voyages of twenty or thirty years, suffering all the injuries of weather and the seasons and climate, where rare and surprising things are seen, and which these men of the study have not seen.

A hundred writers, eyewitnesses, report that they have seen [unicorns] before and after Ludovico Berthamo, who writes in these terms, according to the reports of an author, that he saw two of them on his voyage to Medina or Mecca. (f. 85)

Nicolas then quotes – in Spanish – a passage from a book entitled *En carta, y breve declaration del repartimiento, forma y singularides del Mundo*, in which he reads the testimony of "Louys Berthaman" about unicorns.[132] This is probably Ludovico de Varthema, a Bolognese traveller who claimed to have seen a unicorn in Mecca at the beginning of the sixteenth century. His travel report in the Orient of 1510 is included in *Novis orbis regionum ac insularum veteribus incognitarum, una cum tabula cosmographica*, published in Basel, 1532, by Johann Huttich and Simon Grynaeus. The accompanying map, "Typus Cosmographicus Universalis," drawn by Sebastian Munster with the collaboration of Hans Holbein the Younger includes a "portrait" of Varthema, designated there as "Vartomanus." In 1575, a hundred years before Nicolas, François de Belleforest was already using Varthema's testimony against André Thevet, who doubted the existence of the unicorn.[133] Nicolas concludes:

Therefore I ask our scholars to stop doubting that unicorns exist, since there are so many excellent, well-informed writers who assure us that they do, as well as a thousand intelligent and trustworthy people who have seen them and have graciously put their memoirs at our disposal, in which they indicate all they had seen on their voyages and in foreign lands, where things are seen that one cannot believe, yet they still exist. Sceptics have to remember that not all countries produce everything. *Non omnis fert omnia tellus.* (f. 87)[134]

As one can see, Nicolas was not against all forms of learning from books, but he was against these "stay-at-home savants" who were scornful of travellers' testimony. Unicorns exist for the simple reason that hundreds have been seen by explorers.

INTRODUCTION: *Louis Nicolas's Depiction of the New World*

Whatever the exact relationship between the "Histoire naturelle" and the *Codex*, it is certain that Nicolas was interested not only in giving a written description of the flora and the fauna of the New World but also in producing a visual record – or, as he said, a "treatise of figures" or book of drawings – of its inhabitants, plants, and animals. The main question to ask about the *Codex* drawings is in what sense they can be said to reflect the anachronisms in the text of the "Histoire naturelle."

Certainly, Nicolas would have liked to have had the genius of a "good painter" in order to represent accurately the flora and the fauna of Canada, as he says at the beginning of his section on the birds.

> How passionately I wish I had a little of that fine genius and a little of those strong ideas with which good painters, philosophers and poets are said to be born. Or rather, I would like to have been fortunate enough to have, deeply imprinted in my imagination, all the agreeable mixtures of shapes and plumages that I have observed in an infinite variety of very beautiful birds that are seen on the sea, on lakes, on rivers, on land, and on trees of America; I would make one of the most pleasant pictures that can be imagined. (f. 129)

It is noticeable that the idea of painting from nature does not occur to the author. What he would like is to have a memory of all the beautiful birds he has seen, in order to be able to paint them (or even to recognize them when seen already published!). He does not even consider the possibility of directly painting birds, even dead ones, as Audubon did.

How, then, would an author of the seventeenth century like Nicolas have proceeded to make the illustrations of the *Codex*? Let us take as an example the four pages devoted to plants. They do not all seem to have been copied from books. But this does not mean that one should conclude that they were drawn in Canada. Another possibility has to be explored.

The Gardens

The choice place to observe plants at the time was not in the wild but in "gardens" financed by the king, nobles, religious orders – even apothecaries. The main aim of these gardens was medicinal. Nicolas knew France's most famous gardens well. He refers several times to the garden of the University of Montpellier and the most important gardens of Paris. By the beginning of the twelfth century, Montpellier already had a Faculty of Medicine and, since it was inconceivable to study medicine without learning about the so-called simples or medicinal herbs, it was convenient to have a garden on the premises of the university. In December 1593, Henri IV granted the physician Pierre Richer de Belleval (1564–1632) a chair at the University of Montpellier, sponsored by the connétable de Montmorency, himself an amateur botanist. Belleval was responsible for creating the university's garden. Land was acquired in 1596 and in 1598, and a first catalogue of 1,332 plants was published in 1598. To this garden was joined a *Cabinet de curiosités*. Unfortunately the garden suffered during the troubles of 1621–22

(Montpellier was a Protestant city and was invaded by Louis XIII in 1622). When Nicolas visited it, it had been restored only in part to its previous splendour.

In Paris at the same time, the king also sponsored the modest garden of Jean Robin (1550–1629). Its catalogue, published in 1601, shows that it was less a garden of simples than a pleasure garden. Robin's specialty, maintained by his son Vespasien (1579–1662) was exotic plants and flowers, tulips in particular. It was in his garden that the passion flower bloomed for the first time in Paris, in August 1612. And Robin succeeded also in acclimating some Canadian plants to French conditions.[135]

In 1626, under Louis XIII, and against the will of the Sorbonne, the physician Guy de la Brosse created the Jardin des Plantes, a garden of medicinal herbs in the Faubourg Saint-Victor. In his view it would be useful for teaching medicine – hence the opposition of the Sorbonne, who saw it as possible competition. This garden is represented in an engraving of 1636 (fig. 8) where it is still designated as "the King's garden for the cultivation of medicinal plants." Some famous botanists, such as Joseph Pitton de Tournefort (1656–1708) and the Jussieu brothers, Antoine (1685–1758) and Adrien (1797–1853), worked there. When Georges Cuvier (1769–1832) arrived in Paris in 1795 and was appointed to the Muséum National d'Histoire Naturelle, opened only two years before under the Convention, he still was on the premises of the Jardin des Plantes. Its history is well known.[136]

Nicolas also speaks of other gardens in Paris, such as those in the Tuileries and the Arsenal. The garden of the Tuileries is famous. André Le Nôtre (1613–1700) took charge of it in 1664 and divided it into two terraces, the Terrasse du Bord de l'Eau and the Terrasse des Feuillants. Nowadays, it overlooks the Place de la Concorde. The garden of the Arsenal is less known. In fact, it was the lane with four rows of elms planted by Henri IV in front of the Arsenal, which became a fashionable promenade. This lane no longer exists; the site is today occupied by Boulevard Morland, in front of the Library of the Arsenal.[137]

Fig. 8
"Jardin du Roy pour la culture des plantes médicinales." Engraving of 1636. From A.C. Jenkins, *The Naturalists: Pioneers of Natural History*, 110.

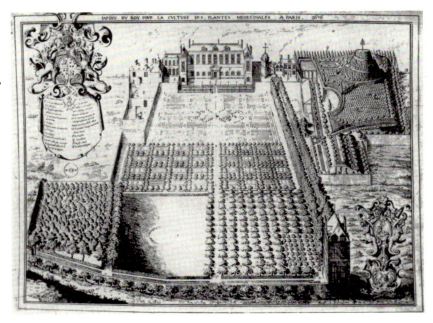

INTRODUCTION: *Louis Nicolas's Depiction of the New World*

There can be no doubt that Nicolas visited these gardens. Moreover, it is possible to show that he was very interested by them. He took pleasure in recognizing three Canadian trees in them: the sumac, the hemlock, and the "white cedar." Here is what he had to say of the sumac. "Apparently, our doctors recognize some particular virtues in its fruit and in the tree itself, since they have given it a place in the famous Royal Garden at Montpellier where I have seen some, as well as in the garden of the same king in Paris and at the Arsenal, of the same kind as in the Indies" (f. 122).

About the hemlock, Nicolas writes: "In France, I have seen some at the Tuileries, at the Royal Garden in Montpellier and in many other places. But since transporting this tree to Spain, Italy and France greatly changes its nature, it is useless there. Not being of the prodigious size that can be seen in the places I spoke about, it would not produce much" (f. 39).

And, finally, about the white cedar: "American cedars have a leaf and a cone like the cypress. The difference between the two can easily be seen in the famous Royal Garden at Montpellier, where I have seen both. Without going so far, one can see the same thing at the Tuileries, where cedars brought from America have been planted" (f. 44).

It is well known that the Jardin des Tuileries had a cypress lane, planted by Claude Mollet, chief gardener of Henri IV. But, to Mollet's despair, the harsh winter of 1608 destroyed the trees. "Certainly, it was the most beautiful alley that we had in France." But, if we are to believe Nicolas, the trees were replaced by Sully at a later date, with "cedars from America." This mention of the Tuileries is interesting in the present context, because it suggests at least in one case – neither the sumac nor the hemlock is depicted in the *Codex* – a possible link between an illustration of the *Codex* and a visit to a French garden. The "white cedar" is represented in the *Codex* (Pl. xvi).

It is possible, then, that Nicolas, following the usage of his time, made some of his drawings not during his Canadian expeditions but, taking inspiration from plants cultivated in gardens, both in Canada and in France. This could explain both the small number of illustrated plants in the *Codex* in comparison with the plants mentioned in the "Histoire naturelle," and the fact that the *Codex* represents three plants – the miner,[138] the "three-colour herb"[139] and the passion flower – which are not mentioned in the "Histoire naturelle."

As mentioned previously, contrary to what we find in *De Historia stirpium Commentarii insignes* by Leonhart Fuchs (1501–1566), Nicolas is not systematic in the representation of each plant. For instance, on Plate xxiii the roots of all the plants are represented, with the exception of the touch-me-not, of which only the flower is portrayed. The only other plant whose flower is represented is the milkweed. The vine on Plate xxiv has no roots. But on the following page, roots are depicted three times out of four, the "small orange tree" alone having none. No plants on Plate xxvi have their roots depicted, and for the passion flower only the flower is represented.

How to explain this inconsistency in presentation? The images provide a good equivalent to what I have called the anachronism of the text. The fact that some organs are represented and not others reflects the absence of a systematic conception of the order of nature, but shows a strong interest in their significance and utility for us.

The *Codex* focuses exclusively on the tubers of the *ounonnata*, for instance, because, as the "Histoire naturelle" explains, the rest of the plant is of no use to Man. It seems, as Marthe Faribault has shown, that *ounonnata* was a generic Iroquois term used to designate all kinds of edible tuber plants.[140] In the "Histoire naturelle," Nicolas distin-

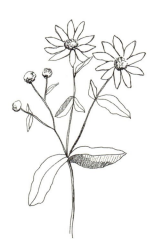

Fig. 9
Jerusalem artichoke,
Helianthus tuberosus L.

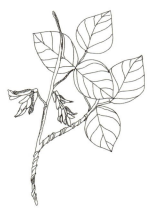

Fig. 10
Hog peanut, *Amphicarpa bractea* L. Fern.

guishes between few edible roots. One reads, for instance, on folio 5: "There are ... three or four kinds of heliotropes or sunflowers whose roots are very good to eat, like those of the *ounannata*, of the *toubinenbourg* [sic]."

Toubinenbourg is Jerusalem artichoke, *Helianthus tuberosus* L. (fig. 9) of the sunflower family.[141] *Ounonnata* in the present context seems to refer to the same plant, or at least to a plant of the same family.

On folio 9, Nicolas mentions the *Outtaragouara*. They are, he said, "a sort of bean [which] bear their fruit differently from ours. The latter produce them outside the earth and in pods, and the former in the earth and without pods. This fruit is much more delicate than the beans of our gardens." This description seems to apply to the hog-peanut, *Amphicarpacea bracteata* (L.) Fern. (fig. 10) or possibly the ground nut, *Apios Americana* Medik. (fig. 11). Nicolas speaks of the American plant as if it were an inverted version of the European one.

On folio 10, Nicolas seems to summarize what he has said about these roots and add new details: "The Americans gather and store a kind of very small, very knotty, extremely bitter root. They eat them in their stew. They dig in the earth and find a kind of small bulb that they like to eat. They use some other roots which are called *toubinenbour* (sic), *ounonnata* and *outtaragouara*." The first plant is not named – it may be a kind of wild onion. The others have already been mentioned: the Jerusalem artichoke and the ground nut, if one takes *ounonnata* as a synonym of *toubinenbour*.

Finally, when the *Codex* (Pl. xxiii) mentions the "*Ounonnata* which sends its roots like truffles," the ground nut may be meant, although the plant depicted there looks more like an arrow-leaf, *Sagittaria latifolia* Willd. (fig. 12), a tuber plant appreciated by the Indians, as noted by Marie-Victorin, which is also known as swamp potato.[142]

As noted before, the *Codex* does not represent the roots of the touch-me-not, *Impatiens capensis* Meerb. (fig. 13).

And indeed, as we learn from the "Histoire naturelle," it is not this aspect that should arouse our curiosity. "The touch-me-not [*noli me tangere*] is another small yellow flower; if you touch it when its seed is mature, it acts as if it were angry and sends this seed against the one who has touched it like so many little darts" (f. 5). Even if folk medicine holds that the touch-me-not counters the effect of poison ivy,[143] it is clear that neither the name nor the description given by Nicolas is related to this usage. Should we conclude that usefulness is not the only source of meaning for the plant? In fact, here the similarities seem more gratuitous. They only show that passions stir the world of plants as much as the world of humans. One could recall here also the example of the *dépiteuse*, or "spiteful plant" (mullein), mentioned earlier.

The case of the "lymphata" is more difficult to interpret. Both the "Histoire naturelle" and the *Codex* mention it. In the "Histoire naturelle" it is described on folio 6, and in the *Codex* on Plate xxiii. Pierre Dansereau has suggested *Asarum canadense* L., wild ginger (fig. 14), as a possible identification of the plant represented in the *Codex*.[144]

However, as Dorothée Sainte-Marie has rightly pointed out, the fruits should develop from the axil near the bract and not from the stem of the leaf as seen here. Charlevoix's illustration is truer to life (fig. 15). Indeed, the knowledgeable Jesuit had a nice illustration of it in his *Description des plantes principales de l'Amérique septentrionale* under the name of the Lychnis of Canada. There is no doubt that he meant the same plant. His picture is realistic enough to guarantee the identification and the scientific name he gives it is already *Asaron canadense*. As Charlevoix writes: "La racine

INTRODUCTION: *Louis Nicolas's Depiction of the New World*

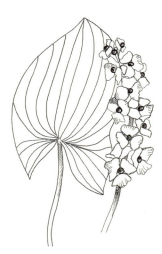

Fig. 11
Ground nut, *Apios americana* Medik. or *Apios tuberosa* Moench.

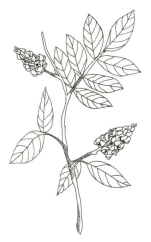

Fig. 12
Broad-leaved arrow-leaf, *Sagittaria latifolia* Willd.

de cette Plante est charnuë, pleine de suc, & s'étend horizontalement. Il en sort des fibres d'une juste longueur, d'une odeur agréable, comme celle de l'*Acorus*, mais plus forte [The root of this plant is fleshy, replete with nectar and grows horizontally. It produces fibres relatively long, smelling good, like the acorus,[145] but stronger]."[146]

In fact, the tuber has a strong flavour of ginger, hence its common name of wild ginger. It also contains a very aromatic essential oil, used in perfumery. This is why it is also designated in French "*nard sauvage* [wild perfume]."[147] The Greeks, who called it *asêron*, which means "unpleasant," did not like its odour. Charlevoix nevertheless tells us that in his day it was used to perfume wine. "On les pile, on les envelope de linge, & on les jette bien nouées dans un tonneau de vin, avec un poids, qui les retiene au fond : on les y laisse trois mois, & elles communiquent au vin un goût très-délicat [The tubers are crushed, wrapped in linen, well tied together and put in the wine barrel with a weight that keeps them at the bottom. They are left there for three months and they give the wine a very delicate taste]."[148] And of course wild ginger also had a medicinal use.

In the description of the "Histoire naturelle," the discrepancies with regard to wild ginger seem to be more significant. Wild ginger is found in forests, especially in maple groves, and on the rocky shores of rivers. It could not be described as a "swamp" dweller. Furthermore, it is a spring flower, not a "full summer" flower as stated. And the brownish purple flower of the wild ginger could not be described as a "large white and yellow tuft," since it grows near the ground, discreet, at the base of the leaves and certainly not "from the stalk of a very large simple with wide leaves that are similar to coltsfoot."[149] What is more, the author knew about wild ginger, since he refers to it a little later: "Ginger," wrote Nicolas, "covers our forest; its root is very fragrant" (f. 7), which is perfectly true. The rhizome contains an aromatic oil used in perfumery. The author did not, then, use the word "lymphata" in "Histoire naturelle" to designate wild ginger. Obviously, for him, these are two different plants.

The problem with the word "lymphata" (or "limphata") is that it seems to have gone out of use for designating a plant today. In Latin, *lymphata* means "water," *lympho*, "to water, to mix with water," but also "to make crazy, to provoke delirium." As a matter of fact, a *lymphatus* is a mentally ill, an insane, a deranged person, and the noun *lymphatus*, denotes mental alienation. I doubt if Nicolas was aware of this etymology, however. He does not mention it in the "Histoire naturelle" and is content to describe the plant as "a very large simple with wide leaves that are similar to coltsfoot."

"Before the flower opens, it has the shape of an artichoke" (f. 6). The comparison with the coltsfoot, *Tussilago farfara* L., (fig. 16) is intended to apply to the leaves only and is not of great help, since the coltsfoot leaf itself resembles the leaf of our garden geranium.

This confusion explains why I was so thrilled when ethno-botanist Anna Leighton proposed a completely different interpretation to me. She went back to the description in the "Histoire naturelle" and suggested that it brought to mind the waterlily, *Nymphæa odorata* or *tuberosa*. Indeed the waterlily is a swamp plant, and the flowers could be described as resembling the "artichoke" when young, and as beautiful "large white and yellow tufts" when mature. Even the allusion to coltsfoot could make sense as a way to give an idea of the size of the leaves of the waterlily. The name *lymphata* would then simply be an indication that the plant lives in water. It may also suggest something of its use. In English, "lymphadentis" is the term for swollen lymph glands and is used to

mean scrofules on the neck, a condition apparently associated with tuberculosis. Perhaps *Nymphæa tuberosa* was refered to as *lymphata* because of the outgrowths on the root and its use in treating lymph-node–related problems. Indeed, the Chippewa Indians used waterlily roots to treat tuberculosis, and the Micmacs used the roots for suppurating glands.

Wild garlic, *Allium tricoccum* Aiton (fig. 17) is represented, of course, by its bulb, the only part of the plant that can be used as food or as medicine.

We should deal at greater length with the representation of the *cotonaria*, by which Nicolas means the milkweed, probably the *Asclepias syriaca* L. (fig. 18). The *Codex* shows the milkweed in flower, even though the "Histoire naturelle" speaks at length of its fruit. "The seed of the plant forms and feeds in a fairly large pouch in the middle of a very beautiful and very fine cotton which, because it is too fine, does not have much body and thus is useless. Attempts to make hats of this have convinced us of its uselessness" (f. 6). This is the reason, of course, that it was not necessary to represent its fruit in the *Codex*. In the "Histoire naturelle," only parts declared to be useful are represented.

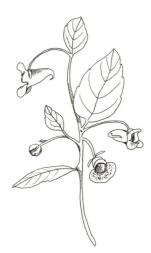

> Its root taken in its time, that is when it begins to grow around mid-May, is much better than asparagus. This root can be preserved; if it is salted, it can be eaten at any time. From the end of the stalk come several tufts formed by innumerable very beautiful, very fragrant flowers, full of an extremely sweet liquid. The little hummingbird feeds on this liquid … The hemp obtained from its stalks is more useful [than the silk from the seeds]; the natives of the country make fine works with it. I have in hand an elegant little bag made by an Indian woman from this sort of hemp. (f. 6)

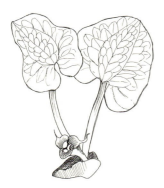

A final example of Nicolas's inconsistency in representing plants is the American white hellebore, which is represented only by its root and two leaves, as if it had no flower. This false hellebore, named *varaire* by Olivier de Serres (1539–1619), the "father" of French agriculture, is very conspicuous both in Europe and in America, with a long stem reaching up to six feet high, large oval leaves, and the long panicle of its yellowish white flowers. Since 1842 it has also been named *verartre* in French, from *veratrum*, as in the scientific name of the plant *Veratrum viride* Ait (fig. 19). The reason it was designated *veratrum* by Lucretius and Pliny was the colour of its root: *vere*, "really," *ater*, "black." Not surprisingly, Nicolas has blackened its roots in the *Codex*. This plant is highly poisonous[150] and has narcotic properties, but Nicolas thought its roots were effective for curing tumours. This is why in the *Codex*, he has represented it as it first appears in spring, when the plant consists predominantly of roots.

Only three plants are shown on Plate XXIV of the *Codex*: the lichen, from which one can make stock that resembles "the most insipid and least nourishing glue in the world"; the *metamin* or maize, and the vine *vitis indica* and *canadensis*. The author has difficulty defining exactly what a lichen may be. As we know now, the lichen is formed of a fungus and an alga living together in symbiosis.[151] Nicolas should be forgiven for not knowing this, since it was not until 1867 that Simon Schwendener (1829–1919) clarified the true nature of lichens.[152] Nicolas describes this lichen as a "a kind of foam, or moss, like a simple called *oreille de Vénus* [ear of Venus]" (f. 11). The "glue" one can make from it is edible, and better than nothing, during time of starvation.

INTRODUCTION: *Louis Nicolas's Depiction of the New World*

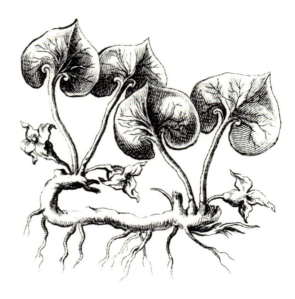

Fig. 15
Lychnis of Canada. Detail of Pl.
xvii in Charlevoix, *Description
des plantes principales de l'Amérique
septentrionale*, 1744.

Fig. 16
Coltsfoot, *Tussilago
farfara* L.

Of all the plants Nicolas describes, the maize, *Zea mays* L., is the best represented. Its roots, stem, flowers, and ears are noted. And indeed, each of its parts has its use, as stated at length in the "Histoire naturelle":

> This simple produces its flower at the same time the ear is formed on the opposite side from its flower, unlike other plants. This kind of wheat has several roots, not too large, from which a sort of tube or cane comes out; it is fairly large at the bottom and sometimes reddish, and becomes smaller as it grows. It grows to seven or eight feet in height. It is round and knotty … [Its] leaves are long, wide, full of veins like those of the canes.From the top of this great tube, foot-long plumages grow […] The ear grows from the knots in the stalk. It is long and wrapped in several tender leaves, green, yellow, red and white, from the end of which grow a kind of filaments, which look like long hairs. The ears, in this country, usually are a foot long; around them the grains are very tightly packed with an attractive arrangement of eight or ten rows. (f. 15)

The vine *Vitis riparia* Michaux (fig. 20) is represented only by a branch with two leaves and a bunch of small dark fruits. Nothing more has to be shown about this vine in Canada, because of its utility in "producing only black grapes" (f. 22), whose sole use is to produce a syrupy, barely drinkable wine.

Four plants are represented on the same page of the *Codex* (Pl. xxv): "wild cherries," the "small orange tree from Virginia," a "plant that bears lemons," and the "fruit of the cranberry-tree." The emphasis here is on the fruit and indeed that is the only element of these plants commented upon in the "Histoire naturelle."

Nicolas particularly praises the "lemon," which in his opinion "is the finest and the rarest of all the simples that I have ever seen in all my travels." This is the way he describes it: "It is more than three geometrical feet high; usually each plant bears up to ten or twelve fruits [in the figure of the *Codex*, it has ten fruits], as large as a turkey egg. The peel of these fruits is entirely like our lemons, and its appearance is the same" (f. 11).

The "pimina" – what we would call the cranberry tree, *Viburnum trilobum* Marsh. (fig. 21) – is represented as a shrub, with its roots, leaves, and fruits. "Its leaf [is] jagged

Fig. 17
Wild garlic, *Allium tricoccum* Ait.

like the hawthorn, but larger. Its fruit is red, yellow and green. It is produced in large clusters" (f. 20).

The "wild cherries" of the *Codex* correspond exactly to the choke cherry of the "Histoire naturelle," that is to say to the *Prunus virgiana* L. (fig. 22). "Its leaf is like that of the apple, and seeing it without fruit one could take it to be a kind of apple tree. In season it is heavily laden with big bunches of fruit, so that it looks more like grapes than cherries. The fruit is fairly large like ours and has a bitter taste" (f. 21).

The "small orange tree from Virginia" is called "the American orange tree" in the "Histoire naturelle."

The shrub has several shoots four or five feet high. They are very thorny and prickly. The thorns are very long, strong and slender, much more so than those at the end of palm or aloe leaves. Not many leaves are seen on the plant. Near the thorns, a very fragrant little white flower appears, and from that is formed a fruit as large as a pea, without a pit. The fruit is similar to a small shell. Its fragrance is stronger than that of the best oranges of Provence, and its bark is like theirs. (f. 21)

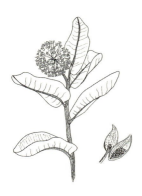

Fig. 18
Milkweed, *Asclepias syriaca* L.

The last page of the *Codex* devoted to plants (Pl. XXVI) juxtaposes a "branch of the Canadian white cedar" and a "branch of the red cedar of Virginia."

The "white cedar" of Nicolas is certainly the *Thuja occidentalis* L. (fig. 23), which, as we know, is not a true cedar. The *Flore laurentienne* tells us that it has always been used in folk medicine and by the Amerindians.[153] It was with a tea made from the *Thuya* leaves that the inhabitants of Stadacona healed Cartier's men from scurvy.[154] Nicolas notes only that the leaves of the white cedar are "astringent, sour and a little bitter" (f. 44). This is why, in the *Codex*, only a branch is represented. For him, it is the only part of the tree that is really useful. Nevertheless, in the "Histoire naturelle," no use is signalled for the strobiles[155] – Nicolas called them "apples" – even if they are well represented in the *Codex*. He limits himself to a comparison with the cypress, which gives him the occasion to criticize Lescarbot, who took our cedar (which is not a cedar!) for a cypress, and to compare it to the cedar of Lebanon! Once again, we are witnessing a mode of knowledge by similarities and analogies which is typical of the time; the real utility of the strobiles is still unknown, but the comparison should lead us one day to their real meaning.

Nothing shows the importance of form – Nicolas would have said the *figure* – more clearly than the last plant represented in the *Codex*. It is the "passion flower that produces the instruments of the Passion of our Lord Jesus Christ." Indeed, one finds here a curious representation of the *Passiflora* or passion flower (fig. 24), also called the "*granadille*" in French. As stated by Nicolas, this flower has at its centre filaments comparable to the crown of thorns, a pistil with three stigmata resembling the nails of the Passion, and leaves that are pointed like spears. Native to South America (Brazil and Peru), this plant cannot be found in Canada.[156] It is not mentioned in the "Histoire naturelle." Nor can it be found in the manuscript of Michel Sarrazin and Sébastien Vaillant,[157] or in Charlevoix's "Description of the Principal Plants of Northern America," or in the Diary of Pehr Kalm.[158] Nevertheless, it was always a favourite of ancient illustrators.

Fig. 19
American white hellebore, *Veratrum viride* Ait.

49

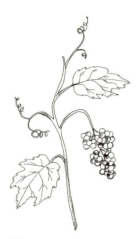

Fig. 20
Vine, *Vitis riparia*
Michaux.

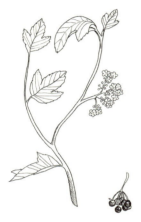

Fig. 21
Cranberry tree, *Viburnum
trilobum* Marsh.

Fig. 22
Wild cherry, *Prunus
virginiana.*

Thomas Johnson included it in his revised version of John Gerarde's famous *Herballs*, 1633, where one sees the *Passiflora incarnata* L., or May apple. Theodorus Zwinger included an engraving of the *Passiflora caerulea* L., in his *Theatrum Botanicum*, published in Basle in 1744 (fig. 25).[159] Georg Dionysius Ehret painted the *Passiflora rubra* L. in 1743 and the *Passiflora serratifolia* L. in 1757.[160] Its popularity is not surprising. In seventeenth-century terms, one could say that the Passiflora is a "monster," meaning something worth showing (*monstré* in Old French). This probably explains its strategic position in the *Codex*, where it ends the section devoted to the plants. Nicolas took great care to draw (or to have drawn) the crown of thorns, the nails – even the vial of precious blood – transforming the signifier into the signified, so that there would be no doubt about the meaning of this plant in his eyes.

The Menagerie

The section on the terrestrial mammals was evidently the subject of more enthusiasm on Nicolas's part. After all he was the author of a "Traitté des animaux à quatre pieds," likely a first draft of the "Histoire naturelle" on the same subject.

However, the zoological iconography of the *Codex* seems to have been elaborated in very different circumstances from the volume devoted to the plants. Zoos and menageries do not seem to have played a similar role to the gardens. Nicolas mentions them only to say that few Canadian animals were put there, not that he has seen animals there. For instance, the Versailles Menagerie is where the "chipmunk" he showed to the king finally ended up. "[His Majesty] was curious[161] enough to order Monsieur Chamarante[162] to have them put in his famous Versailles menagerie" (f. 51). He also believed two tame "wild cats" (f. 66) and two "wood ducks"[163] were kept there. "I believe that it is still possible to see two of them, a male and a female, that were placed in the famous menagerie of Versailles. We brought them from the Indies in our ship called *La Grande Espérance*" (f. 164). And it is probably there that he would have liked to house the bears he had tamed. "These bears would have made a truly fine present for a great man, but, unfortunately, I had no box that they could easily be contained in like the chipmunks that I had the honour to present to His Majesty on my return from the Indies … Besides, the whims of some of my fellow missionaries, who thought it unwise for me to take the trouble to transport such large animals to France, meant that I left them with my friends" (f. 74).

The Cabinet of Curiosities

Another potential source of information could have been the *Wunderkammer* or cabinet of curiosities.[164] Nicolas twice mentions the Bibliothèque Sainte-Geneviève-du-Mont in Paris, where Father Claude du Molinet (1620–1687), its creator, had such a cabinet in which one could see the teeth of a polar bear (f. 79) or the skull of a walrus (f. 120). Indeed, Nicolas declares that he himself had seen a walrus skull at that library. He would have gone, not to the building of that name that, after the mid-nineteenth century was situated behind the Pantheon, but to the former Library of the Sainte-Geneviève Abbey, under the direction of the Regular Canons of Saint-Augustine, which had just been built (1675). Like all the great libraries of the time, this one had its own cabinet of curiosities and it is there that Nicolas would have seen his walrus skull. The

Fig. 23
American arborvitæ,
white cedar, *Thuja
occidentalis* L.

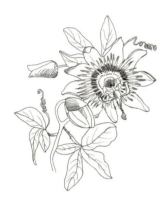

Fig. 24
Passiflora, *Passiflora
caerulea* L.

Figs. 16–24 by Jessica Darveau.

Fig. 25
Left, *Passiflora incarnata*
L. in T. Johnson, ed.
John Gerarde, *Herball,
or, Generall Historie
of Plantes*, 1633; right,
Passiflora cærulea, in
T. Zwinger, *Theatrum
Botanicum*, 1696. Fig.
from Richard G. Hatton,
*The Craftsman's Plant
Book*, 217.

neighbourhood of the "famous Library" was very familiar to him. Elsewhere in his manuscript (f. 85), he mentions Place Maubert, which was nearby.

The main collection at the Bibliothèque Sainte-Geneviève-du-Mont in Paris consisted of old coins, medals, and plaques, and it also contained some Egyptian antiquities and Greco-Roman artifacts, such as sacrificial vessels, lamps, utensils, and weights and measures. But there was also a section devoted to mammals and birds. Claude du Molinet, in his *Cabinet de la Bibliothèque Sainte-Geneviève*, published in Paris in 1692, produced a plate on the library's collection of quadrupeds (fig. 26).

The walrus head seen by Nicolas is represented here, at no. XII, and the polar bear tooth could have been in VII. On the same page there is also a strange gathering of zoological curiosities. The armadillo, a scaly mammal, was a common occurrence in cabinet of curiosities, because its carapace was easily dried and transported. It occurs in the catalogue of ten cabinets reviewed by Wilma George.[165] Live armadillo, on the other hand, do not seem to have been on show either at Versailles or London zoos. The same plate shows also a pangolin, a rhinoceros tusk,[166] a narwhal tooth, a lemming, an Egyptian skink (?), the tusk of a wild boar, if not that of a babyrusa pig from Celebes, a chameleon, a marine turtle,[167] a hippopotamus tooth, and a crocodile. It seems that the cabinet also had porcupine quills, but they are not shown on this plate.

The Austrian ethnographer Christian F. Feest has pointed out that one Indian artifact – albeit a Tupinamba club from Brazil (fig. 27) – was also "in the Peiresc collection at the Bibliothèque Ste. Geneviève in Paris in 1688."[168] It is well established that many items on display at Sainte-Geneviève came from the collections of Nicolas Claude Fabri de Peiresc (1580–1637) of Aix, the rest coming from Achille de Harlay (1629–1712), premier président of the Paris parliament, and a M. Accart, who bequeathed a collection of engravings.[169]

Nicolas also mentions that an apothecary of Toulouse had hung a set of American deer antlers above his door. "When I was still travelling, I sent it to this friend, who displays them" (f. 83). Of course, it is difficult to speak of a collection in this case! We

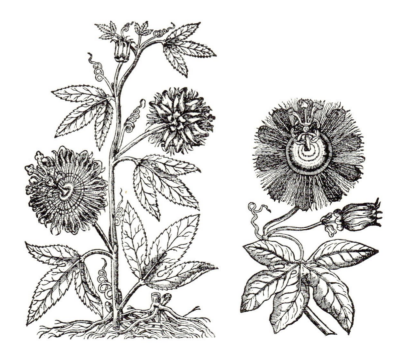

INTRODUCTION: *Louis Nicolas's Depiction of the New World*

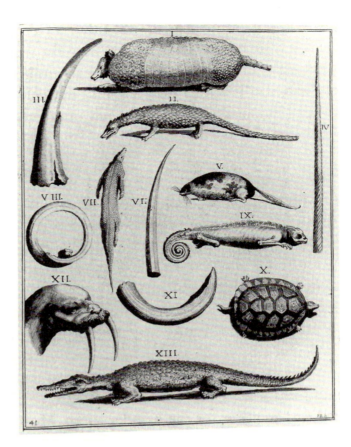

Fig. 26
Claude du Molinet, *Le Cabinet de la Bibliothèque Sainte-Geneviève*, Pl. 41. Fig. from Joy Kenseth, *The Age of the Marvelous*, 131, fig. 24.

should recognize, however, to what extent animal horns and hooves were appreciated by apothecaries. As Thevet used to say: "Corne de tout animal est efficace en quelque maladie [any animal horn is effective against some illness]."[170] Deer antlers were especially valued as an antidote to snake bite, as the deer was considered the natural enemy of any venomous snakes, the viper in particular.

The existence of genuine curiosity cabinets among the apothecaries of southern France is well documented. For example, de Monts, who knew Peiresc, was in contact with the apothecary Paul Contant (c. 1562–1629) from Poitiers, who thanked him for his gifts. Doctors and apothecaries of Poitiers were acquiring American curiosities from their colleagues in La Rochelle, a town with well-known contacts with the New World. In his cabinet, Contant had an eighteen-foot Indian canoe, a feather robe and headdress, daggers, shields, and necklaces made from the teeth of their enemies, all from America.[171] One finds representations of similar objects in the *Codex*.

The Fish Market or Books?

Another possible source of inspiration could have been the fish markets in Europe, at least for the section of the *Codex* devoted to fish. Guillaume Rondelet, for instance, did not disdain this humble source of information during his trips to Holland and Italy.[172] We are told that John Ray and Francis Willoughby acquired most of their specimens for their *De Historia Piscium* (1686) themselves. They bought fish in the markets of Europe: lamprey and sturgeon from Venice; needlefish from Tenby, Wales; swordfish from Reggio. Thomas Platter the Younger, Swiss-born physician, traveller, and famous diarist, sent rare fish from the south of France to Basle in 1596.[173] But this does not seem to have been the case with Nicolas and we have to look elsewhere in search of his sources. His illustrations of fish seem to have come exclusively from books.

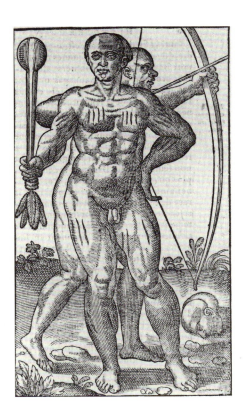

Fig. 27
Tupinamba War Club,
in Jean de Léry, *Histoire
d'un voyage fait en la terre
du Bresil…*, 249.

At the end of his section on plants, Nicolas challenges his readers to find the plants
he has mentioned in his manuscript in the works of a number of authors. "Those
who wish to know more particular things about the treatise on simples, trees, fruits,
flowers, shrubs, and all the other natural things that are found outside the West Indies
have only to consult (as I did to know about what I had not seen or where I had not
been) more than thirty writers in whose work I found nothing of what I have put
forward" (f. 46).

Mind you, he was careful not to issue the same challenge for the section on ani-
mals. And indeed, in the list that follows, we encounter botanists almost exclusively.

> Let them search therefore in Cantacuzene of Constantinople, in Ruel, in Mat-
> thiolus, in Valerius Cordus, Dalechamps, Hippocrates, Galen, Strabo, Eustath,
> Dioscorides, Belon, Theophrastus, Des Moulins the physician, Pliny the master
> naturalist, Boethius, Macrobius, Scaliger, Columel, Gesner, Gaza, Hermolaus,
> Hieronymus Tragus, Bauhin, a disciple of Aesculapius, Festus, Palladius,
> Fuchs, Dodoens, Phocion, Diodorus of Sicily, Cornarius, de Laguna, Johnson,
> Aldrovandi, Rondelet and many others. (f. 46)

The "divine Aristotle" is also named further on. Certainly, the main intention of this
long list is negative. Here are the authors, declares Nicolas, in whose works you will *not*
find the plants illustrated in the *Codex*. The list is nevertheless interesting because it
gives a good idea of the botanical content of a Jesuit library at the time. And it is indica-
tive of the style of research a Jesuit like Nicolas thought he had to undertake before
writing something new.

In that list, Nicolas shamelessly mixes authors of antiquity with more modern writ-
ers. Hippocrates, Galian, Strabo, Dioscorides and Theophrastes, Pliny, Macrobius,
Columella, Festus, Phocio, and Diodorus of Sicily were, with a few others like Varro
(*De Re Rustica*), Martialis (*De Spectaculis*), Plutarch (*De Sollertia Animalium*), Arrian

(*Cynegetica*), Oppianus (*Cynegetica* and *Halieutica*), and Aelianus (*De Natura Animalium*), the basis of natural history in the Renaissance.

More interesting in the present context are the contemporary authors that Nicolas mentions. We cannot identify all of them, but some are well known. I will not comment on them in detail here, since the list is annotated in the notes to the text of the "Histoire naturelle," but simply remark that most of those that can be identified belong to the sixteenth century rather than to the seventeenth, a sure sign of the traditional style of Nicolas's natural history and of the *épistémè* to which it belongs.

The list of authors whom Nicolas consulted is impressive. And in fact, even if it was not intended to do so, it solves the puzzle of his iconographical sources for the zoological section of the *Codex*. As we shall see, Nicolas leaned entirely on Gesner. One should not be shocked by this derivation. As E.H. Gombrich has demonstrated again and again, the representation of the unfamiliar is always based on the familiar.[174] And when the problem is to illustrate a text already full of analogies and similarities, the tendency to start from the known to depict the unknown is reinforced by the quest for the similar to explain the similar. We can say, then, that the art historian's technique of looking for an artist's sources is more than routine in the present case. It is the best way to show the consistency between the *Codex* and the "Histoire naturelle."

TO CLASSIFY

The material that Nicolas had to present was abundant, even unruly, and he needed to organize it one way or another. As we shall see, his classification system is not based on any preconceived idea of the order of nature that taxonomy ought to reflect. On the contrary, he starts from analogies and thinks that one has to group similar things together.

The Plants

Even though Nicolas does not give his explicit criteria for plant classification, they are easy to deduce from his text. His main criterion seems to have been a plant's size. He starts with medicinal herbs and finishes with the "great trees," and treats "seeds" (edible grains) and bushes in between. By doing so, he was giving first place to the simples (medicinal herbs) in his presentation – a traditional way to proceed. We are far from the attitude of Jean-Jacques Rousseau, who scoffed at the idea of botany being a worthwhile study if one was interested only in the "properties" of the plants.

> Ce dégoûtant préjugé est détruit en partie dans les autres pays et surtout en Angleterre grace à Linnaeus qui un peu tire la botanique des écoles de pharmacie pour la rendre à l'histoire naturelle et aux usages économiques; mais en France où cette étude a moins pénétré chez les gens du monde, on est resté sur ce point tellement barbare qu'un bel esprit de Paris voyant à Londres un jardin de curieux plein d'arbres et de plantes rares s'écria pour tout éloge: "Voilà un fort beau jardin d'apothicaire!" À ce compte le premier apothicaire fut Adam. Car il n'est pas aisé d'imaginer un jardin mieux assorti de plantes que celui d'Eden. [This disgusting prejudice is destroyed in part in other countries, and

especially in England, thanks to Linnaeus, who has taken botany a little away from schools of pharmacy to return it to natural history and to economic use; but in France, where this study has least penetrated among any people in the world, people have remained so barbarous in this respect that a clever man from Paris, seeing in London a connoisseur's garden, full of trees and rare plants, cried out for eulogy, "There is a fine garden for an apothecary." According to this view, the first apothecary was Adam, because it is not easy to imagine a garden better furnished with plants than that of Eden].[175]

At the time of Nicolas this attitude was still unthinkable. Every convent and hospital had to have a garden of medicinal herbs in its enclosure. For instance, on the famous "plan Saint-Ours" of the Hôtel-Dieu in Quebec, there was a "garden" near the "pharmacy." So even this famous early Quebec hospital conformed to this practice.

It is no surprise, then, that Nicolas always gives the medical properties of the plants he mentions. For instance, about wild garlic he writes: "Our American garlic has excellent virtues against swellings and all kind of tumours; to use it for this purpose it must be boiled for a short time and crushed while still hot on the swollen part" (f. 6).

He is even interested in Amerindian pharmaceutical lore, as one can see in what he writes about the root of hellebore, a plant illustrated in the *Codex*. "The Indians use it to reduce tumours" (f. 7).

A second criterion for classification is even simpler: alphabetical order. This applies to the list of medicinal herbs given on folios 4 and 5, which starts with "amaranth" and finishes with "violet"; and the list of vegetables, which takes us from "asparagus" to "salsify." Here also, Nicolas was following a traditional pattern. For instance, the *Flora Noribergensis* (1700) by Johann Christoph Volkamer, a work contemporary with the "Histoire naturelle," is organized strictly in alphabetical order.[176]

The Quadrupeds

In dealing with zoological matters, in which he had a greater interest, Nicolas adopted a more complex system. He is even at pains to set out its main characteristics on folios 48 and 49, something he did not consider necessary with plants. His zoological classification system seems at first a little muddled because he uses several systems instead of one. His first criterion has to do with *convenientia*, the correspondence between an animal and its place. Animals live either on the ground, or partly on the ground and partly in water (amphibious), or in the air – or in water exclusively. This is the system used, for instance, by Gabriel Sagard in his *Grand voyage du pays des Hurons* (1632), in which one finds chapters devoted respectively to "Birds," to "Land animals," and to "Fishes and aquatic animals."[177] This system was a way to demonstrate the great correspondence between the animals and the four elements: earth, air, water, and fire (this last one creating some special problems, as one can easily imagine!). It is a very ancient system of classification that was already present in Aristotle, who was quite aware of the problem created by the absence of animals living in the midst of fire. "The fourth class must not be sought in these regions, though there certainly ought to be some animal corresponding to the element of fire, for this is counted in as the fourth of the elementary bodies … Such a kind of animal must be sought in the moon, for this appears to participate in the element removed in the third degree from the earth."[178]

INTRODUCTION: *Louis Nicolas's Depiction of the New World*

Aristotle was hoping that these kinds of animals, which were so clearly absent from "our regions," could be found one day on the moon. Elsewhere in his *Historia animalium*, he cited the salamander, as "a clear case … to show us that animals do actually exist that fire cannot destroy; for this creature, so the story goes, not only walks through the fire but puts it out in doing so."[179] Was Aristotle trying to save *convenientia* in nature with the case of the salamander and some insects found in Cyprus "in places where copper-ore is smelted"?[180] It is possible that he did not himself believe these stories. The *Historia animalium* is a compilation and it is not certain that everything mentioned there was substantiated by Aristotle himself. Nevertheless, it was a widely held "fact," often quoted in favour of the classification of the animals according to the four elements.

This system of classification, consistent with the sixteenth-century *épistémè*, was adopted by Nicolas both in the "Histoire naturelle" and the *Codex*. Books 4 to 7 are devoted exclusively to terrestrial animals, Book 8, to amphibians. Books 9 to 11 deal with birds, and the two last books with fish.

Nicolas then brings forward a second criterion, subordinated to the first, valid only for quadruped terrestrial animals. One can classify them, he says, by the shape of their feet. Clearly, in this case, the ultimate source of this classification is in Aristotle. "There are differences in the feet of quadrupeds. For in some of these animals there is a solid hoof [*mônuxa*], and in others a hoof cloven into two [*dixêla*], and again in others a foot divided into many parts [*poluskidê*]."[181]

But Nicolas seems to be closer to Aldrovandi, an affinity that is not surprising when one thinks of his importance in natural history at the time. "[Aldrovandi's] influence on animal classification affected many of the seventeenth-century collections. His breakdown of mammals into solid-hoofed, cloven-hoofed, and clawed, and the inclusion of whales with mammals, was followed by the Dane Worm (1655), the Italian Cospi (1677) and the Englishman Grew (1681)."[182] To these, one could add authors like the famous English naturalist John Ray (1628–1705), author of *The Wisdom of God Manifested in the Works of the Creation* (1691), which follows Aldrovandi on this as well.[183]

Similarly Nicolas classifies the quadrupeds into animals with "round" feet, cloven-hoofed animals, and animals with "claws." Of the first, like "the horse, the mule or the donkey," he does not speak much, since they are not represented in New World fauna. He explains that an animal with "round" feet would be at a disadvantage in Canada, being prone to slide "one thousand times a day" on ice during the winter. The other kinds of quadrupeds are well represented in Canada.

In the section devoted to terrestrial quadrupeds, the *Codex* first presents the "clawed" animals and then the "cloven-hoofed" ones. Nicolas justifies this order by noting that feet with claws have "much similarity to the human hand," in comparison to the cloven-hoofed ones, and for that reason it makes sense to give them the first place. Similitude – even anthropomorphism – then, remains an important means of knowledge. But Nicolas does not follow his own system too rigidly – the "big snake" and the "deer of Upper Virginia" appear in the section devoted to the clawed animals! He is conscious of going against his own rules, especially with the snake. "This is not the place where I want to speak of this kind of the big snake," he says (f. 60). But when speaking of the mythological animals of the Amerindians, he was carried away by his subject and mentioned the "big snake" in that context. On the other hand, since the

deer of Virginia is the habitual prey of the wolf, he perhaps thought that it made sense to treat one after the other.

Aristotle's third criterion, the one that makes a distinction between the quadrupeds that "lay eggs" and are "covered by a sort of bark" (like the turtles) on one hand and the viviparous animals on the other, is not very useful to Nicolas, whereas for Aristotle the distinction between the *zôokounta* (viviparous) and the *ôotokounta* (oviparous) had been crucial: it is the key classification criterion in his *Generation of the Animals*.[184] Nicolas uses it only in regard to amphibians, because for him the turtle is the only quadruped that lays eggs. "Since I promised at the beginning of this treatise to end it with the four-legged animals which I have named following the Latins *ovipara* and the Greek *ôotoxa, quae cortice teguntur* [which are covered by a shell], or which are rather covered with various scales, I will say that there are so many of them in the Western Indies that it would be difficult for me not only to give a description of them, but even to give their names" (f. 123).

Finally, the last criterion of classification proposed by Nicolas seems to come from Pliny rather than Aristotle. It is size. Pliny begins his treaty on the quadrupeds with the elephant and the one on the birds with the ostrich, evidently because of their size. Nicolas also takes size into consideration, but begins with the smaller animals and finishes with the larger ones. "I do not know if those who do me the honour of reading this natural history will take note of the order that I have kept this far in all my writings, which I have entitled 'the complete knowledge of the New World': always beginning my treatises with the smallest things and finishing with the largest of the same genre and of the same species" (f. 122).

In fact, this was already the system adopted for the plants, whereby the herbs were treated first and the great trees last. One finds the same system among other Canadian writers, for instance, Pierre Boucher in his *Histoire véritable et naturelle des mœurs & productions du pays de la Nouvelle France, vulgairement dite le Canada* (1664),[185] with the difference that, like Pliny, Boucher started his presentation with the moose and finished with the squirrel. Of course, given that a classification by size is basically a classification by similarity, it is no surprise that Nicolas was at ease with it.

The *Codex* devotes ten pages to "terrestrial four-footed animals." This section opens with a really extraordinary page depicting a unicorn and a tiger. We have already discussed the unicorn. Here, it is "a pen-drawn figure" (f. 86), as the "Histoire naturelle" puts it. The caption reads: "Licorne de La mer rouge ou l'on En voit quelques unes on en a porté ou conduit a medine, et a la meque ou les caravanes qui y vont En ont veu [Unicorn of the Red Sea where some are still to be seen. Some have been brought to Mecca or to Medina where the caravans which go there have seen them]."[186] Nicolas took his information on the unicorn from a Spanish author quoted by "Monsieur Thévenot, an illustrious writer of our time" (f. 87). In his "Traitté des animaux à quatre pieds terrestres et amphibies, qui se trouvent dans les Indes occidentales, ou Amerique septentrionale,"[187] he is a little more precise: "Thévenot speaks about the [unicorn] in a book called the Dutch Embassy to China." This could only be the third volume of the *Relations de divers voyages curieux qui n'ont point été publiés* (1681), a compilation by Melchisédec Thévenot, which opens with Nieuhoff's *Ambassade des Hollandois a la Chine ou Voyage des ambassadeurs de la Cie hollandoise des Indes orientales vers le Grand Chan de Tartarie*. But this book, which was not illustrated, is not the

source of the illustration of the unicorn in the *Codex*. Nicolas was probably referring to a very common image of his day.

One thing is certain. This figure of an extraordinary animal plays the same role as the *Passiflora* in the section on plants. One begins (or finishes) with the monsters, that is to say, etymologically speaking, with what is worth showing (*monstrare*) and emphasizing.

The "tiger" shown here is even more out of place in a book on Canadian fauna. One cannot assume that it was a beast familiar in Europe at the time. Montaigne, who claims to have seen one in a menagerie in Florence, described what he saw as "an animal of the size of a big dog, and all spotted in black and white."[188] He probably meant a leopard or a cheetah, rather than a real tiger. The representation in the *Codex* does not bear the characteristic stripes of the tiger and could be any kind of feline with spots (Pl. XXVII).

The following pages deal with less extraordinary animals. Conforming to his method of classification, the author devotes six pages to animals "with claws" and four to "cloven-hoofed animals." In each sub-division, he moves from the smaller beasts to the larger ones: from the squirrel to the bear, and from the deer to the moose.

In the section devoted to the "clawed" animals, the beasts are represented indifferently horizontally or vertically, often symmetrically, as if displayed as a kind of hunting trophy (plate XXVII, for instance). Moreover, seven of these carnivores are represented with their tongues protruding, as if dead. Finally, the "mole of New France," the "weasel," and the "stoat" are represented with their paws on each side of the body, as if the author was depicting pelts rather than living bodies. This is never the case in the other section, where all the cloven-hoofed animals are represented in profile, as one could see them in nature. Only the moose sticks out its tongue.[189] Of course these details of presentation are not insignificant. They suggest that the principal usage of all these animals was to supply fur to man. We have here in zoological terms the equivalent of what we notice about plants: the illustration always stresses usefulness.

It is noticeable that the animals that seem more alive, like those on Plate XXIX, are precisely those with little utility to man, as indicated in the "Histoire naturelle." Of the "woodchuck," for instance, it is said that "although the skin is handsome, there is no trade in it" (f. 58). The rabbits exist just to make "good pâtés" (f. 59). The skin of the small hare could not be used for anything except to make "robes, mittens and caps" for children (f. 59). The "manitou," probably a wolverine, is too "ugly" and "smells [too] bad" to be of any use (f. 59). The great hare is more a curiosity than anything else. Who speaks of the fur of the porcupine? Finally, for Nicolas, the skunk is a "very ugly animal." "Despite the smell of the animal, [the Indians] nevertheless make robes of several skins of the stinking animal, which has nothing to recommend itself except its stench. The very reason that a native will wear it is to be considered brave, and so that people will say that nothing repels him, since he has the determination to wear a robe made of the skin of a very ugly, stinking animal" (f. 64).

It is evident that, except for the "great hare," which derives from Gesner's *cuniculus*, none of these figures take their inspiration from the great Swiss naturalist. Yet, Gesner illustrates a hare (fig. 28) and a magnificent porcupine, which could have furnished excellent models for the corresponding illustrations in the *Codex*.

There are some exceptions to the norm. The "common weasel," the "long-tailed weasel," and the "marten," and in particular the "common fox," seem quite alive in the

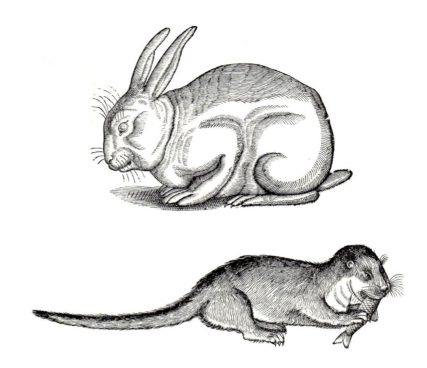

Fig. 28
Rabbit, *Oryctolagus
Cuniculus*, in Edward
Topsell, *The History of
Four-footed Beasts and
serpents*, 86. Fig. from
*Curious Woodcuts of
Fanciful and Real Beasts*.
Konrad Gesner. 11.

Fig. 29
Otter, in Konrad Gesner,
*Nomenclator Aquatilium
Animantium*, 353. Fig.
from *Curious Woodcuts of
Fanciful and Real Beasts*.
Konrad Gesner. 14.

Codex, and as we know, they were considered extremely desirable because of their fur. But most of their representations were copied from Gesner.[190] They participated in another logic in their original context and were not adapted to the system at work in the *Codex*.

In other cases of borrowing from Gesner, such as "the chipmunk," "the yellow squirrel,"[191] the "pigmy shrew," "the least weasel," the "stoat," the "badger," and the "lynx, the skin of which is sold for six gold louis," Nicolas did not have the same problem. They were already represented dead in Gesner, and he could simply change their position.

The *Codex* then devotes four pages (Pls. xxxvii–xl) to amphibians. This class is characterized vaguely in comparison with modern taxonomy, since we find here mammals like the long-tailed weasel, the muskrat, and the beaver, and reptiles like the turtle, but no batrachians like frogs, which are classified with the fishes! Even in this category, the status of the beaver is not clear, since it can be eaten any time, "including Lent and vigils" (f. 114), as if it were a fish. Charlevoix explained why.

> Par sa Queuë il est tout à fait Poisson, aussi a-t-il été juridiquement déclaré tel par la Faculté de Médecine de Paris, & en conséquence de cette Déclaration, la Faculté de Théologie a décidé qu'on pouvoit manger sa Chair les jours maigres. M. Lemery s'est trompé, quand il a dit que cette décision ne regardoit que le train de derrière du Castor. Il a été mis tout entier au même rang que la Maquereuse [To judge by its tail, (the beaver) is clearly a fish. So it was officially declared such by the Faculty of Medicine in Paris, and consequently, the Faculty of Theology decided that we were allowed to eat its flesh on Fridays. Mr. Lemery was wrong when he said this decision applies only to the hind part of the animal. The whole beaver is considered fish flesh.][192]

What defines an amphibian is its capacity to go from water to land and vice versa. But even this is not perfectly clear, since Nicolas closes this series with a "woodchuck (?) as big as a spaniel." It is true that he does not mention it in the "Histoire naturelle."

INTRODUCTION: *Louis Nicolas's Depiction of the New World*

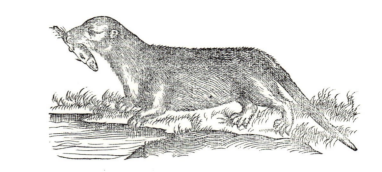

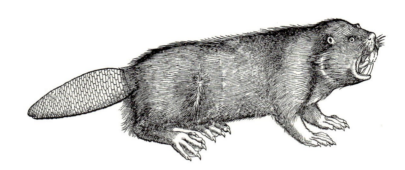

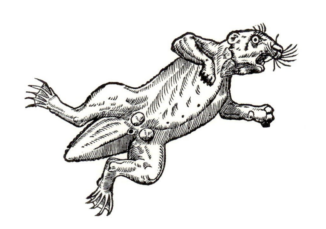

Fig. 30 (*Top*)
"La Loutre, des Latins Loutra & des aucuns anciens Canicule d'eaue," in Pierre Belon du Mans, *La Nature et la diversité des poissons*, 27. Photo: BNF, Paris.

Fig. 31 (*Middle*)
"Beaver," in Edward Topsell, *The History of Four-footed Beasts and Serpents*, 35. Fig. from *Curious Woodcuts of Fanciful and Real Beasts. Konrad Gesner*, 30.

Fig. 32 (*Bottom*)
"Beaver," in Guillaume Rondelet, *Histoire entière des poissons*, f. 177.

The illustrations of this section are far from being all new. For instance, all the animals on Plate XXXVII are taken from Gesner. The otter (fig. 29) is similar to his, including the idea of depicting it with a fish in its mouth, a concept Gesner himself had borrowed from Belon du Mans (fig. 30).

The inversion from Belon du Man's figure to Gesner's is noticeable. This type of inversion is usually a sure sign of the derivation of one illustration from another. Even the fish is inverted, and Nicolas follows Gesner in this detail. Only the otter's hind legs seem to be out of proportion.

The beaver also comes from Gesner (fig. 31).

Intrigued by the legend mentioned above about the testicles of the beaver, Rondelet represented the animal from below, as if it were placed on a glass pane (fig. 32), rather than in profile as in Gesner or in Nicolas.

Finally, the two seals at the bottom of Plate XXXVII come from the "Phoca seu vitulo maris oceani Rondeletius" (fig. 33), and from the "*effigiem hanc vituli mar. ex*

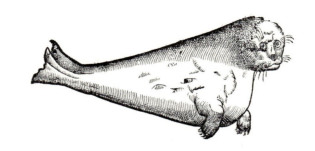

Fig. 33 (*Top*)
"Phoca seu vitulo maris oceani Rondeletius," in Konrad Gesner, *Historia animalium*, 1621, vol. 4, 705. Photo: BNF, Paris.

Fig. 34 (*Middle*)
"Veau de la mer Oceane," in G. Rondelet, *L'Histoire entière des poissons*, f. 343. Photo: BNF, Paris.

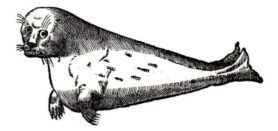

Fig. 35 (*Middle*)
"Effigiem hanc vituli mar. ex Oceano ab amico olim accepi," in Konrad Gesner, *Nomenclator Aquatilium Animantium*. 164. Fig. from *Curious Woodcuts of Fanciful and Real Beasts. Konrad Gesner*, 9.

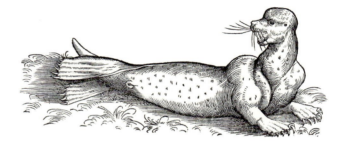

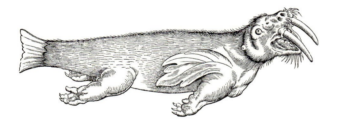

Fig. 36
"Morz," in Konrad Gesner, *Nomenclator Aquatilium Animantium*, 178. Fig. from *Curious Woodcuts of Fanciful and Real Beasts. Konrad Gesner*, 82.

Oceano ab amico olim accepti" (fig. 34), in Gesner. The friend mentioned here, at least for the first figure, could have been Rondelet himself.

Is Nicolas's picture of the *micipichik* (Pl. xxxix) also derived from Gesner's illustrations? Certainly. It comes from Gesner's *Morz* (fig. 36). But is this also true of the turtles? It seems not.

The Swiss naturalist has two figures of the marine turtle: the "*testudo marinis*" (fig. 37) and the "*altera figura testitudinis marinae*" (fig. 38), which are both dorsal views. On the other hand, the *Codex* gives a ventral view of its "great turtle." Moreover, the "small turtle" of the *Codex* bears no relation to Gesner's "testitudo terrestris" (fig. 39).

Even the "mountain rat" (Pl. xl) comes from Gesner, as a comparison with his "mus alpinus" clearly shows (fig. 40).

The "sea horse" on the same page is not original either. Its prototype is in Gesner, who denounces it as fanciful, or perhaps in Ambroise Paré's work, where it has the same orientation as in the *Codex*. Supposedly Neptune's mount, the marine horse was

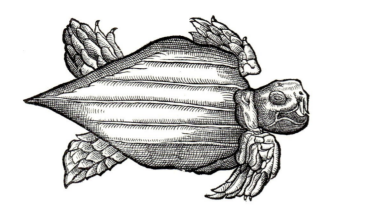

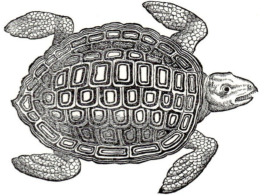

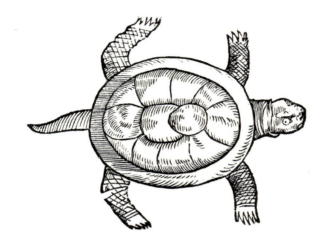

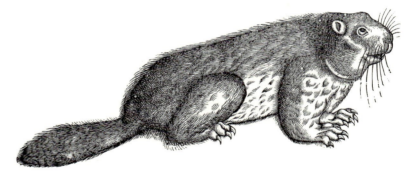

Fig. 37 (*Top left*) "Testitudo marinis," in Konrad Gesner, *Historia Animalium*, 1621, vol. 3. Photo: Bibliothèque nationale de France, Paris. Fig. from edition in Osler Collection, Montreal, McGill University Library

Fig. 38 (*Top right*) "Altera figura testitudinis marinae," in Konrad Gesner, *Nomenclator Aquatilium Animantium*, 184. Fig. from *Curious Woodcuts of Fanciful and Real Beasts. Konrad Gesner*, 82.

Fig. 39 (*Middle*) "Testitudo terrestris," in Konrad Gesner, *Historia Animalium*, 1621, vol. 3, 705. Photo: BNF, Paris.

Fig. 40 (*Bottom*) "Water Rat" in Edward Topsell, *The History of Four-footed Beasts and Serpents*, 406; copied from "mus alpinus" of K. Gesner, *Historia nimalium…*, vol. 1, 481. Fig. from *Curious Woodcuts of Fanciful and Real Beasts. Konrad Gesner*, 12.

often represented in paintings, sculptures, and fountains. In the "Histoire naturelle," Nicolas says, "it whinnies like those seen on the coasts of Senegal" (f. 123). Could Nicolas have confused the hippopotamus, the "river (potamos) horse," with a "sea horse"? If this was the case, he might have been better inspired to copy Belon du Mans, who gave us two much more realistic views of the "sea horse," although, in one of them, the herbivorous hippopotamus eats a crocodile! Even if Nicolas knew Belon du Mans by name, I am not sure that he consulted his book. Gesner remains Nicolas's main source of inspiration.

Only the "water ferret" (Pl. xxxviii) seems less derivative, even though it is quite similar to the "ground ferret" (Pl. xxx). The figure of the muskrat is original. One should note that Nicolas has represented its skin mounted on a wooden ring, as Indians used to do,[193] rather than portraying a living animal.

The Birds

After the amphibians, Nicolas deals with birds, devoting fourteen pages in the *Codex* and three sections in the "Histoire naturelle" to the subject. The birds are divided by *convenientia* to their habitats into two great classes: "an infinite variety of very beautiful birds that are seen on the sea, on lakes, on rivers"; and those that are seen "on land, and on the trees of America" (f. 219). The first are called "sea birds," the second, "land birds." (The term "sea birds" must be understood rather loosely, since it also includes birds that live on lakes or rivers.)

The land birds are divided into two subclasses. Since certain birds are "trained by bird-catchers … for falconry" and others are caught "with … nets and by other means" (f. 129) – in other words, since some "are preyed upon" and others "prey on them and live on them" (f. 144) – there is room for another division, taken from the remarkable analogy of hunting. Further on, Nicolas divides birds of prey into diurnal and nocturnal, giving himself the opportunity to group the owls together. This gives a particular relevance to the curious section of the "Histoire naturelle" devoted to the "terms of falconry" (fs. 145–51), in which one finds the influence of the six volumes of *De arte venande cum avibus* (1245) by Emperor Frederick II (1194–1250), and which also offers further evidence of the importance of hunting in the perception of the animal world.

As Nicolas himself stresses, this passage on falconry is the centrepiece of his section on terrestrial birds. "Perhaps it will not be a bad thing to place them in the middle of this treatise on birds, so that, by my describing river birds at the end of the treatise on birds, they can seize as many as they can with their talons … to the right, to the left, up, and down, on the land, on trees and on the surface of the water" (f. 144). And indeed, his section devoted to marine birds follows the one on terrestrial birds. By giving a central place to birds of prey, Nicolas elegantly solved the problem of *convenientia* to place. If this section had come after the section on marine birds, he would have had to explain why he returned to terrestrial birds. As we can see, hunting is supreme in Nicolas's perception of the animal world. It occupies – literally – the central position! It also further demonstrates his primary criterion for classification – the use man can make of the beast.

Finally, within each category, Nicolas classifies the birds by their size: "Let us begin with the smallest and end with the largest, according to our custom" (f. 129). As we have done for the mammals and the so-called amphibians, we should look in Gesner's *Historia Animalium* for a few examples of borrowing among the bird representations in the *Codex*. Gesner's *Liber III, qui est de Avium natura*, published for the first time in Zurich in 1555 and in a second edition in Frankfurt in 1585, is the most relevant source here.

For instance, it seems likely that Gesner's yellowhammer, *Emberiza cirtinella* (fig. 41), was used as a model for the "oyseau jeaune [yellow bird]" of the *Codex* (Pl. XLI), probably the American goldfinch, *Spinus tristis* (L.).[194]

It may seem odd to suggest that the *Codex* (Pl. XLV) uses Gesner's "domesticated pigeon" (fig. 42) to depict a "partridge," unless we identify the white partridge of America, "which has an exquisite taste" with the willow ptarmigan, *Lagopus lagopus* (L.), which, like Gesner's pigeon, has feathers even on its legs.[195]

Since the "Histoire naturelle" (f. 140) describes the partridge as being as white as alabaster, the description could not apply to the grey partridge, *Perdix perdix* (L.), which

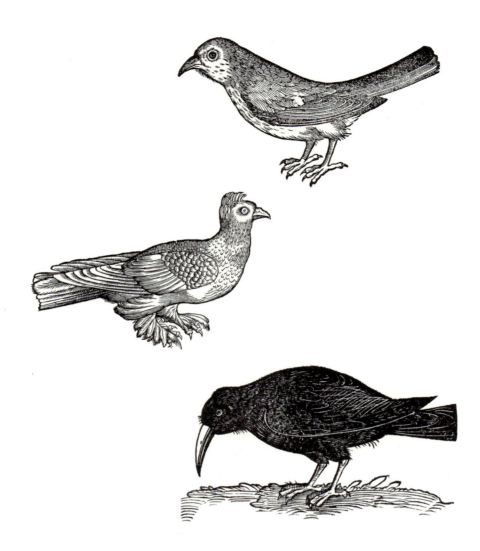

Fig. 41 (*Top*)
Yellowhammer, in Konrad
Gesner, *Historiae Anima-
lium, Liber III, qui est de
Avium natura*, 654. Fig.
from *Curious Woodcuts of
Fanciful and Real Beasts.
Konrad Gesner*, 68.

Fig. 42 (*Middle*)
Domesticated pigeon, in
Konrad Gesner, *Historiae
Animalium, Liber III, qui
est de Avium natura*, 279.
Fig. from *Curious Woodcuts
of Fanciful and Real Beasts.
Konrad Gesner*, 64.

Fig. 43 (*Bottom*)
Chough, in Konrad Gesner,
*Historiae Animalium,
Liber III, qui est de Avium
natura*, 522. Fig. from
*Curious Woodcuts of
Fanciful and Real Beasts.
Konrad Gesner*, 61.

is of European origin and a relatively recent introduction to our fauna. In fact, this case
is even more complicated than that, as I have shown elsewhere,[196] because the *Codex*
(Pl. XLVI) uses Gesner's ptarmigan, *Lagopus mutus*, as a model for its "grey partridge,"
which is in fact our ruffed grouse, *Bonasa umbellus* (L.), as the caption makes clear.
This partridge is remarkable for the noise it makes "beating its wings, with which it
beats the trunk of a rotten tree so vigorously that the sound can be heard half a league
away" (f. 142).

This description applies well to the ruffed grouse. This is not to say that the *Codex*
drawing does not show some transformations in comparison with its model. On the
contrary, feathers have been added on the head (the famous ruff that gives it its name)
and around the throat, a magnificent tail replaces the rather plain one of the model,
and the legs bear no feathers. These adaptations are fascinating in themselves, because
they show the similarities between the Old and the New Worlds being slowly replaced
by more distinct depictions. Gesner's bird is used as a schema to which details are
added to more closely approach reality. Similarly, we have seen Nicolas using Father
Du Creux's engravings of Natives for his own depictions of members of the First
Nations and adding details of his own to be closer to "reality," or at least to what he
perceived of it.

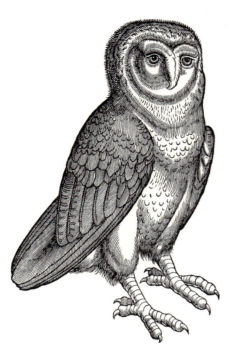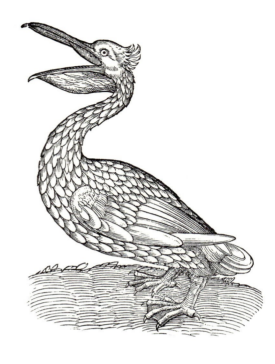

Fig. 44 (*Top left*)
Barn owl, in Konrad Ges-
ner, *Historiae Animalium,
Liber III, qui est de Avium
natura*, 775. Fig. from
*Curious Woodcuts of
Fanciful and Real Beasts.
Konrad Gesner*, 76.

Fig. 45 (*Top right*)
Pelican, in Konrad Gesner,
Icones Avium Omnium,
94. Fig. from *Curious
Woodcuts of Fanciful
and Real Beasts. Konrad
Gesner*, 55.

The *Codex* (Pl. xlviii) seems to have used Gesner's chough (fig. 43), *Pyrrhocorax pyrrhocorax* Tunstall, to represent its crow and raven "with red bill and legs," which was not a bad idea since the chough is the only all-black bird in Europe with red bill and legs.[197] In the "Histoire naturelle" (f. 143), Nicolas distinguishes the crow and raven from the common raven, *Corvus corax* L., and the common crow, *Corvus brachyrhyn-chus* Brehm, which have neither a red bill nor red legs. Since the "crow" and "raven" he has in mind were supposed to live "in the great Bird Island to the north, and in the great gulf of the St Lawrence" (f. 143), it must be a shorebird that he has confused with the chough, a bird not found in Canada.

The "autre chouette" of the *Codex* (Pl. li, repeated on Pl. lii but in reverse) is quite close to Gesner's barn owl, *Tyto alba* (Scopoli) (fig. 44), especially because, contrary to his "chatuant," the great horned owl, *Bubo virgianus* (Gmelin), the *Codex* image does not have ear-tufts.

Finally, the "chete"[198] of the *Codex* (Pl. liv) comes from the white pelican, *Pele-canus onocrotalus* L. of the *Icones Avium Omnium, quae in Historia Avium Conradi Gesneri describuntur, cum Nomenclaturis*, published in Zurich first in 1555 and in a second edition in 1560 (fig. 45).

Nicolas could not resist, however, adding a fish in the beak of this gluttonous bird. Curiously, the pelican is not even mentioned in the "Histoire naturelle." It is a fact that the brown pelican, *Pelecanus occidentalis* L., is not often seen in Canada. W. Earl Godfrey, in his *Birds of Canada* (1986), signals only rare sightings on the coast of British Columbia, and even fewer on the coast of Nova Scotia or the Niag-ara River in Ontario.[199] Of course, these are only few examples of the extent to which the *Codex* drawings are dependent on Gesner's illustrations. Further research should reveal even more.

The Fish

The part of the *Codex* devoted to fish exactly parallels Books 12 and 13 of the "Histoire naturelle." It is divided into two sections: "fresh water" fish and the sea fish. Curiously, Nicolas begins the section of the "Histoire naturelle" on fish with some observations on the frog, which, since he sees it as an aquatic animal, is close to the fish. The *Codex* follows the same order, but on Plate LV groups together four extraordinary beasts, according to a principle of which we have already seen a few examples: the monstrous first, the normal afterward. Indeed images and captions for the following animals appear on this page: "Marine monster killed by the French on the Richelieu River in New France"; "Firefly which can be seen by the thousands, the evening of a nice day on the shores of the St Lawrence River in America"; "Extremely poisonous tailed frog of the north American country"; and "Big green frog found on the shores of the St Lawrence River. When it croaks at night in calm weather, one can hear it from a distance of two leagues."

Since the anthropological content of the *Codex* is discussed later, let us delay the discussion of the first of these "monsters" until that section. For the rest, a whole paragraph of the "Histoire naturelle" is devoted to the firefly:

> Among the remarkable things of America, I find that the firefly should not have the last rank; for on looking at it carefully, one would say that it is a living star which, carried by its own movement amid the shades of the night, shines without receiving its light from the day star. This flying star must nevertheless pay homage to the sun, as it never appears by day except as an ordinary fly.
>
> One is often pleasantly surprised to see what appear to be many little flashes of lightning, which are these insects opening and closing their wings at almost the same time, showing and hiding in a moment their pleasing fire. One can read in a room by holding one of them and moving it along the line that one wants to read. If fifteen or twenty of these fireflies are put in a glass bottle, they serve as a candle for week. (f. 166)

This passage is remarkable, since at the time not many authors were interested in insects. The first monograph devoted exclusively to them, *The Theatre of Insects*, by T. Moffet (1553–1604), an obscure English physician, was published only after his death, in 1634. Moffet speaks of the firefly in chapter XV of his book and gives an illustration on page 112.[200] But it would be surprising if Nicolas had known of this work.

The tailed frog that Nicolas mentions next is quite extraordinary. In the "Histoire naturelle" he has this to say about this strange creature: "The appearance of this aquatic animal does not differ from our frogs in any way except for the tail, which makes it horrible, like a monster. Lake Kinoua-Michich … is famous for the multitude of frogs with a long tail that live in it and croak continually. These frogs are very venomous, although in those lands the toads, snakes and vipers are not venomous" [fs. 170–1]. He seems not to have known that these frogs were near the end of their metamorphosis from the tadpole stage to the adult frog. This is strange, because this developmental stage was already well known in the Medieval era, as this passage of Albertus Magnus demonstrates: "Et cum [ranae] ova egrediuntur, sunt magni capitis et ventrem habent juxta caput et posterius habent caudam cum pinnis ad natandum et postea post Maium

decidit cauda, et formantur ei quatuor pedes [And when frogs are with eggs, they have a big head near their stomach and have a tail to help them swim. After the month of May, their tails disappear and their four feet develop]."[201]

Despite this, even knowledge of the easily observable metamorphosis of the frog had not completely displaced the belief in tailed frogs. Right up until Lacépède (1756–1825), a successor to Buffon, and his *Histoire générale et particulière des quadrupèdes ovipares et des serpents*, 1788–89 (note the date! The Revolution was at his door when he worked on this lofty subject), this myth was still current. Indeed, Nicolas is not the only one in his time to believe in the existence of frogs with tails. Pierre Boucher shared the same conviction. "J'en ay veu d'une troisième sorte, qui sont toutes comme les grenoüilles communes, sinon qu'elles ont une queuë: je n'ay jamais veu de celles-là qu'en un seul endroit, le long d'une petite rivière; mais j'en vis plus d'un cent [I have seen some of a third kind, quite like common frogs in every respect, except that they have tails; I have never seen any of these elsewhere than in one place, alongside of a small river, but there I saw more than one hundred]."[202] At least Boucher did not believe that they were venomous.

The "big green frog" at the bottom of Plate LV is mentioned in the "Histoire naturelle": "At Lac Saint-Pierre, three leagues above the river of Trois-Rivières, one begins to see, hear and eat large frogs such as I have just described. They can be seen for more than six or seven hundred leagues beyond this place" (f. 171). Of course the bull-frog had been observed by other authors: both Sagard and Boucher speak of it. Sagard called it the *oüraon*, almost the form that French Canadians still use today: *ouaouaron*. He describes it thus:

> Outre les Grenoüilles que nous avons par deçà, qu'ils appellant Kiotoutsiche, ils en ont encore d'une autre espece, qu'ils appellant Oüraon, quelques-uns les appellant Crapaux, bien qu'ils n'ayent aucun venin … Ces Oüraons ou grosses Grenoüilles sont vertes, et deux ou trois fois grosses comme les communes; mais elles ont une voix si grosse et si puissante, qu'on les entend de plus d'un quart de lieuë loin le soir, en temps serain, sur le bord des lacs et des rivieres, et sembleroit (à qui n'en auroit encore point veu) que ce fut d'animaux vingt fois plus gros: pour moy je confesse ingenuëment que je ne sçavois que penser au commencement, entendant ces grosses voix, et m'imaginois que c'estoit de quelque Dragon, ou bien de quelqu'autre gros animal à nous incogneu [Besides frogs, such as we have here, which they call *Kitoutsiche*, they have another kind as well which they call *Oüraon*. Some persons say they are toads, although they are not poisonous … These *Oüraons* or big frogs are green, and twice or thrice the size of the common ones. But they have a voice so loud and powerful that they can be heard more than a quarter of league away in the evening, when the weather is calm, on the banks of lakes and rivers, and one who had not seen them would think that they were animals twenty times as large. For my own part I candidly admit that I did not know what to think at first when I heard these loud voices, and I imagined it to be a kind of dragon or some other big animal unknown to us].[203]

Boucher's description is more sober, but agrees in most part with Sagard's. He says that they are:

INTRODUCTION: *Louis Nicolas's Depiction of the New World*

aussi grosses que le pied d'un cheval, [that they are] vertes, & se trouvent sur le bord du grand Fleuve; elles meuglent le soir comme un Boeuf, & plusieurs de nos nouveaux venus y ont esté trompez, croyans entendre des Vaches sauvages: ils ne le vouloient pas croire quand on leur disoit que c'estoit des grenoüilles, on les entend d'une grande lieuë. Les sauvages, Hurons, les mangent, & disent qu'elles sont fort bonnes [… green ones, as large as a horse's foot, that are to be found on the banks of the great river; they bellow in the evenings like oxen, and many of our newly arrived people have been deceived into thinking they heard wild cows, and would not believe those who told them it was only frogs they heard; they may be heard at great distance; the Huron Indians eat them and say they are very good].[204]

Like the "*chétive pécore* [puny animal]" of Lafontaine's fables, the bullfrog, or at least its voice, seems to grow in power from one author to the other: it is heard at "a quarter of league" says the first; at "more than a league," says the other; at "two leagues" says a third!

The grouping of animals on this page of the *Codex* demonstrates that the author follows another logic than that in the "Histoire naturelle," where the frogs are dealt with in Book 8 with the fish, and the firefly in Book 11 with the birds, and the marine monster is not even mentioned. These creatures are all "monstrous." This is evident in the first case, since the tailed frog is described as such. The big frog which bellows like a bull and the firefly which lights our nights are both extraordinary enough to be declared "monstrous," the word "monster" being understood in its etymological sense as something which deserves to be shown (*monstrare*), as already mentioned.

Of course, one thinks of Rondelet as an iconographic source for the section on fish. But it is quite possible that once again Nicolas worked exclusively with Gesner, especially since Gesner himself had obtained from his friend Rondelet permission to use all his illustrations in his own *Historia animalium, liber quartus, qui est de piscibus et aquatilibus* (1558).

Of all the fishes depicted by Nicolas, the one that most intrigued our ancient authors was the *chaousarou*, the longnose gar, *Lepisosteus osseus* L. (fig. 46). Nicolas was convinced that it could reach up to the exaggerated length of "ten to twelve feet" (f. 184). Champlain was closer to the truth when he said: "J'en ay veu qui en contenoyent 5 [I have seen one some five feet long]."[205] This is the maximum length given by zoologists today. The *chaousarou* is represented on the 1612 *Map of New France* by Samuel de Champlain (fig. 47) and by Father Du Creux, who is habitually very parsimonious with illustrations.

One of the rare illustrations in Nicolas's "Traitté des animaux" is also devoted to the longnose gar, where it is shown swallowing a small bird. In the *Codex*, there are two representations of this extraordinary fish: on Plate LXI and at the bottom of the map of the Mississippi. It is also mentioned by Champlain, Sagard, and Pierre Boucher.

Champlain was more interested in the techniques for hunting this fish, which he considered amazing. He based his information on what the Indians had told him.

Ce poisson fait la guerre à tous les autres qui sont dans les lacs, & rivieres: & a une industrie merveilleuse, à ce que m'ont asseuré ces peuples, qui est, quand il

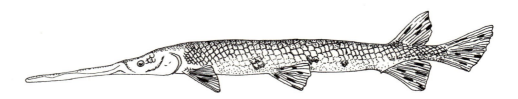

Fig. 46 (*Top*)
Longnose gar, *Lepisosteus osseus* L. (author's drawing).

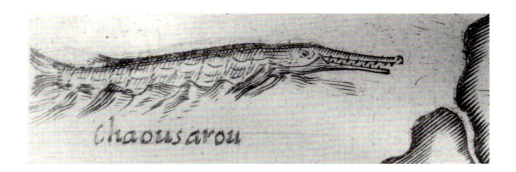

veut prendre quelques oyseaux, il va dedans des joncs ou roseaux, qui sont sur les rives du lac en plusieurs endroits, & met le bec hors l'eau sans se bouger: de façon que lors que les oiseaux viennent se reposer sur le bec, pensans que ce soit un tronc de bois, il est si subtil, que serrant le bec qu'il tient entr'ouvert, il les tire par les pieds soubs l'eau [This fish makes war on all the other fish which are in these lakes and rivers. And, according to what these tribes have told me, it shows marvellous ingenuity in that, when it wishes to catch birds, it goes in amongst the rushes or reeds which lie along the shores of the lake in several places, and puts its snout out of the water without moving. The result is that when the birds come and light on its snout, mistaking it for a stump of wood, the fish is so cunning that, shutting its half-open mouth, it pulls them by their feet under the water].[206]

In fact, as Claude Melançon explains, the longnose gar sometimes swims near the surface of the water, "where its greenish colour gives it the appearance of a moss-covered piece of wood. *It knows this!* and pretends to be carried by the current up to its prey, which is then caught by the middle of the body and kept a long time in its beak before being swallowed."[207]

Sagard saw the longnose gar dead and is the only one to mention what the Indians thought to be a medical property of the head of this fish.

Estant arrivé au lieu nommé par les Hurons Onthradéen, et par nous le Cap de Victoire ou de Massacre, au temps de la traite où diverses Nations de Sauvages s'estoient assemblez, je vis en la Cabane d'un Montagnais un certain poisson qu'ils appellent Chaousarou, gros comme un grand Brochet, il n'estoit qu'un des petits; car il s'en voit de beaucoup plus grands. Il avoit un fort long bec, comme celuy d'une Becasse, et avoit deux rangs de dents fort aiguës et dangereuses, d'abord ne voyant que ce long bec qui passoit au travers une fente de la Cabane en dehors, je croyois que ce fust de quelque oyseau rare, ce qui me donna la curiosité de le voir de plus pres, mais je trouvay que c'estoit d'un

poisson qui avoit toute la forme du corps tirant du Brochet, mais armé de tres fortes et dures escailles, de couleur gris argenté. Il fait la guerre à tous les autres poissons qui sont dans les lacs et rivieres. Les Sauvages font grand estat de la teste, et se saignent avec les dents de ce poisson à l'endroit de la douleur, qui se passe soudainement, à ce qu'ils disent [When we had reached the place named by the Hurons Onthradéen, and by us Cape Victory or Massacre, at the time of trading when different tribes of savages had assembled, I saw in the lodge of a Montagnais a certain fish they call *Chaousarou*, as big as a large pike, and it was only a small specimen, for much larger ones are seen. It had a very long beak like that of a woodcock, and two rows of teeth very sharp and dangerous. At first, only seeing this long beak projecting outside through a crack in the lodge, I thought it belonged to some rare bird and I was curious to look more closely at it, but I found it belonged to a fish with a body shaped quite like that of a pike, but protected by very strong hard scales, silvery grey in colour. It makes war on all other fish in the lakes and rivers. The savages think highly of the head, and bleed themselves with this fish's teeth wherever they have pain, which they say disappears at once].[208]

Boucher's description is more accurate and more precise. He was aware of the poor quality of its flesh.

J'oubliois à vous faire la description d'un poisson, qu'on appelle Poisson armé: il a environ deux pieds & demy de long, & mesme trois pieds; il est tout rond, & a six ou huit poulces de tour; il est quasi également gros par tout: il a une écaille extrémément dure, & qu'on ne sçauroit avoir percé d'un coup d'épée; son bec a environ huit poulces de long, & est dur comme de l'os; armé de trois rangées de dents de chaque costé, qui sont pointuës comme des alesnes: la chair ne vaut pas grand chose à manger. Il est fort facile à prendre, mais il est rare [I was going to forget to give you a description of a fish that we call the armed fish (*poisson armé*); it is about two feet and a half or from that to three feet long; it is quite round and is from six to eight inches in circumference; it is of about the same size from end to end; it has a very hard shell, so hard that one could not pierce through it with a sword; its snout is about eight inches long, and as hard as a bone; it is armed with three rows of teeth on each side that are as pointed as awls; the flesh is not worth much for eating. It is very easy to take, but it is scarce.][209]

Nicolas speaks twice of the longnose gar in the "Histoire naturelle": first in his treatise on plants, because of the rushes where it hides (f. 10), and second, in his treatise on fish, as one would expect. He may have taken his inspiration from Champlain, or like him, from the Indians, when he describes its hunting technique.

This fish devours other fish, and it hunts birds, on which it usually lives all summer. Here is how: as the fish has a very long head, split like a compass, it raises this part of its body out the water, and opens it like a compass in the middle of the tall reeds, where innumerable water birds go to seek food or

shelter. As these birds run here and there, many pass through the mouth of the armed fish, which closes its mouth and dives, and swallows its catch without chewing it. (f. 184)

Something of that description seems to have been expressed in the *Codex* illustration. The drawing is probably inspired by Du Creux's illustration – it is not the only case of borrowing from Du Creux, as we have seen – even if Nicolas has been more successful in attaching the head to the fish body. But Nicolas has opened the beak of his fish, like a compass, with the eye occupying the hinge place. He was less successful in giving a nicely lobed tail to his armoured fish. Du Creux was closer to the truth about this detail, but his source is unknown; his figure is unrelated to Champlain's.

The description of the hunting technique used by the longnose gar as found in Champlain and Nicolas remained standard for a long period. Even Charlevoix, who was habitually rather sceptical of this kind of story, repeated it.

On conçoit bien qu'un tel Animal est un vrai Pirate parmi les Habitants des Eaux; mais on n'imagineroit peut-être pas qu'il fait aussi la Guerre aux Habitans des Airs: il la fait néanmoins, & en habile Chasseur: voici comment. Il se cache dans les Roseaux, de telle sorte qu'on ne peut voir que son Arme, qu'il tient élevée perpendiculairement au-dessus de l'Eau. Les Oiseaux, qui viennent pour se reposer, prennent cette Arme pour un Roseau sec, ou un morceau de Bois, & se perchent dessus. Ils n'y sont pas plutôt, que le Poisson ouvre la Geule, & fait si subitement le mouvement nécessaire pour ravir sa Proye, que rarement elle lui échappe [One will be right to believe that this animal is a real pirate among the inhabitants of water; but it is less easy to imagine that it also makes war with the inhabitants of the air. Nevertheless, it does, and it is a clever hunter. Here is how it proceeds. It hides among the rushes, in such a way that just its beak is visible, holding it perpendicular to the water. The birds that come there to rest take it for a dry reed or a piece of wood, and land on it. The moment they do, the fish opens its jaws and twists its body so fast to catch its prey that they seldom succeed in escaping].[210]

The *Codex* ends its section on fish with Plate LXVI, which is devoted to snakes and to the eel. In the "Histoire naturelle" the two subjects are separate, since the rattlesnake is presented at the end of the treatise on birds (f. 167), and the eel concludes the presentation of the fish. But the homology between the eel and the snake was probably too strong for the author of the *Codex* to resist.

The Natives

It is here, I believe, that a section on the Indians was intended to be included in the "Histoire naturelle." The subject occupies an important section of the *Codex*, but unfortunately a parallel section does not exist in the "Histoire naturelle." The six final books, which were supposed to deal with the Indians, are either lost or were never written. I am inclined to believe the latter since it is the only hypothesis that is consistent with the subtitle given to the "Histoire naturelle." Contrary to the rest of the work, which

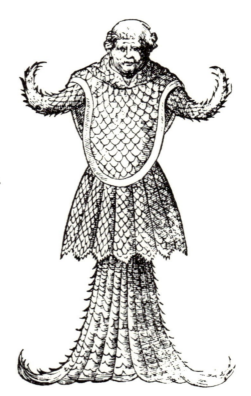

Fig. 48
Marine Man, from Claude Kappler,
*Monstres, démons et merveilles à la
fin du Moyen Age*, 231.

often mentions a division into eighteen books, in the subtitle Nicolas speaks of only
twelve books, which deal exclusively with the subject of natural history. According to
the subtitle, the "Histoire naturelle" is:

> the faithful search for everything rare in the New World, treating in general and
> in particular: Simples, flowers, grains, herbs, fruits, bushes, trees, four-footed
> animals living on land and in water, birds that live on land and those that live
> above or in water; and finally fresh-water fish, and some salt-water ones; vari-
> ous insects, and several reptiles, with their figures. Divided into twelve books.
> By M.L.N.P.

Indians are not even mentioned. It is possibe that, worn out by his task, Nicolas may
have been content with the drawings in the *Codex* and the numerous digressions of the
"Histoire naturelle" on the purposes for which the Indians used the animals and plants.

Not unlike the flora and the fauna, the world of the Natives is to be known through
its similarity to the Ancient World. It is not surprising, then, that Foucault's great
figures of similitude – *æmulatio*, *convenientia*, analogy, and sympathy – are applied here
as well. But before going into detail about their application to our subject, a preliminary
remark is necessary.

Unlike his discourse on natural history, Nicolas's ethnographic discourse, in spite of
his backward-looking style, was not behind the times for this particular subject.
Seventeenth-century "ethnology" was not marked by the same break with the past
that affected natural history, grammar, or economy, to use Foucault's categories. The
old discourse of similitude was maintained. Perhaps because human beings were the
subject matter, the resistance to change was greater. For instance, differences between

people might have been seen as specific and so that they could then have been classi-
fied into a number of races as if one were dealing with a number of species of plants or
animals. This is precisely what the concept of race would try to achieve in the nine-
teenth century. But in the seventeenth century, the belief in the unity of mankind was
still strong enough to encourage recognition of regional differences among people,
the kind of differences that do not threaten the definition of man as a rational animal,
or the rejection as non-human of forms judged to be completely aberrant. In such a
system, you are either human or you are not.

The only situations that might cause one to hesitate, were cases of human monsters,
situated at the border of humanity and animality. But even in these cases, opinions
were divided. For instance, such monsters were represented on the tympana of cathe-
drals as people to whom the Gospel should be announced, since the Apostles were told:
"Go and evangelize all the Nations." But for others, the fact that monsters were mute
indicated an absence of language that could be a sign of their lack of reason. If this were
the case, they were considered to be no better than animals.[211]

There is a trace of this ambivalence in the documents we are considering. As noted
before, Plate LV of the *Codex* is devoted partly to the representation of a human-headed
"marine monster." Its location in the *Codex* suggests that this image might have been
intended to be a fish figure. Unfortunately, the "Histoire naturelle" does not mention
it. There is no doubt, however, that the *Codex* picture comes from the *pictura piscis
Monachi*, literally, the picture of a monk fish, found on page 39, Book 1, of Pierre Belon
du Mans's *De Aquatilibus* (fig. 48). Belon states that it lived only three days and was
mute, but could groan. It was a kind a siren, half-man, half-fish. Belon's illustration was
often copied; one can see an exact copy in Gesner's *Nomenclator Aquatilium Animalium*
and in Book XXI of Ambroise Paré's *Complete Works*, published in Paris in 1585.

Charlevoix, relating the same event, speaks of "Marine Man" in a matter-of-fact
way. However, he is clearly quite sceptical as to the veracity of the "fact" itself.

Je ne sçai quelle croyance on doit donner à ce que j'ai vû dans la Relation
Manuscrite d'un Ancien Missionnaire, qui assure avoir vû un Homme Marin
dans la Riviere de Sorel, trois lieuës au-dessous de Chambly. La Relation est
écrite avec beaucoup de jugement; mais pour mieux constater le fait, & pour
montrer qu'une première apparence ne l'a point trompé, l'Auteur auroit dû
ajoûter à son Récit la Description de ce Monstre. On est quelque fois saisi au
premier coup d'œil d'une resemblance, qui avec des yeux attentifs, & des regards
réfléchis, s'évanouit d'abord. Au reste, si ce Poisson de figure Humaine étoit
venu de la Mer, il auroit fait bien du chemin pour remonter si près de Chambly,
& il seroit assez surprenant qu'on ne l'eût apperçu qu'en cet endroit [I really do
not know what to make of what one reads in a hand-written Relation by a for-
mer missionary, who claims to have seen a Marine Man on the Sorel River (the
Richelieu), three leagues above Chambly. The Relation is written with much
judgment; but to better establish the fact, and to demonstrate that he was not
fooled by appearances, the Author should have added to his report a descrip-
tion of this monster. It sometimes happens that we are at first struck by a
resemblance, which disappears under more attentive scrutiny and some reflec-
tion. To tell the truth, if this Marine monster came from the sea, it would have

to swim quite a long way to reach so close to Chambly, and it would be quite surprising that nobody had seen him before, on his way].[212]

The other case of a being on the margins of humanity found in the "Histoire naturelle" but not illustrated in the *Codex* concerns the supposed existence of a race of hairy humans believed to be the "Savages of America." Like many explorers of his day, Nicolas denounces this medieval myth of the wild man: "All these kinds of gums and putties give me the chance to mention an interesting point that should be known, especially by those who imagine that Indians are necessarily hairy. I must tell these people that they must not believe that they are hairy, and I want to convince them that they do not even have a beard, and that if beard hair should happen to grow on one of them, they can hardly wait to remove it, either by fire or with their fingers or with putty" (f. 33).

Nicolas's thought is perhaps better represented if we note that for him any European who suggested that the Indians are hairy is no better than "the *Outtagami*, the *Mantaoué*, the *Oussaki* and the *Oumalouminé*, [who] say that the thickly bearded Frenchmen are descended from the race of men that they call *Makoua*, which means bear" (f. 78). No! It is no more in the nature of the Indian than of the white man to be hairy like a bear! On this point at least one has to concede that we are similar. The Indians, who loathed beards, took great care of their hairstyles. Nicolas notes that from the seed of the sunflower, "the Americans make a very mild oil" with which they rub their hair (f. 5). From the bones of the moose, they get "a certain oil or a certain grease, which does not congeal, for greasing … their long hair." For Nicolas, this habit was similar to the practice of "the Jews who anointed themselves with other liquids" (f. 99).[213] Nicolas is always fond of comparison. There is another more astonishing one; Nicolas claims that Indians wear wigs! They keep in a bag "the down [of the swan] to make a head ornament for special occasions when they want to appear in public. They make white wigs, which they attach to their hair with moose fat" (f. 163). No doubt this mention of wigs was better appreciated in the seventeenth century than now!

The Amerindians, then, being neither hairy nor monstrous, have the same humanity as Europeans. If they differ from them, it has to be in unessential characteristics. What are these characteristics? Reasoning by similitude will tell us.

To begin with, *æmulatio*. On this, Nicolas's conclusions are clear. As his comparison between the flora and the fauna of the New World with the Old World had led to a conclusion about the imperfection of the former, he proceeds in the same way with regard to the human population. The Amerindians are *sauvages*[214] or *barbares*, and as such they could be considered inferior in comparison to members of a "civilized nation."

Nicolas was convinced that he could demonstrate this inferiority in two domains in particular: religion and behaviour. He describes the Indian nations as "miserable":

[They] consider bears to be divinities and make sacrifices to them. I have looked sorrowfully upon this detestable ceremony only too often. These poor people, blind to the mysteries of our religion, are always erecting altars to their supposed deities. They adorn them with everything beautiful that they have, and the richest furs, the finest weaving and their exceptional paintings are all meant

CODEX CANADENSIS

for that. There, on these abominable altars, the idolaters respectfully affix four or five of the biggest heads of bears that have been killed. They offer them feasts, songs, dances and games, which are the nation's sacrifices. (f. 79)

The belief that the soul of the deceased could be heard in the nocturnal song of the bird *tchipai-zen* is considered to be no better: it is a "fantasy of the Indians" or "the silly ideas of these blind people."

> When they hear it, they greet the soul of the dead person who is in it, and they believe that it is one of their relatives … And if the mood strikes someone, he immediately prepares food to feed this soul, while waiting for the general feast, when the nations will gather to make a solemn feast for all the departed who have died in the past ten years, at the end of which people give so much food to the dead that they have the strength to go to the land of the dead in the north, from which they never return. These are some of the foolish ideas of our Americans concerning their beliefs about the dead. (f. 138)[215]

Since native art seems to him an expression of their religion, it was equally unappreciated. "In their deplorable blindness, some of these unfortunate people have carved or made indecent figures on some chestnut trees. They say that they are genies, and perform acts of worship imitating those others who consider as divinities what nature teaches us to hide" (f. 37).

But, as we have seen for the flora and the fauna, *æmulatio* does not exclude, in some rare and peculiar cases, possible superiorities of the New World. For instance, Nicolas is not infrequently appreciative of the decorative arts of the Indians. Moreover, and this is worth noting, he attributes its perfection to the skill of the women, for whom he expresses much admiration. For example, in speaking of the milkweed, he is enthusiastic about their ability to make small embroidered bags. "Our forest dwellers," he affirms, also "make fine works with their tall rushes, and among other things, the women weave them so well that they make fine braids dyed in various colours and decorated with many figures" (f. 10).

He praises the objects adorned with porcupine quills even more profusely.

> This same hair [porcupine quills], which is so dangerous, is nevertheless much used among the Westerners, whose women make very fine works. First they dye it with various fruits and some herbs or roots, which give yellow, violet, black, reddish and red, so that there is no scarlet as beautiful and brilliant as the one seen in the dyes of the women on very beautiful and rare works, such as precious headbands and snakes that go around the head and hang midway down the leg. A thousand fine designs are seen on these objects. The natives esteem these works highly, and to tell the truth they are considered very fine in France. A belt of this material and of this delicate work is worth as much as 100 *louis d'or*, and I dare to say that it is like those paintings that are priceless … One could say that the work is much finer than the material used, which itself has no beauty except what is given by the dye, and by the forms and shapes that are given to it in designs that are not used in Europe. I can affirm that I have seen

INTRODUCTION: *Louis Nicolas's Depiction of the New World*

Greek-style wreaths of this material that monarchs would not have scorned to put on their head, and various beautiful belts that they would have been pleased to wear. (f. 64)

It is difficult to be more enthusiastic. If Nicolas is sometimes critical about certain Indian ornaments, it is not because he thinks they were badly made but because, like many ecclesiastics of his day, he condemns their use, as much among the Europeans as the Amerindians. "Even the claws are a choice item; the Indians make their ducal or royal crowns in the Greek style. They put them on their heads to adorn themselves. The world's most powerful men are no prouder of their crowns of gold and precious stones than these poor people with their crowns of bear claws" (f. 75). For once, the comparison is not favourable to the Europeans. There is no need to multiply these examples. The repetition of the words "very beautiful" and "rarities" shows that Nicolas's admiration for most of these works was sincere. The talent of Indian women in this field seems to him at least equal to, if not greater than, that of Europeans.

The other item about which Nicolas is less negative than many of his contemporaries is language. Certainly one could find in the "Histoire naturelle" remarks that might be interpreted in a negative light. For instance he says that we should change the name of the American "nightingale … because its warbling and its chirping are not so melodious, because its song is as distant from the song of our nightingale as the language of this country and our way of speaking and our expressions" (f. 131). In fact, Nicolas does not say that the Amerindian languages are inferior. He says that they are *distant* from our own. There is a nuance here. No idea of a hierarchy between the languages is implied. Nicolas uses the word "different" instead of "distant" when he explains that the word *nigakoua* designates a particular fishing technique of the Sioux people (using a net) and adds the rather irrelevant remark that "this saying is very *different* from the *Vado piscari* of the great Saint Peter" (f. 181)![216] Indeed! But one has to consult his *Grammaire algonquine* to see his real feeling about the Amerindian languages. "You must know that, if the customs and the life of the inhabitants of the forest of the Indies are savage, their language is not at all barbaric, and, if their brutishness comes from the fatal freedom of nature, their manner of speech comes from a ray of the Divine Intelligence which God makes shine in their soul."[217]

The second great figure of similitude, the *convenientia*, which indicates the particular relation of the thing to its place, also finds an application in ethnography. The main *convenientia* of the native people to their place is of course, for Nicolas and his century, the *convenientia* of the wild men to the forest. In the "Histoire naturelle" Indians are sometimes designated as: "the inhabitants of these vast forests" (f. 8), "the inhabitants of the vast forests of America" (f. 26), or the *coureurs des bois* (fs. 10 and 20), which in his text always designates Indians, never French Canadians.

In the introduction to his "Second cahier," which deals with the "great trees," Nicolas invites his reader to go deep into the forest with him with Indians as guides.

Let us go ahead and plunge into this limitless bush without a compass. Our natives will get us through it all, despite the greatest obstacles of broken old oaks, firs trees with their branches torn off by the violence of the winds and frosts, pines, hemlocks, spruces, cedars, beeches, maples, sycamores, ironwood, aspen, cultivated and wild ashes, birches, alders, cottonwoods, walnut trees,

chestnut trees, elms of two kinds, lindens, large wild cherries and many other kinds of trees, standing or lying. Despite all that, it will not be possible to confuse our Americans or to make them become disoriented. They will get out of anywhere, like wild animals or like spirits accustomed to this land of shades. As we walk with them they will give us the opportunity to observe all these trees for several years. (f. 28)

Nicolas stresses the fact that native people used reason, observation, and experience in the forest.

The forests produce plantain of all kinds. It grows most commonly in places where people often pass, and … they usually use this to guide them on the routes of various voyages. Without it they would often get lost. I had to use this secret on a great voyage I made to Virginia;[218] the natives had taught it to us. They revealed to us another secret that they use in their travels of four or five hundred leagues to find the direction without getting lost, even though clouds cover the sun. They know the North by looking at the trunks of trees. This is not as difficult as one might think, since the trees of these great forests are always covered with a certain moss which distinguishes the north side from south one. Thus, knowing these two directions, one can form a fairly accurate idea without getting lost, as one would do without this kind of compass which never misleads the inhabitants of these vast forests. (f. 8)

As much as there is a *convenientia* of the natives to the forest, it is equally clear that there is none for Frenchmen in the New World wilderness. Nicolas accords special merit to missionaries for venturing into the forest to preach the word of God. "One can judge from this what sufferings are endured by those who have the charity to follow them to teach them to know God, in travels of a thousand or twelve hundred leagues at once" (f. 178).

The principal analogy between the Indian way of life and the lifestyle of the Old World is hunting. Nicolas does more than just mention that the Indians practise hunting. He makes an elaborate parallel between Amerindian hunting and the hunt as it was conceived in Europe in the seventeenth century. This parallel was not immediately evident, because hunting was not seen as an ordinary sport or a subsistence occupation; it was a noble activity, reserved for kings and nobility. Inviting the French nobles to immigrate to Canada, where they would first have to bring down the king's enemies, Nicolas imagines them already practising the hunt and cultivating the land that they would receive for their services.

Dedicate yourself at last to the fine and noble pursuit of hunting, and exploit the beautiful lands that His Majesty will give you there and that he will establish there under the titles that you will have earned.

There, finally, you will enjoy a pleasant rest, and in the shade of the woods, you will take an innocent pleasure in hunting, which you will never lack. In this pursuit you will keep up your warlike spirit and the finest inclinations of your blood and your nobility. (f. 128)

Clearly, for Nicolas hunting was the *plaisir des rois*, as the expression goes! But in reasoning through similitude, Nicolas does not shrink from applying this notion of hunting to the Indian reality. He cannot say that the Indians who hunt behave like kings and nobles. But he was aware of the similarity. He does say that the Natives are noble "in their own way."

> Now, our Americans, being sovereign and independent of all the powers of the world, are brave warriors, great hunters and entirely detached from what is servile. It must be said that they are certainly very noble, at least in their own way; and that if they obtain from this absolute independence all the advantages that they desire, they are happy in the eyes of the world, not having to answer to anyone for their conduct. If finally, by their bravery in the art of war, by their great reputation for courage and by their incomparable valour [and] if finally, I say, our Indians inspire fear in their enemies and nations furthest away simply by reputation of their name and their arms, then it should be no surprise, since they have become so able, as I say, in the exercise of hunting, which they practise from a tender age and from which all their life they take all the advantages possible: diversion, agility and the marvellous disposition of their bodies, as well as the health that these nobles keep up with these laudable pursuits, which must strike a chord with the noble-hearted men of our invincible French nation. (f. 127)

One has to be careful not to interpret this text as a Rousseauist text before its time. Nicolas was no Lahontan, the famous baron who was critical of the Jesuits and took the side of the natives in his *Mémoires*. One can be sure that, on the contrary, he would have recoiled with horror from the idea that the "sovereign independence" of the "noble savage" could be proposed as an ideal as it would be in the romantic period. Let us not forget that when he wrote it was still the *ancien régime* and the "independence" of a subject was frowned upon.

Nevertheless, Nicolas's line of reasoning by similarities can lead to surprising conclusions. Indians are said to be "very noble," even if it is just "in their manner." Nicolas assumed only one definition of hunting: it was neither a subsistence activity nor a sport but a source of individual prestige. In all its aspects, one can see the irony. To compare the Indians to the French nobility is also to compare the French nobility to natives. To avoid the conclusion that the *sauvages* are "noble," knowledge by comparison would have had to be sacrificed – or another type of hunting thought of. Nicolas's *épistémè* excludes a change of perspective of this sort, which would have permitted a better representation of reality.

Nicolas proposes finally a fourth type of comparison: antipathy (the contrary of sympathy). Having just said that the Indians do not use "salt nor any other form of seasoning," he continues:

> I report this to reply to a thousand people who have questioned me on the way of life of the natives. I answered them that all those I have frequented used, for seasoning, only a few bitter roots. They do not eat greens, since they say they are only for animals. Some nations eat beans, pumpkins, very sweet watermelons, some of which are white like milk and have black seeds; others are reddish

and have seeds of the same colour. Other nations live almost entirely on fish. The Kiristinons usually eat only half-cooked fresh or smoked meat. Sometimes it is half-rotten and full of worms. Among these people, bread and wine are unknown, and they have no salt. The Indians are almost always naked, except for the women, who are always decently dressed from the neck to the knees. These barbarians are always exposed to all kinds of weather, like animals. They are hunters, fishermen, great navigators, brave warriors, indefatigable travellers, etc. (f. 178)

The main condition expressed by this concept of "savagery" or "barbarism" is radical poverty. Not having bread, wine, or salt, these "people" lack what Europeans considered essential. Nor is their poverty approved of, as if it were a kind of monastic virtue. It is seen, rather, almost as folly. In fact, Nicolas describes many of the eating habits as if they were perversions of taste. These "strange people" are attracted by what we hate and repulsed by what we like. For instance they refuse to eat "greens," saying that they are good only for animals (f. 10). Yet they eat with pleasure a fruit that smells bad to the Europeans: "It seems that these strange people have an aversion to everything that we like, and prize everything that we despise; they cannot bear our best smells, and say that they smell bad. Some of them say that the French stink, while we stop our noses so as not to smell them" (f. 19).

Nicolas also marvels at the Indians' avidity for bear grease, which "is a powerful laxative, and those who are unaccustomed to it will have their digestive system affected very violently and painfully … The natives, who are accustomed to this remedy, are not concerned about that and drink the fondue in big gulps, as we would drink a fine wine, and they seem to enjoy this horrible liquid" (f. 74). The symmetry is such that the Indians hate what Europeans like.

> Indians do not like the scent of the muskrat at all and say that the animal we esteem smells bad, as agreeable as its scent may be to Old World persons. Generally speaking, and since the occasion present itself, I will say that these forest people detest all our most fragrant essences and our most exquisite sauces, saying that the former stink, and that the latter are too bitter. This is why they say that the muskrat smells bad: "*Oûinat ouatchak*, he stinks like a muskrat." (f. 111)

Speaking of a fish that he calls "the toad," Nicolas says: "Its taste is very mediocre; but as the Indians have a different taste from ours, they prize it" (f. 173).

The same sort of thing is said about the loach: "Although this fish is quite extraordinary and has a very bad taste, the natives, who eat everything, appreciate it, although we French reject it when we have other things to eat" (f. 175).

Of course, we should not see in this awareness of differences of taste a kind of cultural relativism before its time. Nicolas was not the Ruth Benedict of his day! There is no doubt that Nicolas thought European taste was better, and that by their "bad" taste, the Indians demonstrated their folly. How else, indeed, to characterize their constant preference for what we find disgusting, this upside down scale of values, in which they seem to take pleasure? Who are these "strange persons" if they are not crazy? When one thinks of the way mental illnesses were treated in the seventeenth century, one can only shudder at the thought of the socio-cultural implications of judgments of that kind.

INTRODUCTION: *Louis Nicolas's Depiction of the New World*

To what extent is this approach – particularly the *æmulatio*, which is so characteristic of the "Histoire naturelle" – reflected in the *Codex*? At first one sees how the portraits of Indians from Plates v to xiv and the pages devoted to different aspects of the Indian way of life could be juxtaposed with their European counterparts, as Joseph François Lafitau was to do in his *Mœurs des sauvages amériquains comparées aux mœurs des premiers temps* (1724), in which customs of the Indians were compared – often in the same engraving – with those of the ancients or with those from another part of the Americas. Nicolas does not proceed that way. But to think that there are no traces of *æmulatio* in the *Codex* would be a mistake. In fact there are three pages, if one excludes the dedications, which could be interpreted as expressing *æmulatio*, examples that counterbalance all the Indian iconography of the *Codex*. On Plate lxviii we see "Jacques Cartier, sailor from Saint-Malo who was sent to New France by the late Francis the 1st, King of France and of Navarre, who made him chief of the squadron to discover the state of the St Lawrence River and of New France." The discoverer is represented in a pair of pants that are strangely similar to those of "the captain of the Illinois," (Pl. v). Cartier makes a gesture of authority with one hand and carries a staff in the other. Baron Marc de Villiers thought that the feminine person on the right was his wife. But it is more plausible that it is a religious figure, perhaps the Madonna (see the pedestal on which she is standing) or a symbolic representation of France. Whoever it may be, this is one portrait of a European that can be compared with all the portraits of Indians.

How could the European reader not find the "vessel … equipped by Captain Jacques Cartier who was the first to enter the Saint Lawrence River in Canada," which appears in the drawing of Plate lxvii,[219] superior when compared to all the canoes of the *sauvages* depicted in Plates xvi–xix? How could the reader not have admired the "canon" on Plate lxix and accorded it precedence over all the Amerindian arms on Plate xvi? Nicolas must have judged these clear examples of European superiority sufficient, requiring no further development. And of course the very elaborate three pages of dedication at the beginning of the work show that, in his eyes, "the King of the great Sioux nation" (Pl. viii), or the "captains" (Pls. v and xiv) and the "representative" (Pl. xi) were very petty indeed in comparison with the Sun King, and should be happy to be the subjects of His Majesty, the King of France.

Encouraged by these examples, the reader could not but pity these "poor savages" whose portraits he can see on Plates iv–xiv, along with their religious practices on Pls. iv and xxi, their means of transportation on water and on snow (Pls. xvi–xix), their habitations (Pls. xix–xx), and their medical techniques and cruel treatment of prisoners (Pl. xxii). It is remarkable that their fishing techniques are treated on one page (Pl. xv), whereas their hunting techniques, which occupied such an important place in the "Histoire naturelle," are not depicted but are touched upon only indirectly on Plate xx, where one sees a "hunter returning home with his beaver pelts on his back." Perhaps reluctance to show natives indulging in the *plaisir des rois* was too strong to allow Nicolas to depict such scenes, not to mention the fact that they were much harder to draw. In this manner, he avoided the risk of representing the Indians as nobler than they were.

The *convenientia* of the Indians to the forest, mentioned in the *Histoire naturelle*, is not illustrated as such in the *Codex*. But it seems to me that the function of the two large maps inserted in the *Codex* is to indicate the relation of the different Indian

nations to their place. With the help of these maps, it is always possible to geographi-
cally situate the different "nations" mentioned elsewhere in the *Codex*, including the
"Noupiming-dach-irinouek" of Plate IX, who might otherwise be almost impossible
to locate. This word appears in fact on the "Carte generale" at the level of "Lake Out-
imiskami" and allows us to think that the Noupimin-dach-irinouek were probably a
clan of the Ojibwa. But there is more. These maps help us understand the meaning of
the word "nation" as applied to an Indian group, at a time when, even in Europe, the
word did not yet have all the connotations it would take on in the nineteenth century.
In the seventeenth century, "nation" referred to the link created between an individual
and the place where he was born (*natum, natio*), and not much more. The idea of a
"social contract" according to which men could decide to live together as equal before
the law that they would themselves have agreed upon, keeping for themselves all liber-
ties and natural rights and conceding to the state only what is necessary to assure the
common good and to defend these rights, was not yet envisaged. And of course, the
romantic idea of the *Volksgeist*, conceptualized as an organic entity created by blood
ties, folklore, myths, memories, shared destiny, and common needs, is even further
from the concept of nation in the seventeenth century. The nation then was neither an
aspect of equality between men, nor an aspect of identity. It represented a fact, not a
right – the fact of having been born in a specific place. In that sense Nicolas can speak
of the "natives of the country" without implying that the fact that they had been born
in America gave them any specific right to the territory that they inhabited. The Euro-
pean peasant did not have any such right either. The right to a territory was determined
not by place of birth, nor by the work invested in a place, nor even by money, but by
rank alone. It was the recognized privilege of the kings and the nobles to possess land.
From this perspective, the "natives of the country" could consider themselves subjects
of the king and nothing else.

One realizes, then, the basis for the analogies underlying the representations in
Plates V–XIV. As Anne-Marie Sioui (Blouin) has shown, it is possible to classify them
in a hierarchical order with the "the King of the great Sioux nation" (Pl. VIII) at the
top and the simple "savage" (Pls. VI, VII, X, and XII) at the bottom, with the captains
(Pl. V and XIV), the representative (Pl. XI), the men (Pls. IX and XIII), and even the
young man (Pl. VII), in between, and in that order.[220] These analogies do not proclaim
the autonomy of the Indian nations but flatter the vanity of the king by giving him the
impression that he reigns over many nations and kings, and that even "kings" submit
to his power.

We have shown above that most of these illustrations were taken from Du Creux, a
Jesuit author who could not have escaped Nicolas's attention. The differences between
Nicolas's illustrations and his models concern the mode of presentation, body orna-
mentation, and accessories. Nicolas was especially interested in tattoos and in all kinds
of body ornaments, such as headbands, bracelets, garters, and so on. His interest in tat-
toos deserves some attention. In the "Histoire naturelle" he inquires about the pigments
used for that purpose and about how tattoos were made. The charcoal of the "white
cedar," he writes, "sinks so deeply into the natives' skin that they use it to paint on their
entire body with various figures that they imprint and which can never be removed.
They grind it and, having crushed it, they temper it with ordinary water and soak three
pointed bones with which they prick the skin in such a way that the blood that comes
out mixes with the diluted charcoal. The pictures they engrave never come off the place

INTRODUCTION: *Louis Nicolas's Depiction of the New World*

where they are made" (f. 44). This unbiased account, remarkably free from any value judgments, is not unusual in Nicolas's text. Even when he is suspicious about the religious meaning of some of the tattoos, he gets to the point without comments. "There are found among these barbarians some who engrave this animal [the bear] on some part of their bodies. This means that it is to this personal deity that the native offers all his travels, his hunts and, in a word, everything he does, without exception" (f. 79).

This sober treatment of the matter stands in contrast with the condemnation habitually reserved for tattoos by his contemporaries.[221] For people of his time, tattoos were like the marks looked for on the body during witch trials. Women suspected of witchcraft were undressed and examined carefully to find these "signatures" of the devil, which, when discovered, confirmed the accusation of witchcraft against them.

Other means of body adornment used by the Indians are often described in the "Histoire naturelle": "The people of various nations, particularly the Illinois, are proud to make wreaths, baldrics, necklaces, garters and bandoliers from the heads of these birds [woodpeckers], which they string, one after the other, in the same way that we string our rosary beads" (f. 137).

Elsewhere, we read of ornaments made from feathers, a subject one would expect in any discussion of Indians, but which in fact was quite rare at the time. "Americans use the feathers [of the eagle] to adorn themselves and to make their arrows. They make wreaths from the talons and from the beak … These same people make for themselves hats, ties, and tobacco bags with all the skin of the bird, which they usually skin without removing the feathers" (f. 154).

The swan is another source of material for ornaments. "The people make bags and purses from the skin of the legs and of the feet [of the swan], which they skin very neatly and quickly. They put tobacco and their pipe into these bags, which they first treat with smoke" (f. 163). We are not surprised, then, to see that the drawings of the *Codex* give so much attention to these ornaments of the body in their depiction of Indians. This is in contrast to Du Creux, whose illustrations are more sober – and often inaccurate – in these matters.

Du Creux's presentation was horizontal, so to speak. There was no distinction from one personage to the other. Nicolas preferred a hierarchical presentation. In that way he obtained a mirrored but reversed image of European society.

CONCLUSION

Even if the "Histoire naturelle" and the *Codex* were always intended to circulate separately and in manuscript form, I hope it is now clear that they both reflect the same *épistémè*. The importance they ascribe to the great figures of similarity, as defined by Foucault – that is to say *æmulatio, convenientia*, analogy, and sympathy – is striking; all the more so, since they are so pervasive in a text and an album of drawings that belong to the end of the seventeenth century. These figures give the text and the drawings an archaic flavour that one does not find in other works of the time such as, for instance, Pierre Boucher's *Histoire véritable et naturelle* (1664). Their prominent use explains the constant confrontation of the New World with the Ancient World and helps contextualize the references to Pliny in the text and to Gesner in the drawings.

Printing both the "Histoire naturelle" and the *Codex* in the same volume does not so much fulfil a dream that Louis Nicolas may in fact never have had as it stresses the great similitude of perspective that permeates these two works. We hope that our presentation – with the French text rigorously modernized by professor Réal Ouellet and admirably translated into English by professor Nancy Senior, and with the collaboration of the Thomas Gilcrease Institute, in Tulsa, Oklahoma, for the drawings of the *Codex*, not to mention the generous help we have received from biologists whom we acknowledge separately – will make these extraordinary manuscripts better known to the general public and to scholars. After all, these works are unique both for their age (c. 1675) and for the richness of their content. They are extraordinary early records of New World natural history.

FRANÇOIS-MARC GAGNON, director
The Gail and Stephen A. Jarislowsky Institute of Studies in Canadian Art
Concordia University, Montreal.

1 Charles Germain Marie Bourel de la Roncière, *Histoire de la découverte de la terre. Explorateurs et conquérants*, 225; quoted in B.G. Hoffman, "The *Codex canadiensis*," 387.

2 Robert Hollier, "Où se trouve le *Codex canadiensis?*" 54. My translation.

3 Georges Andrieux, *Importants livres et manuscrits relatifs aux Amériques*, 106.

4 On T. Gilcrease's interest in the *Codex*, see Henry M. Reeves, François-Marc Gagnon, and C. Stuart Houston, "*Codex canadiensis*, an Early Illustrated Manuscript of Canadian Natural History."

5 Raymonde Litalien, responsible for the Public Archives of Canada in Paris (now Library and Archives Canada), checked that for us. Letter to F.-M. Gagnon, Paris, 17 March 1982.

6 We prefer *Canadensis*, as it is better Latin than *Canadiensis*.

7 Charles Bécart de Granville, *Les raretés des Indes: "Codex canadiensis": album manuscrit de la fin du xviie siècle contenant 180 dessins concernant les indigènes, leurs coutumes, tatouages, la faune et la flore de la Nouvelle-France.* My translation. A pirated edition of that de Villiers edition still exists. It was published in Montreal in 1974 by the Éditions du Bouton d'Or. Gaétan Dostie took it upon himself to publish a rearranged version of the same edition under the title of *Codex du Nord amériquain, Québek, 1701, Charles Bécard, Sieur de Granville*, Montreal, Media-Tek and Parti-pris, 1981. Since then, Library and Archives Canada has given us access to a beautifully reproduced presentation of the *Codex* on line: www.collections canada.gc.ca/index-e.html.

8 Bécart de Granville, *Les raretés*, n.p. My translation.

9 Pierre Goubert, *Le siècle de Louis XIV: Études*, 283–4; Hubert Méthivier, *Le siècle de Louis XIV*, 71–2.

10 Méthivier, *Le siècle*, 73.

11 Anne-Marie Sioui, "Qui est l'auteur du *Codex canadiensis?*" argues that the *Codex* can only have been completed *after* 1676.

12 Bécart de Granville, *Les raretés*, n. p.

13 André Vachon, "Bécart de Granville et de Fonville, Charles," in the *Dictionary of Canadian Biography* (DCB/DBC), 2:55–6.

One of the first mentions of Louis Nicolas as a possible author of the *Codex*.

14 Quoted in Bécart de Granville, *Les raretés*, n.p.

15 Fonds français cote 24225; 20.5 x 33 cm, paginated recto-verso by the author. Folio 1 bears at the upper left: "Premier cahier de l'Histoire naturelle de l'Inde occidentale" (R. Ouellet). Henceforth "Histoire naturelle."

16 BN. Fonds français 12223; suppt. fr. 369. The manuscript has 86 folios, 27 x 19 cm.

17 See F.-M. Gagnon, "Fragment de bestiaire: La bête à grand' dent," 3–7.

18 Douglas Brymner, "Report of Douglas Brymner on Archives," in *Report to the Minister of Agriculture of the Dominion of Canada for the Calendar Year 1873*, "Dialectus Américains–Grammaire Algonquin, ou des sauvages de l'Amerique septentrionale; avec la decription du pays"; composée en 1672–74, par Louis Nicolas, prêtre missionnaire. Small folio. This grammar was to be presented to the dauphin, with two dictionaries, a catechism, and two instructive discourses, the whole comprising "The topography of New France, with the lake, the natural history of the trees, fruits, birds, fishes and animals," together with another volume, which treats of "The wars, polity, manners, religion, sacrifices, diseases and remedies," divided into twenty-four books in French, for those who may not wish to apply themselves to the language of the Indians." Brymner, who did know about the "Histoire naturelle," thought this was a joke. "One feels inclined," he wrote, "to ask whether this lengthy enumeration is not a caricature; whether the author really intended to write what he sets down and whether he really did so." See also Augustin and Aloys de Backer and Auguste Carayon, *Bibliothèque des écrivains de la Compagnie de Jésus*, vol. 5, col. 1709, who note that in 1775 the *Grammaire* was in the study of "M. Beaucousin, Avocat au Parlement de Paris."

19 Vivarais (modern spelling), region of the southeast of France, roughly corresponding to the present Département de l'Ardèche. This was a Huguenot region at the time.

20 See Germaine Warkentin, "Aristotle in New France: Louis Nicolas and the Making of the *Codex canadensis*," 83–8.

21 See F.-M. Gagnon, "L'expérience ethno-

graphique de Louis Nicolas," and Guy Tremblay, "Louis Nicolas: Sa vie son œuvre. Les divers modes de transport des Indiens américains," for Louis Nicolas's biography.

22 Guy Tremblay found the baptism certificate of Louis Nicolas at the Church of Jesus Christ of Latter-Day Saints in Salt Lake City, which had a copy of the "Registres paroissiaux catholiques de la ville d'Aubenas en Ardèche (1612–1646). Baptêmes, mariages, sépultures," Film 5 Mi 3; volume R64. The Mormon archives are a great help for this kind of information. Nicolas's birth date is confirmed by the Archives of the Jesuits in Rome, *Tolos.* 10ii, 302v, and 385v.

23 See C.-H. Laverdière and H.-R. Casgrain, *Le Journal des Jésuites*, 326. My translation.

24 Camille de Rochemonteix, *Les Jésuites et la Nouvelle-France au xviie siècle, d'après beaucoup de documents inédits*, 361, n. 3; Guy Tremblay, "Louis Nicolas: Sa vie et son œuvre," 51, nos. 17 and 18 refer to the Archives Départementales de la Charente-Maritime, minutes Cherbonnier, file B 5665, no 10 and to Library and Archives Canada, manuscripts, Kupp Collections, MG 18 o 12, vol. 16, no. 602.

25 Laverdière and Casgrain, *Le Journal*, 301. Pierre de Voyer d'Argenson was governor of New France from 1658 to 1661.

26 This is Guy Tremblay's position (personal communication).

27 Letter from Louis Nicolas, Tournon, to Vicar General Jean-Paul Oliva, Rome, 4 December 1661. Archives romaines de la Compagnie de Jésus, quoted and translated into French by Guy Tremblay, "Louis Nicolas: Sa vie et son œuvre," 3 and 49, n. 7. Father Oliva's answer is addressed to him in Tournon.

28 Auguste Gosselin, "Quelques observations à propos du voyage du P. Le Jeune au Canada en 1660 et du prétendu voyage de M. de Queylus en 1644," sec. 1:35–58.

29 De Rochemonteix, *Les Jésuites*, 1:430–6.

30 See Léon Pouliot, "Le Jeune, Paul," DCB, 1:466.

31 *Catalogue restauré des Jésuites de la Nouvelle France*, Archives of the Company of Jesus, St Jérôme, Quebec.

32 General Archives of the Jesuits in Rome, quoted by C. de Rochemonteix, *Les Jésuites*, vol. 2, 361, n. 3.

33 Laverdière and Casgrain, *Le Journal*, 336.

34 The *Catalogue* notes for 1666: "Sillery.

Louys Nicolas Pater Ludovic. Nicolas Missionariae algonquinae."

35 See Hubert Charbonneau and Jacques Légaré, *Répertoire des Actes de baptême, mariage, sépulture et des recensements du Québec ancien, le xviie siècle*, 1980:7, no. 601; reproduced as Annexe I in Tremblay, "Louis Nicolas: Sa vie et son œuvre."

36 Laverdière and Casgrain, *Le Journal*, 353.

37 General Archives of the Jesuits in Rome, *Catalogue de France*, vol. 23, 246-B.

38 Reuben Gold Thwaites, *The Jesuit Relations and Allied Documents. Travels and Explorations of the Jesuit Missionaries in New France, 1610–1791. The Original French, Latin, and Italian Texts, with English Translation and Notes: Illustrated by Portraits, Maps, and Facsimiles*, 73 vols.; see vol. 51, 71 and 73. Henceforth this work is referred to simply as *Jes. Rel.*

39 Laverdière and Casgrain, *Le Journal*, 356.

40 *Jes. Rel.*, vol. 51, 71 and 73.

41 Marie de l'Incarnation, *Correspondance, 1599–1672*, edited by Dom Guy Oury, 809–10 for the French original; for the English translation we quote from *Words from New France: The Selected Letters of Marie de l'Incarnation*, translated and edited by Joyce Marshall, 342.

42 "Traitté des animaux à quatre pieds," Folio 46v.

43 See W. Vernon Kinietz, *The Indians of the Western Great Lakes, 1615–1760*, 226–30.

44 Without pagination in the *Codex* and placed before page 1.

45 See James Mooney and J.N.B. Hewitt, "Ottawa" in James White, ed., *Handbook of Indians of Canada*, 376.

46 The *Grammaire algonquine*, folio 123, lists the verb *pisintam*, "to listen," and on folio 4 gives *kanis*, "brother."

47 The same source gives *iskoute* as "fire" on folios 9, 53, 40, and 118.

48 *Jes. Rel.*, vol. 54, 167.

49 Robert H. Lowie, *Indians of the Plains*, 212–13.

50 *Jes. Rel.*, vol. 54, 206–7.

51 *Irinouek* is the plural form of *irini*, "man" and *dach* is "and," in Algonquian.

52 See Victor Egon Hanzeli, *Missionnary Linguistics of New France*, 67.

53 *The History of Canada or New France by Father François Du Creux, S.J.*; translated with an Introduction by Percy J. Robinson.

54 *Jes. Rel.*, vol. 51, 259 and 261.

55 Laverdière and Casgrain, *Le Journal*, 361, where it is noted: "The remainder of the

Year 1668, the whole of the year 1669, and the year 1670 up to the month of November, are missing."

56 Oury, *Correspondance*, letter no. 237 from Quebec to her son, 1 September 1668, 810 for the French; Marshall, *Letters*, 342 for the English translation.

57 *Amik* is "beaver" in Algonquian, as the *Codex* itself notes, Pl. XXXVII.

58 See White, *Handbook*, 20.

59 De Rochemonteix, *Relation par lettres de l'Amérique Septentrionale (1709–1710)*, 114. My translation.

60 Jesuits Archives in Rome, Gall. 1101, 45. Letter of F. Le Mercier to F. General, dated from Quebec, 1 September 1668, quoted in Tremblay, "Louis Nicolas: Sa vie et son œuvre," 16 and 54, n46 for a French translation.

61 Oury, *Correspondance*, letter no. 248 from Quebec to her son, 1 September 1669, 840. My translation.

62 Quoted in Antoine Arnaud, *La morale pratique des Jésuites*, in vol. 34 of his *Œuvres*, 729–34, given as Annexe II in Tremblay, "Louis Nicolas: Sa vie et son œuvre."

63 Arnaud, *La morale*, 730.

64 See F.-M. Gagnon and N. Cloutier, *Premiers peintres de la Nouvelle-France*.

65 *Jes. Rel.*, vol. 53, 202.

66 *Jes. Rel.*, vol. 53, 237.

67 Gagnon, "L'expérience," 289.

68 *Jes. Rel.*, vol 55, 41 and 43.

69 "We have seven Missionaries among the five Iroquois Nations," *Jes. Rel.*, vol. 56, 27.

70 *Jes. Rel.*, vol. 57, 89.

71 *Jes. Rel.*, vol. 57, 89–91.

72 See no. 33 on his map, *Iroquois County in New York*, in *Jes. Rel.*, vol. 51, 292.

73 Charles Bécart de Granville, *Les raretés*, n.p.

74 See Bruce G. Trigger, *The Children of Aataentsic: A History of the Huron People to 1660*, vol. 2, 838–9.

75 We have translated *Toniotogehaga* as Tionnontoguen, which was one of the Oneida villages (near what is now Spraker's Basin).

76 The *Catalogue*, vol. 23, reads: "1671–72 in collegio Quebec operarius (Cl. Dablon, rect.); 1672–73 Sillery: L. Nicolas superior, pro-parachus, miss. linguae algonquinae." Quoted in Tremblay, "Louis Nicolas: Sa vie et son œuvre," 24 and 58, n. 70.

77 *Jes. Rel.*, 54, 117.

78 *Jes. Rel.*, vol. 59, 51 and 53.

79 *Jes. Rel.*, vol. 59, 49, modified.

80 The text of this *Memorandum* is reproduced and translated in *Jes. Rel.*, vol. 59, 56–63.

81 He gives a list of the converts at the end of his *Memorandum*.

82 "1673–75: ad promontorium Stae Magdalenae, miss. linguae algonquinae," as stated in the *Catalogue*, vol. 23, quoted in Tremblay, "Louis Nicolas: Sa vie," 27 and 58, n78.

83 See A. Dragon, *Trente robes noires au Saguenay*, 246: "il s'intégra au clergé séculier en 1678."

84 In his *Dictionnaire biographique du clergé canadien-français*, Montreal, 1910, 399.

85 Oury, *Correspondance*, 789, n12.

86 See François-Marc Gagnon, "Figures hors-texte: Note sur *l'Histoire naturelle des Indes occidentales du père Louis Nicolas, jésuite*," 1–15; Anne-Marie Sioui, "Qui est l'auteur du *Codex canadiensis*?" previously defended the same idea.

87 Warkentin, "Aristotle in New France," 71–107.

88 Quoted in Tremblay, "Louis Nicolas: Sa vie et son œuvre," 33 and 61, n97.

89 This was the opinion of Victor Egon Hanzeli, *Missionary Linguistics in New France*, 69: "Louis Nicolas' Algonkin grammar is unique among the manuscripts in the area inasmuch as it is not a working notation but a manuscript intended for publication … The outstanding presentation of this manuscript is no doubt largely due to the fact that it was intended for press and, once printed, for readers who were completely uninitiated in the Amerindian languages."

90 Diane Daviault, *L'algonquin au XVIIᵉ siècle. Une édition critique, analysée et commentée de la grammaire algonquine du père Louis Nicolas.*

91 René Descartes, "Preface to the Reader," *Meditations on First Philosophy*, in Elizabeth S. Haldane and G.R.T. Ross, *The Philosophical Works of Descartes Rendered into English*, vol. 1, 139.

92 "Le libraire au lecteur," in Charles Adam and Paul Tannery, *Œuvres de Descartes. Méditations. Traduction française*, vol. 9:1, 1.

93 Ibid., 2.

94 Patrick O'Brian, Verlyn Klinkenborg, and Ruth S. Kraemer, *The Drake Manuscript in the Pierpont Morgan Library: Histoire Naturelle des Indes.*

95 Or even folio 19. The nineteenth book would have been devoted to a "great captain," named The Turtle, and to the tech-

nique of catching turtles, as told by him and others, as he announces on folio 124.

96 Michel Foucault, *Les mots et les choses: Une Archéologie des sciences humaines*; trans. as *The Order of Things: An Archeology of the Human Sciences*; and Giorgio Agamben, *Signatura rerum. Sur la méthode*, 37–91.

97 I borrow this example from Kay N. Sanecki, *The Complete Book of Herbs*, 203.

98 Ibid.

99 Example given by M. Foucault, *Les Mots*, 42.

100 See Sanecki, *Book of Herbs*, 203.

101 Foucault, *Les mots*, chap. 2, 32–59.

102 François-Xavier Charlevoix, "Journal historique d'un voyage de l'Amérique adressé à Madame la Duchesse de Lesdiguières," Lettre 5, 97, in *Histoire et description générale de la Nouvelle-France*, vol. 3. My translation.

103 But it is a fact that Nicolas was also the author of a *Grammaire algonquine*, recently published by Diane Daviault, *L'algonquin au XVII^e siècle*.

104 Ibid.

105 The English name is leatherwood, *Dirca palustris* L.

106 The Swiss mercenaries who served *ancien régime* France wore striped suits, as do the Swiss guards of the pope even today.

107 In this, Nicolas reveals himself to be a good disciple of Aristotle, who wrote in his *Metaphysics*: "We prefer seeing (one might say) to everything else. The reason is that this, most of all the senses, makes us know and brings to light many differences between things"; see *The Works of Aristotle*, trans. W.D. Ross, vol. 8, *Metaphysica*, Book A, 980a25. On the other hand, Aristotle says in the *De Anima*, Book 2, 9, 421a20 that the sense of touch of humans supersedes that of any animal.

108 *Dictionnaire abrégé de peinture et d'architecture*, Paris, Barrois, and Noyon, 1746, vol. 1, 173.

109 *L'Enclyclopédie ou Dictionnaire raisonné des sciences, des arts et des métiers*, vol. 4, 577. I take these quotations from Laurier Lacroix, *Le fonds de tableaux Desjardins: nature et influence*, PhD Dissertation, Université Laval, 1996, 17 and 18.

110 See for instance Charles Blanc, *Le trésor de la curiosité*, quoting p. iii, a letter by Adophe-Narcisse Thibaudeau to the author.

111 For instance, one finds in Pliny, *Historia naturalis*, Book 2, 46: "Ex iis, quae terra gignuntur, lauri fruticem non ictit [Among things that grow in the ground, it (lightning) does not strike a laurel bush]." See *Pliny: Natural History*, trans. H. Rackham, 1:283. According to the myth of Prometheus, Zeus made the laurel inflammable to punish men who used to give him the inferior parts of the animals (bones and greases) in sacrifice. This of course motivated Prometheus to steal the fire. See Hesiod, *Theogonies*, 535–7, quoted by G.S. Kirk, *The Nature of Greek Myths*, 137.

112 Montpellier was a Protestant centre during the Wars of Religion. Louis XIII defeated the Protestants in 1622 and six years later had all its walls destroyed except the Citadel.

113 Saint Peter's Cathedral, partly destroyed by the Protestants, was rebuilt under Richelieu.

114 See Svetlana Alpers, *The Art of Describing: Dutch Art in the Seventeenth Century*, 80 and 81, figs. 43 and 44.

115 This is a valuable indication for dating the text of the "Histoire naturelle." Might we speculate that Nicolas took refuge at the Monastery of St Ruf after his return from Canada, and wrote his work there?

116 Foucault, *Les mots*, 48; *The Order of Things*, 33.

117 Fos 28v and 29r.

118 Pliny, *Natural History*, Book 8, 47 (translation H. Rackham).

119 See *Pline l'Ancien. Histoire Naturelle. Livre VIII*, trans. A. Ernout ed., Book 8, 13.

120 "Scilicet relicta illic uxore ipse fuga sibi consuluit, quemadmodum castores, ut aiunt, a venatoribus redimunt se ea parte corporis, propter quam maxime expetuntur [He left his wife in the country, that is to say, and sought to secure his own safety by flight, just as beavers, so we are told, ransom themselves from the hunters by that part of their body on account of which they are chiefly hunted]." *Cicero: The Speeches*, N.H. Watts, ed., 271.

121 "Imitatus castora, qui se eunuchum ipse facit cupiens evadere damno testiculi; adeo medicatum intelligit inguem [The beaver thus to escape his hunter tries, / And leaves behind the medicated prize / Happy to purchase with his dearest blood? / A timely refuge in the well-known flood]." Juvenal, *Satire* 12: 34–6, in H.J. Rose, W. Giffard, and J. Warrington, *Juvenal: Satires*, 146.

122 "Si autem alius venator eum sequatur, ergit se, et ostendit virilia, se non habere,

et sic evadit. Est autem animal mansuetum nimis [If another hunter pursues him, he raises himself and shows that he lacks testicles and saves his life that way. It is a very gentle animal]." Quoted in *Speculum Naturae*, 19, chap. 30 by Vincent of Beauvais, who read it in Aelian, *De Natura animalium*, 6:34; see Aelian, *Aelian: On the Characteristics of the Animals*, trans. A.F. Scholfield, 2:50–1.

123 "Per universum Pontum fiber plurimus, quem alio vocabulo dicunt castorem. Lytris similis est, animal morsu potentissimum, adeo ut cum hominem invaserit, conventum dentium non prius laxet quam concrepuisse persenserit fracta ossa. Testiculi ejus adpetentur in usum medellarum: idcirco cum urgeri se intelligit, ne captus prosit, ipse geminos suos devorat [One finds beavers in great number in the Pontus Euxinus region. They are also called castors. They are similar to otters. It is an animal with an extremely strong bite. It does not relax its grip before it is convinced that the bones are broken. Its testicles are sought for their remedial properties. Knowing why it is pursued, and in order to avoid capture, it eats its own testicles]." in Th. Mommsen, *C. Julie Solini Collectanea Rerum Mirabilium*, 81, lines 5–10.

124 "Castores a castrando dicti sunt. Nam testiculi eorum apti sunt medicaminibus, propter quos cum praesenserint venatorem, ipsi se castrant et morsibus vires suas amputant…Ipsi sunt et fibri, qui etiam Pontici canes vocantur[The word castor comes from the word castration. Doctors use their testicles as medicine. So when they see a hunter, the beavers castrate themselves and become impotent with a bite … They are also called beaver or dogs of the Pontus Euxinus]." Isidore of Seville, *Etymologiarum*, Book 12, ii, 21–2.

125 François-Xavier Charlevoix, *Histoire*, vol. 3, 98–9. My translation.

126 *Opus majus*, Pars sexta, vap. 4; ed. J.H. Bridges, *The Opus Majus of Roger Bacon*, reprint Frankfurt on the Main, Minerva, 1964, 2:168–9.

127 "Dicitur autem castor a castrando, non quod seipsum castret ut dicit Ysidorus, sed quia ob castrationem maxime quaeritur. Falsum enim est quod agitatus a venatore castret seipsum dentibus et projiciat castoreum [Castors are named from the verb castrare, not because they castrate themselves as pretends Isidorus, but

because they are pursued principally to be castrated. It is false that, when fearful of the hunters, they castrate themselves with their teeth and throw them their castoreum]." Albertus Magnus, *De Animalibus*, 22:2, chap. 1, 40, 1370.

128 *Hist. Nat.*, 332:26; see, *Pliny. Natural History*, trans. W.H.S. Jones, 8:480–1.

129 Albertus Magnus, *De Animalibus*, 22:2, chap. 1, 40, 1370.

130 "Non potest diu subsistere nisi caudam in aqua teneat, quam habet utioque piscium caudae similem, saporemque ejus et speciem. Unde et a Christianis in jejunio comeditur [It cannot survive for long with the tail, which is similar to a fish tail both in taste and shape, out of water. This why Christians eat it during Lent]." Quoted by Vincent of Beauvais, *Speculum naturale*, 19, chap. 28, 1398. From there, of course, arises the question of how the beaver could maintain its tail in water when the waters freeze during winter. The imagined solution is amusing: the beaver wiggles its tail to stop the water from freezing. But one moment of fatigue or absentmindedness, and there it is, frozen in the ice! This seems to be what Nicolas had in mind. In that position, the hunter may simply have had to collect his beaver set into the ice.

131 A popular expression. According to the *Dictionnaire de l'Académie* 1694: "On dit d'un homme qui n'a jamais fait de voyage, qu'*Il n'a jamais perdu la veuë du clocher de son village*." Father Le Jeune writes: "There are so many strong and robust peasants in France who have no bread to put in their mouths; is it possible they are so afraid of losing sight of the village steeple, as they say, that they would rather languish in their misery and poverty, rather than to place themselves some day at their ease, among the inhabitants of New France, where with the blessings of earth they will far more easily find those of heaven and the soul?" Le Jeune's *Relation*, 1636, in *Jes. Rel.*, vol. 9, 187.

132 In fact, this was probably an even more indirect reference, since Nicolas probably read it in "Thévenot, a famous contemporary writer," quoted a little bit later (f. 87).

133 See Charles André Julien, *Les voyages de découvertes et les premiers établissements (xvᵉ et xvɪᵉ siècles)*, 319, n.7.

134 *Non omnis fert omnia tellus* [Not everything is produced everywhere].

135 Bernard Schnapper, *Le géant, la licorne et la tulipe*, 1:40–2.

136 See Louis Denise, *Bibliographie historique et iconographique du Jardin des Plantes*, and R.C. Howard, "Guy de la Brosse and the Jardin des Plantes in Paris," 195–224.

137 Guide Michelin, *Paris et sa proche banlieue*, Paris, 1965, 157.

138 Probably *Prunus depressa* (Pursh) Gleason.

139 Probably *Erythronium americanum* Ker Gawl.

140 See Marthe Faribault, "Phytonymes nord-américains: étude onomasiologique de la terminologie des racines alimentaires," *Actes du XXe Congrès International de Linguistique et Philologie Romanes*, 4:6 Lexicographie / Galloromania, 109–18.

141 The correct spelling in French is "topinambour."

142 Marie-Victorin et al., *Flore laurentienne*, 616–17.

143 Ibid., 400.

144 See Dorothée Sainte-Marie, *Les Raretés des Indes ou Codex canadiensis*, 25.

145 Acorus is a swamp dweller which, like wild ginger, is a tuber plant. It is known also as Angelika. See Marie-Victorin, *Flore laurentienne*, 845.

146 "Description des plantes principales de l'Amérique septentrionale" in Charlevoix, *Histoire*, vol. 2, 10. My translation.

147 See Lucien Guyot and Pierre Gibassier, *Les noms des fleurs*, 85.

148 François-Xavier Charlevoix, *Histoire*, vol. 2, 11. My translation.

149 See Gisèle Lamoureux and Claude Allard, *Plantes sauvages printanières*, 112–13 for a good description of the *Asarum canadense* L.

150 See Lucien Guyot and Pierre Gibassier, *Les noms des fleurs*, 49.

151 In fact it is a little more complicated than that; see David B. Dusenbery, *Life at Small Scale: The Behavior of Microbes*, 123–5.

152 See a reprint of his famous article "Die Flechten als Parisiten des Algen," in *Verhandlungen der Naturforschenden Gesellschaft in Basel*, 2001, 5:4, 527–50.

153 Marie-Victorin, *Flore laurentienne*, 140.

154 Jacques Rousseau, "L'anneda et l'arbre de vie."

155 The strobiles, or cones, are the inflorescences of gymnosperms, with unisexual flowers composed of scales bearing the pollen sacs or of carpellary leaves which carry the ovules and, later, the seeds.

156 Père Louis-Marie has a mention of it on page 195 and an illustration on page 197 (Pl. 61, fig. 1) in his *Flore-manuel de la province de Québec*, but Marie-Victorin's *Flore laurentienne* ignores it completely.

157 See Bernard Boivin, "La Flore du Canada en 1708, 223–97.

158 Kalm, Pehr, *Voyage de Pehr Kalm au Canada en 1749*.

159 See R.G. Hatton, *Handbook of Plant and Floral Ornament*, 217.

160 See Gerta Calmann, *Ehret: Flower Painter Extraordinary*, Pls. 36 and 59.

161 With the meaning discussed above of "taking care of."

162 Could he be the "marquis de Chamarante" mentioned in Montespan, *Mémoires de Madame la Marquise de Montespan* as one of her lovers?

163 I translate *canard branchu* as "wood duck," *Aix sponsa* L., because, as Charlevoix explains, "it is called that way because it roosts on tree branches." "Journal historique d'un voyage de l'Amérique adressé à Madame la Duchesse de Lesdiguières," in *Histoire*, vol. 3, 156.

164 See Schnapper, *Le géant, la licorne et la tulipe*, 180–247.

165 Wilma George, "Alive or Dead: Zoological Collections in the Seventeenth Century," in Oliver Impey and Arthur McGregor, *The Origins of Museums: The Cabinet of Curiosities in Sixteenth- and Seventeenth-Century Europe*, 180–1.

166 A famous antidote.

167 A delicacy that ended in the pot, the carapace being saved for the museum!

168 Christian F. Feest, "Mexico and South America in the European *Wunderkammer*," in Impey and McGregor, *The Origins*, 241. See also C.F. Feest, "The Collection of American Indian Artifacts in Europe, 1493–1750," in Karen O. Kupperman, ed., *America in European Consciousness 1493–1750*.

169 See William Scupbach, "Some Cabinets of Curiosities in European Academic Institutions," in Impey and McGregor, *The Origins*, 173–4.

170 André Thevet, *La Cosmographie universelle d'André Thevet*, fo 130a.

171 See Schnapper, *Le géant, la licorne et la tulipe*, 222–4, who is quoting Paul Contant, *Le jardin et cabinet poétique de Paul Contant, apothicaire de Poitiers*.

172 See A.C. Jenkins, *The Naturalists: Pioneers of Natural History*, 19.

173 George, "Alive or Dead," 185.

174 E.H. Gombrich, *Art and Illusion: A Study in the Psychology of Pictorial Representation*, 1972.

175 *Jean-Jacques Rousseau. Les rêveries du promeneur solitaire*, Henri Rodier, ed., 92; *The Reveries of a Solitary Walker*, trans. John Gould Fletcher, 140–1.

176 See Calmann, *Ehret: Flower Painter Extraordinary*, 34.

177 The quotes are from Gabriel Sagard, *The Long Journey to the Country of the Hurons* George M. Wrong, ed., 217, 222, and 229.

178 Aristotle, *De generatione animalium*, 3:11, 761b1619 in J.A. Smith and W.D. Ross, *The Works of Aristotle translated into English*, 5, in loc. The authors explain in n6 that "the moon is mentioned as the nearest of the heavenly bodies, which are supposed to move in the region of fire," forming the third envelope of the universe, after air and water.

179 *Historia animalium* 552b15–18, in Smith and Ross, *The Works*, 4, in loc.

180 *Historia animalium*, 552b10–13, in Smith and Ross, *The Works*, 4, in loc.

181 *De partibus animalium*, 4:10, 690a5–7 in Smith and Ross, *The Works*, 5, in loc.

182 George, "Alive or Dead," 186.

183 See William T. Stearn, "Linnean Classification, Nomenclature and Method," 245.

184 *Generation of the Animals*, 2:1, 732a25 and ss.

185 Pierre Boucher, *Histoire véritable et naturelle des mœurs et productions du pays de la Nouvelle-France vulgairement dite le Canada*; English trans., Edward Louis Montizambert, *Canada in the Seventeenth Century*.

186 *Codex*, Pl. xxvii.

187 BN, Fonds français: 12223, fo 37.

188 Quoted by Lazare Saineanu, *L'histoire naturelle et les branches connexes dans l'œuvre de Rabelais*, 49.

189 *Codex*, Pl. xxxvi.

190 The author used the same model for three animals: the weasel, the long-tailed weasel (Pl. xxx), and the "water ferret" (Pl. xxxviii), a sure sign that these three figures come from the same engraving.

191 The "yellow squirrel" of Louis Nicolas is our American red squirrel, *Tamiasciurus hudsonicus* (Erxl.).

192 Charlevoix, *Histoire*, vol. 3, 96–7. My translation.

193 See H. Lalonde, "Le rat musqué. Du trappage à votre porte," *Québec. Chasse et pêche*, 2, 38.

194 Or, possibly, *Dendroica petechia* (L.), yellow warbler.

195 See W. Earl Godfrey, *The Birds of Canada*, 158, for an illustration of the feathered foot of willow ptarmigan.

196 F.-M. Gagnon, "Figures hors-texte, 12–14.

197 See Herman Heinzel, Richard Fitter, and John Parslow, *The Birds of Britain and Europe with North Africa and the Middle East*, 306.

198 The origin of this word escapes us.

199 Godfrey, *The Birds of Canada*, 54.

200 See Paul Delaunay, *La zoologie au seizième siècle*, 221.

201 Book 36, 23, in H. Stadler, ed., *Albertus Magnus. De animalibus libri xxxvi*, 2, 1591.

202 Boucher, *Histoire veritable*, 67; Montizambert translation, 41.

203 Sagard, *The Long Journey*, 235–6.

204 Boucher, *Histoire veritable*, 66; Montizambert translation, 40–1.

205 Champlain, *The Works*, 2:91.

206 Ibid., 2:92.

207 Claude Melançon, *Les Poissons de nos eaux*, 86. My translation.

208 Jack Warwick, Gabriel Sagard, *Le grand voyage*, 304; G.W. Wrong, *The Long Journey*, 231–2.

209 Boucher, *Histoire veritable*, 80–1; Montizambert translation, 46–7.

210 Charlevoix, *Histoire*, vol. 153. My translation.

211 See François-Marc Gagnon and Denise Petel, *Hommes effarables et bestes sauvaiges*.

212 Charlevoix, *Histoire*, vol. 154. My translation.

213 See Sam. 1, 10:1.

214 The French word *sauvage* can mean "wild" in a neutral sense, as in *fleur sauvage*, wild flower. When applied to human beings it is not as pejorative as the English "savage," which almost always implies ferocity and cruelty. See Nancy Senior, "On Whales and Savages," 462–74.

215 Nicolas affirms at this point that he "deals thoroughly" on this subject "at the end of all my works in French," but, as we know, this section was either not written or is lost.

216 Nicolas refers to a passage of the Gospel according to Luke, where Jesus, after having borrowed Saint Peter's boat to speak to the crowd, tells him to throw his "nets to fish" (Luke 5:4).

217 See Daviault, *L'algonquin au xviie siècle*, 22. My translation.

218 Nicolas mentions a few times in the "His-

toire naturelle" a trip he made in "Virginia," a trip that could have finished tragically (f. 11) but which seems to have been the occasion of many interesting observations: on hops (f. 9), the grass snake (f. 9) the orange tree (f. 21), the "wild laurel" (f. 25), the fir tree (f. 29), the chestnut tree (f. 3), the cotton tree [f. 38), the hemp tree (f. 41), and red and white cedars (f. 46).

219 Apparently inspired by an engraving representing the "Saint-Louis, vaisseau amiral de Louis XIII, 1627" from Georges Fournier, *L'Hydrographie*, 1667, 100, according to Auguste Vachon (personal communication, May 1982).

220 Anne-Marie Sioui (Blouin), "Les onze portraits d'Indiens du *Codex canadiensis*," 281–96.

221 See François-Marc Gagnon, "Ils se peignent le visage. Réaction européenne à un usage indien au XVI^e et au début du XVII^e siècles," 363–81.

Text of the captions established and translated by Nancy Senior

MAP (*Overleaf one*)

[Lower right box] General map of the great St Lawrence River, which has been explored more than 900 leagues inland in the West Indies

[Lower right box] Carte generale / du grand fleuve de / S. Laurens qui a esté / decouvert plus de 900 / lieues avant dans les / terres des Indes / occidentales

MAP (*Overleaf two*)

[Top] Rattlesnake, which is found in the country of Manitounie
[Bottom] Chausarou or armed fish
[Lower left box] Map of the new discovery that the missionaries made in the year 1673 beyond the lake of the Illinois. These new lands are called Manitounie

[Top] Serpent asonnete qui se trouve dans le pays de la Manitounie
[Bottom] Chau-sa-rou ou Pois-son ar-mé
[Lower left box] Carte de la nouvelle / Découverte que les missionaires ont / fait en l'année 1673 au dela du / Lac des Ilinois. On appelle ces nou-/velles terres la Manitoünie

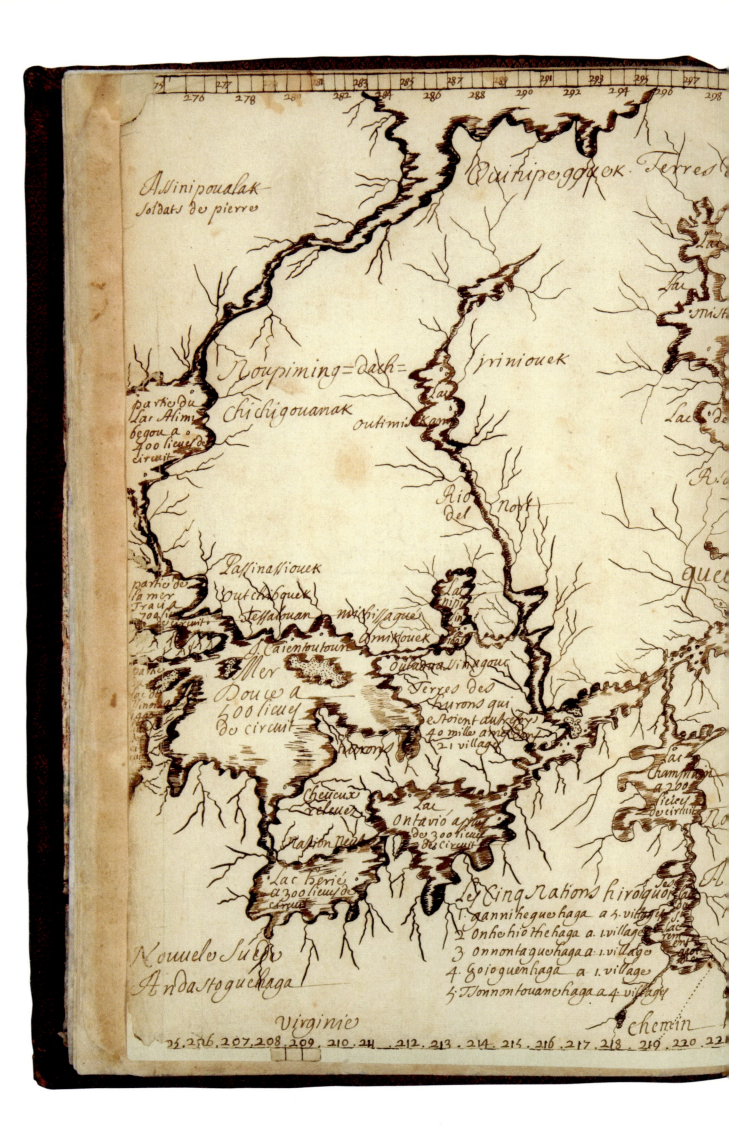

Assinipoualak
soldats de pierre

Ouinipeggyek Terres

Noupiming=dach=
chichigouanak

Jriniouek

partie du
Lac Alim
begou a
400 lieues de
circuit

outimiskam

Lac

Lac de

Rio
del Nort

R.

quel

Passinassiouek

partie de
la mer
Traue
700 au
circuit

Outchibouek

tessalouan missisagués

Lac
nipi
sin

S. Caientoutoun

Amikiouek

partie
du
lac du
Ninoua

Mer
Douce a
400 lieues
du circuit

Outaoua Ninigoue

Terres des
hurons qui
estoient autrefois
40 mille ames en
21 villages

Lac
Champlain
a 200
lieues
du circuit

Cheueux
releues

Hurons

Lac
Ontario a plus
de 300 lieues
de circuit

No

Nation neut

Nouuele Suede
Andastoguehaga

Lac herié
a 300 lieues de
circuit

Les Cing Nations hiroguoi
1. aannihegue haga a 4. villages
2 Onhehiothehaga a. 1.village
3 onnontaguehaga a. 1.village
4. gojoguenhaga a. 1.village
5. Tsonnontouanehaga a 4. villages

Chemin

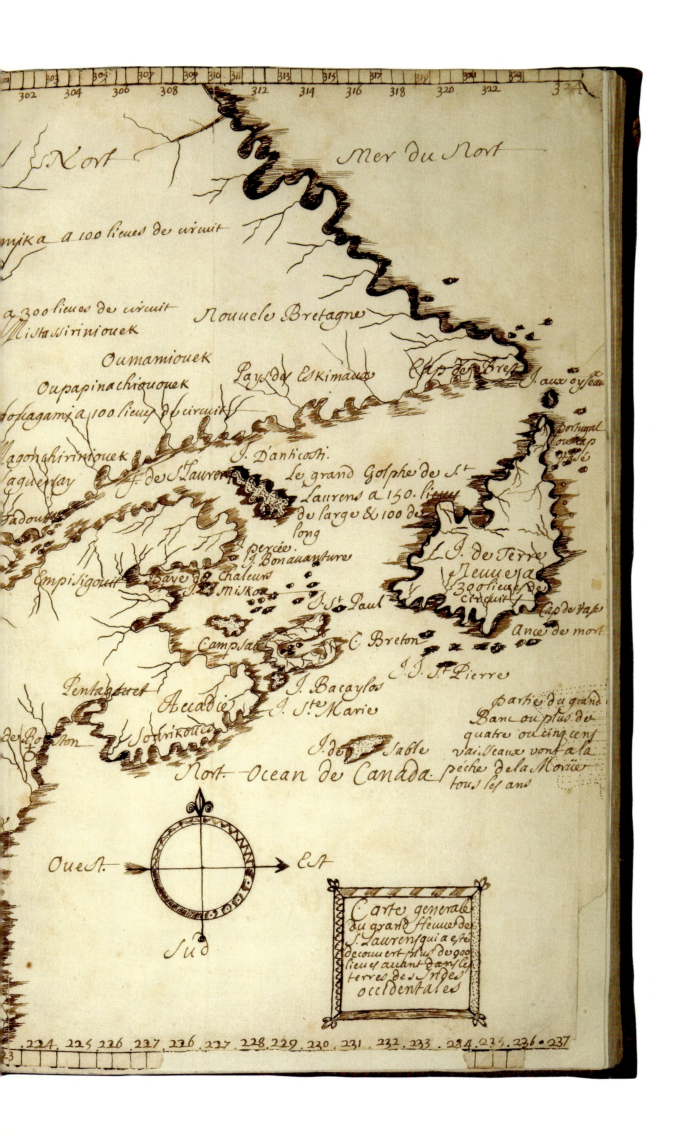

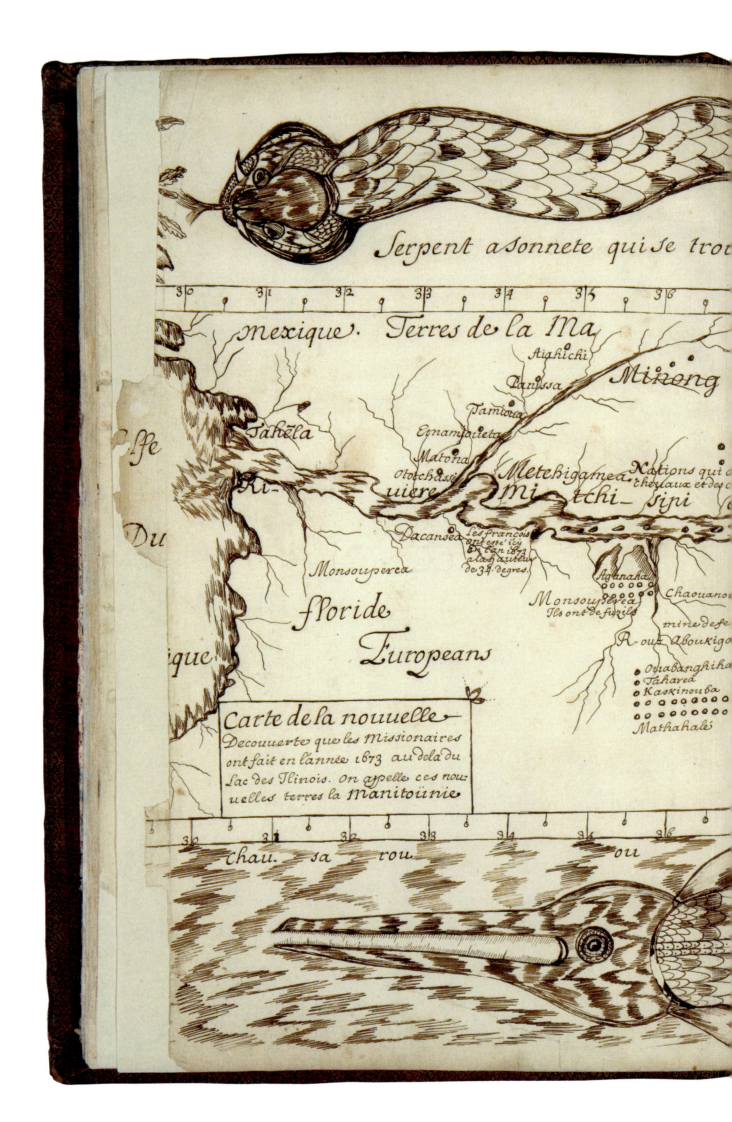

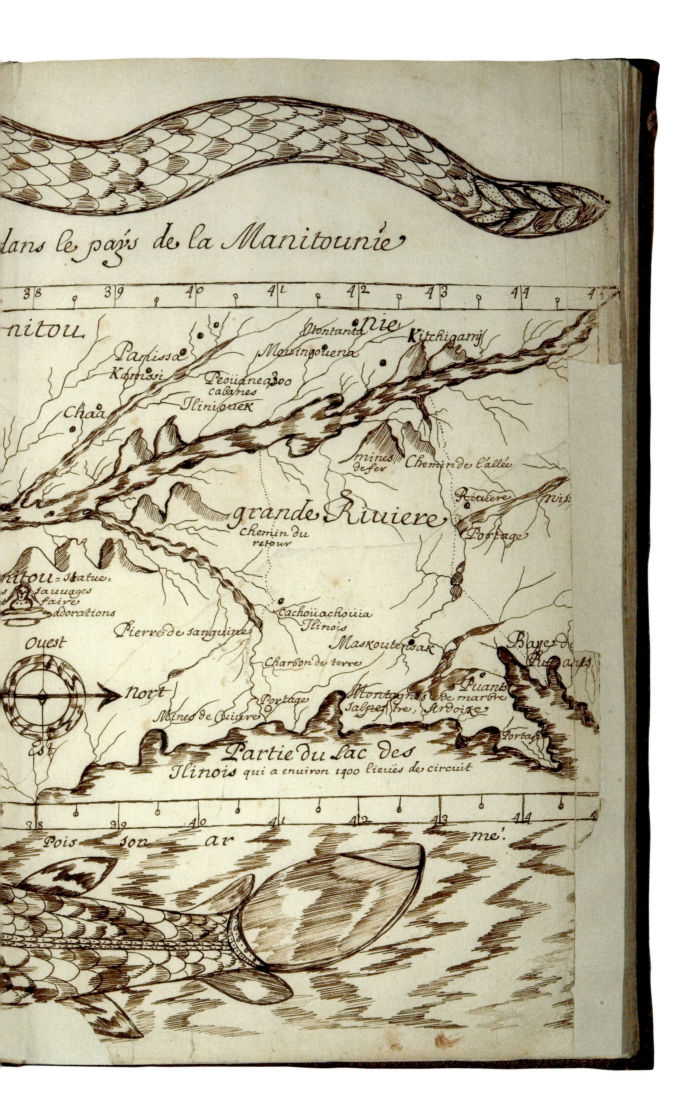

dans le pays de la Manitounie

38 39 40 41 42 43 44 4

nitou
...nie
Papissa ..ontanta Kitchigamj
Kamissi Mowingouena
Chaa Peouaneadoo Ilinioüek
cabanes

grande Riuiere
chemin du retour Mines de fer Chemin de l'allée
Riuiere Miss
Portage

nitou = statue
s ...sauuages
faire
addorations
Cachouachouia
Pierre de sanguines Ilinois
Charbon de terre Maskoutensak Baye des Puants
Ouest
Puants
Nort Montagnes de marbre de marbre
Portage Salpestre, Ardoize
Est Mines de Cuiure Portage

Partie du Lac des
Ilinois qui a enuiron 1400 lieües de circuit

38 39 40 41 42 43 44 4

Pois son ar me.

Royal mace of France, which has by the force of its Crown overthrown almost all Holland, represented by this overturned lion, which is the coat of arms of Holland. The claws of the overturned lion seen on this page mark the victories of Louis the Great, before whom all Holland trembled in the wars that the King waged against the Dutch.

Massue royalle de france / qui a Par la force de sa Couronne renversé presque toute la / Hollande Represantée par ce Lion renversé qui est les amories / de Hollande. Les serres du lion renversé quon voit dans cette page / marquent les victoires de Louis Le grand devant qui toute / la Hollande trembla dans les guerres que le / Roy avoit contre les Hollandois.

p. 1

f. 1

Massue royalle de france

qui a Par la force de sa Couronne renuersé presque toute La
Hollande Represantée par ce Lion renuersé quiest Les armoiries
de hollande Les forpes dution renuersé quon uoit dans cette page

f. 2

marquent Les uictoires de Louis Le grand deuant qui toute
La hollande tremblat dans les guerres que le
Roy auoit conte Les hollandois

Royal Crown of France supported by two globes and two
columns of the *plus ultra*, which overthrows the silver towers
of Castile, re-established today by the same Crown of France
in the person of Philip V, son of His Royal Highness the
Crown Prince of France and grandson of Louis the Great.

Conronne [sic] royalle / de france appuyée sur deux globles
et sur / deux colonnes du plus ultra quy renverse / les tours
dargent de castille relevées aujour- / dhuy par la même
couronne de france – / dans la personne de philipe 5^me / fils
de son Altesse royalle Monsey^r / Le dauphin et petit fils de
louis le grand.

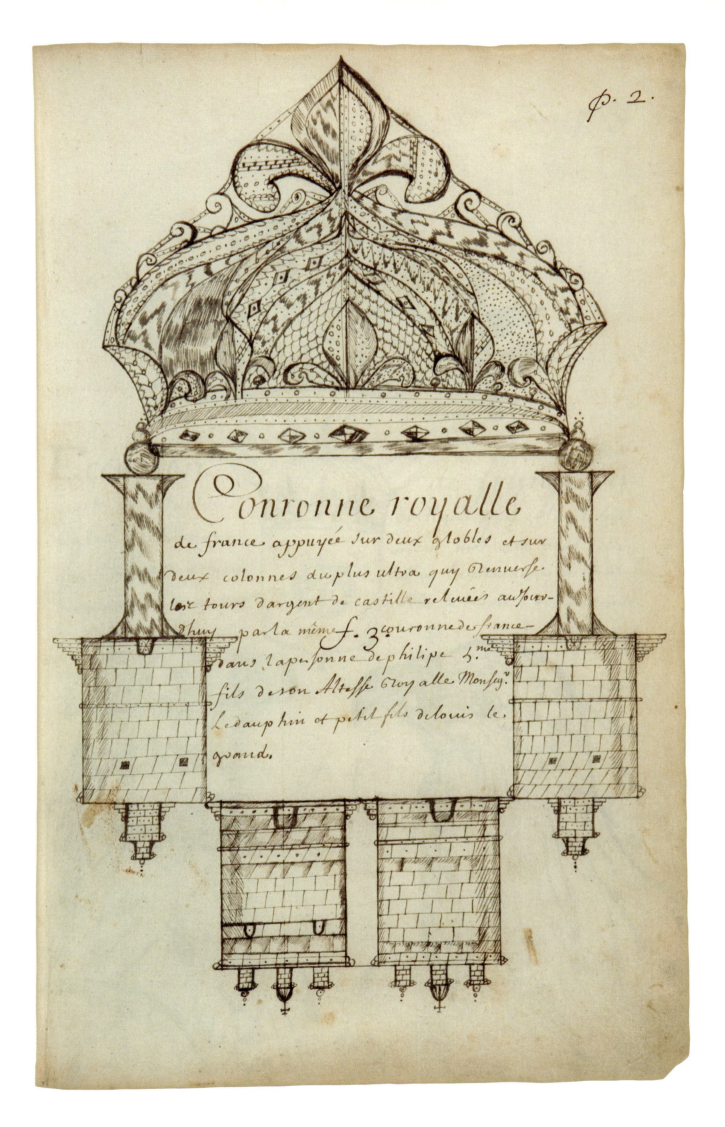

Conronne royalle

de france appuyée sur deux globles et sur
deux colonnes du plus ultra quy renverse
les tours d'argent de castille relevées aujourd-
huy par la même f. 3. couronne de france
dans la personne de philipe 4.me
fils de son Altesse royalle Monseig.r
Le dauphin et petit fils de louis le
grand.

Escutcheon of France, which bears a sun so brilliant that it
dazzles the eagles of Germany. In a word, this means that
France thoroughly defeated Germany in the time of the great
Turenne, who was the terror of the enemies of Louis the
Great.

Eccusson de france qui / porte un soleil si brillant quil eblouit
les / aigles d'Alemagne. en un mot cela veut dire / que la
france a bien battu laglemagne du tems / du grand Turene
qui a este la terreur des Ennemis / de Louis Le grand.

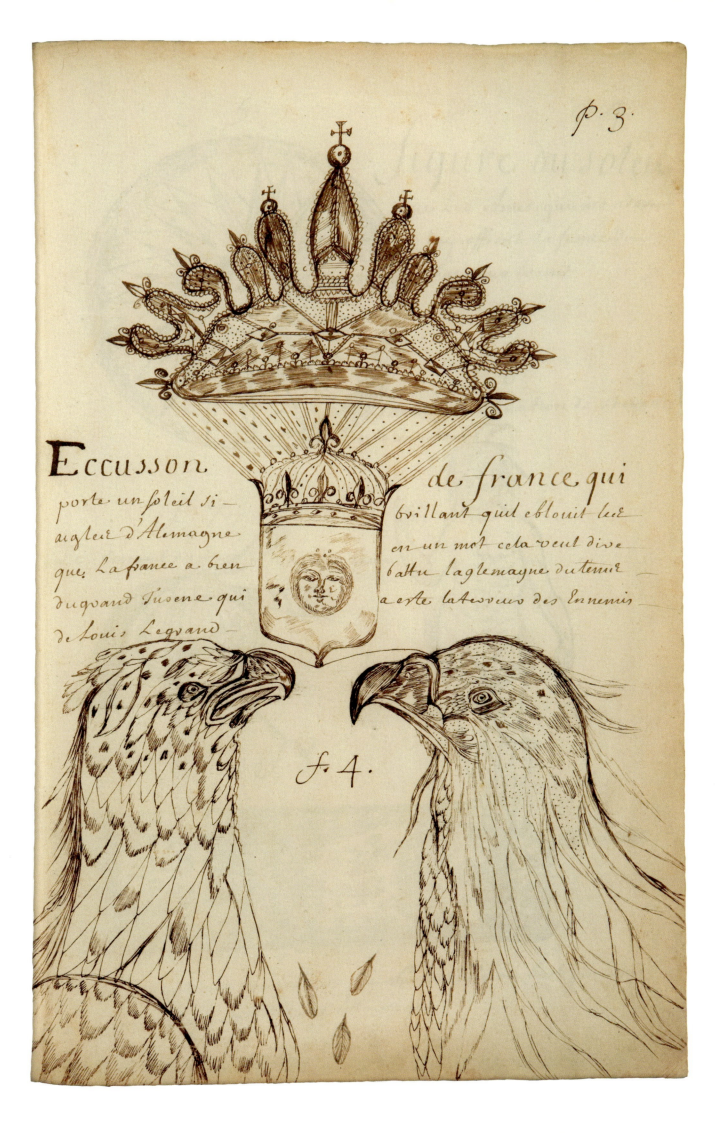

Ecusson de france qui

porte un soleil si — brillant quil eblouit tout
aigleur d'Alemagne en un mot cela veut dire
que. La france a bien battu la glemagne du tems
du grand Eusene qui a este la terreur des Ennemis
de Louis Legrand —

f. 4.

fig. 5 Drawing of the sun, which the Americans worship and
offer it the smoke of tobacco as incense.

fig. 6 Man of the nation of Stonnontouanechaga

fig. 7 Tessabikouont, or headdress of an American

fig. 8 Paving of stones heated red-hot on a fire, on which the
person who appears on this page is made to walk.

fig. 5 Figure du soleil / que les Ameriquains adorent / et luy
offrent la fumée du / tabac pour encent

fig. 6 Sauvage de la nation de Stonno= / ntouanechaga

fig. 7 Tessabikouont ou bonet d'un Ameriquain

fig. 8 Paué des calioux rougis au feu Sur lesquels on fait
promener / le personnage qui paroit dans cette page.

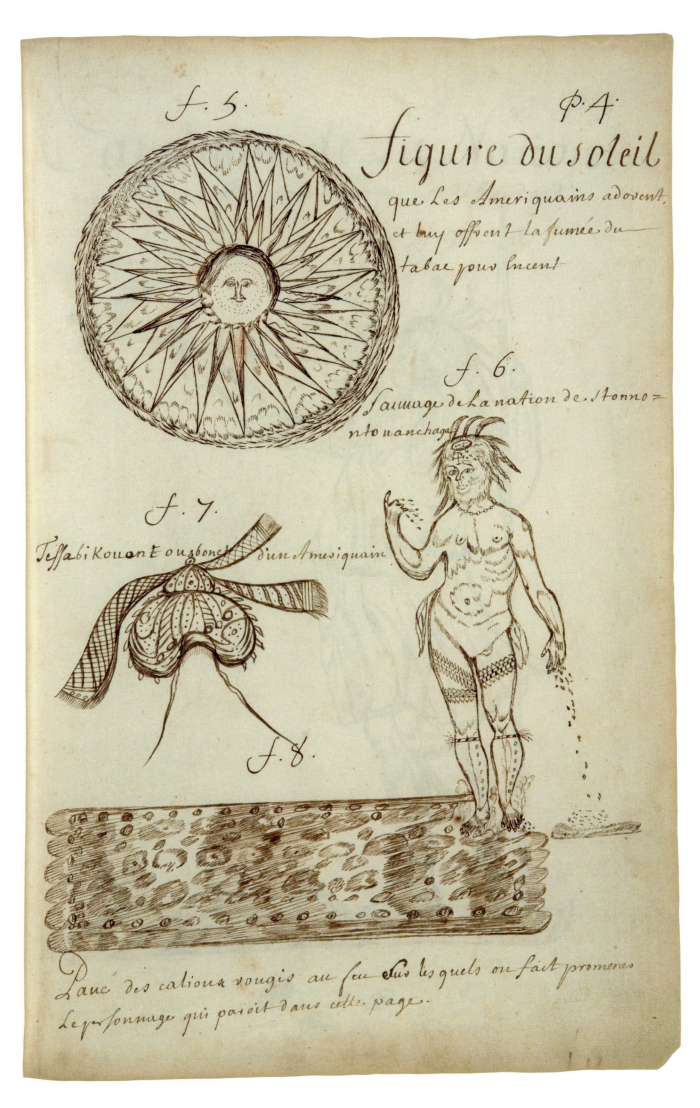

f. 5.

P. 4.

figure du soleil
que les Ameriquains adorent,
et luy offrent la fumée du
tabac pour Incent

f. 6.

Sauuage de La nation de Stonno=
nto nanchaqa

f. 7.

Tessabi Kouan E ou bonet d'un Amesiquain

f. 8.

Paué des caliou a rougis au feu sur lesquels on fait promener
le personnage qui paroit dans cette page.

Captain of the Illinois Nation. He is equipped with his pipe and his spear.

Capitaine de La Nation / des Illinois, Il est armé de sa pipe, et de son dard.

Capitaine de La Nation

des Illinois, Il est armé de sa pipe, et de son dard.

P. 5.

f. 9.

Man of the Outaouak Nation. / Pipe / Tobacco bag

Sauvage de La Nation / outaouaks.
Pipe
sac apeetun

Sauuage de La f. 10. Nation

outaouaks.

Pipe

Jae apectun

Iroquois of the Gandaouaguehaga Nation in Virginia.
Attouguen, war axe
This young man in my presence underwent his war test, by
having some fingernails torn out and the tip of his nose cut
off by his friends, who led him as if in triumph around the
village, to show that he would endure bravely all the tortures
that war enemies would inflict on him if he were captured.

Sauvage hyroquois de La / Nation de gandaouaguehaga
En virginie. /
attouguen ache de / guere
Ce Jeune homme a fait En ma Presance son Essay / de guerre
se faisant arracher des ongles, couper le bout du / nés par ses
camarades qui le menoint comme En triomphe / au tour du
bourg voulant par la qu'on sceut qu'il soufriroit / genereuse-
ment tous les tourments que les Ennemis de guerre lui /
fairoit souffrir en cas qu'il fut prix

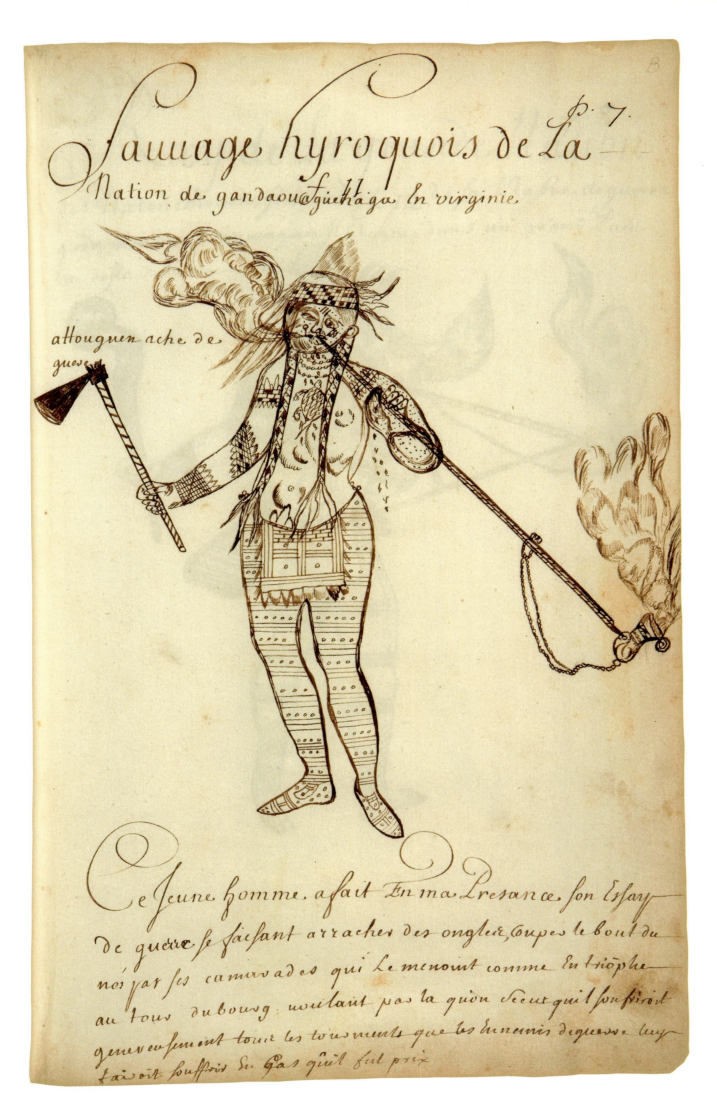

Sauuage hyroquois de La
Nation de gandaouaguehaga En virginie.

p. 7.

attouguen ache de
gueue

Ce Jeune homme, a fait En ma Presance, son Essay
de guerre se faisant arracher des ongles, coupes le bout du
nés par ses camarades qui Le menoint comme En triophe
au tour dubourg; voulant pas la qu'on Sceut qu'il souffroit
genereusement tour les tourments que les Ennemis deguerre luy
faisoit souffrois En Cas qu'il fut pris

King of the great nation of the Nadouessiouek. He is armed
with his war club, which is called *pakamagan*. He reigns in
a great country beyond the Vermilion Sea.

Roy de La grande Nation / des Nadouessiouek, Il est armé
de sa Massue de guerre / qu'on nomme pakamagan, Il regne
dans un grand Pais / au dela de la mer Vermeille

Roy de La grande Nation

des Nadouessiouek, s'est armé f. 12.e de sa Masue de guerre
qu'on nomme pakamagan, il Regne dans un grand Paiis
au d'ssa de la mer vermeil.

P. 8.

Portrait of a man of the nation of the Noupiming-dach-
iriniouek.
Ouakacouat, war axe.

Portrait d'un homme de La / Nation des Noupiming = dach
= iriniouek.
ouakacouat hache de guerre

Portrait d'un homme de la

f. 13.

Nation des Noupiming=dach=iriniouek.

ouaKacouathache deguerre

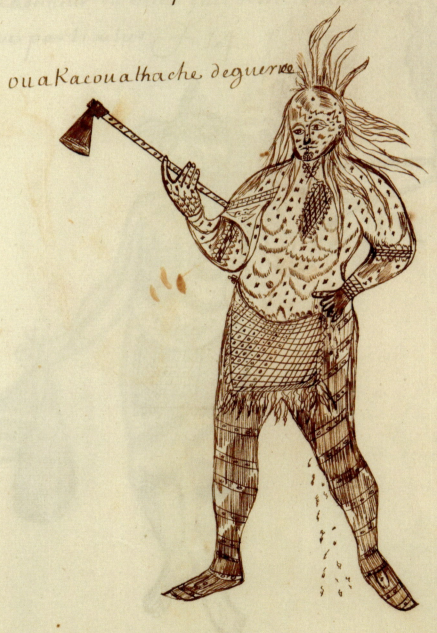

Man of the nation of the Onneiothehaga. He is smoking tobacco in honour of the Sun, which he worships as his personal spirit.

Sauvage de La / Nation des onneiothehaga. Il fume du tabac / a l'honneur du Soleil qu'il adore comme son / genie particulier

Sauuage de La
Nation des onneiothëaga. Il fume du tabac
a L'honneur du Soleil qu'il adore comme son
genie particulier f. 14.

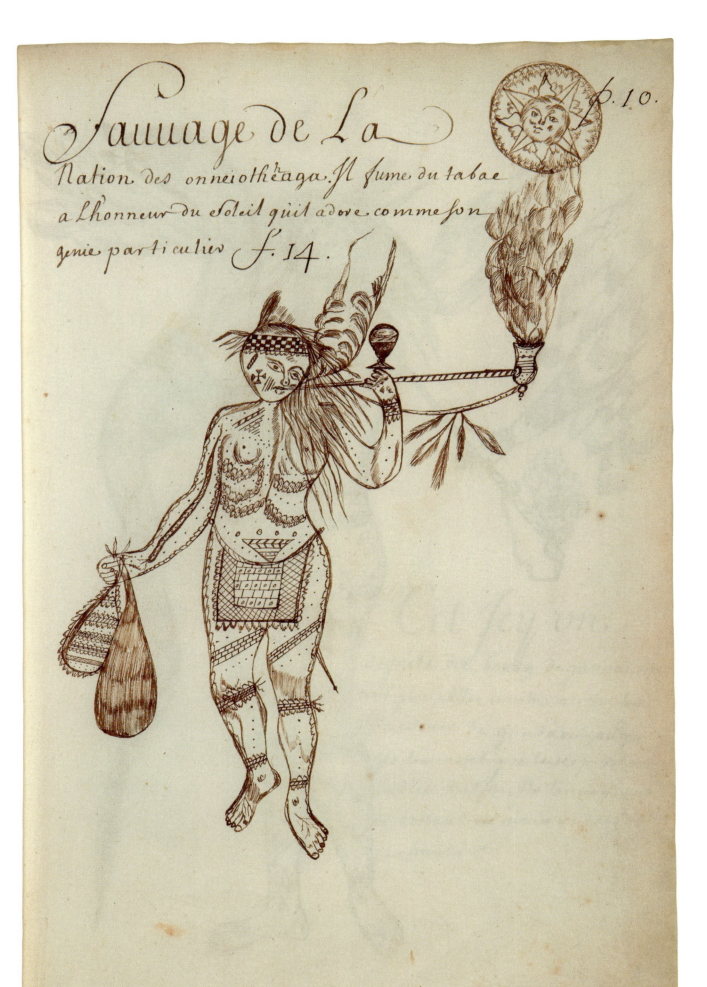

This is a representative sent by the village of Gannachiou-aé
to invite the gentlemen of Gandaouagoahga to a game. They
believe that the snake is the god of fire. They invoke the god
by holding the snake in their hands while dancing and
singing.

C'est Icy un / deputé du bourg de gannachiou = / aré pour
Aller inviter au Jeu les / Messieurs de gandaouagoahga – / Ils
tiennent que le serpent est / le dieu du feu. Ils linvoquent / le
tenant en main en dansant / et chantant

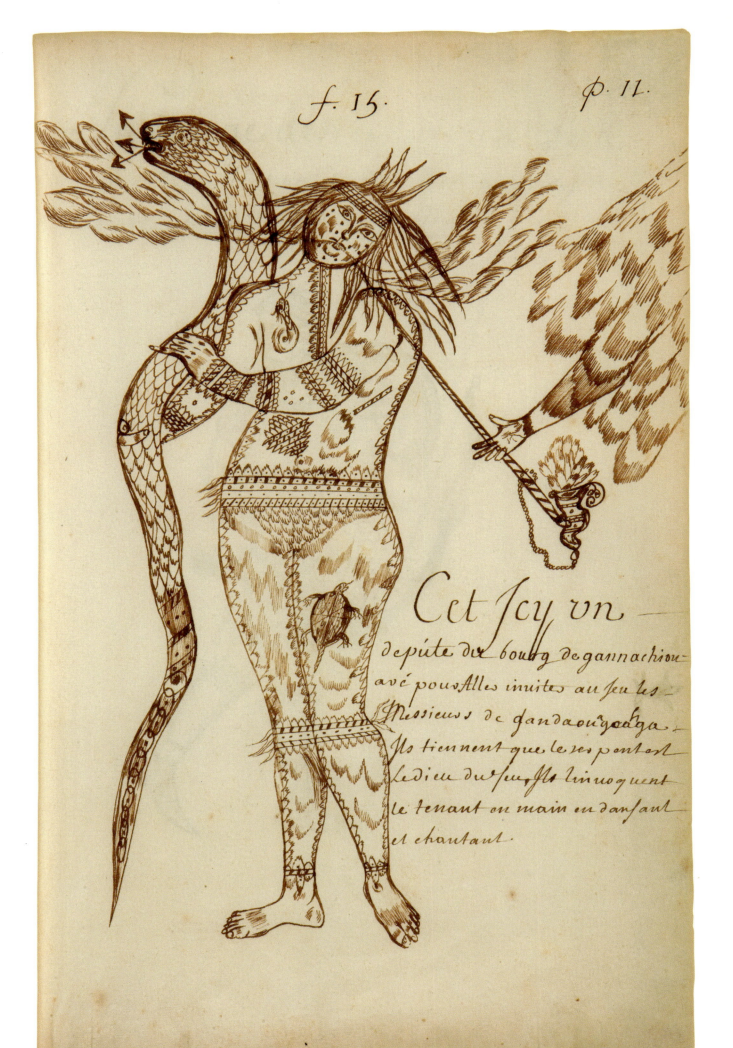

f. 15.

p. 11.

Cet Jcy un ___
depute du bourg degannachiou-
avé pours Alles inuites au jeu les
Messieurs de gandaougoaga.
Ils tiennent que le ser pent est
Ledieu du feu, Ils l'inuoquent
le tenant en main en dansant
et chantant.

Man of the Mascoutensak, which is the Fire Nation. He is equipped with his shield, his spear, and his arrows.

Sauvage des Mascoutensak / qui Est La Nation du feu, Il est armé de son / bouclier, de son dard, et de ses fleches

Sauuage des Mascoutensak
qui Est La Nation du feu, Jl est armé de son
bouclier, de son dard, et de ses fleches
f. 16.

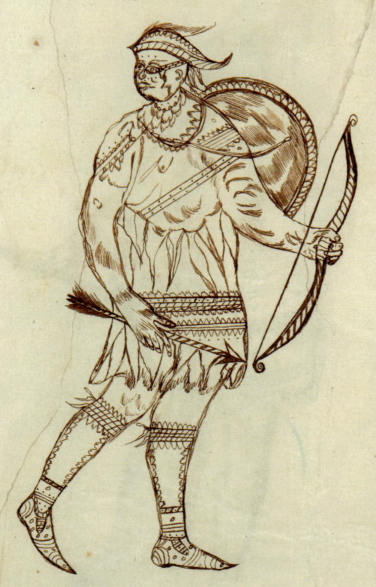

Man of the Amikouek Nation, which supplies many thousands
of beavers to France

Homme de La Nation Des / amikouek dont sa nation fournit
plusiers Milliers / de castors pour la france

homme de La Nation des

amikouek dont sa nations. 17. fournit plusieurs Milliers

de castors pour la france

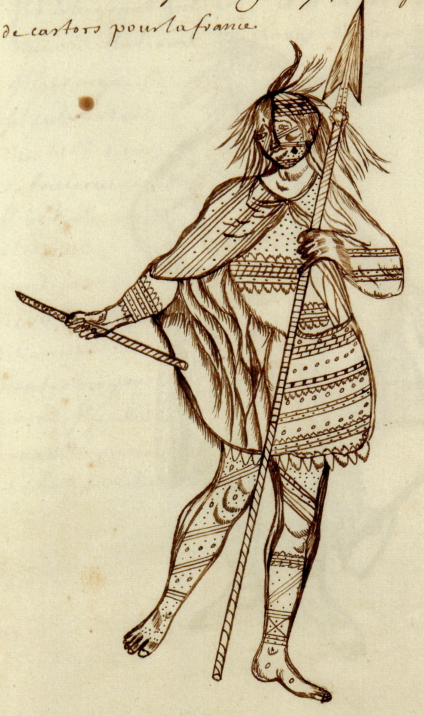

Portrait of a famous one-eyed man. This captain had one eye put out by an arrow. He was a great warrior and was the terror of many surrounding nations. He is addressing his soldiers through a birch bark tube. He urges them to pay attention to him, saying: *Pissintaouik nikanissitik*, Listen to me, my brothers. He was called Iscouakité, which means "burning firebrand."

Portrait d'un Illustre / borgne: ce Capitaine eut un oeil crevé d'un coup de fleche / Il a Esté grand guerrier et la terreur de / diverses Nations du linage de son pais. / Il hasrangue ses / soldats autravers / d'un tube descorse / de bouleau. – / Il les exorte / a lescouter, / leur disant / pissintaouik / Nikanissitik. / escoutes moy mes / freres. Il sapelloit / Iscouakité qui veut / dire le tison allumé [uncertain; end of word hidden by drawing]

Portrait d'un Illustre

borgne: ce Capitaine eut un œil crevé d'un coup de fleche
Il a Esté grand guérier p. 18 et la terreur de
diverse Nationt ou Sauage de son pais.
Il harangue ses
soldats au travers
d'un tube d'escorse
de bouleau.
Il les exhorte
a les escouter,
Leur disant.
pissintaouik
Nikanissitik.
escoutes moy mes
frere. Il s'apelloit
Iscouakité qui veut
dire le tison allumé

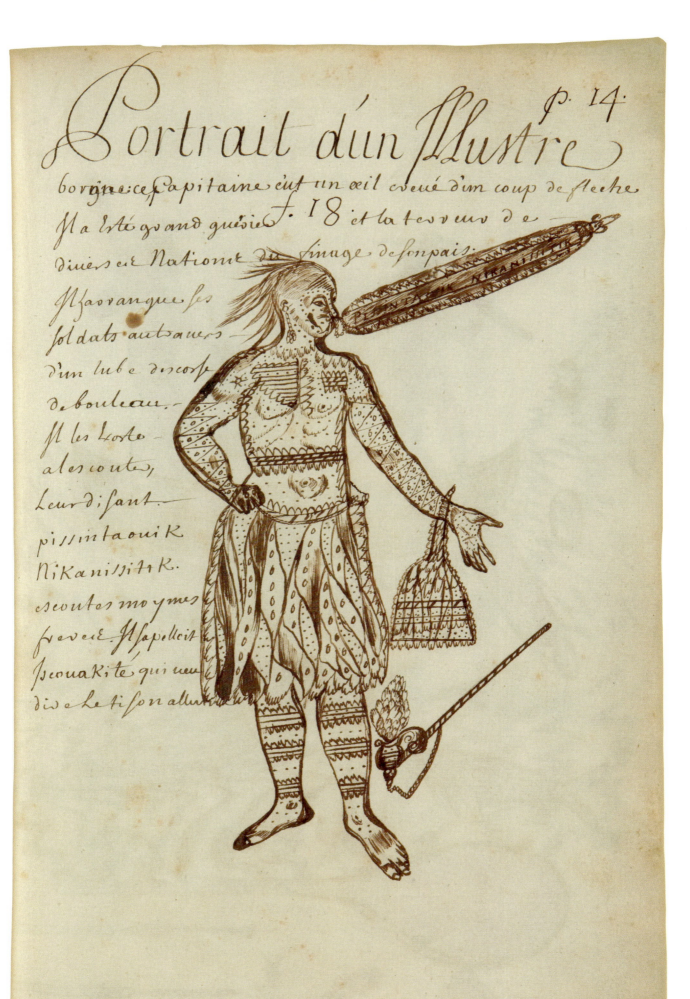

Fishing by the Passinassiouek. I describe this fishing else-
where; it is one of the marvellous things concerning fishing.

Kouabaagan
Atikamek
Bateskoupan
Eskan
Instruments for fishing

La pesche des Sauvages / passinassiouek Je decris cette
pesche ailleur qui est une des / choses tres merveilleusses
touchand La Pesche

kouabaagan
atikamek
Bateskoupan
eskan
Instrumens pour La pesche

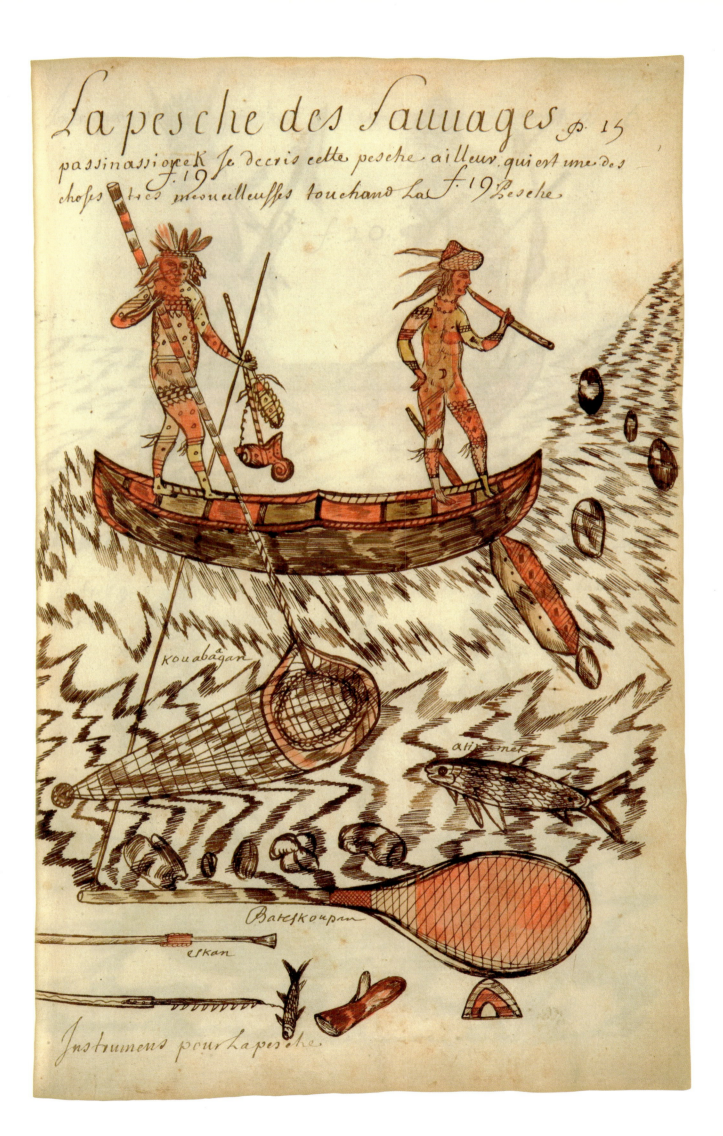

La pesche des Sauuages *p. 15*

passinassiouek Je decris cette pesche aïlleur qui est une des
f:19 choses tres merueilleuses touchand La f:19 Pesche

kouabâgan

atikamek

Bateskoupin

eskan

Instrumens pour La pesche

fig. 20 Americans going to war on the water

fig. 21 Other warriors going full sail on a boat made
 of moose hide

fig. 20 Ameriquains qui vont a la guerre sur leau

fig. 21 Autres guerriers qui vont a plaine voille sur
 un batteau / fait de peau de le lan

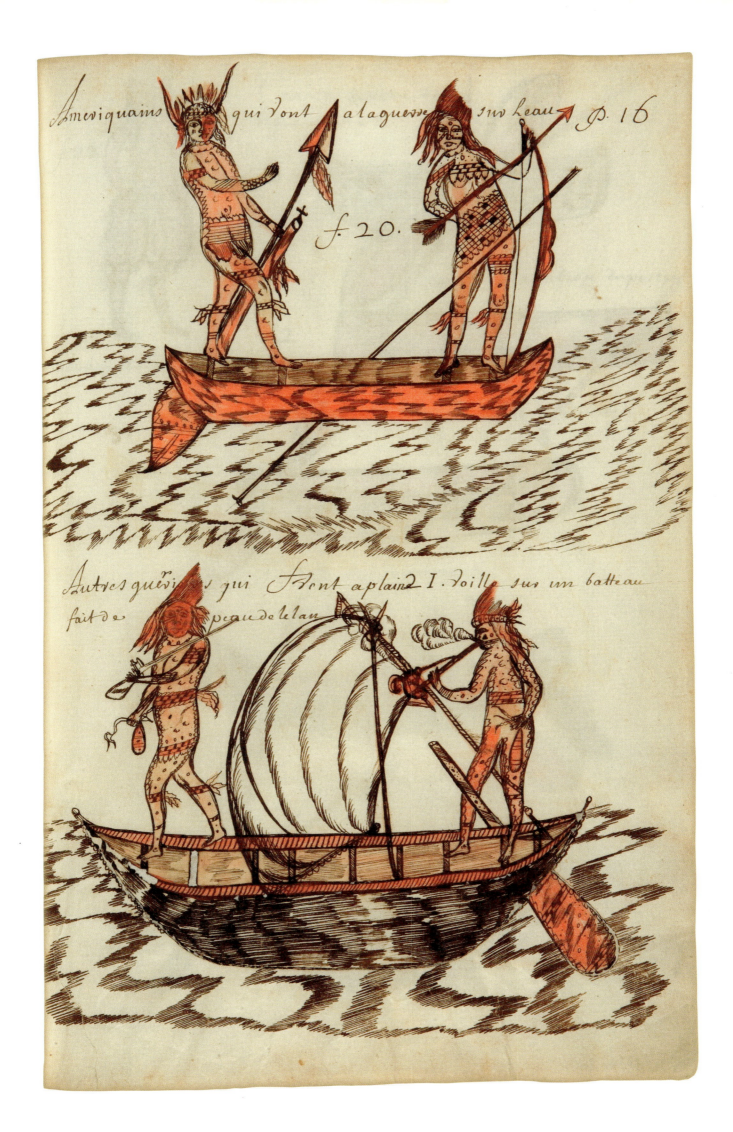

Ameriquains qui vont a la guerre sur l'eau p. 16

f. 20.

Autres guerriers qui front a plaine 1. voille sur un batteau
fait de peau de l'elan

Man of the Esquimaux Nation
1 Canoe made of sea tiger skin
2 Porcupine Nation canoe
3 Magoauchirinouek canoe
4 Amicouek canoe
5 Algonquin canoe

Sauvage de la nation des eschimaux
1 Caneau de peau de / tigre marin
2 canot de lanation du porepie
3 conot des magoauchirinouek
4 Canot des amicouek
5 canot des algonkins

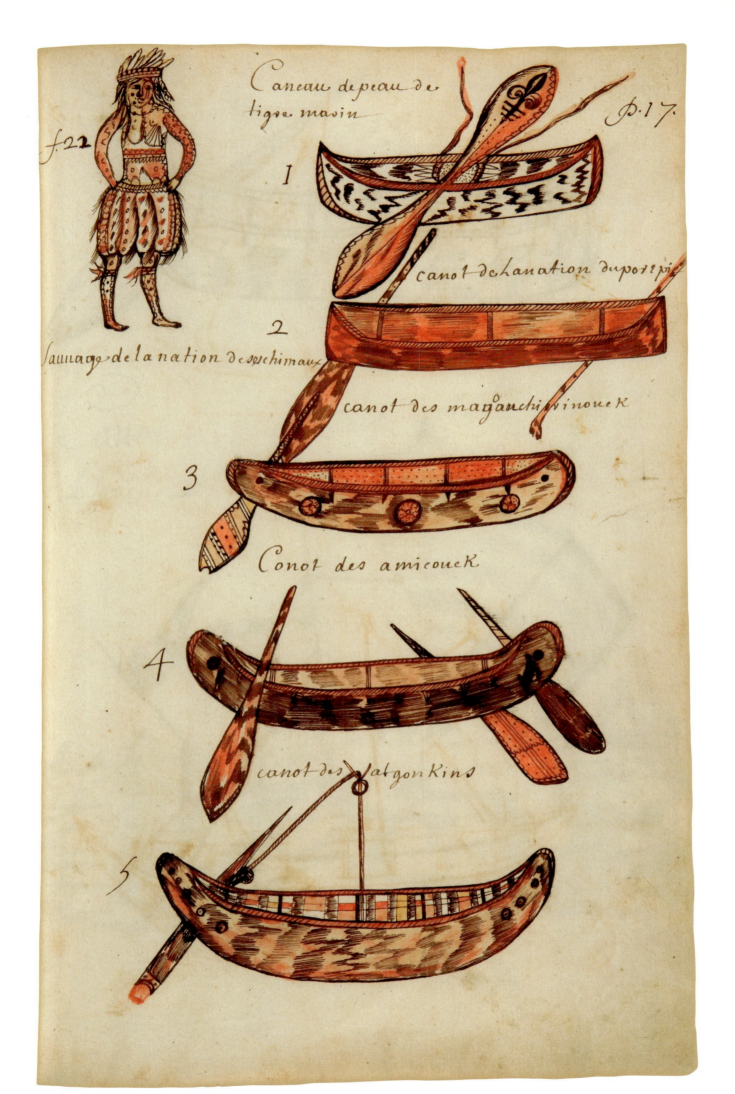

f.22

Caneau de peau de
tigre marin

P. 17.

1

canot de la nation du por: pie

2

Sauuage de la nation des eschimaux

canot des magauchissinouck

3

Conot des amicouck

4

canot des algonkins

5

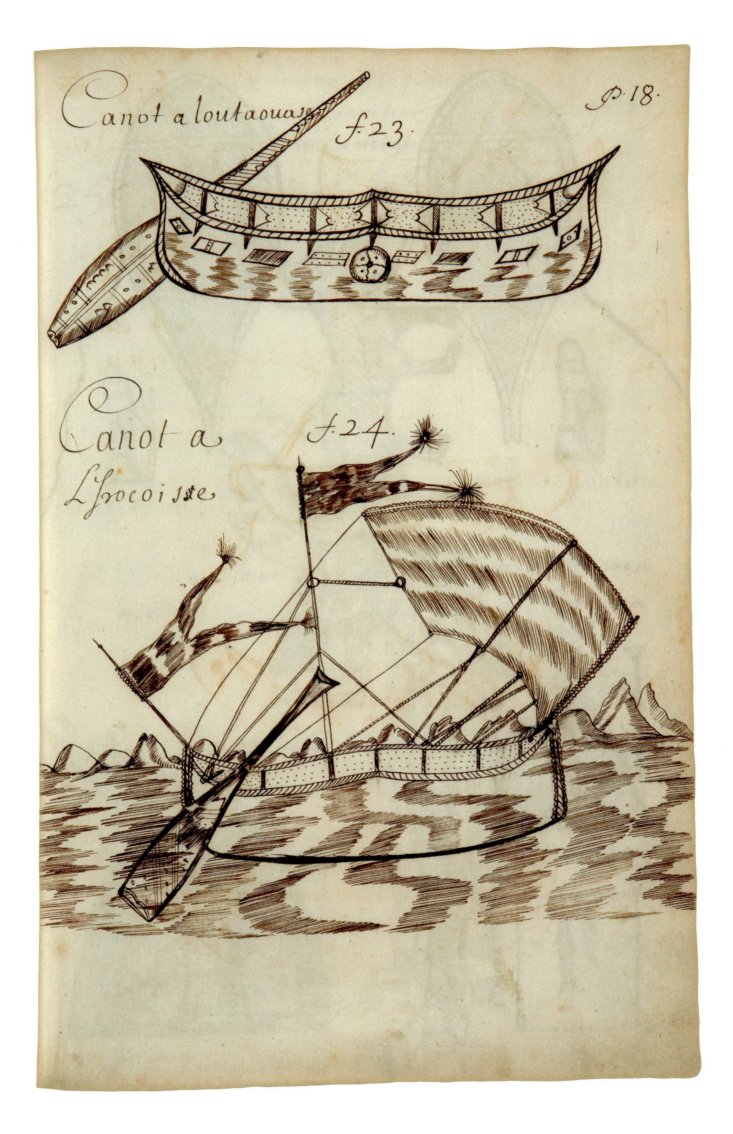

Canot a loutaouase *f.23.*

P.18.

Canot a
L'Jrocoisse *f.24.*

fig. 25 Achimac, or snowshoes, for walking on snow
Makikin shoe
fig. 26 Dog dragging a fish called *namé* or sturgeon
fig. 27 [middle right] Fisherman's cabin
[lower left] Algonquin bark cabin
[lower right] Fish being frozen

fig. 25 achimac ou raquettes / pour marcher / sur la neige
makikin soulier makikin soulier
fig. 26 chien qui traine un poisson quon / appelle namé ou
Eturgeon
fig. 27 [middle right] cabane dun pescheur
[lower left] cabane descorse a lalgonchine
[lower right] Poissons quon fait geler

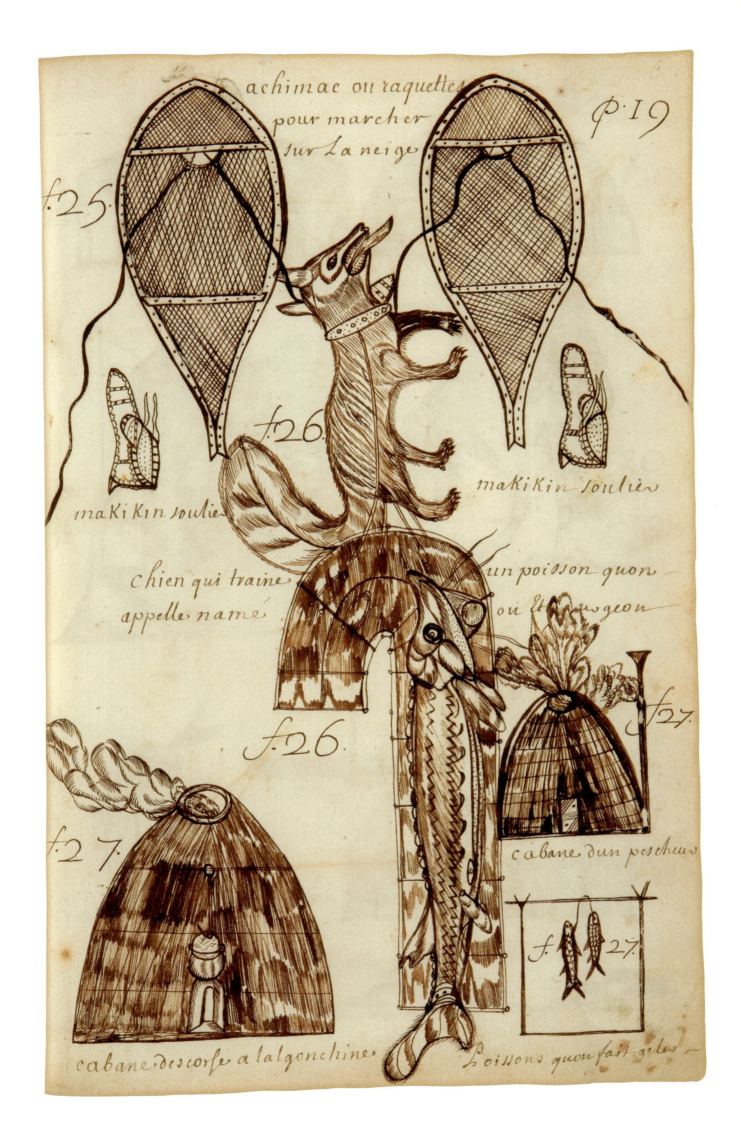

achimae ou raquettes
pour marcher
sur la neige

p. 19

f. 25.

f. 26.

makikin soulie

makikin soulie

chien qui traine
appelle namé

un poisson quon
ou Esturgeon

f. 26.

f. 27.

cabane dun pescheu

f. 27.

f. 27.

cabane descorse a l'algonchine

poissons quon fait griler

fig. 28 [upper left] Huron cabin

fig. 29 [upper right] Kilistinon cabin made of hide

fig. 30 [middle left] Iroquois cabin with two heads of
enemies that they have killed

[middle right] Iroquois who has killed two enemies

fig. 31 Two kinds of wood to make fire by rubbing them
one against the other

fig. 32 [lower left] Man returning from the hunt carrying
beaver pelts

[lower right] Tissaraouata cabin

fig. 28 [upper left] Cabane a lahuronne

fig. 29 [upper right] Cabane a la Kilistinonne elle est faite /
de peau

fig. 30 [middle left] Cabane a lhyroquoisse ou / lon voit
deux testes des ennemis / quils ont tue

[middle right] Iroquois qui a tué deux / Ennemis

fig. 31 deux sortes de bois pour / tirer du feu le frotant / lun
contre lautre

fig. 32 [lower left] sauvage qui revien / de la chasse / charge /
de paux de castors

[lower right] Cabane a la Tissaraouata

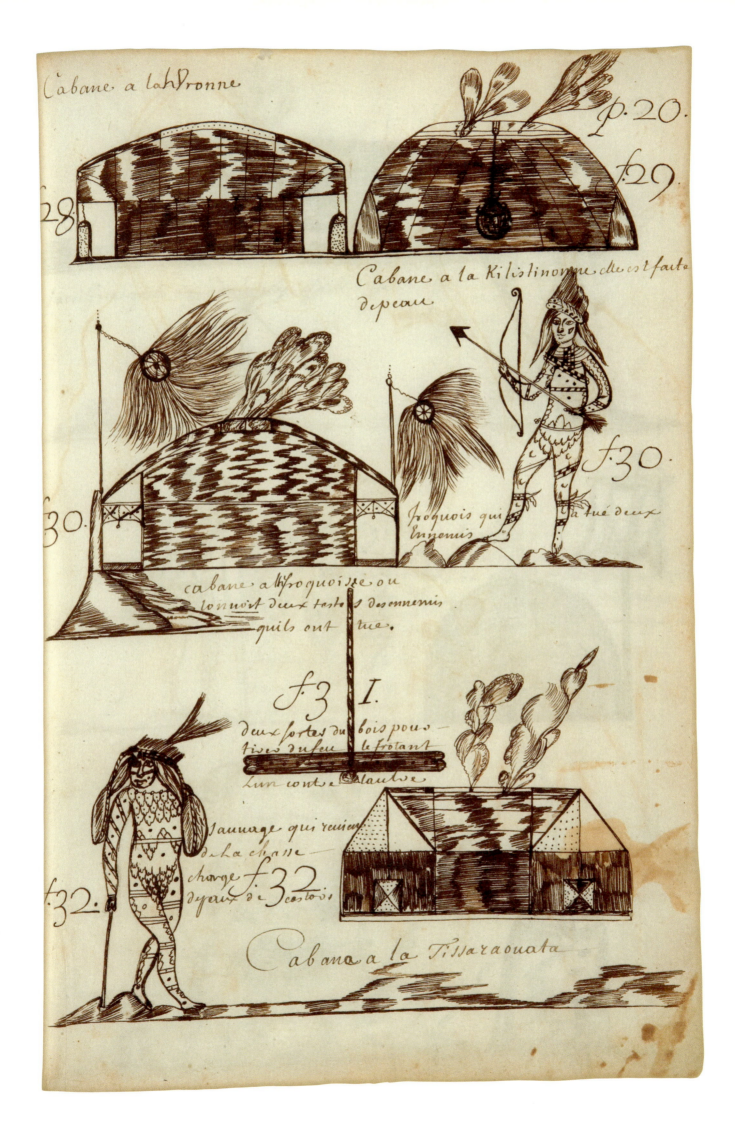

Cabane. a lahvronne

p. 20.

f 29

28

Cabane a la Kilistinonne elle est faite
de peau

f 30.

f 30.

Iroquois qui a tué deux
Ennemis

cabane a Miroquoisse ou
lonnoit deux testes desennemis
quils ont tue.

f 3 I.
deux sortes du bois pour —
tives du feu le frotant
lun contre lautre

sauuage qui reuien
de la chasse
charge f 32
depeau de 3 castors

f 32.

Cabana a la Tissaraouata

fig. 33 Sacrifice that this man is making to the moon

fig. 34 Cabin made of skin, where one sees a skin offered
or sacrificed to Aguakoqué, who is the war god of the
Americans

Drawing of the head of the earth god that this man is going
to see

fig. 35 Portrait of a child in the cradle board

fig. 36 Hammock for putting children to sleep

fig. 37 Mortar for grinding Indian corn

fig. 33 Sacriffice que ce sauvage fait a la Lune

fig. 34 Cabane de peau / ou l'on voit une / peau offerte ou
sacriffiee a aguakoqué / qui est le dieu de la guere / des
ameriquains

figure de la teste du / dieu de la terre que / ce sauvage va voir

fig. 35 Portrait d'un Enfant dans / le bresseau

fig. 36 Branle pour endormir les Enfans

fig. 37 Mortier a piler le bled Dinde

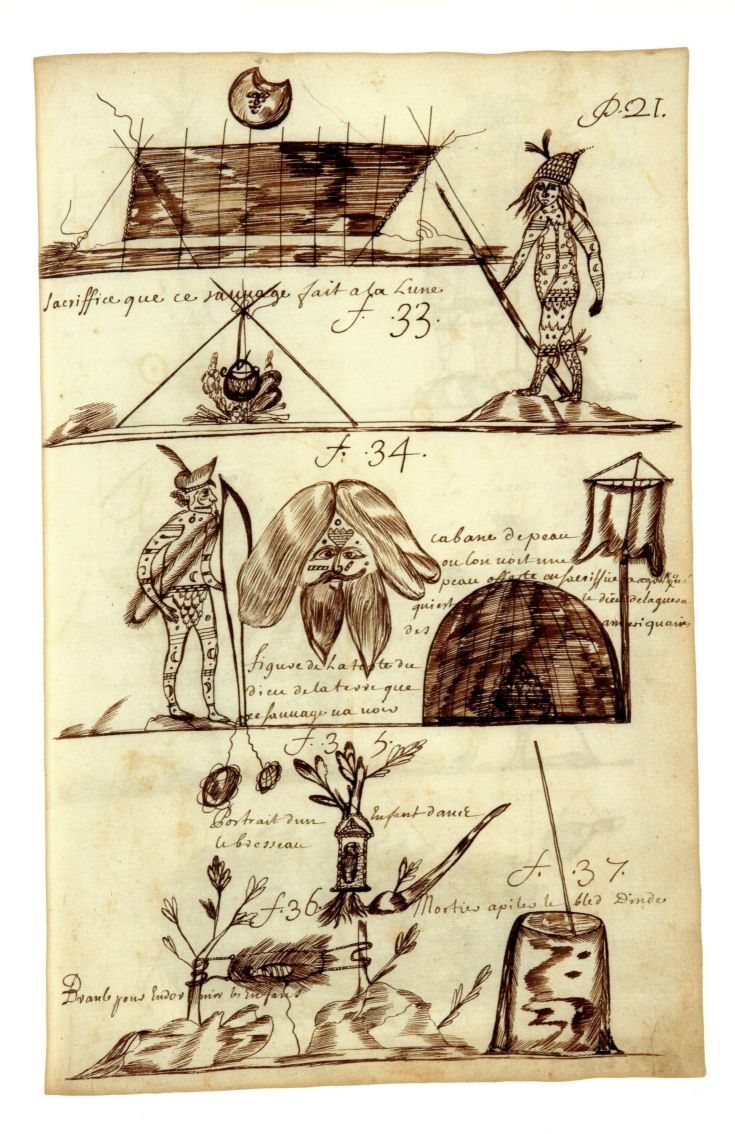

p. 21.

Sacrifice que ce sauvage fait a la Lune
f. 33.

f. 34.

cabane de peau
ou l'on voit une
peau offerte en sacrifice
qui est
des
le dieu de la guerre
americains

figure de la teste du
dieu de la terre que
ce sauvage na noir

f. 35.

Portrait d'un
Enfant dans
le berceau

f. 36.

f. 37.

Mortier a piler le bled d'inde

Branle pour endormir les infans

PL. XXII

fig. 38 [upper left] Drawing of a woman captured in war,
whose nails were all pulled out with teeth. I saw her
burned in the village of Toniotogéhaga for six [ten?] hours
during which she was slowly flayed. She was eaten partly
by the Iroquois and by their dogs.
[top right] Volunteer torturer, who willingly offers himself
to burn prisoners of war and make them suffer.
fig. 39 Healers who wear masks as they are seen here in
order to, by singing and dancing around a sick person that
I represent here at the bottom of this page lying naked on
the skin of a wild beast. The only medicine of these healers
consists of dancing or pouring water on the sick woman
to frighten the devil that makes her sick.
Emicouan

fig. 38 [upper left] figure dune femme prise / a la guerre a
qui on avoit arraché / avec les dans toutes les ongles / Je lay
veue brulé dans le / bour de toniotogéhaga / durant six
[dix?] heures / pendant lesquelles / on lescorcha a petit feu
elle / fut mangée en partie par les / Iroquois et par leurs /
chiens
[top right] Boureau / volontaire /qui soffre volontier / pour
bruler et / faire souffrir / les prisonniers de guerre
fig. 39 Medecins qui se masquent de la facon quon voit Icy /
pour En chantan et dansant au tour d'un malade / que je
represante au bas de cette page couché tout / nu sur une
peau de beste sauvage / toute la drogue de ces medecin
consiste / a danser ou chanter ou verser de lau sur la
malade / pour Epouvanter le diable qui la fait malade
emicouan

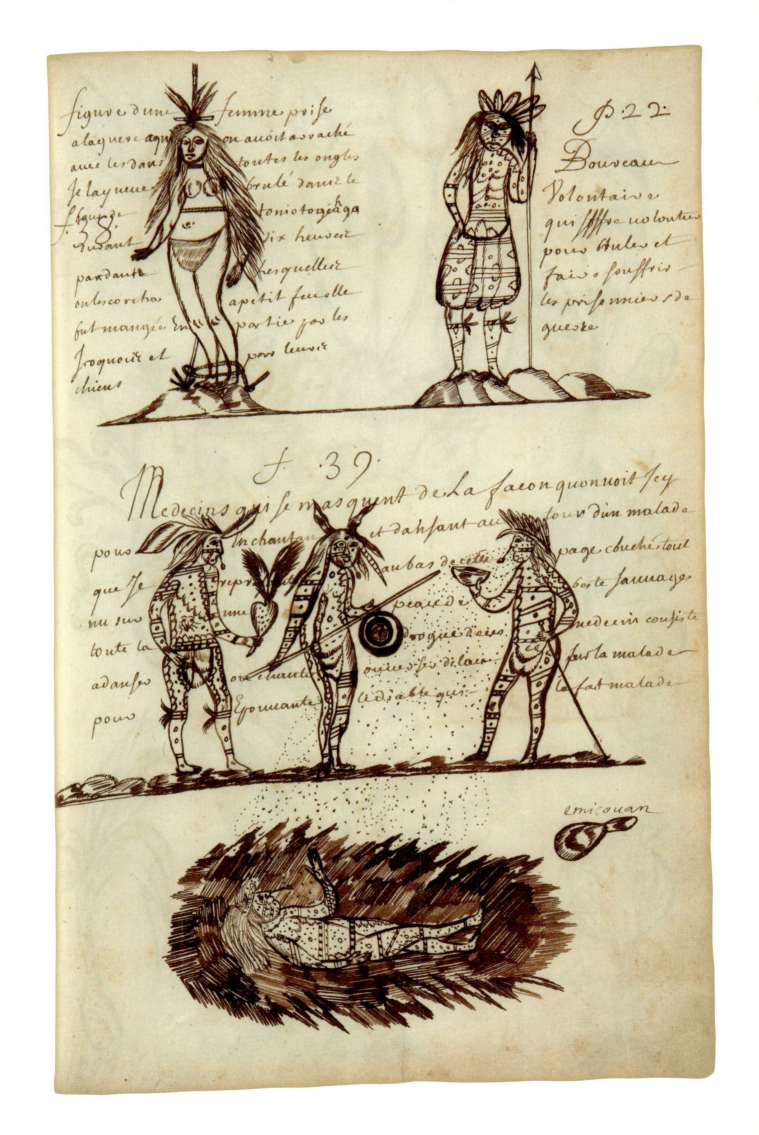

figure d'une femme prise
a laquelle aqu... on auoit arraché
auec les dents toutes les ongles
je la y neue... brulé dans le
f.38 toniotongéaga
pendant dix heures
pardante lesquelles
on lescorcha apetit feuille
fut mangée en partie par les
Jroquois et pour leur...
chiens

p.22

Douceau
Volontaire
qui s'offre volontier
pour bruler et
faire souffrir
les prisonniers de
guerre

f.39

Medecins qui se masquent de la facon qu'on voit jcy ... tour d'un malade
pous en chantant et dahsant au ... page couché tout
que je ... au bas de cette... coste sauuages
nu sur ... peau de...
toute la medecin consiste
adansé ... ou eftant pour la malade
pour Epouuanté le diable qui... le fait malade

emicouan

1 Miner
2 Ounonnata, which grows roots like truffles
3 Three-colour herb
4 Noli me tangere (touch-me-not)
5 Lymphata
6 Wild garlic
7 Cotonaria, which bears honey, cotton, hemp, a beautiful
 flower, and asparagus
8 White hellebore

1 miner
2 ounonnata / qui jette des / racines / comme / les trufes
3 herbe a trois couleurs
4 noli me tangere
5 Limphata
6 ail sauvage
7 Cotonaria qui porte du miel / du couton du chanvre / une
 belle fleur et / des asperges
8 ehlebore blanc

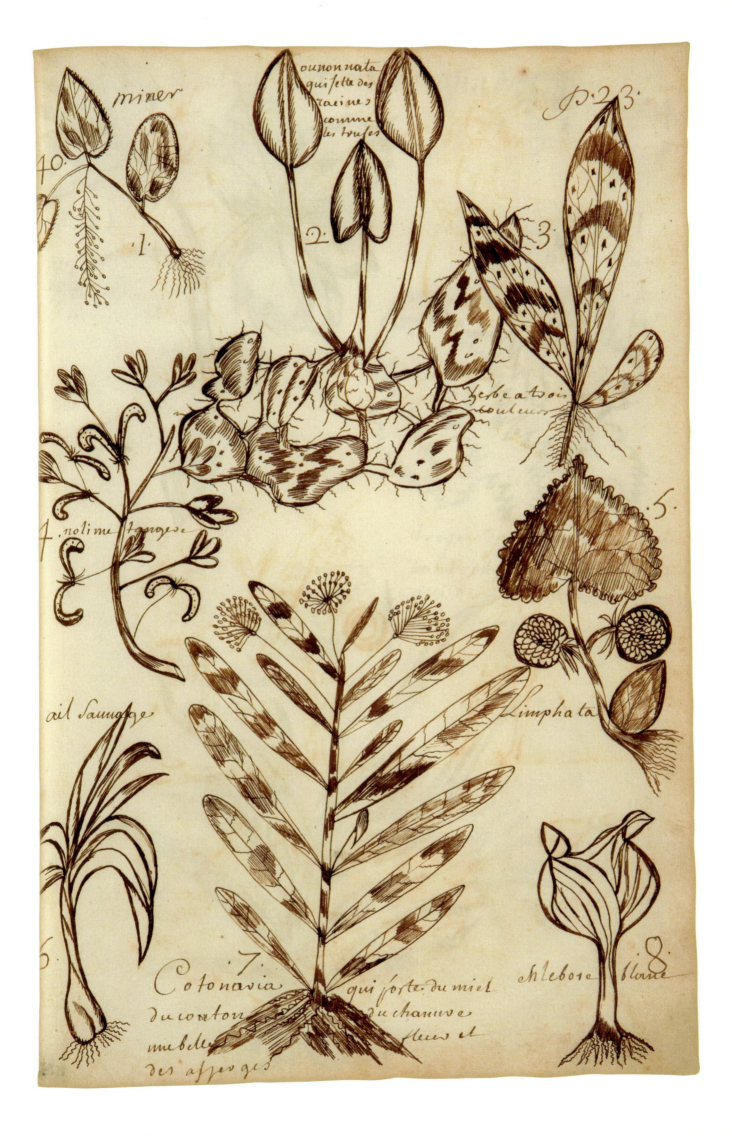

1 *Tripe de roche*, or moss, from which a bouillon is made
 which becomes like a very insipid glue
2 Mentamin, or Indian corn
3 [upper left] *Vitis indica et canadensis*

1 tripe de roche ou mousse / dont on fait quelque boulion /
 qui devient comme de la cole / tres Incipide
2 Mentamin ou / bled dInde
3 [upper left] victis Indica et canadencis

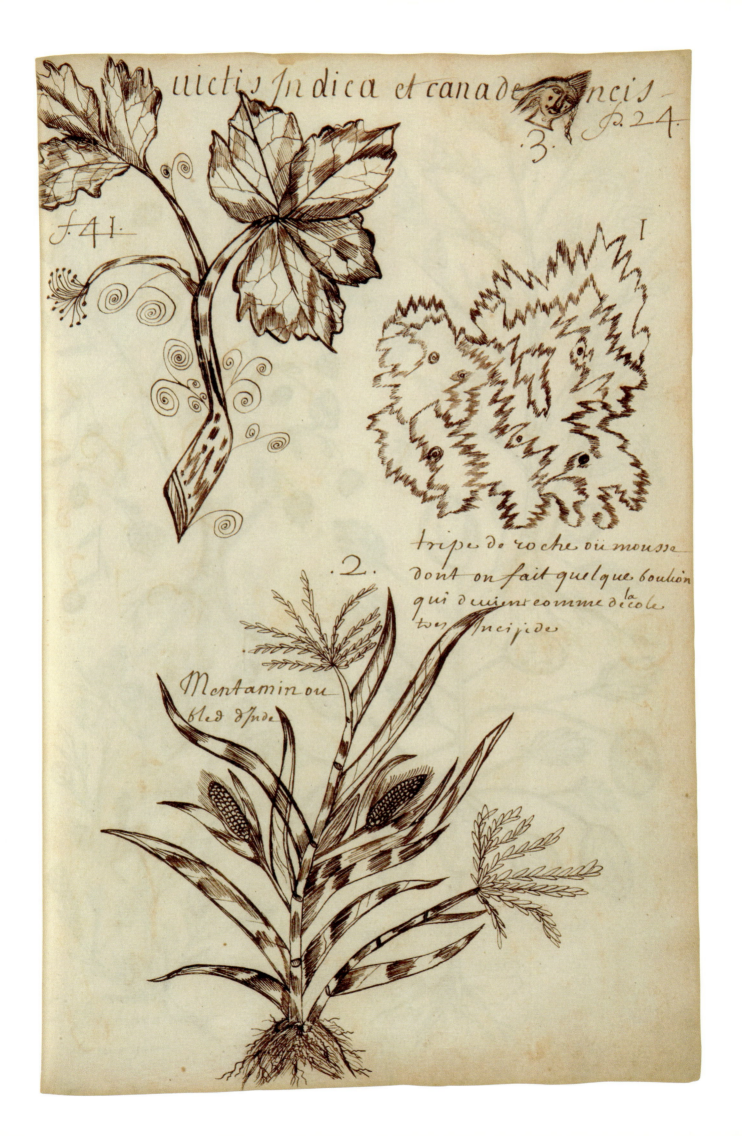

uictis Indica et canade ncis

·3·

p.24.

f.41.

I

tripe de roche oü mousse
dont on fait quelque boution
qui devient comme décole
tres incipide

·2·

Mentamin ou
bled d'Inde

PL. XXV, FIG. 42

Fruit of the pimina
1 Wild cherries
2 Small orange tree of Virginia
3 Plant which bears lemons

fruit du Piminae
1 Serises sauvages
2 Petit oranger / de la virginie
3 Plante qui porte des Citrons

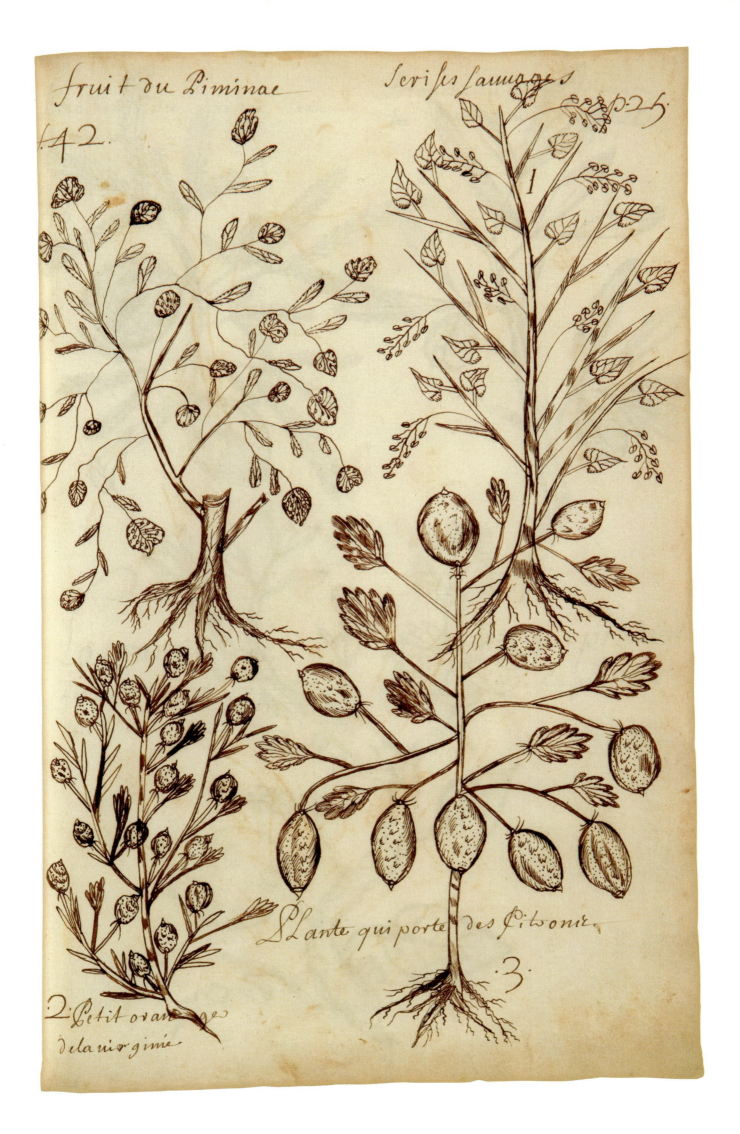

fruit du Piminac — Serises sauuages p.25.

442.

1

Plante qui porte des Pitsonie.

3

2 Petit oran ge
de la virginie

Branch of the white cedar of Canada

1 Branch of the red cedar in Virginia

2 The granadilla, which produces the instruments of the Passion
of Our Lord

Branche du cedre blanc / du canada

1 Branche du cedre Rouge / En virginie

2 La granadille qui produit / Les Instrumens de la passion /
de N.S.J.c.

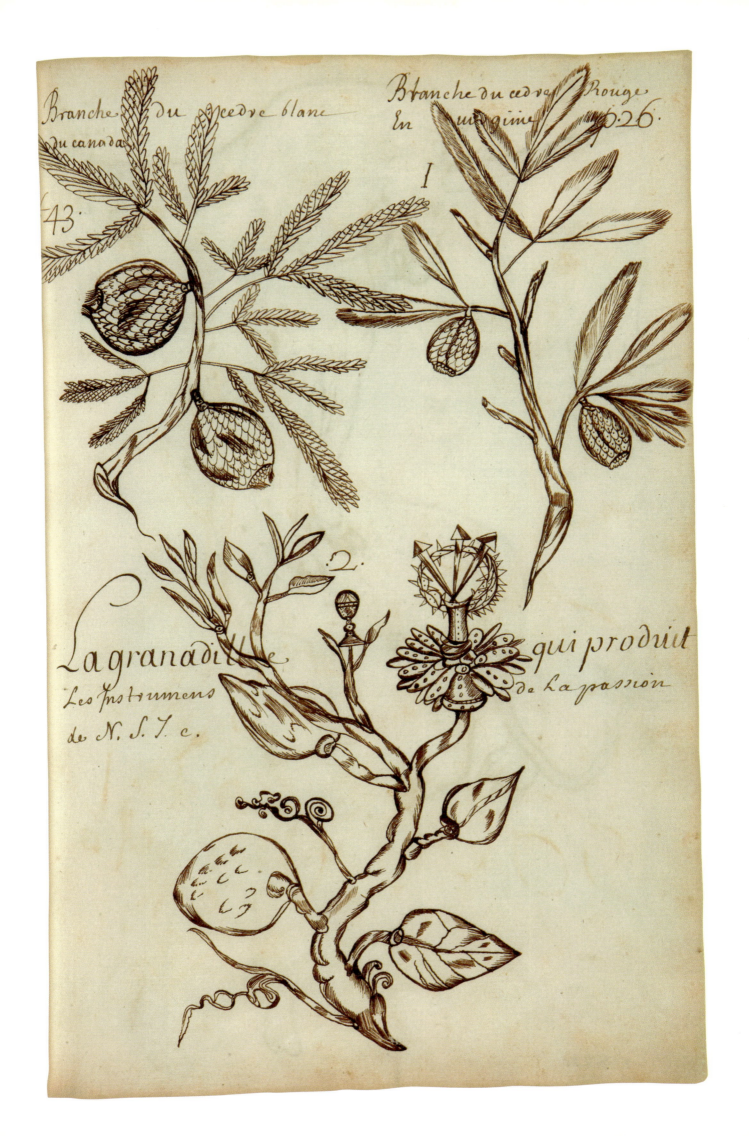

Branche du Cedre blanc
du canada

Branche du cedre Rouge
En virginie ♭26.

43.

I

2.

La granadille

qui produit

Les Instrumens
de N. S. J. C.

de La passion

PL. XXVII, FIG. 44

[A and B] Unicorn of the Red Sea, where some are seen.
Some have been taken to Medina and to Mecca, where the
caravans going there have seen some. [Drawing on the verso
page of the original manuscript.]
Drawing of a tiger

[A and B] Licorne de La / mer rouge ou l'on En voit /
quelques unes on en a porté / ou conduit a medine, et ala
meque / ou les caravanes qui y vont En / ont veu
1 figure d'un tigre

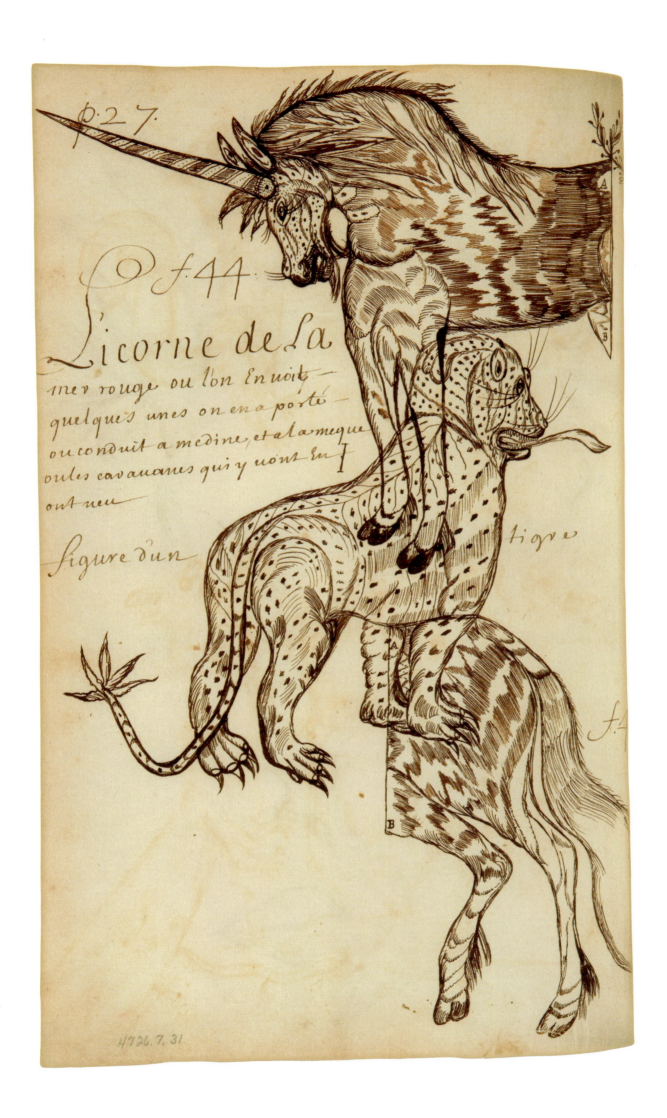

p.27.

p.f.44.

L'icorne de La
mer rouge ou l'on En voit
quelques unes on en a porté
ou conduit a medine, et a la meque
oules cavauanes qui y vont En
ont veu

figure d'un tigre

1 Swiss squirrel [chipmunk], called *oua oningout* in the country
2 Featherless flying squirrel named *anascantaoue*
3 Common yellow squirrel
4 Black-haired squirrel
5 Virginia rat
6 Rat common in the whole country
7 Sharp-nosed rat

1 ecureul suisse nomme dans le pais / oua ouingout
2 Ecureul volant sans pleume nomme / anascantaoue
3 Ecureul commun / jaune
4 Ecureul a la / Robe noire
5 Rat de La Virginie
6 Rat comun dans tout Le pais
7 Rat au museau Egu

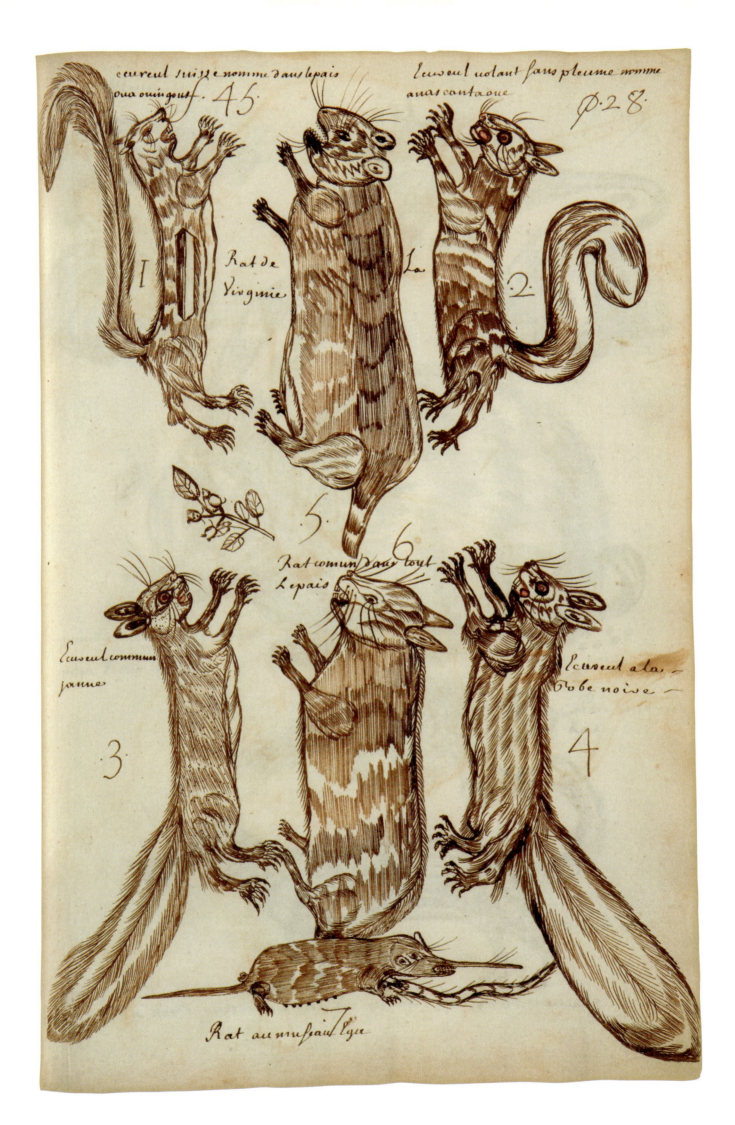

ecureul suisse nomme dans lepais
oua ouingouf. 45.

Ecureul volant fans pleume nomme
anas cantaoue

φ.28.

I

Rat de
Virginie

La

2.

5.

6.

Rat comun dans tout
Lepais

Ecureul commun
jaune

3.

Ecureul a la
robe noire

4.

Rat au museau l'igu

PL. XXIX, FIG. 46

The whistler
1 The manitou
2 [left and right] Common hares
3 Large hare, as big as a milk calf
4 Porcupine or kak
5 The stinking animal because it smells very bad

Le siffleur
1 Le manitou
2 [left and right] Lievres communes
3 grand Lievre aussy grand / qu'un Veau de laid
4 Porc epie ou / kak
5 La beste puante a cause quelle sent fort mauvais

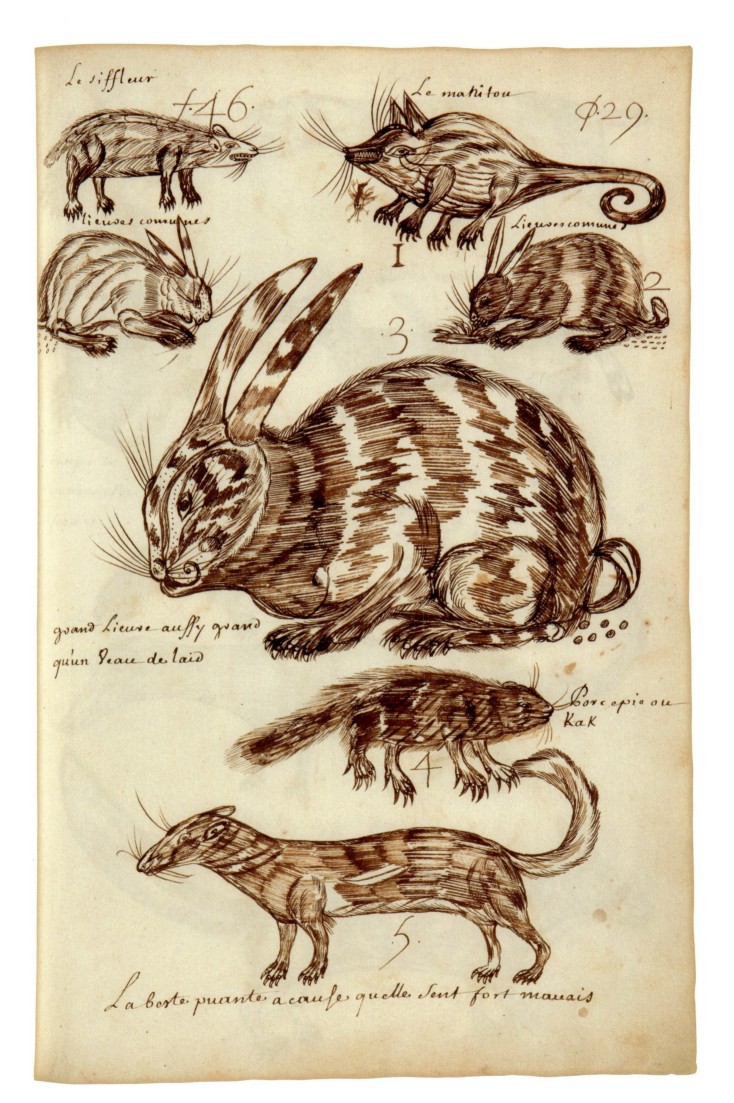

Le siffleur

f.46.

Le matitou

p.29.

Lieures comunes

I

Lieures comunes

2

3

grand Lieure aussy grand
qu'un Veau de lait

Porcepic ou
Kak

4

La beste puante a cause quelle Sent fort mauais

5.

Mole of New France
1 Common weasel
2 Another kind of weasel
3 Ermine
4 Ground ferret
5 Zibeline marten

taupe de / la nouvelle / france
1 Belette commune
2 autre sorte de belette
3 hermine
4 furet de terre
5 martre cybelline

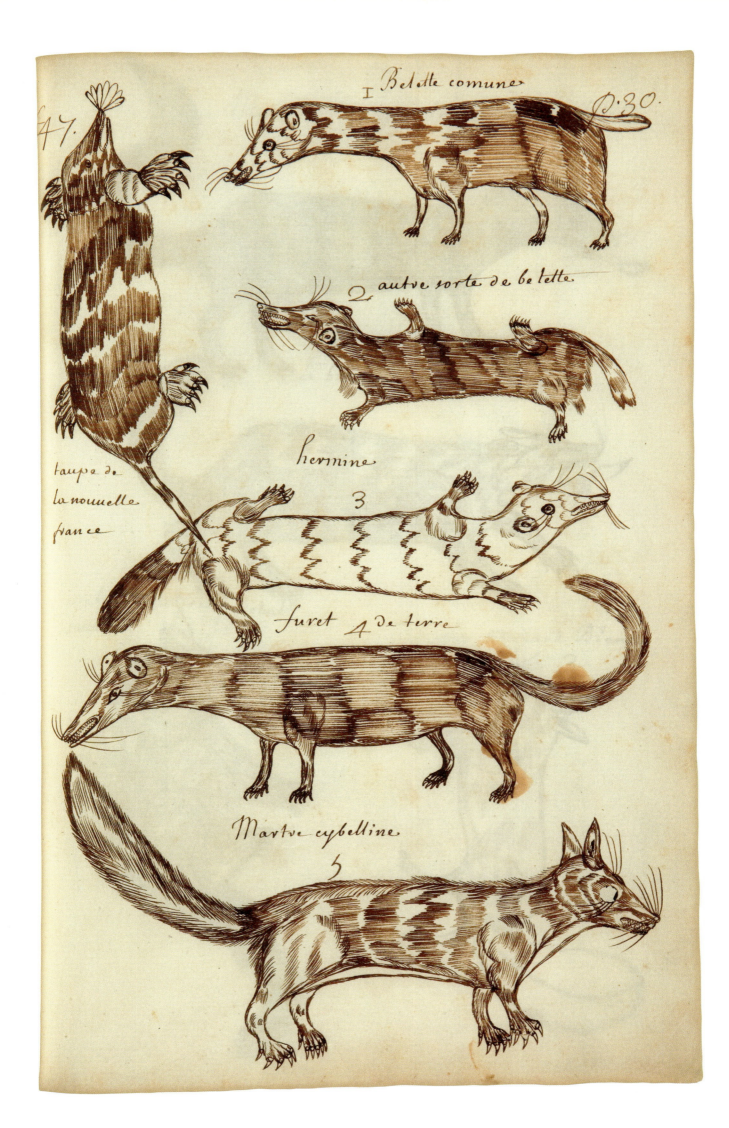

47.

1 Belette comune

P. 30.

taupe de
la nouvelle
france

2 autre sorte de belette

hermine
3

furet 4 de terre

Martre cybelline
5

Manitou or *nigani*, devil's child
1 The badger
2 Esseban, or *attiron*, or wild cat
3 The white fox

Manitou ou nigani Enfant du /diable
1 Le blereau
2 esseban ou attiron ou chat / sauvage
3 Le Renard Blanc

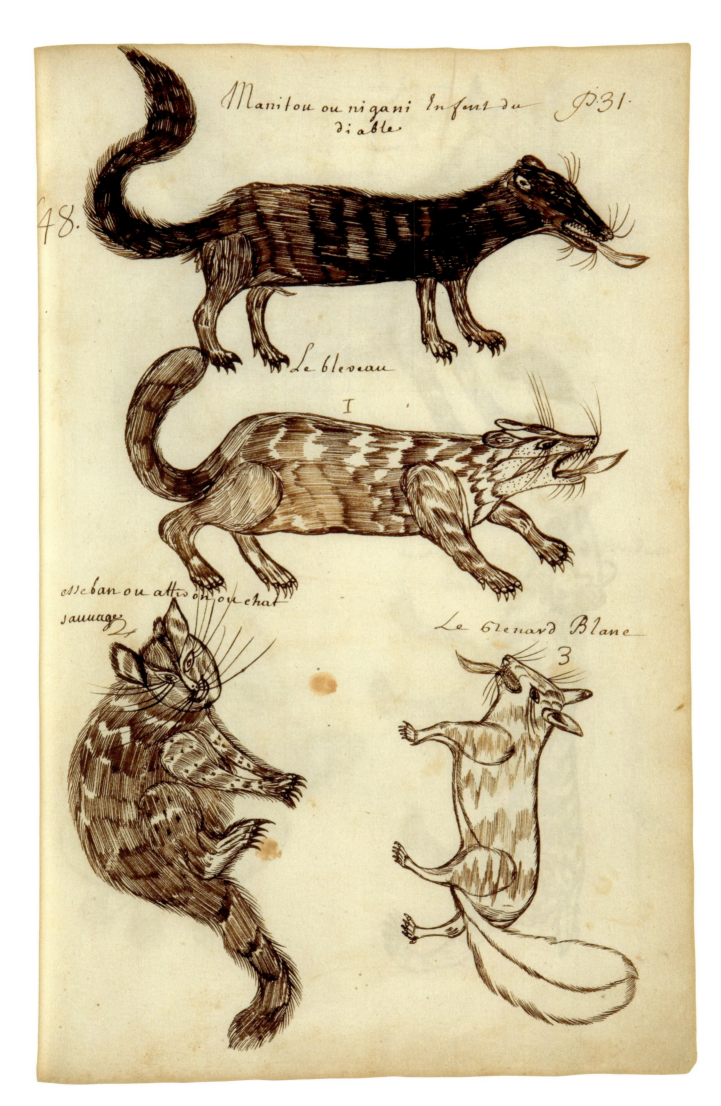

Manitou ou nigani Infant du P.31.
diable

48.

Le bleveau

I

esseban ou attison ou chat
sauvage 2

Le Renard Blanc
3

Common yellow fox, sometimes grey or black, of the
 same form
1 Wolf common in New France
2 Lynx, whose skin sells for six *louis d'or*

Renard comun jaune / et d'autre couleur grise et / d'autre
 noir sous la / mesme figure
1 Loup comun dans la / nouvelle france
2 Loup servie / dont La peau se vend / six Louis dore

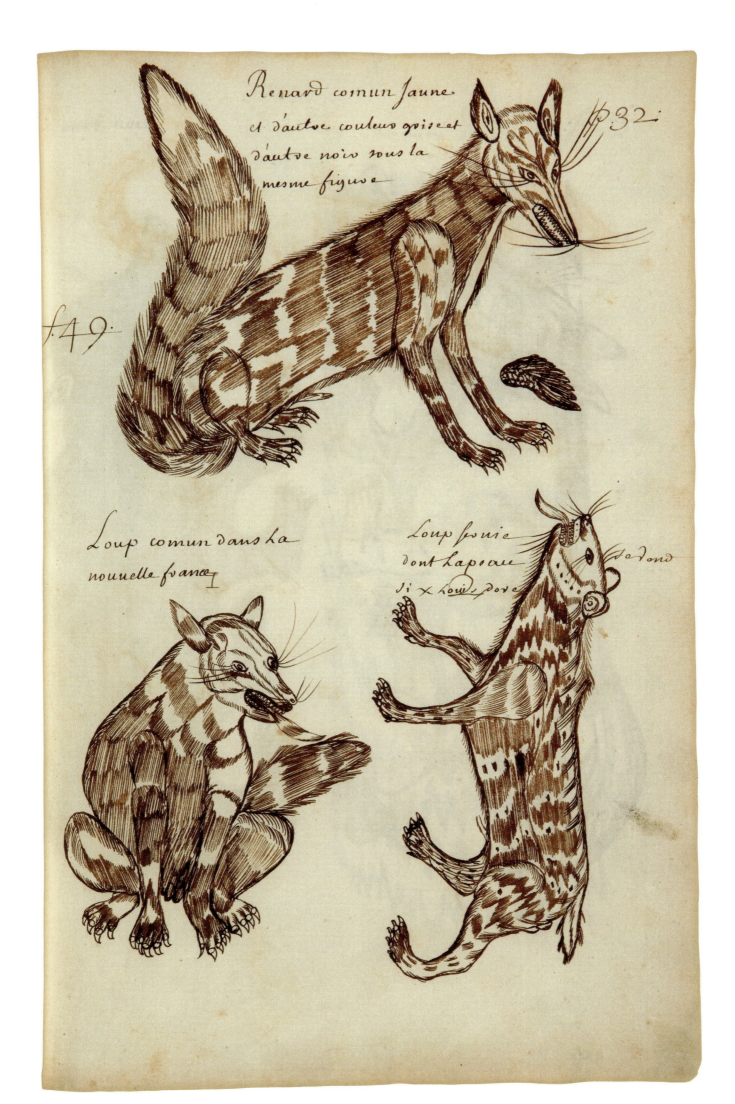

Renard comun jaune
et d'autre couleur gris et
d'autre noir sous la
mesme figure

p. 32.

f. 49.

Loup comun dans la
nouuelle france

Loup jouie
dont la peau
si x louis dore

de dont

Black bear
White bear

ours noir
ours blanc

ours noir ours blanc

f. 50.

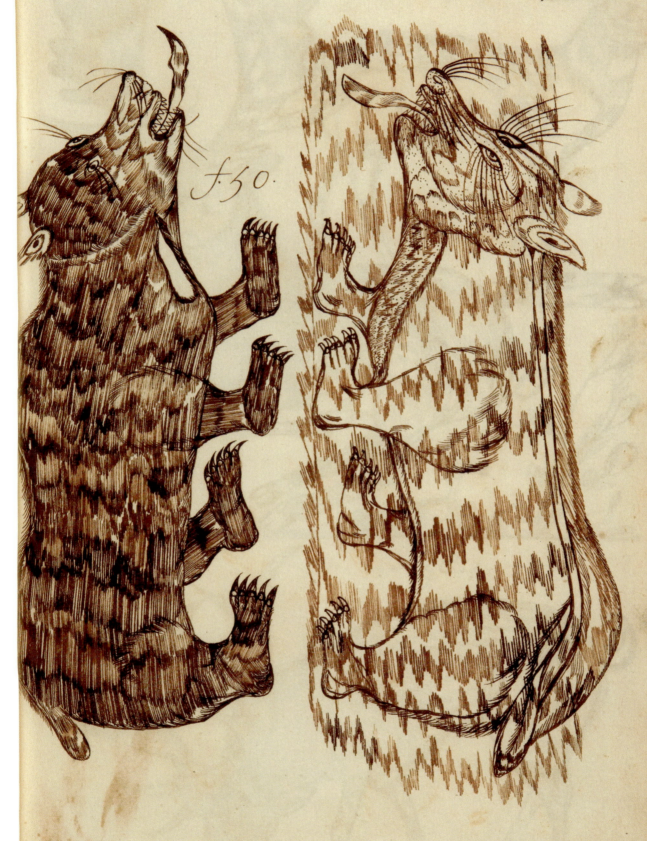

[1] Seenonton
2 Attieirini, or caribou
3 Attic, or stag

[1] seenonton
2 attieirini ou / caribou
3 attic ou Cerf

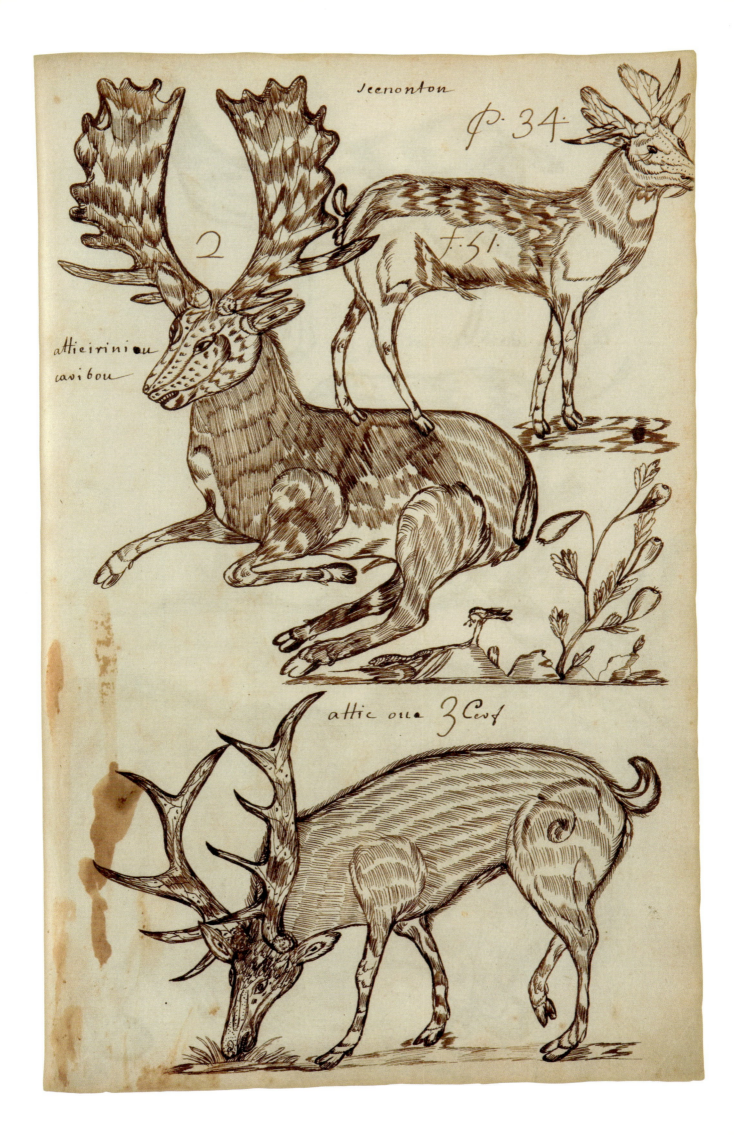

Scenonton

p. 34.

2

f. 51.

attieirini ou
caribou

attic ou a 3 Cerf

1 Doe
2 Fawn
3 Pichichiou

1 Biche
2 fan de Biche
3 Pichichiou

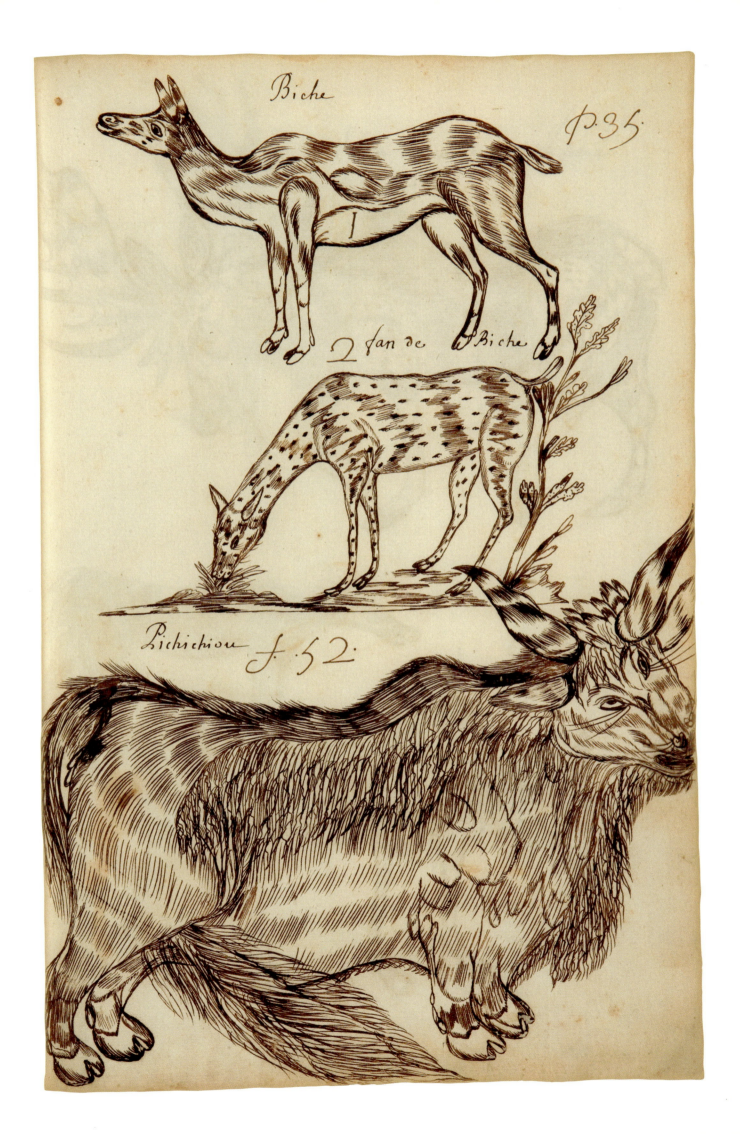

Biche

p. 35.

2 fan de Biche

Pichichiou f. 52.

Elk, or caribou; *alces*, according to the Latins
1, 2 Female elk with her three young from the same litter

Elan ou caribou alces selon / les Latins
1, 2 femelle de leslan / avec sest trois petis / d'une seule ventrée

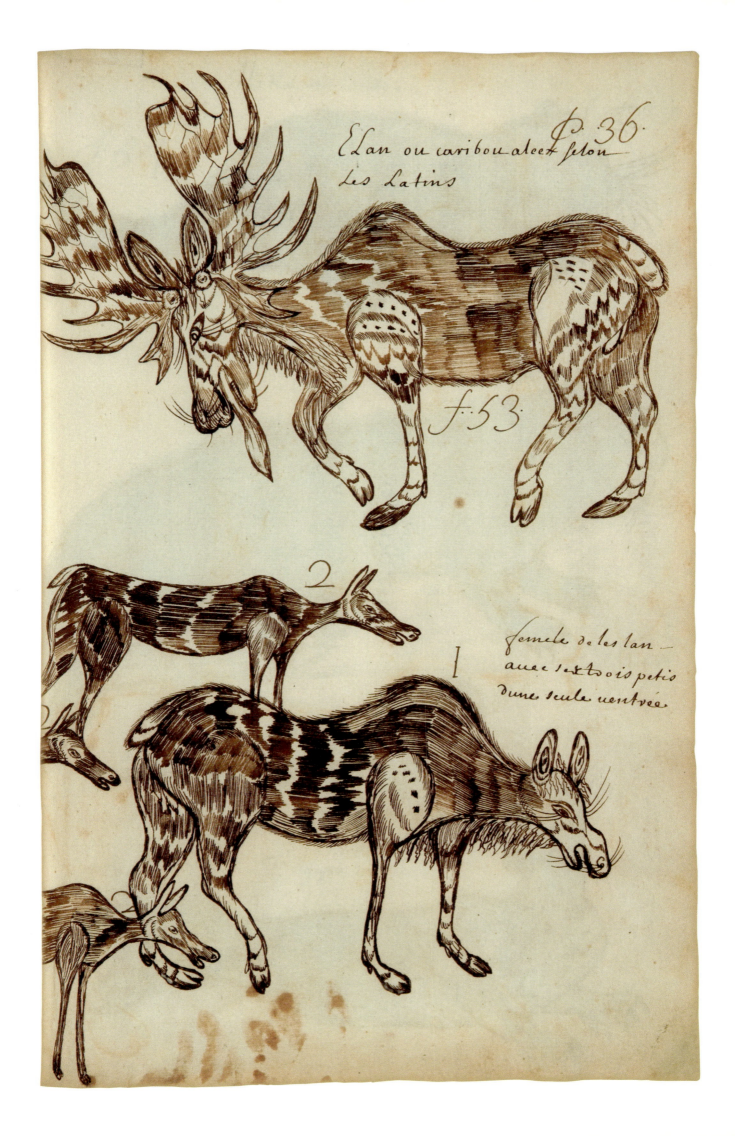

p. 36.

Elan ou caribou alce selon
les Latins

f. 53

2

1

femele de les lan
auec ses trois petis
dune seule uentrée

Nika, or otter
1 Amic, or beaver
2 Sea wolf
3 Sea tiger

Nika ou loutre
1 amic ou castor
2 Loup marin
3 tygre marin

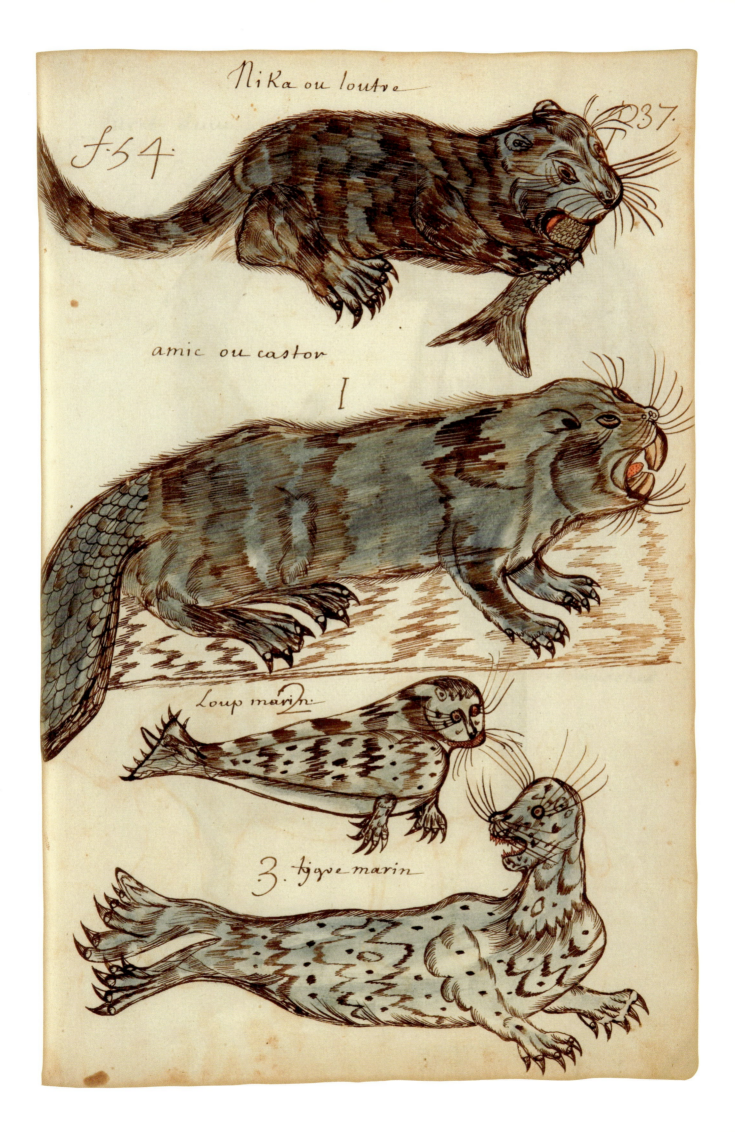

Nika ou loutre

f.54

237.

amic ou castor

I

Loup marin

3. tigre marin

PL. XXXVIII, FIG. 55

Water ferret
Ouatchas, or muskrat

furet deau
ouatchas ou rat musché

furet d'eau

f. 55.

p. 38.

I.

ouakhas ou rat musché

Micipichik, or the god of the waters according to the Americans
1 Michinenh, small turtle
2 Michinak, large turtle of the island of St Helena, which is so
 large that the roof of a large coach can be made from it

micipichik ou le / dieu de Eaux selon / les Americains
1 Michinenh petite tortue
2 Michinak grande tortue de lisle / de st hElaine qui est si grande
 quon fait / l'Imperialle dun grand carosse

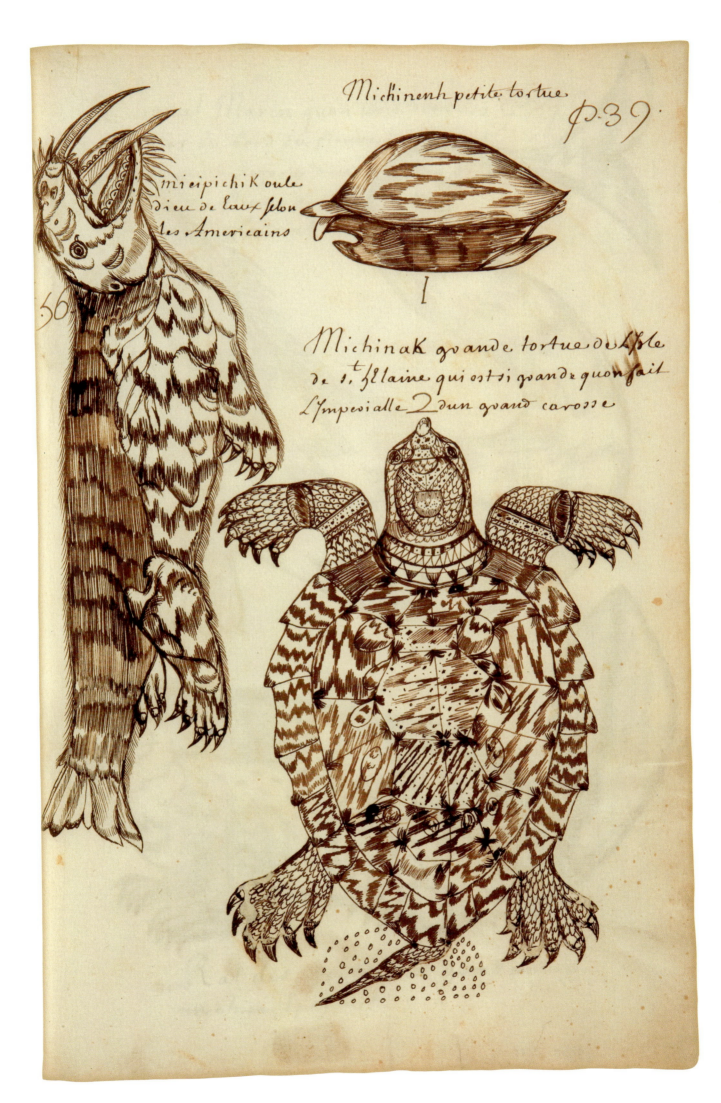

Michinenh petite. tortue

p. 39.

micipichiKoule
dieu de leaux selon
les Americains

I

Michinak grande tortue de L'Isle
de s. HElaine qui est si grande quon fait
L'Imperialle 2 dun grand carosse

Sea horse that is seen in the meadows along the Chisedek
 River, which flows into the St Lawrence River
1 Mountain rat as large as a spaniel

Cheval Marin quon voit dans les / preries du bord du fleuve
 de chisedek / qui se degorge dans / le fleuve de st / Laurent
1 Rat des montagnes grand comme / un chien Epagneul

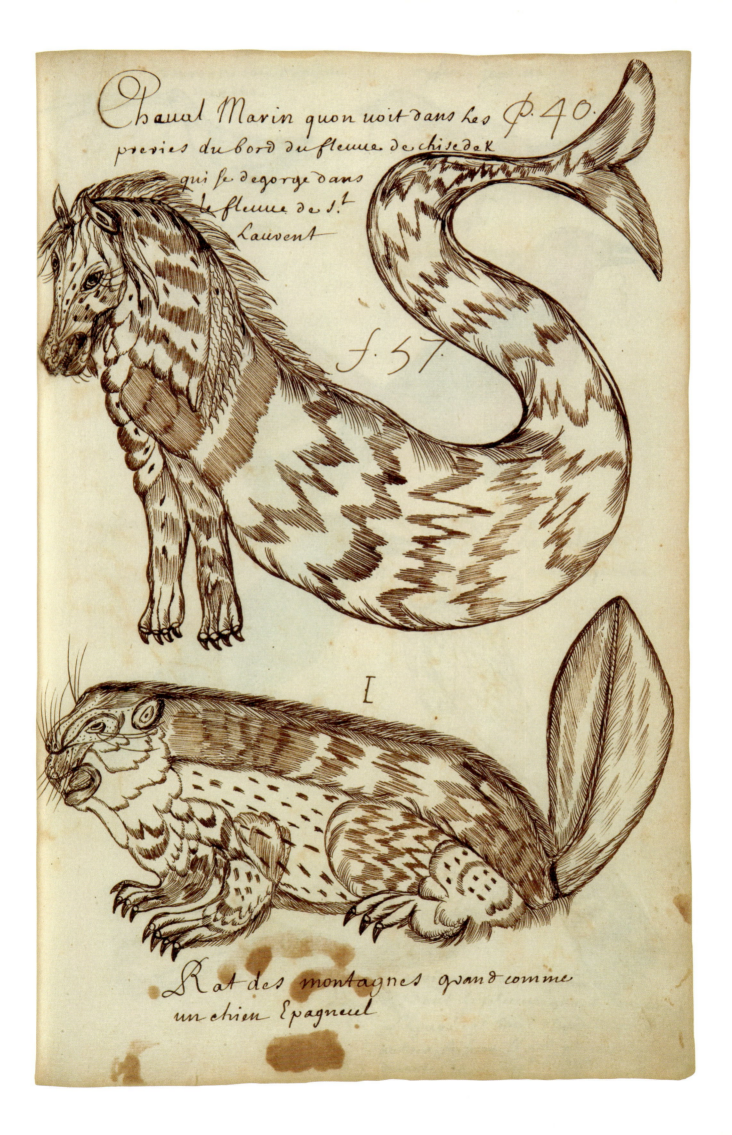

Chaual Marin quon uoit dans les p. 40.
preries du bord du fleuue de chisedek
qui se degorge dans
le fleuue de St
Lauuent

f. 57.

I

Rat des montagnes grand comme
un chien Epagneul

PL. XLI, FIG. 58

Rouroucasou, or hummingbird

1 Yellow bird
2 The red finch
3 The red and black finch
4 Royal blue bird
5 American ortolan
6 American sparrow, whose plumage is quite varied. In winter it is white; in other seasons it is grey mixed with other colours.

Rouroucasou ou oiseau / mouche

1 oyseau jeaune
2 Le pinson rouge
3 Le pinson rouge et noir
4 oyseau royal bleu
5 hortoland / ameriquain
6 moigneau ameriquain / dont le pleumage est tres varie / L'hyver il est tout blanc dans les / autres saisons Il est gris melé de / diverses couleurs

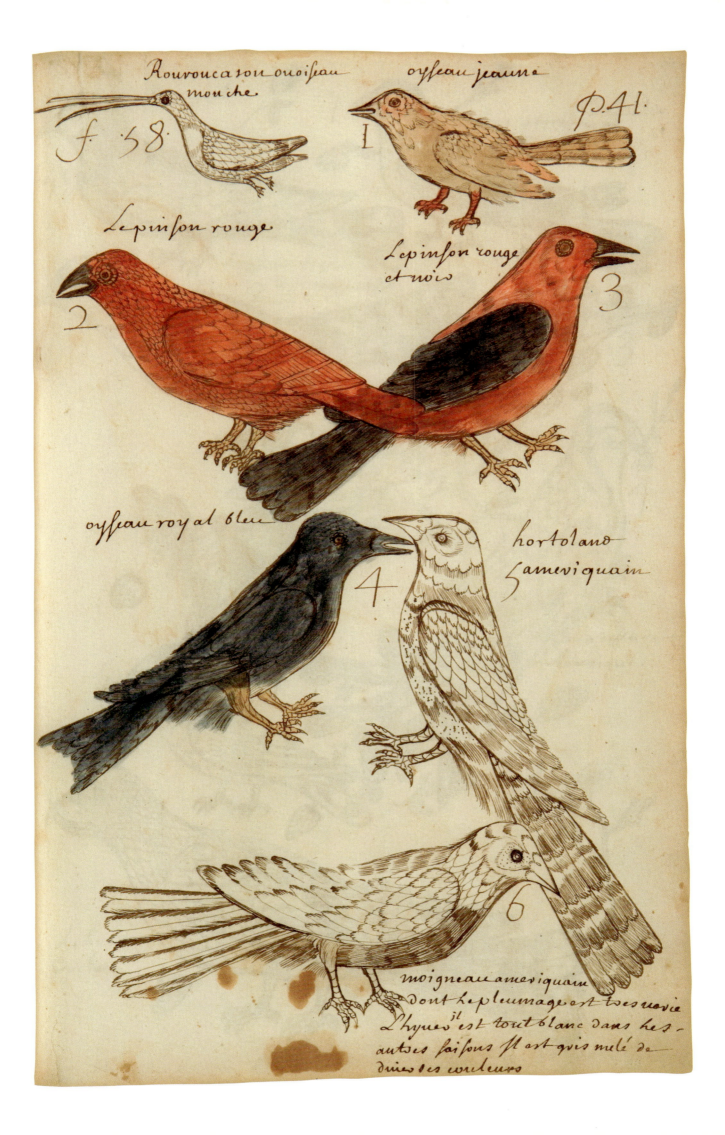

Rouroucason onoiseau
mouche

oyseau jeaune

P. 41.

f. 58.

1

Le pinson rouge

Le pinson rouge
et noir

2

3

oyseau royal bleu

hortolano
Samcriquain

4

moigneau amcriquain
dont le plumage est tres varie
L'hyver il est tout blanc dans les
autres saisons il est gris mele de
diverses couleurs

6

PL. XLII, FIG. 59

Nightingale
1 Red-headed bird
2 The many-coloured porcupine bird. Its plumage is beautiful.
3 The bird without a name
4 American swallow
5 The chickadee
6 The crossbill

Rossignol
1 Loiseau a teste rouge
2 Loyseau bigaré de porc epy le plemage est / beau
3 Loyseau sans nom
4 hIrondelle de / l'Amerique
5 La lardere ou / mesange
6 Le bec Crochu

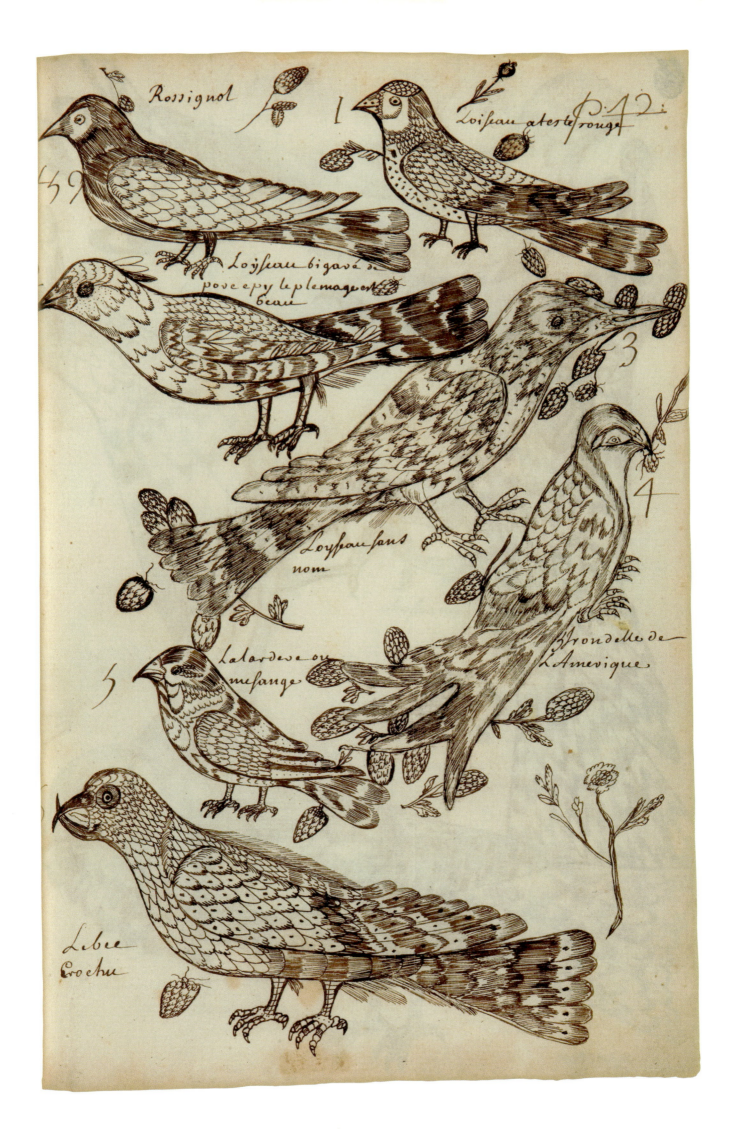

Rossignol 1 Loiseau a teste rouge p. 12

49

Loiseau bigaré de
poré epy le plemage est
beau 3

Loiseau sans
nom 4

Brondelle de
L'Amerique

5 La tardeve ou
mesange

Libec
crochu

The swift
1 The American blackbird
2 Characaro
3 American jay with all-blue plumage

Le Martinet
1 Le merle ameriquain
2 characaro
3 gey ameriquain dun plemage / tout bleu

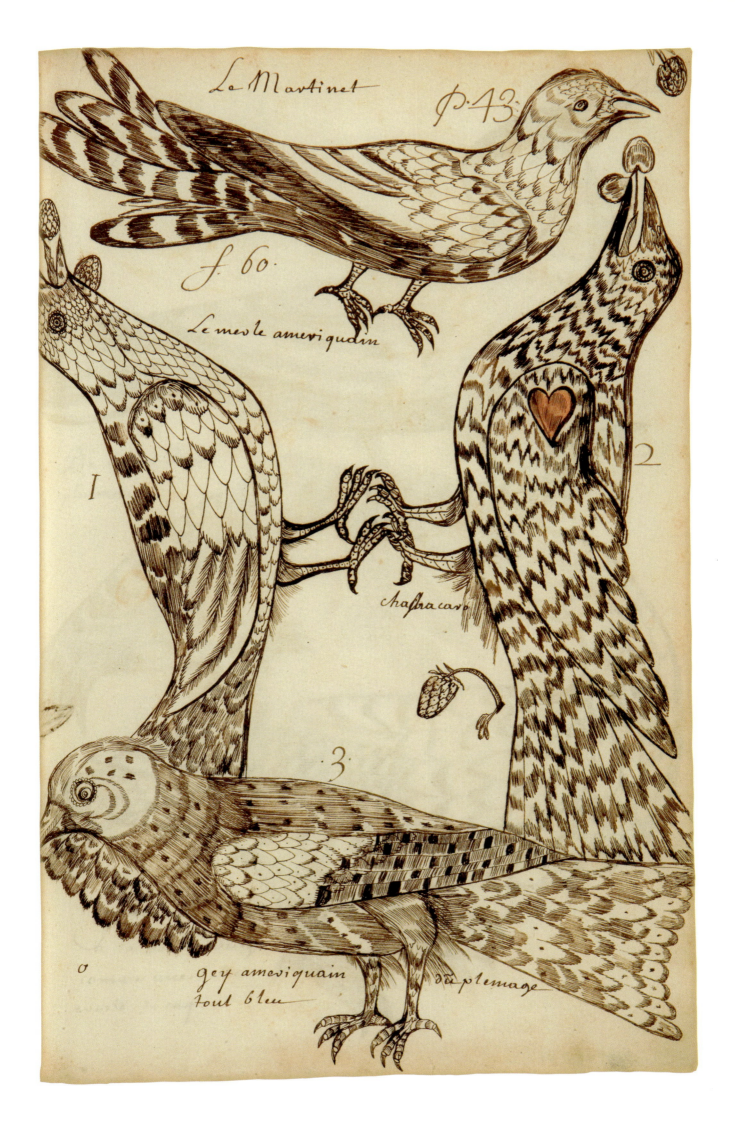

Le Martinet

p. 43.

f. 60.

Le merle ameriquain

1

chassacaro

2

3

o

gey ameriquain
tout bleu

du plemage

American magpie
1 Magpie with very beautiful plumage
2 Large woodpecker with a red head like a fine cock's crest

Pie Ameriquaine
1 Pie a tres Beau / pleumage
2 grand pie Vert / a la Teste rouge / comme une belle / creste
 de coq

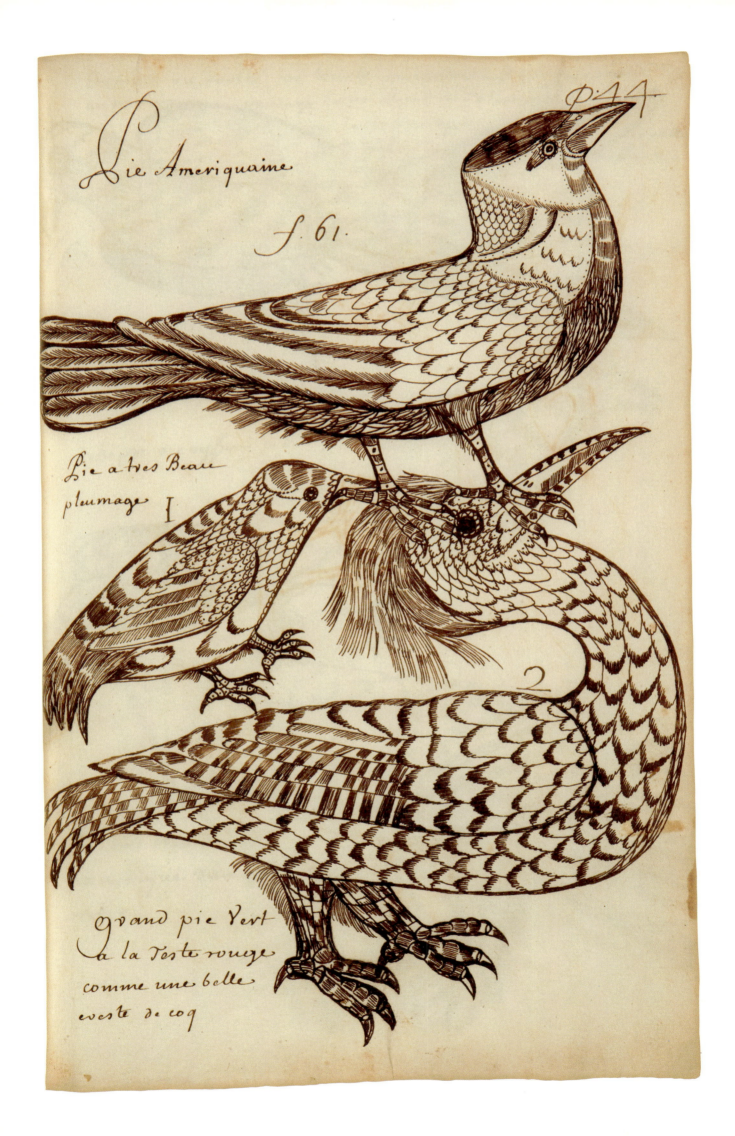

Pie Ameriquaine

f. 61.

P.44

Pie a tres Beau
pleumage 1

2

grand pie Vert
a la Teste rouge
comme une belle
veste de coq

Oumimi, or ourité or pigeon. It is seen in such great quantities at the first passage in spring and in autumn that it is unbelievable unless one has seen it.

1 Tchipai or "dead bird"

2 American white partridge, which has an exquisite taste

Oumimi ou ourité ou tourte on en voit de si grandes quantites / au premier passage du printems et de lautonne / que la chose nest pas croyable / a moins que de la voir

1 tchipai ou oyseau mort

2 Perdris blanche dé / Lamerique dun gout / eschis

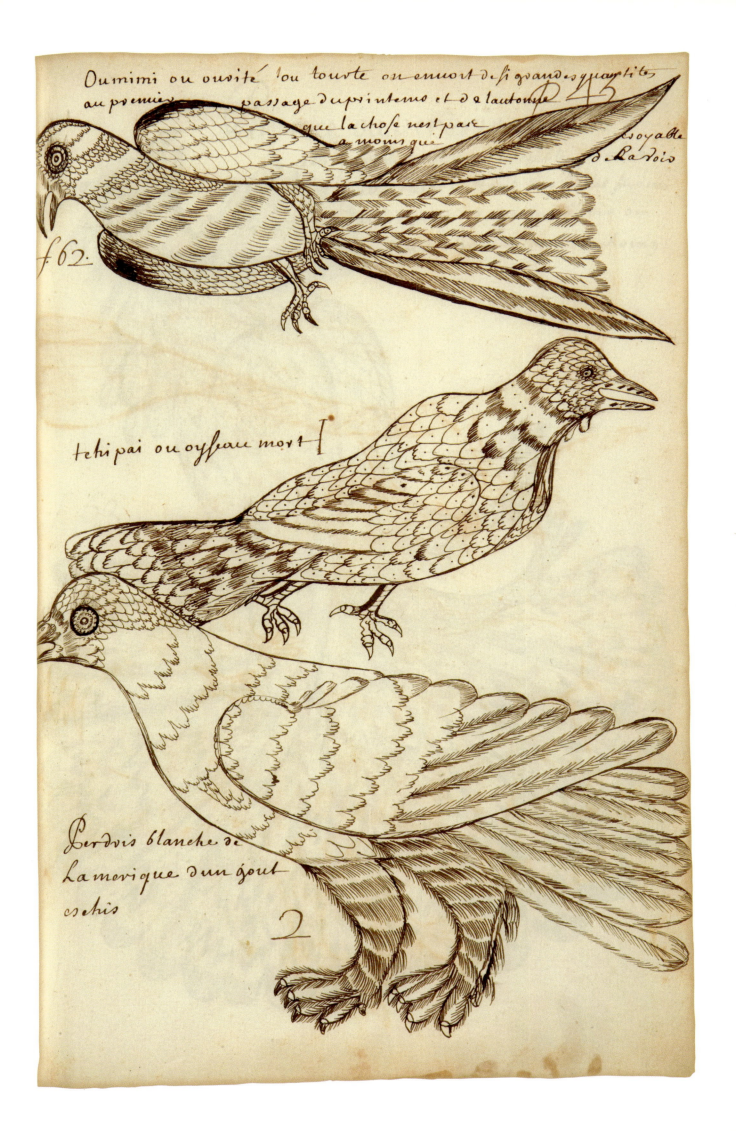

Oumimi ou ouvité Tou tourte on envoit de si grandes quantités
au premier passage du printemps et de l'autonne
que la chose n'est pas incroyable
a moins que d'Aradois

f 62.

tchipai ou oyseau mort

Perdrix blanche de
Lamerique d'un gout
eschis

2

Papace, or grey partridge. This partridge is remarkable because of the noise that it makes beating its wings on a rotten tree in the woods. It can be heard almost a league away.

Papace ou perdris grise / cette perdris est remarcable par le bruit / quelle fait battant des ailles sur un / arbre pouri dans les Bois on / lentend de pres dune lieu Loing

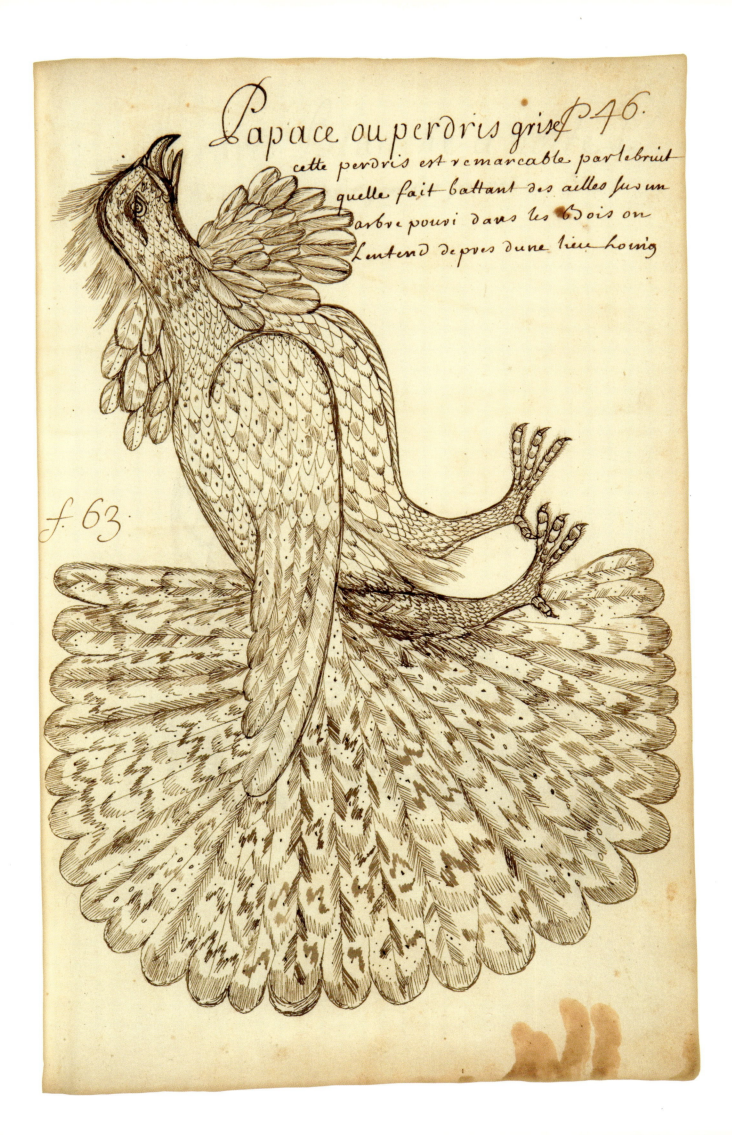

Papace ou perdris grise p46.
cette perdris est remarcable par le bruit
quelle fait battant des ailles sur un
arbre pouri dans les Bois on
l'entend de pres dune lieu loeing

f. 63

White and black partridge with red eyes, black beak and
yellow legs

Perdris Blanche et noire a / yeux Rouges bec noir
jambes jaunes

Perdris Blanche et noire a

p 47.

yeux Rouges bec noir jambes jaunes

f. 64

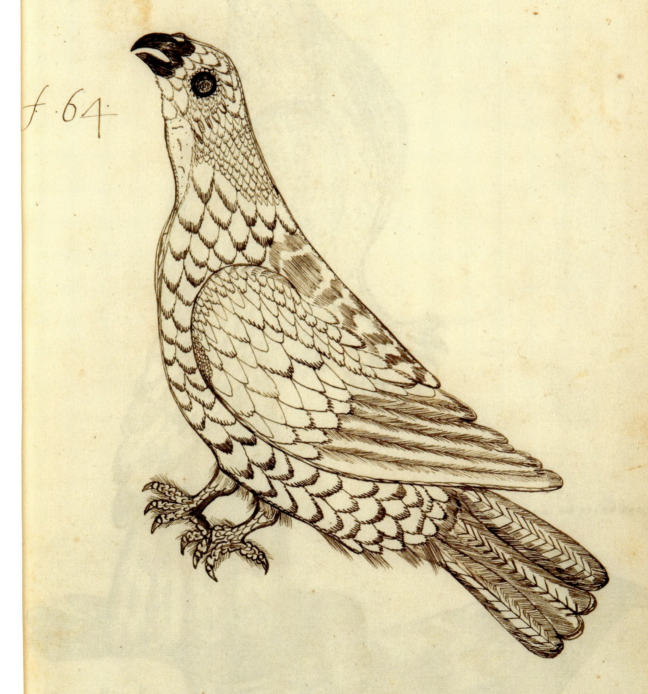

Pheasant-like partridge
2 Crow with red beak and feet
3 Raven with red beak and feet

Perdris fesandeé
2 Corbeau a bec et pied rouge
3 Corneille a bec / et pied rouge

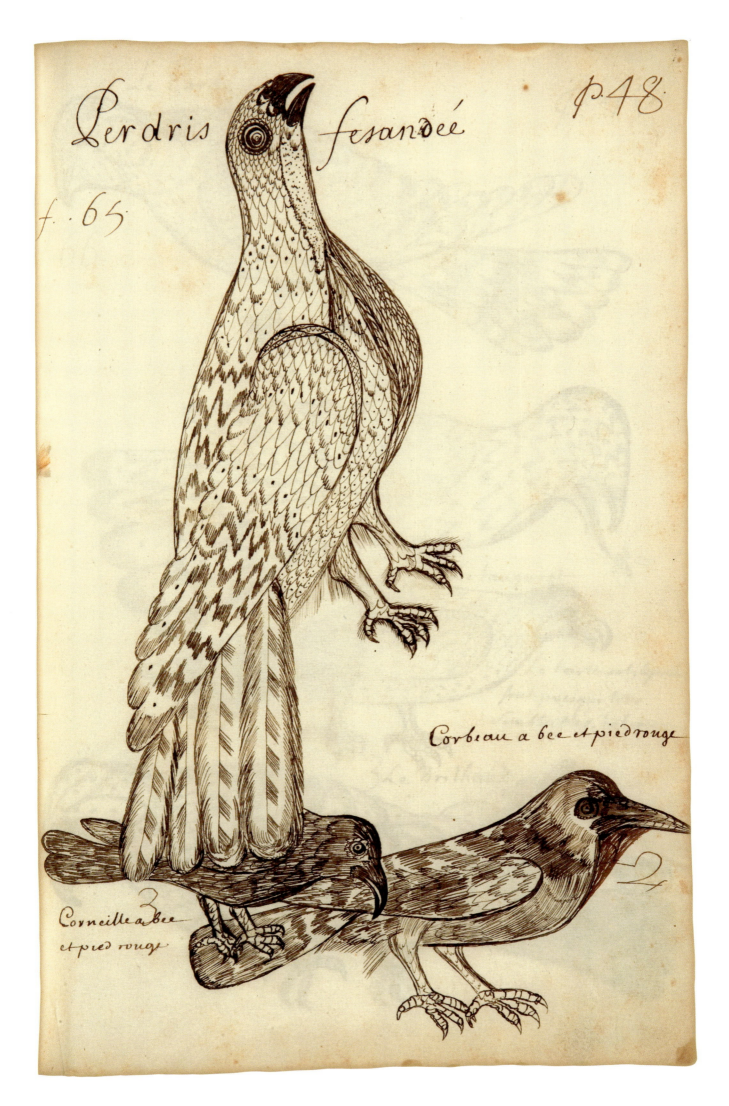

Perdris fesanöéé

p.48.

f. 65.

Corbeau a bec et pied rouge

Corneille a bec
et pied rouge

3

2

The hardi
1 The Turk
2 The taugarot, the tartarot, the sparrow hawk are almost all
 similar; hobby
3 The brilliant

Le hardy
1 Le turc
2 Le taugarot / Le tartarot, lepervie, / sont presque tous /
 semblables, hobereau
3 Le Brilhand

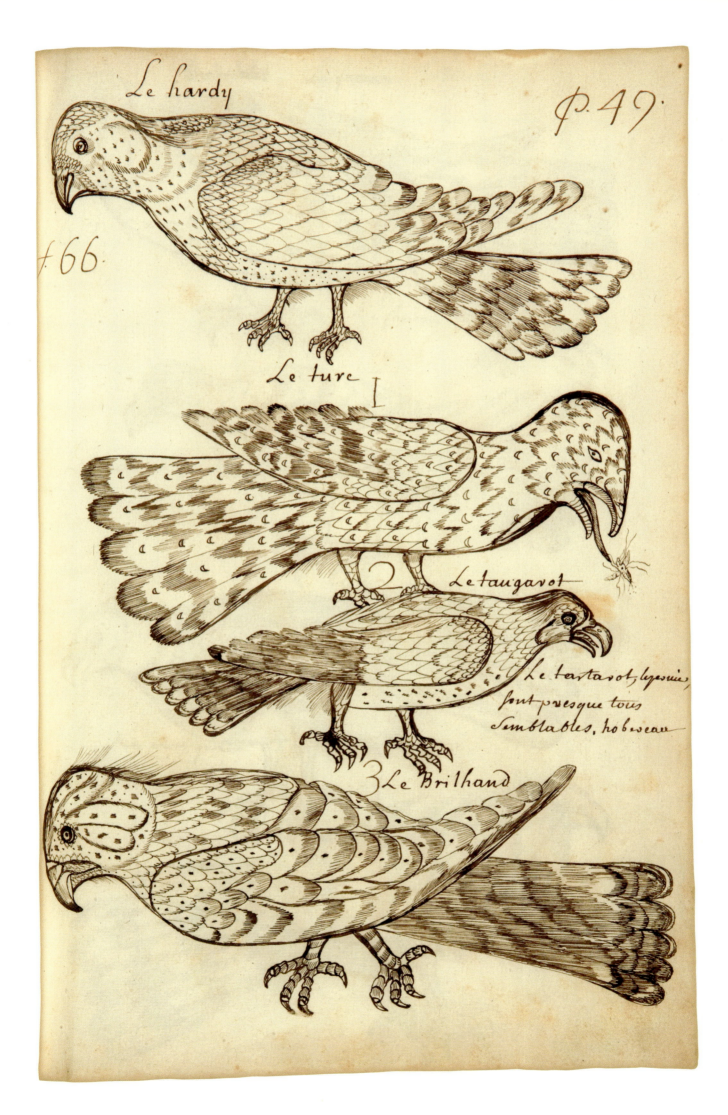

Le hardy

ф. 49.

ф 66.

Le turc

1

Le tangarot

Le tartarot, le peruie,
font presque tous
semblables, hobereau

3 Le Brilhand

PL. L, FIG. 67

Hobby
1 The falcon
2 The goshawk
3 The American eaglet
4 The royal eagle

~~Le faucon~~ hobereau
1 Le faucon
2 Le hautour
3 Leyglon ameriquain
4 Laygle royalle

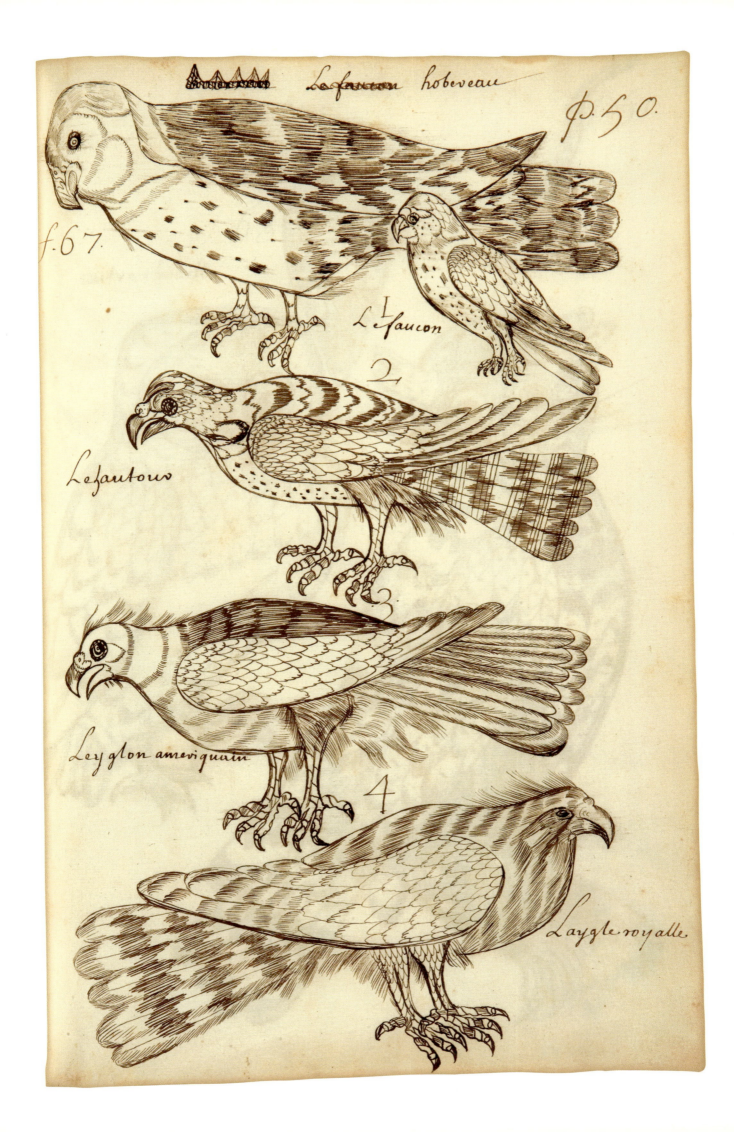

Le faucon hobereau

ф.50.

f.67.

Le faucon

2

Le hautour

Leyglon ameriquain

4

Layglle royalle

PL. LI, FIG. 68

The small owl
Another owl
1 [lower right] Barn owl

La petite chouette
autre chouette
1 [lower right] chatuant

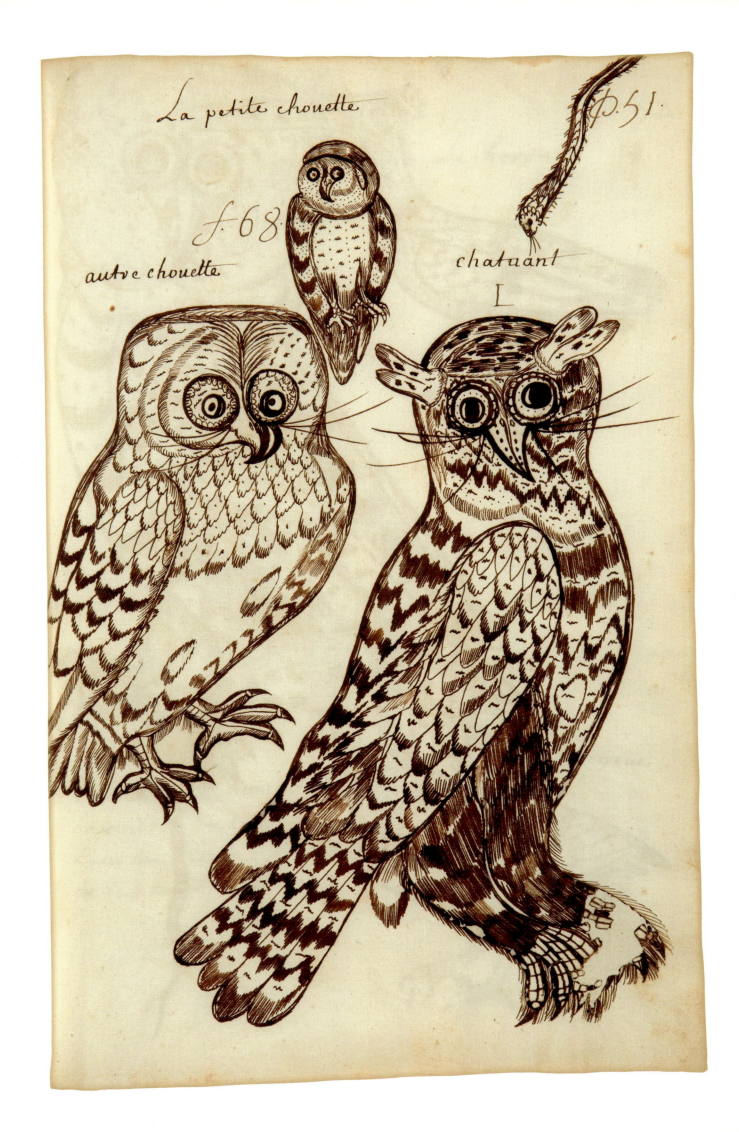

La petite chouette

p. 51.

f. 68.

autre chouette

chatuant

L

Coucoucouou, which can be heard three or four leagues
away in the forest or on river banks [largest figure]
1 The heron
2 The crane

coucoucouou quon entend / La nuit de trois ou quatre /
Lieues loin, dans le foret ou / au bord des rivieres [largest
figure]
1 Le heron
2 La grue

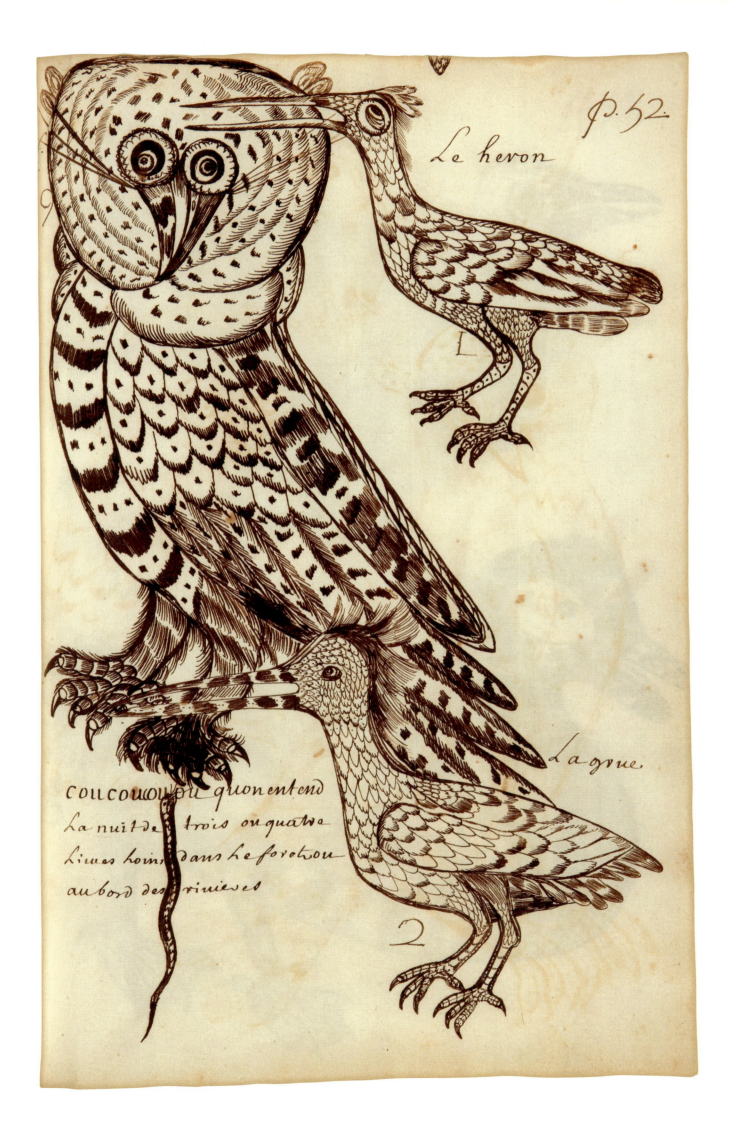

p. 52.

Le heron

La grue

coucoucoucou quon entend
La nuit de trois ou quatre
Lieues loins dans le forêt ou
au bord des rinieres

Wild goose
1 Gander
2 Bustard, or nika

oye sauvage
1 Mane ou / üar
2 Outarde ou nika

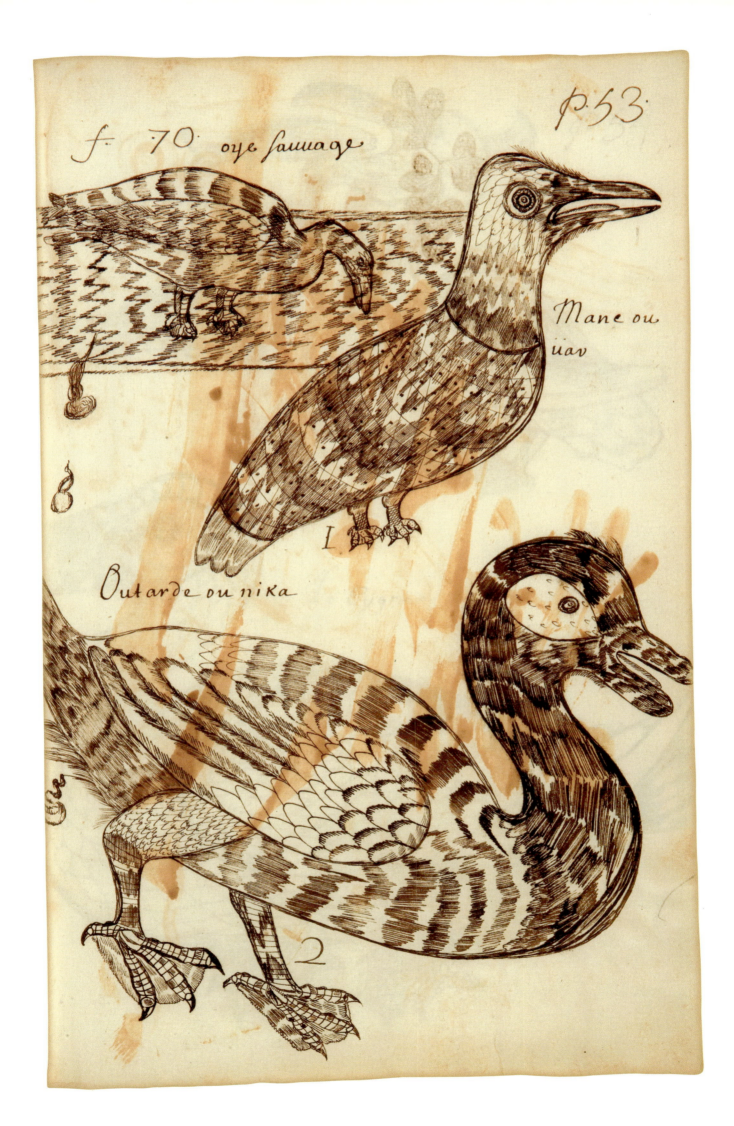

p·53·

f· 70· oye sauuage

Mane ou
iiau

1

Outarde ou nika

2

Cheté
1 Wood duck
2 The swan

cheté
1 canard Branchu
2 Le Cygne

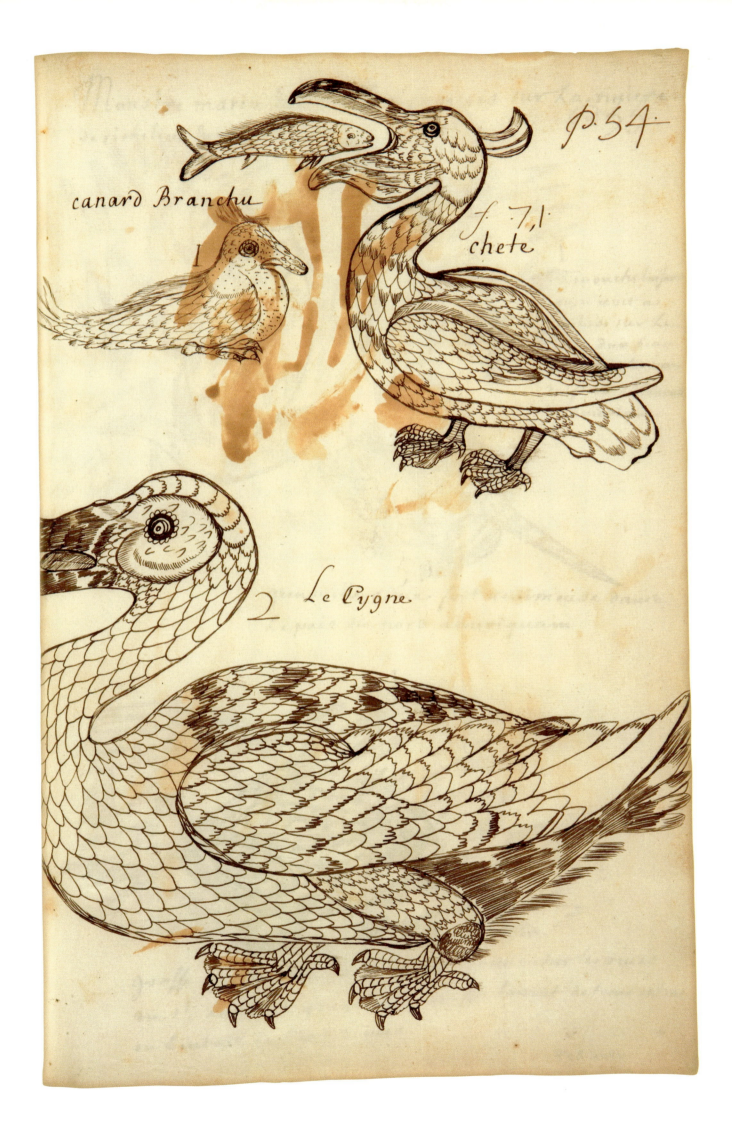

canard Branchu

1

p.54

f. 7.1
cheté

2 Le Cygne

Sea monster killed by the French on the Richelieu River in
New France
1–2 Firefly, which is seen by the thousands on the evening of a
fine day on the banks of the St Lawrence River in America
3 Very poisonous tailed frog, found on the banks of the St
Lawrence. When it croaks at night in calm weather, it can
be heard from two leagues.
4 Big green frog found on the shores of the St Lawrence River.
When it croaks at night in calm weather, it can be heard
from a distance of two leagues.

Monstre marin tue par les françois sur La riviere / de richelieu
En nouvelle france
1–2 mouche luisante / quon voit a / miliers sur le soir dun beau
/ jour sur les rives / du fleue st. Lauran / en Amerique
3 grenouille a cue fort venimeuse dans / le pays du nord
ameriquain
4 grosse grenouille verte quon trouve sur les rives / du st.
Laurent quand elle croasse la nuit de tems calme / on lentend
de Deux Lieues

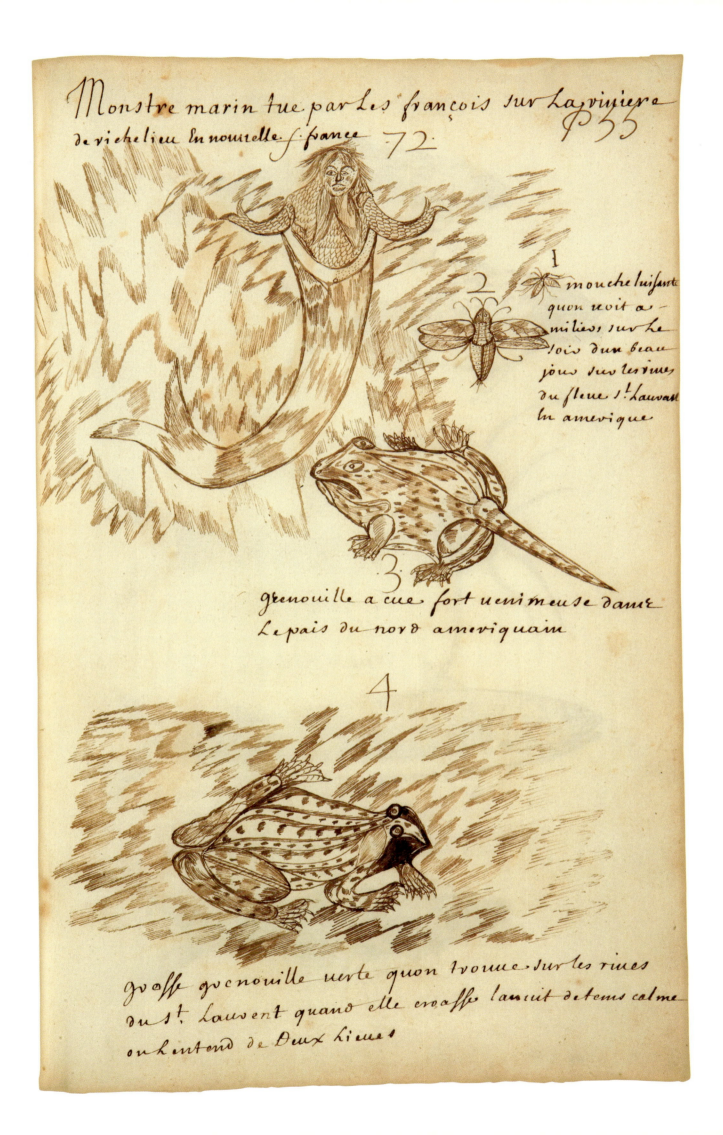

Monstre marin tue par les françois sur La riviere
de richelieu En nouvelle france 72.

P55

1 mouche luisante
 quon voit a
 milieu sur le
 soir dun beau
 jour sur les rives
 du fleue St Laurent
 En amerique

2

3

grenouille a cüe fort venimeuse dans
Le pais du nord ameriquain

4

grosse grenouille verte quon trouve sur les rives
du St Laurent quand elle croasse la nuit de tems calme
on l'entend de Deux Lieües

The smelt
1 The small cod
2 The catfish
3 The small herring
4 The large herring

Le plan
1 Lapetite molue
2 Labarbue
3 Lepetit arent
4 Le grand arent

Le plan

p.56.

f. 73.

La petite molue

I

La barbue

2

Le petit avent

3

Le grand avent

4

The char
1 Carp
2 The toadfish
3 The alose
4 Achigan

Le chevalier
1 carpe
2 le crapeau
3 La Lause
4 Achigan

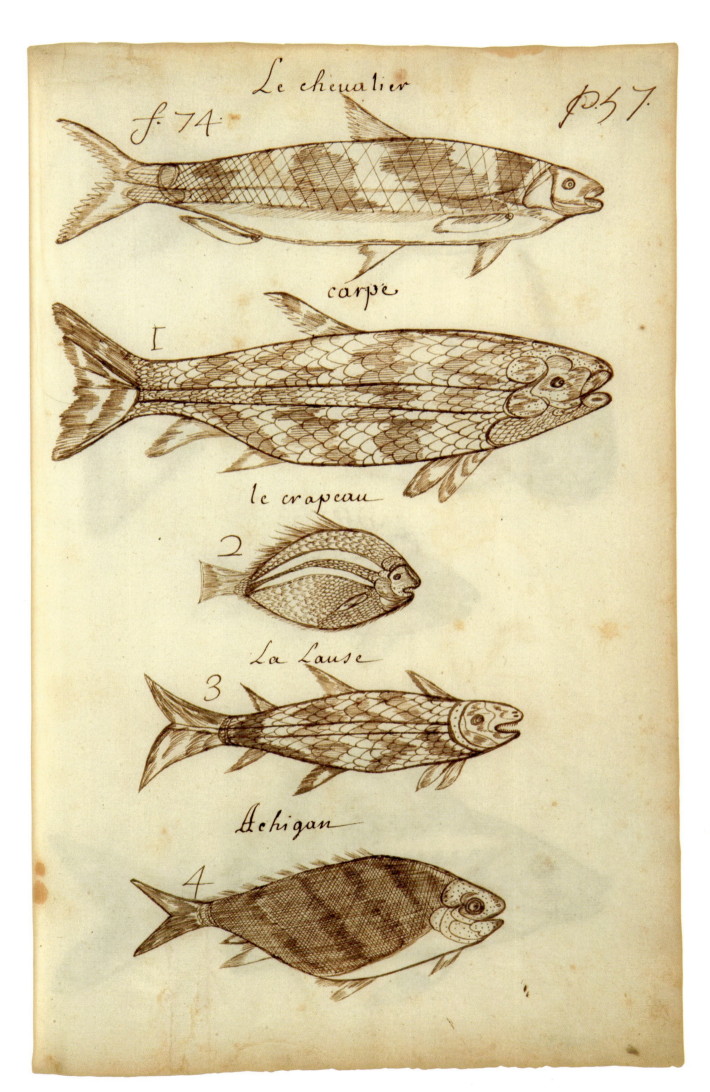

carpe

I

le crapeau

2

La Lause

3

Achigan

4

Marachigan
1 The loach
2 Gold fish
3 The bar

Marachigan
1 La Loche
2 Poisson dore
3 Le Bar

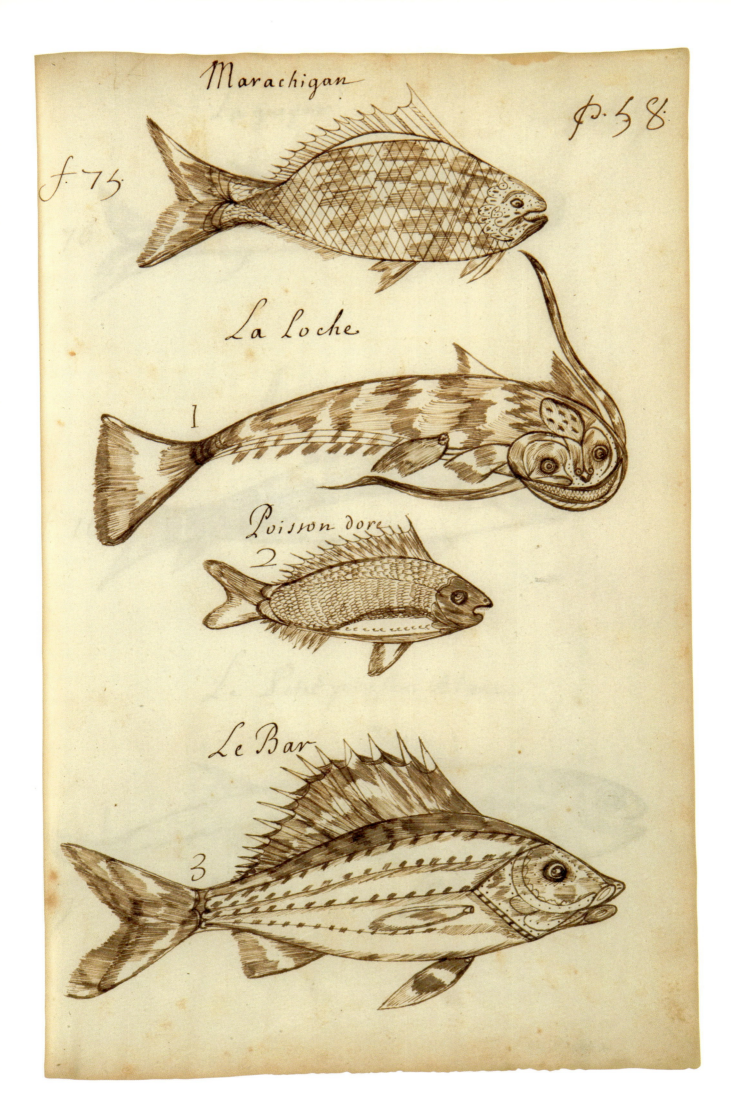

Marachigan

f. 75

La Loche

1

Poisson doré

2

Le Bar

3

The gaine
Another gaine
1 The small white fish

La gueyne
Autre gueyne
1 Le Petit poisson Blanc

La queyne

f. 76.

Autre queyne

f. 76.

Le Petit poisson Blanc

I

fig. 77 [left] Atikamec, the large white fish
fig. 78 The large pike, of extraordinary girth and surprising
 length
1 The common trout

fig. 77 [left] atticamec Le gran poisson / blanc
fig. 78 Le grand Broché dune grosseur / Extraordinaire et
 dune / longuer surprenante
1 La truite comune

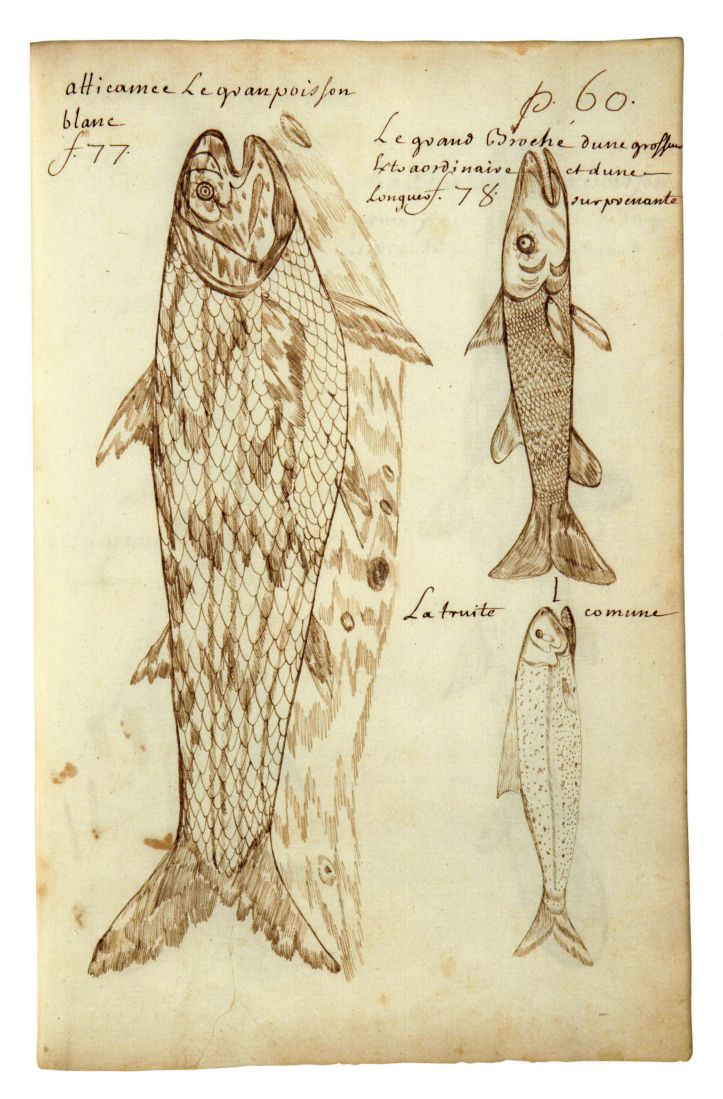

atticamee Le gran poisson
blanc
f. 77.

p. 60.

Le grand Broché d'une grosseur
extraordinaire et d'une
Longues. 78. surprenante

La truite comune

Another kind of trout
1 The big, large trout
2 Chausarou, or armed fish. It is twelve feet long and
 six around.

Autre espece de truite
1 La grosse et la / grande truite
2 chausarou ou poisson / arme il a 12 pieds de long / et
 six de contourd

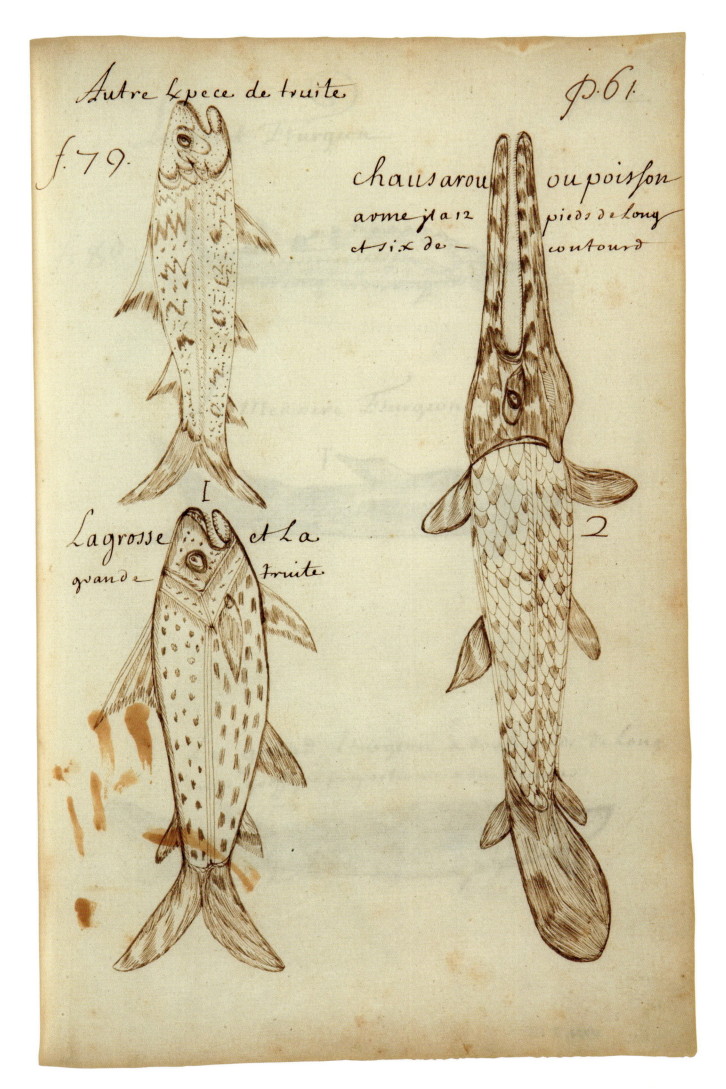

Autre épece de truite

p.61

f.79.

chausarou ou poisson
arme jla 12 pieds de long
et six de — contourd

I
Lagrosse et La
grande truite

2

The small sturgeon
1 The medium-sized sturgeon
2 The large sturgeon, twelve feet long and of a girth in
 proportion to its length.

Le petit Eturgeon
1 Le mediocre Eturgeon
2 Le grand Eturgeon a douze pieds de Long / dune grosseur
 proportionée a sa Longuer

Le petit Esturgeon

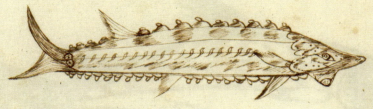

f. 80.

Le Mediocre Esturgeon

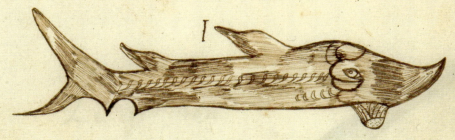

Le grand Esturgeon a douse pieds de Long
d'une grosseur proportionée a sa Longuer

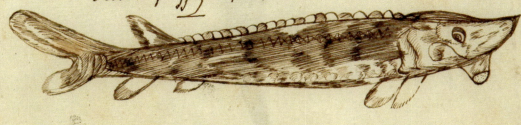

Cod
1 Albacore

Morue
1 Le gelmon

Morue

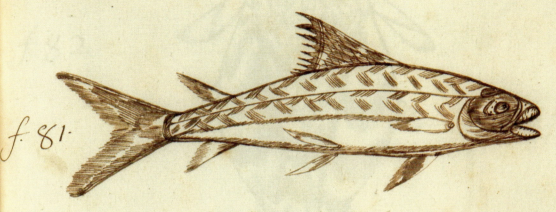

f. 81.

Le gelmon

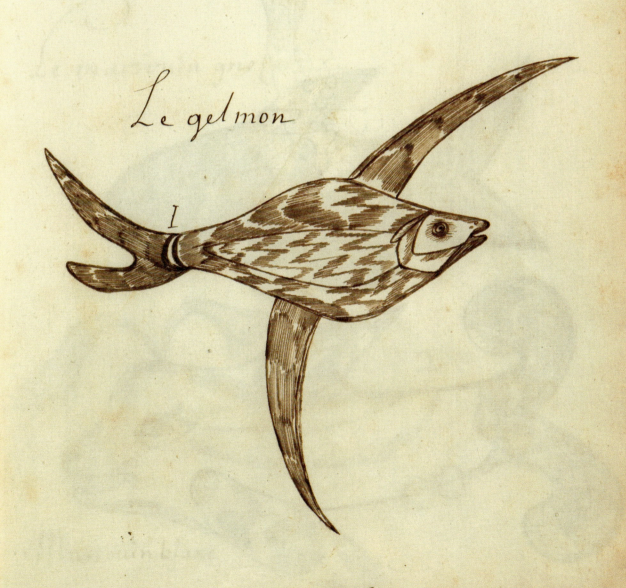

The halibut
1 The grey porpoise
2 White porpoise

Le flectan
1 Le marsouin gris
2 Marsouin blanc

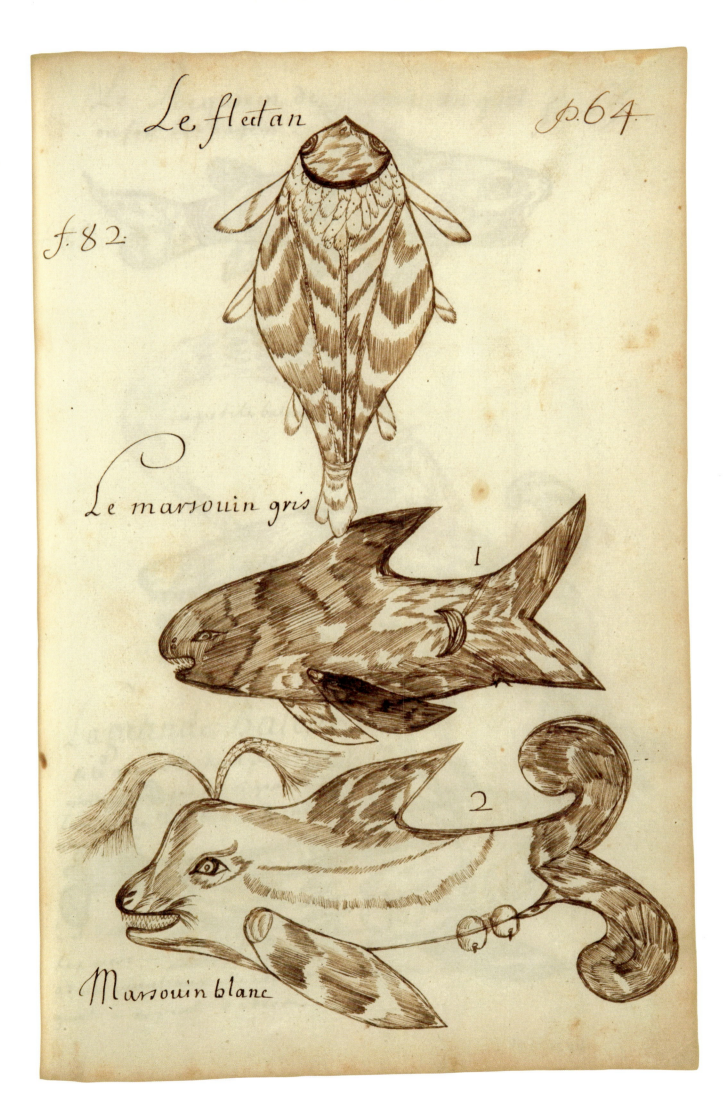

Le fletan

p.64

f.82.

Le marsouin gris

1

2

Marsouin blanc

The shark, from whose skin shagreen is made
1 The small whale
2 The large whale, or *cete grandia*, which is mentioned in the
Holy Scriptures, and which is so large in Nanjing Bay and
in China and elsewhere and in the Eastern seas. It has two
blowholes. It is so large that it covers an area of four acres.

Le Requiem de la peau du quel / on fait le chagrin
1 La petite balene
2 La grande Balene ou / cete grandia dont parle la ste. / escri-
ture qui est si grande dans / Lance de Namkin et En chine
et / ailleurs / et dans / les mers orientalles / a deux evan-
teaux elle couvre par sa grandeur / quatre arpents de terre

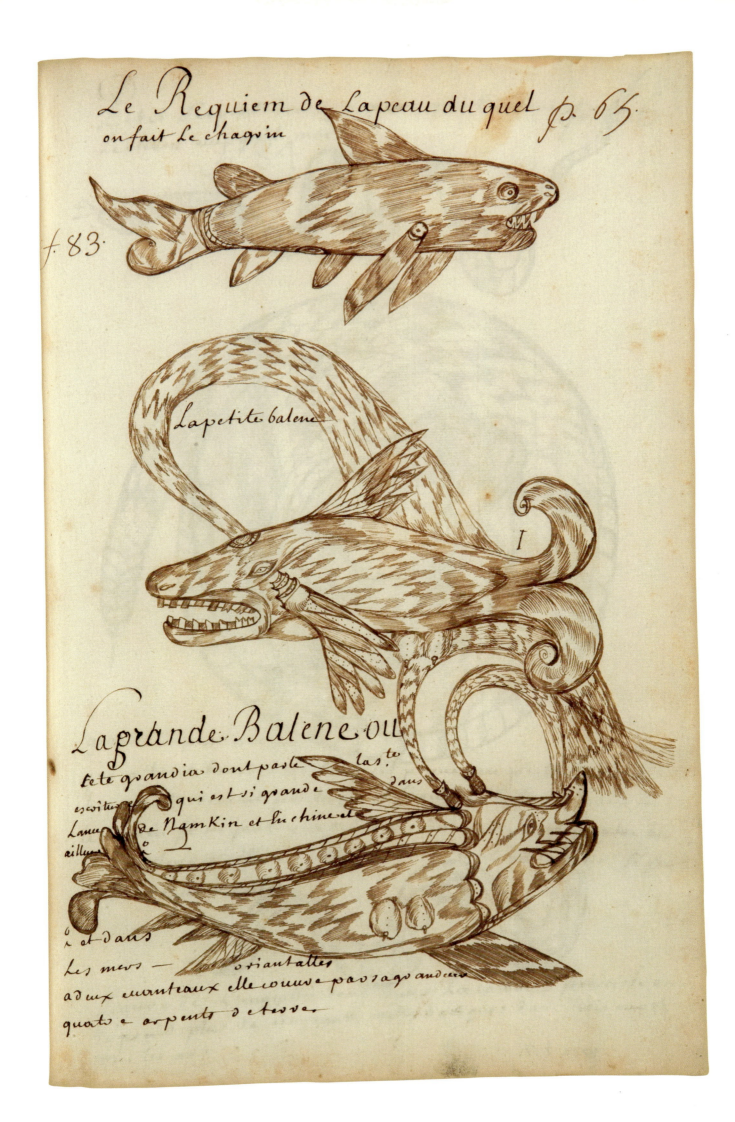

Le Requiem de La peau du quel
on fait le chagrin

f. 83.

La petite balene

I

La grande Balene ou
tete grandia dont parle las.te
escritur qui est si grande dans
Lame de Namkin et la chine et
ailleurs o

o et dans
Les mers —— oriantalles
a deux manteaux elle couure par sago andure
quatre arpents d'terres

Small, very poisonous snake that kills immediately those
 that it bites.
1 Large rattlesnake, which is three fathoms long. If it bites
 someone, within twenty-four hours the person becomes
 very swollen. If one knows the secret to avoid the venom –
 one simply buries the injured part of the body for twenty-
 four hours – one does not feel any pain. Otherwise one is
 sure to die.
2 Picture of the eel. In the French colony, more than fifty
 thousand barrels of them are caught in three months
 every year.

Petit serpent tres venimeux qui tue sur / le cham ceux
 quil mort
1 grand serpent a sonette / qui a trois brasses de long sil
 pique un personne dans les 24 / heures elle devient fort
 enfle et si on sait le secret pour eviter / le venin Il ne faut
 que senterrer durand vingt quatre heures / par la playe
 blessée on ne sent poin de mal autrement Il faut mourir
 sans remede
2 figure de Languille dont dans la colonie francoise on / en
 prend plus de cinquante mille bariques dans trois mois /
 tous les ans

This vessel was equipped by Captain Jacques Cartier, who
was the first to enter the St Lawrence River in Canada.

Ce Vaisseau a esté monté / par le Capitaine Jacques quartier
qui entra le premier / Dans le fleuve de St Laurans / en
Canada

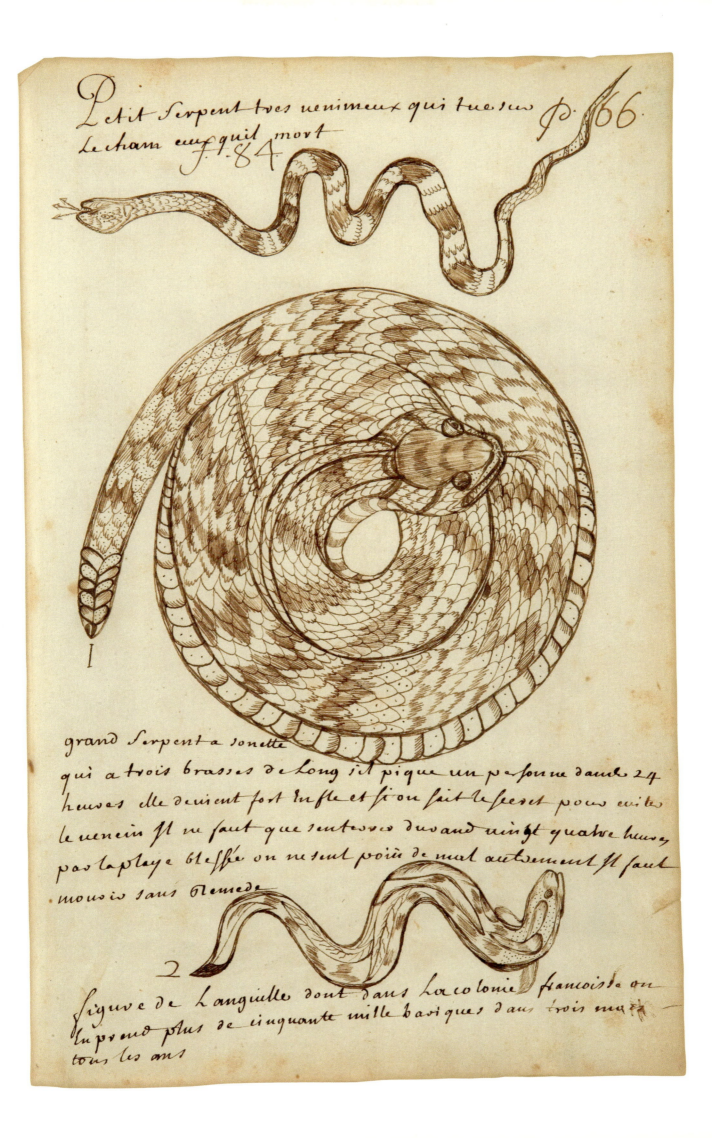

Petit Serpent tres venimeux qui tue sur
le cham euy quil mort
f. 84.

I

grand Serpent a sonette
qui a trois brasses de Long il pique un personne dans 24
heures elle devient fort Enfle et si on fait le secret pour eviter
le venein il ne faut que senterrer durand vingt quatre heures
par laplaye blessée on ne seul point de mal autrement il faut
mourir sans Remede

2

figure de Languielle dont dans Lacolonie francoise on
enprend plus de cinquante mille bariques dans trois mois
tous les ans

Pauillon

flames Trainantef en leau

Voile de

Ce Vaisseau a esté Monté
par le Capitaine Jaques
quartier qui entra le premier
Dans le fleuve de St Laurans
en Canada

petit
hunier

pauillon

voile
Misaine

hune de
Beaupré

Sinalier ou
Beaupré

Mast de Beaupré

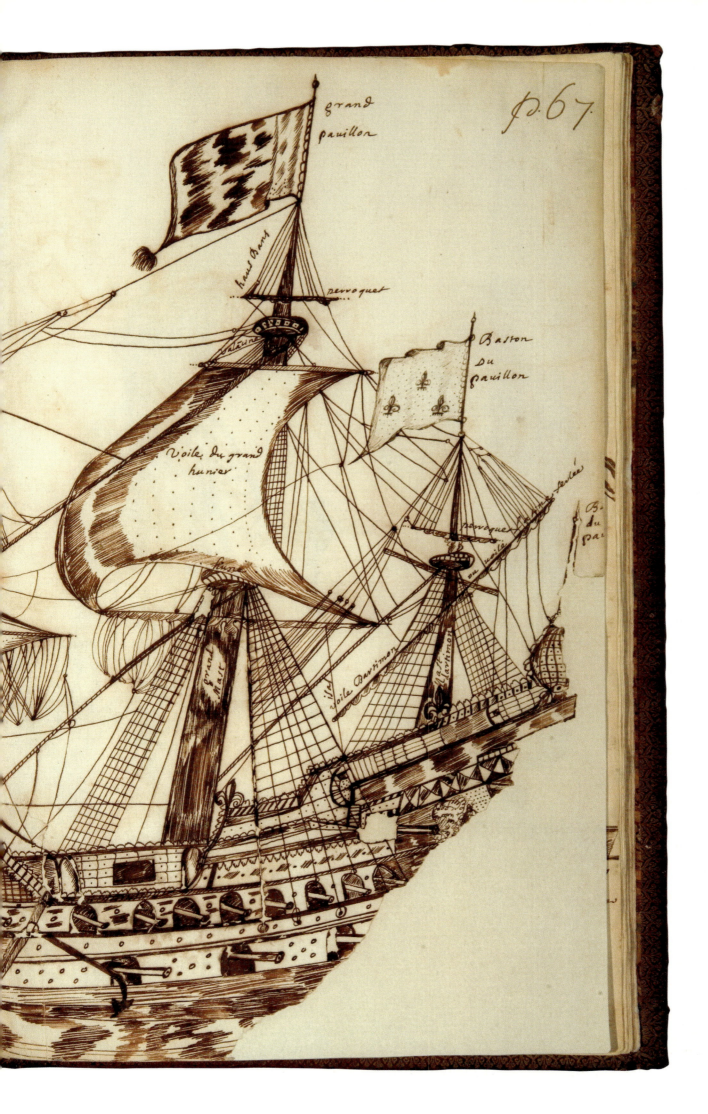

grand
pauillon

p.67.

haut Bans

perroquet

Baston
du
pauillon

Voile du grand
hunier

B.
du
pai

Bevoque

grand
mast

Voile Bartimon

Bartimon

Jacques Cartier, a sailor from St Malo, who was sent to New France by François I of blessed memory, King of France and of Navarre, who made him Squadron Leader to go and explore the St Lawrence River and New France.

Jacques quartier matelot de st. malo qui furent envoyes /
En nouvelle france par d'heureuse memoire francois premier
/ Roy de france et de Navarre qui le fit chef descadre pour /
aller decouvrir la scituation du fleuve de st. Laurans et de /
la nouvelle france

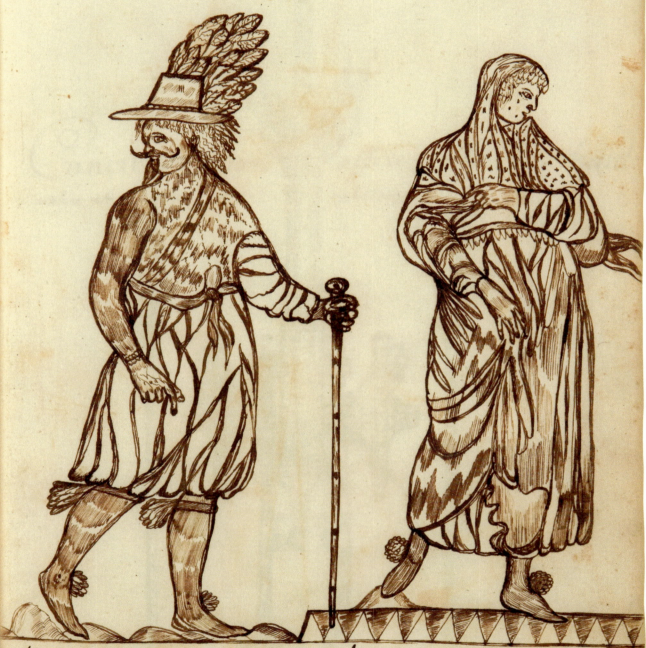

Jacques quartier matelot de st malo qui furent Luroyes
En nouuelle france par d'heureuse memoire francois premier
Roy de france et de Nauare qui le fit chef descadre pour
aller decouurir la scituation du fleuue de st Lauvans et de
La nouuelle france

Canon on its base, of the longest shot and the largest calibre

Canon Sur son affeu de la plus haute / volée et du plus
gros calibre

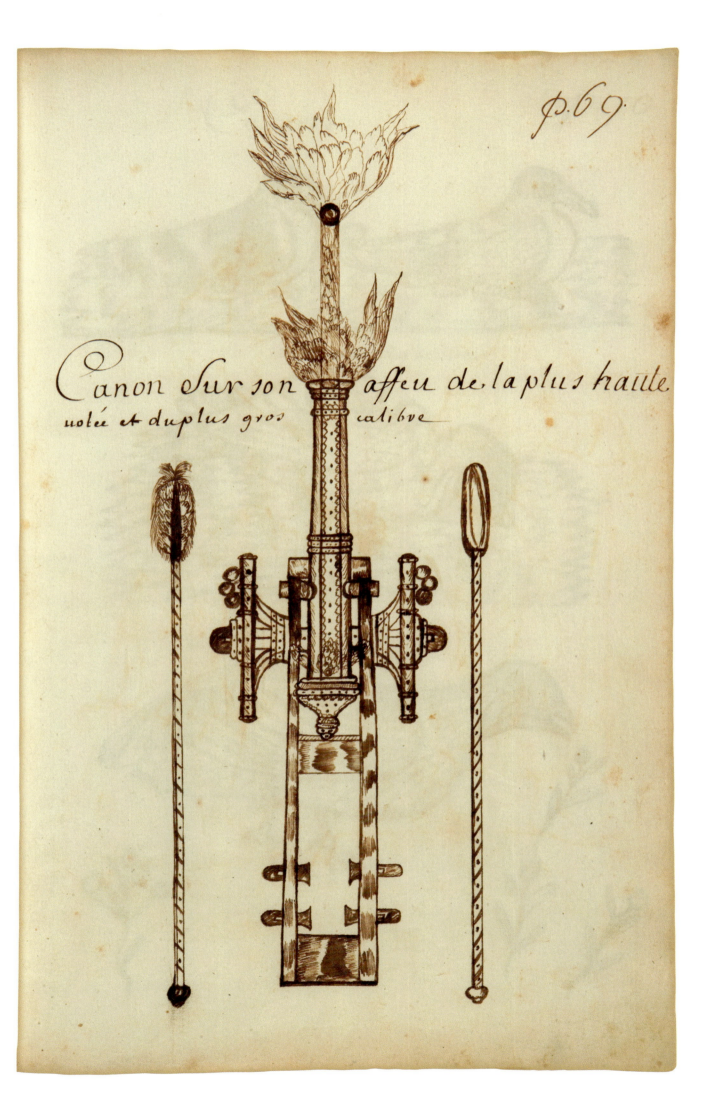

Canon Sur son affeu de la plus haute noteé et duplus gros calibve

Ducks
American goose
Quail

Canards
oye ameriquaine
Cailhe

Canards

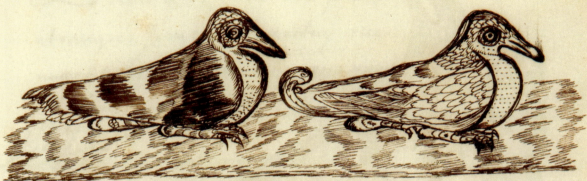

oye ameriquaine

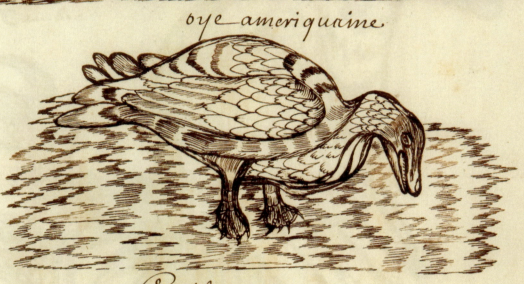

Cailhe

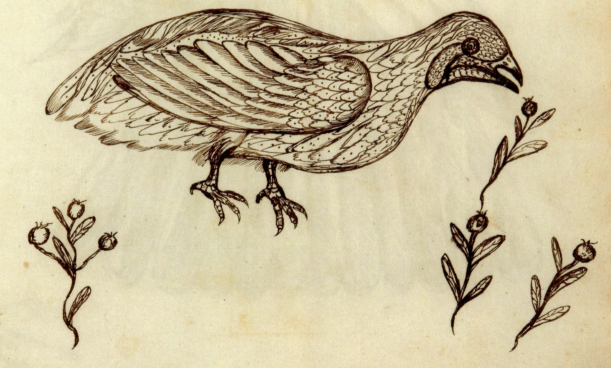

Beautiful pigeon of the foreign countries like the one that
Noah sent from the Ark to see whether the waters of the
Flood had abated, and which returned carrying an olive
branch in its beak

Beau pigeon des pais / etrangers semblable aceluy que / noy
fit sortir de la arche pour scavoir / si les Eaux du deluge
avoint diminue / et qui revint avec une branche / dolivier
qu'il portoit / au bec

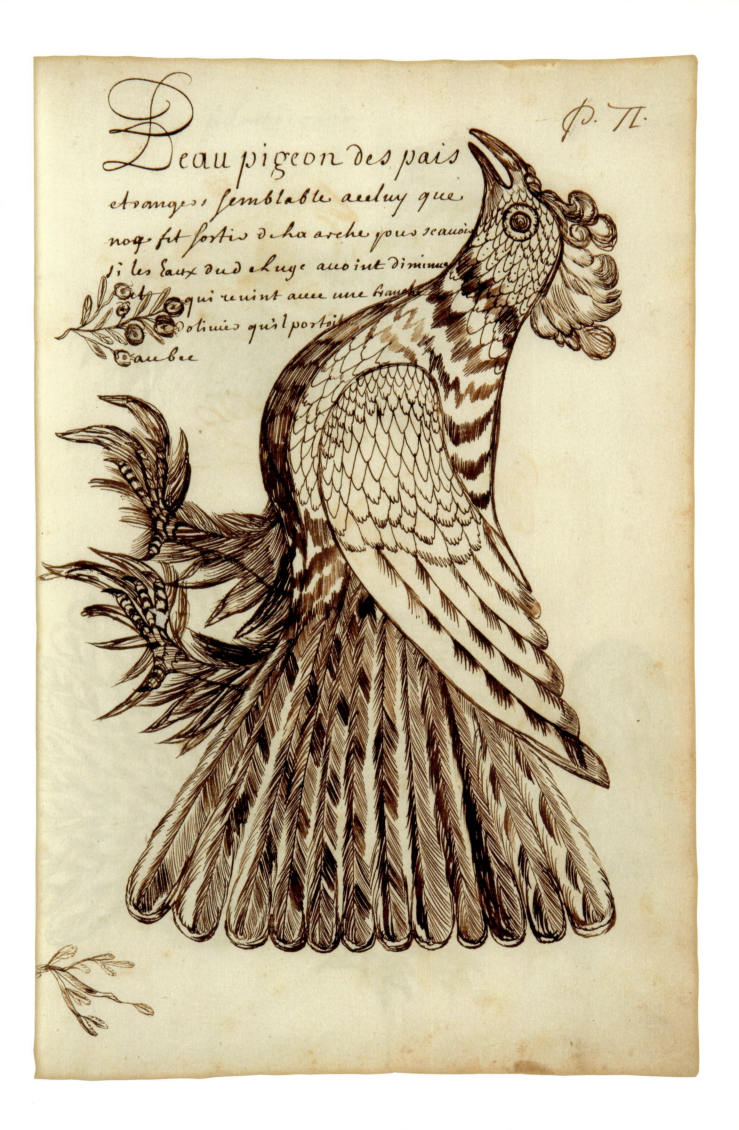

Beau pigeon des païs
etranges, semblable aceluy que
noé fit sortir deha arche pour scauoir
si les eaux dud eluge auoint diminué
et le qui reuint auec une branche
doliuier quil portoit
en bec

P. 71.

American cock
Turkey cock

Coq Ameriquain
Coq dinde

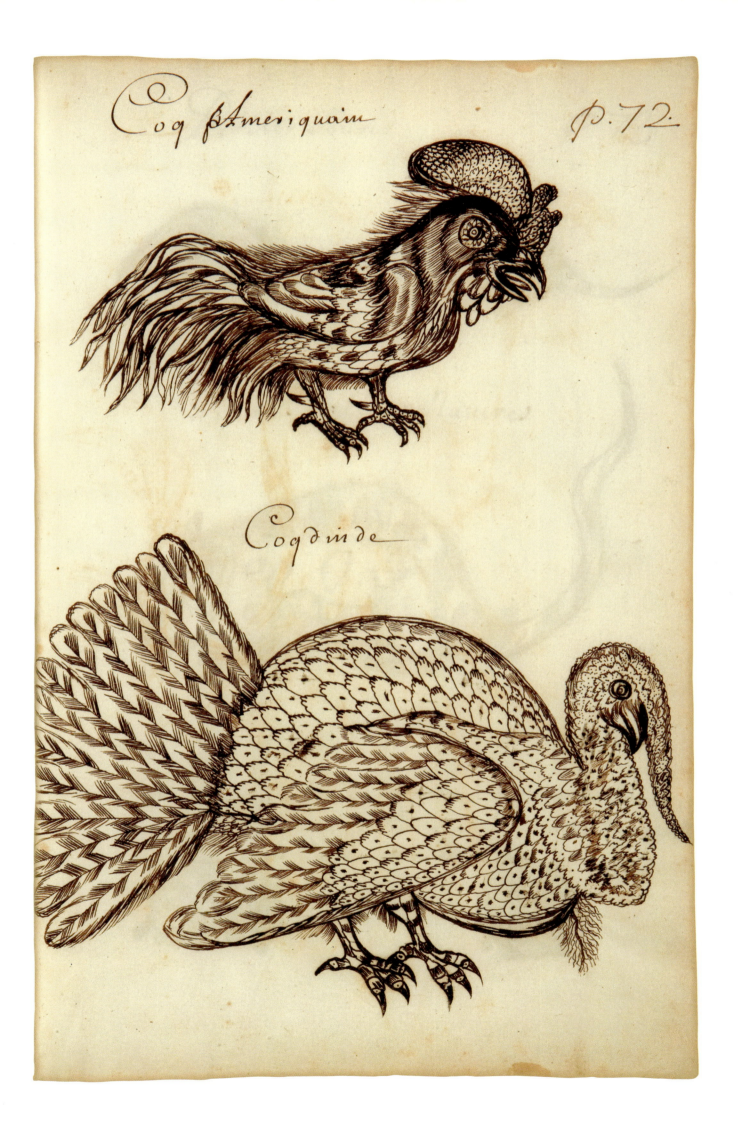

Coq d'Ameriquain

p. 72.

Coq d'inde

Small mice
Large ship rat
Rabbits of the Island of St Bonaventure and the Gulf of
 the St Lawrence River, which is larger that the whole
 Mediterranean Sea

Petites Souris
Grand Rat des Navires
Lapins de LIsle de st. Bonne advanture dans / Le golphe
 du fleuve de st. Laurent qui est plus grand / que toute La
 mer mediteranneé

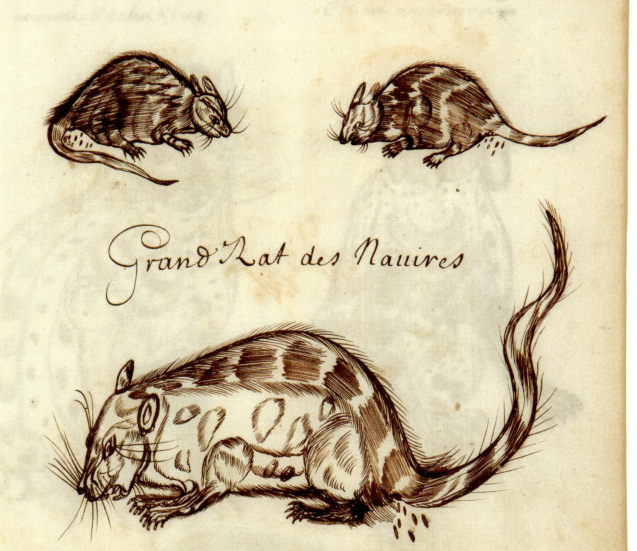

Grand Rat des Navires

Lapins de L'Isle de St Donne aduanture dans
Le golphe du fleuue de St Lauuent qui est plus grand
que toute La mer mediterannee

American cat called *kachakins*
Errars, or *arim*, American dog
Aper, or boar of Virginia, called *couiscouis*

Chat ameriquain / nomme kachakins
errars ou arim / Chien ameriquain
Aper ou sanglier de La virginie qu'on nomme la / Couiscouis

Chat ameriquain
nomme Rachakins

cuvars ou avim p. 74.
Chien ameriquain

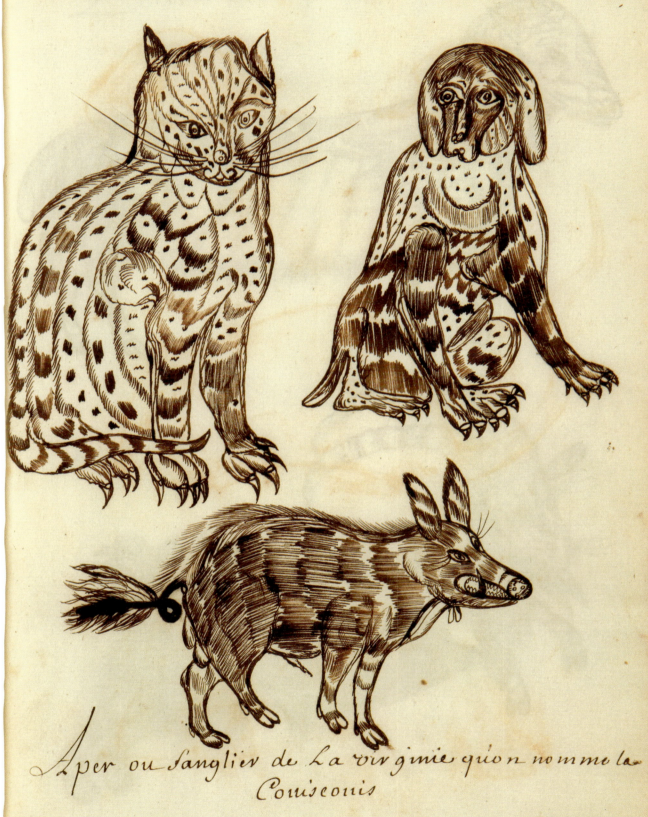

Aper ou sanglier de La virginie quion nomme la
Couisconis

PL. LXXV

American ewe
Hircocervus [goat-stag]

Brebis ameriquaine
hircoser

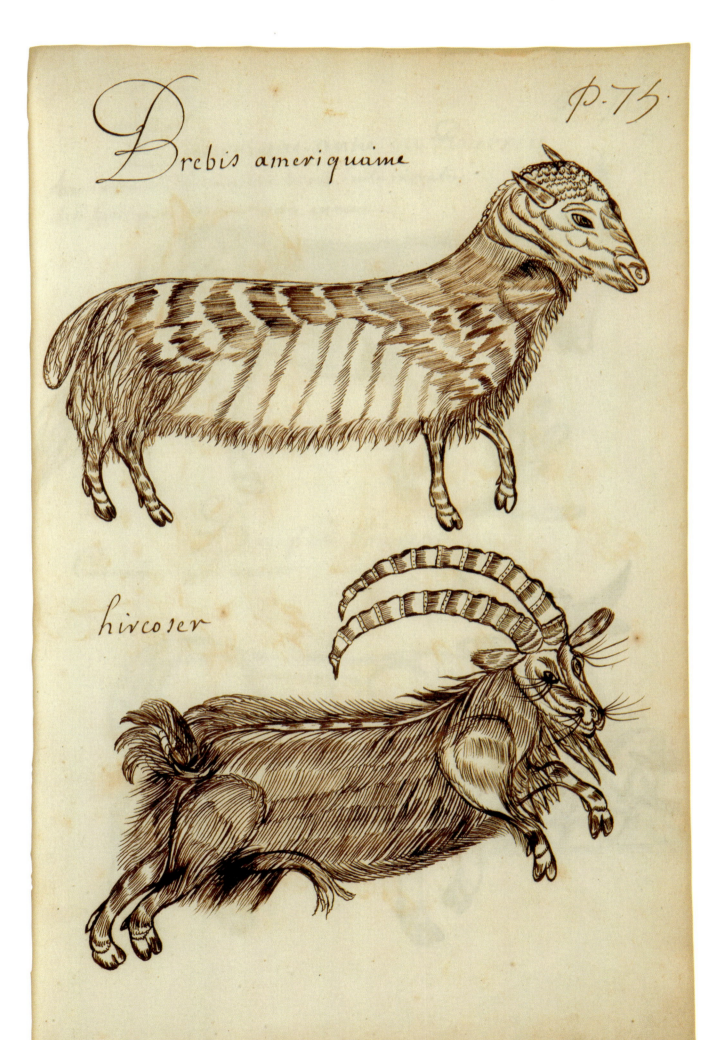

Brebis ameriquaine

hircoser

Donkey or Ass. *Arri animal tardum quae te res lente moratur / Arri fustigera bestia digna manu*
Ox or bull. *Cornuferi ipse caueto*

Bourique, anne ou Bourrou / Arri animal tardum quae te res lente moratur / Arri fustigera bestia digna manu
Boeuf ou Toureau / Cornuferi ipse caueto

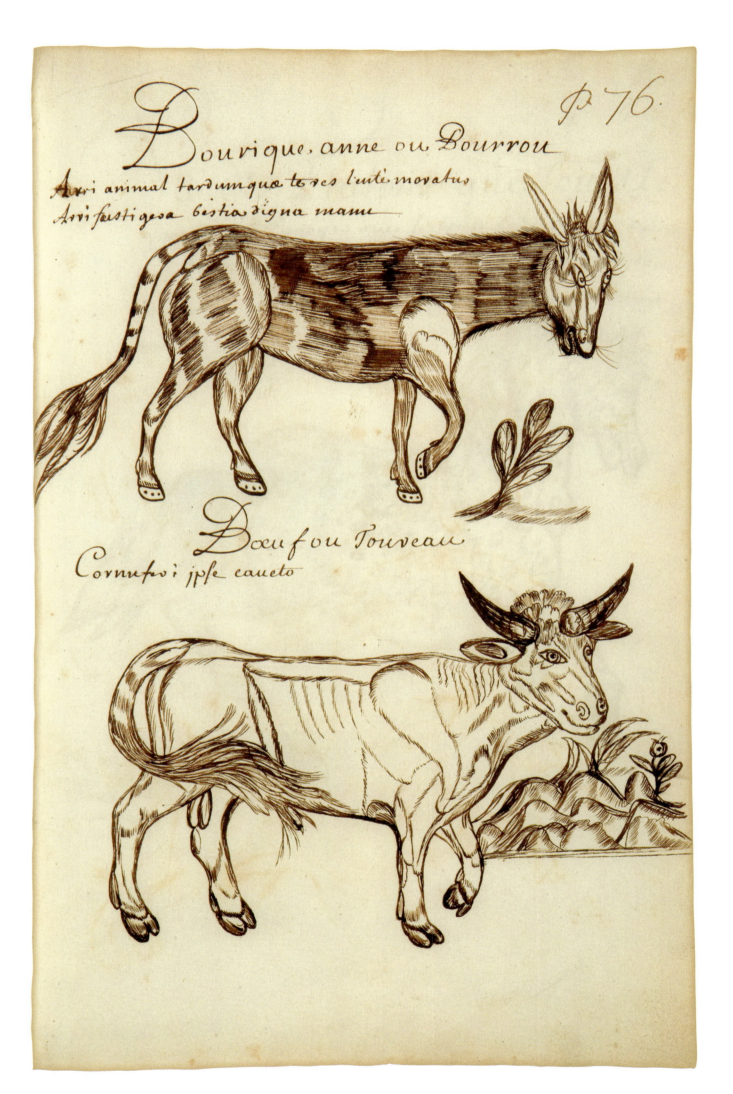

Dourique, anne ou Dourrou

Arri animal tardumque teres lentè moratus
Arri festigosa bestia digna manu

Dœuf ou Touveau

Cornutoi ipse caueto

One of the stallions that Louis the Great sent with sixty fine mares to New France more than thirty years ago. From them were bred some very fine horses, as we have seen.

Vu [Un?] des Etalons que Louis Le grand fit Envoyer avec soixante belles Jumens dans / La Nouvelle france Il y a plus de trente ans dou / sont sortis de hAras de tres Beau chevaux comme / nous l avons Vue

Vu des Etalons que Louis Le
grand fit Envoyer avec soisante belles Jumens dans
La Nouuelle France Il y a plus de trente ans dou
son sortis deshras detres beaux cheuaux comme
nous l'auons Vu —

Horse of New Holland in America and Upper Virginia on
the shores of the Illande Sea

Cheval de La Nouvelle holand^e / En amerique et haute
virginie sur les rives de la mer hIllande

Cheual de La Nouuelle holand

En amerique et haute d'irginie fur les riues de hamessllande

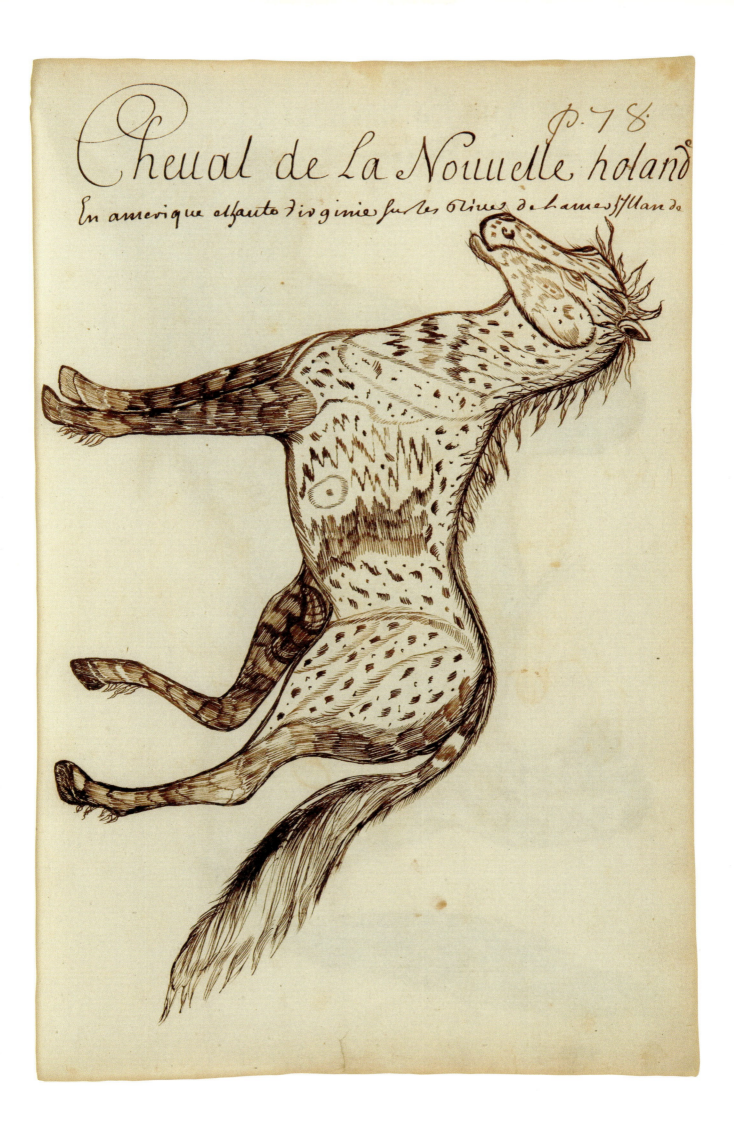

PL. LXXIX

Large ox of New Denmark in America

grand Bœuf du nouveau / D'Anemar En amerique

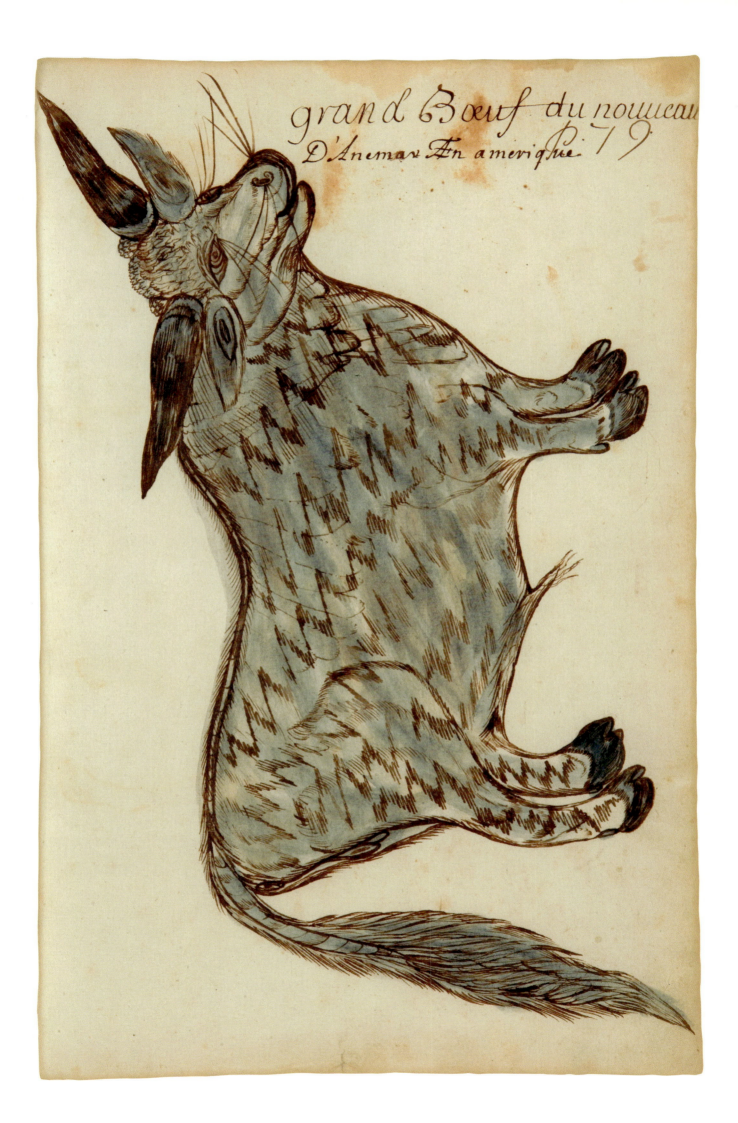

grand Bœuf du nouueau
D'Anemar En amerique. P. 79

THE NATURAL HISTORY

OF THE

NEW WORLD

TRANSLATOR'S PREFACE

Translating a text written several hundred years ago involves questions about how language has changed in the centuries between composition and translation.[1] Two contrasting approaches are possible. The translation can adhere to the wording of the original as closely as possible, while making a comprehensible text. On the other hand, it can depart more or less freely from the original wording in order to express what the translator takes to be the intended meaning.

Advocates of both approaches call for fidelity to the source text, but in different ways. Some prefer to set the translator free from the wording of the original in order to transmit its underlying sense, or to produce, for a public contemporary with the translator, an impression comparable to the one produced by the original work.[2] In contrast, particularly in the context of literary works, some writers consider that serious readers should be willing to make the effort necessary to understand a different way of thinking, and they object to what they judge to be over-adaptation.[3] In practice, translators usually adopt some combination of these two approaches.

In the case of the "Histoire naturelle," a text-based rendering is most appropriate, because of the nature of the work and its historical interest. The question of adaptation to an audience rarely arises, although a particular point will be discussed below. Most of the text consists of descriptions of species; however, other material is included, digressions are frequent, and the author at times indulges in rhetorical effects.

Louis Nicolas's sentences are sometimes long and hard to follow, and the frequent use of commas instead of periods often obscures the divisions between sentences. On occasion we even find ungrammatical sentences in which the author presumably lost track, as in his discussion of *le citron* (f. 11). In by far the greater part of the translation, we follow Nicolas's sentence structure closely, on the basis of the modernized punctuation in R. Ouellet's transcription. We have made changes only when necessary for comprehension.

The fact that the meanings of some words can change with time while others continue unchanged can pose problems for translators. A notable case is the title of the work, which if translated literally ("Natural History of the West Indies"), might lead readers to expect descriptions of tropical flora and fauna instead of northern ones. We are grateful to Germaine Warkentin for suggesting "New World" for "Indes occidentales."

1 This preface is based on Nancy Senior, "Of Whales and Savages: Reflections on Translating Louis Nicolas' *Histoire naturelle des Indes occidentales*," although the article comes to a different conclusion about the translation of one word.

2 This view is held by Eugene Nida, especially in the context of biblical translation (see among many other works *Toward a Science of Translating*), and by Danica Seleskovitch in her studies of translation and interpretation (see D. Seleskovitch and M. Lederer, *Interpréter pour traduire*).

3 See Friedrich Schleiermacher's famous essay, "On the Different Methods of Translating," in André Lefevere, *Translating Literature: The German Tradition from Luther to Rosenzweig*, and Antoine Berman's view that readers should test their view against a foreign one (*The Experience of the Foreign: Culture and Translation in Romantic Germany*, tr. S. Heyvaert).

In the text itself, one of Nicolas's favourite adjectives is *rare*. All sorts of things are *rare*; indeed the subtitle of the "Histoire naturelle" promises "tout ce qu'il y a de rare dans les Indes occidentales." For him the word is usually a general term of praise: the traveller will find "mille petites raretés" along the shores of the Great Lakes (f. 2). The fruit that he calls the *pomme de terre* (which is not the potato) "n'a rien de rare que sa beauté" (f. 18). Sometimes the word is used in the usual present-day sense of unusual or hard to find: the *oranger américain* is "un arbrisseau rare, qu'on ne voit que dans la Virginie, le long du fleuve de Techiroguen" (f. 21). "Les chardons ne sont pas rares; il y en a de toutes les espèces" (f. 9). Sometimes, on the other hand, the term is applied to things that are abundant: chipmunks are "ces rares animaux," although one sees "des grandes bandes" of them (f. 50).

In translating *rare*, we have used the corresponding English term "rare" where rarity seems to be indicated. In other cases, we have used words such as "fine." We have taken a similar approach for the adjective *beau*, which is translated as "beautiful," "fine," or another word, depending on the context, and *curieux*, which, like the English "curious," could at the time have had many meanings, including "odd," "unusual," or "interesting."

Another frequent adjective is *admirable*, used at times in the present-day sense of "laudable" and at others in the older sense of "surprising" or "astonishing."[4] Among the many things that Nicolas finds *admirable* are the firefly, porcupine quills, the compartments of a beaver lodge, the size of the large trout, the cries of bears in their den, and the fact that the flying squirrel's "wings" are covered with hair like the rest of its body. When he says that the story of the two male finches (f. 10) is particularly *admirable*, it is not clear which meaning he has in mind.

The practices of native people include many *admirable* things. Among them are stews made of fat from moose intestines (f. 99), the way of hunting the *tigre marin* by using arrows attached to a hide rope (f. 121), and the technique of catching whitefish by using nets spread out under the ice (f. 179). It is clear from the context that Nicolas admires (in our modern sense) the hunting and fishing techniques in question. However, from his description of the stew, one may guess that he

does not find it appetizing. For *admirable*, as for *rare* and other adjectives, we have tried to understand the meaning and to supply an appropriate word, often "admirable" but sometimes another term such as "remarkable."

As the present Introduction points out, Nicolas classifies animals according to their habitat, a system that was commonly used in the seventeenth century and is found as early as Aristotle's works. The section on birds includes insects, which, like birds, live in the air; the one on fish includes aquatic mammals such as the whale and the porpoise, which are specifically referred to as *poissons*. Nicolas is quite aware of physiological differences between the different species. He says of the whale: "Ce poisson a des poumons, des reins, une vessie [this fish has lungs, kidneys, a bladder]," and states that porpoises are born alive and are nursed by their mother.

This use of the French word *poisson*, like the English "fish," was normal for the time. The entry on *poisson* in the *Thresor de la langue française* (1606) includes soft-fleshed animals such as the cuttlefish, shellfish such as oysters, and "Toute sorte de fort grand poisson, comme balaines [all kinds of very large fish, such as whales]." The entry in the 1694 *Dictionnaire de l'Académie Française* begins with the definition: "Animal qui naist, & qui vit dans l'eau [animal that is born and lives in water]," and the same definition appears in the 1798 edition of this dictionary. Only in the 1835 edition do we see the more restricted modern definition: "Animal à sang rouge et froid, qui respire par des branchies, et qui naît et vit dans l'eau, où il se meut à l'aide de nageoires [red-blooded, cold-blooded animal that breathes by means of gills, and which is born and lives in water, where it moves with the help of fins]." Similarly, Samuel Johnson's *Dictionary of the English Language* (1775) defines "fish" as "an animal that inhabits the water," and quotes Shakespeare's reference in *A Comedy of Errors* to "the beasts, the fishes, and the winged fowls" (the same division by habitat that one finds in the "Histoire naturelle"). A modern reminder of this usage remains in the word "shellfish."

The use of "fish" in the translation to refer to porpoises and whales is thus not simply a literal translation; nor is it a reflection of ignorance on Nicolas's part. Even Linnaeus began by classifying these animals as a

4 The *Dictionnaire de l'Académie Française* gives the following definition of the verb *admirer* in its 1694 and 1798 editions: "Considérer avec surprise, avec estonnement une chose qui est extraordinaire *en quelque manière que ce soit* [to consider with surprise or astonishment a thing that is extraordinary *in any way at all*]"

(emphasis added). Only in the 1835 edition is the definition limited to a favourable sense: "Considérer avec un étonnement mêlé de plaisir, ce qui paraît beau, ce qui paraît merveilleux [to consider with astonishment mixed with pleasure something that appears fine or marvellous]."

special group of fish; only in later editions of the *Systema naturae* did a new classification, *mammalia*, appear. It might thus be said that in Nicolas's time, the whale *was* in fact a fish.

Even a reader with a good general knowledge of seventeenth-century language and literature may have difficulty with specialized subject areas. A particularly hard part of the treatise to translate was the section on falconry. Although Nicolas states that falconry is not practised in the New World, he nevertheless writes many pages about it, giving, as he says, "un extrait de tous les auteurs anciens et modernes." Some passages (see f. 151, for example) seem to have no purpose except to display as much terminology as possible, without any real content.

An enormous challenge, although one not related primarily to translation, has been the task of establishing the identity of the various species of animals, plants, birds, and fish mentioned in the "Histoire naturelle." The *citronnier* is certainly not what we normally call lemon. What is the "devil's child"? What is the "dead bird," believed by native people to be the soul of a dead person? This challenge has been ably met in the notes of François-Marc Gagnon, with the assistance of experts in various specialties.

In the end, one of the hardest things to translate was the apparently simple word *sauvage*.[5] To refer to native people, Nicolas uses a variety of terms, including *Américain* or *Amériquain, Indien, habitant, coureur de bois, naturel du pays,* and other more limited or localized ones such as *Huron, Virginien, Outtagami, Manataoué,* and *Outtaouak*. However, he most frequently uses *sauvage* and *barbare*,[6] terms that pose problems for translators. Although these words could certainly be pejorative in the seventeenth century, they were not always as unfavourable as they seem today. Nicolas's usage is often neutral. In describing the strawberry, for example, he writes: "la fraise que les sauvages nomment

le fruit du coeur" [the strawberry that the *sauvages* call the heart fruit]." In discussing the wood of the walnut tree, he says: "Les barbares s'en servent pour faire des arcs [the barbarians use it to make bows]." And he is aware of the ambiguity of his vocabulary. He speaks with admiration of the way "ces barbares, qui n'ont que le nom de sauvages [these barbarians, who are savages in name only]" make ropes of moose hide (f. 96).

It is quite true that Nicolas is biased in favour of Europe and European culture. And there is no question that, being a missionary, he considers Christianity to be the one true religion. He refers, for instance, to certain beliefs and practices of native people as "aveuglement [blindness]" (f. 37), "jonglerie [charlatan's art]" (f. 124), and "danses … superstitieuses [superstitious dances]" (f. 125). However, these views are to some extent balanced by the many occasions in the "Histoire naturelle" when he expresses admiration for native people and treats Europeans with irony.

How, then, to translate *sauvage*? It is not symmetrical with the English "savage"; the meaning of the current French word *sauvage* has changed less than that of the the English "savage." The bilingual *Robert et Collins Senior* dictionary (1993) gives as English equivalents of the French *sauvage*: "wild," "savage," "unsociable," "unauthorized," and so on. Thus, a wild flower is *une fleur sauvage*, an unsociable man is *un homme sauvage*, and unauthorized camping is *du camping sauvage*. On the other hand, the French equivalents given for the English "savage" are *brutal, méchant, féroce, virulent, furieux, colérique* – all strongly pejorative terms. Other meanings of the French *sauvage*, such as "not domesticated" or "uninhabited," are expressed in English by the adjective "wild."[7]

Seventeenth-century English writers – particularly those who dealt directly with aboriginal people – were less likely to refer to the native people of the Americas as savages than were French writers. For example,

5 The French word *sauvage*, like the English *savage*, comes from Latin *silvaticus* (of the forest).

6 Nicolas uses *sauvage(s)* 154 times as a noun or adjective referring to the people or their language (that is, not counting descriptions of wild plants or animals such as *la fraise sauvage, le boeuf sauvage*); *sauvagesse(s)* is used 5 times and *sauvageons* once, for a total of 160 times. He uses *barbare(s)* 27 times; *Indien(s)* 28 times and *Indienne(s)* 8 times, for a total of 36 times; *Américain(s)* 39 times and *Américaines* twice, for a total of 41 times. In sum, various forms of *sauvage* and of *barbare* together occur 187 times; forms of *Indien* and *Américain*, 77 times.

7 One of the most famous literary references to the *sauvage* occurs in Montaigne's essay "Des cannibales." The author takes advantage of the double nature of the

word and its reference both to natural species and to human beings. People called *sauvages* are savage/wild only in the sense of being natural and unspoiled: "Or je trouve, pour revenir à mon propos, qu'il n'y a rien de barbare et de sauvage en cette nation, à ce qu'on m'a rapporté, sinon que chacun appelle barbarie ce qui n'est pas de son usage […] Ils sont sauvages, de mesme que nous apellons sauvages les fruicts que nature, de soy et de son progrez ordinaire, a produicts: là où, à la vérité, ce sont ceux que nous avons alterez par nostre artifice et detournez de l'ordre commun, que nous devrions appeller plustot sauvages." (Michel de Montaigne, *The Essays of Michel de Montaigne*, M.A. Screech ed.). Translators use, with varying degrees of success, different means of capturing the double sense of the word.

Thomas Harriot[8] calls them "the inhabitants" or "the natural inhabitants"; John White, Bartholomew Gosnold, John Smith, and William Strachey speak of "the inhabitants"; Strachey, Gabriel Archer, Andrew White, Roger Williams,[9] and George Fox (Fox 1672) say "Indians." Other terms are used, sometimes by the same writers: Williams says "natives," Smith "the people," "the naturals," and "the country people." "Savages," although not so frequent as the French *sauvages*, is used by Archer, Smith, Ralph Hamor, John White, and occasionally by Harriot and Strachey.[10]

In the twentieth century, translators have used both "savages" and "Indians." *Sauvages* is rendered as "savages" in Annie N. Bourne's translation of Champlain's *Voyages de la Nouvelle France occidentale, dite Canada*, 1632 (Champlain 1911), in Reuben Gold Thwaites's translation of the *Relations des Jésuites* (*Jesuit Relations* 1896–1901) and the subsequently published extracts (*Jesuit Relations* 1925, and other editions), in H.H. Langton's translation of Sagard's *Grand Voyage au pays des Hurons*, 1632 (Sagard 1939), and in the translation of Thevet's 1586 *Grand insulaire* by Roger Schlesinger and Arthur P. Stabler (Thevet 1986). "Indians" is chosen in William F. Ganong's English version of Leclercq's *Nouvelle Relation de la Gaspésie*, 1591 (Leclercq 1910), Mrs Clarence Webster's version of Dièreville's *Relation du voyage du Port Royal de l'Acadie ou de la Nouvelle France*, 1708 (Dièreville 1933), and W.N. Fenton and E.L. Moore's version of Lafiteau's *Moeurs des sauvages américains comparées aux moeurs des premiers temps*, 1724 (Lafiteau 1974). This sample thus includes four translators between 1896 and 1986 who choose "savages" and three from 1910 to 1974 who choose "Indians."[11]

In the "Histoire naturelle" we have in most cases translated *sauvage* as "native," because that was one of the most common English terms used in Nicolas's time, and is still in current use. It also corresponds to the contrast that Nicolas often makes between the *Français* or European settlers, and the native people, also called *Américains*, *Indiens*, and *naturels du pays*.

Whatever translators do, they run the risk of falsifying or even betraying the author. In translating the "Histoire naturelle" we have chosen various strategies depending on the material involved. In most cases we follow Nicolas's wording closely, as the purpose of the translation – to make Nicolas's work and thought available to readers today – is different from that of

8 See *Virtual Jamestown: First-Hand Accounts of Virginia, 1575–1705*, Crandall Shifflett 2000, <http://etext.lib. virginia.edu/etcbin/jamestown-browse?id=J1009>. This site includes texts by sixteenth- and seventeenth-century writers such as Gabriel Archer, Bartholomew Gosnold, Ralph Hamor, Thomas Harriot, John Smith, and John White. Another useful site is *Documents of the Early South*, http://smith2.sewanee.edu/courses/ 391/DocsEarlySouth/00DocsEarlySouth.html.

9 While Williams's own terms are "Indians" and "natives," he does refer ironically to the use of other words by other European settlers. He writes: "It is a strange truth that a man shall generally find more free entertainment and refreshing among these Barbarians, than amongst thousands that call themselves Christians" (Williams 1963, 46).

10 Thomas Harriot, *A Briefe and True Report of the New Found Land of Virginia* (1588); John White, *The True Pictures and Fashions of the People in that Parte of America now called Virginia* (1588); Bartholomew Gosnold, "Master Bartholomew Gosnold's Letter to his Father, touching his first voyage to Virginia" (1602); John Smith, "Instructions by Way of Advice, for the Intended Voyage to Virginia" (undated, early 17th c.) and *General History of Virginia* (1624); William Strachey, *The History of Travel into Virginia Britannia* (1612); Gabriel Archer, *The Relations of Captain Gosnold's Voyage to the North Part of Virginia* (1602); Andrew White, "The Natural Disposition of the Indians (1640); Roger Williams, *A Key into the Language of America* (1643); George Fox, *Travels in Virginia and North Carolina* (1672); Ralph Hamor, *A True Discourse of the Present Estate of Virginia* (1615).

11 Although Thwaites uses the term "savages" to reflect the authors' French usage in the *Relations des Jésuites*, when speaking in his own voice in the introduction he usually says "Indians." More recently, no doubt as a result of concerns about the connotations of "savages," the translators of F.J. Lafiteau's *Moeurs des sauvages ameriquains* explain: "*Sauvages* we have rendered as 'Indians' because it has come to be the generic term for the aborigines of the New World and their descendants." Their English title is thus *Customs of the American Indians*.

The reverse has occurred in the case of Jacques Cartier's *Voyages*. H.P. Biggar's translation, published in 1924, renders *sauvages* (or, in Cartier's spelling, *sauvaiges*) as "Indians" or uses other terms, depending on the context. Sometimes *femme* becomes "woman," occasionally "squaw." In a 1993 English edition of the *Voyages*, the introduction by Ramsay Cook states that the translation is that of Biggar with the exception of "some minor but interesting alterations and corrections." According to Cook, "Cartier never used the words 'Indian', 'squaw', 'chief', 'tribe', or 'wigwam'. On those occasions where Biggar used them I have reverted to translations of Cartier's terms: 'sauvaige', 'homme', 'gens du pays', 'femme', 'peuple', 'seigneur', 'maison'. These words better express Cartier's outlook and, in some cases, our own" (Cartier 1993, vii–viii).

Nicolas – to make the flora and fauna of Nouvelle France known to the French reader of his time. The challenge for translators, editors, and readers today is to provide a more nuanced understanding by placing his writings in the intellectual and linguistic context of his time.

Louis Nicolas divided the *Natural History* into thirteen books, a structure that allows him to group together in Book 4, for instance, land-dwelling four-legged animals, or birds of prey in Book 10. Marginal notes in the original manuscript also indicate the division of the work into eight "cahiers," which don't bear on Nicolas's organizational scheme but refer to the material aspects of the manuscript. We have noted the division into cahiers in our modernization and translation of the work.

I wish to thank Wayne Hudson for his part in the work of translation, especially for his invaluable contributions in the early stages.

NANCY SENIOR

NATURAL HISTORY,

or the faithful search for everything rare in the New World, treating in general and in particular: Simples, flowers, grains, herbs, fruits, bushes, trees, four-footed animals living on land and in water, birds that live on land and those that live above or in water; and finally fresh-water fish, and some salt-water ones; various insects, and several reptiles, with their figures. Divided into twelve books.
By M. L.N.P.

BOOK ONE

My God, how I regret embarking on an enterprise as difficult as this one of making an account of the New World, where there are so many things to say; and in which, not knowing where best to begin, I confess that I am in great difficulty; for what likelihood is there that, even after twenty years of assiduous work and repeated great travels, I can say all that is necessary about so many fine curiosities of a foreign country, where everything is different from ours? How can I reduce into a small space so many vast lands, and speak in few words of so many different objects about which, if I tried to speak thoroughly, I would never finish? Therefore, leaving aside all other remarks, I will strive to convey to you the state of natural things in a country whose limits we have not yet discovered, although we have seen men who came from five hundred leagues beyond the twelve hundred that we have travelled, either on the Saint Lawrence River, or beyond its source, which we have not yet discovered, although we have been nine hundred leagues beyond its mouth and the place where it flows into the great ocean between the famous island of Newfoundland and that of Bacailos.[1]

Let us first describe an almost infinite country where you will see a remarkable variety of mountains, among others the famous *KicKic Kinouapikouatina*, which in the local language means the great long mountain range; it extends nearly a thousand leagues, beginning in the country of the Eskimos and ending in that of the Nadouessiouek.[2]

It is a wonderful thing to see innumerable fountains, streams, rivers of all sizes, great lakes and innumerable small ones rising from this terrible mountain range covered with thick forests [f. 2] of tall trees interspersed with horrible precipices, frightful caverns, wide valleys, open country as far as the eye can see, great hills full of animals and of several nations of men who, although not numerous, nevertheless have many remarkable things that can be said of their customs, their government, their religion and their sacrifices, as I touch on them in my last works.[3]

If in addition to all that you wish to observe in our Indies, innumerable other mountains, plains, valleys, hills, woods, boulders, precipices, heights, depths, grass lands, brushes, quick sands, savannas that are expanses where one can walk only when there is hard frost, plains extending four hundred to five hundred leagues with stones, rocks, grasses, fruits, rises and falls, good and bad land, cold, heat, ice, snow, rain, frost, fog, storms, earthquakes, unknown animals, birds of innumerable kinds unknown in Europe, fish of enor-

1 The *Carte generale* of the *Codex* has an "I. Bacaylos" south of Cape Breton and north of Nova Scotia.

2 The Sioux. The *Carte generale* of the *Codex* situates the Passinassiouek near the isthmus between Lake Huron and Lake Superior. This was not their habitual abode, which was to the west of the Mississippi, but rather a place where Nicolas might have met them.

3 The author is referring to his *Grammaire algonquine* (BNF, fonds américain, 18954m 13ff). The text has been published by Diane Daviault, *L'algonquin au XVIIe siècle. Une édition critique, analysée et commentée de la grammaire algonquine du Père Louis Nicolas*.

mous size and surprising appearance, and many other things, you will find it all. In particular you will discover very beautiful large lakes, white waters, waterfalls in the middle of the rapids and rocky outcrops where there are often terrible shipwrecks, as I show in my first six books. You will note, in passing through this great land, diamond stones at the foot of a mountain which bears the name of Cape of this precious stone;[4] you will see marbles of all colours, on the banks of the greatest river in the world. In the land one sees coal, plaster, marcasite, flint, stones to make darts, lances, and axes in the traditional style of the Americans.

Under the Montmorency waterfall[5] and under the cascades of the Calumet waterfall[6] you will see stones suitable for making pipes coloured grey, white, black and green. If you want red ones, you have only to climb onto the high mountain seen on the north shore of the Tracy Sea or the great Lake Superior,[7] which the Indians call the great lake. In the country of Nadouessiouek you will buy turquoises which they hang from their ears, from the end of their nose or around their neck; you will obtain very cheaply that other kind of very beautiful blood-red stone, of a very fine and delicate grain. And if it strikes your fancy to build, there is no shortage of limestone, or of fine quarries. On river banks and on the wide shores of the Great Lakes you will find a thousand little rare things, shells and beads of all colours, stones of all colours and of various attractive shapes. Building stone of all grains is not rare. Stones for mills are common; one finds all kinds of instruments for sharpening. Tuff and pumice are very useful for cleaning the skins of wild beasts which the natives kill; for those are the only instruments that they need for such tasks.

Search if you will in the sands of the great sand hills [f. 3] and on all the shores of the Tracy Sea; you will find minerals and fine ingots of red copper, as handsome, as purified and as fine as if it came directly from the furnace. Lead is in the Ouchepé cove[8] and on the shore of a lake that is on the northern lands and in the country of the Outimiskami nation.[9] The slate bed of Lake Champlain is famous, and the lead mine that has been discovered there will perhaps one day supply as much of this metal as necessary for the needs of the whole country.

Iron is there in abundance in the Cap de la Madeleine area,[10] and there is some talk of silver near the Ile aux Coudres,[11] but that is not certain.

On your travels and among all these marvels, you might sometimes be surprised by some fearful earthquake; there have been more than ten of them in my time. The sea is sometimes so agitated that one can hardly comprehend it. A few years ago we saw quite terrifying movements of the earth; mountains separated in two, the course of rivers was changed, trees were uprooted, lands collapsed, rocks were seen flying into the air, and sea monsters roared in an astonishing manner.[12]

In these occurrences the ships suffered terrible shocks on the extraordinary seething of the water. They were obliged to leave their anchors in the sea to head for the open waters; but despite that, they suffered under their keel from the strange movements of the waves which, withdrawing with amazing speed before they realized it from under the ships, these vessels fell suddenly with a strange cracking in all their parts, with danger of being engulfed at any moment.

One sometimes feels winds so strong that people have to hold on to each other for fear of being carried away. Sometimes there are winds that melt all the ice, and refreeze it at the same time, and others on the contrary that freeze it and melt it in turn. As for telling you now how that can happen, I will leave you to think about it, following the advice of those who have told me that if I wished to please persons of the finest taste I should not make any reflections on what I had to say. Thus, finding their advice very judicious, I will try to omit everything that seems to be unnecessary, restricting myself to the most succinct narration of what I have to say.

The remark that I have made concerning the difference of days and nights is worth my stopping a moment to consider it. The day in France is a little more than six hours ahead of that in the Indies; I have proven this by the eclipses marked in the almanacs. This is an easy matter; one has only to note the hour at which an

4 Cape Diamant, on which Quebec City is built.
5 Montmorency Falls, near Quebec City.
6 Probably Grand Calumet Falls on the Ottawa River.
7 In a map from the Jesuit Relation of 1672, Lake Superior is called "Lake Tracy."
8 Could refer to the west end of Lake Superior, where Father Allouez found members of the Chippewa, also referred to as Otchipwe (Ojibwa).
9 The Timiskaming, a band of Algonkin people, living near the lake of the same name, in Quebec; see White, *Handbook of Indians of Canada*, 455. Henceforth White.
10 Near Trois-Rivières, Quebec.
11 Island of the St Lawrence River, above Quebec, near Baie-Saint-Paul.
12 Allusion to the famous 1663 earthquake; see Michel Bideaux, "Le discours de l'ordre et le séisme de 1663," *Revue de l'Université d'Ottawa/University of Ottawa Quarterly*, vol. 48, 1978, 62–83.

eclipse occurs in France, and if one finds that it occurs in the Indies only at the hours that I mark, what I say will be conclusive.

[f. 4] After these general remarks, which do not a little for the knowledge of what I have already said, and what I have yet to tell you, allow me say that I would take great pleasure in seeing you not on Lake Maggiore in Italy, nor on that of Lake Ygrada or Lake Yesso¹³ nor on Lake Como or Lake Constance or even on the lake of Geneva. Those lakes are too small, and are so to speak only frog ponds, and do not deserve the name of lakes among the Americans; nor on innumerable *sakaigans*. This is a name that the natives give to a great number of small lakes that are everywhere in the Indies, much larger than those that I have just named, and which they do not consider real lakes, giving them this disdainful name, as if to say the *sakaigans* are only frog ponds, even though the *sakaigans* are twenty or thirty or even forty leagues around. The fresh-water seas on which they navigate on tree barks are their lakes. The great sea Ocean is the lake par excellence. The Stinking Lake¹⁴ is a powerful genie, they say, to which they make sacrifices: *Manitou-kitchi-gami*, which means the genie of the great lake. Techiro-gouen¹⁵ is one of the smallest. Those of Saint Pierre,¹⁶ Saint Louis,¹⁷ Saint François,¹⁸ Saint Jean, the Saint-Sacrement,¹⁹ the Lake of the Mountains,²⁰ that of the entry of the Creuze River,²¹ the lake of the Abenaquis, which together would make more than 300 leagues around, are not lakes; they are only *sakaigans*. Lake

Champlain, although it is 200 leagues around, Mistassini at 300 leagues,²² Nipissing²³ at 100, Ontario at more than 300, Erie at 300 are only some of those little stars below those of the first magnitude, which extend to 500, like the freshwater sea of the Northern Algonquins,²⁴ like the Tracy Sea at 700, and finally the Mitchigané or Lake of the Illinois,²⁵ which means the lake of men, has a shoreline of 1,400 leagues, with a little high and low tide, which one sees also in the Alimibegou,²⁶ which is another lake on the north side, ten good days away from Lake Superior. Alimibegou is only 400 leagues around. I say nothing about the lake of the Kiristinons,²⁷ which is very large according to these nations, for I have not seen it, although I have passed near it.

That is what I can say in general about a country which I have examined thoroughly, as you have already been able to judge from my first works,²⁸ and as you will acknowledge from eighteen books which I still have to produce.

Treatise on simples, flowers, grains, and herbs that grow naturally and artificially in the country of the New World.

The amaranth,²⁹ the anemone of various colours,³⁰ the hawthorn³¹ larger and much more beautiful that that in France, even its fruit, which, in this country, is as large as hazelnuts, so that the inhabitants [f. 5] give

13 Lake Garda or Lake Ieso.
14 Galinée made a map of the lake region, in which Lake Michigan is called "Lac des Puants," and there also appears on his map a "Nation des Puants," on the west shore of this lake.
15 On folio 9, "Thechiroguen" designates a river, probably the Hudson River.
16 Lac Saint-Pierre is a natural enlargement of the St Lawrence River, about 80 km (50 miles) downstream of Montreal.
17 Lac Saint-Louis is in extreme southwestern Quebec, adjoining the Island of Montreal at the confluence of the St Lawrence and Ottawa rivers.
18 Lac Saint-François borders southeastern Ontario, southwestern Quebec, and northern New York State. It is located on the St Lawrence River between Lake Ontario and Montreal.
19 Lake George, New York State.
20 Lac des Deux Montagnes.
21 The Mattawa River, Ontario.
22 Lake Mistassini is the largest lake in the province of Quebec. It has an area of approximately 2,200 sq km (840 sq mi). It drains into the Rupert River, which rises in the lake and flows west to James Bay. A chain of

islands extends across the lake, nearly dividing it in half. Its indigenous name, meaning "great stone," refers to a large rock in the lake.
23 Lake Nipissing, north of Georgian Bay, in Ontario.
24 Lake Huron.
25 Lake Michigan.
26 Lake Nipigon, which discharges into Lake Superior, Ontario; see White, 19.
27 Or Kristineaux, as they are habitually designated in French. These are the Cree; see White, 117–21.
28 Another reference to his *Grammaire algonquine* and possibly other works unknown to us.
29 Or *Amaranthus retroflexus* L., red-root pigweed, or *Amaranthus graecizans* L., related amaranth, the two species found in Quebec; see Marie-Victorin et al., *Flore laurentienne*, 1964, 198–9. Henceforth "Marie-Victorin."
30 *Anemone* sp. Recorded in New France by Boucher in 1664 (see Jacques Rousseau, "Pierre Boucher, naturaliste et géographe," in Boucher, *Histoire véritable et naturelle …, 1664*, 262–400. All references to J. Rousseau, unless specified otherwise, are to this book, henceforth referred to as Rousseau 1964. Rousseau suggested *A. pulsatilla* L. (synonym: *Pulsatilla vulgaris* Mill.), pasque flower, and *A. coronaria* L. If Nicolas also included

Natural History, or the faithful search for everything rare

it the name of apple, the crown imperial,[32] the wild rose[33] or wild columbine[34] particular to the country, that is, the hummingbird flower, the wallflower[35] of various colours and different fragrances; the gladiolus[36] or the iris[37] in three kinds, native and particular to the country, the imported white lily,[38] the red one common to the country[39] (they flower only at the end of July),

the European lilac,[40] very fine martagon lilies,[41] other wild martagon lilies which have at least thirty flax-grey[42] flowers on each stalk. The people of these countries boil the bulbs and eat them, and apply them to tumours, which reduces swelling. The daisies[43] here are white. There are white, blue, and flax-grey lilies of the valley.[44] There are only single yellow narcissi.[45] A few

native species, *A. canadensis* L. had already been described before 1620 (see H.O. Juel, "The French Apothecary's Plants in Burser's Herbarium," 177–9; henceforth Juel), and *A. virginiana* L. (Marie-Victorin, 232) was in Boivin, "La flore du Canada en 1708"; henceforth Boivin) (Alain Asselin). Note: In addition to citing written sources, we include the names of our consultant experts in parentheses, to gratefully acknowledge their contributions.

31 Probably *Crataegus punctata* Jacq., punctate hawthorn, since Nicolas compares it to the European species, *Crataegus oxyacantha* L.; see Marie-Victorin, 300–1. J. Rousseau (1937) suggested that it is the hawthorn described by Cartier (see J. Rousseau, "La botanique canadienne à l'époque de Jacques Cartier," 151–236; henceforth Rousseau 1937) and by Boucher in New France in 1664. John Josselyn (see Anonymous, *Proceedings of the Essex Institute*, 1848–1856, vol. 1; henceforth Josselyn) describes it in 1672 in New England as being "in common with England" (Alain Asselin).

32 *Fritillaria imperialis* L., which is not a Canadian plant; native of Iran, Afghanistan, and the Hymalayas, introduced in Europe in 1580; see L. Guyot and P. Gibassier, *Les noms des fleurs*, 107 (henceforth Guyot and Gibassier); see also Hatton, *Handbook of Plant and Floral Ornament*, 456, fig. 917. Hatton reproduces its figure as it appears in John Gerarde, *The Herball, or General Historie of Plants*, 153.12. Alain Asselin notes that it was recorded by van der Donck in New Holland (see Adriaen van der Donck, *Description of the New Netherlands*, henceforth van der Donck).

33 Probably native *Rosa blanda* Ait. and/or *R. johannensis* Fernald (Marie-Victorin, 325) (synonym: *R. blanda* Ait. var. *glabra* Crép., USDA). Van der Donck recorded five introduced roses (white, red, cornelian, stock, and eglantine) in New Holland (Alain Asselin).

34 *Aquilegia canadensis* L.; see Marie-Victorin, 228, who mentions also that the hummingbird visits this flower. Alain Asselin states that it is in Jacques-Philippe Cornut in 1635, henceforth Cornut (J. Mathieu and A. Daviault, *Le premier livre de plantes du Canada*) and already present in the Paris Garden list of 1636 as well as in the Montpellier list of 1697 (Magnol, *Hortus Regius Monspeliensis*, henceforth Magnol).

35 Possibly *Erysimum cheiri* L. Crantz., *E. cheiranthoides* L., worm-seed mustard (Marie-Victorin, 270) and even *Hesperis matronalis* L., dame's rocket (Marie-Victorin, 256), since *Hesperis* used to identify *Erysimum* and *Sisymbrium* (see Boivin). The *Giroflea* of J. Ruel was named *Hesperis* (see Ruel, *De natura stirpium libri tres*).

Boivin identified one plant of the 1708 "Flore du Canada" as possibly *E. inconspicuum* (S. Wats.) MacM. (Alain Asselin).

36 *Gladiolus* is cultivated; 250 species are known. See Père Louis-Marie, *Flore-manuel de la province de Québec*, 116; henceforth Louis-Marie. Alain Asselin notes that *Gladiolus* is interpreted simply as a synonym for *Iris*, as indicated by Nicolas. Mattioli specifies that "glayeul" and "flambe" are synonymous with *Iris*, while the French name for Gladiolus is "glai or glaitel" but not "glayeul" (P.A. Mattioli, *De plantis Epitome utilissima*, henceforth Mattioli).

37 The first two native *Iris* species of Nicolas are likely *I. versicolor* L. (Marie-Victorin, 667), larger blue-flag, and *I. setosa* Pallas, setose blue-flag (Marie-Victorin, 668). The third one is possibly *Sisyrinchium angustifolium* Miller, narrow-leaved blue-eyed grass, since it was already described before 1620 (Juel). Josselyn described in 1672 the medical use of *I. versicolor* L. in New England. Boivin 1708 included *I. setosa* Pallas.

38 *Lilium candidum* L., Madonna lily, already recorded by Boucher in 1664 in New France (Rousseau 1964) and van der Donck in New Holland. Nicolas mentions another *Lilium*, "lys des vallées," and its medical use, in the chapter about the moose. He gives its biblical name, *Lilium convallium*, and says it is called "chevrotin" in Paris. He also mentions that the medicinal extract of *L. convallium* has the same effect as the Celtic nard ("nard de Celte"). This nard was probably *Valeriana celtica* L. (Alain Asselin).

39 *Lilium philadelphicum* L., wood lily (Marie-Victorin, 658). Recorded by Boucher in 1664 in New France and by van der Donck in New Holland (Alain Asselin).

40 *Syringa vulgaris* L., lilac; see Louis-Marie, 213. Alain Asselin notes that it is described as several varieties in the Edinburgh Garden list of 1683 (Robertson, "James Sutherland's *Hortus Medicus Edinburgensis*, 1683," 121–51; henceforth Robertson), while the Montpellier Garden list of 1697 had only one *Syringa* (Magnol). The word "lillach" was an officinal word according to R.V.J. Dodoens, *Stirpium historiae pemptades sex sive libri* XXX, (1583), 1616; henceforth Dodoens.

41 Nicolas may have confused our *Lilium canadense* L., wild yellow lily, with *Lilium martagon* L. of Europe (Turk's cap lily), considering that *L. canadense* does occur in a red form. The bulb of this species was eaten (Anna Leighton). Rousseau 1964, 300 states clearly that *Lilium tigrinum* Ker Gawl, tiger lily, is a recent introduction in Eastern Canada (c. 1804). Alain Asselin adds that the wild yellow lily observed by van der Donck in

doubles are seen in gardens. Imported carnations[46] of all kinds are seen, cockscomb[47] double and single, mallow[48] or Easter roses[49] of all colours, double and single, poppies[50] of all colours, double and single; big yellow double buttercups[51] grow in the water in big tufts. There are in flower beds and in the country roses of all kinds, except for the beautiful Damask roses[52]

with a hundred buds on each branch, double and single marigolds,[53] violets without fragrance,[54] sunflowers from which the Americans make very mild oil.[55] They season their stew with it and rub it on their hair.

There are in addition three or four other kinds of heliotropes or sunflowers[56] whose roots are very good to eat, like those of the *ounonnatas*[57] of the *toubinen-*

New Holland is possibly *L. canadense* L. *Erythronium americanum* Ker Gawl, dog's-tooth violet, was described by Cornut in 1635 and in Boivin's "Flore du Canada" in 1708.

42 It is difficult to identify one native species with at least thirty flax-grey flowers on each stalk and producing bulbs eaten and used for medicine. *Polygnatum pubescens* (Willd.) Pursh, hairy Solomon's seal (Marie-Victorin, 644) is a candidate, but Nicolas identifies two Solomon's seals later in the text. Two *Streptopus* species have greenish or rosy flowers (Marie-Victorin, 652), while two *Uvularia* species display yellow flowers (Marie-Victorin, 653). *Uvularia sessilifolia* L., sessile-leaved bellwort, has "creamy" white flowers but in small numbers. *Zigadenus glaucus* Nutt., glaucous zigadenus, has numerous greenish or yellowish flowers and the plant is poisonous. *Uvularia perfoliata* L., perfoliate bellwort, was known in the 1708 "Flore du Canada" as a medicine for native people (Boivin). However, the yellow flowers do not fit with the "flax-grey" described by Nicolas (Alain Asselin).

43 The text suggests that it is not the introduced daisy, *Chrysanthemum Leucanthemum* L., ox-eye daisy (Marie-Victorin, 589) (synonym: *Leucanthemum vulgare* Lam., USDA) but a native species. Possibly one *Erigeron* species with white rays such as *E. canadensis* L., Canada fleabane (Marie-Victorin, 603) (synonym: *Conyza canadensis* var. *canadensis* (L.) Cronq., USDA), which was already present in France in 1656 (Dodoens) and in 1708 (Boivin). *E. annuus* L. Pers., annual fleabane (Marie-Victorin, 604) is another candidate described by Cornut in 1635.

44 The only species in Canada close to the European *Convallaria majalis* L., lily-of-the-valley, is *Maïanthemum canadense* Desf., wild lily-of-the-valley (Marie-Victorin, 649), as suggested by Rousseau 1964, 300; see Hatton, 455, fig. 912, which reproduces an illustration of Gerarde, *The Herball, or General Historie of Plants*, 331.2. Alain Asselin notices that the text specifying white, blue, and flax-grey flower colours favours the interpretation of the introduction of several varieties of *C. majalis* L.

45 This can be only the jonquil, *Narcissus jonquilla* L.; see Hatton, 516. Alain Asselin notes that it was recorded in European gardens and refers to de La Brosse, *Description du jardin royal des plantes médicinales étably par le roi Louis le Juste à Paris*, henceforth de La Brosse); see Robertson and Magnol.

46 Many *Dianthus* species are now cultivated in Quebec (Louis-Marie, 144). But, as noted by Alain Asselin, *Dianthus* species are recorded in New France by Bou-

cher in 1664. One likely candidate here is *D. caryophyllus* L., as suggested by Rousseau 1964. It was also medicinal (Robertson). *D. plumarius* L. and/or *D. barbatus* L. are also candidates.

47 According to Mattioli, "passevelours" refers to *Amaranthus*. Passevelours was later used also for *Pulsatilla vulgaris* Mill, formerly known as *Anemone Pulsatilla* L., pasque flower (Alain Asselin).

48 *Alcea* (formerly, *Althaea*) *rosea* L., hollyhock, reported in New France by Boucher in 1664 as "roses sauvages" (Rousseau 1964, 300).

49 Faribault, "Les phytonymes de l'*Histoire naturelle des Indes occidentales* de Louis Nicolas"; henceforth Faribault 1996, reads "*rozes d'Espagne*," "roses of Spain," which seems to make more sense than "*roses de Pâques*," "Easter roses." It could be also *Althea rosea* L. (Alain Asselin).

50 *Papaver somniferum* L. Powerful medicinal plant present in European gardens (de La Brosse, Robertson, and Magnol all refer to it) (Alain Asselin).

51 *Ranunculus acris* L., tall buttercup (Marie-Victorin, 227).

52 Two rockrose species grow together in the Mediterranean area: *Cistus villosus* L., Soft-hairy rockrose, and *Cistus salviifolifolius* L., sage-leaved rockrose; see N. Feinbrun-Dothan and R. Koppel, *Wild Plants in the Land of Israel*, 56–9.

53 Indigenous yellow *Caltha palustris* L., marsh marigold (Marie-Victorin, 222), and *Nuphar* sp. (Marie-Victorin, 239) are candidates that grow in water. *C. palustris* L. was in the 1708 "Flore du Canada" (Boivin).

54 Probably indigenous *Viola* species without fragrance, to differentiate them from European ones (especially *V. odorata* L.) with more fragrance. See Rousseau 1964 for discussion about indigenous *Viola* sp. reported by Boucher in New France in 1664. Josselyn indicated three kinds of violets in New England in 1672, while van der Donck included *Viola* as a healing herb in New Holland. *V. canadensis* L., Canadian white violet, (Marie-Victorin, 281), although odoriferous, was included in Boivin's "Flore du Canada en 1708" (Boivin) and even described before 1620 by Juel (Alain Asselin).

55 *Helianthus annuus* L., common sunflower (Marie-Victorin, 587–8). As noted by Alain Asselin, this plant was grown and improved by native people. Already noted by early observers such as Champlain, Sagard, and Boucher. The French botanist and physician Charles de l'Écluse described it as *Planta solis* in 1601 (see A. Ubrizsy and J. Heniger, "Carolus Clusius and American Plants"). It was found in European gardens, such as in Edinburgh (Robertson) (Alain Asselin).

bourg.[58] The *outaragouara* produces a root which is eaten and which resembles the fruit of the bean.[59]

All these lands produce tulips of all colours,[60] and double and single white pansies.[61] They are similar to violets, but they have no fragrance, like almost all the other flowers native to the new world.

The cardinal-flower[62] is noticeable for its beautiful colour. In season all the banks of the great northern river[63] are covered with it. Because of its fine red colour it has been given the name cardinal; its stalk is very tall. Two or three kinds of these flowers are seen. The kind that grows among the grain of the French gives them a lot of trouble. When, in winter only, they thresh their grain[64] in barns, the little floating cotton that comes out of it is called "crève-yeux" (eye-blinder), because this downy substance sticks to the eyelids, causing trouble and preventing people from seeing.

Single poppies[65] in various colours are seen everywhere; the double ones are in flower beds.

The lady's-slipper[66] is common; it is a flower found everywhere. Its form gave rise to its name. Its colour tends toward flax-grey at one end and white at the other.

The *noli me tangere*[67] is another small yellow flower. If you touch it when its seed is mature, it acts as if it were angry and sends this seed against the one who has touched it like so many little darts. All this is particular to the country.

[f. 6] One sees in full summer, on lake shores and in swamps, what look like flower beds scattered with innumerable large white and yellow tufts. These flowers grow from the stalk of a very large simple with wide leaves that are similar to coltsfoot.[68] Before the flower opens it has the shape of an artichoke; when open it is very large and very double;[69] it has more than a hundred leaves. This simple is called lymphata.[70] All kinds of larkspur[71] single and double, violet, white and red grow in the country.

56 Among which *Helianthus tuberosus* L., Jerusalem artichoke (Marie-Victorin, 588–9). As for *H. annuus* L., it would be found in European gardens such as in Edinburgh, where it was known as French potatoes or Jerusalem artichoke (Alain Asselin).

57 *Ounonnata* is an Iroquois word, either as a generic term applicable to all edible roots or as applied exclusively to the rhizome of *Sagittaria latifolia* Willd., Broad-leaved arrow-leaf; see Faribault, "Phytonymes nord-américains," 115–16 ; henceforth Faribault 1993; illustrated in the *Codex*, Pl. xxiii, fig. 40.2 as "ounonnata qui jette des racines comme les trufes."

58 *Helianthus tuberosus* L., Jerusalem artichoke.

59 By the description it could be *Amphicarpa bracteata* (L.) Fern, hog-peanut (Anna Leighton). On folio 9, the *Outtaragouara* is described as a wild potato.

60 *Tulipa* sp. is interpreted as tulips introduced into Canada. Possibly *Tulipa gesneriana* L., Didier's tulip (mentioned in Sutherland, according to Robertson). Rousseau 1964 interpreted the tulips of Boucher in New France in 1664 as imported ones. Van der Donck included tulips as imported flowers in 1655 in New Holland. If Nicolas refers to tulip-like native species, it could be *Erythronium americanum* Ker Gawl, dog-tooth violet, already mentioned. This species was previously hypothesized as a native lily-like species. *Erythronium* is possibly illustrated in the *Codex*, Pl. xxiii, fig. 40.3, as "herbe a trois couleurs."

61 *Viola tricolor* L., pansy (see Marie-Victorin, 281–2, who notes that the folkname "pensée" had been current in French since 1541). Asselin adds that *V. canadensis* L. and *V. tricolor* L. are candidates. The latter can be found with yellow or purple flowers in addition to white ones. *V. canadensis* L. was collected before 1620 and is mentioned in the 1708 "Flore du Canada" (Boivin). In 1672 Josselyn considered violets in New England to

be in common with those in England.

62 *Lobelia cardinalis* L., cardinal-flower (Marie-Victorin, 546). Boucher reported it in 1664 in New France and it was part of the 1708 "Flore du Canada" (Boivin) in addition to *L. Kalmii* L. (Marie-Victorin, 546).

63 The Peribonka River.

64 *Lobelia inflata* L., Indian tobacco (Marie-Victorin, 546). The only native *Lobelia* with blue flowers able to grow near dry and cultivated areas. It is poisonous. The eye problems described by Nicolas may have been related to its toxicity. Blue-flowered *Lobelia* from America was previously named *Rapuntium americanum* (Boivin and Magnol). See also Dodart et al., *Mémoires pour servir à l'histoire des plantes*, which provided an illustration of *R. americanum* in 1686 corresponding to *Lobelia inflata* L.

65 The only poppy mentioned by Marie-Victorin, 247, is *Papaver rhoeas* L., corn poppy, which has a red flower, black at the centre.

66 The flowers of *Cypripedium reginae* Walt., showy lady's-slipper, appears red-pink in nature because the largest part – the inflated lip – is streaked with red (Anna Leighton). Could it also be the rare white *C. acaule* Ait., stemless lady's-slipper, or the more prevalent *C. reginae* Walt. (Marie-Victorin, 819–22)? Both species were in the 1708 "Flore du Canada" (Boivin) in addition to the yellow *C. Calceolus* L., yellow lady's-slipper (Marie-Victorin, 820) (synonym: *C. parviflorum* Salisb. var. *pubescens* (Willd.) Knight, usda), which was collected before 1620. Cornut described *C. acaule* Ait. in 1635. The 1636 Paris Garden list included one white *Cypripedium* flower (Alain Asselin).

67 *Impatiens capensis* Meerb., touch-me-not. It could be also *I. pallida* Nutt., yellow jewelweed (Marie-Victorin, 399). The latter has pale yellow flowers, while the former displays orange ones; illustrated in the *Codex*, Pl.

The antennaria[72] grows naturally everywhere, but not the yellow one.

The goldenrod[73] is a very beautiful flower common on the banks of the river.

Since the milkweed[74] produces the most beautiful and the most fragrant of all the flowers that I have observed in foreign countries, it is important that this plant be better known than the others. Therefore I will tell you that its root taken in its time, that is when it begins to grow around mid-May, is much better than asparagus. This root can be preserved; if it is salted, it can be eaten at any time. From the end of the stalk come several tufts formed by innumerable very beautiful, very fragrant flowers full of an extremely sweet liquid. The little hummingbird feeds on this liquid. The seed of the plant forms and feeds in a fairly large pouch in the middle of a very beautiful and very fine cotton which, because it is too fine, does not have much body and thus is useless. Attempts to make hats

of this have convinced us of its uselessness. The hemp obtained from its stalks is more useful; the natives of the country make very fine works with it. I have in hand an elegant little bag made by an Indian woman from this sort of hemp. The seed ripens and sows itself only during the coldest part of winter, on snow and ice.

Here is another memoir on simples found in the Indies.

Absinth[75] of two kinds. Those who, like me, have studied the constitution of the Americans say that there is nothing better against parasites when it is applied on the belly after being heated a little. I have seen wonderful effects.

Garlic[76] similar to that of Gascony grows wherever it is planted.

Wild garlic[77] particular to America grows naturally

XXIII, fig. 40.4 as "noli me tangere." Van der Donck considered the *noli me tangere* as a healing herb in 1655 in New Holland, while Dodoens indicated that this name was an officinal word.

68 The leaf of *Tussilago farfara* L., coltsfoot, is itself compared to the leaf of cultivated geranium (Marie-Victorin, 594 and G. Lamoureux et al., *Plantes sauvages comestibles*, 131). We learn from Alain Asselin that the figure of its leaf painted on doors or walls used to identify shops of apothecaries in Europe. It was a common medicinal species in European gardens.

69 Double, as a term of horticulture, means that the flower has multiple petals. When Nicolas speaks a little later of "100 leaves," he means petals (Anna Leighton).

70 Although the figure in the *Codex*, Pl. XXIII, fig. 40.5, captioned "Limphata" [sic] is a depiction of *Asarum canadense* L., Canadian wild ginger, the *Lymphata* mentioned here is not easy to identify. Leighton suggests that the description brings to mind *Nymphæ odorata* Ait. or *N. tuberosa* Paine, water lily. The word "lymphata" could have a relation to water, the plant habitat, since *lymphatus* in Latin means "watered, mixed with water." Another explanation of the word "lymphata" may come from the use of the plant. Water lily roots were used by Chippewa Indians to treat tuberculosis, especially as a cough medicine. The Mi'kmaq used the roots to treat suppurating glands. In English, *lymphadentis*, the term for swollen lymph glands, is used to designate scrofula on the neck, a condition apparently associated with tuberculosis. Since the root of water lily (in particular *N. tuberosa*) has swellings all along, it looks like swollen glands, which was enough to give old medicine the idea, by analogy, that it could treat lymph-node–related problems.

71 *Delphinium* species; see Hatton, 67–9 for illustrations of a few species. Rousseau 1964 suggested that *D. staphysa-*

gria L. could be the plant recorded by Boucher in New France in 1664.

72 *Anaphalis margaritacea* (L.) Benth. & Hook, pearly everlasting (Marie-Victorin, 574). Described in 1601 by Clusius and collected before 1620 (Juel) (Alain Asselin).

73 Possibly *Solidago graminifolia* (L.) Salisb., narrow-leaved goldenrod (Marie-Victorin, 597–8). However, the reference to gold as its colour could apply to diverse other native plants such as *Caltha palustris* L., marsh marigold (Marie-Victorin, 222) or *Potentilla anserina* L., silverweed (Marie-Victorin, 338) (synonym: *Argentina anserina* (L.) Rydb., USDA), to give only two examples. Several *Solidago* species were mentioned in the 1708 "Flore du Canada" (Boivin). *S. canadensis* L., Canada goldenrod (Marie-Victorin, 601) was in the Edinburgh Garden list of 1683 (Robertson) and in the Montpellier list in 1697 (Magnol) (Alain Asselin).

74 *Aesclepiada syriaca* L., common milkweed (Marie-Victorin, 519); illustrated in the *Codex*, Pl. XXIII, fig.40.7, as "Cotonaria qui porte du miel du coton du chanvre une belle fleur et des asperges." Described by Cornut in 1635 and present in the 1636 Paris garden list (de La Brosse) as well as in the 1697 Montpellier gardens (Magnol). In the 1708 "Flore du Canada" (Boivin), a note indicates that the sweet nectar is harvested for making sugar (Alain Asselin).

75 One of them could be *Artemisia absinthium* L., common wormwood, which is, according to Marie-Victorin, 572, tonic, febrifuge, and stimulating when taken in infusion (Anna Leighton). The other cannot be *A. vulgaris* L., common mugwort (Marie-Victorin, 572), since Nicolas uses the word "armoise" elsewere in the text to identify *A. vulgaris* L. Another less likely possibility is *Abutilon theophrasti* Medic. That, however, had already been described by Clusius in 1601 as a plant found in America (Alain Asselin).

in meadows three or four leagues long. It has only one head like the leek; it grows from seeds, sowing itself, unlike cultivated garlic. It has all the taste and all the odour of the garlic that is eaten in all Guyenne and in all of Spain on bread, on which it is crushed, and where it is spread as if it were the best butter in the world. Our American garlic has excellent virtues against swellings and all kinds of tumors; to use it for this purpose it must be boiled for a short time and crushed while still hot on the swollen part.

Macedonian parsley,[78] also called celery, grows to be so fine and tender in these countries that it seems to change its nature. It fortifies the stomach, warms it, and purges it wonderfully.

[f. 7] Common parsley,[79] flat and curly, grows to a remarkable size. I have noticed that it is easier to grow it here than in other countries.

I have noted, on the banks of the great river, that there is in these countries another quite particular species of parsley much better than our common one and than Macedonian parsley.[80] We made good stews with it when we camped on the northern shores.

There is also in the same places another sort of very rare simple, very fragrant, which we have named "passe-pierre";[81] it is a sort of adder's tongue. Ginger[82] covers our forests; its root is very fragrant.

All the herbs that I am going to name are so common in the country that I would need a large volume

76 *Allium sativum* L., which does not grow wild in Canada.

77 Rousseau 1964, 294–5 referred to three species as wild garlic in Canada: 1) *Erythronium americanum* Ker Gawl, dog's-tooth violet; 2) *Allium tricoccum* Ait., wild leek, probably illustrated in the *Codex*, Pl. xxiii, fig. 40.6, as "ail sauvage"; and 3) *Allium canadense* L., wild garlic proper (Marie-Victorin, 660–1). *E. americanum* Ker Gawl was described in 1635 by Cornut and identified in 1708 as "mild garlic"; "Flore du Canada" (Boivin). It was specified that both French and Indians ate this mild garlic (Alain Asselin).

78 In French, "persil de Macédoine" was widely used with different meanings. As many as nine different plants carried this name. Among them, *Apium graveolens* L., celery, and *Smyrnium olusatrum* L., Alexanders, are the most likely candidates (see G. Cristofolini and U. Mossetti, "Interpretation of Plant Names in a Late Medieval Medical Treatise," 305–19). Rousseau 1964 discussed *S. olusatrum* L., which was in the 1683 Edinburgh Garden list under the name "common Alexanders" (Alain Asselin).

79 Two varieties of *Petroselinum crispum* (Mill.) Nyman ex A.W. Hill. The var. *crispum* is the curly parsley, while the var. *neapolitanum* Davert is the flat one. Parsley is reported by Boucher in New France in 1664 without specifying flat or curly. Van der Donck recorded parsley in New Holland in 1655 (Alain Asselin).

80 *Ligusticum scoticum* L., sea lovage (Marie-Victorin, 418), *Osmorhiza* sp. (Marie-Victorin, 419), *Conioselinum chinense* (L.) bsp, hemlock parsley (Marie-Victorin, 422) and *Sium suave* Walt., water parsnip (Marie-Victorin, 423) are candidates. Rousseau 1964 suggested the first three native species as the wild good-tasting parsley reported by Boucher in New France in 1664 (Alain Asselin).

81 "Passe-pierre" is *Plantago jucoides* Lam., rush-like plantain; see J. Rousseau, "La passe-pierre," in B. Boivin, "Quelques noms vernaculaires de plantes du Québec," 158–62.

82 *Asarum canadense* L., wild ginger (Marie-Victorin, 219); Dansereau has rightly suggested that it is illustrated in the *Codex*, Pl. xxiii, fig, 40.5, under the name "Lim-

phata." *A. canadense* is described by Cornut in 1635 (Mathieu). The Montpellier Garden list includes the *A. canadense* L. of Cornut (Magnol) (Alain Asselin).

83 *Asparagus officinalis* L. (Marie-Victorin, 648). It was reported by Boucher in New France in 1664, by van der Donck in 1655 in New Holland, and by Josselyn in New England in 1672 (Alain Asselin).

84 *Beta vulgaris* L. (Louis-Marie, 140).

85 A variety of *Beta vulgaris*. It was grown for its leaves and stalks as substitutes for spinach and asparagus (Anna Leighton). White beet could have been *B. vulgaris* ssp. *cicla* (L.) Koch. The 1683 Edinburgh Garden list distinguishes the white beet from the red one. It has been suggested that *B. cicla* L. was the white one (Robertson) (Alain Asselin).

86 *Daucus carota* L., wild carrot, of which the cultivated carrot is a variety (Louis-Marie, 204 and Lamoureux et al., *Plantes sauvages comestibles*, 65). These carrots were probably rounded or tapered rather than cylindrical, like the modern ones. Yellow and white varieties existed in addition to the orange ones. Reported by Boucher in New France in 1664 and by Josselyn in New England in 1672. Carrots were also grown in the early New England colonies (see Mack, "Plant Naturalizations and Invasions in the Eastern United States: 1634–1860"; henceforth Mack). They were also considered medicinal in the Edinburgh Garden list.

87 According to Mattioli, *Carum carvi* L. is named "carvi" but not "charvis." The same author describes *Siser alterum* Cam. as "chervy." Chervy corresponds to skirret, *Sium sisarum* L., also known as "chervis." Chervis was also known as "chirouis," "girole," or "carotte blanche." It was well known in Europe during the sixteenth and the seventeenth centuries (Alain Asselin).

88 *Tragopogon pratensis* L. (Marie-Victorin, 552); reported by Boucher in New France in 1664.

89 *Pastinaca sativa* L. (Louis-Marie, 202, and Marie-Victorin, 416). Reported by Boucher in New France in 1664 and by Josselyn in New England in 1672. Already present in colonial Plymouth Bay in 1634 (Mack) (Alain Asselin).

to describe all their particular qualities, and as I would be too boring, I must simply give names: Asparagus,[83] red beets,[84] white beets,[85] carrots,[86] rough chervil,[87] salsify,[88] parsnips,[89] yellow and violet passenades,[90] cultivated and wild. White chicory, cultivated and wild.[91] Cabbages of all kinds,[92] except cauliflower. Head cabbages[93] are so common and so large that they exceed ordinary size. The pumpkins[94] are very different from ours. Cucumbers,[95] coriander,[96] squash,[97] calabashes,[98] chervil, cultivated and wild.[99] This latter is so common that it can be cut with a scythe in many places. This simple has a particular fragrance; it refreshes the chest; it is bigger and taller than our common chervil; as well as another kind of this same simple whose leaf is

musky and anis-like.[100] The hellebore[101] is quite different from that of Europe. Its root is as thick as celeriac, a turnip; the Indians use it to reduce tumours. Nicotiana,[102] gentian,[103] the Queen's herb,[104] *gramen*,[105] henbane,[106] mallow,[107] marsh mallow,[108] milfoil,[109] *mille folium* or *eliokrison milium*,[110] *solis*,[111] St John's wort,[112] shallots,[113] endives,[114] spinach,[115] scarlet,[116] wild red-seeded spinach,[117] fennel[118] of two kinds. Anise.[119] Common melons,[120] very sweet watermelons[121] with black seeds. Others quite red and of a slightly different kind; in Virginia[122] they are as large as the pumpkins which are carried in a basket in Paris. Lettuces[123] of all kinds, black and white romaine lettuce;[124] there are yellow ones called *falanges*[125] that grow quite large

90 Passenades or pastenades? Both words were used. Pastenades could represent varieties of *Pastinaca sativa* L. or *Daucus Carota* L. Mattioli used the word pastenade for *Pastinaca*. Some authors linked both to some sorts of carrots, such as the yellow ones (Alain Asselin).

91 *Cichorium intybus* L., wild chicory (Marie-Victorin, 551). Reported by Boucher in New France in 1664 and by van der Donck in 1655 in New Holland (Alain Asselin).

92 *Brassica oleracea* L. (Louis-Marie, 162). Reported by Boucher in New France in 1664, by van der Donck in 1655 in New Holland, and by Josselyn in New England in 1672 (Alain Asselin).

93 *Brassica oleracea* (L) DC., var. *capitata* (Alain Asselin).

94 *Cucurbita pepo* L., *C. maxima* Duch., *C. moschata* Duch., to name a few (Louis-Marie, 242). See Rousseau 1964 for information about the pumpkins reported by Boucher in New France in 1664.

95 Only two native cucumbers are found in Eastern Canada: *Sicyos angulatus* L., one-seeded bur cucumber and *Echinocystis lobata* (Michx.) T. & G., Wild cucumber; but Nicolas may simply have been thinking of *Cucumis sativus* L., a variety cultivated in France (Louis-Marie, 242). Boucher reported the latter in New France in 1664. *C. sativa* was brought by early colonists to Plymouth Bay in 1634 (Mack) and reported by van der Donck in 1655 in New Holland (Alain Asselin).

96 *Coriandrum sativum* L. (Marie-Victorin, 413). Possibly a first mention in New France, according to Alain Asselin.

97 Members of the *Cucurbitaceae* family: *C. pepo* L., *C. maxima* Duch., or *C. moschata* Duch. (Louis-Marie, 242).

98 *Cucurbita* species or possibly *Lagenaria siceraria* (Molina) Strandl. See comments by Rousseau 1964 about calabashes. If they were gourds, the *Cucurbita* species were native and even cultivated by native people. However, *Lagenaria* was not native and there is still debate about its introduction in America (Alain Asselin).

99 *Anthriscus cerefolium* (L.) Hoffm. (Marie-Victorin, 420) is cultivated chervil; in the old days, Quebec peasants

used *Cryptotaenia Canadensis* (L.) DC, wild chervil, for the same purpose (Rousseau 1964, 294 and Louis-Marie, 242). Other native umbellifers are potential candidates (Boivin) (Alain Asselin).

100 It is difficult to determine whether Nicolas is refering to a wild or cultivated species. If cultivated, it could be *Pimpinella anisum* L. (Louis-Marie, 204). If wild, it could be one o the various members of the *Apiacae* or even the *Liliacae* (Alain Asselin).

101 The *Codex*, Pl. XXIII, fig. 40.8, likely shows *Veratrum viride* Ait., American white hellebore, as "ehlebore blanc"; in Europe *Helleborus niger* L. was used in medicine (Rousseau 1964, 297).

102 Nicolas uses four words for tobacco: "nicotiane," "herbe à la reine," "petun," and "tabac."

103 Many species of *Gentiana* are known in Eastern Canada. In fact, plants called gentian are now put into two genera: *Gentiana* and *Gentianella*. Marie-Victorin, 514–16, lists five species, the commonest being *Gentiana linearis* Fröl., narrow-leaved gentian. He lists also *Gentiana amarella* L., which is included today in the genus *Gentianella* (Anna Leighton). However, is Nicolas referring to native or introduced gentian? The latter hypothesis is favoured, since the yellow gentian, *Gentiana lutea* L. (Marie-Victorin, 514) was a highly esteemed medicine easily available in European gardens (de La Brosse and Magnol) (Alain Asselin).

104 The French ambassador in Lisbon, Jean Nicot (c. 1530–1600) saw tobacco in Portugal for the first time in 1560. He sent the plant to Catherine de Médicis, in whose honour it was for some time named "l'herbe à la reine," the Queen's herb (Guyot and Gibassier, 123).

105 *Gramen* was applied to several members of the *Poacae* family. For example, the 1636 Paris Garden list had twelve *Gramen* species (de La Brosse) while the Montpellier list displayed over seventy *Gramen* species (Magnol) (Alain Asselin).

106 *Hyocyamus niger* L., common henbane; see Hatton, 322, fig. 622 for an illustration. Introduced as a well-known old and powerful medicine that was also potentially mind-altering. Present in European gardens. One of the

Natural History, or the faithful search for everything rare

and remarkably tall. [f. 8] These kinds of salads are the most tender and delicate. Turnips,[126] onions[127] of two or three kinds, chives,[128] sorrel round and pointed,[129] patience dock,[130] artemesia,[131] appatum,[132] lovage,[133] pimpernel,[134] leeks,[135] chives,[136] purslane of three kinds,[137] horseradish,[138] radish,[139] savory,[140] large chives / spring onion,[141] wild thyme,[142] sow-thistle[143] of several kinds.

Pétun[144] *or common tobacco*[145]

According to the natives, this is the god of herbs and of all simples; they call it *Manitou Mingask*. The cultivated tobacco that is sown on various islands, Jesus and Mont Royal islands, and everywhere else is the god of this god, because the Americans find it incomparably better than their ordinary kind. They use this god to worship the other divinities that they recognize.

seeds was found at some New France archaeological sites (Alain Asselin).

107 Marie-Victorin, 380–1 lists six species of *Malva*: *M. moschata* L., musk mallow, *M. neglecta* Wallr., running mallow (the most common in Quebec), and *M. parviflora* L., small-flowered mallow.

108 *Althaea officinalis* L. (Marie-Victorin, 380). Introduced probably as medicine. Reported by van der Donck in New Holland in 1655 (Alain Asselin).

109 *Achillea millefolium* L., milfoil. Reported by van der Donck in 1655 in New Holland and Josselyn in New England in 1672. According to Marie-Victorin, 592, the common yarrow is both native and naturalized in Quebec. This is rather unusual (Alain Asselin).

110 We interpret that *mille folium* is linked to *eliokrison* but not to *milium solis*. Eliokrison is most likely *Elichrisum*, which became *Helichrysum*, a synonym for *Gnaphalium*. Is Nicolas wanting to specify the type of *mille folium*? (Alain Asselin).

111 *Lithospermum officinale* L. (Marie-Victorin, 460), common gromwell. *Milum solis* was the officinal name used by herbalists, apothecaries, and medical doctors for *L. officinale* L. If the interpretation is correct, it could be first mention of this medicinal plant in North America (Alain Asselin).

112 *Hypericum perforatum* L. (Marie-Victorin, 284), whose distribution is restricted to Quebec and New England; but see Louis-Marie, 192, who lists nine species of *Hypericum*. According to Alain Asselin, we may have here a first record in New France.

113 *Allium ascolonicum* L.; see Louis-Marie, 110.

114 *Cichorium endivia* L., if the word refers to true endives. The same word could also apply to C. *intybus* L. (Marie-Victorin, 551), grown partly underground to produce white plantlets, as with true endives (Alain Asselin).

115 *Spinacia oleracea* L.; see Louis-Marie, 140. Reported by Boucher in New France in 1664.

116 "Ecarlate" in old French means *Lychnis* species (see Glossary of R. Ouellet). Several *Lychnis* species were prominent at that time. *L. coronaria* L. is one possibility among several others. The flora in Quebec has *L. alba* Mill. (Marie-Victorin, 204), naturalized in areas settled by humans. However, it is not necessarily the "écarlate" of Nicolas (Alain Asselin).

117 Native *Rumex* species (Marie-Victorin, 187) are likely candidates (Alain Asselin).

118 *Foeniculum vulgare* Mill. (Louis-Marie, 204). It's not clear whether the two kinds corresponding to this

species are in addition to its sweet variety (var. *dulce*), or whether aneth is the second kind? Aneth (*Anethum graveolens* L.) was known as "fenouil bâtard ou puant" (Alain Asselin).

119 In French, the word *anis* was used at least for *Carum carvi* L. (Marie-Victorin, 422) and *Pimpinella anisum* L. The latter, also known as "anis vert," was introduced in France later than most other spicy herbs (Alain Asselin).

120 *Cucumis melo* L. (Louis-Marie, 242). Reported by Boucher in New France in 1664 and previously by Champlain in 1618. Muskmillions (muskmelons) were already grown at Plymouth Bay in 1634 (Mack) (Alain Asselin).

121 Were these melons sweet varieties of *Cucumis melo* L., such as honeydew melons? Or, were they true watermelons, *Citrullus vulgaris* (Thunb.) Matsum. & Nakai? A mixture of both genera is even possible. In all cases, they were all introduced plants. Watermelons were also recorded by Boucher in New France in 1664 (Alain Asselin).

122 Nicolas is referring to south of eastern Lake Ontario or western Lake Erie.

123 *Lactuca sativa* L. has yellow flowers; see Louis-Marie, 262. Reported in New France by Boucher in 1664.

124 The black and white Roman lettuces are *Lactuca sativa* L. var. *longifolia*.

125 The yellow "phalanges" are probably another variety of lettuce, different from the black and white one. The word "falanges," also written "alfanges" used to identify one kind of Roman lettuce that was recommended by Pliny as an antidote for bites by spiders that were also named "falanges."

126 *Brassica rapa* L.; see Louis-Marie, 162. Rousseau 1964 also gives *B. napobrassica* (L.) Mill. as another possibility.

127 *Allium cepa* L. (Louis-Marie, 110). Reported in New France by Boucher in 1664.

128 In old French *cive*, like "chive" in English, comes from the latin *cepa*, onion, and designates *Allium schœnoprasum* (var. *sibiricum*) L., which grows along the St Lawrence River (Rousseau 1964, 295).

129 *Rumex acetosella* L., field sorrel or *Rumex acetosa* L., garden sorrel (Marie-Victorin, 188–9). There are many species of dock, all with potential use as potherbs. One kind of dock, *Rumex patientia* L., a popular European garden vegetable, was introduced in North America and has been occasionally cultivated as one of the "French sorrels," according to M.L. Fernald and A.C. Kinsey,

The forests produce plantain[146] of all kinds. It grows most commonly in places where people often pass, and where they usually use this to guide them on the routes of various voyages. Without it, they would often get lost. I had to use this secret on a great voyage that I made to Virginia; the natives had taught it to us. They revealed to us another secret that they use in their travels of four or five hundred leagues to find the direction without getting lost, even though clouds cover the sun. They know the North by looking at the trunks of trees. This is not as difficult as one might think, since the trees of these great forests are always covered with a certain moss which distinguishes the north side from the south one. Thus, knowing these two directions, one can form a fairly accurate idea without getting lost, as one would do without this

Edible Wild Plants of Eastern North America (New York: Harper & Row, 1958) (Anna Leighton). Nicolas is possibly referring to an introduced *Rumex* such as *R. acetosa* L. and a second native species like *R. Acetosella* L. (Marie-Victorin, 188) or *R. crispus* L. (Marie-Victorin, 190). Or is he possibly describing one of the three introduced species such: *R. acetosa* L. (Marie-Victorin, 189), *R. longifolius* DC. (Marie-Victorin, 190), or *R. obtusifolius* L. (Marie-Victorin, 190)? Boucher recorded one introduced sorrel in New France in 1664 (Alain Asselin).

130 The word "patience" in French can apply to *Rumex longifolius* DC. (synonym: *R. Patientia*) and *R. obtusifolius* L. (Marie-Victorin, 190). Patience was reported by Josselyn in New England in 1672. Possibly a first report in New France (Alain Asselin).

131 *Artemesia vulgaris* L., common mugwort (Marie-Victorin, 572).

132 Marthe Faribault reads "lappatum"; "appatum" does not exist in Latin; *lappa*, on the other hand, meant "burdock." Perhaps, Nicolas meant *Arctium lappa* L., great burdock, or *Arctium minus* (Hill) Bernh., common burdock (Marie-Victorin, 567). Alain Asselin thinks that *lappatum* probably corresponds to *lapathum*, which described several species, including rhubarb (Magnol). Rhubarb is not likely because Nicolas uses this specific word later in the text. *Lapathum* also described various *Rumex* species. One likely candidate is *R. sanguineus* L., also known as *Sanguis draconis herba* (bloodwort). If this is the case, *Sanguis draconis* was also reported by van der Donck in New Holland in 1655.

133 "Hache" designated many Apiaceae, among them *Levisticum* sp. (Juel). It could be *L. officinale* (L.) Koch, lovage, which was adventitious in Quebec (Marie-Victorin, 413) (Alain Asselin).

134 Pimpernel can be applied to *Pimpinella anisum* L. or to *Sanguisorba* species such as *S. officinalis* L. or *S. minor* Scop. Rousseau interpreted "pimpernelle," reported by Boucher in New France in 1664 as *S. minor*. This is probable but the other species is also likely (Alain Asselin).

135 *Allium porrum* L. (Louis-Marie, 110). Reported in New France by Boucher in 1664.

136 Mattioli used the word "porrée" for the French name of *Beta alba*, the white beet. He differentiated the white beet (*alba*) from the red one (*rubra*). Nicolas is probably using "porrée" as Mattioli did. However, if we read "poirée" instead of "porrée," it could be *Beta vulgaris* L. var. *cicla*, Swiss chard. This "bette-à-carde" was recorded by Champlain in Quebec in 1615 (Alain Asselin).

137 *Portulaca oleracea* L., known already by Champlain in 1618 and by Sagard (Rousseau 1964, 296). Marie-Victorin, 202, mentions twenty species of *Portulaca*. However, as indicated by Alain Asselin, there is controversy about the indigenous or introduced nature of *P. oleracea* L. in North America (see R. Byrne and J.H. McAndrews, "Pre-Columbian Purslane [*Portulaca oleracea* L.] in the New World"). Other thick-leaved purslane-like plants could be *Sedum* species like the ones in the Edinburgh Garden (Robertson).

138 *Armoracia rusticana* Gaertn; see Louis-Marie, 162. Possibly a first record in New France.

139 According to the Glossary of R. Ouellet, *rave* describes radish (*radis*). Radish is *Raphanus sativus* L. (Marie-Victorin, 258). We favour this interpretation. Rousseau 1964 also reached the same conclusion for the *rave* of Boucher in 1664. However, rutabaga and even kohlrabi are also potential candidates. The word *rave* was recorded as early as 1606 at Port-Royal in North America. Nicolas indicates elsewhere in the text that the small *raves* are crispy when eaten (Alain Asselin).

140 *Satureja hortensis* L. Possibly a first report in New France.

141 *Ciboule* can be interpreted as a synonym for *ciboulette*, *Allium schœnoprasum* L., chives. However Mattioli used the term *ciboule* for onion, *Allium cepa* L. We do not know why Nicolas would use *ciboule* in addition to onions (Alain Asselin).

142 *Thymus serpyllum* L. (Marie-Victorin, 502). Reported in New Holland by van der Donck in 1655. Possibly a first record in New France (Alain Asselin).

143 Marie-Victorin, 557–8 mentions three species: *Sonchus arvensis* L., corn or field sow-thistle; *Sonchus oleraceus* L., annual sow-thistle; and *Sonchus asper* (L.) Hill, spiny sow-thistle. Josselyn indicated in 1672 that sow-thistle was planted in New England by the English (Alain Asselin).

144 The word *petun* comes from *petunia*, another *Solanea*, which, however, is ornamental and is found in Brazil. See Guyot and Gibassier, 123. *Pétun* and *Tabaco*, as noted by Alain Asselin, were official names for tobacco, *Nicotiana tabacum* L. (Dodoens). Van der Donck listed male and female petun in 1655 in New Holland.

145 Two "common" tobacco species should be distinguished: *Nicotiana tabacum* L. and *Nicotiana rustica* L. (Aztec tobacco). The one sown around Montreal is *N. tabacum* L. – much better, according to Nicolas, than ordinary *N. rustica* L. However, *N. rustica* L. could yield higher levels of nicotine. Tobacco was reported in New France by early discoverers and by Boucher in 1664

Natural History, or the faithful search for everything rare

kind of compass which never misleads the inhabitants of these vast forests.

We find everywhere spurge[147] of five kinds. The bitter milk-white liquid which comes out of this simple cures and kills the root of sores and boils. There is spurge[148] different from ours, and very violent. Hemlock,[149] whose poison is very fast-acting, serves the men and women to poison themselves when they have been extremely offended.

Poison ivy

is a plant particular to our woods.[150] There are two kinds, one of which is very poisonous. Some Frenchmen, not knowing the differences very well, have been made very ill. This herb, when simply touched, causes such unpleasant burning pustules that the affected parts peel painfully. After the swelling that it causes has

gone away, one has fever. A child would die if he were whipped with these kinds of plants. The Solomon's seal [*sigillum salomonis*],[151] which can be gathered everywhere, is very good for relieving those who have hernia. The root is infused to make a tisane, which these sick people drink, and the same root, boiled a little and crushed and applied on the scrotum, brings great relief.

The other kind of Solomon's seal[152] is considered to be poisonous. Its seed is ugly and has a strange colour.

All along the rivers and lakes one sees entire meadows of *arroiesses*,[153] which are a kind of wild pea[154] on which the animals grow fat.

[f. 9] The hop plant[155] found on the banks of the river Thechiroguen,[156] which waters all New Albany, New Orange and the city of Matane in Virginia, and almost as far as the gulf of the Illande Sea,[157] is very

(Alain Asselin); see Hatton, 326, fig. 631 for an early representation.

146 Nicolas may have been thinking of *Plantago major* L., a plantain of European origin that was named "White man's foot," because it occurs along paths walked by Europeans. Alain Asselin reports that it was used by the natives as a trailing sign for the presence of "whites." Van der Donck recorded *Plantago* among healing herbs in 1655 in New Holland. Josselyn included plantain in 1672 in the plants the English planted in New England. Moreover, he specified "English man's foot" when recording plantain. Possibly a first report for New France (Alain Asselin).

147 Could the "tintimale couronné" mentioned here be *Euphorbia myrsinites* L., myrtle spurge, which has an acrid, very poisonous, milky juice? See Hatton, 402, fig. 798. In fact Mattioli had already described at least five different *Euphorbia* species.

148 *Euphorbia helioscopia* L. or *E. cyparissias* L, which are both now naturalized in Quebec (Marie-Victorin, 216); see Hatton, 403, fig. 799 for an early illustration.

149 In Europe, *Conium maculatum* L. has been known as a poison since the Greeks. *Cicuta maculata* L., water hemlock, contains a violent poison, akin to that of *Cicuta virosa* L. of Europe. In French, *C. maculata* L. is called "carotte à Moreau" in memory of a case of poisoning (Rousseau 1964, 297, and Marie-Victorin, 421–2). Reported by Boucher in New France in 1664.

150 *Rhus radicans* L.; the second species could be *Apocynum androsaemifolium* L., spreading dogbane (Marie-Victorin, 392 and 517). *R. radicans* L. was described as early as 1601 by Clusius and was mentioned in the 1708 "Flore du Canada" (Boivin). *A. androsaemifolium* L., another possibility, was described by Dodart in 1686. The expression "herbe aux puces" was used by Mattioli for a different European species (Alain Asselin).

151 If "gathered everywhere" means in all gardens, it could be the introduced *Polygonatum multiflorum* (L.) All. (Marie-Victorin, 643). This species was possibly the

Sigillum Salomonis recorded by van der Donck in 1655 in New Holland. If "gathered everywhere," means in the wild, it could be the native *P. pubescens* (Willd.) Pursh (Marie-Victorin, 644). *Sigillum Salomonis* was a widely used officinal name for *Polygonatum* (Dodoens). The second Solomon's seal could be native, if the first species is the introduced plant. If both Solomon's seals are native, the second one could be *Streptopus* (Marie-Victorin, 651) *Uvularia* (Marie-Victorin, 652) or even *Smilacina* species (Marie-Victorin, 649) (Alain Asselin).

152 Of the three *Smilacina* described by Marie-Victorin, 650–1 – *S. raemosa* (L.) Des., false Solomon's seal; *S. stellata* (L.) Desf, star-flowered false Solomon's seal; and *S. trifolia* (L.) Desf., three-leaved false Solomon's seal – none is poisonous, although the fruit of the latter is strongly catarrhal.

153 Faribault 1996, reads "arrouses" and refers to the *Französiches Etymologisches Wörterbuch*, Bonn-Leipzig-Basle, 1922, vol. 21, 145b, which gives also "'jarosse," a kind of vetch, *Vicia*.

154 Wild peas are probably *Lathyrus maritimus* (L.) Bigel (Marie-Victorin, 350), or possibly *L. palustris* L. (Marie-Victorin, 351). The "peas" of Jacques Cartier are *L. maritimus* (L.) Bigel., according to Marie-Victorin and Rousseau 1964 (Alain Asselin).

155 *Humulus lupulus* L. (Marie-Victorin, 172), if it is an introduced and naturalized hop. However, the text seems to describe one native hop that could be *Carpinus caroliniana* Walt. (Marie-Victorin, 153). *Carpinus* fruits have been used as hop substitutes (Alain Asselin).

156 Hudson River.

157 To signify Maryland ("Mer Illande" as it sounds), that is, Chesapeake Bay.

158 According to Rousseau 1964, the canes reported by Boucher in New France in 1664 could be *Phragmites communis* Trin. (Marie-Victorin, 765) (synonym: *P. australis* (Cav.) Trin. ex Stend.), reed-grass, *Phalaris arundinacea* L., reed Canary grass (Marie-Victorin, 804), and/or *Typha latifolia* L., broad-leaved cat-tail

fragrant and better than ours. The English and Dutch who live on part of these lands use it to make their beer, as well as another which is not so strong or fragrant.

All kinds of canes[158] are found in many places. The hemp[159] that was brought from France grows very well in all French settlements.

The nettles[160] are extraordinary. The Oupouteouatami,[161] who are peoples living around the great Illinois Lake, use them to make much better hemp than ours. The Virginian women make very fine works with it, cords and nets for hunting and fishing.

Thistles[162] are not rare; there are all kinds of them. Wild artichoke[163] is used to curdle milk.

Virginia creeper[164] or black vine is so common along the rivers of Virginia that nothing else is seen. Its seed forms in big clusters like ivy. There is nothing more beautiful or more charming than to see the fine bowers that this sort of vine forms naturally; it climbs on the trees, and attaches itself to walls. Since it is already found everywhere in France, I will say no more about it.

Bluebuttons,[165] ferns of three or four kinds,[166] common plaintain,[167] whose seed is excellent to restore and refresh the blood, are common here. Fumitory,[168] flax,[169] hyssop,[170] coltsfoot,[171] white and red clover[172] grow easily.

The Outtaragouara (Indian potato),[173]

which are a sort of bean, bear their fruit differently from ours. The latter produce them outside the earth and in pods, and the former in the earth and without pods. This fruit is much more delicate than the beans of our gardens.

(Marie-Victorin, 855). The same candidates apply here (Alain Asselin).

159 *Cannabis sativa* L., hemp; see Hatton, 397, fig. 787, for an illustration from L. Fuchs, *De Historia Stirpium*, 1542. Clusius already had it in his 1601 list of plants found in America. Van der Donck recorded it in 1655 in New, Holland and the 1628 Endicott expedition recorded its importation as hemp seeds (Mack). Boucher recorded introduced hemp in New France in 1664 (Alain Asselin).

160 Nicolas refers to native species that could be *Urtica procera* Mühl. (synonym: *U. dioica* L. ssp. *gracilis* (Aiton) Seland, USDA), *Laportea canadensis* (L.) Wedd., or even *Pilea pumila* (L.) A. Gray (Marie-Victorin, 174) or *Boehmeria cylindrica* (L.) Sw. (Marie-Victorin, 175). Rousseau 1964 chose the first two as the probable nettles reported by Boucher in New France in 1664. Dodart described *L. canadensis* (L.) Wedd. in 1686 (Alain Asselin).

161 The Potawatomi people, or Nation of Fire; see White, 1913, 390–4. At the time of Nicolas, they were living on the Fox River, in what is now Wisconsin.

162 Native *Cirsium* species (Marie-Victorin, 581) such as *C. muticum* Michx. or *C. discolor* (Mühl.) Spreng. However, there were possibly early European introductions of *C. arvense* (L.) Scop. and *C. vulgare* (Savi) Tenore (Alain Asselin).

163 According to the Glossaire of R. Ouellet, *chardonnette* means "wild artichoke," *Cynara cardunculus* L. However, the same word was also applied to *Chamaeleon niger* of Mattioli, now known as *Carlina acaulis* L. Nicolas indicates that the plant is used to curdle milk. Flower heads of *Carlina*, *Cynara*, and other Asteracae have been used to curdle milk. It is also possible that Nicolas is referring to the use of a native species (Alain Asselin).

164 *Parthenocissus quinquefolia* (L.) Planch (Marie-Victorin, 406–7). Already described in 1635 by Cornut and in the 1708 "Flore du Canada" (Boivin) (Alain Asselin).

165 Possibly *Knautia arvensis* (L.) Duby, known also as *Scabiosa arvensis* L. (Marie-Victorin, 540) or other species formerly named *Scabiosa*. The Paris Garden list of 1636 included nine kinds of *Scabiosa* (de La Brosse), and *K. arvensis* (L.) Duby was in the 1683 Edinburgh Garden list (Robertson). The *Scabiosa columbaria* L. subsp. *pratensis* (Jord.) Braun-Blanq. of the 1697 Montpellier Garden list was medicinal (Magnol) (Alain Asselin).

166 Marie-Victorin, 105–6, lists no fewer than fifteen species of ferns in Eastern Canada.

167 There is a plantain called "corne de cerf" in French and buck's horn in English; it is *Plantago coronopus* L. It is a European plant that occurs around ports, where Nicolas could have seen it (Anna Leighton).

168 *Fumaria officinalis* L. (Marie-Victorin, 246). Possibly the first report in New France (Alain Asselin).

169 *Linum usitatissimum* L., common flax (Marie-Victorin, 383–4). Reported by van der Donck in New Holland in 1655, by Boucher in New France in 1664, and by Josselyn in New England in 1672. It was one of the seeds brought to America in 1628 by the Endicott expedition (Mack) (Alain Asselin).

170 *Hyssopus officinalis* L. (Marie-Victorin, 490); see Tegwyn Harris, *The Natural History of the Mediterranean*, 69, fig. 8. for an illustration of a species familiar to Nicolas. Alain Asselin adds that it was recorded by van der Donck in New Holland in 1655 and by Boucher in New France in 1664 and. Also brought to America by John Winthrop Jr in 1631 (Mack.).

171 *Tussilago farfara* L. (Marie-Victorin, 594).

172 *Trifolium repens* L., white clover, and *Trifolium pratense* L., red clover (Marie-Victorin, 361); possibly first record in New France.

173 Faribault, in "L'Apios tubéreux d'Amérique: histoires de mots" (henceforth Faribault 1991, and Faribault 1993), 109, has maintained that this plant is *Apios americana* Medik., but Anna Leighton notes that, since the author mentions "beans" in his description, he could be referring instead to *Amphicarpa bracteata* (L.) Fern., hog-

Mullein[174]

or *taxus barbatus*, or spiteful plant, as some call it, flourishes easily in these countries. Its yellow flower, which falls or detaches itself from time to time after the plant has been hit at the foot of the stalk with a switch, has led to the name *dépiteuse*. This same flower is a fast-acting poison for fish. I have often seen the proof of this. Comfrey[175] and cynogloss[176] can be gathered everywhere.

There are strawberries[177] in such great quantity that it is, so to speak, more than astounding. They do not quite have either the delicate sweetness or the sweet fragrance of ours. Dandelion[178] is good as a salad or in stock. Everyone knows that since this simple is a strong laxative, it should be taken in moderation.

Snakeweed[179] is too beautiful and too rare not to say a word about it. It is not so big or so tall in America. Its bulb is very violent. A certain Frenchman that I knew, having eaten some by mistake, rushed to a confessor, believing that he had found death in the pot like those mentioned in Scripture: *Mors in olla*.[180] He got off with a good scare, and after a short illness recovered from his fear.

[f. 10] Bulrushes[181] are prodigiously large, and long as a pike. Great forests of them are found in the coves of lakes and all along the large rivers. The armed fish (longnose gar), which is sometimes twelve feet long,

hides in them to hunt. Here is how: this fish, whose head and mouth are as large as the rest of its body, unlike other fish such as the trout or the pike, which catch their prey by swimming naturally, raises its large mouth out of the water, and opening it like a compass, catches its prey, which never escapes. I said that it hunts, for it lives habitually on game birds, which come in great flocks among the tall reeds. Our hunter or armed fish has only to close its compass quickly; I mean its long beak, which it keeps open to catch the bird that happens to pass through this trap. As soon as it has its prey, which may be a swan, a wild goose, a big duck, a Canada goose, a brant, a gull, a merganser or some other such water bird, it dives deep into the water to devour its prey.

Our *coureurs de bois*[182] make fine works with their tall rushes, and among other things the women weave them so well that they make fine braids dyed in various colours and decorated with many figures. When these rushes are taken out of the water, they make a fine dish for the natives, who suck them at the lower end and draw into their mouth a very sweet liquid. I have done this many times.

There are in the country two other kinds of common rushes: small round ones,[183] and others that are triangular.[184]

The Americans gather and store a kind of very small,

peanut or ground-bean, a plant often confused with *Apios americana* but which has beans produced acrially, like regular beans, and in the soil.

174 *Verbascum thapsus* L., great mullein (Faribault 1996, 106). Perhaps one should read *Thapsus barbatus* instead of *Taxus barbatus*, because originally this plant, which was used as a yellow dye, came from the Island of Thapsos (Guyot and Gibassier, 58). *Barbatus* of course alludes to the hairy cover of the plant. The flowers are rather fragile and will fall off easily if treated as Nicolas suggests.

175 *Anchusa officinalis* L. Reported by Boucher in New France in 1664. Brought to America by John Winthrop Jr in 1631 (Alain Asselin).

176 *Cynoglossum officinale* L., hound's-tongue (Marie-Victorin, 455). Possibly a first mention in New France.

177 *Fragaria virginiana* Duchesne, Virginia strawberry (Marie-Victorin, 342), and *Fragaria vesca* L., which is very similar in appearance and use. In fact, *F. vesca* is the current scientific name for one of our native species (Anna Leighton). Native strawberries were recorded throughout New France by Boucher in 1664 and by early explorers.

178 *Taraxacum officinale* Weber (Marie-Victorin, 553–4). Reported by Josselyn in New England in 1672 as a plant imported by the English. Possibly a first record in New France (Alain Asselin).

179 It is difficult to make a specific identification, since several plants shared the name "serpentine" or "serpentaire" in French. Boucher reported such a plant in 1664. Rousseau 1964 suggested *Polygala senega* L., Seneca snakeroot (Marie-Victorin, 389). Other candidates as diverse as *Botrychium virginianum* (L.) Sw., Virginia grape-fern (Marie-Victorin, 119) and *Arisaema* species (Marie-Victorin, 840) are also candidates. Dodart reported *Arisaema atrorubens* (Ait.) Blume (synonym: *A. triphyllum* [L.] Schott., USDA) in 1686 (Alain Asselin).

180 This play on words refers to a passage in the Book of Kings: "They cried out … 'there is death in the pot.'" (2 Kings 4:40).

181 The tall bulrushes are more likely the canes named above. Nicolas used the word "joncquières" elsewhere in the text, probably to describe large stands of bulrushes.

182 Nicolas often uses this expression to designate, not the French Canadians, but the Amerindians (R. Ouellet).

183 *Scirpus validus* Vahl., Strong bulrush or *S. acutus* (Mühl.) A. Löve & D. Löve. Pointed bulrushes have cylindric stems (Rousseau 1964, 299) (Anna Leighton).

184 *Scirpus americanus* Pers., American bulrush, *S. Torreyi* Olney, Torrey's bulrush, and *S. fluviatilis* (Torr.) Gray (Anna Leighton). River bulrushes all have triangular stems; Rousseau 1964, 299.

185 Several native species have such roots. Impossible to identify (Alain Asselin).

278 NATURAL HISTORY OF THE NEW WORLD

very knotty, extremely bitter root.[185] They eat them in their stew. They dig in the earth and find a kind of small bulb[186] that they like to eat. They use some other roots which are called *toubinenbour, ounonnata* and *outtaragouara*. They do not eat other roots, and never the plants; they say that they are good only for animals.

The *attissaoueian*[187] is a very small root, no thicker than a heavy sewing thread. I cannot express the value of this root, from which the Americans make three or four kinds of red dye. It is so precious among the Indians that there is nothing they prize so much. It is found only in certain places, and as this root is very small, it takes many of them to make a significant amount of dye.

Morsus diaboli (devil's bite or succise)[188] is a little different from the European one. Its peculiarity is its great bitterness; but the great appetite that we sometimes had forced us to act contrary to the custom of the natives, who do not eat herbs, and to put some in our soup. Since all the [f. 11] food in these remote regions is obtained by hunting, hunger makes us find these bitter things sweet, and the insipid taste of *tripe de roche*[189] is an excellent dish when one is starving.

Tripe de roche is like a kind of foam or moss, like a simple called *oreille de Vénus*,[190] usually full of little spiders and interlaced with a thousand filaments of these little animals, where one sees many flies caught in these webs spread out for this purpose. *Insidians taneris crudelis aranea muscis!*[191] This moss is rather sticky when it has rained; but when the sun has beaten down on it for a short time it becomes dry as wood, and even a slight touch causes it to turn into powder, which when put into boiling water makes the most insipid and least nourishing glue in the world. Nevertheless my comrades and I have often found it to taste good when we were starving.

The lemon[192]

This is the finest and rarest of all the simples that I have ever seen in all my travels. It grows at the edge of woods and in meadows in Virginia. It is more than three geometrical feet high; usually each plant bears ten or twelve fruits as large as a turkey egg. The peel of these fruits is entirely like our lemons, and its appearance is the same. It has three colours: greenish, yellowish, and reddish. When mature it is entirely yellow. When it is half ripe it has an excellent taste; when too ripe it is too sweet. Its seed resembles that of the melon, but is smaller. It seeds itself, and returns every year. Its plant dries up and dies every year. It has dentate leaves. I provide a picture of it.

To tell you now why I have described this plant so fully, you should know that one day I was lost with a Frenchman in the woods and the great meadows of

186 Is Nicolas referring to wild *Allium* species or to other species producing small bulbs, such as *Erythronium* (Marie-Victorin, 655) or to *Medeola* (Marie-Victorin, 647)? There are several candidates (Alain Asselin).

187 *Coptis groenlandica* (Oeder) Fern., gold-thread, is known for its bright yellow roots (Marie-Victorin, 230). According to Faribault 1996, 105, the word comes from the Mi'kmaq, *Tisavoyane*. Plants with fine roots that produce a red dye are the bedstraws (*Galium* species, e.g., *G. boreale* L. and *G. tinctorium* L.), and the name "sawayan" has been applied to these also, suggesting it is a general term for "dye" (Anna Leighton). However, when Nicolas refers to three or four kinds of red dye, is he describing only *Coptis*-derived dyes or is he including the deep red dye from *Sanguinaria canadensis* L. (Marie-Victorin, 341)? *S. canadensis* was described by Cornut in 1635 and in the 1708 "Flore du Canada" (Boivin). Other sources of dyes from diverse plants are discussed by Rousseau 1964 (Alain Asselin).

188 *Morsus diaboli* was the officinal name of Mediterranean *Succisa* species, formerly known as *Scabiosa australis* (Wulf.) Reichenb. (Marie-Victorin, 540). It is naturalized in some areas of Quebec. This is not necessarily the *morsus diaboli* of Nicolas. Other *Succisa* species are also candidates. Moreover, some Medieval Herbals used the words *morsus diaboli* for *Pulsatilla vulgaris* Mill., formerly known as *Anemone pulsatilla* L. Is Nicolas referring to native *Anemone* species L. (Marie-Victorin, 230) that are somewhat, although distantly, related to *Pulsatilla*? *Anemone* roots are rather bitter. It is not possible to reach a specific identification (Alain Asselin).

189 Many sources use the French term "tripe-de-roche" for lichens of the Umbilicaria type, which include members of several genera: *Umbilicaria, Lasallia, Actinogyra*. The use of "tripe-de-roche" for this group of lichens is consistent with the Cree/Montagnais terms, which are all *waahkwan*, so there is little doubt as to what Nicolas means here. These lichens were also widely used, as he explains, boiled as a starvation food. What he says about the spiders is amusing. Lichens tend to grow on bare rock faces and could easily house spiders and support webs to catch passing insects (Anna Leighton); see Jacques Rousseau, *Les noms populaires des plantes au Canada français*, 140 (henceforth Rousseau 1955). Illustrated in the *Codex*, Pl. XXIV, fig. 41.1, as "tripe de roche ou mousse dont on fait quelque boulion qui devient comme de la cole tres Incipide."

190 P.-S. Doyon, *L'iconographie botanique en Amérique française du XVIIe au milieu du XVIIIe siècle*, 165, thinks this was the *Sarracenia purpurea* L.

191 "Where we see flies caught in the nets spread out for this purpose"; we were unable to find the source of this phrase.

192 It is hard to guess what Nicolas could have in mind when speaking of a Lemon tree in Virginia. *Citrus*

Virginia, where the grass was almost a quarter of a pike high. I was starving, along with my dear companion, who the day before I found the lemons, had fainted twice. We were starving, as we had hardly eaten anything for several days, and had spent the night beside a beaver dam sleeping on the ground, without covers and without food. The next day, dragging ourselves miserably through the woods to try to find our way again, we fortunately came into a great woods and then into meadows as far as the eye could see, which we had glimpsed from the top of a mountain. We found some of the lemons that I have described, with blackberries. We ate a large amount and gathered enough for several days. Our four comrades, who were lost in the other direction, went hunting green frogs, which tasted good, as they assured us two days later when we met again in the middle of the meadows and on the banks of the river Techiroguen amid an army of Americans whom I had stopped by an impassioned speech asking the general to send thirty or forty of these soldiers to try to find my comrades who were lost and starving.

[f. 12] *Seaweed*
There are two kinds of this sea plant. A multitude of small shellfish stuck together become attached to this herb. They are attached by many little filaments which, binding to each other and to the shellfish in the mud at the edge of the waters, hold them together and prevent the violence of the waves from carrying the shellfish and the plant out to sea, when there is a storm. Sometimes, however, they are not so strongly attached to the earth, and they are carried away by the waves. The leaves of this kind of seaweed are shaped like lobster claws.[193]

The other kind of seaweed[194] is a remarkably large plant. I have seen some of these leaves where each one was larger than a bed cover; the tail of the leaf was as big as a man's arm and two or three arm lengths long. The leaf is extraordinarily strong, and is like a skin made into parchment. Scoters,[195] which are water birds, feed from this plant.

The maidenhair fern[196]
This simple is one of the rarest and most sought-after in the whole country. Not that there are not many in all the woods; but it is precious for its virtue of refreshing the chest by the excellent syrup that is made from it, and which is so sought-after in France that it is sold at four or five écus for a pot. This is almost all that I have observed that is most rare in plants of the Indies.

Now let us say a word about:

Seeds that are found in, or that have been brought into the Indies, and which produce abundantly there.

Millet,[197] oats,[198] barley,[199] rye,[200] lentils,[201] chick peas,[202] beans of all kinds,[203] peas of all sorts,[204] wheat of all kinds. Indian corn is native to the country and almost entirely different from ours at least in colour. I will say in general that all these grains and several others produce very well in these new countries. But since wheat, green peas and Indian corn are the three kinds of grain that are most cultivated, along with barley, I will say a word about each in particular. First I point out that one never sows in autumn nor in winter, but only toward the end of April and during all of May. The lands in the New World are so rich, and the climate so favourable for these kinds of grains and all the things that I have mentioned, that nature produces faster

limon (L.) Burn. f. is native to India; see Guyot and Gibassier, 47. The lemon tree was already known in Greece and the Roman Empire in classical times and was familiar in Europe (Rachel Loewenstein, personal communication, 28 May 2006). But it could be *Podophyllum peltatum* L., May apple, also called wild lemon. It ranges in rich woods of the Central States, eastward to western Quebec and western New England, and southward (Anna Leighton). But as Alain Asselin notes, even if the yellow fruit and the name could indicate *Podophyllum peltatum* L., the height of the shrub (at least three feet), the number of fruits (ten to twelve), and their colours (green, yellow, red), the seed resembling the melon's and its illustration in the *Codex*, Pl. xxv, fig. 42. 3, as "Plante qui porte des Citrons," suggest *Diospyros virginiana* L., common persimon. Both plants were in the 1708 "Flore du Canada" (Boivin).

193 Probably *Fucus* sp. (Alain Asselin).
194 Probably *Laminaria* sp. (Alain Asselin).
195 *Oidemia nigra* (L.), common scoter.
196 *Adiantum pedatum* L. (Rousseau 1964, 297–8 and Marie-Victorin, 124, both of whom mention its medicinal use for pulmonary diseases in New France). Described by Cornut in 1635, recorded by Boucher in New France in 1664, and already present in the Paris Garden in 1636 (Alain Asselin).
197 Possibly *Setaria italica* (L.) Beauv. or *Panicum miliaceum* L., since both "mil" and "millet" were often used without distinguishing them. Boucher recorded "mil" in New France in 1664, while Nicolas uses the word "millet." These words were also applied to other species of genera as diverse as *Sorghum, Holcus,* and *Phalaris.* Nicolas also uses the words "petit millet" elsewhere in the text (Alain Asselin).

than in these countries. As the earth has always been fertilized by the abundance of leaves that decay in the woods from year to year, it is almost pure compost, very fine and rich, so that when woods have been cleared and warmth penetrates into this earth full of compost, it produces faster and almost like the beds made in gardens, where the seeds that are planted sprout immediately and produce faster.

[f. 13] *Barley*

This grain was brought from France, and although the French insist on planting it, they hardly ever eat it. But since they make much beer in this country and barley is used for that, they sell it to brewers who make beer as good as that of Arras.

Wheat

The wheat that is sown in the Indies is not different from ours except that is not quite so heavy and consequently not so good. It degenerates little by little, and is not so nourishing. The harvest of this grain in some years is so good everywhere it is sown that one can already load ships to transport it, already ground and sifted, to the islands of South America. This trade is becoming established, and these goods are traded for sugar, tobacco, cotton and indigo, which are taken to France, to trade again for other goods suitable for the country that are sold much more than in Europe.

People in this country eat only wheat bread; even the poor will not have any other kind. Their dogs would not eat the coarse bread that peasants eat with good appetite in France.

Green peas

This vegetable is gathered in abundance everywhere in the country, and because of its particular goodness it is sold as much as wheat.[205] Not a ship lands that does not load several barrels to take to France, England, or Holland, where they sell well because of that admirable green puree that is made from them. This kind of pea cooks so well and is so abundant that a handful or two make a good puree. Some years there are so many that one hardly knows what to do with them; they are fed to the pigs. They are never eaten by worms. They are extraordinarily large.

Indian corn, Spanish millet or Turkish corn[206]

Of all these names I consider that of Indian corn to be most suitable; for it is certain that it was brought from the New World, and not from Turkey or Spain, or from any part of Asia, whatever some writers may say.[207]

This grain is large as a pea; it is not round, but a little flat on two sides. It has its germ on the other side, where it is attached to the stalk. The outside part is very shiny and striped with various colours.

Sometimes the whole ear, which is usually a foot long and has four or five hundred grains, is quite yellow and shining like gold. Sometimes it is all whitish. [f. 14] At other times it is a dark grey verging on violet; sometimes it is all red; and other times it is so varied with all these colours that it is quite pretty. There are ears of this corn where all the grains are as nicely striped as tulips.

Several nations live entirely on this vegetable, which is coarse. The women are the millers, and their mill consists only of two stones between which these housewives grind it; or else they grill it in a large wooden mortar which they have hollowed out with fire. The pestle is a long bar of some hard wood. Other times they simply boil it whole. Cooked in this way it is extremely coarse and hard to digest, for it is still hard even though it has been boiled four or five hours.

198 *Avena sativa* L. (Louis-Marie, 86). Recorded by Boucher in New France in 1664 and by Josselyn in New England in 1672.

199 *Hordeum vulgare* L. (Louis-Marie, 84). Recorded by Boucher in New France in 1664. Van der Donck mentioned it in 1655 in New Holland and Josselyn in New England in 1672 (Alain Asselin).

200 *Secale cereale* L. (Louis-Marie, 83).

201 *Lens culinaris* Medik. (Marie-Victorin, 345). Recorded by Boucher in New France in 1664.

202 *Cicer arietinum* L. Possibly a first record in New France (Alain Asselin).

203 This word could apply either to native or to introduced beans, since Nicolas writes of "beans of all kinds." The native American kinds were *Phaseolus vulgaris* L. The introduced European kinds could be *Vicia Faba* L. and/or *V. sativa* L. *P. vulgaris* L. was observed in New

France by J. Cartier, and by Boucher in 1664. Clusius described American beans (*P. vulgaris* L.) in 1601. European beans were brought to America in 1628 by Endicott.

204 *Pisum sativum* L. (Louis-Marie, 180). Introduced very early in America, for example with the Endicott expedition in 1628 (Mack). See Rousseau 1964 for early introductions in Acadia and New France (Alain Asselin).

205 *Triticum aestivum* L. (Marie-Victorin, 790). It was also an early introduction in New England (Alain Asselin).

206 *Zea mays* L. First written record in North America by Cartier. Clusius described it in 1601. Illustrated in the *Codex*, Pl. xxiv, fig. 41.2, as "Mentamin ou bled dInde."

207 A reference to the debate that opposed Jean Du Ruel, Leonhart Fuchs, and Hieronymus Bock, who defended an Asiatic origin for corn, and Joachim Camerarius, R.V.J. Dodoens, and Antoine Pinet, who thought –

Natural History, or the faithful search for everything rare

The best way to eat it is to gather it when it is still milky, and to boil it a short time; or simply to spread it out in the sun on bark to dry it, and then put it in bags like those of the Indian women. They make very fine ones from white birch bark which they boil and make a kind of very nice material like hemp from which they make many small utensils. They also use various other kinds of tree bark, suitable to make thread and ropes. Nettles, *cotonaria*, leatherwood, elm bark, bitter walnut bark serve them well for all these kinds of work, and for many others; they even make very fine nets for fishing.

To eat Indian corn prepared in the way I have just described, it is crushed as I have said or boiled, and it is very good; for this reason it is the most expensive.

When one wants to eat it a little better than the usual way, it has to be roasted as the Indians do, either under burning coals or under hot sand, from which it is pulled with a sort of screen to separate it from the coals or the sand. It is eaten whole or ground, and it is good both ways. It is easier to digest and more nourishing when it is made into flour, and a porridge is made of it.

The women who bake it in this country make a sort of bread that is very coarse and thus heavy in the stomach, although the grain from which it is made is a remarkable laxative and purges a little too much. At first, when one is not used to this kind of food, it makes the stomach swell extraordinarily and painfully, so that it seems one is going to burst. A few hours later, all of that passes by a movement of the intestines, with so much evacuation that one is strongly purged and almost starving. But still it is better to use this drug than to starve to death, and to eat it without salt or fat or anything except pure water than to let oneself starve before a cooking pot more suitable to feed unclean animals than human beings, who have as their only stew some poor beans mixed with some pumpkins with no seasoning except plain water.

[f. 15] I must also tell you that the Indian corn grain crushed and boiled in plain water is very good to prevent retention of urine, and to soften the hard stools which cause constipation and terrible pains for many people. I have seen cases where people have been cured of these two afflictions.

Description of the plant of this grain

This simple produces its flower at the same time that the ear is formed on the opposite side from its flower, unlike other plants. This kind of wheat has several roots, not too large, from which a sort of tube or cane comes out; it is fairly large at the bottom and sometimes reddish, and becomes smaller as it grows. It grows to seven or eight feet in height. It is round and knotty, full of spongy pith inside, mild and sweet tasting. A fairly good brown sugar is made from the stalk of this simple. The leaves are long, wide, full of veins like those of the canes. From the top of this great tube, foot-long plumages grow, separated and hanging, sterile and without grain; this is the flower of the plant, which seems useless, since it produces nothing but a yellow colour mixed with a little white and red.

The ear grows from the knots in the stalk. It is long and wrapped in several tender leaves, green, yellow, red or white, from the end of which grow a kind of filaments, which look like long hairs. The ears, in this country, usually are a foot long; around them the grains are very tightly packed, with an attractive arrangement of eight or ten rows.

To sow this corn, little trenches are made, and five or six grains are thrown in after all that is to be sown has sprouted. It is put in water or in a hole covered with earth and manure, and is watered to make it sprout. In this way is hardly ever fails to sprout, unless worms have eaten it in the ground before it can sprout. In this way it grows quickly, and is harvested in the month of September, after being sown at the end of May, or at the very latest around St John's day.

There is nothing in this grain that is not used. The straw is suitable for various purposes. Indian women make very fine shoes painted in various colours; they make bags and cases where they keep their rarest jewels; the soldiers make quivers and many other fine objects that would be admired in Europe.

Others use it to make huts to live in; but our French, who have other things to do, do not bother with that, and simply let their oxen and their cows into the fields to eat [f. 16] this straw. They soon find this useful because the milk from their cows is more abundant than usual. Since this milk is richer and milder-tasting, they make "reserve" butter, as they call it. At this time the cream is the best in the world.

rightly – that it was an American plant. Nicolas agreed with the latter (Doyon, 151).

208 *Fagopyrum esculentum* Moench (Marie-Victorin, 182). Recorded by van der Donck in 1655 in New Holland and by Boucher in New France in 1664 (Alain Asselin).

209 Two natives species are known: *Fragaria vesca* L., American strawberry, and *F. virginia* Duchesne, Virginia strawberry, in Eastern Canada (Rousseau 1964, 292 and Marie-Victorin, 342).

210 *Min* meant "berry" in Algonquian, and has the same root as *meena*, which means "berry" in Cree. See Arok Wolvengrey and Avis et al., *English-Cree and Cree-*

Orysimon, irio or buckwheat[208]
This grain has not yet received much attention in the Indies. However, it grows well here and it is a pleasure to see it under its very green leaves, in the shape of a heart. Its stalk and its branches are red; its flower is white, its grain black, a little long, in the shape of an equilateral triangle. The wheat from this grain is very white. Bread and porridge are made from it. The cakes made on iron sheets have a fairly good taste, but in the end this food is not much better than that made from the Indian corn which our Americans call *mentamin*.

[F. 17] BOOK TWO

Fruits, shrubs and trees of the New World, imported or native to these regions

The desire for knowledge that we all have shows that curiosity is a certain stamp and a sort of divine character imprinted deeply in our souls which eternally leads us to advance in our knowledge. For this reason the eye, which in my opinion is the finest organ of our body, is never satisfied with the various objects presented to it and which it surveys, although they are most delightful; it always tries to discover new things to advance unceasingly toward knowledge which it has not yet discovered. Thus great minds, aroused by curiosity, have marvelled at the smallest plants, which seemed to have nothing worthy of interest; they have zealously studied the differences, qualities, and virtues of each thing, and they have left us their writings. Thus, imitating them, although I am not so able as they, I beg you to receive the names and drawings of some trees and shrubs that are unknown to you, as well as their qualities.

The strawberry that the natives call heart fruit[209]
This fruit has been given this name because of its heart shape. In their language, *outé* means heart, and *min*[210] means fruit in general. Thus by joining these two words and inserting an *-i-* between the parts as the Greeks do to avoid a harsh sound, for the name of the fruit they say *outé-i-min*, which means the heart fruit for two reasons: 1, because it has a heart shape; and 2, because this fruit is good for the heart both for its rare qualities and because it rejoices the heart.

The New World strawberry differs from ours only in that it is smaller, less fragrant and much more common, for which reason people sometimes eat them together.

[f. 18] The raspberry or blood fruit[211]
What we call the raspberry, our nomads call in their language blood fruit, for the same reason that they call the strawberry the heart fruit; for if the strawberry represents the heart, the raspberry looks like blood, and since *min* as I have said means fruit in general, and *miskoui* means blood, they compose a word which means precisely blood fruit, *miskoui-i-min*, because from this fruit comes a liquid that looks like blood and which the natives like to drink because of the very sweet smell of the fruit. Four kinds of it are found: red, black, yellow, and white, in such profusion that the countryside is full of it in some areas.

The black raspberry[212] *called makatémin*
Makaté means "black colour." From this word the Indians call priests the black ones, or rather those dressed in black, or black robes: *ka-makatéouikoreietch*, they say, when they see a priest. *Ka* means who, *makaté* means black, and *koreietch* means dressed. They sometimes insert *-oui-*. I do not know why; but speaking correctly they say simply *makatakoraietch*, the "black robe" or the "priest." And knowing that priests do not marry, they cannot understand how they come into the world. For that reason they believe that they are spirits who have come down from heaven. But I am straying from my subject and acting as a grammarian and a historian rather than a naturalist as I claim to be, since I must tell you that the raspberry plant is a shrub in no way different from that of France, which is like a bramble bush.[213]

The round and the olive-shaped blueberry
The round blueberry or Mount Ida vine, *vitis idêa*[214] grows from a plant a foot and a half tall. Since it is fairly well known in France, I will say only that it is common in all Canada and in all the Indies. The natives collect it in large quantities; they dry it to use in their feasts. It has a good taste, and it tightens the intestines when they are a little too loose, which often happens to people who have only water to drink and meat or fish to

English Dictionaries (C. Stuart Houston).
211 *Rubus idaeus* L. (Marie-Victorin, 331).
212 *Rubus canadensis* L., Canada blackberry (Marie-Victorin, 334) (Leighton).
213 *Rubus arcticus* L. arctic raspberry, which is, however, a low trailing plant that grows along the ground, quite

unlike a bramble bush or the raspberries of France (Marie-Victorin, 330) (Anna Leighton).
214 *Viburnum cassinoides* L. (Marie-Victorin, 534) (synonym: *V. nudum* L. var. *cassinoides* (L.) Torr. & A. Gray., USDA). Possibly a first record in New France (Alain Asselin).

eat, and the ground for a bed, and for a house only bark or the skin of a wild animal.

[f. 19] The long olive-shaped blueberry[215] is common in this country. It does not have a very good taste. A shortage of food makes it seem good, although it is by nature very bitter. It grows on a bush four or five feet high. Its wood is flexible like rope and does not break, especially several days after it has been cut. It can be used to tie anything one wishes, even prisoners of war, who are attached to four stakes driven deep into the ground. It is suitable for covering bottles, making baskets and cups through which liquid does not leak when they are woven by workers who know how to use this wood, which is much stronger and finer than hazel wood and willow. The little screens made with it are very fine and much sought after.

The cowberry or mountain cranberry[216]

It was at Whitefish Point[217] on the banks of the Tracy Sea that I first discovered this pretty fruit. It is a yellow and red fruit no bigger than an ordinary hazelnut, which grows on a very small low creeping shrub. This fruit sets the teeth on edge because it is bitter. It has nothing special except its beauty. It is astringent like the blueberry.

The Trinity fruit[218]

It is no larger than the bead of a rosary, and is red. It is eaten only in cases of necessity. Its name comes from three seeds that grow out of three leaves on a very low shrub.

Another black fruit[219]

This fruit is produced in large clusters on a fairly high bush. It looks very much like elderberries. Europeans have difficulty getting used to the taste of this fruit, which smells bad. The natives like to eat it, as well as all the other things that we do not like. It seems that these strange people have an aversion to everything that we like, and prize everything that we despise; they cannot bear our best smells, and say that they smell bad. Some of them say that the French stink, while we stop our noses so as not to smell them.

The red fruit or elderberry[220]

As this shrub is known to everyone, and the one in the Indies is not different from that of Europe, I will not say anything about it. I will say only that it is very pleasant to see innumerable wild pigeons descend on it to eat the little red fruit with which this bush is covered. People kill great numbers of these birds. The natives of the country purge themselves with this wood, and use it to make an excellent salve for burns.

[f. 20] The red fruit or mountain ash[221]

If it was ever true to say that there are trees that have far more fruit than leaves, that is seen on the wild ash, which has a hundred fruit for one leaf. There are whole forests of them, and as the fruit is always red, the *coureurs des bois* call these places the red woods. The fruit is bitter, coarse and tasteless, small as a common pea. The body of the tree is no larger than our apple trees. Its leaf is like that of the cultivated ash.

215 Nicolas seems to have lumped together several species of blueberry, such as *Vaccinium myrtilloides* Michx. and *V. corymbosum* L. (Marie-Victorin, 442).

216 *Vaccinium vitis-Idaea* L., cowberry, called here by Nicolas "pomme de terre," as it is still designated in Eastern Quebec; Faribault 1996, 108 refers to G. Dulong, *Dictionnaire des canadianismes* (Marie-Victorin, 439–40). Alain Asselin notes that the billberries of Josselyn in 1672 in New England have been identified as cowberries.

217 There is still a Whitefish Point near Sault Ste Marie on the banks of Lake Superior.

218 Faribault 1996, 108 has proposed *Empetrum atropurpureum* Fern. & Wieg., purple crowberry, as a possible identification of this plant (Marie-Victorin, 448). Alain Asselin suggests *Medeola virginiana* L. (Marie-Victorin, 647). Other possibilities exist. *M. virginiana* L. was in the 1708 "Flore du Canada" (Boivin).

219 Possibly *Sambucus Canadensis* L., common elder (Anna Leighton). Possibly an early specific description in New France. Boucher recorded one unidentified

Sambucus in New France in 1664 (Alain Asselin).

220 *Sambucus pubens* Michx. (Marie-Victorin, 530) (synonym: *S. racemosa* var. *racemosa* L., USDA). Possibly an early specific description in New France. Boucher recorded one unidentified *Sambucus* in New France in 1664 (Alain Asselin).

221 In Boucher's *Histoire véritable,* an "arbre à bois rouge" is mentioned. But it cannot be what Nicolas is speaking about, since the fruit (not the wood) is red and is the origin of its Indian name. By calling it "cormier," Nicolas is probably referring to *Sorbus americana* Marsh., mountain ash, which bears edible red fruits, or *Sorbus decora* C.K. Schneid. (Marie-Victorin, 319). Possibly a first description in New France (Alain Asselin).

222 *Prunus depressa* (Pursh) Gleason (Marie-Victorin, 320). Faribault 1996, 106 indicates that "ergominer" is a folkname equivalent to "ragoumier" in French. Synonym: *P. pumila* L. var. *depressa* (Pursh.) Beau., USDA. Possibly a first record in New France and perhaps illustrated in the *Codex*, Pl. XXIII, fig. 40. 1, as "miner."

The ergominer …[222]
or creeping cherry has an exquisite taste. Its appearance is similar to the bigarreau, and its colour is black. This fruit grows on a creeping bush on the sands along the banks of lakes and rivers, and in dry open sandy plains.

The juniper[223]
It is just like ours. The oil made from it has a strong smell and protects against plague. To make it one simply crushes the mature seed, and expresses in a coarse cloth the liquid that comes out of the paste made by crushing the seeds thoroughly.

The cranberry tree[224]
The shrub is handsome; its flower is white, its leaf jagged like hawthorn but larger. Its fruit is red, yellow and green. It is produced in large clusters. It tastes good and is very suitable for making preserves.

Blackberries that grow on brambles[225]
There are three or four kinds. The natives of the country are very partial to this fruit, which is different from ours. There are some that grow in big bouquets. The women make a kind of dye which does not last long.

The attoka[226]
This is a fruit of meadows and swampy places. It ripens only in the snow and ice. It is coarse and sour and sets the teeth on edge. It is no bigger than a musket shot, and has a coarse red skin. The English gather it in extraordinary quantities and use it in place of verjuice. They make very good preserves of it.

The apple[227]
Smaller apples than those I describe here have never been seen in Normandy; larger ones have never been seen in the Indies, although they are no bigger than a large hazelnut. They are appreciated here although, to tell the truth, they are not worth the trouble, as they are very bad, tasteless and full of four or five large, very hard seeds. The tree is very thorny and its leaves are particular and dentate like a hawthorn leaf. Its flower is very fragrant. Its fruit becomes yellow and red. It ripens only at the time of hard frosts.

[f. 21] *Plums*[228]
Only three or four kinds of plums are seen in the New World. The inhabitants eat them green, for as everything is held in common and there are no fences, people take them whenever they wish. They are boiled in potfulls. The three or four kinds of this fruit found here are not worth one good one.

The pear[229]
There is only one kind, whose tree is not very large. The flower is pretty, long and fragrant; the fruit is no bigger than the fine pear-shaped pearls that are worn as ear rings or as lip rings by the Moors. The colour of this fruit is violet, and the taste is sweet and delicate. This is the best fruit in the New World, where it is found everywhere.

The cherry, or wild cherry[230]
This tree is quite different from ours in its fruit, its leaves and its wood, which is very bad-smelling. Its leaf is similar to the peach leaf. The fruit is red and no

223 *Juniperus communis* L. (Marie-Victorin, 138) and possibly including *J. horizontalis* Moench. (Marie-Victorin, 139). The latter one was mentioned in the 1708 "Flore du Canada" (Boivin) (Alain Asselin).
224 *Viburnum trilobum* Marsh. (Marie-Victorin, 533–4). Later Nicolas mentions the Guelder rose, which is in fact the same plant. He may have seen it in flower and not recognized it when in fruit. Possibly a first description in New France (Alain Asselin).
225 One of several black-fruited *Rubus* species (Anna Leighton).
226 The word is Amerindian. It refers to *Vaccinium oxycoccus* L., small cranberry (Faribault 1996, 105; and Marie-Victorin, 440). "Atoca" is in the 1708 "Flore du Canada" (Boivin).
227 One of our two native apple species, *Pyrus coronaria* L., wild crab apple (Anna Leighton). Or perhaps a member of the *Crataegus* species. Already described by early explorers. Boucher recorded it in New France as "épine blanche" in 1664 (Alain Asselin).

228 There are a few species of *Prunus* in Eastern Canada. Marie-Victorin, 320 mentions *Prunus nigra* Ait., Canada plum, and *Prunus domesticus* L., garden plum. Observed by Boucher in 1664 in New France.
229 Could refer to several species of *Amelanchier,* including *A. Bartramiana* (Tausch) Roemer and *A. stolonifera* Wiegand var. (Leighton). *A. laevis,* glabrous shadbush, is still called "petites poires" (small pears) in Quebec (Marie-Victorin, 317).
230 Probably *Prunus pennsylvanica* L. filius (Marie-Victorin, 320). Illustrated in the *Codex,* Pl. xxv, fig. 42.1, and recorded by Boucher in New France in 1664 (Alain Asselin). Marie-Victorin, 321 mentions that the bark produces hydrogen cyanide in contact with water. This could explain the smell mentioned by Nicolas. See P.W. Atkins, *Molecules,* 126–7: "Hydrogen cyanide is an almond-smelling, colorless, poisonous gas, with an odor that fades on prolonged exposure."

bigger than a pea, and the seed is almost that large. Only birds and native children eat them.

The choke cherry[231]

The fruit grows on a very bad-smelling wood; it is quite extraordinary. Its leaf is like that of the apple, and seeing it without fruit one could take it to be a kind of apple tree. In season it is heavily laden with big bunches of fruit, so that it looks more like grapes than like cherries. The fruit is fairly large like ours and has a bitter taste. The flower is pretty and similar to a lilac except that while one has its flower turned up, the other turns it down; the one is flax-grey, the other white.

The American orange[232]

This is a rare shrub, which is found only in Virginia along the Techiroguen which flows into the Illande Sea[233] after passing through New Albany and part of New Holland. The shrub has several shoots four or five feet high. They are very thorny and prickly. The thorns are very long, strong and slender, much more so than those at the end of palm or aloe leaves. Not many leaves are seen on the plant. Near the thorns a very fragrant little white flower appears, and from that is formed a fruit as large as a pea, without a pit. The fruit is similar to a small shell. Its fragrance is stronger than that of the best oranges of Provence, and its bark is like theirs. All that I know with certainty of this fruit from my own experience is that, when one puts it between the teeth and presses it a little and [f. 22] touches it with the tongue, it gives off a liquid so bitter in the mouth and between the teeth that like it or not, one has to keep one's mouth open for about a half hour to allow a certain very clear liquid to flow from the tip of the tongue as if from a faucet. Nothing swells, nothing peels, and in the end one is relieved and the head is very much cleared.

The hawthorn[234]

The hawthorn is not different from the European one except that it multiplies much more, and its fruit is two or three times as large. Its flower is very fragrant and grows in bigger clusters.

Wild roses[235]

There is in the whole country only one kind, which is very common. The flower is red, single, and fairly sweet-smelling. Double roses are not seen, except from rose bushes that have been imported. They lose much of that pleasant fragrance that they have in their native country. This flower opens only at the end of June. The fruit that forms there does not ripen until winter. It grows in the shape of an olive and is good to eat at that time.

Guelder roses[236]

Two or three kinds are seen at the edge of woods. The flowers are white and grow in big bouquets like tufts. They are very fragrant. When the flower is finished, a seed forms like a kind of fruit.

The sumac[237]

Kaouissagan is the name given to this fruit and to this tree, which produces a very sour red fruit. When it is steeped in water it reddens it and makes it sour, so that it has the same effect as vinegar. Apparently, our doctors recognize some special virtues in its fruits and in the tree itself, since they have given it a place in the famous Royal Garden at Montpellier, where I have seen some, as well as in the garden of the same king in Paris and at the Arsenal, of the same kind as in the Indies. The leaf is rather like that of the wild ash. Its fruit is as large as the end of a torch. It is a foot long in the wild country. This fruit is hidden under little hairs that the Latins would call *lanugo*. I do not know whether dyers

231 *Prunus virginiana* L., choke cherry, the commonest cherry in Eastern Canada (Marie-Victorin, 322). Probably the first specific description in New France.
232 Probably *Diospyros virginiana* L., native puckery persimmon, a food and medicinal source for Indians and colonists. The words *putchamin*, *pasiminan*, or *pessamin* are from the Algonquian language for describing dried fruit. The wild persimmon produces a burnt-orange plum-like fruit and has pointed leaf tips that perhaps induced Nicolas to conclude that orange shrubs were very thorny and prickly (Alain Asselin). The orange shrub is illustrated in the *Codex*, Pl. xxv, fig.42.2 as "Petit oranger de la virginie" and it appears rather similar to the illustrated lemon.
233 See note 157 above.
234 There are many species of hawthorn (*Crataegus* species)

and they are all similar in appearance (Anna Leighton).
235 There are several species of wild roses (*Rosa* species) (Anna Leighton).
236 A rare case of borrowing from the English. Nicolas consulted Thomas Johnson, *The Herball, or General Historie of Plantes*, 1633, which was a revised edition of the famous *Herball* of John Gerarde, 1597. Guelder rose is *Viburnum trilobum* Marsh., already mentioned, the Canadian counterpart to the European *Viburnum opulus* L. (Faribault 1996, 110, n. 16; Hatton, 255, fig. 541).
237 *Rhus typhina* L., vinegar-tree or sumach (Marie-Victorin, 391). *Kaouissagan* is probably an Algonquian word (Faribault 1996, 104–5). Sumach was the officinal word for *Rhus* species (Dodoens). *R. glabra* L. was collected in Canada before 1620 (Alain Asselin).

would be able to do something with it like our American women, who use it to give the fine colour to the admirable porcupine hair from which they make such fine work coloured in the most brilliant crimson.

The grapevine[238]

There are very few regions in all the New World where grapevines are not found, producing only black grapes from which one can make wine, but so coarse that it thickens like [f. 23] mustard. It is impossible to drink this wine without adding three or four quarts of water to a quart of wine. Nevertheless some was made formerly in the region of the Tionnontateuronnons;[239] three priests used it for three months to say mass. I do not doubt that very good wine would be made in various places if grapevines were cultivated.

Currants[240]

There are two kinds; one is very coarse, but pleasant when the fruit is mature. The red currants are the best; there are two kinds. One is like those in France; the other is particular to the country of the Passinassiouek, and I have seen them only there.

The shrub rose[241]

It is particular to our great forests. It has no thorns, its leaf is wide, striped with innumerable fibres; its flower is single and red, without fragrance. In the middle of the flower is a circle with little hairs, where a tasteless little fruit forms.

The hazelnut[242]

There are such prodigious quantities of them that one could carry on a considerable trade, if one let them ripen and gathered them to sell them at the right time. But to tell the truth, neither this fruit nor all the others I have mentioned, being uncultivated and growing wild in the great woods, as one can imagine, are as good as ours, or even as good as those that people are

beginning to grow in the French settlements, where they eat cultivated pears and apples of all kinds; from which one can see that it would only take a little effort to have all kinds of good things in this part of the New World, where the inhabitants already have everything found in Europe except for wine. On the other hand they have the best and healthiest waters in the world, and all the advantages of hunting and fishing, which are remarkable and common everywhere, and from which they obtain considerable advantages.

The sympathetic bush[243]

I could not, in my opinion, finish this treatise on fruits and shrubs better than by what seems to me a very interesting remark about the sympathy existing between different objects.

There is a shrub that we have discovered in our forests, from which there flows a sap so violent and so astringent, which affects the mouth so strongly that one is as bothered as if one had bitten into the unripe fruit of the service tree. And if this bitter sap, which flows much [f. 24] more abundantly from the fruit of the tree than from the tree itself, falls on clothing by chance or otherwise when it is not yet ripe, it stains it so surprisingly that there is no way to remove the spots, even if one washes and rewashes the clothing. But when the same tree produces new flowers, all the spots that soiled the clothing disappear gradually by themselves. The same thing has been observed in France for walnuts and for wine, whose spots are never removed until the walnut is ripe or the grape harvest is finished, with this difference that the spots made by the sympathetic bush are not removed by washing but by themselves at the time I have indicated, whereas cloths stained by walnuts and by wine have to be washed and soaked with lye at the time I have said. As for knowing how that happens, I leave it to those who care to talk about it. In the meantime, I will say a word about some other bushes.

238 *Vitis riparia* Michx. (Marie-Victorin, 405–6); illustrated in the *Codex*, Pl. xxiv, fig. 41.3 as "victis Indica et canadencis."

239 The mountains south of Nottawasaga Bay, in Grey and Simcoe counties, Ontario, where the Nation du Petun, or Tobacco Nation (Tionontati) lived when the French encountered them for the first time in 1616. See White, 456.

240 *Ribes* species (Marie-Victorin, 289). Recorded in New France by Boucher in 1664 and by the early explorers. See Rousseau 1964 for discussion about *Ribes* species (Alain Asselin).

241 Probably *Rosa blanda* Ait. (Marie-Victorin, 325) and possibly *R. johannensis* Fernald. Rousseau 1964 discussed early observations of roses. Boucher reported roses in New France in 1664 (Alain Asselin).

242 *Corylus cornuta* Marsh., beaked hazelnut; similar to the European *Corylus avelana* L. (Rousseau 1964, 290 and Marie-Victorin, 152). Asselin notes that *C. americana* Walt. was already described by Clusius in 1601.

243 Left unidentified by Faribault 1996, 108, n. 4. An interesting case of *sympathia*.

The small wild boxwood[244]

Among this quantity of fruits and shrubs found in the New World, an infinite number are seen about which I will say nothing, either because they did not seem extraordinary to me, or because I have not found anything noteworthy to tell you. I will say something only about those that are more particular. The first one is a sort of small boxwood quite different from ours, and creeping. The natives value it for making sacrifices to their gods. There is, they say, in this plant a hidden virtue which pleases the divinities of their forests, and they use it when they want to smoke with their pipes, and when they want their sacrifices to be more acceptable to their manitous. They mix the leaves of the small boxwood with the god of herbs, which is the tobacco that Europeans sell to them at a high price, since it is to the taste of the gods they worship.

The myrtle[245]

All the fir groves and the large cedar groves of the Indies have this shrub growing in them. Its fragrance does not approach that of the myrtle of France. Its particular quality is that it spreads like couch grass. A single plant can produce more than a hundred shoots, which occupy a great space, and make very pleasant greenery which stays the same even through the coldest part of winter.

[Second Cahier of the Natural History of the New World]

[f. 25] *The pepper plant*[246]

All the lakes and almost all the rivers are bordered with this little tree, which is very fragrant when it is in flower; but it produces only a pleasant appearance, without fruit. The leaf when chewed has a pleasant little taste, and the Americans use it to smoke and to offer incense to the gods of the waters; *Michipichi*,

who is their Neptune, is the first to receive their incense. The leaf is a little dentate and about as long as that of the willow or the olive tree, and looks very much like them.

The wild bay tree[247]

I have seen this kind of tree only in the territory of the village of Gandagarho in Virginia. It is not more than three or four feet high. It produces neither flower nor fruit. The wood and the leaf are fragrant; the bark is good in infusions for certain cold pains. The leaf is very much like that of the pink bay tree. I do not know whether the same thing is said about this bay tree as about ours,[248] that is, that lightning does not strike it, which led the poet to say *Laurus fulmineas ridens impune ruinas.*[249]

I leave it to others to say whether that is true, but I would not be surprised at that great marvel if all the bay trees that are in the world were as well marked as one of these trees (which I have seen and touched, and even taken a part of, which I still have), which was cut in the city of Montpellier, where the whole town came to see two fine natural black crosses found in the middle of the trunk of the tree when it was by chance split in order to burn it. It is still kept in the house of Monsieur Forest, near the Citadel. This bay tree was cut in a garden in the city, very near the Church of Saint Pierre in sight of the hospital. That is what I can say, having seen and touched it, as I said. One does not see in the Indies the kinds of bay trees that have always served to crown great poets and conquerors. They are not the kind seen in Naples on the tomb of the prince of poets, which is in white marble in the shape of a little dome. On the top of it from time immemorial a bay tree has taken root in the marble, without any earth to support it. An old tree which was there died a long time before, and another grew naturally; it is still living and still fully green. This is what one reads in the memoirs of the late duc de Guise, on page 352.

244 Real boxwood, *Buxus sempervirens* L. does not exist in America, but *Taxus canadensis* Marsh., dwarf yew, is still called "buis" in Quebec, because of its small size and persistant foliage (Marie-Victorin, 177–8).

245 Possibly *Linnaea borealis* L. (Marie-Victorin, 532) or *Mitchella repens* L. (Marie-Victorin, 524) and even species such as *Gaultheria procumbens* L. (Marie-Victorin, 444) or *Chimaphila umbellata* (L.) Barton (Marie-Victorin, 435). *L. borealis* L. was collected before 1620 and these four species were in the 1708 "Flore du Canada" (Boivin). We favour *Chimaphila* because of its common medicinal use by Indians (*pipsissewa*) (Alain Asselin). The manuscript bears in the margin: "2eme

cahier de l'Histoire naturelle de l'Inde occidentale" (R. Ouellet).

246 *Myrica gale* L., Sweet gale, called "piment royal" in France where it was used as a spice; Marie-Victorin, 156 (Anna Leighton).

247 Probably *Sassafras albidum* (Nutt.), Nees. Its description in the 1708 "Flore du Canada" (Boivin) indicated that it was called "laurier" (Alain Asselin).

248 *Laurus nobilis* L.; Hatton, 394, fig. 780, who reproduces a figure from Mattioli, *Commentarii*, 1565, 131.

249 "The laurel laughing with impunity at the destructions of lightning." (Alban Baudou)

[f. 26] *The shrub with hard seeds*[250]
The wood of this shrub is much used by the natives of
the region where it is found. They make many attrac-
tive small things from it, and use it in war for their
bows and arrows. Its leaf is especially beautiful. From
a pouch that the tree produces, there grows a fairly
large triangular seed, very hard. When rolled in the
mouth it has the same effects as Brazilian tobacco.
This grain does not have the attractive colour of some
other grains seen in other parts of America, which are
black as jet on one side and scarlet on the other. Some
others are quite round and black, and others yet of the
same shape are marbled. The natives make headbands,
necklaces and other small jewelry from them, and fine
rosaries are made from them. The seeds of these kinds
of trees are so hard that it takes a hammer or a stone
to break them.

The elk or moose shrub[251]
It is called by this name because this great animal likes
to eat it. Its leaf is very large and similar to grape leaves.
It is very striped and is held together by many fibres
and tendons. This shrub buds in the coldest season of
snow and ice. It is not very useful, and its wood is
good only for making pencils as fine as India ink.

Stinking wood[252]
This is found in all our great forests. It is remarkable for
three properties: 1) Its second bark, which is very green,
is very medicinal, and purges gently and without dis-
comfort. It is the Americans' sap, cassia and rhubarb;
2) The wood is much used by warriors and hunters,
who make their arrows with so much skill that no ar-
tisan can make them better. At the end they arm them
with hard wood, bone, stone, copper or iron. I have
taken some to France that were judged to be very fine;
3) I say elsewhere that this stinking wood makes fire
when it is rubbed against dry cedar.[253]

The shrub called leatherwood[254]
With this rare shrub, I will finish my account of shrubs
in order to satisfy quickly readers who are curious
about the special qualities of our large trees.

Leatherwood is so useful to the inhabitants of the
great forests of America that they use it not only to
burn, like [f. 27] all other kinds of wood, but they even
make the strongest, finest thread in the world, from
which they make nets of all kinds and sizes for hunt-
ing and fishing. They make fine braids, ropes, bags,
swings, and a thousand other things. It would be quite
suitable for sewing; but as the Americans do not use a
needle for this purpose, but use only awls made of

250 Probably *Ptelea trifoliata* L. (Marie-Victorin, 390). Pos-
sibly a first record in New France (Alain Asselin).
251 According to Faribault 1996, 109, it could be *Viburnum
alnifolium* Marsh., mooseberry (it is a fact that this
plant is still called in Quebec "bois d'orignal" or *Acer
pensylvanicum* L., moosewood or striped maple (Marie-
Victorin, 532 and 395). However, the Cree/Montagnais
word *moosomin* meaning "mooseberry" refers to *Vibur-
num edule* (Michx.) Raf. and *Virbunum trilobum*
Marsh. The leaf described here suggests *Viburnum
edule* more than *Viburnum alnifolium* Marsh.; see leaf
shapes in Marie-Victorin, 533. On the other hand, the
tree called moosewood, *Acer pennsylvanicum* L. is mar-
kedly striped, whereas the *Viburnums* are not. The tree
is a tall slender fast-growing plant (it does not stay
small for long), whereas *Viburnum edule* is a small
shrub. The *Acer* can have very large leaves too if it
grows under the right conditions (Anna Leighton).
252 Left unidentified by Faribault 1994, 108, n. 14.
253 Nicolas refers to a method spread all over North Ame-
rica even in the West Indies, well described by Sagard in
1632: "Ils prenaient deux bâtons de bois de saule, tilleul
ou d'autre espèce, secs et légers, puis en accommodaient
un d'environ la longueur d'une coudée, ou un peu
moins, et épais d'un doigt ou environ; et ayant sur le
bord de sa largeur un peu cavé, de la pointe d'un cou-
teau ou de la dent d'un castor, une petite fossette avec

un petit cran à côté, pour faire tomber à bas sur quelque
bout de mèche ou chose propre à prendre feu, la poudre
réduite en feu, qui devait tomber du trou, ils mettaient
la pointe d'un autre bâton du même bois, gros comme
le petit doigt, ou un peu moins, dans ce trou ainsi com-
mencé, et étant contre terre le genou sur le bout du bâ-
ton large, ils tournaient l'autre entre les deux mains si
soudainement et si longtemps que les deux bois, étant
bien échauffés, la poudre qui en sortait, à cause de cette
continuelle agitation, se convertissait en feu [They take
two sticks of willow, lime, or some other kind of tree,
dry and light, then cut one to about the length of an ell
or a little less, and an inch wide or thereabouts, and on
the broad edge of it slightly hollowed they make a little
pit with the point of a knife or a beaver's tooth, and a
little notch beside it to carry down upon an end of cot-
ton match, or other stuff quick to take fire, the burning
powder which was to fall from the hole. They put the
point of another stick of the same wood, as thick as your
little finger, or a little less, into this hole that has been
started, and kneeling on the end of the broader stick
on the ground they twist the other between their hands
so quickly and so long that the two pieces of wood are
well heated, and the powder that comes away as a result
of this continuous movement is converted into fire]."
R. Ouellet, J. Warwick, eds., *Gabriel Sagard, Le Grand
Voyage du pays des Hurons*, 129–30. For the English

Natural History, or the faithful search for everything rare

bone or hard wood, and moose nerve or other animals as thread, they leave the fine fibres that they get from leatherwood for the other uses that I have mentioned.

The wood of this tree is so strong and bends so readily that it cannot be broken. It resembles another kind of wood called *le pliant* (the bending wood)[255] because it is impossible to break it except with cutting instruments. There are so many filaments beneath the outer bark of the tree that to see it, you would say that it is a rope of fine silk rather than a stick.

The leatherwood shrub that I speak of here is only four or five feet high. It grows thicker with age. The youngest is the best. It cannot be broken, as I said. To get a kind of hemp from it to make necessary objects, one must strip the branches, which bend like ropes, boil in lye the second bark, then dry it, and beat or rub it until it is softened.

The American women do not use a spindle to spin; they simply wrap their prepared fibres on their thighs. After this preparation they dye their thread as they like, to make head bands, belts, necklaces, and ropes to make frames for large nets. Never has such a suitable wood been seen for hitting with a stick than this plant, called *bois de plomb* [lead wood] because of its weight and this admirable flexibility that it has naturally.

The large trees of America

I do not know whether, going a little too deeply into the vast and almost endless forests of the New World, to note all the trees that make them up, I would need some compass of the kind that are best found in Dieppe, and the company of some capable Frenchmen, who dare not venture without a compass into these foreign regions, where one sees only the earth and the sky

through the leaves, and [f. 28] tree branches so thick that one ordinarily can see only four or five steps ahead.

Nevertheless let us go ahead and plunge into this limitless bush without a compass. Our natives will get us through it all, despite the greatest obstacles of broken old oaks, firs with their branches torn off by the violence of the winds and frosts, pines, hemlocks, spruces, cedars, beeches, maples, sycamores, ironwood, aspen, cultivated and wild ashes, birches, alders, cottonwoods, walnut trees, chestnut trees, elms of two kinds, lindens, large wild cherries and many other kinds of trees, standing or lying. Despite all that, it will not be possible to confuse our Americans or to make them become disoriented. They will get out of anywhere, like wild animals or like spirits accustomed to this land of shades. As we walk with them they will give us the opportunity to observe all these trees for several years and to learn all their uses and qualities, and most of their properties. I propose to tell you about each one in particular, after several years of assiduous study of these things. To begin, I will say that

The willow…[256]

has nothing unusual about it, and that very few are seen on the banks of our rivers. It is only very slightly different from ours in its wood and leaves. As it is not cultivated and is not used, it is not as good as ours. It is softer and more porous that those of the fine meadows in France, whose branches are cut for various uses. One never sees any that from a distance look like well-ordered rows of soldiers, like those that formerly frightened the unfortunate marquis d'Ancre, who, knowing that he had powerful enemies at court, on seeing from a distance from his coach and thinking that they were men waiting for him to kill him, was so frightened that he did in his breeches something that I will not say. Our

translation see the re-edition by G.M. Wrong and H.H. Langton, The Champlain Society, 61. Already in 1557 Thevet had reported the same method of making fire: "Celui qui veut faire feu mettra le plus petit bâton en terre, percé par le milieu … fichera le bout de l'autre bâton dedans le pertuis du premier, avec quelque peu de coton et de feuilles d'arbres sèches; puis, à force de tourner ce bâton, il s'engendre telle chaleur de l'agitation et tourment que les feuilles et coton se prennent à brûler, et ainsi allument leur feu [One that will make fire will lay the lesser sticke lying on the ground, pierced through in middle, which he holds with his feete, will put the ende of the other sticke into the hole that is in the other, with a little cotton and dried leaves, then with turning of the sticke, there engendereth such heate, that the leaves sand cotton begin to burne, so that by this

meanes they light fire]." (Thevet, *Singularités de la France antarctique*, 1557, 263; see Thomas Hacket's English translation of 1568, 82 for the English). See also Jean-Pierre Moreau, *Relation d'un voyage infortuné fait aux Indes occidentales* (*Un flibustier français dans la mer des Antilles*), Paris, Payot, 1982, 209–10.

254 *Dirca palustris* L., leatherwood (Nicolas calls it *bois de plomb*, lead wood) (Marie-Victorin, 362–3).

255 Left unidentified by Faribault 1994, 108, n. 14.

256 One thinks of *Salix alba* L., common willow, but it is an European species; in fact, one finds at least forty different species of *Salix* in Quebec. They are not easy to identify (Marie-Victorin, 164–6). Willow trees (as opposed to shrubs) in Quebec could be *Salix nigra* Marsh., *S. lucida* Muhl., or *S. amygdaloides* Andersson (Anna Leighton). *S. cordata* Michx. (Marie-Victorin, 165) was

willows are too branchy and too large to look like those of France.

The alder[257]
The alder differs from ours only in its small size. There are so many of them everywhere that they could supply all the hatters and dyers of Europe. In this country people use the branches to make racks and draining nets for the famous eel fishery of which I will speak in my treatise on fish.

[f. 29] *Ironwood*[258]
This wood is not very common. Its name comes from its hardness. It is the strongest and hardest of all the woods in this country, and the most suitable for making spokes for carts and wagons. This is the only way it is used. It is not very branched; for this reason it grows very high and not very thick. Nevertheless one could make fine parquet floors, sideboards, tables, and all kinds of furniture, for it is nicely whorled and veined, and when it has been planed its grain is as fine as ebony.

The aspen or poplar[259]
The poplar is never as tall or large as ours in France. Aside from that, it is quite similar. Its only particular quality is that it trembles at the least gentle breeze; for this reason it is called *tremble*. Some French settlers have decided to use it for planks which they use in all kinds of different ways.

Spruces[260]
Three kinds are seen. The smallest of the three loses its long round needles in winter. Since its wood is not much used, I will not say any more about it, and will talk instead about the red and white spruces, which dif-fer only in the colour of their bark. These two kinds of trees are very tall, and do not bear fruit. These trees produce galls like the cypress, in such quantity that they are covered with them. Seeing them from a distance one would take them for cypresses. I have no doubt that sieur Lescarbot, who has written about Canada with very little knowledge, was led by this to make a mistake, and to give both these kinds of spruces the name of cypress, for I can assure you that there were never any in all the regions that Lescarbot describes.[261] The wood of these trees is extremely heavy, strong, and gummy.[262] It burns like matches when it is dry. The tree is evergreen and sets off the whiteness of the snow wonderfully. It is suitable for making masts, yards and oars for galleys. Its leaf is needle-shaped but rather short and very prickly at the lower end. It is admirable for making beer. It is used in this way in New Albany in Virginia.[263]

This has been successful in French settlements, where this ingredient has been tried. Even the Indians use this little leaf and infuse it to make drinks which purge them. In a word, this wood is very good [f. 30] for building houses; beams and joists are made of it. When a hole is made in the trunk of the tree when the sap is rising, a strong, sticky liquid like turpentine flows out of it; this is very suitable to make salves, glazes, and paints. It is very good for wounds; it strengthens those who have had lower back pain. It must be swallowed in a moistened wafer in which the thing to be swallowed is wrapped; this is done to avoid its bitterness. This sticky liquid forms a kind of incense that is not as fragrant as that of Arabia, but nevertheless has some smell of incense.

The fir tree[264]
The fir of this foreign country has no similarity to the

already described by Clusius in 1601 (Alain Asselin).

257 *Alnus rugosa* (Du Roi) Spreng., rough alder, since Nicolas mentions its use as dye. A yellow dye was produced from this tree (Marie-Victorin, 151).

258 *Ostrya virginiana* (Mill.) K. Koch (Marie-Victorin, 152–3 and Faribault 1994, 109). Nicolas calls it *bois dur* (hard wood).

259 *Populus tremuloides* Michx., aspen (Marie-Victorin, 163). Rousseau 1964, 289 notes that *Populus tremula* L., the European aspen, is also called "tremble" in France. Recorded by Boucher in New France.

260 Rousseau 1964, 284–5 explains that three species of *Picea* are found in Eastern Canada: *Picea glauca* (Moench.) Voss, White spruce; *Picea mariana* (Mill.) BSP, Black spruce; and *Picea rubens* Sarg., which is less known. It is possible that Nicolas designated *Larix lari-cina* (Du Roi) Koch, a Larch or a Tamarack, as a "red spruce," as is still done in French Canada (Marie-Victorin, 142–4). The red spruce described by Boucher in 1664 corresponded to *Larix*.

261 Lescarbot mentioned the cypress in his *Histoire de la Nouvelle France contenant les navigations, découvertes, & habitations …*, Paris: chez Jean Milot, 1609, 29 or 853 (See also Marc Lescarbot, *The History of New France*, W.L. Grant, ed., 1912, 1914).

262 Pines are gummy, but not spruce (Anna Leighton).

263 Spruce beer is high in Vitamin C, especially when made from red or black spruce (Anna Leighton).

264 *Abies balsamea* (L.) Mill. (Marie-Victorin, 146). Recorded by early explorers and by Boucher in New France in 1664. Nicolas used the word "sapinière" elsewhere in the text to describe stands of fir trees (Alain Asselin).

one found in France; it is very different. It is surprisingly tall, and pointed like the cypress. It is very branchy and consequently very knotty. For this reason it is not suitable for making planks; but it is useful for making beams. The branches with small needles a quarter-inch long are evergreen. They serve as mattresses, beds, and often as house and cover for the natives, as well as for all those who accompany them in their frightful hardships and in the long voyages they make. The gum that comes out of a fine bark, where innumerable large and small blisters form on the trunk and branches of the same tree, would furnish the material for a good business. I compare this very fragrant liquid, and even dare to prefer it, to the best Venetian turpentine. At least I am sure that the Americans use it very successfully to heal all kinds of wounds. There is hardly a French settler who cannot gather several full pots of it every year. A single Indian woman gathers in an afternoon a full bark dish of it. They use it to tar all the inside of their canoes, for this liquid makes its way easily into all the cracks of the bark and seals them well.

The wild pines, red and white[265]
The red pine can be used only for burning, and even so it is used only in extreme need and in places where there is no other green wood. Green or dry, it crackles so much that it chases people away from the fire [f. 31] even though they want to get warm. This wood has so many branches and is so knotty that it cannot be used except to make the wood torches that the Latins called *tadas*.[266] These are little pieces of wood full of a liquid so bituminous that they burn like pitch. Some great lakes are surrounded by this wood, including the one called Saint-Sacrement,[267] which I have visited twice, and almost all the Tracy Sea. Near la Malbaie,[268] they have made an excellent tar that is used to tar ships. Only this tree provides this liquid. I am not sure whether I have said elsewhere how the natives make their tar from this same tree. They have only to go to the woods, cut one of these trees into slivers, and throw the slivers into boiling water. On top of the water, there soon forms a kind of very thick oil which is drawn off with a wooden spoon and thrown into

cold water, where it remains liquid. It is then put into other containers to be used as needed, or to harden completely.

The wild white pine
In almost all regions of the country one see many fine pines from which people make all the works necessary for building and decorating houses where these things are needed; or they would be able to make them easily if they needed them. They make bearing beams more than twenty inches square and more than fifty or sixty feet long. They make fine planks, and they cut all the wood needed for big houses made entirely of wood, for almost all the country houses in which Europeans live are made of wood from the foundation to the top of the roof.

There are places in the country where one can get millions of trees from which one would make double millions of planks and great beams which are double planks. As well, people get from this tree a liquid gum, as I have just said of the red pine. It has more body when it is thrown into cold water, and from there into even colder water. But since it would still be too sticky to please the natives in this form, they mix well-ground charcoal or fine ashes, to give body to this sort of resin; and to make it malleable, they also add fish oil or animal fat. When this putty is prepared it makes a fairly solid body, and it is kept until it is needed. When they need to soften it, they cut it into small pieces with their teeth and chew it until [f. 32] they have softened it so that, with a firebrand that they hold in their hands, they can apply it to the cracks in their canoes. Heating it more with the fire held in their hands, and passing over it a finger wet with their saliva, they give it the proper shape to seal the holes in their boats. They give various colours to this putty, which they call *pikieu*.

All these kinds of gums and putties give me the chance to mention an interesting point that should be known by everyone, especially by those who imagine that Indians are necessarily hairy. I must tell these people that they must not believe that they are hairy, and I want to convince them that they do not even have a

265 *Pinus resinosa* Ait., Norway pine is the "pin rouge" and *Pinus strobus* L., the white pine of L. Nicolas (Marie-Victorin, 140–1). There is no need to call these beautiful trees "bastard," as does Nicolas, probably because they do not produce edible pine nuts like the *Pinus pinea* L. of Europe. Alain Asselin, refering to W.F. Ganong, *The Identity of the Animals and Plants mentioned by the early Voyagers to Eastern Canada and Newfoundland*, series 3, 1909, vol. 3, 197–242, (henceforth Ganong), notes that

early explorers and Boucher in 1664 in New France reported pines without distinguishing the red from the white one. *P. strobus* L. was described by Clusius in 1601. It was part of the 1708 "Flore du Canada" (Boivin) with the additional name "pin de Milor Weimouth."

266 Should read *taedae* (R. Ouellet).
267 Lake George, in New York State.
268 In Charlevoix County, on the St Lawrence River.
269 Notice that this method of cooking did not disappear

beard, and that if beard hair should happen to grow on one of them, they can hardly wait to remove it either by fire or with their fingers or with putty. But as fire is a violent means, and pulling it out one hair at a time is bothersome, they prefer to use putty which serves as a razor. They chew it to soften it, and having softened it by the warmth of their mouth they make a plaster which they apply on the hairs that they want to remove. Once it has hardened on the part, and the hair is embedded in the putty, by pulling it sharply away from the skin to which it had stuck when warm, they easily remove the hair with this razor sharpened by their teeth.

We see then that everything is useful in our red pine and in the white pine. Even the bark is used to make houses and to make a captain's fire, that is to say, in the natives' expression, a fire with a fine clear flame. They make various utensils with it, including cooking pots in which they boil the foods that they want to eat. Whereas our pots and cauldrons are heated by the fire above which they are placed, these good engineers put the fire in their pots. I mean that they throw big stones heated red-hot on the fire into their bark pots to cook their food, in water that boils only because a stone heated red-hot on the fire makes it boil when several are thrown in one after the other.[269] After this interesting invention, I must finish this second book and begin the third one with a description of the beech.

[F. 33] BOOK THREE

in which the rest of the large trees are described

The beech[270]

I find almost no difference between this tree and those known by the same name in France, either in the wood or the fruit. Only the leaf is not so round, and the roots of the tree do not go so deep in the earth; rather they run above ground, and it sometimes happens that fields covered by these trees are not easy to clear. These kinds of trees grow in a sandy soil that is not the

best for wheat; it is better for Indian corn, pumpkins, and watermelons.

The wood is very good for burning. It makes a clear, hot fire, and its embers last a long time. It is suitable for making staves for making boxes and big containers for carrying large amounts of dry goods such as sugar.

Its fruit attracts innumerable wild pigeons, which are hunted with remarkable success, as I say when I speak about this bird in my treatise on birds.

Walnut trees[271]

I have noticed three kinds of walnut in the country which are quite different from those that authors have written about. However, I must agree with them on one thing: it is certain that of our three kinds of walnuts there are some that have a very soft shell and others that have a hard one. Aside from that, all the rest is different. For we do not find in our woods any of those fine walnut trees[272] of Gengembach, Germany along the Rhine, which produce neither leaves nor fruit before St John's Day, but where at that time everything appears in one night. I have seen some of these trees in the territory of Uzès in Languedoc.

This is not the place to speak about those big horse chestnuts,[273] or according to others big walnuts that are like Reinette apples. They are known everywhere in France, particularly at Solieu[274] in Bourgogne, where I have been and where as a specially fine product people make gloves so delicate that a pair of them could be placed in the shell of one of these walnuts, and in other places people make very interesting purses.

I do not have anything so unusual to say; I have only to describe three different kinds of walnut trees and walnuts, two of which are no larger than nutmeg, one kind extremely bitter and the other very mild and [f. 34] as good-tasting as the best walnuts.

The third kind of walnuts that I have found in the forests of the Indies are as large and long as a big Lombard hen's egg. They are extraordinarily hard, and so angular that it is almost impossible to get to the fruit, which is very good.

even after the introduction of metal kettle by the Whites. It is possible that the French could not provide enough of these to the Amerindians, or that the traditional ways did not fade away as fast as it is believed generally. Archeology confirms this.

270 *Fagus grandifolia* Ehrh., American beech (Marie-Victorin, 156). Described by Clusius in 1601, and recorded by Boucher in New France in 1664.

271 *Juglans cinerea* L., butternut, which has hard shells, or *Carya cordiformis* (Wang.) K. Koch, bitternut, and *Carya ovata* (Mill.) K. Koch, shag-bark hickory, both of which have softer shells (Marie-Victorin, 158–60). Rousseau 1964, 289 notes that *Juglans nigra* L. is also found more to the south, in Iroquois country.

272 Probably *Juglans nigra* L., black walnut (Marie-Victorin, 158).

273 *Aesculus hippocastanum* L., common horse chestnut (Marie-Victorin, 87); see Simon and Schuster's *Guide to Trees*, no. 226.

274 Saulieu, known for the Saint-Andoche Basilica, a Burgundian Romanesque style (xIIth-century) building in Côte d'Or in France.

The wood and leaves of these three different walnut trees have some resemblance to ours, and the odour is almost the same.

The wood of the large walnut is handsome, and very easy to work; but as it is much softer and more porous than that of European walnuts, it cannot be polished so well. Although it is used for gun stocks, it can be seen the first time they get wet that this wood loses its luster and is not as strong as the walnut wood of France. This wood is used here to cover houses once it has been made into little shingles the size of the tiles used to cover houses in Paris.

The bitter walnut[275] is remarkable for only three things:

1. For its fruit, which is no bigger than a nutmeg, and so bitter that it is impossible to eat it. On the other hand, it gives off much oil, which the Indian women make after grinding the nuts in their shells in a wooden mortar, or between four stones. They put water in pots and boil it with this walnut paste to bring out the oil.

No one is welcome in the cabins at this time. The women believe that all their oil would evaporate if someone entered their house. This is why they carefully cover their pots so that if by chance someone came into their huts, the person would not be able to see the oil and thus nothing would be lost.

2. The bitter walnut tree is worthy of note for its bark, which people remove to build and roof cabins. This bark becomes harder than even the best-tanned leather. They make boats which are very suitable for use with sails and oars.

3. Certain ties are taken from the bitter walnut tree and used to make ropes for attaching cattle, and thread for sewing shoes.

I must not forget to tell the pleasant method used by the Americans when they want to get green walnut meat or eat walnuts. In France, people use a stick to knock walnuts down from the tree; the Americans use only their axe to cut down the finest trees in the world, and thus to gather the nuts.

Simply marking them would prevent all passers-by from touching them. It is an inviolable custom never to cut a tree that they know someone [f. 35] else has marked; for since lands are held in common, they belong to the first person who occupies them. This way of cutting trees means that they depopulate great areas where one sees nothing but fine trees cut down, which make a very sad sight, where before there were fine

lands laden with fruit. But despite all that, these fierce woodcutters do not lack for fruit every year; for since their country is very large, they only have to go a little further to find new lands where they find better walnut trees. Since they return only every hundred years to live in the lands they had left, their successors find trees of the same kind that their forefathers had cut. If they want to get a nest from the top of a tree, they do not bother to climb it, but cut it down when the mood strikes them, even though it is very large.

The third and best kind of walnut tree is the hard one. These are therefore much more similar to ours. The fruit is small as I have said, but much sweeter, and the oil made from it is very good, and not so strong-smelling as that made in France. The wood of this tree is very handsome and good, and could be used to make all kinds of sculpture. It is veined in white and red, and very fine-grained. The Indians use it to make bows. It is good for burning, and makes very hot embers which last a long time. Its root is quite varied and veined in different colours. The root of the soft-shell walnut is suitable for making baskets; there is no wicker suppler or finer, or better for making bottle covers, and various fine works.

The maple[276]

I will not speak here about the kind of maple that the Latins called *acer*, the Greeks σφένδαμνος, and the Italians call *pie d'occa* because its leaf resembles a goose's foot; and although the great tree that I am to describe here has a leaf that resembles the Italian goose's foot, nevertheless it is not the same tree, nor is it the one that the Stragirites call *clinotrochos*.[277] I intend only to make you acquainted with a great tree that is very common in the Indies and which the Beaver nations call *apouiak*, which means a tree suitable for making oars, which they call *apoui*; or let us say if you like, what is much more likely, that they give the name *apoui* to an oar because of the name *apouiak* which we call in French *érable*, which is a very big, very tall tree that has very thick, hard bark as well as its wood. The one that grows on the mountains and in dry places is the best for all kinds of works it can be used for. Its wood is white and well veined, excellent for burning and there is none better in all of America. The ashes are sought after for making lye. It is taken to Europe by the barrelful and sold at a high price.

[f. 36] At the end of March and well into April when

275 *Carya cordiformis* (Wang.) K. Koch (Marie-Victorin, 159) (Anna Leighton).
276 *Acer saccharum* Marsh., sugar maple (Marie-Victorin, 398). Recorded in New France by Boucher in 1664.

277 A kind of maple, the *Lectirotarium* of the Latins; see de Sève, *Nouveau dictionnaire de l'Histoire Naturelle*, 429 (R. Ouellet).

the sun begins to melt the snow in the afternoon, the inhabitants of the country go into the woods, armed with their axes, to make big holes in the trunks of old maples to get a certain sweet water that flows abundantly from all parts of the tree, to drink as much as they like without fear that this liquid will cause them any illness. They gather this admirable water to make syrup by boiling the maple water until it is reduced by half.[278] I have tried it and found that this syrup was as good and as refreshing as that made from the maidenhair fern, which is so much esteemed that it is sold for four écus a quart here.

You must know that maple water never flows except in the season I have mentioned, when the sun appears, and its heat causes the flow of this sweet liquid, which stops as the sun sinks in the west, and does not flow when it is set, and does not start flowing again until the next day at the time I have said, and while the foot of the tree is covered with snow; for when the snow has melted the tree no longer flows,[279] and does not give anything to drink either to the natives or to the French, and stops weeping for the loss of the snow.

I have observed two or three very interesting things about this same tree. When it is decayed it gives off a very pleasant smell during the summer. This smell is carried far by the winds, and since there is no shortage of these trees in our forests, there is also no lack of the good smell that comes from them.

This same wood when decayed becomes green and shiny so that one could see to read at night by holding it in one's hand. I have seen the wives of the men of the *Oreille de Pierre* nation[280] use it to make green paintings on their worked animal skins. This decayed wood is also used to make tinder. The fire catches easily and lasts a long time, and burns so well that it is very hard to put out. Smokers always have it with them to light their pipes. This is why they carry little sacks full of it, and it is this third wood that they use to keep up the fire

that they have made with two kinds of wood by rubbing them one against the other, as I will explain when I describe the great white cedar.

The red maple[281]

Some people have said that the red maple is the female of the maple, and to tell the truth it is very similar to that tree. Its foliage is almost the same [f. 37] and the only difference is that the foliage of the red maple is larger and thicker and greener. Its wood is all white, and softer than that of the maple. When dry, it is good for burning. It is seen in all open areas and in all woods. It is very pleasant to see how it makes innumerable little stands of trees, the thickest and nicest in the world. The Richelieu, Bouchard, and Percée islands, the islands of the Lake of the Mountains, those of the Borgne de l'Île,[282] of the Petite Nation[283] and innumerable other places are so full of them in the space of three or four hundred leagues, both on the banks of the Saint Lawrence River or on those of the great northern river, that I have not seen anything so fine. Not only does red maple wood have all the qualities that I have noted in maple wood; its root together with the root of that tree is very good for curing pains in the side, provided that the two are infused together for twenty-four hours.

The chestnut tree[284]

I want just to mention that there are many chestnut trees in the woods through which one passes from the end of Saint-Sacrement Lake to the meadows of a village in Virginia called Gandaouaghé.[285] All along this way, which is thirty leagues, there are many large chestnut trees whose fruit is very small, no larger than that of the beech.[286] The Virginians thread together their chestnuts as we thread rosary beads. They use them to make bandoliers like those that tooth pullers make of the teeth of those who put themselves in their hands. These chestnuts are good, and if the trees were grafted

278 You need on average forty litres of maple sap to make one litre of syrup (R. Ouellet).

279 It is not the snow that makes the sap flow, but the alternation of cold nights with bright sunny days (R. Ouellet).

280 Possibly Assiniboine or Stone Indians. See White, 45–8.

281 *Acer rubrum* L., red maple (Marie-Victorin, 396–7). Recorded in New France by Boucher in 1664. The word "plaine" was already used by Mattioli for *Acer* sp. (Alain Asselin).

282 Tessouat, nicknamed "le Borgne de l'Île," was the chief of an Algonquian tribe established at Île aux Alumettes on the Ottawa River, not far from Pembroke (Ontario) (R. Ouellet).

283 The Petite Nation was also an Algonquian tribe, settled around today's Montebello (Quebec); it joined with the

Algonquins of the Island not long after the destruction of Huronia by the Iroquois (R. Ouellet).

284 *Castanea dentata* (Marsh.) Borkh. (Marie-Victorin, 87), although an American species, is not found in Quebec; *Castanea vulgaris* Lam. is the European species that gives the familiar chestnuts ("marrons" in French); not to be confused with *Aesculus hippocastanum* L., already mentioned, now cultivated in Quebec, but imported (Rousseau 1964, 290).

285 The Jesuits had the Mission Saint-Pierre at Gandaouaghé, near the present Fonda, on the west bank of Cayadutta Creek. See F.-M. Gagnon, "L'expérience ethnographique de Louis Nicolas," 290.

286 Nicolas used "Feau" and "flau," an old designation of the beech; see Faribault 1996, 106.

they would produce chestnuts as good as those of French trees.

The natives have not found a better way of gathering this fruit than to set fire to the woods; when all the leaves and some of the undergrowth is burned, the chestnuts are easy to see and gather.

In their deplorable blindness, some of these unfortunate people have carved or made indecent figures on some chestnut trees. They say that they are genies, and they perform acts of worship imitating those others who consider as divinities what nature teaches us to hide. The wood of the chestnut does not make sparks in America as much as it does in the mountains of Vivarais and in the Limousin territory.

[f. 38] The yellow birch[287]

This is one of the biggest and tallest trees of all the northern part of America. Its wood is reddish. It is very delicate, fine and even, hard and marbled. It can be worked very well and easily. It is shiny as glass. When it is worked, all kinds of furniture are made from it, as well as planks, gun-stocks, frames, sleds, and wind shafts for mills. Its bark is fine and burns like straw, as does its wood. Its leaf is almost round and striped, and crisscrossed with innumerable tendons that make it strong.

The great cottonwood, a majestic tree[288]

There are usually none in the townships of this country. I have seen them only on the banks of the river in New Holland that some geographers wrongly call the North River. This one, which waters a large part of the region of New Albany after flowing from the middle of Lake Techiroguen, is far away from the other one, as I have shown elsewhere.

Our cottonwood is a tall and very big tree. Its bark is white; its leaf is round and slightly dentate like that of the aspen. I do not know what use can be made of its wood or of its cotton, which it bears in little pouches. Neither is used much. Since my return from the Indies I have seen trees of this very same kind in Catalonia and at Beaucaire. There is no tree in the world that grows more easily. It seeds itself, and spreads so much that from one root come many shoots, which within a few years produce whole forests.

The hemlock[289]

If large trees have ever been seen, one can say that the hemlock must be put in the first class, since larger ones are hardly to be found in all the Indies. It has extremely thick, rough bark of a reddish colour. The tanners of Pointe de Lévis use it, and have assured me in their tanneries that it is very suitable for preparing their leathers and skins. This tree is so common in the forests that many ships could be filled with it every year to supply as much as the tanners of a large and well-populated country would wish. Its leaf it small and evergreen, very dry. Its smell is strong. The trunk of the tree is useful only for making double planks called *madriers*, which are used for making threshing-floors of [f. 39] barns. This wood is sawed very thickly for, being coarse, it breaks apart and splits a lot. The Outoulipi[290] and all their neighbours make a red dye from the bark I spoke about. They crush it between two stones for boiling it and pressing out the sap, which, on becoming all red, will give this colour to the things they want to tint. This is why the Spanish say when talking about the hemlock bark, "es buena para tegnir."[291] Italians confirm it by saying the same: "Bona per tintori." For this reason I say that it is seen in Spain and in Italy. In France, I have seen some at the Tuileries, at the Royal Garden in Montpellier, and in many other places. But since transporting this tree to Spain, Italy and France greatly changes its nature, it is useless there. Not being of the prodigious size that can be seen in the places I spoke about, it would not produce much, since not many could be taken from places where it is planted and carefully cultivated, and where it is prized for its continual greenery. One could not use it for making huts like those we made in the woods to shelter us from wind, rain, and snow.

The white ash[292]

This tree is no less useful than it is admirable. It is large and very tall. Its bark is very rough. Nevertheless, one sees immediately that the wood underneath it must be

287 In Quebec, "merisier" often designates *Betula alleghaniensis* Britton, and "petit merisier," *Prunus pensylvanica* L. filius, wild red cherry. Nicolas's description applies to the former. Yellow birch, indeed, is one of the tallest trees of the Laurentian flora. It can grow up to 33m (Marie-Victorin, 150).

288 *Platanus occidentalis* L. American sycamore. Identified as "cotonnier" in the 1708 "Flore du Canada" (Alain Asselin).

289 *Tsuga canadensis* (L.), Carr. (Marie-Victorin, 145 and Rousseau 1964, 285–6).

290 The Outurbi, a former Algonquian tribe or band in Ontario, living north of Lake Nipissing, and wandering to the region of Hudson Bay. Nicolas's conteporary, explorer Daniel Greysolon Duluth, used to call them the Outouloubys. See White, 381.

291 It is good for dyeing.

292 *Fraxinus pennsylvanica* Marsh. or *F. nigra* Marsh.

exceptional. Indeed it is very beautiful, clean and hard almost like horn when dry; it is very flexible and does not break easily. It is good for burning and does not smoke much. Its ash is extremely caustic, and it is therefore as prized as that of the maple. It splits well and very straight, and since it is pliable it can be bent into circles, large and small. The natives use it to make their snowshoes.

The leaf is not much different from the European Ash. All sorts of implements, such as cartwheels, are made from the wood. It is suitable for making gun-carriages, and for mounting the halberds and pikes of the largest armies, without using up the trees found in this country, where there is enough to supply all the cartwrights in Paris and more besides.

Moreover, there flows from this fine tree, in season, a liquid much milder and sweeter than that which flows from the maple that I spoke about, and syrup is made from it with more body than is made from the maple water. There is no other way to get this water than the method that is used, which I made note of in my description of the maple.

[f. 40] *The wild ash*[293]

This sort of ash is no different from the other except that its bark is much finer and that the wood hardens much more than that of the white ash, of which it has all the same qualities except that the same sweet liquid does not flow from this tree that flows from the other. It is excellent for making pikes. The natives make spears from it four to five fathoms long to catch trout or sturgeon in the water and under the ice. From it they make the frames of their boats. They even use the bark to make them, and to build their houses. For the French, the wood serves to make fine beams, and to cut all the pieces necessary to make beautiful wooden dwellings that, when covered with pine boards, last a very long time.

White wood[294]

Utility and size distinguish this strong tree. The admirable bark that fishers, hunters, and warriors take from this tree make it important. The first two make nets from it, one to take countless fish, the other to trap countless wild pigeons. Warriors use it for their camps, and for making tents, ropes, strings, and munitions bags. Voyageurs make snowshoes from it so as not to sink into the snow. The tree trunk is very large and very tall. Its wood is so white that the name *bois blanc* has been given to the tree. It is soft and is not easy to work when dry. When covered, it lasts a long time, and beams, girders, and frames of all kinds are made from it. Its leaf is very large; its shape resembles that of the linden, but it is much larger. They make chests from the bark, and pirogues, which are long boats, from the trunk of the tree. They use it to make coffins for burying the dead and cenotaphs to mark where they are buried. When dry, the bark becomes as tough as leather.

The elm[295]

There is hardly any difference between the American elm and the French one. It is sought after for making boats from its bark.[296] A certain gum is made from the bark of the female elm for filling cracks in boats. The bark must be crushed between two stones and then soaked to extract a sticky liquid, which sticks sufficiently well to stop leaks that would sink the boats. From this same bark is made very good string, and even rope. It is well known that this wood is of good use for cartwrights, and for mounting cannon. Other than that, I find nothing exceptional about our two species of elm except their extraordinary height.

[f. 41] *The oak*[297]

The oak in the Indies has only a slight resemblance to the French oak. Its wood is more porous, its leaf very different, its fruit round, its bark finer. There are some of extraordinary girth and height. It is not good for

(Marie-Victorin, 522). Recorded in New France by Boucher in 1664 and by early explorers (Alain Asselin).

293 Could designate either *Fraxinus pennsylvanica* Marsh., red ash, also called bastard ash in English or *Fraxinus nigra* Marsh., black ash (Marie-Victorin, 522 and Rousseau 1964, 288).

294 *Tilia americana* L., American linden, still called "bois blanc" in Quebec (Marie-Victorin, 382 and Rousseau 1964, 289–90).

295 *Ulmus americana* L., American elm (Marie-Victorin, 170 and Rousseau 1964, 288). Described by Clusius in 1601. Recorded in New France by Boucher in 1664 and

by early explorers (Alain Asselin).

296 In letter xvi of his *Nouveaux Voyages en Amérique,* Lahontan notes that the heavy canoes of elm bark built by the Iroquois are not as swift as those made of birch bark. See R. Ouellet and Alain Beaulieu, eds., *Lahontan. Œuvres complètes,* 1990, 360.

297 As Rousseau 1964, 288 explains, four oak species are known in Quebec: *Quercus rubra* L., red oak; *Quercus bicolor* Willd., swamp white oak; *Quercus alba* L., white oak; and *Quercus macrocarpa* Michx., mossy-cup oak (Marie-Victorin, 154–5). Alain Asselin notes that *Q. rubra* L. was described by Clusius in 1601.

burning. It is used for framing ships.[298] When it dries, it becomes quite hard. Yet it is not as good as the French oak and it is not so sought after for making ships. I have learned, however, from a few pilots and several shipwrights that it can be made to last as long as French oak. Whether it was already used for the construction of vessels, or for some other work, they said that they knew from experience that a vessel made from Indian oak becomes very good and durable if it is taken to salt water when it is first made, filled with salt water at some secure harbour, and left to stand in it for some time. The salt water gives firmness to the wood, and having been left thus for some time in the salt water, the vessel only needs to be pierced in various places to let out the salt water that is inside. In this way they ensure that the Indian wood becomes solid and long-lasting. I have seen very good vessels built in the Indies and they are some of the best sailing boats. Monsieur Talon,[299] who was the *intendant* in the part of New France occupied by the French, had some 500-ton cargo vessels made of it.

The leaf of the white oak is very good for healing wounds, and the natives make their nails grow back with it after someone has torn them off with their teeth. I discovered by experience this secret from a Virginian American whose nails were all torn out and who had one finger cut off and his arm stabbed. I would see him every day, going to the woods to cut white oak leaves. He crushed them between two stones, chewed them, and applied this residue to the end of his fingers. Seeing that it was difficult for him to dress his own wounds, I dressed them myself. With this remedy, in a short time, he healed perfectly and his nails came back as beautiful and clean as ever, as I can affirm. This leaf does not have this effect if it is not chewed after being crushed as I said.

The birch and the true paper birch[300]
The birch that Germans call *Brichembaoum*,[301] the natives *Ouigouach*, the Greeks παπύρος, and other nationalities *briza*, is a very branchy, very tall tree of mountainous forests. It likes the cold country. Its wood is soft and thus easy to work. The inhabitants of the country make [f. 42] various implements from it, such as sleds, oars, or snowshoe frames. The smoke is foul smelling and rapidly goes to the head. Charcoal is made from the tree trunk as well as the branches.

The natives of the Algonquin language use mainly the bark, from which they make this heavenly boat that we call a canoe, after the Dutch in whose language a small boat is called a *canot*.[302] I called it heavenly to describe the convenience of navigation in a canoe. Voyages of a thousand or twelve hundred leagues can be made in a bit of bark over immense lakes, passing through the most frightening and dangerous places in the world where the hardiest of men very often tremble. Honestly, it is something exceptional to see eight or ten large men, with all their baggage and much merchandise, entrust themselves to a piece of bark, along with another serving as a sail, and venture to make a crossing of twenty leagues, or fifteen or ten without landing, and most often of four or five. It is a thing so amazing that it is almost impossible to say or to understand: it has to be seen and put into practice, as missionaries, their companions and bands of warriors, hunters, or voyageurs do every day, for it to be believed. Oh God, how many times the hair stands on end in these encounters; how many times a day one is in danger of perishing, or being dashed to pieces against rocks or boulders in the middle of the precipices that it is necessary to pass through almost as fast as the swiftest and most daring bird flies. However, it is preferable somehow to find oneself on these flying birch barks than in brigantines, in which one suffers death at every moment, rarely able to approach land. One can go ashore from canoes a hundred times a day if one wishes, when one travels by the sheltered waters of the coast as it is usually done, without ever seeing any land on the other shore of our great lakes.

This same bark that serves to build boats for our Americans is of great use to them for many other things. They make dishes from it, which they call *oura-*

298 The French *bâtiments* could here stand for buildings or ships.
299 Jean Talon, intendant of New France from 1656 to 1668 and from 1670 to 1672.
300 *Betula papyrifera* Marsh., canoe birch (Marie-Victorin, 150). Recorded in New France by Boucher in 1664 and by early explorers. Present in the 1708 "Flore du Canada" (Alain Asselin).
301 The correct German word would be *Birkenbaum.*
302 According to Raymond Arveiller, the term *canot* was created by French sailors from the Spanish *canoa*, and was used as early as 1599 by Captain Bruneau. On the other hand, Arveiller thought that it was rarely documented until 1640 (Raymond Arveiller, *Contribution à l'étude des termes de voyage en français (1505–1722)*, Paris, Éditions d'Artrey, 1963, 151). We beg to differ, since missionaries and explorers of New France used the word *canot* systematically, to designate the Amerindian boat made from birch bark; see Charles Lalemant (1626) and Paul Le Jeune (1632–1640), for example – even Champlain, in 1603 (R. Ouellet).

gan.[303] They make bowls, spoons and boxes for their clothes or for the bones of their dead, which they transport out of friendship and respect on all their voyages. They make coffers from it, water buckets, houses, and many other kinds of work.

The little birch or the true paper birch[304]

There are two colours of them in the country; some are white and some are red. Both are as delicate as satin. The white is the most beautiful. It is easy to write on it; the quill glides without wearing out. One single tree can supply enough paper to make a large book. The outer bark and all the others are full of [f. 43] bitumen, and burn like torches with a very hot, clear flame. The smoke that comes out is foul smelling and extremely black. The natives make small torches from it, and the great torches with which they burn their prisoners of war. They use the same torches for the fishing they do at night at certain times of the year.

The wood of these two kinds of birch is very soft and very pliable. The natives make the frames of their snowshoes from it in various shapes. The charcoal made from this wood burns very hot; the smoke is dangerous to the eyes.

When a hole is made in one of these trees, clear water flows from it. When it is drunk by those with gallstones, they get better. It bursts the stone, and expels all the gravel. The water removes blotches from the face and makes a fine and beautiful complexion. It even cures mouth ulcers.

The cedar[305]

Although several writers have dealt with the names of all the trees I have just described, I wanted to say a word about them, for I was certain that everything they had reported was different from everything I had to say, and that although I have given the same names as they have to the simples and trees that I had to talk about, it was only to adapt myself as much as I could to the ideas that skilled botanists might form from reading the leading writers on this subject. However, to tell the truth, the ideas that are taken from reading books of this nature are very different from those one has in the places where one has seen the things described, and about which enlightened minds would say infinitely more excellent things than I have reported, having noticed all the peculiarities in a country far removed from our own, where almost everything is different, particularly the cedar, two species of which I am now going to describe to end this third book, and all the treatise on simples and on trees, by describing the white cedar and the red and white cedar.

The white cedar

This is a very tall tree, which I do not hesitate to compare to the highest bell tower in France. But people in the Indies who have seen only the common cedar will be surprised at what I suggest, since it is true that this tree is not commonly of the height that I first gave it, for ordinarily it is only 100 or 120 feet tall. But I have only to send them into winter quarters to the country of the Nauqués,[306] the Outchiboueks,[307] or the Passinassioueks,[308] who are nomads of the great open region between the Tracy Sea and the great Lake of the Illinois, which is 1,400 leagues around. There they will see some trees that three tall men would have trouble reaching around [f. 44] and whose tops are over two or three hundred feet above the ground, and they will not be surprised by my statement, but will be convinced of the truth of what I say.

At the end of the branches of this beautiful tree, whose small leaves never wither, not even during the worst winters, can be seen small cones similar to those of the cypress. The Asian cedars that are seen in Phoenicia and on Mount Lebanon have a bigger cone and their leaf is quite different, and very similar to juniper leaves. American cedars have a leaf and a cone like the cypress. The difference between the two can easily be seen in the famous Royal Garden at Montpellier, where I have seen both. Without going so far,

303 Algonquian word mentioned in the *Grammaire algonquine* with this meaning. Still used with this meaning in the French Canadian folk language. See Dulong, *Dictionnaire des canadianismes*, 20 and 361.

304 Nicolas may be talking about another form or variety of *Betula papyrifera*, paper birch. It is the only species with bark that peels off like paper. *B. neoalskana* occurs in the east (Anna Leighton). They could be forms or varieties of *Betula papyrifera* Marsh. (Marie-Victorin, 150), *B. populifolia* Marsh. (Marie-Victorin, 149), or even *B. pumila* L. (Marie-Victorin, 151) (Alain Asselin).

305 *Thuya occidentalis* L. (Marie-Victorin, 140). Recorded in New France by Boucher in 1664 and by early explorers.

Considered by J. Rousseau, in "L'anneda et l'arbre de vie," as the "annedda" that saved Cartier and his crew in the winter of 1536. This is probable, but it is only indirect evidence. Described by Clusius in 1601 (Alain Asselin). Illustrated in the *Codex*, Pl. XXVI, fig. 43.1.

306 Noquets were visitors of the Sault and came from the south of Lake Superior. *Jes. Rel.*, vol. 55, 159. See W.V. Kinietz, *The Indians of the Western Great Lakes 1615–1760*, 318 (henceforth Kinietz).

307 The Chippewa.

308 On its *Carte generale*, the *Codex* locates the "Passinassiouek" just north of the "Outchibouek," and devotes Plate XV, to "La pesche des Sauvages passinassiouek."

one can see the same thing at the Tuileries, where cedars brought from America have been planted.

The cedar trunk is ordinarily very straight. It narrows gradually from the foot to the peak like the cypress, which according to Lescarbot grows in our lands, although none ever have.

The cedar bark appears quite fine, yet one finds a lot of furrows. If it is raked or scratched with a knife or the fingernails, it appears green. If one pushes a little deeper, it is red, and if one removes it entirely it is all white. It is therefore a very rare bark, carrying four vivid and distinct colours: 1. dark grey, 2. bright green, 3. wine-red, 4. thick white. This bark is so pliable that all kinds of ties are made from it, and even ropes. Houses and various implements are made from it.

The branches always point upwards. The clumps of branches are beautiful and very wide, with small leaves that are always green and sweet smelling. They are astringent, sour, and a little bitter.

Two sorts of incense or resinous pitch can be gathered from the bark of the tree trunk. One is liquid and foul smelling, pungent and strong in odour, transparent like amber. The other is dry and serves as incense. The odour is not disagreeable, but it is not as fragrant as Arabian incense.

The bark and the wood burn very well; they do not smoke much, and make a very clear flame, and the ash is soft. The wood, both green and dry, crackles so much that, as well as making a troublesome noise, the fire leaps onto one's clothes. Its charcoal goes out immediately and it becomes very good for drawing. It sinks so deeply into the natives' skin that they use it to paint their entire body with various figures that they imprint and which can never be removed. They grind it and, having crushed it, they temper it with ordinary water and soak three pointed bones with which they prick the skin in such a way that the blood that comes out mixes with the diluted charcoal. The pictures they engrave never come off the place where they are made.

As the charcoal made from white cedar gives off sparks because it is bituminous, the gunpowder made from it is twice as violent as ours and with double the effect.

There is no doubt that Egyptian *cedria*[309] can be made from our cedar. A sticky liquid can be collected, which flows [f. 45] from the entire body of the tree, and which serves to embalm the body by soaking a cloth in it. The cloth and the body embalmed with this liquid will never decompose.

The body of this cedar's wood is quite full of twisted knots. However, some can be found that is so straight, and splits so cleanly, that the natives make poles four or five fathoms long.[310] It can be divided into so many pieces that the Indians line their canoes with these strips so slender that to see them, one would say that they were glued, or that they formed part of the body between the bark against which they are applied and the floorboards, which are strips of the same wood the thickness of two or three *écus*, hooped and turned in a semi-circle, specially made to keep the shape that was given to the bark of the canoe so that it glides more easily over the water and so it does not sink. I could hardly say to how many uses the American cedar is appropriate. Drums, many small tools, oars, paddles, shelves, platters, spoons, fences, beams are made from it. One could make beautiful parquetry and furniture of all kinds, which do not decay and are sweet smelling, and everything of an extraordinary lightness. The posts and fences that are made from it last for twenty or thirty years in the ground without rotting and only spoiling a little, and then only on the surface.

The wood is worked very easily and neatly, and its grain is so fine and well veined or rippled, that there is much pleasure in seeing all the works the natives do with it. In France, cork is used to support fishing nets and in America cedar is used in the shape of sword blades. Its odour refreshes the brain marvellously.

The red and white cedar[311]

The difference between the red and white cedar and the one that is only white is noticeable in every way: in the leaf, the height, the wood, the knots, the colour and the odour. There is nevertheless a certain similarity, so that one must say that there is a great resemblance between the two and that consequently they have to be given the same name and be differentiated by colour.

309 See *The History of Herodotus*, transl. George Rawlinson (http://classics.mit.edu//Herodotus/history.html), where Herodotus describes the second method of embalming corpses in Ancient Egypt: "Syringes are filled with oil made from the cedar-tree, which is then, without any incision or disembowelling, injected into the abdomen. The passage by which it might be likely to return is stopped, and the body laid in natrum the prescribed number of days. At the end of the time the cedar-oil is allowed to make its escape; and such is its power that it brings with it the whole stomach and intestines in a liquid state. The natrum meanwhile has dissolved the flesh, and so nothing is left of the dead body but the skin and the bones."

310 From 4 to 30 feet.

311 *Juniperus virginiana* L., red cedar (Marie-Victorin, 138–9); Rousseau 1964, 283 already notes that *kedros* in Greek is a *Juniperus*.

Its half-white, half-red, very fragrant wood, although twisted and extremely knotty, and its shorter, thicker leaf make it quite different, as well as its small size.

[f. 46] I have seen it only along the banks of Lake Champlain, and in some of the coves of the Lake of the Saint-Sacrament[312] and in the Bay of Error, so named since our army, which was going to the Iroquois over the snow and ice, got lost there because of the imprudence and impetuosity of some Frenchmen, because of whom we accomplished nothing in this campaign, where it would have been easy for us to defeat our enemy, who, instead of being caught, caused over a hundred brave Frenchmen to perish.

On the highest mountains of Virginia, I also saw some red and white cedars. The Virginians make some ingenious objects from this kind of cedar, which has all the other qualities of the white cedar. Those are all the most exceptional things I can say about what I have dealt with so far.

Those who wish to know more particular things about the treatise on simples, trees, fruits, flowers, shrubs, and all the other natural things that are found outside the New World have only to consult (as I did to learn about what I had not seen or where I had not been) more than thirty writers in whose work I found nothing of what I have put forward.

Let them search therefore in Cantacuzene of Constantinople,[313] in Ruel,[314] in Matthiolus,[315] in Valerius Cordus,[316] Dalechamps,[317] Hippocrates,[318] Galen,[319] Strabo,[320] Eustath,[321] Dioscorides,[322] Belon,[323] Theophrastus,[324] Des Moulins the physician,[325] Pliny the master naturalist, Boethius,[326] Macrobius,[327] Scaliger,[328]

312 Lake George, New York.

313 Cantacuzene of Constantinople. Possibly John VI Cantacuzene (c. 1293–1383), who was Byzantine emperor (1347–55). He wrote his memoirs dealing with history and religion. We could not determine the relationship to the citation by Nicolas (Alain Asselin).

314 Jean Ruel (1474–1537) was physician to Francis I and a translator of Dioscorides. He wrote *De natura stirpium libri tres* (Paris, 1536). This treatise dealt with botanical knowledge at the end of the fifteenth century. He was also known as Jean Ruelle, Jean de la Ruelle, or Jean du Ruel. He also produced a translation of *Pedacii Discoridis* in 1516 (Alain Asselin).

315 Pietro Andrea Gregorio Mattioli (1501–1577), author of the famous *Commentarii in libros sex Pedacii Dioscorides*, Venice, 1544. Nicolas may have known Jean des Moulins's French translation of this work, *Commentaires sur les six livres de Ped. Dioscoride, … de la matière médicinale … mis en françois sur la derniere edition latine de l'autheur*, Lyon, 1572.

316 Valerius Cordus (1515–1544). Born in Erfurt, this German scientist studied botany and medicine in Marburg and Wittemberg. A pioneer of fieldwork in botany, he travelled extensively in Germany, Italy, and Provence. He published his *Adnotationes in Dioscoridis de medica materia libri v*, Josias Richelius, 1563. Gesner cites also his *Stirpium descriptionis liber quintus*, 1563. See Johann Bauhin et al., *Historia plantarum universalis*, Yverdon, 1650–51, 109, n. 75.

317 Jacques Dalechamps (1513–1588), author of *Historiae generalis plantarum. Pars altera, continens reliquos novem libros*, Lyon: apud Guilielmum Rovillium [chez Guillaume Rouillé], 1586, of which Jean des Moulins made a French translation, published in Lyon in 1615, and in a second edition in 1653. Dalechamps was the editor of Pliny, *Historia Naturalis*. See W.N. Fenton and E.L. Moore, trans., Joseph-François *Lafitau: Customs of the American Indians Compared with the Customs of Primitive Times*, Toronto, The Champlain Society, 1974, vol. 1, 214, n.1.

318 Hippocrates (c. 460 BCE–c. 377 BCE). Considered the most important author in ancient Greek medicine.

319 Galen (129–201). Stands second only to Hippocrates in influence as far as Greek medicine is concerned.

320 Strabo (c. 69 BCE–19 CE). A great geographer who was also a historian. Often considered "the" geographer by several authors. He wrote forty-seven books about history and seventeen about geography.

321 Eustathius (died c. 1198) was a great Byzantine grammarian, and wrote on various other subjects. He was also known as Eustathius of Thessalonica (Alain Asselin).

322 Dioscorides (c. 40–c. 90). Pedanius Dioscorides is the famous author of *De medica materia libri sex* (c. 77), which influenced medicine and botany for centuries. He described approximately 600 plants and their medicinal properties. For more than 1,500 years, it was the ultimate reference, which was called "the most successful botanical textbook ever written." For a long time, no plant was considered officinal unless it was described by Dioscorides (Alain Asselin).

323 Pierre Belon du Mans (1517–1564). Author of *L'histoire naturelle des estranges poissons marins*, Paris, 1551; *De Aquatilibus*, Charles Estienne, Paris, 1553; *Nature et diversité des poissons avec leurs pourtraicts, representez au plus pres du naturel*, 1555. In his book *L'histoire de la nature des oyseaux avec leurs descriptions et naïfs portraits*, Belon argues that the bat should not be classified as a bird. Belon introduced the *Thuya* to France. He wrote also *De arboritum coniferis*, 1553. Nicolas's discussion about the difference between the cedar and the cypress (f. 44) comes from Belon.

324 Nicolas may have consulted the Joannes Bodaeus edition of the *Peri Phutikôn Istoriôn* by Theophrastus, published in Amsterdam in 1644.

325 Jean des Moulins (f. 1572).

326 Ancius Manlius Torqautus Severinus Boethius (480–524 CE).

327 Ambrosius Theodosius Macrobius (f. 430 CE).

328 Jules-César Scaliger (or else, his son Sylvius). A great

Columel,[329] Gesner,[330] Gaza,[331] Hermolaus,[332] Hieronymus Tragus,[333] Bauhin, a disciple of Aesculapius,[334] Festus,[335] Palladius,[336] Fuchs,[337] Dodoens,[338] Phocion,[339] Diodorus of Sicily,[340] Cornarius,[341] de Laguna,[342] Johnson,[343] Aldrovandi,[344] Rondelet[345] and

many others. All of these gentlemen and all of these famous naturalists will teach them, along with the great and divine Aristotle,[346] an infinity of very beautiful things about Nature, who delights in having us marvel at her Master in countless different beautiful objects

commentator of Theophrastus' *Historia plantarum*. Scaliger's book *Commentarii et animadvertationes* was published in Leyden in 1584 by the son after the father's death.

329 Columelle (4–70 CE). Author of the famous *De re rustica* about agriculture in the antiquity. This treatise is made up of thirteen books, including the last one about tree management (Alain Asselin).

330 The contribution of Conrad Gesner (1516–1565) to botany is interesting. His manuscript *Historia plantarum*, c. 1565, is one of the rare texts of its time to have understood the importance of flower structures in plant taxonomy. See Gerta Calmann, *Ehret: Flower Painter Extraordinary*, Boston, New York Graphic Society, 1977, 25 and 27. Nevertheless, Gesner is best known by the five volumes of his *Historia animalium,* Frankfurt, 1551–87.

331 Theodorus Gaza (1398–1475). Greek humanist and a well-known translator of some works of Aristotle and Theophrastus.

332 Hermolaus Barbarus (1453–1493). Italian humanist who tanslated works by Dioscorides, Aristotle, and Pliny, among others. In 1493 he wrote *Castigationes plinianae*, in which he surveyed more than five thousand errors in the translations of Pliny's *Historia Naturalis* (Alain Asselin).

333 Latinized form of German botanist's name, Hieronymus Bock (1498–1554), author of *Kreuterbuch*, Frankfurt, 1551 and 1587.

334 Designated as a disciple of Aesculapios, that it is to say, a physician, Bahuin (sic) is Jean Bauhin (1541–1613), physician of Frederick I, Count of Montbéliard and Duke of Wurtemberg. He was the co-author of *Historia plantarum universalis* (Yverdon, 1650–51), and the sole author of a *De Plantis a divis sancti sive nomen habentibus* (Basle, Conrad Waldkirch, 1591), which deals with plants named after gods or saints. This work includes a very useful list of synonyms of plant names between the Ancients and the Moderns. Bauhin was a correspondent of Gesner. See Augustin Sabot and Claude Longeon, *Conrad Gesner. Vingt lettres à Jean Bauhin, fils (1563–1565)*, Université Saint-Étienne, 1976.

335 Sextus Pompeius Festus, 2nd Century CE.

336 Rutilius Taurus Aemilianus Palladius, 4th century CE. Latin agronomist who wrote *De re rustica*, in which he copied Columelle and other authors (Alain Asselin).

337 Famous German botanist, Leonhard Fuchs (1501–1566) taught medicine in Tübingen from 1535 until his death. His *De Historia Stirpium commentarii insignes*, Basel, at Isingrinus, 1542, mentions for the first time some American plants, such as maize and the pumpkin. See K.N. Sanecki, *The Complete Book of Herbs*, 195.

338 Rembert Dodoens (1517–1585), author of *Cruydeboeck*, 1554. His book was translated into French by Charles de l'Écluse (Clusius) as *Histoire des plantes.* See Sanecki, 196.

339 Phocion (402–318 BCE). Greek author who did not leave writings of his own. However, Plutarch (c. 46–126 CE), who was a famous encyclopedist, wrote about Phocion (Alain Asselin).

340 Diodorus of Sicily (c. 90–20 BCE). Famous historian of antiquity who wrote about the period from c. 1150 to 60 BC.

341 Janus Cornarius, latinized form of Jean Hagenbut. He is the translator of works by Aetius. Nicolas probably knew the revised edition of his book, published in Lyon in 1549 by Hugues de Solier under the title *Aetii Medici Sermones sedecim per Janum Cornarium conscripti, Recesserunt in duas priores libros Scholia per Hugonem Solerium.*

342 Andres de Laguna (1464–1534). Worked in Rome close to the popes (1545–54) and translated several works from antiquity on natural history and medicine (Alain Asselin).

343 Thomas Johnson, author of *The Herball or General Historie of Plants, Gathered by John Gerarde of London Master in Chirurgie, Very much enlarged and Amended by Thomas Johnson Citizen and Apothecarye of London*, printed by Adam Islip Joice Norton and Richard Whitakers, London, 1663 (1,630 pages). It is probably Nicolas's main source on plants of Virginia. See Doyon, 121.

344 Ulisse Aldrovandi (1522–1605), great Italian naturalist who taught in Bologna from 1553, and in 1567 created the first botanical garden of this city, which he directed. Gesner considered him the best botanist of his time. See Oreste Mattiroto, *L'opera botanica di Ulisse Aldrovandi*, Bologna, 1897.

345 Guillaume Rondelet (1507–1566) was a professor of medicine at Montpellier. He is the author of a *Commentarii in aliquot capita libri primi Dioscoridis*. Dalechamps and Bauhin were his students. Rondelet is principally known as an ichthyologist. His *De piscibus marinis Libri, XVIII, in quibus verae piscium effigies expressa sunt*, Lyon, Mace Bonhomme, 1554–55 and his *Universae aquatilium Historia pars altera*, published as the second section of the latter, are famous. Laurent Joubert translated it under the title *Histoire entière des Poissons composée premièrement en latin ... avec leurs pourtraits au naïf*, Lyon, Mace Bonhomme, 1558. See Willy Ley, *Dawn of Zoology*, Englewood Cliffs, New Jersey, Prentice-Hall, 1968, 153. Nicolas quotes from memory his *Libri de Piscibus, in quibus verae piscium effigies expressae sunt.*

346 Aristotle (384–322 BCE). Considered by Nicolas as "great and divine," Aristotle was the most influential

that we cannot know or even understand other than by looking at them and examining them closely in the course of several repeated journeys, where it is necessary to study oneself, and to enjoy, or at least have the curiosity to look attentively at what one finds exceptional. For unless [f. 47] one does that, one passes and passes again many times by the places where there are curious things and things worth noticing, without seeing them there; and it is quite useful to make these things known to the public, who remain ignorant because of the travellers who take no interest in anything as they pass by the places where there are beautiful things to see and know. This misfortune happens to a hundred thousand people who find voyages tedious and who think of nothing but their destination, at the end of which they are as learned as when they set out on great voyages, for what reason I do not know. These kinds of people are no more commendable for it, nor learned. As for me, I have made a careful study, and I took great pleasure in observing everything beautiful and curious that I was able to discover on my travels. So be content with this little knowledge that I present and that I discovered in foreign lands over a very long time. See, after what I have just said about the forests filled with the trees I described; see, I say, living peacefully in these great lands, the animals that I am going to present to you over the course of three books in which I am going to have you consider about sixty or eighty quite different four-legged animals.

BOOK FOUR

Treatise on land, water and amphibious four-footed animals that are seen in the New World or in Northern and Western America

As I have undertaken the natural history of the northern and western regions of this vast America, it is important not to omit anything that is most valuable. And since the animals that one meets there are to be the subject and material of three books, I thought it was useful, [f. 48] before going into detail, to say a word in general and to point out that Nature, which wants to appear admirable everywhere and in particular in animals, so that it is amazing to see the great number and variety, is indeed marvellous in forming four-footed animals. Some animals have round feet like the horse, the mule and the ass; others have cloven or forked feet like the ox, the elephant, the unicorn, the deer and the fallow deer, the roe deer, the caribou and the goat; and finally, some have feet with claws and nails. Among these there are two kinds; some have claws and nails only, like the lion, the tiger, the dog, the panther, the bear, the cat, the marten, the fox and others. The beaver, the sea tiger, the muskrat, the seal etc. have webbed feet with nails.

It seems that Nature, that wise worker, did not want there to be any envy among animals; for if she was pleased to give four feet to some, she wished to favour others by giving them only two feet but also two wings. And she has decreed that anything not in the order she has established will be considered defective, and that people would consider anything against her rules to be monstrous.

I do not have to describe here anything except perfect[347] and rare animals that are not seen in France or in any place in the East, or in any place near us.

But since among the animals of America there are those that live on land, those that live both on land and in water, which we call amphibious, and others that live only in the water and that are thus simply aquatic, I will speak of them all separately, after pointing out that in the first lands of our great America there are not naturally any of those kinds of animals that the Greeks called ἀκίδες [akides] that is animals whose feet are not cloven;[348] others call them animals with solid or round and strong feet, *solidipeda* ζῶα [zôa]; the Latins called them *cornipeda*, agreeing with the Greeks. *Solipeda*, says another.[349]

All the animals of America have cloven hooves, *bisulca*[350] (διχηλά ζῶα [dixèla zôa]), animals with

Greek philosopher in the world of ideas, including natural history.

347 "Perfect" in the sense of "complete." Aristotle had already distinguished (excluding animals born spontaneously) between the viviparous and the oviparous. "What we term an egg is a certain completed result of conception out of which the animal that is to be develops, and in such a way that in respect to its primitive germ it comes from part only of the egg, while the rest serves for food as the germ develops. A "grub" on the other hand is a thing out of which in its entirety the animal in its enti-

rety develops, by differentiation and growth of the embryo" (Aristotle, *History of Animals*, Book 1, Part 5, 489a; D'Arcy Wentworth Thompson, trans.).

348 The manuscript erroneously says *animaux à pied fendu*. Non-cloven feet were expected.

349 These distinctions were made already by Aristotle, *History of Animals*, Book 2, Part 1, 499b.

350 *Bisulcus*, -a, -um (*bis sulcus*), split in two; *bisulca*, fissipedes as distinct from solipedes. See Aristotle, *History of Animals*, Book 2, part 1, 499b.

Natural History, or the faithful search for everything rare

cloven hooves like the crayfish. Aristotle calls them animals with pincer-feet,[351] and this is no more than is necessary for them to run on ice for six or seven continuous months, and where round-footed animals would not be able to keep their balance without slipping a thousand times a day.

Animals with hooves and claws will have the first rank in this description under the name of πολικιδες, και πὸλιδακτὺλον [*polikides, kai polidaktulon*] as having several fingers, to speak like the Greeks, and also the Latins *animalia multipliciter digitata*, having much similarity to the human hand. There are even birds that have this advantage; they are divided into two kinds, those with nails and those with flat feet. *Alias digitatas aves esse dixit, alias palmipedes,* says one naturalist following (f. 49) another. And I say after them that one can distinguish two more kinds of four-footed animals. Among that great multitude of four-footed animals, some lay eggs like tortoises; these could be called *ovipara,* or ωοτοκα [*ôotoka*], *quae cortice teguntur,* covered by a sort of bark. The others are also four-footed, but their young are born alive, *vivipara,* or ζώοτοκα [*zôotoka*] *et pilisista teguntur,* and these are hairy at birth. I will begin with these.

[Third Cahier of the Natural History of the New World]

Chipmunks[352]

It is not without reason that I begin the description of four-footed animals by the four different kinds of squirrels which are commonly seen in the terrible forests of the New World.

This animal should no doubt be ennobled, and hold the first rank in this book; for it has already received its letters of nobility from the mouth of the most august and most invincible Monarch of the world, that is, Louis the Great. This honour has been confirmed by the mouth of the most enlightened and most learned of our Dauphins, ratified by the most devout Queen in the universe,[353] and finally recognized by the most ac-

complished court of the most flourishing state and the most powerful monarchy on earth.

I mean that all these illustrious persons, having seen only one kind of these animals, which I had brought from beyond the great ocean and which I had the honour to present to His Majesty, found them so fine and so rare, and so well trained that they all agreed that they were very charming for the beauty of their fur and for the smallness of their bodies, and for the graces which nature had bestowed on them. Here is a faithful description of them.

The natives of the country call by the name *ouaouin-gouch* the animal that the French call the Swiss squirrel (chipmunk), because of the variety of its hair, which is adorned with various beautiful colours like the uniforms of Swiss guards.

The animal is very small, and of a pleasant appearance, with a wonderful coat. The base colour is slightly yellow and a little russet. It is striped on both sides with lines of different colours. These marks are about two inches long and about as wide, and resemble the figure which I make here:

Two of these lines are white like ermine fur, and the two others are black like jet. Between the black colour and the white colour [f. 50] there is another quite different one, a gold colour no wider than a bit of sewing thread, which sets off the two others nicely. The coat is whitish on the belly. The whole animal is no longer that the figure seen here:

It has a diameter of one inch, and is three inches around. Its tail is longer than its body, very big and bushy with fairly long hair. It draws its tail gracefully up to the tip of its nose, laying it on top of its body, and folds it over again so that it seems to have a helmet. The head is in proportion to the whole body. Its eyes are large and very lively, and its ears are fairly short though a little raised, so that they make the animal very agree-

351 See Aristotle, *De Partibus Animalium,* 690a, where διχήλα means "cloven-footed." The comparison with the crayfish is probably Louis Nicolas's idea.

352 *Tamias striatus* (L.), eastern chipmunk; we follow A.W.F. Banfield, *The Mammals of Canada* (henceforth Banfield) for the scientific name of the animals; here 96–9. We have also consulted W.H. Burt and R.P. Grossenheider, *A Field Guide to the Mammals*; here, 108 (henceforth Burt and Grossenheider). The eastern chipmunk is depicted in the *Codex,* Pl. XXVIII, fig. 45.1,

as "ecureul suisse nomme dans le pais oua ouingout." Gabriel Sagard, *Le grand voyage du pays des Hurons,* 316 gives *ohihoin* as the Huron name of the animal. Ganong, 239 explains that it got its name "Suisse," thanks to "its stripes, which apparently suggested those of the uniform of the Swiss soldiery," including those engaged by the pope. Lahontan also used the same name.

353 Louis de France, the son of Louis XIV and Marie-Theresa of Austria (R. Ouellet).

able. It is very alert and very lively. It climbs everywhere with wonderful speed, and it jumps nimbly from branch to branch, and even from one tree to another. It makes in the trees its main dwelling in holes where it withdraws, and it stores up food there in storage chambers for living over the winter, which it spends partly in sleeping and partly in gnawing away at its food; I say gnawing, for it cannot eat otherwise, being unable to chew; it gnaws as mice do, with the difference that it holds in its paws what it wants to eat, that is walnuts, hazelnuts, beechnuts, and all kinds of other hard fruits. Its fingers and claws are long enough to allow it to hold on easily when climbing.

These rare animals have an exquisite taste, and they are as delicate as ortolans[354] when they are only three or four months old. The natives grill them without skinning them. They also prepare them in other ways, and keep the skins carefully to make clothing for their children. Recently the merchants of Europe have come to prize them and buy them at a high price, as well as the skins of the three other kinds of squirrels.

There is great pleasure in seeing great troops of these little animals run in the fields covered with Indian corn, which they gather industriously when they feel winter approaching. Many times a day they fill two little pouches that they have beside their jaws, as monkeys do; they empty them into their storerooms which are always close to their nests, where they leave a hole to pass when they want to go to eat, and another to relieve themselves so as not to soil their living quarters. They come out of these dwellings around the fifteenth of the month of March, when the snows are beginning to soften every afternoon. They go to play in the sun and run on the trees; for this reason the natives have given this month the name of "month of squirrels," which is in their language *ouaouingouch-kizis*,[355] that is to say the "sun of the squirrels," to mean the month of the squirrels, taking the sun for a month, like astrologers who assign an imaginary celestial animal to the sun each month of the year.

[f. 51] At about this time these little animals go into heat and begin to make the woods echo with their different cries, which sometimes resemble those of large rats; at other times they vary them in a kind of song, which is more like a bird's song than the cry of a four-footed animal. They can be seen chasing after each other, biting and hugging, and making a thousand pleasant movements and lively leaps.

Their young are born in the month of May, and shortly after that they have a second litter. They frequent places where there are hazel, plum, walnut and beech trees, and other such trees.

If a chipmunk is taken from the nest when it is very young, one can very easily tame and train it, and teach it various amusing little tricks. To do this one must keep it without food for a while. When it is hungry it becomes bright, active, and frisky, and to have the pleasure of seeing it fill its pouches one must have an ear of Indian corn or another grain. The chipmunk will then jump and leap and throw itself on the grain with almost incredible speed, and fill its pouches to go and empty them in its storerooms, and return quickly several times to do the same thing until it has taken the last bit of grain. It then goes to eat with such speed and eagerness that it is incredible how this animal can move its jaws so fast.

These animals must be touched often and given a little sugar to accustom them to eating from the hand, and in a little while one will see them play and become very familiar. To have the fullest pleasure one needs two, male and female. They come to eat, and they run on a dining table without getting anything dirty. They jump on a bed, climb on a tapestry, and do a thousand tricks; but watch out for the cat. If one is careful to make sure that the cat does not catch them, one will have an extraordinary pleasure to see these two squirrels dart away like lightening to go to some safe place from which they will watch the enemy, squeaking and running everywhere to find an even safer place, scolding the cat a thousand times with such violence that they would soon die of it if one did not remove the object of their fear.

As I have said, His Majesty did me the honour of receiving from my hand two of them that did everything that I have just said. He was curious enough to order Monsieur Chamarante to have them put in his famous Versailles menagerie, where there are the finest and rarest curiosities in the world, both birds and four-footed animals, which in my opinion are the finest curiosities on earth after human beings, since the others are usually only the work of some clever men, and these are the works of the world's greatest Master.

[f. 52] *The flying squirrel*[356]
I would have liked very much to have the three other species of squirrels that I have seen in the Indies. I am

354 Small wild bird valued as a table delicacy.
355 Louis Nicolas's *Grammaire algonquine*, 525, translates *kizis* by "month," "moon," and *kisis* by "sun." See also

Mary R. Haas, "The Proto-Algonquian Word for 'Sun,'" 60–5.
356 *Glaucomys sabrinus* (Shaw), Northern flying squirrel;

sure that His Majesty, who is moved by the noble desire to learn and to see everything that is beautiful, curious, and rare in nature (and to whom it would have been a great pleasure and honour to present them, as I did the first and finest of these four kinds of rare animals), would have been pleased to receive them, since they are all extremely interesting in their way, and very particular in their species, since they all have some things in common and some very different.

For the flying squirrel, which the Indians call *anachkanataoûé*,[357] has everything that I have just said in common with the chipmunk except for its size which is rather remarkable, and its coat which is different, being greyish. The most admirable thing about this animal is that, from the shoulder to the thigh, it has a skin as hairy as all the rest of its body, which extends like a wing on each side when it wants to leap from one tree to another from above, not from below, for it never jumps that way. When it wants to take off, it makes a kind of jump, and then its wings spread out like a fan, and holding them rigid without moving them it arrives where it wants to land and grasp. Having caught on to a branch, it runs at incredible speed wherever it fancies. Its tail is much finer, bushier, and bigger than the chipmunk's, and it draws the tail up gracefully. It has extraordinarily large eyes for the smallness of its body; they are not as bright as those of the chipmunk, although they are very lively. Its voice differs very little from the chipmunk's. When this animal is dead, though small, it becomes as big as a large ball if it is inflated. In that state it becomes translucent because of the delicacy of its skin, which is pink.

The yellow squirrel[358]
This third kind of squirrel is bigger, taller, and longer than the first and second. The *coureurs de bois* have given it the name *achitamoû*.[359] This third species is the one most like European squirrels. However, the animal is not as big and its coat is not as reddish, for it has a yellow tinge, except that the end of its fur is a sort of very pleasant light grey. The tip of its nose is like that of a hare; the head is very large, the ears a little straight and pointed. It is livelier than the other species of its kind.

There is nothing finer than one of these animals when it is tamed. Its agility, speed and a sort of cleverness make it invisible when it fears some enemy.

[53] *Black squirrels*[360]
This sort of squirrel, which in the country is called *missanik*,[361] is unquestionably the most curious and most sought-after. A single squirrel of this kind is larger than three of the others. As to its appearance, there is not much to say. The colour is different; it is of a handsome black. The animal has a very long, bushy tail in proportion to its body. All its coat is shiny as a mirror. These black squirrels are not as common as the others; this is why they are very much prized. A garment of these skins is sold for more than three hundred écus among the natives. Their children and adults kill all these four kinds of animals with certain arrows that are blunted so as not to spoil the skin.

see Banfield, 145–7 and Burt and Grossenheider, 123–4; depicted in the *Codex*, Pl. xxviii, fig. 45.2, as "Ecureul volant sans pleume nommé anascantoue." *Anascantoue*, or *anachkantaoûé*, is the Iroquois name of the animal. Mentioned by Champlain in 1632 as "escurieux vollans" and by Le Jeune (Ganong, 214).

357 Mary Haas has *anikwa* for squirrel in "A New linguistic Relationship in North America: Algonquian and the Gulf languages"; see 252.

358 *Tamiascurus hudsonicus* (Erxleben), red squirrel; see Banfield, 138–42 and Burt and Grossenheider, 120–1; depicted in the *Codex*, Pl. xxviii, fig. 45.3, as "Ecureul commun jaune." The figures of the *Codex* depicting animals were not drawn directly from nature. Dorothée Sainte-Marie, *Les Raretés des Indes ou Codex Canadiensis*, checked C. Gesner, *Historiae animalium libri i–iv. Cum iconibus. Liber i. De quadrupedibus viviparis*, which she consulted in the 1621 ed., Charles Froschoverus, Frankfurt, at McGill University, as one possible source of inspiration. It is clear for instance that the "Ecureul commun jaune" was copied from Gesner, 1621,

vol. 1, 845. We note also that N. Denys, *Description géographique et historique*, 1672, made a clear distinction between the three eastern species: the red squirrel, the ground squirrel (the *suisse*), and the flying squirrel (Ganong, 214).

359 *Acitamo*, "squirrel" in Ojibwa. See G.L. Piggott and A. Grafstein, *An Ojibwa Lexicon*, 11 (henceforth Piggott and Grafstein). Modern Algonkin says *adjidimus*, "squirrel." See R. Gilstrap, *Algonkin Dialect Relationships in North Western Quebec*, 44 (henceforth Gilstrap).

360 *Sciurus carolinensis* Gmelin, eastern grey or black squirrel; see Banfield, 132–6; and Burt and Grossenheider, 117–18; depicted in the *Codex*, Pl. xxviii, fig. 45.4, as "Ecureul a la Robe noire." Pierre Boucher, who made the distinction between four species of squirrel, knew also the "Escurieux noir" found only "au pays des Iroquois" (Rousseau 1964, 311–12).

361 *Missanig*, "black squirrel." See International Colportage Mission, *A Concise Dictionary of the Ojibway Indian Language*, 100; *anik* is "squirrel" in Cree (C. Stuart Houston).

New World mice

In the Indies no rat or mouse similar to those of the Old World is seen, except those that a ship (which ran aground near the coast of Cap au Diable,[362] which is between the city of Quebec and the famous residence of Sillery[363]) brought into the New World.[364] Since that time they have multiplied so much that there are only too many of them in all French houses, where this vermin ruins entire barns full of grain. The cats that were brought from France following the arrival of the rats and mice are their Iroquois.

Little field mice[365]

All the vast forests of the north and the western or the sunset direction are filled with *mulots* (field mice), which are a kind of mouse. These animals make their dwelling under ground, and make their storerooms there and cause trouble for the Americans who cultivate Indian corn. The animal is bigger than our ordinary mice; its coat is almost yellow, its head and eyes are large, and its tail is very long.

The sharp-nosed mouse[366]

One also sees in the woods other very small mice. Their colour is rare, and similar to a certain green colour. The nose is two fingers long and very slender. The animal digs in the earth with it like a mole. The natives cook them on a spit like larks, without skinning or drawing them. They roast them and eat them as delicacy.

Large rats found in the meadows that are along the River Techiroguan in Virginia[367]

The country of which I speak is the one inhabited by the Lower Iroquois.[368] I have seen them hunt a certain kind of large rat around the end of April. So many of these animals are found in the fields and meadows that even very small boys kill hundreds of them within a few hours. These rats are a good dish according to the taste of the Virginians. They roast them without skinning or drawing them. The meat is certainly very delicate, and would taste better than rabbit if it were prepared in the French way. Young pigeons or chickens do not have a more delicate taste than these rats, which have a handsome, fairly thick coat of a grey colour.

[f. 54] The appearance of this rat is a little unusual, as its hindquarters are very large. Its tail and legs are very short. It has fine hair and short rounded ears, and is as large as one of our largest rats.

The large rat par excellence

This is the finest and rarest of all the rats that live underground and ordinarily on the mountains. To walk it really leaps from a sitting position on its thighs. When eating it uses the two front paws as if it had two hands, like a monkey. It is as tall as a hare and has a big body. Its appearance is like that of a large rat, for which reason it is called by that name. It has a very wide back, and hair that looks rather bristly or coarse. It is reddish, though some are seen that are less colourful. It has large bright eyes that seem to protrude from the head; its ears are so short that they can barely be seen. Its face is like the hare's, with yellow beaver-like teeth.

362 One would expect, because of the locality (between Quebec and Sillery), "Cap Diamant" instead of Cap au Diable. A "Pointe de Tous les Diables" exists, but near Tadoussac.

363 The Jesuit Residence near Quebec.

364 *Rattus norvegicus* (Berkenhout), Norway rat, brown rat, or house rat; see Banfield, 222–3 and Burt and Grossenheider, 195; depicted in the *Codex*, Pl. xxviii, fig. 45.6, as "Rat comun dans tout Le pais." Boucher 1664 knew that the house rat was imported from France: "Voilà les animaux que l'on nous a amenés de France" (Rousseau 1964, 314).

365 Nicolas probably did not suspect the variety of mice one could find in Eastern Canada. Rousseau 1964 encountered the same problem in interpreting Boucher's *Histoire naturelle*. The "mice" could be any of the following: *Peromyscus maniculatus* (Wagner), deer mouse (see Banfield, 164–70 and Burt and Grossenheider, 158–9); or *Synaptomys cooperi* Baird, southern bog lemming (see Banfield, 187–90 and Burt and Grossenheider, 176); or *Microtus pennsylvanicus* (Ord.), meadow vole (see

Banfield, 201–2 and Burt and Grossenheider, 183–4); or *M. chrotorrhinus* (Miller), yellownose vole (see Banfield, 218 and Burt and Grossenheider, 188); or *Zapus hudsonius* (Zimmermann), meadow jumping mouse (see Banfield, 227–9 and Burt and Grossenheider, 196–7); or *Napaeozapus insignis* (Miller), woodland jumping mouse (see Banfield, 227–9 and Burt and Grossenheider, 199); all of which have many subspecies!

366 *Microsorex hoyi* (Baird), pigmy shrew; see Banfield, 20–2 and Burt and Grossenheider, 12–14; depicted in the *Codex*, Pl. xxviii, fig. 45.7, as "Rat au museau Egu"; copied from the *mus arancus* of Gesner, 1621, vol. 1, 74–7.

367 The figure of the *Codex*, Pl. xxviii, fig. 45.5, labelled "Rat de La Virginie" does not represent a rodent. It could be a *Procyon lotor* (L.), raccoon, but with its ringed tail shortened.

368 Probably Oneida territory, south of Oneida Lake and including the upper waters of the Susquahana. See White, 361.

Natural History, or the faithful search for everything rare

It does not chew; it only gnaws. Its claws are pointed, and its black whiskers resemble the tiger's. Its tail is more that two palms long; it is big and has thick hair. Its thighs are large but short. The entire lower belly is very hairy as well as its thighs. It walks like a bear, standing up on its hind legs. All its flesh is covered by a sort of matter that is neither flesh nor fat, but a mixture of the two, like the meat of the beaver and the muskrat. Nevertheless it has a very pleasant taste. This animal becomes bigger rather than longer with age. These kinds of rats have a cry like ours; but when the weather is about to change they seem to whistle in a tone like the sweet German flutes. They usually eat hard fruits, but spend a full six months sleeping, without eating anything at all. Their usual dwelling has two exits or two entrances. It is built underground in the form that I show here.

B is its nest. A and C are the two exits. One must note that these rats never go through exit C, so as not to get dirty, for C serves as a common place to throw their excrement out of their home, because it would get them dirty or infect them. For this reason these animals are so clever as to make this hole on a slant, so that their excrement flows out by itself, unlike hole A, which is above and by which they go out. Their bed is made of dry grass.

Before the heavy snows cover the earth, these rats gather together and withdraw into their nests. Often eight or ten of them are found in the same hole B. They roll together like a ball of yarn to keep warm and to sleep, as I have said, six months of the year. I have found and killed as many as twenty together.

The mole[369]

The American mole is very similar to ours, but it has two rather remarkable features. It has a longer tail [f. 55] and the end of its nose is very different: it has seven or eight little bits of flesh with bones, which make the shape of a carnation. The two nostrils are the base of it. Its coat is fine but is more grey than black. This mole seems to have fairly large eyes, but they are of a material like horn, which can be seen clearly, with eyes very protruding.

Various kinds of weasels[370]

I have not found anything different in the weasels of Europe and those of America except for the size and the difference in their coat.

These animals are all carnivorous, and are very quick at stealing the eggs from the nests of birds and chickens. They kill little birds and chicks. It is amusing to see them loaded with a hen's egg, which they put under their long neck. They put this egg under their lower jaw, so that it touches their chest, and carry it off. One might say that in this state they look like little trained horses that are pulled strongly by the reins to make them hold their heads properly. These weasels hold their body in this shape; they make amusing curvets as they carry their prey to their underground storehouses. As these foreign weasels are much larger than ours, they not only attack chickens and eggs, but also furiously attack larger fowl, and slaughter so many in one night or more that they kill as many as forty or more if they find them. If this happens today on one farm, the neighbouring farmer had better beware tomorrow. On the first night these animals only bleed the birds in a way that cannot be seen except when the hen is plucked;

369 *Condylura cristata* (L.), starnose mole; Banfield, 35–8; Burt and Grossenheider, 17; depicted in the *Codex*, Pl. xxx, fig. 47, as "taupe de la nouvelle france"; copied from Gesner, 1621, vol. 1, 93. According to Rousseau 1964, 315, Boucher in 1664 may have meant by "taupe," in addition to *C. cristata* and *Microsorex hoyi* already mentioned, any of the following animals: *Parascalops breweri* (Bachman), hairy-tailed mole (see Burt and Grossenheider, 18–19); *Sorex cinereus* Kerr, masked shrew (see Burt and Grossenheider, 3); *Sorex fumeus* Miller, smoky shrew (see Burt and Grossenheider, 5); *Sorex arcticus* Kerr, arctic shrew (see Burt and Grossenheider, 5); *Sorex gaspensis* Anthony and Goodwin, Gaspé shrew (see Burt and Grossenheider, 6 and 8); *Sorex pa-* *lustris* Richardson, American water shrew (see Burt and Grossenheider, 12); and *Blarina brevicaudata* (Say), short-tailed shrew (see Burt and Grossenheider, 15–16).

370 If we exclude the ermine and the ferret, which are mentioned below, Nicolas may be referring to *Mustela nivalis* (L.), least weasel (Burt and Grossenheider, 56; Banfield, 325–7 mentions the sub-species *Mustela nivalis rixosa* (Bangs); or to *Mustela nigripes* (Audubon and Bachman), black-footed ferret (Banfield, 327–9 and Burt and Grossenheider, 58–60); or even to *Mustela vison* Schreber, mink (Banfield, 329–32 and see Burt and Grossenheider, 60). Boucher in 1664 may also have been referring to one or the other of these animals (Rousseau 1964, 314). The *Codex* has a "Belette comune," Pl.

under its ear one can see a small red spot, through which the blood has been sucked.

These three or four kinds of weasels found in the Indies eat everything and could be given the Greek name ζῷα παμφαγα [zôa pamphaga], *animalia omnia voratia*, animals that devour everything, or rather they should be called bloodsuckers, or even more fittingly blood drinkers, Δελα [bdela], *sanguisuga*, πιναιματον [pinaimaton], *sanguinem bibens*. This animal is of the same nature as the weasels that Erasmus spoke of, and said that *fugiens, pessimè pediti*.[371] In any case, I am certain that the place where it has passed through and done its killing does not smell good, and that if it has been in a chicken coop or in a pigeon roost, it is not easy to get the chickens or pigeons to return, because of the strong smell that the murderous animal has left there.

The natives use the skins of all kinds of weasels for various purposes, but they do not value them as much as all those of the animals that I have already described, and of the others whose picture and description I will give.

The Indians eat the flesh of weasels although it is very tough, and very bad-smelling. But this should be not surprising [f. 56], since all kinds of foods are good to them.

Horses that have died by some accident make a good dish for them; they make feasts of them that please them as much as the flesh of their elk.

One day I was asked if the French ate them. I first said not; but realizing that I was contradicting an honourable man, I took it back, saying that in some cases French soldiers ate them in war. That was enough for several people to go and dismember a fine mare that had drowned. They had a war feast with singing and dancing as if it were a most important matter, in the manner of the Americans.

The ermine[372]
Although this animal does not differ from the weasel in size and appearance except for its rare white colour, I want to say a word about it to have you admire it and see that it merits it for its charming beauty or for its uses.

In this country, one sees very fine ones, whose complete description I intend to give to you. This beautiful ermine is three or four times larger than our weasels. The entire coat of this fine animal is as white as snow, and one must not think that it is spotted or striped all over the body like the furs on the backs of presiding judges in France. No, I repeat, the animal is all white except for its black tail, which sets off the white of the whole animal in a most elegant way. This is the reason it has become customary to pull some hairs from the tail of the ermine and mix them into the fur, to make the white stand out.

This animal is a carnivore like the weasels I have spoken of. It is rare; I mean that not many of them are seen, and for this reason not everything called by that name is really ermine. Is it not well known that in these times everyone does what is done around noon, four leagues from Lyon in the town of Charabara, where people shout from all sides: Charabara, charabara, charabara, let anyone who can fool his companion do so. At these words everyone folds up his cloth and leaves, and the fair ends for fear of being robbed or cheated. Let people be on their guard, but in any case the ermine is a beautiful animal of which there are very few. Some of the finest ones are known in France.

The ferret[373]
This animal is distinguished from the weasel only by its size, length, and height. Its coat is brown; its tail is black and long with thick hair. The animal is carnivorous. It is seen everywhere. It has sharp, quick eyes, very shiny though small; its ears are round and short. It lives on hares and other animals. There are two kinds of ferrets, water and land ones.

[f. 57] *Black and yellow zibeline martens or sables*[374]
Since the zibeline marten is one of the animals that the ancient Latins and the moderns call *quadrupeda*, four-

xxx, fig. 47.1 and an "autre sorte de belette," fig. 47.2. The first one comes from Gesner, 1621, vol. 1, 753.

371 "When running away, the sphondyla leaves a very bad fart." The text of Erasmus, *Adages* III, 7, 37 is a Latin translation of verse 1077 of Aristophanes' *The Peace*. The sphondyla is a snake according to Pliny, but an insect according to Aristotle (Alban Baudou).

372 *Mustela erminea* (L.), ermine, short-tail weasel; see Banfield, 320–3 and Burt and Grossenheider, 55–6; depicted in the *Codex*, Pl. xxx, fig. 47.3, as "hermine"; copied from Gesner, 1621, vol. 1, 753. Mentioned first by Champlain in 1632 and described in 1672 by Nicolas

Denys (Ganong, 215). Boucher mentioned "belettes," but without specification.

373 *Mustela frenata* Lichtenstein, long-tail weasel; see Banfield, 323–5, and Burt and Grossenheider, 58; depicted in the *Codex*, Pl. xxx, fig. 47.4, as "furet de terre."

374 *Martes americana* (Turton), marten; see Banfield, 315–18 and Burt and Grossenheider, 54; depicted in the *Codex*, Pl. xxx, fig. 47.5, as "martre cybelline"; copied from Gesner, 1621, vol. 1, 765. Mentioned first by Cartier in 1535. Champlain gives a picture of the "Martre" on his 1612 map. Mentioned in Newfoundland in 1583 as "marternes" by Edward Haies, *Sir Humphrey Gilbert's Voyage*

footed animals, and the Greeks *tetrapoda* and following the great philosophical genius, the famous Aristotle, who called them *peza*, this will be the place to say something about it. As this animal is not very different from the martens and beech martens[375] seen in these countries, I will not have much to say to describe its appearance.

I will mention that this animal is very lively, that it is greedy, clever, and carnivorous. Our natives catch many of them when a little snow has fallen and these animals no longer can hunt the rats, mice, field mice, and all kinds of small animals that they found in great numbers before the woods and lands were covered with snow. These animals withdraw into their dens to spend five or six months without coming out. The martens can no longer hunt the animals, and the Indians can set traps for them. The Americans kill almost as many as they want, either in this way or with blunt arrows, or with guns that they load with small shot, so as not to spoil the skins. They trade the pelts with French merchants, who buy as many as they can, competing with each other, to send them to France or England or Holland. This is a profitable trade for them; a single merchant can sell four or five thousand *livres* worth, some more, some less. Each skin is worth twenty *sols* in this country.

These skins are used to make fine furs, since the tail of this animal is very black and lustrous and suitable to make trims. The natives use these skins to make tobacco bags; the women make swaddling for their babies in them, and they make fine rich dresses. The hair of this animal is an inch long, very thick and fine. Some of these martens are yellow as gold, except the tail, which is long and bushy and black as jet. The feet have long claws, so that the animal climbs trees very fast and holds on well. When the mood strikes it or it is threatened by some enemy, it leaps nimbly from branch to branch, and from tree to tree, which is not too difficult since the tree branches touch almost everywhere and thus the animal travels fast. It has a clever, mischievous face and eyes. Its teeth are sharp; the end of the nose up to the eyes is white mixed with grey. It has coarse whiskers like the tiger.

The martens that have a black coat are no different from the others. The pelt is worthless if they are not killed in winter or late fall.

The flesh is tough and almost like that of the weasel. [f. 58] But our natives, who have no need of mustard, find it tasty. This animal, as I have said, being unable to hunt in winter as it did before the ground was covered with snow, follows them everywhere in their hunts in winter in the deep snows, where they kill many elk. Often, after skinning the animals, they leave all the meat when the elk is not very big. This allows them to hunt martens all winter, for since the martens want to eat this meat left behind, the hunters catch them, either in nets or in traps. In this way, they make great piles of marten skins. They even catch wolves that come their way to scramble along with the martens for the spoils of the elk carcasses. But if I say that these animals often have difficulty biting into this meat, people will not believe me. But believe it or not, I will say that since this flesh is frozen as hard as marble, the animals, instead of eating it, only sharpen their teeth and starve like Tantalus in the middle of food: *quaerit aquas in aquis et poma fugacia captat.*[376]

The marten prefers fir groves to other parts of the woods.

The whistler[377]

I present to you here an animal which is very special in three ways: first because of its beautiful coat, second, because of its small size, and third, for the pleasant mixture of different colours in its coat, which is yellowish, rather bright, and set off by a very fine grey at the end of the hairs, which are neither too short nor too long. The animal is no larger or longer than one of our average cats. The grey, which gives variety to the colour of its skin is not too thick, but it is distributed in proper proportion, and so well mixed with another black colour that it makes the animal very attractive. The base of the coat is covered with yellow as I have said, and mixed in with this colour grow other hairs which are a little longer, coloured black and grey, which make the whole animal look very graceful. But the rarest thing about this animal is a whistling which is

to *Newfoundland* (Ganong, 224). Mentioned in 1664 by Boucher (Rousseau 1964, 310).

375 *Martes foina* (Erxleben). See G. Corbet and D. Ovenden, *The Mammals of Britain and Europe*, 184 and pl. 24.

376 "In the midst of the water he thirsts and the fruit that he desires escapes his grasp." Nicolas quotes from memory. Ovid's *Artis Amatoriae*, lib. 2, v. 605–6 reads: "*O bene, quod frustra captatis arbore pomis / Garrulus in media Tantalus aret aqua!* [Well is it that the garrulous

Tantalus clutches in vain at the apples on the tree, and parches in water's midst]." Trans. J.H. Mozley, *Ovid. The Art of Love, and Other Poems*, 106 (Latin) and 107 (English).

377 *Marmota monax* (L.), woodchuck; Banfield, 107–10; Burt and Grossenheider, 92; depicted in the *Codex*, Pl. XXIX, fig. 46 as "Le siffleur." Mentioned by Le Jeune in 1636 (Ganong, 239) and by Boucher in 1664 (Rousseau 1964, 311).

very much like the song of the nightingale.[378] It is for this special quality that the name "whistler" has been given to it. It is easy to tame. It is not difficult about what it eats, and although it is of the animals with claws it does not climb trees. Its main dwelling is holes in trees. These animals are not found everywhere, and they are rare even in the places where they do live. The flesh is good to eat. Although the skin is handsome, there is no trade in it, because there are so few of these animals that they are hard to find.

Rabbits[379]

Rabbits are not seen in the New World except on Bonaventure Island, famous for cod fishing, which is almost on the same parallel as Anticosti Island, which hydrographers call Assumption Island,[380] which is off one of the largest gulfs in the world. It is in a west-northwest direction. Even so, the rabbits I speak of were [f. 59] brought from France by one of the Newfoundland ships that fish along the American coasts. These rabbits have multiplied so much in this island that fishermen can make good pâtés. Captain Poulet[381] treated us to this game on his ship when we met him at anchor in Bonaventure Harbour on 15 May 1661.

Small hares that are found in all regions of the New World[382]

This hare is not as good as the ordinary hares of France. It does not taste as good as ours, especially in winter when it survives by eating the tips of fir branches, which keep it from dying in winter, when it cannot eat the grass that the deep snow covers everywhere. At this time it becomes all white; but in spring it regains its grey colour and a new taste that is similar to that of our hares.

There is a remarkable thing about this animal: nature has provided it with extraordinarily large hind paws. The two front paws are ordinary and in proportion to the animal. It was necessary for the animal to have two very large paws to keep itself up and not sink into the snow; the paws serve as snowshoes. The skin is hardly ever used except for children, for whom people make dresses, mittens and caps.

The manitou;[383] or the animal that the natives consider to be a spirit

The colour of this ugly animal is a fairly brownish grey. It is about as large as one of our big cats, and smells very bad. Its head and snout are very similar to that of the pig. Its mouth is well cut and large, filled with very sharp strong teeth. The animal is more carnivorous that one can express. Its whiskers are as large and strong as those of the water-dwelling sea tiger. Its tail is almost twice as long as its body; it is half covered with hair and half bare. The animal is extremely strong at the tip of its tail, by which it hangs from branches, from which it leaps quickly, firmly and nimbly from tree to tree or from one branch to another to catch birds. Hanging by the tip of its tail in this way, it seems to have two stomachs. It has a pouch under its thighs which extends to beneath the neck, in which there are eight teats. It hides its young there after they are born. This pouch is lined with delicate hairs, like the down of a swan. Even the male has this pouch; he takes his turn hiding and carrying the little manitous, which take refuge there themselves when they are afraid of something. These vicious little animals smell so bad that even dogs hesitate to approach them. This animal, like the wolf, bites everything that it meets; it kills chickens and all the birds that it can get its claws into. It also eats fruit.

[f. 60] Concerning the particular thing that I have just reported about the little manitous, which when frightened take refuge in the pouch that their father and mother have under the stomach, and about how the parents carry them, this is a rare thing, and a fine natural phenomenon. But when we realize that in the case of little mice, to escape from the enemy and to help each other, one holds on to the mother's tail and another to this one's tail, and another to that one's tail and so on, we will not marvel so much at the manitous.

378 Modern observers who describe its voice as a shrill whistle would not agree with Louis Nicolas's comparison.

379 *Leporidae* sp.

380 On his *Map of New France*, 1609, Marc Lescarbot gives both names to the island: "Anticosti" and "I. de L'Assomption."

381 Captain Laurent Poulet. See Introduction by F-M. Gagnon, 10–11.

382 *Lepus americanus* Erxl., snowshoe hare; Banfield, 80–5; Burt and Grossenheider, 205; depicted twice in the *Codex*, Pl. xxix, fig. 46.2, as "Lievres communes." Cartier, in 1534, thought he saw both hares and rabbits, for he speaks of *liepvres* and *connins*. Champlain and Lescarbot both used *Lapin*, while Denys usually used *Lapin*, but occasionally *Lièvre*, apparently considering them to be the same animal (Ganong, 222). Boucher speaks of "Liévres" [sic] in 1664 (Rousseau 1964, 311).

383 Probably *Didelphis virginiana* Kerr, Virginia opossum, according to Banfield, 3–5; *D. marsupialis* (L.), according to Burt and Grossenheider, 1–2; depicted in the *Codex*, Pl. xxix, fig. 46.1, as "Le manitou."

Who would think that the woodcock, which is a heavy bird and has no talons, carries its young from one place to another by flying? And yet there is nothing more certain. The wood duck, which is the finest bird in the world,[384] nests in tree trunks, and from there, when the young are hatched, it carries them on its back into the water. How can that be done? People think they are joking when they say, "If you do that I'll give you a white blackbird." And yet it is quite certain that they exist. A most trustworthy man assured me that he had fed one for a long time. Not more than a year ago, a thousand people, including me, saw white thrushes and quails. Nature can do more things than we think, and animals have instincts more curious than we can believe. Who would have thought that a cat, seeing another fall into a well, would have rung a bell that was nearby to call for help for its friend? In the same place another cat played dead on a roof after wetting its paws and then walking on millet grains, which sticking to its fur attracted sparrows to eat, and the cat caught and ate them. A very honest man told me during a trip one of the most surprising things in the world. He assured me that a shepherd, adult and of good sense, saw one day a big bush that was walking by itself, as it seemed to him, toward his flock. What surprised him the most in his fear and astonishment was that this bush stopped from time to time. Finally, when he himself had stopped to consider the matter carefully, and the bush had stopped quite near to his flock, he saw a big wolf come out from behind the bush and leap onto his flock. The story of the elephant that was sent to a coppersmith to get a cauldron repaired, and then went to the river to see if it did not leak, and seeing that the water ran out, brought it back to the worker and scolded him; this is too well known to all those who read. I will say no more about it. There are a thousand surprising stories about dogs and lions, and yet no one with good sense calls them in question.

The great snake that Northerners and Westerners call manito-kinebik *(snake-spirit) or* kiche-kinebik[385] *(the great snake)*

[f. 61] This is not the place where I want to speak about the kind of big snakes that are as big and long as the largest beams that can be seen. At the sea shore one fairly often sees some of these monsters, which are less to be feared when they are large, and which, being almost unable to move, can be killed easily when one has the courage to approach them. I want to tell you briefly about another kind of very big snake. They are vigorous, strong, and extremely fast both in water and on land. They devour anything that can be eaten. This is a devil, a spirit, say the natives, which is so strong and so big that it can stop a wild ox; wrapping it with its tail around some root, it devours it easily. It has such subtle hearing that it hears its prey at more than half a league. It is armed on its back with several great spines. It is as bold as a lion. It sometimes leaps into brigantines to devour men. This kind is not seen in the New World; but I am sure that they exist elsewhere, and that several trustworthy authors[386] who have written about rare curiosities in the world and in China assert that they have seen them, as I have elsewhere.

The great hare[387]

Some people, even those who are learned and have a good mind and refined taste but have not travelled, will not believe that there are hares as large as ten-day-old calves or as one-year-old sheep. However, it is certain that more than two thousand leagues from the place I am talking about here there are some of that size. The natives of these lands call them *oulana*, and our Westerners call them *michabous*.[388] The flesh of these big hares is of a finer and more succulent taste that that of our small hares. This hare, then, is extraordinary for its size. It is not seen commonly; there are some only in the countries of the Eskimos of the North and the West in the great island of Minoung in the middle of the Tracy

384 *Aix sponsa*, still called *branchu* in Quebec and in French Canada. Lahontan held the same opinion: "Ceux qu'on appelle *Branchus*, quoique petits sont les plus beaux; ils ont le plumage du coû éclatant par la variété & le vif des couleurs, qu'une fourrure de cette espéce n'aurait point de prix en Moscovie ou en Turquie" (Ouellet and Beaulieu, *Mémoires* in Lahontan. *Œuvres complètes*, 579) (R. Ouellet).

385 Nicolas's *Grammaire algonquine* translates *kinebik* as "snake" and *Manitou* as "spirit"; *kiché* denotes "size."

386 Nicolas could be referring, for instance, to Olaus Magnus, *Historia de Gentibus Septentrionalibus*, 1648 who spoke of "a very large Sea-Serpent of a length upwards of 200 feet and 20 feet in diameter which lives in rocks and in holes near the shore of Bergen; it comes out of its cavern only on summer nights and in fine weather to destroy calves, lambs, or hogs, or goes into the sea to eat cuttles, lobster, and all kind of sea crabs" (quoted by Richard Ellis, *Monsters of the Sea*, New York, Alfred A. Knopf, 1994, 41–2).

387 *Lepus europaeus* Pallas, European hare; Banfield, 90–2; Burt and Grossenheider, 205–6; depicted in the *Codex*, Pl. XXIX, fig. 46. 3, as "grand Lievre aussy grand qu'un Veau de laid"; figure copied from Gesner, 1621, vol. 1, 605.

388 *A Concise Dictionary of the Ojibway Indian Language*, 100 *gives missábos* as "hare."

Sea,[389] which is more than seven hundred leagues from the lands of the Eskimos. As for the little hares I spoke of, they are found in all the vast country of the Indies. There are even islands that have been given the name of Hare Island, because they are full of them.

When going to Kaouj[390] in a brigantine fifty leagues below the country of the Berziamites,[391] our sailors pointed out to me several little islands full of hares, and eggs of big and little ducks unknown in France. The skiff was sent with two sailors, who very quickly brought us enough for all the crew to eat for five days.

[f. 62] Before going on to other things, I must mention that the Great Hare is considered by the natives to be a great and very powerful god.[392] They believe firmly that he is a great divinity who makes decisions, and makes the great snows that fall on the earth. He is the master of this weather, and makes rain and ice when he wants, and unmakes them when it pleases him to have pity on men, say the Americans, so that these men, who are his relatives, can kill many elk. The folly of some is so great and so surprising that they say openly and in their right minds that they are directly descended from this majestic divinity, so beautiful, so pure and so white; for they confuse the divinity of the great hare with the snow, and the cause with the effect. For this reason they put in their escutcheon, as their arms,[393] a great hare that makes the snow fall; and I have known an entire great family that was pleased and honoured to say that all their race was of this divine blood.

The eldest of this divine family and of this great relation with the gods of the air was very proud to bear the name of these agents. He was called *Michabous*,[394] which means the Great Hare, and so as to keep in mind his divine nobility, he was always dressed or wrapped in the manner of the natives in a robe of the skins of hares, which had to be killed during the time of snows so that these rare skins would be all white, and

so that this illustrious elder descended from the great hare god would always wear the livery and the colour of this divinity.

When the snows are not deep, and when not enough has fallen to catch the great elk, all is lost; the divinity is angry and must be appeased by sacrifices which are feasts of bears, beaver or elk.

When these same snows do not melt at the usual time, the divine majesty of *Michabous* is angry. Dances, feasts and songs are necessary to appease the great hare Michabous, who is also called in their language *Ka-micha-gounikecht*, which means word for word, he who is the great snow maker.

[F. 63] BOOK FIVE

I begin this fifth book of my *Natural History* according to the plan that I had made, and which in my opinion will be found good, since I continue the description of the animals which I began in the preceding books.

The porcupine[395]

The porcupine is an animal with claws. It needs them because, living on tree bark, it has to be able to climb up the tree to remove the bark from the foot to the top. The animal is very ugly. It is found in different sizes according to the region where it lives. They all have a large round head, eyes like a pig, a big pug snout, short round ears and long coarse bristly hair, under which there is another kind of hair which is not seen. It is white at one end and black at the other. I can best compare it to that of the hedgehog, which it resembles entirely except that it is much longer and bigger, according to the age of the animal and according to the region where these animals are found. This second hair is so strongly attached to the skin that it is very hard to

389 Presumably Isle Royale, Michigan.

390 "Tadoussac" would make more sense in this context.

391 The Bersiamites are a small Algonquian tribe composing the eastern group of the Montagnais, inhabiting the banks of Bersimis River, which enters the St Laurence River 75 miles below Tadoussac. See White, 62.

392 Nicolas Perrot, in his *Mémoire sur les mœurs, coustumes et religion des sauvages de l'Amérique Septentrionale* (written between 1697 and 1705), speaks of the *Oussakia*, as the great god of the Ottawa people. See Kinietz, *The Indians of the Western Great Lakes 1615–1760*, 289.

393 For a few examples of these "arms" among the natives, see eight illustrations in Lahontan's *Mémoires* (Ouellet and Beaulieu, *Œuvres complètes*, 726–7).

394 Father Rasles gives *Michabou* as the "Great Hare" and describes it as one of the great families of Ottawa people. See Kinietz, 246.

395 *Erethizon dorsatum* (L.), porcupine; Banfield, 233–6; Burt and Grossenheider, 199–200; depicted in the *Codex*, Pl. XXIX, fig. 46.4, as "Porcs epie ou kak"; the *Codex* drawing does not seem to come from Gesner, 1621, vol. 1, 563. The word *kak* is still in use in Algonquin today; see Gilstrap, 12. The Ojibwa pronounce ka:kw; see Piggott and Graftein, 39. According to Ganong, 234, the word occurs first in Richard Hakluyt's translation of Captain Alphonse in 1542, as *porkespicks*, and is given by Champlain, in 1603, as *Porcs-epics*. There is a poor picture of the animal on the Desceliers map of 1542. Boucher mentioned it in 1664 (Rousseau 1964, 310–11).

pull out; but the porcupine detaches it and throws it with such speed and so rigidly at the dogs that pursue it that it often kills them.³⁹⁶ And if the hunter is not careful to remove the hairs promptly, all the dogs that are speared with them die; and the hunter himself must take care not to be wounded by these hairs, for the hair is so sharp that it works its way into the flesh without being felt. I have seen hunters crippled for two or three months, until this hair worked its way out on the other side from the first wound. To avoid this accident, the hunter going to hunt the porcupine dresses in leather, in order not to be pierced.

When the hunters return carrying these animals, their wives, who are responsible for all little works having to do with refinement, are careful to pull as many of these big hairs as they want to make fine works of this material, as I will explain later. And as soon as that is done, they burn the animal on the outside and scrape it well with knives, in the same way that pigs are prepared.

The body of this animal is very ugly; they have short legs, their tail is big and fairly long, although it looks as if it were cut off at the tip. The animal usually lives in holes in rocks or in trees. It is amusing to see young dogs, which have not seen these kinds of animals, cry and run away as if they has been whipped when, trying to bite the animal, they get their mouth full of this hair, and their mouth is bleeding all over.

[f. 64] This same hair, which is so dangerous, is nevertheless much used among the Westerners, whose women make very fine works. First they dye it with various fruits and some herbs or roots, which give yellow, violet, black, reddish and red, so that there is no scarlet as beautiful and brilliant as the one seen in the dyes of the women on very beautiful and rare works, such as precious headbands and snakes that go around the head and hang midway down the leg. A thousand fine designs are seen on these objects. The natives esteem these works highly, and to tell the truth they are considered very fine in France. A belt of this material and of this delicate work is worth as much as 100 *louis d'or*, and I dare to say that it is like those paintings that are priceless.

One sees a hundred other decorations, on shoes and stockings, on breeches and on tobacco bags, on robes of wolf, beaver, or otter skin, on two or three kinds of belts, jerkins and on other things. They are so rare and so precious that one could say that the work is much finer than the material used, which itself has no beauty except what is given by the dye, and by the forms and shapes that are given to it in designs that are not used in Europe. I can affirm that I have seen Greek-style wreaths of this material that monarchs would not have scorned to put on their head, and various beautiful belts that they would have been pleased to wear.

The stinking animal³⁹⁷

Here is another very ugly animal that I present to you, which is called *chigak*.³⁹⁸ It smells so bad that if you have been so unfortunate as to be soiled even a little by the urine of the animal, you must resolve not to frequent other people for some time if you do not wish to bother them. The natives' dogs, to which that happens fairly often, are miserable; they are chased away everywhere because no one can bear their stench.

Their masters, despite the smell of the animal, nevertheless make robes of several skins of the stinking animal, which has nothing to recommend itself except its stench. The very reason that a native will wear it is to be considered brave, and so that people will say that nothing repels him, since he has the determination to wear a robe made of the skins of a very ugly, stinking animal.

The skin is not at all delicate; the hair is coarse and bristly. The colour is between grey and ash-coloured. On both flanks one sees white marks about half a foot long and three inches wide, and tear-shaped.

The flesh is coarse, stinking, hard, and smells like an old dog [f. 65]. When necessary, however, it is eaten without mustard.

The animal lives underground like the fox and the badger. Its face is similar to that of the fox. Its fat softens the nerves and eases the pain of gout and sciatica.

The devil's child³⁹⁹

This is what the French call this animal, because it is black as jet and has an extraordinarily red mouth. The natives call it *outchik*.⁴⁰⁰ The animal is handsome; it is one of the rarest that are seen in the New World.

Its hair is exceptional and fine. The skin is prized for

396 This not true, of course. The porcupine does not throw its quills, but can hit with its tail and leave its quills in the skin of a dog or other animal (R. Ouellet).

397 *Mephitis mephitis* (Schreber), striped skunk; Banfield, 338–41; Burt and Grossenheider, 65; depicted in the *Codex*, Pl. xxix, fig. 46.5, as "La beste puante a cause quelle sent fort mauvais." The drawing is not very

convincing. It looks as if Nicolas copied a weasel (possibly *Mustela nivalis* L.) from Gesner. Boucher in 1664 knew about the "beste puante" (Rousseau 1964, 311) but Ganong doesn't mention it.

398 The word *sigak* is still in use today. See Gilstrap, 15.

399 *Martes pennanti* (Erxl.), fisher (Pecan); Banfield, 318–20; Burt and Grossenheider, 54–5; depicted in the

making caps, trimmings, and muffs. The flesh has an exquisite taste; it is a little bland, but seasoning makes up for that.

The American badger[401]

It is twice as large as the fox; its nose is not so sharp. Its hair is quite different – coarse, long, ash-coloured, marked on the flanks by two fairly large white stripes. It is carnivorous; its flesh is coarse.

French cats and wildcats

Our French colonists, of whom about twenty thousand souls live along a shore of eighty leagues on both sides of the Saint Lawrence River, have brought all kinds of cats to the Americas. Some of the world's most beautiful cats, from France, Spain and England are seen here.

The wild cat[402] is ugly, with long and rather fine hair. It is yellowish, interlaced with dark grey and striped with black. It has a big long tail striped with different sizes of black rings. The animal becomes as big and tall as the strongest largest monkey or Barbary ape seen in America. It is a flesh-eater. Consequently, it is armed with fierce teeth and terrible claws, with which it nimbly climbs trees although it looks awkward.

It is unbelievable how expert it is at finding food. Consequently, it is so fat that four fingers of fat normally cover all its flesh.

When it has discovered the paths of the deer or elk that travel in groups to the watering hole, the wild cat cleverly perches itself on a convenient branch in the path that it has found. There it lies in wait, not moving. When a deer or an elk passes within reach of one of its leaps, it wastes no time, and catches hold of the animal's forequarters with its teeth and claws. I mean that this cat, sitting on the shoulders of a deer or an elk, [f. 66] hangs on so tightly with its claws and teeth that the animal in its grip cannot get free from its enemy. The animal can keep moving for a time, running as fast as it can, but the cat, intensifying its bites and gripping more with its claws, eventually brings down its prey, which has lost its blood and hence its strength. The animal is overwhelmed two or three leagues from where it was taken. The cat eats its fill of the spoils, and when it has satisfied its hunger, it goes to sleep in some safe place. On waking, and having digested, it returns to its prey, starts to eat again as much as it wants, and does not quit its kill until it is finished. It then returns to its branch to take another new beast, jumping on it as be-

Codex, Pl. XXXI, fig. 48 as "Manitou ou nigani Enfant du diable." George F. Aubin, *A Proto-Algonquian Dictionary*, 112, no. 1605 translates *ni:ka:ni* by "ahead," "leading," and *nigani*, by "before," "the foremost." One suspects that the natives considered the fisher as the first of its weasel family. It should not be confused with the animal depicted in the *Codex*, Pl. XXIX, fig. 46.1, also called "Manitou," but which is an opossum. According to Ganong, 230, Dièreville (*Relation du voyage du Port Royal de L'Acadie ou de la Nouvelle France*, Amsterdam, 1710) was the first to call it "Peccan," in 1710. See A.F. Chamberlain, "Algonquian Words in American English," 240, who cites Father Sébastien Rasle calling an animal *pékané* in Abenaki. Boucher knew the "pescheur," fisher (Rousseau 1964, 311).

400 *Outchik* is the Algonquian name of the fisher. It is important not to base the translation only on the French phrase "enfant du diable," since that expression was employed inconsistently by the French in the seventeenth century and was used at different times by different authors to refer to wolverines, fishers, or skunks. The Algonquian word *outchik*, however, definitely refers to the fisher (French, *pécan*). See A. Silvy (*Dictionnaire Montagnais-Français*), (henceforth Silvy), who translated the Montagnais of the seventeenth-century *8tchek8* by "enfant du diable" and *k8ik8chatche8* as "blaireau" – but referring to the wolverine; B. Fabvre et al. (*Racines montagnaises*, 1695; henceforth Fabvre) give also *8tchek8* for the Montagnais of the same period and translate it by "pecans, enf(ant)s du diable." For them *k8ikchake8*, is "blaireau," referring to the wolverine; L. Drapeau (*Dic-

tionnaire montagnais-français*, 1991) (henceforth Drapeau), for the Montagnais of today *utskek*, gives "pecan"; R. Rhodes (*Eastern-Ojibwa-Chippewa-Ottawa Dictionary*) translates the Ojibwa *jig;wjiig* by "fisher," and J. Hewson (*A Computer-Generated Dictionary of Proto-Algonquian*), the Proto-Algonquian **we ye-kwa*, also by "fisher." "Wolverine" is a very different word, usually some form of *kuakuatsheu* in Innu. It should be noted that many of the seventeenth-century Jesuits and other French writers used the term *"blaireau"* for "wolverine" before *carcajou* became standard. The illustration of the *Codex* excludes the meaning "skunk"; but it could represent a fisher as "enfant du diable" and a wolverine as "Blaireau" (John Bishop). See Rousseau 1964, 309–10, who translates "enfant du diable" by wolverine and *carcajou*. Throughout these notes, we have maintained the "8" of our sources. The "8" stands in for a similar-looking non-Roman character pronounced like the *oo* in *boot*.

401 *Taxidea taxus* (Schreber), badger; Banfield, 335–7; Burt and Grossenheider, 64; depicted in the *Codex*, Pl. XXXI, fig. 48.1, as "Le blereau"; copied from Gesner, 1621, vol. 1, 686. Champlain mentions in his list of 1632 an *espece de blereaux*; Le Jeune used it the same way. It is possible, however, that both meant the wolverine. Lahontan speaks of the "Carcajous," as "an animal not unlike a Badger" (Ganong, 206). Boucher knew it only as "Enfant du diable" (Rousseau 1964, 309–10).

402 *Lynx rufus* (Schreber), bobcat; Banfield, 351–4; Burt and Grossenheider, 81–2; depicted in the *Codex*, Pl. XXXI, fig. 48.2, where it looks rather like a raccoon, as "esse-

fore. This is the usual way of life of the wild cat that the Virginians, in whose country I have seen very large ones, call *attiron*, and which the people of the cat nation (or *Outissaraouata* in Virginian) call *esseban*.[403] They give the name to the whole nation: *Essebanak,* the Cat nation.[404] I think it is because there is an infinity of them in their country, which I discuss in my General Map.

The wild cat makes its den in a hollow tree or under the ground. Sometimes it withdraws into hollows in rocks. Its fat is used to soothe the nerves and to relieve pain. It has an exquisite taste, according to the natives. Its skin, which is covered with long thick hair, is very warm. The Indians make beautiful robes out of it.

Although this animal appears quite stupid, it can be well trained and it follows its master everywhere. I have seen two raised, nursed by a female dog that loved them with a passion. They followed her everywhere and came back from everywhere. I believe they were brought to France for Versailles.

The four species of fox
If the fox were as free as man, I would say that it would be one of its finest ruses to disguise itself in so many colours and in so many ways as it appears only in the North, where foxes are seen as white as snow, as black as jet, yellow like ours and of a grey peculiar to the country.

The skin of the black fox[405] is the most highly prized and therefore the most precious; in the country they are sold for as much as six louis d'or. I have only seen them in the country of the *Papinachois*, that is, the Laughing nation.[406]

The sovereign captain of the nation, who was called *Ka-chinacait*, which means the Liar,[407] presented the captain of our frigate[408] with some fine ones in my presence. This gift was almost priceless, so beautiful were the pelts that this captain Liar gave.

[f. 67] The white fox[409] is also exceptional and quite beautiful, but they are not so highly valued because the fur is not so fine, and because it soils easily. It is not sought after as much as the black.

The yellow ones[410] are not prized in the country; they look like our own.

The grey fox is handsome; its fur is longer than an ordinary fox's. Its pelt is suitable for large furs, for making hats that give a proud look to soldiers who wear them, as long as the very large tail is hitched up over the hat. The four kinds of fox are carnivorous.

I do not wish to discuss lions or tigers, here although I have seen some in the country. They are so rare, and besides, they are so well known that I do not want to say anything about them.

ban ou attiron ou chat sauvage." *Esseban* is its Algonquin name, or *e:ssipan* in Ojibwa (see Piggott and Grafstein, 31) and *attiron*, its Iroquois one. Cartier mentioned *Chatz Sauvaiges* in 1535, meaning perhaps both the lynx and the bobcat. Lescarbot compared his *Chat sauvage* with the *Leopard* (Ganong, 210). It was mentioned in 1664 by Boucher as "chat sauvage" (Rousseau 1964, 310).

403 *Attiron* is Iroquoian, perhaps Huron. Gabriel Sagard (1632) gives the Huron word for "Chat sauvage" as *Tiron. Esseban* is Algonquian, however, being the word for "raccoon." See Silvy, where *esseban* is translated in Montagnais of the seventeenth century as "gros animal"; Fabvre translates in the same manner: "a(nim)al gros, gras"; Rhodes and Hewson are more specific, giving the translation "Racoon" for *esban* and **e-hsepana*, respectively (John Bishop).

404 The Cat nation or Erie, a sedentary Iroquoian tribe, inhabiting the territory extending south from Lake Erie probably to the Ohio River. See White, 146.

405 Probably *Alopex lagopus* (L.), arctic fox, which comes in two colour phases: blue or white; Banfield, 295–8; Burt and Grossenheider, 75. The *Codex*, Pl. XXXI, fig. 48.3 depicts a "Renard Blanc" and Pl. XXXII, fig. 49 a "Renard comun jaune et d'autre couleur grise et d'autre noir sous la mesme figure"; his "Renard comun" figure is

inspired by Gesner, 1621, vol. 1, 966. It is not usual for early writers to distinguish between Fox species. Ganong, 236 notes that only Nicolas Denys made some "clumsy" attempt at it. Boucher knew that one could encounter a black fox in Eastern Canada, but "rarely" (Rousseau 1964, 309).

406 The Papinachois or Opâpinagwa, "they cause you to laugh," were a Montagnais tribe or division living in the seventeenth century about the headwaters of the Manikuagan and Outarde Rivers, north of the Bersiamites; see White, 382.

407 According to G.F. Aubin, *A Proto-Algonquian Dictionary*, 51, no. 691, to be a liar is *kelawesk*, and a deceiver, *gaginawishk*, or *kagi:nawišk*, or *kakinawišk*. The *Concise Dictionary of Ojibway Indian Language*, Toronto, 1903, 91 gives similarly *kakenushwihkid* for "liar."

408 Pierre Fillye from Brest, who was the captain of the *Noir de Hollande*. See Introduction by Gagnon, 10–11.

409 During the winter, the arctic fox has white fur. Nicolas may have thought it was another species. It is depicted in the *Codex*, Pl. XXXI, fig. 48.3, as "Le Renard Blanc."

410 *Vulpes vulpes* (L.), red fox, according to Banfield, 298–301; *V. fulva* (L.), according to Burt and Grossenheider 72–3; depicted in the *Codex*, Pl. XXXII, fig. 49, as "Renard comun jaune et d'autre couleur grise et d'autre noir sous la mesme figure"; copied from Gesner, 1621, vol. 1,

French dogs and wild dogs

Many dogs, transported from Europe, are raised in all the New World. In particular, one sees the big ones that are taught to pull great burdens over snow and ice. Our Frenchmen use them as cart horses. This kind of dog charges after all game, furred or feathered, which it chases zealously even in water. It occupies the big animals long enough for the hunter, who comes in great strides over the deepest snow in his snowshoes, to make his shot. Some of these dogs are bold enough to hold the elk by the end of its snout. No matter how much the moose, which is an extremely tall and strong animal, lifts and shakes the dog to rid itself of this enemy, which is going to cause it to be killed by the huntsman, the dog does not let go until its prey is overcome. However, occasionally elk are so vigorous that, having lifted the dog in the air, they shake it off, batter it with their forelegs and trample it with such promptness that they immediately disembowel it. This misfortune sometimes befalls the hunter who is trampled by the elk, which has no other defence.[411] I have seen two natives and a Frenchman trampled.

The handsome dogs I am talking about are English and St Malo mastiffs. It is unbelievable how useful these dogs are to hunters, who have them carry all their equipment and themselves when they are tired.

In the *Outtaouak* country,[412] over two thousand leagues from France, I had trained two of them so well in all these exercises that these nations, admiring them, never having seen such a thing, held a meeting to find out if it would be useful to make a sacrifice to them as they did to their gods. These men never grew tired of saying [f. 68] that our dogs have infinitely more wit than their own. "They are spirits," they said, "and ours are only stupid beasts. They only have enough sense to hunt beaver or moose. These people's dogs resemble their masters: they are extremely intelligent, they are skilful at everything like the people of the Great Wooden Canoe nation." That is how they refer to the French. I give the etymology in my early works; it is most agreeable. *Keghet*, they say of our dogs, putting one hand over their mouth in admiration, and striking the ground with the other, "*Keghet ounchita ribonakak ouemissigouchi animouek*:[413] in truth, and in good faith, the Frenchmen have clever dogs."

As among the French there are all the breeds of dogs that we have in France, there is every breed in all the lands of the Indians. There are so many that thirty or forty of them can be seen in one very small cabin, having bed and board with their masters and sleeping everywhere.

There is no species or breed of wild dog that is not very good for hunting. They are all naturally trained. They look like the wolf and the fox, and thus they are the enemies of poultry like these animals, and they are constantly at war with them. As their masters speak a different language and act quite differently from the French, the dogs imitate them in that way. They are melancholic like the natives, they bark differently; their howls are like a wolf's. They chase after sheep like wolves, so that there is hardly any doubt that they were born of these two animals, having all their appearance and all their instincts.

The dogs taste exquisite; for that reason they are always fed on venison or fish. A feast of dog is considered to be sumptuous. They are roasted like pigs and the head is the captain's part.[414]

Whenever the Indians want to go to war, they fatten up the dogs for feasts and sacrifices. They are, they say, pleasing to the god Mars, whom they call *Ouskira-guetté*, the fierce god of war and the fury of armies.

They hang many dogs on tall masts or on poles that

966. Mentioned in 1664 by Boucher (Rousseau 1964, 309).

411 Chrestien Leclercq wrote the same in his *Nouvelle Relation de la Gaspésie* (1691): "Il s'élance quelquefois avec tant de furie sur les Chasseurs & sur les chiens, qu'il ensevelit & les uns & les autres dans la neige, en sorte que plusieurs sauvages en sont souvent estropiez, leurs chiens restant morts sur la place [At times it charges with such fury upon the hunters and their dogs, that it buries them both in the snow, with the result that a number of Indians are often crippled by them, while their dogs are killed on the spot]." R. Ouellet ed., *Chrestien Leclercq. Nouvelle relation de la Gaspésie*, 530; William F. Ganong, *New Relation of Gaspesia, with the Customs and Religion of the Gaspesian Indians*, 275–6). See also R. Ouellet and A. Beaulieu, eds., Lahontan, *Œuvres complètes*, 328.

412 Father Le Mercier, in the *Relation* of 1667, mentions that the Ottawa claimed that the Ottawa River belonged to them; but he adds that the ancient habitat of the Ottawa had been an area around Lake Huron. See White, 374.

413 Most of these words are mentioned in the *Grammaire algonquine: keghet*, "en vérité"; *ounchita*, "véritablement"; *ribouaka*, "avoir de l'esprit," "être intelligent"; *ouemistigouchiouek*, "les Français." Modern Algonquin has *animush* for "dog" (see Gilstrap, 11) and Ojibwa, *animo88* (see Piggott and Grafstein, 18).

414 In his *Grand voyage du pays des Hurons* (1632), Sagard stated: "la teste entiere est toujours donnée & présentée au principal Capitaine (the whole head is always given as a present to the head chief)," (J. Warwick, ed., *Le grand voyage*, 1, chap. 9, 200; Wrong, ed., *The Long Journey*, 113).

are peeled from bottom to top, to sacrifice them to *Ki-igouké*,[415] the god of day, that is, the sun. Sometimes more than twenty or thirty can be seen in the same place, put there as offerings by various people who have suspended them in honour of the deity that they worship.

Before going any further, it will not be out of place to report a very strange thing about the extraordinary effect of some wild dogs' liver. A Frenchman found himself with a band of natives deep in the woods, hoping to find [f. 69] good hunting as usual. They hunted everywhere, but were not able to kill anything except a few porcupines. As it turned out, they were forced to eat their dogs, their leathers and all their shoes.[416] (I have seen, and accompanied on a mission, others who were ravenous enough in the prairies of lower Virginia to catch four or five half-green frogs for supper, one of these very small animals for each man. I remember finding myself with a band of six or seven natives and two Frenchmen in the middle of the woods in wintertime, where for twenty-four days we were able to kill only two very small birds.)

But let us return to the subject. They ate, then, all their leathers and their shoes. They even spent several days with nothing to eat. During this famine, something unfortunate happened to the young Frenchman who was, as I have said, of the starving band. On one of those sad long days of fast they finally killed a dog. The Frenchman, not content with the small portion he had been given, took the discarded dog liver without thinking, cooked it and ate it. He was told to throw it away, he was assured that it would harm him and that it would make his skin fall off, but his hunger was so urgent that he went voraciously on with his meal. His skin fell off several days later as he had been warned. He found that he had changed his skin like a snake. Americans have a long experience of this surprising effect.

Wolves[417]

I will not begin this discussion by talking about a single wolf, since in the forest they are found in many different kinds. There are large, small, and middle-sized ones, all of different sorts.

The large wolves are very different from ours. Their fur and all the skin are exceptional, and a native thinks he is well dressed if he has four or five wrapped around him, decorated with their beautiful tails, which he lets hang down from the knee, with their heads and ears up.

Small wolves have different hair; whereas the large ones have very beautiful yellow, grey or white hair, the small ones have very coarse hair, and since they have nothing else of interest I will say no more about them.

The Lynx[418]

The lynx, which is the most rare, and the most beautiful and useful of the three species, deserves a word in particular. This handsome animal has almost nothing in common with our own, and except for the feet, it is completely different in size, shape, hair and tail.

Its skin is one of the most beautiful, most rare and most precious pelts that can be seen. The animal has a fairly long body, a beautiful colouring and [f. 70] fine, long and bushy fur. Its yellowish colour is interlaced with a handsome grey. It has a short, three-coloured tail of yellow, white and black. It is not two feet in height. It is very good to eat. The intestines have a delicate taste.

The natives give it a quite different name from the other wolves in order to distinguish it. They call it *pichiou*[419] and they call the others *mahinganak*.[420]

415 Cf. *kigikat*, "il fait jour" (*Grammaire algonquine*).

416 For the French as much as for the natives, boiled or roasted leather was often the last resource to prevent starvation; see for instance, Jean de Léry, *Histoire d'un voyage en terre de Brésil*, Fr. Lestringant ed., Paris, Livre de Poche, 1994, 528–9; *Relation* of 1651–1652 (*Jes. Rel.*, vol. 37, 260); *Relation* of 1670–1671 (*Jes. Rel.*, vol. 55, 144) (R. Ouellet).

417 *Canis lupus* (L.), grey wolf; Banfield, 289–95; Burt and Grossenheider, 70–2; depicted in the *Codex*, Pl. xxxii, fig. 49.1, as "Loup comun dans la nouvelle france"; no relationship with Gesner's figure, 1621, vol. 1, 634. Lescarbot was the first to use the word *loup*. He says they occurred in Acadia. Cartier in 1535 spoke rather of *Louere* or *Louier* (Ganong, 223). Boucher knew the *Loup-cervier* and the *Loup commun* (Rousseau 1964, 309).

418 *Lynx Canadensis* Kerr, lynx, according to Burt and Grossenheider, 80–2; or *Lynx lynx* (L.), according to Banfield, 349–51; depicted in the *Codex*, Pl. xxxii, fig. 49.2, as "Loup servie dont La peau se vend six Louis dore"; copied from Gesner, 1621, vol. 1, 6. This animal should not be confused with *Lynx rufus*, the bobcat mentioned previously. *Loup cervier* is an old French name for the European lynx, transferred to the smaller American species. Mentioned first by Champlain in 1608 and also briefly described by Denys (Ganong, 223). Mentioned also by Boucher 1664 (Rousseau 1964, 309), and by Lahontan (R. Ouellet and A. Beaulieu, eds., *Œuvres complètes*, 562).

419 *Peshewh*, "lynx." See *A Concise Dictionary of the Ojibway Indian Language*, 1903, 53.

420 The same source, 113, gives *maheengun*, (pl. -*ug*) as "wolf."

I have never noticed that New World wolves,[421] which are seen by the score, have the quality that is attributed to the European ones of taking the voice away from the people they see before the people see them. It is not true to say what an old writer of epigrams said of a certain Balbus, who had the whooping cough or who had drunk a little too much:

Balbule forte lupi, te conspexere priores;
Aut jacet iramodico lingua sepulta mèro[422]

Neither one is true in the forests far from Europeans, for there is no wine.

All wolves are so wild that they are never domesticated well. Some nations esteem these animals and bear their name.[423] These nations are numerous and warlike, and stand up to the Iroquois. They live in very beautiful country by the sea. The men are very tall and well built. They have made a king, and have given him guards. They make war with the English of Boston and along the coast as far as New Albany.

Wolf pelts are all used in the country where they are killed. The habitants wear them, and they make bonnets from them like the Lombardy peasants of the poet:

Fulvos lupi de pelle galeros
Tegmen habent capitis.[424]

The white-tailed deer or the Virginia deer[425]
This animal has much in common with the chamois that are killed in the high mountains of the Dauphiné or the Alps. The colour and the antlers are different. The coat is yellowish; the horn is bluish. The whole of

this quick lively animal is shown in the drawing. It leaps ten or twelve feet high in a single bound. It only jumps and bounds, and it covers twenty feet in one jump. They are found only in warm country. In winter, they would not be able to get through snow. Their flesh is delicate and has an excellent taste. It is not possible to put a price on the skin, which is very delicate and of a fine grain. Hunters dress their families, making shoes, stockings and jerkins out of it.

[f. 71] *The black bear*[426]
As the bear is a well known animal in Europe, I will not repeat what the great naturalist[427] and others have written about it. I will only point out that the black bear is just like the ones we see in the Alps, in the Dauphiné, the Pyrenees, Germany, Poland, Muscovy, Sweden, Denmark, and in all the other places in Europe and Asia where yellowish ones are found.

The black bear is black all over, and even if it has a white mark under the neck, it should not be given any name other than black, as lustrous and shiny as satin.

Besides these black bears, we have others whiter than swans, for they have no marks. I will say a word about them.

What distinguishes black bears is that they are bigger, better built, stronger and wilder. They are common throughout the country. The white ones are more rare and are only seen in the Northern lands and on Anticosti Island, and on another island in the open glacial sea, which for this reason bears the name White Bear Island, where two unusual things are seen. The first is an open area or very large depression in the island, to which place, at the time when the birds are moulting,

421 Although we do not classify the lynx in the wolf family, the fact that it was called "loup-cervier" in French explains why Nicolas classified it among the *Canidae*.

422 "Did the wolves, Balbulus, by chance see you first, or was your tongue numb, covered by wine taken immoderately?" Nicolas found these verses in Aldrovandi, *De quadrupedibus digitatis viviparis libri tres et de quadrupedibus digitatis oviparis libri duo*, 1645, attributed to a Joannes Franciscus Apostolus, speaking about wolves (*Epigrammata*, 111) (Alban Baudou).

423 The Wolves or Delaware, who occupied the entire basin of the Delaware River in east Pennsylvania and southeastern New York, together with most of New Jersey and Delaware. The French called them *Loups*, a term likely originally applied to the Mahican on the Hudson River, afterwards extended to the Munsee division and to the whole group. See White, 125.

424 The exact quotation is: "Fulvosque lupi de pelle galeros / Tegmen habent capiti," Virgil, *Aeneid*, Book 7, 688–9 (Alban Baudou): "And spoils of yellow wolves adorn their head" (Dryden trans.).

425 *Odocoileus virgianus* (Zimmermann), whitetail deer; Banfield, 391–5; Burt and Grossenheider, 218; depicted in the *Codex*, Pl. xxxiv, fig. 51 as "seenonton." This is its Iroquois name. Lescarbot speaks of the *cerf au pié-vite*, the swift-footed deer, in Acadia, in addition to the moose and the caribou. Leclercq, *Nouvelle Relation de la Gaspésie* (1691), speaks of hunting *cerfs* in Gaspé. Both can only mean the Virginia deer (Ganong, 209). This animal was later called *chevreuil* in Quebec (Rousseau 1964, 307).

426 *Ursus americanus* Pallas, black bear; Banfield, 305–8; Burt and Grossenheider, 46–7; depicted in the *Codex*, Pl. xxxiii, fig. 50, as "ours noir"; Gesner's bear, 1621, vol. 1, 941 has no relation to our figure. Mentioned by all writers from Cartier, in 1534, onward. There is a picture, but without name, on Champlain's map of 1612 (Ganong, 229). Mentioned in 1664 by Boucher (Rousseau 1964, 307 and 309).

427 Probably Pliny the Elder.

they go in such numbers that if a man or animal fell in he would be lost in the feathers. To believe this fact, one has to have seen the frightening passage of the wild geese, Canada geese, swans, more than thirty kinds of duck, saw-bills (becs-de-scie), which are a bird the size of the Cheté swan,[428] which is as big as a sheep, gulls, cormorants and an infinity of other birds that fill the skies. The second thing, which is more surprising than the first, is that it is a marvel to see in the middle of the glacial sea a great bay that does not freeze, where vessels are safe and afloat during the worst hardships of winter, and surrounded by ice so thick that the thing is more than a marvel all around the island of Douabaskos.[429]

American bear are extraordinary in height and size. I have seen some of a surprising height that were killed in the lake of the Nipissiriniens.[430] They were at least as tall as a four-year-old bull, and larger, covered all over with four fingers of fat. We feasted upon them, all one hundred men that we were.

When the Oreille nations[431] were living on the land at the end of the Tracy Sea, 500 leagues from Quebec City at Chagouamigoung, all through the winter that I spent with these peoples, I saw them bring huge ones that the young men went to hunt seven or eight days from there. This respected animal, as the travellers say, is naturally very wild, and there is no way to tame it other than when it is very young. It is extremely strong; it climbs [f. 72] trees with a fury if pressed, it puffs like a dragon, it froths at the mouth like a wild boar, it roars like a lion, and bellows like a bull. It imitates pigs. Its eyes are usually bright, small, charged with red, and rascally. It seems to have four eyes: there are the two natural ones, and two more appear to be formed from two yellow marks placed above the real eyes. The fur around its great mouth is also yellowish. It has short ears, always pricked up like a fox's. It never lays them down except to the rear, when it is about to make a leap or start running, or to get angry. But it lifts them up as soon as it is suspicious, as if it wants to stand guard. It has a rather long pointed snout, and a large head. When surprised by a hunter or by dogs, it snorts as it flees, like a wild boar. This animal is truly fearsome. It is armed with big furious claws. It has twenty that are very long, in proportion to its age. When it runs, it kicks up a cloud of dust.

I have not seen or heard the hunters tell of any that will throw stones at a pursuer, as those of Europe are said to do.

It is a singular pleasure to flush one out from up its tree with gunshots or arrow shots. When it is mortally wounded, it drops like a stone, which finishes it off. But when it is only slightly wounded, it climbs down, enraged and growling horribly, and it is at this time that one must be careful that in attacking us, as it will do, it does not kill us and eat us.

This misfortune happened not long ago to an Indian who was devoured down to the marrow. As the animal is big and tall, it is hard to kill, and it rarely remains in the same place even after several mortal blows.

I observed everything I have just said when I was hunting this animal, particularly on the shores of a great island that is almost in the middle of the freshwater sea of the upper Algonquins which is 500 leagues around. There on the water I saw a huge male bear run through by five or six sword thrusts by the natives who attacked it when it was swimming from one island to another. It seems to have much intelligence, or rather a marvellous instinct for lodging over the winter and for protecting itself from the rigours of the extremely cold season of the North and West of the New World, although it is at the same latitude as our France.

It makes a cave under the ground to live in, when it does not find a large hole in a tree. If it finds one, [f. 73][432] it withdraws into it for five or six months, taking no food. It is amazing how it can live, for during that whole time it does not come out to look for food. There is no doubt about this, for it leaves no tracks on the snow, which would be seen if it even set foot outside. However, at the end of the winter these animals have more fat than any pig.[433] Its good health can be seen from its fur, which gleams like the finest black satin.

428 The pelican; see further in the section on birds.
429 On folio 158, Nicolas mentions "the Island of Ouabsaskous," an unknown location.
430 Lake Nippissing.
431 "Oreilles nations" is certainly a misreading for Outa8aks. See "Traitté des animaux," f. 24.

432 The manuscript bears in the margin: "4^{eme} cahier de l'Histoire naturelle de l'Inde occidentale."
433 Cf. Pliny, *Historia Naturalis*, Book 8, 129: "*Procedunt vere, sed mares præpingues* [They come out in spring time and the males then are very fat]."

*Arri animal tardum quae te res lente moratur
Arri fustigera bestia digna manu.*[434]

Around the fifteenth of April, the females give birth to two or three young.

A short time ago, I was presented with two bear cubs, a male and a female. They were no larger than common cats. I set out to train them, but finally succeeded only by using terrible measures, after various bites and repeated scratches to my hands. After treating the bears with kindness, seeing that it was useless, I saw that I had to change my method. The first thing I did was to pull out with pliers and cut till they bled my bears' teeth and claws, and to give them great blows with a stick until I knocked them unconscious. I struck them harshly before, during and after they transgressed. This way I tamed them so well that they would promptly do everything I taught them. Despite all my harshness to these beasts, they would fight each other with such ferocity on occasion that, however much I beat them with my stick, it was almost impossible for me to break the habit. The female was always the most obstinate.

Crowds of natives would come at the sound of these combats and cries to marvel at something they had never seen in their land. Finally, with all this beating, the ferocious temperaments softened, so much so that nothing remained but fierce looks, with a kind of hum, which was like a challenge that one bear would make to the other and that it was never possible to prevent. These animals could be seen coming and going; they would play with dogs and small children, they would do a thousand amusing tricks, a hundred pretty jumps and kicks. One day, one of these bears wanted to approach a fine ass, recently arrived from Old France. The ass, not understanding that the bear's intentions were friendly, went into such a frenzy that it started to kick and strike the bear with its four feet. The bear would have been killed by the ass, which had thrown it to the ground, but for its howling, which brought help running. I would never have believed that an ass could defend itself with such agility, and truly, it could not be said of this ass what is normally said of this kind of animal:

[f. 74] But returning to my bears' other activities, I will say that they danced, stood up and walked like men. They deftly handled a halberd, put their paws in their mouth and handled a musket. Crowds of Indians would come to see these movements, made in their manner by these animals that they never believed could be trained. These bears would have made a truly fine present for a great man, but unfortunately I had no box that they could easily be contained in like the chipmunks that I had the honour to present to His Majesty on my return from the Indies at his residence at Saint-Germain-en-Laye. Besides, the whims of some of my fellow missionaries, who thought it unwise for me to take the trouble to transport such large animals to France, meant that I left them with my friends.

Before going any further, I have to say that among the Indians of Virginia I saw domestic and pet bears that they train to carry them up into the trees that they cannot climb and where they have some business to do. They used the animal as a ladder. The animal, which is very strong, allows a man to mount it from the rear. Holding on thus, the man is carried by the bear up to the highest branches. In this case, there is no fear of the animal dropping the man, for having twenty big claws, it firmly grasps the tree bark and climbs with incredible speed.

Let us leave the bear's abilities and say something about this illustrious animal's natural characteristics. Let us start with the way nature made it and the way the natives want it: big, tall and fat. They have no shortage of these, for they kill some that are monstrous in height and size, and very fat. I have seen them bring back seven or eight at a time, just as I describe. The countrymen make their own kind of stew from bears' flesh and fat. They melt the fat and mix it with Indian corn to season it. At other times, they serve it in big chunks with their meal. This grease is a powerful laxative, and those who are unaccustomed to it will have their digestive system affected very violently and painfully. It is satisfying enough to eat once, but often the lack of other food forces those who are indisposed to it to eat

434 Almost the same text appears under the picture of a "Bourique, anne ou Bourrou," in the *Codex*, 76: "*Arri animal tardumquae te res lente moratus/ Arri fustigera bestia digna manu.*" Marthe Faribault translates: "Stop! Stubborn animal! What makes you go so slow? Stop! Animal deserving a blow from my hand." We were unable, however, to find the source of these sentences.

it again. The natives, who are accustomed to this remedy, are not concerned about that and drink the fondue in big gulps, as we would drink a fine wine, and they seem to enjoy this horrible liquid. I have also seen old Iroquois women who are [f. 75] so thrifty that when they are invited to a feast of great cauldrons of melted bear grease, they drink as much of it as they are offered. At the end of the feast, they solemnly leave and go home, take a large platter of wood or bark and, putting their finger down their throat, make themselves vomit the bear grease that they just swallowed. They use it as seasoning for the first soup they will make for the whole family or for the guests at a magnificent banquet, where no one refuses this dish.

I said there were black bears in all the great country of the Indies, but they live mainly where there are walnuts, acorns, chestnuts, hazelnuts, apples, plums and other wild fruit. These animals hunger less for meat than they do for fruit. They enjoy pumpkins and cucumbers, and they are [so] fond of Indian corn that in a single night they ravage great fields of this vegetable, causing a remarkable amount of damage.

The flesh of the black bear, which no one would dare look at in Europe, has an exquisite, delicate taste in the countries of the New World. When it is larded with fat, it is excellent roasted. It is somewhat bland if only boiled. It is very good *en pâte*, and I am sure it would pass for a very good venison. If the animal is two or three years old, the flesh is very tender, and more so if it is younger. Some that are killed have meat so tough that there is no way to eat it unless it is tenderized and crushed between two stones as the natives do.

But those who are often forced, for lack of everything else, to eat raw, stinking tallow, are not so fussy in the country, where one suffers many ills.

Bear fat, which is good for loosening the stomach, is just as good for relieving attacks of the cold pains but not for attacks of the hot pains. Mixed with brandy, it softens the hardening or contractions of the nerves, and it relieves gout.

The whole animal is put to good use: none of the fat or the flesh is wasted, and the skins are widely used for beds, covers, and clothing for the huntsmen and their families.

The Nadouessiouek[435] make fine shoes from the skins, leaving the fur inside and wrapping the skin around the outside, where they make a thousand beautiful designs and add feathers painted in various beautiful colours.

Even the claws are a choice item; the Indians make their ducal and royal crowns in the Greek style. They put them on their heads to adorn themselves. The world's most powerful men are no prouder of their crowns of gold and precious stones than these poor people with their crowns of bear claws.

From the same skin, they make bags for their tobacco and their pipes. They use them to make doors for their houses. They are forced sometimes to eat these doors. [f. 76] I ate some in one situation where our entire band really needed to do so. The only sauce for this dish consists of throwing scraps of skin onto the coals of the fire. Finding myself with a squad of natives in winter lodgings deep in the woods, I was forced to watch dogs being killed to save us from dying. Finding ourselves with almost nothing else to eat, and seeing that the natives were dying of hunger, I secretly said to two Frenchmen who were with me that our lives were in danger if we were not on our guard. It was even more dangerous because the man who was leading us was a difficult man, and he was seeing his wife and two of his children die. Under these circumstances, we resolved to guard ourselves by sleeping the three of us side by side, with our weapons at hand. One of us stayed awake while the other two slept. We did this as long as we thought there was a danger of being killed as we slept and then eaten by cannibals who would have no difficulty massacring us to satisfy their hunger.[436]

The skin of the respected animal (as it is known in the country: *goûané-àgoûianer oukouari* – the bear, they say, is a great captain[437]) is also used for hauling. That is to say that a hunter, having killed a bear, skins it, and then after dismembering it and dressing it to his satisfaction, drags this burden over the ground and snows in the skin.

It is more satisfying to see a live, well-trained bear pulling whatever one wants. Some Frenchmen I was with in Iroquois country had trained one to do this work quite nicely; it even pulled men.

435 The Sioux people. They are named as such in the *Codex. Nadowessioux* is a French corruption of *Nadowe-is-iw*, the appellation given them by the Chippewa. It signifies "snake," "adder" – and by analogy, "enemy." See White, 429.

436 On this subject see Leclercq, *Nouvelle relation de la Gaspésie.* He had personal knowledge of cases of cannibalism among the Mi'kmaq; see Ganong, 115, 220, and 341. A case is also reported, but upon hearsay, by Le Jeune (*Jes. Rel.*, vol. 8, 29) (R. Ouellet).

437 This appears to be an Iroquoian phrase. Sagard (1632) gives *agnouoin* as the Huron word for "bear" (John Bishop).

The call of this respected one (among the natives) is not too frightening if it is not angered. It is furious when it is tethered; if the fancy takes it, it can be so troublesome in this state that it has to be let go. When the weather is going to turn bad, the bear cries extraordinarily and with such rage as it paces continually in the prison in which it is enclosed that it seems as if one can simultaneously hear a lion roaring, a bull bellowing, wolves howling and the raging of some furious wild boar that is snorting in anger and frothing with rage, so that it is quite appropriate here to cite a few lines of the poet who said of the enchanted island:

Hinc exaudiri gemitus iraeque leonum
Vincla recusantum et sera sub nocte rudentum
Sætigerique sues atque in præsepibus ursi
Sævire ac formae magnorum ululare laporum
Quos hominum ex facie dea sæva potentibus herbis
Induerat Circe in vultus ac terga ferarum.[438]

The animal stirs in its prison with such regular, well-measured and quick movements that its restlessness provides no less astonishment and wonder than [f. 77] do its continual cries throughout the night and a good part of the day.

During these strange movements, it follows its own tracks and beats a path so hard and well-trod that it never fails to follow exactly the same trail that it has marked with its paws.

I have already said that this animal likes to climb trees, and if I had not been eyewitness to it, I would not have believed it. But having examined many a time the damage it does to branches, I can no longer doubt it. It cuts the biggest ones by bending them, and it adjusts them so well that it makes a sort of platform up above, where it goes to rest, to better take the air and to sleep, but especially to eat the fruit. It does not decamp until it has finished it all.

When it is hungry and has nothing to eat, it licks its front paws[439] with such speed and makes a humming sound from within its chest that is so varied and so agreeable that people stop to listen to it for their entertainment. They can see a great white froth forming which is so fine, so viscous and thick that if one did not look very closely, it would not appear to be froth unless the little bubbles could be seen that we can distinguish in every sort of froth. This kind of froth can best be compared to a well-beaten egg white or whipped cream. This viscous froth, as I said, has body and, being very sticky, serves as food for the bear, and through the entire winter, the animal survives on it, eating nothing else. This is so certain that it is beyond any doubt, particularly after a meticulous observation over a whole winter examining attentively every movement of the two bears that I had trained.

I was extremely surprised to see that these animals, which in other times would swallow a cauldron full of cooked and mashed Indian corn, in winter would eat less in four or five days that they would otherwise eat in a quarter of an hour.

I heard them humming constantly, day and night, and not knowing what it meant, I went down to the pit I had put them in for the winter. Many times I found them licking each other and I observed, by the speed with which they were licking, making their hum as they did it, that the froth that I spoke about was forming exactly on the place that they were licking. I sometimes discovered the two bears' ears covered in froth, sometimes the middle of the belly was bathed in it, and sometimes another part, and it was thus that these animals nourished themselves. I had only to present them with the end of my finger to hear their usual music and to see the froth forming instantly on the end of the finger that they pressed with such violence that it seemed as if they wanted to extract some liquid.

Pliny and his followers did not lie when they said that the bear's penis is a bone.[440] I was curious enough to anatomize a bear and convince myself of it. I even kept one for a long time [f. 78] that I took from the animal myself and presented to a famous doctor.

438 Nicolas is quoting a famous passage of Book 6 of the *Aeneid*, l: 15–20, where Virgil describes the departure of the Trojans from Circe's "enchanted island": "From hence were heard, rebellowing to the main, / The roars of lions that refuse the chain, / The grunts of bristled boars, and groans of bears, / And herds of howling wolves that stun the sailors' ears. / These from their caverns, at the close of night, / Fill the sad isle with horror and affright. / Darkling they mourn their fate, whom Circe's pow'r, (That watch'd the moon and planetary hour,) / With words and wicked herbs from humankind / Had alter'd, and in brutal shapes confin'd." (Dryden trans.).

439 Cf. Pliny, *Historia Naturalis*, Book 8, 127: "Ab iis diebus resident, ac priorum pedum suctu vivunt [After this period of sleep, they sit up and survive by licking their front paws]." Compare Charlevoix, vol. 3, 117 on the same subject: "il tire alors de ses pattes, en les léchant, une substance, qui le nourrit, comme quelques-uns l'ont avancé; c'est sur quoi il est permis à chacun de croire ce qu'il voudra [then it extracts from its paws, by licking them, a substance that sustains it, as some have claimed; but on this matter everyone is free to believe what he wishes]."

440 It is Aristotle who said in his *Historia animalium*, Book 9, 6, 612b15–17: "The penis of the bear is a bone ... and

Natural History, or the faithful search for everything rare

I have not been able to see whether the bear is as misshapen at birth as all the writers say it is,[441] without having seen it. I can only confirm that when it is as small as a cat, as I have seen, it is malformed. It appears to be all of one piece and quite badly shapen, and even when it grows big it has a big ugly body.

I must report what they say about the bears of the Vosges in Austrasia[442] concerning their winter food. It is said that before it snows, this animal eats some roots that it finds underground, and having eaten them it is not hungry for a long time and it immediately falls into a profound slumber.[443] This is confirmed by an amusing incident.

One day, a cowherd saw from a distance a large bear scratching at the earth and greedily eating a root. Once the beast had withdrawn, the herdsman went to the place where he had seen the bear. The good fellow got the idea of eating the same root the bear had eaten. When he returned home, his need for sleep became so great that he was unable to resist this invincible tyrant and he succumbed to sleep. He slept a long time, and on waking he recounted his adventure to his comrades.[444]

If this is true, and there is nothing unreasonable in it, why would our Indian bear not do the same before the ground is covered with four or five feet of snow, and more than twenty in some places? And if the dormouse sleeps five or six months without waking, why would the bear not have the same ability?

To leave nothing unsaid of what I know of the bear, I do not think it will offend if I recount here everything

I saw in the Western lands. I said that the bear is considered a respected animal and a beast of the highest nobility, but I did not say that for this reason it is well fed and that old Indian women often bring it something to eat in the prisons where it is confined.

On this subject, I remember an amusing situation I found myself in when for their entertainment, several Frenchmen decided to dress a trained bear as a gentleman of the country. They led him, in this outfit, through all the huts of a village on the coast of Virginia. All the habitants tried to outdo one other with the presents they gave to the supposed gentleman. He was not accustomed to all the affection and the kinder people were to him, the more he shouted like a madman. But if he was given something to eat, he calmed down immediately, only to recommence his shouts if the platter was taken away.

Other nations glory in bearing the name of this noble animal. The *Outtagami*, the *Mantaoué*, the *Oussaki* and the *Oumalouminé*[445] believe that the bear is a species or a certain nation of hairy men who let themselves to be killed out of pity for other men and have them live off the meat of their bodies. They say that the thickly bearded Frenchmen are descended from the race of men that they call *Makoua*,[446] which means a bear.

[f. 79] Finally, other nations, such as the *Outtouak*, the *Outtaouassinagouk*, the *Mitchissaguek*, the *Maramagouek*, the *Keskakoueiak*,[447] and several other unhappy nations consider bears to be divinities and make

is supposed to be a remedy against stranguria. Grated, it is given to the sick." This is probably why Nicolas said he gave it to a doctor. On the other hand, it is not exactly what Pliny, in *Historia Naturalis*, Book 11, 261, said: "Urso quoque, simul atque expiraverit, cornescere aiunt [We are told that the penis of the bear takes on the consistency of horn when it dies]."

441 For example, Pliny, *Historia Naturalis*, Book 8, 126 : "Hi sunt candida informisque caro, Paulo muribus major, sine oculis, sine pilo, ungues tantum prominent; hanc lambendo paulatim figurant [The cubs are first just a mass of shapeless white flesh, slightly bigger than a rat, eyeless, hairless, with only the claws visible. It is by licking this mass that little by little the mother give it a shape]." One could find the same idea in Ovid, *Metamorphosis*, Book 15, 379–80: "Nec catulus, partu quem reddidit ursa recenti, / Sed male viva caro est; lambendo mater in artus / Fingit et in formam, quantam capit ipsa, reducit [A cub that a she-bear has just brought forth is not a cub, but a scarce-living lump of flesh; but the mother licks it into shape, and in this way gives it as much of a form as she has herself]." F.J. Miller, trans., Ovid, *Metamorphoses*, Book 2, 391.

442 Vosges was a wooded area in Lorraine; and Austrasia

a kingdom in Eastern Gaul with Metz as its capital (R. Ouellet).

443 Pliny, *Historia Naturalis*, Book 8, 129 indicates rather that it is at the end of their hibernation that "herbam quondam arum nomine laxandis intestinis, alioqui concretis, devorant circaque surculos dentium praedomantes ora [they swallow a herb named aron, in order to loosen the bowels, which are otherwise constipated, and they rub their teeth on tree-stumps to get their mouths into training]."

444 The "Traitté des animaux à quatre pieds," f. 28v attributes this story to "Ulisse Aldrouan," that is, to Ulysse Aldrovandi (1522–1605) and to Konrad Gesner (1516–1565).

445 *Outtagami*, "people of the shore," is one of the earliest and most widespread names attached to the Fox; the *Mantaoué* or Mantouek could be the Mun-dua tribe of the Chippewa tradition; the *Oussaki* are the Sauk in Ojibwa; the *Oumalouminé* are the Menominee; see B.G. Trigger, *Handbook of North American Indians. Northeast*, vol. 15, respectively on 646, 770, 654, and 723.

446 Gilstrap, 32 gives *makwa*, and Piggott and Grafstein, 70, *makkw* for "bear."

447 The *Outtouak* are the Ottawa (White, 379); the *Out-*

sacrifices to them. I have looked sorrowfully upon this detestable ceremony only too often. These poor people, blind to the mysteries of our religion, are always erecting altars to their supposed deities. They adorn them with everything beautiful that they have, and the richest furs, the finest weaving and their exceptional paintings are all meant for that.

There, on these abominable altars, the idolaters respectfully affix four or five of the biggest heads of bears that have been killed. They offer them feasts, songs, dances and games, which are the nation's sacrifices.

There are found among these Indians some who engrave this animal on some part of their bodies. This means that it is to this personal deity that the native offers all his travels, his hunts and, in a word, everything he does, without exception.

The great white bear that is seen only in the Northern lands of America[448]

The animal in question is more aquatic than terrestrial, for it only rarely leaves the sea, and it usually lives on fish. The white bear's favourite dish is little whales that it chases out to sea. It also eats every kind of aquatic game bird. This amazing animal fishes deftly for sea wolves, sea tigers, and sea dogs. But when it is pressed by hunger, it devours everything before it, even the fiercest beasts. A man named Aoûtanik told me that on his travels to the North, he saw the killing of some of these man-eating white bears.

The sailors of Captain Jacques Cartier's crew encountered one of these white bears during a sea crossing of fourteen leagues.[449] This animal had left dry land for the great Bird Island,[450] which lies to the north, different from the one in the Gulf of Saint Lawrence.

This bear was as big as an ox. Its flesh is delicate, like that of a young steer that has never worked.

Since the journey I made with the Dutch captain Pitre, I have seen white bears and huge sea lions, and if anyone was curious to see one, he can do so by visiting La Rochelle, and without going so far away, he has only to go to the library of Ste-Genevieve-du-Mont in Paris, where Father Molinet would show him the teeth.

[f. 80] I do not know whether Captain Pitre, whom I just mentioned, took these white bears for sea lions that he assured me he saw on his northern voyage, where he loaded his vessel with the oil of two whales he had taken, which he sold for ten thousand écus. He said that they had very big teeth from which objects were made that were more beautiful, delicate, and precious than from the biggest, most monstrous teeth from the biggest elephants. I have seen elephant teeth that when joined together would make an archway that a man of six feet could walk underneath wearing his hat and not touch anything. These rarities are commonly seen in maritime towns, in the homes of collectors who amass everything rare that is brought back from foreign lands where these towns do business.

[F. 81] BOOK SIX[451]

The caribou[452]

This animal is peculiar to the American forests and it is not even common in all regions of this great country. It thrives in northern lands. It is not very different from the deer in body shape, but its antlers are not at all similar, for they are wing-shaped like elk antlers.[453] My drawing of this animal is perfectly true to life. The

taouassinagouek could be related to the Ottawa, but their affiliation remains in doubt (Trigger, *Handbook*, 772); are the *Mitchissaguek* the Mitchigamea, an Illinois tribe (ibid., 680)? The *Maramagouek* could be the Marameg, an Ojibwa tribe (ibid., 770). The identity of the *Keskakoueiak* remains a mystery.

448 *Ursus maritimus* Phipps, polar bear; Banfield, 311–13; Burt and Grossenheider, 50, who give *Thalarctos maritimus* Phipps as the scientific name; depicted in the *Codex*, Pl. XXXIII, fig. 50, as "ours blanc." Champlain names an *Ours marin*, in a list from 1603 (Ganong, 229); Boucher says: "L'ours est de couleur noire, il n'y en point de blancs en ces quartiers" (Rousseau 1964, 307).

449 See Cartier's *First Relation*, chap. 3, folio 52 recto.

450 In reviewing information given by H.P. Biggar, *The Voyages of Jacques Cartier and a Collection of Documents relating to Jacques Cartier and Sieur de Roberval*, 32, n. 8, Michel Bideaux clearly distinguished between two is-

lands, both called Birds Island: one that is known today as Île Verte, near Blanc-Sablon, and Funk Island, near Newfoundland (*Jacques Cartier. Relations*, Presses de l'Université de Montréal, 1986, 321, n. 142).

451 Nicolas presents this title in the margin.

452 *Rangifer tarandus* (L.), woodland caribou; Banfield, 357–67; Burt and Grossenheider, 220; depicted in the *Codex*, Pl. XXXIV, fig. 51.2, as "attieirini ou caribou"; the image is inspired by the "dama" of Gesner, 1621, vol. 1, 307. Lescarbot first used the word, with this spelling, in 1609. It is the Mi'kmaq name of the animal, *Xalibu* given by Rand, *English-Micmac Dictionnary*, 234, as *Kaleboo*, meaning "the shoveller," from its habit of shovelling away the snow with its broad feet to obtain the lichens on which it feeds (Ganong, 208). Mentioned in 1664 by Boucher, by Leclercq in 1691, and in 1743 in the periodical *Journal de Trévoux* (Rousseau 1964, 306–7).

453 That is, moose antlers.

hair colour is somewhat greyer than that of a doe. Many of these animals are seen together with deer in certain regions where the inhabitants, having no other wood, use the antlers of this animal, which are shed every year, for burning.

The flesh of the animal tastes very good. It is tender and delicate, and when it is fat, it is fit for a king. This delicacy comes no doubt from the long journeys that the caribou are made to take by certain little flying animals and others that attach themselves doggedly to their skin and worm their way into the beast's long hair. They pierce the skin in so many places that it looks like a sieve. The first animals that pursue the caribou are named in the local tongue *saghimek*; in Languedoc they are called *cousins*. The second are *issegak*.[454] These vermin look like the large lice found on the skin of sheep. These animals so cover the caribou that it is amazing. What is more, if one of these *issegak* attaches itself to men's skin, which often happens to those who frequent the natives, it has to be cut in two, because it is so embedded, so stuck to the man's flesh that it is impossible to pull it out entirely without making a sizeable cut. The part that remains in the skin stays alive for several days, although the animal is cut in two, and embeds itself even more. This little insect is extremely troublesome, and finally makes deep wounds in the flesh that are a torment for ten to twelve days.

Although this enemy normally attacks the caribou in winter, there is relief in summer when the hair falls off, beginning at the start of spring. Its renewed leather is stronger, finer, more solid and longer lasting, I believe, than any in the world.

The hunters' wives clean and dress the caribou skins so skilfully and so well that nothing more beautiful can be prepared from animal skin.

Very fine works are made from this skin, particularly when the natives use it for the front and back of their snowshoes, which are absolutely necessary for coming and going during the winter and without which it is impossible to go out of the cabin to find something to eat.

The ones that monseigneur le Dauphin accepted from my [f. 82] hand (in his chamber, where he asked me the finest questions in the world for more than two hours in the presence of the princes of Conti and la Rochesurion,[455] and all his court at Saint-Germain-en-Laye upon my return from my first voyage to the Indies), were made by the most able of the Montaignais women, who are the world's best snowshoe binders. No chamois, no deer, elk or buffalo skin can match the caribou's for making shirts, drawers, gloves, stockings, jackets and many other things, when the skin is prepared by the hands of a Papinachois woman. I dare say there is no master craftsman in France or anywhere else who can do so well in so little time. She takes one night to prepare these skins with water, fire, a rope, a stone and a little bit of moose liver to make it white as snow, softer than velvet and lustrous as white satin. If, after that, an able Frenchman wishes to prepare these skins with oil, nothing more beautiful, more golden, or more useful can be seen than caribou skins. They are so strong that I have often defied extremely strong men to cut very small, very narrow strips, which I presented to them. I can say that I hardly go anywhere without it, so as to have it put to the test by the strongest men that I show it to on occasion, to verify that caribou skin is the world's strongest skin, and consequently the best when it has the other qualities I mentioned, which is certain unless it is worn out or because of some accident. Caribou skin can be washed and put in soap as often as one likes, but care must be taken when washing it to wring it out strenuously and squeeze out all the water, placing it a little distance from a fire, rubbing it constantly until it is dry. It can be exposed to sunlight if one takes care to rub it well from time to time. This way it can be made to last fifteen or twenty years. It is expensive in Paris, where furriers, if they know what it is, will pay ten or twelve écus for one that will provide enough for a pair of drawers or a shirt that will last as long as I said. Furthermore, the skin is warm in winter, and very cool in summer. I say this from twenty years' experience, during which I used these kinds of skins after I discovered how good they are in the Indies where the natives use them to make every kind of clothing and shoes, which although light, last a very long time.

454 *Saghimek* and *issegak* are Algonquian words. Silvy gives *Satchimeu* for "maringouin" in seventeenth-century Montagnais; Fabvre, *Sakime*8 for "maring8ins" or "m8cherons," and *Exaguai* for "poux d'orignal (moose lice)" in the same language; according to Daniel Drapeau, the Montagnais of today say *satshimeu* for "moustique," and Rhodes gives *zgime* or *zgimenh* for mosquito in the Ojibwa-Chippewa of today (John Bishop).

455 The two princes mentioned are probably Armand de Bourbon, prince de Conti (1629–1666) and possibly a relative of Charles de Bourbon, prince de La Roche sur Yon (1515–1565).

[f. 83] *The American deer*[456]

The name "deer" is so widely known in Europe, and several writers have portrayed it so well and described it in every detail, that it seems unnecessary to talk about it any more. Nevertheless, as the American deer is a little different from the one that we see in these countries and the manner of hunting it is distinctive, perhaps it will be pleasing to someone to learn the differences between the two.

The American deer is notably larger, stronger-limbed, and therefore stronger than the strongest ones seen in the famous forest at Fontainebleau and elsewhere in Europe. Its antlers are also extraordinarily bigger and longer. There is a set of them of an incredible size and height over an apothecary's door in Toulouse. While I was still travelling, I sent it to this friend, who displays them.

There are areas of our country where five or six hundred of these animals can be seen together. The fawns are so beautifully speckled all over the body with white, yellow, grey and black that they seem more like tigers' young than those of the females that graze everywhere.

The Indian deer hunt is very different from the hunt in France. Westerners, who are the world's most able hunters, do not bother with all the affectation of that country's hunters. And although they have large packs of dogs just as the greatest lords do, and although they are not accompanied by grooms, they have no interest in that in their way of hunting. A canoe with two or three paddles and a bundle of fifteen or twenty stone-, bone- or copper-tipped arrows or a gun or two replace the big operation that we make of hunting here.

One single hunter, with no dog and no groom, having discovered the tracks and routes of the beast he is searching for, lies in wait for it alone, examines the tracks and droppings, defeats its ruses, diverts, spears or lets it run at just the right time, and is not thrown off track as he stays on the trail of the beast and the usual prey of the hunt, which are normally browsing animals that do not bite.

Browsing animals include moose, caribou, deer, wild oxen, the monoceros,[457] elephants, the *pichikiou*, and many others. There are so many biting animals

that they are countless: the wolf, bear, fox, dog, otter and others are biters.

The hunter hardly ever sends dogs after wild animals, and although the dogs of this hunter are every bit as good as our bloodhounds, our hunting dogs, our Artois basset hounds, our greyhounds and our mastiffs, he hardly uses them in summer. He takes the place of them all and it can be said that he, in himself, has the qualities of a great hunter and a large pack of [f. 84] well-trained hunting dogs. However much a beast turns around and retraces its steps, the hunter recognizes perfectly all the disturbances in the undergrowth and the hoof marks. Provided that the animal has just passed by recently, our hunter almost always flushes it, very rarely losing his trail marker; and, going in circles without ever getting thrown off track, he flushes out and trails the deer or the moose back into the bush as he wishes. What is even more amazing is that he distinguishes tracks on snow, even though the beast passed by quite a long time ago and the markers are covered with recently fallen snow.

At other times, the hunter, on discovering one or more animals browsing in their pasture, crawls like a snake. Only rarely does the hunter not achieve his aim.

Our nimble and skilled hunters do not mind if the deer that resists and that they have flushed out has a knobby head and polished antlers, nor if it is dangerous to attack; they pierce it swiftly with a dart that they throw from afar, or an arrow, or they pierce it with a gunshot or a final sword stroke. None of them sets about cutting off the right foot to present it to the prince of the hunt or rather the one who presides over the venery.

It is true that they take the *massacre*, which is the head, with the heart, not to give the first cut to the bloodhounds, but for a feast or to make it known that they have killed an animal that everybody will soon be eating.

In the country of the Virginians, all the spoils are used for feasting upon and for seasoning the whole boiling pot with excrement. Therefore they clean neither the stomach nor the intestines of the animal, saying that everything inside is only shoots and grass cooked inside the animal, and that the French are much more ridiculous than they are when they eat

456 *Cervus elaphus* (L.), wapiti or American elk; see Banfield, 371–4; Burt and Grossenheider, 215 call it *Cervus canadensis* Nelson to distinguish it from the *C. elaphus*, the red deer of Europe; depicted in the *Codex*, Pl. XXXIV, fig. 51.3, as "attic ou Cerf"; the image is inspired by Gesner, 1556, vol. 1, 326. The early voyagers appear to have applied the name *Cerf* to the wapiti, because of its

resemblance with the red deer of Europe (Ganong, 209). Mentioned by Boucher in 1664 perhaps as "vache sauvage" (Rousseau 1964, 307).

457 The unicorn. In the chapter "De Monocerote" in Gesner's *Historia animalium*, the illustration is unmistakably of a unicorn.

grass, raw in a salad or cooked in a pot, saying that it is much more natural cooked in a beast's stomach than otherwise. I will discuss this dish more fully when I deal with the elk, the last of the four-legged, cloven-hoofed, browsing animals, which I will describe and examine formally inside and out.

The American deer is as fast as an arrow from a bow, like a flash that is there and then is there no more, or a lightning bolt from a cloud: its movement is so rapid that it only appears for a moment and it seems to fly rather than run. Despite all that, the hunter, in letting it do so, succeeds in killing it through patience, for he fashions his course after the deer's.

Everyone knows that deer marrow tastes excellent and is used for a thousand remedies. In particular it is used to relax the muscles and tendons and to relieve the pain of gout although it does not cure it, according to the universal axiom of doctors of medicine:

Tollere nodosam nescit medicina podagram.[458]

This line is *sempiterne veritatis*[459] as the Scholastics say. Here is one even truer:

Contra vim mortis, non est medicamen in hortis.[460]

The skin is very useful. It is strong and when well prepared it is better than elk hide. Our hunters use the antlers to make various indispensable tools. Crushed and dried antler points are good to give to worm-infested children. The beautiful and rich works the native women make from the deer's thick hair are unbelievable. They carefully pull it from the animal, sort it out and tint it various very bright colours. The works of embroidery they make from it are always of diverse patterns that they make on their little looms.

[f. 85] *The unicorn*
I do not know what to say about the appalling error that has crept in even among many learned people who are otherwise very knowledgeable, but have seen nothing of the admirable things produced by nature because they have never lost sight of their parish church tower, and who hardly know how to get to the Place Maubert or the Place Royale without asking the way. I say that these people are stubborn to insist that there is no unicorn anywhere in the world. I would like to ask them if they believe in other things that they

have not seen and that are much more extraordinary. They would say yes, they believe in them because authors they trust have reported them. And if I tell them that the same writers assert that there are unicorns, what will they say? Will they contradict themselves, claiming that they believe part of what is said by the authors they have read, and that they do not believe the other part? Where did they learn such discernment? Was it on the Pont-Neuf, where these scholars only cross in threes, adorned with furs and fine hats, carried in their chair or driven in a coach that has both sides plugged up to avoid draughts? Goodness me no, this sort of genius must not be believed. Faith must be put into a thousand excellent and courageous men who have suffered and seen rare things, at arms on land and sea, on voyages of twenty or thirty years, suffering all the injuries of weather and the seasons and climate, where rare and surprising things are seen, which these men of the study have not seen.

A hundred writers, eyewitnesses, report that they have seen [unicorns], before and after Ludovico Berthamano,[461] who writes in these terms, according to the reports of an author, that he saw two of them on his voyage to Medina or Mecca. Here are his own words. They are in Spanish that I took word for word from the original. As this Spanish is not too difficult, I will not translate it.

El licor, como testifica Lodovico Berthamano, el qual a visto dos en Mecha, tiene la cabeca como un caballo, con un cuerno muy agoudo de tres cubitos de largo en la frenta, es d'el grandor d'un caballo de trenta mezes, tiene las piernas delgadas, y los pieds hendidos como un [f. 86] venado, los pieds detras tiene muy pelludos, tiene color de cassanna poco mas rubio. Esté animal paresse fiero; pero esta templado cum cierto dulcor.

El cuerno tiene efficassissima virtud contra todas maneras de ponçonna. Este animal se cria en Etiopia.

These words are taken from a book entitled *En Carta, y breve declaration del repartimiento, forma y singularidades del Mundo.*

The pen-drawn figure that I provide of this animal, perfectly representing the one that I saw killed, and all that was just described by Lodoico Berthamano, leads me to change my mind, for if this writing ever sees the light of day, those who do not understand a word of Spanish, as are all those who have studied neither Latin

458 "The healing art knows not how to remove crippling gout" (Ovid, *Pontians*, Book 1, 3, 23, A.L. Wheeler, trans., Loeb edition).
459 One could expect *sempiterne veritas*, a truth of always.

460 "Against the power of death, there is no remedy in the garden."
461 See Gagnon, Introduction, 41.

nor this fine, pompous and bombastic language, will be delighted to see what I have just reported in our own language according to the Spanish style.

The unicorn, according to Louys Berthaman who saw two at Mecca, has a horse's head.[462] *It has a pointed horn in the middle of the forehead, very pointed and three cubits long.*[463] *It is the height of a thirty-month horse. It has slender legs with cloven hooves like a bull. The hind legs are much hairier than the forelegs. It is a reddish chestnut colour. This animal appears proud because it is endowed with a certain grace.*[464] *The unicorn's horn* [f. 87] *is very powerful against all kinds of poison. This animal originates in Ethiopia.*

That is what Monsieur Thévenot,[465] an illustrious writer of our time, reports. It is evident from seeing his works that inquiring minds are infinitely indebted to him for the curiosities that he collects from all over the world in order to share them with the public.

I have read in his admirable works what he reports about the unicorn, according to trustworthy voyagers whose memoirs he had.

Therefore I ask our scholars to stop doubting that unicorns exist, since there are so many excellent, well-informed writers who assure us that they do, as well as a thousand intelligent and trustworthy people who have seen them and have graciously put their memoirs at our disposal, in which they indicate all that they had seen on their voyages and in foreign lands, where things are seen that one cannot believe, yet they still exist. Sceptics have to remember that not all countries produce everything. *Non omnis fert omnia tellus.*[466]

The great American wild ox …[467]
which the Indians call *pichikiou* in all of Louisiana and in the great kingdoms of Manitounie and Kizissiane, which are lands twice the size of Europe.

I would not have given another name to this great animal than the one given to it by the Manitounians, the Louisians and the Kizissians; however, since it has everything that could be wished for in common with

the oxen in our lands, I thought that I could do no better than to name it the great American wild ox, instead of simply calling it *pichikiou*, which is a foreign word that comes from nearly three thousand leagues from France. This big powerful animal lives only in warm regions and open expanses such as the prairies, where it eats most of its food, only rarely browsing [f. 88], contrary to the moose, which browses more often than it grazes, having very long legs and a very short neck, the opposite of the *pichikiou*, which has extremely short legs and a long neck.

The animal that I describe here is naturally as heavy as the Asian rhinoceros that has to have a fire lit between its legs to get it to walk or work. But when our ox is provoked a little vigorously, it becomes wild and angry and it sometimes kills the hunter, trampling him furiously under its feet and throwing him with its horns like a bale of hay.

The Louisians and their neighbours, who only kill them with arrows and take only as many as they need to live on, are more economical than the natives who live near the French. They kill all the beasts that they come across with no regard for future needs. The former are much more prudent than the latter, for it often happens that they fast for several months of the year.

The eagerness of the civilized nations to get all the pelts they can, at the lowest price, from the Iroquois, the Huron and all the Algonquian nations has inspired this massacre by two or three Americans. Even if there are five or six hundred beasts at a time, they kill everything, although they are sure that all the meat will rot along with some of the furs. They are so accustomed to killing all the animals they meet that quite often you will see a large band of these murderers amusing themselves by killing a rat that they will unearth with a stick if by chance the animal has taken refuge there. But among our Manitounians and their allies it would be a crime to kill more animals than is necessary, although there are so many of these animals in their country that in one meadow less than a quarter of a league long in a pleasant little valley, four or five hundred oxen may be

462 On this person see Gagnon, Introduction, 41; and "Experientia est magistra rerum," 47–61, especially 55–61.
463 A *coudée* or cubit is approximately equal to the length of the forearm.
464 Nicolas mistranslates this passage. One should read: "This animal seems proud, but it has also a certain sweetness" (R. Ouellet).
465 Jean de Thévenot (1633–1667), French traveller who was in the Middle East, in Persia, and in India. His *Voyages* were published in 1684. It could be also his uncle Mel-

chisedech Thévenot (1620?–1692), also a traveller, who published between 1663 and 1672 his *Relations de divers voyages curieux* (R. Ouellet).
466 Virgil, *Bucolics*, 4, 39: "No land produces everything." In the text of Virgil, there is no negation at the beginning of the sentence.
467 *Bison bison* (L.), American bison or buffalo; Banfield, 377–80; Burt and Grossenheider, 224; depicted in the *Codex*, Pl. XXXV, fig. 52, as the "Pichichiou"; it has little resemblance to the *bisontis* of Gesner, 1621, vol. 1, 128.

seen, which resemble from a distance a newly worked field in a country where the soil is naturally black.

The *pichikiou* is almost as big as an elephant. At least it is bigger, longer and stronger-limbed than the strong oxen of the Camargue in Provence. It has the same shape, but its hair is very different, half a foot long and curly like that [f. 89] of the most handsome poodle. The hair of this ox is all black at the extremity; the rest is brown. Its head is long, wide and large, and so are the eyes. Its nose is in proportion with its whole body, that is to say it is very wide. Its horns are big, long, black and well-shaped, and adorn the animal well. They are turned a little like a screw, and are much longer and thicker than the horns of our tallest and oldest oxen.

Our foreigners are proud to wear them on their heads on many occasions, as I have seen with my own eyes, and they think they are dressed beautifully with this ornament. Elsewhere, they take it as a great insult even to talk about it.

The animal's tail has thick, handsome black hair, long and trailing. Nature has favoured it with a very long tail for chasing away flies, which are vicious in hot countries and which lodge stubbornly in its long hair.

When it runs and when it is angry, it extends its tail so forcefully that it holds it stiffly in such a way that it looks more like a fighting bull in an amphitheatre than an ox that roams vast prairies four or five hundred leagues long, and beyond that as far as the Western sea.

It seems to have a horse saddle on its shoulders, but this is merely a natural hump that distinguishes it and never fails to make it appear proud and frightening.

The flesh is coarse but very solid and it tastes like our best beef. Its fat is very similar, that is to say that it is yellow like the finest gold of Peru or Brazil.

Hunters amass great quantities of this fat for feasting upon and to use it as if it were the best, most excellent butter in the world, to season their corn which unseasoned is very bland.

The female *pichikiou* is so fertile that she usually bears two calves, quite often three or even four depending on her age. There is no difference between the male and [f. 90] the female other than that seen between the oxen and cows of our lands.

The skin is very useful to the natives, who although they usually do not wear anything in these parts, nevertheless make beautiful robes from it, which they value more highly than those of beaver pelts or handsome otters. Having cleaned one side and leaving the hair on the other, they paint a thousand grotesque figures on it. They take care not to take out this beautiful hair that is seen on these skins, using it for covers and mattresses when there are very cold nights in their warm country.

In a word, they use this skin for everything. It is essential to them, and a few things are enough to equip a native, who can say truthfully what the ancient philosopher said, "*Heu quantis non egeo.*" Oh, how many things are there in the world that I have no need of; or even with the wise Greek[468] who claimed that he carried all his riches with him: *Omnia mea mecum porto.*[469] If this ancient Bias was able to say that truthfully, all our Indians can honestly say it, since they are attached to nothing but living from day to day, without attempting to amass anything, or to leave anything to their wives or children. Consequently, they are never seen to quarrel, nor to plead for goods whose advantages they do not seek, as do civilized nations whose self-interest gnaws them to the marrow, in a manner about which I have nothing to say, as everybody knows all too well, particularly the poor, who groan under the violent oppression all around them.

[F. 91] BOOK SEVEN

The moose,[470] *or Canadian elk, or according to the Latins* alces, *or to the natives of the country,* Mouns[471]

Rousseau 1964, 309 indicates that a sub-species, *Bison bison pennsylvanicus*, now extinct, could be found from New York State to Georgia on the Atlantic Coast.

468 The Greek Sophist Hippias of Elis (fifth century), put down by Plato in his *Dialogues*. In *Hippias minor*, 368b, Socrates tells him: "You said once you had come to Olympia having made yourself everything that you were wearing on your body" from his ring to his shoes, and by the way his mantle. The Jesuit Paul Le Jeune, made the same observation in 1632: "They are like the Grecian Philosopher who would wear nothing that he had not made" (*Jes. Rel.*, vol. 5, 24) (R. Ouellet).

469 "I wear on me everything that I own"; but this a false interpretation. Hippias wanted to show not that he was poor and possessed almost nothing, but that he knew how to make everything that he wore by himself.

470 *Alces alces* (L.), moose; Banfield, 368–70; Burt and Grossenheider, 218–20. A male, a female and three young are depicted in the *Codex*, Pl. xxxvi, fig. 53, 1 and 2 as "Elan ou caribou *alces* selon Les Latins" and "femele de l'eslan avec trois petis d'une seule ventrée"; they seem inspired by a reverse image of Gesner's *Alce*, 1621, vol. 1, 1. "Caribou" is a misnomer in that context. *Élan* or *Alces* in Latin refers to the European elk, transferred natu-

The moose is so common in the vast Indian forests that it does not deserve to be forgotten in the treatise on four-legged animals. And since it is the Indians' principal food, curious people will be glad to know almost all that can be told about this animal and the great advantages that New World inhabitants take from it, how the hides are transported to Europe, and how it is put to use there.

I think that to begin with, it would be good to provide a description of this celebrated animal. It is taller than the tallest he-mule, and many are found that are bigger and fatter than the most beautiful coach horse. These assertions should not surprise anyone, since it is certain that some of these old forest dwellers are encountered that appear to be very long-lived. This is known from the antlers, which tell their age by the number of points around the edge of the main growth.

The animal is well proportioned. It is nine feet in length. It has a big, long head that is similar to that of a sea horse or hippopotamus. The eyes are very small in proportion to the head. They are not bright, so that it makes the animal appear stupid. Their colour is black. The animal does not see a long way. It has an extremely big, wide snout as well as two wide-open nostrils. It has a keen sense of smell and it smells its enemy from so far away that it can easily flee. However, as it is not too frightened in the deep silence of the woods, this animal turns its head in all directions to sniff, while one approaches it to kill it. Nature, which has not given it sharp vision, has replaced this defect with the sense of smell and with acute hearing, which collects from a great distance the sound of what is making a noise by means of two great ears that are longer and wider than those of the great asses of the Barbary Coast.

Moose antlers are very different from those of the deer, which has [f. 92] round, very long ones, with as many points as it has years. The moose's antlers are flat and as wide as a fully spread eagle's wing. I have seen and measured one with a six-foot opening or spread from one antler to another. This same antler was three and a half feet in height. The antlers fall off every year at the end of autumn, and it is a curious thing to see the moose leaning its head to one side or the other depending on which half of his antlers has fallen off. As the antler falls off, another can be seen forming that will appear in springtime bigger than the one that has

just fallen. It appears through a knob which grows at the same time that the antler is growing, like that of a mushroom that swells and then hollows itself out little by little, until the fruit has reached its consistency and its perfect maturity, with the difference that one happens in several hours and the other, only over several months.

The moose has a very short neck: that is why it browses more often than it grazes, although it can do both. It is at least twenty-four or twenty-five inches across the chest. The shoulders are noticeably higher than the rest of its body, and it appears to be harnessed with a saddle. Its hindquarters are no less than three feet wide. When it runs, it lifts up its short tail like a deer, and therefore it resembles it. It has thick, very long legs. From the end of the hind hoof to the haunch, it measures no less than five or six feet. The forequarters are a little lower, except for the hump on the shoulders. These four legs are in good proportion to the whole body. It has a cloven foot like an ox. The horn is black and shiny (I can show some that I use to relieve those who suffer from epilepsy). The eight ergots on the four legs are large in proportion to the animal's age. The underside of the hoof is sharp, and the animal uses it like iron hooks to stand, walk and even run on the most slippery ice. It often even spreads its cloven hoof as far as it can, opening it to support itself on the snow when it is strengthened by freezing, so as not to sink in as much.

The animal is graceful when it is in good health. It is beautiful during the summer, not having the coarse, thick hair that it has in winter. It has a kind of [f. 93] long beard all along its lower jaw. It is different from the billy goat's flat one. This one is long and continuous to the middle of the chest. To understand it better, it must be considered as the opposite of a horse's mane, which is on top of the neck, whereas this one is below.

In the summer, the beast's hair is short and all black. A little later, it becomes grey and then imperceptibly becomes black again in autumn, and it stays this colour for the whole winter. However, it is interspersed with some grey, yellowish and white hairs that the women make into fine objects, which I will discuss below.

Sometimes, moose are seen that are as white as swans, but this is rare. If by chance the hunters kill one, they sacrifice it to the sun.

Some time ago, sailing the Saint Lawrence River to enter the Great Northern River which is three hun-

rally to the moose which is a similar American animal (Ganong, 215). See Rousseau 1964, 304–5 for a useful discussion on the words *orignak*, *original*, and *original fonds* in French texts.

471 *Mouns* is an Algonquian word. Silvy gives *m8s8* for

"original" in seventeenth century Montagnais; Fabvre agrees with him; Drapeau gives *mush* in the Montagnais of today; and Hewson, **mo.swa* in Proto-Algonquian for moose (John Bishop).

dred leagues in length, and from there having arrived (by the Fourche River and after having crossed Lake Nipissing and come down the Frenchman River) at a great island in the freshwater sea, I found the head and feet of one of these white animals hung on the top of a tall tree, which it was necessary to cut down to remove this offering made to the sun by the Beaver nation and the Outarde nation who worship this star. This sacrifice was made out of a devotion that is peculiar to these two nations. Through this act of idolatry, they wanted to pray to the sun for a good journey when they were going to a fair that was being held 500 leagues from their country.

Besides the black, grey and yellow hair that the animal's entire coat is covered with, there is some of a green colour in the middle of the cleft in the four feet. That is the description of the exterior of the moose.

Almost all of the New World and all of the North is home to the moose. The animal frequents the pine forest; it also likes the beautiful woodlands where it goes in the cold weather. If it is not chased violently out on to the ice or across a river, it does not leave the woods. The hunter is so skilful that he often leads it to his cabin door to give it the deathblow.

Our animal does not stay in the woods in hot weather. It goes to the edge of the woods, and to the shores of the lakes, the rivers or the sea. At this time, it leaves the woods to flee the cruel persecution of the flies, which often force it to throw itself in the water to escape these tyrants and thieves of the patience of man and beast, these blood-drunkards and tormentors. Bands of moose are commonly seen grazing around or in the middle of great marshes, or the middle of meadows, and sometimes they come to graze in the fields of the French, where they are killed.

[f. 94] When the land is covered with snow, the animal makes a kind of bed, quite different from an ox's. When it wants to sleep, it supports itself on the end of its great snout. That is why nature has formed hairless skin on the end of the muzzle that is very hard like a callous, which prevents it from hurting itself as it holds up its big heavy head on the snow or on the ground. Once the snow has melted and the good weather has arrived, this animal could be taken for an amphibian as it constantly wallows in the water, or swims distances of three or four leagues across a river or from one island to another. It sometimes comes as a pleasant surprise in the middle of the woods when a large beaten

path is discovered, and if one were not sure of being nowhere near a town, finding these paths so well worn, one would think that one was at the gates. It is the moose, coming and going in crowds to the watering place that beat the paths this way. In other places, so many of their tracks can be seen when the earth is soft that you would say all the herds of cattle of the famous Cantal in the Auvergne have passed by the paths you are on; and that it would hardly be good to be there as these bands of animals go by, for one would be in an awkward position, surrounded by fighting and horn-butting. It is here in these places that the natives do some good hunting with their snares. I will say a word about that elsewhere.

The moose's usual diet is fir shoots. It is also fond of a certain tree that is called the moose tree because of it. It eats mud, and dives to a depth of twenty feet to go and gorge itself on this earth at the bottom of the waters, and on a certain grass that resembles coltsfoot.

Toward the end of August this great wanderer, this migratory animal, starts to rut, and the female, who is no different from him except that she has no antlers, gives him one fawn in the first two years that she gives birth, near the end of May. The other years she carries two at a time, and quite often three.

I do not know what to call the cry of the Alces, but it is neither a lowing nor a bellowing. It is a sort of a muffled sound, much like the bleating of a large billy goat, which the animal inflects in different ways, sometimes drawling, and other times cutting it off short. It seems to form these two letters: "h" "e", [f. 95] which it often repeats, sometimes in a harsh tone, sometimes in a soft one.

After everything I have just said, it is now time to put on the trail of this great animal a hunter armed with a good rifle, or a bow and arrows, a spear or a long sword attached to a quarter- or half-staff with which to pierce or spear his prey. See him, if you like, armed with a great flint stone cut in the form of a partisan,[472] firmly fixed in place with sturgeon glue at the end of a javelin.

Let us now, if you agree, provide our hunter with a large packet of snares that he will set out where he finds the beast's trails. We must not forget to give him a good axe and a big butcher's knife. With this equipment he will do marvels and make astounding catches and great kills of many moose.

472 A "partisan" is similar to a halberd, that is, an axe or *ha-chette* mounted on a pole, with the addition of a point. The partisan is symmetrically shaped, like a *fleur de lys*.

This is the place to explain all the ways that the native kills and hunts moose.

The easiest and surest way to hunt moose is to be equipped with a good pair of excellent snowshoes, the weapons I spoke of, and a good compass, or at least a good idea of how to travel in the woods and how to get out again without getting lost. The hunter is sure never to get lost; he only has need of a weapon and some meagre animal skin to put around himself in the middle of the coldest winter. In this gear, he searches left and right for the animal tracks, which he almost always finds, and often in such great numbers that he has difficulty to sorting out their different routes in the snowy forest areas trampled by so many animals.

Finally, having picked up the trail, he runs so directly after the beast that he soon finds it. Depending on whether the snow is deep, hard or soft, the hunter butchers all the beasts that he pursues so that the blood that flows out will not corrupt the flesh, and so that the heat is released, and so that nothing gets spoiled. If a hunter has become too thirsty during the hunt, he drinks the blood of the first animal he topples, and if it is a nursing female, he will drink the milk, which in my opinion is the best milk in the world, very thick and very sweet. I know this, for I have drunk my fill of it on occasion, and I was not bothered if it was mixed with a little blood, for hunger fears nothing.

Once the beast is disembowelled, the hunter takes the heart, the tongue or the head as proof of his kill. Fearing that the beast will freeze, he covers it with snow. Experience has taught him this secret, and if he were to forget, the next day when he comes to get the meat of the dead beasts, he would no longer be able to skin them because they would be frozen hard as iron.

[f. 96] Since hunting with other weapons is not very different from hunting with the sword, with which I imagine that the hunter kills beasts by spearing them from a short distance or by piercing them from three or four paces, one can readily see how moose are killed without my giving any more explanation. But rifle hunting is a little different from the others, and so is snare hunting and it is necessary to say a word about them in particular.

Aside from the ordinary use of the gun, one often hears a moose killing itself on the beaten trail. As it passes without noticing anything, it pulls the trigger by means of a cord that has been adjusted to fire the rifle, so that it wounds the beast in a vital organ, from which

it dies on the spot or quite close by. Having set his weapon so well, the hunter never fails to kill whatever passes by the place where the gun is. This hunting is dangerous, and terrible accidents happen. While I was in the Indies, a woman who walked past a place where there was a set gun was killed. I saw a young man whose leg was shattered. This hunt has been prohibited in the French colonies.

Snare hunting, which is called *la chasse des collets* among the French, is much more innocuous and there is no danger to men. The hunter has no fear of being trampled, attacked or killed by the moose, which is a danger in the other kinds of hunting.

The natives are very content with this kind of hunt because of the great ease they have in taking moose in all the seasons of the year. With the moose itself, these barbarians, who are savages in name only, have found a way to make very strong cords from moose hide, which they cut in long straps. Entwining them the way rope-makers do, they make snares stronger than the thickest ropes. They dry these ropes, and for fear that the rain may wet them again, they wrap them neatly with white wood[473] bark. Finally, they attach their snares to thick long poles of the strongest wood they can find. Leaving a slipknot at one end, they widen out the snare in an oval shape big enough for a moose to put its neck through and not to be able to get out. As it runs with the rope around its neck, it pulls the pole, which immediately gets caught up in the trees. The moose, in its efforts to pull out, strangles itself.

[f. 97][474] I have had the pleasure of going on this sort of hunt and seeing the animal strangle itself with great violence.

[Fifth Cahier of the Natural History of the New World]

In this way, thirty or forty moose are taken in a short time, for along a single fence of half a league that the natives make, they place twenty or thirty snares in various openings, where the moose unfailingly get caught up. Never jumping over the fence, they run along it until they find a specially made opening where a snare has been put to catch the beast, which once caught, never escapes.

The final ruse for catching the moose and killing it in the most agreeable way in the world is to push it into

473 In the section on trees, *le bois blanc* is translated as "white wood."

474 The manuscript bears in the margin: "5^eme cahier de l'Histoire naturelle de l'Inde occidentale."

the water or to meet it there, which very often happens during the three months when the flies rule the woods and make the animals come out in droves. It is a royal pleasure to find oneself in a canoe in pursuit of three or four large moose, on which our hunters sometimes boldly jump for pleasure or to deliver the deathblow when it is time, before the animal can make land. Sometimes they simply make it do a thousand caracoles on the water, where they flit quickly about in their canoes all around to divert the animal, and to make it stop at the most convenient place to kill it. They often take it by tip of the ear to lead it to where it must be killed. It must always be given the deathblow before it can set foot on land: otherwise, a strong animal would sink the little bark boat.

A certain well-to-do merchant in Quebec City, who was hunting among the islands of Lake Saint Pierre, wanted to have the pleasure of killing a moose once in his life. Finding one that was crossing from one island to another, he had the rowers of his small boat set out after it. Having reached it, he had a line attached around its neck and pulled it toward land, where he wanted to have the satisfaction of killing it. Pulling a little too hard, he gave the beast the chance to get on land, and forgot that he was still on the rope that was attached to the moose, which, having set foot on land, tried to get away with such force and such speed that, making the line unfurl, it knocked the merchant over in his boat. Since the moose was still pulling, the line had to be cut to save the merchant, and to let the moose go with the cord around its neck.

[f. 98] It is time, after so many different hunts, and it is fitting that having killed so many animals, we make a dissection or anatomize the moose, as I have promised. I am going to start with the innermost thing, which is the marrow, finishing with the skin, which is the animal's other extremity, and the outermost.

Since the moose has big and very thick bones, it is obvious that it must have a lot of marrow, which is sought after for two or three uses.

The first is that it tastes excellent and is very good to eat, even raw just after the moose has been killed. It is even better cooked, and if it is melted, there is no butter more soft or delicate. If it is left to go cold, one can make little cakes of it that are much appreciated.

Secondly, it is widely sought after for easing the pain of gout. Mixed with a little brandy, it relieves marvellously all kinds of pain. Those who know how to refine it make it whiter than the finest Montpellier wax.

I refined a lot of it, which I sent to my friends in France. This same marrow is good for seasoning all kinds of sauces, and it is good for fricassee. The candles that some people make from it light up better than our own. I have very often seen many natives who had saved over a hundred pounds of it for one winter. It is truly the best dish these people have. Consequently, they value it highly. In some countries I was in, a bladder full of marrow sells for two beaver robes. And as a mark of the esteem the Indians have for the alces marrow, they believe they are making a great present to a friend if they give him a few pounds of it. Among them, it is a present worthy of giving to ambassadors who come to their country to negotiate a peace treaty.

The bone of the moose is widely used among the Indians, because they use it: to arm their arrows in more than twelve ways; to make awls, needles, punches, and many rare instruments for painting; for skinning bear, beaver, otter and muskrat; to clean and dress the skins of the same beast. They use it to make dice in their fashion, knife handles, mace ornaments, soup spoons and a thousand trinkets to hang around their children's necks. Even the women adorn themselves with it. [f. 99] A thousand little bone utensils are found in the homes: darts and harpoons for spearing wolves, sea tigers, sturgeon, pike that two men would find it hard to carry and huge 50-pound trout. Finally, bead makers and particularly sculptors could use it to make desirable pieces because the bone is large, straight, long and white as alabaster. On the other hand our natives, having a great multitude of them, either abandon them or smash them, with stones or axe heads, for boiling. They then take from it a certain oil or a certain grease, which does not congeal, for greasing the whole body, particularly the face and their long hair, as did the Jews who anointed themselves with other liquids. They have given the name of *roûminkoûan* to this precious balm of the Indies, which is truly a refined taste.

The intestine, which the Greeks call επιπλοον,[475] and our doctors *culum*, or the large intestine, has an exquisite taste. It is bigger than a tall man's arm. It is full of a very fine grease that is very good to eat, and leaves no discomfort in the stomach. That is why wonderful dishes are made from it in the woods, and here is how. All the Indian women do is press it a little to make something come out, if you understand me, and without bothering to wash it, they twist it in order to cook it in the way I illustrate here:

475 See Aristotle, *History of Animals,* Book 3, part 4, 519b. In
 fact the *epiploön* is a part of the peritoneum.

And, larding three little sticks to hold it in place and hanging it with a piece of string from a stick that serves as a trammel, they turn it until it is cooked. Finally, the hunters make a feast of some importance out of it, giving each guest a piece a foot long. The seasoning that remains inside serves as spice and mustard.

As for the other intestines, they are eaten simply, mixed with blood from which is made a broth that the natives call the blood drink, or *miskoûioûaboû*,[476] which they value, saying that this kind of broth is very nourishing. Everything is very good for people who have nothing for food but meat or fish, which they half cook, and as much as they want of snow or the world's freshest water to drink.

[f. 100] It is hard to convince oneself of one thing that is nonetheless true among the wanderers of the woods. They sometimes have such a dearth of food that they are forced to season their pot with animal excrement, and their hunger makes them find everything good, even this sharp sauce. I know a Frenchman very well who, finding himself in a caravan with some natives, wished a thousand times to do what the prodigal son[477] desired; he would have plunged his head into a filthy animal's trough to catch hold of some cabbage stalk to satisfy his hunger. And I can say from my own many years of experience that in these foreign lands where no one eats bread, one always feels a certain weakness and a certain faintness, accompanied by a continual dog-like hunger that is only the result of this unimaginable lack of nourishing food. I have quite often taken great pleasure in seeing and hearing newcomers from France who protested that it would be impossible for them to lead their lives in the way the natives do, and that they found the sight of their dirty way of eating to be repugnant. But eventually, under the circumstances, they became used to it out of pure necessity, like the other old settlers, the inseparable companions of the Indians.

The paunch or the stomach of the beast is quite clean if one turns it over, scrapes it out and removes the grosser matter from inside it. The water that is used to cook this part of the animal, which becomes very green and thick like good pea soup, and which is one of the natives' best drinks, cleans this powerful animal's great paunch. Even the foam that comes out of it is a dish desired by those who are around the pot, who drink it with pleasure, putting their leftovers back into the pot for fear of losing any. This part of the animal is called *ouinassak*, which means stinking bag. I saw a captain who had chosen this name as a mark of repute.

The kidneys, which are very large, are excellent roasted when they are covered with a beautiful, very white fat.

The spleen, the liver and the lung do not taste too good. The liver has a peculiar quality for blanching hides that are being cleaned.

The *epiploön*, to say a word in the style of the Greek doctors, or the caul, which envelopes the innards, is as big as a tablecloth. It is white, strong and tastes good.

[f. 101] All the flesh of the beast, generally speaking, tastes very good and digests easily. It is not coarse or heavy, and a lot can be eaten without fear that it will overfill the stomach or do harm, even if only half-cooked and all bloody.

A certain Talaon, an American, ate a whole quarter with no ill effect. I can say that I know of no venison in the world that is nearly as good or as delicate as moose flesh. Deer flesh is much tougher, heavier, coarser and indigestible. Boar meat is not comparable to it. Europeans, who are much better cooks than Americans and who have seasonings, use it to make pastries and very delicate dishes.

The moose's heart is a morsel prized among the hunters, and they usually sacrifice it during the feasts for Kiigouké, who is the god of the day. A bone is found in the middle of the heart that is said to be

476 The word *miskoûioûaboû* is Algonquian. See previous note on the raspberry for discussion of *miskoûii-*. *Aboû* refers to "broth" (often *ab8i* in historic Jesuit Montagnais dictionaries). Although Silvy and Fabvre do not mention the "blood drink," Fabvre refers to a number

of other broths, including one made from bones. He translates *8ssigab8i* as "b8illon d'os origl." (for broth of moose bones). (John Bishop).

477 See Luke 15:11–32.

Natural History, or the faithful search for everything rare

good for preventing or curing fevers. They hang it around children's necks.

The animal's rump and the end of its tail are choice morsels when it is a big one. The hunters collect them prodigiously to offer feasts to one another and to sacrifice them all to the god of the hunt, who is called Keoussetch, which means "the hunter." If they want to conserve the choice cuts that are destined to honour the god of hunters, they dry them over smoke, and that is called *boucaner*.

The brisket, which means the breast, and the rib meat, which is the flesh between the skin and the ribs, are truly a delicacy if the beast is in good health when it is killed. The hunters make reserves of it so big that piles of over a thousand beasts can be seen in the storerooms of two or three families who have worked all winter curing them. I went to feasts where six or seven hundred animals were distributed at once.

The usual job of the hunters' wives is to go through the woods to skin the animals and to select the best of them and leave the rest to the dogs. Crows, wolves and foxes also take advantage of this.

Imagine seeing, in the middle of the woods, these butchers and beautiful dissectors of the moose that their husbands have killed. They select all the best cuts and they haul them over the snow to their cabins to smoke them in the manner I am going to describe.

The meat smoker looks more like one of the Furies than a woman. She has a stinking head, covered in grease that she rubs herself with every day, rolled-up sleeves or arms that are bare like her feet and legs. The skins she [f. 102] wears are all soaked with blood. Her face is covered with stinking black grime that mixes with the grease that flows from everywhere to form a horrible make-up. It would scare off any *précieuse* if she saw these butcher women, who look more like fauns, centaurs or the satyrs that are described to us in mythology, than like women.

Who would not be horrified to see, in addition to what I just described, pieces of meat laid out on the floor of the cabin, filled with the animal's hair and the hair of dogs that eat their fill of and then make their beds upon them? On the other side, a child, who has hands like a Moor because they are covered in grime, crying desperately because he wants something to eat, holding a knife, tries to cut a chunk of meat and throw it on the coals for a moment and then devour it. Another soils himself on his mother's knee, and she wipes him with her hand and continues with her work without bothering to wash her hands. She readies the meat for hanging on rods over the smoke and turning over from time to time, so that the smoke, acting more quickly, can dry it out sooner. To hurry along the meat, she tramples them under her feet, which are very dirty and full of filth so awful I dare not describe it. And yet, this food and its seasoning have to be eaten: that, or die of starvation. Finally, to hurry along their task, our smokers pierce their quarters of meat in a thousand places with small pointed sticks, so that the meat dries out from heat and smoke passing through the holes that they have made, more quickly than if they had not done so.

While the smoking is being done, the cauldron is boiling and, as I have said, for fear of wasting anything, the froth is eaten from a very large spoon. If there is a little left over, it is thrown back in and the few kitchen implements are cleaned in it. I spent an entire winter eating and drinking the broth in which such meat has been cooked, and where a child who had open sores did this fine work twenty times a day.[478] However, I suffered no ill effect, thank God, and it is necessary to get used to living like this or else renounce the noblest calling on Earth, which is to preach Jesus Christ to these infidels who have no knowledge of Him. By the grace of God, one can adapt to this way of life so well that the only discouraging thing is not to have any of this well-prepared meat to eat or this good consommé to drink. That is the life that Jesuit missionaries and those who follow their example lead in this country.

The moose bladder is a piece too important not to say a word about it. It is so useful to the hunters that they could hardly do without it for applying to burns or scratches, for keeping the beast's grease and melted marrow in, and for using as bottles [f. 103] They use another part of the same beast to the same effect: the throat, when it is big and inflated like an intestine, holds two quarts of brandy.

The best part of the animal is the head, which is all good. The tongue makes an exquisite dish when simply boiled. It is over a foot and a half long and as thick as a tall man's arm. Some natives eat more than a hundred in one winter.

The very long and very wide nose tastes no less exquisite. When simply flambéed and boiled, it is very delicate. The flesh, or rather a certain very fine, white fat, is so soft and succulent that it delights the palate and fortifies the heart at the same time. It is a little gummy, but not irritatingly so, and the jelly made

478 See *Jes. Rel.,* vol. 6, 243–69 for a similar comment under Le Jeune's pen (R. Ouellet).

from it, which is not comparable to that found on the best tables, comes in different colours.

The eyes, which look small on the animal before it is killed, are as big as the largest pippin apples. They taste much better than calves' eyes. The rest of the head is good meat, particularly that taken from the ears to the end of the mouth.

The brain is as delicate as a calf's, but only a little can be found in a head as big as the moose's. I think that is why the animal is so stupid, with its tremendously thick skull.

Doctors say that the left hind foot is an extremely effective remedy for epilepsy. But from the thousand that say it, there is not one who is not passing along hearsay, having had no experience of it. I can assure you that the exterior part of the hoof of either hind leg has the same effect. I admit to having being sought out from afar to provide, at any price, a small packet of it to give to a woman tormented by epilepsy. I did it with all the more pleasure because I was sure that these people were coming to look for me after learning of the remarkable recovery of a famous Carthusian prior of Languedoc. I had cured him, even though he was old, with the first dose that I gave him of part of the moose foot that I took from the animal in the New World before coming back to France, where I received as much as eight gold louis for one part of a real moose foot. I still have half of it, which is the part that I have mentioned. Some use it ineffectively, not knowing how to use it or apply it, but as I have never sought profit for myself, I will now explain how to use this remedy.

The power of moose foot taken from the two extremities of either hind foot, as I said, is so great that it would take a whole book to discuss it properly, and to have it bought not at the price of gold, but at the price of diamonds, [f. 104] the highest-valued ambergris, or even everything precious that there is. First of all, this foot has the power to cure epilepsy[479] when it is applied to the heart by making from one part of it a ring that is worn on the ring finger of the left hand. When an attack comes, one must put a little of it in the palm, which is then closed, while touching the left ear of the patient with some more.

The remedy has an extraordinary effect when grated into a little of the water distilled from the lily-of-the-valley that is celebrated in the Scriptures,[480] where it is called *lilium convallium*, and which can easily be found in all the hedgerows of the vineyards in Languedoc, where this distilled water is stronger because of the hot country. In order to make it clear what plant or bush this lily-of-the-valley is, it is the lily that is greatly prized in Paris, and of which the flower is so beautiful and sweet-smelling, but which in Paris cannot have the quality that it has in the hot country where it is distilled for the use that I propose. Some can be found in Paris that is suitable for distilling if it is picked in places and flowerbeds where the suns shines strongly against walls. This will substitute for the effect produced by the heat of the sun in the warm country on the *lilium convallium*, known in Paris as chevrotin. Celtic nard[481] has the same effect as distilled water of the lily-of-the-valley.

The same moose hoof works very well against the malady called *purpura*. When it is applied on the heart, it expels the wind that troubles so many people; it stops the flow of blood, if taken ground up; it cures ordinary and lientric diarrhoea; it purges black bile, cures every kind of dizzy spell and lachrymal fistula,[482] kills worms, gets rid of colic, purifies the humours, relieves palpitations of the heart and returns it to normal, purges the brain marvellously and fortifies weak hearts and weak limbs.

The power of the horn of the moose's hind foot was learned from the moose itself, which often falls down from epilepsy. To bring itself round, it only has to rub its ear with one of these feet and it immediately gets back up. Hunters noticed this quality as they chased this animal.

It would not be very difficult to send more than ten or twelve thousand moose feet to France each year on board vessels that trade in a country where over 100,000 moose are killed every year. One could get as many as one liked, for a reasonable price. Rich people who are affected by these cruel afflictions would be delighted to send for some if they knew its qualities, which they will be able to learn from these carefully chosen words.

The vanity of even the most curious ladies could be satisfied by buying beautiful bracelets made from the moose's four feet and as lustrous as the finest jet. Epileptics [f. 105] could also use the bracelets, with one

479 On this, see Leclercq, ed. Ganong, 275: "Its hoof is cloven, and the left hind foot is a remedy against epilepsy; but it must be secured, say the Indians, at a time when the animal is itself ill from this malady, of which it cures itself by placing this left foot to its ear" (R. Ouellet). See also Antoine Schnapper, *Le géant, la licorne, la tulipe*, 87ff.

480 Cant. 2:1.
481 Alternatively, *Nardus celtica*.
482 A lachrymal fistula is the small opening left after the bursting of an abscess in the upper part of the tear-duct, near the root of the nose.

difference: it is not important to the ladies which foot they are made from; as for the sick who wish to use them, they must obey the rules I have given for their use.

Even the ergots of the beast are used by the natives, who make prized necklaces from them. They use them on their garters, where they put finely worked ones threaded on little strings. They make a kind of rosette from them, similar to those worn by persons of quality on their garters and on their shoes, where our Indians always put them, as well as on their instep and around their leg. In this outfit, walking solemny at a steady pace, these performers seem to be playing castanets, while others resemble lepers who ask for alms with the rattles they have on the end of their feet.

From everything I say and from all that I still have to say, it will be seen that to our Western and Northern Americans, the moose is what some trees are to the Indians of the East, trees in or upon which they find everything they need to survive. They find food in the fruit, clothes in the bark, and provision for all their other needs. I notice that our natives, besides what I said about all the parts of the moose, not only find something to eat in all the moose parts but also find everything they need for their maintenance and housekeeping. They can easily do without everything that we find so important and that we could not forgo without considerable difficulty.

If the native wants to make a cabin from moose hides, he can do so. The Kilistinon, who are people of the North, make them with several skins that they sew together. In this way they make tents that sleep thirty or forty people. If they want thread to sew them, they take sinew from the moose and dry it.

If the men of the Virgin nation are in need of a canoe, they only have to sew together three or four skins with string that they make from the same skin, mount them all on a cedar frame, and in a few short hours they have a beautiful boat that is not as fragile and hard to steer as the ones made of bark, in which there is a danger of shipwreck a thousand times a day. Yet they are the quickest and easiest boats to navigate with, able to land anywhere at any time, and to be put in whatever place on land to protect it from the angry waves, wind and [f. 106] storms, something which could not easily be done, if at all, with boats of another kind, which are very often lost, and can be seen smashed on the coast, beach or riverbanks after a violent storm. It would even be possible to do with a moose skin boat what ship owners from Lyon do. Arriving in Avignon or Beaucaire or further down the famous River Rhone, they sell their boat at the end of their voyage. Our natives do the same thing: when they have finished using it, they sell

their moose skin canoe in exchange for commodities from the French, who quickly take the boats apart, fold up the skins and dry them for taking to merchants who pay them what they are worth, or they keep them for themselves and have them shipped to France where they do well out of it.

If a hunter needs shoes, stockings, trousers, a skin to cover himself, a cap, mittens, sleeves, a jerkin or whatever he pleases, his wife, who is a fine tailor, seamstress and shoemaker will soon provide him with all that from various moose skins that she will quickly start working on.

If snowshoes are required for running over the snow, a man and his wife will have them made from moose skin in three or four days.

If a warrior wants to mount a spear, a bow and an arrow, moose skin will provide him with strings to attach the spear, a string for his bow, and sinew for adjusting his arrows. If he wants to make a leather shield, he makes one from moose skin that is so big that it covers his whole body and so tough that no arrow can pierce it.

If a sick person needs a pillow, a mattress, some covers or anything else, the skin and hair of the alces will provide him with all of them. If the sick one should wish to drink a broth like consommé or jelly, he will have it in less than a quarter of an hour from the scrapings from the inside of the skin, which are boiled in water. From the same preparation, the ladies of the country make a glue suitable for making beautiful designs and rich paintings that they do on bleached moose skins.

Our hunters make all kinds of ropes from the skin of the moose, and use it in so many different ways [f. 107] that it would be boring to repeat them all.

To finish, I will just say that the fine baldrics, belts, sword belts, along with beautiful breeches and all these rare jerkins, known as *buffles*, that are seen on the backs of our dragoons, grenadiers and horsemen, and very often on the backs of the best and bravest officers, are all made from this fine moose skin, which takes so many different shapes. Those large costly gloves are made from this same skin.

The most refined women, and the ablest in all kinds of work, after removing and separating the white black, grey and yellow moose hairs, make very rare and finely worked objects.

The Virginian women in particular show their skill at this. On their embroidery frames, they make bags more beautiful than anything, decorative headbands, bracelets, garters, headbands or tump-lines for carrying heavy loads. It is surprising to see how delicate and

finely worked these things are. It is hard to find objects that are more varied in the different shapes imagined by these women, or better made. I do not know if the ablest master embroiderers in countries where the people are civilized and workmanship is the most perfect could make more beautiful things from this material; nor if people with the finest and strongest imagination could make finer shapes in their drawings than the Iroquois women do in the work they do with moose hair. Besides its various fine natural colours of black, white, grey, yellow and green, they dye it very bright reds, browns, etc. They intermingle it all so agreeably that there is nothing more curious.

I said that, having begun the anatomy of the moose with the marrow, which is the part most hidden, I was going to finish with what is most visible, which is the skin. Indeed, I want to keep my word and say that as well as all the rarities of the skin that I have reported, our skilful women workers take from inside the skin a certain parchment [f. 108] that they call *agouramak*. This parchment is greatly useful to them for making bags and wrapping for their parcels.

I have said nothing about the fine use they make of the moose's great ears. The hunters like them for making caps, which they use quite often. Some winter days when it has snowed in the night, the branches that are loaded with snow are extremely bothersome to the hunters, who, as they pass underneath, shake the snow, which falls on their heads. Having to shake off this snow impedes their progress. Since the caps they make from moose ears protect them from this inconvenience, they use them.

The skin of the *manichis*,[483] which is the moose fawn, is unbelievably useful for children, for whom swaddling clothes and robes so fine and well-painted are made that that there is good reson to admire them.

The tobacco pouches that warriors have made for themselves of this skin are so charming, so refined and so decorated with painted designs that nothing so precious can be seen among these people, nothing they value more highly, nor guard more carefully for wearing on special occasions, particularly when this *kaskipitagan*,[484] which means tobacco pouch, is embroidered and decorated with different coloured porcupine quills.

It is evident, then, from everything I have just related and from many things I could go on to say, that the skin of the moose and even its entire body is of great use, from the largest to the smallest part of the animal. I wanted to speak a little more about it than the other animals to show those who honour me by reading my memoirs the great use and utility of this fine animal, either to the advantage of the Americans in whose country the animal lives, or for the Europeans who take useful items from it, and merchants who take great riches, for they get these rare and beautiful skins, and even the whole animal from the Indian hunters for almost nothing.

[F. 109] BOOK EIGHT

Amphibious animals, particularly the ferret that lives in the water and on land

Now I must speak about aquatic and amphibious animals. Having told you about land animals, I give first place to the water ferret.[485] Since it is differs very little from the ferret that lives solely on land, I will say nothing except that its natural instinct causes it to reside ordinarily in the water. There it lives on fish, mussels and oysters; it kills muskrats, and makes war on the beaver, even in the middle of its lodge, where it kills it, small though it is. The other ferret, which is inclined toward land, never goes in the water unless it is forced to do so. The fur and the shape of this waterdweller are nothing special. The people of the country eat it when they are able to kill it. This animal is a foot long and as big around as an arm.

The large muskrat[486]

If there was ever a country in the world where it could be said with truth that the rats are the size of cats, it can be truly said of the country of the New World, where the rats are as big as cats in all dimensions. But concerning the animal in question, I will say that I do not know why our Frenchmen gave the name "rat" to the animal I describe, and which I illustrate with a drawing in which I think I have managed to represent the animal as well as possible. It is true that the muskrat – since we

483 The word *manichis* is an Algonquian word. Silvy translates *manichich* as "jeune orignal." Fabvre translates *Man chich* as " Ieune petit orig(na)l" (John Bishop).

484 The word *kaskipitagan* is an Algonquian word. Silvy translates *kastipitagan* as "sac à pétun." Fabvre translates *Kastipit gan* the same way (Bishop).

485 Could it be *Lontra Canadensis* (Schreber), river otter,

even if Nicolas mentions the otter below (f. 112)? See Banfield, 341–4 and Burt and Grossenheider, 60–3.

486 *Ondatra zibethicus* (L.), muskrat; Banfield, 197–201; Burt and Grossenheider, 193–4; depicted in the *Codex*, Pl. XXXVIII, fig. 55.1, as "ouatchas ou rat musché"; not represented in Gesner. Champlain first mentions *Rats musquests* in 1603, although Cartier had already descri-

must call it that – has two extremities similar to the large rats we find to our chagrin in our houses. It has a rat's teeth and tail. It is easy to know why it is called the musk rat, since I am sure that all through April, May and June, the animal smells so strongly of musk that the meat cannot be eaten at this time because it tastes so much of musk. It is not for eating that [f. 110] the hunter tries to kill the muskrat at that time; it is to get the skin and the testicles, one to trade and the other to extract the musk, as I will explain. Although I have said that the muskrat has a tail like a rat, and this is true, I will say, however, that the tail is much thicker and longer, and is scaled like a beaver's. It is endowed here and there with long hair.

The rest of its body is very hairy and covered with hair so fine and so dense that nothing could be more beautiful or better for furs. This short hair is as delicate as can be imagined, and is more like swan's down than the hair of a four-legged animal. In addition to this, the coat is covered with another longer, coarser hair, which, however, is very shiny and gives a wonderful lustre to the entire skin.

Of these kinds of rats there are some with an all black coat, others whose coat is all grey, and others almost all yellow; yet there are not three different species. The yellowish and grey ones all seem to be bluish under the long hair.

Very large and beautiful coats are made in the country from the skins; they are highly sought after in France and they ordinarily sell there for more than fifty or sixty écus. If the animal is killed between the beginning of April and the end of June, the skin, the flesh and the testicles are all musk as I said; if it is killed after this season, it no longer smells of musk. Traders in the Indies amass a great number of testicles and they charge a high price for them in France; a pair has brought as much as one écu. The price has gone down a little. I think this is because the operators of Paris public baths (as I have often been informed by several people) did not do as well out of it as those who adulterate real musk by making a mix of these testicles with genuine musk.

The muskrat hunt takes place at three times and in various ways, in autumn, winter and spring. In winter,

when it rains and the water swells under the ice, there are people who know how to kill them with spears or swords fitted onto a quarterstaff. Only the Americans hunt this way, and consequently it is only they who see the muskrat in this season, through the bulrushes where they hide.

[f. 111] Autumn muskrat hunting is no less interesting than what is done in winter or spring, as I will describe. This animal, which likes to be almost always in the water, becomes a land dweller in autumn, albeit on the lake shore or on the riverbank, where it makes large holes, not too deep in the ground, where seven or eight can be taken at a time. Plugging the animal's entrance is all that is needed to take everything in the lair. It must be noted that in this season, as well as in winter and summer, the muskrat cannot properly be called the musk rat because, during these three seasons, this large rat does not smell of musk, either in its flesh, its skin or its testicles. Yet the skins are no less precious; they are sought after even more, particularly by those who are not pleased by the scent of musk, which the musk rat has too much of during the three months I indicated. In fact, I will say that there is no pleasure in wearing a fur that was all made from the skin of muskrats killed in springtime, for the odour is too strong.

Everyone takes part in the spring muskrat hunt, and so many of them can be seen during this season that a single hunter can kill two or three thousand in three months. In this season, they are killed by guns loaded with lead pellets. At this time, there are two kinds of profit: one from the skin and the other from the testicles, which are dried in paper hung up to smoke.

Indians do not like the scent of the muskrat at all and say that the animal we esteem smells bad, as agreeable as its scent may be to Old World persons. Generally speaking, and since the occasion presents itself, I will say that these forest people detest all our most fragrant essences and our most exquisite sauces, saying that the former stink, and that the latter are too bitter. This is why they say that the muskrat smells bad: "Oûinat-ouatchak, he stinks like a muskrat."[487]

The muskrat makes a lodge like a beaver, but instead of making it with tree branches, it builds its

bed them clearly in 1535 as *raz sauvaiges* or even as *ratz*. Lescarbot called it *rat porte-musc* and Denys *rat Musqué*. It is represented on Champlain's map of 1612 (Ganong, 236). Mentioned in 1664 by Boucher (Rousseau 1964, 312 and 314).

487 Sylvy translates *8atchask* in Montagnais of the seventeenth century as "rat musqué"; he gives *8initeu* for

"cela pue, *quid uritur*." Fabvre also translates *8atchask* by "rat musqué" and *8in ten*, as "empuantir"; he gives also *8in te8* as "cela sent mal; ce qui brule." In Montagnais of today *utshâshk* is a "rat musqué" (according to Daniel Clément, *La Zoologie des Montagnais*, Louvain, Paris, Peeters, 1995) (henceforth Clément); Rhodes gives *wzhashk or zhashk* as "muskrat" in the Ojibwa-Chippewa-

dwelling with rushes. It is an amphibious animal that lives part of its life in the water and another part on land. When swimming, it has to come up for air from time to time and breathe like the beaver, the otter and all amphibious animals. The muskrat's forelegs have nailed claws and its hind legs are webbed and have nails, like swan's feet.

This rare and beautiful animal can be domesticated the same way as the beaver and the otter, which I will describe in talking about these two animals. [f. 112] Our great rat looks almost like a beaver, and if it were not for the tail, it would be taken for a small beaver. The beaver's tail is flat, viewed from above or below, and the muskrat's is flat on the sides and perfectly resembles the file used to sharpen a pitsaw. The pelts that are collected in one canton of this country make a good business. There are few hunters who kill fewer than four or five hundred in a few days, and these could be passed on in France for ten or twelve thousand livres.

The otter[488]

Although three kinds of otter are found in the great waters of the New World, there are not three different species of these animals. And although black, grey and reddish ones can be seen, they are nevertheless similar in everything else. All three kinds have a flat head with a flat nose, and sharp teeth that are close together and well lined up. Their eyes, whiskers, paws and tails are all exactly the same.

Very large, jet black ones are killed. The short hair under the black is very fine, an inch and a half long. It is so beautiful and so delicate that it is admired as soon as it is seen. It never loses its appealing lustre; the fur is special, and therefore prized, and hunters prize nothing more. They have coats of highest quality made from it by their wives, who use all their abilities to do wonders with their paintings. These coats are made from the skins of sixteen to twenty otters, which would be priceless among civilized peoples who like or need furs. Merchants of the Indies fall over each other to get at these pieces.

Papinachois country, or the land of the Laughing Nation, is the beautiful country where these black otters are killed. However, they are found in the entire Northern region. The other otters that are grey or yel-

lowish are common throughout the country. The Upper Algonquins have some that are rather special.

The otter makes its home where fish abound, and usually lives on them, or on the shellfish that it catches from the depths. It makes caverns in the earth and in the water from which it must come out to breathe. In the icy season, it makes holes in order to come out for a walk on the frozen snow, and only when the sun is shining upon them.

Pliny was in error,[489] or shall we say he was misled, when it was reported to him that the otter was similar to the beaver. In my opinion there is a big difference, for the otter's only similarity to the beaver is its hind feet. What people must have meant to tell [f. 113] Pliny was that this animal has much in common with the beaver because of its tendency to dive and to make its home in the water. It is completely different from the beaver in every other way. The beaver gnaws while the otter chews its food, one like a rat, the other like a dog, and they feed on different species.

The otter whistles agreeably, and has a certain kind of song that sounds more like a bird than like a four-legged animal. It is a glutton and eats everything, almost like a dog. Natives eat them, although the flesh is very tough and foul smelling.

It easily becomes well-domesticated, but I have never seen any as well trained or as intelligent as Swedish otters, which I am assured are so docile that when they are trained, the cooks of large houses only have to order them to go and catch a fish in the pond or castle reservoir and they immediately obey, bringing fish to the cooks as many times as they are asked.

Western otters retain a wild mentality. They are not as skilled as Swedish otters and not as intelligent; yet it is true that when they are domesticated and trained, they follow their masters everywhere and go fishing. But they bring nothing back, and eat all their catch.

But in recompense for the intelligence of the Swedish otters, the skins of the otters of the Indian countries are more beautiful, more prized and more sought after, and the annual trade in them could well reach fifteen or sixteen thousand livres.

Hunting for them is not much different from hunting beaver.

Ottawa of today; and Hewson, *wa?šaškwa* in Proto-Algonquian (John Bishop).

488 Nicolas could not have known the difference between *Lontra canadensis* (Schreber), River otter, and *Enhydra lutris* (L.), sea otter, which is found on the Pacific Coast; Banfield, 344–6; Burt and Grossenheider, 63;

depicted in the *Codex*, Pl. xxxvii, fig. 54, as "Nika ou loutre"; copied from Gesner, 1621, 4, 515. Mentioned first by Cartier in the old form, *louere*, and by Champlain in 1603 (Ganong, 223). Boucher mentioned it also in 1664 (Rousseau 1964, 312).

489 *Historia Naturalis*, 8, 47.

The beaver[490]

Although the beaver, which we call *amik*,[491] is a very well-known animal and everybody talks about it,[492] I have nevertheless resolved to tell everything I know about it, and to reveal many peculiarities. The authors who have written about it without having seen it have never discovered what I have studied myself a hundred times about the beaver, its lodge and its astonishing handiwork. After reading what I have to say, those who know what a beaver is will be confirmed in their knowledge, and those who have never seen one or perhaps only heard of them slightly, will be able to discuss them learnedly.

The animal is the size of a large sheep, but not so tall; its legs are no more than half a foot long. The two forefeet have claws; the hind feet have claws and are webbed like a duck's feet. Its tail is fourteen or fifteen inches long, and more than six inches wide toward the rump. [f. 114] The tail is hairless, with black scales two inches thick. It is the shape of a partisan halberd blunted into a rounded end. The animal's nose is flat, and its head is large and almost round, with short ears. Its hair is three or four inches long, lustrous and very shiny, according to its colour, which is one of three variants: white, black or a somewhat yellowish burnt chestnut. In other words, the white beaver has an all-white coat, and the black one is all black. Aside from that, they are exactly as I described, including the yellowish ones.

Under the beaver's outer long hair there is another kind, which is the hair that is widely sought after to make expensive hats or even cloth. But as this cloth is too fine, it is useless, beaver hair being too light and too short to hold together as a good material.

Beaver testicles, whose medical name is *castoreum* and which the Indian hunters call *ouissinak*,[493] are excellent for various illnesses. A woman who is tormented by *mal de mère* feels much better when some of it is burnt under her nose and she smells the bad odour. A pound sells for as much as twenty écus.

Not all testicle meat is suitable for medication, and it is necessary to distinguish and choose between the four testicles the beast has, of which two are used for medicine. The other two are only worth throwing to the dogs. The good ones are used in theriac.[494] Testicles that are full of humours are the good ones, and those are the ones that should be chosen.

All the animal's flesh is good to eat, although a little bland and in need of flavouring. It is eaten during at any time, including Lent and vigils.[495]

The beaver has two kinds of teeth. Like muskrats, it has large and small ones, molars and incisors, and it is the latter about which I have interesting things to say. There is nothing more remarkable about this animal than these teeth, and whatever people may say in praise of beaver pelts, for me there is nothing more praiseworthy than its incisor teeth. They are three inches long and a third of an inch wide, with a dull yellow colour, and sharper than the best-honed razors. They are curved a little inward, where they are white. There are only two below and two on the upper jaw of this nature.

[f. 115] The beaver is one of those animals that the Latins called *mordax*, the biter. The Indians call it *amik ka takouanketch*, the beaver who bites.[496] It was given this name because of the animal's skill and strength with its teeth, with which it cuts down trees two or

490 *Castor canadensis* Kuhl, beaver; Banfield, 158–62; Burt and Grossenheider, 151–3; depicted in the *Codex*, 37, fig. 54.1; figure copied from Gesner, 1621, vol. 4, 309. The old French name was *bièvre*. Cartier wrote *byeures*. Champlain already used *castor*, and gives a poor picture of it on his map of 1612 (Ganong, 205–6). Mentioned at length in 1664 by Boucher. The *Dictionnaire de Trévoux* (1743) still used *bièvre* and *castor* (Rousseau 1964, 312).

491 The word *amik* is Algonquian. Both Silvy and Fabvre give *amisk** as "castor." The word still exits as *amishk** in the Montagnais of today (see Clément); Rhodes gives *mik* or *amik* for "beaver" in the Ojibwa-Chippewa-Ottawa of today. In Proto-Algonquian, we have **ame kwa*, according to Hewson (John Bishop).

492 See F.-M. Gagnon, *Images du castor canadien*.

493 *Ouissinak* is an Algonquian word. Silvy translates *8ichinau*, pl. *-nauak*, as "rognons de castor" (beaver kidneys). Fabvre gives the same translation for *8ichinau* pl. *na8ak*. Clément translates *uîshinai* as "testicule … glande à castoréum (castor)" (John Bishop).

494 Or treacle (archaic meaning), fr. L. *theriaca*. An antidote to poison, especially the bite of a poisonous snake. According to the *Dictionnaire de l'Académie*, 1694, its ingredients included viper flesh. It was said to fortify the heart as well as being an antidote to poison. It was also used in times of hunger: for instance, the Jesuit Louis André, after having been in vain in the woods "to hunt for roots, acorns, and a kind of moss called by the French rock tripe," tried to ease his hunger with "an old Moose-skin" and realized that one day he might have to eat "Native shoes … and some books … taking a little Theriac, after eating such an unaccustomed diet" (*Relation* of 1670–71, *Jes,. Rel.*, vol. 55, 142–4) (R. Ouellet).

495 See Denys: "It is permissible to eat them during Lent, as is the case with the otter in France," *The Description and Natural History of the Coasts of North America (Acadia)*, 1672, ed. W.F. Ganong, 361 (R. Ouellet); see also F.-M. Gagnon, *Images du castor canadien*, 35–47.

496 This is an Algonquian phrase, *amik* referring to the beaver, as we have seen above (John Bishop).

three times the size of a *poinçon*,[497] and even the size of a small wine vat. The forest is filled with a thousand obstacles, trees that the beavers have toppled by gnawing at them. In one night, two beavers will cut down one of these great trees to make sluices that they need for their dwellings. It is an animal that likes the water and cannot live anywhere other than in what are called *cabanes de castor* or beaver lodges, which the animals build in such a way that there are remarkable compartments inside. One of them is used as the beaver bedroom, where it rests and sleeps comfortably and where it produces its young. It is so well organized that, as it sleeps or rests, it can dip its tail in the water to prevent its drying out, which would seriously harm the animal and put it in danger of dying if it dried out entirely for a long time. It makes a roof for its lodge, and another compartment for going in the water when it wants. When the weather is fine, it can be seen going out on its roof to sleep, or to relax in the sun.

The beaver likes wet or very watery places. It usually chooses a spot where it is able (by means of some spring, brook or little stream of water that it stops with a strong and powerful dam that it makes) to create a pond.

After choosing the place between two mountains or on some plain in the middle of which there is a spring and a hollow where it can make its reservoir, the beaver starts by making a strong embankment, so firm and watertight that men could not make anything like it or as strong with the same materials. Before it starts to build, it uses its incisor teeth to cut a large quantity of branches, which it drags to the place where it wishes to build its house. It arranges, intertwines and adjusts these branches so well that, to see this complex construction, one would say that one of those birds that make the best nests had worked there, if it had had the strength, because everything is so well done. The difference is that a nest opens upwards and this house has its opening underneath, where there are three or four holes that serve as entrances and exits in the water for the animal. In the midst of this structure, there is a very well-built level [f. 116] where the beaver can safely live sheltered from the ravages of the weather. From this level, it comes and goes in the water to another compartment. In a word, its lodge is so well constructed and so strong that it can only be demolished with difficulty, everything being so well intertwined with tree branches cemented with turf that no musket ball could penetrate. I think that even several shots from a culverin[498] or several discharges from a falconet[499] could not knock it down.

After this work is finished, the beaver does not waste time, but makes its dam to hold as much water as it needs. Here is how it does the job.

This animal, having made the lodge that I have just described, returns to the place it already noticed before it began building its abode. It immediately sets to work. There are only two workers at first, the male and the female. They stand on their hind legs to start their work, and each begins to gnaw on its side of the tree, so skillfully and efficiently that two animals can bring down the tree wherever they want. After that, they take down another they have also gnawed, piling them one on top of another to stop the water at the height of their first level, so adeptly that they always raise the water level to the desired height.

Once the major work of the dike is completed, they intertwine countless branches around the large trees they have knocked down. If by chance a branch on one of the large trees that they felled is preventing the trunks from lying flat on the ground, they soon remedy this problem by gnawing off the branches in such a way that the trunks lie perfectly against the earth, and the water cannot flow or leak. To plug all the openings where the water could escape, these animals lift from the ground great pieces of turf with their teeth and their paws, to fill the holes where the water may leak out. Their big, strong tail serves as a trowel[500] for battering these lumps of sod and making them as solid as cement. They make a kind of barrier or breakwater that they raise to the level of the first storey of their lodge, which is often a good quarter of a league away. I have seen, and navigated on, ponds that the beavers had made where the water was so deep that large brigantines could have sailed there, as well as the largest galleys.

The beaver does this amazing job in less than twenty-four hours. If sometimes one has not managed to catch it, and if it was not wounded when its dam was broken, by the next morning the whole thing is mended. These embankments are eight feet wide and a quarter of a league in length. [f. 117] If the water

497 A small wine barrel containing a little more than 200 quarts.
498 Large cannon with long bore used in early sixteenth century.
499 Light cannon used in sixteenth and seventeenth centuries.

500 Even though it was a quite common belief, it is not true that the beaver used his tail as a trowel. See Denys, *Histoire naturelle*, 289–90; Chrestien Leclercq, *Nouvelle Relation de la Gaspésie*, 535; Lahontan, *Nouveaux voyages* in *Œuvres complètes*, 389–90.

Natural History, or the faithful search for everything rare

overflows the dam and rises too high inside the lodge, the animals can be seen quickly swimming out to the dam to open it somewhere to let the water flow out until it reaches the desired height. If it is not yet high enough, they raise their dike so expertly that the water rises to the level they wish.

The skill of these beasts is no less remarkable in that they have the intelligence or rather the instinct to protect themselves from floods when the snow melts. For this reason they make several levels in their lodge, and toward the end of autumn, our animal has the foresight to cut many large trees, which it sinks to the bottom of the lagoon, so that it can eat them under the ice during the winter. Fearing that the wood may float to the top, freeze and not be removable from the icy surface, the beaver loads it with heavy weights to make it sink to the bottom where the water does not freeze.

The beaver ingeniously makes its bed from very soft and well-crushed bulrushes in such a way that it can lie down softly and warmly. Some say that the beaver leaves its lodge in hot weather, but I know that this is not so, having seen beavers killed in their lodge even in that weather.

When the dams are broken, they work on them as I have said. As gnawing so much takes the edge off their teeth, they need to sharpen them, not on stones, for they do not know how to use them, but they rub them one against the other with such force and skill that the teeth get as sharp as the sharpest knives. This happens often and it must be noted that their teeth grow extraordinarily, since by gnawing and sharpening them often, they wear them out quickly; and yet they are very long.

Finally in its lodge, the beaver multiplies rapidly in a short time. Where there were only two of them many are seen, and if they are left alone they are seen in troops. One day, as I was inquiring of a man of the North, where I had not been, whether there were many beavers there, he replied to me that they were everywhere as many as a dog has fleas. The natives have killed so many there, and still kill so many each year, that there is a very good trade and the revenue from them is so great that it is hard to calculate.

Beaver are hunted with rifle, spear, and arrow, with snares made from skin or finally with traps.

The animals' gatherings are worthy of admiration.

From time to time, they troop together to help each other as ants do when several join in to pull something that one cannot carry. These beavers get along so well that they lodge together in great numbers; but if eventually [f. 118] they multiply so much that the lodge is too small, some families move away to another place to start new colonies.

There is such a large number of these animals throughout the Indies that feasts are held where five or six hundred beavers are eaten at a single meal.

The animal is easy to train when it is young. It eats everything that can be gnawed. It stands up while eating, taking its food between its two forepaws. It eats extremely fast. Its voice is a kind of agreeable whistle like that of the otter.

The beast's insides are very similar to those of a pig. The beaver's spleen is very small. It has large, wide kidneys, well covered with very good-tasting fat. But the head and the tail are the best; they are the captain's choice.

Beavers live on the leaves and bark of the poplar, the alder and many other trees.

I do not agree with those who have written, based on false reports, that the beaver is caught by the tail, which freezes, they say, and sticks to the ice, and being stuck like this, the beaver can easily be taken by the hunter.[501] Although this animal is quite stupid and awkward, it is not that stupid and is much too clever for that. And if there is any country on earth where that should happen, one would certainly see it in the Northern Indies and particularly in all the northern passages where the rigours of winter last for nine or ten months and where the ice on the seashore is more than 360 feet thick.

It is true that natives fish for the beaver under the ice, which they cut through with iron blades, but it is never true that the beaver's tail sticks to the ice.

In a region where I was some time ago during the winter with natives, I saw them do this combined hunting and fishing, which is done with a sword and a net made from skin so that if the beaver escapes the steel, it does not avoid the net.

I do not know if I mentioned that sometimes one is hampered in the forests by the ravages wreaked by beavers felling countless large trees to fill their bellies with the leaves, as the poet said:

501 Perhaps reflecting some medieval author, Lescarbot wrote in *Histoire de la Nouvelle France,* 1612, Book 6, ch. 20, 423–4: "on tient qu'estant amphibie ... il faut qu'il ressente toujours l'eau, et que sa queuë y trempe." Thomas de Cantimpré (1201–1272) had written much earlier in his *De rerum natura*: "Non potest diu subsis-tere nisi caudam in aqua teneat [Beavers cannot survive long without having their tail constantly in water]." Quoted in Vincent de Beauvais (1190–1264), *Speculum Naturale* (edited by the Duaci Benedictine Fathers), 1624, Book 19, chap. 28, col. 1398.

Saepe ergo horrificis erosâ dentibus ornô
Exsatiat ventrem, fronde repletque suum
Phyber etc.⁵⁰²

Apart from the beaver that I have just described, there is another sort, which is the same as this one except that it is inclined to live in a house built from earth in the water, which it likes more than does the common beaver, which it surpasses a little in size.

[f. 119] It is also not true to say, and the reader is deceived by these agreeable untruths, when one says that the beaver, sensing himself chased by a hunter, tears off his testicles so that the hunter will be content with that, and with the sweet smell that people wrongly suppose the beaver's testicles to have, and with other uses for which they are sought.⁵⁰³ This animal must always be pursued a long way before it is killed, or before it dives into the water without cutting off its testicles, which, far from having a pleasant odour, are very smelly indeed.

*The sea tiger or sea wolf*⁵⁰⁴
I would not have given the name of wolf to a marine animal that is more like a tiger than a wolf, for first, it has a head as big as a tiger's, similar eyes, horrible whiskers of long, thick, straight hair, and a mouth armed with many small and large, very sharp teeth. The skin is spotted and flecked like a tiger's; the hair is short, lustrous like satin, and it never fears the rain. It differs from a land tiger in that it has very short ears, although it has very acute, subtle hearing. Its entire body is long and round, the roundness diminishing gradually and proportionately from the shoulders down to the end of the thighs, which are extremely short and hardly noticeable.

This animal has four feet. The two in front have small claws, similar to a dog's. I said that these legs were very short: the rear ones are even more so, but the feet are webbed like those of a goose or a swan, and serve as paddles for swimming. The beast's tail seems to be joined to these oars in such a way that the swimming animal appears to have a fleur-de-lis on its extremity.

This sea tiger is usually very fat, and so much oil can be taken from it that it can make a sizeable business. This is the best oil for oiling skins and turning them a golden yellow. It is used for burning. It congeals a little in winter. It is widely used at sea to mix with coal tar and for pitching masts, cables and all kinds of ropes, and even the exterior of the hull of a vessel.

All the animal's intestines are delicate to eat. The tongue is a dish fit for a king. When the tiger is young, its cry is like a child's. One night, as I was strolling along the upper deck of the brigantine where we were anchored off the Northern coast, it came as a pleasant surprise to hear an infinity of these cries, which always make a melancholy impression, and send one, in the dark of night, into a [f. 120] strange terror, seeing oneself on the one hand in the middle of an immense expanse of water all around, and on the other hand considering that the slightest gust of wind could break your cable and throw you against a rocky shore, where a dismal shipwreck is assured. This misfortune befell two vessels that perished without hope. What heightens the terror is that the river is sure to be as wide as the eye can see and that it is two or three hundred fathoms deep, like the high seas, where there is no hope of being saved, and where one is certain of soon being devoured by fish.

The whole of the great river is full of sea tigers, or sea wolves, which have no differences that I can see other than size, the sea tiger being much larger than the sea wolf. They can be seen by the thousands together from the entrance to the gulf as far as Tadoussac.

502 Nicolas probably borrowed this quotation from Diego de Funes y Mendoça Aristòtil, *Historia general de aves y animales,* Valencia, Pedro Patricio Mey, 1621, who declares, quoting "Stroza Pater" (that is, the poet Titus Vespasianus Strozzi, author of *Eclogae,* 1513): "*Ancipitis vitae est Castor, nunc vivit in undis, / Nunc spretis térras ille frequentat aquis. / Saepe ergo horrificis erosa dentibus orno, / Exsatiat ventrem fronde repletque suum* [The beaver lives like a snake, sometimes it lives in water, / Sometimes, after it has left the waters, it dwells on the earth. / Often then, with ash gnawed with his horrible teeth / He satisfies his belly and fills it with leaves]" (Alban Baudou).

503 This was a belief common among the Ancients. Pliny in *Historia Naturalis,* vol. 8, 109 wrote : "easdem partes sibi ipsi Pontici amputant fibri periculo urgente, ob hoc se peti gnari [The Pontus Euxinus beavers cut off their own genitalia when they are in danger; they know that it is why they are sought after]"; Aelianus, *On the Characteristics of Animals,* vol. 2, 50–1 says the same thing. Cicero used this legend when comparing a certain Aris, who had left his wife behind, to a beaver because he was afraid to be killed by the Roman governor of Sardinia, M. Aemilius Scaurus, who supposedly had an eye on his wife. See N.H. Watts, *Cicero: The Speeches,* 270–1. Similarly, Juvenal compared his friend Catullus to the beaver because he threw all his merchandise overboard to save his life during a shipwreck. See *Satire* 12, 30–6.

504 The word *loup marin* was first used by Cartier in 1535, and future writers also used the term. Denys describes two kinds, but without naming them. Champlain made a good depiction of it on his map of 1612. We recognize the harbour seal, *Phoca vitulina* (L.). In 1691 Leclercq said the common kind were distinguished by the name

Natural History, or the faithful search for everything rare

Around the islands of Brion and la Madeleine, which are almost in the middle of the gulf, some can be seen as big as oxen, eighteen feet long. Here and there, one sees mixed among them other animals whose names I do not know, which are prodigious in size, and which have teeth like an elephant, that is to say teeth six feet in length. These animals go on land like a sea tiger. Since I wrote this, I have seen the head of one of these animals in the famous library of Ste-Geneviève-du-Mont. The fish was young and therefore its teeth were not yet so long.

Large sea tigers are not as fat as the average-sized ones that are commonly seen all along the northern shore of the river between Anticosti Island and the dry land of the Eskimo nations, the Oumiamis, their neighbours, allies and close relatives, and the Papina-chois and other nations, as far as the land of the Man-gounchiriniouek,[505] who eat them and whose main source of food they are. In particular, they are eaten by those who live among the Mantounoc Islands as far as the Saint Jean River, and even beyond that, keeping north towards the Eskimos' lands. The simple fact of eating sea tigers brought them into a cruel war with the Acadians, who, with no other reason or interest, go to war with the nations of the North simply because the people of those lands eat the sea wolf. To avenge the affront that they think these poor nations, who were not even aware the Acadians existed, do to them, the Acadians undertake crossings of twenty or thirty leagues in small boats known as biscayans, which are small skiffs [f. 121]

[Sixth Cahier of the Natural History of the New World]

that the Basques, who go every year to fish for cod near the Acadian coast, abandon after using them for fishing in the Gaspé Bay or Percée Island. These Acadian natives go to take prisoners of war in the lands of the nations of sea tiger- and sea wolf-eating peoples. When these prisoners are caught, they are immediately killed, burned or eaten as if they had committed some great crime or gravely offended the Acadians. From this it

can be seen that it is not only in Iroquois country that men are butchered like sheep, and that there is more than one region where people of a different nation are eaten when they are captured in war, and only when one nation is embittered against the other for reasons that are slight and often unknown.

The way the Eskimo hunt sea tigers is impressive, for they do it with arrows that they attach to the end of a rope made of skin; having speared the animal thus, they lead it to wherever they choose to kill it.

Other nations go about it more simply; they shoot their spears and arrows freely, but there is great danger of losing the animal, which will dive if wounded. If it is mortally wounded it will die in the water, from which it does not come up for two or three days; or it falls into the hands of another who, finding the carcass by chance on the shore where the tide has carried it, reaps the benefit that the hunter would have had if he had taken it when he delivered the death blow.

Still others use a gun to kill sea tigers. If the animal is struck in the head it dies immediately, but it is never stopped by other wounds.

The most agreeable hunt of all begins in early autumn. When the tides are very high and the days are fine, these tigers like to come on land to sun themselves and sleep comfortably while the tide goes out and leaves them dry. If hunters find them they are sure to kill all of them that are high and dry and they are sure to make a good haul, finding four or five hundred. These animals, when they see they are lost, howl like mad dogs as they are beaten to death with sticks. A single blow on the nose kills them immediately. This animal, hardly able to move itself, is not as fearsome as one might think, even though it has a large mouth full of fierce teeth.

Its skin is very useful, for, [f. 122] as well as making clothing and using it for all their other needs, the natives make canoes that are constructed to be so convenient and so safe that it is not possible ever to perish in this kind of boat. I have drawn it and given a description of it in my book of drawings and, so that you do not even have to go so far, I will say that a native builds a boat with two or three sea tiger skins. He gives it the shape of a purse on top, in which he encloses himself

Oüaspous, which is the modern Mi'kmaq name for the seal, from a larger seal called *Metauh*, probably Nicolas's *tigre marin*, the harp seal, *Phoca groenlandica* (Erxleben) (Ganong, 223). On the harbour seal, see Burt and Grossenheider, 85; depicted in the *Codex*, Pl. xxxvii, fig. 54.2, as "Loup marin"; figure copied from Gesner, 1621, vol. 1, 705. On the harp seal, see Burt and Grossen-

heider, 87–8; depicted in the *Codex*, Pl. xxxvii, fig. 54.3, as "tygre marin"; figure copied from Gesner, 1621, vol. 1, 706. Boucher speaks only of the "loup marin" (Rousseau 1964, 315–16).

505 On the "Carte generale" of the *Codex*, the Mangounchi-riniouek are situated on the Saguenay River, north of Tadoussac.

around the waist, holding a paddle with the ends both alike. His oar serves as sail, mast, rudder and rigging. The man in his canoe has no trouble with crosswinds, trade winds or storm winds. If it goes straight or furls, if turns to windward or not, if it turns or if it is straight, one stroke of his two-handed paddle takes it out of danger in any event.

The evil spirit known in the native tongue as Matchi Manitou or Michipichi[506]

I do not know if those who do me the honour of reading this natural history will take note of the order that I have kept this far in all my writings, which I have entitled "the complete knowledge of the New World": always beginning my treatises with the smallest things and finishing with the largest of the same kind and the same species.

The animal that I want to describe here, being the largest of all the four-legged animals that I have discussed so far, will, along with turtles, close the treatise on all four-legged terrestrial and aquatic animals that I have described.

This animal, being monstrous, would be better known by the drawing that I have made of it than by my inadequate description. It extends about three armspans, that is eighteen feet in length. It is big in proportion to its body, which is covered in hairy skin similar to that of a sea tiger. It has four beaver-like feet and its tail is reminiscent of that animal. It seems to have a bigger head than the proportions of its body would demand, and this head is quite extraordinary. Its teeth are huge, particularly two that it has in its upper jaw. They are about two feet long, square, pointed and as beautiful as the finest ivory.

[f. 123] This animal, which resembles a monster more than a perfect animal, is seen only around a few Northern islands in the Gulf of Saint Lawrence. The people who live around the great lakes say they have seen them on the banks. A young man from the Outouliby nation who had killed one presented me with a tooth of this animal that they call michi-pichi. This was a rare gift. I made a present of it to Monsieur Cotrou, the intendant of the country. The drawing I provide of this monster will introduce it better than my pen can do.

The sea horse[507]

Since this animal is well known and everyone talks about it following what writers have said, I will just give

an exact representation of it and say that it is seen around the Brion Islands where it comes ashore. It frequents the Chichedek River,[508] which is on the north side of the Gulf of Saint Lawrence. It whinnies like those seen on the coasts of Senegal, where it is killed in numbers. I have seen the entire heads of some that were killed in these countries; they are similar to the head of a horse or a moose. This is what I have observed about amphibious animals.

Turtles

Since I promised at the beginning of this treatise to end it with the four-legged animals, which I have named, following the Latins, *ovipara*, and the Greeks, ωοτόχα [oötóka], *quae cortice teguntur*, or which are rather covered with various scales, I will say that there are so many of them in the Western Indies that it would be difficult for me, not only to give a description of them, but even to give their names; that is why I will limit myself to saying very little of the turtles that are seen in all of America.

All large and small turtles have the same shape; they differ only in colour. Some are striped with red and yellow; some are grey, black or violet, and their scales are so varied that no other animal of this kind in the world is as beautiful.

We see all sizes of turtles in the Indies that are similar to those of Europe. Some are two feet in diameter; they are caught with a line. They live on plants, fish and shellfish. They often take feathered game by surprise in the reeds and eat them avidly.

[f. 124] The turtle has a shell so strong that whatever weight may be put on it, it cannot be crushed. The head, the tail and the feet are similar to those parts of a lizard, except for the tip of its beak which is a kind of very sharp horn that serves as teeth for cutting its food.

Turtles taken with a hook, as I said, have a very soft shell. Their flesh is excellent, and as white and delicate as the best capons.

The biggest turtles lay four or five hundred eggs at a time, which they hide in the sand and come to brood every day by only looking at them. Every species tastes good. The turtle egg is round and covered in a strong thin coating almost like parchment. It is what makes these eggs break less easily than ordinary eggs. And although they are always soft like a fat hen's egg, they can only be broken with a knife.

506 *Michi* for "ugly" or "bad" in Algonkin; *mathi* in Cree (C. Stuart Houston).
507 A mythical animal often represented with the Nereids or other sea creatures.

508 The Moisie River.

Natural History, or the faithful search for everything rare

The turtle is so difficult to kill that unless it neck is wrung or it is boiled in water, it cannot be made to die for three or four days even though it has been pierced all over with a knife. However, the natives know the secret to killing it quickly. I have seen it first hand.

Americans in general venerate this animal. They wear it around their neck, their waist, etc., as though it were a rare jewel. Others hang it from their ears and delight in bearing its name. Entire nations glory in the name of Turtle nation: "*Mikinak nir,*[509] I come from the people of the Turtle," they say.

I knew a great captain with this name, and I could make a pleasing report of the hunting stories that he and many others tell about this animal. But as I say a word about it at the beginning of my nineteenth book, I will not talk about it here.

I will simply say in passing that the natives use the turtle as the main instrument of their religion, which is their charlatan's art, and they spend days and nights [f. 125] with a dying person, holding a turtle shell filled with pebbles which makes a dull noise as they vigorously shake this *outki*, or *manitou*, as they call it.[510] This is supposed to give life and health to the dying person, who nevertheless usually dies amid the dancing, singing and noise being made all around him, accompanied by horrible crying and howling. The *manitou* or genie, they say, has the power to chase away the devils or evil spirits in the cabin or in the body of the dying person.

Quite often, bands of old women dressed as furies can be seen doing such superstitious dances around the sick person that there is reason to be astonished by this blindness. They stamp their feet and clap their hands, shouting at the top of their voices one word, "*tetchiaroun, tetchiaroun, tetchiaroun,*" which means "both of them, both of them, both of them," with so many nuances and different tones that I wonder if the great Baptiste[511] and the skillful Molinier would learn anything, one for his opera, the other to delight the Languedoc Estates with their beautiful music.

Concerning the differences among turtles, every species can be found, be it in the woods, the rivers or the meadows, of a size two or three times bigger than those found in France or elsewhere in Europe. Others

are three or four feet long and three feet wide. Some are as much as six feet long and proportionately wide. Others are so big that six men can easily fit in the shell, and turning it over, they make a boat. These great turtles are taken when they come ashore to lay their eggs in the sand, where they make a pit deep enough to lay seven or eight hundred eggs at once. As many as twelve or fifteen hundred have been found, on which sixty persons can feed for more than one day. When the turtle lays, it sounds like a cannon going off. At this sound, hunters go to catch her before she reaches the high seas. Two men have only to turn her over to catch her; she is so heavy that she cannot get back on her feet. The eggs and the flesh of all kinds of turtles are as good as chicken and the fattest veal. [f. 126] The eggs of the large turtle are like those of the biggest chickens. They hatch in the sand by the warmth of the sun, watched over by the turtle, which comes ashore every day to hatch them with her eyes only. Finally, the little turtles can be seen coming out from under the sand like frogs out of water.

It can be seen clearly from what I have just said in this treatise on four-legged animals that I have opened a wide field for those who already take an interest in, or who will come in time to enjoy the hunt[512] or, to put it correctly, hunting for game animals, or coursing with packs of dogs and grooms (who let go of the chain or leash with which they were holding hounds, *bifaux*, *cournaux*, and bloodhounds, accompanied by bitches), as is done by the nobility in the most illustrious and flourishing state in the world, under the blessed reign of Louis le Grand.

Well-ordered hunting is a noble pursuit for gentlemen, good for the health and also enjoyable and very profitable for the household. As it is very suitable to the practice of arms, it is one of the most admirable exercises that can be done by all our illustrious nobility.

Our Indians, although they are the wildest in the world, believe that they are the noblest of men, and have no stronger inclination, after war, than to become accomplished in this noble pursuit of hunting, which they enjoy infinitely. Therefore they find in it the three advantages that I just spoke about. These gentlemen, seeing themselves as the most independent of all

509 *Mikinak nir* is an Algonquian phrase, *nir* referring to "I" and *Mistinak* to "turtle." Silvy and Fabvre translate *mistinak8* or *Miskinak8* as "tortue" in seventeenth-century Montagnais; Rhodes gives *mkinaak* for turtle in today's Ojibwa-Chippewa-Ottawa. The Proto-Algonquian word for "turtle" is **mehkena.hkwa*, according to Hewson. Fabvre translates *nir* by "moi" (John Bishop).

510 *Ouki* is a Huron word; *Manitou*, an Algonquian word.

The *Jesuit Relations* discuss extensively the notion of *Oki*, as a Huron appellation for spirits or demons (John Bishop).

511 Jean-Baptiste Lully (1632–1687).

512 Nicolas uses the term *vénerie*, for which the *Dictionnaire de l'Académie*, 1694, gives the same definition as Nicolas: hunting with dogs.

the free inhabitants of the earth, devote themselves with a passion to war and hunting, which are the genuine and highest mark of the oldest nobility which, as soon as it was introduced to the world, was born of independence, strength and valour of arms, and the terror of war, and from all other exercises which have nothing lowly or servile about them. Do we not see that our kings, even the most powerful, have no stronger or nobler passion than war for conserving or justly extending the limits and the power of their states, and the diversion of hunting for relaxing after the fatigue of their campaigns?

[f. 127] Now, our Americans, being sovereign and independent of all the powers of the world, are brave warriors, great hunters and entirely detached from what is servile. It must be said that they are certainly very noble, at least in their own way; and that if they obtain from this absolute independence all the advantages that they desire, they are happy in the eyes of the world, not having to answer to anyone for their conduct. If finally, by their bravery in the art of war, by their great reputation for courage and by their incomparable valour, or if you wish, by the terrible heat of the flames with which they consume their enemies in the unspeakable torments suffered (for very good reasons, which sensible people will approve after hearing them, as I say elsewhere in these memoirs) by their miserable victims, whom they sacrifice to the god of war after taking them in their campaigns five or six hundred leagues away from their country, where they go to take men who are their enemies only because they are from a different nation than theirs, having given them no reason to go to war with them; if finally, I say, our Indians inspire fear in their enemies and nations furthest away simply by the reputation of their name and their arms, then it should be no surprise, since they have become so able, as I say, in the exercise of hunting, which they practise from a tender age and from which all their life they take all the advantages possible – diversion, agility and the marvellous disposition of their bodies, as well as the health that these nobles keep up with these laudable pursuits, which must strike a chord with the noble-hearted men of our invincible French nation.

Take heart, then, brave and illustrious gentlemen of France, and go to our foreign lands; this in itself will be a mark of your courage. Go into these vast forests to become accomplished in one of the noblest roles of your station, which raises you above ordinary men. Make yourself worthy by taking up arms against our King's enemies, if you can find any foolhardy enough to dispute the conquests His Majesty has made there.

Go there and hoist the fleurs-de-lis that the enemies of our kingdom have tried to bring down, but in vain. It is [f. 128] a land of conquest. They are no longer permitted to rule there, as they have dared to try, but with no effect. And after you have brought down their proud lion with a royal mace adorned with fleurs-de-lis that the Indians will put in your hand, dedicate yourself at the proper time to the fine and noble pursuit of hunting, and improve the lands that His Majesty will give you there and that he will establish there under the titles that you will have earned.

There, finally, you will enjoy a pleasant rest; and in the shade of the woods, you will take an innocent pleasure in hunting, which you will never lack. In this pursuit you will keep up your warlike spirit and the finest inclinations of your blood and your nobility, which will increase and which will give rise, perhaps, after all your efforts, to one of the most illustrious states there has ever been, born only of nobility, for to everything there is a beginning. The empires of Rome, Greece, China and the Tartars sprang up from very little.

But after you have had infinite pleasure in the pursuit of hunting, take up falconry and hawking, which I will present to you after these pages, in which I am going to discuss the birds seen in the Indies. If, after all that, you enjoy fishing, you will see many agreeable places that I point out to you in advance, filled with every kind of fish not seen in our Europe, whose names, drawings and descriptions I will give you at the end of my natural history.

BOOK NINE

Treatise on Birds

[f. 129] How passionately I wish I had a little of that fine genius and of those strong ideas with which good painters, philosophers and poets are said to be born. Or rather, I would like to have been fortunate enough to have, deeply imprinted in my imagination, all the agreeable mixtures of shapes and plumages that I have observed in an infinite variety of very beautiful birds that are seen on the sea, on lakes, on rivers, on land, and on the trees of America; I would make one of the most pleasant pictures that can be imagined.

Would to God that I were some capable musician; for, after making a picture, I would delight you with a charming melody from all the various songs of the birds that I undertake to describe.

Natural History, or the faithful search for everything rare

I would make my hummingbird hum; I would make my grey partridge that can be heard at half a league beat the drum, I would go into a fugue, and I would make not my nightingale, but rather my dead bird sing with so many nuances and with so many various tones that sometimes I would go down so low that you would hardly hear me; sometimes I would raise my voice so high that you would seem to hear a very agreeable falsetto; I would do a counter tenor and a tenor. I would not omit even the slightest aspirations. In short I would not forget anything of my art, to make you admire the extraordinary vocalizations of the jay, the magpie, the crane, the heron, the hawk, the goose, the swan, the bustard, the cormorant, the gull, the *happefoie* [shearwater], the murres, the loons, the ducks of more than twenty kinds, and all the other birds that you will see, whether those that bird-trainers train for falconry, or those that bird-catchers catch with their nets and by other means.[513] Let us begin with the smallest and end with the largest, according to our custom.

The hummingbird[514]

This is the rarest, most beautiful and most wonderful of all those seen in the new world, whether it be for its small size, its rapid wing beat, or for the agreeable variety of colours seen on its plumage.

The entire body of the bird is hardly more than an inch long. Its beak is of the same length. It uses it only to reach deep into flowers to get the nectar. [f. 130]. It flutters around like a bee, making a constant little pleasant buzzing, which is a little surprising when the bird passes by someone like lightning. It is so intent on feeding on the nectar of flowers that it can sometimes be caught easily, although it is always in the air. The noise that it makes with its wings prevents it from hearing the sound of someone approaching.

Its plumage is covered with a very beautiful green glaze under which one can see a golden yellow, and a wonderful silvery white, accompanied by all kinds of the brightest colours.

The female does not differ from the male except that the male seems to have a burning coal under the throat.

It is a very curious thing to see the nest of the hummingbird, which is only rarely found. The nest is no larger than half the shell of an ordinary hen's egg. The eggs are in proportion to the bird and to the nest, and are no larger than an ordinary pea.

One sees many of these little birds, which the Americans call *rouroukassou*,[515] when the flowers are open and the trees are in bloom.

When Europeans first lived in the Indies, these birds were precious. Ladies of the court wore them instead of earrings; but the fashion has passed, and collectors are content to have them in their studies. But unfortunately for them, clothes moths eat them and cause their feathers to fall. That would not happen if they kept them in containers with candle tallow, for there is nothing so harmful to this vermin called moths.

513 Nicolas uses the terms *oyzeleur* and *oyzellier,* always clearly written in the manuscript. Here he makes a distinction between *oyzeleurs* who, according to him, train birds, and *oyzelliers,* who catch them. Elsewhere, on f. 146, he uses both words for those who catch birds. In fact, it seems that the use of these two words was in part overlapping at the time. For instance, in the first edition of the *Dictionnaire de l'Académie* (1694, the closest in date to Louis Nicolas's text) the *oiseleur* is "celuy qui se plaist, qui s'amuse à prendre des oiseaux à la pipée, aux filets, ou autrement, & qui en fait son occupation ordinaire." On the other hand, the *oiselier* is "celuy dont le mestier est de prendre, d'eslever, & de vendre des oiseaux." We have translated the sentence here so as to make sense in the context (N. Senior).

514 *Archilochus colubris* (L.), ruby-throated hummingbird (M. Gosselin, henceforth Gosselin); depicted in the *Codex*, Pl. XLI, fig. 58, as: "Rouroucasou ou oiseau mouche." Michel Gosselin and Jeff Harrison are the ornithologists who helped us in the identification of birds. In acknowledgment, we name them in parentheses as we have done for our other consultants. We also refer to W.E. Godfrey, *The Birds of Canada* (henceforth Godfrey). For the *Archilocus colubris* (L.) see

Godfrey, 337. Ganong, 227 notes that Sagard, Le Jeune, and Denys gave an umistakable description of the bird. Rousseau 1964, 323 notes that it is mentioned by Boucher in 1664.

515 *Rouroukassou* is an Algonquian word. Silvy and Fabvre give r8r8kas8 or R8r8gas8, as "oiseau-mouche, oiseau-fleur," or "oyseaux-mouches." Atikamekw Sipi (Atikamekw Nation Council), *Notcimiw kekwan ka ici aitakok Atikamekw [Coup d'oeil sur les plantes et les animaux du territoire Attikamekw],* Version préliminaire, La Tuque, QC: Atikamekw Sipi, 1999, gives *rorokasiu* as the "Ruby-throated hummingbird"; Rhodes gives *naanooshkeshiins, nenookashiins nenooshkaashiins* for "hummingbird" in today's Ojibwa-Chippewa-Ottawa (John Bishop). As Gosselin has remarked to me, many native names of birds are onomatopoeic. For sure, *rouroukasou* sounds like a hummingbird.

516 The "very bright yellow" contrasting with the wing and tail feathers suggests *Spinus tristis* (L.), known also as *Carduelis tristis* (L.), American goldfinch (Gosselin); Godfrey, 571. Or *Dendroica petechia* (L.), yellow warbler (J. Harrison, henceforth Harrison); Godfrey, 466. One of them is depicted in the *Codex*, Pl. XLI, fig. 58.1 as "oyseau jeaune." Ganong, 210 believes that Cartier men-

The yellow bird[516]

This bird, which is also very small, is peculiar to America. The only special thing about it is the very bright yellow, set off a little by a brown colour that shades the wing and tail pennae. The bird is no larger than our wren.

The red bird[517]

This bird has nothing special about it except its very bright fire colour. It is the size of a sparrow.

The red and black bird[518]

It is covered all over with a brilliant red mantle, like the finest scarlet. Its pennae, that is in bird-catchers' language, its wings and tail are black as jet, and it is no larger than our ortolans.

[f. 131] *The blue bird or royal bird*[519]

You would say on seeing this bird that it has come down from that beautiful firmament and that in passing through the heavens it took pleasure in colouring its mantle with those lovely azure colours. Its coat is therefore royal; but it is bordered on all sides with a brown colour sprinkled with another greyish colour, which sets off the feathers nicely, and the whole coat makes the bird pleasing. In my opinion this is the reason why it is called the royal bird, because it wears the colours of royalty. It is the size of the red bird, and its song is neither too soft nor too harsh.

The ortolan[520]

The plumage, taste and song are all different from ours, and this bird is rather rare in the country. It is white, grey, black, yellow, etc. Its body is the same as those of this country.

The sparrow; or the white and grey bird[521]

This bird has two sets of clothing, if I may say so. It is like the hare, which is grey in summer and white in winter. This is why it has been given the two names that I have mentioned. After spending all summer in grey plumage, it changes to so much white toward the end of the winter that it can rightly be called the white bird.

It has a fine taste, although most of the time it lives only on snow. It is one of those birds called birds of omen, for it is a sign of cold and snow when it begins to appear at the end of October.

The nightingale[522]

Although this fine name has been given to this bird of the Indies, it does not deserve it, because its warbling and its chirping are not so melodious, because its song is as distant from the song of our nightingale as the language of the country differs from our ways of speaking and our expressions, and because its plumage and its size are very different.

tioned the goldfinch when he spoke of the "Chardonne-reulx."

517 *Carpodacus purpureus* (Gmelin), purple finch (M. Gosselin and J. Harrison); Godfrey, 563; depicted in the *Codex*, Pl. XLI, fig. 58.2, as "Le pinson rouge." Since this bird has a very melodious voice, it is not surprising that the *Codex* calls it a "pinson" (Catherine Broué, personal communication). "Oiseau rouge" is one of the folk names of the purple finch (M. Gosselin). In fact, the purple finch is neither purple nor "fire" red; Roger Tory Peterson (1980) likened it to "a sparrow dipped in raspberry juice."

518 *Piranga olivacea* (Gmelin), scarlet tanager; Godfrey, 496; depicted in the *Codex*, Pl. XLI, fig. 58.3, as "Le pinson rouge et noir." Nicolas describes its nuptial plumage (M. Gosselin).

519 *Sialia sialis* (L.), Eastern bluebird (M. Gosselin and J. Harrison); Godfrey, 421; depicted in the *Codex*, Pl. XLI, fig. 58.4, as "oyseau royal bleu."

520 There is a bird in Europe called the ortolan bunting, *Emberiza hortulana* (L.). Based on Nicolas's description of his North American ortolan, however, a better possibility is *Dolichonyx oryzivorus* (L.), bobolink (M. Gosselin and J. Harrison); Godfrey, 547; depicted in the

Codex, Pl. XLI, fig. 58.5, as "hortoland ameriquain," the usual folk name for the bobolink, but sometimes applied to *Eremophila alpestris* (L.), horned lark (Rousseau 1964, 72 and Godfrey, 372–3). In favour of the bobolink is the fact that the *Codex* pictures it as an icterid, blackbird family (M. Gosselin). James K. Sayre, *North American Bird Folknames and Names* lists the following North American bird species that have been given the colloquial name of ortolan: sora, horned lark, eastern meadowlark, each of them presumably edible, the first two highly edible (C. Stuart Houston). Ganong affirms that the ortolan is mentioned in Leclercq (1691) and in Lahontan (1703) but he believes they were referring to the snow bunting, *Plectrophenas nivalis* (L.), a confusion that Nicolas does not make.

521 *Plectrophenas nivalis* (L.), snow bunting (M. Gosselin); Godfrey, 545; depicted in the *Codex*, Pl. XLI, fig. 58.6 as: "moigneau ameriquain dont le pleumage est très varié. L'hyver il est tout blanc dans les autres saisons Il est gris melé de diverses couleurs."

522 Rossignol is the usual folk name of *Melospiza melodia* (Wilson), song sparrow; Godfrey, 531, or *Zonotrichia albicollis* (Gmelin), white-throated sparrow, depending on the region (M. Gosselin); Godfrey, 535.

The red-headed bird[523]

The bird that I describe here is quite lively. It has some similarity to our canaries and our goldfinches. Its plumage is all grey-brown, except for a little red tuft[524] on top of its head. It is a little like [f. 132] a linnet. Its body is like that of our goldfinches, about which I will say something interesting, although there are none in the New World. The thing is worth knowing, especially since I fear that not one of all those who saw it with me in the city of Montpellier will write anything about it. And since I am describing the birds of America, people will not be displeased that I tell them something about two goldfinches in France which is more valuable and more remarkable than all that I have said and have to say about birds.

I have more than two or three thousand witnesses who will confirm that in the year 1676, for two or three months, they saw at the monastery of Saint Ruf[525] a wild male goldfinch, which was free and had never been domesticated, come into the rooms where there was another male goldfinch, domesticated, in a cage that it had never left. Its song had such a captivating charm for the wild goldfinch that there was no use pushing him out and hiding his beloved under covers. This little animal despaired, so to speak, until he found what he was looking for, and because he could not get into the cage, these two birds kissed each other by touching their beaks. This love lasted three or four months until one of the monks of the order that I mentioned gave these two birds to his General. I do not know whether the two birds left each other afterward. My pen cannot express how remarkable I found this.

The many-coloured porcupine bird[526]

The bird that I describe here is no larger than a sparrow. Its plumage is very beautiful and varied. The bird has three marks on each of the wing pennae on the right and on the left. These marks are extraordinary, for one can distinguish three very bright colours on the tip of each wing.[527] They are like three little pinions, which stand out from the other feathers, and in a quite different manner, which is easily distinguished by the colours, yellow, red and white, which look more like the hair of the porcupine than anything else. The same colours are seen on top of the bird's head. It has a tuft of this kind of hair when it wants, and that makes this bird look very beautiful and quite extraordinary. There is nothing particular on the tail feathers or on the rest of the body, or on the mantle. Its flesh is delicate, and its song is charming.

[f. 133] *The anonymous bird*[528]

I call the bird that I describe here the bird without a name, because the Americans do not give it any other name than the general one of bird, without any other distinction except that of *pirechens*, or *piré*, or *pilé*, or *pilechens*, which are all common names that all have the same meaning.[529] It is the general word that the Americans use, as we use a common word that means all birds without differentiating them.

The bird in question here is the size of one of our common thrushes, or one of those that are called Italian thrushes. Its plumage has nothing very extraordinary about it, except that it is spotted with white, which is scattered proportionally on the whole mantle and on all the wing and tail pennae, where one sees innumerable little circles the size of an ordinary "O." This bird has nothing in common with our [European] birds. In autumn it is so fat that it is almost unable to fly, and it is very good to eat. I do not know whether its song is very pleasant, for I have never heard it sing. Its flight is swift. One rarely sees these anonymous birds.

523 *Acanthis flammea* (L.), common redpoll (M. Gosselin); Godfrey, 568; depicted in the *Codex*, Pl. XLII, fig. 59.1, as "L'oiseau à teste rouge."

524 In fact, the French word "houppe" (here correctly translated as "tuft") is rather misleading, since it is instead a red spot (C. Stuart Houston).

525 The abbey of the canons of Saint Ruf was established in the eleventh century in Valence, (Drôme), France; it was demolished by the Protestants in 1567, but reconstructed in the seventeenth century. Valence is situated on the east bank of the Rhône River.

526 *Bombycilla garrulus* (L.), Bohemian waxwing; Godfrey, 439; a winter visitor (M. Gosselin), depicted in the *Codex*, Pl. XLII, fig. 59.2, as: "L'oyseau bigaré de porc epy le plemage est beau."

527 Nicolas's terminology is confusing here. Clearly, he must mean "tips of wing feathers," not "wing tips," and presumably his red is the waxy tip of secondary feathers. The white similarly is near feather tips not at wing tip (C. Stuart Houston).

528 Possibly juvenile *Eremophila alpestris* (L.), horned lark (M. Gosselin and C. Stuart Houston); Godfrey, 372; depicted in the *Codex*, Pl. XLII, fig. 59.3, as "Loyseau sans nom." Curiously, the drawing could be inspired by the *Nucifraga caryocatactes* (L.), the European nutcracker of Gesner, *Historiae Animalium, Liber III, qui est de Avium natura*, 2nd edition, 1585, 245.

529 However, the *Grammaire algonquine* folio 92 translates *piré* by "perdrix" (partridge). Silvy and Fabvre agree. *Pire8* is "perdrix" for the Montagnais of the seventeenth century and *pirechich* or *pirechi8* is "petit oiseau." Clément gives *pineshish* for "petit oiseau en général" and

The swallow[530]

I have not noticed that this little bird has any resemblance to the swallows that many people say come from the direction of Greece, and particularly from Athens. It does not even have any similarity to the swallows of that poor country, which has so little wood that people have to heat ovens with the bodies of those little swallows, which having drowned while crossing the sea, and been tossed up by the waves of a fierce storm onto the sea shore, and dried by the heat of the sun on the burning sands, are thrown like wood into furnaces, where they are burned like straw to cook bread.

Our American swallows do not nest in the manner of those fine Athenian swallows. They have the instinct of a certain remarkably beautiful bird that is seen and caught along the banks of rivers of the warm regions of Languedoc, and which cloth merchants seek out carefully to hang them in their store rooms, for fear that moths or the worms that eat cloth will do damage. This bird is called the *arnié*. These birds make their nests in very deep holes that they make in the sand like our swallows, which are so fertile that it is a wonder to see infinite numbers and flocks covering the air along the dunes that one sees here and there along the Saint Lawrence River. In less than a quarter of an hour one could catch hundreds of these little birds, which are very delicate.

[f. 134] *The crossbill*[531]

This bird with a cross bill, as I represent it in my figures, is so beautiful that it is charming because of its different colours, so varied that there is in my opinion no paint brush delicate enough, no colour bright enough to represent it properly.

Its bill looks like two hooks and for this reason it is called the crossbill bird. I have never understood how it can eat; for its beak is not like that of parrots, or of long-winged hunting birds, which all have the hooked beak turned down. These crossbill birds have their bill turned from right to left and from left to right. Their song is sad. Their flesh is very delicate, with a fine taste.

The tit[532]

Here again is one of the most pleasant plumages that can be seen. All sorts of colours are seen on the feathers and on the mantle of this charming little bird.

Because of the pretty wimple that looks very white on the neck of this bird, it is called by the name *nonnette* [little nun], and its song is as pleasant as its wimple. One might think that this little inhabitant of the air, earth and woods would have two good qualities, one to delight the eye and the other to charm the ear; but its song is too sad to give pleasure to the ear.

The swift[533]

As the American swift hardly differs from that of France, I do not know what to say, except that it is a little larger. The only other difference I find is in the song, which is rather disagreeable.

The ouzel [American robin][534]

Its song, its mantle, its feathers, its plumage and its down are entirely different from all the ouzels that I have seen in other lands.

The male is all grey on the back and the shoulders. It is reddish on the breast, and grey-white under the abdomen. Its pennae are between grey and black. The beak is yellow. It whistles pleasantly. They gather in flocks before the winter, which they go to spend in warm regions.

The female is covered with grey all over. She lays eggs of a colour between green and blue. Others lay eggs of celadon green. It is an infallible sign of spring when this bird begins to appear and to sing.

pineu for any *Tetraonidae* in today's Montagnais. Partridge is *bne* in today's Ojibwa-Chippewa-Ottawa (Rhodes) and **pele-wa*, in Proto-Algonquian (Hewson) (John Bishop).

530 *Riparia riparia* (L.), bank swallow (M. Gosselin); Godfrey, 377; depicted in the *Codex*, Pl. XLII, fig. 59. 4, as "LIrondelle de lAmerique." Champlain first mentions the "airondelle" in 1603 (Ganong, 221); Boucher, "les hirondelles" in 1664 (Rousseau 1964, 322).

531 Crossbill species (J. Harrison). In the *Codex* drawing, Pl. XLII, fig. 59, bottom of the page, the lack of wing bars suggests *Loxia curvirostra* (L.), red crossbill; Godfrey, 565.

532 *Poecile atricapillus* (L.) or *Parus atricapillus* (L.), black-capped chickadee (M. Gosselin); (Godfrey, 398); depic-ted in the *Codex*, Pl. XLII, fig. 59.5, as "La lardere ou mesange."

533 Rousseau 1964, 73 suggests *Chaetura pelagica* (L.), chimney swift; Godfrey, 335; depicted in the *Codex*, Pl. XLIII, fig. 60, as "Le Martinet," but *Progne subis* (L.), purple martin, described in Godfrey, 374 is more likely, because Nicolas said it is larger than a swift in Europe and is the size of the robin and the jay in America. The *Codex* shows a long-tailed bird. The martin is more likely to attract attention than the swift. *Martinet*, the French name for swift, has the same etymology as the English *martin* (M. Gosselin).

534 *Turdus migratorius* (L.), American robin (Godfrey, 429), a member of the blackbird family; depicted in the *Codex*, Pl. XLIII, fig. 60.1, as "Le merle ameriquain";

People consider it a joke to say "I'll give you a white blackbird," as if being black were in the nature of this bird, and never white. But I want to make it known that there are white blackbirds.[535]

[f. 135] *The starling*
I have discovered two kinds that are bigger and taller than ours. They do not have the varied colours seen on the mantles and feathers of the [European] starlings[536] of our countryside, which are so well trained in Paris to speak. I have seen some that spoke much better than the best-raised parrots. Ours are barbarous, and no one tries to teach them anything.

There is one kind[537] that is all black; but they are so beautiful that, on their mantle and on all their pennae, all the varieties of colours are easily seen through a brilliant glaze that shows perfectly all the brightness of the colours that are ordinarily seen on the neck of our rarest pigeons when the sun shines through. The trees are sometimes so full of them that there are more birds than leaves.

The other kind[538] of starling is much more beautiful than this first one; for in addition to the fine plumage that I have just spoken of, it has on the back of both wings a heart that is so distinct that there is nothing more precise, nor of a more beautiful golden colour, set off by a very fine bright red like a golden glaze on the whole surface of the heart, which is almost as large as a French *double* or *liard* coin[539] on each side, in the place that I have indicated. The Indians esteem this bird and often adorn themselves with it. They think that they have on their head, or hanging from their neck or ear, as fine an ornament as our most elegant officers who have a fine beaver or vicuña hat with a plume of feathers dyed in the brightest and finest colours.

These kinds of starlings are not seen everywhere. I have seen and killed some only toward the Îles Percées[540] and the plains of Virginia; but there are so many in those vast lands that it is prodigious. The

flesh is not very good to eat; it is tough when cooked. This is what I have observed about these rare birds, whose song is very pleasant. As it is very easy to catch them, they could be taught to speak. In my opinion they would speak much better than ours, since the beak can move freely.

[f. 136] *The Indian jay*[541]
While this bird is much smaller than the jays that are seen in the oak groves of France, it is nevertheless no less beautiful or less fine, with the charming variety of its plumage and its pleasant royal mantle, quite different from that of our common jays. There is no one in Europe who does not know jays, and everyone knows what they look like; but there are very few people in France who know what the Indian jays look like, unless they have seen imported ones, or have taken the trouble go to the places where they are.

I will tell you therefore that the jay in question here is covered by a very beautiful azure plumage on its entire mantle, as the sky appears to us on the finest days, or during the calmest evenings. The whole mantle seems to be lined with whitish grey under the bird's abdomen.

Its warbling, its whistling and all the pleasant nuances of its song are much more melodious than those of our jays, and if one were not sure that the same bird whistles and sings in more than twenty different ways, one would easily think it was as many different birds.

The American magpie[542]
If the jay of which I have just spoken is entirely different from the French jay, the magpie which I am going to describe to you briefly is no less different from those that are seen in so many different regions of Europe.

I have never been able to find any similarity except for the name that the French have given it, and which I use also because I do not know any other name for a foreign bird that is not at all like ours except that it flies and has feathers. It is certainly badly named; for what

mentioned by Lescarbot, Denys (Ganong, 225), and Boucher (Rousseau 1964, 322).

535 Albinism is most common in black birds.
536 In fact, *Sturnus vulgaris* (L.), starlings, were not introduced in America (New York City) until 1890; Godfrey, 452.
537 *Quiscalus quiscula* (L.), common grackle; Godfrey, 555; not depicted in the *Codex*.
538 *Agelaius phoeniceus* (L.), red-winged blackbird (M. Gosselin); (Godfrey, 548); not depicted in the *Codex*.
539 Old copper coin of France equivalent of three *deniers* or a quarter of a cent.

540 Percé Rock, on the Gaspé peninsula, Quebec.
541 *Cyanacitta cristata* (L.), blue jay (M. Gosselin and J. Harrison); (Godfrey, 382); depicted in the *Codex*, Pl. XLIII, fig. 60.3, as "gey ameriquain dun pleumage tout bleu." Mentioned by Lescarbot (Ganong, 218) and by Boucher (Rousseau 1964, 323).
542 *Perisoreus canadensis* (L.), grey jay (M. Gosselin); (Godfrey, 381); depicted in the *Codex*, Pl. XLIV, fig. 61, as "Pie Ameriquaine." The French word "*pie*" is still a common folkname of this bird. Mentioned by Boucher (Rousseau 1964, 323).

reason is there to use the name magpie for an ash-coloured bird, which has no similarity to magpies, not even to the single magpie that I saw, 900 leagues from the mouth of the Saint Lawrence River?[543] There was no difference from ours in the plumage, but it was much smaller.

The creeper[544]

The creeper is such a small bird that I almost forgot it. It climbs trees so fast that it makes itself almost invisible. It has different colours. I have never heard it sing. It lives on ants and worms.

[f. 137] *Four kinds of woodpeckers that are seen overseas*[545]

In the forests of the north and toward the west one sees four different kinds of woodpeckers. They all have a very fine plumage.

The woodpecker that the Indians call *papassé*[546] is quite remarkable for the strange noise that it makes in the forests with its beak striking against the trees. It can be heard more than half a league away, even though it is very small. These birds, though small, make innumerable holes of all shapes on rotten trees, from which they get a great quantity of vermin, on which they feed.

Among these four kinds of woodpeckers, there is one that is certainly a bird of omen to predict weather.[547] According to its different songs one can tell infallibly, from long experience, whether the weather will soon be fine or if it will be severe, rainy, windy, cold, etc.

This is different from the third kind; when it sings, one can be sure that the weather will soon be very severe.

But the big woodpecker,[548] which is the most beautiful of all four kinds, is special in that it is painted with three fine colours. It has on its head a very beautiful and very large crest of such a bright red that it dazzles the eyes. The people of various nations, particularly the Illinois, are proud to make wreaths, baldrics,[549] necklaces, garters and bandoliers from the heads of these birds, which they string, one after the other, in the same way that we string our rosary beads.

The bird is the size of a hen. Its whole mantle is covered with a thick shiny black; it is spotted all over with white, even on the wing and tail feathers. Its flesh is coarse, and is no better than that of our green or spotted woodpeckers.[550]

All these are song birds and are migratory.[551] They spend six months in the region, the woods and meadows, like the passenger pigeon or wild pigeon, about which I will say some very interesting things after I have described the "dead bird," as the natives of the country call it. *Tchipai-zen*, they say: certainly this bird is the soul of a dead person.

The dead bird, called tchipai-zen[552]

It is a pure fantasy of the Indians who affirm that there is a dead bird, in whose body the soul of a man or a woman enters, and comes and sings at the places where they camp. [f. 138] Although I reject all these silly ideas of these blind people, I say it is certain that there is a bird, which I have seen and heard, which sings with such ardour and so continuously that there is no interruption in its song, or rather in its amazing warbling.

This is a fugue of bird music so lively that in the space of six or seven hours it is never interrupted, not

543 Probably Chaquamegon, at the western tip of Lake Superior, which Nicolas visited in 1667. See Gagnon, Introduction, 14–17. In this case, it is the real magpie, black-billed magpie, *Pica hudsonia* (Sabine) (M. Gosselin); (Godfrey, 393).

544 *Certhia familiaris americana* Bonaparte, sub-species of brown creeper; the tree creeper in Europe is extremely similar, so Nicolas would have been familiar with it in France (M. Gosselin); Godfrey, 406; not depicted in the *Codex*.

545 Some of the eight species of woodpeckers known in Eastern Canada. See Rousseau 1964, 323.

546 *Papassé* in Algonquian for "woodpecker" is not unlike *paphasces* in Cree, where it means "small woodpecker" (C. Stuart Houston).

547 The woodpecker that is a "bird of omen to predict weather" is certainly *Colaptes auratus* (L.), northern flicker; Godfrey, 352. Rain bird and weather bird are among its folk names (M. Gosselin).

548 *Dryocopus pileatus* (L.), pileated woodpecker (M. Gosselin); (Godfrey, 354); depicted in the *Codex*, Pl. xliv.

 fig. 61.2, as "grand pic Vert a la Teste rouge comme une belle creste de coq."

549 A belt slung from the shoulder to the opposite hip, to hold a sword or a bugle.

550 French names in Peterson's *Field Guide to the Bird of Britain and Europe* are *Pic vert* for green woodpecker, and *Pic mar* for middle spotted woodpecker. We translated "Pycs marcs (for *marqués*) by *spotted* rather than *brown* (M. Gosselin's suggestion).

551 Woodpeckers would not be classified today as "song birds." Except for the *Melanerpes erytrocephalus* (L.), red-headed woodpecker (Godfrey, 344), the Northern Flicker, and the *Sphyrapicus varius* (L.) the yellow-bellied sapsucker, most woodpeckers are not migratory (J. Harrison).

552 Probably *Caprimulgus vociferus* Wilson, whip-poor-will (Godfrey, 332). Many aboriginal names are onomatopoeic and trisyllabic, as is *tchipai-zen*. (Gosselin); depicted in the *Codex*, Pl. xlv, fig. 62.1, as "tchipai ou oyseau mort." *Cipay* in Cree means "death" or "spirit" (C. Stuart Houston).

even with the slightest pause, so that there is reason to be amazed to hear this bird make such a great effort for so long without dying.

I do not know what the plumage of this bird is like, since I have seen it only at dusk, or heard it sing as I have said. It never appears during the day; it sings only at night. It seemed to me to be the size of a blackbird. Our hunters say that it would not dare appear during the day, for people would make war against it. When they hear it, they greet the soul of the dead person who is in it, and they believe that it is one of their relatives: "Kitaramikourimin tchipai-zen. We greet you, O soul of the dead." And if the mood strikes someone, he immediately prepares food to feed this soul, while waiting for the general feast, when the nations will gather to make a solemn feast for all the departed who have died in the past ten years, at the end of which people give so much food to the dead that they have the strength to go to the land of the dead in the north, from which they never return. These are some of the foolish ideas of our Americans concerning their beliefs about the dead. I discuss this matter thoroughly at the end of my French works.

The passenger pigeon, or wild pigeon[553]
Since this bird is one of the principal recreations of all the inhabitants of the great Indies, both northern and western, my readers will perhaps be pleased to know its peculiarities:

1. This pigeon is as large as a common pigeon.

2. Its plumage is always similar, and the mantle of all the males is always uniform, so that when you see one you see what the others are like. The same is true of the females, which are clothed quite differently from the males. The only thing that differentiates the male from the female is a reddish colour. The whole mantle of this wild pigeon is ash grey; all [f. 139] the pennae are striped with a yellowish colour. The tail pennae are spotted at the end of each feather. But the four feathers at the end of the tail pennae are notably longer than those of the middle of this part of the tail pennae, so that the bird has an extremely forked tail. This difference can be seen even when the bird is flying in such large flocks that it exceeds anything that can be imagined by someone who has not seen it.

3. This bird passes through twice in the year, first in spring and secondly toward the end of summer. There are years when the passage is so great that people kill as many as they like with clubs in the streets of Mont Royal [Montreal]; they even shoot them from windows, when flocks of them are passing.

4. The pleasure is no less when in a morning one sees seven to eight hundred of them taken by two or three persons, who stretch out a little net across a valley. And if with a single gun shot one killed more than a hundred, would one not say that there must be many of them during their migration? This happened on the Beaupré coast,[554] where I saw and saw again the hunter who killed 120 at a time. It is very common for a hunter to return with many of these birds in an hour, after firing only four or five shots.

5. Would it not be surprising if in a single morning one saw more than seven or eight thousand of these pigeons on the ground in the middle of an encampment? This is very common.

6. It is not rare that one crosses expanses three or four leagues long, so full of the nests of these birds that it would seem almost incredible to me if I had not seen it many times.

7. It is no small entertainment to be present on these occasions where one sees great catches of these young pigeons as delicate and fat as those raised domestically. Seven or eight thousand people, men, women and children, take part in this hunt for a month. They return so fat, along with their dogs, that it is unbelievable.

8. There have been years when many French people salted them for whole nights after having seen them for a long time during the season. In short, I will say that it is prodigious when for fifteen or twenty days one sees flocks pass which cover the sky all this time over a space more than three or four leagues long. When they land in the fields, they soon ruin them; and among the French there is an order of the Sovereign Council[555] not to leave any tree in the fields, for fear that these birds will stop to rest there and swoop down upon the grain.

553 *Ectopistes migratorius* (L.), passenger pigeon (M. Gosselin); Godfrey, 301; depicted in the *Codex*, Pl. xlv, fig. 62, as "*Oumimi* ou *ourité* ou tourte on en voit de si grandes quantites au premier passage du printems et de lautomne que la chose n'est pas croyable a moins que de la voir"; mentioned already in 1534 by Cartier as "teurtres." Champlain and Lescarbot used the word "Palombe" for the same bird (Ganong, 240). Boucher spoke of "tourtes ou tourterelles" (Rousseau 1964, 320).

554 On the north shore of the St Lawrence, downstream from Quebec City.

555 The Sovereign Council was chaired by the intendant, who was one of the most powerful men in the colony, in charge of the finances, but serving under the governor-general.

[f. 140] *The white partridge*[556]

The delightful colour of this beautiful bird leads me to give it first rank among the four kinds of partridge that are killed in the forests of the Indies.

There is no alabaster whiter than the whole mantle of the New World white partridge. All the tail and wing pennae are set off by a thin gold line that runs all along each feather and heightens the white colour that is the background of the bird's entire mantle. The beak, very black and shiny, together with the bright red around the eyes, gives a great lustre to the head and the whole body of one of the most beautiful birds that one could see. Instead of birds' feet and legs, it has very well-proportioned hares' feet, which serve as snowshoes for this bird; in my opinion, this is a considerable subject for amazement for naturalists. The bird that I describe here never appears in the region except on ice and snow, which make up its main food,[557] and on which it is nourished. It is fat at that time and has an exquisite taste, unlike the three other kinds, which do not have a good taste in this severe season.

The black partridge[558]

Whereas whiteness is the beauty of the white partridge, the colour of jet is the ornament of the black partridge.

Its round head, its gold eyes bordered with blood-red[559] give great lustre to this very beautiful bird, which has innumerable white spots all over its mantle, breast and tail feathers.

One sees something special on the feet of our black partridge, although it might appear that there is no difference from those of the partridges seen in France. Those who study things a little more closely will find a very notable difference in what seem to be innumerable little feet, like those of caterpillars, which serve as hooks for this bird to hold itself on its perch; for I must point out that all four different kinds of partridge seen in the Indies [f. 141] perch on trees, unlike those in other regions, which land only on the ground. Our black partridge has an excellent taste in autumn.

The grey partridge[560]

While the colour of the grey partridge's mantle is quite different from other partridges, and its shape and its behaviour are not like those of other kinds, it is no less agreeable; for to see it adorned with a great tuft on its head, its well-formed beak, its bright eyes circled with golden yellow, its neck trimmed with a fine big black ruff mixed with white and bordered with yellow, its entire mantle with a background of light grey speckled with several different colours: white, yellow, black, etc., with all its pennae striped with gold, silver, black, grey, white, and spotted with various shapes; its extremely long tail which it often displays in the shape of a fan or a wheel, like a turkey cock; all this gives no less grace to this fine bird than the other beauties which I have described give to our other partridges.

Since hunting this partridge which perches on trees is very pleasant, it is well worth describing.

An Indian who has discovered a group of partridges usually takes them all very easily, in three ways.

1. With his arrow, he pierces them one after the other; these animals are stupid enough to let themselves all be killed without moving.

2. Even when they are killed with a gun, the noise does not frighten them. They continue to stay firmly on the branch until they are injured or killed. Clearly these birds are accustomed to the noise that tree branches make when frost makes them break with a noise as loud as a musket, and it is rather pleasant, when one is in the middle of a forest at the time of the great frosts in these regions, at which time one is pleasantly surprised to hear at the same time from all sides what sound like gun shots, when a number of branches from different trees break by the force of the frost.

3. When the hunter who is hunting this game in the woods takes a long pole twenty or thirty feet long, and attaches at the end [f. 142] a snare, this bird does not know to flee, but allows itself to be caught without flying away or moving in any other way, until it is seized by the neck. Then it beats its wings a little, without at all startling the others, which let themselves be caught in turn.[561]

556 Nicolas, Boucher (Rousseau 1964, 320), and Denys (Ganong, 231) each distinguished three kind of partridges. The first one named by Nicolas is the *Lagopus lagopus* (L.), willow ptarmigan (M. Gosselin); Godfrey, 158; depicted in the *Codex*, Pl. XLV, fig. 62. 2, as "Perdris blanche de Lamerique dun gout eschis."

557 The ptarmigan picks insects from the snow surface in spring. Snow is not considered part of its diet, but it sometimes uses snow in winter in lieu of water.

558 *Canachites canadensis* (L.), known also as *Dendragapus*

canadensis (L.), spruce grouse (M. Gosselin); Godfrey, 156; not depicted in the *Codex*.

559 In fact, the eyes are brown and it has a strip of bright red erectile skin that is seen above the eye.

560 *Bonasa umbellus* (L.), ruffed grouse (M. Gosselin); Godfrey, 160; magnificently depicted in the *Codex*, Pl. XLVI, fig. 63. The captions reads: "Papace ou perdris grise cette perdris est remarcable par le bruit quelle fait battant des ailles sur un arbre pouri dans les Bois on l'entend de pres dune lieu Loing."

Natural History, or the faithful search for everything rare

This bird is very delicate to eat toward the end of autumn, but during the winter it is dry as wood. Thus it only grazes (if one can say this word of a bird) on the trees, since all the ground is covered by two or three feet of snow for the extent of nearly a thousand leagues.[562] The bird cannot graze in the usual way as geese do, or peck like other ordinary birds.

Toward the end of April, when this bird begins to build its nest and to go into heat, its call is unique, and unknown to all hunters, bird catchers and bird sellers of France. Other birds use their beaks and their different voices to call to each other; but this one uses only a certain way of beating its wings, with which it beats the trunk of a rotten fallen tree so vigorously that the sound can be heard half a league away. It seems to those who are not accustomed to this kind of noise that it is distant thunder. There in a few words is what I have observed about this grey partridge.

Another pheasant-like grey partridge[563]

Although I call this partridge grey, it is nevertheless quite different from the one I have just described; but since its colour is very similar to the common grey partridge, I could not give it a name other than grey, and differentiate it simply calling it pheasant-like. The plumage and the particular behaviour of this partridge, although having some resemblance to the grey partridge, distinguish it sufficiently. Be that as it may, I present this bird to you as a fourth kind of partridge which is very fine and has a good taste.

It tends to perch at the top of the tallest trees, where it spends most of its time. It nests on the ground, like all the other kinds of partridge. Its plumage is almost uniform, a little varied nevertheless with some dull colours. It is wilder than the other kinds.

The crow and the raven[564]

As there is nothing in these two birds different from ours except their language (if I may be allowed to use the word in this case), I will only point out that of all the birds I have seen in the New World, these two are the only ones that are exactly the same as the birds of this kind that are seen in all of Europe. I am speaking here only of land birds, not those that frequent the water, for a good part of these are hardly different at all, at least from our common ducks.

The raven of the Indies never croaks; but it has a certain wild cry that always inspires melancholy in those who hear it in the thick, dark and horribly silent vast forests of America.

This fine bird is considered to be a divinity, and the magicians of the country use it for various spells. They consult this oracle, which they always carry, embalmed, on their greatest travels. They treat it with respect, and often ask it to communicate the powers of health to roots from which they make drinks for their patients. Others hang it from the tip of a stick at the top of mountains, and there, like Taborites,[565] they wait for three full days for the answer to questions they have asked this manitou, or genie, which does not answer them. But since the person who consults this oracle does nothing but think about what he has asked, and dreams about the same thing when sleeping, this is enough to say that the raven has spoken to him. Everyone believes him.

The crow's song is not much more melodious than that of the common raven, or of the other kind of raven, or the other kind of crows (seen in the great Bird Island to the north, and in the great gulf of the Saint Lawrence), which have a red beak and legs, and which have their young in holes that they make in the sand like rabbits.[566]

561 Hence it was known from early days as the "Fool Hen" (C. Stuart Houston).

562 Over 3,000 miles.

563 Since Nicolas was probably in Manitoulin, far to the west, the description of a bird perching high in the willows and aspen would fit nicely *Pediocetes phasianellus* (L.) known also as *Tympanuchus phasianellus* (L.), sharp-tailed grouse (C. Stuart Houston and M. Gosselin); (Godfrey, 163–4); depicted in the *Codex*, Pl. xlviii, fig. 65, as "Perdris fesandeé."

564 *Corvus brachyrhynchos* Brehm, American crow (Godfrey, 394) and *Corvus corax* (L.), common raven (Godfrey, 396) according to M. Gosselin; depicted in the *Codex*, Pl. xlviii, fig. 65.2, as "Corbeau a bec et pied rouge" and in fig. 65.3, as "Corneille a bec et pied rouge," probably inspired by *Pyrrhocorax pyrrhocorax* (L.), chough, in Gesner, 522. Champlain speaks of

"corbeau" in 1604 (Ganong, 212), but Boucher already distinguished the "corbeau" from the "corneille" (Rousseau 1964, 323).

565 The Taborites, active in Bohemia in the fifteenth century, were followers of Jan Hus (1369–1415). They received their name from their custom of assembling on hills, to which they gave Scriptural names such as Tabor, Horeb, Mount Olive. It is probably this habit of going to "the top of mountains" – rather than the worship of the crow or any form of divination – that brought to Nicolas's mind the comparison with the Taborites. On the followers of Jan Hus, see J. Wilhelms, "Hussites" in *The Catholic Encyclopedia*, vol. 7, New York: Robert Appleton, 1910.

566 No species fits perfectly the description of a crow with a curved bill, depicted in the *Codex*, but three candidates dig nests or use crannies on bird islands. The black

[f. 144] *The turkey*[567]

As this big bird hardly differs from our turkeys, since we have them only from this place, and this bird is very common and well known to everyone, I do not have much to say. I will only mention that the one caught in these foreign lands of the Indies is much more delicate to eat, and is more lively and wild than those that have been domesticated in our Europe.

The American turkey goes about in flocks, and although it does not often really fly, nevertheless it goes so fast that it is rare for a good runner to catch it. It has two or three movements at the same time: it walks, runs and flies without losing touch with the ground, like the ostriches of Africa. Its plumage is finer than that of domesticated turkeys. The people adorn themselves with it at least as proudly as our most elegant courtiers do with their finest feathers in various colours.

That is all I have to say about land birds that are preyed upon. Let us now say something about those that prey on them and live on them. And perhaps it will not be a bad thing to place them in the middle of this treatise on birds, so that by my describing river birds at the end of the treatise on birds, they can seize as many as they can with their talons in the middle of their feet, to the right, to the left, up, and down, on land, on trees, and on the surface of the water. Those are the ones I am to speak of, as I said, at the end of the treatise on birds, and show you such a great multitude of them that you will have good reason to be astonished in contemplating all the different kinds of these inhabitants of the great waters of Northern and Western America.

[F. 145] BOOK TEN

[Seventh Cahier of the Natural History of the New World]

Names of hunting birds or birds of prey that I have observed in the northern part, and in the cantons of the western part of America.

the Merlin
the Turk or mosquito eater
the Taugarot or Tartarot
the Sparrow Hawk
the Brilliant
the Musket or the male of the sparrow hawk
the Hobby
the Falcon
the Goshawk
the Eaglet
the Eagle

All these birds are diurnal birds; the following are nocturnal birds:

The Hornless Owl
The Hooting Owl
Two kinds of Owls[568]

I believe that it is not out of place to say a word here about the terms of falconry, and everything that concerns it, so that those who take the trouble to read the descriptions that I will give of birds of prey will do so with much more pleasure and much more knowledge. They will find all the terms of this fine occupation of the nobility, who take pride in knowing the art of falconry. I have made here an extract of all the ancient and modern authors, so that those who want to know how to train birds of prey need not take the trouble of going to look in ten or twelve authors, whom I put here in a few words.[569]

I will say in general that this fine occupation, or this art of the nobility teaches one how to tame raptors, predators or birds of prey as the art calls them; this occupation, as I say, teaches the way to train the bird of prey, and to use it for hunting game suitable to the bird that is being trained.

guillemot, *Cepphus gryllle* (L.), (Godfrey, 290), has red legs and feet but a black beak, although the mouth lining is red (M. Gosselin); *Oceanodroma leucorhoa* (Vieillot), Leach's storm-petrel (Godfrey, 48) has a slightly curved bill and is nearly black, but the black legs and beak do not fit (J. Harrison); *Fratercula arctica* (L.), Atlantic puffin (Godfrey, 296) has red legs and a prominent, largely orange bill, but has a white belly, and Nicolas may well have known it by its French name, *macareux* (C. Stuart Houston).

567 *Meleagris gallopavo* (L.), wild turkey (M. Gosselin);

Godfrey, 165; depicted in the *Codex*, Pl. LXXII, as "Coq dinde"; mentioned by Boucher (Rousseau 1964, 319–20).

568 Since most of these birds will be presented individually further along, we will give their identification at that point.

569 As Nicolas admits, this discussion of falconry and its terminology has nothing to do with the natural history of the New World. He appears at times to be using as many terms as possible; several paragraphs consist of nothing but terminology, without real content.

This fine art takes its name (although it applies to all long-winged birds) from the falcon, which is the noblest species of all hunting birds and birds of prey.

The *affaiteur*, as he is known in the art, [f. 146] or, to speak more clearly, the bird trainer, is called falconer or master of the hunt.

The *oiseleur*, or *oiselier*, is different from the falconer; one trains birds, the other catches them. These are two different tasks, but both are noble, and even the highest and greatest nobles do not hesitate to perform them sometimes, either in training their own birds, or in taking them by hand from their eyries, or in nets during their migrations, or with birdlime, although to tell the truth this is not the noblest part of falconry. It is the occupation of the officers of the nobleman who enjoys falconry, while the nobleman rides horseback with all his retinue, following the bird's flight.

All the diurnal birds that I have mentioned above are naturally inclined to seeking and hunting game, and they live on their prey. For this reason, nature has armed them with beaks and supplied them with talons and sharp claws, and provided them with fine talons or claws in proportion to their size and to their prey. The pennae of their wings and tail are long and free, along with their pinions, to turn with agility in all directions as if they were so many rudders.

If the birds of the Indians' country were trained, tamed or taught the ways of falconry, although they are untrained[570] by nature, they would not fail to pursue with vigour the prey of France, which, being much more delicate than their ordinary food, would entice them and make them brilliant.

When a sor-hawk or red-hawk, that is, a bird that has not yet moulted its first plumage, pursues its prey, it is very slow and not very vigorous, and it will have a hard time living if it does not take its prey by surprise. It is for this reason that it leaves the nest very late, and has to be partly fed for a long time.

But the bird that has moulted attacks with much more ardour and speed, being lighter. One sees such great quantities of them toward the end of autumn that our French people have to watch out for their fowl.

One could train birds of the fist and of the lure[571] that would soon be as good as those of France, and there would be plenty of long-winged and short-winged birds. One would find all kinds, some hard and some easy to train, some fierce and some docile.

[f. 147] One sees innumerable ones that are well grown and formed, with well-developed pennae, as long as they should be. American birds are well proportioned for the most part; others are so fat that they hardly fly any more. The eagles of the country usually have this fault, and consequently they are quite often killed with a stick.

Birds that are of the same colour on the mantle and the pennae are not too common in the country. They are almost all mixed and spotted with different colours.

I truly do not know what name to give to so many long-winged and short-winged birds. I have not been able to discover precisely the number and the different species of those that would be birds of the lure and of the fist, although I know that in France those who have treated this matter have said that there are more than eight species of the lure, and only two of the fist.

If, after all these various things, and these exact terms of falconry, I still wanted to give you all the proper terms for the parts of the bird, and all the names that are given to these same parts, I would tell you, to amuse and to teach you at the same time, all the secrets of this noble amusement, that their pennae, their plumage and their down are as fine as those of other birds in countries where the rarest ones are seen.

All long-winged and short-winged birds have twelve large hollow feathers, six on each wing, and twelve on the tail. These are the feathers that are properly called the wing and tail pennae.

The *couvertures* (coverts) are the feathers from the neck to the tail. The *manteau* (mantle) is all the feathers of the body; the *mailles* are the marks and spots of a different colour from the main plumage and from the whole mantle.

Maillure or *tavelures de mailles* are different coloured speckles on the plumage.

Aiglures are various little red spots.

Bigarrure, tavelure d'aiglures on the back of the bird are reddish marks that can be distinguished on the pennae and on the mantle of the grown bird.

The lines that cross the tail pennae are called *barres de queue* or tail bars.

The *tour be bec* (cere) is the little circle that is seen on the beak, of a colour different from the whole beak. Various birds have it on the feathers on the beak.

[f. 148] The *grain* is the wart seen only on the beak of the goshawk.

570 Nicolas uses *niais*, a term referring to a young bird of prey. The *Dictionnaire de l'Académie* (1694) explains that in the strict sense, this adjective is used only of a young bird taken from the nest: *un oiseau niais*. Although he is discussing falconry, Nicolas seems to be influenced in

this sentence, as in other places, by the ordinary-language meaning of "foolish" or "simple" (N. Senior).

571 According to Frederick II, the long-winged (true falcons) return to the fist; the short-winged hawks (he calls them falcons) return to the lure. In Nicolas's case,

The *main*, or hand, is the foot or claw. This term is never used except for birds of prey, and one would speak improperly if one said the hand of a partridge or of a quail; one must say the foot of the quail etc.

The *serres*, or talons, are the nails or claws.

The *jabot* is the maw.

The *gésier*, or gizzard, is the stomach.

The *brayet*, the bird's hindquarters, are the feathers under the tail pennae and under the legs or the thigh of the bird.

The *émeut*, or mute, of the bird is its droppings.

On the marks of a good bird

A short stout beak, a black tongue, pinions well raised toward the head, and covered by the feathers of the lower neck, or coverts, a well-shaped body, a broad breast, a very open pelvis, the undertail coverts well along the tail; the undertail coverts are under the tail pennae.[572]

It is a good sign when the scales on the legs and the toes and next to the talons are rough, and the talons black, big, long and very pointed. The upper pennae all of a piece, that is, all the same colour.

Pennae in the right number: six on each wing and twelve on the tail, full and not damaged or crumpled.

When the bird is heavy on the fist, this is one of the best signs, and finally if its tail is not too long, or grafted, or crumpled.

On the terms of falconry

It is proper to begin with the term or noun that gives rise to all the others; for if that one were omitted, there would be none, and if the bird is not trained by a careful, painstaking and assiduous *affaitage* ("manning" or "training"), one can never expect to see the miraculous effects of manning, since this is what makes a bird that is naturally wild, fierce, proud, hard to tame, and passionately determined to be free, after long being free in the air, come to accept servitude as soon as it is called by the falconer whose voice it recognizes.

And one could never expect to see it take wing, or mantle over [its prey], carry [it] in flight, and fly at the right height [*entre deux airs*], and never so high as to be out of sight.

But it is a princely pleasure to see it after its perfect training rise on the wing, mount, soar, and discover its prey; or leave the fist when the hunter gives the cry,

with fine wings and body, and with such speed and grace, although sometimes it may have a slightly injured wing or a crumpled or broken feather. At other times, without this fault, it is a pleasure and a marvel to see it tethered with all its plumage, attached by a leash to its perch, or on the fist. Often one is equally charmed and surprised to see one's bird, in the middle of it flight, see another prey, and seize it with its claw so skillfully and quickly that one hardly notices it, for it is done before one realizes what is happening.

It is certainly a pleasure without equal to see a bird swoop down on its prey with the speed of lightning, and charge it a hundred times in a moment from above, from below, from the left and from the right and from all sides, until it binds to it.

Is it not a very agreeable and amusing thing to see eyes bright as lightning, quick movements, a well-turned head and beak, adorned with all the most beautiful colours that make a fine bird? That good health, those talons, those rings, those pennae, that mantle, those coverts, that pattern of spots, and all those different colours; is all this not admirable on a bird that is either on the perch, or moulting, when one gives the *cure* or casting, that is, the pill or ball of tow or cotton every evening, which it swallows to purge itself? After it has vomited it in the morning full of that phlegm that made it heavy and slow at the hunt, it can follow the troop of hunters and dogs, which it would not be able to follow so well if it were not purged.

[f. 150] That descent, that climb, that lure, that call of the falconer, that whistle, that bird made of red leather with beak and wings, which the falconer raises, lowers, and whirls around in the air in all kinds of ways, to catch the attention of the bird that he is calling.

That pleasant instruction that the trainer[573] gives, and that training that he practises so attentively to have the bird come at the first call from its master and instructor. That flesh still warm or too cold that is endewed[574] and that finally goes from the crop down to the stomach.

How fine it is to see that bird which lands on the ground instead of a branch, rises, flies suddenly and swiftly, goes up like an arrow, spreads its wings, flies with closed wings, swoops down as fast as lightning, turns rapidly, comes and goes from all sides at once, slows down and starts up again, straightens out, rises again and again, comes close to the prey; rests briefly

the peregrine and northern goshawk are among the North American long-winged.

572 The correct name for the underside, between belly and tail, is *crissum* (M. Gosselin).

573 The word used by Nicolas is *oiseleur*, although he has

earlier made a distinction between *affaiteur* (trainer) and *oiseleur* (bird catcher). Here he clearly means trainer (N. Senior).

574 To endew (*enduire*) is to eat or digest (N. Senior).

when it has flown too far, takes flight gracefully when the leash is let go and the jesses[575] are released.

All that is something most interesting to see; as well as to see it eat its share of the quarry, or to see it learn during training to see and hear everything without being disturbed or frightened, and to leave the fist or the perch without bating.[576]

What can be more extraordinary than a bird so well trained on the fist or on the perch, which has learned to know the trainer by his voice, his clothes, the caresses that he gives, handling the bird gently, touching it lightly on the front of the body and on the head (*fricando blando popismate frontem*), at other times stroking it with the hand on the mantle from the tip of the beak to the end of the tail feathers, and using great kindness and patience, suffering the whims of a wild, capricious, angry and proud bird.

One cannot be better entertained than by seeing a bird rise on the wing and fly high after the falconer has raised the cry.

It is scarcely less pleasure to see it attached by a cord, to bathe it to keep its feathers in good condition, to seel[577] its eyes with thread if it is not hooded, or simply to blindfold it with a leather hood. All these things are done with an untrained bird to make it docile, to transport it, to train it to follow the hunting party, to follow the lancers and dogs, and to go before them when necessary. [f. 151]

One must admit that it gives great satisfaction to slip the bird, to see it mount in some long plain where in less than an hour the bird is very tired and covered with blood after all the quarry it has killed. To give the bird part or all of the quarry, to reduce its weight by washing its meat, feeding it more sparingly than usual.

To see it with all its furniture of bells, jesses, leashes, creances[578] and hood.

To weather it or introduce it to being outdoors, to see it take flight, to watch it swoop down like a thun-derbolt, or stoop[579] to the lure like lightning, in order to accustom it to hunting its quarry.

Finally, I cannot express the pleasure felt by those who enjoy and practise falconry when they see the bird scanning or watching for its quarry; when they see it leave the hunting party, return, catch its prey in its claws, swoop, pursue its quarry, ring up, ring up again, bind to the prey; seize it, leave it, start again its pursuit, survey where it went, come, fly, dart, shock, charge, and carry it, land on a branch or on the ground, stop, and do all the other wonderful performances of the best-trained birds.

But after all these terms, let us return to our descriptions.

The merlin[580]

The merlin is the smallest bird of prey. It has hardly any more body than a turtledove. It has bright eyes, and its head is handsome. Its mantle, coverts and rump are a mixture of colours. Its pennae are spotted with a reddish colour, and all its plumage is ringed. Its beak and talons are very black; on the foot, around the eyes and around the beak it is yellow. It is the lightest and fastest of all falconry birds. It attacks vigorously; but as it is very small and weak it attacks only small quarry that have no defense. It is not good to eat except in soup, where it makes a very white stock.

The Turk or eater of mosquitoes, which are a kind of fly called cousins[581]

The name eater of mosquitoes (*mangeur de marin-gouins*) is used by most French people of the colony, who imagine that this bird lives on these insects. As for me, I give it a nobler name; I call it the Turk, because its plumage is spotted with white crescents on a brown mantle and pennae. Its head is larger than the proportion to its body [f. 152] would require, so that a large egg would go easily into its beak. The Turk is hardly larger

575 Jesses (*des jets*) are leather straps that are attached to the bird's legs (N. Senior).

576 To bate (*s'abattre*) is to fly from the perch or fist in an attempt to escape (N. Senior).

577 To seel (*ciller*) is to sew a newly trapped hawk's eyelids together with thread. In his treatise *De Arte Venandi cum Avibus* (1248; translated by C.A. Wood and F.M. Fyfe, *The Art of Falconry*, Stanford, California: Stanford University Press, 1943), Emperor Frederick II of Hohenstaufen states that this must be done as soon as the bird is caught, and he gives instructions on how to do it (Book 2, chap. 37). In the glossary of that treatise, the translators say that seeling is "an early, cruel device, later abandoned for the hood." According to the website of the British Falconers' Club, seeling is an Eastern practice and is never done in the West (N. Senior).

578 A creance (*une créance*) is a long leash used in training (N. Senior).

579 To stoop (*s'élancer*) is to descend rapidly on the prey (N. Senior).

580 Not a merlin, but *Falco sparverius* (L.), American kestrel (M. Gosselin); (Godfrey, 148); not depicted in the *Codex*. The reddish flight feathers indicate a female kestrel, which has some rufous feathers on its breast. Boucher referred vaguely to "l'Epervier" and "l'Emerillon" (Rousseau 1964, 319).

581 *Chordeiles minor* (Forster), common nighthawk (M. Gosselin); Godfrey, 330; depicted in the *Codex*, Pl. XLIX, fig. 66.1, as "Le turc."

than the merlin [American kestrel]. The pennae, which are very long, make it seem larger than it is. Its flight is straight and very quick; its cry is drawn-out and very unpleasant, especially early in the morning when it begins to fly two or three hours before dawn when the weather is going to be good. I would almost have put the Turk at the head of the nocturnal birds, for to tell the truth it hardly appears during the day, and it is seen only in great flocks an hour before night, making a thousand great swoops near people. That gives Indian children the opportunity to pursue them vigorously, and to kill some occasionally with clubs. I believe that the prey of this bird is rats, mice and small snakes.[582]

The Taugarot or Tartarot. The sparrow hawk or the musket[583]

As these two species of birds have almost nothing different about them from those seen in Europe, I will say only that there are far more of them in the forests of the Indies than in our fine open lands in France; toward the autumn they avidly pursue innumerable small land and water birds.

The brilliant[584]

This is the most suitable name that can be given to this bird, which is unknown to all writers on long-winged falconry. This brilliant is so lively and so fast in flight that it is incredible. It is so bold that I considered giving it the name *Hardi*. It flies straight into everything; it even enters houses to seek and attack the prey that it is pursuing. It is not afraid to swoop in the middle of people if it sees prey in proportion to its talon, and it carries it off so fast that it can hardly be seen. It attacks chickens and pigeons, and seizes them on land and in the air.

It has stiff, strong and well separated pennae. Its mantle is almost all white, without spots or rings. It is one of the best long-winged birds in the world. It relies very much on its wing pennae, which are strong

and carry it with great speed to seize the prey which attracts it and is to its taste. It is black on and around the beak, and its talons are black. It is good to eat, and is never too fat. It is a good bird to train when it is taken from the nest. Otherwise it is always fierce, and hard to train.

[f. 153] The hobby[585]

This bird of prey is so fast in the regions of the Indies where there are frightful forests that, because it rises above them with incredible speed, it is rare to see its plumage unless one surprises it at the edge of the woods when it is looking for its prey to swoop down on it like lightning. It is seen only at two times: spring or autumn. In autumn it devastates the young fowl of the French farmers. This bird seems not to be very alert but this is not so at all, as far as I have been able to see. I find it fairly similar to the hobby of Languedoc.

The falcon[586]

The falcon has always been considered the king of the long-winged birds, and for that reason, as I have said, the noble name of falconry has been given to this occupation of hunting birds, which is one of the highest occupations of the rich nobleman. The falcon bears many marks that distinguish it easily from other birds of prey. It has some black, or at least some markings of that colour, which cause it to be admired. This jet colour is set off by a very bright yellow around the beak and on the legs, the scales and all the hand of the bird, which is armed with very sharp black talons. The front of its plumage is of a reddish colour, sprinkled with black speckles, like so many little hearts or ermine spots. It is as fast as lightning in flight, and it passes much faster than the wind.

The goshawk or tiercel[587]

The tiercel, or tercel, and the goshawk are the same kind of hunting bird. One is the male and the other the

582 The nighthawk is an insect-eater. It could not eat small birds or mammals as a similarly sized kestrel or merlin would do.

583 The *Codex*, Pl. XLIX, fig. 66.2, depicts only the "taugarot," adding that "Le tartarot, lepervie, sont presque tous semblables, hobereau." One could be *Accipiter striatus* Vieillot, sharp-shinned hawk (Godfrey, 137), almost a dead-ringer for the very similar *Accipiter nisus* (L.), European sparrowhawk. On the other hand, *Accipiter cooperii* (Bonaparte), Cooper's hawk (Godfrey, 138) could correspond to the "sparrow hawk or the musket" (M. Gosselin).

584 Possibly *Falco rusticolus* (L.), gyrfalcon, in white colour phase (Godfrey, 151); depicted in the *Codex*, Pl. XLIX,

fig. 66.3, as "Le Brilhand." Although the Gyrfalcon is an arctic and sub-arctic species, it is seen sporadically in winter both in Europe and south-eastern Canada (M. Gosselin).

585 Probably *Falco columbarius* L., merlin, a European bird (M. Gosselin); Godrey, 149; depicted in the *Codex*, Pl. L, fig. 67, as "hobereau." The caption "Le faucon" is barred, since it is used for fig. 67.1, just below.

586 *Falco peregrinus* Tunstall, peregrine falcon (M. Gosselin); Godfrey, 150; depicted in the *Codex*, Pl. L, fig. 67.1, as "Le faucon." The word "faucon" was also sometimes used by Lescarbot and Denys to designate the peregrine falcon (Ganong, 216).

587 *Accipiter gentilis* (L.), northern goshawk (Gosselin);

female. Neither is as large as those of France, where the male, as in the Indies, is smaller than its female.[588] While the female has silvery feathers spotted with black, the male has reddish ones, ringed with black spots.[589] This male and female have bodies very much extended by the wing and tail pennae. Their beak and talons are strong, very sharp and black. The entire mantle is fine and shiny with a black background. The rump covers half the tail feathers.

They attack their prey rather awkwardly, and they are not very wary,[590] allowing themselves to be approached and killed fairly easily by the hunter. They fiercely attack pigeons and chickens, which they take by surprise on the edge of the woods and around houses that are not far away.

[f. 154] *The eaglet*[591]
By the word eaglet, I do not mean the young of an eagle. I mean to distinguish two species of eagles, which are usually seen in fairly large numbers on the shores of the great lakes and the large rivers, where they nest on high trees.

The eaglet is a very large bird that has white tail pennae and black wing pennae. Its beak is yellow, with white around it, and all the plumage from its neck to near the pinion is white. The talons are very large and black. The feet and the legs are yellow. The whole mantle and its down are greyish. The bird has bright, piercing eyes of an azure colour. The whole foot and the legs are covered by thick scales, which is the mark of a good bird.

The bird usually flies slowly, and lives on fish rather than game. For this reason it swoops down to the water like lightning falling from above to catch big fish, which it seizes and eats with such avidity, filling itself so full that one can often catch it alive, or at least kill it with a stick, since the bird can no longer perch on trees or fly in the air, its crop being too full.

The Americans use the feathers to adorn themselves and to make their arrows. They make wreaths from the talons and from the beak, which is very large, hooked and broad. These same people make for themselves hats, ties and tobacco bags with all the skin of the bird, which they usually skin without removing the feathers. Some French people make fine candlesticks of the leg, the foot and the talons. It is amazing how fine and useful these candlesticks are when they are elegantly decorated with silver or some other metal, on which one places little candles of white wax. Many people have them as a curiosity in their chapels or their oratories.

The eagle[592]
The eagle has nothing different from the eaglet except a larger body, and plumage between black and greyish, spotted and coloured with yellow, white, black and grey in equal proportion on the whole mantle. The wing pennae are more black than any other colour; those of the tail are spotted with white. The beak and talons are black. The whole is in proportion to a large body; the leg is large and yellow.

The eagle[593] of the Indies is so strong that it can carry off a sheep. I know a Canadian Frenchman named Joliet who between the age of six and seven was carried more than a hundred feet by an eagle that would have devoured him if he had not been rescued. I heard this

Godfrey, 138; depicted in the *Codex*, Pl. L, fig. 67.2, as "Le hautour."

588 "Tiercel," or "tercel," is the male of any falcon species, and "falcon" is the term for the female of any falcon species. As was well known by people who practiced falconry at the time, there is a reversed sexual dimorphism: female raptors are larger than male raptors in almost every raptor species, including owls as well as eagles, hawks, etc. This is reflected in the name "tiercel" itself as mentioned in seventeenth-century dictionaries. For example Nicot's *Thresor de la langue françoyse*, 1606, explains under "tiercelet" that "aucuns estiment qu'il soit ainsi appelé, parce qu'il est un tiers plus menu que la femelle [Some think it is called by this name because it is a third smaller than the female]."

589 Nicolas has erred. What he describes as gender differences are in fact age differences.

590 "Ils sont même assez niais." The goshawk seemed awkward to Nicolas when it killed pigeons and chickens, because it killed its prey slowly by repeated, numerous puncture wounds with its feet, compared to a falcon,

which usually kills quickly with a snap of the neck (John Hanbidge, pers. comm.).

591 *Haliaeetus leucocephalus* (L.), bald eagle; Godfrey, 127; depicted in the *Codex*, Pl. L, fig. 67.3, as "Leyglon ameriquain." Its yellow beak, white head and white tail, and the use of feathers by aboriginals confirm the identification. The bald eagle is mainly a fish eater (M. Gosselin). Champlain in 1632 knew how to distinguish between two species, the bald eagle and the golden eagle. Lescarbot and Denys seem to have known only the bald eagle and a smaller species, possibly the gyrfalcon (Ganong, 202).

592 A juvenile bald eagle, whose plumage is darker, without white head and tail, until to maturity at five years of age. The javelin appears larger than the adult because of its longer feathers. Depicted in the *Codex*, Pl. L, fig. 67.4, as "L'aygle royalle."

593 *Aquila chrysaëtos* (L.), golden eagle (M. Gosselin); Godfrey, 145. It does kill and eat lambs and even fawns of fifteen pounds, but even the largest female eagle, at ten pounds cannot fly off a hundred feet with that weight.

from his own mouth and from those who had seen this terrible incident.[594]

After land, air and diurnal birds, the continuation of my history requires me to speak of birds of the night, and to finish this treatise on birds by those that fly or live on the waters.

[f. 155] Nocturnal birds

The bat[595]

Although the bat is not really a bird, having no feathers, and having teeth, and eight or ten toes with little claws, I will say nevertheless that the bat is in a way a sort of bird, since it flies. Since this flying animal is no different from those of our France except for a smaller body, I will not say anything more, and will begin with…

The small owl…[596]

has plumage completely different from ours, but is spotted with white on all the mantle. It is smaller in the body and seems to be brighter than ours. I have seen and fed some that were not as big as goldfinches.

The large owl[597]

This bird is the biggest and tallest that I have ever seen in all my travels.

All the mantle and all the tail and wing pennae have a white background. It is spotted with black spots on all the plumage, which sets off the white colour pleasantly. It has a very big black beak, a little long and hooked, with big whiskers made of a strong stiff hair like the whiskers of a tiger. Its head is extraordinarily big, its ears are prodigiously large, its gullet and the opening of its beak are frighteningly wide. The eyes are bright, the talons are very long, big and black. All of the foot, the fingers and the legs, which are very short, is much more hairy than a hare's foot, and this hair is so thick and so straight that it is more like egret feathers than anything else. In a word, this is a very fine bird, which is as large as a sheep. It is more than six feet from the tip of one wing to the other, and if the bird is old it is more than eight feet.[598] Its voice is so loud that in the silence of the night it can be heard nearly two leagues away.

At each part of its song, it repeats seven or eight times this monosyllable: *khou, khou, khou, khou, khou, khou, khou, khou*, with so many tones that however dreadful it is in the fearful night, it is still admirable.

When one is navigating at night in the channels or the many pleasant canals of the beautiful islands at the end of Lac Saint Pierre,[599] one hears these birds more than two leagues away. If I were not afraid to keep you too long, I would say a thousand other fine things about our birds of the woods and the land, and the birds that live on and in the waters, about which I still have to speak. But as I am afraid of [f. 156] boring you, I will say only a little, or almost nothing except the name of the birds that I have observed in such great numbers and variety on the rivers, the lakes and the sea, that if I tried to name them all, not only would this be impossible, since I do not know the names, but I would become tiresome. Here are just a few about which I have written something, after warning you that the plumage in general is quite different from all the birds that live on land and in the woods.

594 This incredible story was added by Nicolas in the right margin of folio 154.

595 Bat species, probably insectivore. Although Nicolas is aware that a bat "is not really a bird," he places it with birds, not with other mammals. He is following the older custom of classifying animals according to their habitat rather than their anatomy. In the definition given in the first (1694) edition of the *Dictionnaire de l'Académie* and repeated in later editions, a bat is a "*Sorte d'oiseau nocturne qui a des ailes membraneuses, & qui ressemble à une souris.*" By the same reasoning, the whale was also classified as a fish despite its anatomy (N. Senior).

596 *Aegolius acadicus* (Gmelin), saw-whet owl, a tiny owl, almost as small as *Glaucidium gnoma* (Wagler), the pygmy owl of the far west; Godfrey, 328. But it is a gross exaggeration to say "not as big as goldfinches." The *Codex*, Pl. LI, fig. 68, distinguishes between "La petite chouette" and "autre chouette." This "autre chouette" is probably *Strix varia* (Barton), barred owl, which is common in Quebec and Ontario (M. Gosselin); God-

frey, 323. Lescarbot and Champlain spoke only of "Hibou" without distinction (Ganong, 221); Boucher did not do much better (Rousseau 1964, 319).

597 *Bubo virginianus* (Gmelin), great horned owl; Godfrey, 310; depicted in the *Codex*, Pl. LI, fig. 68.1, as "chatuant." In addition to the great horned owl, also known as the "grand hibou," the *Codex* also shows a "coucoucouou quon entend La nuit de trois ou quatre Lieues loin dans la foret ou au bord des rivieres" (Pl. LII, fig. 69), which looks like *Strix nebulosa* (Forster), great grey owl (Godfrey, 324). Both Denys and Boucher mention the "Chathuant" (Ganong, 221 and Rousseau 1964, 319).

598 The wingspan of great horned owl can be 56 inches (1.4m), so six feet (1.8m) is an approximation, but the wingspan does not increase in an older bird. However, the closest European relative, the eagle owl, *Bubo bubo* (L.) can be 20 percent larger than the great horned owl (C. Stuart Houston).

599 A widening of the St Lawrence River from Sorel down almost to Trois-Rivières.

The beak, the foot, the tail and wing pennae, and almost all the other parts are different, and have very little in common. The eyes of sea birds are quite round. One sees in this infinite variety of birds some hooked beaks, others a little long and others quite flat, wide and very serrated. Others have a beak like a saw. One also sees heads of different shapes: round, flat, and wide ones. There are short feet, round ones, long ones, flat ones with webs and nails, and other feet with nails only. One sees legs of various shapes: triangular, round, flat, and others almost square. All this is in general; but here is something more particular that I have to say.

Names of water birds

Larks

I have seen more than ten or twelve different species, which frequent the shores of the water and never inland areas. Near Tadoussac there is a large headland that juts out a league into the Saint Lawrence River, which in autumn is completely covered with larks,[600] and for this reason it called *la Pointe aux alouettes*.[601] Hunting is good there, and often more than a hundred of these birds are killed with a single shot.

One sees long-legged sandpipers of three or four kinds.[602]

Plovers of four or five kinds.

Divers of more than fifteen kinds.

Small ducks of more than six plumages.

Water grouse[603] of two or three kinds.

Little chickens of the sea.[604] One species.

Small Gulls[605] of three different kinds.

Large Gulls of two kinds.

Streles[606] or sea pigeons.[607] Two or three kinds.

Fauquets[608] of four of five kinds.

[f. 157] Gannets[609] of one kind. This bird is as big as a goose. It never goes more than three or four leagues out to sea. For this reason pilots observing them take special care not to come to land by accident, particularly when they have lost their way by the violence of the winds. If they do not know the lands that they are seeking, they rejoice, and head for the harbour without fear, and usually land without difficulty.

Tangueux. These are large birds.[610]

Happe-foie.[611]

Cormorants. Their beak and plumage are fine and particular.

Geese of two kinds. These birds are very delicate.

Common ducks of all kinds, and all sorts of plumage.

Small black ducks.

Other small black and white ducks that are called *jacobins*.[612]

Large black ducks.

Ducks that are grey all over.

Common sawbills.[613]

Larger sawbills.

600 In addition to land birds known as *alouette*, or lark, the same term is a folk name of small waders, "peeps," stints of the genus *Calidris* (M. Gosselin).

601 Still an extant place name, an extensive mud flat at the mouth of the Saguenay River.

602 *Chevaliers* are small waders. Sayre lists the folkname as applied to willet, pectoral, and spotted sandpipers, and yellowlegs.

603 Possibly *Fulica americana* (Gmelin), American coot (Godfrey, 174) and *Gallinula chloropus* (L.), common moorhen (M. Gosselin); Godfrey, 173). Denys (Ganong, 234) and Boucher (Rousseau 1964, 317) mentioned "poules d'eau" to designate the same birds.

604 Probably *Oceanodroma leucorhoa* (Vieillot), Leach's storm-petrel; Godfrey, 48; but *Plautus alle* (L.) Dovekie, and one species of *phalaropes* known to sometimes migrate to South-Eastern Quebec, the *Steganopus tricolor* (Vieillot), Wilson's phalarope, are not to be excluded (M. Gosselin).

605 *Mauves*, an old name for small gulls, smaller than a kittiwake.

606 *Streles,* a rendering of *estrelet,* a folk name for terns.

607 Sayre asserts that in English "sea pigeons" was applied colloquially to harlequin duck, dowitcher, guillemot, murre, and arctic and black terns.

608 Shearwater, a non-breeding visitor of several species.

609 Nicolas uses *margot*, a well-known folkname of *Morus bassanus* (L.), known also as *Sula bassanus* (L.), northern gannet (M. Gosselin); Godfrey, 51; Cartier in 1534, Champlain in 1604 and Denys used also "margaulx," "margos" or "margot" for the Gannet (Ganong, 224).

610 Former folk name of *Pinguinus impennis* (L.), great auk (M. Gosselin); Godfrey, 289. Champlain discovered them on the Tusket Islands in 1604; Lecarbot calls them "gros tangueux"; Sagard in 1636 calls them "guillaume autrement tangueux" (Ganong, 239–40). Boucher also uses this name, but Rousseau 1964, 317 believes that he meant *Alca torda* (L.), razor-billed auk.

611 A name applied to birds attracted by fish offal. *Puffinus gravis* (O'Reilly), great shearwater (Godfrey, 43) and *Fulmarus glacialis* (L.), northern fulmar (Godfrey, 41) are most often associated with this behaviour off the Grand Banks (M. Gosselin). Denys seems to refer to the latter with this name (Ganong, 220).

612 A folkname of *Aythya fuligula* (L.), tufted duck in Europe (Godfrey, 105). Nicolas may have meant scaup, bufflehead, or goldeneye ducks, all in black-and-white garb (M. Gosselin and C. Stuart Houston). The Jacobins were formerly Dominican Fathers, dressed in black and white.

Other sawbills even larger, with a long beak, hooked at the end.

Sawbills of a fourth kind, very big and almost as tall as swans, with yellow sides on the mantle.

Ducks with the largest body,[614] which are found toward the Kaoûj Islands near the Mantoûnoc Islands, also called the Sept-Îles,[615] on the north side of the great river. In season, I have seen two sailors fill a row-boat with the eggs of these big ducks in less than two hours.

Halbrans of various species. The word *halbran* in general means a young duck that is still downy; but in addition to that, there are various species of birds that are called halbrans.

Finally, there are snipes of three or four different kinds, and several other birds whose names the natives of the country do not know any more than I do.

[F. 158] BOOK ELEVEN

Continuation of the Treatise on Birds

All these birds, and a great number of others of which I do not speak here, are so numerous and so fertile, each in its own kind, that it is impossible to imagine or record it. I have just said that in season, in certain places, such a great quantity of eggs are found that it is hard to believe. I can scarcely believe it myself, for it seems that there much be a magic charm to see so many eggs on little rocky islands. For this reason the name of Egg Islands[616] has been given to those that are along the north side of the Saint Lawrence River.

The famous Bird Island[617] that I have seen in the middle of the Gulf of Saint Lawrence, although small, is so full of eggs in spring and summer that it is not possible to take a step without crushing some; and one cannot walk without sinking to the knees in bird droppings, which cover the island so that it seems doubly white, either because of this or because of the great multitude of birds that are there and are all white. Innumerable

other birds of the same kind flutter about to rest; the others which are already there defend their ground as well as then can, since the land is not sufficient to receive so many inhabitants. As a result fierce fights are seen all about the island, and one hears a very loud noise,[618] much greater than would be produced by a large fair of three or four thousand women. One cannot approach the island, much less land on it, without being armed with a good sabre, or a good strong stick, and one never goes there except out of curiosity or necessity when one wants to provide a good meal to a ship's crew tired out by the labours of a trip of 1,250 leagues from our lands of France to this place. To confirm this, I will say that in the innumerable mouths by which our great Saint Lawrence River flows into the sea, there is another Bird Island[619] much larger than the one I have just men-tioned, which is 14 or 15 leagues from land, and from the great, famous island of Newfoundland which is 300 leagues in circumference. The island is at latitude of 49 degrees 40 minutes.[620] It is so covered with birds that all the ships from France could be filled with them, and it would not be noticed that any had been taken. This fact will confirm another which I report from the Island of Ouabaskous, [f. 159] where one sees a valley where there are so many feathers that a strong man would never be able to get out, and would die. Even the large animals of the country are lost when they are chased this way by the hunter. It is a pleasure to take boats full of these birds in a moment.

After all these remarkable things, would you not think that I have nothing more to say about birds, and that I would not have any more to add to the picture that I proposed to paint at the beginning of this trea-tise? Herons, cranes, wild geese, bustards, loons, swans, big bills,[621] wood ducks and their young will provide the final touches and the finest glazes.

The heron[622]

All hunters know that this river or marsh bird is noted for the length of its legs, which are proportionate to its body. Its beak, neck, eyes and the crest on its head

613 Merganser. Many diving ducks have serrated bills for gripping fish.

614 *Somateria mollissima* (L.), common eider; Godfrey, 107.

615 Nicolas was in Sept-Îles. He even wrote a *Mémoire pour un missionnaire qui ira au 7 isles que les sauvages appel-lent Manisounagouch, ou bien Mansounok.*

616 Îles aux Oeufs, on the north shore of the St Lawrence River, facing Anticosti Island. The site was made famous by Sir Hovenden Walker (1656/66–1725/28), naval com-mander of the failed British expedition against Quebec in 1711.

617 Great Bird Islands, north of the Îles-de-la-Madeleine (or Magdalen Islands).

618 Made by the gannets.

619 Funk Islands.

620 This is [approximately] the latitude of Anticosti Island, but Nicolas is likely referring here to a smaller island.

621 Here "big bills" must refer to pelicans (M. Gosselin).

622 *Ardea herodias* (L.), great blue heron (M. Gosselin); Godfrey, 61; depicted in the *Codex*, Pl. LII, fig. 69.1, as "Le heron." Cartier confuses it with the grue or the crane, but Champlain, Lescarbot, and Denys identify it

make it remarkable to all those who know what a long-winged bird is. Its whole mantle is ash coloured.

Heron Island, in the middle of the waterfall or rather the terrible rapids of the Sault Saint-Louis,[623] is well known in the whole French colony, and it is known that in season so many eggs of these birds are found there that it is not difficult for several people to return loaded with them in very little time. If one prefers to give the herons time to hatch their eggs, imagine the marvel it is to see innumerable little herons on a small island.

The crane[624]

The crane is one of those birds that land on the ground or on branches, as well as the heron. This is a migratory bird that is seen in great flocks in the fair season [spring]. I have seen an island that bears the name of this bird.[625] Its call is extraordinary, and it can be heard more than a league away. [f. 160] The male and the female have a large crest[626] which is spotted with a very fine red.

Their mantle and pennae are not very different from those of the heron. The flesh of the crane is very delicate; that of the heron does not approach it. The young of both are ugly and look like monsters when they are still downy.

Wild geese[627]

The Cap-aux-Oies, below Île-aux-Coudres,[628] on the right going up the river, and the islands of the same name above Île aux Coudres, on the left side of the same river going upstream, have turned white more than a million times from the plumage of the prodigious multitude of these birds that went there, not more than twenty years ago.

It was no small marvel to see such great flocks of them that they covered the sun, inviting and offering a fine opportunity to more than a hundred hunters who went there, and still go there in spring and au-

tumn to kill so many geese that it surpasses anything one could imagine.

These birds are much smaller than the geese of France, and they are as different in their plumage as they are similar in their body. Their flesh is delicate, and the bird is very fat in autumn.

The plumage is always uniform, that is, the male is always distinguished by his plumage which is always the same on all males. The female's is similar on all females. The wing and tail pennae are black; the rest of the mantle is ash grey. The female's is more whitish. Both have a black beak, a little sharp and all serrated, as well as the tongue which is covered with a very rough skin, and supported in the middle by a bone that gives an extraordinary strength to this part of the bird to cut big roots on which the bird feeds at the edge of rivers and swamps. The area around the beak is reddish. The bird has black eyes. The cry of the Indian goose is clearer and lighter than that of domestic geese. This long-winged bird, before taking flight, takes in its beak a stone the size of a musket ball, to [f. 161] force itself not to make any noise in the air, so as not to warn birds of prey of its passage. This being so, it is not pleasant to find oneself beneath the flight of innumerable geese, which when they want to land and rest on some open area that pleases them, drop the stone that they had in their beak.

The loon[629]

What shall I say about the famous interpreter of the western Americans' great god of the sea, that they name Michipichi? Shall I say that it is the deepest diver of the sea, with the most colours and the most spots of all birds, the most aquatic, the most timid and the loudest? Shall I say that this is an infallible bird of augury, that it never sings except when there will soon be wind or rain? If I say that, I will have said part of what I know about it, confirming the delusion of the people, who firmly believe that this bird is the inter-

correctly (Ganong, 220). Boucher mentions it also (Rousseau 1964, 318).

623 Just above the more famous Lachine Rapids.

624 *Grus canadensis* (L.), sandhill crane (M. Gosselin); Godfrey, 176; depicted in the *Codex*, Pl. LII, fig. 69.2, as "La grue." The description of this bird is extremely important. It proves that candhill cranes once migrated through the St Lawrence Valley in considerable numbers. While all early observers mention "grue," one might think they confused it with the young great blue heron. However, Nicolas's writings confirm their presence (J. Harrison).

625 There are two "Île aux Grues," one near Montmagny, the other near Maskinongé (R. Ouellet).

626 Rather, a patch of red skin, not elevated.

627 *Chen caerulescens* (L.), known also as *Anser caerulescens* (L.), snow goose (M. Gosselin); Godfrey, 76; depicted in the *Codex*, Pl. LIII, fig. 70, as "oye sauvage." Cartier had already spoken of "oyes sauvages, blanches et grises" in 1535. Lescarbot thought they were two different species (Ganong, 229). Boucher knew the "oye sauvage" as well as Nicolas (Rousseau 1964, 317).

628 Near the present site of the town of Baie-Saint-Paul.

629 *Gavia immer* (Brünnich), common loon (M. Gosselin); Godfrey, 22; depicted in the *Codex*, Pl. LIII, fig. 70.1, as "Mane ou üar." Champlain mentions it twice: in 1604 and 1632; Denys calls it "Plongeon" (Ganong, 221). Boucher writes "huart" (Rousseau 1964, 318).

preter of the god of the sea, which they think is a huge monster that they call Michipichi, whose portrait I give in my drawings,[630] as well as that of the loon. When the skin and plumage of a loon were presented to our very illustrious monarch, the great Louis XIV, now happily reigning, it was found to be very fine and extraordinary. I knew an Indian named Alouabé, who claimed to be the only person who understood the language of the loon, and that in this way he knew what this Michipichi wanted when he was angry.

The bustard[631]

This very high-flying bird is so common in the New World in spring and autumn that there are entire days and nights when one sees and hears nothing but millions of large birds that look like our large geese of Languedoc.

Lac Saint-Pierre, which is only three leagues from the town of Trois-Rivières, is sometimes so surrounded, and its inlets so covered with them, that whenever one advances in a canoe or a rowboat, one hears what sounds like some horrible crash of thunder, accompanied by such loud repeated cries that I do not think an army of twenty or thirty thousand men would make more noise.

Not too long ago, as I was travelling by the shore of this fine lake on a clear, calm, moonlit night, when the surface of the water was smooth, I was almost terrified to hear and see such an amazing thing. With every stroke of the paddle we made, from the middle [f. 162] of the great forests of rushes, which are as thick as the thumb of a large man and as tall as a pike, there rose so many flocks of bustards that someone less accustomed to this noise would have easily believed that he was in the middle of a battle. These birds, which have very long strong wings, took flight so quickly that one would have thought it was an earthquake or thunder.

This kind of goose has a mantle of various colours: grey and brown with a little white, black and yellow,

with a certain blue. The tail and wing pennae are very black. The whole head is almost black. There are only two white marks around the eyes, which set off the velvety black of the head and wings of the bird and give it a handsome appearance. The bustard has very lively and piercing round eyes with a black background. Its voice is very loud. This bird sees and senses things from far away, and as it is on its guard, it leaves quickly. It flies straight, and can go for a day and a night without resting; this is known by observation, when they are seen arriving from the mainland onto islands that are at sea, and 200 leagues from the land on all sides. The flesh of this bird is very good tasting and nourishing. Its feathers are very good, especially for writing. Its down is fine, and the feathers from all the body are excellent for making bed coverings. Often seven or eight are killed at a single shot.

Very fine table covers are made from the neck skin of the bird; they are prepared well and sewn together with a needle.

The swan[632]

This is without doubt the king of the water birds. Its trumpet-like call, its proud bearing and majestic air, its admirable whiteness, its noble pride on the waters, which it seems to disdain when swimming, fleeing the tumult of other birds; all these make it noticeable above all other birds on the waters. Its bright eyes, its very high, straight and swift flight show that it has particular qualities in every way. These things together with its size, which exceeds that of other birds, certainly earn for it the name of king of the water birds. The Americans have given it the name of captain, *ounkima oua-bisi*, the white captain;[633] they also say that the swan is the governor of innumerable subjects that frequent the waters as it does.

[f. 163] Swans are not as commonly seen as other great flocks of sea birds; nevertheless one sees fine flocks of them almost everywhere. But what I con-

630 See *Codex*, Pl. xxxix, fig. 56: "*micipichik* ou le dieu de Eaux selon les Americains."

631 *Branta canadensis* (L.), Canada goose (M. Gosselin); Godfrey, 80; depicted in the *Codex*, Pl. liii, fig. 70.2, as "Outarde ou nika." Cartier named it "oultarde"; Champlain knew of it already in 1603; Lescarbot and Denys describe it accurately (Ganong, 229). Boucher calls it "outarde" (Rousseau 1964, 317).

632 *Olor columbianus* (Ord.), known also as *Cygnus columbianus* (Ord.), tundra swan; Godfrey, 72; depicted in the *Codex*, Pl. liv, fig. 71.2, as "Le Cygne." It migrates through the Great Lakes area, but *Cygnus buccinators* (Richardson), trumpeter swan (Godfrey, 73) also occurred there in the past. Nicolas noted the trumpet-like

call, but the two species are not easily told apart. Cartier and Champlain spoke of "signe" (Ganong, 239). It is possible that Boucher had observed *Olor c.* (Rousseau 1964, 317).

633 These are Algonquian words, *ounkima* referring to "captain" and *oua-bisi* to "swan." Our sources agree: Silvy gives *8tchimou* for "capitaine"; and *8abisi8* for "cygne" in seventeenth-century Montagnais; Fabvre gives *8kimou* for "capitaine, chef, g8v(erne)ur, Int(en)d(an)t" and *8abisi8* for "Cygnes, gros oyseaux t8t blancs"; Rhodes gives *waabzii,* for "swan" in today's Ojibwa-Chippewa-Ottawa; Hewson gives **wekima-wa* for "chief" and **wa-pesiwa* for "swan" in Proto-Algonquian; the same author signals *okima-w* for "chief" or

Natural History, or the faithful search for everything rare

sider especially fine is a certain down under the mantle of the swan, which is so beautiful and white that no more curious plumage could be seen. There is no ermine or snow whiter than the skin of this swan when it has been skinned and plucked to the down. If several of these skins were joined together after being well prepared by an Indian woman according to her custom, one could, without fear of being rejected, present them to a king, who would appreciate them because they are so rare and so useful.

There is nothing more suitable to warm the chest of someone who has a chest cold, and to prevent whooping cough. For this reason the skins are valued and costly in France, where merchants bring as many as they can.

The people make bags and purses from the skin of the legs and feet, which they skin very neatly and quickly. They put tobacco and their pipes into these bags, which they first treat with smoke. They often save some of the down to make a head ornament for special occasions when they want to appear in public. They make white wigs, which they attach to their hair with moose fat.

The wing pennae are very big and long, and when they are cleaned properly they are highly prized for writing. They are called *plumes de conte* (fairy-tale quills).

Swan flesh is not very good to eat since it is very tough, but hunters make stews of it.

The big and long-beaked bird with a double stomach, which the Indians call cheté

The *cheté* appears only on certain small lakes where there are many fish. This bird is rare and of a very particular kind. To see great flocks of them from a distance, one would take them for swans, because their mantle and pennae are all white, their neck is long,

their feet are black, and even the size of the body is similar to that of the swan. [f. 164] The difference and the special trait is in the beak and a certain pouch beneath it, which serves as a first stomach, where it warms its prey before it finishes cooking it in the second stomach, and digesting it.

Its beak is a foot long, and is as big as the arm of a large man. These birds rest their beak on their neck, which they bend for this purpose, as if to serve as a support for this large, long master beak.

Nature has formed beneath this beak a pouch which opens and closes more or less according to the quantity of fish that the bird encloses there. This pouch is made of a very delicate skin covered with feathers, and is very supple. When it is closed it contracts so quickly that all along the beak nothing is seen, in order not to frighten the fish that the bird wants to catch. These birds enlarge the pouch so quickly when it is time, and open it so fast and so wide that the head of a large man would go into it without difficulty. The fish enters into it like a net, which the bird closes with the same speed that it had opened it.[634]

The wood duck and its duckling[635]

We do not have in our old France this rare kind of duck, which roosts on branches instead of landing on the ground like other species. One does not see that crimson or that golden yellow circling the eyes of our finest ducks, or spotting a very beautiful and large plumage in the shape of a helmet on their heads, as one sees it on the head feathers of the wood duck, which are the finest in various plumage that one can see, and almost the finest that one can imagine. Imagine the most beautiful green in the world, set off by a brilliant glaze of silvery grey shining like crystal; black, satin

"king" in today's Cree; and *okima*, "chief, leader" in today's Ojibway (John Bishop).

634 A similar description of the *cheté* is found in the *Jesuit Relations* for 1670–1671. The Thwaites translation, vol. 55, 191–9, reads: "The same river, of which we are speaking, is broken up by several small lakes, on which are seen in great numbers certain rare birds of a very peculiar sort, called by the natives Chete. One would take them for Swans, from a distance, as they have the latter's white plumage and long necks, their feet, and bodies of the same size; but the point of difference and curiosity lies in the beak, which is fully a foot in length, and as thick as one's arm. They usually carry it resting upon the neck, which they bend back for the purpose, as if to offer it a most inviting bed. They maintain this posture to relieve themselves of its weight, except when they use it for fishing; for then it is wonderful to see

how, beneath this beak, nature has fashioned a sort of net, – which opens and shuts, more or less, according to the supply of fish therein enclosed. This net is made of skin, of extremely fine and elastic texture; when closed, it is gathered up so well and so snugly all along the under side of the beak that nothing of it is seen, in order that the fishes may not take fright at it; but, at the proper time, the birds can enlarge it so quickly and open it so wide that it would easily hold a man's head. Swimming at the same time to meet the fish, or waiting for it below the rapids, while it comes down, they hold this net stretched for it, and make it enter as into a fishing net, whereupon they promptly shut it lest the fish escape. Thus God teaches man artificial fishing, by the lesson furnished by these natural fishers."

635 *Aix sponsa* (L.), wood duck; Godfrey, 82; depicted in the *Codex*, Pl. LIV, fig. 71, as "canard Branchu." Both

white, red, incarnadine, azure, the colour of dawn, grey-violet, celadon green, in a word all the mixture of colours; you will see it on the mantle and pennae of this beautiful wood duck. Its beak, the area around the beak and its neck are varied with so many colours that by saying that all colours are there, I have said it all.

I believe that it is still possible to see two of them, a male and a female, that were placed in the famous menagerie of Versailles. We brought them from the Indies in our ship called *La Grande Espérance*.

The soft little cry of this duck is so melodious, so charming and so pleasant that one has to have heard it to imagine it. Its very delicate flesh makes it sought after by those who have fine and discriminating taste. Its nest is remarkable because unlike most ducks, it makes the nest in a hole high in a tree. When the little ducklings have hatched, it takes them on its back and pennae and carries them over water and land without harming them. The woodcock does the same thing in France.

[f. 165] *Flying insects*

It is neither inappropriate nor out of place to give here a little list of flying insects and to say in a few words what I have observed that is most particular about these various animals, which are seen in such numbers in the vast northern and western forests that it is beyond imagination.

Biting midges, which are small, almost invisible insects,[636] are so numerous and so bothersome that it seems that one is burned with a spark every time one of these insects lands on the hands or on the face.

Biting insects which are a little larger give no less trouble than various innumerable other flies about which I will say nothing, because I have not observed anything particular about them except the frightful quantity seen in the woods, from which they drive people and animals for three months in June, July and August.

Bees smaller than ours are seen, hideous bumblebees, strange scarab beetles, stag beetles of two or three misshapen species, very small cicadas, mosquitoes, other kinds of biting insects, infinite numbers of midges, common flies, very large horseflies, ridiculous and very venomous wasps; when they bite, one is surprised as if one were hit by musket ball. Others are seen that are very long and very venomous. And as one

sees innumerable kinds of caterpillars, one also sees innumerable species of butterflies of all colours and several different sizes. As for grasshoppers, I have never seen so many anywhere else, or any that had these two great peculiarities. The first is that that they all have a pattern like a human face perfectly distinguished on their stomach. Secondly, they make a great noise when flying. Finally I will tell you about the firefly, and I will show it to you in the dreadful darkness of the night. We will see the mosquito in the day, and we will suffer its discomfort in the night.

Mosquitoes or maringouins, *which in Languedoc are called* cousins *or "thieves of patience" or "drunkards on human blood"*

I do not think that they are wrong to call those Languedoc mosquitoes "thieves of patience" or "little drunks on human blood," since both expressions are so true that it could not be said better. A single one of these thieving insects will often be capable of preventing a person from sleeping for whole nights by its bites, and by its very annoying sound; and when one is covered with them, what will one do? And if one catches handfuls of them every moment, what will one say? [f. 166] Smoke is the only thing that can keep these pesky things away. But the remedies that people use are themselves worse than the mosquitoes. But since smoke often chases away these little torturers, people prefer being harassed by two enemies for a while rather than suffering from both for whole nights. But at other times, there is no use being surrounded by four fires, these little tyrants, these extraordinary drinkers, lower their heads and charge, so to speak, through their cruelest enemy, the smoke. They usually make their fiercest attacks two or three hours before dawn, and the same time after sunset.

If someone is forced to stop for a single moment, these thieves of the greatest patiences attack him so quickly, and make such a loud sound, that there are very few people who can keep their patience. It is very difficult to drink, and it is even harder when the traveller has to stop to answer the call of nature. If he suffers only a million bites he is fortunate, although it seems that his bottom is on fire, no matter what fly-chasers he carries with him. Finally, if he has to lie down to sleep or to rest a little from rowing all day, these combatants attack fiercely in such great numbers

Leclercq in 1691 and Dièreville in 1713 spoke of "canard branchu" (Ganong, 207). Boucher, who spoke only of "canard," does not permit any precise identification (Rousseau 1964, 318).

636 *Moustiques*, a term that ordinarily means mosquitoes, but is used here by Nicolas in a broader sense for biting insects. For mosquitoes, he uses *maringouins* or *cousins* (N. Senior).

over all the body that however many he kills it seems that for one killed, a hundred others attack. Each of these insects applies its snout to the skin, to draw through the pores the purest blood, and one sees them so tightly attached and holding themselves so steady by beating their wings that it seems that they would like to hide themselves under the skin from which they suck the blood of the patients.

All the forests of the Indies are so infested by all sorts of biting insects that it is beyond what one could believe.

One sees a very small species of biting insect that is venomous. When they bite, there are swellings as big as peas, which last and are painful for two or three hours.

The firefly

Among the remarkable things in America, I find that the firefly should not have the last rank; for on looking at it carefully, one would say that it is a living star which, carried by its own movement amid the shades of night, shines without receiving its light from the day star. This flying star must nevertheless pay homage to the sun, as it never appears by day except as an ordinary fly.

One is often pleasantly surprised to see what appear to be many little flashes of lightning, which are these insects, opening and closing their wings at almost the same time, showing and hiding in a moment their pleasing fire. One can read in a room by holding one of them and moving it along the line that one wants to read. If fifteen or twenty of these fireflies are put in a glass bottle, they serve as a candle for a week.

[f. 167] After all these curious observations it is time to finish and to begin the treatise on fish, which, contrary to innumerable insects that bother the inhabitants of the forests, are very advantageous and useful. But as I realize that I have said nothing special about the innumerable kinds of large and small snakes that are seen in the great lands of America, I beg you to allow me to say a word about the finest and most dangerous snake in the world, which is seen in almost all regions of Virginia, but particularly in Louisiana, in the great Manitounie[637] which is next to it, and in the vast Kizissiane which borders it on the north as far as the Vermilion Sea, which we have not yet seen, since according to the report of the natives it is more than 500 leagues further than the more than 1,200 leagues that

we have travelled from the entrance to the Gulf of Saint Lawrence to Manitounie.

It is the rattlesnake that I propose to you here as the most beautiful and most dangerous snake of all the western lands.

The rattlesnake

There are two kinds of rattlesnake. The smaller of the two kinds has its rattle under the lower jaw. This rattle is simply a sort of stone the size of a bullet of medium calibre enclosed as if in a parchment pouch attached to the skin of the snake. When the snake moves, it makes a noise to warn the hunter to withdraw or watch out lest the snake attack him. The bite of this snake kills within 24 hours if one does not use the remedy that I will describe, which must be applied when one is bitten by the terrible, great rattlesnake that has its rattle at the end of its tail, formed by several segments that fit one into the other and make a rather loud noise when the snake is running, crawling or jumping with great leaps.

The large rattlesnake's rattle is considered a divinity among the western Americans. The embalmed skin of this large snake is the finest thing one can see. Its flesh is very white and delicate and very good to eat. One has only to cut off the head to remove all the venom from the animal. Some of these snakes are eighteen to twenty feet long, and as thick as the thigh of a large man. More than twenty men can fill themselves for a whole day at the rattlesnake feasts that the Indians hold.

They call it *kiché kinebik* (the great snake), *manitou-kinebik* (the admirable snake or the snake spirit), *maratachi-kinebik* (the bad snake).[638] Others farther away call it the lord of snakes, *tentislacocaukqui*; this is the real meaning of this Indian word.

The snake has a viper's head. Its mouth is very large, fiercely armed with incisors, canines and molars in both jaws. Its eyes are frightful, almost all red. It has on the upper jaw a tusk on each side; that is, it has two teeth that stick out of its mouth two or three fingers long; depending on its age, they are [f. 168] more or less long. On the tip of each of these teeth, which are as sharp as needles, can be seen a very small hole through which all the snake's venom comes out, as it has none anywhere else. This venom is very powerful; it causes all the body of the person who has been bitten to swell incredibly. The wounded person turns black and dies

637 The Mississippi Valley; see map in the *Codex*.
638 *Kinebik* is an Algonquian word, whereas *kinepik* is Cree (C. Stuart Houston).

within a few hours if, as soon as he is bitten, he does not dig into the earth and bury the injured part there, and remain in this state for twenty-four hours, during which he has no pain and no appearance of swelling or bites. This remedy is better than all the orvietan[639] of Rome. It costs nothing, and is found everywhere. I believe that the effect of this remedy comes from all the earth that draws out the venom that it communicates to snakes.

Our rattlesnake is faster on stones and rocks than on open ground. The age of the animal can be seen from the number of segments at the end of the tail, which form its rattle. If the snake kills by its bite in a short time, it dies twenty-four hours after biting. It normally lives twelve months without eating or drinking. These venomous teeth cure headaches by pricking with the same teeth the neck and head of the patient. This confirms the common proverb that says that when the animal is dead, the venom is dead also. The fat of the snake cures hot and cold pains, and sick people obtain relief by hanging the head of the snake from their neck.

This rattlesnake has the finest skin in the world. Lizard skin does not approach it, with all the variety of its colours. The inhabitants of the country prize it highly.

The Upper Algonquins have given a very fitting name to the snake; they call it *maratachi-kinebik* or *maratachiouakisi kinebix*, which means: the bad snake attacks people to devour them when they are least expecting it. If anyone is unfortunate enough to let the snake wrap itself around him, he is infallibly lost for, as it is extremely strong, there is no way to get free from these coils. This is why, when it has seized some large animal, it devours it. This should not be considered very extraordinary in these vast lands, where there are not as many inhabitants as in our France, where less than three years ago in Dauphiné a snake was killed that had grey and violet skin, and whose skin, eighteen or twenty feet long, can still be seen.

I was assured by the report of the most learned gentleman of France that a snake about twenty feet long was killed at the gates of Clamecy.[640] Its skin was similar in colour to that of large lizards. This snake was so fierce that it attacked large calves and cows in the meadows that I have seen at the gates of Clamecy. It caught these animals by the end of the snout and took

them into a small valley at the end of the meadows, where it devoured them.

The same gentleman, with whom I had a long conversation, also assured me that he had seen in these same meadows a two-headed snake, which the Greeks call *amphybene*, which means snake with two walks or two opposite movements. This snake was so venomous that a girl died two or three moments after being bitten. The snake was greyish in colour. When it was dissected, as it was an extraordinary thing, one heart and two livers were found. It is not known how this monster was engendered. "Could one not say," this gentleman said to me, "that this monster could have been formed from two snakes cut in the middle, which happened to meet and attached themselves together naturally, as it is known to happen to a snake cut into several pieces, which then come together and reattach themselves?" When that happens, one sees snakes with scars and a ring around their flesh which is raised above the rest of the snake's skin. It was in fact observed that the amphybene snake was extraordinarily large toward the middle of the body.

These are the most particular things that I have observed. Now let us come to the fish of America.

[F. 169] BOOK TWELVE

[Eighth Cahier of the Natural History of the New World]

Treatise on Fish[641]

This would be the place to talk about all the immense waters that are seen in northern America, and in all parts of western America, to see infinite numbers of fish swimming there.

I would say that frequent strong, impetuous winds, mists, fogs, frosts, very deep snows that in many places last six months of the year, and nine or ten in the North, heavy rains, and very thick ice, as high as mountains and wide as plains more than two or three hundred leagues long and wide; as well as the ordinary marvel of the formation of waters about which philosophers dispute so much, affirming that it occurs in innumerable subterranean caverns; all this, I say, makes innumerable fine fountains, streams, rivers,

639 A counterpoison, also called Venice treacle; said to have been invented in Orvieto, Italy.
640 In Burgundy, west of Vézelay (R. Ouellet).

641 For the identification of fish, we have benefited greatly from the excellent Master's thesis of Dorothée Sainte-Marie, *Les Raretés des Indes ou Codex canadiensis,*

Natural History, or the faithful search for everything rare

large marshes, lakes of innumerable shapes and of surprising size; from which issue so many fine majestic rivers that flow into the sea, after rolling their beautiful waters through lands, one more than three hundred leagues, another more than nine hundred and another more than eight hundred leagues of known navigation. All these waters mixing together give life and nourishment to innumerable fish. I intend to describe some of them: if not all, at least those that are the best known in these lands. I do not wish to say anything more in this treatise on fish about these great waters, of which I have said enough in my previous books. I will simply say that in navigations in America one finds such a prodigious number of fish that one is sometimes afraid one has run aground on some sand bank, when one is surrounded by an infinite multitude of fish. One sees grey porpoises, dolphins, whales, small whales, *stadains*, dorades, albacore, bonito, and flying fish in great schools[642] that often fall onto the upper deck of ships. After this little word, here are the names of the fish that I wish to describe, which are the best known in the West and in the North.

the smelt
the small cod
small catfish
large catfish
small herring
large herring

char
white carp
red carp
toadfish
the loach
achigan or bass
malachigan or drum

gold fish

alose or shad
bar or bass
salmon
gaine
small white fish
large white fish
armed fish or garfish
pike
three kinds of trout
three kinds of sturgeon

[f. 170] The fish that I have just listed can be caught in the fresh waters of the North in different places and seasons. While fresh water provides the fish I have just mentioned, salt water gives us the following fish:

cod or stockfish
large cod
albacore
halibut
small grey porpoises

white porpoises
sharks
small whales
large whales

In addition to all these fish, one sees on the shores of our seas and on the banks of our rivers all kinds of shellfish, mussels, winkles, whale lice and innumerable other shellfish of which one can gather a supply in a short time.

On all the shores of fresh water, and even in many places on land one sees several kinds of very venomous toads, various kinds of salamander, and another small four-footed animal that the natives call *oukikatarang*.

premier recueil illustré de la flore et de la faune de la Nouvelle-France, submitted in 1980 at the Faculté d'Études Supérieures of the Université de Montréal. Sainte-Marie consulted Vianney Legendre, former biologist at the Ministère de Loisir, de la Chasse et de la Pêche, Province de Québec, and Professor Étienne Magnin of the Département des sciences biologiques, Université de Montréal.

642 Nicolas is perhaps recalling a passage from Lescarbot: "Cinq degrés Nord dudit Équateur, et cinq degrés suroest du même Équateur, nous trouvâmes si grand nombre de poissons et de diverses espèces, que quelquefois nous pensions être asséchés sur lesdits poissons. Les espèces sont marsouins, dauphins, baleines, stadins, dorades, albacorins, pelamides, et le poisson volant, que nous voyions voler en troupe comme les étourneaux en notre pays [Five degrees north of the Equator, and five degrees south-west of it, we found so great number of fish of such divers species that sometimes we thought we have run aground on them. The species are porpoises, dolphins, whales, stadins, albacore, pelamides, and the flying fish, which we saw fly in troops like the starlings in our country]." (*Histoire de la Nouvelle-France*, Paris, Adrian Périer, 1617, 52, 148–9; trans. from W.L. Grant, trans., Marc Lescarbot. *History of New France*, The Champlain Society, Toronto, 1907, vol. 1, p. 335).

There are many common frogs, grey, red, yellow, green, and others that are spotted with green, black, grey and white; others that are hump-backed; and frogs with tails that are seen only in the North and are very venomous. But what is unusual, and unknown in Europe, is that people eat frogs that bellow like bulls, and that can be heard more than a league away. A single one fills a dish.

If I say little about all these rare things, and if I mix in all the main things that I have observed, giving the principal figures with their colours, usages, fishing etc., I will have done what has never been undertaken in these countries, to satisfy the curious.

I begin as usual with the smallest things; but I deliberately finish this treatise by one of the medium-sized ones, as will be seen, when I finish my whole natural history with a description of eels. This is too rare a thing, and I end with this kind of fish to inspire in curious people a desire to go see this marvel at the gates of Quebec, where for three months they will be able to feast on eels prepared in a hundred ways. If by chance their great curiosity leads them to follow all the routes that I have traced in my map[643] and in my first six books, they will surely taste all the species about which I will speak.

Frogs with a tail
The appearance of this aquatic animal does not differ from our frogs in any way except for the tail, which makes it horrible, like a monster.

[f. 171] Lake Kinoua-Michich, which means the fairly long lake, is famous for the multitude of frogs with a long tail that live in it and croak continually. These frogs are very venomous, although in those lands the toads, snakes and vipers are not venomous.

The large frog
In Lac Saint-Pierre, three leagues above the river of Trois-Rivières, one begins to see, hear and eat large frogs such as I have just described. They can be seen for more than six or seven hundred leagues beyond this place.

The smelt[644]
The smelt is a very small fish which begins to appear on the banks of the Saint Lawrence when the great work of the famous eel fishery is about to end. The ebb and flow of the sea, which enters more than 250 leagues into the river, pushes the smelt into the nets that have been spread. This famous fishery is so productive, abundant and advantageous for all the French of the flourishing colony which grows every day, that many persons of merit and high intellect consider that this is as great a providence for the subsistence of the country as was that heavenly manna[645] that fell every day like a wonderful dew around the camp of the Israelites.[646]

The smelt that I speak of here tastes very good when prepared in the French manner. The largest is less than three fingers long. It is delicate, and the whole thing is eaten.

The small cod[647]
The fish is called by this name because of its great similarity to the large cod. Many people think that this is the same cod that is caught in so many places in the Indies, and which, coming from the high seas, lives under the ice of New France during the greatest cold period of this country. Fishing began only twelve or thirteen years ago, although the French founded their colony more than sixty or eighty years ago.

This fishery takes place beginning on the coast of Batiscan,[648] which is a village two leagues long, and ends toward Trois-Rivières, from which there are six leagues of navigation. Within an hour, a child of ten or twelve years who makes a little hole in the ice catches two or three hundred with pins [f. 172] bent in the shape of fish hooks. People who work at this easy fishing always salt barrels full. The fish tastes very good, and has no hard scales.

Small and large catfish[649]
By describing the small kind of catfish, I will be describing at the same time the large one, which differs from the former only in quality and in size.

643 See *Carte generale* in the *Codex*.
644 *Osmerus mordax* (Mitchell), rainbow smelt, depicted in the *Codex*, Pl. LVI, fig. 73. Boucher also calls it *éplan* (Rousseau 1964, 330).
645 See Exodus 16:1–36.
646 Exodus 26:15.
647 Possibly *Microgadus tomcod* (Walbaum), tomcod or *poulamon* (in French), also called in Sainte-Anne-de-la-Pérade, "petits poissons des cheneaux." Depicted in the *Codex*, Pl. LVI, fig. 73.1, as "Lapetite molue."
648 Locality on the north shore of the St Lawrence River, between Trois-Rivières and Quebec City. Sainte-Anne de la Pérade, famous for its winter tomcod fishery, is nearby.
649 The small species is *Ictalurus nebulosus* (Lesueur), brown bullhead, and the big one is *Ictalurus punctatus*

The small catfish is not found in all parts of the river; I have seen it only in the lands of the Outchibouek, whom we very improperly call the Sauteurs,[650] since some ignorant people have called one of the most majestic rapids in the world a *saut*, and since the Outchibouek nation live around and at the end of the rapids, they gave the name "Sauteurs" to these people, who are the most capable, clever and handsome Indians in the world.

Both the small catfish and the large one are only rarely caught in nets, but are caught abundantly with fish hooks and spears, or with harpoons. The skin of these two species of fish is as slimy as an eel's.

Catfish have a very large head and mouth, armed with four or five rows of teeth. The fish is called *barbue* [bearded] because of four long whiskers that it has around the jaws. Its skin is blackish, but its flesh is white as snow and very delicate. It takes seasoning as well as an eel. Most large catfish weigh seven or eight pounds. In the whole fish there is only a backbone which is delicate and surrounded by a very fine fat, which makes a very good, very white stock. I have seen natives return from catching catfish after killing two or three hundred pounds of them with their swords.

The small and the large herring[651]
This fish has been given the name "herring" because of the great similarity to the one caught in the English Channel by the coast of Normandy, and called in those regions *les enfants de Dieppe*. Its flesh is very white and very delicate. Its backbone, though small, is strong and dangerous. I have seen this kind of small herring caught only below the foot of the Tracy waterfall,[652] and under the ice. Children make various holes and spear this fish at a depth of two fathoms, when it passes

in schools by the holes that they have made, where they catch as many as they wish.

As I have discovered no difference between the herring that is caught off the shores of France and the one that is caught in the freshwater sea of the Upper Algonquins, and in the Tracy Sea, I have nothing to say about the appearance of the fish. I will only affirm that it is a fine and quite particular thing to see natives in a little bark canoe go one or two leagues [f. 173] from shore to fish with their nets, which they throw thirty or forty fathoms deep. They take such prodigious amounts of fish that they do not know what to do with them. This kind of fishing takes place in autumn. The opinion of those who say that there are no herring in fresh waters does not fit with what I have just said, since I assure you that all the great lakes of America where there are herring have only fresh water.

The char[653]
The char is a species of those white fish that we see in France, and that in some places are called *gardons* and in others *chabots*; but it has a much finer taste. Its scales are very tender and its flesh is very white. I have seen them only in the great Tracy and Nipissing lakes, in the freshwater sea. It is only a half a foot long.

The carp[654]
The white carp differs from the red only in its colour. As soon as the ice has melted, people catch as many as they like at the entry of all the little rivers that flow into the great lakes. They are all of the same size. We ate only the heads, which have an exquisite taste.

Besides white carp and the red ones, we caught common carp of a prodigious size. The small rapid that is near the city of Mont Royal[655] is famous for the fine,

(Rafinesque), channel catfish. Folknames in French make a distinction between "barbotte" and "barbue." One of them is depicted in the *Codex*, Pl. LVI, fig. 73.2, as "Labarbue." Champlain spoke of "Barbeaux" in 1613 and Hennepin, in 1698, of "Barbues de grandeur prodigieuse" (Sainte-Marie, 145). Boucher spoke of "barbue" only and may have confused the two species (Rousseau 1964, 329–30).

650 Ojibway or Chippewa. The main body of the Chippewa lived near the Sault Ste Marie. They were found by the Jesuits as early as 1642 and were given by them the name of *Sauteux*, inhabitants of the Sault (see *Jes. Rel.*, 1670 and White, 98).

651 Nicolas knew the *Clupea harengus* (L.), Atlantic herring, but is speaking here exclusively of the *Coregonus ardetii* (Lesueur), shallow water cisco, or lake herring. However, both are depicted in the *Codex*, Pl. LVI, figs. 73.3, and 4 respectively, as "Lepetit arent" and "Le grand

arent." Denys, in 1672, describes the "hareng" as a sea fish (Sainte-Marie, 174). Boucher witnessed the fishing of lake herring in Huron country (Rousseau 1964, 328).

652 Probably Sault Ste Marie.

653 Nicolas could have known the *Salvelinus alpinus* (L.), char, which is common in Lake Leman and in the North of Europe; but the fish he saw in Canada was the *Salvelinus arcticus* (Pallas), the red char. In 1534 Cartier spoke of the "truyte" and Champlain of a "truitiere" near Port Royal (Ganong, 241). Boucher also spoke of "truite" (Rousseau 1964, 328).

654 *Cyprinus carpio* (L.), carp, depicted in the *Codex*, Pl. LVII, fig. 74.1, as "carpe." Cartier, Champlain (Ganong, 208–9), and Boucher (Rousseau 1964, 331–2) knew the "carpes."

655 The Lachine Rapids near Montreal.

656 We know of six species of sunfish in Eastern Canada:

large carp that are caught there in such great numbers and in so little time that it is marvellous.

The sunfish[656]

Because it is so ugly, this fish is called by the illustrious name of *crapaud* (toad).[657] Its taste is very mediocre; but as the Indians have a different taste from ours, they prize it and say that it is *ouinganchj*, which means good-tasting.

The shad or alose[658]

Its appearance is no different from those that I have seen caught beneath the Saint-Esprit bridge in Languedoc. It has far more bones, and does not seem to taste as good. The catch is abundant after the ice has left the banks of the great Hochelaga River,[659] which we now call the Saint Lawrence because the good Jacques Cartier entered it safely on that day.[660] Fishing for alose is open as soon as the ice (which in some years is twenty or thirty feet thick) has broken up and been thrown onto the banks, or has sunk, or at least has been carried away by the winds together with rapids which take it to the sea.

[f. 174] When the sea has withdrawn and all the banks of the river are dry, one sees the saddest sight that can be imagined. All those open areas that have remained dry, for a quarter of a league and in some places for a league, are covered by mountains of ice, which the ebb and flow of the sea has swept along, and will take back at the first high tide, which occurs twice every twenty-four hours. I must also mention something here, since I am speaking about ice and about fishing for alose, which are caught in nets spread out of the water when the tide is low and all the banks of the river are without ice. The ice is so thick and so large

that it attaches itself to pieces of boulder and carries them along; although some are as big, long and tall as ships, they are carried along for several leagues. This happened in the year 1675 at nine or ten leagues below the city of Québec, very near one end of the famous Île d'Orléans, where one can see five great boulders in the middle of the river,[661] which the inhabitants took to be so many Dutch ships coming to attack the port of Québec. The alarm was raised in all the countryside until someone went close enough to see that it was only five boulders that the ice had carried there. One can judge by the size of these pieces of rock, either by what can be seen or what is under water, how extremely high the tides are and how remarkably deep our river is, for this great machinery of ice and stone does not float in low water. I have taken the opportunity to say this when speaking about fishing for alose, which are taken out of the water, suspended in nets, when the tide has gone out.

The achigan[662] and the malachigan[663]

As these two kinds of fish differ very little, I see no difficulty in putting them together and saying that the achigan and the malachigan are remarkable and very good. They have firm, very white flesh, with few bones. These fish are usually a foot and a half long. Their scales are very small, but are so hard that it is very difficult to eat the fish if they have not been scaled very carefully. Both kinds of fish have seven or eight rows of very sharp teeth. The malachigan is blacker than the achigan. They are peculiar to the Saint Lawrence River and to our great lakes.

[f. 175] The loach[664]

Although this fish is quite extraordinary and has a

Lepomis gibbosus (L.), pumpkinseed; *Lepomis megalotis* (Rafinesque), longear sunfish; *Lepomis macrochirus* (Rafinesque), bluegill; *Pomoxis nigromaculatus* (Lesueur), black crappie; and *Ambloplites rupestris* (Rafinesque), northern rock bass (Sainte-Marie, 152) Nicolas depicted one of them in the *Codex*, Pl. LVII, fig. 74.2, as "le crapeau."

657 In the French of today, we identify this fish as a "crapet" instead of a "crapaud" (toad). The "crapet" should not be confused with *Lophius americanus* (Cuvier), American angler.

658 *Alosa sapidissima* (Wilson), American shad, which is quite similar to the European species, *Alosa alosa* (L.), probably the one depicted in the *Codex*, Pl. LVII, fig. 74.3, as "La Lause."

659 Cartier speaks of the "grand fleuve de Hochelaga" in the *Second Relation*, chap. 2 (see Bideaux, 132). See H.P. Biggar, *Voyages*, 108, n. 91, on the history of the naming

of the St Lawrence River.

660 That is, 10 August.

661 Could Nicolas have meant the islands of the Archipelago of Montmagny, situated on east side of the Island of Orléans? (R. Ouellet).

662 There are two species of Achigan in Eastern Canada: *Micropterus salmoides* (Lacépède), largemouth bass, and *Micropterus dolomieu* (Lacépède), smallmouth bass; one of them is depicted in the *Codex*, Pl. LVII, fig. 74.4, as "Achigan." Hennepin calls it "achigan" (Sainte-Marie, 154) and Boucher, "ouchigan" (Rousseau 1964, 332), both reflecting its Algonquian name.

663 *Aplodinotus grunniens* (Rafinesque), freshwater drum, or sheephead, depicted in the *Codex*, Pl. LVIII, fig. 75, as "Marachigan."

664 Nicolas must have known *Cobitis taenia* (L.), spined loach, which was (and still is) very common in Languedoc-Roussillon in France, a region he knew quite well.

very bad taste, the natives, who eat everything, appreciate it, although we French reject it when we have other things to eat.

This fish is two feet long. It is very thick as far as the middle of the abdomen. It is caught only in the great lakes. It is ugly; it has a very wide, flat head and mouth with seven or eight rows of big teeth. Like the pike, it feeds on other fish, and although it is well-supplied with teeth, it swallows its prey without chewing it. It has no scales, like the eel. Its skin is very slippery and extremely slimy. The flesh is tough and rope-like. One thing made us seek this fish more than all others: as one finds a rose amid thorns, we found a liver that was white as snow, of a size extremely large in proportion to the fish, of the finest, most delicate and most savoury taste in the world, in the middle of very coarse flesh.

To prepare this rare part of the fish, we simply put it on the end of a pointed stick planted in the ground by the fire, where this liver, when heated, began to produce a foam like whipped cream or well-beaten egg white. In a moment it was cooked. Its smell and taste cannot be described, for it seems as if all the tastes of the most delicate meats are included in this one, which has the quality of cheering the heart and fortifying it greatly. I forgot to say that the loach, called *missamee,* has two large whiskers.

The gold fish[665]

The gold fish has no similarity to another fish that is called *daurade*[666] on the shores of the Gulf of Leon.[667] We have called it the gold fish because of that beautiful dark gold colour seen on its whole body, covered with very small scales, so firmly attached to the skin of the fish that if it is left [f. 176] out of water for even a short time, it has to be skinned rather than scaled. A grill or boiling water must be used to scale it.

This fine fish has an exquisite taste; it has strong white flesh, and almost no bones.

I have seen them caught in such great quantities in the freshwater sea that they were carried only in full

bags. I have seen it as common in our camps as are the pebbles on river banks.

Large catfish[668]

I have already described this fish. I only want to say that this fish is so greedy that it is easily caught with a fishing line, which is a rope sixty or eighty fathoms long[669] with hooks every six feet, which is thrown into the river with two stone anchors. It is a pleasure when in less than an hour one catches hundreds of them, five, six, seven or eight pounds each. The Indians have only to go the foot or end of a rapid in the catfish season to kill great numbers of them with a stick, or to spear them at one or two fathoms deep, and very often at a depth of one foot. The whole river is, so to speak, paved with this fish. Those are the two ways to catch catfish.

The bar[670]

This fish is one of the most beautiful and one of the best in the world. Its whole body is silvery, and all the underside of the abdomen is white as snow and shining like white satin. It has two black stripes on each side. It tastes even better than it looks. Its flesh is firm and as white as milk. It has only one bone, and its scales are not too hard.

This fish is caught in two or three ways: with a net, or with a seine, which is a kind of net similar to those that I have seen on our Mediterranean shores. Some bar that are caught are two or two and a half feet long, and one foot wide. Some famous fishermen use a sparrow hawk to catch bass.

[f. 177] The salmon, and the gaine au bec crochu[671]

I do not separate these two fish, because of the great similarity between them. The only difference is that the snout of the *gaine* is sharper and more pointed, and hooked.

The head and abdomen of both are sought after for their taste, and people hold feasts on these two parts. However, all the rest of the body is good also. The

Our species in Canada is the *Lota lota lacustris* (Walbaum), burlot or ling, depicted in the *Codex*, Pl. LVIII, fig. 75.5, as "La Loche." Known by Boucher under the same name (Rousseau 1964, 330–1).

665 *Stizostedion vitreum* (Mitchell), walleye, depicted in the *Codex*, Pl. LVIII, fig. 75.2, as "Poisson dore." Hennepin (Sainte-Marie, 158) and Boucher (Rousseau 1964, 332) call it "le poisson dorez."

666 In the Mediterranean, it would be *Sparus aurata* (L.), sea bream.

667 The Rhône River emerges in the Gulf of *Leon*, west of Marseille.

668 See folio 172.

669 That is, four or five hundred feet (122–152m) long. The *brasse* (translated as fathom), formerly used to measure land, is now used only for measuring the depth of water.

670 *Morone saxatilis* (Walbaum), striped bass, depicted in the *Codex*, Pl. LVIII, fig. 75.3, as "Le Bar." Champlain mentions it in 1613. Sainte-Marie, 160 and Boucher knew of it (Rousseau 1964, 329).

671 *Salmo salar* (L.), Salmon, depicted in two forms (male and female) in the *Codex*, Pl. LIX, fig. 76, respectively as "La gueyne" and "Autre gueyne." Depicted on Champlain's 1612 m (Sainte-Marie, 162). Mentioned by Boucher, possibly as an adapted-to-sweet-water species,

flesh of both fish is very red. These two fish are caught in fresh and in salt water. Like the alose, they are caught at low tide, and out of the water. A considerable number are caught in two seasons: in spring and at the beginning of autumn. Barrels full of them are salted and shipped to France and to France's southern islands, where they are traded for tobacco, sugar, cotton and indigo.[672]

The small and the large white fish[673]

The small and the large white fish are hardly caught anywhere except in our great lakes, and never in salt water. I do not believe that a better fish can be found in the world. These two kinds of white fish are peculiar to the Indies, and I do not think there are any elsewhere. At any rate the Latin and French authors do not say a word about them, and do not give a picture of them, not even Rondelet,[674] who undertook to give us information about many fish, both saltwater and freshwater. The Americans have given the name *atikamek*[675] to the white fish, and a whole nation that was formerly very rich in every kind of pelts, particularly beaver, was pleased to bear this name.[676]

The small white fish is only a foot long, and wide in proportion. It is so delicate to eat that is melts in the mouth when it is cooked simply in water without salt or any other seasonings, which are not used among the natives. I report this to reply to a thousand people who have questioned me on the way of life of the natives. I answered them [f. 178] that all those I have frequented used, for seasoning, only a few bitter roots. They do not eat greens, which they say are only for animals. Some nations eat beans, pumpkins, very sweet watermelons, some of which are white like milk and have black seeds; others are reddish and have seeds of the same colour. Other nations live almost entirely on fish. The Kiristinons[677] usually eat only half-cooked

fresh or smoked meat. Sometimes it is half-rotten and full of worms. Among these people, bread and wine are unknown, and they have no salt. The Indians are almost always naked, except for the women, who are always very decently dressed from the neck to the knees. These Indians are always exposed to all kinds of weather, like animals. They are hunters, fishermen, great navigators, brave warriors, indefatigable travellers, etc. One can judge from this what sufferings are endured by those who have the charity to follow them to teach them to know God, in travels of a thousand or twelve hundred leagues at once, coming or going with a paddle eternally in their hands like convicts, with bare feet on portages, loaded with baggage like porters, with snowshoes on their feet in the winter on the snow, pulling a sled bearing all the clothing, food and everything necessary for saying mass, exposed with no shelter or house to all kinds of weather, to rain, wind, shipwreck, cold, heat, snow, ice, hail, freezing weather, fog, and frost so cold that often big pieces of ice form on the hair and the beard as well as on the eyelids and eyelashes and on the whole face; sleeping very uncomfortably still dressed and on the ground; and if amid all this misery one becomes ill, one is more miserable than a dog.

On such occasions a piece of white fish serves as consommé, boiled in plain water or roasted at the end of a stick.

This white fish is caught in all seasons in the lakes at a depth of thirty or forty fathoms, and sometimes at only three or four, depending on the place and the season.

I have very often seen natives who threw their nets thirty fathoms deep under the ice in the Tracy Sea. Here is how it is done.

[f. 179] Around Christmas time, when the ice is strong, they walk on this ice two or three leagues onto

found in the Great Lakes at his time (Rousseau 1964, 327–8 and n. 54).

672 See J. Mathieu, *Le commerce entre la Nouvelle-France et les Antilles au XVIII^e siècle*, Montreal, Fides, 1981.

673 The small white fish is *Coregonus artedii* (Lesueur), shallow water cisco, and the large white fish is *Coregonus clupeaformis* (Mitchell), lake whitefish, both depicted in the *Codex*, Pl. LIX, fig. 76.1, as "Le Petit poisson Blanc" and Pl. LX, fig. 77, as "atticamec Le gran poisson Blanc." Sainte-Marie, 164 attracts the attention on *Codex*, Pl. XV, fig. 19, with the following caption about the fishing of the "atticamec": "La pesche des Sauvages passinassiouek Je decris cette pesche ailleur qui est une choses tres merveilleuse, touchand la pesche." Boucher mentions these fish too (Rousseau 1964, 333).

674 Guillaume Rondelet, author of *Libri de piscibus marinis*

(1554) and *Universæ aqualitium historiæ pars altera* (1555).

675 Algonquian, as contrasted with *atihkamek* in Cree (C. Stuart Houston).

676 The Attikamegue (Chippewa: the water caribou) were a band of Montagnais residing, when first known, in the province of Quebec, north of the St Maurice Basin (*Jes. Rel.*, 1636) and accustomed to going up the St Lawrence to trade with the French (White, 53). See C. Melançon, *Les poissons de nos eaux*, 136 for the meaning of their name.

677 The Cree, constructed from *Kristinaux*, French form of *Kenistenoag*, given as one of their own names (White, 117). Both *Kristinons* and *Kiristinons* are used in English today, but the *Kir-* form, which Nicolas uses, seems to be much more common.

Natural History, or the faithful search for everything rare

the lake where they know that fishing is good. They make a hole with an axe. When the hole is made, they sound the depth of the lake, and when then have found that, they continue to make as many holes as the net is long, with the holes every four or five paces in a straight line. They pass the net from one hole to another under the ice with a long pole that a man pulls from one hole to the other, as another reaches over to him the pole at the end of which the net is attached. When the whole net is spread out, they drop two anchors, one at each end of the net, to make the net go to the bottom. And to keep it stretched out at the top, they tie two ropes on the ice to two pegs that have been planted in the ice for this purpose, which have been sealed with water which freezes as it is thrown around the pegs. Instead of lead, which is used in France, they use small round pebbles attached with birch bark. And whereas in Europe cork is used to hold up the net, our fishermen use strips of cedar shaped like sword blades, which are attached also all along the top of the net at intervals with the same kind of bark to hold it up.

When the net is spread out in this way, and the holes at the two ends are closed so that they will not en-large, the fishermen withdraw until early the next morning. They then return with another dry net, which they put in the place of the one that they had spread the day before to catch white fish. They draw up their net so full of this fish, and it is even more pleas-ant in that they find in their nets, mixed in with the white fish, big pike two or three feet long and trout that weigh up to forty or fifty pounds. Often sturgeon is mixed in this net.

I deliberately wanted to say a word here about these different fish that are caught, because it is true that it is only by chance that one finds all these kinds of fish caught together. Ordinarily each of these fish is caught at different times and places, but in the same way. Thus when I talk about the other fish in particular, as I do here for the white fish, I will not have to describe again the remarkable method that the natives have invented to catch fish.

That is one clever way to catch fish; and here are oth-ers that are no less clever, which I [f. 180] will describe,

after portraying the large white fish, which is at least two feet long and one foot wide. Everything is excellent in this fish, and it is very good when it is simply boiled for a short time in water until just done. The flesh is very savoury, firm and white as milk; it has no bones, and is streaked with such a mild fat that it easily makes a sort of very fine, clear golden oil, very mild-tasting, excellent for burning and making fricassees, and espe-cially for treating skins with oil. It has no bad smell.

This admirable white fish has only one bone, which is more like cartilage than what is usually called fish bone. This bone is surrounded by a strip of fat that runs from the snout of the fish to the base of its tail. This fat is so mild and so succulent that it cheers the heart marvellously, melting in the mouth like sugar. The water in which this fish has been boiled is very white and makes a very good soup. The scales of the fish are large as a *denier* coin. Neither the scales nor the fins or the tips of the tail are too hard. When one wants to have the pleasure of eating fish made into jelly as white as snow, one has only to boil the whole fish for a longer time. It is all reduced to a soup, with no ap-pearance of fish left.

This same fish is very good when smoke-dried; but if it is roasted and cooked in and by its fat which reaches all parts of it, then it is excellent. When it is roasted it is not called *atikamek*, which means white fish; the Sauteurs give it another name, *nametté*. When simply boiled it keeps its first name. When smoke-dried it is given a third name, *apoualak*.[678]

In the stomach of this fish one finds something that is not seen in any other: a lump the size of two eggs, very white and with a very particular, delicious taste. It is fit for a captain, the natives say: *unkima-oumitchin*,[679] the food of the one who governs. By that they mean to express the goodness of a food which is served at feasts where the best parts are given to the captains.

This large white fish likes to swim in clear open wa-ter, and in the rushing water in the middle of great rapids.

I can say here that I have seen innumerable times the finest and most abundant fishing that can ever be seen

678 All these words are Algonquian. In the Montagnais of the seventeenth century, *attikameg** meant "poisson blanc," according to Silvy c. 1678–84 and Fabvre, c. 1690. The Montagnais have maintained the same meaning for *attikamek*, and Clément (1995) translates correctly by "grand corégone." Rhodes (1985) translates *dikmeg* in Ojibwa-Chipewa-Ottawa by "white fish"; and Hewson (1993) also translates **atekame-kwa* in Proto-Algonquian by "white fish" (John Bishop).

679 These words are Algonquian. *Ounkima* means "cap-tain," according to the *Grammaire algonquine*, 33. *Mit-chin* is the word for "food." Silvy (c. 1678–84) translates *mitchin* by "aliment" in seventeenth-century Monta-gnais; and Fabvre (c. 1690) gives "nourriture" for the same word; Hewson (1993) translates the Proto-Algonquian **mi- imi* by food; the Cree *mi- im* and the Ojibwa *mi- im* mean also food (John Bishop).

through the great falls of the outlet of the great Lake Superior which is now called the Tracy Sea, and its outlet the Sault Sainte-Marie,[680] [f. 181] which is 300 leagues from Quebec at the 46th degree of latitude. In the middle of the waterfall, two men go in a canoe in which they have two kinds of poles, each one four fathoms long. One is used to stick into the ground and to hold them against the frightening turbulence of the water, the currents and the terrible rapids. These argonauts push their canoes violently into the middle of the rapids, until they arrive at places where they know that there are so many of these big white fish that the entire bottom of the water seems to be paved with them, or rather they are piled up one on the other in such numbers that they have only to drop their second pole, at the end of which there is a net in the shape of a cone or hood. Each time they raise it, as they do quickly, they bring up five or six large white fish. I give a picture of the net in my figures.[681] As soon as they have emptied their net into the boat, they continue to throw it into the water again, and each time they scoop up, as their word expresses it, five or six more fish. This is done so quickly that there is not a canoe that does not return in less than an hour, filled with a hundred or a hundred and twenty of these fish. When the fish has been unloaded on the ground, the canoe simply returns to the middle of the rapids, and returns as full as the first time. It is hardly considered fishing if a hundred canoes are not filled every day that they want to undertake this fishing, which lasts nearly six months every year, or never less than three.

The wonderful thing about this kind of fishing is even more rare and remarkable because the Sauteur are so accustomed to it that they do not hesitate to venture into the middle of these frightening currents and turbulent water, which make anyone dizzy looking at them from a distance. They go, I say, while the moon is shining in the middle of these frightening precipices. If it happens that by a wrong stroke of the pole or the paddle the boat overturns, as they are all naked and they can swim like fish, they are not bothered. They are carried in a moment seven or eight hundred feet from the foot of the rapid, where they retrieve their boat where the water is more than eight pikes deep, and climb back into it, joking and laughing at each other

about losing their fish and about their adventure, having also lost their *koûabahagan*, which is their pot spoon as they say, with which they scoop out the fish as if from a pot. This word is related to what they say when they are going to do this kind of fishing; they say that they are going to scoop up fish: *nigakoûabahoûa*, they say (I will scoop up fish), when they are going to do this kind of fishing. This saying is very different from the *Vado piscari* of the great Saint Peter.[682]

This fish is so common in the camp that some of it has to be thrown out, and for this reason they often catch only as much as necessary for them to eat.

[f. 182] Great ships could easily be filled with these fish in a short time. In the two seasons of spring and autumn this fishing draws many people all around the waterfall, or rather these majestic rapids, which join three lakes so prodigious that one of them, called the Freshwater Sea, is no less than 500 leagues; another, called Lake Superior or the Tracy Sea, is not less than 700 leagues; and the other one is 1,400 leagues, and is called Lake Illinois. From these lakes there come so many people to take advantage of the Sauteur fishing that one can count bands of two to three thousand people who live there happily.

If our gentlemen sometimes want to entertain themselves by making bonfires and a sort of fireworks, they have only to boil their white fish in cauldrons arranged to form different shapes, and at the same time throw some of the liquid of the cauldrons into each fire that is beneath the cauldrons. A thousand different shapes can be seen rising all at once to the height of a pike, all coming out of a picture that has been made from the different position of the cauldrons. If it is round, one sees all these different *attitudes*, to use this painter's term, coming out of a circle of fire. If the cauldrons are placed in the shape of a fleur-de-lys one sees a fleur-de-lys which, so to speak, gives birth to as many different forms as spoonfuls of the liquid from the white fish are thrown on the fire, as this liquid, being mixed with the melted fat from the fish, evaporates in flames turned in innumerable shapes. This exercise is a game of the Indians which they perform fairly often to entertain themselves. This flame is so subtle and has so little body that it can be considered almost like elemental fire.

680 Sault Ste Marie is situated at the eastern entrance of Lake Superior. Today there are two cities of that name, one in Ontario and one in Michigan, on either side of the rapids.

681 See *Codex*, Pl. xv, fig. 19, as noted above. One can see also on that figure the net called *kouabaagan*, the fish *atikamek*, and other fishing equipment. This is one of

the rare mentions that clearly connect the *Codex* to the "Histoire naturelle des Indes Occidentales."

682 Nicolas is quoting John 21:3 in the Vulgate: "Dicit eis Simon Petrus: 'Vado piscari,' Dicunt ei: 'Venimus et nos tecum' [Simon Peter said to the others: 'I am going fishing.' 'We will come with you,' they told him]."

Natural History, or the faithful search for everything rare

The pike[683]

Since the pike which I intend to describe here differs only in its extraordinary size from the common pike of France, I need only describe the particular manner used to catch it. It is caught in nets, as I have said. But the natives kill it with spears and arrows with such skill that they are as adroit as the most capable archers; and as archers hunt quail and partridge on land, these people go after pike in water as dogs go in search of game. They have such acute vision that they see the pike in the water through a thousand obstacles, and spear it.

In winter they catch it with a fish hook or with a spear under the ice, where they make holes a foot and a half in diameter. They cover them with beaver skins or with tree branches leaning on a little arch, under which they hide their heads. They hold in their hand a very long pole, at the end of which is a serrated harpoon in the form of a spear. At the end of the harpoon there is a fish or a skillfully made fish-shaped object. They continually move this pole to make the fish move as if it were swimming. The pike, which is very greedy and very large, or the big trout, sees this fish and comes to swallow it. The fisherman, taking his time, throws his spear and spears the fish, which is caught at the end of a string that holds the harpoon. The harpoon is attached to the pole that I have mentioned, which is as round and polished as the handle of a lance. The fisherman thus pulls the big fish very slowly, for fear that it will escape by some violent effort that it would make if it were pulled out of the water too fast.

It is a wonderful thing to see the perseverance of the fisherman, who remains for three or four hours in the harshest weather leaning on the ice, always looking into the water to make another catch.

Common trout[684]

These trout have the same appearance as ours, but they do not have the taste or the colour inside or outside. Their flesh is red, almost like the salmon's. It is dryer and firmer, and for this reason they do not have much taste. The smell is a little strong and wild. As for the skin, nothing finer can be seen, or better spotted with red, yellow, grey, white and violet. Very large ones are hardly ever seen.

Medium or many-coloured trout[685]

The medium trout is fairly big. It is the most beautiful fish that can be imagined, in the same shape as our finest trout. Their spots and the shape of the speckles are all different, and the infinite colours are so bright that nothing rarer can be seen. This fish is worthy of being painted. It tastes very good.

Large trout[686]

This kind of fish is found only in fresh water seas and in deep water, so that to catch them in nets, the nets (or the lines that are spread for this purpose) must be thrown at twenty or [f. 184] twenty-five fathoms deep, and often more than forty.

The size of this fish is remarkable. Monstrous ones are seen, with a frightening head and mouth, capable of swallowing children. A million teeth are seen in their mouth. The whole head is a royal dish; the eyes are better than calf eyes. The belly has a fine taste. The stomach of the fish is prodigiously large and strong; the natives use it to make bags. A single one of these fish feeds more than twenty men at feasts, where often several of them feed a whole village or a whole camp.

It is amusing to see the natives when they catch this fish, in the same way that they catch pike, under the ice with a harpoon, as I have said. The fisherman lying on the ice, holding his spear in his hand, whistles, sings and harangues the trout, entreating it to come. He calls it Grandmother: "Come, come, Grandmother," he says. "Come, come, have pity on me, come feed me, ho, ho, ho!" he adds in his language. "*Noûkoûmis pimatcha, pimatcha, chaouerimir, pimatcha achamir, nigaouikounké, nigaouikounké*,[687] I will feast, I will feast, *undachiiaien*, if you come here."

683 *Esox lucius* (L.), northern pike, depicted in the *Codex*, Pl. LX, fig. 78, as "Le grand Broché dune grosseur Extraordinaire et dune longuer surprenante." Boucher mentions it in the same terms (Rousseau, 331).

684 *Salvelinus fontinalis* (Mitchell), brook trout, speckled trout, depicted in the *Codex*, Pl. LX, fig. 78.1, as "La truite commune." As we have already seen, Boucher knew about the trout (Rousseau 1964, 328).

685 Could have been *Oncorhyncus mykiss* (Walbaum), rainbow trout, if it were not that this Western species was only recently introduced in the Parc National des

Laurentides, in Quebec (Sainte-Marie, 169). Nevertheless, the *Codex*, Pl. LXI, fig. 79, depicts an "Autre espece de truite."

686 *Salvelinus namaycush* (Walbaum), lake trout, Mackinaw trout, depicted in the *Codex*, Pl. LXI, fig. 79.1, as "La grosse et la grande truite." The Sieur Le Beau, in his *Avantures du Sr C. Le Beau*, 1738, devoted an illustration to the fishing of this large trout (Sainte-Marie, 170).

687 These phrases are Algonquian. Silvy (c. 1678–84) translates *n8k8m* as "ma grand-mère." Fabvre (c. 1690) translates *n8k8m* as "ma grd mere." And *cha8erimau* as

The armed fish[688]

The name "armed fish" is very well suited to this fish, for truly one could say that it is armed in a remarkable manner from head to tail. Its mouth is almost as long as the rest of its body, which is covered as if by a very strong coat of mail, made of scales so strong that a big spear of very sharp iron can scarcely pierce it. The fish has an extremely strong tail; with one blow it would kill a man, and it breaks all nets. Its teeth are very strong, and pointed like the sharpest needles, and it has innumerable ones. The fish is dangerous. It is killed only from curiosity, since it is not very good to eat.

Some are found that are ten or twelve feet long; they would be as fearsome as a crocodile if they had four legs and as many feet. This fish devours other fish, and it hunts birds, on which it usually lives all summer. Here is how: as the fish has a very long head, split like a compass, it raises this part of its body out of the water, and opens it like a compass in the middle of the tall reeds, where innumerable water birds go to seek food or shelter. As these birds run here and there, many pass through the mouth of the armed fish, which closes its mouth and dives, and swallows its catch without chewing it. I will soon say that the large cod does the same thing, a little differently from the armed fish, which rises straight up as if it were standing; whereas the cod and the large trout of our lakes swim naturally when they swallow whole ducks that they have just caught at the surface of the water.

There are few Indians who do not very carefully keep the heads of the armed fish that they kill, to cure themselves of headaches by pricking themselves with the teeth of the fish. They also use them as a lance to bleed themselves on all parts of the body, very adroitly and without fear of harming their nerves. They are not as scrupulous as capable surgeons; they boldly prick all their veins, and bleed so much that they look as if they have been flayed.

[f. 185] *The small sturgeon*[689]

I have noticed three kinds of sturgeons, only two of which frequent our great lakes. The small one is only two feet long. Its body is five-cornered. It is delicate. It has a large head, a pointed nose and, under the middle of its head, a pouch-like mouth that it opens and closes. It is a greyish colour on the back and flanks, and white underneath. It has some very tough scales on its skin, along the angles[690] and nowhere else.

The medium-sized sturgeon

I call it medium-sized even though it is usually four or five feet long, to distinguish it from that prodigious sturgeon of seven or eight and sometimes twelve feet long with a surprising girth. The medium sturgeon is common throughout the country. It is taken with a line, a net or a spear like a northern pike. It is beaten with rods or stoned at the foot of the rapids. This fish is excellent, very fleshy and nourishing. The end of the tail is a foot long and of a much more delicate taste than the tail of the best cod. When it is boiled more than usual it softens and melts like fat, and when it cools, this stock is as thick as the finest jelly. The fish does not have a backbone, but a kind of tender cartilage that can be eaten. The underside of the abdomen has an exquisite taste. The skin has no scales, only about twenty marks on its back like so many little shields made of tortoiseshell. In its belly, there are a million eggs the size of horseradish seeds, from which the fishers make a kind of bread that smells bad; but it tastes good when there is nothing better to eat. It is said that from this huge number of eggs, only one hatches. The natives affirm this, and they are to be believed, for they are great naturalists. This fish is useful for the mild golden oil taken from it, which is good for burning and for treating skins.

The fish's stomach is large and thick, in the form of a parchment, and a fine, strong glue is made from it. All the rare bouquets and pictures that one sees that are

"av(oi)r c(om)passion pitié de qlq(un)" (John Bishop).

688 *Lepisosteus osseus* (L.), longnose gar, depicted in the *Codex*, Pl. LXI, fig. 79.2, as "chausarou ou poisson arme il a 12 pieds de long et six de contoure." It aroused the curiosity of several of the early voyageurs. Champlain depicts it on his 1612 map. Sagard, 1636, mentions it. Du Creux, in his *Historiae Canadensis seu Novae Franciae libri decem*, 1664, Pl. I, facing 50 gives an illustration; Boucher describes it (Rousseau 1964, 333); Hennepin, 1698, in the *Jesuit Relations, passim* and Lahontan also mention it (Sainte-Marie, 171–2).

689 Five species of sturgeon are found in Canada, but only two in Quebec: *Acipenser oxyrhyncus* (Mitchell), Atlantic sturgeon, and *Acipenser fulvescens* (Rafinesque), lake

sturgeon. The former is depicted in the *Codex*, Pl. LXII, fig. 89.1, where it is said: "Le grand Eturgeon a douse pieds de long dune grosseur proportionneé a sa longueur." The latter is on 80 as "Le petit Eturgeon." It is hard to see what Nicolas meant by his "medium-sized sturgeon," unless it could be *Acipenser brevirostrum* (Lesueur), shortnose sturgeon. Lescarbot is the first to name it; Champlain gives an illustration on his 1612 map; Denys describes it well (Ganong, 216). Boucher knew about it (Rousseau 1964, 328). Sainte-Marie, 177 refers to *Codex*, Pl. XIX, where one sees a "chien qui traîne un poisson quon appelle *namé* ou Eturgeon."

690 Likely the bony plates on their back and their sides called "scutes" in English.

Natural History, or the faithful search for everything rare

said to be made from fish glue, are indeed made from the stomach of this glue-producing fish, as well as from the stomach of the large sturgeon. The natives use this glue for feathering their arrows and tipping their spears with gunflints to kill their enemies or their great wild beasts.

This fish has a large nerve running from the tip of its nose to the end of its tail. It looks as if it were a snow-white serpent. It is good cooked; it is crunchy like little radishes. This nerve is full of good-tasting, snow-white marrow.

The large sturgeon
There is no difference between this sturgeon and the one I just described except for its prodigious size and extraordinary length. It is no different otherwise. I have seen only one of this large species, which was washed up on the banks of a large river. I was amazed to see the size of this beautiful fish that the tide had brought ashore. Truly, it was bigger than a *muid*[691] and long in proportion. Unfortunately, I could not take advantage of it, for it was already all rotten.[692]

[f. 186] The cod[693]
A quire of paper would not be enough to write everything I would have to say about cod. But as other people have spoken about it, and as I have said a little about it at the beginning of my memoirs, it will suffice to say here that this fish is so common in the Saint Lawrence River that descending from Tadoussac and coming back toward our France as far as the island of Newfoundland, with its beautiful and famous Placentia Bay,[694] there are countless places where the cod are fished, particularly on the banks of the Saint Lawrence. Gaspé Bay, Île Percée, Orphan Bank, Green Bank, all the small banks, all around Bacalos Island,[695] the famous Grand Banks and countless other places are well known without my talking about them any further. I would only say that these places are mines as rich as

those of Potosí,[696] Ophir,[697] and Peru, and that Cape Sable alone is as good as all of them. In a few hours there, a single man will find enough to feed many people for a long time from his catch of the biggest, fattest and most beautiful cod in the world. I provide a very careful drawing of it, and since it is quite similar to a trout and since the drawing shows that it is very similar to those seen everywhere in France, there is no need to discuss it further.

Suffice it to say that the cod fishery is one of the wonders of the world, and if the inhabitants of the new lands alone traded in it, it could be said that New France would soon be a very rich and powerful kingdom. All the places I mentioned are close to Canada or part of Canada itself. Every year, there are over four or five hundred ships from European nations on the Baltic Sea that come to fish for cod, and to harvest a little of this inexhaustible manna. It is taken with a length of rope called a line, at the end of which a fishhook is baited, all in proportion to the size of the fish's mouth. I have hardly noticed any difference between this fish and our great lake trout.

The albacore[698]
The albacore is a large fish that is round along its length. It seems to have two long, large wings, sharp though narrow. They look like scythes with the handles attached backwards. This fish is taken with a line behind a vessel on the open sea, even at full sail. The fish is beautiful, and seems to be covered with every colour like the neck of a pigeon. It has no scales and it tastes good.

The halibut[699]
The halibut is a prodigiously large fish. It is shaped almost like a sole or a ray. The flesh is very white, but it is quite coarse and comes off in great slices like flaky pastry. It is very wide, with the mouth turned underneath, near the belly and away from the head. When floating, this fish looks like a table.

691 According to the *Dictionnaire de l'Académie*, 1694, a *muid de vin* contains 280 quarts (265 litres).

692 See also *Codex*, Pl. xix, a "chien qui traine un poisson quon appelle *namé* ou Eturgeon," probably Nicolas's "large sturgeon."

693 *Gadus morhua* (L.), Atlantic cod, depicted in the *Codex*, Pl. lxiii, fig. 81, as "Morue." A depiction of the cod appears already in Giovanni Battista Ramusio's *Delle Navigationi et Viaggi*, 1550; Champlain depicts it on his 1612 map; Hennepin and Denys speak of cod fishing. *Il Gazzettiere Americano*, 1763 devotes one plate to the cod (Sainte-Marie, 178–9). Boucher calls it "la moluë" (Rousseau 1964, 234–7).

694 In Newfoundland.

695 Newfoundland.

696 Bolivian city famous for the silver mines in the area. Potosí is said to have been the largest city in the Americas at its height in the seventeenth century.

697 Country from which gold was brought for King Solomon's temple. See 1 Kings 9:28 and 10:11, and 2 Chronicles 9:10. Different locations have been proposed, including various parts of Africa and present-day Yemen.

698 *Thunnus alalunga* (Bonaterre), albacore. Found in the Mediterranean and very rarely in the Western Atlantic, it would have been more familiar in this form than our *Thunnus thynnus* (L.), bluefin tuna. The Mediterranean

[f. 187] At sea, it is taken with a line. It can also be speared. A soldier, seeing one of these fish floating as it slept, threw his pike at its back. Seeing that the fish was not disturbed by this and was carrying away his pike, he promptly threw himself on top of it to retrieve it without waking the fish.

This trait is reminiscent of what some good writers say of seamen, who, believing they saw a rock in the open sea, landed upon it in their boat to go and boil their kettle. When they had lit a fire, and the fire was burning, the fish that they had mistaken for a rocky islet woke up and dived, leaving these mariners in trouble when all their equipment was lost. They quickly started to swim for their rowboat to get back to the ship as fast as they could.[700]

The grey porpoise or the small sea pig[701]
The colour of the grey porpoise is a little on the black side. Nevertheless it is called the grey porpoise to distinguish it from the beautiful white porpoise, about which I have already said a word and which I will discuss again, after saying that the grey porpoise is the sea pig that is talked about so much. Its whole body does have some resemblance to a pig, even though it is definitely a fish.[702] It is so fat that it seems to be made from the lard that often surprises many people during Lent when they are given a nice slice of this fine yellowish lard on their pea purée.[703]

The fish is round along its length, and very white under the belly. Its blood, taken warm, fortifies the nerves. It has fierce teeth. The intestines all taste of pork belly. It is very bony and has no backbone. The crest on its back is delicate to the taste; so is the tail. Some are seen that are twelve feet long. They are speared from the stern of ships, where they are often seen in great schools.

The white porpoise[704]
I have already said elsewhere almost everything that I am going to say again here, so as not to take anything away from the importance of this fine fish, and so the curious reader does not need to have recourse to my earlier works.

[f. 188] I said that the white porpoise is a large fish of eighteen or twenty feet and a girth in proportion to its length. There are some over five feet in diameter.

This little sea monster has very small eyes, which resemble those of a pig. It has a large head, a very large mouth armed with terrifying incisors, canines and molars. Its entire skin is fine, without scales, milky white and an inch thick. This animal has three or four fingers of a fat that is suitable only for making oil. Its sex is distinguished as between bulls and cows. It is round along its length. It is much bigger in the front than at the tail, which is turned differently from other fish. As it is a little like a whale, it has its tail turned the same way.

The entire Saint Lawrence River seems covered with them as far as the Tadoussac coast. This fish avidly attacks eels, and swallows so many that five or six hundred can be found in its stomach.

The young, which come fully formed and alive from the mother's belly, attach themselves so strongly to her teats that they often seem to be joined on to it.[705]

This porpoise has a hole or spout in the middle of its head as does a whale. It can be seen and heard breathing a hundred times a day. It even casts water in a little plume to the height of a half pike. The least of

species is depicted in the *Codex*, Pl. LXIII, fig. 81.1, as "Le gelmon."

699 *Hippoglossus hippoglossus* (L.), Atlantic halibut, depicted in the *Codex*, Pl. LXIV, fig. 82, as "Le flectan." Mentioned by Champlain in 1604, by Lescarbot (Ganong, 217) and by Denys (Sainte-Marie, 181).

700 A possible reference to the famous legend of Saint Brendan, the Irish saint and hero of the sixth century.

701 *Phocaena phocaena* (L.), harbour porpoise. In fact, this "grey porpoise" is black on the back and white on the underside. Illustrated in the *Codex*, Pl. LXIV, fig. 82.1, as "marsouin gris." Ramusio, 1550, calls it *delfino* and explains that its French name, *marsouin*, comes from the German, *Meerschwein*, translated as *porco di mare* (Sainte-Marie, 183–4).

702 The French word *poisson* and the English "fish" were commonly used to refer to marine mammals. Both the 1694 and the 1798 *Dictionnaire de l'Académie Française* define *poisson* as "Animal qui naist, & qui vit dans

l'eau." Samuel Johnson's *Dictionary of the English Language* (1775) defines "fish" as "An animal that inhabits the water," and quotes Shakespeare's reference in *A Comedy of Errors* to "The beasts, the fishes, and the winged fowls" (the same division by habitat that one sees in the "Histoire naturelle"). This broader use of the term survives in the English "shellfish." See also Nicolas's description of the whale (N. Senior).

703 See Lucien Campeau, *Monumenta Novae Franciae*, 1979, vol. 2, 178–9, n. 41, for a debate on the beaver. In the *Mémoires de l'Académie des Sciences*, 1704, Michel Sarrazin defended the ichthyologic nature of the beaver.

704 *Delphinapterus leucas* (Pallas), beluga; illustrated in the *Codex*, Pl. LXIV, fig. 82.2, as "Marsouin blanc." Denys (Ganong, 224) and Boucher (Rousseau 1964, 315) knew about it.

705 Even though writers such as Nicolas were aware that in certain marine species mothers suckled their young, these species were still classified as fish because of their

these fish sell for fifty écus. I saw some anatomized by a Dutch captain who was commanding our ship, and who came from the northern coasts where he had seen large numbers of sea lions. Two whales that he had caught brought him 10,000 écus.[706]

The shark or requiem, *commonly known as the* requin[707]

This dangerous fish could pass for a sea monster. They are seen in coastal waters and in the open sea; they are large and long, with a girth to match their length of eighteen or twenty feet.

The mouth of this fish is prodigiously large. It has four or five rows of long teeth whose size depends on its age. They are usually two or three inches in length and one inch in width. They are slightly curved, and they slice and cut like a razor. They are very hard. The fish is as greedy as can be imagined; it gorges itself on everything. It is daring and fierce, and although it has teeth as I described, it swallows things whole, even men, and for this reason it is named the requiem. [f. 189] It throws itself out of the water sometimes to swallow passers-by and sometimes it bites at boats' oars in its rage when it cannot get what it wants.

This shark is the fish that is ordinarily seen swimming around navies to eat the dead men that are thrown into the sea, where it never attacks a swimming person or someone who moves around a great deal. But if one stops, it strikes as fast as lightning, and cuts off or breaks a whole limb, if it does not swallow the person whole. In order to eat, it must turn upside down because of its mouth, whose upper jaw is noticeably longer than the lower.

The entire length of its body it has only one single bone, divided into large, wide vertebrae. The female produces live young, and she is so fertile that she has as many as fifteen.

If the young are ready to come out soon, even though the mother is killed, they are fed for some time in barrels of sea water. They are good to eat at this age; later they are not eaten because their flesh has too strong a smell, similar to tow. The dried brain of this fish relieves kidney stones. It is very white. Depending on the age of the fish, thirty or even forty jars of liver oil can be taken, and several more from the intestines. It is a coarse blackish or violet colour.

The small whale[708]

They are very common from the mouth of the great river as far as Tadoussac, and even as far as the parallel of Chafaud aux Basques.[709] They are seen far out in the river and sometimes within a pistol-shot of dry land, where they stay in the same place for hours on end. They looks like rocky islets. It is the same species as those that are fished in India and off the coasts of Biscay,[710] which are at least 36 cubits long and 8 or 10 across. Their mouth opens to at least 18 or 20 feet. The small whale has no teeth. Instead, on its jaws it has two great blades of black horn with hairy ends like pigs' bristles. It is 4 ells[711] from one eye to the other. When the animal is alive the eyes appear very small, but when they are removed they are as big as a man's head. The small whale has what look like two wings at its sides, which serve as fins and as a refuge for its young, where it hides them and carries them.

[f. 190] The tail of these whales is so big that by mov-

habitat; see note on the porpoise, above. In early editions of his *Systema Naturae* (first edition 1735), (L.) placed *Plagiuri*, including whales and dolphins, among the fish. Later, however, he gave more importance to reproduction than to many other characteristics. In the tenth edition (1758) he introduced a new order, *Mammalia*, which included not only what were previously called quadrupeds but also marine animals such as the porpoise, the dolphin, and the whale (N. Senior).

706 For their oil.
707 Illustrated in the *Codex*, Pl. LXV, fig. 83, as "Le Requiem de la peau duquel on fait le chagrin." The word *requiem* according to Furetière, came from the fact, that "quand on en est mordu, il n'y a rien autre chose à faire qu'à chanter un *Requiem* [when one is bitten, there is nothing else to do but sing a requiem]" (Furetière, 1690). The same explanation was given half a century earlier by the Dominican Father Dutertre, a missionary in the West Indies (*Histoire générale des îles*, 4, 1, chap. 1, 268). The word occurs in Sagard (*Le grand voyage*, R. Ouellet and J. Warwick eds., 97), in Denys (*Histoire naturelle*,

1672, 272–3), in Leclercq (*Nouvelle Relation de la Gaspésie*, 1691, 549), and in R. Challe (*Journal d'un voyage fait aux Indes orientales*, 1721, F. Deloffre and M. Menemencioglu, eds., Paris, Mercure de France, 1983, vol. 1, 163).
708 Probbaly *Eubalaena glacialis* (Müller), northern right whale, since Nicolas notes that its nose is "black in colour." Depicted in the *Codex*, Pl. LXV, fig. 83.1, as "La petite balene." Rousseau gives thirteen species of cetaceans found in the Gulf of St Lawrence, north of Nova Scotia, and on the coat of Newfoundland and Labrador, and among them our *Ebalaena g*. But it is difficult to know which one Boucher designates by "baleneaux" or "grosses baleines" (Rousseau 1964, 315). The same remark applied to the "ballaine" of Champlain's 1612 map and his map of the Island of Sainte-Croix (Sainte-Marie, 191).
709 Just south of Tadoussac, on the north shore of the St Lawrence River.
710 North shore of Spain.
711 According to the *Dictionnaire de l'Académie*, 1694, the *aune* (Eng. "ell") was equal to three feet six inches

ing it, they stir up the sea water all around for quite a distance, so that it boils up in a strange manner, and there is a danger that small vessels and even brigantines and frigates will be capsized; in a word it is well to steer away from this monster.

The small whale's nose is short and flat, and black in colour. It has a hole in the middle of its head to expel water and to breathe.[712] It makes a sound like cannon fire, and at sea it can be heard from further away.

The female produces live young. The small whale's bones are enormous. A single rib is more than 24 or 25 feet long, and as thick as a man. Some of this size can be seen at La Tremblade,[713] La Rochelle,[714] Bayonne[715] and other places where I have seen and measured them. At Frontignan[716] one can be seen on the left side of the parish church, hanging high on the wall. It is a good 18 feet long, and I noticed that it is not complete.

The Chafaud aux Basques in the New World still shows various prodigious bones of the small whale. They are seen at the foot of a very high mountain, where in days gone by the Basques melted down these monsters to obtain oil from their fat. The flesh of the young of this whale is quite good when salted. In various countries, beams and fences are made from whale bones.[717] In La Rochelle, I have seen them driven into the ground at the corners of houses as guards to prevent passing carts from hitting the corner of the house.

The large true whale[718]

Not far off the coasts of America can be seen very large whales; there are even some in the Gulf of Saint Lawrence. When these great sea monsters are mating they can be seen in groups. They are heard breathing so strongly, expelling water from their nostrils to the height of two pikes, that it sounds as if they are going to burst. In their great effort audible to our ears, these whales make a sound like a distant muted lowing that is nevertheless very high. When two or three males meet near a female, they attack one another so furiously and engage in such a fierce combat, hitting each other astonishingly with their fins and tails, that it sounds as though two warships of the first class are blasting each other with cannon fire.

[f. 191] One good fellow who wrote about the great whale maintains something that I would not wish to say, never having seen whales the size that he describes. Nor do I wish to criticize him, as I am quite sure that some things in nature are almost unbelievable, and one should not disbelieve them just because one has not seen them.

This author says that there are whales as big as four French *arpents* of land in all dimensions,[719] and he assumes that each arpent of land is 19 perches long on each side, each perche nine feet long and each foot twelve inches,[720] which means that that each whale can cover an area of land having 1,444 feet[721] or 17,328 inches.[722]

(1.1m). Four *aunes* would thus be 14 feet (4.3m). The 1762 edition specifies that this applies to the Paris *aune*. Measures varied widely from one region to another.

712 In fact, like all *Mysticeti*, it has two blowholes.

713 Port situated North of the Gironde River, near Royan and South of La Rochelle.

714 City between La Tremblade and Nantes, on the Atlantic Coast of France.

715 On the right bank of the Adour, at the border between the Basque Country and France.

716 Frontignan La Peyrade, between the Mediterranean Sea and the Gardiole massif, between Sète and Montpellier, in France.

717 See Pliny, *Historia Naturalis*, Sonnier, trans. 1994, 132, who mentions this use of whale bones.

718 Possibly *Balaenoptera musculus* (L.), blue whale; illustrated in the *Codex*, Pl. LXV, fig. 83, 2, as "La grande Balene ou *cete grandia* dont parle la ste. escriture qui est si grande dans Lance de Namkin et en chine et ailleurs et dans les mers orientalles a deux evanteaux elle couvre par sa grandeur quatre arpents de terre."

719 Lescarbot gives also "quatre arpens de terre de longueur" as a whale's measurement, and refers to Pliny, *Historia Naturalis*, Sonnier, trans. 1994, 131.

720 Nicolas specifies the value of the measurements he is using, in view of the regional differences. The terms *perche* and *arpent* could refer either to linear or to surface measures. A linear *perche* could be 18 feet (the Paris *perche*), 20 or 22 feet (appr. 6m). As a unit of area, the *perche* had four sides of one linear *perche* each; thus the Paris *perche* was 324 ft² (about 30 m²). An *arpent* normally contained 100 square *perches*, making the Paris *arpent* 32,400 ft² or 3,010 m². Nicolas's source further complicates the matter by using a *perche* of 9 feet, which is similar to the Roman *perche* of 10 feet (N. Senior).

721 The person who did this calculation, whether Nicolas or his source, left out a step. 9ft/*perche* x 19 *perches* = 171ft per side: 171 ft x 171 ft = 29,241 ft² per *arpent*. Four arpents of surface area would thus be 116,964 ft², or 16,842,816 in² – approximately 10,866 m². In the calculation described in the text, the 9 ft/*perche* is omitted (N. Senior).

722 Even if the number of square feet were correct, the conversion to inches is wrong. It is based on inches per linear foot, whereas it should be square inches per square foot (1,444ft² x 144 = 207,936 in², about 134 m²) (N. Senior).

The Maréchal de Bassompierre[723] says in his memoirs that as he was going on a mission to Spain he passed through Bayonne, where he was shown a small whale washed up on the shore that was 50 feet long, although some fishers claimed that this monster was no more than eight days old.

As much as I am able to conjecture from what I have seen of whales and the sea, one should not believe too much of what a Spaniard named Garcie[724] wrote. He says that the American natives fish for whales with two wooden stoppers and a club to drive them into its blowholes and thus kill the whales.[725]

I made a journey of close to 1,400 leagues with a Dutch captain who had just returned from whale fishing. He assured me that whales were taken quite differently from what the Spaniard says; and, as many people have written about it, I will not say what I saw on this point, having nothing different to add.

I will only say that the whale is a very dangerous animal; here is the proof. This animal is so strong that it easily lifts large boats and sinks them. This misfortune occurred not too long ago off the coast of our America. A whale colliding with a boat lifted it out of the water and caused the death of almost all who were on board the shattered boat. It is true that the whale was killed and the sea was red with its blood for 40 paces on either side of the boat, that is 80 paces across.

Other whales turn vessels over. And there are whales that swallow so much water that when they come to expel it through the holes on top of their heads, they put vessels in danger of being sunk. When there is about to be, or when there is indeed a violent storm or *tempête manifeste*, as they say at sea, whales can be seen rising above the waves with so much vigour, and they agitate the sea so much in the place where they dive back in to

the water that, stirring up a double storm, they cause even the biggest ships that are caught up in it to go down with all hands. From what I saw near the steep edges of the Grand Bank, I can confirm that the whale [f. 192] is the most terrifying animal of all the world and all the seas. If it passes at only 20 or 30 paces from a vessel, it seems like a devil let loose, it goes so fast. The sound and the seething of the water that it creates frighten everyone. It looks like a great rushing stream or a river flood that flows as fast as lightning.

The Latins were right, I think, to say that the whale was the beast of the sea because of its inordinate size, *bellua marina*. Our natives call it *matchi-manitou-kikoûns*, the evil demon or the evil fish spirit; others simply say *mamistinga kikouns*,[726] the big fish par excellence.

It is so big, in fact, that its tongue fills more than three *muids*.[727] The whale usually lives on small fish. When it has eaten too much fish or other food, its terrible crying and lowing can be heard from over two leagues away in calm conditions.

Some time ago, close to Cap de Frie[728] in the Gulf of Guanabara,[729] which means "the cape that I keep in sight," a whale was taken that was so fierce that no one dared to approach this beached monster until it was dead. As it was struggling to survive and regain the open sea, it made the earth tremble around its body, and the sound of its thudding and its lowing could be heard more than two leagues away. After all the natives and all the French from the neighbouring coast had taken as much as they wanted, there was still over two-thirds of it left. It was a marvel to see the bones of this mountain, so to speak, which had to be climbed with long ladders.

This terrible monster's tail is made in various cres-

723 François de Bassompierre (1759–1646) was a marshal of France, active under Henri IV and Louis XIII. He is the author of *Mémoires du Maréchal de Bassompierre contenant l'histoire de sa vie et de ce qui s'est fait de plus remarquable à la cour de France pendant quelques années*, published in Cologne in 1665.

724 Pierre Garcie-Ferrande, French sailor born in St Gilles in Poitou, c. 1430, but of Spanish descent. He was the author of *Le grand routier, pilotage & encrage de mer*, in manuscript form since 1483, but printed in 1502. Thirty-two French and eight English editions of this work are known.

725 See Lescarbot, *Histoire de la Nouvelle France*, Book 6, 433–4, where he quotes Joseph Acosta, *Historia natural y moral de las Indias*, translated into French in 1598, Book 3, chap. 15, for a description of the same hunting technique.

726 These phrases are Algonquian. See previous notes for

Manitou. *Kiokoûns* refers to fish. Rhodes (1985) translates *gigoonh* as "fish." *Matchi-* is a prefix that is used to indicate evil, or some other negative quality (see Fabvre, 142 or Silvy, 69 for examples). Pierre Laure (1726) translates "malhonnête (dishonest)" as *matchi-* in comparisons (John Bishop).

727 That is, 840 quarts (or about that many litres) at 280 quarts to a *muid*.

728 The Vallard map of 1547 depicting the South Land bears the Brazilian place names *Cap Fria* and *Rio de enero*. The names are given as *C. de Frye* on the Harleian map of Brazil, and CAP DE FRIE, *C. de Frye et R. de Janeyro* on the Desceliers map, *Amerique ou Bresill*. Those place names have remained on the map of Brazil until the present day as *Cabo Frio* and *Rio de Janeiro* (so named by Gaspar de Lamos in January 1502).

729 The Gulf of Guanabara, on whose shores Rio de Janeiro is situated, in Brazil.

cent shapes. It is so big that it resembles the sail of a large ship. The hide is blackish, tough and thick, firm and strong, with no hair or scales. It is attached to a thickness of more than a foot of very yellow fat, from which is made oil worth 10,000 or 12,000 écus if the whale is of the largest size.

This fish has lungs, kidneys and a bladder. The sexes can be clearly distinguished. The female gives birth to her calf, or at the most two, alive and fully formed. She feeds them with milk and they hang on tightly to their mother's breasts. The mothers will swallow them if they are afraid and regurgitate them afterwards.[730]

On opening them, fishers often find in their belly amber, some froth, water, foam and algae which are marine plants. Signs of fish are not often seen in this great belly, [f. 193] and never any kind of flesh, for the whale does not eat any.[731]

In short, this animal is so prodigious in every way, particularly in size, that it could feed a powerful army for more than a day. Some people mistakenly give the name of whale rib to the fin bones that are used for women's dresses, but since whale ribs are two or three times bigger than those of the small whale, they cannot be used for this purpose.

There is another kind of whale[732] which has four clawed feet, a pointed hook nose, two large teats covered in big scales, two holes on its head as do other whales, and a very large sail on its forehead that serves as its guide.

This kind of whale is as big as a mountain. They easily sink the largest ships they encounter, if they are not turned away by the sound of drums, the fanfare of trumpets and the thunder of cannon fire. To distract them, empty barrels are thrown to them[733] as the ship heads at full sail over the vast ocean seas, where those sailors I spoke about lit a fire on a sleeping whale.[734] Even though seeing these monsters is extremely frightening, it is nevertheless a pleasure to watch one of the barrels that have been thrown in the sea flying into the air, launched sky high by the whale with the end of its nose.[735]

When one of this size is caught and the sea has pushed it on the beach, very long ladders are needed to climb upon it and very large axes to cut it up. A short time ago, a dead one was found on the coast of the island of Faré.[736]

To finish what I have to say about the whale, I will now report a marvel that happened to a Portuguese vessel that was going to India. It found itself one fine morning besieged by a sea monster whose head was higher than the highest part of the poop deck, which is always astern; and with its tail it besieged the ram of the same vessel (the ram is the front of a ship). This tail was as wide as a sail that covered the sea on that side. All the people aboard were afraid and believed themselves lost; and not knowing what to do, they resolved to do nothing but prepare to die and pray to God, who quickly delivered them from this danger. The whale withdrew from the vessel as quietly as it had come. *Creavit deus cete grandia.*[737]

[f. 194] *The eel*[738]
Contrary to my usual practice, I am deliberately ending this treatise on fish and my nineteenth book with one of the smallest species. But as I am making this exception for the eel, I am going to say a few words to you about it and finish as quickly as possible my complete natural history, and so undertake, in six books, the story of all the rare and interesting things that I have noticed in my comings and goings of more than 15,000 or 16,000 leagues of travel. You will find very diverting things in it.

The amazing thing seen in the Northern and Western New World concerning eels has made me resolve to tell you here that there are so many of them that it is a miracle, or rather a marvellous divine providence.

730 False information already in medieval *Bestiaries*; see Gabriel Biancotto, *Bestiaires du Moyen Age*, Paris 1992, who quotes Brunetto Latini, *Le Livre du trésor*, 1263, 170.

731 See *Speculum Regale*, quoted in Y. Cohat, *Vie et mort des baleines*, Paris, Gallimard, 1986, 19.

732 From here on, the description is completely fanciful and inspired directly from old illustrations.

733 Nicolas is describing a scene illustrated in the section of Gesner, *Historia Animalium,* 1587, devoted to marine animals (*De Cetis*), 177.

734 See above, f. 187, apropos the halibut.

735 Illustrated in Gesner; see Cohat, *Vie et mort des baleines*, 16.

736 By speaking of "l'ile Faré," Nicolas betrays that he took this information from Gesner, 176, where we find: "*Cetus ingens, quem incolae Farae insule ichtyophagi, tem-*

pestatibus appulsum, unco comprehesnum ferreo, securibus dissecant, et partiuntur inter se [The inhabitants of the Farae Island, who eat only fish, have caught with their iron hooks a huge Cetacean pushed ashore by the storms and, having cutting it in pieces, share it among themselves]" as a caption to a figure showing people cutting a whale beached on land. It could be the Faroe Islands in the North Atlantic Ocean.

737 Genesis 1:21: "Creavitque Deus cete grandia [And God created great whales]."

738 *Anguilla rostrata* (Lesueur), American eel, depicted in the *Codex*, Pl. LXVI, fig. 84.2, as "figure de Languille dont dans la colonie francoise on en prend plus de cinquante mille bariques dans trois mois tous les ans." Boucher mentions it also (Rousseau 1964, 331).

During three months of every year, twenty or thirty thousand barrels full, each containing five hundred of them, are taken within a range of only 15 or 16 leagues from one or the other side of the Saint Lawrence.

The eel of this country tastes much better than the eels caught in France, and it is so common that there are fishers who have found five or six thousand of them in their nets in one day. They are excellent, and keep very well if salted. Five thousand eels fill ten barrels or ten *poinçons*.739 Each barrel, in which there are five hundred, sells on the shore and almost from the net for thirty livres. It is a marvellous food, in that it is so fat that it needs no seasoning. It is eaten roasted without seasoning; and even boiled, it serves as butter and fat for making soup.

The fishing of this species is remarkable. It begins in August and does not end until after All Saints' Day. The fishers set their traps and nets on the riverbank when the tide has gone out. The rising sea covers all these devices, and when it goes down again, leaving the shore dry once more, our fishers find countless eels in their nets, traps and various pens that they set up for the purpose. The heaviest catch is under the waning moons of September and October, when the nights are very dark. Sometimes so many are caught that the fishers are forced to give them away, and even to throw away prodigious quantities if they are short of salt. The eels are caught in nets, and ashes are thrown onto them. At this time there is a terrible writhing among the eels, which tie themselves together in knots. [f. 195] They are taken by the dozen and put in sacks to be taken from there to the barrels, which are on the shore, where they are thrown by the bagful to have a little salt put on them, so that in their extraordinary wriggling they finish casting off the extremely sticky silt and slime from their skin. The eel, which is very hardy, and lives for five or six hours out of water when uninjured, dies in less than an hour after it has been sprinkled with ashes and salt as I just described. Some time after it is dead, it is washed very clean without gutting it. When the eels are dry or the water has seeped out, they are placed in very clean barrels that are kept from one year to another. To that end, a bed of salt is thrown in at the bottom, then a layer of eels, a layer of salt, a layer of eels, until the barrel is filled or until there are at least five hundred in each one. It must be noted here that the Canadian eel is bigger than that of France, usually by a factor of three.

The eel is taken a second way: with a spear. Only the natives practise this kind of fishing, which they do at night with torches. It takes them hardly any time at all to spear canoes full of them in less than half a foot of water. Their way of preparing eel is to open it up along the back and to smoke it, and then make large bundles of them when they have been smoked enough, for these people do not use salt.

But to give you a complete understanding of the eel, I will say that its French name *anguille* comes from its snake-like shape. *Anguilla*, the Latins say; *quasi ab angue cuius speciem fert.*740

Ordinarily it is born in fresh waters. In France on the Languedoc coasts, it is born, lives and is caught in salt water. The ponds at Frontignan and Maguelone741 are full of them in the season when they produce. I saw the famous eel fishery at the gates of Frontignan, where they are caught with string nets, whereas our Frenchmen catch them with wooden nets. They are much smaller than in the Indies. I will take this opportunity to say that in the same place I saw another marvellous fishery, where the fish are taken in nets that are out of the water, when the path of a certain large, very good fish whose name escapes me, is blocked off. The fish cannot find a way out and so it throws itself into the net.

In the New World the eel is born, lives and is caught in freshwater lakes, ponds and rivers and never anywhere else. All those who have seen and examined the eel know well that it is a long fish, slimy, without scales, slippery, armed with very small teeth, and easily skinned. The skins are widely used among the French and the natives. Some use them as straps for their flails. The natives treat them and make long tresses to tie up girls' hair. The women who do this use all the intestines, and the liver in particular, to soften the skins and to clean them.

[f. 196] The eel has only two fins, small eyes and flat ears. Its mouth is rather wide; its nose is sharp with two holes at the end. It lives only on silt. It has a large, flat head. The male is distinguished from the female by the head, which is smaller and not as wide in the female. The flesh is fat and oily.

The eel is born from rotting material as worms are in earth. An experiment was done with a dead horse that was dragged into the pond at Maguelone near Montpellier. When it was rotten, an infinity of little eels was found under it and all around it. Someone said

739 See *poinçon* in the Glossaire.
740 "The eel has almost all the characteristics of the snake."

741 A small island near Palavas and Montpellier in the South of France, famous for its twelfth-century cathedral.

that eels are formed from old dead eels, and that is more likely.

Aristotle maintained that the eel is born neither from the male nor from the female, like ordinary animals; and to tell the truth, I have never seen, in the countless eels that I have opened up or seen opened, that there were any eggs or any trace of semen in their entrails.

In my own opinion, I would suggest that the eel has on the outside a secret regenerative power that we do not understand. It deposits this in the silt or sand when an infinity of them intertwine themselves in great mounds. When this external seed, which is attached to the outside of the skin, falls off, it is converted into silt, from which eventually come the prodigious quantity of eels that we see on the banks of the Saint Lawrence River, from the great Cape Tourmente to Montreal. This distance of about 80 leagues makes up the space of the entire French colony, which already numbers nearly twenty thousand souls.

This opinion should not be rejected, I think, since all learned people acknowledge that many animals are engendered in rotting material, such as the scorpion, the snake and even the mouse. Why can the same not be said of the eel?

Whatever the truth may be, it is more important for us to know that countless eels are caught and eaten than to know where they come from, how they are formed or whether they go to die in the salt water of the river. I defer judgment on this, but I have never seen it, and it must not be so, for a convincing reason: for if it were, then our river, which does not suffer any filth within it, would have expelled them onto its banks in the first storm, or even with the first wind that blows there continually from either the south, the north, the west or the east across its great breadth.

After that, it is time for me to end my natural history, and to begin my six final books on the state of the more than hundred nations that I frequented in the Indies, where you are going to see a thousand rarities of that vast country.

THE END

Natural History, or the faithful search for everything rare

HISTOIRE NATURELLE
DES INDES OCCIDENTALES

MODERNISATION DU TEXTE FRANÇAIS

Nous avons établi le texte de Louis Nicolas sur le manuscrit conservé à la Bibliothèque nationale de France (Ms. fr. 24225). Pour le rendre accessible à un large public, nous avons modernisé l'orthographe, l'accentuation et la ponctuation. Nous avons enlevé la majuscule aux noms communs et l'avons ajoutée aux noms propres. Tout en conservant ce que nous pouvions de la ponctuation originale, fort anarchique, nous avons transformé ce qui risquait de provoquer contresens ou de gêner considérablement la lecture. Nos interventions les plus fréquentes ont porté sur le gommage de la virgule entre le sujet et le verbe (entre la principale et la complétive), sur le remplacement de virgules et de deux-points par le point-virgule, et sur l'introduction de deux-points et de guillemets pour marquer le style direct. Selon que le sens l'exigeait, nous avons remplacé les deux-points suivis de la majuscule par un point ou par une virgule suivie de la minuscule. Enfin, nous avons corrigé les fautes de typographie manifestes.

Les mots disparus du français moderne, ou dont le sens a changé, sont marqués d'un astérisque la première fois qu'ils apparaissent dans chacun des treize «Livres», pour être ensuite répertoriés dans le glossaire.

On ne trouvera pas dans les notes en bas de pages la traduction de toutes les notes de la traduction anglaise de «l'Histoire naturelle». Nous n'avons retenu que les notes d'identifications des plantes et des animaux, ce qui nous a permis de donner les noms français actuels des espèces mentionnés par Nicolas. On notera que les références à Banfield pour les mammifères et à Godfrey pour les oiseaux renvoient ici à la traduction française de ces ouvrages, d'où les différences de pagination

avec les références aux éditions anglaises citées en bas des pages de la *Natural History of the New World*.

Il arrive à Louis Nicolas d'ajouter un mot ou deux entre les lignes, voire même des passages entiers dans les marges du texte. Nous les avons indiqués en les mettant entre deux traits obliques (/ /).

Louis Nicolas a divisé son texte en treize livres, regroupant par exemple, dans le quatrième, les «animaux terrestres», et dans le dixième, les «oiseaux de chasse ou de rapine». Il a tenu à signaler aussi, en marge, chacun des huit «cahiers» qui ne touchent plus l'organisation de la matière, mais renvoient plutôt au support matériel du texte; nous les avons mentionnés dans notre transcription.

Je tiens à remercier vivement trois collègues qui m'ont été d'une aide précieuse pour les citations en latin et en grec : Alban Baudou et André Daviault pour le latin et Gilles Maloney pour le grec.

RÉAL OUELLET

HISTOIRE NATURELLE,

ou la fidèle recherche de tout ce qu'il y a de rare dans les Indes occidentales: où il est traité, en général et en particulier, des simples, des fleurs, des grains, des herbes, des fruits, des arbrisseaux, des grands arbres, des animaux à quatre pieds terrestres et aquatiques, des oiseaux qui vivent sur la terre et de ceux qui vivent dessus ou dedans l'eau, et enfin des poissons d'eau douce, et de quelques-uns de la salée, de divers insectes et de plusieurs reptiles avec leurs figures. Divisé en douze livres. Par M. L. N. P.*

LIVRE PREMIER

Mon Dieu que je suis fâché de m'être embarqué dans une entreprise aussi difficile qu'est celle de faire un narré* du Nouveau Monde, où il y a tant de choses à dire, et où, ne sachant par où bien commencer, j'avoue que je suis étrangement* en peine, car quelle apparence* y a-t-il, même après vingt ans d'un travail assidu et de fort grands voyages réitérés, je puisse dire tout ce qu'il faut de tant de belles curiosités d'un pays* étranger, où toutes choses sont différentes du nôtre? Quel moyen de réduire en petit tant de si vastes terres et de parler en peu de mots de tant de différents objets, desquels si je voulais discourir à fond je n'aurais jamais fait*? Ainsi, laissant tout autre discours*, je vais m'attacher à vous faire comprendre l'état des choses naturelles d'un pays dont nous n'avons pas encore découvert les bornes, quoique nous ayons vu des hommes qui venaient de cinq cents lieues* au-delà des douze cents que nous avons parcourues, soit sur le fleuve de Saint-Laurent, ou au-delà de sa source que nous n'avons pas encore / découverte /, quoique nous ayons été à neuf cents [lieues] au-delà de son embouchure et de sa décharge dans le grand océan, entre la fameuse île de Terre-Neuve et entre celle de Bacailos.

Établissons donc en premier lieu l'état d'un pays presque infini, où vous allez voir une variété admirable de montagnes, et entre autres la fameuse / *Kickic* / *Kinouapikouàtina*, qui veut dire, en langue du pays, la / grande / longue montagne: aussi* a-t-elle bien près de mille lieues, à commencer au pays des Esquimaux et à finir à celui des Nadouessiouek.

C'est une chose bien rare de voir une infinité de fontaines, des ruisseaux, des rivières de toutes les grandeurs, de grands et une infinité de petits lacs sortir du sein de cette affreuse montagne toute couverte de forêts très épaisses de bois de [f. 2] haute futaie, entrecoupées de précipices horribles, de cavernes épouvantables, de vallées très vastes, de campagnes à perte de vue, de grandes collines pleines d'animaux et de plusieurs nations d'hommes qui, bien qu'elles ne soient pas nombreuses, ne laissent pas d'avoir bien de choses rares qu'on peut dire de leurs mœurs, de leur police*, de leur religion, de leurs sacrifices, comme je le touche dans mes derniers ouvrages.

Si, avec tout cela, vous voulez considérer* dans nos Indes une infinité d'autres montagnes, de plaines, de vallons, de collines, de bois, de rochers, de précipices, d'éminences, d'enfoncements, de pelouses, de broussailles, de terres tremblantes, de savanes, qui sont de plages* où l'on ne peut marcher que lorsqu'il gèle bien fort, des gravières de quatre à cinq cents lieues d'étendue de pierres, de cailloux, des herbes, de fruits, de montées, de descentes, de bonne et mauvaise terre, du froid, du chaud, de glaces, de neiges, de pluies, de frimas, des brouillards, de tempêtes, des tremble-terre*, des animaux inconnus, des oiseaux d'une infinité d'espèces qu'on ne connaît point en Europe, de poissons d'une grandeur démesurée et d'une figure surprenante, et bien d'autres choses. Vous y trouverez de tout; et particulièrement vous y découvrirez de très beaux et de très grands lacs, des rapides et des sauts* au milieu des brisants, des rochers, où très souvent l'on fait de fort tristes* naufrages, comme je le fais

voir dans mes six premiers livres. Vous remarquerez, en passant sur cette grande terre, des pierres de diamant au pied d'une montagne qui porte le nom de cap de cette pierre précieuse; vous verrez des marbres de toutes les couleurs, sur les rives du plus grand fleuve du monde. Dans les terres, on voit du charbon, du plâtre, des marcassites*, des pierres à feu, des pierres à faire des dards*, des lances et des haches à l'ancienne façon* des Américains*.

Sous le saut de Montmorency et sous les cascates ou cascades du saut aux Calumets, vous verrez des pierres propres à faire des pipes de couleur grise, blanche, noire et verte. Si vous en voulez des rouges, vous n'aurez qu'à grimper sur la haute montagne qu'on voit sur la plage du nord de la mer Tracy, ou du grand lac Supérieur, que les Barbares nomment le *Grand Lac*. Dans le pays des Nadouessiouek, vous y achèterez des turquoises qu'ils pendent à leurs oreilles, au bout de leur nez ou à leur col*. Vous y aurez, à fort bon marché, cette autre sorte de très belle pierre rouge comme du sang, au grain très fin et fort délicat. Et si l'envie vous prenait de bâtir, la pierre à chaux n'y manque pas, ni des belles carrières. Sur le bord des rivières et sur les vastes rives des Grands Lacs, vous trouverez mille petites raretés, des coquillages, des porcelaines* de toutes manières*, des pierrotages de toutes les couleurs et de diverses figures fort agréables. La pierre de taille de tout grain n'y est pas rare. Les pierres pour les moulins y sont communes; on y en trouve pour affiler toute sorte d'instruments. Le tœuf*, la pierre ponce y sont d'un grand usage pour y passer* en blanc les peaux des bêtes fauves que les sauvages tuent, car c'est là tous les instruments qu'il leur faut pour toutes ces sortes d'ouvrages*.

Fouillez si vous voulez dedans les sables des grands monts [f. 3] de sable et sur toutes les rives de la mer Tracy, vous y trouverez des minéraux et quelque beau lingot de cuivre rouge aussi beau et aussi purifié, et aussi fin que s'il sortait du fourneau. Le plomb est dans l'anse des Ouchepé et sur le bord d'un lac qui est sur les terres du nord et dans le pays de la nation des Outimiskami. L'ardoisière du lac Champlain est célèbre, et la mine de plomb qu'on y a découverte fournira peut-être un jour autant de ce métal qu'il en sera besoin pour la nécessité de tout le pays.

Le fer y est en abondance dans la terre du Cap-de-la-Madeleine; on fait quelque bruit qu'il y a de l'argent bien près de l'île au Coudre; cela n'est pas sûr.

En chemin faisant et parmi toutes ces merveilles, vous pourriez quelquefois être surpris de quelque effroyable tremblement de terre : il y en a eu plus de dix de mon temps. La mer y est si émue* quelquefois qu'on ne saurait le comprendre; il y a quelques années que* nous vîmes des émotions* de la terre tout à fait épouvantables : des montagnes se séparèrent en deux, le cours de diverses rivières fut changé, les arbres arrachés, des terres s'éboulèrent; on vit des rochers sauter en l'air, les monstres marins mugissaient d'une étonnante manière.

Dans ces rencontres*, les vaisseaux souffrirent des effroyables secousses sur les bouillonnements extraordinaires des eaux : ils furent obligés de laisser leurs ancres en mer pour se tirer au plutôt* au large; mais nonobstant cela, ils souffrirent sous leur quille des étranges émotions des flots qui, se retirant d'une merveilleuse* vitesse, et comme imperceptiblement de dessous les navires, ces bâtiments tombaient tout d'un coup avec un craquement étrange de toutes leurs parties avec danger d'être engloutis à chaque moment.

On sent des coups de vent si rudes qu'on est contraint de se tenir l'un l'autre de crainte qu'on a d'en être enlevé. Il y souffle parfois des vents qui fondent toutes les glaces et qui les regèlent en même temps, et d'autres tout contraires qui les gèlent et qui les fondent à leur tour. De vous dire maintenant comment cela se peut faire, je veux vous le laisser à penser, pour suivre l'avis de personnes qui m'ont dit que, si je me voulais rendre agréable aux personnes du goût le plus fin, je devais ne faire aucune réflexion sur ce que j'avais à raconter : ainsi, trouvant leur avis très judicieux, je tâcherai de retrancher tout ce qui me paraîtra inutile, m'attachant simplement au narré le plus succinct de tout ce que j'aurai à dire.

La remarque que j'ai fait touchant les différences des jours et des nuits mérite qu'on s'arrête un moment pour la considérer. Le jour est en France six heures entières, et un peu davantage plus tôt qu'aux Indes; j'en ai fait les épreuves* par les éclipses marqués dans les almanachs. La chose est facile : on n'a qu'à remarquer à quelle heure il arrive en France, et si on trouve qu'il n'arrive aux Indes qu'aux heures que je marque*, ce que je dis sera démonstratif.

[f. 4] Après ces remarques générales, qui ne font pas peu pour la connaissance de ce que j'ai déjà dit et de ce que je vous dois faire savoir, permettez-moi de vous dire que je prendrais un singulier plaisir de vous voir non pas sur le lac Majeur en Italie, ni sur celui d'Ygrada, ou d'Yesso, ni de Côme, ni de Constance, ni même sur celui de Genève. Ces lacs sont trop petits, et ne sont pour ainsi dire que des grenouillères, et ne méritent point le nom de lacs parmi les Américains, non plus qu'une infinité de *sakaigans*. C'est un nom que les sauvages donnent à un très grand nombre de petits lacs qu'il y a par toute l'Inde, bien plus grands que tous ceux

que je viens de nommer, et qu'ils n'estiment pas comme les véritables lacs, leur donnant un nom de mépris*, comme qui dirait les *sakaigans* ne sont que des grenouillères, quoique les *sakaigans* aient vingt ou trente ou même quarante lieues de tour. Les mers douces sur lesquelles ils naviguent, sur des écorces d'arbres, sont leurs lacs. La grande mer océane est le lac par excellence. Le lac Puant, c'est un puissant génie disent-ils, auquel ils font des sacrifices : *Manitou-kitchigami*, qui veut dire le génie de grand lac. Techirogouen est un des plus petits. Ceux de Saint-Pierre, de Saint-Louis, de Saint-François, de Saint-Jean, du Saint-Sacrement, le lac des Montagnes, celui de l'entrée à la rivière Creuse, le lac des Abenaquiois, qui feraient tous ensemble plus de trois cents lieues de circuit* ne sont pas des lacs, ce ne sont que des *sakaigans*. Le lac Champlain, bien qu'il ait deux cents lieues de tour, Mistassin trois cents, Nipissin cent, Ontario plus de trois cents, Herié trois cents, ne sont que de ces petites étoiles audessous de celles de la première grandeur, qui s'étend à cinq cents comme la mer Douce des Algonquins Supérieurs, comme la mer Tracy à sept cents et comme enfin le Mitchigané, ou le lac des Illinois, qui veut dire le lac des Hommes, a mille quatre cents lieues de

contour avec un peu de flux et de reflux, qu'on sent encore dans l'Alimibegou, qui est un autre lac sur la côte du nord à dix grandes journées loin du lac Supérieur. Alimibegou n'a que quatre cents lieues de tour. Je ne dis rien du lac des Kiristinons, qui est fort grand au rapport* de ces nations, car je ne l'ai pas vu, bien que j'en sois passé bien près.

Voilà ce que je puis dire en général d'un pays que j'ai fort examiné comme vous avez déjà pu juger de mes premiers ouvrages, et comme vous avouerez par dixhuit livres qu'il me reste à vous produire.

Traité des simples, des fleurs, des grains et des herbes qui croissent naturellement et artificiellement dans le pays des Indes occidentales

L'amarante[1], l'anémone de diverses couleurs[2], l'aubepin[3] plus gros et beaucoup plus beau que celui de France même en son fruit, qui est gros en ce pays comme des noisettes, de sorte que les habitants [f. 5] lui donnent le nom de pommes; la couronne impériale,[4] l'églantine[5] ou l'aquilegia rouge particulière au pays (c'est la fleur à l'oiseau-mouche),[6] la giroflée[7] de diverses couleurs et de différentes odeurs, le glaïeul[8] ou

1 *Amaranthus retroflexus* L., amarante réfléchie, ou *Amaranthus graecizans* L., amarante parente. On trouve les deux espèces au Québec; voir Frère Marie-Victorin, *Flore laurentienne*, 198–9; désormais, «Marie-Victorin».

2 *Anemone* sp. Observées en Nouvelle-France par Pierre Boucher en 1664 (voir Jacques Rousseau, «Pierre Boucher, naturaliste et géographe», dans Pierre Boucher, *Histoire véritable et naturelle…, 1664*, 262–400; désormais, Rousseau 1964). Rousseau proposait *A. pulsatilla* (L.) (synonyme : *Pulsatilla vulgaris* Mill.), pulsatille vulgaire et *A. coronaria* L., anémone de Caen. Si Nicolas avait en vue des espèces indigènes, on penserait plutôt à *A. canadensis* L., anémone du Canada, déjà décrite avant 1620 (voir H.O. Juel, «The French Apothecary's Plants in Burser's Herbarium», 177–9; désormais, Juel) et à *A. virginiana* L., anémone de Virginie (Marie-Victorin, 232), mentionnée en 1708 (B. Boivin, «La flore du Canada en 1708», 223–89; désormais, Boivin) (Alain Asselin).

3 Probablement la *Crataegus punctata* Jacq., aubépine ponctuée, étant donné que Nicolas la compare à une espèce européenne, la *Crataegus oxyacantha* L., aubépine commune (Marie-Victorin, 300–1). Selon Rousseau, c'est l'aubépine décrite par Jacques Cartier (voir J. Rousseau, «La botanique canadienne à l'époque de Jacques Cartier», 151–236; désormais, Rousseau 1937) et par Boucher en 1664. John Josselyn (voir *Proceedings of the Essex Institute*, 1848–1856, t. 1; désormais, Josselyn) la décrit en Nouvelle Angleterre en 1672 et affirme qu'elle ne diffère pas de l'espèce qu'on trouve en Angleterre (Alain Asselin).

4 *Fritillaria imperialis* L., fritillaire ou couronne impériale, qui n'est pas une plante canadienne; originaire de l'Iran, de l'Afghanistan et des Himalayas, elle n'est introduite en Europe qu'en 1580; voir L. Guyot et P. Gibassier, *Les noms des fleurs*, 107; voir aussi R.G. Hatton, *Handbook of Plant and Floral Ornament*, 456, fig. 917. Hatton tire son illustration de John Gerarde, *The Herball, or Generall Historie of Plants*, 153.12; désormais, Hatton). Alain Asselin note que van der Donck la signale en Nouvelle-Hollande (voir van der Donck, *Description of the New Netherlands*; désormais, van der Donck).

5 Probablement *Rosa blanda* Ait., rosier inerme et/ou *R. johannensis* Fernald, rosier du fleuve Saint-Jean (Marie-Victorin, 325) (synonyme : *R. blanda* Ait. var. *glabra* Crép., USDA), tous deux appelés «rosier sauvage» ou «églantier». Van der Donck connaissait cinq espèces de rosiers déjà introduits en Nouvelle-Hollande (Alain Asselin).

6 *Aquilegia canadensis* L., ancolie du Canada; voir Marie-Victorin, 228, qui constate aussi que l'oiseau-mouche visite cette fleur. Mentionnée dans Jacques Philippe Cornut en 1635 (voir J. Mathieu et A. Daviault, *Le premier livre de plantes du Canada*; désormais, Cornut); on la trouve dans la liste du Jardin de Paris en 1636 ou dans celle de Montpellier en 1697 (voir P. Magnol, *Hortus Regius Monspeliensis,* 1697; désormais, Magnol) (Alain Asselin).

7 Possiblement *Erysimum cheiri* (L.) Crantz., *E. cheiranthoides* L., vélar giroflée (Marie-Victorin, 270), voire même *Hesperis matronalis* L., julienne des dames

l'iris[9] de trois façons, naturel et particulier au pays, le lys blanc transporté*[10], le rouge commun au pays[11] (ils ne fleurissent qu'à la fin de juillet), le lilas d'Europe[12], des martagons très beaux[13], d'autres martagons sauvages qui ont du moins* trente fleurs à chaque tige de couleur de gris de lin[14]. Les peuples de ces pays font

bouillir les oignons et les mangent, et les appliquent sur les tumeurs qui désenflent. Les marguerites[15] y sont blanches. Il y a des muguets blancs, bleus et gris de lin*[16]. Il n'y a que des narcisses jaunes simples[17]. On en voit quelques doubles dans les jardins. On y voit des œillets de toutes les façons transportés[18], passe-

(Marie-Victorin, 256), étant donné que *Hesperis* sert à identifier *Erysimum* et *Sisymbrium* (voir Boivin). La *Giroflea* de J. Ruel est nommée *Hesperis* (voir J. Ruel, *De natura stirpium libri tres* ; désormais, Ruel). Boivin hasarde que l'une des plantes de «La flore du Canada en 1708» est *E. inconspicuum* (S. Wats.) MacM. (Alain Asselin).

8 Le *Gladiolus* est cultivé; on en connaît 250 espèces. Voir Père Louis-Marie, *Flore-manuel de la province de Québec*, 116 (désormais, Louis-Marie). Asselin note qu'on se sert du terme *Gladiolus* comme synonyme de l'iris, comme l'indique Nicolas. Mattioli affirme que le «glayeul» et la «flambe» sont synonymes de l'iris, tandis que le nom français du *Gladiolus* est «glai ou glaitel» et non pas «glayeul» (P.A. Mattioli, *De plantis Epitome utilissima*; désormais, Mattioli).

9 Les deux premières espèces indigènes d'iris mentionnées par Nicolas sont vraisemblablement *I. versicolor* L., l'iris versicolore (Marie-Victorin, 667), et *I. setosa* Pallas, l'iris à pétales aigus (Marie-Victorin, 668). La troisième espèce pourrait être *Sisyrinchium angustifolium* Miller, bermudienne à feuilles étroites, puisqu'on la connaissait déjà avant 1620 (Juel). Josselyn mentionne en 1672 les usages médicinaux de l'*I. versicolor* L. en Nouvelle-Angleterre. Boivin identifie correctement l'*I. setosa* Pallas.

10 *Lilium candidum* L., lis blanc, est déjà signalé en Nouvelle-France par Boucher (Rousseau 1964) et par van der Donck en Nouvelle-Hollande. Nicolas décrit un autre lis, le «lys des vallées», dans la section qu'il consacre à l'orignal et indique ses usages médicinaux à cet endroit. Il lui accorde son nom biblique, *Lilium convallium*, et nous apprend qu'on le nomme «chevrotin» à Paris. Il ajoute qu'il produit les mêmes effets thérapeutiques que le «nard de Celte», probablement *Valeriana celtica* L. (Alain Asselin).

11 *Lilium philadelphicum* L., lis de Philadelphie (Marie-Victorin, 658). Observé par P. Boucher en Nouvelle-France en 1664 (Rousseau 1964) et par van der Donck en Nouvelle-Hollande (Alain Asselin).

12 *Syringa vulgaris* L., lilas vulgaire (Louis-Marie, 213). On en décrit plusieurs variétés dans la liste de 1683 du Jardin d'Édimbourg (F.W. Robertson, «James Sutherland's *Hortus Medicus Edinburgenis*, 1683», 121–51; désormais, Robertson), alors que la liste de 1697 du Jardin de Montpellier ne contient qu'une *Syringa* (Magnol). R. v. J. Dodoens, dans son *Stirpium historiae pemtades sex sive libri* xxx, 1616; désormais, Dodoens) affirme que le mot «lillach» appartient au vocabulaire médical.

13 Nicolas a peut-être pris notre *Lilium canadense* L., lis du Canada pour le *Lilium martagon* L., lis martagon

d'Europe, d'autant qu'il arrive que le nôtre aussi soit rouge. Les bulbes sont comestibles (Anna Leighton). Rousseau 1964, 300 explique que le *Lilium tigrinum* Ker Gawl, lis tigré, est d'une introduction récente (vers 1804) dans l'est du Canada. Alain Asselin croit que le lis sauvage jaune observé par van der Donck en Nouvelle-Hollande pourrait bien être notre *L. canadense* L. Par contre, *Erythronium americanum* Ker Gawl, l'érythrone d'Amérique, est décrit par Cornut en 1635 et on le trouve aussi en 1708 chez Boivin).

14 Il n'est pas facile d'identifier l'espèce indigène qui comporterait au moins trente fleurs gris de lin sur chaque tige et posséderait des bulbes comestibles. *Polygnatum pubescens* (Willd.) Pursh, sceau de Salomon pubescent (Marie-Victorin, 644) est un candidat, mais Nicolas identifie plus loin deux autres Sceaux-de-Salomon. Deux espèces de *Streptopus* portent respectivement des fleurs verdâtres ou roses (Marie-Victorin, 652), alors que deux espèces d'*Uvularia* portent des fleurs jaunes (Marie-Victorin, 653). *Uvularia sessilifolia* L., uvulaire à feuilles sessiles, possède des fleurs d'un blanc crème mais pas en aussi grand nombre que L. Nicolas le suggère. *Zigadenus glaucus* Nutt., zigadène glauque, porte plusieurs fleurs verdâtres ou jaunâtres et la plante est vénéneuse. *Uvularia perfoliata* L., uvulaire perfoliée est mentionnée en 1708 par Boivin pour ses vertus médicinales chez les Amérindiens. Par contre il est difficile de parler de fleur gris de lin dans ce cas (Alain Asselin).

15 Le texte suggère qu'il ne s'agit pas de *Chrysanthemum Leucanthemum* L., la marguerite des nomenclatures populaires (Marie-Victorin, 589) mais d'une espèce indigène. Peut-être une espèce d'*Erigeron* à rayons blancs comme l'*E. canadensis* L., érigéron du Canada, qu'on connaissait déjà en France en 1656 (Dodoens) et qui est mentionné dans «La Flore du Canada en 1708» (Boivin). Cornut en 1635 nous met sur la piste d'une autre espèce possible, *E. annuus* (L.), érigéron annuel.

16 La seule espèce voisine de la *Convallaria majalis* L., muguet, au Canada est la *Maïanthemum canadense* Desf., maïanthème du Canada (Marie-Victorin, 649) selon Rousseau 1964, 300; voir Hatton, 455, fig. 912, qui reproduit une illustration de J. Gerarde, *The Herball, or Generall Historie of Plants*, 331.2. Le fait que Nicolas mentionne diverses couleurs est probablement signe qu'on avait déjà introduit quelques variétés de *C. majalis* L. en Nouvelle-France (Alain Asselin).

17 Il ne peut s'agir que de *Narcissus jonquilla* L., jonquille; voir Hatton, 516. Asselin constate qu'on en trouvait déjà dans les jardins européens; voir G. de La Brosse, *Description du jardin royal des plantes médicinales étably par le roi Louis le Juste à Paris*; désormais, de La Brosse);

velours[19] doubles et simples, passe-roses[20] ou roses de Pâques[21] de toutes couleurs, doubles et simples, pavots[22] de toutes couleurs, doubles et simples, renoncules jaunes[23], grosses et doubles, croissent dans l'eau à grosses houppes. Il y a, dans les parterres et à la campagne, des roses de toutes les espèces, excepté de ces belles roses de Damas[24] à cent boutons à chaque rameau, des soucis doubles et simples[25], des violettes sans odeur[26], des tournesols dont les Américains font de l'huile fort douce[27]. Ils en assaisonnent leurs bouillies et s'en frottent les cheveux.

Il y a encore trois ou quatre autres sortes de différents héliotropes ou tournesols[28] dont les racines sont très bonnes à manger, comme celles des *ounannatas* des *toubinenbourgs*[29]. Les *outaragouara* jettent* une racine que l'on mange et qui ressemble au fruit du haricot[30].

Toutes ces terres produisent des tulipes de toutes couleurs[31], des pensées blanches, doubles et simples[32]. Elles ressemblent à la violette, mais elles n'ont point d'odeur, comme presque aussi toutes les autres fleurs naturelles au pays du Nouveau Monde.

La cardinale[33] se fait remarquer par sa belle couleur.

voir aussi Robertson and Magnol (Alain Asselin).

18 Plusieurs espèces de *Dianthus* sont maintenant cultivées au Québec (Louis-Marie, 144). Boucher les signale en 1664 (Rousseau 1964, 84). Un candidat vraisemblable, comme l'a proposé Rousseau 1964, est le *D. caryophyllus* L., qui avait des vertus médicinales en plus (Robertson). *D. plumarius* L. et *D. barbatus* L. se présentent aussi comme des candidats éventuels (Alain Asselin).

19 D'après Mattioli, «passevelours» ne désigne qu'un *Amaranthus*. Mais, on a employé ce mot plus tard pour désigner la *Pulsatilla vulgaris* Mill., anciennement connue sous le nom d'*Anemone pulsatilla* L., anémone pulsatille (Alain Asselin).

20 *Alcea* (ancienne *Althaea*) *rosea* L., rose trémière, signalée en Nouvelle-France par Boucher en 1664 sous le nom de «rose sauvage» (Rousseau 1964, 300).

21 M. Faribault, «Les phytonymes de l'*Histoire naturelle des Indes occidentales* de Louis Nicolas : image du lexique botanique canadien à la fin du XVIIe siècle», dans Thomas Lavoie, *Actes du quatrième Colloque international de Chicoutimi, Québec, 21–24 Septembre 1994*, Max Niemeyer Verlag, Tübingen, 1996; désormais, Faribault 1996, lit «rozes d'Espagne», qui semble mieux convenir que «roses de Pâques». Il pourrait aussi s'agir d'*Althea rosea* L. (Alain Asselin).

22 *Papaver somniferum* L., pavot (opium). Puissante plante médicinale, déjà dans les jardins d'Europe (de La Brosse, Robertson et Magnol) (Alain Asselin).

23 *Ranunculus acris* L., renoncule âcre (Marie-Victorin, 227).

24 On connaît deux espèces de cistes en Méditerranée : *Cistus villosus* L., ciste de Crête et *Cistus salviifolius* L., ciste à feuilles de sauge; voir N. Feinburn-Dothan et R. Koppel, *Wild Plants in the Land of Israel*, 56–9.

25 Ou la *Caltha palustris* L., populage des marais (Marie-Victorin, 222), est une fleur jaune indigène ou une espèce de *nénuphar* (Marie-Victorin, 239), qui l'un et l'autre poussent dans l'eau. *C. palustris* est déjà mentionné chez Boivin, «La flore du Canada en 1708» (Alain Asselin).

26 Probablement une de nos violettes (*Viola*) sans odeur, ce qui la distingue de la *V. odorata* L. européenne. Boucher en signale une espèce en Nouvelle-France en 1664 (Rousseau 1964). Josselyn connaissait déjà trois espèces de violettes en Nouvelle-Angleterre et van der Donck compte une *Viola* parmi les plantes à vertu médicinale.

V. canadensis L., violette du Canada (Marie-Victorin, 281), odiférante, est signalée dans «La flore du Canada en 1708» (Boivin) et décrite par Juel avant 1620 (Alain Asselin).

27 *Helianthus annus* L., hélianthe annuel (Marie-Victorin, 587–8). Asselin nous apprend que les Amérindiens cultivaient cette plante. Connu des premiers découvreurs, Champlain, Sagard et Boucher, l'hélianthe est décrite sous la désignation *Planta solis* par le botaniste et médecin français Charles de l'Écluse (Carolus Clusius) en 1601. (Voir A. Ubrizsy et J. Heniger, «Carolus Clusius and American Plants», 424–35). On la trouvait dans les jardins en Europe, notamment à Édimbourg (Robertson) (Alain Asselin).

28 Parmi lesquels on compte l'*Helianthus tuberosus* L, hélianthe tubéreux (Marie-Victorin, 588–9). On le cultivait dans les jardins d'Édimbourg en tant que «French potatoes» ou «Jerusalem artichoke» (Alain Asselin).

29 *Helianthus tuberosus* L.

30 Cette description fait penser à *Amphicarpa bracteata* (L.) Fern, amphicarpe bractéolée (Marie-Victorin, 355) (Anna Leighton). Au folio 9, Nicolas décrit l'*Outaragouara* comme une pomme de terre sauvage.

31 Des variétés de *Tulipa*, si l'on songe à des espèces introduites au Canada, dont la *Tulipa gesneriana* L. (mentionnée par James Sutherland, selon Robertson). Rousseau 1964 croit que les tulipes mentionnées par Boucher sont d'introduction récente. Van der Donck les mentionne parmi les fleurs importées en Nouvelle-Hollande en 1655. Il se pourrait que Nicolas ait eu en vue *Erythronium americanum* Ker Gawl, déjà mentionné. On a déjà fait l'hypothèse que cette plante était une forme indigène du lis. Il est vraisemblable qu'elle soit une *Erythronium*, représentée dans le *Codex*, Pl. XXIII, fig., 40.3, sous la désignation «herbe a trois couleurs».

32 *Viola tricolor* L., violette tricolore (Marie-Victorin, 281–2 note que le nom populaire «pensée» existe depuis 1541). *V. Canadensis* L. et *V. tricolor* pourraient également être visées ici. Cette dernière se trouve avec des fleurs jaunes, pourpres ou blanches. On collectionnait déjà en 1620 la *V. tricolor*, qui est mentionnée aussi chez Boivin «La flore du Canada en 1708». En 1672, Josselyn affirme que les violettes de la Nouvelle-Angleterre sont pareilles à celles de l'Angleterre (Alain Asselin).

33 *Lobelia cardinalis* L., lobélie du cardinal (Marie-Victorin,

Dans la saison, tout le bord du grand fleuve du nord en est bordé. Son beau rouge lui a fait donner le nom de cardinale. Sa tige est fort haute. On voit de deux ou trois espèces de ces fleurs. Celle des trois espèces qui naît dans les blés des Français leur donne bien de l'exercice*[34]. Lorsque, pendant l'hiver seulement, ils battent leurs blés dans des granges, le petit coton volant qui en sort se nomme des *crève-yeux* : ce duvet, s'attachant avec incommodité sur les paupières, empêche de voir.

L'on voit partout des coquelicots[35] de diverses couleurs simples. Les doubles sont dans les parterres.

La pantoufle de Notre-Dame[36] est commune : c'est une fleur qu'on trouve partout. Sa figure lui a mérité son nom. Sa couleur tire sur le gris* de lin par un bout; elle est blanche par l'autre.

Le *noli me tangere* [37] est une autre petite fleur jaune. Si on la touche lorsque sa graine est dans sa maturité,

elle se met comme en colère et décoche cette graine contre celui qui la touche comme autant de petits dards. Tout cela est particulier au pays.

[f. 6] On voit en plein été, sur le bord des lacs et au milieu des marais, comme de parterres parsemés d'une infinité de grosses houppes blanches et jaunes. Ces fleurs naissent de la tige d'un simple extrêmement grand à feuilles larges, qui ressemblent beaucoup au pas d'âne[38]. Auparavant* que la fleur s'épanouisse, elle a la figure d'une pomme d'artichaut. Étant ouverte, elle est fort grande et fort double, a plus de cent feuilles. On nomme ce simple *lymphata*[39]. Toutes les sortes de pied d'alouette[40], simple et double, violet, blanc et incarnadin*, croissent dans le pays.

L'immortelle blanche[41] croît naturellement partout. La jaune n'y vient point.

Le foit* d'or[42] est une très belle fleur commune sur les rives du fleuve.

546). Boucher la mentionne en 1664 (Rousseau 1964) et elle est incluse dans «La flore du Canada en 1708» (Boivin), avec la *L. Kalmii* L., lobélie de Kalm.

34 Il ne peut s'agir que de la *Lobelia inflata* L., lobélie enflée (Marie-Victorin, 546), à fleurs bleues et qui pousse en terrain sec près des espaces cultivés. Elle est vénéneuse. L'affection aux yeux mentionnés par Nicolas a sans doute rapport à sa toxicité. On la connaissait aussi sous le nom de *Rapuntium americanum* (Boivin et Magnol). Voir aussi D. Dodart et coll., *Mémoires pour servir à l'histoire des plantes*, qui en 1686 donne une illustration de *R. americanum* qui correspond à *Lobelia inflata* L.

35 Le seul pavot mentionné par Marie-Victorin, 247 est le *Papaver Rhoeas* L., pavot coquelicot à fleur écarlate et centre noir.

36 Les fleurs du *Cypripedium reginae* Walt., cypripède royal, ont un caractère rose foncé parce que le labelle très gonflé est blanc panaché de magenta (Anna Leighton). Il pourrait s'agir de *C. acaule* Ait., cypripède acaule, ou de *C. reginae* Walt. (Marie-Victorin, 819–22). Les deux espèces sont mentionnées dans «La Flore du Canada en 1708» (Boivin) ainsi que le *C. Calceolus* L., cypripède jaune, sabot de la vierge jaune, qu'on collectionnait avant 1620. Cornut décrit le *C. acaule* Ait. en 1635. Une année plus tard, une variété blanche est signalée dans la liste du Jardin de Paris (Alain Asselin).

37 *Impatiens capensis* Meerb., impatiente du cap, à fleurs orangées, ou *I. pallida* Nutt., impatiente pâle, à fleurs jaune pâle (Marie-Victorin, 399); représentée dans le *Codex*, Pl. XXIII, fig. 40.4, sous la désignation «noli me tangere». Van der Donck classe la première dans les plantes médicinales en 1655 en Nouvelle-Hollande, alors que Dodoens croyait que son nom provenait de la pharmacie (Alain Asselin).

38 On compare la feuille de *Tussilago Farfara* L., tussilage farfara à la feuille du géranium (Marie-Victorin, 594;

voir aussi G. Lamoureux et coll., *Plantes sauvages comestibles*, 131). On peignait la forme de sa feuille aux portes des apothicaires en Europe afin de les identifier. Il s'agit d'un simple courant dans les jardins (Alain Asselin)

39 Bien que la figure du *Codex*, Pl. XXIII, fig. 40.5 marquée «Limphata (sic)» soit une représentation de l'*Asarum canadense* L., asaret du Canada, la *Lymphata* décrite ici est probablement la *Nymphea odorata* Ait., nymphéa odorant, ou la *N. tuberosa* Paine, nymphéa tubéreux, nénuphar blanc (Anna Leighton). Voir notre essai en introduction.

40 Une espèce de *Delphinium*; voir Hatton, 67–9 pour l'illustration de quelques espèces. Rousseau 1964 croit que Boucher désignait la *D. staphysagria* L. en Nouvelle-France en 1664.

41 *Anaphalis margaritacea* (L.) Benth. & Hook, anaphale marguerite (immortelle blanche) (Marie-Victorin, 574). Décrite par Clusius en 1601 et collectionée avant 1620 (Juel) (Alain Asselin).

42 Peut-être *Solidago graminifolia* (L.) Salisb., verge d'or graminifoliée (Marie-Victorin, 597–8). Il est vrai que la mention de la couleur or pourrait faire penser à d'autres plantes indigènes telles que *Caltha palustris* L., populage des marais (Marie-Victorin, 222) ou la *Potentilla Anserina* L., potentille ansérine (Marie-Victorin, 338), pour n'en citer que deux exemples. «La flore du Canada en 1708» en mentionnait plusieurs espèces (Boivin). *S. canadensis* L., verge d'or du Canada (Marie-Victorin, 601) se trouve dans les jardins d'Édimbourg en 1683 (Robertson) et de Montpellier en 1697 (Magnol) (Alain Asselin).

43 *Aesclepiada syriaca* L., asclépiade commune (Marie-Victorin, 519); représentée dans le *Codex*, Pl. XXIII, fig. 40.7, comme la «Cotonaria qui porte du miel, du coton, du chanvre, une belle fleur et des asperges». Cornut la décrit en 1635 et elle est mentionnée sur la liste du Jar-

Comme la cotonnière[43] produit la plus belle et la plus odoriférante de toutes les fleurs que j'ai remarquées dans les pays étrangers, il est important que cette plante soit plus connue que les autres. Aussi vous dirai-je que sa racine, prise en son temps, c'est-à-dire quand elle commence à pousser, environ* la mi-mai, est beaucoup meilleure que les asperges. Cette racine est de réserve* si on la sale. On en mange en tout temps. Il sort au bout de la tige plusieurs houppes formées par une infinité de fort belles fleurs bien odoriférantes, pleines d'une rosée extrêmement emmiellée. Le petit oiseau-mouche se nourrit de cette liqueur*. La graine de la plante se forme et se nourrit dans une assez grande bourse, au milieu d'un très beau et d'un très fin coton qui, pour* être un peu trop délié, n'a pas assez de corps, et ainsi il est inutile. L'expérience qu'on en a faite, en faisant faire des chapeaux, nous a convaincus de son inutilité. Le chanvre qu'on tire de la tige, est plus utile : les naturels du pays en font de fort beaux ouvrages. J'ai en main un petit sac fort propre*, fait par une Indienne*, de cette sorte de chanvre. La graine ne mûrit et ne se sème d'elle-même que pendant la plus grande rigueur de l'hiver sur les neiges et sur les glaces.

Voici un autre mémoire des simples qu'on trouve dans l'Inde.

L'absinthe[44] de deux façons. Ceux qui ont étudié, avec moi, la constitution des Américains disent qu'il n'y a rien de meilleur contre la vermine, en l'appliquant sur le ventre, après l'avoir un peu chauffé. J'en ai vu des effets merveilleux.

L'ail[45], semblable à celui de Gascogne, produit partout où on le plante.

L'ail sauvage[46], et qui est tout particulier à l'Amérique, croît naturellement dans des prairies de trois ou quatre lieues de long. Il n'a qu'une tête comme le poivrot*. Il vient par graines seulement de lui-même, au contraire de l'ail franc*. Il a tout le goût et toute l'odeur de celui qu'on mange dans toute la Guyenne et dans toute l'Espagne sur du pain, sur lequel on l'écrase et où l'on l'étend comme si c'était du meilleur beurre du monde. Notre ail américain a des vertus excellentes pour abattre les enflures et toute sorte de tumeurs; pour s'en servir à ces effets*, il faut le faire bouillir un peu de temps et l'écraser ensuite tout chaud sur la partie enflée.

Le persil de Macédoine[47], nommé autrement du *céleri*, devient si beau et si tendre dans ces contrées qu'il semble changer de nature. Il fortifie l'estomac, il l'échauffe et le purge à merveille.

[f. 7] Le persil commun[48], plat et frisé, y vient d'une prodigieuse grandeur. J'ai remarqué qu'il est plus aisé de le cultiver qu'en d'autres pays.

J'ai pris garde, sur les rives du grand fleuve, qu'il y a une espèce toute particulière dans ces terres d'un autre persil[49] bien meilleur que notre commun et que celui de Macédoine. Nous en faisions de bons ragoûts* lorsque nous campions sur les plages* du nord.

Il y a aussi, dans les mêmes endroits, une autre sorte

din de Paris en 1636 (de La Brosse) et celle du Jardin de Montpellier en 1697 (Magnol). Boivin nous apprend qu'on faisait du sucre avec son «miel» (Alain Asselin).

44 L'une des deux pourrait être *Artemisia absinthium* L., dont les fleurs, d'après Marie-Victorin, 572, prises en infusion seraient «toniques, fébrifuges [et] stimulantes» (Anna Leighton). L'autre ne peut pas être *A. vulgaris* L., puisque Nicolas la désigne du nom d'«armoise» un peu plus loin. Pourrait-il alors s'agir d'*Abutilon theophrasti* Medic.? Clusius la décrit déjà en 1601 comme plante que l'on trouve en Amérique (Alain Asselin).

45 *Allium sativum* L., qui ne pousse cependant pas à l'état sauvage au Canada.

46 Rousseau 1964, 294–5 identifiait trois espèces d'ail sauvage au Canada : 1) *Erythronium americanum* Ker Gawl, érythrone d'Amérique, bien qu'il affirme qu'il n'a «jamais noté de consommation de bulbes d'érythones»; 2) *Allium tricoccum* Ait., probablement représenté dans le *Codex*, Pl. XXIII, fig. 40.6, sous la désignation «ail sauvage»; et 3) *Allium canadense* L., (Marie-Victorin, 660–1). *E. americanum* Ker Gawl est décrit par Cornut dès 1635 et s'identifie chez Boivin (1708) sous la désignation de l'«ail doux». On y affirme que et les Indiens et les Français en consommaient.

47 Cette expression désigne au moins neuf plantes. Parmi celles-ci, *Apium graveolens* L., céléri, et *Smyrnium olusatrum* L., maceron sont les plus vraisemblables. Voir G. Cristofolini and U. Mossetti, «Interpretation of Plant Names in a Late Medieval Medical Treatise», 305–19. *S. olustratum* L. est mentionné par Rousseau en 1964; on le trouve dans la liste des jardins d'Édimbourg en 1683 sous la désignation «common Alexanders» (Alain Asselin).

48 Deux variétés de *Petroselinum crispum* (Mill.) Nyman ex A.W. Hill, Persil, la première étant *crispum*, la «frisée», et la deuxième, *neapolitanum*, la «plate», sont visées ici. Boucher parle du «percil sauvage» sans préciser la variété parmi les plantes de la Nouvelle-France (Rousseau 1964, 295–6). Van der Donck signale le persil en Nouvelle-Hollande en 1655 (Alain Asselin).

49 *Ligusticum scoticum* L., livèche écossaise (Marie-Victorin, 418), *Osmorhiza* sp. (Marie-Victorin, 419), *Conioselinum chinense* (L.) BSP, Coniosélinum de Genesee (Marie-Victorin, 422) et *Sium suave* Walt., berle douce (Marie-Victorin, 423) sont tous des candidats éventuels. Rousseau 1964 signalait que les trois premières espèces étaient vraisemblablement celles visées par Boucher en Nouvelle-France en 1664 (Alain Asselin).

de simple fort rare et fort odoriférant, que nous avons nommé de la *passe-pierre*[50] : c'est une espèce de langue de serpent. Le gingembre[51] couvre nos forêts; la racine en est fort odoriférante.

Toutes les herbes que je vais nommer sont si communes dans le pays qu'il me faudrait un grand volume pour en dire toutes les particularités*, et comme je serais trop ennuyant*, il faut se contenter des simples noms : asperges[52], betteraves rouges[53], betteraves blanches[54], carottes[55], charvis[56], salsifis[57], panets, [58] pas-senades jaunes et violettes,[59] franches et sauvages, chicorée[60] blanche, franche et agreste*, choux[61] de toutes les espèces, excepté le chou-fleur. Les choux pommés[62] y sont si communs et si gros que cela passe l'ordinaire. Les citrouilles[63] sont fort différentes des nôtres, concombres[64], la coriandre[65], la courge[66], les calebasses*[67], cerfeuil franc et agreste[68]. Ce dernier y est si commun qu'on peut le faucher en bien des endroits. Ce simple est d'une odeur particulière; il rafraîchit la poitrine; il est plus gros et plus grand que le nôtre commun, aussi

50 «Passe-pierre» désigne *Plantago jucoides* Lam., plantain joncoïde; voir J. Rousseau, «La passe-pierre», chez B. Boivin, «Quelques noms vernaculaires de plantes du Québec», 145–62; surtout 158–62.

51 *Asarum canadense* L., asaret du Canada (Marie-Victorin, 219). Pierre Dansereau a affirmé avec raison que c'est cette plante qui est représentée dans le *Codex*, Pl. XXIII, fig. 40.5, sous la désignation «Limphata». Cornut le connaissait en 1635 (Mathieu). On le trouvait dans la liste des jardins de Montpellier (Magnol) (Alain Asselin).

52 *Asparagus officinalis* L., (Marie-Victorin, 648). Boucher en 1664 en Nouvelle-France (Rousseau 1964), van der Donck en 1655 en Nouvelle-Hollande, et Josselyn en Nouvelle-Angleterre en 1672 signalent tous son existence (Alain Asselin).

53 *Beta vulgaris* L. (Louis-Marie, 140).

54 Une variété de la précédente. On consommait ses feuilles et ses tiges comme substitut de l'épinard et de l'asperge (Anna Leighton). La «betterave blanche» serait peut-être *B. vulgaris* subs. *cicla* (L.) Koch. Une liste du jardin d'Édimbourg fait la distinction entre les variétés rouge et blanche en 1683 (Robertson estime que la blanche pourrait être *B. cicla*) (Alain Asselin).

55 *Daucus carota* L., qui est la carotte sauvage et dont la cultivée est une variété (Louis-Marie, 204 et Lamoureux et coll. *Plantes sauvages et comestibles*, 65). Ces carottes étaient probablement effilées plutôt que cylindriques. On en connaissait des variétés blanche, jaune et orange. Boucher en 1664 et Josselyn en 1672 en signalent l'existence respectivement en Nouvelle-France et en Nouvelle-Angleterre. Voir R.N. Mack, «Plant Naturalizations and Invasions in the Eastern United States : 1634–1860», 77–90; désormais, Mack). La liste d'Édimbourg la traite comme plante médicinale (Alain Asselin).

56 Selon Mattioli, le *Carum carvi* L. est le «carvi» et non le «charvis»; le «chervy» serait le *Siser alterum* Cam., une carotte blanche. Dans ce cas, il s'agirait plutôt de *Sium sisarum* L. Le chervis était connu également sous les noms de «chirouis», «girole» ou «carotte blanche», plante bien connue en Europe aux 16ᵉ et 17ᵉ siècles (Alain Asselin).

57 *Tragopogon pratensis* L. (Marie-Victorin, 551); Boucher le signale en Nouvelle-France en 1664.

58 *Pastinaca sativa* L. (Louis-Marie, 202 et Marie-Victorin, 416); signalé par Boucher en Nouvelle-France en 1664 et par Josselyn en Nouvelle-Angleterre en 1672. On le connaissait déjà en 1634 dans la Baie de Plymouth (Mack) (Alain Asselin).

59 On écrivait *passenades* ou *pastenades*. La pastenade était ou bien une variété de *Pastinaca sativa* L., ou bien *Daucus Carotta* L. Mattioli employait le mot *pastenade* pour *Pastinaca*. Certains auteurs y voient une carotte jaune (Alain Asselin).

60 *Cichorium intybus* L. (Marie-Victorin, 551); signalée par Boucher en Nouvelle-France en 1664 et par van der Donck en Nouvelle-Hollande en 1655 (Alain Asselin).

61 *Brassic oleracea* L. (Louis-Marie, 162); signalé par Boucher en Nouvelle-France en 1664, par van der Donck en Nouvelle-Hollande en 1655, et par Josselyn en Nouvelle-Angleterre en 1672 (Alain Asselin).

62 *Brassica oleracea* (L.) DC. (pour indiquer Augustin-Pyramus De Candolle), var. *capitata* (Alain Asselin).

63 *Cucurbita pepo* L., *C. maxima* Duch., *C. moschata* Duch., pour n'en nommer que quelques-unes (Louis-Marie, 242); signalé par Boucher en Nouvelle-France en 1664 (Rousseau 1964).

64 On connaît deux concombres indigènes dans l'est du Canada : *Sicyos angulatus* L., concombre anguleux, et *Echinocystis lobata* (Michx.) T. & G., concombre sauvage; mais il se peut que Nicolas n'ait eu en vue que *Cucumis sativus* L., une variété cultivée en France (Louis-Marie, 242). Boucher signale ce dernier en Nouvelle-France en 1664; les premiers colons l'ont apporté avec eux dans la Baie de Plymouth (Mack) et van der Donck le signale en Nouvelle-Hollande en 1672 (Alain Asselin).

65 *Coriandrum sativum* L. (Marie-Victorin, 413). D'après Alain Asselin, il s'agit d'une première mention pour la Nouvelle-France.

66 Une cucurbitacée : *C. pepo* L., *C. maxima* Duch., ou *C. moschata* Duch. (Louis-Marie, 242).

67 Peut-être *Lagenaria siceraria* (Molina) Strandl. Voir Rousseau 1964 à ce sujet. Si l'on pense à une cucurbitacée, il s'agirait d'une plante indigène déjà cultivée par les Amérindiens. Par contre la *Lagenaria* n'est pas indigène et on ne s'entend pas encore sur les circonstances de son introduction en Amérique (Alain Asselin).

68 *Anthriscus cerefolium* (L.) Hoffm., variété cultivée (Marie-Victorin, 420 qui décrit *A. sylvestris* [L.] Hoffm., anthrisque des bois ou persil sauvage). Anciennement

bien qu'une autre espèce de ce même simple, dont la feuille est musquée et anisée[69]. L'ellébore[70] est tout différent de celui de l'Europe : sa racine est grosse comme une rave*; les Indiens s'en servent pour abattre des tumeurs. La nicotiane*, la gentiane[71], l'herbe* à la reine, le gramen[72], la jusquiame[73], la mauve[74], la gui-

mauve[75], *mille folium*[76] ou *eliokrison milium*[77] *solis*[78], millepertuis[79], échalotes[80], endives[81], épinards[82], écarlate[83], épinards sauvages à la graine rouge[84], fenouil de deux façons[85], anis[86]. Melons communs[87], melons d'eau fort sucrés à la graine noire[88]. D'autres, tout rouges, sont d'une espèce un peu différente : ils sont

les paysans du Québec utilisaient la *Cryptotaenia canadensis* (L.) DC, cryptoténie du Canada, pour le même usage (Rousseau 1964, 294 et Louis-Marie, 242). Il pourrait également s'agir d'une autre ombellifère (Boivin) (Alain Asselin).

69 Il est difficile de savoir si Nicolas désigne une espèce sauvage ou cultivée. Dans ce dernier cas, il pourrait s'agir de *Pimpinella anisum* L. (Louis-Marie, 204). Si nous avons affaire à une espèce sauvage, elle serait membre de la famille des apiacées ou des liliacées (Alain Asselin).

70 Le *Codex*, Pl. XXIII, fig. 40.8, représente vraisemblablement *Veratrum viride* Ait., sous la désignation «ehlebore blanc»; en Europe on utilisait *Helleborus niger* L. à des fins médicinales (Rousseau 1964, 297).

71 On connaît plusieurs espèces de *Gentiana* dans l'est du Canada. On les distribue aujourd'hui entre deux genres : *Gentiana* et *Gentianella*. Marie-Victorin, 514–16 en nomme cinq espèces, dont la plus commune est *Gentiana linearis* Fröl., gentiane à feuilles linéaires. Il mentionne aussi *Gentiana amarella* L., qu'on classe aujourd'hui avec les *Gentianella* (Anna Leighton). Nicolas avait-il cependant en vue une variété cultivée? C'est fort possible. *Gentiana lutea* L. (Marie-Victorin, 514), la gentiane jaune, avait des vertus curatives bien appréciées et on la trouvait facilement dans les jardins d'Europe (de La Brosse et Magnol) (Alain Asselin).

72 Ce mot désignait des membres de la famille des Poacées. Ainsi, un jardin à Paris en donnait en 1636 une liste de douze espèces (de La Brosse), et celui de Montpellier en connaissait au-dessus soixante-dix (Magnol) (Alain Asselin).

73 *Hyocyamus niger* (voir Hatton 322, fig. 622, pour une illustration). Plante connue en Europe pour ses vertus médicinales, voire hallucinogènes. On en a retrouvé des graines sur des sites archéologiques au Québec (Alain Asselin).

74 Marie-Victorin 380–1 nomme six espèces de *Malva*, dont *Malva moschata* L., mauve musquée, *M. neglecta* Wallr., mauve négligée (celle qui est la plus commune au Québec), et *M. parviflora* L., mauve parviflore.

75 *Althea officinalis* L. (Marie-Victorin, 380). Introduite vraisemblablement comme plante médicinale. Connue de van der Donck en Nouvelle-Hollande en 1655 (Alain Asselin).

76 *Achillea millefolium* L. achillée millefeuille, ou herbe à dindes. Connue de van der Donck en Nouvelle–Hollande en 1655 et de Josselyn en Nouvelle-Angleterre en 1672. Marie-Victorin, 592 affirme qu'elle existe au Québec à la fois comme plante indigène et comme plante introduite, ce qui est assez remarquable (Alain Asselin).

77 Nous lions *mille follium* à *eliokrison*, mais non pas à *milium solis*. *Eliokrison* est probablement *Elichrisum*, qui est devenu *Helichrysum*, synonyme de *Gnaphalium*. Nicolas entendait-il spécifier une forme de *mille folium* en associant ces mots comme il l'a fait? (Alain Asselin).

78 *Lithospermum officinale* L. (Marie-Victorin, 284), grémil officinal. *Milium solis* était le nom pharmaceutique de la plante. Si notre interprétation est exacte, il s'agirait d'une première mention en Amérique du Nord (Alain Asselin).

79 *Hypericum perforatum* L. (Marie-Victorin, 284), millepertuis commun, qu'on ne trouve qu'au Québec et en Nouvelle-Angleterre. Louis-Marie, 192 en signale neuf espèces. Il pourrait s'agir d'une première mention en Nouvelle-France (Alain Asselin).

80 *Allium ascolonicum* L. (Louis-Marie, 110).

81 *Cichorium endivia* L., si Nicolas parle de la véritable endive. Mais le même mot s'applique à *C. intybus* L. (Marie-Victorin, 551), qu'on fait pousser en partie sous terre pour obtenir des feuilles blanches comme celles de la véritable endive (Alain Asselin).

82 *Spinacia oleracea* L. (Louis-Marie, 140). Boucher le signale en Nouvelle-France en 1664.

83 En vieux français on nommait «écarlate» une espèce de *Lychnis*. On en connaissait plusieurs. *L. coronaria* L. pourrait en être une. Au Québec, Marie-Victorin, 204 parle de *L. alba* Mill., qui se retrouve en zones habitées. Mais il n'est pas certain que ce soit l' «écarlate» de Nicolas (Alain Asselin).

84 Vraisemblablement une espèce de *Rumex* (Marie-Victorin, 187) (Alain Asselin).

85 *Foeniculum vulgare* Mill. (Louis-Marie, 204). La seconde espèce n'est peut-être que la variété *dulce*. On pourrait aussi penser à *Anethum graveolens* L., aneth odorant, connu sous le nom de «fenouil bâtard ou puant» (Alain Asselin).

86 En français le mot *anis* désignait le *Carum carvi* L. (Marie-Victorin, 422) et le *Pimpinella anisum* L., connu également sous la désignation «anis vert». Ce dernier fut introduit en France après la plupart des épices (Alain Asselin).

87 *Cucumis melo* L. (Louis-Marie, 242). Champlain en signale la présence en Nouvelle-France en 1618; Boucher en 1664. On en faisait pousser aussi dans la Baie de Plymouth en 1634 (Mack.) (Alain Asselin).

88 S'agissait-il d'une variété sucrée de *Cucumils melo* L. ou d'un véritable melon d'eau, *Citrullus vulgaris* (Thunb.) Matsum. & Nakai? Il existe même des mélanges des deux genres. De toute manière on a affaire à des plantes introduites. Boucher signalait le melon d'eau en Nouvelle-France en 1664 (Alain Asselin).

gros en Virginie comme des citrouilles à hottée de Paris. Laitues[89] de toutes façons, chicons noirs et blancs[90]; il y en a de jaunes qu'on nomme des *phalanges*[91] : ils deviennent fort gros et d'une hauteur [f. 8] prodigieuse. Ces sortes de salades sont les plus tendres et les plus délicates. Naveaux[92], oignons de deux ou trois façons[93], cives[94], civettes[95], oseille, ronde et pointue[96], patience[97], l'armoise[98], l'appatum[99], de la hache*[100], pimpinelle[101],

poireau[102], pourée[103], pourpier de trois espèces[104], raifort[105], rave*[106], sarriette[107], ciboule[108], serpolet[109], laiteron de plusieurs espèces[110].

Pétun ou tabac commun[111]

Selon les sauvages, c'est le dieu des herbes et de tous les simples : *manitou mingask*, l'appellent-ils. Le tabac franc qu'on sème dans diverses îles, de Jésus et de Mont-

89 *Lactuca sativa L.*, qui porte des fleurs jaunes (Louis-Marie, 262). Signalée en Nouvelle-France en 1664 par Boucher.

90 Les deux sont *Lactuca sativa L.*, var. *longifolia*.

91 Il s'agit probablement d'une troisième variété de laitue. Le mot *falanges*, écrit parfois *alfanges*, désignait une laitue romaine recommandée par Pline contre les piqûres d'araignées, également appelées *falanges*.

92 *Brassica rapa* L. navet (Louis-Marie, 162). Rousseau 1964 propose *B. napobrassica* (L.) Mill. comme une autre possibilité.

93 *Allium cepa* L. (Louis-Marie, 110). Signalé en Nouvelle-France par Boucher en 1664.

94 En vieux français *cive*, tout comme *chive* en anglais, dérive du mot latin *caepa*, «oignon» et désigne *Allium Schoenoprasum* (var. *sibiricum*) L., «ciboulette», qui pousse le long du Saint-Laurent (Rousseau 1964, 295).

95 Autre nom vernaculaire de la ciboulette.

96 *Rumex acetosella* L., rumex petite-oseille, ou *R. Acetosa*, rumex oseille (Marie-Victorin, 188–9). Il y a plusieurs espèces de *Rumex*, qui peuvent toutes servir de plantes potagères. *Rumex patientia* L., épinard-oseille, déjà populaire en Europe, fut introduit et cultivé en Amérique (Anna Leighton). Il se peut aussi que Nicolas ait eu en vue l'une ou l'autre des espèces introduites en Nouvelle-France : *R. Acetosa, R. longifolius* D.C. (Marie-Victorin, 190) ou *R. obtufolius* L. (Marie-Victorin, 190). Boucher mentionne une des espèces introduites en Nouvelle-France (Alain Asselin).

97 Le mot «patience» renvoie à *Rumex longifolius* D.C., syn. de *R. patientis* ou à *R. obtusifolius* L. (Marie-Victorin, 190). Josselyn la signale en Nouvelle-Angleterre en 1672. Il est possible que ce soit une première mention en Nouvelle-France (Alain Asselin).

98 *Artemesia vulgaris* L., armoise vulgaire (Marie-Victorin, 572).

99 Comme *appatum* n'existe pas en latin, Marthe Faribault a proposé de lire *lappatum*; *lappa*, en latin est la bardane. Il se peut que Nicolas ait voulu parler ou d'*Arctium lappa* L., bardane majeure, ou d'*Arctium minus* (Hill) Bernh., bardane mineure (Marie-Victorin, 567). Mais, comme le fait remarquer Alain Asselin, il pourrait être question de *Lapathum*, qui désigne ou la rhubarbe ou une forme quelconque de *Rumex*. Un candidat éventuel, en plus de la bardane, pourrait être *R. sanguineus* L., connu aussi sous la désignation «sang-dragon» que van der Donck signalait en Nouvelle-Hollande en 1655.

100 Le mot *ache* désignait plusieurs ombellifères, en particulier des *Levisticum* sp. (Juel). Il pourrait s'agir de *L.*

officinale (L.) Koch., une plante adventice au Québec (Marie-Victorin, 413) (Alain Asselin).

101 Ou bien *Pimpinella anisum* L. ou bien une *Sanguisorba* comme *S. officinalis* L. ou *S. minor* Scop. Rousseau interprète la pimprenelle, mentionnée par Boucher en Nouvelle-France en 1664 comme une *S. minor*. Cela est possible, mais d'autres espèces conviendraient tout aussi bien (Alain Asselin).

102 *Allium porrum* L. (Louis-Marie, 110). Signalé en Nouvelle-France par Boucher en 1664.

103 Mattioli se servait du mot «porrée» pour désigner *Beta alba*, la betterave blanche. Il faisait d'ailleurs la distinction entre la blanche (*alba*) et la rouge (*rubra*). Mais si on lisait *poirée* au lieu de *porrée*, il pourrait s'agir de *Beta vulgaris* L., var. *cicla*, bette à carde. Champlain la mentionne déjà en 1615 à Québec (Alain Asselin).

104 *Portulaca oleracea* L., connu déjà de Champlain et de Sagard (Rousseau 1964, 296). Marie-Victorin, 202 mentionne vingt espèces de *Portulaca*. On discute cependant toujours le caractère importé ou indigène de *P. oleracea* L. dans l'Amérique du Nord. Voir R. Byrne et J.H. McAndrews, «Pre-Columbian Purslane (*Portulaca oleracea* L.) in the New World», 253 et 726–7. D'autres plantes semblables, à feuilles épaisses, pourraient être une espèce de *Sedum* comme celle qui poussait dans les jardins d'Édimbourg (Alain Asselin).

105 *Armoracia rusticana* Gaertn. (Louis-Marie, 162). Peut-être mentionné ici pour la première fois en Nouvelle-France.

106 La rave est un radis, donc *Raphanus sativus* L. (Marie-Victorin, 258). Boucher employait le même mot dans le même sens (Rousseau 1964). Mais le rutabaga, voire même le chou-rave, pourrait être visé ici. Le mot *rave* est employé à Port-Royal en 1606 (Alain Asselin).

107 *Satureja hortensis* L. Peut-être une première mention en Nouvelle-France.

108 *Ciboule* est probablement un synonyme de *ciboulette*, *Allium Schoenoprsum* L. Mattioli utilise le mot *ciboule* pour désigner l'oignon, *Allium caepa* L. (Alain Asselin).

109 *Thymus serpyllum* L. (Marie-Victorin, 502). Connu de van der Donck en 1655 en Nouvelle-Hollande. Peut-être une première mention en Nouvelle-France (Alain Asselin).

110 Marie-Victorin, 557–8 en donne trois espèces : *Sonchus arvensis* L., laiteron des champs, *Sonchus oleraceus* L., laiteron potager et *Sonchus asper* (L.) Hill., laiteron épineux. Josselyn en connaît le deuxième en 1672 en Nouvelle-Angleterre (Alain Asselin).

111 Il faut faire la distinction entre *Nicotiana tabacum* L. et

Royal, et partout ailleurs, est le dieu de ce dieu parce que les Américains le trouvent incomparablement meilleur que leur commun. Ils se servent de ce dieu pour faire des adorations aux autres divinités qu'ils reconnaissent.

Les forêts produisent du plantain[112] de toutes façons. Il vient plus communément dans les endroits où l'on passe souvent et ordinairement. On se guide par là dans les routes de divers voyages, sans quoi on s'égarerait souvent. J'ai été obligé de me servir de ce secret dans un grand voyage que je fis en Virginie : les sauvages nous l'avaient appris. Ils nous découvrirent un autre secret dont ils usent dans leurs voyages de quatre ou cinq cents lieues pour connaître le rhumb* de vent qu'on court sans se pouvoir égarer, bien que les nuages couvrent le soleil. Ils connaissent la route du nord en regardant le tour des arbres, et la chose n'est pas si difficile qu'on pourrait se persuader, puisque toujours les arbres de ces grandes forêts sont couverts d'une certaine mousse qui fait distinguer le côté du nord de celui du sud. Ainsi, sachant* ces deux côtés du monde, on se forme une idée assez juste pour ne point s'égarer comme l'on ferait sans cette espèce de boussole qui ne trompe jamais les habitants de ces vastes forêts.

Nous trouvons partout du tintimale* couronné de cinq espèces[113]. L'humeur âpre et blanche / comme du lait / qui sort de ce simple guérit et fait mourir la racine des dartres et abat les feux volages*. Il y a du catapuce[114] différent du nôtre et très violent. La ciguë*[115], dont le venin est fort présent*, sert aux sauvages, hommes et femmes, pour s'empoisonner quand on leur a fait quelque grand déplaisir.

L'herbe à la puce[116]
est une plante particulière à nos bois. Il y en a de deux espèces, dont l'une est fort venimeuse. Quelques Français n'en connaissant pas bien les différences s'en sont trouvés très incommodés. Cette herbe, en la touchant seulement, fait venir sur la peau des pustules si fâcheuses* et si brûlantes que les parties lésées* en pèlent avec douleur. Après que les enflures qu'elle avait causées sont abattues, on a la fièvre. Un enfant en mourrait si on le fouettait avec ces sortes d'herbes. Le *sigillum salomonis*, qu'on peut recueillir partout[117], est fort bon pour soulager ceux qui ont la hernie. On fait infuser la racine dont on fait de la tisane, qu'on fait boire à ces sortes de malades, et la même racine, un peu bouillie et concassée et appliquée sur la bourse, soulage beaucoup.

L'autre espèce de *sigillum salomonis*[118] passe pour venimeuse. Sa graine est vilaine et d'une étrange couleur.

Tout le long des rivières et des lacs, l'on voit des

Nicotiana rustica L., le tabac aztèque. Celui qu'on cultive dans la région de Montréal est le *N. tabacum* L., qui, selon Nicolas, aurait été bien meilleur que *N. rustica* L. Mais ce dernier était plus fort en nicotine. Les premiers découvreurs, ainsi que Boucher en 1664, mentionnent le tabac en Nouvelle-France; voir Hatton, 326, fig.631, pour une illustration ancienne.

112 Nicolas pensait à *Plantago major* L., un plantain d'origine européenne que les Amérindiens appelaient «le pied du Blanc», parce qu'on le trouvait le long des sentiers fréquentés par les Blancs. C'était donc un signe de leur présence. Van der Donck note un *Plantago* parmi ses herbes médicinales en 1655 en Nouvelle-Hollande. Josselyn inclut le plantain parmi les plantes d'origine anglaise cultivées en Nouvelle-Angleterre en 1672. Il l'appelle même «English man's foot». Possiblement une première mention en Nouvelle-France (Alain Asselin).

113 Peut-être l'*Euphorbia myrsinites* L., l'euphorbe de Corse, qui produit une sève laiteuse pouvant provoquer des irritations de la peau et des yeux. Voir Hatton, 402, fig. 798. Mattioli décrivait cinq espèces d'euphorbes (Alain Asselin).

114 *Euphorbia helioscopia* L. ou *E. cyparissias* L., tous deux aujourd'hui naturalisés au Québec (Marie-Victorin, 216); voir Hatton, 403, fig. 799, pour une illustration ancienne.

115 En Europe, *Conium maculatum* L. est connu depuis les Grecs comme toxique. *Cicuta maculata* L., la cicutaire maculée, contient un poison violent, semblable à celui de *Cicuta virosa* L. en Europe. On l'appelait «carotte à Moreau» rappelant un cas d'empoisonnement (Rousseau 1964, 297 et Marie-Victorin, 421–2). Boucher la mentionne en 1664.

116 *Rhus radicans* L. La deuxième espèce, mentionnée tout de suite après, pourrait être *Apocynum androsaemifolium* L. (Marie-Victorin, 392 et 517). Clusius décrit *R. radicans* L. dès 1601. «La flore du Canada en 1708» (Boivin) la mentionne. Dodart en 1686 décrit plutôt *A. androsaemifolium* L. Mattioli utilisait l'expression «herbe aux puces» pour décrire une espèce européenne différente (Alain Asselin).

117 Si l'expression «on peut (le) recueillir partout», signifie «dans tous les jardins», nous pourrions avoir affaire à une plante importée, *Polygnatum multiflorum* (L.) All. (Marie-Victorin, 643). Cette espèce serait peut-être le *Sigillum Salomonis* mentionné par van der Donck en 1655 en Nouvelle-Hollande. Un *Polygnatum* prenait souvent le nom officinal de *Sigillum Salomonis* (Dodoens). Mais si le mot «partout» signifie «à l'état sauvage», on peut penser à une plante indigène, *P. pubescens* (Willd.) Pursh (Marie-Victorin, 644). Si Nicolas envisageait deux plantes indigènes, la deuxième pourrait être une espèce ou de *Streptopus* (Marie-Victorin, 651) ou d'*Uvularia* (Marie-Victorin, 652), voire même de *Smilacina* (Marie-Victorin, 649) (Alain Asselin).

118 Marie-Victorin, 650–1 décrit trois espèces de *Smilacina* : *S. racemosa* (L.) Desf., smilacine à grappes, *S. stellata*

prairies entières des arroiesses[119], qui sont une sorte de petits pois agrestes[120] dont les animaux s'engraissent.

[f. 9] Le houblon[121], qui se trouve sur les bords de la rivière de Thechiroguen (qui va mouiller toute la Nouvelle-Albanie, la Nouvelle-Orange et la ville de Manate), en Virginie et presque jusque[122] dans le golfe de la mer Illande, est très odoriférant et meilleur que le nôtre. Les Anglais et les Hollandais qui habitent une partie de ces terres s'en servent pour faire leur bière, aussi bien que d'un autre qui n'est pas si fort ni si odoriférant.

On trouve en beaucoup d'endroits de toute sortes de cannes[123]. Le chanvre[124] qu'on a transporté de France vient fort bien dans toutes les habitations* françaises.

Les orties[125] sont extraordinaires. Les Oupouteouatamis, qui sont des peuples qui habitent autour du grand lac des Illinois, en font du chanvre beaucoup

meilleur que le nôtre. Les Virginiennes en font de fort beaux ouvrages, des cordages et des filets pour la chasse et pour la pêche.

Les chardons[126] ne sont pas rares; il y en a de toutes les espèces. La chardonnette*[127] y sert à faire prendre le lait.

La couleuvrée[128], ou vigne noire, est si commune le long des rivières de la Virginie qu'on ne voit que cela. Sa graine vient par grosses touffes comme le lierre. Il n'y a rien de plus beau ni guère de plus charmant que de voir les beaux cabinets* que cette sorte de vigne forme naturellement. Elle grimpe sur les arbres et s'attache fort aux murailles. Il y en [a] déjà par toute la France. Ainsi je n'en dis plus rien.

La scabieuse[129], la fougère de trois ou quatre espèces[130], la corne de cerf[131], dont la graine est souveraine pour refaire et pour rafraîchir le sang, y sont com-

(L.) Desf., smilacine étoilée, et *S. trifolia* (L.) Desf., smilacine trifoliée, mais aucune n'est vénéneuse, bien que le fruit de la dernière soit fortement catarrheux.

119 Faribault 1996 lit «arrouses» et renvoie au *Französiches Etymologisches Wörterbuch*, Bonn-Leipzig-Basle, 1922, t. 21, 145b, qui interprète aussi «arosse» comme une sorte de vesce, *Vicia*.

120 Si Nicolas entendait des pois sauvages, il pourrait s'agir de *Lathyrus maritimus* (L.) Bigel (Marie-Victorin, 350) ou peut-être de *L. palustris* L. (Marie-Victorin, 351). Les pois dont parle Jacques Cartier sont des *L. maritimus* (L.) Bigel, d'après Marie-Victorin et Rousseau (1964) (Alain Asselin).

121 *Humulus lupulus* L. (Marie-Victorin, 172), un houblon importé et naturalisé. Pourtant, Nicolas semble décrire une espèce indigène, peut-être *Carpinus caroliniana* Walt. (Marie-Victorin, 153). On utilisait ses fruits comme substitut du houblon (Alain Asselin).

122 Comme plus loin (p. 418), la «mer Illande» est mise ici pour *Maryland*. Le «golfe de la mer Illande» désigne la baie de Chesapeake, dont la plus grande partie se trouve dans l'état du Maryland.

123 Selon Rousseau 1964, les «cannes» signalées aussi par Boucher en 1664 en Nouvelle-France seraient ou *Phragmites communis* Trin., roseau commun (Marie-Victorin, 765), ou *Phalaris arundinacea* L., phalaris roseau (Marie-Victorin, 804), ou *Typha latifolia* L., massette à larges feuilles (Marie-Victorin, 855), ou bien les trois à la fois. Ces trois identifications semblent ici recevables (Alain Asselin).

124 *Cannabis sativa* L.; voir Hatton, 397, fig. 787, pour une illustration tirée de L. Fuchs, *De Historia Stirpium*, 1542. Clusius la mentionne en 1601 dans une liste de plantes américaines. Van der Donck, également, en Nouvelle-Hollande en 1655. Endicott enfin signale en 1628 son importation sous forme de graines (Mack). Boucher savait en 1664 qu'il avait été introduit en Nouvelle-France (Alain Asselin).

125 Si Nicolas vise une espèce indigène, nous pourrions avoir affaire à *Urtica procera* Mühl., ou *Laportea canadensis* (L.) Wedd., ou *Pilea pumila* (L.) A. Gray (Marie-Victorin, 174), ou même à *Boehmeria cylindrica* (L.) Sw. (Marie-Victorin, 175). Rousseau croit que les deux premières sont probablement les espèces visées par Boucher en 1664. Dodart décrit *L. canadensis* (L.) Wedd., en 1686 (Alain Asselin).

126 Une espèce de *Cirsium* (Marie-Victorin, 581) comme le *C. muticum* Michx. ou le *C. discolor* (Mühl) Spreng. Il ne faut pas cependant éliminer la possibilité d'une introduction de *C. arvense* (L.) Scop. ou de *C. vulgare* (Savi) Tenore (Alain Asselin).

127 Suivant le glossaire, la chardonnette serait *Cynara Cardunculus* L., cardon. Cependant le même mot pourrait s'appliquer au *Chameleon niger* de Mattioli, connu maintenant sous le nom de *Carlina acauli*. L. Nicolas indique que la plante sert à faire «prendre» le lait. Les têtes florales de la *Carlina* C, de la *Cynara* et d'autres Astéracées ont, en effet, été utilisées pour faire cailler le lait. Nicolas peut donc désigner ici une espèce indigène (Alain Asselin).

128 *Parthenocissus quinquefolia* (L.) Planch, parthénocisse à cinq folioles (Marie-Victorin, 406–7). Décrite par Cornut dès 1635 et mentionnée dans «La flore du Canada en 1708» (Boivin) (Alain Asselin).

129 Possiblement *Knautia arvensis* (L.) Duby, connue aussi sous le nom de *Scabiosa arvensis* L. (Marie-Vicorin, 540) ou d'autres espèces du groupe que l'on désignait comme *Scabiosa*. Une liste du jardin à Paris en 1636 en mentionnait neuf espèces (de La Brosse), et *K. arvensis* (L.) Duby paraît sur une liste du Jardin d'Édimbourg (Robertson). La *Scabiosa columbaria* L. subs. *pratensis* (Jord.) Braun-Blanq., la scabieuse colombaire, est déclarée médicinale dans la liste du Jardin de Montpellier en 1697 (Magnol) (Alain Asselin).

130 Marie-Victorin, 105–6 énumère une quinzaine d'espèces de fougères dans l'est du Canada.

munes. Le fume-terre[132], le lin[133], l'hysope[134], le tussi-lage[135], le trèfle blanc et rouge[136] y croissent aisément.

Les Outtaragouara[137]

qui sont une sorte de haricots, portent leur fruit bien différemment des nôtres. Ceux-ci les produisent hors de terre et dans les gousses, et ceux-là dans la terre et sans gousse. Ce fruit est bien plus délicat que les haricots de nos jardins.

Le bouillon blanc[138]

ou le *taxus barbatus*, ou la *dépiteuse* comme l'appellent quelques-uns, fleurit aisément dans ces contrées. Sa fleur jaune, qui tombe ou qui se détache de temps en temps, après un coup de houssine* qu'on donne sur le pied de la tige, lui a fait donner le nom de dépiteuse. Cette même fleur est un venin présent* pour le poisson. J'en ai vu souvent la preuve. La langue de bœuf[139] et de chien[140] s'y peuvent cueillir partout.

Il y a des fraises[141] en si grande quantité que cela passe en quelque façon le prodige. Elles n'ont pas tout à fait ni cette délicate douceur ni cette douce odeur des nôtres. La dent-de-lion[142] y est bonne en salade et en bouillon. Tout le monde sait assez que ce simple, étant fort laxatif, il faut le prendre avec modération.

La serpentine[143] est trop belle et trop rare pour n'en dire mot. Elle n'est pas si grosse ni si grande dans l'Amérique. Son oignon est fort violent. Un certain Français que j'ai connu, en ayant mangé par mégarde, courut à un confesseur, croyant d'avoir trouvé la mort dans le pot, comme ceux dont l'Écriture fait mention : *Mors in olla*.

[f. 10] Le jonc[144] est prodigieusement gros et long, de la hauteur d'une pique*. On en voit des grandes forêts dans les anses des lacs et tout le long des grandes rivières. Le poisson armé, qui est quelquefois long de douze pieds, s'y cache dedans pour y chasser. Voici comment : ce poisson, qui a la tête et le museau partagé

131 La «corne de cerf» est une plante européenne, *Plantago coronopus* L., qui croît dans les ports où Nicolas aurait pu la voir (Anna Leighton).

132 *Fumaria officinalis* L. (Marie-Victorin, 246). Peut-être une première mention en Nouvelle-France (Alain Asselin).

133 *Linum usitatissimum* L. (Marie-Victorin, 383–4). Van der Donck le signale en Nouvelle-Hollande en 1655, Boucher en Nouvelle-France en 1664, et Josselyn en Nouvelle-Angleterre en 1672. Sa graine fut importée en Amérique dès 1628 avec l'expédition Endicott (Mack) (Alain Asselin).

134 *Hyssopus officinalis* L. (Marie-Victorin, 490); voir Tegwyn Harris, *The Natural History of the Mediterranean*, 69, fig. 8, pour une illustration d'une espèce familière à Nicolas. Alain Asselin ajoute que van der Donck la signale en 1655 en Nouvelle-Hollande, et Boucher en 1664 en Nouvelle-France. John Winthrop Jr en emporta en Amérique en 1631 (Mack).

135 *Tussilago farfara* L. (Marie-Victorin, 594).

136 *Trifolium repens* L., pour le blanc et *Trifolium pratense* L., pour le rouge (Marie-Victorin, 361); possiblement une première mention en Nouvelle-France (Alain Asselin).

137 Marthe Faribault, «L'Apios tubéreux d'Amérique : histoires de mots» (désormais, Faribault 1991, et Faribault 1993), 109 croit qu'il s'agit de l'*Apios americana* Medik.. Anna Leighton estime qu'on aurait plutôt affaire ici à l'*Amphicarpa bracteata* (L.) Fern., amphicarpe bractéolée, plante que les Anglais appellent «hog peanut», puisque Nicolas en compare les fruits à des haricots.

138 *Verbascum Thapsus* L. (Faribault 1996, 106). Peut-être faudrait-il comprendre *Thapsus barbatus* au lieu de *Taxus barbatus*, car, à l'origine, cette plante, que l'on utilisait comme teinture jaune, venait de l'île de Thapsos (Guyot et Gibassier, 58). *Barbatus* fait allusion à

l'aspect duveteux de la plante. Les fleurs sont plutôt fragiles et risqueraient de tomber si on les traitait de la manière décrite par Nicolas.

139 *Anchussa officinalis* L., buglosse officinal, connu de Boucher en 1664 en Nouvelle-France. John Winthrop Jr serait responsable de son introduction en Amérique en 1631 (Alain Asselin).

140 *Cynoglossum officinale* L., cynoglosse officinal (Marie-Victorin, 455). Peut-être la première mention en Nouvelle-France (Alain Asselin).

141 *Fragaria virgiana* Duchesne, fraisier de Virginie (Marie-Victorin, 342) et *Fragaria vesca* L., fraisier des bois, qui lui ressemble beaucoup. *F. vesca* L. est le nom scientifique d'une de nos espèces indigènes (Anna Leighton). Les premiers découvreurs et Boucher en 1664 signalent la présence des fraisiers sur tout le territoire de la Nouvelle-France.

142 *Taraxacum officinale* Weber (Marie-Victorin, 553–4). Signalé en 1672 par Josselyn en Nouvelle-Angleterre comme une plante importée. Peut-être la première mention en Nouvelle-France (Alain Asselin).

143 Il est difficile de donner une identification précise, puisque plusieurs plantes ont pris le nom de «serpentine» ou de «serpentaire». Boucher la mentionne en 1664. Rousseau 1964 l'identifie à *Polygala Senega* L., polygala sénéca, ou sénéca (Marie-Victorin, 389). Mais d'autres candidats aussi variés que *Botrychium virginamum* (L.) Sw., botryche de Virginie (Marie-Victorin, 119) et qu'une *Arisaema* (Marie-Victorin, 840) pourraient convenir. Dodart signale l'existence d'*Arisaema atrorubens* (Ait.) Blume, ariséma rouge-foncé en 1686 (Alain Asselin).

144 Probablement les «cannes» déjà nommées plus haut. Nicolas parle ailleurs de «joncquières» pour indiquer une grande étendue de ces roseaux.

également avec le reste de son corps, et tout au contraire des autres poissons, qui attrapent leur proie en nageant naturellement, comme la truite ou le brochet, celui-ci élève son grand bec hors de l'eau, et l'ouvrant comme un compas, attend ainsi sa proie qui ne lui échappe jamais. J'ai dit qu'il chasse car, en effet, il vit ordinairement de gibier à plume qui, venant se jeter à grandes bandes parmi les grands joncs dont je parle, notre chasseur ou notre poisson armé n'a qu'à fermer son compas avec vitesse : je veux dire son long bec qu'il a ouvert exprès pour attraper l'oiseau qui vient passer au travers de ce piège. À même temps, le poisson qui tient sa chasse, qui est souvent un cygne, une outarde, une oie sauvage, un gros canard, une brenage*, un goéland, un bec-de-scie ou tel autre oiseau de marine*, plonge bien avant* dans l'eau pour y faire curée de son gibier.

Nos coureurs de bois[145] font de très beaux ouvrages de leurs grands joncs, et entre autres, les femmes les entrelacent si bien qu'elles en font de fort belles nattes teintes de diverses couleurs et ornées de beaucoup de figures. Ce jonc, étant tiré hors de l'eau, fournit un ragoût aux sauvages qui, le suçant par le bout d'en bas, font couler dans leur bouche une humeur* fort sucrée : c'est ce que j'ai expérimenté bien des fois.

Il y a dans le pays deux autres sortes de joncs communs : petits, ronds[146] et d'autres à trois angles[147].

Les Américains font provision d'une sorte de racines fort petites, fort noueuses, et extrêmement amères[148]. Ils les mangent dans leur bouillon. Fouillant dans la terre, ils y trouvent une espèce de petits oignons[149] qu'ils mangent avec plaisir. Ils usent de quelques autres racines qu'on nomme des *toubinenbour*, des *ounonnata* et des *outtaragouara*. Du reste, ils ne mangent point d'autres racines et jamais d'herbes, disant qu'elles ne sont faites que pour les animaux.

L'*attissaoueian*[150] est une fort petite racine, pas plus grosse qu'un gros filet à coudre. Je ne peux pas exprimer la valeur de cette racine dont les Américains font trois ou quatre sortes de couleurs rouges. Elle est si précieuse parmi les Barbares qu'il n'y a rien qu'ils estiment tant. On n'en trouve qu'en certains endroits, et comme cette racine est fort déliée*, il en faut beaucoup pour faire une teinture considérable.

Le *morsus diaboli*[151] est un peu différent de celui de l'Europe. Ce qu'il a de fort particulier, c'est une grande amertume; mais le bon appétit que nous avions quelquefois nous obligeait de passer* la règle des sauvages, qui ne mangent point d'herbe, et d'en mettre dans notre soupe. Et comme toutes les provisions [f. 11] de bouche qu'on a dans ces pays perdus sont à bout des armes, le bon appétit fait qu'on trouve ces amertumes douces, et les douceurs très fades de la tripe de roche sont des mets très exquis, quand d'ailleurs on se trouve dans certaines conjonctures* à mourir de faim.

La tripe de roche[152] est comme une certaine bave, ou je ne sais quelle sorte de mousse en façon d'un simple, qu'on nomme l'*oreille de Vénus*, pleine pour l'ordinaire* de petites araignées et entrelacée de mille filaments de ces petits animaux, où l'on voit bien des

145 Nicolas emploie souvent cette expression pour désigner, non les colons d'origine française, mais les Amérindiens.

146 *Scirpus validus* Vahl., ou *S. acutus* (Mühl.) A. Löve & D. Löve, à tiges cylindriques (Rousseau 1964, 299).

147 *Scirpus americanus* Pers., *S. Torreyi* Olney et *S. fluviatilis* (Torr.) Gray à tiges triangulaires (Anna Leighton). Voir aussi Rousseau 1964, 299.

148 Description trop vague pour permettre une identification (Alain Asselin).

149 Nicolas fait-il allusion à une espèce d'*Allium* ou à une autre espèce à bulbe telle qu'un *Erythronium* (Marie-Victorin, 655) – voire même à une *Medeola* (Marie-Victorin, 647)?

150 *Coptis groenlandica* (Oeder) Fern., coptide du Groenland, plante tinctoriale à rizhome jaune (Marie-Victorin, 230). D'après Faribault 1996, 105, son nom commun, «savoyane», dérive du Mi'kmaq *Tisavoyane*. Les racines de certaines espèces de *Galium*, telles que *G. boreale* L. ou *G. tinctorium* L., également désignées comme de la savoyane, produisent une teinture rouge (Anna Leighton). Il se peut que Nicolas inclut dans sa liste de plantes tinctoriales la *Sanguinaria canadensis* L. (Marie-Victorin, 341), d'autant plus que la sanguinaire

est déjà décrite par Cornut en 1635 et mentionnée dans «La flore du Canada en 1708» (Boivin). Voir aussi Rousseau 1964 sur les plantes tinctoriales (Alain Asselin).

151 *Morsus diaboli* était le nom officinal d'une espèce méditerranéenne de *Succisa,* connue jadis sous le nom de *Scabiosa australis* (Wulf.) Reichenb. (Marie-Victorin, 540). Elle a été naturalisée dans quelques régions du Québec. Mais elle n'est pas forcément la *Morsus diaboli* de Nicolas. D'autres espèces de *Succisa* sont possibles. Bien plus, certains herbiers médiévaux utilisaient cette expression pour la *Pulsatilla vulgaris* Mill., connue aussi comme l'*Anemone pulsatilla* L. Nicolas pensait-il à une espèce indigène d'anémone (Marie-Victorin, 230) ayant quelque rapport à la *Pulsatilla*? Les racines de l'anémone sont plutôt amères. Il n'est guère possible d'être plus précis dans nos identifications (Alain Asselin).

152 Plusieurs sources utilisent l'expression «tripe-de-roche» pour désigner des lichens de type *Umbilicaria* qui comprend plusieurs genres : *Umbilicaria, Lasallia, Actinogyra*. Le lichen décrit par Nicolas est fort probablement l'*Umbilicaria papulosa* et ce que les Cree et Montagnais désignaient comme le *waahkwan*. On mangeait les lichens bouillis en cas de famine. Ce que Nicolas raconte

mouches prises à ces filets tendus pour* cette fin. *Insidians taneris crudelys aranea muscis!* Cette mousse est assez gluante quand il a plu; mais lorsque le soleil a dardé un moment ses rayons dessus, elle devient sèche comme du bois, et tant soit peu qu'on la touche, elle se réduit en poudre, laquelle, étant jetée dans l'eau bouillante, se forme en colle la plus insipide et la moins nourrissante du monde. Néanmoins, fort souvent je l'ai trouvée de bon goût avec mes camarades, lorsque nous mourions de faim.

Du citron[153]

C'est ici le plus beau et le plus rare de tous les simples que j'aie jamais remarqué dans tous mes voyages. Il croît à l'orée des bois et au milieu des prairies de la Virginie. Sa hauteur est de plus de trois pieds géométriques. Ordinairement, chaque plant apporte* dix ou douze fruits, aussi gros qu'un œuf de poule* d'Inde. L'écorce de ce fruit ressemble entièrement à nos citrons. Sa figure est la même. Il a trois couleurs : un peu vert, un peu jaune, un peu rouge. Dans sa maturité, il est tout jaune. Quand il est à demi mûr, il est d'un excellent goût; étant trop mûr, il est trop doux. Sa graine ressemble à celle du melon, mais elle est plus petite. Elle se sème d'elle-même et revient tous les ans, sa plante se déssèchant et mourant tous les hivers. Sa feuille est dentelée. J'en donne la figure.

Pour vous dire maintenant pourquoi j'ai si bien fait la description de cette plante, c'est qu'il faut savoir qu'un jour, m'étant égaré avec un seul Français dans les bois et dans les vastes prairies de la Virginie, où le foin y était presque de la hauteur d'un quart de pique et y mourant de faim avec ce cher camarade qui, le jour auparavant que je rencontrasse des citrons, m'était tombé deux fois en défaillance dans le chemin, mourant de faim, ayant souffert déjà quelques jours sans beaucoup manger et ayant passé une nuit sur le bord d'une écluse

de castor, couché à plate terre, sans nulle couverture et sans vivres. Le lendemain, nous traînant misérablement dans les bois pour tâcher de nous remettre dans notre route, nous tombâmes heureusement dans un grand fonds de bois et ensuite dans des prairies à perte de vue, que nous avions vu du haut d'une montagne. Nous trouvâmes des citrons, que je décris ici, avec des mûres de buisson. Nous en mangeâmes beaucoup et en fîmes provision pour quelques jours. Nos camarades, qui étaient égarés de l'autre côté, au nombre de quatre, furent* à la chasse de quelques grenouilles vertes, qu'ils trouvèrent de bon goût, comme ils nous en assurèrent deux jours après que nous nous trouvâmes ensemble au milieu des prairies et sur le bord de la rivière de Techiroquen, au milieu d'une armée d'Américains, que j'avais arrêtés par une harangue que je fis, priant le général de faire détacher trente ou quarante de ces soldats pour aller à la recherche de mes camarades qui étaient égarés et qui mouraient de faim.

[f. 12] *Du varech*

Il y a de deux espèces de cette herbe marine. Il s'attache contre cette herbe, une infinité de petits coquillages pris l'un à l'autre. Cette liaison se fait par beaucoup de petits filaments qui, se liant et s'insinuant dans le limon du bord des eaux et contre le coquillage, l'un et l'autre sont retenus et empêchent la violence des vagues, quand il y a tempête, d'emporter au large et l'herbe et le coquillage, qui pourtant ne sont pas quelquefois si fort attachés contre terre qu'ils ne soient enlevés par les flots. Cette espèce de varech est faite dans son feuillage comme les serres des écrevisses.[154]

L'autre espèce de varech[155] est une herbe prodigieusement grande. J'ai vu de ces feuilles dont une était plus ample qu'une grande couverture de lit. La queue de la feuille était grosse comme le bras d'un homme et longue de deux ou trois brasses*. La feuille est extra-

à propos des araignées est amusant. Adhérant à la face verticale des rochers, ces lichens pouvaient leur servir d'abri et de tremplin pour y tendre leurs toiles (Anna Leighton). Voir Jacques Rousseau, *Les noms populaires des plantes au Canada français*, 140 (désormais, Rousseau 1955). Ce lichen est représenté dans le *Codex*, Pl. XXIV, fig. 41.2, sous la désignation «tripe de roche ou mousse dont on fait quelque bouillon qui devient comme de la colle très insipide». P.-S. Doyon, *L'iconographie botanique en Amérique française du XVIIe au milieu du XVIIIe siècle*, 165, compare la figure du *Codex* à quatorze autres illustrations ressemblant de près à la sienne et démontrant qu'il s'agit bien d'un lichen.

153 À quoi Nicolas pouvait-il penser en parlant du citronnier en Virginie? *Citrus limon* (L.) Burn. f. est natif des Indes (Guyot et Gibassier, 47). On connaissait le citron-

nier en Europe depuis l'Antiquité classique (Rachel Löwenstein, lettre à Gagnon, 26 mai 2006). Mais il pourrait aussi s'agir de *Podophyllum peltatum* L., pomme de mai, parfois désigné comme citronnier sauvage? On le trouve dans les états du centre des États-Unis et jusque dans l'ouest du Québec et l'ouest de la Nouvelle-Angleterre (Anna Leighton). Il s'agirait plutôt de *Diospyros virgiana* L., plaqueminier de Virginie, ce que semblent indiquer la hauteur de l'arbuste (au moins trois pieds), le nombre de fruits (dix à douze), leurs couleurs (vert, jaune et rouge) et le fait que leurs graines ressemblent à celles du melon (Alain Asselin). Par contre, les deux plantes sont nommées dans «La flore du Canada en 1708» (Boivin).

154 Probablement une espèce de *Fucus* (Alain Asselin).

155 Probablement une espèce de *Laminaria* (Alain Asselin).

ordinairement forte, elle ressemble à une peau passée en parchemin. De cette herbe se forment les macreuses[156] qui sont des oiseaux de marine.

Du capillaire[157]

Ce simple est un des plus rares et un des plus recherchés de tout le pays. Ce n'est pas qu'il n'y en ait beaucoup dans tous les bois, mais il est précieux pour cette vertu* qu'il a de rafraîchir la poitrine par l'excellent sirop qu'on en fait et qui est si recherché en France, où l'on vend le pot* quatre ou cinq écus*. Voilà à peu près ce que j'ai remarqué de plus rare des plantes des Indes.

Disons maintenant un mot …

Des semences qu'on trouve ou qu'on a transportées dans les Indes et qui y produisent abondamment

Le millet[158], l'avoine[159], l'orge[160], le seigle[161], les lentilles[162], les pois chiches[163], les haricots de toutes les espèces[164], les pois de toutes façons[165], le froment de toutes les sortes. Le blé d'Inde est naturel au pays et presque tout différent du nôtre, du moins pour la couleur. Je dirai en général que tous ces grains et plusieurs autres produisent très bien dans ces terres nouvelles. Mais comme le blé froment, les pois verts, et le blé d'Inde sont les trois sortes de grains qu'on cultive le plus, avec l'orge, je dirai un mot de chacun en particulier, après vous avoir fait remarquer qu'on ne sème jamais en automne ni pendant l'hiver, mais seulement pendant les mois d'avril et sur la fin seulement, et pendant tout le mois de mai. Les terres de ces pays sont si grasses et le climat y est si favorable, pour ces sortes de grains et de toutes les choses dont j'ai parlé, que la nature y fait ses productions plus vite qu'en ces pays. Les terres se trouvant de tout temps engraissées par cette multitude de feuilles qui pourrissent toujours dans les bois d'un an à l'autre, la terre n'est presque que du fumier très fin et fort gras de sorte que, quand on a défriché quelque bois, la chaleur, venant à pénétrer cette terre toute pétrie de fumier, elle produit plus vite et à peu près comme les couches qu'on fait dans les jardins, où l'on voit que les graines qu'on y sème naissent d'abord* et produisent plus vite.

[f. 13] De l'orge

Ce grain a été transporté de la France, et si les Français s'attachent beaucoup à en semer, ils n'en mangent pourtant guère. Mais comme l'on fait beaucoup de bière dans le pays, et qu'on se sert pour cela de l'orge, ils le vendent aux faiseurs de bière, qui en brassent d'aussi bonne que celle d'Arras.

Du froment

Le froment qu'on sème en l'Inde, n'est pas différent du nôtre, qu'en ce qu'il n'est pas tout à fait si pesant, ni par conséquent si bon. Dégénérant peu à peu, il n'est pas si nourrissant. La récolte de ce grain est quelques années si heureuse, partout où l'on le sème, qu'on en peut déjà charger divers vaisseaux pour le transporter tout moulu et tout passé* dans les îles de l'Amérique méridionale. Ce trafic* a commencé à s'établir, et on [a] changé cette marchandise en sucre, en tabac, en coton, en indigo, qu'on porte en France, pour changer encore ces marchandises en d'autres propres au pays qu'on vend beaucoup plus que dans l'Europe.

On ne mange dans le pays que du pain de froment :

156 *Oidemia nigra* (L.), la macreuse noire.
157 *Adiantum pedatum* L., plante médicinale utilisée contre les maladies pulmonaires en Nouvelle-France (Rousseau 1964, 297–8 et Marie-Victorin, 124). Décrite par Cornut en 1635 et signalée par Boucher en 1664. On la connaissait déjà en 1636 au Jardin de Paris (Alain Asselin).
158 Possiblement *Setaria italica* (L.) Beauv. ou *Panicum miliaceum* L. On employait souvent les mots *mil* ou *millet* sans distinction. Ainsi Boucher mentionne la présence du «mil» en 1664 en Nouvelle-France, alors que Nicolas parle de «millet». Pour rendre les choses plus compliquées, on sait qu'on employait ces mots pour désigner d'autres espèces telles que les *Sorghum*, *Holcus* et *Phalaris*. Nicolas utilise aussi l'expression «petit millet» ailleurs dans le texte (Alain Asselin).
159 *Avena sativa* L. (Louis-Marie, 86). Signalé par Boucher en 1664 en Nouvelle-France et par Josselyn en Nouvelle-Angleterre en 1672 (Alain Asselin).
160 *Hordeum vulgare* L. (Louis-Marie, 84). Signalée par Boucher en 1664 en Nouvelle-France, par van der Donck en Nouvelle-Hollande en 1655, et par Josselyn en 1672 en Nouvelle-Angleterre (Alain Asselin).
161 *Secale cereale* L. (Louis-Marie, 83).
162 *Lens culinaris* Medik. (Marie-Victorin, 345). Signalée par Boucher en 1664 en Nouvelle-France.
163 *Cicer arietinum* L. Possiblement une première mention en Nouvelle-France (Alain Asselin).
164 Peut aussi bien s'appliquer à des espèces indigènes qu'importées, puisque Nicolas parle de haricots «de toutes les espèces». L'espèce indigène est *Phaseolus vulgaris* L., alors que l'espèce venue d'Europe serait *Vicia Faba* L. ou peut-être *V. sativa* L. Cartier nomme déjà la première, comme Boucher le fera en 1664. Clusius décrit une espèce américaine, *P. vulgaris* L. en 1601. En 1628, l'expédition d'Endicott apporta des fèves européennes en Amérique (Alain Asselin).
165 *Pisum sativum* L. (Louis-Marie, 180). Introduit très tôt en Amérique, entre autres par l'expédition d'Endicott en 1628 (Mack). Voir Rousseau 1964 pour des détails sur

même les plus pauves n'en veulent pas d'autre. Leurs chiens ne voudraient pas manger le gros pain que les paysans mangent avec appétit en France.

Des pois verts
On recueille par tout le pays ce légume en abondance et il se vend, à cause de sa bonté particulière, autant que le froment[166]. Il n'y a point de navire qui mouille à la rade, qui ne s'en charge de plusieurs tonneaux pour porter en France, en Angleterre et en Hollande, où ils sont d'un très grand débit, à cause de cette admirable purée verte qui s'en fait. Cette sorte de pois cuit si bien et abonde si fort qu'une poignée ou deux fait une bonne purée. Il y en a tant, des années qu'il y a, qu'on ne sait presque qu'en faire. On en engraisse les cochons. Jamais les vers ne les rongent. Ils sont gros extraordinairement.

Du blé d'Inde, du mil d'Espagne ou du blé de Turquie[167]
De tous ces noms, je n'en trouve point de plus convenable que celui de blé d'Inde, car il est certain qu'il a été porté des Indes occidentales et non pas de Turquie, ni d'Espagne, ni d'aucune partie de l'Asie, quoi qu'en disent quelques écrivains.

Ce grain est gros comme un pois; il n'est pas rond : il est un peu plat des deux côtés. Il a son germe de l'autre, par où il est attaché à sa tige. La partie de dehors est fort luisante et fouettée* de diverses couleurs.

Tantôt, tout l'épi, qui est ordinairement long d'un pied, a quatre ou cinq cents grains, est tout jaune et reluisant comme de l'or; tantôt, il est tout blanchâtre, d'autres fois, il est tout gris, fort [f.14] chargé, tirant sur une couleur violâtre. Enfin, on en voit qui est tout rouge, et d'autres fois, tellement varié de toutes ces couleurs qu'il paraît agréable. Il y a des épis de ce blé dont tous les grains sont aussi joliment fouettés que les tulipes.

Plusieurs nations ne vivent que de ce légume, qui est grossier. Les femmes sont les meunières, et leur moulin n'est fait que de deux pierres, entre lesquelles ces ménagères le concassent, ou bien elles le grillent dans un grand mortier de bois qu'elles ont creusé avec du feu. Le pilon est une longue barre de quelque bois dur. D'autres fois, sans façon, elles le font bouillir tout entier. Cuit de cette manière, il est extrêmement grossier et fort indigeste, car il est toujours dur quoiqu'il ait boulli les quatre ou cinq heures.

La meilleure façon de le manger est de le cueillir lorsqu'il est encore en lait et de le faire bouillir un peu de temps ou, sans autre peine, de le tendre au soleil sur des écorces pour le faire sécher, et le mettre ensuite dans des sacs à la mode des Indiennes, qui en font de très beaux, de l'écorce du bois* blanc, qu'elles font bouillir et en font une espèce de très beau chanvre, dont on fait mille petits ustensiles*, aussi bien que de diverses autres sortes d'écorces d'arbres fort propres pour faire du fil et des cordages. L'ortie, la cotonaria, le bois de plomb, l'écorce d'orme, celle du noyer amer leur sont fort propres pour toutes ces sortes de travaux et pour plusieurs autres, jusque même à faire de très beaux filets pour la pêche.

Quand on veut manger le blé d'Inde préparé de la façon que je viens de dire, on le pile comme j'ai dit ou l'on le fait bouillir, et il est très bon : aussi est-il le plus cher.

Quand on veut le manger un peu meilleur que l'ordinaire, il faut le faire rôtir à la mode des Barbares, ou sous la cendre brûlante ou sous le sable ardent*, d'où on le tire avec une espèce de crible pour le séparer d'avec la cendre ou d'avec le sable. On le mange ainsi tout entier ou l'on le pile. Il est bon des deux façons. Il est moins indigeste et plus nourissant étant en farine et on en fait de la bouillie.

Les boulangères du pays en font une sorte de pain qui est fort rude : aussi charge-t-il beaucoup l'estomac, quoique le grain dont il est pétri soit merveilleusement* laxatif et qu'il purge un peu trop. Dans les commencements, qu'on n'est pas accoutumé à ces sortes de vivres, le ventre s'enfle extraordinairement et avec douleur, de telle manière qu'il semble qu'on va crever. Quelques heures après, tout cela passe par un bénéfice* de ventre et avec tant d'évacuation qu'on se trouve extrêmement purgé et mourant presque de faim, mais encore vaut-il mieux user de cette drogue* que de mourir de faim et la manger sans sel, sans graisse et sans autre chose que de l'eau toute pure, que de se laisser mourir de faim, auprès d'une chaudière* plus commode* à donner à manger à des animaux immondes qu'à des hommes qui n'ont pour tout ragoût que quelques méchants* haricots, mêlés avec quelques citrouilles, sans nul assaisonnement que de l'eau toute claire.

[f. 15] Au reste, je crois être obligé de dire ici que le grain de blé d'Inde concassé et bouilli dans de l'eau

son introduction précoce en Acadie et en Nouvelle-France.
166 *Triticum aestivum* L. (Marie-Victorin, 790). Introduit de bonne heure en Nouvelle-France et en Nouvelle-Angleterre (Alain Asselin)

167 *Zea mays* L.; signalé pour la première fois par Cartier; décrit par Clusius en 1601; représenté dans le *Codex*, Pl. XXIV, fig. 41.2, sous la désignation «Mentamin ou bled dInde».

Histoire Naturelle, ou la fidèle recherche de tout ce qu'il y a de rare

seulement est très bon pour guérir des rétentions d'urine et pour ramollir les duretés qui empêchent, avec des effroyables incommodités, plusieurs personnes d'aller à la selle. J'ai vu des belles expériences pour guérir de ces deux incommodités.

Description de la plante de ce grain
Ce simple produit sa fleur au même temps qui forme son épi, d'un côté tout opposé à sa fleur, au contraire des autres plantes. Cette espèce de froment a plusieurs racines qui ne sont pas trop grosses, dont il sort un tuyau en façon de canne, assez gros par le bas, qui est quelquefois rougeâtre et qui va en rétrécissant à mesure qu'il croît. Il se pousse de sept à huit pieds de hauteur. Il est rond et noueux, plein de moelle spongieuse au dedans, douce et sucrée. On a fait de la cassonnade assez bonne de la paille de ce simple, dont les feuilles sont longues, larges, pleines de veines et comme celle des cannes. Tout au haut de ce grand tuyau, il sort des pleumaches* d'un pied de long, séparés, pendant en bas, stériles et sans grain. C'est la fleur de la plante qui semble être inutile, puisqu'elle ne produit rien qu'une couleur jaune mêlée d'un peu de blanc et de rouge.

L'épi sort du bout des nœuds de la tige. Il est long et enveloppé de plusieurs feuilles tendres, vertes, jaunes, rouges, blanches, au bout desquelles il sort une certaine façon de filaments, qui ressemblent à des cheveux assez longs. Les épis ont ordinairement dans ce pays un pied de long, autour desquels les grains sont fort serrés avec un agréable arrangement de huit ou dix lignes.

Pour semer ce blé, on fait des petites fosses, où l'on jette cinq ou six grains après avoir fait germer tout ce qu'on en veut semer. On le met dans l'eau ou dans un trou couvert de terre et de fumier, qu'on arrose pour le faire germer. De cette façon, il ne manque guère à venir; autrement les vers l'ont mangé dans la terre avant qu'il puisse germer. De cette manière, il croît en peu de temps, et la récolte se fait au mois de septembre, ayant été semée environ la fin de mai, ou tout au plus tard vers la Saint-Jean.

Il n'y a rien qu'on ne profite* en ce grain. La paille est propre à divers usages. Les Indiennes en font de fort beaux souliers peints de diverses couleurs; elles en font des sacs et de grandes trousses*, où elles enferment leurs plus rares* bijoux. Les soldats en font des carquois et plusieurs autres raretés qui seraient estimées en Europe.

D'autres en font des cases pour y loger, mais nos Français, qui ont d'autres occupations, ne s'amusent point à cela et se contentent de lâcher leurs bœufs et leurs vaches dans les champs pour y faire manger cette [f. 16] paille, où ils trouvent bientôt des avantages par le lait qu'ils tirent de leurs vaches avec plus d'abondance qu'à l'ordinaire. Ce lait étant plus gras et plus doux, ils en font du *beurre de réserve**, comme ils appellent. C'est en ce temps qu'on mange la meilleure crème du monde.

De l'orysimon, irio, ou blé noir[168]
On n'a pas jusqu'ici fait beaucoup d'état de ce grain dans les Indes. Il y croît pourtant bien, et c'est un plaisir de le voir sous sa feuille fort verte, portant la figure d'un cœur. Sa tige et ses branches sont rouges, sa fleur est blanche, son grain noir, un peu long, en figure de triangle équilataire. La farine que ce grain rend est fort blanche. On en fait du pain et de la bouillie. Les tourteaux* qu'on fait sur les plaques de fer sont d'assez bon goût, mais au bout, cette nourriture n'est guère meilleure que celle du blé d'Inde que nos Américains nomment *mentamin*.

[F. 17] DEUXIÈME LIVRE

Des fruits, des arbrisseaux, et des arbres des Indes occidentales, transportés ou naturels dans ces terres

Le désir que nous avons tous de savoir fait paraître que la curiosité est un certain cachet*, et je ne sais quel divin caractère imprimé bien avant dans nos âmes qui nous porte éternellement à pousser toujours plus avant nos connaissances : d'où il arrive que l'œil, qui est à mon avis le plus bel organe de notre corps, n'est jamais si satisfait des différents objets qui se présentent à lui et sur lesquels il s'arrête, quoiqu'ils soient les plus charmants, qu'il ne tâche toujours d'y découvrir des choses nouvelles pour s'avancer sans relâche dans les termes* de quelques lumières qu'il n'avait pas encore découvertes. C'est ainsi que des grands génies, touchés de la curiosité, ont bien voulu admirer jusqu'aux plus petites plantes qui semblaient n'avoir rien d'estimable, et qu'ils ont étudié avec affection* les différences, les qualités et les vertus* de chaque chose, et ils ont bien voulu nous

168 *Fagopyrum esculentum* Moench (Marie-Victorin, 182), sarrasin. Van der Donck en signale la présence en Nouvelle-Hollande en 1655 et Boucher en Nouvelle-France en 1664 (Alain Asselin).

en laisser des mémoires. Ainsi, à leur imitation, bien que j'en sois fort incapable, je vous prie de recevoir les noms et les figures de quelques fruits, de quelques arbres et de quelques arbrisseaux qui vous sont inconnus, aussi bien que leurs qualités.

De la fraise que les sauvages nomment le fruit du cœur[169]
C'est ainsi que ces hommes ont nommé ce fruit, à cause de la figure* du cœur qu'il porte. En leur langue, *outé* veut dire cœur et *min* veut dire du fruit en général. Ainsi, joignant ces deux mots ensemble, ils nous donnent, en insérant un *-i-* entre deux, pour éviter à la façon des Grecs la rudesse de la prononciation, le nom de la fraise. Ils disent *outé-i-min*, qui signifie proprement le fruit du cœur pour deux raisons : 1 – parce qu'il en porte la figure; 2 – parce que ce fruit est ami du cœur, tant pour ces rares* qualités que parce qu'il le réjouit. La fraise du Nouveau Monde ne diffère en rien de la nôtre qu'en ce qu'elle y est plus petite, moins odoriférante et beaucoup plus commune : d'où vient que les personnes s'en nourissent quelque temps indifféremment ensemble.

[f. 18] *De la framboise ou du fruit du sang*[170]
Ce que nous appelons la framboise, nos errants le nomment en leur langue le *fruit du sang*, pour la même raison qu'ils nomment la fraise le *fruit du cœur*. Ils donnent à celui-ci le nom de fruit du sang, car si l'un représente le cœur, celui-ci ressemble à du sang ; et comme *min*, comme j'ai dit, signifie du fruit en général, et *miskoui* du sang, ils composent un mot qui veut dire justement le fruit du sang, *miskoui-i-min*, parce que de ce fruit, il en sort une liqueur* qui semble* du sang, que les sauvages boivent avec plaisir, à cause de cette odeur fort douce qui sort de ce fruit dont on voit de quatre espèces : du rouge, du noir, du jaune et du blanc, avec tant de profusion que les campagnes en sont toutes jonchées en divers climats*.

La framboise noire[171] est appelée *makatéming. Makaté* signifie couleur noire. C'est de ce mot que ces barbares ont pris occasion* de nommer les ecclésiastiques les *noirs*, ou plutôt les *habillés de noir* ou les *robes*

noires. *Ka-makatéouikoreietch*, disent-ils, voyant un prêtre. *Ka* signifie «qui», *makaté* «du noir» et *koreitch* «vêtu». Ils insèrent *oui* quelquefois, je ne sais pourquoi, mais parlant correctement, ils disent simplement *makatakoreiatch*, «la robe noire» ou «le prêtre». Et sachant que ces sortes de gens ne se marient point, ils ne peuvent pas comprendre comment ils viennent au monde. C'est pour cela qu'ils croient qu'ils sont des génies descendus du ciel. Mais je ne prends pas garde que je représente plutôt ici un grammarien et un historien qu'un naturaliste dont je fais état, puisque je vous dois de dire que ce qui porte la framboise est un arbrisseau qui ne diffère en rien de celui de France, qui ressemble à une ronce[172].

[f. 19] *Du bleuet rond et rond en olive*
Le bleuet rond, ou la vigne du mont Ida, *vitis idêa*[173], sort d'une plante haute d'un pied et demi géométrique. Étant assez connu en France, je n'en dirai rien, si ce n'est qu'il est commun dans tout le Canada et dans toute l'Inde occidentale. Les sauvages en font partout des grandes provisions : ils le font sécher pour s'en servir au besoin dans des festins. Il est d'un bon goût; il resserre le ventre quand on l'a un peu trop libre, ce qui arrive très souvent à des gens qui n'ont que de l'eau à boire et de la viande ou du poisson à manger, pour lit la plate terre et pour maison une écorce ou une peau de bête fauve.

Le bleuet long en olive[174] est commun dans le pays. Il n'est pas de trop bon goût. Le défaut* de vivre le fait trouver fort bon, quoique de son naturel il soit fort amer. Il naît d'un arbrisseau haut de quatre à cinq pieds. Son bois est pliant comme de la corde sans rompre, particulièrement quand il y a quelques jours qu'il est coupé. On peut en lier tout ce qu'on veut, même les prisonniers de guerre qu'on attache à quatre piquets plantés bien avant* dans la terre. Il est propre à couvrir des bouteilles, à faire des paniers et des tasses où la liqueur ne pénètre point quand elles sont tissées par les ouvriers qui savent se servir de ce bois, qui est bien plus fort et plus beau que le coudrier* et que l'osier. Les petits écrans qu'on en fait sont rares et fort recherchés.

169 On en connaît deux espèces indigènes dans l'est du Canada : *Fragaria vesca* L. et *F. virgiana* Duchesne (Rousseau 1964, 292 et Marie-Victorin, 342).

170 *Rubus idaeus* L. (Marie-Victorin, 331).

171 *Rubus canadensis* L. (Marie-Victorin, 334) (Anna Leighton).

172 *Rubus arcticus*, qui est une plante plus ou moins rampante, très différente des framboisiers de France (Marie-Victorin, 330) (Anna Leighton).

173 *Viburnum cassinoides* L. (Marie-Victorin, 534). Possiblement une première mention en Nouvelle-France (Alain Asselin).

174 Nicolas semble avoir mis sous la même rubrique plusieurs espèces de bleuets, telles que *Vaccinium myrtilloides* Michx. et *V. corymbosum* L. (Marie-Victorin, 442).

De la pomme de terre[175]

C'est sur la pointe aux Poissons Blancs, sur les rives de la mer Tracy, où j'ai découvert pour la première fois ce beau fruit. C'est une pomme jaune et rouge qui n'est pas plus grosse qu'une noisette commune, laquelle naît d'un très petit arbrisseau fort bas et rampant contre terre. Ce fruit agace les dents parce qu'il est âpre. Il n'a rien de rare que sa beauté. Il est restringent* comme le bleuet.

Du fruit de la Trinité[176]

Il n'est pas plus gros qu'un grain de chapelet. Il est rouge. On n'en mange que dans la nécessité*. Son nom provient de trois grains qui sortent de trois feuilles sur un arbrisseau fort bas.

D'un autre fruit noir[177]

Ce fruit est produit à grosses touffes d'un arbrisseau assez élevé. Il retire* beaucoup à la graine des hièbles* et du sureau. Les Européens ne peuvent guère s'accoutumer au goût de ce fruit qui est puant. Les sauvages le mangent avec plaisir, aussi bien que toutes les autres choses que nous n'aimons pas. Il semble que ces étranges personnes ont de l'aversion de tout ce qui nous plaît et qu'elles estiment tout ce que nous méprisons*. Elles ne peuvent souffrir nos meilleures odeurs et disent qu'elles sentent mauvais. Plusieurs disent que les Français sont puants lorsque nous nous bouchons le nez pour ne pas les sentir.

Du fruit rouge ou du sureau[178]

Comme cet arbrisseau est connu de tout le monde et que celui des Indes n'est pas différent de celui de l'Europe, je n'en dirai rien. Je dirai seulement qu'il y a bien de la satisfaction d'y voir venir fondre dessus une infinité de pigeons sauvages pour manger le petit fruit rouge dont cet arbrisseau est tout couvert. On y tue un nombre infini de ces oiseaux. Les naturels du pays se purgent avec ce bois et en font un excellent onguent pour la brûlure.

[f. 20] *Du fruit rouge ou du cormier bâtard*[179]

S'il a jamais été vrai de dire qu'il se trouve des arbres qui ont beaucoup plus de fruits que de feuilles, cela se voit sur le cormier sauvage qui a cent fruits pour une feuille. On en voit des forêts entières, et comme le fruit est toujours rouge, les coureurs des bois appellent ces endroits les *bois rouges*. Le fruit est amer, grossier, insipide, petit comme un pois commun. Le corps de l'arbre n'est pas plus grand que nos pommiers, sa feuille ressemble à celle du cormier franc*.

L'ergominer…[180]

ou la cerise rampante est d'un goût exquis. Sa figure est semblable aux bigarreaux, sa couleur est noire. Ce fruit naît sur un arbrisseau rampant sur les sables des rives des lacs et des rivières, dans les plaines arides, découvertes et sablonneuses.

Du genèvre[181]

Il est tout semblable au nôtre. L'huile qu'on en fait est d'une odeur forte. Elle préserve de la peste. Pour la faire, il ne faut que piler le grain dans sa maturité, exprimer* dans un gros linge le suc qui sortira de la pâte qu'on aura faite en pilant bien les grains.

175 On appelle encore au Québec «pomme de terre» la *Vaccinium vitis-Idaea* L. Sur ce sujet, Faribault 1996, 108 nous renvoie à G. Dulong, *Dictionnaire des canadianismes,* (Marie-Victorin 439–40). Alain Asselin nous signale que les «billberries» de Josselyn (1672) ont été identifiés aux airelles.

176 Faribault 1996, 108 propose *Empetrum atropurpureum* Fern. & Wieg. comme identification possible (Marie-Victorin, 448). Alain Asselin suggère plutôt *Medeola virginiana* L. (Marie-Victorin, 647). Mais il y a d'autres possibilités. *M. virginiana* L. est mentionnée dans «La flore du Canada en 1708» (Boivin).

177 Possiblement *Sambucus canadensis* L. (Anna Leighton). Boucher mentionne un *Sambucus* non-identifié en Nouvelle-France en 1664, mais il s'agit ici d'une identification plus précise; peut-être une première mention en Nouvelle-France (Alain Asselin).

178 *Sambucus pubens* Michx. (Marie-Victorin, 530). Possiblement une première mention spécifique en Nouvelle-France. Le *Sambucus* de Boucher n'est pas spécifié (Alain Asselin).

179 Boucher mentionne aussi un «arbre à bois rouge», mais ce ne peut être celui dont parle Nicolas, puisque c'est le fruit (et non le bois) qui est rouge. C'est d'ailleurs de cette couleur du fruit que l'arbre tire son nom indien. En l'appelant «cormier», Nicolas envisage probablement le *Sorbus americana* Marsh., qui porte des baies rouges, ou le *Sorbus decora* C.K. Schneid. (Marie-Victorin, 319). Peut-être une première mention en Nouvelle-France (Alain Asselin).

180 *Prunus depressa* (Pursh) Gleason (Marie-Victorin, 320). Faribault 1996, 106 note qu'«ergominer» est le nom populaire du ragoumier. Il se peut qu'il s'agisse d'une première mention en Nouvelle-France. Représenté dans le *Codex*, Pl. XXIII, fig. 40.1, sous la désignation «miner».

181 *Juniperus communis* L. (Marie-Victorin, 138) et probablement *J. horizontalis* Moench. aussi (Marie-Victorin 139). Ce dernier est mentionné dans «La flore du Canada en 1708» (Boivin) (Alain Asselin).

Du pimina[182]

L'arbrisseau est rare, sa fleur est blanche, sa feuille dentelée comme l'aubépine, mais plus grande. Son fruit est rouge, jaune et vert. Il est produit à grosses touffes. Il est d'un bon goût, fort propre à faire des confitures.

Des mûres qui naissent sur les ronces[183]

Il y en a de trois ou quatre espèces. Les natifs du pays aiment fort ce fruit qui est différent du nôtre. Il y en a qui viennent à gros bouquets. Les femmes en font quelque sorte de teinture qui ne dure pas longtemps.

De l'attoka[184]

C'est un fruit de prairie et des lieux marécageux. Il ne mûrit que dans les neiges et au milieu des glaces. Il est rude, aigre et agace les dents. Il n'est pas plus gros qu'une balle de mousquet. Il est couvert d'un gros rouge. Les Anglais en font des provisions extraordinaires et s'en servent au lieu de verjus. Ils en font de très bonnes confitures.

De la pomme[185]

On n'a jamais vu en Normandie de plus petites pommes que celles que je propose ici. On n'en a jamais vu de plus grosses dans l'Inde, quoiqu'elles ne soient pas plus grandes qu'une grosse noisette. On les estime dans le pays, quoique, à dire le vrai, elles n'en vaillent pas la peine, étant fort mauvaises, sans goût et pleines de quatre ou cinq gros pépins fort durs. L'arbre est fort épineux, d'un feuillage fort particulier, tout denté comme la feuille d'aubépine. Sa fleur est fort odoriférante, son fruit devient jaune et rouge et il ne mûrit que par les grandes gelées.

[f. 21] *De prunes*[186]

Il y se voit trois ou quatre sortes de prunes seulement dans le Nouveau Monde. Les habitants les mangent toutes vertes, car, comme tous les biens sont communs et qu'il n'y a nulle clôture, chacun en prend quand et comme il lui plaît. On les fait bouillir à pleines chaudières. Les trois ou quatre espèces qu'on trouve de ce fruit n'en valent pas une bonne.

De la poire[187]

Il n'y en a que d'une espèce, dont l'arbre n'est guère gros. La fleur est belle, longue et odoriférante; le fruit n'est pas plus gros que ces belles perles, de la figure de poire, qu'on pend aux oreilles ou à la lèvre des Maures. La couleur de ce fruit est violette, le goût est doux et délicat. C'est le meilleur fruit qui soit dans le pays de l'Inde occidentale, où l'on en trouve partout.

Du cerisier ou merisier[188]

Cet arbre est tout différent du nôtre pour* son fruit, pour sa feuille et pour son bois, qui est fort puant. Sa feuille rapporte* à celle des pêches. Son fruit est rouge et pas plus gros qu'un pois. Son noyau est presque de cette grandeur. Il n'y a que les oiseaux et les petits sauvages qui donnent* dessus.

Du cerisier à grappes[189]

Le fruit sort d'un bois fort puant, est fort extraordinaire. Sa feuille est comme celle du pommier, et à le voir sans fruit, on le prendrait pour une sorte de ces arbres. Dans la belle saison, il est prodigieusement chargé de grandes grappes, de sorte qu'il semble qu'on voie plutôt des raisins que des cerises, qui sont assez grosses, semblables aux nôtres. Le goût en est amer, la fleur est belle et rapporte à celle du lilas, avec cette différence que l'un pousse sa fleur en haut et celui-ci la tourne en bas; l'une est grideline* et l'autre blanche.

182 *Viburnum trilobum* Marsh. (Marie-Victorin, 533–4), viorne trilobée et pimbina. Un peu plus loin Nicolas mentionne la «rose de Gueldre» qui est en fait la même plante. Il est possible qu'il l'ait vue en fleurs et n'ait pas su la reconnaître en fruits. Possiblement une première mention en Nouvelle-France (Alain Asselin).

183 Une forme de *Rubus* à fruits noirs (Anna Leighton).

184 Le mot, d'origine amérindienne, désigne *Vaccinium oxycoccus* L., canneberge (Faribault 1996, 105 et Marie-Victorin, 440). Le terme «Atoca» encore utilisé au Québec, se trouve dans «La flore du Canada en 1708» (Boivin).

185 L'une ou l'autre de nos deux espèces indigènes, probablement *Pyrus coronaria* L., (Anna Leighton). Ou encore une espèce de *Crataegus*, signalée par les premiers découvreurs. Boucher en parle comme de l'«épine blanche» en 1664 (Alain Asselin).

186 On connaît quelques espèces de *Prunus* dans l'est du Canada, sous la désignation *P. nigra* Ait. ou *P. domesticus* L. (Marie-Victorin, 320). Signalé en 1664 par Boucher en Nouvelle-France.

187 Peut se rapporter à plusieurs espèces d'*Amélanchier*, dont *A. Bartramiana* (Tausch.) Roemer et *A. stolonifera humilis* Wiegand (Anna Leighton). On appelle toujours les fruits d'*A. laevis*, «petites poires» au Québec (Marie-Victorin, 317).

188 Probablement *Prunus pennsylvanica* L. filius (Marie-Victorin, 320); représenté dans le *Codex*, Pl. xxv, fig. 42.1, sous la désignation «Serises sauvages» et signalé par Boucher en 1664 (Alain Asselin). Marie-Victorin, 321 affirme aussi que l'écorce libère de l'acide cyanhydrique au contact de l'eau. C'est dans doute l'origine de la mauvaise odeur signalée par Nicolas. Voir P.W. Atkins, *Molecules*, 126–7.

189 *Prunus virgiana* L., cerisier de Virginie, le plus commun

De l'oranger américain[190]

C'est un arbrisseau rare, qu'on ne voit que dans la Virginie, le long du fleuve de Techiroguen qui va se rendre dans la mer Illande, après avoir mouillé toute la Nouvelle-Albanie et une partie de la Nouvelle-Hollande. L'arbrisseau a plusieurs rejetons à quatre ou cinq pieds de hauteur. Ils sont tous fort épineux et piquants; les épines sont longues, fortes et déliées*, beaucoup plus que celles qui sont au bout des feuilles du palmier ou de l'aloès. On voit peu de feuilles sur l'arbrisseau. Bien près des épines, on voit bourgeonner une petite fleur blanche fort odoriférante, et de là, il se forme un fruit gros comme un pois sans pépin. Le fruit rapporte à un petit coquillage. Son odeur est plus forte que l'odeur des meilleurs oranges de Provence, son écorce les ressemble. Tout ce que je sais de plus sûr de ce fruit par ma propre expérience est que le mettant entre les dents, le serrant un peu et [f. 22] le touchant avec la langue, il laisse couler une humeur* si âpre, dans la bouche et entre les dents, que malgré qu'on en ait, il faut qu'environ une demi-heure on tienne la bouche ouverte pour en laisser sortir une certaine humeur fort claire qui coule du bout de la langue comme d'un robinet. Rien n'enfle, rien ne s'écorche, et à la fin, on se trouve soulagé et le cerveau fort purgé.

De l'aubepain[191]

L'aubepain n'est différent de celui de l'Europe qu'en ce qu'il multiplie* notablement plus et que son fruit est deux ou trois fois plus gros. Sa fleur est fort odoriférante et vient à plus grosses touffes.

Des rosiers sauvages[192]

Il n'y en a dans tout le pays que d'une sorte, qui y est fort commune. La fleur est rouge, simple et d'une as-sez bonne odeur. On ne voit point de roses doubles, que de celles dont les rosiers ont été transportés. Elles y perdent beaucoup de cette agréable odeur qu'elles ont dans leur pays naturel. Cette fleur n'épanouit qu'à la fin de juin. Le garancier qui s'y forme ne mûrit qu'en hiver. Il croît en forme d'olive et il et bon à manger en ce temps.

Des roses de Gueldre[193]

On en voit de deux ou trois façons* sur l'orée des bois. Les fleurs en sont blanches et à gros bouquets comme des houppes qui sont odoriférantes. Quand la fleur est passée, il se forme quelque graine comme une espèce de fruit.

Du vinaigrier[194]

Kaouissagan, c'est le nom qu'on donne à ce fruit et à cet arbre qui produit un fruit rouge fort aigre. Le faisant tremper dans de l'eau, il la rougit et la fait devenir aigre, de sorte qu'elle a le même effet que le vinaigre. Apparemment que messieurs nos médecins reconnaissent quelque vertu particulière dans les fruits et dans l'arbre, puisqu'ils ont bien voulu lui donner une place dans ce fameux jardin du roi, à Montpellier, où j'en ai vu, aussi bien qu'au jardin du même roi, à Paris et à l'Arsenal, de même nature que celui des Indes. La feuille est assez semblable à celle du frêne bâtard. Son fruit est gros comme le bout d'un flambeau; il est long du pied dans le pays sauvage. Ce fruit est caché sous un petit poil que les Latins nommeraient *lanugo*. Je ne sais si les teinturiers en pourraient faire quelque chose de bon comme nos Américaines qui s'en servent pour donner cette première teinture à cet admirable poil du porc-épic, dont elles font de si beaux ouvrages*, teints du plus éclatant vermillon.

de son espèce dans l'est du Canada (Marie-Victorin, 322). Probablement une première mention spécifique en Nouvelle-France (Alain Asselin).

190 Probablement *Diospyros virginiana* L., plaqueminier de Virginie, une source de nourriture et de médicaments chez les Indiens et les colons. Les mots *putchamin, pasiminan* et *pessamin* désignent en Algonquien les fruits secs. Le plaquemier sauvage produit un fruit orangé foncé de la grosseur d'une prune et porte des feuilles très pointues. C'est probablement la raison pour laquelle Nicolas le déclare «fort épineux et piquant» (Alain Asselin). Il est représenté dans le *Codex*, Pl. xxv, fig. 42.2, sous la désignation «Petit oranger de la virginie» et ressemble beaucoup au citron également illustré.

191 Il existe plusieurs espèces de *Crataegus,* tous assez semblables en apparence (Anna Leighton).

192 On connaît plusieurs espèces de roses sauvages (*Rosa*) (Anna Leighton).

193 Une des rares fois où Nicolas emprunte de l'anglais. Il aurait consulté Thomas Johnson, *The Herball, or General Historie of Plants*, 1633, qui était en fait une nouvelle édition du fameux *Herball* de John Gerarde, de 1597. Il s'agit du *Viburnum trilobum* (Marsh.), déjà mentionné, l'équivalent canadien du *Viburnum opulus* L. d'Europe (Faribault 1996, 110, n. 16 et Hatton, 255, fig. 541).

194 *Rhus typhina* L., sumac vinaigrier (Marie-Victorin, 391). *Kaouissagan* est probablement son nom algonquien (Faribault 1996, 104–5). «Sumac» était le nom officinal des *Rhus* (Dodoens). On cueillait déjà *R. glabra* L. au Canada avant 1620 (Alain Asselin).

De la vigne[195]

Il y a fort peu de climat dans toutes les Indes occidentales où l'on ne trouve des ceps de vigne et qui ne produise des raisins noirs seulement, dont on peut faire du vin, mais si grossier qu'il s'épaissit com [f. 23] me de la moutarde. Il n'est pas possible de boire de ce vin si, sur une pinte*, on n'en met trois ou quatre d'eau. On en fit néanmoins autrefois dans les pays des *Tionnontateuronnons*, dont trois prêtres usèrent durant trois mois pour dire la messe. Je ne doute pas qu'enfin on ne recueillît de fort bon vin en divers endroits, si on y cultivait la vigne.

Des groseilliers[196]

Il y en a de deux espèces, l'une est fort agreste* et néanmoins agréable quand le fruit est en maturité. Les groseilles rouges sont les meilleures; il y en a de deux espèces : l'une est comme celles de France, l'autre est particulière au pays des *Passinassieouek*, et je n'en ai vu que là.

Du rosier arbrisseau[197]

Il est particulier à nos vastes forêts. Il est sans épines, sa feuille est large, rayée d'une infinité de fibres : sa fleur est simple et rouge, sans odeur. Au milieu de la fleur, on voit un cercle chargé de petits cheveux où il se forme un petit fruit insipide.

Du noizilier ou du coudrier[198]

Il y en a partout de si prodigieuses quantités qu'on en pourrait faire un commerce assez considérable, si on les laissait mûrir et qu'on eût soin de les amasser pour les débiter en son temps. Mais pour dire le vrai, ni ce fruit, ni tous les autres dont je viens de parler, étant sans culture et comme des sauvageons parmi les grands bois, on juge bien qu'ils ne sont pas de la bonté des nôtres, ni même de ceux qu'on commence à cultiver dans les habitations françaises, où l'on mange des poires et des pommes franches* de toutes les façons : d'où l'on peut voir qu'il n'y a que le soin à prendre pour avoir toute sorte de bonnes choses dans cette partie du Nouveau Monde où les habitants ont déjà de tout ce qu'on

trouve en Europe, à la réserve* du vin. Aussi, en échange*, ils ont les meilleurs et les plus salutaires eaux du monde et tous les avantages de la chasse et de la pêche qui, étant extraordinaire et commune partout, ils en tirent des avantages considérables.

De l'arbrisseau sympathique

Je ne saurais, à mon avis, mieux finir ce traité des fruits et de / quelques / arbrisseaux que par une remarque qui me paraît fort curieuse, touchant la sympathie qui se trouve entre les différents objets.

C'est d'un arbrisseau que nous avons découvert dans nos forêts, duquel il découle un suc si violent et si astringent, qui se prend à la bouche si fortement qu'on en est autant incommodé que lorsqu'on mordrait dans une corme* qui ne serait pas mûre. Et si ce suc si âpre, qui sort bien [f. 24] plus abondamment du fruit de l'arbre que de l'arbre même, tombe par hasard ou autrement quand il n'est pas encore mûr sur du linge, il le tache d'une manière si surprenante qu'il n'y a pas moyen d'en enlever les taches, quoiqu'on lave et relave ce linge; mais lorsque le même arbre pousse des nouvelles fleurs, toutes les taches dont le linge avait été sali, s'effacent insensiblement d'elles-mêmes. On a remarqué en France la même chose pour les noix et pour le vin, dont les taches ne s'enlèvent jamais que lorsque la noix est mûre et que les vendanges sont faites, avec cette différence de notre arbre sympathique, que les macules* qu'il fait ne s'enlèvent pas par la lessive mais d'elles-mêmes, au temps que j'ai marqué*, où il faut bien laver et passer par la lessive les linges qui auraient été tachés par le suc des noix et par du vin au temps aussi que dits. De savoir maintenant comment cela se fait, c'est à ceux à qui il plaira d'en discourir. En attendant, je vais dire un mot des quelques autres arbrisseaux.

Du petit buis sauvage[199]

Parmi cette quantité de fruits et d'arbrisseaux qu'on découvre dans le Nouveau Monde, il s'y en voit un nombre infini dont je ne veux dire mot, soit qu'ils ne m'aient pas paru extraordinaires ou que je n'aie rien pu

195 *Vitis riparia* Michx. (Marie-Victorin, 405–6), représentée dans le *Codex*, Pl. xxiv, fig. 41.3, sous la désignation «victis Indica et canadencis».

196 Une espèce de *Ribes* (Marie-Victorin, 289). Signalé en Nouvelle-France en 1664 par Boucher et par les premiers découvreurs. Voir Rousseau 1964 pour un exposé sur nos différentes espèces de groseilliers (Alain Asselin).

197 Probablement *Rosa blanda* Ait. (Marie-Victorin, 325) et possiblement *R. johannensis* Fernald. Boucher les

signale en Nouvelle-France en 1664. Rousseau 1964 offre un exposé sur les premières observations de rosiers en Nouvelle-France (Alain Asselin).

198 *Corylus cornuta* Marsh., noisetier à long bec, semblable au *C. avelana* L. d'Europe (Rousseau 1964, 290 et Marie-Victorin, 152). *C. americanus* Walt. est déjà décrit par Clusius en 1601 (Alain Asselin).

199 On ne trouve pas en Amérique le véritable *Buxus sempervirens* L., buis commun, mais le *Taxus canadensis* (Marsh.), if du Canada, est également appelé «buis» au

découvrir de remarquable à vous faire savoir. Je dirai seulement quelque chose de ceux qui sont plus particuliers. Le premier qui se rencontre est une sorte de petits buis, tout différent du nôtre et rampant. Les sauvages en font état pour en faire des sacrifices à leurs dieux. Il y a, disent-ils, dans cette herbe une vertu occulte qui plaît aux divinités de leurs forêts, et ils s'en servent quand ils veulent fumer avec leurs pipes et quand ils veulent que leurs sacrifices soient plus agréables à leurs manitous. Ils mêlent la feuille du petit buis avec le dieu des herbes, qui est le tabac que les Européens leur vendent bien cher, puisqu'il est du goût des dieux qu'ils adorent.

De la myrte[200]

Toutes les sapinières et toutes les grandes cédrières de l'Inde sont jonchées de cet arbrisseau. Son odeur n'approche pas de l'odeur de la myrte de France. Il a cela de propre qu'il se provigne* comme le chiendent. Une seule plante est capable de faire plus de cent rejetons qui occupent un fort grand espace et font une très agréable verdure qui dure toujours, même pendant la plus forte rigueur de l'hiver.

[Deuxième cahier de l'Histoire naturelle de l'Inde occidentale]

[f. 25] Du poivrier[201]

Tous les lacs et presque toutes les rivières sont bordés de ce petit arbre, qui est fort odoriférant quand il est en fleur; mais il ne produit qu'une belle apparence sans fruit. La feuille, étant mâchée, a quelque petit goût assez agréable, et les Américains s'en servent pour fumer et pour offrir de l'encens aux dieux des eaux. *Michipichi*, qui est leur Neptune, a les premiers encensements. La feuille est un peu dentelée et longue, à peu près comme celle du saule ou de l'olivier, et lui ressemble beaucoup.

Du laurier sauvage[202]

C'est seulement dans le territoire du village de Gandagarho en Virginie que j'ai vu de cette sorte d'arbre. Il n'est pas plus haut que de trois ou quatre pieds*, il ne produit ni fleur ni fruit; le bois et la feuille sont odoriférants. L'écorce est bonne en décoction pour certaines douleurs* froides. La feuille rapporte beaucoup à celle du laurier rose. Je ne sais si on dit de cette sorte de lauriers ce qu'on dit des nôtres,[203] que la foudre ne les touche pas, ce qui a donné l'occasion à un poète de dire : *Laurus fulmineas ridens impune ruinas*.

Si cela est vrai, je m'en rapporte*, mais je ne m'étonnerais pas de cette grande merveille, si tous les lauriers qui sont dans le monde étaient aussi bien marqués qu'un arbre de cette espèce (que j'ai vu et touché et pris même une partie que je garde encore), qui fut coupé dans la ville de Montpellier, où toute la ville courut pour voir deux belles croix naturelles de couleur noire, qu'on trouva dans le milieu du tronc du corps de l'arbre, en le fendant par hasard pour le faire brûler. Cela se garde* encore dans la maison de monsieur Forest, assez proche de la citadelle. Ce laurier fut coupé dans un jardin de la ville, tout proche l'église Saint-Pierre, à la vue de l'hôpital. Voilà ce que je puis assurer pour l'avoir vu et touché comme j'ai dit. On ne voit point dans les Indes de ces sortes de lauriers qui ont servi de tout temps à couronner les grands poètes et les illustres conquérants. Ils ne sont pas de l'espèce de ceux qu'on voit à Naples, sur le tombeau du prince des poètes, lequel, étant de marbre blanc, fait en petit dôme sur le haut duquel, de temps immémorial, un laurier a pris racine dans le marbre sans qu'il y ait aucune terre pour le conserver. Un vieux même qui y était, étant mort depuis longtemps, la nature en a repoussé un autre qui vit encore, et il est dans son entière verdure : c'est ce qu'on lit dans les mémoires de feu monseigneur le duc de Guise (page 352).

Québec, à cause de sa petite taille et de son feuillage permanent (Marie-Victorin, 177–8).

200 Possiblement *Linnaea borealis* L. (Marie-Victorin, 532) ou *Mitchella repens* L. (Marie-Victorin, 524), voire même une espèce comme *Gaultheria procumbens* L. (Marie-Victorin, 444) ou *Chimaphila umbellata* (L.) Barton (Marie-Victorin, 435). *L. borealis* L. fut observé avant 1620 et ces quatre espèces sont mentionnées par Boivin. *Chimaphila* nous semble la plus probable à cause de son utilisation médicinale par les Indiens (*pipsissewa*) (Alain Asselin).

201 Le «poivrier» est *Myrica gale* L., appelé «piment royal» en France où l'on s'en servait comme épice (Marie-Victorin, 156) (Anna Leighton).

202 Probablement *Sassafras albidum* (Nutt.) Nees. On le nomme «laurier» dans «La flore du Canada en 1708» (Boivin) (Alain Asselin).

203 *Laurus nobilis* L.; Hatton, 394, fig. 780, qui en reproduit une illustration prise dans Matthiolus, *Commentarii*, 1565, 131.

[f. 26] *De l'arbrisseau à grains durs*[204]

Le bois de cet arbrisseau est d'un grand usage aux naturels du pays où il se trouve. Ils en font mille petites gentillesses*. Ils s'en servent à la guerre pour leurs arcs et pour leurs flèches. Sa feuille est rare en sa beauté; il sort du milieu d'une bourse que cet arbre jette une graine triangulaire assez grosse et fort dure. La roulant dans la bouche, elle a les mêmes effets du tabac du Brésil. Ce grain n'est pas de cette belle couleur de ces autres grains qu'on voit en d'autres endroits de l'Amérique, qui sont noirs comme du jaiet* d'un côté et rouge de l'autre comme de l'écarlate. D'autres sont tout ronds et tout noirs, et enfin d'autres, dans la même figure, sont tout marbrés. Les sauvages s'en font des tours de tête, des colliers et plusieurs autres petits bijoux. On en fait de rares* chapelets. Au reste, les grains de ces sortes d'arbres sont si durs qu'il faut le marteau ou la pierre pour les casser.

De l'arbrisseau de l'élan, ou de l'orignac[205]

Il est ainsi appelé à cause que ce grand animal en mange volontiers. Sa feuille est fort grande, elle a bien du rapport* à la feuille de vigne. Elle est infiniment rayée et soutenue de beaucoup de fibres et de plusieurs tendons. Cet arbrisseau bourgeonne dans la plus rude saison des neiges et des glaces. Il est assez inutile, et son bois n'est propre qu'à faire des crayons* aussi beaux que l'encre de la Chine.

Du bois puant

Il s'en trouve dans toutes nos plus vastes forêts. Il est remarquable pour trois propriétés : 1° En ce que sa seconde écorce, qui est fort verte, est fort médicinale et purge doucement et sans incommodité : c'est la sève, la casse et la rhubarbe dont se servent les Américains. 2° Le bois est d'un très grand usage pour les guerriers et pour les chasseurs, lesquels en font leurs flèches avec tant de politesse* qu'il n'y a point d'artisan qui peut les faire mieux qu'ils les font. Ils les arment au bout de bois dur, d'os, de pierres, de cuivre et de fer. J'en ai apporté en France qui ont été trouvées fort

rares. 3° Je dis ailleurs que ce bois puant fait du feu lorsqu'on le frotte contre le cèdre sec.

De l'arbrisseau qu'on appelle du bois de plomb[206]

C'est par ce rare arbrisseau que je veux finir de parler des arbrisseaux, pour entretenir au plus tôt les curieux des raretés de nos grands arbres.

Le bois de plomb est si utile aux habitants des vastes forêts de l'Amérique, qu'il leur sert non seulement pour brûler comme [f. 27] toutes les autres sortes de bois, mais ils en font même du fil le plus fort et le plus fin du monde, dont ils font des filets de toutes façons et de toutes grandeurs pour la chasse et pour la pêche. Ils en font des belles nattes, des cordes, des sacs, des branles* et mille autre choses. Il serait fort propre à coudre; mais comme les Américains ne se servent point d'aiguille pour cet effet* et qu'ils n'usent que de quelques alènes faites avec des os ou du bois dur, et du nerf d'élan ou des autres animaux qui leur sert de fil, ils laissent le beau chanvre qu'ils tirent du bois de plomb pour les autres usages que j'ai dit.

Le bois de cet arbre est si fort qu'on ne saurait le rompre si fort il plie. Il ressemble à une autre espèce de bois qu'on nomme le *pliant* parce qu'il est impossible de le rompre qu'avec des instruments tranchants. Il y a tant de filaments sous la première écorce de l'arbre, qu'à le voir vous diriez que c'est plutôt un cordon de soie bien fine qu'un bâton.

L'arbrisseau de plomb, dont je parle ici, n'a que quatre ou cinq pieds de hauteur. Il grossit selon son âge. Le plus jeune est le meilleur. On ne saurait le rompre, comme j'ai dit. Pour en tirer une espèce de chanvre, dont on fait des ouvrages nécessaires, il faut écorcer les branches qui sont pliantes comme des cordes, faire bouillir dans une lessive la seconde écorce, ensuite la faire sécher et la battre ou la frotter jusqu'à ce qu'on l'a bien adoucie.

Les Américaines ne se servent point de quenouille pour filer : elles retordent seulement leur chanvre bien préparé sur leurs cuisses. Après ces apprêts, elles donnent la teinture qui leur plaît à leur fil pour en faire des

204 Probablement *Ptelea trifoliata* L. (Marie-Victorin, 390) ptéléa trifolié. Il est possible que ce soit une première mention en Nouvelle-France (Alain Asselin).

205 Selon Faribault 1996, 109, il s'agit ou de *Viburnum alnifolium* (Marsh.), qu'on appelle encore au Québec «bois d'orignal», ou d'*Acer pensylvanicum* L., érable de Pennsylvanie, dont le nom populaire est également «bois d'orignal» (Marie-Victorin, 533 et 395). Toutefois, le mot Cree-Montagnais *moosomin* désigne plutôt les baies de *Viburnum edule* (Michx.) Raf. et *V. trilobum* Marshall. La feuille décrite ici ressemble plus à celle de

V. edule qu'à celle de *V. alnifolium* (voir Marie-Victorin, 533, fig. 188). Par ailleurs, l'écorce de l'*Acer Pennsylvanicum* L. est verte rayée de noir, alors que celle des *Viburnum* ne l'est pas. Cet arbre pousse haut et grêle, et ne reste pas longtemps de petite taille, alors que *V. edule* est un petit arbuste. *Acer* peut également avoir de grandes feuilles s'il pousse dans les bonnes conditions (Anna Leighton).

206 *Dirca palustris* L., dirca des marais (Marie-Victorin, 362–3).

tours de tête, des ceintures, des colliers et des cordages pour faire des maîtres* à de grands filets. Jamais on n'a vu de bois plus propre à bâtonner* que le bois de plomb, ainsi appelé à cause de sa pesanteur et de cette flexibilité admirable qu'il a naturellement.

Des grands arbres de l'Amérique

Je ne sais si m'enfonçant un peu trop avant* dans les vastes et dans presque les immenses forêts des Indes occidentales, pour y remarquer tous les arbres qui les composent, je n'aurais pas besoin de quelque boussole, de celles qu'on touche* le mieux à Dieppe, et de la compagnie de quelques habiles Français, qui n'osent guère se commettre* dans ces étranges pays sans compas, où l'on ne voit que la terre et le ciel à travers les feuilles et les branches des [f. 28] arbres si épaisses qu'on ne voit pas ordinairement plus loin de quatre ou cinq pas.

Mais n'importe, allons-y et pénétrons à travers ces infinies broussailles sans cadran*. Nos sauvages nous tireront de partout et du plus grand embarras des vieux chênes rompus, des sapins ébranchés par la violence des vents et des gelées, des pins, des pruches, des épinettes, des cèdres, des hêtres, des érables, des plaines, des bois durs, des trembles, des frênes francs et bâtards, des bouleaux, des aunes, des cotonniers, des noyers, des châtaigniers, des ormeaux de deux espèces, des tillots*, des gros merisiers et de plusieurs autres sortes d'arbres, tant debout que renversés. Tout cela dit, il ne sera pas capable de renverser l'idée de nos Américains, ni de leur faire perdre ni leur nord, ni leur tramontane : ils sortiront de partout comme des fauves* ou comme des génies, fort accoutumés dans ce pays des ombres, et en marchant avec eux, ils nous donneront le loisir de considérer* tous ces arbres durant plusieurs années pour y apprendre tous leurs usages, toutes leurs qualités et la plupart de leurs propriétés dont je prétends vous entretenir de chacun en particulier, après plusieurs années d'une étude de ces choses fort assidue. Et pour commencer je dirai que

Le saule…[207]
n'a rien de particulier et qu'on en voit bien peu sur les rives de nos rivières. Il n'a qu'une bien petite différence des nôtres dans son bois et dans ses feuilles. Comme il n'est pas cultivé et qu'il n'est d'aucun usage, il ne vaut pas le nôtre. Il a cela qu'il est plus mou et plus poreux que ceux de ces belles prairies, à qui on coupe les branches en France pour divers usages. On n'en voit jamais qui ressemblent de loin de files de soldats bien rangées qui firent peur autrefois à cet infortuné le Marquis d'Ancre, qui, sachant bien qu'il avait à la cour de puissants ennemis, en voyant de loin de dedans son carrosse, et se persuadant que c'étaient des hommes qui l'attendaient pour le tuer, fit de peur dans son haut-de-chausse* ce que je ne veux pas dire. Nos saules sont trop brancheux et trop grands pour ressembler à ceux de France.

De l'aune[208]
L'aune ne diffère en rien des nôtres qu'en petitesse. Il y en a tant partout qu'on en pourrait fournir à tous les chapeliers et à tous les teinturiers de l'Europe. On se sert dans le pays de branches pour en faire des claies et des nasses pour cette fameuse pêche d'anguilles dont je parlerai dans mon traité des poissons.

[f. 29] *Du bois dur*[209]
Ce bois n'est guère commun. Il a tiré son nom de sa dureté. Il est aussi le plus fort et le plus solide de tous les bois du pays, et le plus propre à faire des essieux pour les chariots et pour les charrettes. C'est là le seul usage qu'on lui donne. Il n'est guère branchu : c'est pour cela qu'il devient fort haut et qu'il ne grossit pas. On ne laisserait pas d'en faire de beaux parquetages* et de beaux buffets, de belles tables et même toute sorte de meubles, car il est bien madré* et fort ondoyé*, et quand la doucine* a passé dessus, il a le grain aussi fin que l'ébène.

Du tremble ou du peuplier[210]
Le peuplier n'est jamais ni si haut ni si gros que le sont les nôtres en France; du reste, il est tout semblable. Il n'est propre que pour trembler au souffle du moindre

207 On pense spontanément à *Salix alba* L., mais il s'agit d'une espèce européenne. En fait, on trouve près d'une quarantaine d'espèces de *Salix* au Québec et elles ne sont pas faciles à identifier (Marie-Victorin, 164–6). Si nous envisageons un arbre (plutôt qu'un arbuste), il pourrait s'agir ou de *Salix nigra* Marshall, ou de *S. lucida* Muhl., voire même de *S. amygdaloides* (Andersson) (Anna Leighton). *S. cordata* Michx. (Marie-Victorin, 165) est déjà décrit chez Clusius en 1601 (Alain Asselin).

208 *Alnus rugosa* (Du Roi) Spreng, d'autant plus que Nicolas mentionne son emploi en teinture. On en obtenait, en effet, une teinture jaune (Marie-Victorin, 151).
209 *Ostrya virginiana* (Mill.) K. Koch (Marie-Victorin, 152–3 et Faribault 1994, 109).
210 *Populus tremuloides* Michx. (Marie-Victorin, 163). Rousseau 1964, 289 note que *Populus tremula* L. se nomme aussi «tremble» en France. Boucher le signale en Nouvelle-France.

petit zéphyr, et c'est la raison pourquoi on l'appelle du *tremble*. Quelques habitants français se sont avisés d'en faire des planches qui ne laissent pas de leur servir à divers usages.

Des épinettes[211]
Il s'en voit de trois façons. La plus petite des trois espèces quitte sa feuille longue et ronde pendant l'hiver, et comme son bois n'est pas d'un grand usage, je n'en dis mot, pour parler de l'épinette rouge et de la blanche, entre* lesquelles il n'y a de différence que dans leurs écorces qui sont de différentes couleurs. Ces deux sortes d'arbres sont fort hautes et infructueuses. Ces arbres jettent des galles comme le cyprès, en telle quantité qu'ils en sont tout chargés. À les voir de loin, on les prendrait pour des cyprès et je ne fais aucun doute que le sieur Lescarbot, qui a écrit avec bien peu de connaissance quelque chose du Canada, n'ait pris de là occasion de se tromper et de donner à ces deux sortes de pruches, le nom de cyprès, car je puis assurer que jamais il n'y en eut dans tous les pays que Lescarbot décrits. Le bois de ces arbres est extrêmement pesant, fort et gommé. Il brûle comme des allumettes quand il est sec. Il est vert en tout temps et relève à merveille la blancheur des neiges. Il est propre à faire des mâts, des vergues et des rames pour les galères. Sa feuille est ronde, en long, mais assez courte et fort piquante au bout d'en bas. Elle est admirable dans l'infusion de la bière : on s'en sert à cet usage dans la Nouvelle-Albanie, dans les confins de la Virginie.

On s'en trouve déjà assez bien dans les habitations* françaises, où l'on a essayé cet ingrédient. Les Barbares mêmes usent de ce petit feuillage et le font infuser pour faire des breuvages qui les purgent. En un mot, ce bois est fort bon [f. 30] pour bâtir des maisons : on en fait des poutres et des soliveaux. Faisant un trou au tronc de l'arbre pendant qu'il est en sève, il en coule une humeur* forte et gluante comme la térébenthine, qui est fort propre à faire des onguents, des glacis et des peintures. Elle est fort bonne pour les plaies; elle renforce ceux qui ont eu des tours de reins. Il faut l'avaler dans une oublie* mouillée, dans laquelle on enveloppe ce qu'on en veut avaler : c'est pour éviter son amertume qu'on s'en sert ainsi. Cette humeur gluante se forme en espèce d'encens, qui n'est pas si odoriférant que celui d'Arabie, mais qui ne laisse pas d'avoir quelque odeur de l'encens.

Du sapin[212]
Le sapin du pays étranger n'a aucun rapport à celui qu'ontrouve en France : il est fort différent. Il est d'une hauteur surprenante. Il porte sa pointe comme le cyprès. Il est fort branchu, et par conséquent, fort noueux. Il n'est guère propre, à cause de cela, à faire des ais*, mais il est commode pour faire des poutres. Les branches à petites feuilles, longues d'un quart de pouce*, sont toujours vertes et servent de matelas et de lit, et souvent de maison et de couverture aux sauvages, aussi bien qu'à tous ceux qui les accompagnent dans leurs fatigues effroyables et dans les longs voyages qu'ils font. La gomme qui sort au travers d'une écorce fort fine, où il se forme au dehors une infinité de grosses et de petites ampoules au tronc et aux branches du même arbre, fournirait de quoi faire un joli commerce. Au reste, je compare cette liqueur très odoriférante et j'ose même la préférer à la meilleure térébenthine de Venise. Du moins, je suis sûr que les Américains s'en servent très utilement pour se guérir de toute sorte de blessures. Il n'y a guère d'habitant* français qui n'en peut ramasser tous les ans plusieurs pleins pots. Une seule Indienne en ramasse dans une après-dînée un plein plat d'écorce. Elles s'en servent pour goudronner tout le dedans de leurs canots, car cette humeur liquide s'insinue aisément dans les fentes des écorces et les bouche bien.

Du pin bâtard, rouge et blanc[213]
On ne peut se servir du pin rouge que pour brûler.

211 Selon Rousseau 1964, 284–5 on trouve trois espèces de *Picea* dans l'est du Canada : *Picea glauca* (Moench.) Voss, épicéa glauque, ou épinette blanche; *Picea mariana* (Mill.) BSP, épicéa marial, ou épinette noire; et *Picea rubens* Sarg., dont ce dernier est le moins connu. Il se peut que Nicolas ait eu en vue *Laris laricina* (Du Roi) Koch, un mélèze qu'on appelle encore, au Québec, «épinette rouge» (Marie-Victorin, 142–4). L'épinette rouge décrite par Boucher en 1664 correspond au *Larix*.
212 *Albies balsamea* (L.) Mill (Marie-Victorin, 146). Signalé par les premiers découvreurs et par Boucher en 1664 en Nouvelle-France. Nicolas utilise le mot «sapinière» pour désigner un groupement de sapins (Alain Asselin).
213 *Pinus resinosa* Ait. est le pin rouge et *P. strobus* L., le pin blanc de Nicolas (Marie-Victorin, 140–1). Il n'y a aucune raison d'appeler ces arbres magnifiques «bâtards», comme le fait Nicolas, peut-être seulement parce qu'ils ne produisent pas de pinons comme *P. pinea* L. d'Europe. Ni les premiers découvreurs ni Boucher en 1664 ne semblent avoir fait la différence entre le pin rouge et le pin blanc (W.F. Ganong, *The Identity of the Animals and Plants Mentioned by the Early Voyagers to Eastern Canada and NewFoundland*, series 3, 1909, t. 3, 197–242; désormais, Ganong). *P. strobus* L. est décrit par Clusius en 1601 et mentionné dans «La flore du Canada en 1708» (Boivin), où on lui accorde aussi le nom de «pin de Milor Weimouth» (Alain Asselin).

Encore ne s'en sert-on qu'à l'extrémité* et dans les lieux où il n'y a point d'autre bois vert et sec. Il pétille si fort qu'il chasse d'auprès du feu ceux qui [f. 31] d'ailleurs veulent se chauffer. Ce bois est si branchu et si noueux qu'on ne saurait s'en servir que pour faire ces flambeaux de bois que les Latins ont appelés *tædæ*. Ce sont de petits bouts de bois pleins d'une humeur si bitumineuse qu'ils brûlent comme la poix résine. Plusieurs grands lacs sont bordés de ce bois, et entre autres, celui qu'on appelle du Saint-Sacrement, que j'ai parcouru deux fois, et presque toute la mer Tracy. Proche de la Malbaie, on a fait faire du goudron très excellent dont on se sert pour gommer les vaisseaux. Ce seul arbre fournit cette liqueur. Je ne sais si je dis ailleurs la façon dont les sauvages font leur goudron de ce même arbre : ils n'ont qu'à aller au bois et couper par plusieurs éclats un de ces arbres et jeter les mêmes éclats dans de l'eau bouillante, au-dessus de laquelle, dans peu de temps, on voit former une espèce d'huile fort épaisse qu'on tire avec une cuiller de bois et qu'on jette dans de l'eau froide, où elle s'entretient* liquide, pour la jeter dans d'autres vases et s'en servir au besoin ou pour la durcir entièrement.

Du pin bâtard blanc

L'on voit presque dans toutes les contrées du pays quantité de beaux pins dont on fait, en effet, dans les lieux où l'on en a besoin et où l'on peut faire aisément, tous les ouvrages nécessaires pour la bâtisse et pour l'ornement des maisons. On fait des poutres qui portent* plus de vingt pouces en carré et plus de cinquante ou de soixante pieds de long. On en fait des belles planches et on taille tout le bois qui est nécessaire pour des grands corps de logis, qu'on construit de bois seulement, car presque toutes les maisons des champs que les Européens habitent sont de bois, depuis le fondement jusqu'au plus haut du toit.

Il y a des endroits dans le pays d'où l'on peut tirer des millions d'arbres, desquels on ferait des doubles millions d'ais et de gros madriers, qui sont des doubles ais. On tire encore de cet arbre de la gomme liquide, comme je viens de dire du pin rouge. On en tire qui a plus de corps lorsque, la faisant, on la jette dans de l'eau froide, et de celle-là, dans une autre plus froide; mais comme encore elle serait trop gluante selon la fantaisie des sauvages de cette façon, ils y mêlent du charbon bien pilé ou de la cendre bien fine pour donner du corps à cette sorte de résine; et pour la rendre maniable, ils y mêlent encore de l'huile de poisson ou de la graisse des bêtes fauves. Ce mastic, étant ainsi disposé, fait un corps assez solide, et on le garde jusqu'au besoin.

Et lorsqu'il faut le ramollir, ceux qui en ont besoin le coupent à petits morceaux avec les dents et le mâchent jusqu'à [f. 32] ce qu'ils l'ont ramolli, de telle sorte qu'ils puissent, avec un tison de feu qu'ils tiennent à la main, l'appliquer sur les fentes de leurs canots; achevant de le chauffer avec le feu, qu'ils tiennent à la main et passant le doigt dessus mouillé avec leur salive, ils lui donnent la figure qu'il faut pour boucher les trous de leurs bateaux. Ils donnent diverses couleurs au mastic qu'ils nomment *pikieu*.

Toutes ces sortes de gommes et de mastics me donnent occasion de ne pas oublier une curiosité qui doit être celle de tout le monde, et particulièrement de ceux qui s'imaginent qu'il est de l'essence du sauvage d'être velu. J'ai à leur dire qu'ils ne doivent plus croire que les sauvages soient velus, et je veux bien qu'ils se persuadent qu'ils n'ont seulement pas de la barbe et que s'il arrive qu'il en vienne quelque poil à quelques-uns, ils n'ont nulle patience qu'ils ne l'aient arrachée ou par le feu, ou avec les doigts, ou avec du mastic. Mais comme le feu est violent et que d'arracher poil à poil est une chose importune, ils aiment mieux se servir du mastic qui leur sert de rasoir. Ils le mâchent pour le ramollir, et l'ayant radouci par la chaleur de leur bouche, ils en font un emplâtre et l'appliquent sur les poils qu'ils veulent arracher; et l'ayant laissé refroidir sur la partie et le poil s'étant insinué dans le mastic, en le tirant avec violence de dessus la peau où il s'était attaché étant chaud, ils enlèvent aisément le poil avec le rasoir qu'on avait affilé avec les dents.

Ainsi, l'on voit que tout est utile dans notre pin rouge et dans l'arbre du pin blanc. L'écorce même sert pour faire des maisons et pour allumer un feu de capitaine, c'est-à-dire, parlant à la sauvage, un beau feu clair. Ils en font divers ustensiles, et entre autres, ils en fabriquent des chaudières* où ils font bouillir les viandes qu'ils veulent manger. Et au lieu que nos chaudières et nos marmites sont réchauffées par le feu sur lequel on les met, nos braves ingénieurs mettent le feu dans leurs chaudières : je veux dire qu'ils jettent de gros cailloux rougis au feu dans leurs chaudières d'écorce pour y faire cuire ainsi leur viande, dans de l'eau qui ne bout que parce qu'une pierre rougie dans le feu la fait bouillir lorsqu'on y en jette plusieurs successivement les unes après les autres. Après ce rare tour d'esprit, il faut finir ce deuxième livre et commencer le troisième par la description du hêtre ou du fau.

où l'on décrit le reste des grands arbres

Du hêtre ou du fau[214]

Je ne trouve presque aucune différence de cet arbre à ceux de France qui portent le même nom, ni pour le bois ni pour le fruit. La feuille seulement n'est pas si ronde et les racines de l'arbre ne s'enfoncent pas si avant* dans la terre. Elles courent plutôt dessus et il arrive, de là, que les champs qui sont couverts de ces arbres ne sont pas si aisés à défricher. Ces sortes d'arbres naissent dans un sol sablonneux, qui n'est pas le meilleur pour le blé froment; il est plus propre* pour le blé d'Inde, pour les citrouilles et pour les melons d'eau.

Le bois est fort bon à brûler. Il fait un feu clair, chaud, et sa braise dure longtemps. Il est propre à faire du merrain*, dont on fait des caisses et des grands vaisseaux pour transporter en affluence partout les marchandises sèches comme le sucre.

Son fruit attire un nombre infini de pigeons sauvages, dont on fait une merveilleuse chasse, et telle que je la décris lorsque je parle de cet oiseau dans mon traité des oiseaux.

Des noyers[215]

J'ai remarqué de trois sortes de noyers dans le pays, qui sont toutes différentes de celles dont les auteurs ont écrit. Il est pourtant vrai qu'il faut que je convienne avec eux d'une chose : qu'il est sûr que de nos trois espèces de noix, il y en a qui ont la coquille fort tendre et d'autres qui l'ont fort dure, et qu'à cela près, tout le reste est différent. Car nous ne trouvons point dans nos bois de ces rares* noyers[216] de Gengembach, en Allemagne, le long du Rhin, qui ne produisent ni feuille ni fruit avant la Saint-Jean, mais, qu'en ce temps, tout paraît en une nuit. J'ai vu de ces arbres dans le territoire d'Uzès en Languedoc.

Ce n'est pas ici que je veux parler de ces grosses noix chevalines[217] ou, selon d'autres, des grosses noix qui sont comme des pommes de reinette. On les connaît par toute la France et particulièrement à Solieu en Bourgogne, où j'ai passé et où l'on fait par rareté des gants si délicats qu'on en peut mettre une paire dans la coquille d'une de ces noix, et ailleurs, on en fait des bourses fort curieuses.

Je n'ai rien de si rare à dire. Je ne dois que produire ici trois différentes espèces de noyers et des noix, dont deux façons* ne sont pas plus grandes que des noix muscades, et dont les unes sont extrêmement amères, les autres fort douces et d'un [f. 34] aussi bon goût que les meilleurs noix.

La troisième sorte de noix que j'ai trouvée dans les forêts des Indes sont aussi grosses et aussi longues qu'un grand œuf de poule lombarde. Elles sont extraordinairement dures et elles sont si anguleuses qu'il n'y a guère de moyen d'en avoir le fruit, qui est fort bon.

Le bois et la feuille des trois différences de noyers ont quelque rapport* à nos noyers. L'odeur est presque la même.

Le bois du gros noyer est beau et très aisé à mettre en œuvre, mais comme il est bien plus mou que celui des noyers d'Europe et qu'il est plus poreux, il ne se polit pas si bien, et si on s'en sert pour la monture des fusils, on voit bien à la première fois qu'ils se mouillent, que ce bois, perdant son lustre, n'est pas d'un corps si solide que celui du bois de noyer de France. On se sert dans le pays de ces bois pour couvrir des maisons après qu'on en a fait de petits ais* de la grandeur des tuiles dont on couvre les maisons à Paris.

Le noyer amer[218] n'est remarquable qu'en trois choses :

1° En son fruit qui n'est pas plus gros qu'une noix muscade et qui est si amer qu'il n'est pas possible d'en pouvoir manger, mais aussi, en échange*, il rend beaucoup d'huile que les Indiennes font après avoir pilé les noix dans leurs coquilles dans un mortier de bois ou entre quatre pierres. Elles mettent de l'eau dans des chaudières qu'elles font bouillir avec cette pâte de noix pilées d'où l'huile sort.

Personne n'est guère bienvenu en ce temps dans les cabanes : les sauvagesses croiraient que toute leur huile s'évaporerait si quelqu'un entrait chez elles. C'est pour cette raison qu'elles couvrent soigneusement leurs chaudières de peur / que si / par hasard, quelqu'un entrait dans leurs cases, ils ne puissent pas voir l'huile et qu'ainsi il n'y ait rien de perdu.

2° Le noyer amer est remarquable pour son écorce

214 *Fagus grandifolia* Ehrh. (Marie-Victorin, 156). Déjà décrit chez Clusius en 1601 et signalé par Boucher en 1664 en Nouvelle-France.

215 *Juglans cinerea* L., noyer cendré, aux noix dures, ou *Carya cordiformis* (Wang.) K. Koch, caryer cordiforme, et *C. ovata* (Mill.) K. Koch, caryer ovale, qui ont tous deux des noix plus molles (Marie-Victorin, 158–60).

Rousseau 1964, 289 note qu'on trouve *Juglans nigra* L. également plus au sud, en territoire iroquois.

216 Probablement *Juglans nigra* L. (Marie-Victorin, 158).

217 *Aesculus hippocastanum* L., marronnier d'Inde (Marie-Victorin, 87); Simon and Schuster, *Guide to Trees*, no 226.

218 *Carya cordiformis* (Wang.) K. Koch (Marie-Victorin, 159) (Anna Leighton).

qu'on enlève pour faire et pour couvrir des cabanes. Cette écorce devient si dure que le cuir le mieux tanné ne l'est pas tant. On en fait même des bateaux qui sont fort propres pour aller à voiles et à rames.

3° On tire du noyer amer de certaines attaches dont on fait des cordes propres à attacher des bœufs, et on en fait du fil pour coudre des souliers.

Je ne dois pas oublier de dire ici l'agréable façon dont se servent les Américains quand ils veulent faire des cerneaux ou quand ils veulent manger des noix. En France, on se sert d'une perche quand on veut abattre des noix et eux ne se servent que de la hache pour couper les plus beaux arbres du monde et pour recueillir ainsi les noix.

Il suffirait cependant parmi eux de les avoir marqués pour empêcher tous les passants d'y toucher. C'est une coutume inviolable de ne couper jamais un arbre qu'ils savent qu'un [f. 35] autre a marqué, car les terres, étant communes, elles appartiennent au premier qui les occupe. Cette manière d'abattre les arbres fait qu'ils dépeuplent de grands territoires où l'on ne voit que de très beaux arbres renversés qui font une figure* fort triste, là où l'on ne voyait que de belles campagnes chargées de fruits; mais avec tout cela, ces terribles bûcherons ne manquent point de fruit tous les ans, car leur pays étant fort vaste, ils n'ont qu'à aller un peu plus loin et y chercher de nouvelles terres où ils trouvent de plus beaux arbres de noyer. Et ne revenant que de cent en cent ans, réhabiter les terres qu'ils ont quittées, leurs successeurs y trouvent des arbres de la même nature que ceux que leurs pères y avaient coupés. S'ils veulent avoir un nid de dessus un arbre, ils ne prennent guère la peine d'y monter, mais ils l'abattent quoiqu'il soit bien gros quand la fantaisie leur en prend.

La troisième espèce de noyer, et la meilleure, est le noyer dur. Aussi*, ont-ils beaucoup plus de rapport aux nôtres. Le fruit est petit comme j'ai dit, mais bien plus doux, et l'huile qu'on en fait est très bonne et n'est pas d'une odeur si forte que celle qu'on fait en France. Le bois de cet arbre est très beau et bon, et on pourrait en faire tous les ouvrages* de sculpture. Il est blanc et rouge, bien madré*, et d'un grain fort fin. Les Barbares s'en servent pour faire des arcs. Il est bon à brûler. La braise est chaude extraordinairement et dure longtemps. Sa racine est bien variée et ondoyée* de diverses couleurs. Celle du noyer tendre est fort propre à faire des paniers. Il n'y a point d'osier qui soit plus souple, ni qui soit plus beau, ni plus propre à clisser* des bouteilles et à faire divers beaux ouvrages fort fins.

De l'érable[219]

Je ne veux pas parler ici de cette sorte d'érable que les Latins ont appelé *acer*, les Grecs σφενδαμνος et les Italiens nomment *pie d'occa*, à cause que sa feuille a bien rapport au pied de l'oie, et quoique le grand arbre que je dois décrire ait une feuille qui a bien du rapport au pied d'oie d'Italie, ce n'est pourtant pas le même arbre, ni celui que les Stragirites appellent *clinotrochos*. Je prétends seulement vous donner la connaissance d'un grand arbre qui est fort commun dans les Indes et que les nations du Castor nomment *apouiak*, qui veut dire un arbre propre à faire des rames, qu'ils appellent *apoui*, ou disons, si vous voulez, avec bien plus d'apparence* qu'ils ont donné le nom d'*apoui*, à un aviron, à cause du nom d'*apouiak* que nous nommons en français un *érable*, qui est fort gros et un fort grand arbre qui a l'écorce fort épaisse et fort dure, aussi bien que son bois. Celui qui croît sur les montagnes et dans les lieux secs est le meilleur pour tous les ouvrages auxquels on peut l'employer. Son bois est blanc et bien madré, à belles ondes*, excellent à brûler, et il n'y en a pas de meilleur dans toute l'Amérique. Les cendres en sont recherchées pour faire la lessive. On porte en Europe des pleines barriques et on l'y vend bien cher.

[f. 36] À la fin du mois de mars et bien avant dans celui d'avril, lorsque le soleil, toutes les après-dînées seulement, commence de faire fondre les neiges, les habitants du pays vont dans les bois, armés de leurs haches, faire de grands trous dans le corps des vieux érables pour y arrêter une certaine eau sucrée qui découle de toutes les parties de l'arbre avec abondance pour en boire autant qu'il leur plaît, sans craindre que cette liqueur* leur cause aucune incommodité. On fait provision de cette admirable eau, pour en faire du sirop en faisant bouillir l'eau d'érable jusqu'à ce qu'elle est diminuée à demi. J'en ai fait l'épreuve* et trouvé que ce sirop était aussi bon et aussi rafraîchissant que celui qu'on fait de l'herbe du capillaire qui est si estimé et si cher qu'on en vend quatre écus* la pinte* dans le pays.

Il faut savoir que l'eau de l'érable ne coule jamais que dans la saison que j'ai dit et lorsque le soleil paraît et qu'il influe* par sa chaleur à faire couler cette liqueur sucrée, qui s'arrête à mesure que le soleil décline vers son occident et qui ne coule plus lorsqu'il est couché et ne recommence de couler que le lendemain, à l'heure que j'ai dit et pendant le temps que le pied de l'arbre est couvert de neige, car lorsque les neiges sont fondues, l'arbre ne coule plus et ne donne plus à boire, ni aux

219 *Acer saccharum* Marsh., (Marie-Victorin). Signalé en Nouvelle-France en 1664 par Boucher.

sauvages ni aux Français, et cesse de pleurer la perte de la neige.

J'ai remarqué encore deux ou trois choses fort rares* du même arbre : c'est que, étant pourri, il exhale une odeur fort agréable pendant l'été. Cette odeur est portée fort loin par les vents, et comme il ne manque pas de ces arbres dans nos forêts, on ne manque pas aussi de sentir les exhalaisons de la bonne odeur qu'il en sort.

Ce même bois pourri devient vert et luisant de telle manière qu'on pût voir lire la nuit durant quelque temps en en tenant à la main. Et j'ai vu les femmes des hommes de la nation de l'Oreille de Pierre s'en servir pour faire des peintures vertes sur leurs peaux passées*. On use encore de ce bois pourri pour faire de la mèche : le feu y prend aisément et se conserve longtemps, et avec tant d'attachement* qu'il est très difficile de l'éteindre. Les fumeurs en sont toujours pourvus pour allumer le feu dans leurs pipes. C'est pour cela que les sauvages en portent de pleins petits sacs, et c'est ce troisième bois dont ils se servent pour conserver le feu qu'ils ont tiré de deux sortes de bois, en les frottant l'un contre l'autre, comme je le dirai quand je décrirai le grand cèdre blanc.

De la plaine[220]

Quelques-uns ont voulu dire que la plaine est l'érable femelle, et pour dire le vrai, la plaine a bien du rapport à cet arbre. Son feuillage est presque le même [f. 37] et il n'y a que cette différence que le feuillage de la plaine est plus grand, plus touffu et plus vert. Son bois est tout blanc et plus mou que celui de l'érable. Étant sec, il est fort et bon à brûler. On en voit dans toutes les plages* et dans tous les bois, et on a bien du plaisir d'en voir faire une infinité de petits bocages les plus touffus et les plus agréables du monde. Les îles de Richelieu, les îles Bouchaud, les îles Percées, les îles du lac des Montagnes, celles du Borgne de l'Île, de la Petite Nation et une infinité d'autres lieux en sont si chargés dans l'espace de trois ou quatre cents lieues*, soit sur les rives du fleuve de Saint-Laurent, soit sur celles du grand fleuve du nord, que je n'ai rien vu de si beau. Outre que le bois de la plaine a toutes les qualités que j'ai remarquées dans le bois de l'érable, sa racine jointe avec celle de cet arbre est fort bonne pour guérir les maux

de côté, pourvu qu'on les fasse infuser vingt-quatre heures toutes les deux ensemble.

Du châtaignier[221]

Je ne veux que faire savoir qu'il y a quantité de châtaigniers dans le bois qu'il faut passer depuis le bout du lac du Saint-Sacrement jusque dans les prairies d'un village de la Virginie qui s'appelle Gandaouaghé. Dans tout ce chemin qui est de trente lieues, on voit beaucoup de grands châtaigniers dont le fruit est fort petit et pas plus grand que le fruit que porte le feau*. Les Virginiens enfilent leurs châtaignes comme nous enfilons nos grains de chapelet : ils en font des bandoulières à peu près comme les arracheurs de dents en font des dents qu'ils arrachent à ceux qui se mettent entre leurs mains. Ces châtaignes sont bonnes, et si les arbres étaient entés, ils produiraient d'aussi bonnes châtaignes que les arbres de France.

Les sauvages n'ont pas trouvé une manière plus commode pour amasser ce fruit que de mettre le feu dans les bois, qui, brûlant toutes les feuilles et une partie des broussailles, le leur découvre / aisément / pour le cueillir.

On déplore l'aveuglement de quelques-uns de ces misérables qui, ayant gravé ou fait des figures peu honnêtes* sur quelques châtaigniers, ils disent que ce sont des génies et ils leur font quelques adorations à l'imitation de ces autres qui tiennent pour des divinités ce que la nature même nous apprend à cacher. Le bois du châtaignier n'est pas si pétillant en Amérique qu'il l'est sur les montagnes du Vivarais et dans le territoire des Limousins.

[f. 38] Du merisier[222]

C'est un des plus gros et un des plus grands arbres de tout le Septentrion américain. Son bois tire sur la couleur rouge. Il est fort délicat, fin, bien uni, dur, marbré. Il se travaille fort proprement* et fort facilement, il est luisant comme du verre. Lorsqu'il est mis en œuvre, on en fait toute sorte d'ouvrages de menuiserie, des planches, des montures de fusil, des membrures, des traîneaux, des arbres pour des moulins. Son écorce est fine. Elle brûle comme de la paille, aussi bien que son bois. Sa feuille est presque ronde, bien rayée et tissue* d'une infinité de tendons qui la rendent forte.

220 *Acer rubrum* L., érable rouge (Marie-Victorin, 396–7). Mattioli emploie le mot «plaine» pour désigner une espèce d'*Acer*. Boucher signale l'érable rouge en Nouvelle-France en 1664 (Alain Asselin).

221 *Castanea dentata* (Marsh.) Borkh. (Marie-Victorin, 87), bien qu'elle soit une espèce américaine, ne se trouve pas au Québec. L'espèce européenne qui produit les mar-

rons est *Castanea vulgaris* Lam. À ne pas confondre avec *Aesculus hippocastanum* L. signalé plus haut. On le cultive au Québec, mais c'est une espèce importée (Rousseau 1964, 290).

222 Au Québec «merisier» désigne souvent *Betula alleghaniensis* Britton, et «petit merisier», *Prunus pennsylvanica* L. filius. La description de Nicolas s'applique au

Du grand cotonnier, puissant arbre[223]

Il n'y en a pas communément dans tous les cantons* du pays. Je n'en ai vu que sur les bords de la rivière de la Nouvelle-Hollande que quelques géographes appellent mal à propos la rivière du Nord. Celle-ci, qui arrose une grande partie du pays de la Nouvelle-Albanie après qu'elle est sortie du milieu du lac de Techiroouen, est fort éloignée de l'autre comme je l'ai fait voir ailleurs.

Notre cotonnier est donc un grand et fort gros arbre. Son écorce est blanche, sa feuille est ronde, un peu dentelée comme celle du tremble. Je ne sais à quoi peut servir son bois ni son coton qu'il porte dans des petites bourses. Ni l'un ni l'autre ne sont guère en usage. Depuis mon retour des Indes, j'ai vu en Catalogne et à Beaucaire de ces sortes d'arbres sans nulle différence. Il n'y a point d'arbre au monde qui vienne plus aisément. Il se sème de lui-même et se provigne* si fort que d'une racine il en sort une infinité de rejetons d'où, en peu d'années, on voit des forêts entières.

De la pruche[224]

Si jamais on a vu de grands arbres, on peut dire que la pruche doit être mis dans la première classe puisqu'on n'en voit guère de plus grands dans toute l'Inde. Il a l'écorce extrêmement grosse et fort rude; elle est d'une couleur rougeâtre. Les tanneurs de la pointe de Lévis s'en servent et m'ont assuré dans leurs tanneries qu'elle est fort propre pour préparer les cuirs et les peaux. Cet arbre est si commun dans les forêts qu'on pourrait charger tous les ans plusieurs vaisseaux pour en fournir autant que les tanneurs d'un grand pays bien peuplé en voudraient. Sa feuille est petite, toujours verte, et d'une qualité fort sèche; son odeur est forte. Tout le gros de l'arbre n'est commode que pour faire des doubles ais* qu'on nomme des *madriers* et desquels on planche* les [f. 39] batteries* des granges. On scie ce bois fort épais, car étant fort rude, il éclate, et il se fend beaucoup. Les Outoulipi et tous leurs voisins font une couleur rouge de l'écorce dont j'ai parlé. Ils la brisent entre deux pierres pour la faire bouillir et pour en exprimer* le suc qui, devenant tout rouge, donne cette couleur aux choses qu'on veut teindre. C'est pour cela que les Espagnols disent, en parlant de l'écorce de la

pruche : *es buena para tegnir*. Les Italiens l'assurent en disant la même : *Bona per tintori*. Ce qui me fait dire qu'on en voit en Espagne et en Italie. Pour en France, j'en ai vu aux Tuileries, au Jardin du Roi à Montpellier et en beaucoup d'autres endroits. Mais comme cet arbre, transporté en Espagne, en Italie et en France, change beaucoup de nature, il est inutile, et n'étant pas de cette prodigieuse grandeur qu'on le voit où j'ai dit, il ne fournirait guère vu que d'ailleurs on ne pourrait pas tirer / beaucoup / des lieux où l'on l'a planté et où l'on le cultive avec soin, et où l'on le prise pour sa verdure continuelle. Et on ne s'en saurait pas servir pour en faire des cases comme nous faisons dans les bois pour nous mettre à l'abri des vents, des pluies et des neiges.

Du franc frêne[225]

Cet arbre n'est pas moins utile qu'il est admirable. Il est gros et fort haut. Son écorce est fort rude. Néanmoins, à le voir, on juge bien d'abord* que le bois qui est dessous doit être rare. Aussi* est-il fort beau, bien net et dur, presque comme de la corne quand il est sec, fort pliant, et qui ne se casse pas aisément. Il est très bon à brûler, il fume peu. Sa cendre est extrêmement caustique : aussi est-elle autant estimée que celle de l'érable. Il fend très bien et fort droit. Et comme il est pliant, on en pourrait faire des cercles grands et petits. Les sauvages en montent souvent leurs raquettes.

La feuille n'est pas bien différente du frêne de l'Europe. On fait toute sorte d'instruments, / du bois / des roues pour le charroi*. Il est propre pour faire les affûts du canon et pour monter les hallebardes et les piques des plus nombreuses armées sans craindre d'achever les arbres qu'on trouve dans le pays, où il y en a pour fournir tous les charrons de Paris et d'ailleurs. Au reste, il coule de ce bel arbre, dans la saison, une liqueur bien plus douce et bien plus sucrée que celle de l'érable dont je vous ai parlé. Et on en fait du sirop qui a bien plus de corps que celui qu'on fait de cette eau qui découle de l'érable et on n'a point d'autre façon d'avoir de cette eau que la méthode qu'on tient et que j'ai marquée dans la description de l'érable.

[f. 40] *Du frêne bâtard*[226]

Cette sorte de frêne ne diffère de l'autre qu'en ce que

premier. Le bouleau des Alléghanys, qui peut atteindre la hauteur de 33m, est l'un des plus grands arbres de la flore laurentienne (Marie-Victorin, 150).

223 *Platanus occidentalis* L., identifié au «cotonnier» dans «La flore du Canada en 1708» (Alain Asselin).

224 *Tsuga canadensis* (L.) Carr (Marie-Victorin, 145 et Rousseau 1964, 285–6).

225 *Fraxinus pensylvanica* Marsh. ou *F. nigra* Marsh.

(Marie-Victorin, 522). Signalés par les premiers découvreurs et par Boucher en 1664 en Nouvelle-France (Alain Asselin).

226 Pourrait s'appliquer autant à *Fraxinus pensylvanica* Marsh., frêne rouge, appelé aussi «bastard ash» en anglais, qu'à *F. nigra* Marsh., frêne noir (Marie-Victorin, 522 et Rousseau 1964, 288).

son écorce est beaucoup plus fine, et le bois durcit beaucoup plus que celui du franc frêne dont il a toutes les qualités, hormis qu'il ne coule pas de cet arbre ici cette liqueur sucrée qu'on tire de l'autre. Il est rare pour faire des piques. Les sauvages en font des dards* de quatre à cinq brasses* de long pour accrocher les grosses truites ou l'esturgeon dans les eaux, et sous les glaces. Ils en font les maîtres* de leurs bateaux. Ils se servent même de l'écorce pour en faire, et pour construire des maisons. Le bois sert aux Français pour en faire des belles poutres et pour en tailler toutes les pièces qui leur sont nécessaires pour faire des beaux logis de bois, qui, étant bien couverts de planches de pin, durent fort longtemps.

Du bois* blanc[227]

L'utilité et la grandeur font distinguer ce puissant arbre ici. L'écorce admirable que les pêcheurs, les chasseurs, et les guerriers enlèvent d'autour de cet arbre, le rendent considérable*. Les deux premiers en font des filets, les uns pour prendre une infinité de poissons et les autres pour attraper une infinité de pigeons sauvages. Les guerriers en usent pour leur campement et pour se faire des tentes, des cordages, des attaches et des sacs pour y mettre leurs munitions. Les voyageurs en font des raquettes pour ne pas enfoncer dans les neiges. Le corps de l'arbre est fort gros et fort haut. Son bois est si blanc qu'il lui a mérité le nom de bois blanc. Il est mou d'autre part, et il n'est pas trop aisé à travailler quand il est sec. Étant couvert, il dure longtemps et on en fait des ais*, des poutres et toute sorte de charpente. Sa feuille est fort grande et ressemble en sa figure celle du tillot*, mais elle est bien plus ample. On en fait des coffres des écorces et des pirogues qui sont des longs bateaux du tronc de l'arbre. On en fait des bières pour ensevelir les morts et des cénotaphes pour montrer où ils sont enterrés. L'écorce étant sèche devient dure comme du cuir.

De l'ormeau[228]

Il n'y a guère de différence entre l'ormeau de l'Amérique et entre celui de France. Il est fort recherché pour faire des canots de son écorce. On fait une certaine gomme de l'écorce de l'ormeau femelle pour boucher les fentes des bateaux. Il faut concasser cette écorce entre deux pierres et la faire tremper pour lui faire venir une humeur* gluante et qui s'attache suffisamment pour boucher les voies d'eau qui feraient couler à fond les canots. On fait de cette même écorce de fort bonnes attaches et même les cordages. Tout le monde sait assez que ce bois est de bon usage pour les charrons et pour monter des canons. Du reste, je ne trouve rien de particulier à nos deux espèces d'ormeau qu'une hauteur extraordinaire.

[f. 41] Du chêne[229]

Le chêne des Indes n'a que bien peu de ressemblance à celui de France : son bois est plus poreux, sa feuille bien différente, son fruit tout rond, son écorce plus fine. Il y en a d'une grosseur et d'une hauteur extraordinaire. Il ne vaut rien à brûler. On s'en sert pour la charpente des bâtiments. Quand il sèche, il devient assez dur. Il n'a pourtant pas cette bonté du chêne de France et il n'est pas aussi recherché pour faire le gabarit des vaisseaux. J'ai pourtant su de quelques habiles pilotes et de plusieurs charpentiers de navire qu'on peut le faire durer autant que le chêne de France. Soit qu'il soit déjà en œuvre pour la construction des vaisseaux ou employé à quelque autre ouvrage*, ils disaient qu'ils savaient par expérience qu'un vaisseau fait de chêne dans les Indes devient fort bon et d'un long usage, si d'abord* qu'il est fait, on le mène* à l'eau salée et que, le faisant remplir sur quelque port assuré de la mer d'eau salée, qu'on le laisse croupir* quelque temps dedans, cette eau salée donnait de la fermeté à ce bois, et qu'étant demeuré ainsi quelque temps dans l'eau salée, on n'avait qu'à percer le vaisseau en divers endroits pour laisser sortir l'eau salée qui est dedans. / C'est ainsi / qu'ils assurent que le bois des Indes s'affranchit* et qu'il devient solide et de longue durée. J'ai vu de très bons vaisseaux bâtis dans les Indes, et ils étaient des meilleurs voiliers. Monsieur Talon, qui a été intendant dans la partie de la Nouvelle-France que les Français occupent, en a fait bâtir de cinq cents tonneaux de cargaison.

La feuille du chêne blanc est fort bonne pour guérir les blessures, et les sauvages s'en font revenir les ongles après qu'on les leur a arrachées avec les dents. J'ai découvert par épreuve* ce secret d'un Américain* virginien à qui on avait arraché tous les ongles, coupé un doigt et percé le bras. Je le voyais tous les jours aller au

227 *Tilia americana* L., tilleul d'Amérique, encore nommé «bois blanc» au Québec (Marie-Victorin, 382 et Rousseau 1964, 289–90).

228 *Ulmus americana* L., (Marie-Victorin, 170 et Rousseau 1964, 288); décrit par Clusius en 1601 et signalé par les premiers découvreurs et par Boucher en 1664 (Alain Asselin).

229 Rousseau 1964, 288 explique que l'on connaît quatre espèces de chênes au Québec : *Quercus rubra* L., chêne rouge, *Q. bicolor* Willd., chêne bicolore, *Q. alba* L., chêne blanc et *Q. macrocarpa* Michx., chêne à gros fruits (Marie-Victorin, 154–5). Clusius décrit *Q. rubra* L. dès 1601 (Alain Asselin).

bois, y cueillir des feuilles de chêne blanc. Il les pilait entre deux pierres, il les mâchait et en appliquait le marc au bout de ses doigts. Et voyant qu'il avait de la peine à se panser, je le pansais moi-même. Avec cette drogue*, dans peu de temps il guérit parfaitement et ses ongles revinrent aussi belles et aussi nettes que jamais. Voilà ce que je puis assurer. Cette feuille n'a point cet effet si elle n'est mâchée après être pilée comme j'ai dit.

*Du bouleau et du vrai papier*²³⁰
Le bouleau que les Allemands nomment *brichem-baoum* et les sauvages *ouigouach*, les Grecs παπύ ρος, et d'autres nations *briza*, est un arbre fort branchu et fort haut dans les forêts montagneuses. Il aime le pays froid. Son bois est mou et en cela il est facile à travailler. Les habitants du pays en font [f. 42] divers ustensiles*, comme sont des traînes, des rames, des cercles, des raquettes. La fumée est fort puante et elle entête* furieusement*. On fait du charbon du tronc de l'arbre et des branches aussi.

Le principal usage du gros bouleau pour les sauvages de la langue algonquine est l'écorce dont ils font ce divin bateau, que nous appelons *canot*, après les Hollandais, qui, en leur langue, nomment un petit bateau *canot*. Je l'ai appelé divin pour faire connaître la belle commodité qu'on a par la navigation du canot avec lequel on peut faire avec un bout d'écorce, des voyages de plus de mille ou douze cents lieues sur les lacs immenses et passer par des lieux les plus affreux et les plus dangereux du monde et où fort souvent les plus hardis tremblent. De bonne foi, c'est quelque chose de bien particulier que de voir huit ou dix grands hommes, avec tout leur bagage et force marchandises, se commettre* sur une écorce avec une autre qui leur sert de voile et se hasarder à faire des traverses* de vingt lieues, de quinze, de dix, sans prendre terre, et le plus souvent de quatre et de cinq. La chose est si prodigieuse qu'elle ne peut presque pas se dire, ni guère comprendre : il faut la voir et la mettre en pratique comme le font tous les jours les missionnaires et ceux qui les accompagnent avec des bandes de guerriers, de chasseurs ou de voyageurs pour la croire. Bon Dieu, combien de fois les cheveux se hérissent dans ces rencontres, combien de fois le jour on est en risque de périr et d'être mis en pièces contre des rochers ou des cailloux qui sont au milieu des précipices au milieu desquels il faut passer presque aussi vite que ferait un oiseau du plus vite et du plus raide vol. Cependant, on aime en quelque façon mieux se voir sur ces écorces volantes que dans des brigantins dans lesquels on souffre la mort à chaque moment, sans pouvoir approcher d'aucune terre que rarement, où tous les jours, cent fois si on veut, on se débarque des canots quand on va à la rade des côtes, ce qu'on fait d'ordinaire, sans jamais voir aucune terre de l'autre bord de nos grands lacs.

Cette même écorce qui sert pour faire des bateaux à nos Américains leur est d'un grand usage pour bien d'autres choses : ils en font des plats qu'ils nomment *ouragan*; ils en font des écuelles, des cuillères, des boîtes à mettre leurs hardes* et des ossements de leurs morts, qu'ils charrient* par amitié et par respect dans tous leurs voyages; ils en font des coffres, des seaux à puiser de l'eau, des maisons, et plusieurs autres ouvrages.

Du petit bouleau, ou du vrai papier fin
Il y en a de deux couleurs dans le pays : il y en a du blanc, il y en a du rouge. Tous les deux sont aussi délicats que du satin. Le blanc est le plus beau et on y écrit aisément dessus : la plume coule sans s'user. Un seul arbre peut fournir autant de papier qu'il en faut pour faire un gros livre. La première écorce avec toutes les autres sont pleines de [f. 43] bitume et brûlent comme des flambeaux dont la flamme serait très ardente et fort claire. La fumée qui en sort est fort puante et extrêmement noire. Les sauvages en font des torches et des gros flambeaux dont ils brûlent leurs prisonniers de guerre. Ils se servent des mêmes flambeaux pour la pêche qu'ils font la nuit en certaines saisons de l'année.

Le bois de ces deux sortes de bouleau est fort doux et fort pliant. Les sauvages en font les cercles de leurs raquettes de diverses figures*. Le charbon qu'on fait de ce bois est fort ardent*, la fumée est dangereuse pour les yeux.

Quand on fait un trou à ces arbres, il en découle de l'eau fort claire, qui, étant bue par ceux qui ont la pierre*, ils s'en trouvent bien, elle la rompt et rejette toute la gravelle*. Elle enlève les taches du visage et fait le teint beau et fort fin. Elle guérit même les ulcères de la bouche.

Du cèdre blanc
Quoique plusieurs écrivains aient traité du nom de tous les arbres que je viens de décrire, je n'ai pas voulu laisser d'en dire un mot dans la certitude que j'avais

230 *Betula papyrifera* Marsh. (Marie-Victorin, 150). Signalé par les premiers découvreurs et par Boucher en 1664. Mentionné dans «La flore du Canada en 1708» (Boivin) (Alain Asselin).

que tout ce qu'ils avaient rapporté n'était guère semblable à tout ce que je devais dire, et que si j'ai donné les mêmes noms qu'eux aux simples et aux arbres dont je devais parler, ce n'a été que pour m'accommoder autant qu'il se pourrait aux idées que les habiles botanistes auraient pu se former de la lecture des principaux écrivains sur ces matières. Quoique, à dire le vrai, les pensées qu'on prend dans la lecture des livres de cette nature sont bien différentes de celles qu'on a sur les lieux où l'on a vu les choses dont on parle et desquelles des esprits bien éclairés diraient infiniment plus de belles choses que celles que j'ai rapportées, ayant remarqué toutes les particularités dans un pays fort éloigné du nôtre et où presque tout y est différent, et particulièrement le cèdre dont voici deux espèces dont je vais faire la description pour finir ce troisième livre et tout le traité des simples et des arbres, en donnant la connaissance du cèdre blanc et du cèdre rouge et blanc.

Du cèdre blanc

C'est un arbre fort haut et que je compare hardiment au plus haut clocher de France. Mais les personnes qui sont dans l'Inde et qui n'ont vu que du cèdre commun, seront surprises de ce que j'avance, puisqu'il est vrai que communément cet arbre n'est pas d'une si grande hauteur que je lui donne d'abord, car ordinairement, il n'a que cent ou cent vingt pieds* de haut. Mais je n'ai qu'à les renvoyer en quartier d'hiver, au pays des Naukés, des Outchiboueks ou des Passinassioueks qui sont errants dans la grande plage* de terre qui se trouve entre la mer Tracy et le grand lac des Illinois qui a mille quatre cents lieues de tour : ils y en verront que trois grands hommes auraient de la peine à embrasser, et qui [f. 44] poussent leurs pointes plus de deux ou trois cents pieds hors de la terre, et ils ne seront pas surpris de ma proposition, étant convaincus de la vérité que j'avance.

L'on voit au bout des branches de ce bel arbre dont les petites feuilles ne flétrissent jamais, non pas même durant les plus rudes hivers, des petites pommes à peu près comme celles des cyprès. Les cèdres de l'Asie, que l'on voit dans la Phanice et sur le mont Liban, portent des pommes plus grosses et leur feuille est différente et ressemble beaucoup à celle du genévrier. Les cèdres américains ont la feuille et la pomme comme le cyprès. On peut voir aisément la différence de l'un et de l'autre dans le fameux jardin du roi à Montpellier, où j'ai vu de l'un et de l'autre. Et pour n'aller pas si loin, on voit la même chose aux Tuileries où l'on a planté des cèdres portés* de l'Amérique.

Le tronc du cèdre est ordinairement fort droit. Il se rétrécit insensiblement depuis le pied jusqu'à la cime comme le cyprès, que Lescarbot veut qu'il naisse dans nos terres bien que jamais il n'y en ait eu.

L'écorce du cèdre paraît assez fine; on y découvre pourtant bien des raies. Si on la ratisse ou si on la gratte avec un couteau ou avec les ongles, elle paraît verte; si on pousse un peu plus avant elle est rouge, et si enfin on l'enlève entièrement, elle est toute blanche. Voilà donc une écorce fort rare chargée de quatre couleurs fort vives et fort bien distinguées : 1° du gris chargé, 2° de vert fort éclatant, 3° du rouge vineux, et 4° d'un blanc épais. Cette écorce est si pliante qu'on en fait toute sorte de liens et même des cordes. On en fait des maisons et divers instruments.

Les branches portent toujours leurs pointes en haut. Le bouquet des branches est beau et fort large, à petites feuilles toujours vertes et odoriférantes. Elles sont astringentes, aigres, et un peu amères.

On peut amasser sur l'écorce du tronc de l'arbre deux sortes d'encens ou de poix résine : l'une est liquide et fort puante, âpre et forte pour son odeur, transparente comme de l'ambre jaune; l'autre est sèche, elle sert d'encens et l'odeur n'en est pas désagréable, mais elle n'est pas si odoriférante que l'encens de l'Arabie.

L'écorce et le bois brûlent très bien, font peu de fumée en faisant un feu fort clair, la cendre est douce. Le bois vert et sec est si pétillant qu'outre qu'il est fort importun pour le bruit, il brûle en ressautant* tous les habits. Son charbon s'éteint d'abord* et il devient fort bon pour crayonner. Il s'imprime si avant dans la peau des sauvages qui s'en servent pour se peindre tout le corps par diverses belles figures qu'ils y gravent, qu'il ne s'efface jamais plus. Ils le pilent, et l'ayant brisé, ils le mêlent avec de l'eau commune* et y trempent trois pointes d'os dont ils se piquent la peau de telle manière que le sang qui sort de la piqûre se mêle avec ce charbon détrempé. La figure qu'on grave ne s'efface jamais de la partie où on l'a fait.

Comme le charbon qui se fait du cèdre blanc brûlé est fort pétillant à cause* qu'il est bitumineux, la poudre qu'on en fait est au double violente de la nôtre et a un double effet.

Il n'y a point de doute qu'on ne puisse faire la *cedria* des Égyptiens de nos cèdres, où l'on peut ramasser une liqueur gluante qui découle [f. 45] de tout le corps de l'arbre, qui sert pour embaumer les corps en trempant un linge dedans. Ce linge et les corps embaumés avec cette liqueur deviennent incorruptibles.

Le corps du bois de cette sorte de cèdre est assez plein de nœuds tordus. Il s'en trouve pourtant de si

droit, et qui se fend si proprement que les sauvages en font des perches de quatre à cinq brasses de long. Il se divise même en tant de pièces que les barbares en doublent commodément leurs canots de ces lames si déliées* qu'on dirait, à les voir, qu'elles sont collées ou qu'elles ne font qu'un corps entre l'écorce contre laquelle elles sont appliquées et entre les varangues qui sont d'autres lames du même bois tournées et demi-cerclées, faites exprès, de l'épaisseur de deux ou trois écus* pour retenir à raison* la figure qu'on a donnée à l'écorce du canot, afin qu'il coule plus aisément sur les eaux et qu'il ne s'y enfonce pas. Je ne saurais guère bien dire à combien d'usages le cèdre de l'Amérique est propre : on en fait des caisses de tambour, mille petits ustensiles*, des rames, des avirons, des ais*, des plats, des cuillères, des palissades et des poutres. On pourrait en faire du très beau parquetage* et des meubles de toutes les façons, incorruptibles et fort odoriférants, et le tout d'une légèreté extraordinaire. Les pieux et les palissades qu'on en fait durent les vingt et les trente ans dans la terre, sans se pourrir et sans s'altérer que bien peu et seulement superficiellement.

Au reste, ce bois se travaille si facilement, si proprement, et son grain est si fin et si bien madré* ou ondoyé* qu'il y a bien du plaisir de voir tous les ouvrages que les sauvages en font. En France, on se sert du liège pour soutenir les filets des pêcheurs, et en Amérique, on se sert de cèdre en forme de lames d'épée. Son odeur recrée* merveilleusement le cerveau.

Du cèdre rouge et blanc
La différence qui est entre le cèdre rouge et blanc, et entre celui qui n'est que blanc seulement, est fort notable presque en tout : dans la feuille, dans la grandeur, dans le bois, dans les nœuds, dans la couleur et dans l'odeur. Il y a néanmoins je ne sais quel certain rapport qui fait qu'on ne saurait s'empêcher de dire qu'il y a bien de la ressemblance entre les deux et qu'ainsi il faut leur donner le même nom, le différenciant par les couleurs.

Son bois blanc à demi, et rouge à demi, très odoriférant, sa feuille un peu plus courte et plus épaisse, son bois, quoique tordu et extrêmement noueux, le différencient assez, aussi bien que sa petitesse.

[f. 46] Je n'en ai vu que le long des rives du lac Champlain et dans quelques anses du lac du Saint-Sacrement et dans la *baie d'Erreur*, ainsi nommée depuis que notre armée, qui allait aux Iroquois sur les neiges et sur les glaces, s'y égara par l'inconsidération et par l'ardeur de quelques Français qui furent la cause* qu'on ne fit rien dans cette campagne où il nous était très aisé de défaire nos ennemis, qui, au lieu d'être pris, firent périr plus de cent braves Français.

Sur les plus hautes montagnes de la Virginie, j'ai vu encore quelques cèdres rouges et blancs. Les Virginiens font quelques ouvrages curieux de cette sorte de cèdre, qui a d'ailleurs toutes les autres qualités du cèdre simplement blanc. Voilà ce que je peux dire de ce que j'ai vu de plus particulier de ce que je viens de traiter jusqu'ici.

Ceux qui voudront savoir des choses plus particulières de tout le traité des simples, des arbres, des fruits, des fleurs, des arbrisseaux et de toutes les autres choses naturelles, qui se trouvent hors des Indes occidentales, n'auront qu'à consulter (comme j'ai fait pour savoir ce que je n'avais pas vu et où je n'avais pas été) plus de trente écrivains dans lesquels je n'ai rien trouvé de ce que j'ai avancé.

Qu'ils cherchent donc dans Cantacuzène de Constantinople, dans Ruel, dans Matthiol, dans Valère Codre, Dalechamp, Hippocrate, Galien, Strabon, Eustathe, Dioscoride, Belon, Théophraste, Demoulins le médecin, Pline, le maître des naturalistes, Cloace, Macrobe, Scaliger, Columelle, Gesner, Gaze, Hermolae, Traque, Bahuin, disciple d'Esculape, Feste, Pallade, Fusche, Dodon, Phocion, Diodore de Sicile, Cornaro, Lacuna, Jounston, Aldroüan, Rondelet et plusieurs autres. Tous ces messieurs et tous ces fameux naturalistes leur apprendront avec le grand, avec le divin Aristote, une infinité de très belles choses de la nature, qui se plaît à nous faire admirer son maître dans une infinité de beaux objets différents que nous ne pouvons pas savoir, ni même comprendre qu'en les voyant et en les examinant de bien près dans la route de plusieurs grands voyages réitérés, où il faut s'étudier et se plaire, ou du moins avoir la curiosité de voir avec attention ce qu'on trouve de particulier, car à moins [f. 47] que de cela on passe et on repasse bien des fois dans des lieux où il y a des choses très curieuses et fort dignes de remarques sans l'y voir et qu'il est fort utile de faire savoir au public qui demeure ignorant par la faute de ceux qui voyagent et qui ne se piquent de rien, passant par des lieux où il y a de très belles choses à voir et à savoir. Ce malheur arrive à cent mille personnes qui s'ennuient des voyages et qui ne pensent qu'à la fin de leur route, au bout de laquelle ils sont aussi savants que lorsqu'ils ont entrepris de fort grands voyages, je ne sais par quel esprit. Et ces sortes de gens n'en sont pas plus louables ni plus spirituels. Pour moi, j'ai fait une étude particulière* et je me suis fait un plaisir bien sensible* de remarquer tout ce que j'ai pu découvrir de beau et de curieux dans mes courses. Ainsi contentez-vous de ce peu que je présente et que j'ai découvert dans des pays étrangers durant fort longtemps. Voyez ensuite de ce que je viens de dire dans les forêts garnies d'arbres

que j'ai décrits, voyez, dis-je, vivre paisiblement dans ces vastes pays, les animaux que je vais vous présenter dans le narré* de trois livres où je vais vous faire considérer* soixante ou quatre-vingts animaux à quatre pieds tous différents.

QUATRIÈME LIVRE

Traité des animaux terrestres, aquatiques et amphibies, à quatre pieds, qui se voient dans les Indes occidentales, ou dans l'Amérique septentrionale et dans l'occidentale

Comme j'ai entrepris l'histoire naturelle du pays du septentrion et de l'occident de la vaste Amérique, il est important de ne rien omettre de ce qui est de plus précieux. Et puisque les animaux qu'on y rencontre doivent faire le sujet et la matière de trois livres, j'ai cru qu'il était fort à propos, [f. 48] avant que de venir au détail, de dire un mot en général et de faire savoir que la nature, qui veut paraître partout admirable, et en particulier sur les animaux, que la chose tient du prodige, tant pour la multitude que pour la variété, est en effet merveilleuse lorsqu'elle nous forme des animaux à quatre pieds, dont quelques-uns les ont ronds comme le cheval, le mulet et l'âne, d'autres l'ont fendu ou fourchu comme le bœuf, l'éléphant, la licorne, le cerf, le daim, le chevreuil, le caribou, le bouc, et plusieurs enfin les ont à griffes et à ongles. Parmi ceux-ci, il y en a de deux espèces : les uns à griffes et à ongles simplement, comme le lion, le tigre, le chien, la panthère, l'ours, le chat, la martre, le renard et plusieurs autres; le castor, le tigre* marin, le rat musqué, le loup-marin, etc., les ont à ailes et ongles.

Il semble que cette sage ouvrière n'ait pas voulu qu'il y eût de l'envie entre* les animaux, car, si elle a pris plaisir à fournir quatre pieds aux uns, elle a voulu avantager les autres en leur donnant deux pieds seulement et deux ailes. Et elle a voulu qu'on tînt pour défectueux tout ce qui ne serait pas dans l'ordre qu'elle avait établi et que l'on criât au monstre si quelque était contre ses règles.

Je ne dois point produire ici que des animaux parfaits* et rares, qu'on ne voit point en France, ni dans aucun endroit de l'Orient, ni en aucun lieu de notre voisinage.

Mais comme parmi les animaux de l'Amérique, il y en a des terrestres, des aquatiques et des terrestres tout ensemble, que nous appelons d'amphibie, et d'autres qui ne vivent que dans l'eau, et par conséquent, qui sont simplement aquatiques. Je parlerai de tous séparément, après avoir averti que, dans les premières terres de notre grande Amérique, il n'y a point naturellement de ces sortes d'animaux que les Grecs appellent ἀκίδες [akides], c'est-à-dire des animaux à pied fendu. D'autres les nomment des *animaux à pied solide* ou rond / et fort /, *solidipeda* ζωα [zôa]. Les Latins les appellent *cornipeda*, s'accordant avec les Grecs. *Solipeda*, dit un autre.

Tous les animaux de l'Amérique antérieure ont le pied fourchu, *Bisulca dicela* (διχηλα ζωα [dixèla zôa]), animaux à pied fendu comme l'écrevisse. Aristote les appelle *animaux au pied de tenailles*, et elles ne sont pas trop fortes pour courir sur les glaces de six ou de sept mois continuels, et où les animaux à pied rond ne sauraient se soutenir sans glisser mille fois le jour.

Les animaux onglés et à griffes tiendront dans ce narré* le premier rang sous le nom de πολικιδες, και πὸλιδακτὺλον [polikides, kai polidaktulon], comme ayant plusieurs doigts pour parler avec les Grecs et aussi les Latins : *animalia multipliciter digitata*, ayant bien du rapport* aux mains des hommes. Il y a même des oiseaux qui ont cet avantage, et ils sont divisés en deux espèces : en onglés et en pieds plats : *alias digitatas aves esse dixit, alias palmipedes*, dit un naturaliste après [f. 49] un autre. Et je dis après eux qu'on distingue encore deux espèces d'animaux à quatre pieds. Parmi cette multitude innombrable d'animaux à quatre pieds, il s'y en voit qui font des œufs comme les tortues, qu'on peut nommer *ovipara*, ou bien ωοτό κα [ôotoka], *quae cortice teguntur*, couverts comme d'une écorce. Les autres sont aussi à quatre pieds, mais ils font leurs petits en vie : *vivipara*, ωοτόκα [zôotoka] et *pilisista teguntur*, et ceux-ci sont velus en naissant et c'est par ceux-ci que je veux commencer.

[Troisième cahier de l'Histoire naturelle de l'Inde occidentale]

Des écureuils suisses[231]

Ce n'est pas sans raison que je commence la description des animaux à quatre pieds par les quatre diffé-

231 *Tamias striatus* (L.), tamia rayé, mieux connu au Québec sous le nom de suisse; voir A.W.F. Banfield, *Les Mammifères du Canada*, 90–2 (désormais, Banfield). Nous avons aussi consulté W.H. Burt et R.P. Grossen-

heider, *A Field Guide to the Mammals*, Boston, Houghton Mifflin, 1976, 108 (désormais, Burt et Grossenheider). Par ailleurs, voir le *Codex*, Pl. XXVIII, fig. 45.1, pour une représentation de l'animal, désigné alors comme

rences d'écureuils qui se voient communément dans les terribles forêts de l'Inde occidentale.

Cet animal doit sans doute être ennobli et tenir le premier rang dans ce livre, car il a déjà reçu ses lettres de noblesse de la bouche du plus auguste et du plus invincible monarque du monde : c'est de Louis le Grand. Elles ont été confirmées par celle du plus éclairé et du plus savant de nos dauphins, et ratifiées par la plus pieuse reine de l'univers, et enfin, elle a été reconnue par la cour la plus accomplie du plus fleurissant état et de la plus puissante monarchie de la terre.

Je veux dire que toutes ces illustres personnes, ayant vu une seule espèce de ces animaux que j'avais apportés d'au-delà du grand océan et que j'eus l'honneur de présenter à Sa Majesté, les trouvèrent si beaux et si rares*, et si bien dressés qu'elles dirent d'un commun accord qu'ils étaient fort jolis, tant pour* la beauté de leur poil que pour la petitesse de leur corps et pour les belles grâces dont la nature les avait embellis. En voici la description bien au vrai.

Les natifs du pays appellent *ouaouingooch* l'animal que les Français nomment l'*écureuil suisse*, à cause de la variété du poil de sa peau qui est chamarrée de diverses belles couleurs comme le sont d'ordinaire les habits des Suisses.

L'animal est fort petit et d'une figure* agréable, d'un poil merveilleux. Le fond de sa robe tire sur le jaune et un peu sur la feuille morte. Il est barré sur les deux flancs de diverses lignes de différentes couleurs. Ces marques sont longues d'environ deux pouces*, et larges à peu près, et ressemblent à la figure que je marque ici.

Deux de ces lignes sont blanches comme la peau de l'hermine. Les deux autres sont noires comme du jaiet*; et entre la couleur noire et entre la couleur blanche, [f. 50] il s'en voit une autre toute différente, et de couleur d'or, pas plus large qu'un bout de fil à coudre, qui relève agréablement les autres deux. Le poil est comme blanc sous le ventre. Tout l'animal n'est pas plus long que la figure qu'on voit ici ensuite.

Il a un pouce de diamètre et trois en rondeur. Sa queue est plus longue que son corps, fort grosse, bien fournie de poil, assez longue. Il la retrousse de bonne

grâce jusqu'au bout de son museau, la couchant par-dessus son dos, et il la fait encore replier par-dessus, en sorte qu'il semble que l'animal a un casque. La tête est proportionnée à tout le corps, ses yeux sont gros et fort vifs, ses oreilles sont assez rases, un peu pourtant relevées, en sorte qu'elles rendent l'animal fort agréable, qui, d'ailleurs, est fort éveillé et fort vif. Il grimpe avec une merveilleuse vitesse partout et il saute avec agilité de branche en branche, et même d'un arbre à l'autre. Il fait dessus sa principale demeure dans des trous où il se retire, et il y fait sa provision dans des greniers pour vivre durant l'hiver, qu'il passe une partie à dormir, et l'autre partie à ronger ses vivres. Je dis ronger, car il ne saurait manger autrement, ne pouvant point mâcher, mais il ronge à la façon des souris avec cette différence qu'il tient entre ses pattes ce qu'il veut manger, qui sont des noix, des noisettes, de la faine et toute sorte d'autres fruits durs. Il a les doigts de sa patte et les griffes assez longues pour pouvoir se retenir aisément en grimpant.

Ces rares animaux sont d'un goût très exquis, et ils sont aussi délicats que les ortolans quand ils n'ont que trois ou quatre mois. Les sauvages les grillent sans les écorcher. Ils les habillent* d'autres fois et en conservent avec soin les peaux pour en faire des robes à leurs enfants. Depuis peu, les marchands d'Europe en font cas et les achètent chèrement, aussi bien que les autres peaux des autres trois espèces d'écureuils.

Il y a bien du plaisir de voir des grandes bandes de ces petits animaux courir parmi les champs couverts de blé d'Inde, qu'ils ramassent avec bien de l'économie*, quand ils sentent approcher l'hiver. Ils en remplissent, bien des fois le jour, deux petites bourses qu'ils ont à côté de leur mâchoire de même façon que les singes, lesquelles ils vont vider dans leurs greniers qui sont toujours bien près de leur nid, où ils laissent un trou pour passer quand ils veulent aller manger, et un autre pour y faire leurs crottes, de peur de salir leur demeure ordinaire. Ils sortent de ces demeures environ* le quinzième du mois de mars, lorsque les neiges commencent à s'adoucir tous les après-midi. Ils vont s'égayer au soleil et commencent à courir sur les arbres, et c'est de là que les Sauvages ont pris occasion* de donner à ce mois le nom des écureuils, qui se dit en leur langue *ouaouingouch-kizis*, comme qui dirait le soleil des écureuils, pour dire le mois des écureuils, prenant ainsi le soleil pour un mois, à la façon des astrologues qui assignent un animal imaginaire et céleste au soleil chaque mois de l'année.

«ecureul suisse nomme dans le pais oua oningout». J. Warwick, Gabriel Sagard, *Le grand voyage du pays des Hurons*, 352, donne *ohihoin* en huron. Ganong, 239

explique qu'il doit son nom à ses raies, qui ressemblent à celles des costumes de la garde suisse du pape. Lahontan ne les appelle pas autrement.

[f. 51] Environ ce même temps, ces petits animaux entrent en amour et commencent à faire retentir les bois de leurs différents cris qui ressemblent quelquefois à ceux des grands rats; d'autres fois, ils les varient en un certain ramage, qui tient plus de l'oiseau que de l'animal à quatre pieds. On les voit s'entrechasser l'un l'autre, se mordre, s'entrelacer et faire mille agréables passades et des sauts bien lestes.

Ils mettent bas au mois de mai, et peu de temps après, ils font leur seconde portée. Ils fréquentent les lieux où il y a des coudriers*, des pruniers, des noyers, des hêtres ou des faux* et autres tels arbres.

Ce suisse, étant pris dans le nid lorsqu'il est encore bien jeune, est très aisé à familiariser*, à dresser et à lui apprendre divers petits tours de passe-passe, et fort divertissants. Pour cela, il faut le faire jeûner longtemps. Quand il a faim, il vient brillant, remuant et bien frétillant; et pour avoir le plaisir de lui voir remplir ses bourses, il faut avoir un épi de blé d'Inde ou tel autre grain. On le verra à même temps venir à sauts et à bonds se jeter à corps perdu et d'une vitesse presque incroyable sur le grain dont il remplira ses bourses pour les aller vider dans ses magasins et revenir au plus vite, plusieurs fois, pour refaire la même chose, jusqu'à ce qu'il ait pris le dernier grain. Ensuite de quoi, il va manger avec tant de vitesse et avec tant d'avidité qu'il n'est pas croyable comment cet animal peut remuer les mâchoires si vite.

Il faut toucher souvent ses animaux, leur donner un peu de sucre, les accoutumer à manger sur la main, et dans quelque temps, on les verra jouer et devenir très familiers*. Si on veut avoir le plaisir entier, il en faut avoir deux, mâle et femelle. Ils viennent manger et courir sur une table où l'on mange sans rien salir. On les voit bondir sur un lit, grimper sur une tapisserie et faire mille tours; mais gare le chat. Si on a soin d'y prendre garde et qu'il ne les prenne pas, on aura un plaisir extraordinaire de voir partir comme un éclair, ces deux écureuils, pour se rendre en quelque lieu d'assurance* d'où ils regarderont l'ennemi en criant et courant de toutes parts, pour chercher encore quelque lieu plus assuré* où, étant arrivés, ils regarderont le chat en criant et comme lui disant mille injures avec tant de violence qu'ils en crèveraient bientôt si on ne leur ôtait de devant le sujet* de leur crainte.

Sa Majesté, comme je l'ai déjà dit, m'a bien voulu faire l'honneur d'en recevoir deux de ma main qui faisaient tout ce que je viens de dire. Elle a bien eu la curiosité de commander à monsieur Chamarante, qu'on les mît dans sa fameuse ménagerie de Versailles où l'on voit les plus belles et les plus rares curiosités du monde, soit en oiseaux, soit en animaux de quatre pieds, qui sont, à mon avis, les plus belles curiosités qu'on puisse avoir sur terre après les hommes, puisque les autres ordinairement ne sont que l'ouvrage de quelques habiles hommes et celles-ci sont des œuvres du plus grand maître du monde.

[f. 52] *De l'écureuil volant*[232]

J'aurais souhaité avec passion* d'avoir eu les autres trois espèces d'écureuils que j'ai vu dans les Indes. Je suis sûr que Sa Majesté, qui est touchée de cette belle passion de savoir et de voir tout ce qu'il y a de beau, de curieux et de rare dans la nature (et à qui je me serais fait un grand plaisir et un grand honneur de les présenter, comme j'ai fait la première et la plus belle de ces quatre sortes de rares animaux), les aurait reçues avec agrément, étant toutes extrêmement curieuses en leur genre, et toutes particulières en leur espèces, ayant toutes quelque chose de commun et quelque chose de bien différent.

Car l'écureuil volant que les Indiens appellent *anachkantaoûé* a tout ce que je viens de dire commun avec l'écureuil suisse, excepté sa grosseur qui est assez notable et sa robe qui est différente, tirant sur le petit gris. Ce qui est de plus admirable en cet animal est que, depuis l'épaule jusqu'à la cuisse, il a une peau aussi velue que tout le reste de son corps, qui s'étend comme une aile de chaque côté, lorsqu'il veut s'élancer d'un arbre à l'autre, du haut en bas et non pas du bas en haut, car il ne se lance jamais de même. Quand il veut partir pour s'élancer, il fait comme un saut et pour lors ses ailes s'étendent comme un éventail, et sans les remuer, il arrive avec raideur là où il veut s'agriffer*. S'étant pris à une branche, il court avec une vitesse incroyable là où son imagination le porte. Il a la queue beaucoup plus belle, mieux fournie et plus grosse que celle de l'écureuil suisse. Il la retrousse de bonne grâce. Il a les yeux extraordinairement gros pour la petitesse de son corps; ils ne sont point si brillants que ceux du suisse quoiqu'il les ait fort vifs. Sa voix ne diffère guère de celle de l'écureuil suisse. Cet animal étant mort, quoique petit,

232 *Glaucomys sabrinus* (Shaw), grand polatouche (Banfield, 134–6 et Burt et Grossenheider, 123–4); représenté dans le *Codex*, Pl. xxviii, fig. 45.2, comme «Ecureul volant sans pleume, nomme anascantoue». *Anascantoue* et *anachkantaoûé* sont les noms iroquois de l'animal. Champlain le mentionne en 1632 comme un «escurieux vollans». Le père Le Jeune le connaissait (Ganong, 214); Pierre Boucher en 1664 aussi (Rousseau 1964, 311–12).

devient aussi gros qu'un grand ballon si on l'enfle. En cet état il devient diaphane, à cause de la délicatesse de sa peau qui est rose.

De l'écureuil jaune[233]

Cette troisième espèce d'écureuils est plus grosse, plus grande et plus longue que la première et que la seconde. Les coureurs des bois lui ont donné le nom d'*achitamoû*. Cette troisième espèce approche le plus des écureuils d'Europe. L'animal n'est pourtant pas si gros, son poil n'est pas si rougeâtre, car il tire beaucoup sur le jaune, avec cette différence que le bout de son poil fait comme un petit gris fort agréable. Il a le bout du museau comme le lièvre, la tête fort grosse, les oreilles un peu droites et pointues. Il a plus de vivacité que les autres espèces de son genre.

On ne peut rien voir de plus beau qu'un de ces animaux apprivoisé. Son agilité, sa vitesse et presque sa subtilité* le rendent invisible lorsqu'il craint quelque ennemi.

[f. 53] Des écureuils noirs[234]

Cette sorte d'écureuil, qu'on appelle dans les pays *missanik*, est sans contredit la plus curieuse et la plus recherchée. Un seul écureuil de cette différence est plus gros que trois des autres. Pour la figure, il n'y a guère à dire. La couleur est différente et d'un beau noir. L'animal a la queue fort longue, bien fournie et proportionnée à tout son corps. Toute la robe est luisante comme un miroir. Ces écureuils noirs ne sont pas communs comme les autres : c'est pourquoi ils sont

fort estimés. Une robe de ces peaux se vend plus de trois cents écus* parmi les Barbares. Les petits et les grands Sauvages tuent toutes ces quatre sortes d'animaux avec de certaines flèches, toutes émoussées pour ne pas leur gâter la peau.

Des souris du Nouveau Monde

On ne voit point dans les Indes aucun rat, ni aucune souris semblable à celles de l'Ancien Monde que* celles qu'un navire (qui s'échoua proche des côtes du cap au Diable qui est entre / la ville de / Québec et la fameuse résidence de Sillery) porta dans le Nouveau Monde[235], qui, depuis ce temps-là, ont multiplié* de telle manière qu'on n'en trouve que trop dans toutes les habitations* françaises, où cette vermine ruine des granges entières pleines de blé. Les chats qu'on a transportés de France ensuite de la descente des rats et des souris sont leurs Iroquois.

Des petits mulots[236]

Toutes les vastes forêts du septentrion et de l'ouest ou du couchant du soleil sont remplies de mulots, qui est une espèce de souris. Ces animaux font leur demeure sous la terre et y font leurs greniers, et ils ne laissent pas d'incommoder les Américains qui cultivent le blé d'Inde. L'animal est plus gros que nos communes souris; il a la robe presque jaune, la tête grosse et les yeux; sa queue est fort longue.

De la souris au museau pointu[237]

L'on voit encore dans les bois d'autres fort petites sou-

233 *Tamiascurus hudsonicus* (Erxleben), écureuil roux (Banfield, 127–31 et Burt et Grossenheider, 120–1). Représenté dans le *Codex*, Pl. xxviii, fig. 45.3, sous la désignation «Ecureul commun jaune»; représentation inspirée de Gesner, 1621, t. 1, 845. Boucher, en 1664, connaissait déjà quatre espèces d'écureuils parmi lesquelles l'écureuil «roux comme en France» (Rousseau 1964, 311). N. Denys, *Description géographique et historique*, 1672 faisait clairement la distinction entre les trois espèces communes sur la côte est (Ganong, 214).

234 *Sciurus carolinensis* Gmelin, écureuil gris ou noir (Banfield, 123–5 et Burt et Grossenheider, 117–18); représenté dans le *Codex*, Pl. xxviii, fig. 45.4, comme l'«Ecureul a la robe noire». Boucher le mentionne en 1664, notant qu'on ne le trouve que dans «le pays des Iroquois» (Rousseau 1964, 311–12).

235 *Rattus norvegicus* (Berkenhout), rat surmulot (Banfield, 207–8 et Burt et Grossenheider, 195); représenté dans le *Codex*, Pl. xxviii, fig. 45.6, comme «Rat comun dans tout Le pais». Boucher le mentionnait en 1664 parmi «les animaux que l'on nous a amenés de France» (Rousseau 1964, 314).

236 Nicolas ne pouvait probablement pas soupçonner le

nombre d'espèces de souris qui se trouvent dans l'est du Canada. Rousseau 1964, 314 fut aux prises avec le même problème en commentant le texte de Boucher. Sa «souris» pouvait être : *Peromyscus maniculatus* (Wagner), souris sylvestre (Banfield, 152–6 et Burt et Grossenheider, 158–9); ou *Synaptomys cooperi* Baird, campagnol-lemming de Cooper (Banfield, 173–6 et Burt et Grossenheider, 176); ou *Microtus pennsylvanicus* (Ord.), campagnol des champs (Banfield, 194–7 et Burt et Grossenheider, 183–4); ou *M. chrotorrhinus* (Miller), campagnol des rochers (Banfield, 203–4 et Burt et Grossenheider, 188); ou *Zapus hudsonius* (Zimmermann), souris sauteuse des champs (Banfield, 212–14 et Burt et Grossenheider, 196–7); ou bien *Napaeozapus insignis* (Miller), souris sauteuse des bois (Banfield, 214–16 et Burt et Grossenheider, 199). De chacune, on connaît plusieurs sous-espèces.

237 *Microsorex hoyi* (Baird), musaraigne pygmée (Banfield, 20–1 et Burt et Grossenheider, 12–14), désignée dans le *Codex*, Pl. xxviii, fig. 45.7, comme «Rat au museau Egu», inspiré directement du *Mus arancus* de Gesner, 1621, t. 1, 74–7.

ris. La couleur en est rare, rapportant* une certaine couleur verte. Son museau est long de deux doigts, fort délié*, dont il fouille dans la terre comme la taupe. Les sauvages les embrochent comme des alouettes sans les écorcher ni éventrer. Ils les font rôtir et ils les croquent comme un bon morceau.

Des gros rats qu'on trouve dans les prairies qui sont le long de la rivière de Techiroguen en Virginie[238]

Le pays dont je parle est celui qu'habitent les Iroquois inférieurs. J'y ai vu chasser une certaine espèce de gros rats sur la fin d'avril. On trouve tant de ces animaux dans les champs et dans les prairies qu'il n'y a pas jusqu'aux fort petits garçons qui n'en tuent des centaines dans l'espace de quelques heures. Ces rats sont un bon mets au goût de ces Virginiens. Ils les rôtissent sans les écorcher ni sans les éventrer. Et il est sûr que la viande en est très délicate et d'un goût meilleur que le lapin, si elle était apprêtée à la française. Les pigeonneaux ni les poulets ne sont pas d'un goût plus délicat que ces rats qui ont la robe fort belle et assez grande, de la couleur du petit gris.

[f. 54] La figure de ce rat est un peu extraordinaire, étant fort gros sur le train de derrière. Sa queue est fort courte aussi bien que ses jambes. Son poil est fin, ses oreilles sont rondes et rasés; il est gros comme un de nos plus gros rats.

Du gros rat par excellence

Voici le plus beau et le plus rare de tous les rats qui habitent sous la terre et ordinairement sur les montagnes. Ses démarches ne sont que des sauts, assis toujours sur ses cuisses. Quand il mange, il se sert des deux pattes de devant comme s'il avait deux mains à la façon des singes. Il est grand comme un lièvre, son corps est gros, sa figure retire* entièrement au gros rat. C'est pour cette raison qu'on l'appelle le *gros rat*. Il a le dos fort large, son poil paraît assez hispide* ou grossier. Il est comme rougeâtre. On en voit néanmoins dont la couleur est moins chargée. Il a les yeux gros, étincelants, et ils semblent sortir de la tête; ses oreilles sont si courtes qu'à peine elles paraissent. Son museau approche de celui du lièvre; il a la dent de castor et de couleur jaune. Il ne mâche point, car il ne fait que ronger. Ses ongles sont pointues, sa moustache au poil noir rapporte* à celle du tigre. Sa queue a plus de deux

palmes* de longueur; elle est grosse bien fournie de poils. Ses cuisses sont grosses, mais courtes. Tout le dessous du ventre est extrêmement velu, aussi bien que ses cuisses. Il marche comme l'ours, se dressant sur les pattes de derrière. Tout le dessus de sa chair est entouré d'une certaine je ne sais quelle matière, qui n'est ni chair, ni graisse, mais un mélange de tous les deux comme la viande du castor et du rat musqué. Cela ne laisse pas d'avoir un goût assez agréable. Cet animal grossit avec le temps beaucoup plus qu'il ne devient long. Ces sortes de rats crient comme les nôtres; mais quand le temps va changer, ils semblent siffler et avoir le ton de ces flûtes douces d'Allemagne. Ils se nourrissent de fruits durs ordinairement, mais ils passent bien six mois à dormir, et sans manger quoi que ce soit. Leur demeure ordinaire a deux sorties ou deux entrées. Elle est faite sous la terre de la figure que je représente ici

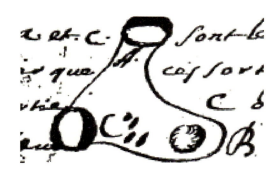

B est son nid; A et C sont les deux sorties. Il faut pourtant remarquer que ces sortes de rats ne passent jamais par la sortie C, de peur de se salir, car cette sortie C leur sert de lieux communs pour jeter, hors de leur demeure, leurs crottes qui les saliraient ou qui les infecteraient. C'est aussi pour cela que ces animaux ont l'adresse de faire ce trou en penchant afin que les crottes coulent dehors d'elles-mêmes, au contraire du trou A qui est en haut, par où ils sortent. Leur lit est fait d'herbe sèche.

Auparavant* que les grandes neiges couvrent la terre, ces rats s'assemblent et se renferment dans leurs nids. On en trouve souvent ensemble huit ou dix dans le même trou B. Ils s'entreroulent comme un peloton pour s'entreréchauffer et pour dormir, comme j'ai dit, dix mois de l'année. J'en ai trouvé et tué jusqu'à vingt ensemble.

238 La figure du *Codex*, Pl. xxviii, fig. 45.5, intitulée «Rat de La Virginie», ne représente pas un rongeur. Il se peut qu'il s'agisse du *Procyon lotor* (L.), le raton-laveur, mais avec seulement un bout de sa queue annelée.

De la taupe[239]

La taupe de l'Amérique a bien du rapport avec les nôtres, mais elle a deux choses assez extraordinaires. Elle a la queue plus [f. 55] longue et le bout du museau extrêmement différent, y ayant sept ou huit petits bouts de chair garnis d'os qui font la figure d'un œillet. Les deux trous de son museau en font le fond; son poil est fin, mais il tire plus sur le gris que sur le noir. Elle paraît avoir d'assez gros yeux, mais ils sont d'une matière comme de la corne : ce qui se voit distinctement, ses yeux avançant fort au dehors.

De diverses sortes de belettes[240]

Je n'ai rien trouvé de différent aux belettes d'Europe de celles de l'Amérique, qu'en la grandeur et en la différence du poil.

Ces animaux sont tous carnassiers et dérobent avec empressement les œufs des nids des oiseaux et des poules. Elles tuent les petits oiseaux et les poulets. C'est une chose agréable que de les voir chargées d'un œuf de poule, qu'elles mettent sous leur col, qu'elles ont bien long. Elles mettent cet œuf sous la mâchoire d'en bas et, le faisant toucher à leur poitrine, elles l'emportent. On dirait à les voir en cet état que ce sont de fort petits chevaux de manège à qui on tire fort la bride pour leur bien faire porter la tête si bien. Ces belettes portent leur corps dans ce col. On voit des courbettes agréables lorsqu'elles charrient leur proie dans leur magasin, qu'elles font dans la terre. Et comme ces belettes étrangères sont bien plus grandes que les nôtres, elles ne se contentent pas de donner* sur les poulets et sur les œufs, mais elles attaquent avec fureur les grandes volailles et en font un si grand carnage, dans une seule nuit, qu'elles en tuent jusqu'à quarante et davantage, si elles en trouvent. Et si cela arrive aujourd'hui chez un habitant, gare le voisin à demain. Ces

animaux se contentent pour la première nuit de saigner ses volailles sans qu'il y paraisse que lorsqu' / on plume la poule, / sous l'oreille de laquelle on voit une petite rougeur : c'est par là que le sang a été sucé /.

Ces trois ou quatre sortes de belettes qu'on voit dans les Indes mangent de tout et on peut leur donner le nom grec qui porte ζωα παμφαγα [*zôa pamphaga*], *animalia ommia voratia*, des animaux qui dévorent tout, ou plutôt il faudrait les nommer des *sangsues* ou bien encore, plus à propos, des *sang-suce*. Δελα [*bdela*], *sanguisuga*, πιναιματον [*pinaimaton*], *sanguinem bibens*. Buvant le sang, cet animal est de la même nature des belettes dont Érasme a parlé et dit que *fugiens, pessimè pediti*. Du moins je suis bien sûr que là où il a passé et fait tuerie, il n'y sent pas trop bon et que, s'il a été dans un poulailler ou dans une volière de pigeons, il n'est guère aisé d'y faire rentrer les poules ou les pigeons, à cause de la forte odeur que l'animal meurtrier y a laissé.

Les Sauvages se servent à divers usages des peaux de toutes les sortes de belettes; mais ils ne les estiment pas tant* comme ils font toutes celles des animaux dont j'ai déjà parlé et des autres dont je dois donner et la figure et la description.

Les Barbares mangent la chair des belettes quoiqu'elle soit fort dure et fort puante; mais il ne faut pas s'en étonner [f. 56] puisque toutes viandes sont bonnes pour un Sauvage. Les chevaux morts par quelque accident* leur servent de bon ragoût : ils en font des festins qui leur sont aussi agréables que la chair de leurs élans.

Un jour, on me demanda si les Français en mangeaient. D'abord je répondis que non; mais prenant garde que je contredisais un homme d'honneur, je me dédis, assurant que dans des rencontres* les soldats français en mangeaient à la guerre. Il n'en fallut pas da-

239 *Condylura cristata* (L.), condylure étoilée (Banfield, 34–6 et Burt et Grossenheider, 17), représentée dans le *Codex*, Pl. xxx, comme «taupe de la nouvelle-france», mais directement inspirée de Gesner, 1621, t. 1, 93. Boucher en 1664, selon Rousseau 1964, 315 pouvait appeler «taupe» – en plus de la *C. cristata* et du *Microsorex hoyi* déjà signalés – l'une ou l'autre des espèces suivantes : *Parascalops breweri* (Bachman), taupe à queue velue (Banfield, 30–2 et Burt et Grossenheider, 18–19); ou la *Sorex cinereus* Kerr, musaraigne cendrée (Banfield, 8–10 et Burt et Grossenheider, 3); ou la *Sorex fumeus* Miller, musaraigne fuligineuse (Banfield, 15–17 et Burt et Grossenheider, 5); ou la *Sorex arcticus* Kerr, musaraigne arctique (Banfield, 17 et Burt et Grossenheider, 5); ou la *Sorex gaspensis* Anthony and Goodwin, musaraigne de Gaspé (Banfield, 18–19 et Burt et Grossenheider, 6 et 8); ou la *Sorex palustris* Richardson, musaraigne palustre

(Banfield 12–15 et Burt et Grossenheider, 12); ou enfin la *Blarina brevicaudata* (Say), grande musaraigne (Banfield, 21–4 et Burt et Grossenheider, 15–16). Nicolas a probablement connu les mêmes hésitations.

240 Si l'on exclut l'hermine et le furet nommés ci-après, Nicolas pourrait vouloir dire la *Mustela nivalis* (L.), la belette pygmée (Banfield, 305, qui précise la sous-espèce, *Mustela nivalis rixosa* (Bangs), ou Burt et Grossenheider, 56, qui l'assimile à la *Mustela rixosa* (L.) de l'Ancien Monde); mais il pourrait aussi s'agir de la *Mustela nigripes* (Audubon et Bachman), le putois d'Amérique (Banfield, 305–6 et Burt et Grossenheider, 58–60), voire même le *Mustela vison* Schreber, le vison d'Amérique (Banfield, 306–9 et Burt et Grossenheider, 60). Le *Codex*, Pl. xxx, fig. 47.1, représente une «Belette commune» et, fig. 47.2, une «autre sorte de belette». La première est inspirée de Gesner, 1621, t. 1, 753.

vantage pour déterminer diverses personnes à aller démembrer une belle jument qui venait de se noyer. On en fit festin de guerre, on y chanta, on y dansa comme dans une affaire de la dernière importance à la mode des Américains.

De l'hermine[241]

Quoique cet animal n'ait rien de différent du corsage* et de la figure de la belette, que sa rare couleur blanche, j'ai bien voulu en dire un mot pour vous le faire admirer et pour vous le faire d'autant plus remarquer qu'il le mérite mieux, soit pour sa charmante beauté, soit pour ses usages.

On en voit de très rares dans le pays dont je prétends vous donner une entière connaissance. Cette belle hermine est trois ou quatre fois plus grosse que nos belettes. Toute la robe de ce bel animal est blanche comme de la neige et il ne faut pas se persuader que cet animal soit moucheté de rayons par tout le corps, comme on nous fait paraître les peaux en France, sur le dos de messieurs nos présidents des parterres. Non, dis-je, encore une fois, l'animal est tout blanc à la réserve* de sa queue qui est toute noire, qui relève le blanc de tout l'animal avec un lustre de la dernière bonne grâce. Et c'est de là qu'on a pris la coutume de tirer du poil de la queue de l'hermine pour l'entremêler au milieu de la peau pour relever le blanc.

Cet animal est carnassier comme les belettes dont j'ai parlé. Il est rare : je veux dire qu'on en voit peu. C'est pourquoi tout ce qu'on appelle de l'hermine ne l'est pas. Quoi! Ne sait-on pas que dans ce temps tout le monde fait ce qu'on fait, environ midi à quatre lieues* de Lyon dans les bourgs de Charabara où l'on crie tout haut de tous côtés : «Charabara, charabara, charabara, trompe son compagnon qui peut». À ces mots, chacun plie la toile, s'en va et la foire finit de peur qu'[on] a d'être volé ou d'être trompé. Y prend garde qui voudra, mais quoique s'en soit, l'hermine est un très bel animal dont il y en a très peu. On connaît en France quelques-unes des plus belles.

Du furet[242]

On ne distingue guère cet animal de la belette qu'en sa grosseur, qu'en sa longueur et qu'en sa grandeur. Son poil est de couleur de bure, sa queue est noire, longue, bien fournie de poil. L'animal est carnassier. On en voit partout. Il a les yeux fins, vifs, et fort brillants, quoique petits. Ses oreilles sont rondes et rases. Il vit de lièvres et d'autres animaux. Il y a de deux espèces de furets : d'eau et de terre.

[f. 57] *Des martres zibelines noires, et des jaunes*[243]

Puisque la martre *cybellyny* est un de ces animaux que les anciens Latins et les modernes appellent *quadrupeda*, animaux à quatre pieds, et les Grecs *tetrapoda* et selon le grand génie de la philosophie, le fameux Aristote, qui les a nommés *peza*, ce sera ici le lieu d'en dire quelque chose. Et comme cet animal n'est pas bien différent des martres et des fouines[244] qu'on voit en ces pays, je n'aurai pas bien des choses à dire pour le décrire touchant sa figure.

Je dirai en passant que cet animal est fort vif, qu'il est goulu, gourmand, fort fin, et carnassier. Nos sauvages en prennent quantité dès qu'il a tombé un peu de neige et lorsque ces animaux sont privés de la chasse qu'ils faisaient sur les rats, sur les souris, sur les mulots et sur toute sorte de petits animaux qu'ils trouvaient en grand nombre auparavant que les bois et les terres fussent couverts de neiges. Ces animaux, s'étant retirés dans leurs tanières pour y passer cinq ou six mois sans en sortir, ne donnent plus occasion aux martres de leur donner la chasse et donnent lieu aux Indiens de leur tendre des pièges. Les Américains en tuent presque autant qu'ils veulent, ou de cette manière, ou avec des flèches émoussées, ou avec des fusils qu'ils chargent avec du petit plomb, de peur de gâter les peaux. Ils troquent les pelleteries avec les marchands français qui en achètent tout autant qu'ils peuvent, à l'envie même les uns des autres pour les faire passer en France, ou en Angleterre, ou en Hollande, et dont ils font un commerce avantageux : un seul marchand en peut débiter pour quatre ou cinq mille livres*, et

241 *Mustela erminea* (L.), hermine (Banfield, 299–301 et Burt et Grossenheider, 55–6), représentée dans le *Codex*, Pl. xxx, fig. 47.3, comme l'«hermine» et inspirée de Gesner, 1621, t. 1, 753. Mentionnée pour la première fois en 1632 par Champlain; Denys en donne une description en 1672 (Ganong, 215). Boucher mentionne les «belettes» en passant, et sans les distinguer.

242 *Mustela frenata* Lichtenstein, belette à longue queue (Banfield, 302–4 et Burt et Grossenheider, 58); désignée dans le *Codex*, Pl. xxx, fig. 47.4, comme «furet de terre».

243 *Martes americana* (Turton), martre d'Amérique (Banfield, 293–7 et Burt et Grossenheider, 54), désignée dans le *Codex*, Pl. xxx, fig. 47.5, comme «martre cybelline»; sa figure est inspirée de Gesner, 1621, t. 1, 765. Cartier la connaissait dès 1535. Edward Haies, *Report of the Voyage of Sir Humphrey Gilbert in Newfoundland*, signale des «marternes» à Terre-Neuve en 1583. Champlain a représenté une «Martre» sur sa carte de 1612 (Ganong, 224). Boucher la connaissait aussi (Rousseau 1964, 310).

244 *Martes foina* (Erxl.). Voir G. Corbet et D. Ovenden, *The Mammals of Britain and Europe*, 184 et Pl. 24.

d'autres plus et d'autres moins. Chaque peau vaut dans le pays vingt sols*.

Ces peaux servent pour faire des rares fourrures, la queue de ces animaux étant fort noire, fort luisante et fort propre* pour en faire des garnitures. Les sauvages usent de ces peaux pour faire des sacs à tabac; les femmes en font des langes pour leurs enfants. Elles en font de belles robes fort riches. Le poil de la bête a un pouce de long, il est fort épais et très fin. Il y a de ces martres qui sont jaunes comme de l'or, excepté la queue qui est longue, bien fournie et noire comme du jaiet*. Les pattes sont fort griffées de manière que l'animal monte d'une extrême vitesse sur les arbres et s'y tient bien attaché. Et quand la fantaisie lui en prend ou qu'il est pressé de quelque ennemi, il saute lestement d'une branche à l'autre et d'un arbre à l'autre, ce qui ne lui est pas trop difficile puisque les branches des arbres se touchent presque partout : ainsi l'animal a bientôt fait du chemin. Il a le museau fin et fripon, aussi bien que les yeux; ses dents sont aiguës, le bout du museau est noir. Le reste jusqu'aux yeux est blanc et gris mêlé. Il a les moustaches rudes comme le tigre.

Les martres qui ont la robe toute noire n'ont rien de différent des autres. Il faut remarquer que le poil ne vaut rien si elles ne sont tuées en hiver ou vers la fin de l'automne.

La chair est dure et presque de la même nature que celle de la belette. Mais nos sauvages, qui n'ont que faire de moutarde, [f. 58] la trouvent d'un bon goût. Cet animal, comme je l'ai dit, ne pouvant plus chasser comme il faisait avant que la terre fût couverte de neige, suit partout les sauvages dans les chasses qu'ils font tout l'hiver sur les hautes neiges où ils tuent force élans, dont très souvent après avoir écorché les bêtes, ils abandonnent toute la viande quand l'élan n'est pas gros. Cela leur donne occasion de faire la chasse des martres tout l'hiver, / car les martres, / voulant manger de ces viandes abandonnées, les sauvages les prennent, ou dans des lacets* ou sous des attrapes. Aussi*, ils font de grands amas de peaux de martres. Ils y attrapent même des loups qui viennent de leur côté pour faire curée avec les martres des charognes des élans abandonnés; mais si je dis que ces animaux ont fort souvent de la peine à mordre dans ces viandes, on ne voudra pas le croire. Mais, se le persuade qui voudra, je dirai cependant que ces chairs, étant gelées dur comme du marbre, ces animaux, au lieu de manger, ne font qu'affiler leurs dents et enragent de faim comme

Tantale au milieu des viandes : *quærit aquas in aquis et poma fugacia captat.*

La martre se plaît plus dans les sapinières que dans les autres endroits des bois.

Du siffleur[245]

Je vous présente ici un petit animal fort rare en deux ou trois manières* : premièrement pour* la beauté de son poil; deuxièmement pour la petitesse de son corps, et troisièmement, pour l'agréable mélange des couleurs différentes de sa robe qui est d'une couleur jaunâtre, assez vive, et relevée d'un très beau petit gris au bout du poil, qui n'est ni trop ras, ni trop long. L'animal n'est pas plus grand ni plus long qu'un de nos médiocres* chats. Le petit gris qui varie la couleur de sa peau n'est pas trop épais, mais il est divisé avec une juste proportion et si bien mélangé d'une autre couleur noire, que cela rend l'animal fort agréable. Le fond de la robe est couvert du jaune que j'ai dit. Et parmi cette couleur, il se pousse d'autres poils qui sont un peu plus longs, teints de noir et de gris, qui donnent une fort bonne grâce à tout l'animal. Mais ce que je trouve de plus rare en cet animal, est un sifflement qui rapporte* beaucoup au chant du rossignol, et c'est pour cette rare qualité qu'on lui a donné le nom de siffleur. Il s'apprivoise aisément, il n'est pas difficile en son manger, et quoiqu'il soit de ces animaux onglés, il ne grimpe pourtant pas sur les arbres. Sa principale demeure est dans les trous des arbres. Il ne se trouve pas de ces bêtes dans tous les quartiers*, et même elles sont rares dans les endroits où elles se tiennent. La chair est bonne à manger. Quoique la peau soit belle, on n'en fait nul trafic à cause du peu de ces animaux qu'on ne trouve qu'assez rarement.

Des lapins

On ne voit point de lapins dans tout le Nouveau Monde que dans la fameuse île Bonaventure (pour la pêche de la morue), qui est presque en même parallèle que la grande île d'Anticosti que les hydrographes nomment *de l'Assomption* qui est au large d'un des plus grands golfes du monde. On la pose au rhumb* du vent d'ouest-nord-ouest. Et même encore les lapins dont je parle ont [f. 59] été transportés* de France par quelqu'un des navires terreneuviens qui vont à la pêche le long des côtes de l'Amérique. Ces lapins ont si fort multiplié* dans cette île qu'ils fournissent aux pêcheurs de quoi faire de bons pâtés. Le capitaine Poulet nous ré-

245 *Marmota monax* (L.), marmotte commune (Banfield, 98–102 et Burt et Grossenheider, 92), représentée dans le *Codex*, Pl. xxix, fig. 46, comme «Le siffleur», mentionnée par Le Jeune en 1636 (Ganong, 239) et par Boucher en 1664 (Rousseau 1964, 311).

gala de cette venaison dans son navire lorsque nous le rencontrâmes, mouillé à la rade de Bonaventure, le quinzième de mai de l'année 1661.

*Des petits lièvres qui se trouvent dans toute la plage**
de l'Inde occidentale[246]
Ce lièvre n'est pas plus grand que les lapins ordinaires de France. Il n'est pas de si bon goût que les nôtres, particulièrement en hiver qu'il ne vit qu'en broutant la pointe des branches de sapin qui l'empêchent de mourir en hiver ne pouvant pas manger de l'herbe que les grandes neiges couvrent partout. En ce même temps, il devient tout blanc, mais au printemps il reprend sa couleur grise et un goût tout nouveau qui approche de celui de nos lièvres.

Il y a en cet animal une chose très remarquable : c'est que la nature l'a pourvu d'une patte extraordinairement grande sur le train de derrière; les deux pattes de devant sont communes* et proportionnées à l'animal. Il était nécessaire que ce lièvre eût deux pattes fort grandes pour se soutenir et ne pas enfoncer dans les neiges : ses pattes lui servent de raquette. La peau n'est presque de nul usage que pour les enfants auxquels on fait des robes de ces peaux, des mitaines, et des bonnets.

Du manitou[247], *ou de l'animal qui est un génie dans*
la pensée des sauvages
La couleur de cette laide bête est d'un gris assez brun. Elle est grande comme un de nos gros chats et sent fort mauvais. Sa tête et son museau rapportent beaucoup à celle du cochon; elle a la gueule bien fendue et grande, bien garnie de dents fort affilées et fortes. L'animal est carnassier au-delà de ce qu'on saurait dire. Sa moustache est aussi grande et aussi forte que celle du tigre* marin. Sa queue est presque aussi longue deux fois que son corps; elle est à demi velue et à demi pelée. Il est fort extrêmement dans le bout de sa queue, par laquelle il se pend aux branches, d'où il s'élance avec vitesse, avec raideur et avec agilité d'arbre en arbre ou d'une branche à l'autre pour / prendre des oiseaux / et ainsi, pendu par le bout de sa queue, il semble avoir deux ventres. Il a une bourse au-dessous des cuisses, qui s'étend jusqu'au-dessous du col dans laquelle il a huit mamelles. Il y cache ses petits après les avoir faits.

Cette bourse est fourrée* d'un petit poil fort délicat comme le duvet d'un cygne. Le mâle même a cette bourse : il y cache et il y porte à son tour les petits manitous qui s'y réfugient d'eux-mêmes quand ils craignent quelque chose. Ces petits méchants animaux sont si puants que les chiens même balancent* à les aborder. Cet animal mord comme le loup tout ce qu'il rencontre, tue les poules et tous les oiseaux qu'il peut agriffer. Il mange aussi du fruit.

[f. 60] Pour ce qui est de la particularité que je viens de rapporter des petits manitous qui se réfugient, ayant peur, dans la bourse que leur père et leur mère ont dessous le ventre et que ceux-ci les emportent, la chose est rare et c'est une fort belle naturalité*; mais lorsque nous saurons que les petites souris, pour se secourir l'une l'autre et pour échapper l'ennemi, se prennent l'une à la queue de leur mère et l'autre à la queue de celui qui tient sa mère, et l'autre à la queue de l'autre, et ainsi du reste, nous n'admirerons pas tant les manitous. Qui dirait que la bécasse, qui est un oiseau lourd et qui n'a point de serres, emporte ses petits d'un lieu en un autre en volant? Cependant, il n'y a rien de plus sûr. Le canard branchu, qui est le plus bel oiseau du monde, niche dans des troncs d'arbres, et de là, quand ses petits sont éclos, il les emporte sur son dos dans l'eau : comment cela peut-il se faire? On croit railler* quand on dit : «Si tu fais cela, je te donnerai un merle blanc». Cependant, il est très sûr qu'il y en a. Un homme des plus dignes de foi m'a protesté* qu'il en avait nourri un fort longtemps. Il n'y a pas un an que mille personnes ont vu avec moi des grives blanches et des cailles. La nature peut plus de choses que nous ne pensons et les animaux ont les instincts plus curieux que nous ne saurions croire. Qui pourrait se persuader qu'un chat, en ayant vu tomber un dans un puits, eût sonné une cloche qui était là proche pour faire venir au secours de son camarade? Dans le même endroit un autre chat faisait le mort sur un toit au soleil après avoir mouillé ses pattes et ensuite a marché sur du petit millet qui, s'attachant à son poil, appelait des moineaux pour manger, et le chat en faisait curée. Un très honnête homme me raconta dans un voyage une des choses du monde les plus surprenantes. C'est qu'il me protesta qu'un berger, homme fait et de bon sens, vit un jour un

246 *Lepus americanus* Erxl., lièvre d'Amérique (Banfield, 76–80 et Burt et Grossenheider, 205), représenté à deux reprises dans le *Codex*, Pl. xxix, fig. 46.2, comme «Lièvres communs». Cartier distingue dès 1534 entre le lièvre et le lapin, car il parle des *liepvres* et des *connins*. Champlain et Lescarbot, par contre, ne parlent que de *lapins*. Denys utilise alternativement les mots *lièvre* et *lapin,* mais il n'est pas clair qu'il faisait la distinction

entre les deux (Ganong, 222). En 1664 Boucher parle des *liévres* (sic) (Rousseau 1964, 311).
247 Probablement le *Didelphis virginiana* Kerr, opossum d'Amérique (Banfield, 3–5 et Burt et Grossenheider, 12 sous le nom de *Didelphis marsupialis*); représenté dans le *Codex*, 29, fig. 46.1, sous la désignation «Le Manitou». Il s'agit probablement d'une première mention de cet animal en Nouvelle-France.

grand buisson qui marchait à son avis de lui-même sur son troupeau. Ce qui le surprenait le plus dans sa peur et dans son étonnement, c'est qu'il voyait que ce buisson s'arrêtait de temps en temps. Enfin, s'étant arrêté lui-même pour bien considérer la chose, et le buisson s'étant arrêté tout proche de son troupeau, il vit un gros loup sortir de derrière le buisson et se jeter sur son troupeau. L'histoire de l'éléphant envoyé à un chaudronnier pour lui raccommoder* une chaudière*, là la porta à la rivière pour voir si elle ne répandait pas; voyant que l'eau coulait, [il] la rapporta à l'ouvrier en grondant, cela est trop connu de tous ceux qui lisent. Je n'en veux pas dire davantage. Il y a mille histoires surprenantes des chiens et des lions, et cependant personne de bon sens ne les révoque* pas en doute.

Du gros serpent que les Septentrionaux et les Occidentaux appellent manitou-kinebik (génie-serpent), ou kiché-kinebik (le grand serpent)

[f. 61] Ce n'est pas ici où je veux parler de cette sorte de gros serpents qui sont gros et longs comme les plus grandes poutres qu'on pût voir. C'est au bord de la mer où l'on voit assez souvent quelques-uns de ces monstres qui sont d'autant moins à craindre qu'ils sont plus grands et qui, ne pouvant presque pas se remuer, on les tue comme l'on veut, lorsqu'on a le courage de les aborder. C'est d'une autre espèce de fort gros serpents dont je veux vous entretenir un moment. Ils sont vigoureux, forts, extrêmement vites*, et dans l'eau et sur la terre. Ils dévorent tout ce qui se peut manger. C'est un diable, un génie, disent les sauvages, qui est si fort et si gros qu'il peut arrêter un bœuf sauvage : l'entortillant avec sa queue contre quelque racine, il le dévore facilement. Il a l'ouïe si subtile qu'il entend venir sa proie de plus d'une demi-lieue*. Il est armé sur le dos de plusieurs grandes épines. Il est hardi comme un lion. Il saute quelquefois dans les brigantins pour dévorer les hommes. On n'en voit point de cette sorte dans l'Inde occidentale, mais je suis sûr qu'il s'en trouve ailleurs et que plusieurs auteurs dignes de foi, qui ont écrit les raretés du monde et de la Chine, assurent qu'ils en ont vu aussi bien que moi ailleurs.

Du grand lièvre[248]

Plusieurs personnes même savantes, de bon esprit et d'un goût fin, mais qui n'ont pas perdu leur clocher de vue, ne veulent pas croire qu'il y ait des lièvres grands comme des veaux de quinze jours ou comme des mou-

tons d'un an. Cependant, il est sûr qu'à plus de deux mille lieues du lieu dont je veux parler ici, il s'en trouve de la grandeur que je dis. Les natifs de ces terres les nomment *oulana*, et nos Occidentaux *michabous*. La chair de ces grands lièvres est bien du goût plus fin, plus succulent que la chair de nos petits lièvres. Ce lièvre ici est donc extraordinaire pour sa grandeur. On n'en voit pas communément : il n'y en a que dans les pays des Esquimaux du côté du nord et vers l'ouest dans la grande île de Minoung, au milieu de la mer Tracy qui est éloignée de plus de sept cents lieues des terres des Esquimaux. Pour ce qui est des petits lièvres dont j'ai parlé, il y en a dans tout le vaste pays des Indes. Il y a même des îles à qui on a donné le nom des îles aux Lièvres, à cause qu'elles en sont pleines.

Passant au *Kaouj* dans un brigantin à cinquante lieues au-dessous du pays des Berziamites, nos matelots me firent considérer* plusieurs îlets pleins de lièvres et des œufs de gros et de petits canards inconnus en France. On y envoya l'esquif* avec deux matelots qui, dans fort peu de temps, nous apportèrent de quoi manger pour tout l'équipage et pour cinq jours.

[f. 62] Au reste avant que de passer à d'autres choses, il faut savoir que le Grand Lièvre passe pour un grand dieu fort puissant parmi les sauvages. Ils se persuadent fortement que c'est une grande divinité qui dispose et qui fait les grandes neiges qui tombent sur la terre. Il est le maître de ce météore; il lève tout en eau quand il veut; en glace, il le fait, il le défait quand il lui plaît, pour avoir pitié des hommes, disent les Américains, afin que ces hommes qui sont ses parents puissent tuer beaucoup d'élans. Et la folie de quelques-uns passe si avant*, et elle est si surprenante qu'ils disent franchement et de tout leur bon sens qu'ils sont descendus en droite ligne de cette divinité majestueuse, si belle, si pure et si blanche, car ils confondent la divinité du Grand Lièvre avec la neige et la cause avec l'effet. C'est pourquoi ils mettent dans leur écusson, pour leurs armes, un grand lièvre qui fait tomber de la neige. Et j'ai connu toute une grande famille qui se faisait un plaisir et un grand honneur de dire que toute leur race était de ce sang divin.

L'aîné de cette divine famille et de cette fameuse parenté des dieux de l'air se faisait bien de l'honneur de porter le nom de ces agents : il s'appelait *Michabous*, qui veut dire le Grand Lièvre. Et pour ne pas s'oublier de sa divine noblesse, il était toujours vêtu ou entouré, à la mode des sauvages, d'une robe de peaux de lièvres

248 *Lepus europaeus* Pallas, lièvre d'Europe (Banfield, 84–6 et Burt et Grossenheider, 205–6); représenté dans le *Codex*, Pl. XXIX, fig. 46.3 sous la désignation «grand Lièvre aussy grand qu'un Veau de lait»; la figure est copiée de Gesner, 1621, t. 1, 605.

qu'il fallait tuer pendant le temps des neiges, afin que ces rares* peaux fussent toutes blanches et que cet illustre aîné, descendu du dieu Grand Lièvre, portât toujours les livrées* / et la couleur / de cette divinité.

Quand les neiges ne sont pas hautes et qu'il n'en a pas tombé assez pour arrêter les grands élans, tout est perdu : la divinité est en colère et il faut l'apaiser par des sacrifices qui sont des festins d'ours, de castor, ou d'élan.

Quand ces mêmes neiges ne fondent pas au temps ordinaire*, la majesté divine de Michabous est fâchée : il faut avoir recours aux danses, aux festins, aux chansons et apaiser le Grand Lièvre, Michabous, qu'ils appellent encore en leur langue *Ka-micha-gounikècht*, qui veut dire, mot à mot, *celui qui est le grand faiseur de neige.*

[F. 63] CINQUIÈME LIVRE

Je commence ce cinquième livre de mon *Histoire naturelle* par la suite que je me suis proposée et qu'on trouvera à mon avis assez juste, puisque je continue de suite la description des animaux que j'ai commencée dans les livres précédents.

Du porc-épic[249]
Le porc-épic est un animal à ongles griffées. Il lui est nécessaire de les avoir de cette manière parce que, vivant d'écorce d'arbre, il faut qu'il y puisse monter pour les écorcer depuis le pied jusqu'à la cime. L'animal est fort laid. On en trouve de diverses grandeurs selon les climats qu'il habite. Ils ont tous la tête grosse et ronde, les yeux de cochon, le museau gros et camard, l'oreille rase et ronde, le poil long, grossier et fort hispide*, sous lequel il y en a un autre qui ne paraît point. Il est blanc par un bout et noir par l'autre. Je ne saurais mieux le comparer qu'à celui du hérisson, auquel il ressemble entièrement, avec pourtant cette différence qu'il est beaucoup plus long et plus gros selon l'âge de la bête et selon le climat* où l'on trouve de ces animaux. Ce second poil tient si fort avec la peau qu'on a bien de la peine à l'arracher; mais le porc-épic le détache et le

lance avec tant de vitesse et avec tant de raideur contre les chiens qui le poursuivent que, bien souvent, ils les tuent. Et si le chasseur n'a pas soin de les tirer promptement, infailliblement tous les chiens qui en sont dardés en meurent, et il faut bien que le chasseur lui-même prenne garde de n'être pas blessé de ces sortes de poil, car ce poil est si aigu qu'il s'insinue de lui-même et entre dans la chair sans qu'on le sente. J'ai vu des chasseurs estropiés durant deux ou trois mois et jusqu'à ce que ce poil soit sorti de lui-même de l'autre côté opposé à la première blessure. Pour éviter cet accident, le chasseur voulant aller à la chasse du porc-épic se revêt de cuir, afin de n'être pas percé.

Lorsque le chasseur arrive chargé de ces animaux, leurs femmes, qui ont le soin de tous les petits travaux qui tendent à la gentillesse*, ont un soin tout particulier de tirer autant de ce gros poil qu'elles veulent faire de beaux ouvrages* de cette matière, comme je dirai plus bas. Et d'abord* que cela est fait, elles brûlent l'animal à l'extérieur et le raclent bien avec des couteaux, de la même façon qu'on prépare les cochons.

Le corps de ces animaux est fort mal fait : ils ont les jambes courtes, leur queue est grosse et assez longue, quoiqu'elle semble avoir été coupée au bout. La demeure ordinaire de l'animal est dans des trous de rocher ou dans des trous d'arbre. Il y a quelque plaisir sensible* de voir les jeunes chiens, qui n'ont plus vu de ces sortes d'animaux, crier et s'enfuir comme si on les avait fouettés, lorsque, voulant mordre l'animal, ils se sont rempli la gueule qui saigne de partout de ce poil dont j'ai parlé.

[f. 64] Ce même poil, qui est si malin*, est cependant d'un grand usage parmi les Occidentaux, dont les femmes / font de beaux ouvrages /, l'ayant mis en teinture avec divers fruits et quelques herbes ou quelques racines, qui donnent le jaune, le violet, le noir, le rougeâtre et le rouge, de telle sorte qu'on ne voit point d'écarlate, ni si belle ni si éclatante que celle qu'on voit dans la teintures des sauvagesses sur de très beaux et de très rares* ouvrages, comme sont des tours de tête précieux, des serpents qui entourent la tête et qui vont battre à demi-jambe. On voit sur ces travaux mille belles figures*. Les sauvages estiment beaucoup ces

249 *Erethizon dorsatum* (L.), porc-épic de l'Amérique (Banfield, 216–19 et Burt et Grossenheider, 199–200); représenté dans le *Codex*, Pl. XXIX, fig. 46.4, sous la désignation «Porc epie ou kak»; le dessin du *Codex* ne semble pas s'inspirer de Gesner, 1621, t. 1, 563. Le mot *kak* est encore d'usage courant chez les Amérindiens de langues algiques; voir Gilstrap, 12. Les Ojibway prononcent *ka:kw*; voir Piggott et Grafstein, 39. Le mot apparaît pour la première fois en Amérique sous la plume du capitaine Alphonse, traduit par Hakluyt en 1542 sous le nom de *porkespicks*. Desceliers l'a représenté sur une carte de la même année, mais assez pauvrement. Champlain le nomme *Porc-epic* dès 1603 (Ganong, 234). Boucher aussi mentionne l'animal en 1664 (Rousseau 1964, 310–11).

choses, et de bonne foi, on les trouve rares en France. Un ceinturon de cette matière et de ce travail délicat vaut jusqu'à cent louis d'or, et j'ose avancer qu'il est de la nature de ces tableaux qui n'ont point de prix.

On voit cent autres gentillesses aux souliers, aux bas, aux brayers*, aux sacs à pétun*; sur les robes de peau de loup, de castors, de loutre; sur des ceintures de deux ou trois façons, justaucorps, et sur plusieurs autres choses si rares et si précieuses qu'on peut dire que l'ouvrage est beaucoup plus beau que la matière dont on se sert, qui d'elle-même n'a nulle beauté que celle qu'on lui donne par la teinture, par les tours et par les retours qu'on lui fait faire dans des figures* dont on n'use pas en Europe.

Je puis assurer que j'ai vu des couronnes à la grecque de cette matière, que des monarques n'auraient pas dédaigné de mettre sur leur tête, ni de se ceindre de diverses très belles ceintures.

De la bête puante²⁵⁰

Voici encore un fort vilain animal que je vous présente, qui se nomme *chigak*. Il est si puant que, si on a été assez malheureux que d'être souillé tant soit peu de l'urine de l'animal, il faut se résoudre de ne fréquenter personne de quelque temps, si vous ne voulez les bien incommoder. Les chiens sauvages à qui cela arrive assez souvent sont misérables* : on les chasse de partout, car on ne saurait souffrir leur puanteur.

Pour leurs maîtres qui, nonobstant la puanteur de l'animal, ne laissent pas de faire des robes de plusieurs peaux de la bête puante, qui n'a rien de recommandable que sa puanteur, cela même est la cause* pour laquelle un sauvage s'en couvrira pour passer pour brave

et afin qu'on dise que rien ne le rebute, puisqu'il a bien la résolution de porter un manteau fait des peaux d'un animal fort laid et fort puant.

La peau n'a rien de délicat, le poil en est rude, grossier et hispide. La couleur est entre le gros gris et le cendré; on voit sur les deux flancs des marques blanches, longues d'un demi-pied*, larges de trois pouces* et de la figure d'une larme.

La chair est grossière, puante, dure et sent le vieux chien. [f. 65] Dans l'occasion* cependant, on la mange sans moutarde.

L'animal loge sous la terre comme le renard et comme le blaireau. Sa figure rapporte* à celle du renard. Sa graisse adoucit les nerfs, soulage des douleurs de la goutte et de la sciatique.

De l'enfant du diable²⁵¹

C'est ainsi que les Français ont appelé cet animal, à cause qu'il est noir comme du jaiet* et qu'il a la gueule extraordinairement rouge. Les sauvages le nomment *outchik*. L'animal est beau et il est un des plus rares qu'on n'ait dans les Indes occidentales.

Son poil est rare et fin. La peau est estimée pour faire des bonnets, des garnitures et des manchons. La chair est d'un goût exquis, elle [est] un peu fade, mais le haut goût* corrige cela.

Du blaireau américain²⁵²

Il est deux fois aussi gros que le renard, son museau n'est pas si affilé, son poil est tout différent, grossier, long, rude, d'une couleur cendrée, marqué sur le flanc de deux barres blanches assez grandes. Il est carnassier, sa chair est grossière.

250 *Mephitis mephitis* (Schreber), moufette rayée (Banfield, 338–41 et Burt et Grossenheider, 65); représentée dans le *Codex*, Pl. xxix, fig. 46.5, comme «La beste puante a cause quelle sent fort mauvais», mais la figure n'en est pas très convaincante. Il se peut que Nicolas se soit contenté de copier une belette dans Gesner. Boucher mentionne la «beste puante» en 1664 (Rousseau 1964, 311). Ganong semble l'avoir oubliée.

251 *Martes pennanti* (Erxl.), pékan (Banfield, 297–9 et Burt et Grossenheider, 54–5), représenté dans le *Codex*, Pl. xxxi, fig. 48, comme le «Manitou ou nigani Enfant du diable». George F. Aubin, *A Proto-Algonquian Dictionary*, Ottawa, Musées nationaux du Canada, 1975, 113, no 1605 traduit *ni:ka:ni* par «en avant, en tête» et *nigani* par «avant, meilleur». On soupçonne que les Amérindiens considéraient le pékan comme le premier, ou le meilleur de la famille des mustélidés. On ne doit pas le confondre avec le «Manitou» du *Codex*, Pl. xxix, fig. 46.1, qui est un opossum. Selon Ganong, 230, Dieréville

est le premier qui l'ait appelé *pékan*, en 1710. A.F. Chamberlain, «Algonquian Words in American English», 15, 1902, 240, cite aussi le père Sébastien Rasle, qui connaît un animal que les Abénaquis appellent le *pékané*. Boucher, quant à lui, parlait du *pescheur*, comme en anglais (fisher) (Rousseau 1964, 311).

252 *Taxidea taxus* (Schreber), blaireau d'Amérique (Banfield, 312–14 et Burt et Grossenheider, 64), représenté dans le *Codex*, Pl. xxxi, fig. 48.1, sous la désignation «Le blereau»; figure copiée dans Gesner, 1621, t. 1, 686. Champlain mentionne dans une liste de 1632 «une espèce de Blereaux»; Le Jeune en parle de la même manière. Mais il se peut que l'un et l'autre renvoient au glouton commun ou carcajou. Lahontan, par exemple, que les carcajous «sont à peu près faits comme des blereaux» (R. Ouellet et A. Beaulieu, *Œuvres complètes*, 333–4). Boucher ne le connaît que sous l'appellation «Enfant du diable» (Rousseau 1964, 309–10).

Des chats français et des chats sauvages

Nos habitants* français qui demeurent au nombre d'environ vingt mille âmes le long d'une plage de quatre-vingts lieues*, au bord des deux côtés du fleuve du Saint-Laurent, ont porté* des chats de toutes les façons dans l'Amérique. On y en voit des plus beaux du monde : de France, d'Espagne et d'Angleterre.

Le chat sauvage[253] est laid, d'un poil long et assez fin. Il tire sur le jaunâtre, entremêlé d'un gros gris et barré de noir. Sa queue est longue, grosse et annelée de divers tours de poil noir. L'animal devient gros et grand comme les plus forts singes ou magots qu'on voit en Amérique. Il est carnassier : aussi* est-il armé de furieuses dents et de griffes horribles avec lesquelles il monte bien lestement sur les arbres quoiqu'il paraisse bien lourd.

Il n'est pas croyable combien il est fin pour chercher à vivre. Aussi est-il si gras que quatre doigts de graisse ordinairement couvrent toute sa chair.

Quand il a découvert les voies ou le chemin des cerfs ou des élans qui vont à bandes à l'abreuvoir, le chat sauvage a l'adresse de se percher sur une branche bien commode dans le chemin découvert. Là, il se met en sentinelle sans branler*, et lorsqu'un cerf ou un élan passent dessous à la juste portée d'un saut que le chat doit faire, il le fait sans perdre temps et s'agriffe* de bec et d'ongle, comme l'on dit, sur le train de devant de l'animal. Je veux dire que ce chat, étant assis sur les épaules d'un cerf ou d'un élan, il s'y [agrippe] [f. 66] si fortement avec les griffes et avec les dents qu'il n'est plus possible que l'animal qui est pris par le chat puisse se défaire de son ennemi. Et l'animal peut bien aller de beau temps* et courir autant qu'il peut, le chat, redoublant à chaque moment ses morsures / et s'agriffant toujours davantage, / fait enfin tomber sa proie, qui, ayant perdu tout son sang, n'a plus de force. L'animal étant terrassé à deux ou trois lieues du lieu de sa prise, le chat fait sa curée, et quand il a mangé tout son soûl, il va dormir en quelque lieu d'assurance* jusqu'à ce que, s'éveillant et sa digestion étant faite, il retourne à

sa proie, recommence à manger autant qu'il veut et ne quitte point sa prise qu'elle ne soit achevée, pour retourner sur sa branche et reprendre encore quelque nouvelle bête en sautant dessus comme la première fois. Voilà de quoi vit ordinairement le chat sauvage que les Virginiens, dans le pays desquels j'en ai vu de très gros, appellent *attiron*; et ceux de la nation Chatte, qui se nomment aussi en virginien *outissaraouata*, appellent le chat sauvage *esseban*, d'où ils ont donné le nom à toute une nation : *Essebanak*, la nation des Chats. Je crois que c'est à cause qu'il y en a une infinité dans leur pays, dont je parle dans ma carte générale.

Le chat sauvage fait sa tanière dans des arbres creux ou sous la terre; quelquefois, il se retire dans les trous des rochers. Sa graisse sert pour adoucir les nerfs et pour enlever les douleurs. Il est d'un goût exquis parmi les sauvages. Sa peau, étant fort velue et d'un poil long, est fort chaude. Les Indiens s'en font des belles robes.

Quoique cet animal paraisse fort stupide, il s'apprivoise bien et il suit partout son maître. J'en ai vu élever deux qui tétaient une chienne qui les aimait avec passion*; et ils la suivaient partout et revenaient de partout. Je crois qu'on les a fait passer en France pour Versailles.

De quatre espèces de renards

Si le renard était aussi libre que l'homme, je dirais que se serait un tour de ses finesses que de se déguiser en tant de couleurs et en tant de façons, dans lesquelles il paraît seulement du côté du nord, où l'on voit des renards blancs comme de la neige, des noirs comme du jaiet, des jaunes comme les nôtres et des gris tout particuliers au pays.

Les peaux des noirs[254] sont les plus estimées : aussi sont-elles des plus précieuses. Dans le pays, on les vend jusqu'à six louis d'or. Je n'en ai vu que dans les pays des Papinachois, c'est-à-dire chez la nation du Rire.

Le souverain capitaine de la nation qui s'appelait Ka-Chiracait, qui veut dire le menteur, en fit de rares présents devant moi au capitaine de notre frégate. Ce

253 *Lynx rufus* (Schreber), lynx roux (Banfield, 327–31 et Burt et Grossenheider, 81–2); représenté dans le *Codex*, Pl. xxxi, fig. 48.2, sous la désignation «esseban ou attiron ou chat sauvage», mais il ressemble plutôt à un raton-laveur. De toute manière *esseban* est son nom algonquien – on dit *e:ssipan* en ojibway (voir Piggott et Grafstein, 31) – et *attiron* est son nom iroquois. Cartier parle déjà de *chatz Sauvaiges* en 1535, se référant sans doute autant au loup-cervier qu'au lynx roux. Lescarbot compare le *chat sauvage* au *léopard* (Ganong, 210). Boucher aussi mentionne le «chat sauvage» (Rousseau 1964, 310).

254 Peut-être *Alopex lagopus* (L.), renard arctique, qui

connaît deux colorations : bleue (qui va du noir au gris) ou blanche (Banfield, 275–7 et Burt et Grossenheider, 75). Le *Codex* lui consacre deux figures : Pl. xxxi, fig. 48.3, «Le Renard Blanc»; et Pl. xxxii, fig. 49, «Renard comun jaune et d'autre couleur grise et d'autre noir, sous la mesme figure»; la figure de son «Renard commun» s'inspire de Gesner, 1621, t. 1, 966. Il est rare que les auteurs de l'époque tentent de distinguer des espèces parmi les renards. Ganong, 236 note que Denys s'y est essayé sans beaucoup de succès. Boucher affirme du renard «qu'il s'en trouve quelque fois des noirs, mais bien rarement» (Rousseau 1964, 309).

présent n'avait presque point de prix, si belles étaient les pelleteries que ce capitaine le menteur donna.

[f. 67] Les renards blancs ne laissent pas d'être rares et fort beaux, mais ils ne sont pas fort estimés à cause* que le poil n'est guère fin et parce qu'il se salit aisément. On ne court pas après comme après le noir.

Les jaunes sont méprisés* dans le pays; ils sont de la figure des nôtres.

Le renard gris est beau, son poil est plus long que l'ordinaire des autres renards. Sa pelleterie est propre* pour des grosses fourrures, pour faire des bonnets qui donnent une mine fière aux soldats qui en portent, pourvu que la queue, qui est fort grosse, soit retroussée sur le bonnet. Ces quatre sortes de renards sont carnassiers.

Je ne veux parler ici ni du lion, ni du tigre, quoique j'en aie vu quelques-uns dans le pays. Ils y sont si rares, et d'ailleurs ces animaux sont si connus que je n'en veux rien dire.

Des chiens français et des chiens sauvages
On nourrit force chiens dans toute l'Inde occidentale, qui ont été transportés* de l'Europe. On y en voit particulièrement de ces grands auxquels on apprend à traîner de gros fardeaux sur les neiges et sur les glaces. Nos Français s'en servent comme des chevaux de voiture. Ces sortes de chien donnent* sur tout le gibier à poil et plume, qu'ils poursuivent avec ardeur même dans l'eau. Ils amusent la grosse venaison autant qu'il est nécessaire pour donner loisir au chasseur de faire son coup qui vient à grand pas sur la hauteur des neiges avec ses raquettes. Il y a de ces chiens qui sont assez hardis pour arrêter l'élan par le bout du mufle. L'élan, qui est un animal extrêmement grand et fort, a beau les élever et les secouer rudement pour se défaire de cet ennemi, qui va lui faire donner le coup de mort par le veneur, il ne quitte point sa prise que* sa proie ne soit terrassée. Mais aussi il se rencontre quelquefois des élans qui sont si vigoureux qu'ayant élevé en l'air le chien qui les tient par le bout du mufle, ils l'échappent si souvent et si rudement qu'ils l'abattent sous leurs pieds de devant et le foulent* avec tant de promptitude qu'ils l'éventrent d'abord*. Ce malheur arrive aussi quelquefois au chasseur qui est foulé par l'élan qui n'a nulle autre défense. J'ai vu deux sauvages et un Français foulés.

Ces beaux chiens dont je parle sont des dogues d'Angleterre et de Saint-Malo. On ne saurait croire combien ces chiens sont utiles aux chasseurs qui les chargent de tout leur attirail et d'eux-mêmes quand ils sont las.

J'en avais si bien dressé deux dans le pays des Outtauoak, à plus de deux milles lieues de France, à tous ces exercices, que ces nations les admirant, n'ayant jamais vu telle chose, tinrent conseil pour savoir s'il ne serait pas expédient* de faire des sacrifices comme à leurs divinités. Ces hommes ne se lassaient point de dire [f. 68] que nos chiens avaient infiniment plus d'esprit que les leurs. «Ce sont des manitous, disaient-ils, et les nôtres ne sont que des bêtes fort stupides. Ils n'ont point d'esprit que pour chasser le castor et les orignaux. Les chiens de ces gens ressemblent à leurs maîtres : ils ont infiniment de génie, ils sont adroits à tout, comme ces gens de la nation du Grand Canot de bois». C'est ainsi qu'ils nomment les Francs. J'en donne l'étymologie dans mes premiers ouvrages; elle est très agréable. «Keghet», disent-ils enfin de nos chiens, en se fermant la bouche avec la main par admiration et frappant la terre avec l'autre. «Keghet ounchita ribouakak ouemissigouchi arimouek : en vérité et de bonne foi, les chiens des Français ont bien de l'esprit».

Comme il y a parmi les Français de toutes les espèces de chiens que nous avons en France, il y en a aussi de toutes les espèces dans toutes les terres des barbares. Il y en a même un si grand nombre qu'on en voit les trente et quarante dans une même fort petite cabane qui vivent à pot* et feu avec leurs maîtres et couchent pêle et mêle.

Il n'y a point d'espèce ou de sorte de chien sauvage qui ne soit très bon pour la chasse, et ils sont tous dressés naturellement. Ils tiennent de la figure du loup et du renard, aussi sont-ils ennemis de la volaille comme ces animaux, et ils leur font une guerre implacable. Et comme leurs maîtres parlent un langage et sont d'une humeur fort différente de celle des Français, les chiens les imitent en cela : ils sont mélancoliques comme les sauvages, ils aboient différemment, leurs hurlements sont comme ceux des loups. Ils donnent* sur la brebis comme ces animaux, de sorte qu'il n'y a guère à douter qu'ils ne soient sortis de ces deux animaux en ayant toute la figure et tous les instincts.

Ces chiens sont d'un goût exquis : aussi sont-ils toujours nourris de venaison ou du poisson. Le festin de chien passe pour être célèbre* : on les brûle comme les cochons; la tête est le morceau du capitaine.

Toutes les fois que les Indiens veulent aller à la guerre, [ils] gavent les chiens pour les festins et pour les sacrifices. Ils sont, disent-ils, du goût du dieu Mars, qu'ils appellent *Ouskiraguetté*, le dieu foudroyant de la guerre / et de la fureur des armées /.

On pend aussi force chiens sur des grands mâts ou sur des mais*, qu'on pèle depuis le bas jusqu'au haut,

pour les sacrifier à *Kiigouké*, le dieu du jour qui est le soleil. On en voit quelquefois plus de vingt ou trente en même endroit comme autant d'anathèmes* que diverses personnes ont appendu* à l'honneur de la divinité qu'ils adorent.

Avant que de passer plus avant*, il ne sera pas hors de propos de rapporter une chose fort étrange touchant l'effet* extraordinaire du foie de quelques chiens sauvages. L'histoire est d'un Français qui se trouvait avec une bande de sauvages bien avant dans les bois, espérant d'y trouver [f. 69] à l'ordinaire bien de la chasse. Ils chassèrent partout sans pouvoir rien tuer que peu de porc-épics, de sorte qu'ils furent contraints de manger leurs chiens, tous leurs cuirs, et même tous leurs souliers. (J'en ai vu et accompagné en mission d'autres qui furent bien ravis dans les prairies de la basse Virginie d'attraper quatre ou cinq grenouilles à demi vertes pour souper, chacun avec un seul de ces animaux fort petit. Je me souviens de m'être encore trouvé avec une bande de six ou sept sauvages et de deux Français, au milieu des bois pendant l'hiver, où, de vingt-quatre jours durant, nous ne pûmes jamais tuer que deux fort petits oiseaux.)

Mais revenons à notre propos. Nos sauvages mangèrent donc tous leurs cuirs et leurs souliers; ils passèrent même plusieurs jours sans rien manger pendant cette famine. Il arriva un accident fâcheux au jeune Français qui était, comme j'ai dit, de la bande des affamés. Un de ces tristes et de ces longs jours de jeûne, on tua enfin un chien. Le Français, n'étant pas content de la petite part qu'on lui avait faite, se porte sans délibérer* sur le foie du chien qu'on avait jeté, le fait cuire, le mange. On lui dit de jeter ce foie; on l'assure qu'il lui fera mal, qu'il lui fera tomber la peau. Mais la faim le presse; il continue son repas avec avidité, et la peau lui tombe quelques jours après comme on lui avait prédit. Il se trouva avoir changé de peau comme les serpents. Les Américains ont une longue expérience de cet effet surprenant.

Des loups²⁵⁵

Je ne commence pas ce discours* pour parler d'un seul loup, puisqu'on en voit dans les forêts de différentes façons : il y en a de grands, de petits et de médiocres*, tous de différente espèce.

Les grands loups sont fort différents des nôtres. Leur poil et toute la peau sont rares, et un sauvage croit d'être assez bien vêtu s'il en a quatre ou cinq autour de lui, ornées de leurs belles queues, qu'ils laissent pendre depuis le genou en bas, et la tête et les oreilles en haut.

Les petits loups ont le poil différent; et au lieu que ceux-là l'ont fort beau, de couleur jaune, grise et blanche, ces petits l'ont fort grossière, et n'ayant rien d'ailleurs de rare, je n'en dirai plus rien.

Du loup-cervier²⁵⁶

Le loup-cervier, qui est le plus rare, le plus beau et le plus utile de trois espèces de loups, mérite bien qu'on en dise quelque chose en particulier. Ce bel animal n'a presque rien de semblable aux nôtres, et si on en ôte les pattes, on le trouvera tout différent pour* sa grandeur, pour sa figure, pour son poil et pour sa queue.

Sa peau fait une des plus belles, une des plus rares et une des plus précieuses pelleteries qu'on saurait voir. L'animal est d'une figure assez longue, d'une belle couleur, d'un poil [f. 70] fin et long et fort épais. Sa couleur jaunâtre est entremêlée d'un beau gris. Il a la queue courte et variée de trois couleurs : elle est jaune, blanche et noire. Il n'a pas deux pieds de hauteur, il est très bon à manger, les intestins sont d'un goût délicat.

Les sauvages lui ont donné un nom tout différent des autres loups pour le différencier : ils le nomment *pichiou*, et les autres, ils les appellent *mahinganak*.

Je n'ai jamais remarqué que les loups des terres neuves, qu'on voit à vingtaines, aient cette propriété qu'on donne à ceux de l'Europe d'ôter la voix aux personnes qu'ils voient avant que d'être découverts des mêmes personnes, et il n'est pas vrai de dire qu'un ancien faiseur d'épigrammes, disait d'un certain Balbe qui avait la coqueluche ou qui avait un peu trop bu :

255 *Canis lupus* (L.), loup (Banfield, 270–5 et Burt et Grossenheider, 70–2); représenté dans le *Codex*, Pl. XXXII, fig. 49.1, sous la désignation «Loup comun dans la nouvelle-france»; sans rapport avec la figure du loup dans Gesner, 1621, t. 1, 634. Lescarbot serait le premier à employer le mot *loup*, affirmant qu'on le trouve en Acadie. Cartier utilise les termes *louere* ou *louier* en 1535 (Ganong, 223). Boucher fait la distinction entre le loup-cervier et le Loup commun (Rousseau 1964, 309).

256 *Lynx canadensis* Kerr, ou *Lynx lynx* (L.), loup-cervier (Banfield, 325–7 et Burt et Grossenheider, 80–2), représenté dans le *Codex*, Pl. XXXII, fig. 48.2 sous la désignation «Loup servie dont La peau se vend six Louis dore»; figure copiée dans Gesner, 1621, t. 1, 6. On ne doit confondre cet animal avec le lynx roux mentionné précédemment. Le mot *loup-cervier* a toujours désigné le lynx européen; on a appliqué le terme à l'espèce américaine, qui est pourtant plus petite. Mentionné pour la première fois par Champlain en 1608, il est décrit brièvement par Denys (Ganong, 223). Boucher le mentionne aussi en 1664 (Rousseau 1964, 309) et Lahontan en 1703 (Ouellet et Beaulieu, *Œuvres complètes*, 362).

Balbule forte lupi, te conspexere priores;
Aut jacet iramodico lingua sepulta mèro.

Ni l'un ni l'autre ne sont pas vrais dans les forêts écartées des gens venus de l'Europe, car il n'y a point de vin.

Tous les loups sont si farouches que jamais ils ne s'apprivoisent bien. Quelques nations estiment ces animaux et en portent le nom. Ces nations sont nombreuses, belliqueuses et font tête aux Iroquois. Elles habitent un très beau pays le long de la mer. Les hommes sont fort grands et fort bien faits. Ils ont fait un roi, lui ont donné des gardes. Ils font la guerre aux Anglais de Boston et de toute la côte jusqu'à la Nouvelle-Albanie.

Toutes les peaux des loups sont d'usage dans le pays où l'on les tue. Les habitants s'en habillent : ils en font des bonnets comme ces paysans lombards dont parle un fameux poète :

Fulvos lupi de pelle galeros
Tegmen habent capitis.

Du scennonton, ou du chevreuil de la haute Virginie[257]
Cet animal a bien du rapport* à ces chamois qu'on tue sur les hautes montagnes du Dauphiné ou sur celles des Alpes. La couleur et le bois sont différents, le poil est jaunâtre, sa corne est blatte*. On verra dans la figure tout l'animal qui est vif et très vite* : il s'élance plus de dix ou douze pieds d'un seul saut, en haut. Il ne fait que sauter et bondir, il emporte vingt pieds d'un saut. Il n'y en a que dans les pays chauds, et l'hiver ils ne se sauraient tirer des neiges. La chair en est très délicate et d'un goût excellent. On ne saurait estimer la peau qui est fort délicate et d'un grain fin. Les chasseurs en habillent leurs familles, en font des souliers, des bas et des justaucorps.

[f. 71] *De l'ours noir*[258]
Comme l'ours est un animal assez connu dans l'Europe, je ne ferai pas état* de rien rapporter de ce que le grand naturaliste et les autres qui en ont écrit disent de cet animal. Je ferai seulement savoir qu'outre que l'ours noir a tout commun avec ceux que nous voyons sur les Alpes, en Dauphiné, sur les monts Pyrénées, en Allemagne, en Pologne, en Moscovie, en Suède, en Danemark, et dans tous les autres lieux de l'Europe et de l'Asie où il se trouvent des jaunâtres.

L'ours noir n'a rien que du noir, et s'il est marqué sous le col* d'une marque blanche, cela ne fait pas qu'on ne lui doive donner le nom de *noir*, lustré et reluisant comme du satin.

Outre ces ours noirs nous en avons d'autres tous blancs plus que les cygnes, car ils n'ont aucune tache. J'en dirai un mot.

Les ours noirs ont cela de fort particulier qu'ils sont plus grands, plus membrus, plus forts, plus sauvages et plus farouches. Ils sont communs* dans tous le pays. Les blancs sont plus rares, et on n'en voit que dans les terres du nord et dans l'île d'Anticosti, et dans cet autre qu'on trouve au large de la mer glaciale, qui porte pour ce sujet* le nom de l'île des Ours Blancs, où l'on voit deux choses rares : la première est une plage ou une très grande enfonçure qu'il y a dans l'île, où, pendant le temps que les oiseaux muent, ils s'en vont en cet endroit en telle quantité que, si un homme ou un animal y tombe, il se perd dans la plume. Pour croire cette vérité, il faut avoir vu l'effroyable passage des oies sauvages, des outardes, des cygnes, des canards de plus de trente différences, des becs-de-scie qui est un oiseau grand comme le cygne du Cheté, qui est gros comme un mouton, des goélands, des cormorans et d'une infinité d'autres oiseaux qui couvrent l'air de partout. La seconde rareté, qui est plus surprenante que cette première, est que c'est un prodige de voir au milieu de la mer glaciale une grande anse qui ne gèle point et où les vaisseaux sont en assurance* et à flot pendant les plus terribles rigueurs de l'hiver, et entourée de glaces si épaisses que la chose passe le prodige tout autour de l'île Douabaskos.

La grandeur et la grosseur de l'ours américain est extraordinaire. J'en ai vu tuer dans le lac des Nipissiriniens d'une grandeur surprenante : ils étaient du moins* aussi grands et plus gros qu'un taureau de quatre ans : ils étaient couverts de quatre doigts de graisse de partout. On ne manqua pas d'en faire festin général à cent hommes que nous étions.

257 *Odocoileus virginaus* (Zimmerman), cerf de Virginie (Banfield, 365–8 et Burt et Grossenheider, 218); représenté dans le *Codex*, Pl. xxxiv, fig. 51, sous la désignation «seenonton», c'est-à-dire sous son nom iroquois. Lescarbot le nommait le *cerf au pié-vite* et savait le distinguer de l'orignal et du caribou. Leclercq dans sa *Nouvelle Relation de la Gaspésie*, 1691, décrit une chasse aux *cerfs*. Tous deux ne peuvent que désigner le cerf de Virginie (Ganong, 209). Aujourd'hui, on l'appelle ordi-

nairement *chevreuil* au Québec (Rousseau 1964, 307).
258 *Ursus americanus* Pallas, ours noir (Banfield, 283–6 et Burt et Grossenheider, 46–7), représenté dans le *Codex*, Pl. xxxiii, fig. 50, sous la désignation «ours noir»; mais la figure ne s'inspire pas de l'ours de Gesner, 1621, t. 1, 941. Cet animal est mentionné par tous les auteurs depuis Cartier en 1534 jusqu'à Boucher en 1664. Il est même représenté, sans être nommé, sur la carte de 1612 de Champlain (Ganong, 229 et Rousseau 1964, 307 et 309).

Lorsque les nations des Oreilles habitaient les terres du bout de la mer Tracy, à cinq cents lieues loin de la ville de Québec sur la pointe de Chagouamoigoung, tout l'hiver que je passai avec ces nations, j'en vis apporter des monstrueux que la jeunesse* allait tuer à sept ou huit journées de là. Cet animal de considération*, comme disent les errants, est d'un naturel fort farouche, et il n'y a pas moyen de l'apprivoiser que lorsqu'il est fort jeune. Il est extrêmement fort : il grimpe [f. 72] sur les arbres avec furie. Étant pressé*, il souffle comme un dragon, il écume comme un verrat, il rugit comme le lion et meugle comme un taureau. Il contrefait le cochon. Il a ordinairement les yeux étincelants, petits, chargés de rouge, fripons. Il semble avoir quatre yeux : il en a deux naturels, deux autres apparents* formés de deux taches jaunâtres qui sont placées au-dessus de ces yeux. Le poil qui est autour de sa grande gueule est aussi jaunâtre. Il a les oreilles courtes et toujours dressées comme le renard; il ne les abat jamais qu'en arrière, et quand il veut faire quelques sauts ou prendre sa course ou se mettre en colère; mais il les relève d'abord* en se défiant* et comme voulant se mettre en sentinelle. Il a le museau un peu long et affilé, la tête grosse. S'il est surpris par le chasseur ou par les chiens, il ronfle en fuyant comme un sanglier. De bonne foi, cet animal est formidable. Il est armé de grosses et de furieuses griffes : il en a vingt qui sont fort longues, à proportion de son âge. En courant, il fait relever une nuée de poussière.

Je n'ai point vu ni appris des veneurs qu'il lance des pierres contre ce qui le poursuit, comme l'on dit que font ceux de l'Europe.

C'est un plaisir tout singulier de le dénicher de dessus les arbres à coups de fusils ou à coup de flèches. Lorsqu'il est blessé à mort, il tombe comme une pierre et s'achève de tuer; mais s'il n'est que légèrement blessé, il descend à reculons avec furie en grondant horriblement, et c'est en ce temps qu'il faut se tenir sur ses gardes et prendre garde qu'en nous attaquant, ce qu'il fait, il ne nous tue pas pour nous dévorer.

Ce malheur arriva il y a fort peu de temps à un Indien qui fut dévoré jusqu'aux moelles. Comme l'animal est gros et grand, il est très difficile à tuer, et bien rarement demeure-t-il sur place, après même plusieurs coups mortels.

Dans la chasse où je me suis trouvé de cet animal, j'ai observé tout ce que je viens de dire, et particulièrement sur les bords d'une grande île qui est presque au milieu de la mer Douce des Algonquins supérieurs, qui a cinq lieues de circuit*, où je vis percer sur l'eau un fort grand ours mâle de cinq ou six coups d'épée par des sauvages qui l'allèrent attaquer lorsqu'il traversait à la nage d'une île à l'autre.

Il semble avoir bien de l'esprit, ou plutôt un instinct merveilleux pour se loger pendant l'hiver et pour se garantir des rigueurs de cette saison extrêmement froide dans le climat du Nouveau Monde / septentrional* et occidental /, quoiqu'il soit à peu près sous les mêmes élévations* de notre France.

Il fait une caverne sous la terre quand il ne trouve pas des gros trous aux arbres pour s'y loger : s'il en rencontre, [f. 73] il s'y retire pendant cinq ou six mois sans y porter aucuns vivres, et on s'étonne fort de quoi il peut vivre, car de tout ce temps-là il ne sort point pour aller chercher à manger, ce qui est si vrai qu'on ne trouve aucune de ses pistes sur la neige, qu'on verrait s'il sortait un seul pas. Cependant ces animaux sont si gras à la fin de l'hiver qu'il n'y a point de cochon qui ait le lard si épais, et ce qui marque son embonpoint*, c'est que sa peau est reluisante comme le plus beau satin noir.

[Quatrième cahier de l'Histoire naturelle de l'Inde occidentale]

Environ le 15e du mois d'avril, les ourses mettent bas et font deux ou trois petits.

Il y a peu de temps qu'on me fit présent dans le pays de deux ourceaux, mâle et femelle. Ils n'étaient pas plus gros que des chats communs*. J'entrepris de les dresser, mais je n'en vins à bout que d'une terrible manière, après diverses morsures et après des égratignures réitérées qu'ils me faisaient aux mains. Après bien des caresses que je leur faisais, voyant qu'elles ne servaient de rien, je m'avisai qu'il fallait changer de méthode, de sorte que la première chose que je fis fut d'arracher avec des tenailles et de couper jusqu'au sang les dents et les griffes de mes ours, de les battre à gros coups de bâtons jusqu'à les laisser sur le carreau. Je les frappais rudement avant, pendant et après qu'ils avaient fait des fautes : de cette manière, je les rangeai* si bien qu'ils faisaient avec promptitude tout ce que je leur avais appris. Nonobstant tous les maux que je faisais à ces bêtes, ces terribles animaux se colletaient tous deux de temps en temps avec tant de fureur que j'avais beau donner de grands coups de bâtons, qu'il n'était pas possible de les faire déprendre. La femelle était toujours la plus opiniâtre.

Les sauvages venaient en foule aux clameurs de ces rudes combats et de ces cris pour admirer* ce qu'ils n'avaient jamais vu dans ces contrées. Enfin, à force de battre, cette humeur farouche s'adoucit si fort qu'il ne resta plus que des regards toujours affreux, avec un certain je ne sais quel bourdonnement, qui était

Histoire Naturelle, ou la fidèle recherche de tout ce qu'il y a de rare

comme un défi que ces ours se faisaient l'un à l'autre et qu'il ne fut jamais possible d'empêcher. On voyait aller et venir partout ces animaux; ils se jouaient avec les chiens et avec les plus petits enfants, ils faisaient mille belles passades, cent sauts et cent ruades agréables. Un de ces ours voulut un jour attaquer un bel âne venu nouvellement de l'ancienne France, lequel n'entendant* pas ce jeu de l'ours qui voulait le caresser*, l'âne se mit en telle fantaisie* qu'il commença à ruer et à frapper des quatre pieds sur l'ours qui aurait été tué par l'âne qui l'avait terrassé, si on ne fût venu à son secours au bruit de ces hurlements. Je n'aurais jamais cru qu'un âne fût si agile à se défendre; et de bonne foi, on ne pourrait pas dire à cet âne ce qu'on dit ordinairement à ces sortes d'animaux :

Arri animal tardum quæ te res lente movatur
Arri fustigera bestia digna manu.

[f. 74] Mais pour revenir aux autres exercices* que mes ours faisaient, je dirai qu'ils dansaient, qu'ils se tenaient debout, qu'ils marchaient comme les hommes, qu'ils maniaient fort adroitement la hallebarde, qu'ils tenaient leur patte dans leur gueule et qu'ils faisaient plusieurs autres beaux tours avec l'exercice* du mousquet, de sorte que les Indiens venaient à la foule voir faire tous ces mouvements, en leur langue, à des animaux qu'ils n'auraient jamais cru qu'on pût dresser. De bonne foi, ces ours étaient un présent à faire à quelque grand; mais par malheur je n'avais point de boîte où je les pusse renfermer aussi aisément que les petits écureuils suisses que j'eus l'honneur de présenter à Sa Majesté, à mon retour des Indes, dans son louvre* de Saint-Germain-en-Laye. D'ailleurs, la fantaisie* de quelques-uns de mes compagnons missionnaires qui ne furent pas d'avis que je me donnasse la peine de conduire de si gros animaux en France fit que je les abandonnai à mes amis.

Avant que de passer plus avant, il faut que je dise que j'ai vu dans la Virginie, parmi les barbares, des ours domestiques et très familiers, qu'ils instruisent* pour les porter sur les arbres où ils ne peuvent pas monter et où ils ont affaire. Ces animaux leur servent d'échelle. Cet animal qui est extrêmement fort souffre qu'un homme le collette* par derrière, et le tenant ainsi, il le porte jusqu'au plus hautes branches. En ce cas, il ne faut pas craindre que l'animal laisse tomber son homme car, ayant vingt grandes et grosses griffes, il s'attache furieusement* à l'écorce de l'arbre et monte avec une vitesse incroyable.

Mais laissons ces adresses de l'ours et disons quelque chose des particularités naturelles de cet illustre animal. Prenons-le tel que la pure nature l'a fait et de la façon que les sauvages les désirent, bien grands, bien gros et bien gras. Tout cela ne leur manque pas, car ils en tuent des monstrueux, et en grandeur et en grosseur, et fort gras. J'en ai vu apporter à la fois les sept ou huit de la manière que je les décris. Les gens du pays font des ragoûts à leur mode de la chair et de la graisse des ours. Ils font fondre la graisse et la mêlent avec du blé d'Inde pour l'assaisonner. Ils en servent à d'autres fois de gros lopins* dans leur repas. Cette graisse est extrêmement laxative et fait aller de haut et de bas ceux qui n'y sont pas accoutumés avec violence et grande douleur. L'on est assez content de s'en être repu une fois, mais souvent, le défaut* d'autres vivres oblige ceux qui s'en sont trouvés fort incommodés d'en remanger. Les sauvages, qui sont accoutumés à ce mitridat*, se jouent de cela en en buvant de la fondue à longs traits, comme nous boirions du bon vin, et cette horrible liqueur* leur paraît bien agréable. Et j'ai vu des vieilles femmes chez les Iroquois, qui [f. 75] sont si ménagères* qu'étant invitées à des festins qu'on fait à grandes pleines chaudières de graisse d'ours fondue, elles en boivent autant qu'on leur en présente, et à la fin du festin, s'en vont fort gravement chez elles, y prennent un grand plat de bois ou d'écorce, et se mettant le doigt dans l'œsophage, se provoquent à vomir cette graisse d'ours qu'elles viennent d'avaler, pour s'en servir d'assaisonnement à la première soupe qu'elles feront pour toute la famille ou pour ceux qu'elles inviteront à un magnifique banquet, où personne ne se rebute de ce mets.

J'ai dit qu'il y avait dans tout le grand pays des Indes des ours noirs, mais leur principale demeure est là où il y a des noix, des glands, des châtaignes, des coudriers*, des pommiers, des pruniers et plusieurs autres fruits sauvages. Ces animaux, étant moins carnassiers qu'ils sont avides de fruits, ils mangent avec plaisir les citrouilles, les concombres, et ils sont gourmands du blé d'Inde qu'ils ravagent avec un dégât notable / dans une nuit des grands champs couverts de ce légume /.

La chair de l'ours noir, qu'on n'oserait regarder en Europe, est d'un goût exquis et très délicat dans le pays du Nouveau Monde. Et quand elle est bien entrelardée de graisse et de chair, elle est excellente rôtie. Elle est un peu fade si elle n'est que bouillie. Elle est très bonne en pâte, et je suis sûr qu'elle passerait pour une très bonne venaison. Si l'animal n'a que deux ou trois ans, la chair est fort tendre; elle l'est plus s'il est plus

jeune. On en tue dont la chair est si dure qu'il n'y a pas moyen d'en manger si elle n'est bien venée* et pilée entre deux pierres comme font les sauvages.

Mais ceux qui sont souvent obligés, au défaut* de toutes autres choses, de manger de la graisse de chandelle bien puante et toute crue ne font pas tant de façon dans le pays, où l'on souffre bien des maux.

La graisse de l'ours, qui est bonne pour dilater, ne l'est pas moins pour soulager ceux qui sont attaqués de douleurs* froides, et non pas des chaudes. Mêlée avec de l'eau-de-vie, elle ramollit les duretés et les rétrécissements des nerfs, elle soulage les goutteux.

Tout l'animal se met à profit, car, outre qu'on ne perd rien ni de la graisse ni de la chair, les peaux sont de grand usage pour faire les lits, les couvertures de lits et les habits pour les veneurs et pour leur famille.

Les Nadoussiouek en font des souliers rares, y laissant le poil en dedans, et passant bien la peau par le dehors, où l'on fait mille belles figures avec des plumes peintes de diverses belles couleurs.

Les griffes même sont d'un usage recherché, et les barbares se font des couronnes ducales et royales à la grecque : ils les mettent sur leurs têtes pour s'en parer; les plus puissants de la terre ne sont pas plus vains*, avec leurs couronnes d'or et de pierreries, que le sont ces pauvres gueux avec leurs couronnes de griffes d'ours.

Ils font de la même peau des sacs pour mettre leur tabac et leur pipe. Ils s'en servent pour faire les portes de leurs chaumines*. Ils sont obligés quelquefois de manger ces portes. J'en ai mangé [f. 76] dans une rencontre* où toute notre bande en avait bien besoin. Toute la sauce de ce mets consiste à jeter sur des charbons des lambeaux de cette peau. Me trouvant avec une escouade de sauvages dans un quartier d'hiver fort avant* dans les bois, j'ai été contraint d'y voir tuer des chiens pour nous empêcher de mourir. Et nous trouvant sans presque aucun aliment et voyant que les sauvages mouraient de faim, je dis secrètement à deux Français qui étaient avec moi qu'il y avait danger de notre vie si nous ne nous tenions sur nos gardes. La chose était d'autant plus dangereuse que le sauvage qui nous conduisait était un homme fâcheux*, et qu'il voyait mourir sa femme et deux de ses enfants. Dans cette conjoncture, nous résolûmes de nous garder couchant tous trois l'un près de l'autre nos armes à la main. L'un de nous devait veiller pendant que les autres deux dormiraient. Nous le fîmes tout autant de temps que

nous jugeâmes qu'il y avait du danger d'être tués en dormant et d'être mangés ensuite par des anthropophages qui n'auraient fait nulle difficulté de nous massacrer pour rassasier leur faim.

La peau de l'animal de considération* (c'est ainsi qu'on le nomme dans le pays *goûané-àgoûianer oukouari* : l'ours, dit-on est un grand capitaine) sert encore pour faire des traînes, c'est-à-dire qu'un chasseur, ayant tué un ours, l'écorche, et l'ayant dépecé, il met toute la chair dans la peau, et l'ayant accommodé* à sa fantaisie, il traîne tout ce fardeau sur les places et sur les neiges dans la peau.

Il y a plus de satisfaction de voir un ours en vie bien dressé traîner lui-même tout ce qu'on veut. Quelques Français, avec qui j'étais chez les Iroquois, en avaient dressé un qui faisait ce manœuvre fort agréablement; il traînait même des hommes.

Le cri de ce considérable* (parmi les sauvages) n'est point trop affreux s'il n'est en colère. Il enrage quand il est attaché : si la fantaisie l'en prend, il est si importun en cet état qu'il faut le lâcher. Lorsqu'il doit faire mauvais temps, les ours crient extraordinairement avec tant de rage, en se promenant continuellement dans les prisons où l'on les enferme, qu'il semble qu'on entend tout à même temps le rugissement des lions, le meuglement des taureaux, le hurlement des loups et les rages de quelques furieux sangliers qui ronflent de colère en écumant de rage, de sorte qu'on pourrait rapporter ici fort à propos quelques vers du poète lorsqu'il parle de l'île enchantée :

Hinc exaudiri gemitus iræque leonum
vincla recusantum et sera sub nocte rudentum,
sætigerique sues atque in præsepibus ursi
sævire ac formæ magnorum ululare laporum
quos hominum ex facie dea sæva potentibus herbis
induerat Circe in vultus, ac terga ferarum.[259]

L'animal se remue dans son cachot d'un mouvement si régulier, si bien compassé* et si prompt, qu'il ne donne pas moins d'étonnement que d'admiration* dans toutes ces agitations, aussi bien [f. 77] que par ces cris continués, les nuits entières et une grande partie du jour.

Pendant ces étranges mouvements, il se trace et il se bat un chemin si dur et si bien mesuré qu'il ne manque jamais de revenir à pas comptés justement sur les mêmes pistes qu'il avait marquées avec ses pattes.

[259] «Des sangliers et des ours s'agitaient furieusement dans leurs cages; et des formes de grands loups hurlaient. Tous avaient eu une face humaine, mais Circé, la cruelle déesse aux herbes puissantes, leur avait donné des figures et des croupes de bêtes sauvages» (Virgile, *Énéide*, éd. et trad.. J. Perret, Paris, Belles Lettres, t. 2, 8–11).

J'ai déjà dit que cet animal prend plaisir de monter sur les arbres, et si je n'en étais témoin oculaire, j'aurais de la peine à le croire; mais ayant considéré* bien des fois les ravages qu'il fait sur les branches, je ne puis plus en douter : il y coupe des plus grosses en les pliant, et il les ajuste si bien qu'il en fait comme un théâtre* tout au haut, où il va se reposer pour prendre mieux l'air et pour y dormir, mais particulièrement pour y manger le fruit, et il n'en décampe jamais qu'il n'ait tout achevé.

Quand il a faim et qu'il n'a pas de quoi manger, il se lèche les pattes de devant avec tant de vitesse et en poussant du fond de sa poitrine un grand bourdonnement si varié et si agréable qu'on s'arrête volontiers pour se divertir en l'écoutant et pour voir former en même temps une grosse écume fort blanche et très fine, si liée et si épaisse que, si on n'y regardait de bien près, on ne jugerait pas que ce fût de l'écume si on n'y voyait toutes ces petites ampoules que nous distinguons dans toutes les sortes d'écumes. On ne saurait mieux comparer cette sorte d'écume qu'à un blanc d'œuf très bien battu ou à de la crème bien fouettée. Cette écume bien liée, comme j'ai dit, a du corps, et étant fort gluante, sert d'aliment à l'ours; et pendant tout l'hiver, cet animal s'en sustente et ne mange rien plus. Cela est si certain qu'il n'y a aucun lieu d'en douter, particulièrement après une expérience recherchée* pendant tout un hiver en considérant attentivement tous les mouvements des deux ours que j'avais dressés.

J'étais extrêmement surpris de voir que ces animaux, qui dans d'autres temps avalaient une grande pleine chaudière de blé d'Inde cuit et pilé dans la saison de l'hiver, dans quatre ou cinq jours, ils n'en mangeaient pas autant qu'ils faisaient les autres fois dans un quart d'heure.

Je les entendais bourdonner éternellement, et de jour et de nuit, et ne sachant ce que cela voulait dire, je descendis dans la fosse où je les avais placés pour leur hiver, je les trouvai bien des fois qui se léchaient l'un l'autre et je pris garde que, par la vitesse incroyable avec laquelle ils se léchaient, poussant avec action leur bourdonnement, l'écume dont j'ai parlé se formait justement sur l'endroit où ces animaux se léchaient. Tantôt je découvrais les oreilles de ces deux ours couvertes de cette écume, tantôt le milieu du ventre en était baigné et tantôt une autre partie; et c'est de cette manière que ces animaux se rassasiaient. Je n'avais qu'à leur présenter le bout du doigt pour entendre leur musique ordinaire et pour voir d'abord* former leur écume sur le bout de ce doigt qu'ils pressaient, avec tant de violence avec leur langue, qu'il semblait qu'ils en voulussent tirer quelque liqueur.

Pline et ceux qui ont été de son avis n'ont pas menti quand ils ont dit que la verge de l'ours était un os.[260] J'ai eu la curiosité de faire l'anatomie de l'ours et de me convaincre là-dessus. J'en ai même gardé long [f. 78] temps que j'ai pris moi-même sur la bête et dont j'ai fait présent à un fameux médecin.

Je n'ai pas bien pu voir si l'ours est aussi informe que tous les écrivains le disent (sans l'avoir vu) lorsqu'il naît; j'assure seulement qu'étant petit, comme je l'ai vu, de la grosseur du chat, il est très mal fait et il semble être tout d'une pièce et assez mal formé; et même lorsqu'il devient grand, on voit un gros corps fort maussade*.

Je ne sais que dire tout haut ce qu'on rapporte des ours de la Vosge en Austrasie touchant leur vivre pendant l'hiver : on dit que cet animal, avant qu'il tombe de la neige, mange quelque racine qu'il trouve dans la terre, et qu'en ayant mangé, il n'a nulle faim de longtemps* et qu'il est pris d'abord* du profond sommeil. On confirme cela par un accident* fort agréable.

Un certain vacher vit un jour d'assez loin un grand ours qui grattait la terre et qui mangeait une racine avec avidité. La bête s'étant retirée, le gardeur de vaches s'en alla au lieu où il avait vu l'ours. Ce bon garçon s'amusa à manger de la racine que l'ours avait mangée. S'en retournant, il lui prit une si grande envie de dormir que, ne pouvant résister à ce tyran invincible, il succomba au sommeil. Il dormit longtemps, et s'étant éveillé, il raconta son aventure à ses camarades.

Si cela est vrai, comme il n'y a rien de contraire au bon raisonnement, pourquoi est-ce que nos ours des Indes ne feront pas la même chose auparavant que les terres soient couvertes de quatre ou cinq pieds de neige et de plus de vingt en quelques endroits? Et si le gliron* dort cinq ou six mois sans s'éveiller, pourquoi est-ce que l'ours n'aura pas la même vertu*?

Pour ne rien laisser à dire de ce que je sais de l'ours, on ne sera à mon avis pas fâché que je raconte ici tout ce que j'en ai vu dans les pays occidentaux. J'ai dit qu'on regardait l'ours comme un animal considérable* et comme une bête de la haute noblesse; mais je n'ai pas dit que dans cette vue on lui faisait des festins et que des vieilles Indiennes lui apportaient souvent à manger dans les prisons où l'on les enferme.

À ce propos, je me souviens d'une assez agréable rencontre* où je me trouvai lorsque, pour se divertir, quelques Français s'avisèrent d'habiller en gentil-

260 Pline écrivait plutôt que, sitôt que l'ours est mort, sa verge durcit comme de la corne («Histoire naturelle», t. 11, 109).

homme du pays un ours apprivoisé, qu'ils menèrent en cet équipage* par toutes les cases d'un village sur les côtes de la Virginie. Tous les habitants se piquaient en l'envi à qui ferait plus de présents au gentilhomme prétendu, qui, n'étant pas accoutumé à tant de caresses*, criait comme un perdu à mesure qu'on lui faisait plus de bien; mais si on lui donnait à manger, il s'apaisait d'abord* pour reprendre ses cris dès qu'on cessait de lui présenter le plat.

D'autres nations font gloire de porter le nom de ce noble animal. Les Outtagami, les Mantaoué, les Oussaki et les Oumalouminé croient que les ours sont une espèce ou une certaine nation d'hommes velus qui se laissent tuer par pitié aux autres hommes pour les faire vivre des viandes de leurs corps. Ils disent que les Français, qui sont fort barbus, sont descendus de cette race d'hommes qu'ils appellent *Makoua*, qui veut dire un ours.

[f. 79] Enfin d'autres nations, comme les Outtaouaks, les Outtaouassinagouk, les Mitchissaguek, les Maramogouek, les Kaskakouaiak· et plusieurs autres misérables nations tiennent les ours pour des divinités et leur font des sacrifices. J'ai vu que trop souvent, avec bien du chagrin, cette détestable cérémonie. Ces pauvres aveugles dans les mystères de notre religion ne laissent pas de dresser des autels pour ces prétendues divinités. Ils les ornent avec tout ce qu'ils ont de beau : les plus riches peaux et les plus belles nattes avec leurs rares peintures y sont destinées.

Là, sur ces abominables autels, les idolâtres attachent avec respect quatre ou cinq des plus grosses têtes des ours qu'on a tués. Ils leur offrent des festins, des chansons, des danses et des jeux qui sont les sacrifices du pays.

Il s'en trouve parmi ces barbares qui se font graver cet animal en quelque partie de leur corps : cela veut dire que c'est là la particulière* divinité à laquelle ce sauvage offre tous ses voyages, toutes ses chasses, et en un mot tout ce qu'il fait sans nulle exception.

Du gros ours blanc qui se voit seulement dans les terres du nord de la grande Amérique[261]
L'animal dont il est ici question est plus aquatique que terrestre, car il ne quitte qu'assez rarement la mer et qu'ordinairement il vit de poisson. Les mets les plus friands* de l'ours blanc sont les balenons, qu'il poursuit jusqu'à la haute mer. Il mange aussi toute sorte de

gibier à plume aquatique. Ce prodigieux animal pêche avec adresse les loups, les tigres et les chiens marins; mais lorsqu'il est pressé de la faim, il dévore tout ce qui se présente devant lui, les bêtes même les plus furieuses. Un sauvage nommé *Aoûatanik* m'a assuré avoir vu tuer de ces ours blancs dans son voyage du nord qui dévoraient les hommes.

Les matelots de l'équipage du capitaine Jacques Cartier rencontrèrent un de ces ours blancs dans une traverse* de quatorze lieues de large. Cet animal avait passé de terre ferme jusqu'à la grande île aux Oiseaux qui est du côté du nord, et différente de celle qu'on voit au milieu du golfe de Saint-Laurent. Cet ours était grand comme un bœuf. Sa chair est délicate comme celle d'un jeune taureau coupé* et qui n'a point travaillé.

Depuis la course que j'ai faite avec le seigneur Pitre, Hollandais et capitaine de vaisseau, j'ai vu et des ours blancs et des lions marins fort gros; et si quelqu'un avait la curiosité d'en voir, il peut le faire en passant à La Rochelle; et pour n'aller pas si loin, il n'a qu'à aller dans la bibliothèque de Sainte-Geneviève-du-Mont, à Paris : le P. Molinet lui en fera voir les dents.

[f. 80] Je ne sais si le seigneur Pitre, dont je viens de parler, n'a point pris ces ours blancs pour des lions marins, qu'il m'assurait avoir vus dans son voyage du nord, où il chargea son vaisseau de l'huile de deux baleines qu'il prit et qu'il vendit dix mille écus*. Il disait que les dents étaient fort grosses, desquelles on faisait des ouvrages beaucoup plus beaux, plus délicats et plus précieux que des plus grosses et des plus monstrueuses dents des plus grands éléphants dont j'ai vu des dents qui, étant jointes l'une contre l'autre, faisaient une arcade sous laquelle un homme haut de six pieds passait son chapeau à la tête sans rien toucher. On voit communément ces raretés dans les villes maritimes, chez des curieux qui font amas* de tout ce qu'on apporte de rare des pays étrangers, avec lesquels ces villes ont commerce.

[F. 81] SIXIÈME LIVRE

Du caribou
Cet animal est particulier aux forêts de l'Amérique, et il n'est même pas commun dans tous les quartiers* de ce grand pays. Il se plaît beaucoup dans les terres du

261 *Ursus maritimus* Phipps, ours blanc (Banfield, 289–91 et Burt et Grossenheider, 50 qui le nomment *Thalarctos maritimus*); représenté dans le *Codex*, 33, fig. 50, sous la désignation «ours blanc». Champlain le nomme l'*ours*

marin, dans une liste de 1603 (Ganong, 229); Boucher affirme que «l'ours est de couleur noire, il n'y en point de blancs en ces quartiers» (Rousseau 1964, 307).

Histoire Naturelle, ou la fidèle recherche de tout ce qu'il y a de rare

nord. Il n'est guère différent du cerf pour le corsage*, mais pour le bois il n'a rien de semblable, car il est fait en aile comme celui de l'élan. La figure* que j'en donne le représente parfaitement au naturel. La couleur du poil est un peu plus grisâtre que celle de la biche. On voit beaucoup de ces animaux pêle et mêle avec les cerfs dans certaines contrées où les habitants*, n'ayant point d'autre bois, se servent de celui de ces animaux qui tombe tous les ans pour s'en chauffer.

La chair de l'animal est de fort bon goût : elle est tendre et délicate et si elle est grasse, c'est un manger royal. Sans doute que cette grande délicatesse provient des longues courses que font faire au caribou certains petits animaux volants et certains autres qui s'attachent opiniâtrement sur sa peau et qui s'insinuent entre le grand poil de la bête de laquelle ils percent la peau en tant d'endroits qu'elle ressemble à un crible. Les premiers animaux qui lancent* le caribou se nomment, en langue du pays, *saghimek*; en Languedoc, on les appelle des *cousins*, et les seconds, *issegak*. Ces vermines ressemblent à ces gros poux qu'on trouve sur la peau des moutons. Le caribou est si couvert de ces animaux que la chose en est surprenante. Au reste, si quelqu'un de ces *issegak* s'attache à la peau des hommes (ce qui arrive assez souvent à ceux qui fréquentent les sauvages), il faut couper l'animal en deux, car il est si enfoncé et si collé à la chair de l'homme qu'il est impossible de l'arracher tout entier, à moins qu'on fasse un escarre* considérable, et la partie qui reste dans la chair, demeurant quelques jours en vie (quoique l'animal soit coupé en deux), s'enfonce toujours plus avant*, de sorte que ce petit insecte incommode extrêmement et fait enfin des plaies fort profondes dans la chair dont on est bien tourmenté durant les dix ou douze jours.

Quoique le caribou soit ordinairement attaqué de cet ennemi en hiver, l'été il s'en délivre par son poil qui tombe dès le commencement du printemps, et son cuir, se refaisant, je ne crois pas qu'on en puisse trouver un au monde de plus fort, de plus solide, de plus fin et d'une plus longue durée.

Les femmes des veneurs passent* et habillent* si à propos* et si bien les peaux du caribou qu'on ne peut rien voir de plus beau en matière de peaux passées.

On fait de ces peaux de très beaux ouvrages, et particulièrement les sauvages s'en servent pour faire le devant et le derrière de leurs raquettes, qui est un instrument qui leur est absolument nécessaire pour aller et pour venir pendant l'hiver, sans quoi il est impossible de sortir de la cabane pour aller chercher à vivre.

Celles que monseigneur le Dauphin agréa de ma [f. 82] main (dans sa chambre, où il me fit les plus belles questions du monde durant plus de deux heures à la présence de mes seigneurs les princes de Conti, de la Rochesurion et de toute sa cour à Saint-Germain-en-Laye, au retour de mon premier voyage des Indes) en étaient faites par la plus habile des Montagnaises, qui sont les femmes du monde qui travaillent le mieux pour entrelacer les raquettes. Il n'y a point de chamois, point de peau de cerf, ni d'élan, ni de buffle qui égale celle des caribous pour faire des chemisettes, des caleçons, des gants, des bas, des vestes et plusieurs autres choses. Quand ces peaux sortent de la main d'une Papinachoise qui se sera occupée à passer des peaux, j'ose dire qu'il n'y a point de maître en France ni ailleurs qui puisse si bien faire dans le peu de temps qu'elle emploie pour passer ces peaux dans une nuit, avec de l'eau, du feu, une corde et une pierre, et un peu de foie d'élan pour lui donner une blancheur comme celle de la neige, une douceur plus fine que celle du velours et un lustre éclatant comme du satin blanc. Que si après cela un habile François veut passer ces peaux à l'huile, on ne voit rien de plus beau, ni de plus jaune, ni d'un meilleur usage que les peaux des caribous, qui sont si fortes que j'ai souvent défié des hommes extrêmement forts d'en couper de fort petites et fort étroites aiguillettes que je leur présentais. Et je puis dire que je ne vais guère sans cela pour en faire faire l'épreuve* aux plus forts à qui je les présente dans l'occasion* pour vérifier que la peau du caribou est la plus forte peau du monde, et par conséquent la meilleure quand elle a les autres qualités que j'ai dit, ce qui est sûr à moins qu'elle fût pourrie, ou par un grand usage ou par quelque accident*. La peau du caribou se peut laver et mettre à la lessive autant de fois qu'on veut, mais il faut prendre garde que, quand on l'a lavée, il faut la tordre avec violence et en bien exprimer* toute l'eau, la présenter ensuite au feu un peu de loin et la frotter incessamment jusqu'à ce qu'elle est sèche. On peut l'exposer au soleil et avoir soin de la bien frotter de temps en temps. De cette manière, on la fera durer les quinze et vingt ans. Elle est chère à Paris où les marchands pelletiers, quand ils la connaissent, en font payer dix ou douze écus* d'une seule qui fournira pour faire un caleçon ou une chemisette qui durera autant que j'ai dit. Au reste, cette peau est fort chaude en hiver et fort fraîche en été. Je parle après une expérience de vingt ans pendant lesquels j'ai usé* de ces sortes de peaux après en avoir découvert la bonté* dans les Indes, où les sauvages s'en font de toute sorte d'habits et de souliers, lesquels, quoique déliés*, durent fort longtemps.

[f. 83] *Du cerf américain*[262]

Le nom de cerf est si connu dans l'Europe, et plusieurs écrivains en ont si bien fait le portrait* et si bien décrit toutes les particularités* qu'il semble être inutile d'en parler davantage; néanmoins, comme le cerf de l'Amérique est un peu différent de celui que nous voyons dans ces pays et que la chasse en est toute particulière, quelqu'un sera peut-être bien aise* d'apprendre les différences de l'un et de l'autre.

Le cerf américain est notablement plus grand, plus membru, et par conséquent plus fort que les plus forts qu'on voit dans la fameuse forêt de Fontainebleau et ailleurs en Europe. Son bois est aussi extraordinairement plus gros et plus haut. On en voit un à Toulouse sur la porte d'un apothicaire qui est d'une prodigieuse grosseur et d'une hauteur surprenante. Étant encore dans mes courses, je l'envoyai à cet ami qui en fait parade.

Il y a des plages* et diverses contrées dans nos pays étrangers où l'on voit cinq ou six cents de ces animaux ensemble. Les faons en sont si beaux qu'ils sont mouchetés par tout le corps de blanc, de jaune, de gris et de noir : on diroit à les voir que ce sont plutôt des tigres que des faons de biche qui paissent pêle et mêle.

La chasse du cerf des Indes est toute différente de celle du cerf de France. Les Occidentaux, qui sont les plus habiles chasseurs du monde, se mettent fort peu en peine de toutes les façons* des veneurs de ces pays. Et bien qu'ils aient de fort grandes meutes de bons chiens, aussi bien que les plus grands seigneurs, et qu'ils ne soient point accompagnés de piqueurs*, ils méprisent* tout cela dans leur manière* de vénerie. Un canot, avec deux ou trois avirons, et un paquet de quinze ou vingt bonnes flèches armées de pierre, d'os, ou de cuivre, un fusil ou deux, suppléent à tout ce grand appareil* de chasse qu'on fait ici.

Un seul sauvage sans chien et sans piqueurs, ayant découvert les voyées* et les pistes de la bête qu'il recherche, guette à lui seul, juge bien des voyées et des fumées*, défait les ruses, détourne, lance, laisse courir bien à propos et garde le change* en suivant la bête et le gibier ordinaire de la vénerie qui sont pour l'ordinaire des bêtes de brout* et qui ne mordent point.

Les bêtes de brout sont l'orignac, le caribou, le chevreuil, le cerf et la vache* sauvage, le monosserot*, l'éléphant, la vache sauvage, le *pichikiou** et plusieurs autres;

les animaux mordants sont en si grande quantité qu'on n'en sait pas le nombre : le loup, l'ours, le renard, le chien, la loutre et les autres sont des mordeurs.

Le veneur sauvage ne met presque jamais les chiens après les bêtes fauves*. Et quoique les chiens de ce chasseur et de ce piqueur vaillent bien nos gros limiers*, nos courants* et nos allants*, nos bassets d'Artois, nos lévriers et nos mâtins, ils ne s'en servent guère l'été. Il supplée à tout et l'on peut dire qu'il a, tout seul, et les qualités d'un très bon veneur et de toute une grande meute de chiens [f. 84] bien dressés à la vénerie. Et la bête a beau aller sur soi et revenir sur ses erres*, le veneur connaît parfaitement bien toutes les abattures* et toutes les foulures*. Et la bête n'a qu'à aller de bon temps*, notre piqueur la lancera* presque toujours, ne perdant que bien rarement les brisées*, et fera ses cernes* sans prendre le change*, il débuche* et rembuche* le cerf ou l'orignac comme il veut. Et ce qui est encore bien surprenant, c'est qu'il démêle les voyées* sur les neiges, quoiqu'il y ait assez longtemps que la bête ait passé et que ses brisées soient couvertes de quelque nouvelle neige tombée depuis peu.

D'autres fois, sans façon, le barbare chasseur, découvrant une ou plusieurs bêtes dans quelque prairie dans son viandis*, et qu'elle viande* actuellement*, il se traîne comme un serpent pour les aller tuer. Et il est assez rare que le chasseur ne vienne à bout de son dessein.

Nos lestes et nos adroits veneurs se mettent peu en peine si le cerf qui tient les abois* et qu'ils ont lancé porte tête fraisée* et brunie, ni s'il est dangereux à l'attaque; ils le dardent brusquement ou en effet avec un dard, qu'ils lancent de loin ou avec une flèche, ou s'ils le percent d'un coup de fusil ou enfin d'un coup d'épée, on n'en voit aucun se mettre en devoir de couper le pied droit pour le présenter au prince qui chasse ou plûtot qui préside au déduit* de la vénerie.

Il est vrai qu'ils prennent le massacre* qui est la tête, avec le cœur, non pas pour faire le premier devoir* à leurs limiers, mais pour en faire festin ou pour faire savoir qu'ils ont tué une bête dont ils feront bientôt un repas à toute leur suite.

On se sert dans le pays des Virginiens de toute la curée* pour faire festin et pour assaisonner du fiant* toute la chaudière : aussi* ils ne nettoient point ni la panse ni les tripes de l'animal, disant que tout ce qui est

262 *Cervus elaphus* (L.), wapiti (Banfield, 371–4, mais Burt et Grossenheider, 215–16 donnent plutôt *Cervus canadensis* Nelson comme son nom scientifique pour le distinguer du *C. elaphus*, nom habituel du cerf d'Europe); représenté dans le *Codex*, Pl. XXXIV, fig. 51.3, sous la désignation «attic ou Cerf»; la figure s'inspire de Gesner, 1556, t. 1, 326. On l'a appelé d'abord *cerf* à cause de sa ressemblance avec le cerf d'Europe (Ganong, 209). Boucher le désignait peut-être sous le nom de *vache sauvage* (Rousseau 1964, 307).

dedans n'est que du brout ou de l'herbe cuite dans l'animal et que les Français sont bien plus ridicules qu'eux lorsqu'ils mangent de l'herbe crue en salade ou cuite dans le pot, disant qu'elle est bien plus naturelle cuite dans l'estomac d'une bête qu'autrement. Je parlerai de ce ragoût plus amplement en décrivant l'élan qui sera la dernière des bêtes à quatre pieds, de brout et de pied fourchu, dont je ferai le portrait* et l'anatomie* fort régulièrement*, et pour l'intérieur et pour l'extérieur.

Au reste, le cerf de l'Amérique est si vite* à la course qu'il semble une flèche qui part, un éclair qui paraît en ne paraissant plus, ou un / carreau* / [de] foudre qui se détache de la nue, son mouvement étant en quelque façon si violent qu'il ne paraît qu'un moment, et il semble plutôt voler que courir. Avec tout cela, le sauvage, le laissant faire, il vient à bout de la tuer par sa patience, car après la course du cerf il fait la sienne.

Tout le monde sait que la moelle du cerf est d'un excellent goût et qu'elle sert pour mille drogues*, et particulièrement on en use pour adoucir les nerfs et pour faire passer les douleurs de la goutte quoiqu'elle ne la guérisse pas, selon l'axiome universel de messieurs les médecins :

Tollere nodosam nescit medicina podagram.

Ce vers est sempiterne veritatis, comme l'on dit dans l'école; en voici un qui est encore plus véritable* :

Contra vim mortis, non est medicamen in hortis.

/ La peau est d'un grand usage. Elle est forte, et étant bien habillée*, elle vaut mieux que la peau de l'élan. Le bois sert à nos chasseurs pour faire divers petits ustensiles* qui leur sont nécessaires. L'andouillette* étapée* est bonne pour donner aux enfants qui sont tourmentés des vers. On ne croirait pas que nos sauvagesses fassent de très beaux et de tres riches ouvrages* du grand poil du cerf, qu'elles arrachent soigneusement de dessus la bête. Elles le trient avec soin et lui donnent la teinture de diverses couleurs fort éclatantes. Elles en font des ouvrages au petit métier qui sont toujours des diverses figures* qu'elles en forment souvent sur leur petit métier./

[f. 85] De la licorne
Je ne sais que dire de l'effroyable erreur qui s'est glissée parmi même force gens de cabinet qui d'ailleurs sont fort savants, mais qui, n'ayant rien vu des choses admirables que la nature produit parce qu'ils n'ont jamais perdu de vue le clocher de leur paroisse, et qui ne savent presque pas sans demander le chemin de la place Maubert ou de la place Royale. Ces sortes de personnes, dis-je, s'attachent avec une opiniâtreté blâmable à dire qu'il n'y a point de licorne en aucun endroit du monde. Sur cela je voudrais leur demander s'ils croient bien d'autres choses qu'ils n'ont pas vues et qui sont bien plus extraordinaires. Ils me diraient que oui, qu'ils les croient parce que des bons auteurs auxquels ils ajoutent foi les rapportent. Et si je leur dis que les mêmes écrivains assurent qu'il y a des licornes, que diront-ils? Se voudront-ils contredire, assurant qu'ils croient une partie des auteurs qu'ils ont lus et qu'ils ne croient pas l'autre?) Ou est-ce qu'ils ont appris ce discernement? Est-ce sur le Pont-Neuf où les gens de cabinet ne passent que trois en trois bien fourrés*, bien embéguinés* dans une chaise* où l'on les porte, ou dans un carrosse qu'ils font boucher de tous côtés, de peur des vents coulis*. Non, non, de bonne foi, ce n'est pas ces sortes de génies qu'il faut croire, mais il faut ajouter foi à mille braves hommes généreux qui ont souffert et vu des choses rares*, à l'armée sur mer, sur terre dans des voyages de vingt ou de trente ans, souffrant toutes les injures des temps, des saisons et des climats, où l'on voit ce qui est de rare et de surprenant, et que ces gardeurs de cabinet n'ont pas vu.

Cent écrivains, témoins oculaires, assurent qu'ils ont vu, devant* et après Lodoico Berthamano[263], qui assure en ces termes, dans un auteur qui le rapporte, qu'il en a vu deux dans son voyage de Médine ou de la Mecque. Voici ses propres termes; ils sont en espagnol que j'ai tiré mot à mot de l'original. Comme cet espagnol n'est pas trop difficile, je ne l'expliquerai pas en français.

El licor, como testifica Lodoico Berthamano, el qual a visto dos en mecha, tiene la cabeca como un caballo, con un cuerno muy agudo de tres cubitos de largo en la frenta, es d'el grandor d'un caballo de trenta mezes, tiene las piernas delgadas, y los pieds hendidos como un [f. 86] venado, los pieds detras tiene muy pelludos, tiene color de cassanna poco mas rubio. Esté animal paresse fiero; pero esta templado cum cierto dulcor.

El cuerno tiene efficassissima virtud contra todas maneras de ponçonna. Este animal se cria en Ethiopia.

Ces mots sont tirés d'un livre qui se nomme En carta, y breve declaration del repartimiento, forma y singularidades del Mundo.

La figure que je donne de cet animal, peinte avec la plume, représentant parfaitement celle que j'ai vu tuer

263 Voir Gagnon, Introduction, 41.

et tout ce que vient de dépeindre Lodoico Berthamano fera que je change d'avis, car si jamais cet écrit voit le jour, ceux qui n'entendent* aucun mot d'espagnol, comme sont tous ceux qui n'ont pas étudié le latin ni cette belle langue extrêmement emphatique et bien ampoulée, seront bien aise de voir ce que je viens de rapporter en notre langue et selon le style espagnol.

La licorne, comme assure Louys Berthaman, lequel en a vu deux à la Mecque, a la tête comme un cheval; elle a une corne au milieu du front, fort pointue et longue de trois coudées; elle est de la grandeur d'un cheval de trente mois. Cet animal a les jambes déliées*, les pieds fourchus comme un taureau; les pieds de derrière sont beaucoup plus velus que ceux de devant. Elle est de la couleur de châtaigne, mais un peu plus rouge. Cet animal paraît fier parce qu'il est paré d'une certaine bonne grâce. La corne de la* [f. 87] licorne a une très grande vertu contre toute sorte de poison. Cet animal naît en Éthiopie.*

C'est ce que rapporte monsieur Thévenot, illustre écrivain de notre temps. Il ne faut que voir ses ouvrages pour dire d'abord que les curieux lui ont des infinies obligations des curiosités qu'il ramasse de tous les endroits du monde pour en faire part au public.

J'ai lu dans ces ouvrages admirables ce qu'il rapporte de la licorne après* des voyageurs dignes de foi desquels il a eu tous les mémoires.

Je ne veux donc pas que désormais nos gens de cabinet doutent de l'existence des licornes, puisqu'il y a tant de braves* écrivains bien informés qui nous en assurent après mille gens de tête et dignes de foi qui en ont vu et qui nous ont fait la grâce de nous faire un présent de leurs mémoires, où ils avaient marqué* tout ce qu'ils avaient vu dans leurs voyages et dans les pays étrangers, où l'on voit des choses si rares qu'on ne saurait croire, et cependant elles ne laissent pas d'être. Les incrédules doivent se souvenir que tous les climats* ne produisent pas de tout : *Non omnis fert omnia tellus.*

Du grand bœuf sauvage américain que les barbares nomment pichikiou[264] *dans toute la Louisiane, dans le grand royaume de la Manitounie et dans tout celui de la Kizissiane, qui sont les terres deux fois plus grandes que toute l'Europe*
Je n'aurais pas donné d'autre nom à ce grand animal que celui que lui donnent les Manitouniens, les Louisains et les Kizissiens; mais comme il a tout le rapport* qu'on peut souhaiter aux bœufs de nos terres, j'ai cru

que je ne pouvais pas le mieux nommer que le *grand bœuf sauvage américain*, au lieu de l'appeler simplement *pichikiou*, qui est un mot étranger et de près de trois mille lieues* loin de France. Ce gros et ce puissant animal n'habite que les pays chauds et les terres découvertes, comme sont les prairies où il prend sa principale nourriture, ne broutant que rarement, tout au contraire de l'élan qui broute plus [f. 88] souvent qu'il ne s'amuse à paître, ayant d'un côté les jambes fort hautes, et de l'autre le col* fort court, au contraire du *pichikiou*, qui a les jambes extrêmement courtes et le col fort long.

L'animal dont je fais ici le portrait* est d'un naturel aussi pesant que le rignosserot* d'Afrique et de l'Asie, auquel on met le feu entre les jambes pour l'exciter* à la marche ou au travail; mais quand notre bœuf est lancé un peu vigoureusement, il devient farouche et furieux, et il tue quelquefois le veneur, le foulant aux pieds avec fureur et le faisant sauter avec ces cornes comme il ferait une botte de foin.

Les Louisains et leurs voisins, qui ne les tuent qu'avec la flèche, n'en faisant mourir qu'autant qu'il leur en faut pour vivre, sont plus prévoyants que les sauvages voisins des Français qui tuent toutes les bêtes qu'ils rencontrent sans avoir nul égard aux nécessités de l'avenir : ceux-là sont bien plus prudents que ceux-ci ne sont sages, car il arrive souvent de là qu'ils jeûnent quelques mois de l'année.

L'avidité des nations policées* pour avoir à l'envi au meilleur marché qu'elles peuvent les pelleteries des Iroquois, des Hurons et de toutes les nations algonquines leur ont inspiré ce massacre que deux ou trois Américains font. Quant il y aurait cinq ou six cents bêtes à la fois, ils tuent tout quoiqu'ils soient sûrs que toutes ces viandes pourriront avec une partie des pelleteries. Ils sont si accoutumés à cette tuerie de tous les animaux qu'ils rencontrent que, fort souvent, vous verrez une nombreuse bande de ces meurtriers s'amuser à tuer un rat qu'ils déterreront d'une canne dans la terre si l'animal s'y est réfugié par hasard. Mais parmi nos Manitouniens et leurs alliés, ce serait un crime de tuer plus d'animaux que leur nécessité ne demande, quoiqu'il y ait tant de ces bœufs dans leur pays que, dans une seule prairie qui n'aura pas un quart de lieue de long dans quelque agréable vallon, on y verra les quatre à cinq cents bœufs, lesquels d'un peu loin ressemblent à un champ nouvellement labouré dans quelque climat où la terre est naturellement noire.

264 *Bison bison* (L.), bison (Banfield, 377–80 et Burt et Grossenheider, 224); représenté dans le *Codex*, Pl. xxxv, fig. 52, sous la désignation «Pichichiou»; sans trop de rapport avec le *bisontis* de Gesner, 1621, t. 1, 128.

Rousseau 1964, 309 mentionne qu'une sous-espèce maintenant disparue, *Bison bison pennsylvanicus*, se trouvait autrefois de l'état de New York jusqu'à la Georgie sur la côte Atlantique.

Le *pichikiou* est presque aussi gros qu'un éléphant; il est du moins* plus gros plus long, plus membru que ces puissants bœufs de l'île de la Camargue en Provence; il en a toute la figure, mais son poil est bien différent, étant long d'un demi-pied, frisé comme celui [f. 89] des plus beaux barbets. Le poil de ce bœuf est tout noir à l'extrémité, le reste est de couleur de bure*. Il a la tête longue, large et fort grosse; les yeux le sont aussi. Son mufle est fort proportionné à tout son corps, c'est-à-dire, qu'il est bien large. Sa corne est grosse, longue et noire, bien tournée, et elle orne bien son animal. Elle est un peu tournée en vis; elle est bien plus longue et bien plus grosse que celle des plus grands et plus vieux bœufs de nos bœufs.

Nos étrangers font gloire dans plusieurs rencontres* (comme j'en suis témoin oculaire) d'en porter sur leurs têtes, et ils croient d'être bien parés de cet ornement, dont on fait un grand sujet d'injure ailleurs d'en parler seulement.

La queue de l'animal est bien fournie d'un beau crin noir; elle est longue et traînante. La nature l'a ainsi avantagé d'une queue fort longue pour s'en servir à chasser les mouches qui sont malignes* dans les pays chauds et qui se logent opiniâtrement dans son long poil.

Quand il court et qu'il est en colère, il étend sa queue avec tant de force qu'il la tient bien raide, de manière qu'il ressemble plutôt à un taureau d'amphithéâtre et de combat / qu'un bœuf errant dans des vastes prairies de quatre cents ou cinq cents lieues de long et au-delà, jusqu'à la mer de l'Ouest /.

Il semble avoir sur ses épaules une selle de cheval, mais ce n'est qu'une grande bosse naturelle qu'il a comme une belle éminence* qui ne laisse pas de le faire paraître fier et affreux.

La chair est grossière mais bien solide, et elle est d'un même goût que celle de nos meilleurs bœufs; sa graisse est toute semblable, c'est-à-dire qu'elle est jaune comme le plus bel or du Pérou ou du Brésil.

Les chasseurs en font des prodigieux amas pour en faire des festins et pour s'en servir comme si cette graisse était le meilleur et le plus excellent beurre du monde, pour assaisonner leur gros bled d'Inde, qui est fort insipide sans quelque assaisonnement.

La femelle du *pichikiou* est si feconde qu'elle porte ordinairement deux veaux, assez souvent trois, et enfin quatre, à mesure qu'elle est plus ou moins âgée. Il n'y a pas d'autre différence entre le mâle et [f. 90] la femelle que celle qu'on voit entre les bœufs et les vaches de nos terres.

L'usage de la peau de ces animaux est fort utile aux sauvages, qui, quoique d'ordinaire ils soient tout nus vers ces quartiers, ils ne laissent pourtant pas d'en faire de belles robes qu'ils estiment beaucoup plus que celles des peaux de castors ou de belles loutres. Les ayant passées d'un côté et laissant le poil de l'autre, ils y peignent mille figures grotesques. Ils n'ont garde d'arracher ce beau poil qui se voit sur ces peaux, s'en servant de couverture et de matelas, diverses nuits très froides qu'il fait dans leur pays chaud.

En un mot, cette peau leur sert à tout, et elle leur est fort nécessaire. Et peu de chose équipe bien un sauvage qui peut véritablement dire ce que disait ce philosophe ancien : «*Heu quantis non egeo!*, he! combien y a-t-il des choses dans le monde dont je n'ai que faire?», ou bien avec ce sage de la Grèce qui assurait qu'il portait sur lui toutes ses richesses : «*Omnia mea mecum porto*». Si ce Bias ancien a pu dire cela avec vérité, tous nos Indiens le peuvent dire de bonne foi, puisqu'ils ne sont attachés à rien qu'à vivre du jour à la journée sans se mettre en peine d'amasser rien ni de rien laisser, ni à leurs femmes ni à leurs enfants : aussi* ne les voit-on jamais quereller ni plaider pour le bien dont ils ne recherchent pas les avantages, comme les nations policées* que l'intérêt ronge jusqu'aux moelles, et d'une manière dont je n'ai rien à dire, tout le monde ne le sachant que trop, et particulièrement les pauvres qu'on opprime partout avec une violence qui fait gémir les gens de bien.

[F. 91] SEPTIÈME LIVRE

De l'orignak, qu'on appelle autrement l'élan, ou avec les Latins alces, *et avec les originaires du pays,* mouns[265]
L'élan, étant fort commun dans les vastes forêts de l'Inde, mérite bien qu'on ne l'oublie pas dans le traité des animaux à quatre pieds. Et puisqu'il fait la principale nourriture des barbares, les curieux seront à mon

265 *Alces alces* (L.), orignal (Banfield, 368–71 et Burt et Grossenheider , 218–20); un mâle, une femelle et trois jeunes sont représentés sur Pl. XXXVI, figs. 53.1 et 2 du *Codex*, où on les décrit comme «Elan ou caribou alces selon les Latins» et «femelle de leslan avec ses trois petis d'une seule ventrée»; pourrait s'inspirer d'une image en sens inverse de l'*Alces* de Gesner, 1621, t. 1, 1. Nicolas est dans l'erreur en l'appelant *caribou*. *Élan* ou *Alces* en latin, renvoie à l'élan européen, qui ressemble à notre orignal (Ganong, 215). Voir Rousseau 1964, 304–5 pour un exposé utile sur les appellations *orignak, orignal* et *orignac*.

avis bien aise de savoir presque tout ce qu'on peut dire de ce grand animal et les grands avantages que les habitants du Nouveau Monde en tirent, et comme* de là on en transporte les pelleteries en Europe et ce qu'on y en fait pour l'usage des hommes.

Je pense que pour bien commencer il sera bon que je donne d'abord la figure* de ce célèbre animal et que je dise qu'il est plus haut que les plus grands mulets, et qu'il s'en trouve quantité qui sont plus gros et plus gras que les plus beaux chevaux de carrosse. Ces avances* que je fais ici ne doivent pas surprendre personne puisqu'il est sûr qu'on rencontre de ces vieux habitants des vastes forêts qui marquent avoir bien des années : cela se connaît à leur bois qui marque leur âge à mesure qu'il y a plus d'andouillettes* au bord de ce grand bois.

L'animal est bien proportionné : il est long d'une brasse et demie, il a la tête grosse et longue, et a beaucoup de rapport à celle du cheval marin ou de l'hippopotame. Les yeux sont fort petits à proportion de la tête et ils ne sont point brillants, de sorte que cela fait paraître la bête stupide. La couleur en est noire. Il ne voit pas de loin. Il a le mufle extrêmement gros et fort large, aussi bien que deux naseaux fort ouverts. Il a l'odorat fin et il sent son ennemi de si loin qu'il peut le fuir aisément, mais comme il n'est pas trop effarouché dans le profond silence des bois, cet animal tourne la tête de tous côtés pour flairer, tandis qu'on l'approche pour le tuer. La nature qui ne lui a pas donné une vue si perçante a suppléé à ce défaut par l'odorat et par l'ouïe, qu'il a très fine, entendant de fort loin, ramassant* le son de ce qui fait du bruit avec l'organe de deux grandes oreilles plus longues et bien plus larges que celles de ces grands ânes de Barbarie.

Le bois de l'élan est tout différent de celui du cerf qui a le bois [f. 92] rond et fort long, entouré d'andouillettes* autant qu'il a d'années; mais l'élan a le bois plat et large comme une grande aile d'aigle éployée. J'en ai vu et mesuré qui avaient six pieds* d'ouverture ou de large d'un bois à l'autre. Ce même bois avait trois pieds et demi de hauteur. Ce bois tombe tous les ans à la fin de l'automne et c'est une chose fort curieuse de voir l'orignac pencher la tête tantôt d'un côté et tantôt de l'autre, selon que la moitié de son bois est tombée, et à mesure que ce bois tombe on en voit un autre qui se forme pour paraître au printemps plus grand que celui qui vient de tomber. Il paraît au travers d'une bourse qui croît à même temps que ce bois pousse comme celle d'un champignon qui s'enfle et qui se crève peu à peu, jusqu'à ce que ce fruit soit dans sa consistance et dans sa parfaite maturité, avec cette différence que l'un se fait dans quelques heures et l'autre seulement dans quelques mois.

L'orignac a le col* fort court : c'est la raison pourquoi il broute plus souvent qu'il ne peut paître, quoiqu'il fasse et l'un et l'autre. Il a le poitrail de vingt-quatre ou vingt-cinq pouces* de large / du moins* /, les épaules sont notablement plus élevées que le reste de son corps, et il semble être harnaché d'une selle de cheval. Sa croupe n'a guère moins de trois pieds de large, et quand il court il relève sa courte queue comme le cerf; aussi* l'a-t-il semblable. Il a les jambes grosses et fort hautes. Depuis le bout de la corne du pied de derrière jusqu'au haut de la hanche, il n'a guère moins de cinq ou six pieds de hauteur. Le devant est un peu plus bas à la réserve* de la bosse qu'il a sur les épaules. Ces quatre jambes sont fort bien proportionnées à tout le corps. Il a le pied fendu comme le bœuf. La corne en est noire et bien luisante (j'en peux faire voir dont je me sers pour soulager ceux qui sont attaqués du haut mal*). Les huit ergots qu'il a sur ces quatre jambes sont gros à proportion de l'âge de la bête. Tout le dessous de la corne du pied est fort tranchant et cela sert à l'animal comme de grappins de fer pour se pouvoir soutenir, marcher, et même courir sur les glaces les plus glissantes. Et même souvent, il écarte autant qu'il peut son pied fendu, l'entrouvrant pour se soutenir sur les neiges quand elles sont fortes par la gelée, afin de n'y point tant enfoncer.

L'animal a fort bonne grâce quand il est dans son embonpoint*. Il est beau pendant l'été, n'ayant point le poil, ni si long ni si hispide* qu'il l'a en hiver. Il a comme [f. 93] une grande barbe tout le long de la mâchoire d'en bas. Elle diffère de celle du bouc, qui l'a comme plate, celui-ci l'ayant longue et continuée jusqu'au milieu du poitrail. Et pour mieux le comprendre, il faut considérer que cet animal a sa jube* tout au contraire du cheval qui l'a sur le col, et celui-ci dessous.

Dans la belle saison de l'été, le poil de la bête est fort ras et tout noir. Un peu de temps après, il devient gris et insensiblement il redevient noir en automne, et il continue dans cette couleur durant tout l'hiver; il est pourtant entremêlé de quelques poils gris, jaunâtres et blancs dont les femmes font de beaux ouvrages, comme je le dirai plus bas.

On voit quelquefois des orignaux blancs comme des cygnes, mais cela est rare. Quand par hasard les veneurs en tuent quelqu'un, ils en font sacrifice au soleil.

Il y a quelque temps que, naviguant sur le fleuve de Saint-Laurent, pour entrer dans la grande rivière du Nord, qui a trois cents lieues* de course, et de là étant arrivé (par la rivière de la Fourche et après avoir traversé le lac de Nipissing et descendu la furieuse rivière des Français) dans une grande île de la mer Douce, je

trouvai la tête et les pieds d'un de ces animaux blancs pendus à la cime d'un grand arbre, qu'il fallait couper pour renverser cet anathème* offert au soleil par la nation du Castor et par celle de l'Outarde qui adorent cet astre. Ce sacrifice avait été fait par une dévotion toute particulière de ces deux nations qui, allant à une foire qui se tenait à cinq cents lieues de leur pays, voulaient par cet acte d'idolâtrie prier le soleil de leur faire la grâce de faire un bon voyage.

Outre le poil noir, le gris et le jaunâtre dont toute la robe de l'animal est couverte, on en trouve de couleur verte dans le milieu de la fente des quatre pieds. Voilà le portrait extérieur de l'élan.

Presque toute l'Inde occidentale et toute la septentrionale nourrissent des élans. L'animal fréquente les sapinières; il aime aussi les beaux et les francs bois où il se tient pendant le froid, et s'il n'est lancé* avec violence jusque sur les glaces ou sur le trajet d'une grande rivière, il n'abandonne pas les bois. Le chasseur est si adroit qu'il le mène souvent jusqu'à la porte de sa cabane pour lui donner le coup de mort.

Notre animal ne tient point le bois quand il fait chaud : il se tient à l'orée et au bord des lacs, des rivières ou de la mer. En ce temps, il quitte les bois pour fuir l'étrange* persécution des mouches qui l'obligent de se jeter souvent dans l'eau pour se délivrer de ces tyrans et de ces voleurs de la patience des hommes et des bêtes, de ces ivrognes de sang et de ces persécuteurs. On voit communément des bandes d'élans qui paissent autour ou au milieu des grands marais et au milieu des prairies; et quelquefois ils viennent paître dans les champs des Français où l'on les tue.

[f. 94] Pendant le temps que les terres sont couvertes de neige, l'animal fait comme une espèce de lit bien différent de celui du bœuf; et voulant dormir, il s'appuie sur le bout de son gros mufle. C'est pour cela que la nature lui a formé sur le bout du museau une peau sans poil qui est fort dure et comme un callus* qui l'empêche de se blesser en appuyant sa grande et sa lourde tête sur la neige ou sur la terre. Les neiges étant fondues et le beau temps venu, on prendrait cet animal pour une bête d'amphibie en la voyant vautrer continuellement dans l'eau ou nager en faisant des trajets de trois ou de quatre lieues d'un bord de rivière à l'autre ou d'une île à l'autre. On est quelquefois agréablement surpris au milieu des bois lorsqu'on y rencontre des grands chemins battus, et si on n'était pas persuadé qu'on n'est pas auprès de quelque ville, on croirait qu'on est aux portes, se trouvant dans des chemins si battus. Ce sont les élans qui, passant et repassant à foule pour aller à l'abreuvoir, battent ainsi ces chemins. En

d'autres endroits, on voit tant de leurs pistes lorsque la terre est mouillée, tellement que vous diriez que toutes les vacheries* du célèbre Cantal en Auvergne ont passé par les chemins où vous vous trouvez, et où il ne ferait guère bon quand ces bandes d'animaux passent, car on s'y trouverait embarrassé au milieu des combats et des coups de cornes. C'est dans ces mêmes endroits que les sauvages font des grosses chasses avec leurs lacets*. J'en dirai un mot en son lieu.

Le viandis* ordinaire de l'élan est le brout* du sapin. Il s'attache aussi à un certain arbre qu'on nomme à cause de cela l'*arbre de l'élan*. Il mange de la terre glaise et plonge à la hauteur de vingt pieds pour s'en aller repaître au fond des eaux de cette terre et d'une certaine herbe qui ressemble au tussilage.

Vers la fin du mois d'août, ce grand coureur de bois et animal de passage entre en rut, et sa femelle, qui ne diffère en rien de lui qu'en ce qu'elle n'a point de bois, lui produit un faon les deux premières années qu'elle met bas, vers la fin du mois de mai; les autres années, elle en porte deux d'une ventrée* et assez souvent trois.

Je ne sais quel nom donner au cri de l'*alces*, car ce n'est pas un meuglement, ni un hurlement : c'est un certain bruit sourd qui rapporte* beaucoup au bêlement d'un gros bouc, que cet animal varie avec mesure, le traînant quelquefois, et d'autres fois, le coupant fort court. Il semble seulement former les deux lettres suivantes : h.e., [f. 95], lesquelles il redouble souvent, les distinguant tantôt par un avant âpre, et tantôt par un doux.

Il est temps, après tout ce que je viens de dire, de mettre aux trousses de ce grand animal un veneur armé d'un bon fusil ou d'un arc avec des flèches, d'un dard ou d'une longue épée attachée sur le bout d'un quart ou d'une demi-pique* pour en percer ou pour en darder sa proie. Voyez-le, si vous voulez, armé d'une grande pierre à feu taillée en forme de pertuisane*, fortement collée au bout d'un javelot avec de la colle d'esturgeon.

Chargeons, si vous l'agréez, notre chasseur d'un gros paquet de lacets qu'il tendra à l'endroit où il a découvert les voyées* de la bête. Il ne faut pas oublier de le fournir d'une bonne hache et d'un grand couteau de boucher. Avec cet attirail, il fera des merveilles et des étranges prises ou de terribles massacres* de plusieurs élans.

C'est donc ici le véritable lieu de donner la connaissance de toutes les façons dont le sauvage tue et chasse les orignaux.

La plus aisée et la plus assurée méthode de chasser l'élan est d'être muni d'une bonne paire d'excellentes

raquettes et des armes dont j'ai parlé, d'une bonne boussole ou du moins d'une forte idée pour savoir se conduire dans les bois et pour en ressortir quand on veut sans s'y égarer. Pour le sauvage, il est sûr qu'il ne s'y perdra jamais, et il n'a que faire que d'une arme et de quelque méchante* peau pour s'entourer un peu au milieu des plus rudes frimas. Dans cet équipage*, il cherche à droite et à gauche la piste d'une bête qu'il ne manque guère de rencontrer, et souvent en tel nombre qu'il a bien de la peine dans le ravage* que font plusieurs animaux d'en démêler les différentes routes.

Mais enfin, étant entré dans les voyées, il court si droit dessus la bête qu'il la découvre bientôt; et selon que les neiges sont hautes et plus ou moins fortes, molles ou dures, le chasseur fait la curée de toutes les bêtes qu'il lance*, de peur que le sang qui extravase ne corrompe la chair et afin que, la chaleur s'évaporant, rien ne se gâte. Que si dans la course le veneur s'était trop altéré, il boit le sang du premier animal qu'il renverse, et si c'est une femelle qui allaite, il en boit le lait, lequel à mon avis est le meilleur lait du monde, bien épais et bien sucré. Je le sais pour en avoir bu en telles rencontres* des plains plats, et je ne me mettais guère en peine s'il y avait quelque peu de sang mêlé : la faim n'a horreur de rien.

La bête étant éventrée, le sauvage veneur en prend le cœur, la langue ou la tête pour montrer qu'il a fait massacre*. Et de peur que la bête ne gèle, il la couvre de neige. L'expérience lui a appris ce secret et s'il y manquait, il ne pourrait plus, le lendemain qu'il vient quérir* la viande des bêtes tuées, les écorcher parce qu'elles seraient gelées dur comme du fer.

[f. 96] La chasse des autres armes n'étant guère différente de celle de l'épée avec laquelle je suppose que le veneur a tué les bêtes en les dardant d'un peu loin ou en les perçant de trois ou quatre pas, l'on voit assez comment on fait le massacre de l'orignac sans que je donne aucun autre éclaircissement, mais la chasse du fusil étant un peu différente des autres, aussi bien que celle des lacets*, il en faut dire un mot en particulier.

Outre l'usage ordinaire du fusil, on entend souvent dans les chemins battus de la piste de l'orignac, lequel, y passant sans rien découvrir, se tue lui-même en faisant détendre, par le moyen d'une corde qu'on a ajustée pour faire lâcher le fusil, qui doit blesser la bête dans une partie noble* dont elle doit mourir, ou sur la place ou bien proche de là, le chasseur ayant tellement bien disposé son fusil que cela ne manque jamais de tuer ce qui passe à l'endroit où est le fusil. Cette chasse est dangereuse et il arrive des accidents fâcheux. Du temps que j'étais dans les Indes, une femme passant à l'endroit où

il y avait un fusil tendu fut tuée. J'ai vu un jeune homme qui eut la jambe fracassée. On a défendu cette chasse dans les habitations* françaises.

La chasse des lacets, qu'on appelle, parmi nos Français, la chasse des *collets*, est bien plus innocente* et il n'y a nul danger pour les hommes. Il n'y a pas à craindre que le chasseur soit ni foulé*, ni attaqué, ni tué de l'élan comme il y a du danger dans les autres chasses.

C'est dans cette façon de chasse que les sauvages sont bien aise, à cause de la grande facilité qu'ils ont à prendre les élans dans toutes les saisons de l'année. Avec l'élan même, ces barbares, qui n'ont que le nom de sauvage, ont trouvé l'invention de faire des cordages très forts de la peau de l'orignac qu'ils coupent en longues courroies. Et faisant comme les cordiers pour les entortiller, ils font des lacets plus forts que de grosses cordes. Ils font sécher ces cordages, et de peur que la pluie ne les remouille, ils les entourent proprement* de l'écorce de bois* blanc. Ils attachent enfin leurs lacets à de fort grosses et à de fort longues perches du bois le plus fort qu'ils peuvent trouver, et laissant au bout un nœud courant, ils élargissent le collet en figure d'ovale, aussi grande qu'il faut pour que l'orignac y passe son col et qu'il ne puisse plus se dégager, et qu'en courant, la corde au col, il traîne la perche, qui, s'embarrassant d'abord* entre les arbres, l'élan se forçant en tirant, il s'étrangle lui-même.

[f. 97] J'ai eu le plaisir de me trouver à cette sorte de chasse et de voir l'animal s'étrangler avec grande violence.

[Cinquième cahier de l'Histoire naturelle de l'Inde occidentale]

On prend de cette façon dans bien peu de temps les trente et les quarante orignaux, car le long d'une seule haie que les sauvages feront de demi-lieue, ils placeront à divers passages vingt ou trente collets, où infailliblement les orignaux vont s'engager*. Ne sautant jamais par-dessus la haie, ils coulent tout du long jusqu'à ce que, trouvant un passage qu'on pratique à dessein et où l'on met un lacet pour y engager la bête, qui n'en échappe jamais s'y engageant.

Enfin la dernière industrie* du sauvage, pour prendre l'élan et pour le massacrer d'une manière la plus agréable du monde, est de le pousser dans l'eau ou de l'y rencontrer, ce qui arrive très souvent lorsque les mouches règnent pendant trois mois dans les bois, d'où elles font sortir ces animaux en foule. C'est un plaisir de roi de se voir dans un canot à la poursuite de

trois ou quatre grands élans sur lesquels nos sauvages sautent quelquefois hardiment par plaisir et pour leur donner le coup de mort quand il sera temps, auparavant* que l'animal puisse prendre terre. Ils se contentent d'autres fois de leur faire faire mille caracoles où ils voltigent tout autour dans leurs canots avec vitesse pour détourner l'animal et le faire prendre port* à l'endroit le plus commode pour le tuer. Ils le prennent souvent par le bout de l'oreille pour le conduire au lieu où il faut faire le massacre. Il faut toujours leur donner le coup de mort auparavant qu'ils puissent prendre pied sur terre, car autrement l'animal, qui est fort, coulerait à fond le petit bateau d'écorce.

Un certain honnête homme, marchand à Quebek, se trouvant un jour dans l'occasion* de cette chasse entre* les îles du lac Saint-Pierre, voulut avoir le plaisir de tuer une fois en sa vie un élan : en trouvant un qui traversait d'une île à l'autre, [il] fit donner* dessus par les matelots qui conduisaient sa barque. L'ayant atteint, il le fit attacher par le col avec un câble et tirant à terre, où il voulait avoir la satisfaction de le tuer, tendant un peu trop et donnant le loisir à la bête de prendre terre et ne prenant pas garde qu'il était sur le câble avec lequel on avait attaché l'élan, qui ayant pris terre, s'efforça de se sauver avec tant de force et avec tant de vitesse que, faisant défiler le câble, il fit tomber le marchand dans sa barque; et comme l'élan tirait toujours, il fallut couper le câble pour sauver le marchand et laisser sauver l'élan la corde au col.

[f. 98] Il est temps après tant de différentes chasses et il est juste qu'après avoir tué tant d'animaux nous fassions la dissection ou l'anatomie* de l'élan puisque je m'y suis engagé. Je vais commencer par la chose la plus intérieure qui est la moelle, pour finir par la peau qui est l'autre extrémité de l'animal et la plus extérieure.

L'orignac ayant des grands et des forts gros os, l'on juge bien d'abord qu'il doit avoir beaucoup de moelle, qui est fort recherchée pour deux ou trois usages.

Le premier est qu'elle est excellente et d'un très bon goût à manger, même toute crue quand l'élan vient d'être tué. Elle est encore meilleure cuite, et si on la fait fondre, il n'y a point de beurre qui soit ni si doux, ni si délicat; que si enfin on la laisse refroidir, on en fait des petits pains qu'on mange avec appétit.

Secondement, elle est fort recherchée pour adoucir les douleurs de la goutte. Etant mêlée avec un peu d'eau-de-vie, elle soulage merveilleusement de toute sorte de douleurs. Ceux qui la savent raffiner la font devenir plus blanche que la plus belle cire de Montpellier. J'en ai raffiné beaucoup que j'envoyais à mes amis en France. Cette même moelle assaisonne bien toutes

sortes de sauces et elle est très bonne à fricasser. Quelques-uns en ont fait des chandelles qui éclairent beaucoup mieux que les nôtres. J'ai vu fort souvent plusieurs sauvages qui en avaient réservé* dans un hiver plus de cent livres chacun. C'est de bonne foi le meilleur ragoût* que ces gens aient : aussi l'estiment-ils beaucoup. En divers pays où j'ai été, une pleine vessie de moelle se vend deux robes de castor. Et pour une grande marque que la moelle de l'*alces* est fort en recommandation*, les barbares croient de faire un grand présent à un ami s'ils lui en donnent quelques livres : c'est un présent parmi eux digne à faire à des ambassadeurs qui viennent traiter de paix dans leur pays.

L'os de l'élan est aussi d'un grand usage parmi les Indiens, car 1º ils en arment leurs flèches de plus de douze manières; 2º ils en font des alênes, des aiguilles, des poinçons et plusieurs rares* instruments à faire leurs peintures; 3º ils s'en servent pour écorcher les ours, les castors, les loutres et les rats musqués; 4º ils en passent* ou habillent* les peaux de la bête même, ils en fabriquent des dés à leur manière, des manches de couteaux, des ornements à leurs massues, des cuillères pour manger leur soupe et mille gentillesses* qu'ils pendent au col de leurs enfants. Les femmes même s'en [f. 99] parent. On trouve mille petits ustensiles* faits des os dans les cases; on y voit des dards et des harpons pour darder les loups et les tigres marins, des esturgeons, des brochets que deux hommes auraient peine de porter, et des grosses truites qui pèsent les cinquante livres; 5º les faiseurs de chapelets, et particulièrement les sculpteurs, en feraient des pièces recherchées parce que l'os est fort gros, bien net, long et blanc comme de l'albâtre; au lieu que nos sauvages, dans la grande multitude qu'ils en ont, ou ils les abandonnent, ou ils les brisent avec des pierres ou avec la tête des haches pour les faire bouillir et ensuite en tirer une certaine huile ou une certaine graisse qui ne se fige point pour s'en engraisser tout le corps, mais particulièrement le visage et tous leurs grands cheveux à la mode des juifs qui s'oignaient autrefois avec d'autres liqueurs*. Ils ont donné le nom de *roûmin koûan* à ce précieux baume des Indes qui est de bonne foi d'un goût recherché.

Le boyau, que les Grecs appellent πιπλοον [*épiploön*], nos médecins, *culum*, ou le *boyau culier*, est d'un goût exquis. Il est plus gros que le bras d'un grand homme. Il est d'une graisse fort fine qui est fort bonne à manger et qui ne laisse point de dégoût sur le cœur. C'est pour cela qu'on en fait des ragoûts admirables dans les bois, et voici comment. Les Indiennes ne font que le presser un peu pour en faire sortir, vous m'entendez* bien, et sans prendre la peine de le laver, elles

le tortillent pour le faire cuire de la manière dont je donne ici la figure.

Et, y entrelardant trois petits bâtons pour le tenir ferme et le pendant avec une attache à un bâton qui sert de crémaillère, elles le font tourner et retourner jusqu'à ce qu'il soit cuit. Et enfin les chasseurs en font un festin de conséquence, en donnant à chacun des invités un pied de long. L'épicerie* qui a resté dedans sert de haut goût* et de moutarde.

Pour les autres boyaux, ils se mangent sans façon, mêlés avec du sang dont on fait des bouillons que les sauvages nomment la *boisson de sang, miskoûioûaboû*, qu'ils estiment, disant que cette sorte de bouillon est fort nourrissante. Tout est fort bon pour des gens qui n'ont pour toute sorte d'aliments rien que de la viande ou du poisson qu'ils font cuire à demi et de la neige ou de l'eau la plus fraîche du monde tant qu'il leur plaît à boire.

[f. 100] On aura de la peine à se persuader une chose qui ne laisse cependant pas d'être véritable parmi les errants des bois, qui ont quelquefois une si grande disette de vivres qu'ils sont obligés d'assaisonner leur pot* de la fiente des animaux, et que la faim leur fait trouver tout bon et même cette sauce verte. Je connais fort particulièrement un Français qui, se trouvant en caravane avec les sauvages, a souhaité mille fois ce que l'enfant prodigue désirait : il aurait plongé sa tête dans une auge d'animaux immondes pour y attraper quelque tronc de chou pour rassasier sa faim. Et je puis dire par ma propre expérience de bien des années que, dans ces pays étrangers où l'on ne mange point de pain, on sent éternellement je ne sais quelle faiblesse et quelle certaine grande défaillance, accompagnée d'une continuelle faim canine* qui ne provient que de ce défaut* incompréhensible de vivres nourrissants. J'ai pris assez souvent un grand plaisir de voir et d'entendre les nouveaux venus de France qui protestaient* qu'il leur serait impossible de mener* et de vivre à la manière des sauvages et qu'ils avaient une grande répugnance de voir seulement leur saleté à manger. Mais enfin, dans l'occasion, ils s'y sont faits par pure nécessité, comme les autres vieux habitants* et inséparables compagnons des Indiens.

La panse ou l'estomac de la bête est assez nette si on la tourne un moment pour la racler et pour faire tomber le plus gros de la matière qui est dedans. L'eau qui fait cuire cette partie de l'animal et qui en devient toute verte et épaisse comme de la bonne purée, et qui est une des meilleures boissons des sauvages, nettoie assez cette grande panse d'un puissant animal. L'écume même qui en sort est un ragoût recherché par ceux qui sont autour du pot, qui la boivent avec plaisir, rejetant dans le même pot ce qui leur en reste, de peur que rien ne se perde (cette partie de l'animal s'appelle *ouinas-sak*, qui veut dire en notre langue un sac puant). J'ai vu un capitaine qui avait choisi ce nom comme illustre.

Les rognons, qui sont fort gros, sont excellents rôtis lorsqu'ils sont couverts d'une belle graisse fort blanche.

La rate, le foie et le poumon ne sont pas de trop bon goût. Pour le foie, il a une qualité toute particulière pour blanchir les peaux qu'on passe.

L'*épiploön*, pour dire un mot à la mode des médecins grecs ou la toile ou la crépine qui entoure tous les boyaux est grande comme une belle nappe; elle est blanche, forte, et d'un bon goût.

[f. 101] Toute la chair de la bête, généralement parlant, est d'un fort bon goût et d'une très facile digestion : elle n'est ni grossière, ni pesante, et l'on en peut manger beaucoup sans craindre qu'elle charge l'estomac ou qu'elle fasse mal, n'étant même que demi-cuite et toute sanglante.

Un certain Talaon, Américain, en mangeait de bon appétit tout un quartier sans être incommodé. Et je puis dire que je ne connais point de venaison au monde qui approche de la bonté* et de la délicatesse de la chair de l'élan. La chair du cerf est bien plus dure, plus pesante, plus grossière et plus indigeste; celle du sanglier ne / lui est / pas comparable. Les Européens, qui sont bien mieux / accommodants* / que les Américains et qui ont des épiceries, en font des pâtisseries et des ragoûts très délicats.

Le cœur de l'orignac passe pour un morceau recherché parmi les veneurs, et ordinairement ils en font un sacrifice dans les festins à Kiigouké, qui est le dieu du jour. On trouve un os au milieu du cœur qu'on dit être bon pour empêcher ou pour guérir des fièvres. On en pend au col des enfants.

La croupe de l'animal et le bout de la queue sont des rares morceaux quand il est gros. Les veneurs en font des prodigieux amas pour s'entrefestiner et pour sacrifier le tout au dieu qui préside à la chasse, qu'ils appellent *Keoussetch*, qui veut dire le chasseur. Et s'ils veulent conserver longtemps les bons morceaux destinés à honorer le dieu des veneurs, ils les font sécher à la fumée, et c'est ce qu'on appelle *boucaner*.

Le brechet, qui veut dire le poitrail, et les plats côtés, qui sont la chair qui se trouve justement entre la peau et les côtes, sont de bonne foi des morceaux friands. Si la bête est dans son embonpoint* quand on la tue, les chasseurs en font de si grandes provisions qu'on en voit des tas de plus de mille bêtes dans des magasins de deux ou trois familles qui ont travaillé tout un hiver à les boucaner*. Je me suis trouvé dans des festins où l'on distribue de six à sept cents animaux à la fois.

C'est le commun* emploi des femmes des chasseurs de courir dans les bois pour aller écorcher les animaux et d'y faire le choix de tout ce qui est bon et d'abandonner tout le reste de l'animal pour la curée* des chiens; les corbeaux, les loups et les renards en profitent.

Imaginez-vous donc de voir au milieu des bois ces charcuteuses et ces belles faiseuses d'anatomie des élans que leurs maris ont tués, qui choisissent tous les meilleurs morceaux qu'elles traînent sur les neiges dans leurs cabanes pour les y boucaner de la manière que je vais dire.

La boucanière ressemble plutôt à une mégère qu'à une femme. Elle a la tête puante, chargée de graisse dont elle se frotte tous les jours, les manches retroussées ou les bras nus, aussi bien que les pieds et les jambes. Les peaux dont elle se [f. 102] couvre sont toutes ensanglantées. Tout leur visage est couvert d'une crasse fort noire et fort puante, qui, se mêlant avec la graisse qui coule de toutes parts, fait un horrible fard qui ferait fuir de bien loin ces illustres précieuses, si seulement elles voyaient ces bouchères, qui donnent plutôt de l'air* aux faunes, aux centaures ou à ces satyres qu'on nous dépeint dans les fables qu'à des femmes.

Qui n'aurait pas de l'horreur de voir, joint* à ce que je viens de dire, des morceaux de viande au fond d'une cabane, rangés à terre, remplis de poil de la bête et des chiens qui, après s'en être soûlés, se couchent dessus? Un enfant de l'autre côté qui a les mains comme un Maure à cause* qu'il les a couvertes de crasse, qui pleure comme un désespéré parce qu'il veut

manger, tenant un couteau, et s'efforce de couper quelque lopin* de viande pour le jeter un moment sur les charbons et le dévorer ensuite. Un autre se salit sur les genoux de sa mère qui l'essuie avec la main, et sans prendre la peine de les laver, poursuit son ouvrage commencé et apprête ses viandes pour les poser sur des perches à la fumée et pour les tourner de temps en temps sens dessus dessous afin que la fumée, agissant plus vite, elle se puisse plutôt* sécher. Et pour faire que ces chairs se pressent davantage, la sauvagesse les foule sous les pieds qui sont fort sales et pleins d'ordures si vilaines que je n'ose pas en parler. Et cependant il faut manger de ces ragoûts et de ces poivrades ou mourir de faim. Et enfin nos boucaniers, pour presser leur boucan, percent en mille endroits, avec de petits bâtons pointus, leurs quartiers de viande pour les faire sécher plutôt par le moyen de la chaleur et de la fumée qui, passant par ces trous qu'elles viennent de faire, la chair sèche beaucoup plus vite qu'elle ne ferait.

Pendant que le boucan* se fait, la chaudière bout de son côté, et comme j'ai dit, de peur que rien ne se perde, on profite de l'écume qu'on prend avec une cuillère fort grande. Que s'il en reste un peu on la rejette dedans et on y lave même ces rares instruments de batterie de cuisine. J'ai passé tout un hiver à manger et à boire du bouillon où telle viande avait été cuite et où un enfant qui avait les écrouelles* fluentes* faisait ce beau métier* vingt fois le jour. Cependant, Dieu merci, je n'ai pris aucun mal, et il se faut faire à cette vie ou renoncer au plus noble métier du monde qui est de prêcher Jésus-Christ à des infidèles qui n'en ont nulle connaissance. On s'accoutume si fort, par la grâce que Dieu donne, à cette manière de vivre, que rien ne rebute que de n'avoir pas souvent de quoi manger de ces viandes si proprement apprêtées et de boire de ces bons consommés. / C'est la vie que mènent dans ces pays les missionnaires jésuites et ceux qui veulent les imiter. / [266]

La vessie de l'orignac est une pièce de trop grande importance pour n'en dire pas un mot. Elle est si utile aux chasseurs qu'à peine pourraient-ils s'en passer pour l'appliquer sur des brûlures et sur des écorchures, et pour y mettre dedans les graisses et moelles fondues de la bête, et pour s'en servir de bouteilles aussi bien que [f. 103] d'une autre partie de la même bête dont ils usent pour les mêmes effets* : c'est le gosier, qui, étant fort gros et étant soufflé comme un boyau, tient deux pintes* d'eau-de-vie.

266 On trouvait déjà, en 1634, chez le jésuite Paul Le Jeune une description semblable de «ce qu'il faut souffrir» en vivant et mangeant avec les Sauvages (*Jesuit Relations*, t. 5, 242–8).

La tête est la meilleure partie de l'animal, tout y étant fort bon. La langue est un mets très exquis, et sans autre apprêt que de la faire bouillir. Elle a plus d'un pied* et demi de long et elle est grosse comme le bras d'un grand homme. Tel sauvage en mange plus de cent dans un hiver.

Le mufle, qui est fort grand et fort large, n'est pas d'un goût moins exquis, et sans autre façon que de le flamber et de le faire bouillir, il est très délicat. La chair, ou plutôt une certaine graisse bien fine et fort blanche, est si douce et si succulente qu'elle réjouit à même temps le palais et fortifie le cœur. Elle est un peu gluante, mais sans importunité, et la gelée qu'on en fait n'est pas comparable à celles qu'on voit sur les meilleures tables, de diverses couleurs.

Les yeux, qui paraissent petits sur la bête avant qu'on la tue, sont gros comme les plus grandes pommes de reinette et d'un goût bien plus fin que les yeux de veau. Tout le reste de la viande de la tête est bonne, mais singulièrement ce qu'on enlève depuis les oreilles jusqu'au bout de la gueule.

La cervelle est délicate comme celle du veau, mais on en trouve bien peu dans une si grande tête comme est celle de l'élan. Et c'est pour cela que je pense que l'animal est si stupide, son crâne étant furieusement épais.

Les médecins disent que le pied gauche du train de derrière est souverain pour l'épilepsie, mais de mille qui le disent, il n'y en a pas eu un qui ne le dise par rapport, sans en avoir fait nulle expérience. Et moi j'assure par expérience que la partie extérieure de la corne des deux pieds de derrière a le même effet et j'avoue d'avoir été recherché de bien loin pour en fournir, à quelque prix que ce fût, une petite parcelle, pour donner à une femme travaillée du haut mal. Je le fis avec d'autant plus de plaisir que j'étais sûr que ces personnes venaient me rechercher après avoir appris l'admirable guérison d'un prieur d'une fameuse chartreuse du Languedoc, que j'avais guéri, quoiqu'il fût vieux, dans la première prise que je lui donnai d'une partie du pied d'élan que j'avais pris sur la bête dans les Indes, avant que de revenir en France, où j'ai eu jusqu'à huit louis d'or d'une partie d'un véritable pied d'élan dont j'en garde encore la moitié, qui est la partie que j'ai dit. Plusieurs s'en servent inutilement, faute d'en savoir* l'usage et l'application, mais comme je n'ai jamais été intéressé, je donne ici la manière d'user de ce remède afin que le public en profite.

La vertu* du pied de l'élan, pris dans les deux extrémités des pieds de derrière indifféremment, comme j'ai dit, est si grande qu'il faudrait un volume pour en bien discourir : et / pour la faire / acheter non pas au prix de l'or mais au prix des diamants, [f. 104] des pierreries les plus estimées, de l'ambre gris, mais même de tout ce qu'il y a de précieux ensemble, car premièrement ce pied a la vertu de guérir du haut mal, appliqué sur le cœur, en faisant faire d'une partie un anneau qu'on portera au doigt annulaire de la main gauche, et quand l'accès viendra, il faudra en mettre un peu dans la paume de la main gauche, qu'on fermera, en touchant d'une autre partie l'oreille gauche du malade.

La drogue* a un effet extraordinaire prise râpée dans un peu de l'eau distillée du lys des vallées qui est si célèbre dans l'Écriture, où il est appelé *lilium convallium*, qu'on trouve aisément dans toutes les haies des vignobles du Languedoc où cette eau distillée a plus de vertu qu'ailleurs / à cause du pays chaud /. Et afin qu'on ne soit pas en peine de savoir quelle plante ou quel arbrisseau est ce lys des vallées, c'est ce chevrotin* dont on fait tant de cas à Paris et dont la fleur est si belle et si odoriférante, mais qui ne peut pas avoir à Paris cette vertu qu'elle a dans le pays chaud où l'on distille cette fleur pour l'usage que je propose. On en peut trouver cependant de fort propres* à distiller à Paris si on les prend dans des endroits et dans des parterres où le soleil donne fort contre des murailles. Ces précautions suppléeront à l'effet que produit la chaleur des pays chauds sur le *lilium convallium*, qu'on appelle du *chevrotin* à Paris. Le nard de Celte a le même effet que l'eau distillée du lys des vallées.

La même corne du pied d'élan est fort bonne contre le mal qu'on appelle le *pourpre*. L'appliquant sur le cœur, elle expulse les vents renfermés qui incommodent tant de gens; elle arrête le flux de sang, prise râpée; elle guérit de la diarrhée et de la lienterie*; elle purge la bile noire, guérit toute sorte de vertiges, de fistules lacrymales, tue les vers, fait passer la colique, purifie les humeurs*, soulage les palpitations de cœur et le remet en son naturel, purge à merveille le cerveau, fortifie dans les défaillances du cœur et dans les faiblesses des jambes.

On a appris la vertu de la corne des pieds de derrière de l'orignac, de l'orignac même qui, tombant souvent du haut mal, pour se faire revenir, n'a qu'à se frotter l'oreille d'un de ses pieds : il se relève debout. Les veneurs ont remarqué cette propriété en chassant cet animal.

Il ne serait pas fort difficile de faire passer en France tous les ans plus de dix ou douze mille pieds d'élan par les vaisseaux qui trafiquent* dans un pays où l'on tue tous les ans plus de cent mille élans : pour un prix raisonnable, on en aurait autant que l'on voudrait. Et les personnes riches, qui sont touchées de ces maux fâcheux*, seraient bien aise* d'en faire venir si elles en

savaient les vertus, qu'elles pourront apprendre dans ces remarques fort recherchées*.

La vanité même des dames les plus curieuses se pourrait contenter, achetant de très beaux bracelets, qu'on fait de la corne des quatre pieds de l'élan, aussi reluisants que le plus beau jaiet*. Les épileptiques [f. 105] pourraient aussi user de ces bracelets, avec cette différence qu'il n'importe pour les dames de quelque pied que ce soit qu'ils soient faits; mais pour les malades qui en veulent user, ils devraient garder les règles que je donne pour leur usage.

Il n'y a pas jusqu'aux ergots de la bête qui ne soient d'usage à nos sauvages qui en font des colliers qu'ils estiment beaucoup. Ils en usent aux jarretières où ils en mettent plusieurs bien travaillés et enfilés à des petites cordes. Ils en font des espèces de roses, semblables à celles que les personnes de qualité portaient autrefois aux jarretières et au-dessus des souliers, où nos Indiens ne manquent pas aussi d'en mettre, ni sur le col-du-pied*, tout autour de la jambe. Dans cet équipage*, ces baladins, en marchant avec étude et à pas réglés, semblent jouer des castagnettes et d'autres ressemblent à ces lépreux qui demandent l'aumône avec des cliquettes* qu'ils auraient au bout des pieds.

De tout ce que je dis et de tout ce qui me reste encore à dire, on jugera bien que l'élan est à nos Américains occidentaux et septentrionaux ce que certains arbres sont aux Indiens orientaux, dans ou sur lesquels ils trouvent tout ce qui leur faut pour leur subsistance : ils y trouvent de quoi se nourrir dans les fruits, de quoi se vêtir dans les écorces et de quoi fournir à toutes leurs autres nécessités. / Et nos sauvages /, outre ce que j'ai dit de toutes les parties de l'orignac, je remarque que non seulement ils trouvent à vivre dans toutes les parties de l'élan mais même qu'ils y trouvent tout ce dont ils ont besoin pour leur entretien et pour leur ménage*; et ils se peuvent aisément passer de tout ce dont nous faisons tant de cas et dont nous ne saurions nous passer sans des incommodités notables.

Si le sauvage veut faire une cabane avec des peaux d'orignac, il le peut. Les Kilistinons, qui sont des peuples du nord, en construisent avec plusieurs peaux qu'ils cousent ensemble, et de cette manière ils font des tentes à loger trente ou quarante personnes; s'ils veulent du fil pour les coudre, ils en tirent du nerf même de l'orignac qu'ils font sécher.

Si les hommes de la nation des Vierges sont en peine de canot, ils n'ont qu'à coudre trois ou quatre peaux ensemble avec de la corde qu'ils font de la même peau, monter le tout sur un gabarit* de cèdre, et dans bien peu d'heures, ils ont un très beau bateau qui n'est pas ni fragile ni si tournant que ceux qui sont faits d'écorce, dans lesquels il y a mille dangers de faire tous les jours des tristes naufrages, quoique la navigation de cette sorte de bateau soit la plus prompte et la plus commode du monde, pouvant prendre terre là où l'on veut et quand on veut, et mettre son bateau en quelque endroit que ce soit à terre, pour le garantir de la fureur des vagues, des vents et des [f. 106] tempêtes, ce qu'on ne peut guère faire, du moins aisément, dans une autre sorte de bateaux, lesquels on perd très souvent, les voyant briser sur les côtes et sur les plages ou / sur les / rivages des rivières quand la tourmente est un peu trop violente. Il peut enfin, de son bateau de peau, faire comme les patrons de Lyon, lesquels, arrivant à Avignon ou à Beaucaire, ou plus bas le long du célèbre fleuve du Rhône, vendent leurs bateaux au terme de leur voyage; et nos sauvages faisant la même chose, après un usage qui leur a été utile, vendant leur canot de peau d'élan, ils en tirent des bonnes denrées* des Français qui ne tardent guère à démonter ces bateaux pour replier les peaux, les faire sécher pour les porter au magasin des marchands qui leur en donnent ce qu'elles valent; ou bien ils les réservent* eux-mêmes pour les envoyer à leurs frais en France où ils y trouvent bien leur compte.

Si un chasseur a besoin de souliers, de bas-de-chausse*, d'un brayer*, d'une peau pour se couvrir, d'un bonnet, de mitaines, de manches, d'un justaucorps et tout ce qu'il vous plaira, sa femme, qui est bonne tailleuse, couturière et cordonnière, l'aura bientôt pourvu de tout cela, de diverses peaux d'orignac qu'elle mettra bientôt en œuvre.

S'il faut avoir des raquettes pour courir sur les neiges, dans trois ou quatre jours un sauvage et sa femme en auront bientôt bâti de la peau d'un orignac.

Si un guerrier veut monter un dard*, un arc et une flèche, la peau d'élan lui fournit des cordes pour attacher le dard, une corde pour l'arc et du fil de nerf pour ajuster ses flèches. S'il veut faire un bouclier en cuir, il en fait un de la peau de l'orignac, si grand qu'il s'en couvre tout le corps et si dur qu'il n'y a point de flèche qui puisse le percer.

Si un malade a besoin de cuissin*, d'un matelas, d'une couverture ou de telle autre chose, la peau de l'alces et le poil lui fourniront tout cela; que si le malade se plaisait à boire du bouillon qui ressemblât à un consommé ou à de la gelée, dans moins d'un quart d'heure il en aura avec des raclures qu'on tire du dedans de la peau et qu'on fait bouillir avec de l'eau. De cette même drogue, les dames du pays font une certaine colle propre à faire des belles figures et des riches peintures qu'elles font sur les peaux des élans passées en blanc.

Nos veneurs font mille sortes de cordages des peaux de l'orignac et s'en servent en tant d'autres usages [f. 107] que j'ennuierais si je voulais les rapporter tous.

Pour finir, je dirai seulement que tous les beaux baudriers, ceintures, ceinturons, avec ces belles culottes et tous ces rares colletins* qu'on appelle des *buffles** et qu'on voit sur le dos de nos dragons, de nos grenadiers et de nos cavaliers, et fort souvent sur le dos des plus braves et des plus généreux officiers, sont faits de cette belle peau d'élan qui prend tant de différentes figures*. Ces gros gants de prix sont faits de cette même peau.

Les plus polies dames sauvagesses et les plus adroites dans toute sorte d'ouvrage, après avoir tiré et après avoir séparé le poil blanc de l'orignac d'avec le noir, d'avec le gris et d'avec le jaune, en font des ouvrages bien rares et très bien travaillés.

Les Virginiennes, particulièrement, font paraître en cela leur adresse. Elles en font des sacs au petit métier, qu'on ne voit rien de si beau, des tours de tête, des bracelets, des jarretières, des frontaux* ou des colliers à porter des fardeaux qu'il est surprenant de voir combien tous ces ouvrages sont délicats et fort finement travaillés. On ne voit guère d'ouvrages qui soient ni plus variés de diverses figures de l'invention des ouvrières, ni mieux pratiqués. Et je ne sais si les plus habiles maîtres brodeurs des pays où les gens sont polis et où les métiers sont dans leur dernière perfection, feraient de plus beaux ouvrages en ces matières, ni si ces gens de la belle et de la plus forte idée pourraient trouver des plus beaux tours avec leurs crayons*, que font les dames iroquoises dans leurs ouvrages, qu'elles bâtissent du poil de l'élan auquel, outre les diverses belles couleurs naturelles qu'il a, étant blanc, noir, gris, jaune, vert, elles lui en donnent d'autres fort éclatantes par leurs teintures rouges, brunes, etc. Elles entremêlent le tout si agréablement qu'il n'y a rien de plus curieux.

J'ai dit qu'ayant commencé l'anatomie de l'élan par la moelle, qui est la partie la plus cachée, je finirais par celle qui se voit le plus, qui est la peau. En effet, je veux tenir ma parole et dire qu'outre toutes les raretés* de la peau de l'élan que j'ai rapportées, nos adroites ouvrières tirent encore du dedans de la peau un certain [f. 108] parchemin, qu'elles nomment *agouramak* : ce parchemin leur est d'un grand usage pour faire des sacs et des enveloppes pour faire leurs paquets.

Je n'ai rien dit du bel usage qu'on fait des grandes oreilles de l'élan où les chasseurs trouvent de quoi faire des bonnets dont ils usent* assez souvent. Certains jours dans l'hiver qu'il a neigé la nuit et que les branches des arbres, étant chargées de neige, incommodent extrêmement les veneurs, qui, passant dessous, secouent la neige qui, leur tombant dessus la tête, les empêche de faire chemin, les occupant à secouer cette neige, les bonnets qu'ils font des oreilles de l'élan les garantissant de cette incommodité, ils en usent.

La peau du *manichis*, qui est le faon de l'élan, est d'un usage incroyable pour les enfants auxquels on en fait des langes et des robes si rares et si bien peintes qu'il y a de quoi les admirer.

Les sacs à pétun* que les guerriers s'en font faire sont si mignons, si polis et si enrichis avec des peintures figurées qu'on ne voit rien de si précieux parmi ces gens, ni qu'ils estiment plus, ni qu'ils gardent plus soigneusement pour s'en parer dans l'occasion, et particulièrement quand ce *kaskipitagan*, qui veut dire sac à tabac, est brodé et figuré avec du porc-épic de différentes couleurs.

L'on peut voir donc, enfin, de tout ce que je viens de rapporter et de bien des choses que je pourrais dire encore, que la peau de l'élan et que toute la bête même est d'un grand usage, puisque la plus grande partie de l'animal jusqu'à la plus petite, dont j'ai bien voulu parler un peu plus au long que des autres animaux pour faire voir, à ceux qui me feront la grâce de lire ces mémoires, les grands usages et les grandes utilités de ce bel animal, soit pour l'avantage des Américains, du pays* desquels cet animal est habitant, soit pour les Européens qui en tirent des grandes commodités et les marchands, des grandes richesses, puisqu'ils ont presque pour rien des veneurs indiens ces rares et ces belles peaux, et même tout l'animal quand il leur plaît.

[F. 109] HUITIÈME LIVRE

Des animaux d'amphibie, et en particulier du furet qui vit dans l'eau et sur la terre

C'est ici où je dois parler des animaux aquatiques et d'amphibies. Et après vous avoir entretenu des terrestres, je donnerai le premier lieu* au furet d'eau[267],

267 Pourrait-il s'agir de la *Lontra canadensis* (Schreber), loutre de rivière, même s'il sera question de la *loutre* plus loin, au folio 112 (Banfield, 318–20 et Burt et Grossenheider , 60–3)?

lequel n'étant guère différent du furet qui vit seulement sur la terre, je n'en dirai rien autre chose, si ce n'est que son instinct naturel le porte à faire sa demeure ordinaire dans l'eau. Il y vit de poissons, de moules, d'huîtres. Il y tue le rat musqué et va faire la guerre au castor jusqu'au milieu de sa cabane où il le tue, tout petit qu'il est. L'autre furet, ayant inclination pour la terre, n'entre jamais dans l'eau, s'il n'y est poussé avec violence. Le poil et la figure* de cet habitant des eaux n'a rien de particulier. Les natifs du pays le mangent quand ils peuvent le tuer. Cet animal est long d'un pied* et gros comme le bras.

Du gros rat musqué[268]

Si jamais il y a eu quelque pays dans le monde où l'on a pu dire, avec vérité, que les rats y sont aussi gros et aussi grands que les chats, on le peut dire de bonne foi du pays des Indes occidentales où les rats sont, en toute dimension, aussi gros que les chats. Mais pour ce qui touche l'animal dont je dois traiter ici, je dirai que je ne sais pas pourquoi nos Français ont voulu donner le nom de rat à l'animal que je dois décrire et dont je donne le portrait* par une figure où j'ai, à mon avis, aussi bien rencontré* qu'on le puisse pour bien représenter l'animal. Il est vrai que le rat musqué – puisqu'il faut l'appeler ainsi – a deux extrémités semblables aux gros rats que nous voyons avec chagrin* dans nos maisons : il a les dents et la queue comme les rats. Je ne suis pas en peine de savoir pourquoi on le surnomme le rat musqué, puisque je suis sûr que durant tout le mois d'avril, tout le mois de mai et tout le mois de juin, l'animal sent tellement le musc qu'on ne saurait même en manger la viande en ce temps, tant elle a le goût du musc. Ce n'est donc pas pour cela qu'en ce [f. 110] temps le chasseur cherche à tuer le rat musqué; mais c'est pour en avoir les pelleteries et les testicules : l'un pour trafiquer* et l'autre pour en tirer le musc comme je dirai. Quoique j'aie dit que le rat musqué a la queue comme nos rats et que cela soit vrai, je dirai cependant qu'il l'a bien plus grosse et beaucoup plus longue, à mailles* ou à écailles comme le castor. Elle est fournie d'espace en espace de quelque grand poil.

Tout le reste de son corps est fort velu et couvert d'un poil si fin et si épais qu'on ne peut rien voir de plus beau, ni rien de meilleur pour les fourrures. Outre ce petit poil qui est aussi délicat qu'on puisse imaginer et qui ressemble plutôt au duvet du cygne qu'au poil d'un animal à quatre pieds, toute la robe est couverte d'un autre poil plus long et plus rude, lequel néanmoins, étant fort luisant, donne un admirable lustre à toute la peau.

Il y a de ces sortes de gros rats qui ont toute la robe noire, d'autres qui l'ont grise et d'autre presque toute jaune, lesquels ne font pourtant pas trois différentes espèces. Les jaunâtres et les gris semblent être tous bleuâtres sous le gros poil.

On fait, dans le pays, de ces peaux, de fort grandes et de fort belles robes qui sont bien recherchées en France et elles s'y vendent communément plus de cinquante ou plus de soixante écus*. Si l'animal est tué depuis le commencement d'avril jusqu'à la fin de juin, la peau, la chair et les testicules ne sont que musc, comme j'ai dit; s'il est tué après cette saison, il ne sent plus le musc. Ceux qui trafiquent dans les Indes font des grands amas des testicules et ils les vendent chèrement en France. On a vendu les deux jusqu'à un écu; le prix en est un peu diminué. Je crois que cela vient de ce que les baigneurs de Paris (du moins plusieurs personnes m'en ont assuré bien des fois) n'y ont pas trouvé si bien leur compte que ceux qui falsifient le vrai musc, par le trop grand mélange qu'ils font de ces testicules avec le véritable musc.

La chasse du rat musqué se fait en trois temps et de diverses façons : en automne, en hiver et au printemps. Quand il pleut en hiver et que les eaux grossissent sous les glaces, il y a des gens qui les savent bien tuer avec des dards* ou avec des épées emmanchées au bout d'un quart de pique*. Il n'y a que les Américains* qui usent de cette sorte de chasse; aussi n'y a-t-il qu'eux qui connaissent, dans cette saison, le rat musqué à travers quelques joncs où ils sont cachés.

[f. 111] La chasse qu'on fait des rats musqués dans la saison de l'automne n'est pas moins curieuse que celle qu'on fait en hiver et que celle qu'on fera au printemps, comme je dirai. Cet animal, qui se plaît d'être presque toujours dans l'eau, se rend, en ce temps de l'automne, habitant de la terre, mais tout au bord des lacs ou sur les plages* des rivières, où il fait des grands trous qui ne sont point trop enfoncés dans la terre, où l'on en prend ordinairement sept ou huit à la fois. On n'a qu'à boucher l'entrée de l'animal pour prendre tout ce qui se trouve dans la tanière. Il faut remarquer qu'en cette saison, aussi bien que dans celle de l'hiver et que dans celle de l'été, le rat musqué ne peut pas être

268 *Ondatra zibethicus* (L.), rat musqué (Banfield, 183–6 et Burt et Grossenheider, 193–4); représenté dans le *Codex*, Pl. XXXVIII, fig. 55.1, sous la désignation «ouatchas ou rat musché». Champlain parle le premier, en 1603, des *rats musquests*, même si, à vrai dire, Cartier les décrit clairement sous le nom de *raz sauvaiges* ou *ratz* dès 1535. Lescarbot les appelle *rat porte-musc* et Denys, *rat musqué*. Champlain les a représentés sur sa carte de 1612 (Ganong, 236). Boucher les mentionne en 1664 (Rousseau 1964, 312 et 314).

proprement appelé le rat musqué parce que, pendant ces trois saisons, ce gros rat ne sent point le musc, ni dans sa chair, ni dans sa peau, ni dans ses testicules. Cependant, les peaux n'en sont pas moins précieuses : elles sont même plus recherchées, particulièrement de ceux qui n'agréent point trop la senteur du musc que le rat musqué a trop forte dans les trois mois que j'ai marqués*. En effet, je dirai qu'il n'y a point de plaisir de porter une fourrure qui soit toute montée des peaux des rats musqués qu'on tue au printemps, car l'odeur en est trop forte.

La chasse du rat musqué qui se fait au printemps est commune à tout le monde, et l'on voit tant de ces animaux dans cette saison qu'un seul chasseur en tuera les deux à trois mille dans trois mois. C'est avec le fusil qu'on les tue durant le printemps et avec du menu plomb. On fait en ce temps deux profits : l'un de la peau et l'autre des testicules qu'on fait sécher dans du papier qu'on pend à la fumée.

Les Indiens* n'aiment du tout point la senteur du rat musqué et disent que cet animal que nous estimons sent mauvais, quoique sa senteur soit agréable aux personnes de l'Ancien Monde. Et pour parler en général puisque l'occasion s'en présente, je dirai que ces gens de bois ont de l'horreur de toutes nos essences les plus odoriférantes et de nos sauces les plus exquises, disant que celles-ci sont trop amères et que les autres sont puantes. Et c'est pour cela qu'ils disent que le rat musqué sent mauvais : «*Oûinat-ouatchak*, il pue le rat musqué».

Le rat musqué fait sa loge comme le castor, mais au lieu que celui-ci la fait avec des branches d'arbres, celui-là fait sa demeure avec des joncs. C'est un animal d'amphibie qui demeure une partie de sa vie dans l'eau et une autre partie sur la terre. Quand il nage, il faut qu'il prenne son vent de temps en temps et qu'il respire comme font les castors, les loutres et tous les animaux d'amphibie. Le rat musqué a les pieds du train de devant à griffes onglées et ceux de derrière sont ailés et onglés comme les pieds des cygnes.

Ce rare* et ce bel animal s'apprivoise de même que le castor et comme la loutre, comme je dirai parlant de [f. 112] ces deux animaux. Notre gros rat a presque toute la figure du castor, et n'était la queue, on le prendrait pour un petit castor. Le castor a la queue toute plate, soit en regardant le dessus, soit en considérant*

le dessous, et le rat musqué l'a toute plate sur les côtés et ressemble entièrement à ces limes dont on se sert pour raccommoder* les scies à scier de long. Toute la pelleterie qu'on ramasse dans un canton* du pays fait un assez beau commerce. Il y a peu de chasseurs qui n'en tuent les quatre à cinq cents dans fort peu de jours, et ainsi on en passe bien, en France, pour dix ou douze mille livres*.

De la loutre[269]

Quoiqu'on trouve de trois sortes de loutres dans les grandes eaux du Nouveau Monde, elles ne font pourtant pas trois différentes espèces de ces animaux, et bien qu'on en voie des noires, des grises et des rougeâtres, elles sont néanmoins semblables pour tout le reste. Toutes les trois façons* ont la tête plate, le museau abattu, les dents bien aiguës, fort pressées et bien rangées. Elles ont les yeux, les moustaches, les pattes et la queue entièrement semblables.

On en tue de fort grandes et noires comme du jaiet*. Le petit poil qui est dessous le noir est très fin, long d'un pouce et demi; il est si beau et si délicat que d'abord* qu'on le voit, on l'admire. Il ne perd jamais cet agréable lustre qu'il a. La pelleterie en est rare : aussi* est-elle bien précieuse, et les chasseurs n'ont rien qu'ils estiment tant. Il s'en font faire à leurs femmes des robes de haut prix, qui, y employant toute leur industrie*, font des merveilles avec leurs peintures. Ces robes sont faites des peaux de seize ou de vingt loutres qui n'auraient point de prix parmi les nations policées* qui aiment ou qui ont besoin des fourrures. Les marchands des Indes courent à ces pièces comme l'on court au feu.

Le pays des Papinachois, c'est-à-dire de la nation du Rire, est la belle terre où l'on tue ces loutres noires. On en trouve néanmoins dans toute la plage du nord. Les autres loutres qui sont de couleur grise ou jaunâtre sont communes dans tout le pays. Les Algonquins supérieurs en ont quelques-unes d'assez rares.

La loutre fait sa demeure dans les lieux poissonneux et vit ordinairement de poissons ou de coquillages qu'elle va pêcher au fond de l'eau. Elle fait des cavernes dans la terre et dans l'eau d'où il faut qu'elle sorte pour respirer. Dans la saison des glaces, elle fait des trous pour se promener sur les neiges gelées et seulement quand le soleil luit dessus.

269 Nicolas ne pouvait connaître la différence entre la *Lontra canadensis* (Schreber), loutre de rivière, et l'*Enhydra lutris* (L.), loutre de mer, qui se trouvait sur la côte Pacifique (Banfield, 318–22 et Burt et Grossenheider, 63); représentée dans le *Codex*, Pl. xxxvii, fig. 54, sous la désignation «Nika ou loutre»; figure copiée dans

Gesner, 1621, t. 4, 515. Mentionnée pour la première fois par Cartier sous son ancien nom *louere* et par Champlain en 1603 (Ganong, 223). Boucher la mentionne aussi en 1664 (Rousseau 1964, 312 et 314) et Lahontan en 1703 (Ouellet et A. Beaulieu, *Œuvres complètes*, 333, 564, 566).

Pline s'est trompé, ou disons mieux qu'on l'a trompé, lorsqu'on lui a rapporté que la loutre était semblable au castor. Pour moi, j'estime qu'il y a bien de la différence, car la loutre n'a rien de semblable au castor que les pieds de derrière. Apparemment on a voulu dire à [f. 113] Pline que cet animal est fort semblable au castor pour son inclination qu'il a de plonger et de faire sa principale demeure dans l'eau. Pour tout le reste, il est totalement différent du castor qui mange en rongeant et celui-ci en mâchant : l'un comme les rats et l'autre comme les chiens, et leurs vivres sont tout de diverses espèces.

La loutre siffle agréablement et a comme une certaine manière de ramage qui tient plus de l'oiseau que de l'animal à quatre pieds. Elle est goulue et mange de tout, presque comme les chiens. Les sauvages la mangent quoique la chair en soit fort dure et fort puante.

Elle s'apprivoise très bien et fort facilement; mais je n'en ai jamais vu de si privées*, ni qui aient tant d'esprit comme en ont les loutres de Suède qu'on assure qu'elles sont si dociles que, lorsqu'on a dressé quelques-unes, les cuisiniers des grandes maisons n'ont qu'à leur commander d'aller quérir du poisson dans les étangs ou dans les réservoirs des environs des châteaux, et d'abord elles obéissent et portent les poissons aux cuisiniers tout autant de fois qu'ils les emploient pour cet office*.

Les loutres de l'Occident tiennent de l'humeur des sauvages. Elles ne sont pas si adroites que les loutres suédoises et n'ont pas tant d'esprit. Il est pourtant bien vrai que lorsqu'elles sont apprivoisées et qu'elles sont dressées, qu'elles suivent partout leur maître et qu'elles vont à la pêche; mais elles n'en rapportent rien et mangent toute leur prise.

Mais en revanche de ce bel esprit des loutres de Suède, les peaux des loutres du pays barbare sont plus belles, plus précieuses et plus recherchées et le trafic* qui s'en fait tous les ans, peut bien monter jusqu'à quinze ou seize mille livres.

La chasse qu'on en fait n'est pas bien différente de celle du castor.

Du castor[270]
Bien que le castor que nous appelons *amik* soit un animal très connu et que tout le monde en parle, j'ai néanmoins résolu de dire ce que j'en sais et d'en découvrir plusieurs particularités dont les auteurs qui en ont écrit sans l'avoir vu n'ont jamais découvert ce que j'ai moi-même étudié cent fois sur le castor, sur sa cabane et sur ses ouvrages surprenants. Après ce que je vais dire, ceux qui savent ce que c'est que le castor seront confirmés dans leur science et ceux qui n'en ont jamais vu ni peut-être entendu parler que bien légèrement, en pourront discourir savamment.

L'animal est gros comme un grand mouton, mais il n'est pas si élevé sur les jambes, qui n'ont qu'un demi-pied de haut. Les deux pieds de devant sont onglés; ceux de derrière sont onglés et ailés comme les pieds de canard. Sa queue est longue de quatorze ou quinze pouces, et [f. 114] elle en a plus de six vers le croupion; elle est sans poil et à écailles noires, grosses de deux pouces d'épaisseur. Elle a la figure d'une pertuisane* émoussée en cercle sur l'extrémité du bout. Le museau de l'animal est fort abattu; sa tête est grosse et presque ronde; ses oreilles sont rases; son poil est long de trois ou quatre pouces, lustré et fort luisant selon sa couleur, qui est de trois différences : de blanc, de noir et de châtain brûlé et un peu jaunâtre : c'est-à-dire que le castor qui est blanc a toute sa robe couverte de cette couleur, et celui de couleur noire est aussi tout noir, et du reste, il est semblable en tout à celui que j'ai décrit, de même que celui qui est jaunâtre.

Sous le premier grand poil du castor, il y en a un autre qui est ce poil si recherché pour faire ces chapeaux de prix et même du drap. Mais comme ce drap est trop fin, il n'est d'aucun usage, le poil du castor étant trop délié* et trop court pour souffrir la liaison qui est nécessaire à faire de bonnes étoffes.

Les testicules du castor, que la médecine appelle *castoreum* et les chasseurs indiens *oûissinak*, sont excellents pour diverses maladies. Les femmes qui sont travaillées du mal de mère s'en trouvent fort bien quand on leur en brûle auprès du nez et quand on leur en fait sentir la mauvaise odeur. La livre se vend jusqu'à vingt écus.

Toute la chair de testicules n'est pas propre* pour les médicaments, et il faut savoir faire le choix et / savoir / distinguer parmi quatre testicules que la bête a, quels sont les deux qui servent à la médecine, car les autres deux ne valent rien qu'à jeter aux chiens. Ceux qui sont

270 *Castor canadensis* Kuhl, castor (Banfield, 146–50 et Burt et Grossenheider, 151–3); représenté dans le *Codex*, Pl. XXXVII, fig. 54.1, sous la désignation «amic ou castor»; figure copiée dans Gesner, 1621, t. 4, 309. Son nom en vieux français était *bièvre*. Cartier le nomme encore ainsi (*byevres*), mais Champlain emploie déjà le mot castor. Il en donne une représentation peu convaincante sur sa carte de 1612 (Ganong, 205–6). Boucher le décrit en détail en 1664, et Lahontan en 1703 (Ouellet et Beaulieu, éd., *Œuvres complètes*, 690–705). Le *Dictionnaire de Trévoux* utilise encore indifféremment *bièvre* ou *castor* en 1743 (Rousseau 1964, 312).

bien choisis se mettent dans le composition du thé-
riaque. Ces testicules qui sont pleins d'humeur* sont
les bons et c'est ceux-là qu'il faut choisir.

Toute la chair de l'animal est bonne à manger; elle
[est] cependant un peu fade et demande d'être prépa-
rée au haut goût*. On en mange en tout temps de ca-
rême, de vigiles, etc.

Le castor a deux sortes de dents : comme les rats
musqués, il en a de grandes et de petites, de molaires
et d'incisoires, et c'est de ces dernières que j'ai des
choses curieuses à dire, car cet animal n'a rien de si re-
marquable que les dents, et tout le monde a beau esti-
mer la peau de castor, pour moi je trouve quelque
chose de plus rare à dire des dents incisoires* du cas-
tor, qui sont longues de trois pouces et larges d'un
tiers de pouce, colorées d'un jaune fort couvert*, et
tranchantes plus que les rasoirs les mieux affilés. Elles
sont un peu courbées en arc en dedans où elles sont de
couleur blanche. Il n'en a que deux en bas et deux sur
la mâchoire d'en haut de cette nature.

[f. 115] Le castor est un de ces animaux que les latins
ont appelé *mordax*, le mordeur, et les Indiens *amik ka
takouanketch*, le castor qui mord. Ce nom lui a été
donné à cause de l'adresse et à cause de la force que cet
animal fait paraître avec ses dents avec lesquelles il
coupe et abat des arbres, deux ou trois fois gros comme
des poinçons* et même aussi gros que certaines cuves.
On trouve mille embarras, dans les forêts, des arbres
que les castors ont renversés en les rongeant. Deux
castors abattent, dans une nuit, un de ces puissants ar-
bres pour faire des écluses qui leur sont nécessaires
pour leur demeure. C'est un animal qui aime l'eau et
qui ne saurait vivre sans s'y placer dans des loges qu'on
appelle, dans le pays, *des cabanes de castor*, qui sont bâ-
ties par ces animaux de telle manière qu'il y a des com-
partiments admirables dedans. Il y en a un qui sert de
chambre au castor, où il se repose et où il dort à son aise
et où il fait ses petits. Il est si bien pratiqué* qu'il peut,
à mesure qu'il dort ou qu'il repose, tremper sa queue
dans l'eau de peur qu'elle ne sèche, ce qui nuirait beau-
coup à l'animal et le mettrait en danger de mourir si
elle séchait entièrement et longtemps. Il fait un toit à
sa loge et un autre compartiment pour se tenir dans
l'eau quand il veut. Quand il fait beau, on le voit aller
sur son toit pour y dormir et pour s'y reposer au soleil.

Le castor se plaît dans les lieux humides et fort
aquatiques. Il y choisit ordinairement une place où il
puisse (par le moyen de quelque fontaine, de quelque
ruisseau ou de quelque petit filet d'eau qu'il arrête
avec une forte et une puissante digue qu'il fait) former
un étang.

Le lieu choisi entre deux montagnes ou dans quelque

plaine au milieu de laquelle il y ait quelque fontaine et
quelque enfonçure où il puisse faire son réservoir, il tra-
vaille d'abord à faire une puissante chaussée, si ferme
et si bien bouchée qu'il n'est pas possible que les
hommes en puissent faire ni de semblables ni de si
fortes avec les matériaux dont se sert l'animal, lequel,
avant que de la commencer, coupe avec ses dents inci-
soires une grande quantité de branches qu'il charrie à
l'endroit où il veut bâtir sa maison. Il arrange, entrelace
et ajuste si bien tout ce branchage qu'on dirait à voir
cette machine*, que c'est un de ces oiseaux qui font des
mieux leur nid, qui y a travaillé, s'il en avait eu la force,
tout y étant si bien disposé, avec cette différence qu'un
nid a son ouverture en haut et cette maison l'a tournée
en bas, où il y a trois ou quatre trous qui doivent ser-
vir d'entrée et de sortie dans l'eau à l'animal. Au milieu
de tout ce gabarit*, il y a un étage très bien pratiqué afin
que le [f. 116] castor puisse s'y tenir en assurance* et y
demeurer à couvert des injures* du temps. De cet étage,
il va et vient dans l'eau dans un autre compartiment.
En un mot, son logement est si bien construit et si fort
que malaisément le peut-on démolir, tout y étant bien
entrelacé avec des branches d'arbres cimentées avec du
gazon qu'il n'y a point de balle de mousquet qui y
puisse pénétrer. Je pense même que divers coups de
couleuvrine* ou diverses décharges de fauconneaux*
ne pourraient pas l'abattre.

Après ce travail, le castor ne s'amuse plus qu'à faire
son écluse pour retenir de l'eau autant qu'il y en faut.
Voici comme* il s'y prend.

Cet animal, ayant disposé de son logement de la ma-
nière que je viens de dire, s'en retourne à l'endroit
qu'il a déjà remarqué auparavant* qu'il entreprît la fa-
brique de son logis. Il s'y met d'abord* en besogne. Il
n'y a que deux ouvriers au commencement : le mâle et
la femelle. Ils se dressent sur les pieds de derrière pour
commencer leur travail et chacun se met à ronger de
son côté, mais avec tant d'adresse et avec tant d'éco-
nomie que ces deux animaux font tomber l'arbre là où
ils veulent. Et après celui-là, ils en font tomber un au-
tre qu'ils rongent aussi, les entassant les uns sur les au-
tres pour arrêter l'eau jusqu'à la hauteur de leur pre-
mier étage, si à propos qu'ils ne manquent jamais de
faire monter l'eau jusqu'au point qui leur plaît.

Tout le gros ouvrage de la digue étant fait, ils entre-
lacent une infinité de branches autour des gros arbres
qu'ils ont abattus. Que si, par hasard, il y a quelque
branche des grands arbres qui ont été abattus qui em-
pêche que les troncs ne joignent* pas bien contre terre,
ils remédient bientôt à cet incident* en rongeant de si
près ces branches qu'ils font en sorte que les troncs, joi-
gnant parfaitement contre terre, l'eau ne peut pas cou-

ler ni se perdre. Et pour bien boucher toutes les voyées* par où l'eau pourrait s'écouler, ces animaux vont enlever de dessus la terre, avec leurs dents et avec leurs pattes, des grands gazons pour les porter à leur écluse pour en boucher les trous par où les eaux s'écoulent. Leur queue, qui est fort large, leur sert comme d'une truelle pour battre ces mottes de terre et pour les faire tenir comme si c'était du ciment. Ils font comme une espèce de grande muraille ou de grand môle qu'ils élèvent au niveau du premier étage de leur cabane qui est bien souvent à un grand quart de lieue* de là. J'ai vu et navigué sur des étangs que les castors avaient faits où les eaux étaient si hautes que des gros brigantins* y auraient pu voguer, aussi bien que des galères de la première grandeur.

Le castor fait des travaux surprenants dans moins de vingt-quatre heures. Si on a manqué quelquefois de le prendre et qu'il ne soit pas blessé lorsqu'on a rompu sa chaussée, dès le lendemain au matin, la machine est raccommodée*. Ces chaussées ont huit pieds de large et un quart de lieue de [f. 117] long. Que si l'eau surnage par-dessus l'écluse et qu'elle montât trop haut dans sa demeure, on voit ces animaux aller promptement à la nage à leur digue pour l'ouvrir en quelque part pour faire couler l'eau jusqu'à la hauteur qu'ils veulent; que si enfin elle ne monte pas à la hauteur qu'ils souhaitent, ils élèvent leur digue si à propos qu'elle monte jusqu'au point qu'ils souhaitent.

L'adresse de ces bêtes n'est pas moins remarquable en ce qu'elles ont l'esprit ou plutôt l'instinct de se garantir des grandes inondations pendant que les neiges fondent, élevant pour ce sujet* divers étages dans leurs cabanes; et vers la fin de l'automne, notre animal a la prévoyance de couper force gros bois qu'il fait couler au fond de son étang pour en pouvoir vivre sous les glaces pendant l'hiver; et de peur que ce bois, venant à flotter, il ne se gelât et ne se prît avec les glaces sur la superficie des eaux, il le charge de gros fardeaux pour le faire couler à fond où l'eau ne gèle pas.

Son industrie le porte à faire son lit de jonc très doux et bien brisé, en sorte qu'il puisse coucher mollement et chaudement. Quelques-uns ont voulu dire que le castor abandonne son logis au temps des grandes chaleurs, mais j'ai la science* du contraire, ayant vu, en ce temps-là même, tuer le castor dans sa demeure.

Les écluses étant rompues, ils y travaillent comme j'ai dit. Et comme ils ont rongé infiniment, leurs dents s'émoussent de telle manière que ces animaux ont besoin de les affiler, non pas avec des pierres, car ils ne sauraient s'en servir, mais ils les frottent l'une contre l'autre avec tant de violence et avec tant d'adresse qu'elles tranchent comme les couteaux les mieux affi-

lés. Cela leur arrivant fort souvent, il faut dire que les dents leur croissent extraordinairement puisque, en rongeant et en les aiguisant souvent, ils les usent beaucoup et cependant ils les ont fort longues.

Enfin, le castor étant logé, il multiplie* beaucoup et dans peu de temps : où il n'y en avait que deux, on y en voit plusieurs; et si on les laisse en repos, on les y voit à bandes. Un jour, m'informant d'un sauvage du nord où je n'avais pas encore été, s'il y avait bien des castors, il me répondit qu'il y en avait autant qu'un chien avait de puces partout. Les sauvages y en ont tant tué et y en font encore tant mourir tous les ans que le commerce en est fort grand et le provenu* va si haut qu'on ne peut pas bien le savoir au juste.

La chasse du castor se fait avec le fusil, avec le dard, avec la flèche, ou avec des filets qu'on fait de peau, ou enfin avec des attrapes.

L'assemblée de ces animaux paraît assez admirable; lorsque de temps en temps on les voit s'attrouper pour s'entraider, comme font les fourmis qui se joignent plusieurs ensemble à traîner ce qu'une seule ne peut pas porter, ces castors s'accordent si bien qu'ils logent ensemble en grand nombre; mais si enfin [f. 118] ils multiplient tant que leur logement soit trop petit, quelques familles se détachent pour s'aller placer ailleurs et y faire des nouvelles colonies.

Au reste, il y a un si grand nombre de ces animaux dans toutes les Indes, qu'il s'y fait des festins où l'on mange plus de cinq ou six cents castors dans un seul repas.

L'animal s'apprivoise aisément étant petit. Il mange de tout ce qui se peut ronger : il se dresse en mangeant, prenant sa viande* entre les deux pattes de devant; il mange extrêmement vite. Sa voix est un certain sifflement agréable, comme celui de la loutre.

Tout l'intérieur de la bête est fort semblable à celui du pourceau. La rate du castor est très petite. Il a les reins très grands et fort larges, couverts de beaucoup de graisse, laquelle est d'un fort bon goût; mais la tête et la gueule l'emportent, et ce sont les morceaux du capitaine.

Les castors vivent de la feuille et de l'écorce du peuplier, de l'aunier* et de plusieurs autres arbres.

Je n'entre pas dans la pensée de ceux qui ont dit par écrit, sous des faux rapports, que le castor se prend de lui-même par la queue qui se gèle, disent-ils, et qui s'attache contre les glaces, et qu'étant ainsi attaché, le chasseur le prend facilement. Cet animal, bien qu'il soit sot et bien lourd, ne l'est pourtant pas jusqu'à ce point, car il est bien plus fin que cela. Et s'il y a aucun* pays sur toute la terre où cela dût arriver, sans doute on le verrait dans les Indes septentrionales, et principale-

ment dans toutes les routes du nord où les rigueurs de l'hiver durent neuf ou dix mois, et où il se trouve sur les rives de la mer des glaces de plus trois cent soixante pieds d'épaisseur.

Il est bien vrai que les sauvages pêchent le castor sous la glace qu'ils rompent avec des tranches de fer; mais il n'est jamais vrai de dire que la queue du castor s'attache contre la glace.

Dans une campagne que je fis il y a quelque temps pendant l'hiver avec les sauvages, je leur vis faire cette chasse et cette pêche tout ensemble, qui se fait avec l'épée et avec le filet fait de peau, afin que, si le castor échappe le fer, il n'évite point le filet.

Je ne sais si j'ai dit qu'on se trouve quelquefois fort embarrassé dans les forêts parmi les ravages que les castors y ont faits en y abattant une infinité de gros arbres pour les ronger avec leurs feuillages pour s'en remplir le ventre comme le dit un poète :

Sæpe ergo horrificis erosâ dentibus ornô
exsatiat ventrem, fronde repletque suum
phyber, etc.

Outre le castor que je viens de dépeindre, il y en a d'une autre sorte qui ne diffère en celle-ci que par la seule inclination qu'il a de se contenter d'une maison faite de terre dans l'eau où il se plaît plus que le castor commun, et qu'il surpasse encore un peu en grandeur.

[f. 119] Il n'est pas encore vrai de dire, et on amuse un lecteur par ces agréables menteries*, quand on dit que le castor, se sentant pressé du chasseur, s'arrache les testicules afin que le chasseur, se contentant de cela, et pour la bonne odeur aussi qu'on suppose faussement que les testicules du castor ont, et pour les autres utilités qu'on recherche. En le poursuivant à mort, cet animal tire* toujours de long quand on le poursuit ou il se jette dans l'eau sans se couper les testicules qui, bien loin d'avoir quelque odeur agréable, sont fort puants.

Du loup, ou du tigre marin[271]
Je n'aurais pas donné le nom de loup à un animal marin qui tient plutôt du tigre que du loup, car, premiè-

rement, il a la tête grosse comme le tigre, les yeux semblables, la moustache affreuse, brochée de gros poils fort longs et bien raides, la gueule bien ferrée* et bien garnie de force petites et de force grosses dents très aiguës. La peau est toute martelée* et toute mouchetée comme celle du tigre. Le poil est fort ras, épais, luisant comme du satin, et il ne craint jamais la pluie. Il diffère du tigre de terre en ce qu'il a les oreilles fort rases, et néanmoins il a l'ouïe très fine et très subtile. Tout son corps est long en rond, et cette rondeur diminue insensiblement avec une juste proportion depuis les épaules jusqu'au bout des cuisses, qui sont extrêmement courtes, et on ne les distingue presque pas.

Cet animal a quatre pieds. Les deux de devant sont à petites ongles, et à peu près comme celles du chien. J'ai dit que ses jambes étaient fort courtes : celles du train de derrière le sont beaucoup plus. Mais les pieds sont ailés, comme ceux de l'oie ou comme ceux du cygne, et lui servent comme d'aviron pour nager. La queue de la bête semble le toucher avec ces deux rames, de manière que l'animal, en nageant, semble avoir une fleur de lys sur cette extrémité.

Ordinairement, ce tigre marin est fort gras, et on en tire tant d'huile qu'il s'en peut faire un commerce bien considérable. Cet huile est le meilleur de tous les huiles pour passer* les peaux à l'huile et pour les jaunir comme de l'or. On s'en sert pour brûler. Il fige un peu dans la rude saison. On en use beaucoup sur mer pour mêler avec le goudron, pour empoisser les mats, les câbles et tous les cordages, et même tout l'extérieur du corps des vaisseaux.

Tous les intestins de l'animal sont délicats à manger. La langue est un manger royal. Quand le tigre est jeune, il crie comme un enfant. Pendant la nuit, me promenant sur le tillac du brigantin* où nous étions mouillés au large de la côte du nord, j'étais agréablement surpris d'entendre une infinité de ces cris qui ne laissent pas enfin de rendre mélancolique, et de faire entrer dans l'horreur* de [f. 120] la nuit, dans une je ne sais quelle horreur inexplicable, se voyant d'un côté au milieu d'une plaine immense d'eau qui vous environne* de partout, et de l'autre, lorsque vous considé-

271 L'expression *loup marin* paraît d'abord chez Cartier en 1535; elle est retenue par tous les auteurs par la suite. Denys en distingue deux espèces, mais il ne les nomme pas. Champlain en a fait une excellente figure sur sa carte de 1612. On y reconnaît le *Phoca vitulina* (L.), phoque commun. En 1691, Leclercq affirme que les Mi'kmaq distinguaient le phoque commun (*oüaspous*) et un phoque de plus grande taille (*metauh*), probablement le tigre marin de Nicolas, notre *Phoca groenlendica* Erxl., Phoque du Groenland (Ganong, 233). Sur le phoque commun, voir Banfield, 345–8 et Burt et Grossenheider, 85; représenté dans le *Codex*, Pl. XXXVII, fig. 54.2, sous la désignation «Loup marin»; la figure est copiée dans Gesner, 1621, t. 1, 705. Sur le phoque du Groenland, voir Banfield, 350–3 et Burt et Grossenheider, 87–8; représenté dans le *Codex*, Pl. XXXVII, fig. 54.3, sous la désignation «tygre marin»; sa figure est copiée dans Gesner, 1621, t. 1, 706. Boucher ne parle que de «loup marin» en 1664 (Rousseau 1964, 315–16).

rez que le moindre coup de vent peut rompre votre câble, et vous jette sur une côte de rocher, où assurément on fait des tristes* naufrages : ce malheur arriva à deux vaisseaux qui périrent sans ressource. Et ce qui augmente cette horreur, est que l'on est sûr que le fleuve est large à perte de vue et qu'il a deux à trois cents brasses* de profondeur, comme la haute mer, où il n'y a point d'espérance de se sauver et où l'on est certain d'être bientôt dévoré des poissons.

Tout le grand fleuve est plein de tigres ou de loups-marins entre lesquels je ne mets nulle différence qu'en la grandeur, le tigre étant beaucoup plus grand que le loup de la mer. On les voit à milliasses* ensemble depuis l'entrée du golfe jusqu'à Tadoussac.

Du côté des îles de Brion et de la Madeleine qui sont presque au milieu du golfe, l'on en voit des gros comme des bœufs et longs de dix-huit pieds. On y découvre aussi pêle et mêle d'autres certains animaux dont je ne sais point le nom, qui sont prodigieusement grands, qui ont des dents comme l'éléphant, c'est-à-dire que ces dents ont plus d'une brasse* de longueur. Ces animaux vont à terre comme le tigre marin. Depuis que j'ai écrit ceci, j'ai vu la tête d'un de ces animaux dans la fameuse bibliothèque de Sainte-Geneviève-du-Mont. Le poisson était jeune, et ainsi il n'avait pas encore ses dents si longues.

Les grands tigres marins ne sont pas si gras que les médiocres*, qu'on voit communément tout le long de la plage* du nord du fleuve, entre l'île d'Anticosti et entre la terre ferme des peuples esquimaux, des Oumiamis, leurs voisins, leurs alliés et leurs proches parents, et des Papinachois et autres peuples, jusque dans le pays des Mangounchiriniouek, qui en mangent et qui en font leur principale nourriture, et particulièrement ceux qui sont dans l'entre-deux des îles de Mantounoc, jusqu'à la rivière Saint-Jean, et même au-delà, tirant toujours au nord du côté des Esquimaux, auxquels cette seule chose de manger du loup-marin a attiré une cruelle guerre avec les Acadiens, lesquels, sans autre raison ni sans autre intérêt, vont faire la guerre aux nations du nord seulement parce que les hommes de ces terres mangent du loup-marin. Et pour se venger de cet affront, qu'ils pensent que ces misérables nations (qui ne savaient seulement* pas s'il y avait des Acadiens au monde) leur font, les Acadiens entreprennent de faire des traverses* de vingt ou de trente lieues dans des petits bateaux qu'on appelle des *biscayennes**, qui sont de petits esquifs* [f. 121]

[Sixième cahier de l'Histoire naturelle de l'Inde occidentale]

que les Basques, qui vont tous les ans à la pêche de la morue vers les côtes des Acadiens, y abandonnent après s'en être servis à leur pêche, dans l'anse de Gachepé ou à l'île Percée. Ces sauvages acadiens vont faire des prisonniers de guerre dans les terres de la nation des mangeurs de tigres et de loups-marins, lesquels, étant pris, sont tués sur-le-champ, brûlés ou mangés comme s'ils avaient fait des grands crimes ou offensé beaucoup les Acadiens. D'où l'on voit que ce n'est pas seulement pas dans le pays des Iroquois où l'on écartèle les hommes comme des moutons à la boucherie et que l'on est pas anthropophage dans un seul pays où l'on mange les hommes d'une différente nation lorsqu'ils sont pris à la guerre, et lors seulement qu'une nation est fort aigrie contre l'autre pour des raisons fort légères et qu'on ne sait souvent pas.

La chasse du tigre marin est admirable chez les Esquimaux, car ils la font avec des flèches qu'ils attachent au bout d'une corde de peau, et ayant ainsi dardé* l'animal, ils le conduisent là où il leur plaît pour l'achever de tuer.

D'autres nations ne font point de façon : ils lâchent leurs dards et leurs flèches à toute aventure*, mais aussi il y a bien du danger de perdre l'animal qui, se sentant blessé, coule à fond. Et si sa plaie est mortelle, il meurt dans l'eau d'où il ne revient que deux ou trois jours après, ou il tombe entre les mains d'un autre qui, le trouvant mort par rencontre* sur la grève où la marée l'a porté, profite de l'avantage qu'aurait eu le chasseur s'il l'avait pris lorsqu'il lui donna le coup de mort.

D'autres encore se servent du fusil pour tuer le tigre marin. Si l'animal est frappé à la tête, il meurt subitement, mais il n'arrête jamais pour les autres blessures.

La chasse la plus agréable de toutes est celle qui se fait au commencement de l'automne : lorsque les marées sont hautes et lorsqu'il fait quelques beaux jours, ces tigres se plaisent d'aller à terre pour y prendre la chaleur du soleil et pour y dormir à leur aise pendant que la mer se retire et les y laisse à sec. Si ceux qui vont à cette chasse les découvrent, ils sont assurés de tuer tout ce qu'il y a de tigres échoués, et ils sont sûrs de faire une riche prise, découvrant plus de quatre ou cinq cents de ces animaux qui, se voyant perdus, crient comme des chiens enragés pendant qu'on les assomme à coups de bâtons. Un seul coup donné sur le nez les fait mourir tout sur-le-champ. Cet animal, ne pouvant presque pas se remuer, il n'est pas à craindre comme l'on pourrait penser, quoiqu'il ait une grande gueule garnie de furieuses* dents.

Sa peau est fort propre à divers usages, car [f. 122] outre que les sauvages du pays s'en habillent et s'en servent pour toutes leurs nécessités, ils en font des canots construits d'une manière si commode et si sûre qu'on ne peut jamais périr dans ces sortes de bateaux. J'en donne la figure et la description dans mon traité des figures, et pour ne pas même vous renvoyer si loin, je dirai qu'un sauvage bâtit un bateau avec deux ou trois peaux de tigre marin. Il donne à son bateau la figure d'une bourse par en haut dans laquelle il s'enferme jusqu'à la ceinture tenant en main un aviron qui a les deux bouts égaux. Sa rame lui sert de voile, de mât, de gouvernail, de cordage. Le barbare, étant placé dans son canot, se met fort peu en peine si son bateau va de vent largue*, de vent alizé ou d'un vent de tempête, s'il va droit ou s'il cargue*, ou encore s'il est à la bouline* ou non, s'il tourne ou s'il est droit : un seul coup d'aviron à deux mains le met hors de danger dans tous ces accidents*.

Du mauvais génie nommé en langue sauvage Matchi Manitou, *et autrement* Michipichi

Je ne sais si ceux qui me feront la grâce de lire cette histoire naturelle prendront garde à l'ordre que j'ai gardé jusqu'ici dans tous mes écrits, que j'ai intitulé «la parfaite connaissance du Nouveau Monde», commençant toujours dans tous mes traités par les choses les plus petites pour finir par les plus grandes du même genre et des mêmes espèces.

L'animal dont je veux faire ici le portrait, étant le plus grand de tous les animaux / à quatre pieds / dont j'ai parlé jusqu'ici, fera la clôture, conjointement avec les tortues, du traité de tous les animaux terrestres et aquatiques à quatre pieds / dont j'ai fait la description /.

L'animal étant fort monstrueux serait plutôt connu par la figure que j'en donne que par ma description grossière. Il a environ trois brasses de long, c'est-à-dire dix-huit pieds-de-roi d'étendue. Il est gros à proportion de tout son corps qui est couvert d'une peau velue à peu près comme celle du tigre marin. Il a quatre pieds comme le castor et sa queue rapporte* un peu à celle de cet animal. Il semble qu'il a la tête plus grosse que la proportion de son corps ne demanderait, et elle est fort extraordinaire. Ses dents sont fort monstrueuses, et particulièrement deux qu'il a à la mâchoire d'en haut : elles ont près de deux pieds de long, toutes carrées, fort pointues et aussi belles que le plus fin ivoire.

[f. 123] Cet animal, qui ressemble plutôt a un monstre qu'à un animal parfait*, n'est vu qu'autour de quelques îles du nord dans le golfe de Saint-Laurent. Les sauvages qui demeurent autour des grands lacs disent en avoir vu sur les rives. Un jeune homme de la nation des Outouliby, en ayant tué un, me fit présent d'une dent de cet animal qu'ils nomment *michi-pichi*. Ce don était rare. J'en fis un présent à monsieur de Cotrou, intendant dans le pays. / La figure que je donne de ce monstre le fera plus connaître que ma plume. /

Du cheval marin
Comme cet animal est fort connu et que tout le monde en parle d'après ce qu'en ont dit les écrivains, je me contente d'en donner la figure fort exacte* et de dire qu'on en voit autour des îles de Brion, où ils prennent terre. Ils fréquentent fort la rivière de Chichedek qui est dans la côte du nord du golfe du fleuve Saint-Laurent; il hennit comme ceux qu'on voit sur les rives du Sénégal où l'on en tue quantité. J'en ai vu des têtes entières fort grosses venues de ces pays : elles rapportent fort à la tête du cheval et de l'élan. Voilà ce que j'ai remarqué des animaux d'amphibie.

Des tortues
Puisque j'ai promis au commencement de ce traité de le finir par les animaux à quatre pieds, et qui sont de ceux que j'ai appelés avec les Latins *ovipara* et avec les Grecs ωοτόχα [oötóka], *quæ cortice teguntur*, ou qui sont plutôt entourés de diverses écailles, je dirai qu'il y en a tant, dans les Indes occidentales, qu'il me serait bien difficile, je ne dis pas d'en faire les portraits*, mais même d'en donner les noms : c'est pourquoi je me retranche* à dire fort peu de chose des tortues qu'on voit dans toute l'Amérique.

Toutes les grandes et toutes les petites tortues sont de la même figure : elles ne diffèrent qu'en couleurs. Il y en a des fouettées* de rouge et de jaune, des grises et des noires et des violettes, et si bien variées sur leurs écailles qu'il n'y a rien au monde de plus beau dans cette sorte d'animaux.

Nous voyons dans les Indes des tortues de toutes les grandeurs communes à celles de l'Europe. On en voit de deux pieds de diamètre, on les prend avec la ligne. Elles vivent d'herbe, de poissons et de coquillages. Elles surprennent fort souvent le gibier à plume parmi les joncs et le mangent avec avidité.

[f. 124] La tortue a l'écaille si forte que, quelque fardeau qu'on y mette dessus, on ne la saurait écraser. La tête, la queue et les pieds sont semblables à toutes ces parties du lézard, à la réserve* du bout de son bec qui est d'une espèce de corne fort aiguë et extrêmement tranchante : cela lui sert de dents pour couper ce qu'elle veut manger.

Les tortues qu'on prend à l'hameçon, comme j'ai dit, ont l'écaille fort tendre. La chair en est excellente,

et elle est blanche et délicate comme celle des meilleurs chapons.

Les tortues de la première grandeur se déchargent dans une seule ponte de plus de quatre ou cinq cents œufs qu'elles cachent dans le sable et viennent les couver tous les jours en les regardant seulement. Toutes les différentes espèces sont d'un bon goût. L'œuf de la tortue est tout rond et couvert d'une pellicule forte presque comme du parchemin. C'est ce qui fait que ces œufs ne se cassent pas si facilement que les œufs communs*. Et quoiqu'ils soient toujours mous comme ces œufs mollets que les poules grasses font, néanmoins, ils ne se cassent point qu'avec un couteau.

La tortue est si difficile à tuer qu'à moins que de lui tordre le col* ou de la faire bouillir dans l'eau, on ne peut pas la faire mourir de trois ou quatre jours, quoiqu'on l'ait percée d'une part à l'autre à coups de couteaux. Cependant, les sauvages savent* le secret pour la faire mourir subitement. J'en ai vu l'expérience.

Les Américains* ont beaucoup de vénération, parlant en général, pour cet animal. Ils le pendent à leur col, à leur ceinture, etc., comme si c'était quelque rare* bijou. D'autres en pendent à leurs oreilles et se font un plaisir tout singulier d'en porter le nom. Les nations entières font gloire de se nommer la *nation de la Tortue* : «*Mikinat nir*, je suis sorti de peuples de la Tortue», disent-ils.

J'ai connu un grand capitaine de ce nom, duquel j'aurais de quoi faire un agréable narré* touchant les véneries, que lui et plusieurs autres racontent de cet animal. Mais comme j'en dis un mot au commencement de mon 19ᵉ livre, je n'en parlerai pas ici.

Je dirai seulement en passant que les sauvages font de la tortue le principal instrument de leur religion, qui est leur jonglerie*, et qu'ils passent des jours et des nuits [f. 125] entières auprès d'un malade prêt à mourir, tenant en main une écaille de tortue, laquelle ils remplissent de gravier qui fait quelque bruit sourd. Lorsqu'ils remuent avec action et avec une grande vitesse cet *outki* (ou ce *manitou*), comme ils l'appellent, qui doit donner la vie et la santé au malade moribond qui, ordinairement, ne laisse pas de mourir au milieu des danses, des chansons et du sabbat qu'on fait autour de lui, accompagné de cris et de hurlements horribles. Ce manitou (ou ce génie), disent-ils, a le pouvoir de chasser les diables ou les méchants génies qui sont dans la cabane ou dans le corps de celui qui va expirer.

On voit assez souvent des bandes de / vieilles / femmes qui, étant habillées en mégères, font des danses si superstitieuses autour du malade qu'il y a de quoi s'étonner de cet aveuglement. Elles battent des pieds et des mains, crient à pleine tête, tenant une tortue et disant ce seul mot *tetchiaroun, tetchiaroun, tetchiaroun*, qui veut dire *tous deux, tous deux, tous deux*, avec tant de nuances et avec tant de différents tons que je ne sais si le grand Baptiste et le savant Molinier n'y apprendraient pas quelque chose, l'un pour son opéra, et l'autre pour réjouir les États du Languedoc dans leur belle musique.

Pour ce qui touche la différence des tortues, on en trouve de toutes les espèces, soit dans les bois, soit dans les rivières, soit dans les prairies qui sont deux ou trois fois plus grandes que celles qu'on voit en France et ailleurs dans l'Europe. D'autres ont trois à quatre pieds de long et trois de large. Il y en a qui ont jusqu'à six pieds, et de largeur à proportion. D'autres sont si grandes que six hommes se placent aisément dans la coquille, et en la renversant, ils en font des bateaux. On prend ces grandes tortues quand elles sortent de la mer pour aller faire leurs œufs dans le sable où elles font une fosse assez profonde pour y faire une décharge de sept ou huit cents œufs à la fois. On en a même trouvé jusqu'à douze ou quinze cents dont soixante personnes peuvent se nourrir plus d'un jour. Lorsque la tortue fait cette décharge, il semble qu'on entend un coup de fauconneau* au bruit duquel on va pour la prendre auparavant* qu'elle puisse regagner la haute mer. Deux hommes n'ont qu'à la renverser sur son dos pour la prendre : elle est si lourde qu'elle ne peut plus se mettre sur ses pieds. Les œufs et la chair de toutes les espèces de tortues valent le poulet et le veau le plus gras. Les œufs de [f. 126] la grande tortue sont comme ceux des plus grosses poules. Ils éclosent dans le sable par la force de l'ardeur du soleil et par le regard de la tortue qui sort tous les jours de la mer pour les venir couver avec les yeux seulement. Et enfin, on voit sortir des petites tortues de dessous le sable comme les grenouilles de l'eau.

On jugera sans doute bien de tout ce que je viens de dire, dans ce traité des animaux à quatre pieds, que j'ai découvert un grand champ à ceux qui affectionnent déjà ou qui prendront avec le temps la noble inclination d'aimer à se divertir à la vénerie, laquelle, à proprement parler, est la chasse qui se fait après la bête à poil et à la course de meutes de chiens et des piqueurs* (qui leur lâchent la chaîne ou la laisse avec laquelle ils retenaient les mirauts*, les brifaux* et les cournaux* avec plusieurs limiers*, accompagnés des lisses*), ainsi qu'on la pratique parmi la noblesse du plus illustre et du plus florissant état du monde sous l'heureux règne de Louis Le Grand.

La vénerie bien réglée est un noble exercice pour le gentilhomme, fort utile à la santé, et un sujet également divertissant (et très profitable à la ménagerie) et qui, étant parfaitement conforme à l'exercice des armes, est un des plus considérables* qui se puisse pratiquer par toute notre illustre noblesse.

Nos barbares Indiens, quoique les plus sauvages du monde, se croyant les plus nobles des hommes, n'ont point de plus forte inclination après celle de la guerre que de se rendre parfaits dans le noble exercice de la chasse où ils se plaisent infiniment. Aussi y trouvent-ils les trois avantages dont je viens de parler. Ces messieurs, se voyant les plus indépendants de tous les habitants* les plus libres de la terre, ils s'attachent avec passion* et à la guerre et à la chasse, qui sont le véritable caractère et l'unique marque de la plus haute et de la plus ancienne noblesse qui, d'abord* qu'elle a été introduite dans le monde, n'a pris sa naissance que de l'indépendance, de la force et de la valeur des armes, et de la terreur de la guerre et de tous les autres exercices qui n'ont rien de bas ni de mécanique*. Ne voyons-nous pas que nos rois, même les plus puissants, n'ont point de plus forte ni de plus noble passion que la guerre pour conserver ou pour étendre justement les limites et la puissance de leurs états, et le divertissement de la chasse pour se délasser après les fatigues de leurs campagnes.

[f. 127] Or, nos Américains sauvages, étant souverainement indépendants de toutes les puissances de la terre, sont des braves guerriers, des grands veneurs, et entièrement détachés du mécanique. Il faut dire qu'ils sont sans doute très nobles, du moins à leur manière, et que si, de l'absolue indépendance qu'ils ont, ils en tirent tous les avantages qu'ils souhaitent, ils sont en cela heureux selon le monde, ne devant répondre à personne de leur conduite. Et que, si enfin par leur bravoure dans le métier de la guerre, par la fameuse réputation de leur vaillance et par l'incomparable valeur, ou, / si vous voulez, / par la terrible chaleur de leurs flammes avec lesquelles ils consomment leurs ennemis dans des tourments inouïs qu'ils font souffrir (pour de très bonnes raisons, et que les gens de bon sens approuvent après les avoir entendues, comme je le dis en quelque part dans ces mémoires) aux misérables victimes qu'ils sacrifient au dieu de la guerre (qu'ils ont pris dans leurs campagnes de cinq cents ou six cents lieues loin de leurs pays, où ils vont prendre des hommes qui ne leur sont ennemis que parce qu'ils sont d'une différente nation que de la leur, sans leur avoir jamais donné nulle occasion de leur aller faire la guerre), que si enfin, dis-je, nos Indiens se rendent formidables* à

leurs ennemis et aux nations les plus éloignées par la seule réputation de leur nom et de leur armes, il n'en faut pas être surpris, puisqu'ils se sont rendus aussi habiles que je le dis dans l'exercice de la vénerie qu'ils pratiquent dès leurs plus tendres années et où ils trouvent, toute leur vie, tous les avantages imaginables, le divertissement, l'agilité et la merveilleuse disposition de leurs corps, aussi bien que la santé qui s'entretient dans son embonpoint* parmi ces nobles et parmi ces très louables exercices qui doivent piquer d'honneur les gens qui ont du cœur comme en a la noblesse de notre invincible nation française.

Courage donc, messieurs, brave et illustre noblesse française, allez dans nos pays étrangers : cela même sera une marque de votre courage. Allez dans ces vastes forêts vous rendre habiles par un des plus beaux emplois* de votre état qui vous élève par-dessus le commun des hommes. Rendez-vous recommandables* par l'exercice des armes contre les ennemis de notre roi, si vous en trouvez qui soient assez téméraires pour lui disputer les conquêtes que Sa Majesté y a faites. Allez-y soutenir les fleurs de lys que les ennemis de son royaume y ont voulu abattre, mais en vain. C'est une [f. 128] terre de conquête. Il ne leur est plus permis d'y dominer, comme ils ont bien osé l'entreprendre, mais sans nul effet*. Et après que vous aurez terrassé leur fier lion avec une massue royale chargée de fleurs de lys que les sauvages vous mettront en main, attachez-vous à la bonne heure au bel et au noble exercice de la chasse et à y faire valoir des belles terres que Sa Majesté vous y donnera et qu'elle érigera sous les plus beaux titres que vous aurez mérités.

Vous y pourrez enfin jouir d'un doux repos, et sous l'ombre des bois, vous y prendrez vos plus innocents plaisirs dans l'emploi de la chasse qui ne vous y manquera pas. C'est dans cet exercice que vous y entretiendrez l'esprit martial et les plus belles inclinations de votre sang et de votre noblesse qui s'y augmentera et qui donnera peut-être, après tous vos soins, une heureuse naissance à un des plus illustres états qui ait jamais été, n'étant commencé que par de la noblesse, car il y a en toutes choses un commencement. L'empire des Romains, des Grecs, des Chinois et des Tartares a commencé par peu de chose.

Mais après vous être infiniment recréés dans l'exercice de la vénerie, prenez celui de la fauconnerie et de la haute volerie* que je vous présente en suite de ces pages dans ce que je m'en vais dire des oiseaux qu'on voit dans les Indes. Et si après tout cela, vous vous plaisez à la pêche, vous verrez bien des endroits que je vous marque par avance, très agréables, remplis de

toute sorte de bons poissons qu'on ne voit pas dans notre Europe, dont je vous donnerai à la fin de mon histoire naturelle les noms, les figures et les portraits.

NEUVIÈME LIVRE

[f. 129] C'est avec bien de la passion* que je souhaiterais d'avoir ici un peu de ce beau génie et un peu de cette forte idée avec laquelle on dit que les bons peintres, les philosophes et les poètes naissent. Ou bien plutôt, je voudrais bien avoir été assez heureux pour avoir profondément imprimé dans mon imagination tous les agréables mélanges des figures* et des plumages que j'ai remarqués dans une infinie variété de très beaux oiseaux qu'on voit, et sur la mer et sur les lacs, sur les rivières et sur la terre, et enfin sur les arbres de l'Amérique. Je ferais un des plus agréables tableaux qu'on puisse imaginer.

Plût à Dieu que je fusse quelque habile musicien, car, après avoir fait un tableau, je vous régalerais d'une charmante mélodie de tous les divers chants des oiseaux que j'entreprends de décrire.

Je ferais bourdonner mon oiseau-mouche, battre du tambour à ma perdrix grise qu'on entendrait de demi-lieue*. J'entrerais en fugue et je ferais gazouiller non pas mon rossignol, mais bien plutôt mon oiseau mort avec tant de nuances et avec tant de divers tons, que tantôt je descendrais si bas qu'à peine m'entendriez-vous, tantôt, je pousserais si haut ma voix qu'il vous semblerait entendre quelque fort agréable fausset. Je ferais la haute-contre et la taille*. Je ne laisserais même pas les moindres aspirations. En un mot, je n'oublierais rien de mon art, pour vous faire admirer le chant extraordinaire du geai, de la pie, de la grue, du héron, du milan, de l'oie, du cygne, de l'outarde, du cormoran, du goéland, des happe-foie, des marmettes, des huards, des canards de plus de vingt espèces, et tous les autres oiseaux que vous allez voir, soit de ceux que les oiseleurs dressent pour la haute volerie*, soit de ceux que les oiseliers* prennent avec leurs filets et avec d'autres machines*. Commençons par les plus petits pour finir, à notre ordinaire*, par les plus grands.

De l'oiseau-mouche[272]

C'est l'oiseau le plus rare, le plus beau et le plus merveilleux de tous ceux qu'on voit dans le Nouveau Monde, soit pour* sa petitesse, soit pour sa vitesse à voler, soit enfin pour l'agréable variété des couleurs qu'on découvre sur son plumage.

Tout le corps de l'oiseau n'a guère plus d'un pouce* de long. Son bec est de la même longueur. Il ne s'en sert que pour fouiller jusque dans le fond des fleurs, pour en attirer* [f. 130] la rosée. Il vit en voltigeant comme l'abeille, poussant incessamment un certain petit bourdonnement agréable qui surprend un peu lorsque l'oiseau passe comme un éclair auprès de quelqu'un. Il est si attentif à se repaître de la rosée des fleurs qu'on le prend quelquefois fort aisément, quoiqu'il soit toujours en l'air. Le bruit qu'il fait avec l'aile l'empêche d'entendre le bruit qu'on fait en l'approchant.

Son plumage est couvert d'un fort beau glacis vert sous lequel on découvre un jaune doré, et un admirable blanc argenté accompagné de toutes les variétés de plus vives couleurs.

La femelle ne diffère en rien du mâle, si ce n'est qu'en ce que le mâle semble avoir un charbon de feu sous la gorge.

C'est une chose fort curieuse que de voir le nid de l'oiseau-mouche qu'on ne trouve que rarement. Le nid n'est pas plus grand que la moitié de la coque d'un œuf de nos médiocres* poules. Les œufs sont proportionnés et à l'oiseau et au nid, et ne sont pas plus gros qu'un pois commun*.

On voit beaucoup de ces petits oiseaux que les Américains* nomment *rouroukassou* lorsque les fleurs sont épanouies et que les arbres sont en fleurs.

Dans les commencements que* les Européens habitèrent les Indes, ces oiseaux étaient précieux : les dames de la cour en portaient au lieu de pendants d'oreilles, mais la mode en est passée et les curieux se contentent de les tenir par rareté dans leurs cabinets; mais il leur arrive un malheur que les mites, les mangeant, font tomber toute la plume. Cela n'arriverait pas s'ils les gardaient dans des boîtes avec du suif de chandelle, car il n'y a rien de si contraire à cette vermine qu'on appelle des *mites*.

272 *Archilochus colubris* (L.), colibri à gorge rubis (M. Gosselin); représenté dans le Codex, Pl. XLI, fig. 58, sous la désignation «Rouroucasou ou oiseau mouche». Les ornithologues Michel Gosselin et Jeff Harrisson nous ont aidés dans la section sur les oiseaux. Qu'ils trouvent ici l'expression de notre gratitude pour leur expertise et leur patience. Nous les nommerons entre parenthèses comme nous l'avons fait pour nos autres informateurs.

Nous renverrons également à l'ouvrage classique de W.E. Godfrey, *Les oiseaux du Canada*, Musée National du Canada, Ottawa, 1967, (dans le cas présent, 266–7), et aux listes de Ganong, 227 et de Rousseau 1964, 323 déjà utilisées dans les sections précédentes. Ganong en particulier signale que Le Jeune (1635) et Denys parlent tous deux de l'oiseau mouche et que Lescarbot lui donnait son nom mi'kmaq, *niridau*.

De l'oiseau jaune[273]

Cet oiseau, qui est encore très petit, est particulier à l'Amérique. Il n'a rien / d'extraordinaire / qu'un jaune très vif, qui est un peu relevé d'une couleur brune qui fait ombrage aux pennes d'ailes et de queue. L'oiseau n'est pas plus gros que notre roitelet.

De l'oiseau rouge[274]

Celui-ci n'a rien de singulier que sa couleur de feu très vive. Il est de la grandeur d'un moineau.

De l'oiseau rouge et noir[275]

Il est tout couvert d'un manteau* rouge et brillant comme la plus belle écarlate. Il a les pennes, c'est-à-dire en terme de l'art d'oiseliers, les ailes et la queue noires comme du jaiet*, et il n'est pas plus gros qu'un de nos ortolans.

[f. 131] *De l'oiseau bleu, ou de l'oiseau royal*[276]

Vous diriez à le voir qu'il est descendu de ce beau firmament, et qu'en passant à travers les cieux, il s'est plu d'y faire teindre son manteau de ces belles couleurs azurées. Son manteau est donc à la royale, mais il est bordé de tous côtés d'une couleur de bure*, semé* d'une autre couleur grisâtre qui relève agréablement les pennes et tout le manteau, et rend l'oiseau agréable. Et c'est à mon avis la raison pour quoi on l'a nommé *l'oiseau royal*, puisqu'il en porte les couleurs. Il est de la grandeur de l'oiseau rouge, et son chant n'est ni trop doux ni trop rude.

De l'ortolan[277]

Le plumage, le goût, le chant sont tous différents du nôtre, et cet oiseau est assez rare dans le pays. Il est blanc, gris, noir, jaune, etc. Il est de même corsage que ceux de ce pays.

Du moineau, ou de l'oiseau blanc et gris[278]

Cet oiseau a deux sortes d'habits (s'il m'est permis de le dire ainsi) : il est comme le lièvre qui est gris pendant l'été et blanc durant l'hiver. C'est pourquoi on lui a donné les deux noms que j'ai marqués*. Après avoir passé toute la belle saison sous un plumage gris, il se varie* de tant de blanc sur la fin de l'hiver que l'on peut avec raison le nommer *l'oiseau blanc*.

Il est d'un goût rare, quoique la plupart du temps il ne vive que de neige. C'est un de ces oiseaux qu'on appelle *d'augure*, car il présage le froid et la neige, lorsqu'il commence de paraître à la fin d'octobre.

273 Son «jaune très vif» en contraste avec la couleur des ailes et de la queue fait penser au *Spinus tristis* (L.), connu aussi sous le nom de *Carduelis tristis* (L.), le chardonneret jaune (M. Gosselin) (Godfrey, 440–2). Mais on a aussi avancé *Dendroica petchis* (L.), fauvette jaune ou paruline jaune (J. Harrison) (Godfrey, 376–7). C'est l'un ou l'autre qui est représenté dans le *Codex*, Pl. XLI, fig. 58.1, sous la désignation «oyseau jeaune». Ganong, 210 croit que Cartier l'a mentionné en parlant du «Chardonnereulx».

274 *Carpodacus purpureus* (Gmelin), roselin pourpré (M. Gosselin et J. Harrison) (Godfrey, 432); représenté dans le *Codex*, Pl. XLI, fig. 58.2 sous la désignation «Le pinson rouge». Comme cet oiseau possède un chant très mélodieux, il n'est pas surpenant, selon Catherine Broué, que le *Codex* l'appelle un pinson. «Oiseau rouge» est encore le nom populaire du roselin pourpré au Québec (M. Gosselin). En réalité, le Roselin n'est ni pourpre, ni rouge feu. Roger Tory Peterson, 1980, le décrivait comme «a sparrow dipped in raspberry juice»!

275 *Piranga olivacea* (Gmelin), tangara écarlate (Godfrey, 422–3); représenté dans le Codex, Pl. XLI, fig. 58.3, sous la désignation «Le pinson rouge et noir». Nicolas le décrit dans son plumage nuptial (M. Gosselin).

276 *Sialia sialis* (L.), merle bleu à poitrine rouge (M. Gosselin et J. Harrison) (Godfrey, 345–6); représenté dans le *Codex*, Pl. XLI, fig. 58.4 sous la désignation «oyseau royal bleu».

277 On connaît en Europe le bruant ortolan, *Emberiza hortulana* (L.). Mais si l'on se fie à la description de son ortolan d'Amérique, Nicolas avait sans doute en vue le *Dolichonyx oryzivorus* (L.), le goglu (M. Gosselin et J. Harrison) (Godfrey, 407), représenté dans le *Codex*, Pl. XLI, fig. 58.5, sous la désignation «hortoland ameriquain». C'est le nom populaire habituel du goglu. Mais il arrive que l'on désigne aussi de cette manière l'*Eremophila alpestris* (L.), l'alouette cornue (Rousseau 1964, 72 et Godfrey, 302–3). C.S. Houston nous a signalé l'ouvrage de J.K. Sayre, *North American Bird Folk Names and Names*, Foster City, California, Bottlenrush Press, 1996, dans lequel le terme ortolan est attribué à plusieurs espèces, toutes présumément comestibles. Ganong, 228 signale des mentions dans Leclercq (1691) et Lahontan (1703), qui à son avis désigneraient le *Plectrophenax nivalis* (L.), le plectrophane des neiges, une confusion que Nicolas ne fait pas.

278 *Plectrophenax nivalis* (L.), le plectrophane des neiges (M. Gosselin) (Godfrey, 480–1), représenté dans le *Codex*, Pl. XLI, fig. 58.6, sous la désignation «moigneau ameriquain dont le plumage est tres varié. L'hyver il est tout blanc dans les autres saisons Il est gris melé de diverses couleurs».

Du rossignol[279]

Quoiqu'on ait donné ce beau nom à cet oiseau des Indes, il ne le mérite cependant pas, tant à cause que son ramage et ses gazouillements ne sont point si mélodieux, que parce que son chant est aussi différent du chant de notre rossignol que le langage du pays* est éloigné, et de nos façons de s'énoncer* et de nos idiomes, que parce que son plumage et sa grandeur sont bien dissemblables.

De l'oiseau à la tête rouge

Cet oiseau que je propose* ici est assez frétillant. Il a quelque rapport* à nos serins et à nos tarins. Son plumage est tout gris brun, excepté une petite houppe rouge qu'il a au haut de la tête.[280] Il tient quelque chose de la linotte. Son [f. 132] corsage* est comme celui de nos chardonnerets dont je vais dire une chose rare quoiqu'il n'y en ait point dans les Indes occidentales. La chose est digne d'être sue, d'autant plus que je crains que personne de tous ceux qui l'ont vu avec moi dans la ville de Montpellier n'en écrive jamais rien. Et puisque je suis après la description des oiseaux de l'Amérique, on ne sera pas fâché que je fasse savoir un trait de deux chardonnerets de France qui vaut plus et qui est plus admirable que tout ce que j'ai dit des oiseaux et que tout ce que j'en dois dire.

J'ai plus de deux ou de trois mille témoins qui diront avec moi que, l'année 1676, durant deux ou trois mois, qu'ils ont vu chez les messieurs les religieux de Saint-Ruf un chardonneret mâle, sauvage et libre, sans jamais avoir été apprivoisé, venir dans les chambres où était un autre chardonneret mâle apprivoisé dans une cage d'où il n'était jamais sorti. Son chant était un philtre si engageant pour le chardonneret sauvage qu'on avait beau le pousser dehors et cacher son amant* sous des manteaux, ce petit animal se désespérait pour ainsi dire jusqu'à ce qu'il aurait rencontré ce qu'il cherchait, et ne pouvant entrer dans la cage, ces deux oiseaux s'entrecaressaient perpétuellement se donnant le bec l'un à l'autre. Ces amours durèrent trois ou quatre

mois, jusqu'à ce qu'un religieux de l'ordre que j'ai nommé fit un présent de ces deux oiseaux à son général. Je n'ai pas su si, du depuis*, les deux oiseaux se sont quittés. Ma plume ne peut pas expliquer tout ce que j'ai vu d'admirable là-dessus.

De l'oiseau bigarré de porc-épic[281]

L'oiseau que je représente* ici n'est pas plus gros qu'un moineau. Son plumage est fort beau et fort bien varié. L'oiseau a trois marques sur chaque penne d'aile à droite et à gauche. Ces marques sont fort extraordinaires, car on distingue trois couleurs fort vives sur le bout de chaque aile : ce sont comme trois petits ailerons qui avancent en dehors du rang des plumes et d'une manière toute différente qui se distingue aisément par les couleurs même (jaune, rouge et blanche) qui ressemblent plutôt au poil du porc-épic qu'à toute autre chose. On voit les mêmes couleurs sur le haut de la tête de l'oiseau. Il se fait une crête de ces sortes de poil quand il veut, et cela fait paraître cet oiseau fort beau et fort extraordinaire. Il n'a rien d'ailleurs de particulier sur les pennes de queue, ni sur le reste de son corps, ni sur son manteau. Sa chair est délicate. Son chant est charmant.

[f. 133] *De l'oiseau anonyme*[282]

J'appelle l'oiseau dont je fais ici le portrait *l'oiseau sans nom* parce que les Américains ne lui en donnent point d'autre que le nom général d'oiseau, sans nulle autre distinction que celui de *pirechens*, ou de *piré*, ou de *pilé*, ou enfin *pilechens*, qui sont tous les noms communs, et qui ont tous la même signification parce que c'est le mot général dont se servent les Américains*, comme nous usons d'un mot commun qui signifie tous les oiseaux sans les différencier.

L'oiseau dont il est ici question est aussi* gros comme une de nos grives communes ou comme une de celles qu'on appelle des *grives italiennes*. Son plumage n'a rien de fort extraordinaire qu'un martelage* blanc qui est parsemé avec proportion sur tout le man-

279 «Rossignol» est le nom populaire du *Melospiza melodia* (Wilson), pinson ou bruant chanteur (Godfrey, 474–6) ou du *Zonotrichia albicollis* (Gmelin), pinson ou bruant à gorge blanche (Godfrey, 470–1), selon les régions (M. Gosselin).

280 *Acanthis flammea* (L.), sizerin à tête rouge (M. Gosselin) (Godfrey, 438–9); représenté dans le *Codex*, Pl. XLII, fig. 59.1 sous la désignation «Loiseau a teste rouge».

281 *Bombycilla garrulus* (L.), jaseur de Bohème (Godfrey, 356–7); il niche au Yukon, mais il hiverne dans le sud; on peut le voir en hiver dans le sud-ouest du Québec (M. Gosselin); représenté dans le *Codex*, Pl. XLII,

fig. 59.2, sous la désignation «Loyseau bigaré de porc epy le plemage est beau».

282 Peut-être un jeune *Eremophila alpestris* (L.), alouette cornue (M. Gosselin et C. S. Houston) (Godfrey, 302–3); représenté dans le *Codex*, Pl. XLII, fig. 59.3, sous la désignation «Loyseau sans nom». Chose curieuse, le dessin du *Codex* pourrait s'inspirer du casse-noix de Gesner, *Historiae Animalium, Liber III, qui est de Avium natura…*, 2e éd., Francfort, 1585, 245, probablement l'espèce européenne, *Nucifraga caryocatactes* (L.), le casse-noix moucheté, dans le cas de Gesner.

teau et sur toutes les pennes d'aile et de queue, où l'on voit une infinité de petits ronds grands comme un O commun. Cet oiseau n'a rien de commun avec nos oiseaux. Dans la saison d'automne, il est si gras qu'il ne peut presque pas voler, et il est d'un très bon manger. Je ne sais si son chant est fort agréable, car jamais je n'en ai entendu chanter. Son vol est prompt. On ne voit guère de ces oiseaux anonymes.

De l'arondelle, herondelle ou hirondelle[283]

Je n'ai pas remarqué que ce petit oiseau eût aucune ressemblance aux hirondelles que plusieurs assurent nous venir du côté de la Grèce, et particulièrement d'Athènes. Il n'y a même point de rapport avec les hirondelles de ce pauvre pays si dépourvu de bois qu'on y est contraint de chauffer les fours du corps de ces petites hirondelles qui, s'étant noyées en traversant la mer et rejetées par les vagues de quelque rude tempête sur les rives de la mer, et séchées par l'ardeur du soleil sur les sables brûlants, on les jette comme du bois dans les fournaises où elles brûlent comme de la paille pour y faire cuire du pain.

Nos hirondelles américaines ne nichent point à la façon de ces belles hirondelles athéniennes. Elles ont l'instinct d'un certain oiseau, admirablement beau, qu'on voit et qu'on prend le long des bords des rivières des pays* chauds du Languedoc et que les marchands drapiers recherchent avec soin pour les pendre dans leurs magasins, de peur que les mites, ou ces vers qui rongent les étoffes, n'y fassent nul* dommage. L'oiseau se nomme l'arnié. Ces oiseaux font leur nid dans des trous fort profonds qu'ils font dans le sable comme nos hirondelles, qui sont si fécondes que c'est un prodige d'en voir des infinités et des volées à couvrir l'air le long des dunes qu'on rencontre d'espace en espace le long du fleuve de Saint-Laurent. Dans moins d'un quart d'heure, on peut avoir des centaines de ces petits oiseaux qui sont fort délicats.

[f. 134] ### Du bec crochu[284]

Cet oiseau au bec crochu, tel que je le représente dans mes figures*, est si beau qu'il est charmant pour* la différence de ces couleurs si bien variées* qu'il n'y a, à mon avis, point de pinceau assez délicat, ni de couleurs assez vives pour le bien représenter.

Son bec ressemble à deux crochets, et c'est pour cela qu'on nomme l'oiseau le bec crochu. Je n'ai jamais bien pu comprendre comment il peut manger, car son bec n'est pas ni comme celui des perroquets, ni comme celui des oiseaux de la haute volerie* qui ont tous le bec en croc tourné en bas. Ces becs crochus l'ont tourné de droite à gauche, et de gauche à droite. Son chant est triste. Sa chair est fort délicate, et d'un goût fin.

De la lardère, nonnette ou mésange[285]

C'est encore ici un des plus agréables plumages qu'on puisse voir. On distingue toute la variété des couleurs sur les pennes et sur tout le manteau de ce petit aimable oiseau.

L'agréable guimpe, qui paraît fort blanche sur le col* de cet oiseau, lui a fait donner le nom de nonnette. Si son ramage était aussi agréable que sa guimpe, on pourrait dire que ce petit habitant de l'air, de la terre et des bois, aurait deux belles qualités : l'une pour réjouir la vue et l'autre pour recréer l'ouïe. Mais son chant est un peu trop triste pour donner du plaisir à ce sens.

Du martinet[286]

Le martinet des Indes occidentales, ne différant guère de celui de notre France, je ne sais qu'en dire, sinon de lui donner un peu plus de grandeur. Du reste, je n'y trouve qu'un peu de différence pour le chant, qui est assez désagréable.

Du merle[287]

Son chant, son manteau, ses pennes, son plumage, son duvet sont tout dissemblables de tous les merles que j'ai vus dans d'autres terres.

283 *Riparia riparia* (L.), hirondelle des sables (M. Gosselin) (Godfrey, 305–6); représentée dans le *Codex*, Pl. XLII, fig. 59.4, sous la désignation «hIrondelle de lAmérique». Champlain est le premier à mentionner l'«airondelle» en 1603 (Ganong, 221); Boucher parle des «hirondelles» en 1664 (Rousseau 1964, 322).

284 Une espèce de bec-croisé (J. Harrison). Pl. XLII du *Codex* (figure en bas de la page) semble s'appliquer au *Loxia curvirostra* (L.), le bec-croisé rouge. On notera l'absence de bandes sur les ailes (Godfrey, 442–3).

285 *Poecille atricapillus* (L.) ou *Parus atricapillus* (L.), mésange à tête noire (M. Gosselin) (Godfrey, 318–9); représenté dans le *Codex*, Pl. XLII, fig. 59.5 sous la désignation «La lardere ou mesange».

286 Rousseau 1964, 73 croyait qu'il pouvait s'agir du *Chaetura pelagica* (L.), le martinet ramoneur (Godfrey, 264–5); représenté dans le *Codex*, Pl. XLIII, fig. 60, sous la désignation «Le Martinet». *Progne subis* (L.), l'hirondelle pourprée (Godfrey, 309–10) pourrait être une meilleure identification, puisque L. Nicolas affirme qu'il s'agit d'un oiseau plus gros que le martinet d'Europe. Le *Codex* montre un oiseau à longue queue, plus susceptible d'attirer l'attention que le martinet (M. Gosselin).

287 *Turdus migratorius* (L.), merle américain (Godfrey, 339–40); représenté dans le *Codex*, Pl. XLIII, fig. 60.1 sous la désignation «Le merle ameriquain»; mentionné par Lescarbot, par N. Denys (Ganong, 225) et par P. Boucher en 1664 (Rousseau, 322).

Le mâle est tout gris sur le dos et sur les épaules. Il est rougeâtre sur la poitrine, gris blanc sous le ventre. Ses pennes sont entre grises et noires. Le bec est jaune. Il siffle agréablement. Ils s'assemblent à troupes avant l'hiver qu'ils vont passer dans les pays chauds.

La femelle est toute couverte de gris. Elle fait des œufs de couleur tirant entre le vert et le bleu. D'autres en font de couleur vert céladon*. Cet oiseau marque infailliblement le printemps quand il commence à paraître et à chanter.

On pense se moquer quand on dit «Je te donnerai un merle blanc», comme s'il était de l'essence de cet oiseau d'être noir et jamais blanc. Mais je veux bien qu'on sache qu'il y a des merles blancs.

[f. 135] De l'étourneau, ou du sansonnet
J'en ai découvert de deux espèces qui sont plus gros et plus grands que les nôtres. Et ils ne sont du tout* point variés de ces belles couleurs qu'on distingue sur les manteaux et sur les pennes des sansonnets de nos campagnes[288] qu'on dresse si bien à Paris à parler. J'y en ai vu qui parlaient beaucoup mieux que les perroquets les mieux appris*. Les nôtres sont barbares, et personne ne s'attache à leur apprendre quelque chose.

Il y en a une espèce[289] qui sont tout noirs, mais d'ailleurs* ils sont si beaux qu'on découvre aisément sur tout leur manteau et sur toutes leurs pennes toute la grande variété des couleurs à travers un glacis fort brillant qui laisse voir parfaitement toute la vivacité des couleurs qu'on voit ordinairement sur le col de nos plus rares* pigeons, lorsque le soleil donne à travers. Les arbres en sont quelquefois si chargés qu'il y en a plus que de feuilles.

L'autre espèce de sansonnets est[290] bien plus belle que cette première, car outre qu'elle a tout le beau plumage dont je viens de parler, elle a sur le dos de deux ailes un cœur, mais si bien distingué qu'il n'y a rien de plus juste ni de plus belle couleur dorée et relevée d'un très beau rouge fort vif en glacis doré sur toute la superficie du cœur qui est presque aussi grand qu'un double*, ou un liard* de France de chaque côté situé en la place que j'ai dit. Les Indiens font état de cet oiseau, et ils s'en parent fort souvent, et ils pensent de

n'avoir pas un moindre ornement sur leurs têtes, ou pendu à leur col, ou à l'oreille, que nos plus lestes* officiers, qui ont un beau chapeau de castor, ou un vigonne* accompagné du plumet bigarré des plus vives et des plus belles couleurs dont on a teint les plumes desquelles il est fait.

On ne voit pas partout de ces sortes d'étourneaux. Je n'en ai vu et tué que vers les îles Percées et dans les prairies de la Virginie. Mais il y en a tant dans ces vastes pays que la chose va au prodige. La chair n'en est pas trop bonne à manger : elle est dure à la cuisson. Voilà tout ce que j'ai remarqué de ces rares* oiseaux dont le ramage est fort agréable. Comme il est fort aisé d'en avoir, on pourrait les apprendre à parler. Pour moi, je crois qu'ils parleraient beaucoup mieux que les nôtres, ayant le tour du bec bien dégagé.

[f. 136] Du geai des Indes[291]
Si cet oiseau est de beaucoup plus petit que les geais qu'on voit sur les chênaies de France, il n'en est pas néanmoins ni moins beau, ni moins rare par la charmante variété de son plumage et de son agréable manteau royal tout différent de celui de nos geais communs. Il n'est personne en Europe qui n'ait connaissance du geai, et chacun sait assez comme* il est fait, mais il y a bien peu de gens en France qui sachent comme les geais des Indes sont faits à moins que d'en avoir vu des transportés* ou d'avoir pris la peine eux-mêmes de s'être portés* sur les lieux où ils sont.

On saura donc que le geai dont il est ici question est revêtu d'un très beau plumage azuré sur tout son manteau, comme le ciel nous paraît dans les plus beaux jours ou pendant les nuits les plus sereines. Tout le tour du manteau semble être doublé de gris blanchâtre sous le ventre de l'oiseau.

Son ramage, ses sifflements et toutes les agréables nuances de son chant sont bien plus mélodieuses que celles des nôtres, et si l'on n'était sûr qu'un même oiseau siffle et chante de plus de vingt différentes façons, on croirait aisément entendre autant de divers oiseaux.

De la pie américaine[292]
Si le geai dont je viens de parler est entièrement diffé-

288 En fait, le *Sturnus vulgaris* (L.), l'étourneau sansonnet, ne fut pas introduit en Amérique (ville de New York) avant 1890 (Godfrey, 360–1).

289 *Quiscalus quiscula* (L.), mainate bronzé (Godfrey, 419–20); non représenté dans le *Codex*.

290 Il s'agit d'*Agelaius phoeniceus* (L.), carouge à épaulettes (M. Gosselin) (Godfrey, 411–13); non représenté dans le *Codex*.

291 *Cyanacitta cristata* (L.), geai bleu (M. Gosselin et J. Harrison) (Godfrey, 311–2); représenté dans le *Codex*, Pl. XLIII, fig. 60.3 sous la désignation «gey ameriquain dun plemage tout bleu». Lescarbot le mentionne (Ganong, 218). Boucher également (Rousseau 1964, 323).

292 *Perisoreus canadensis* (L.), geai gris (M. Gosselin) (Godfrey, 310–11); représenté dans le *Codex*, Pl. XLIV, fig. 61 sous la désignation «Pie Ameriquaine». «Pie» est toujours le nom populaire de cet oiseau. Boucher le connaissait (Rousseau 1964, 323).

rent de celui de la France, la pie dont je vais vous donner la brève description n'est pas moins dissemblable de celles qu'on voit en Europe sur tant de différentes terres.

Je n'ai jamais pu découvrir nulle convenance que le nom que les Francs lui ont donné, et que j'appelle ainsi avec eux pour ne savoir point d'autre nom d'un oiseau étranger qui ne ressemble du tout point à aucun des nôtres qu'en ce qu'il vole et qu'il a des plumes et qu'on peut assurer être bien mal nommé, car quelle apparence* y a-t-il qu'on appelle pie un oiseau tout cendré et qui n'a aucun rapport aux pies, non pas même à la seule que j'ai vue, à neuf cents lieues loin de l'embouchure du fleuve de Saint-Laurent?²⁹³ Il n'y avait nulle différence des nôtres pour le plumage, mais elle était bien plus petite.

Du grimpereau²⁹⁴
Le grimpereau est un oiseau si petit que peu s'en est fallu que je ne l'aie oublié. Il grimpe sur les arbres avec tant de vitesse qu'il se rend pour ainsi dire invisible. Il est habillé de diverses couleurs. Je ne l'ai jamais ouï chanter. Il vit de fourmis et de vers.

[f. 137] De quatre espèces de pics qu'on voit au-delà de la mer²⁹⁵
On rencontre, dans les forêts du septentrion et du côté du couchant du soleil, quatre différentes façons de pics. Ils sont tous d'un très beau plumage.

Le pic que les sauvages appellent *papassé* est fort remarquable pour l'étrange bruit qu'il fait dans les forêts avec son bec frappant contre les arbres. On l'entend de plus de demi-lieue, quoiqu'il soit fort petit. Ces oiseaux, quoique fort petits, font une infinité de niches de toutes figures* sur les arbres pourris dont ils tirent une grande quantité de vermine dont ils se nourrissent.

Parmi ces quatre sortes d'espèces de pics, il y en a une dont on peut assurer être un oiseau d'augure²⁹⁶ pour distinguer les temps, et selon son divers chant, on sait infailliblement, par des longues expériences*, s'il fera bientôt beau temps ou s'il sera rude, pluvieux, venteux, froid, etc.

Au contraire de l'autre qui est la troisième espèce, lequel, lorsqu'il chante, on peut assurer qu'il fera bientôt quelque fort rude temps.

Mais le gros pic²⁹⁷ qui est le plus beau de toutes les quatre espèces est rare* en ce qu'il est peint de trois rares couleurs. Il a sur la tête une très belle et une fort grande houppe, teinte d'un rouge si vermeil qui éblouit la vue. Les barbares de diverses nations, et particulièrement les Illinois, font gloire de se faire des couronnes, des baudriers et des tours de col, des jarretières et des bandoulières des têtes de ces oiseaux qu'ils enfilent l'une après l'autre de la même manière que nous enfilons nos grains de chapelet.

L'oiseau est gros comme une poule. Tout son manteau est chargé d'un noir épais et fort luisant. Il est maillé* partout de blanc, même sur les pennes d'aile et de queue. Sa chair est grossière et ne vaut pas plus que celle de nos pics-verts et que celle de nos pics-marcs.

Tous ces oiseaux sont de chant²⁹⁸ et de passage, de six mois de terre, de bois et des prés, aussi bien que la tourte ou le biset sauvage dont je vais dire des choses fort curieuses après que j'aurai décrit l'*oiseau mort* comme le nomment les naturels du pays. *Tchipai-zen*, disent-ils, assurément cet oiseau est l'âme d'un trépassé.

De l'oiseau mort nommé tchipai-zen²⁹⁹
C'est une pure rêverie des Indiens qui assurent qu'il y a un oiseau mort et dans le corps duquel il entre une âme d'un homme ou d'une femme qui vient chanter auprès des endroits [f. 138] où l'on campe. Rejetant toutes les sottes opinions de ces aveugles, je dis qu'il est

293 Probablement Chaquamegon, à l'extrémité occidentale du lac Supérieur, où Nicolas se trouva en 1667 (voir l'Introduction). Dans ce cas, l'oiseau aperçu par Nicolas est la *Pica hudsonia* (Sabine), pie bavarde (M. Gosselin) (Godfrey, 313).

294 *Certhia familiaris americana* Bonaparte, sous-espèce du *Certhia familiaris* (L.), grimpereau brun. Le grimpereau d'Europe, très semblable, ne pouvait être que familier à Nicolas (M. Gosselin) (Godfrey, 327); non représenté dans le *Codex*.

295 On en connaît huit espèces dans l'est du Canada. Voir Rousseau 1964, 323

296 Ce ne peut être que le *Colpates auratus* (L.), le pic doré (Godfrey, 273–4); il est nommé «l'oiseau de pluie» dans les nomenclatures populaires (M. Gosselin).

297 *Dryocopus pileatus* (L.), grand pic (M. Gosselin) (God-

frey, 275–6); représenté dans le *Codex*, Pl. XLIV, fig. 61.2, sous la désignation «grand pie Vert a la Teste rouge comme une belle creste de coq».

298 On ne classerait pas les pics aujourd'hui comme des oiseaux chanteurs. De plus, sauf le *Melanerpes erytrocephalus* (L.), le pic à tête rouge et le *Sphyrapicus varius* (L.), le pic maculé, la plupart des pics ne sont pas migrateurs (J. Harrison).

299 Probablement le *Caprimulgus vociferus* Wilson, engoulevent bois-pourri (Godfrey, 259–61). Les noms d'oiseaux indigènes sont souvent des onomatopées et trisyllabiques comme le *tchi-pai-zen* (M. Gosselin). Il est représenté dans le *Codex*, Pl. XLV, fig. 62.1, sous la désignation «tchipai ou oyseau mort». C.S. Houston note que *Cipay* en langue cree veut dire «mort» ou «esprit».

constant* qu'il y a un oiseau que j'ai vu et entendu, nommé comme je viens de dire, qui chante avec tant d'ardeur et avec une telle continuation, qu'il n'y a point d'entre-deux dans sa chanson ou plutôt dans son ramage surprenant.

C'est une fugue de musique d'oiseau si fort animée que, dans l'espace de six ou de sept heures, elle n'est jamais entrecoupée, non pas même de la moindre pause, de sorte qu'il a de quoi être surpris extrêmement d'entendre cet oiseau durant un si long temps après un effort si rude*, sans crever.

Je ne sais de quel plumage est cet oiseau, ne l'ayant vu qu'entre chien et loup et ouï* chanter comme j'ai dit. Il ne paraît jamais le jour et il ne chante que la nuit. Il m'a paru de la grosseur d'un merle. Il n'oserait, disent nos chasseurs, paraître le jour, car on lui ferait la guerre. Lorsque les barbares l'entendent, ils saluent l'âme du trépassé qui est dedans et ils croient que c'est quelqu'un de leur parents : «*Kitaramikourimin tchipaizen*, nous te saluons, ô âme de trépassé assurément». Et si la fantaisie en prend à quelqu'un, tout sur-le-champ, il fait festin pour donner à manger à cette âme en attendant qu'on fasse le festin général, lorsque les nations s'assembleront quand on fera la fête solennelle pour tous les trépassés qui sont morts dans l'espace de dix ans, au bout desquels on donne tant à manger aux âmes des trépassés qu'elles ont assez de force pour aller au pays des morts du côté du septentrion et d'où elles ne reviennent jamais. Voilà une partie des folies de nos Américains touchant leur foi pour les trépassés. Je traite la chose à fond sur la fin de tous mes ouvrages français.

De la tourte, ou du biset sauvage[300]
Puisque cet oiseau fait une des principales récréations de tous les habitants des grandes Indes, et septentrionales et occidentales, on sera peut-être bien aise* d'en savoir les particularités*, qui sont

1° que ce biset est grand comme un pigeon commun;

2° que son plumage est toujours semblable, et le manteau de tous les mâles est éternellement uniforme, si bien que qui en voit un, voit comme tous les autres sont faits, et ainsi des femelles qui sont vêtues* bien autrement que les mâles. Il n'y a qu'une couleur rougeâtre qui distingue le mâle d'avec la femelle. Tout le manteau de ce pigeon sauvage est gris cendré. Toutes les pennes sont [f. 139] fouettées* d'une couleur assez

jaune. Les pennes de queue sont maillées au bout de chaque plume, mais les quatre plumes des extrémités des pennes de la queue sont fort notablement plus longues que les autres plumes du milieu de cette partie des pennes de queue, en sorte que l'oiseau a la queue extrêmement fourchue. On distingue bien cette différence même quand l'oiseau vole en si grandes bandes que la chose passe de beaucoup l'idée qu'on s'en peut former avant que de l'avoir vu.

3° Cet oiseau passe* deux fois l'année : premièrement au printemps; deuxièmement vers la fin de l'été. Et il y a des années que le passage* en est si grand qu'on en tue tant qu'on veut à coups de bâtons dans les rues de Mont-Royal; on leur tire des fenêtres même lorsqu'il en passe des bandes.

4° Le plaisir n'est pas moindre, lorsque, dans une matinée on en voit prendre les sept à huit cents à deux ou trois personnes, lesquelles tendent un petit filet qui traverse un vallon. Et si, d'un seul coup de fusil, on en tuait plus de cent, ne dirait-on pas qu'il faut qu'il y en ait beaucoup pendant la saison du passage? Ce coup est arrivé sur la côte de Beaupré, où j'ai vu et revu le chasseur qui en tua cent vingt d'un seul coup. La chose est très commune qu'un chasseur revienne chargé de ces oiseaux dans une heure après avoir tiré quatre ou cinq coups seulement.

5° Ne serait-on pas étonné si, dans une seule matinée, on voyait plus de sept ou huit mille / de ces tourtes / sur le carreau au milieu d'un petit cabanage *? Cela est fort commun.

6° Ce n'est pas une chose trop rare qu'on traverse des plages* de trois ou quatre grandes lieues* de long, tellement garnies des nids de ces oiseaux que la chose me paraîtrait presque incroyable si je n'en avais été spectateur bien des fois.

7° Ce n'est pas encore un petit divertissement de se trouver dans ces occasions* où l'on voit de grandes prises de ces pigeonneaux aussi délicats et aussi gras que ces pigeons qu'on élève dans des chambres. Sept ou huit mille / personnes /, tant hommes que femmes et enfants, vont faire cette chasse durant un mois : ils en reviennent tous si gras avec leurs chiens que la chose surpasse la croyance.

8° Il s'est trouvé des années que beaucoup de Français en ont salé des muids* tout pleins après en avoir vu longtemps pendant la saison. En un mot pour finir, je dirai qu'il y a du prodige lorsque, durant quinze ou

300 *Ectopistes migratorius* (L.), tourte (M. Gosselin) (Godfrey, 242–2); représenté dans le *Codex*, Pl. xlv, fig. 62 sous la désignation «*Oumimi* ou *ourité* ou tourte on en voit de si grandes quantites au premier passage du printems et de lautonne que la chose n'est pas croyable à

moins que de la voir». Cartier en parle déjà en 1534 comme des *teurtres*, mais Champlain et Lescarbot préfèrent la nommer *palombe* (Ganong, 240); Boucher parle de *tourtes* ou de *tourterelles* (Rousseau 1964, 320).

vingt jours, on en voit passer des bandes qui couvrent l'air durant tout ce temps-là l'espace de plus de trois ou quatre lieues de long. Quand cela tombe dans des champs, ils les ont bientôt perdus. Et parmi les Français, il y a une ordonnance portée par le Conseil souverain de ne laisser aucun arbre dans leurs champs, de peur que ces oiseaux ne s'y reposent pour, de là, fondre sur leurs grains.

[f. 140] *De la perdrix blanche*[301]

La ravissante couleur de ce bel oiseau m'invite à lui donner le premier rang parmi les quatre espèces de perdrix qu'on tue dans les forêts des Indes.

Il n'y a point d'albâtre qui soit plus blanc que tout le manteau de la perdrix blanche du Nouveau Monde. Toutes les pennes de queue et d'aile sont relevées du filet d'or qui, courant avec son jaune admirable tout le long de chaque plume, rehausse la couleur blanche qui fait le fond de tout le manteau de l'oiseau. Le bec fort noir et fort reluisant*, accompagné d'un rouge vermeil qui entoure les yeux de cette perdrix, ne donne pas un petit lustre à une tête et à tout un corps d'un des plus beaux oiseaux qu'on saurait voir. Considérer, au lieu de pieds et de jambes d'un oiseau, des pattes de lièvre très bien proportionnées, et qui servent de raquette à cet oiseau, ce n'est pas, à mon avis, un petit sujet d'admiration pour les naturalistes. L'oiseau que je décris ici ne paraît jamais dans le pays que sur les glaces et sur les neiges dont il fait sa principale nourriture et dont il se nourrit. Il est gras en ce temps-là, et d'un goût exquis, au contraire des autres trois espèces qui n'ont aucun bon goût dans cette rude saison.

De la perdrix noire[302]

Si la blancheur fait toute la beauté de la perdrix blanche, la couleur du jaiet* fait tout l'ornement de la perdrix noire.

Sa tête ronde, ces yeux dorés et bordés d'un rouge incarnadin*, ne donnent pas un petit lustre à ce très bel oiseau qui est maillé* sur le devant de la poitrine et sur tout son manteau, aussi bien que sur les pennes, d'une infinité de mouchetures blanches.

On voit quelque chose de rare sur les pieds de notre perdrix noire quoiqu'il semble qu'il n'y a nulle dif-

férence de ceux des perdrix qu'on voit en France. Mais ceux qui étudient les choses un peu de près y trouvent une différence bien notable dans une infinité d'une sorte de petits pieds qui ressemblent à ceux des chenilles, qui servent d'autant de petits crochets à cet oiseau pour se tenir sur la perche, car il faut remarquer que toutes les quatre différentes sortes de perdrix qu'on voit dans [f. 141] les Indes perchent sur les arbres, au contraire de celles des autres terres qui ne font que motter*. Notre perdrix noire est d'un goût excellent dans sa saison d'automne.

De la perdrix grise[303]

Si la couleur du manteau de la perdrix grise est toute différente des autres perdrix, et si sa figure* et si son inclination n'ont rien de semblable à celle des autres espèces, elle n'est pourtant pas moins agréable, car à la voir ornée d'une grosse houppe sur la tête, son bec bien tourné, ces yeux brillants et entourés d'un cercle jaune comme de l'or, son col paré d'une belle grande fraise noire bigarrée de blanc et bordée de jaune; tout son manteau a fond de petit gris, martelé* de plusieurs différentes couleurs (blanche, jaune, noire, etc.) avec toutes ses pennes rayées d'une couleur d'or et d'argent, de noir, de gris, de blanc, et mouchetées de diverses figures; sa queue, extrêmement longue, qu'elle fait très souvent paraître en forme d'un éventail, et faisant la roue à la façon du coq* d'Inde, ne donnent pas une moindre grâce à ce bel oiseau que les autres beautés que j'ai remarquées donnent de l'éclat à nos autres perdrix.

La chasse de cette perdrix qui perche sur les arbres, étant fort agréable, mérite bien que j'en parle.

Un Indien qui a découvert la compagnie de perdreaux les prend ordinairement tous fort facilement de trois manières.

1º Avec la flèche, il les darde* l'un après l'autre : ces animaux sont assez sots pour se laisser tous tuer l'un après l'autre sans branler*.

2º Lors même qu'on les tue à coups de fusil, le bruit ne les épouvante point : ils tiennent toujours ferme sur la branche jusqu'à ce que l'on les blesse ou qu'on les tue. Apparemment, ces oiseaux sont accoutumés au bruit que font les branches d'arbre quand la gelée les fait rompre avec un bruit aussi éclatant qu'un coup de

301 Comme Boucher (Rousseau 1964, 320) ou Denys (Ganong, 231), Nicolas distingue trois espèces de perdrix. La première mentionnée est le *Lagopus lagopus* (L.), le lagopède des saules (M. Gosselin) (Godfrey, 130–1), représenté dans le *Codex*, Pl. xlv, fig. 62.2 sous la désignation «Perdris blanche de Lamerique dun gout eschis».

302 *Canachites canadensis* (L.), connu aussi sous le nom de

Dendragapus canadenssis (L.), tétras des savanes (M. Gosselin) (Godfrey, 127–9), non représenté dans le *Codex*.

303 *Bonasa umbellus* (L.), gelinotte huppée (M. Gosselin) (Godfrey, 129–30); magnifiquement représentée dans le *Codex*, Pl. xlvi, fig. 63, sous la désignation «Papace ou perdris grise. Cette perdris est remarquable par le bruit qu'elle fait battant des ailles sur un arbre pouri dans les Bois. On L'entend de pres d'une lieu Loing».

mousquet, et la chose est assez agréable, lorsqu'on se trouve au milieu des forêts pendant le temps des grandes gelées de ces contrées, auquel temps on est quelquefois agréablement surpris au même temps que de toutes parts on entend comme des coups de fusils lorsque plusieurs branches et de divers arbres se rompent par la force de la gelée.

3° Lorsque le chasseur sauvage qui court dans les bois après ce gibier prend une longue perche de quatre ou de cinq [f. 142] brasses* de long, et qu'il attache au bout un lacet*, cet oiseau ne sait point fuir, mais il se laisse prendre sans branler, ni aucunement remuer qu'il ne soit pris par le collet. Et pour lors, il bat un peu des ailes sans que cela étonne nullement les autres qui se laissent tous enlacer* successivement.

Cet oiseau est fort délicat à manger vers la fin de l'automne; mais pendant l'hiver il est sec comme du bois : aussi* ne fait-il que brouter (si l'on peut dire ce mot d'un oiseau) sur les arbres, toute la terre étant couverte de quatre ou de cinq pieds* de neige dans l'espace et le long d'une plage* de près de mille lieues. L'oiseau ne peut pas paître à son ordinaire comme font les oies, ou becqueter comme le reste du commun* des oiseaux.

Vers la fin du mois d'avril, lorsque cet oiseau commence de vouloir nicher et d'entrer en amour, son appeau* est tout à fait inouï et inconnu à tous les chasseurs, à tous les oiseleurs* et à tous les oiseliers* de France. Les autres oiseaux se servent de leur bec et de leur différente voix pour se réclamer* ou pour se rappeler; mais celui-ci se sert seulement d'une certaine façon de battre les ailes, dont il frappe avec tant de vigueur un tronc d'un arbre abattu et pourri, qu'on en entend le bruit d'une demi-lieue loin. Et il semble à ceux qui ne sont pas accoutumés à cette sorte de bruit que c'est un coup de tonnerre qu'on entend venir de loin. Voilà en peu de mots ce que j'ai remarqué de cette perdrix grise.

D'une autre perdrix grise et faisandée[304]

Quoique j'appelle cette perdrix *grise*, elle ne laisse pourtant pas d'être d'une espèce toute différente de celle que je viens de décrire; mais comme sa couleur rapporte* beaucoup à la perdrix grise commune je n'ai pas pu lui donner un autre nom que de grise, me contentant de la différencier par le mot de *faisandée*. Le plumage et l'inclination toute particulière de cette perdrix, bien qu'elle ait quelque rapport à la grise la distinguent assez. Et quoi que c'en soit, je vous présente cet oiseau pour une quatrième espèce de perdrix, qui est fort belle et d'un bon goût.

Son inclination la porte à se percher toujours sur le plus haut des plus grands arbres où elle fait sa plus longue demeure. Elle niche à terre comme toutes les autres espèces de perdrix. Son plumage est comme uniforme, un peu varié néanmoins de quelques basses* couleurs. Elle est plus sauvage que les autres espèces.

[f. 143] De la corneille et du corbeau[305]

Comme il n'y a rien dans ces deux sortes d'oiseaux que le langage (s'il m'est permis d'appliquer ce mot dans cette rencontre*) de différent / des nôtres /, je n'en dirai qu'un mot pour faire savoir que, de tous les oiseaux que j'ai vus dans le Monde Nouveau, il n'y en a que ces deux espèces ici qui soient parfaitement semblables aux oiseaux de cette sorte qui se voient dans toute l'Europe : ce que j'entends* seulement des oiseaux de terre, et non pas de ceux qui fréquentent les eaux, car une bonne partie de ceux-ci n'ont guère de différence, du moins entre* nos canards communs.

Le corbeau des Indes ne croasse jamais; mais il a un certain cri bien sauvage qui ne laisse pas d'inspirer quelque mélancolie à ceux qui l'entendent dans l'épaisseur, dans les ombres et dans l'horrible silence des vastes forêts de l'Amérique.

Ce bel oiseau passe pour une divinité, et les bateleurs du pays s'en servent pour divers enchantements. Ils consultent cet oracle qu'ils portent toujours, embaumé, dans leurs plus grands voyages. Ils lui portent du respect et lui demandent souvent qu'il communique des vertus de santé à quelques racines dont ils font des breuvages pour les malades. D'autres le pendent au bout d'un bâton sur le sommet des montagnes, et là, comme des Taborites, ils attendent les trois jours entiers les résolutions des affaires qu'ils ont proposées à ce manitou, ou à ce génie qui ne leur répond rien; mais comme ce-

304 Comme il est probable que Nicolas avait visité l'île Manitoulin, sa description d'un oiseau perchant haut dans les arbres pourrait correspondre à la *Pediocetes phasianellus* (L.), connue aussi sous le nom de *Tympanuchus phasianellus* (L.), la gelinotte à queue fine (C.S. Houston et M. Gosselin) (Godfrey, 134–5); représentée dans le *Codex*, Pl. XLVIII, fig. 65 sous la désignation «perdris fesandeé».

305 *Corvus brachyrhynchos* Brehm, corneille américaine et

Corvus corax (L.), le grand corbeau (M. Gosselin) (Godfrey, 315–16 et 313–15). Le *Codex* représente en Pl. XLVIII, fig. 65.2 un «corbeau a bec et pied rouge» et en fig. 65.3 une «corneille a bec et pied rouge» qui semblent tous deux s'inspirer du *Pyrrhocorax pyrrhocorax* (L.), la crave à bec rouge telle qu'on la trouve dans Gesner, 522. Champlain ne parle que de corbeaux (Ganong, 212), mais Nicolas et Boucher (Rousseau, 1964, 323) font déjà la distinction entre corbeau et corneille.

lui qui va consulter cet oracle ne fait que rêver sur ce qu'il a proposé, et s'endormant là-dessus, il rêve la même chose, et c'est assez pour dire que le corbeau lui a parlé : tout le monde l'en croit.

La corneille n'a pas un chant guère plus mélodieux que le corbeau commun, non plus que cette autre espèce de corbeaux et que cette autre sorte de corneilles qu'on voit dans la grande île aux Oiseaux, du côté du nord et dans le grand golfe de Saint-Laurent, qui ont le bec et les jambes rouges et qui font leurs petits dans des trous qu'ils font dans le sable comme les lapins.

[f. 144] *Du coq* d'Inde*[306]

Ce gros oiseau n'étant guère différent des nos coqs d'Inde, puisque nous n'en avons que de ces lieux, et cet oiseau étant très commun et connu de tout le monde, je n'ai pas bien des choses à dire. Je ferai seulement savoir que celui qu'on prend dans ces terres étrangères de l'Inde est bien plus délicat à manger, qu'il est plus vif et plus sauvage que ceux qu'on a apprivoisés dans notre Europe.

Le coq d'Inde américain va par bandes, et quoiqu'il ne vole pas souvent tout à fait, il ne laisse pas d'aller si vite qu'il est rare qu'un bon coureur l'attrape, car il a deux ou trois mouvements en même temps : il marche, il court et vole sans perdre terre, comme les autruches de l'Afrique. Son plumage est plus beau que celui des coqs d'Inde apprivoisés. Les sauvages s'en parent avec du moins* autant de fierté que nos plus lestes* courtisans de leurs plus beaux plumets de diverses couleurs.

Voilà enfin tout ce que j'ai à dire des oiseaux terrestres qui souffrent la rapine*. Disons ensuite de cela quelque chose de ceux qui la font et qui en vivent. Et peut-être ne sera-t-il point mal de les placer au milieu de ce traité des oiseaux, de sorte qu'en décrivant, sur la fin du traité des oiseaux, les oiseaux de rivière, ils en puissent lier* autant qu'ils pourront avec leurs serres au milieu de leur main*, à droite et à gauche, en haut et en bas, à terre, sur les arbres et sur la superficie des eaux. C'est de ceux-là que je dois parler, comme j'ai dit, à la fin du traité des oiseaux, et vous y en faire voir une si grande multitude que vous n'aurez pas peu de sujet de vous étonner en admirant toutes les différentes espèces de ces habitants des grandes eaux de l'Amérique septentrionale et occidentale.

[Septième cahier de L'Histoire naturelle de l'Inde occidentale]

Noms des oiseaux de chasse ou de rapine que j'ai remarqués dans la partie septentrionale et dans les cantons* de la partie occidentale de l'Amérique*

l'émerillon
le faucon
le turc ou le mangeur de maringouins
l'autour
le taugarot ou le tartarot*
l'aiglon
l'épervier
l'aigle
le brillant
le mouchet, ou le mâle de l'épervier
le hobereau
Tous ces oiseaux sont oiseaux de jour; les suivants sont oiseaux de nuit :
la chouette
le chat-huant
le hibou de deux façons*

Je crois qu'il n'est pas hors de propos de dire ici un mot des termes de la fauconnerie et de tout ce qui la touche, afin que ceux qui prendront la peine de lire les descriptions que je ferai ensuite des oiseaux de proie le fassent avec beaucoup plus de plaisir et / beaucoup plus / de connaissance. Ils trouveront tous les termes de ce beau métier de la noblesse, qui se pique de savoir l'art de la fauconnerie. J'ai fait ici un extrait de tous les écrivains anciens et modernes, pour ne donner pas la peine à ceux qui voudront savoir comment il faut gouverner* les oiseaux de rapine d'aller chercher dans dix ou douze auteurs ce que je mets ici en peu de mots.

Je dirai donc, en général, que ce bel emploi, pour ne pas dire cet art de la noblesse, apprend à apprivoiser les *voleurs*, les *rapineurs* et les *oiseaux de proie*, comme l'art les appelle. Cet emploi, dis-je, enseigne la manière d'assurer* l'oiseau de proie, et à l'employer à propos à la volerie* du gibier proportionné à l'oiseau qu'on dresse.

Ce bel art prend son nom (quoiqu'il s'applique à tous les oiseaux de haut vol*) du faucon, qui est la plus noble espèce de tous les oiseaux de chasse et de rapine.

306 *Meleagris gallopavo* (L.), dindon sauvage (M. Gosselin) (Godfrey, 141–2); représenté dans le *Codex*, Pl. LXXII sous la désignation «Coq dinde»; mentionné par P. Boucher (Rousseau 1964, 319–20).

L'*affaiteur**, comme l'art le nomme, ou pour parler plus clairement, l'*apprivoiseur* des oiseaux de chasse [f. 146] s'appelle *fauconnier*, aussi bien que *maître chasseur* au déduit* de la volerie.

L'*oiseleur*, ou *oiselier*, chasseur d'oiseaux de proie, est différent du fauconnier : l'un dresse l'oiseau, l'autre le prend; ce sont deux emplois différents; mais ils sont tous deux nobles. Et même la plus haute et la plus grande noblesse ne fait nulle difficulté de s'y occuper quelquefois, soit en dressant son oiseau, soit en le prenant à la main dans l'aire* ou au filet sur des passages*, et à la glu*, quoiqu'à dire le vrai ce n'est pas la plus noble partie de la fauconnerie. C'est l'emploi des officiers du seigneur qui se plaît à la fauconnerie, cependant* que le gentilhomme voltige à cheval avec tout son cortège sous le vol de l'oiseau.

Tous les oiseaux du jour que j'ai nommés dans l'autre page sont naturellement portés à la quête et à la chasse du gibier, et ils vivent de leur proie. C'est pour cela que la nature les a armés de bec et fournis d'ongles, de serres et de griffes aiguës, et pourvus d'une belle main* ou d'une belle patte proportionnée à leur grandeur et à leur gibier. Ils ont les ailes et la queue, qu'on appelle autrement *pennes fortes*, d'aile et de queue : ces pennes sont longues et bien dégagées, accompagnées de leurs guidons* pour tourner avec agilité de tous côtés comme si c'étaient autant de gouvernails.

Si les oiseaux du pays sauvage étaient affaités*, apprivoisés ou fauconnés* au déduit de la haute volerie, bien qu'ils soient niais de leur naturel, ils ne laisseraient pas de donner* avec vigueur sur la proie de France qui, étant beaucoup plus délicate que la leur commune*, les affriandirait* et les rendrait brillants.

Quand l'oiseau sor*, ou de sorage (c'est-à-dire du premier plumage qui n'a pas encore mué) donne sur le gibier, on le voit fort lent, et sans beaucoup de vigueur. Et s'il n'use de surprise, il est extrêmement embarrassé pour vivre. Et c'est pour cette raison qu'on le voit sortir bien tard de l'aire, et qu'il se fait abécher* longtemps.

Mais l'oiseau qui a mué donne avec bien plus d'ardeur et avec bien plus de vitesse, étant plus léger. On en voit de si grandes quantités sur la fin de l'automne qu'il faut que nos Français prennent bien garde à leurs volailles.

On pourrait faire des oiseaux de poing et de leurre* qui seraient bientôt aussi bien fauconnés que ceux de France. Et on ne manquerait pas aussi de ceux qui sont de la haute et de la basse volerie : on en trouverait de toutes les espèces qui sont, et de bonne et de mauvaise affaire*, c'est-à-dire de ceux qui sont les plus farouches et de ceux qui sont les plus dociles.

[f. 147] On en voit un nombre infini de ceux qui sont bien allongés, bien entiers, et à pennes bien nourries, avec toute la longueur qu'elles doivent avoir. Les oiseaux américains sont encore bien proportionnés pour la plupart, d'autres le sont trop, si gras, et en si bon point* qu'ils ne volent presque plus. L'aigle du pays tombe ordinairement dans ce défaut, et il arrive aussi de là que fort souvent on en tue à coups de bâton.

L'oiseau d'une pièce, c'est-à-dire de même couleur par-dessus le manteau et par-dessus les pennes, n'est pas trop commun dans le pays. Ils y sont presque tous bigarrés, maillés* et mouchetés de diverses couleurs.

Je ne sais, de bonne foi, quel nom donner à tant d'oiseaux qu'on voit de haute et de basse volerie; je n'ai pas pu découvrir au juste le nombre et les différentes espèces de ceux qui seraient de leurre et de poing, quoique je sache bien à peu près qu'en France ceux qui ont traité de cette matière ont dit qu'il y en a plus de huit espèces de leurre, et deux seulement de poing.

Si après toutes ces différentes choses et ces véritables termes de la fauconnerie, je voulais encore vous donner tous les termes propres des parties de l'oiseau et tous les noms qu'on donne à ces mêmes parties, je dirais, pour vous divertir et pour vous apprendre en même temps tous les secrets de ce noble divertissement, que leur pennage, leur vêtement* et leur parure de plumes, leurs pennes et leur duvet sont aussi beaux que ceux des autres oiseaux des pays où l'on en voit de plus rares*.

Tous les oiseaux de la haute et de la basse volerie* ont douze grosses plumes à canons*, six à chaque aile et douze à la queue : ce sont ces plumes qu'on appelle, proprement, les *pennes d'aile et de queue*.

Les *couvertures* sont les plumes depuis le col* jusqu'à la queue. Le *manteau* est toute la plume du corps, les *mailles** sont les marques et les taches d'une différente couleur que le gros du pennage et de tout le manteau.

*Maillure** ou *tavelures de mailles* sont diverses couleurs de parures.

Les *aiglures** sont diverses petites taches rousses.

Bigarrure, tavelure d'aiglures sur le dos de l'oiseau sont ces marques rousses qu'on distingue sur le pennage et sur le manteau de l'oiseau allongé.

On nomme *barres de queue* les lignes qui traversent les pennes de queue.

Bec, tour de bec, est un petit cercle qu'on distingue sur le bec d'une différente couleur de tout le bec. Divers oiseaux l'ont à la plume sur le bec.

[f. 148] Le *grain* est la verrue qu'on distingue sur le bec de l'autour seulement.

La *main**, c'est le pied de l'oiseau ou la patte : ce terme ne s'applique jamais que pour les oiseaux de

rapine, et on parlerait improprement si on disait : «la main d'une perdrix ou d'une caille»; il faut dire : «le pied de la perdrix, le pied de la caille», etc.

Les *serres* sont les ongles ou les griffes.

Jabot, c'est la falle.

Gésier, c'est l'estomac.

*Brayet**, cul d'oiseau, sont les plumes de dessous les pennes de queue et du jarret ou de la cuisse de l'oiseau.

*Émut** de l'oiseau, c'est sa fiente.

Des marques d'un bon oiseau

Le bec court et gros, la langue noire, l'aileron ou le guidon fort relevé vers la tête et couvert de plumes du bas col que j'ai nommées *couvertures*, le corps bien carré, la poitrine large, l'entre-cuisse fort ouvert, le brayet tombant bien avant* le long de la queue. Le brayet est justement dessous les pennes de queue.

Les écailles des jambes et des doigts de la main de l'oiseau, et les plus proches des serres, c'est un bon signe quand elles sont rudes, les serres les plus noires, grosses, longues et fort pointues. Le pennage de dessus tout d'une pièce, c'est-à-dire tout d'une même couleur.

Les pennes d'un juste nombre : six à chaque aile et douze à la queue, bien nourries et nullement abbrencées, c'est-à-dire froissées.

Quand l'oiseau est pesant sur le poing, c'est une des meilleures marques, et si enfin il n'a pas la queue trop longue, ni entée*, ni aucunement froissée.

Des termes de la fauconnerie

Il est juste de commencer par le terme et par le nom qui donne lieu à tous les autres, car si celui-là était supprimé, il n'y en aurait aucun et si l'oiseau n'est *affaité** par un *affaitage* ou apprivoisement exact*, pénible et fort assidu. Il ne faut jamais prétendre de voir les miraculeux effets de l'affaitage, puisque c'est le seul affaitage qui fait qu'un oiseau, lequel est naturellement sauvage, farouche, fier, hagard*, bourru, fantasque [f. 149] et passionné de sa liberté, après avoir tenu longtemps avec un extrême plaisir la campagne libre au milieu des airs, ne se vienne mettre en servitude au premier rappel ou au premier réclame* ou réclamage du fauconnier affaiteur ou apprivoiseur duquel il reconnaît la voix.

Il ne faut, dis-je, pas attendre de voir les oiseaux être sur les ailes, ni tenir dessus, ni soutenir sur aile et voler entre deux airs*, et jamais si haut que ce soit à perte de vue.

Mais c'est un plaisir de prince de le voir, après son parfait affaitage, monter sur les ailes*, s'élancer en l'air, pour y voler entre deux et pour y découvrir sa proie, partir du poing avec un ou deux *gare**, de belle aile et de beau corps, avec tant de vitesse et avec tant de bonne grâce, bien que assez souvent il soit un peu halbrené*, ayant quelque plume affolée* et faussée. D'autre fois, sans ce défaut*, c'est un plaisir et une merveille de le voir bien allongé avec tout son pennage, attaché sur ses longes* dessus la perche ou sur le poing, que bien souvent on est également charmé et tout ensemble surpris de voir son oiseau prendre le change*, quand, au milieu de son vol, il rencontre un gibier casuel* sur les routes de celui qu'il poursuit et qu'il le lie* et qu'il l'enveloppe* d'un coup de main avec tant d'adresse et avec tant de vitesse qu'on n'y prend presque pas garde, car le coup est plus tôt fait que prévu.

C'est assurément un divertissement sans égal de voir fondre un oiseau sur son gibier, aussi vite qu'un éclair, et lui donner la charge avec une attaque impétueuse, de lui voir redoubler cent fois dans un moment ses charges et ses recharges et charger son gibier en haut, en bas, à droite, à gauche et de tous les côtés jusqu'à ce qu'enfin il l'a lié dedans ses serres.

N'est-ce pas quelque chose de bien agréable et de bien divertissant de voir un œil brillant comme un éclair, un remuement frétillant, une tête et un bec bien tournés, chamarrés de toutes les plus belles couleurs qui font un oiseau rare*. Cet embonpoint*, ces serres, ces mailles, ces pennes, ce manteau, ces couvertures, ce mouchetage et toutes ces différentes bigarrures ne sont-elles pas admirables sur un oiseau qui est ou sur la perche ou dans la mue*, où l'on lui présente la cure*, la pilule ou la pelote d'étoupes ou de coton tous les soirs, laquelle il avale pour se purger; après qu'il a passé sa gorge et qu'il vomit dès le matin chargé de ce flegme* qui le rendait pesant après le déduit*, le train* de la chasse et la troupe des chasseurs et des chiens qu'il ne saurait poursuivre sans s'écarter du déduit, si on ne le purgeait pas ainsi.

[f. 150] Cette descente, cet essor, ce leurre*, ce rapeau*, ce réclame, cet appeau*, cet oiseau fait de cuir rouge garni de bec et d'ailes, que le fauconnier hausse, baisse, tourne et retourne en l'air, en bas et de toutes manières pour le faire voir à l'oiseau qu'il réclame.

Cette agréable instruction que cet oiseleur* fait et cet affaitage* qu'il pratique avec tant d'empressement pour faire venir l'oiseau au premier réclame de son maître et de son instructeur. Cette gorge* chaude ou trop froide qu'on passe et qu'on repasse, qu'on enduit*, qu'on met à bas* et qu'on fait enfin descendre du jabot dans la mulette*.

Qu'il fait beau voir cet oiseau qui prend motte*, au lieu de prendre branche, cette pointe*, ce vol soudain et rapide, cet admirable guindage*, comme un trait, cet éploiement* d'ailes, ce pliage*, cette descente vite*

comme le foudre, ces pointes, ces pointages*, ces cara-coles, ces va, ces viens de tous côtés en même temps, ces remises*, ces reparts*, ces ressources* ou ces pointes d'oiseaux réitérées, cette venue par tête ou tête-à-tête sur le gibier; cette courte reprise* quand il a trop volé, cette bonne grâce de se mettre au vol ou de voler à la toise* quand on lâche la longe et quand on donne la li-berté aux jets*.

Voir, dis-je, tout cela, c'est quelque chose de bien cu-rieux, aussi bien que de la voir abbacher* ou de le voir acharner* en l'affaitant ou l'accoutumant à voir et à ouïr tout sans qu'il se trouble et sans qu'il s'effarouche ou qu'il s'abatte en partant de la main ou de la perche.

Que peut-on voir de plus extraordinaire qu'un oi-seau si bien affaité sur le poing et sur la perche à qui on se fait connaître à la voix, au visage, aux habits, aux ca-resses qu'on lui fait, lui maniant doucement, et d'un fort fin attouchement, le devant du corps et de la tête (*fricando blando popismate frontem*), lui passant d'au-tres fois la main dessus le manteau depuis le bout du bec jusqu'au bout des pennes de queue et usant d'une grande condescendance* et d'une patience affecté à souffrir l'humeur bizarre de l'oiseau farouche, fan-tasque, colère et dépiteux*.

On ne peut pas être plus diverti que de voir mettre à mont* un oiseau et de le pousser en haut pour le faire voler après deux ou trois gare.

On n'a guère moins de plaisir de le voir assurer* avec une ficelle, le baigner pour lui faire la plume, le voir cil-ler* avec du fil faute* de chaperon*, ou bien simple-ment le voir chaperonner* avec du cuir. C'est à un oi-seau neuf* qu'on fait toutes ces choses pour le rendre paisible, le faire charrier*, le dresser à suivre le déduit de la chasse, à se tenir derrière le train* des piqueurs* et des chiens, et à les devancer quand il en est besoin. [f. 151]

Il faut avouer qu'on a une grande satisfaction de voir mettre l'oiseau dedans, l'oiseler* ou le voir actuelle-ment* appliqué à la chasse dans quelque longue plaine où dans moins d'une heure l'oiseau est harassé et tout couvert de sang après le grand carnage qu'il a fait sur son gibier. Voir faire le devoir* à l'oiseau, lui faire plaisir ou le paître*, l'estimer, lui abattre* son embon-point* en détrempant sa viande, le paissant* plus so-brement qu'à l'ordinaire.

Le voir garni de tout équipage* de sonnettes de Lor-raine, de jets, de longes, de filières* et de chaperon.

Le jardiner* ou l'égayer, lui faire prendre l'air ou l'essor*, le considérer* fondre comme un carreau* du foudre, ou s'élancer aussi vite qu'un éclair sur son leurre* pour l'accoutumer à commencer à s'employer au vol actuel* du gibier.

Enfin, je ne saurais expliquer ni dire le plaisir que ressentent ceux qui se plaisent et qui s'attachent à la chasse de l'oiseau quand ils le voient écumer, c'est-à-dire épier son gibier, quand ils le remarquent s'écarter du déduit, s'y remettre*, empiéter*, fondre, giboyer*, guinder*, reguinder*, lier, envelopper, partir, redon-ner*, remettre, venir, voler, décocher*, choquer*, char-ger, charrier*, brancher*, motter, arrêter et faire tous les autres merveilleux effets* d'un oiseau des mieux affaités.

Mais après tous ces termes, revenons à nos descrip-tions particulières.

De l'émerillon[307]

L'émerillon est le plus petit oiseau de rapine : il n'a guère plus de corps qu'une mauvis ou tourterelle. Il a les yeux brillants, sa tête est fine, son manteau, ses couvertures et son brayet sont bigarrés de diverses couleurs. Ses pennes sont martelées et mouchetées de couleur rougeâtre ou de tavelures. Toute sa vêture* est maillée. Il a le bec et les serres fort noires. La main, les jambes, le tour des yeux et du bec sont jaunes. C'est le plus léger de tous les oiseaux et le plus vite de toute la fauconnerie. Il est hardi à l'attaque, mais comme il est fort petit et fort faible, il ne donne que sur le petit gi-bier qui est sans défense. Il n'est bon à manger que dans la soupe dont il fait le bouillon fort blanc.

Du turc, ou du mangeur de maringouins, qui sont une espèce de mouches qu'on appelle des cousins[308]

Je le nomme le *mangeur de maringouins* après* le com-mun* des Français de la colonie qui s'imaginent qu'il vit de ces insectes. Pour moi, je lui donne un nom plus noble et je l'appelle le *turc* parce que toute sa vê-ture est martelée de croissants blancs sur un fond de manteau et de pennes de couleur de bure*. Il a la tête plus grosse que la juste proportion de son corps [f. 152] ne demanderait, de telle manière qu'un gros œuf en-trerait aisément dans son bec. Ce turc n'est guère plus grand que l'émerillon. Les pennes, qui sont extrême-ment longues, le font paraître plus grand qu'il n'est. Son vol est raide et fort prompt, son cri est traînant et

307 Non pas le faucon émerillon, mais *Falco sparverius* (L.), la crécerelle américaine (M. Gosselin); Godfrey, 123–4, non représentée dans le *Codex*. La description de Nico-las semble s'appliquer d'avantage à la femelle qu'au mâle. Boucher parle vaguement d'«oyseaux de proye de

plus de quinze sortes, dont je ne sçay pas les noms, si-non de l'épervier et de l'émerillon» (Rousseau 1964, 319).
308 *Chordeiles minor* (Forster), l'engoulevent commun (M. Gosselin); Godfrey, 261–62; représenté dans le *Codex*, Pl. XLIX, fig. 66.1, sous la désignation «Le turc».

fort désagréable, particulièrement dès le grand matin quand il commence à voler deux ou trois heures avant le jour, lorsque le temps doit être beau. Pour bien peu de chose, j'aurais mis ce turc à la tête des oiseaux de nuit, car, pour dire le vrai, il ne paraît guère le jour, et on ne le voit qu'à fort grandes bandes, une heure avant la nuit, faire mille passades fort promptes tout auprès des personnes. Cela donne l'occasion aux petits sauvages de les poursuivre vigoureusement et d'en tuer quelquefois à coups de bâtons. Je crois que le propre* gibier de cet oiseau sont des rats, des souris et des petits serpents.

Du taugarot, ou du tartarot*. De l'épervier, ou du mouchet[309]

Ces deux espèces d'oiseaux n'ayant presque rien de dissemblable de ceux qu'on voit en Europe, je dirai seulement qu'il y en a beaucoup plus dans les forêts des Indes que sur nos belles terres découvertes de France, lesquels, vers la saison de l'automne, donnent avec avidité sur une infinité de petits oiseaux de terre et d'eau.

Du brillant[310]

C'est le nom le plus convenable qu'on puisse donner à cet oiseau inconnu à tous les écrivains de la haute volerie*. Ce brillant est si frétillant et si vite au vol que cela n'est pas croyable. Il est hardi ou si téméraire que j'ai balancé* à lui donner ce nom. Il se jette avec raideur partout, il entre même dans les maisons pour giboyer et pour donner sur la proie qu'il poursuit. Il ne craint pas de fondre au milieu des personnes s'il y voit du gibier proportionné à sa main*, et il l'enlève avec tant de vitesse qu'on ne le voit presque pas. Il donne sur les poules, sur les pigeons et les lie* à terre et en l'air.

Il a les pennes raides, longues, fortes et bien dégagées. Son manteau est presque tout blanc, sans tavelures, ni mailles, ni mouchetures. C'est un des oiseaux du monde le mieux allongé. Il se fie beaucoup à ces pennes d'aile qui sont fortes et qui le portent avec une grande vitesse sur le gibier qui lui agrée et qui est de son

goût pour l'envelopper*. Son bec, son tour de bec, ses serres sont noires. Il est bon à manger, il n'est jamais trop gras. Et c'est un oiseau de bonne affaire* quand il est pris dans la hère*; autrement, il est toujours farouche et de mauvaise affaire.

[f. 153] Du hobereau[311]

Cet oiseau de rapine est si vite dans les quartiers* de l'Inde où il y a des horribles forêts que, s'élevant par-dessus avec une incroyable vitesse, qu'il est rare de découvrir son plumage à moins que de le surprendre à l'orée des bois lorsqu'il écume* ou qu'il épie son gibier pour donner comme un éclair dessus. On ne le voit qu'en deux temps : au printemps et en automne; et c'est dans cette dernière saison qu'il désole* la jeune volaille des habitants français. Cet oiseau paraît niais mais il ne l'est point du tout. Autant que je l'ai pu remarquer, je le trouve assez semblable à l'hobereau de nos quartiers du Languedoc.

Du faucon[312]

Le faucon a toujours passé jusqu'ici pour le roi des oiseaux de la plus haute volerie, et c'est pour cela, comme j'ai dit, qu'on a donné le noble nom de la fauconnerie à ce métier de la chasse de l'oiseau qui fait une des plus nobles occupations du gentilhomme aisé. Le faucon porte force marques qui le distinguent aisément de tous les autres oiseaux de rapine. Il a du noir, ou du moins* certaines marques de cette couleur qui le font admirer. Cette couleur de jaiet* est relevée d'un jaune fort éclatant qui fait le tour du bec de l'oiseau et qui peint agréablement les jambes, les écailles et toute la main du même oiseau qui est armée de serres noires et fort aiguës. Il a le devant des parures d'une grosse couleur rousse, semée de maillures noires, comme autant de petits cœurs ou de mouches d'hermine. Il est prompt au vol comme un éclair, et il passe bien plus vite que le vent.

309 Le *Codex*, Pl. XLIX, fig. 66.2, ne représente que le «taugarot», ajoutant que «le tartarot, l'épervie sont presque tous semblables, hobereau». L'un pourrait être l'*Accipiter striatus* Vieillot, l'épervier brun (Godfrey, 105) et l'autre, qui lui ressemble beaucoup, l'*Accipiter nisus* (L.), l'épervier d'Europe. Par ailleurs l'*Accipiter cooperii* (Bonaparte), l'épervier de Cooper (Godfrey, 106), pourrait correspondre à son «épervier ou mouchet». (M. Gosselin).

310 Possiblement *Falco rusticolus* (L.), le gerfaut, en phase de coloration pâle (M. Gosselin) (Godfrey, 119–20); représenté dans le *Codex*, Pl. XLIX, fig. 66.3 sous la dési-

gnation «Le Brilhand». Même s'il vit dans l'arctique, il est observé de temps à autre en Europe et dans le sud-ouest du Canada.

311 Probablement *Falco columbarius* (L.), faucon émerillon, espèce rencontrée aussi en Europe (M. Gosselin) (Godfrey, 122–3); représenté dans le *Codex*, Pl. L, fig. 67, sous la désignation «hobereau». L'auteur a biffé les mots «Le faucon», puisqu'il l'utilise juste en dessous pour la fig. 67.1.

312 *Falco peregrinus* Tunstall, faucon pélerin (M. Gosselin) (Godfrey, 121–2); représenté dans le *Codex*, Pl. L, fig. 67.1, sous la désignation «Le faucon». Il se peut que

De l'autour et du tiercelet[313]

Le tiercelet et l'autour ne font qu'une même espèce d'oiseau de chasse : l'un est le mâle et l'autre la femelle. Ni l'un ni l'autre ne sont si grands que ceux de France, où le mâle, aussi bien que dans les Indes, est plus petit que sa femelle; et si celle-là a les parures argentées martelées* de noir, celui-ci les a roussâtres et maillées de mouchetures noires. Ce mâle et cette femelle sont d'un corsage* fort allongé par les pennes de queue et d'aile. Leur bec et leurs serres sont fortes, bien aiguës et fort noires. Tout le manteau est beau, luisant et à fond noir. Le brayet couvre la moitié des pennes de queue.

Ils donnent assez pesamment sur le gibier et ils sont même assez niais, se laissant approcher et tuer assez facilement à la remise. Ils donnent fortement sur les pigeons et sur les poules, qu'ils surprennent à l'orée des bois et autour des habitations qui n'en sont guère loin.

[f. 154] *De l'aiglon*[314]

Par ce mot d'aiglon, je ne veux pas dire le petit d'une aigle. Je prétends seulement distinguer deux espèces d'aigles qu'on voit ordinairement en assez bon nombre sur la rive des grands lacs et des grandes rivières où elles nichent sur des arbres extrêmement hauts.

L'aiglon est un oiseau fort grand, qui a les pennes de queue blanches et celles des ailes noires. Son bec est jaune et son tour de bec est blanc, et toute la parure de son col jusque tout proche de l'aileron est blanche. Les serres sont fort grandes et noires, la main et les jambes sont jaunes. Tout le manteau et ses fourrures* sont grisâtres. L'oiseau a les yeux brillants, fort perçants et d'une couleur azurée. Toute la main et les jambes sont garnies de très fortes écailles, ce qui est la marque d'un bon oiseau.

L'oiseau vole ordinairement lentement, et il vit plutôt de poisson que de gibier. C'est pourquoi il fond sur l'eau comme un éclair, tombant de haut en bas pour en tirer le gros poisson qu'il prend et qu'il mange avec tant d'avidité et dont il se soûle si fort que, très souvent, ou l'on le prend en vie ou du moins le tue-t-on à coups de gros bâton, l'oiseau ne pouvant plus se guinder* sur les arbres ou en l'air, son jabot étant trop plein.

Les Américains* se servent de la plume pour s'en parer et pour garnir leurs flèches. Ils se font des couronnes des serres et du bec, qui est fort grand, gros, bien crochu et fort large. Ces mêmes barbares se font des bonnets, des cravates et des sacs à pétun* de toute la peau de l'oiseau qu'ils écorchent ordinairement sans le plumer. Quelques Français font de rares* chandeliers de cabinet de la jambe, de la main et des serres. On ne saurait croire que ces chandeliers soient aussi beaux et aussi utiles qu'ils le sont quand ils sont proprement* garnis d'argent ou de quelque autre métal où l'on pose de petits cierges de cire blanche. Plusieurs en ont par rareté, ou à leurs chapelles ou à leurs oratoires.

De l'aigle[315]

L'aigle n'a rien de différent de l'aiglon qu'un plus grand corsage et un plumage entre le noir et entre le grisâtre, martelé, tavelé, moucheté, bigarré de jaune, de blanc, de noir et de gris, avec une égale proportion par tout le manteau. Les pennes d'aile sont plus noires que d'autre couleur. Celles de la queue sont mouchetées de blanc. Le bec est noir et les serres aussi. Le tout est proportionné à un grand corps. La jambe est grosse et jaune.

/ L'aigle des Indes est si fort qu'il enlève un mouton. J'ai connu un Français canadien, nommé Joliet, qui, à l'âge d'entre six et sept ans, fut enlevé plus de cent pas par un aigle qui l'aurait dévoré si on ne fût venu à son secours. C'est ce que j'ai appris de sa bouche et de ceux qui avaient vu cette funeste prise de cet enfant. /

Après les oiseaux de terre, le l'air et du beau jour, la suite de mon histoire demande que je parle de ceux de la nuit et que je finisse ce traité des oiseaux par ceux qui volent ou qui vivent sur les eaux.

[f. 155] *Des oiseaux de nuit*

De la chauve-souris

Bien que la chauve-souris ne soit pas proprement un oiseau, n'ayant point de plumes et ayant des dents et huit ou dix pattes garnies de petites griffes, je dirai néanmoins que la chauve-souris est une je ne sais

Lescarbot et Denys aient désigné la même espèce par le même mot (Ganong, 216).

313 *Accipiter gentilis* (L.), autour (M. Gosselin) (Godfrey, 103–5); représenté dans le *Codex*, Pl. L, fig. 67.2 sous la désignation «Le hautour».

314 *Haliaeetus leucocephalus* (L.), aigle à tête blanche (M. Gosselin) (Godfrey, 115–16); représenté dans le *Codex*, Pl. L, fig. 67.3, et appelé «Leyglon ameriquain». Le bec jaune, la tête blanche, la queue blanche et l'utilisation

de ses plumes par les Indiens confirment cette identification. En fait, l'aigle à tête blanche se nourrit presque exclusivement de poissons. En 1632, Champlain savait distinguer entre l'aigle à tête blanche et l'aigle doré. Par contre Lescarbot et Denys ne semblent avoir connu que l'aigle à tête blanche et la crécerelle américaine (Ganong, 202).

315 *Aquila chrysaëtos* (L.), aigle doré (M. Gosselin) (Godfrey, 114–15).

quelle espèce d'oiseau puisqu'elle vole. Cet animal volant, n'ayant aucune différence que d'un plus petit corsage que celles de notre France, je n'en dirai pas autre chose pour parler d'abord

De la chouette[316]

qui a tout son plumage différent des nôtres, martelé néanmoins de blanc sur tout le manteau. Elle est plus petite de corsage et elle semble avoir plus de brillant que les nôtres. J'en ai vu et j'en ai nourri qui n'étaient pas si grosses que des chardonnerets.

Du gros hibou[317]

Cet oiseau est le plus gros et le plus grand que j'aie jamais vu dans toutes mes courses.

Tout le manteau et toutes les pennes de queue et d'aile sont à fond blanc. Il est martelé en mouchetures noires par tout le plumage, qui relèvent agréablement la couleur blanche. Il a le bec noir et fort gros, un peu en long et crochu, orné de grosses moustaches faites d'un poil fort et raide comme les moustaches du tigre. Sa tête est extraordinairement grosse, ses oreilles sont prodigieusement grandes, son gosier et l'ouverture de son bec effroyablement larges. Les yeux sont étincelants, ses serres sont longues et grosses et noires. Toute sa main, ses doigts, ses jambes, qui sont fort courtes, sont beaucoup plus velus que la patte du lièvre, et ce poil est si épais et si droit qu'il tient plutôt de la plume de l'aigrette que d'autre chose. En un mot, c'est un très bel oiseau qui est grand comme un mouton. Il a plus de six pieds* d'ouverture d'un bout d'une aile à l'autre, et si l'oiseau est vieux, il en a plus de huit. Il a la voix si haute que pendant le silence de la nuit, on l'entend de près de deux lieues* loin.

À chaque couplet de sa chanson, il redouble sept ou huit fois ce monosyllabe : *khoû, khoû, khoû, khoû, khoû, khoû, khoû, khoû*, avec tant de nuances que son chant, tout affreux qu'il est pendant l'horreur de la nuit, ne laisse pas de se faire admirer.

Quand on navigue la nuit, dans les chenaux ou sur les infinis canaux les plus agréables du monde des belles îles de Richelieu, au bout du lac Saint-Pierre, on entend ces oiseaux de plus de deux lieues loin. Si je ne craignais de vous tenir trop longtemps, je dirais encore mille belles choses de nos oiseaux des bois et de terre et des oiseaux qui habitent dessus et dedans les eaux, desquels il me reste de parler; mais comme j'ai peur de vous [f. 156] ennuyer, je me contenterai de dire peu de chose ou presque rien que le simple nom des oiseaux que j'ai remarqués en si grand nombre et en tant de différences sur les rivières, sur les lacs et sur la mer que si je voulais seulement entreprendre de les nommer tous, outre qu'il me serait impossible de le faire, n'en sachant pas les noms, je me rendrais trop importun. En voici donc seulement quelques-uns dont j'ai écrit quelque chose, après avoir averti de prendre garde que le plumage en général est tout différent de tous les oiseaux qui fréquentent la terre et les bois.

Le bec, le pied, la tête, les pennes de queue et d'aile et presque toutes les autres parties sont différentes et n'ont que bien peu de ressemblance. Les yeux des oiseaux de marine* sont tout ronds.

On voit dans cette infinie variété d'oiseaux quelques becs crochus, d'autres l'ont un peu long, et d'autres, tout plat et large et fort dentelé. D'autres l'ont comme une scie. On remarque aussi des têtes de diverses figures*, des rondes, des plates et des larges. On découvre aussi des pieds courts, des ronds, des longs, des plats à ailes et à ongles, d'autres tout ronds à ongles seulement.

On considère* encore des jambes de diverses figures, en triangle, en rond, en plat et d'autres presque en carré. Tout ceci est en général, mais voici quelque chose de plus particulier dans la suite de ce qu'il me reste à dire.

Noms des oiseaux de la marine

Alouettes

J'en ai vu de plus de dix ou douze espèces différentes qui fréquentent toutes les rives des eaux et jamais la

316 *Aegolius acadicus* (Gmelin), petite nyctale, un petit hibou, presqu'aussi petit que *Glaucidium gnoma* Wagler, la chouette naine qui vit dans l'ouest du Canada, mais tout de même plus gros qu'un chardoneret! Dans le *Codex*, Pl. LI, fig. 68, on fait la distinction entre «la petite chouette» et une «autre chouette», probablement *Strix vara* Barton, la chouette rayée qui est commune au Québec et en Ontario (M. Gosselin) (Godfrey, 258, 251 et 253–4 respectivement). Lescarbot et Champlain ne parlent que de hibou, sans distinction (Ganong, 221). Boucher ne fait guère mieux (Rousseau 1964, 319).

317 *Bubo virginianus* (Gmelin), grand-duc (Godfrey, 248–9); représenté dans le *Codex*, Pl. LI, fig. 68.1, sous la désignation «chatuant». Le *Codex* représente aussi (Pl. LII) un «coucoucouou quon entend la nuit de trois ou quatre lieues loin dans la foret ou au bord des rivieres», qui ressemble à la *Strix nebulosa* Forster, la chouette cendrée (Godfrey, 254–5). Denys et Boucher parlent tous deux du «chat-huant» (Ganong, 221 et Rousseau 1964, 319).

pleine terre. Tout proche de Tadoussac, il y a une grande pointe de terre qui avance une lieue dans le fleuve de Saint-Laurent qui est, dans la saison d'automne, tout couverte d'alouettes, et c'est à cause de cela qu'on l'a nommée la pointe aux Alouettes. On y fait de beaux coups et fort souvent on tue plus de cent de ces oiseaux d'un seul coup de fusil.

On voit des chevaliers de trois ou quatre façons*.

Des pluviers de quatre ou cinq différences*.

Des plongeurs de plus de quinze espèces.

Des sarcelles de plus de six plumages.

Des gélinottes d'eau[318] de deux ou trois manières*.

Des petits poussins de mer,[319] une espèce.

Des mauves de trois façons dissemblables.

Des goélands de deux façons.

Des strèles* ou des pigeons de mer deux ou trois espèces.

Fouquets quatre ou cinq différences.

[f. 157] Des margots d'une façon[320] : cet oiseau est gros comme un oie. Il ne va jamais plus de trois ou quatre lieues au large de la haute mer. C'est pourquoi les pilotes, se réglant* là-dessus, redoublent leurs soins et la garde du vaisseau de peur qu'ils ont d'aborder les terres inconsidérément, particulièrement quand ils ont perdu la tramontane ou leur route par la violence des vents. S'ils ne connaissent pas les terres qu'ils cherchent, ils se réjouissent et vont sans crainte donner dans le port et y mouillent ordinairement heureusement.

Des tangueux[321] : ce sont des gros oiseaux.

Des happe-foie[322].

Des cormorans leur bec et leur plumage sont rares et particuliers.

Des bernaches de deux façons : ces oiseaux sont fort délicats.

Des canards communs de toutes les façons et de toute sorte de plumage.

Des petits canards noirs.

D'autres petits canards noirs et blancs qu'on nomme des *jacobins*[323].

Des grands canards noirs.

Des canards tout gris.

Des becs-de-scie communs.

Des becs-de-scie plus grands.

Des autres becs-de-scie encore plus grands, à bec fort long et crochu au bout.

Des becs-de-scie de la quatrième espèce, fort gros et presque aussi grands que les cygnes, à flancs jaunes sur le manteau.

Des canards du plus grand corsage[324] qui se trouvent vers les îles du Kaoûj, près des îles de Mantoûnoc, qu'on appelle autrement les Sept-Îles, du côté du nord du grand fleuve. Dans la saison, j'ai vu deux matelots charger une chaloupe des œufs de ces gros canards dans moins de deux heures.

Des halbrans de diverses espèces. Ce mot, de halbran pris en général signifie un jeune canard qui est encore au poil follet. Mais outre cela il y a diverses espèces d'oiseau qu'on appelle *halbrans*.

/ On voit enfin des bécassines de trois ou quatre différentes espèces et plusieurs autres oiseaux dont les natifs du pays ne savent pas les noms, non plus que moi. /

318 Possiblement *Fulica americana* (Gmelin), foulque américaine (Godfrey, 150–1) et *Gallinula chloropus* (L.), gallinule commune (Godfrey, 149–50) (M. Gosselin); Denys parle de «poule d'eau» (Ganong, 234) et Boucher désigne aussi les mêmes oiseaux comme des «poules d'eau» (Rousseau 1964, 317).

319 Vraisemblablement *Oceanodroma leucorhoa* (Vieillot), pétrel cul-blanc (Godfrey, 51–2); mais il se pourrait aussi qu'il s'agisse du *Plautus alle* (L.), mergule nain ou d'une espèce de *phalarope* (*Steganus tricolor*, Vieillot), phalarope de Wilson, est un rare migrateur dans le sud-est du Québec (M. Gosselin).

320 Margot est le nom populaire du *Morus bassanus* (L.), connu aussi sous le nom de *Sula bassanus* (L.), fou de bassan (M. Gosselin) (Godfrey, 36–8). Cartier en 1534, puis Champlain en 1604 et Denys utilisent «margaulx», «margos» ou «margot», pour le désigner (Ganong, 224).

321 Nom populaire ancien du *Pinguinus impennis* (L.), grand pingouin (M. Gosselin) (Godfrey, 228–9); Champain est le premier à les avoir découvert sur les îles Tusket en 1604; Lescarbot parle de «gros tangueux»;

Sagard en 1636 le désigne comme «guillaume ou autrement tangueux» (Ganong, 239 et 240); Boucher emploie le même mot, mais Rousseau 1964, 317 croit qu'il désignait ainsi l'*Alca torda* (L.), le gode.

322 Mot qu'on applique à des oiseaux attirés par les déchets de poisson. Ce comportement se retrouve le plus souvent chez le *Puffinus gravis* (O'Reilly), le grand puffin ou le *Fulmarus glacialis* (L.), le fulmar boréal, sur les Grands Bancs (M. Gosselin). Denys décrit très bien cette dernière espèce (Ganong, 220).

323 Nom populaire de l'*Aythia fuligula* (L.), le morillon fuligule de l'Europe. Mais Nicolas aurait pu avoir en vue aussi bien une des espèces de morillon de nos régions, ou le petit garot ou le garot commun, qui sont tous noir et blanc (M. Gosselin et S. Houston). Les Jacobins appartenaient à l'Ordre des Dominicains, qui s'habillaient de noir et de blanc.

324 *Somateria mollissima* (L.), eider commun (Godfrey, 90–1).

Continuation du traité des oiseaux

Tous ces oiseaux, et un grand nombre d'autres dont je ne parle point ici, sont si multipliés et si féconds, chacun dans son espèce, qu'il n'est pas possible de se l'imaginer, ni d'en faire la minute*. Je viens de dire que dans la saison et que dans certains lieux on trouve une si grande quantité d'œufs qu'on aurait de la peine à croire ce qui en est. Je ne pourrais pas moi-même me le persuader, car il semble qu'il y a de l'enchantement de voir tant d'œufs sur des petits îlets de rocher auxquels, pour ce sujet*, on a donné le nom des îles aux Œufs qui sont le long de la bande du nord du fleuve de Saint-Laurent.

La fameuse île aux Oiseaux, quoique petite et que j'ai vue au milieu du golfe du Saint-Laurent, en est si pleine dès le printemps et pendant tout l'été, qu'il n'est pas possible d'y faire un pas sans en écraser, et on ne peut pas y faire une seule démarche sans s'enfoncer jusqu'au genou dans l'émut* ou dans la fiente des oiseaux, dont toute l'île est si couverte qu'elle en paraît doublement blanche, soit pour ce sujet, soit pour la grande multitude des oiseaux qui y sont, qui sont tout blancs. Une autre infinité des mêmes oiseaux voltige tout autour pour s'y reposer; les autres qui y sont déjà défendent la place autant qu'ils peuvent, voyant bien que le terrain n'est pas suffisant pour recevoir tant d'habitants, si bien qu'on voit tout autour de l'île des combats horribles et on y entend un bruit fort éclatant, et bien plus haut que ne serait celui d'une grande foire de trois ou quatre mille femmes. On ne saurait aborder à la rade de l'île, ni encore moins y prendre terre sans être armé d'un bon sabre ou d'un bon gros bâton. Et on n'y va jamais que par curiosité ou par nécessité quand on veut un peu régaler un équipage de navire harassé des travaux d'un trajet de mille deux cent cinquante lieues qu'il y a de nos terres de France jusqu'à ce lieu.

Pour confirmer ce que je viens de dire, j'assurerai que, dans les infinies embouchures par lesquelles notre grand fleuve Saint-Laurent se décharge dans la haute mer, il y a encore une île aux Oiseaux bien plus grande que celle dont je viens de parler, qui est à quatorze ou quinze lieues loin de terre ferme et de la grande et fameuse île de Terre-Neuve qui a trois cents lieues de circuit. L'île est sous l'élévation de 49° 40'; elle est si couverte d'oiseaux que tous les navires de France s'en chargeraient sans qu'il se connût qu'on en eût pris un. Cette vérité en confirmera une autre que je rapporte de l'île d'Ouabaskous, où l'on voit une [f. 159] vallée où il y a tant de plumes qu'un homme bien monté y périrait et n'en saurait jamais sortir. Des grands animaux même du pays s'y perdent quand ils sont lancés de ces côtés-là par le chasseur. C'est un plaisir que de prendre des pleines barques de ces oiseaux dans un moment.

Après tous ces prodiges ne croiriez-vous pas que je n'ai rien de plus à dire des oiseaux et que je n'aurais plus aucun trait à donner au tableau que j'ai proposé au commencement de ce traité? Les hérons, les grues, les oies, les outardes, les huards, les cygnes, les grosbecs, les canards branchus et leurs halbrans* en feront les dernières touches, et les plus beaux glacis.

Du héron[325]

Tous les chasseurs savent assez que cet oiseau de rivière et de marécages se fait remarquer pour* la hauteur de ses jambes qui sont proportionnées à son corsage. Son bec, son col*, ses yeux et sa houppe (ou sa hure sur la tête) le rendent remarquable à tous ceux qui savent ce que c'est qu'un oiseau du haut vol*. Tout son manteau* est cendré.

L'île au Héron, au milieu du saut, ou plutôt du terrible rapide Saint-Louis, est fort connue dans toute la colonie française pour savoir que, dans la saison, on y trouve tant d'œufs de ces oiseaux qu'il n'est pas difficile à plusieurs personnes d'en revenir chargées en peu de temps. Que si on aime mieux donner le loisir aux hérons d'éclore leurs œufs, jugez un peu de la merveille qu'il y a de voir, dans un petit îlet, une infinité de petits hérons.

De la grue[326]

La grue est un de ces oiseaux qui mottent* ou qui prennent terre et qui branchent* aussi bien que le héron. C'est un oiseau de passage qu'on voit en grandes

325 *Ardea herodias* (L.), grand héron (M. Gosselin; voir Godfrey, 43–5); représenté dans le *Codex*, Pl. LII, fig. 69.1 sous la désignation «le heron». Cartier le confond en 1534 avec la grue; mais Champlain, Lescarbot et Denys le connaissent (Ganong, 220). Boucher le mentionne (Rousseau 1964, 318).

326 *Grus canadensis* (L.), grue canadienne (M. Gosselin; voir Godfrey, 144–5); représentée dans le *Codex*, Pl. LII, fig. 69.2 sous la désignation «La grue». La mention de cet oiseau dans le présent contexte prouve qu'il fut un temps où cet oiseau migrait dans la vallée du Saint-Laurent en grand nombre. Si d'autres auteurs confondent parfois la grue et le héron, ce n'est pas le cas de Nicolas (J. Harisson).

bandes dans la belle saison. J'ai vu une île qui porte le nom de l'oiseau. Son chant est extraordinaire et on l'entend de plus d'une grande lieue.

[f. 160] Le mâle et la femelle ont une fort grande houppe sur la tête qui est maillée* d'un très beau rouge. Leur manteau et leur pennes ne sont pas bien différents de celles du héron. La chair de la grue est fort délicate; celle du héron n'en approche pas. Les petits de l'un et de l'autre sont fort laids et ressemblent à des monstres lorsqu'ils sont au poil follet.

Des oies sauvages[327]
Le Cap-aux-Oies, sous l'île au Coudre, à la droite en remontant le fleuve, et les îles du même nom au-dessus de l'île au Coudre, placées du côté de la gauche du même fleuve de Saint-Laurent en le remontant, ont blanchi plus d'un million de fois du plumage de la grande et prodigieuse multitude de ces oiseaux qui s'y retiraient, il n'y a pas plus de vingt ans.

Ce n'était pas une petite merveille d'en voir de si grandes bandes qu'elles couvraient le soleil, qui invitaient et qui présentaient une belle occasion à plus de cent chasseurs qui s'y rendaient et qui s'y portent encore dans les saisons du printemps et dans celle de l'automne pour y faire de si grands carnages des oies que la chose surpasse l'idée qu'on s'en pourrait former.

Ces oiseaux sont beaucoup plus petits que les oies de France, et ils sont autant différents en plumage qu'ils sont semblables en corsage*. Leur chair est délicate et l'oiseau est fort gras en automne.

Le plumage est toujours uniforme, c'est-à-dire qu'un mâle est toujours distingué par son plumage qui est toujours le même sur tous les mâles. Celui de la femelle est semblable sur toutes les femelles. Les pennes d'aile et de queue sont noires; le reste du manteau est gris cendré. Celui de la femelle est plus blanchâtre. L'un et l'autre ont le bec noir un peu affilé et tout dentelé, aussi bien que la langue qui est couverte d'une peau fort grossière et soutenue dans le milieu d'un os qui donne une force extraordinaire à cet oiseau dans cette partie pour couper de grosses racines dont l'oi-

seau se nourrit au bord des rivières et des marécages. Le tour du bec est roussâtre, l'oiseau a l'œil noir. Le cancan de l'oie des Indes est plus clair et plus délié que celui des oies domestiques. Cet oiseau du haut vol, avant de prendre son essor*, se charge dans le bec d'une pierre grosse comme une balle de [f. 161] mousquet pour se contraindre à ne faire point de bruit en l'air, pour ne pas avertir l'oiseau de proie de son passage. Cela étant, il ne fait pas bon se trouver sous la volée d'une infinité d'oies qui voulant motter et se réjouir sur quelque belle plage* qui leur agrée, se déchargent de la pierre qu'elles avaient dans le bec.

Du huard[328]
Que dirai-je du truchement* et du fameux interprète du grand dieu de la marine* des Américains* occidentaux qu'ils nomment *Michipichi*? Dirai-je que c'est le plus grand plongeur de la mer, le plus bigarré et le plus martelé* de tous les oiseaux, le plus aquatique, le plus timide et le plus braillard? dirai-je que c'est un oiseau d'un augure infaillible et qu'il ne chante jamais qu'il ne doive bientôt après ou venter ou pleuvoir? Si j'assure tout cela, j'aurai dit une partie de ce que j'en sais en confirmant la rêverie* des sauvages qui croient fermement que cet oiseau est l'interprète du dieu de la marine, qu'ils pensent être un grand monstre qu'ils nomment *Michipichj*, dont je donne le portrait dans mes figures*, aussi bien que du huard, dont une peau avec son plumage, étant présentée à notre très illustre monarque Louis le Grand, quatorzième du nom, régnant à présent heureusement, fut trouvé fort belle et fort extraordinaire. / J'ai connu un nommé Alouabé, Indien, qui se disait l'unique personne qui entendait* le langage du huard, et que par là, il savait ce que Michipichi désirait lorsqu'il était en colère. /

De l'outarde[329]
Cet oiseau du plus haut vol est si commun dans le Nouveau Monde, et pendant la saison du printemps et pendant celle de l'automne, qu'il y a des jours et des nuits entières qu'on ne voit et qu'on n'entend rien au-

327 *Chen caerulescens* (L.), aussi appelé *Anser caerulescens* (L.), oie blanche (M. Gosselin; voir Godfrey, 62–4), représentée dans le *Codex*, Pl. LIII, fig. 70, sous la désignation «oye sauvage». Cartier parlait déjà en 1535 des «oyes sauvages, blanches et grises». Lescarbot croyait que les oies adultes (blanches) et les jeunes (gris) formaient deux espèces différentes (Ganong, 229). Comme Nicolas, Boucher connaissait l'«oye sauvage» (Rousseau 1964, 317).

328 *Gavia immer* (Brünnich), huart à collier (M. Gosselin; voir Godfrey, 11–14; représenté dans le *Codex*, Pl. LIII,

fig. 70.1, sous la désignation «mane ou üar». Champlain le signale en 1604 et l'inclut dans sa liste de 1632. Denys le désigne plutôt comme «plongeon» (Ganong, 221). P. Boucher écrit «huart» (Rousseau 1964, 318).

329 *Branta canadensis* (L.), bernache canadienne (M. Gosselin; voir Godfrey, 56–8), représentée dans le *Codex*, Pl. LIII, fig. 70.2, sous la désignation «Outarde ou nika». Cartier la nommait «oultarde»; Champlain la connaissait dès 1603; Lescarbot et Denys la décrivent très bien (Ganong, 229). Boucher la connaissait sous le nom d'«outarde» (Rousseau 1964, 317).

tre chose que des millions d'oiseaux gros, et de la figure de nos grandes oies du pays du Languedoc.

Le lac Saint-Pierre, qui n'est éloigné de la ville des Trois-Rivières que de trois lieues*, en est quelquefois si bordé et les anses en sont si couvertes qu'à chaque avance qu'on y fait, ou en canot ou en chaloupe, on dirait qu'on entend quelque horrible fracas du tonnerre accompagné de cris si hauts et si redoublés que je ne crois pas qu'une armée de vingt ou de trente mille hommes en fît guère plus.

Il n'y a pas trop longtemps que, naviguant sur les rives de ce beau lac une nuit au clair de la lune et d'un calme parfait et tout plat, comme l'on dit, sur la mer, j'étais presque épouvanté d'entendre et de voir un tel prodige. À chaque coup de rame que nous donnions, il s'élevait du milieu de grandes [f. 162] forêts de joncs qui sont de la grosseur du pouce d'un grand homme et de la hauteur d'une pique*, de si nombreuses bandes d'outardes que quelqu'un moins accoutumé à ce bruit se serait aisément persuadé d'être au milieu d'une bataille. Ces oiseaux, qui ont l'aile forte et bien allongée, s'envolaient et prenaient leur essor avec tant d'empressement qu'on aurait dit que la terre tremblait ou que le tonnerre grondait.

Cette espèce d'oie a le manteau assez bigarré de gros gris, de couleur de bure*, un peu chargé de blanc, de noir et de jaunâtre, avec un certain gros bleu. Les pennes d'ailes et de queue sont fort noires, toute la tête est presque noire. Il y a seulement deux marques blanches qui lui entourent les yeux et qui, relevant le noir velouté de toute la tête et de toutes les parures* de l'oiseau, lui donnent une belle grâce. L'outarde a l'œil rond et fort vif, fort perçant, à fond noir. Sa voix est fort haute. Cet oiseau découvre et sent de loin, et comme il est défiant*, il est prompt au départ. Son vol est raide et dure un jour et une nuit sans reposer : cela se sait par expérience, lorsqu'on les voit arriver de terre ferme dans les îles qui sont au large et loin de la même terre ferme de deux cents lieues de tous côtés. La chair de l'outarde est d'un très bon goût et fort nourrissante. La plume est très bonne et particulière* pour bien écrire. Son duvet est fin, la plume de toute la vêture* est admirable pour faire des couettes. On en tue assez souvent sept ou huit d'un coup de fusil.

On fait des tapis de table fort rares* de la peau du col de l'oiseau qu'on passe proprement* et qu'on joint ensemble avec l'aiguille.

Du cygne[330]

C'est ici sans contredit le roi des oiseaux de la marine*. Son fanfare de trompette, son port orgueilleux et tout son air majestueux, son admirable blancheur, sa noble fierté sur les eaux, qu'il semble dédaigner en nageant, fuyant le grand tumulte de tous les autres oiseaux, le font bien remarquer par-dessus tout ce qu'il y a d'oiseau sur les ondes. Avec ces yeux brillants, ce vol très haut, raide et vite*, font bien voir qu'il a des choses bien particulières en tout lui-même, et sa grandeur qui surpasse celle des autres oiseaux, lui peuvent sans doute bien mériter le nom de roi des oiseaux de marine puisque d'ailleurs les Américains lui ont donné le nom de capitaine, *ounkima oua-bisi*, le capitaine blanc, étant, ajoutent-ils, le gouverneur d'une infinité de sujets qui fréquentent les eaux comme lui.

[f. 163] On ne voit pas tant de cygnes qu'on voit d'autres grandes bandes de diverses espèces d'oiseaux de marine. Néanmoins, on en voit presque partout d'assez belles troupes. Mais ce que je trouve de plus rare, sous le manteau du cygne, est un certain duvet qui est si beau et si blanc qu'on ne saurait rien voir de plus curieux en vêture d'oiseau. Il n'y a point d'hermine, ni de neige plus blanche que la peau de ce cygne quand on l'a écorché et plumé jusqu'au duvet. Si plusieurs de ces peaux étaient jointes ensembles après qu'une Indienne les aurait passées* fort proprement de sa façon*, on pourrait, sans crainte d'être rebuté, les présenter à un roi qui en ferait de l'estime*, et pour la rareté et pour l'utilité.

Il n'y a même rien de plus propre pour réchauffer une poitrine refroidie et pour empêcher la coqueluche; et c'est pour cela que ces peaux sont estimées et qu'elles coûtent cher en France, où les marchands en font porter* le plus qu'ils peuvent.

Les sauvages font des sacs et des bourses de la peau des jambes et des pieds qu'ils écorchent fort proprement et avec empressement. Ils mettent du tabac et leur pipe dans ces sacs qu'ils embaument auparavant à la fumée. Ils y gardent souvent du duvet de réserve du même oiseau pour s'en faire un ornement de tête dans les meilleures occasions* quand ils veulent paraître en public. Ils s'en font des perruques blanches qu'ils font tenir sur leurs cheveux avec de la graisse d'élan.

Les plumes des pennes d'aile sont fort grosses et fort longues, et lorsqu'elles sont bien hollandées*, on les estime beaucoup pour écrire. On les appelle des *plumes de conte*.

330 *Olor columbianus* (Ord.), nommé aussi *Cygnus columbianus* (Ord.), cygne siffleur (Godfrey, 54–5); représenté dans le *Codex*, Pl. LIV, fig. 71.2, sous la désignation «Le Cygne». Il émigre à travers les Grands Lacs. À l'époque, le *Cygnus buccinator* (Richardson) faisait de même (Godfrey, 55–6). Nicolas a noté son cri de trompette, mais les deux espèces ne sont pas faciles à distinguer. Cartier et Champlain mentionnent le «signe» (Ganong, 239). Il se peut que Boucher ait observé l'*Olor c.* (Rousseau 1964, 317).

La chair du cygne n'est guère bonne à manger, étant fort dure. Les chasseurs néanmoins en font des ragoûts.

Du gros et du long bec à double estomac, que les Indiens nomment cheté

Le cheté ne paraît que sur certains petits lacs fort poissonneux. Cet oiseau est rare et d'une espèce bien particulière. À en voir d'un peu loin des grandes troupes, on les prendrait pour des cygnes, parce qu'ils en ont le manteau et les pennes toutes blanches, le col fort long, les pieds noirs et même la grosseur du corps approche de celle du cygne.

[f. 164] Sa différence et sa rareté sont dans le bec, avec une certaine bourse qu'il a dessous et qui lui sert comme d'un premier estomac où il réchauffe sa proie pour l'achever de cuire dans son second estomac et pour en tirer sa nourriture.

Son bec a un pied* de long et il est gros comme le bras d'un grand homme. / Ces oiseaux / appuient leur bec sur leur col, qu'ils replient à ce dessein comme pour servir de lit à ce gros, grand et long maître bec.

La nature a formé, au-dessous de ce bec, une bourse qui s'ouvre et qui se ferme plus ou moins, selon la quantité de poisson que l'oiseau y enferme. Cette bourse est faite d'une peau bien délicate, couverte de plume. Elle est très souple. Étant fermée, elle se resserre si proprement que, tout le long du dessous du bec, rien ne paraît, afin de ne pas épouvanter le poisson qu'il veut prendre à la pêche. Ces oiseaux élargissent cette bourse si prestement quand il est temps et l'ouvrent avec tant de vitesse et si largement que la tête d'un gros homme y entrerait sans peine. Le poisson s'y engage comme dedans un filet qu'ils resserrent avec la même vitesse qu'ils l'avaient ouvert.

Du canard branchu et de son halbran*[331]

Nous n'avons pas, dans notre ancienne France, de cette rare espèce de canard qui branchent* au lieu de motter* comme les autres espèces. On ne voit pas de ce vermillon ni de ce jaune d'or qui entoure les yeux de nos plus beaux canards, ni qui martelle de tavelures un très beau et un fort grand plumage en forme d'un beau casque sur leurs têtes comme l'on le voit sur les parures de têtes / du canard branchu / qui sont bien les plus belles en différent plumage qu'on puisse voir et presque imaginer. Figurez-vous le plus beau vert du monde, relevé d'un glacis doré d'un gris argenté et luisant comme

du cristal, le noir, le blanc satiné, le rouge, l'incarnadin*, l'azur, la couleur d'aurore, le gris de lin, le vert céladon, et en un mot tout le mélange des couleurs, vous le verrez sur le manteau et sur les pennes de ce beau canard branchu. Son bec, son tour de bec, son col sont variés de tant de couleurs qu'en disant qu'on les découvre toutes, j'ai tout dit.

Je crois qu'on en peut voir encore deux : un mâle et une femelle qu'on a mis à la fameuse ménagerie de Versailles, que nous avons portés* des Indes dans notre vaisseau nommé *La Grande Espérance*.

Le doux petit chant de ce canard est si mélodieux, si charmant et si agréable que, pour le bien concevoir, il faut l'avoir entendu. / Sa chair très délicate le fait rechercher de ceux qui ont le goût fin et bien épuré. / Son nid est remarquable puisqu'il le fait contre le naturel ordinaire des canards, dans un trou d'arbre bien élevé, où ces petits halbrans, étant éclos, il les prend sur son manteau de dos et sur ces pennes, et les emporte sur l'eau et sur la terre sans les blesser. La bécasse fait la même chose en France.

[f. 165] Des insectes volants

Ce n'est ni hors de propos, ni hors de rang*, que je vais donner ici une petite liste des insectes volants, et que je dise en peu de mots ce que j'ai remarqué de plus particulier de ces différents animaux, qu'on voit en si grand nombre, dans les vastes forêts de l'aquilon et du couchant, que la chose semble surpasser l'idée qu'on s'en peut former.

Les brûlots, qui sont des petits moustiques presque imperceptibles y sont en si grand nombre et si incommodes qu'il semble qu'on est brûlé d'une étincelle de feu à chaque fois qu'un de ces insectes se repose ou sur les mains ou sur le visage.

Les moustiques qui sont un peu plus grands n'y donnent pas moins d'exercice* qu'une autre infinité de diverses mouches dont je ne dirai mot pour* n'y avoir rien remarqué de fort particulier que l'effroyable quantité qu'on en voit dans les bois dont elles chassent les hommes et les animaux trois mois, durant juin, juillet et août.

On voit des abeilles plus petites que les nôtres, des bourdons fort hideux, des escarbots* étranges, des cerfs-volants de deux ou trois espèces informes, de fort petites cigales, des cousins, d'autres moustiques, des moucherons infinis, des mouches communes, des taons

331 *Aix sponsa* (L.), canard huppé (Godfrey, 77–8); représenté dans le *Codex*, 54, fig. 71, sous la désignation «canard Branchu». Leclercq le mentionne aussi en 1691 comme le «canard branchu» et Dièreville le suit

là-dessus en 1713 (Ganong, 207). Boucher parle seulement de «canard» et ne permet pas de préciser davantage (Rousseau, 318).

fort gros, des guêpes ridicules et fort venimeuses : en piquant on est surpris comme si on était frappé d'un coup de balle de mousquet. On en voit d'autres fort longues et fort venimeuses. Et comme l'on voit une infinité de sortes de chenilles, on voit aussi d'une infinité d'espèces de papillons de toutes couleurs et plusieurs différentes grandeurs. Pour des sauterelles, je n'en ai jamais tant vu ailleurs ni qui aient deux grandes particularités* / comme celles-là / : premièrement, elles portent toute la figure* du visage de l'homme parfaitement distingué sur leur estomac*; secondement, elles font un grand bruit en volant. Enfin je vous parlerai de la mouche de feu, ou de la mouche luisante, et je vous la ferai voir dans l'horreur des ténèbres de la nuit. Pour le maringouin ou le cousin, nous le verrons le jour et nous souffrirons ses incommodités la nuit.

Des maringouins qu'on appelle en langue d'Oc *des* cousins, *des larrons de la patience et des ivrognes du sang des hommes*
Je ne crois pas qu'on ait trop mal rencontré* quand on a nommé ces cousins du Languedoc des larrons de la patience et des petits ivrognes du sang humain, puisque l'un et l'autre sont si vrais qu'on ne saurait mieux dire en fait de donner des noms. Un seul de ces voleurs d'insectes sera souvent capable d'empêcher de dormir des nuits entières, par ses piqûres et par le bruit d'un son très importun. Et quand on en est couvert, que sera-ce? Et si on les prend à poignées à chaque moment qu'en dira-t-on? Il n'y a que la seule fumée qui puisse écarter [f. 166] ces importuns. Mais les remèdes qu'on entreprend de faire sont plus incommodes que l'incommodité même des maringouins. Mais comme fort souvent la fumée donne la chasse à ces petits bourreaux, on aime mieux être harassé de deux ennemis pour quelque temps que de souffrir les insultes* des deux les nuits entières. Mais d'autres fois on a beau se mettre entre quatre feux et s'en entourer, ces petits tyrans et ces étranges biberons* passent tête baissée, pour ainsi dire, au travers de leur plus cruel ennemi. Ils livrent leurs plus rudes combats ordinairement deux ou trois heures avant le jour, et autant de temps après le soleil couché.

Que si la nécessité oblige quelqu'un d'arrêter un seul moment, ces voleurs des plus grandes patiences viennent fondre avec tant de vitesse sur lui et ils sonnent si haut de leur trompe qu'il y a bien peu de personnes auxquelles la patience n'échappe. On a bien de la peine à boire et on en ressent bien davantage quand quelque nécessité naturelle presse le voyageur. S'il ne souffre qu'un million de piqûres, il n'est pas trop incommodé quoiqu'il semble qu'il ait le feu aux cuisses,

quelques émouchoirs* que le passant porte. Que si enfin il faut se coucher pour dormir ou pour un peu reposer, donnant quelque relâche à la rame qu'on tient tout le jour à la main, ces combattants viennent à l'étourdi à l'assaut, et en si grand nombre sur tout le corps, qu'on a beau tuer, il semble que pour un qu'on a défait il en vient cent autres à la charge. Chacun de ces moucherons applique si adroitement sa trompe sur la peau pour en tirer, à travers les pores, le plus pur sang. Et on les voit si fort agrafés et se raidir si fortement avec un battement d'ailes qu'il semble qu'ils voudraient se cacher dessous la peau au travers de laquelle ils sucent le sang des patients.

Toutes les forêts des Indes sont si infestées de toute sorte de moucherons que la chose va au-delà de ce qu'on en saurait croire.

On voit une fort petite espèce de moustiques qui sont venimeux : lorsqu'ils piquent, il naît des enflures grosses comme des pois, et qui durent deux ou trois jours avec douleur.

De la mouche à feu, ou de la mouche luisante
Parmi les choses qui sont admirables sur les terres de l'Amérique, je trouve que la mouche à feu n'y doit pas tenir de dernier rang, car, à la bien considérer, on dirait que c'est un astre vivant qui, emporté de son propre mouvement au milieu des ténèbres de la nuit, brille sans recevoir sa lumière du bel astre du jour. Il faut néanmoins que cet astre volant rende hommage au soleil, ne paraissant jamais le jour que comme une mouche du commun*.

L'on est fort souvent agréablement surpris lorsque, sans y penser, on s'imagine voir autant de petits éclairs qu'on voit de ces insectes qui, étendant et resserrant presque en même temps leurs ailes, font paraître et font cacher en un moment leur agréable feu avec lequel on peut lire dans une chambre si on prend la peine d'en tenir un et de le conduire successivement tout le long de la ligne qu'on veut lire; que si ayant une bouteille de verre, on y enferme quinze ou vingt de ces mouches à feu, elles servent de chandelle huit jours durant.

[f. 167] Après toutes ces curieuses* remarques, il est temps de finir et de commencer le traité des poissons, qui, tout au contraire d'une infinité d'insectes fort incommodes aux habitants des forêts, sont d'un très grand avantage et d'un profit singulier. Mais comme je prends garde que je n'ai rien dit de particulier des infinies sortes des grands et des petits serpents qu'on voit dans les vastes terres de l'Amérique, je vous prie de souffrir que je dise un mot du plus beau et du plus dangereux serpent du monde, qu'on voit presque dans toutes les contrées de la Virginie, mais particulièrement

dans la Louisiane, dans la grande Manitounie qui lui est limitrophe et dans la vaste Kizissiane qui la borde du côté du nord jusqu'à la mer Vermeille / que nous n'avons pas encore vue, puisque, selon le rapport* des sauvages, elle est plus de cinq cents lieues loin au-delà de près de douze cents lieues que nous avons parcourues depuis l'entrée du golfe de Saint-Laurent jusqu'à la Manitonie /.

C'est le serpent à sonnette que je propose ici comme le plus beau et comme le plus dangereux serpent de toutes les terres de l'Occident.

Du serpent à sonnette

Il y a de deux sortes de serpents à sonnette. La plus petite des deux espèces a sa sonnette sous la mâchoire d'en bas. Cette sonnette n'est autre chose qu'une manière* de gravier gros comme une balle de fusil de médiocre* calibre renfermé comme dans une bourse de parchemin attachée à la peau du serpent qui, venant à se remuer, fait du bruit pour avertir le chasseur de se retirer ou de se tenir sur ses gardes de peur que le serpent ne l'attaque. La morsure de ce serpent fait mourir dans vingt-quatre heures, si on ne fait pas le remède que je dirai qu'il faut appliquer lorsqu'on est mordu du terrible et du grand serpent à sonnette qui a sa sonnette au bout de la queue, formée par diverses mailles enchâssées les unes dans les autres qui font un assez grand bruit quand le serpent va courant, rampant ou sautant à grands élans.

Cette manière* de sonnette du grand serpent à sonnette passe pour une divinité chez les Occidentaux de l'Amérique. Au reste, on ne peut rien voir de plus beau que la peau embaumée de ce grand serpent. Sa chair est fort blanche, fort délicate et fort bonne à manger. On n'a qu'à couper la tête pour ôter tout le venin de l'animal dont on en voit de dix-huit ou vingt pieds* de long, et gros comme la cuisse d'un grand et d'un gros homme. Plus de vingt hommes peuvent s'en rassasier tout un jour dans les festins que les barbares en font.

Ils le nomment *kiché kinebik* (le grand serpent), *manitou-kinebik* (l'admirable serpent ou le génie serpent), *maratachi-kinebik* (le méchant serpent). D'autres plus éloignés l'appellent le *seigneur des serpents* : *tentislacocauhguj*. C'est la juste signification de ce mot barbare.

Le serpent a la tête de vipère, sa gueule est fort grande, furieusement armée de dents incisives*, de canines, et de molaires aux deux mâchoires. Son œil est effroyable, presque tout rouge. Il a sur la mâchoire d'en haut une défense de chaque côté, c'est-à-dire qu'il a deux dents qui lui sortent de la gueule, deux ou trois doigts de long selon l'âge qu'il a. Elles sont plus ou moins longues. Sur la pointe de [f. 168] chacune de ces dents aiguës comme des aiguilles, on découvre un fort petit trou d'où sort tout le venin du serpent n'en ayant point ailleurs. Ce venin est fort présent* : il fait enfler le corps de la personne piquée de la dent d'une manière incroyable; le blessé devient tout noir et crève dans peu d'heures si, d'abord* qu'il est mordu, il ne creuse dans la terre pour y ensevelir la partie lésée* et demeurer en cet état vingt-quatre heures durant, pendant lesquelles il ne sent aucune douleur ni aucune apparence d'enflure ni de morsure. Ce remède vaut plus que tout l'orviétan romain; il ne coûte rien et il se trouve partout. Je crois que ce remède serait bon par toute la terre qui attire le venin qu'elle communique aux serpents.

Notre serpent à sonnette est plus vite* sur les pierres et sur les rochers que dans les plaines. On connaît l'âge de l'animal au nombre des mailles* qu'il a au bout de la queue et qui font sa sonnette. Si le serpent fait mourir par sa morsure dans peu de temps, il meurt aussi vingt-quatre heures après avoir mordu. Il vit naturellement douze mois sans boire ni manger. Ses dents venimeuses guérissent du mal de tête en piquant des mêmes dents le col et la tête du malade. Et de là on vérifie le proverbe commun qui dit que la bête étant morte, le venin l'est aussi. La graisse du serpent guérit les douleurs chaudes et froides*. On soulage les malades avec la tête du serpent qu'on leur pend au col.

Ce serpent à sonnette est vêtu de la plus belle robe du monde. La peau du lézard n'en approche pas avec toute la variété de ces couleurs. Les habitants du pays en font grand état.

Les Algonquains supérieurs ont donné un nom très convenable au serpent qu'ils l'ont appelé *maratachi-kinébik*, ou bien *maratachiouakisi-kinebix*, qui veut dire : le méchant serpent se lance sur les hommes à l'heure qu'ils y pensent le moins pour les dévorer. Si on est assez malheureux de se laisser entortiller au serpent, on est perdu infailliblement car, étant extrêmement fort, il n'y a pas moyen de se dégager du milieu de ces plis et des replis qu'il fait; c'est pourquoi, quand il a lié quelque gros animal, il le dévore, et il ne faut pas trouver cette dernière chose fort extraordinaire dans des pays vastes et barbares où il n'y a pas tant d'habitants que dans notre France, où, depuis moins de trois ans, on a tué en Dauphiné un serpent à la robe grise et violâtre dont on voit la peau de dix-huit ou vingt pieds-de-roi de long.

Je suis sûr, par le rapport du plus savant gentilhomme de France, qu'on trouva et qu'on tua un serpent d'environ vingt pieds de long aux portes de Clamecy. Sa robe rapportait* aux couleurs de la vêture* des gros lézards. Au reste, ce serpent était si furieux qu'il

attaquait des grands veaux et des vaches dans la prairie que j'ai vue aux mêmes portes de la ville que j'ai nommée. Ce serpent prenait ces animaux par le bout du mufle et les menait dans le fond d'une petite vallée au bout des prairies, et là ils les dévoraient.

Le même gentilhomme, avec qui j'ai conversé fort longtemps, m'a encore assuré qu'il avait vu dans ces mêmes prairies un serpent à deux têtes que les Grecs nomment *amphybène*, qui veut dire un serpent à deux marches ou à deux mouvements contraires. Ce serpent était si venimeux qu'une fille en mourut dans deux ou trois moments après avoir été piquée. Le serpent était de couleur grisâtre. / L'anatomie en étant faite comme d'une chose fort extraordinaire, on ne trouva qu'un cœur et deux foies au serpent. On ne sait comment ce monstre avait été engendré. «Ne pourrait-on pas dire, me disait le gentilhomme, que ce monstre pouvait s'être formé de deux serpents coupés par le milieu qui, venant à se rencontrer, se seraient liés ensemble naturellement, comme l'on sait qu'il arrive du serpent coupé en diverses parties qui se reprennent ensemble venant à se rejoindre?» Et en effet, quand cela arrive, on voit des serpents cicatrisés, et un tour de leur chair qui relève plus que le reste du corps du serpent. Et on remarque qu'en effet le serpent amphybène avait quelque grosseur extraordinaire vers le milieu du corps.

Voilà ce que j'ai remarqué de plus particulier. Venons aux poissons de l'Amérique. /

[F. 169] DOUZIÈME LIVRE

[Huitième cahier de l'Histoire naturelle de l'Inde occidentale]

Traité des poissons[332]

Ce serait ici le lieu de parler de toutes ces eaux immenses qui se voient dans l'Amérique septentrionale et dans tous les quartiers* de l'occidentale pour y voir nager une infinité de poissons.

Je dirais que des vents fréquents, fougueux et fort impétueux, que des brumes, des brouillards, des grêles, des neiges très hautes, et qui durent en bien des endroits six mois de l'année, et neuf ou dix du côté du nord, des grosses pluies et des glaces fort épaisses,

hautes comme des montagnes, et larges comme des plaines de plus de deux ou trois cents lieues* d'étendue en long et en large, sans exclure cette merveille ordinaire de la formation des eaux dont les philosophes disputent tant, assurant qu'elle se fait dans une infinité de cavernes souterraines; font, dis-je, une infinité de belles fontaines, de ruisseaux, de rivières, de grandes marées, de lacs d'une infinité de figures* et d'une grandeur surprenante, d'où il sort tant de beaux fleuves si majestueux qui coulent dans la mer après avoir roulé leurs belles eaux dans les terres : l'une trois cents lieues, l'autre plus de neuf cents et l'autre, plus de huit cents de navigation connue. Toutes ces mêmes eaux, se brouillant et s'entremêlant ensemble, donnent la vie, nourrissent et conservent une infinité de poissons dont je prétends donner quelques descriptions, sinon de tous, au moins de ceux qui sont les plus connus dans ces terres, ne voulant plus rien dire, dans ce traité des poissons, de ces grandes eaux dont j'ai assez parlé dans mes livres précédents. Sachez seulement, pour dire ceci en passant, que, dans les navigations de l'Amérique, on trouve un si prodigieux nombre de poissons qu'on craint quelquefois d'être échoué sur quelque banc de sable lorsqu'on est entouré d'une multitude infinie de poissons : on ne voit que des marsouins gris, des dauphins, des baleines, des balenons, des stadains, des dorades, des albacorains*, des pelamides*, des poissons volants à grandes troupes qui tombent fort souvent sur le tillac des vaisseaux. Recevez donc seulement, après ce petit mot, des noms de poissons que je veux décrire et qui sont les plus connus dans l'Occident et dans le Nord.

L'éplan*
la petite morue
petites barbues
grandes barbues
petits harengs
grands harengs

chevaliers
carpes blanches
carpes rouges
le crapaud
la loche
achigan

332 Pour l'identification des poissons nous avons grandement bénéficié des travaux de Dorothée Sainte-Marie, auteure d'un excellent mémoire de maîtrise, *Les Raretés des Indes ou Codex canadiensis, premier recueil illusté de* *la flore et de la faune de la Nouvelle-France*, Mémoire présenté à la Faculté des Études Supérieures de l'Université de Montréal, 1980.

maratchigan
le poisson doré

aloses
bar
saumon
la gaine*
petit poisson blanc
grand poisson blanc
le poisson armé
le brochet
trois espèces de truites
trois espèces d'esturgeons

[f. 170] Les poissons dont je viens de donner la liste se prennent dans les eaux douces du septentrion en différents lieux et en différentes saisons. Que si l'eau douce nous fournit les poissons que je viens de nommer, la marine nous donne les suivants :

les merluches, ou tocfichs
les grandes morues
les gelmons*
les flétans
les petits marsouins gris

les marsouins blancs
le requiem*
les balenons
les grandes baleines

Outre tous ces poissons, l'on voit, sur les rives de nos mers et sur les bords de nos fleuves, de toute sorte de coquillages, des moucles*, des vigneaux, des poux de baleine et une infinité d'autres coquillages dont on peut se charger en peu de temps.

Dans tous les bords des eaux douces, et même en plusieurs endroits de la terre, on voit plusieurs différences* de crapauds fort venimeux, diverses espèces de salamandres et un autre petit animal à quatre pieds que les sauvages nomment *oukikatarang*, quantité de grenouilles communes, des grises, des rouges, des jaunes, des vertes et d'autres qui sont martelées* de vert, de noir, de gris et de blanc; d'autres qui sont bossues, de ces grenouilles à queue qu'on voit seulement dans le nord, qui sont fort venimeuses; mais ce qui est plus rare et inouï en Europe, on mange des grenouilles qui meuglent comme des taureaux et qu'on entend de plus d'une lieue loin. Une seule remplit un plat.

333 *Osmerus mordax* Mitchell, éperlan d'Amérique, représenté dans le *Codex*, Pl. LVI, fig. 73, sous la désignation «Le plan». Boucher l'appelle *éplan* (Rousseau 1964, 330).

Si je dis peu de chose de toutes ces raretés, et que j'y entremêle tout ce que j'aurai observé de plus considérable, donnant les figures* principales avec leurs couleurs, les usages, les pêches, etc., j'aurai fait ce qu'on n'a jamais entrepris de ces pays pour satisfaire les plus curieux.

Je commence donc, à mon ordinaire*, par les plus petites choses; mais je finis exprès ce traité par une des médiocres* comme l'on verra, lorsque je finirai toute mon histoire naturelle par la description des anguilles. La chose est trop rare et je finis par cette espèce de poisson pour donner envie aux curieux d'aller voir la merveille aux portes de Québec, où, durant trois mois, on pourra les régaler de cent façons avec des anguilles. Que si par hasard l'ardeur de leur curiosité les portait à aller faire un tour dans tous les chemins que j'ai tracés dans ma carte et dans mes six premiers livres, assurément, ils y goûteraient de toutes les espèces dont je vais parler.

Des grenouilles à queue

La figure de cet animal aquatique n'a rien de différent de nos grenouilles que cette queue qui le rend affreux et comme un monstre.

[f. 171] Le lac Kinoua-Michich, qui veut dire le lac un peu long, est fameux pour la multitude des grenouilles à longue queue qui l'habitent et qui y font un continuel croassement. Ces grenouilles sont fort venimeuses, bien que dans ces pays-là les crapauds, les serpents et les vipères ne le soient point.

De la grosse grenouille

C'est dans le lac Saint-Pierre, trois lieues au-dessus de la rivière des Trois-Rivières, qu'on commence de voir, d'entendre et de manger des grosses grenouilles telles que je viens de les dépeindre. On en voit au-delà du lieu que je viens de nommer plus de six ou sept cents lieues loin.

De l'éplan*333

L'éplan est un fort petit poisson qui commence à paraître sur les rives du Saint-Laurent lorsque le grand effort de la célèbre pêche de l'anguille veut finir. Le flux et le reflux de la mer, qui entre plus de deux cent cinquante lieues dans le fleuve, jette et pousse l'éplan dans les nattes qu'on a tendues pour cette fameuse pêche, qui est si féconde, si abondante et si avantageuse à tous les Français de la florissante colonie qui se forme tous les jours, que plusieurs personnes de mérite et

d'une haute spéculation* estiment que ce n'est pas une moindre providence, pour la subsistance du pays, que l'était cette céleste manne qui tombait tous les jours comme une admirable rosée autour du camp des Israélites.

L'éplan dont je parle ici est d'un fort bon goût étant accommodé à la française. Le plus grand n'a pas trois doigts de long. Il est délicat et tout s'y mange.

De la petite morue[334]

Ce poisson est ainsi appelé à cause du grand rapport* qu'il a [à] la grande morue; et force gens pensent que c'est cette même morue qu'on prend en tant d'endroits des Indes, qui venant de la haute mer se vient ranger* sous les glaces de la Nouvelle-France pendant le plus grand froid de ce pays. On n'en a découvert la pêche que depuis douze et treize ans, quoiqu'il y ait plus de soixante ou quatre-vingts ans que les Français ont commencé leur colonie.

Cette pêche se fait à commencer sur la côte de Batiscan, qui est un village lequel a deux lieues de long et finit vers les Trois-Rivières d'où il y a six lieues de navigation. Dans l'espace d'une heure un enfant de dix à douze ans qui fait un petit trou sur la glace en prend deux ou trois cents avec des épingles pliées en [f. 172] forme d'un hameçon. Ceux qui s'attachent à cette pêche si aisée ne manquent pas d'en saler des pleins poinçons*. Au reste, le poisson est de très bon goût, et n'a point d'écaille rude.

Des petites et des grandes barbues[335]

En décrivant la petite espèce des barbues, j'aurai en même temps fait le portrait de la grande, laquelle ne diffère de celle-ci qu'en bonté et qu'en grandeur.

La petite barbue ne se trouve pas par tout le fleuve : je n'en ai vu que chez les Outchibouek, que nous appelons les Sauteurs fort improprement, quelques ignorants ayant appelé un rapide le plus majestueux du monde un saut, et parce que la nation des Outchibouek demeure autour et au bout du rapide, ils les ont appelés les Sauteurs, qui sont les sauvages les plus ha-

biles et les plus spirituels et les mieux faits du monde.

La petite barbue ni la grande ne se prennent que rarement au filet, mais avec abondance avec des hameçons, des dards*, ou avec des harpons. La peau de ces deux espèces de poissons est aussi limoneuse que celle de l'anguille.

Les barbues ont la tête et la gueule fort large, armée de quatre ou de cinq rangs de dents. Le poisson est appelé barbue à cause de quatre longues barbes qu'elle a autour des mâchoires. Sa peau est noirâtre, mais sa chair est blanche comme de la neige, et fort délicate. Elle porte son assaisonnement aussi bien que l'anguille. Le commun des grandes barbues pèse sept ou huit livres*. Dans tout le poisson, il n'y a qu'une arête qui est délicate et entourée d'une graisse fort fine, qui fait un bouillon fort blanc et très bon. / J'ai vu des sauvages revenir de la pêche de la barbue qui en avaient tué à coups d'épée deux ou trois cents livres. /

Du petit et du grand hareng[336]

Ce poisson a été nommé *hareng* à cause du grand rapport qu'il a à cet autre qu'on prend dans la Manche vers les côtes de Normandie, et qu'on appelle en ces quartiers*-là des *enfants de Dieppe*. Sa chair est fort blanche et fort délicate. Son arête quoique petite est forte et dangereuse. Je n'ai vu pêcher cette sorte de petit hareng que sous le pied du saut Tracy et sous les glaces. Les enfants y font divers trous et dardent ce poisson à deux brasses de profondeur, lorsqu'il passe à bandes vis-à-vis des trous qu'ils ont faits où ils en prennent autant qu'ils veulent.

Comme je n'ai découvert aucune différence du hareng qu'on pêche au bord des côtes de France d'avec celui qu'on prend dans la mer Douce des Algonquins supérieurs et dans la mer Tracy, je n'ai rien à dire sur la figure du poisson. J'assurerai seulement que c'est une chose rare et assez particulière de voir des sauvages sur une petite écorce aller une ou deux lieues au large prendre, [f. 173] avec leurs filets qu'ils jettent à trente ou quarante brasses* de profondeur, où ils en prennent de si prodigieuses quantités qu'ils ne savent qu'en faire.

334 Possiblement le *Microgadus tomcod* Walbaum, le poula-mon qu'on appelle aussi à Sainte-Anne-de-la-Pérade, au Québec, le «petit poisson des chenaux». Il est représenté dans le *Codex*, Pl. LVI, fig. 73.1, sous la désignation «Lapetite molue».

335 La plus petite espèce est l'*Ictalurus nebulosus* (Lesueur), la barbotte brune, et la plus grande, l'*Ictalurus punctatus* (Rafinesque), la barbue commune. L'une des deux est représentée dans le *Codex*, Pl. LVI, fig. 73.2, sous la désignation «Labarbue». En 1613, Champlain signalait la présence de «barbeaux», alors que Hennepin, en 1698, parlait de «barbues de grandeur prodigieuse» (Sainte-

Marie, 145). Boucher, qui ne parle que de «barbuë», semble avoir confondu les deux espèces (Rousseau 1964, 329–30).

336 Nicolas connaissait le *Clupea harengus* Mitchell, le hareng de l'Atlantique, même s'il ne parle ici que du *Coregonus ardetii* Lesueur, le cisco de lac. Toutefois les deux candidats sont représentés dans le *Codex*, Pl. LVI, fig. 73.3 et 4, sous les désignations «Lepetit arent» et «le grand arent». Denys (1672) mentionne le «hareng» parmi les poissons de mer (Sainte-Marie, 147). Boucher a été témoin de la pêche du cisco dans la région des Grands Lacs (Rousseau 1964, 328).

Cette sorte de pêche se fait en automne. L'opinion de ceux qui disent qu'il n'y a point de hareng dans les eaux douces n'est pas conforme à ce que je viens de dire, puisque j'assure que tous les grands lacs de l'Amérique où il y a du hareng n'ont que des eaux douces.

Du chevalier[337]
Le chevalier est une espèce de ces poissons blancs que nous voyons en France et qu'on appelle en quelques endroits des *gardons*, et ailleurs des *chabots*; mais il est de goût bien plus fin. Son écaille est fort tendre, sa chair très blanche. Je n'en ai vu que dans les grands lacs de Tracy, de Nipissing, dans la mer Douce. Il n'a qu'un demi-pied de long.

Des carpes[338]
La carpe blanche ne diffère de la rouge qu'en sa couleur. D'abord que les glaces sont fondues, on en prend autant qu'on veut à l'entrée de toutes les petites rivières qui se dégorgent* dans les Grands Lacs. Elles sont toutes d'une égale grandeur. Nous n'en mangions que les têtes, qui sont d'un goût exquis.

Outre les carpes blanches et outre les rouges, nous en prenions des communes d'une prodigieuse grosseur. Le petit rapide qui est proche de la ville de Mont-Royal est fameux pour les belles et pour / les grandes / carpes qu'on y prend en si grand nombre et dans si peu de temps que la chose est merveilleuse.

Du crapaud[339]
La laideur de ce poisson lui a mérité cet illustre nom[340]. Il n'y a rien que de fort commun dans le goût que sa chair a; mais comme les barbares ont un autre goût que le nôtre, ils en font état et disent qu'il est *ouinganchj*, qui veut dire d'un bon goût.

De l'alose[341]
Sa figure n'est pas différente de celle que j'ai vu pêcher sous le pont du Saint-Esprit en Languedoc. Elle a beaucoup plus d'arêtes et ne me semble pas de si bon goût. La pêche en est féconde après que les glaces sont parties des rives du grand fleuve d'Hochelaga, que nous appelons aujourd'hui Saint-Laurent, à cause que le brave Jacques Cartier y entra heureusement à tel jour. La pêche de l'alose est donc ouverte dès aussitôt que les glaces (qui ont des années qu'il y a vingt ou trente pieds d'épaisseur) se sont allées échouer et briser sur les côtes ou qu'elles ont coulé à fond, ou que du moins elles ont été poussées au large du fleuve par les vents, aidées de rapides qui les emportent jusqu'à la mer.

[f. 174] Quand la mer s'est retirée et que tous les bords du fleuve sont à sec, on voit la plus triste perspective qu'on saurait imaginer : toutes ces plages, qui sont demeurées à sec à un quart de lieue et en plusieurs endroits demi-lieue, sont couvertes de montagnes de glaces, que le flux et le reflux de la mer y a charriées, pour les venir reprendre au premier flot ou à la première fois que la marée sera haute, ce qui arrive toujours deux fois de vingt-quatre en vingt-quatre heures. Il faut encore remarquer ici en passant, puisque je parle par hasard des glaces, et à l'occasion de la pêche des aloses qu'on prend avec des filets qu'on tient hors de l'eau, lorsque la marée est basse et que tous les bords du fleuve sont sans glaces, il faut, dis-je, remarquer que les glaces sont si épaisses et si grandes que, s'attachant à des pièces de rochers détachées, elles les enlèvent, quoiqu'il y en ait d'aussi grosses, d'aussi longues et d'aussi hautes que des navires, qui sont emportées plusieurs lieues loin. Ce que je dis ici est arrivé en l'année 1675 à neuf ou dix lieues au-dessous de la ville de Québec, et tout proche d'un bout de la fameuse île d'Orléans, où l'on voit cinq grands rochers au milieu du fleuve et que les habitants du pays prirent pour autant de vaisseaux hollandais qui venaient faire descente au port de Québec. Tout le pays en fut alarmé jusqu'à ce qu'on fût allé reconnaître de bien près que

337 Nicolas connaissait peut-être le *Salvenilus alpinus* (L.), l'omble chevalier, qui se rencontrait dans le nord de l'Europe et jusqu'au lac Léman. Le poisson qu'il vit au Canada était le *Salvelinus arcticus* (Pallas), l'omble arctique ou truite rouge. Cartier parlait déjà de «truytes» en 1534 et Champlain signalait une «truitiere» près de Port Royal (Ganong, 241). Boucher connaît aussi les «truites» (Rousseau 1964, 328).

338 *Cyprinus carpio* (L.), carpe commune; représentée dans le *Codex*, Pl. LVII, fig. 74.1, sous la designation «carpe». Cartier et Champlain parlent de «carpes» (Ganong, 208–9). Boucher aussi mentionne les «carpes» (Rousseau 1964, 331–2).

339 On connaît six espèces de crapet dans l'est du Canada : *Lepomis gibbosus* (L.), crapet-soleil; *Lepomis megalotis* (Rafinesque), crapet à longues oreilles; *Lepomis macrochirus* (Rafinesque), crapet arlequin; *Promoxis nigromaculatus* (Lesueur), crapet calicot, appelé «marigane» dans la région des Deux-Montagnes; et *Ambloplites rupestris* (Rafinesque), crapet de roche (Sainte-Marie, 152). Nicolas a représenté l'un d'entre eux dans le *Codex*, Pl. LVII, fig. 74.2, sous la désignation «le crapeau».

340 Aujourd'hui on le désigne plutôt comme «crapet» que «crapaud». On ne doit pas cependant le confondre avec le *Lophius americanus* Cuvier, la baudroie de mer.

341 *Alosa sapidissima* Wilson, alose d'Amérique, qui ressemble beaucoup à l'espèce européenne, *Alosa alosa* (L.), alose d'Europe, dont s'inspire probablement la fig. 74.3 du *Codex*, Pl. LVII, où on la nomme «La Lause».

ce n'était que cinq rochers que les glaces avaient charriés là. On peut juger de la grosseur de ces pièces de rocher, soit de ce qui paraît au dehors, soit de ce qui est enfoncé dans l'eau, de quelle prodigieuse hauteur sont les marées et de quelle admirable profondeur est notre fleuve, car ces grandes machines* de glace et de pierre ne flottent pas en des eaux basses. J'ai pris occasion* de dire ceci parlant de la pêche de l'alose, qu'on prend hors de l'eau pendue dans les filets, lorsque la mer s'est retirée.

De l'atchigan[342] et du maratchigan[343]
Comme ces deux espèces de poisson ne sont guère différentes, je ne fais nulle difficulté de les mettre ensemble et de dire que l'atchigan et le maratchigan sont admirables et fort bons, et d'une charnure ferme, à peu d'arêtes, et fort blanche. Ces poissons sont ordinairement d'un pied et demi de long, à la très petite écaille, mais si forte et si dure qu'on en est beaucoup incommodé en les mangeant si on n'a eu un soin fort particulier de les écailler. Ces deux sortes de poissons ont sept ou huit rangs de dents fort aiguës. Le maratchigan est plus noir que l'atchigan. Ils sont particuliers au fleuve de Saint-Laurent et à nos grands lacs.

[f. 175] De la loche[344]
Quoique ce poisson soit tout extraordinaire et d'un très mauvais goût, les sauvages, qui mangent de tout, en font état, bien que nous autres Français le rejetions quand nous avions d'autres choses à manger.

Ce poisson a deux pieds de long; il est fort gros jusqu'au milieu du ventre. Il ne se pêche que dans les plus grands lacs. Il est laid. Il a la tête et la gueule fort large et fort plate, à sept ou huit rangs de grosses dents. Il se nourrit comme le brochet d'autres poissons, et quoiqu'il soit bien denté, it avale sa proie sans la mâcher. Il n'a point d'écaille, comme l'anguille. Sa peau est fort glissante et extrêmement limoneuse. La chair est dure et comme cordée. Une seule chose nous faisait rechercher ce poisson plus que tous les autres, et comme l'on trouve la rose au milieu des épines : nous trouvions un foie blanc comme de la neige, d'une grosseur démesurée à proportion de la grandeur du poisson, et d'un goût le plus fin, le plus délicat et le plus savoureux du monde /, au milieu d'une chair fort grossière /.[345]

Nous ne faisions point d'autre apprêt à cette rare* partie du poisson que de la mettre au bout d'un bâton à pointes, et planté dans la terre auprès du feu, où ce foie échauffé commençait à écumer d'une écume semblable à la crème fouettée ou au blanc d'œuf bien battu. Dans un moment il était cuit. Son odeur et son goût ne se peuvent pas expliquer, car il semble que tous les goûts des viandes les plus délicates soient renfermés dans celle-là qui a la qualité de réjouir le cœur et de la fortifier extrêmement. / J'oubliais de dire que la loche, nommée *missamee*, a deux grandes moustaches. /

Du poisson doré[346]
Le poisson doré ne tient rien de cette belle espèce d'un autre poisson qu'on appelle la *dorade*[347] sur les rives du golfe de Léon. Nous l'avons appelé le *poisson doré* à cause de cette belle couleur de l'or bruni qu'on voit sur tout son corps, couvert de très petites écailles, si attachées à la peau du poisson que, si on le laisse [f. 176] tant soit peu hors de l'eau, il faut se résoudre d'écorcher plutôt le poisson que de l'écailler : il faut le gril ou l'eau bouillante pour en venir à bout.

Ce beau poisson est d'un goût exquis, d'une chair forte et blanche; il n'a presque point d'arête.

J'en ai vu prendre de si grandes quantités dans la mer Douce qu'on ne les portait qu'à pleins sacs. Je l'ai vu aussi commun dans nos campements que le sont les cailloux au bord de diverses rivières.

342 On connaît deux espèces d'achigan dans l'est du Canada : *Micropterus salmoides* (Lacépède), l'achigan proprement dit; et *Micropterus dolomieu* Lacépède, l'achigan à petite bouche; l'un d'entre eux est représenté dans le *Codex*, Pl. LVIII, fig. 74.4, sous la désignation «Achigan». Hennepin parle d'«achigan» (Sainte-Marie, 154) et Boucher d'*ouchigan* (Rousseau 1964, 332), essayant tous les deux de reproduire son nom algonquien.

343 *Aplodinotus gruniens* (Rafinesque), malachigan, représenté dans le *Codex*, Pl. LVIII, fig. 75, sous la désignation «Marachigan».

344 Nicolas connaissait certainement la *Cobitis taenia* (L.), loche de rivière, qui était (et est encore) abondant dans le Languedoc-Roussillon en France, région qu'il connaissait bien. L'espèce correspondante au Canada est la *Lota lota lacustris* (Walbaum), lotte de rivière, représentée dans le *Codex*, Pl. LVIII, fig. 75.1, sous la désignation «La Loche». Connue de Boucher sous le même nom (Rousseau 1964, 330–1).

345 Nicolas a d'abord écrit : «et voilà comme nous trouvions la bonté au milieu d'une chair de poisson aussi mauvaise que je viens de la dépeindre», mots qu'il a biffés pour les remplacer par les mots suivants : «au milieu d'une chaire fort grossière».

346 *Stizostedion vitreum* (Mitchell), le doré jaune ou blanc, représenté dans le *Codex*, Pl. LVIII, fig. 75.2, sous la désignation «Poisson dore». Hennepin (Sainte-Marie, 158) et Boucher (Rousseau 1964, 332) l'appellent le «poisson dorez».

347 En Méditerranée, il s'agirait de *Sparus aurata* (L.), daurade royale.

Des grandes barbues

J'ai déjà décrit ce poisson. Je veux seulement dire que ce poisson est si goulu qu'il se prend facilement à la ligne, qui est une corde longue de soixante ou de quatre-vingts brasses armée d'autant d'hameçons, qu'on jette dans le fond de la rivière avec deux ancres de pierre. C'est un plaisir, lorsque dans moins d'une heure on en prend des centaines de cinq, de six et de sept ou huit livres la pièce. Les Indiens n'ont qu'à aller au pied ou au bout d'un rapide dans la saison que la barbue donne pour en assommer une infinité à coups de perche ou pour les darder à une ou à deux brasses d'eau, et fort souvent à un pied. Toute la rivière est, pour ainsi dire, pavée de ce poisson. Et voilà les deux façons de pêcher la barbue.

Du bar[348]

Ce poisson est un des plus beaux et un des meilleurs du monde. Il a tout le corps argenté et tout le dessous du ventre blanc comme de la neige et reluisant comme du satin de cette couleur. Il est croisé sur les deux flancs de deux barres de noir de chaque côté. Il est encore meilleur au goût qu'il n'est beau; sa chair est ferme et elle est blanche comme du lait. Il n'a qu'une arête, ses écailles ne sont point trop rudes.

La pêche de ce poisson se fait de deux ou trois façons, au filet, ou à la senne, qui est une espèce de bouillet* semblable à ceux que j'ai vus sur les côtes de notre Méditerranée. On prend des bars qui ont deux pieds de long, deux pieds et demi et un de large. Quelques pêcheurs célèbres se servent de l'épervier pour la pêche du bar.

[f. 177] *Du saumon et de la gaine au bec crochu*[349]

Je ne sépare pas ces deux poissons, pour la grande ressemblance qu'ils ont. La gaine ne diffère en rien du saumon que par le bout de son museau qu'elle a un peu plus affilé et crochu.

La tête et le ventre de l'un et de l'autre sont d'un goût recherché, et on fait des festins de régal de ces

deux parties. Tout le reste du corps néanmoins est bon. La chair de l'un et de l'autre poisson est fort rouge. Ces deux poissons se pêchent dans l'eau douce et dans la salée. On le prend comme l'alose à marée basse et hors de l'eau; la pêche qu'on en fait est fort considérable en deux saisons : au printemps et au commencement de l'automne. On en sale des pleines barriques qu'on transporte en France et aux îles du Midi, où l'on en fait échange avec du tabac, du sucre, du coton et de l'indigo.

Du petit et du grand poisson blanc[350]

Le petit et le grand poisson blancs ne se pêchent guère que dans nos grands lacs, et jamais dans l'eau salée. Je ne crois pas qu'on puisse trouver au monde un meilleur poisson. Ces deux espèces de poissons blancs sont particulières aux Indes, et je ne pense pas qu'il y en ait ailleurs. Du moins les auteurs latins ni français n'en disent mot ni n'en donnent point la figure, non pas même Rondelet, qui a fait état* de nous donner connaissances de quantité de poissons, et de marine* et d'eau douce. Les Américains* donnent le nom d'*atikamek* au poisson blanc, et une nation entière, qui était autrefois fort riche en toute sorte de pelleteries, mais particulièrement en castor, en voulait bien porter le nom.

Le petit poisson blanc n'a qu'un pied de long; il est large à proportion. Il est si délicat au manger qu'il fond à la bouche cuit seulement à l'eau pure, sans sel ni nul autre assaisonnement desquels on n'use point parmi les sauvages. Je rapporte ceci pour répondre à mille personnes qui m'ont questionné sur la manière de vivre des sauvages auxquelles j'ai répondu que [f. 178] tous les sauvages que j'ai fréquentés n'ont pour tout mets et pour toutes viandes et pour tous ragoûts* que quelques racines amères. Ils ne mangent point d'herbes, car ils disent que les herbes ne sont que pour les brutes*. Quelques nations mangent des haricots, des citrouilles, des melons d'eau fort sucrés, dont quelques-uns sont blancs comme du lait, à la graine noire; d'au-

348 *Morone saxatilis* (Walbaum), bar rayé, représenté dans le *Codex*, Pl. LVIII, fig. 75.3, sous la désignation «Le Bar». Champlain le signalait en 1613 (Sainte-Marie, 160). Connu de Boucher (Rousseau 1964, 329).

349 *Salmo salar* (L.), saumon atlantique, représenté sous deux formes (mâle et femelle) dans le *Codex*, Pl. LIX, fig. 76, respectivement, sous la désignation «La gueyne» et «Autre gueyne». Le saumon apparaît déjà sur la carte de 1612 de Champlain (Sainte-Marie, 162). Boucher le mentionne aussi, peut-être sous la forme adaptée aux eaux douces que l'on trouvait de son temps dans le lac Ontario et le lac Champlain (Rousseau 1964, 327 et 328, voir aussi la note 54, 328).

350 Le «petit poisson blanc» est le *Coregonus artedi* Lesueur, le cisco de lac, et le grand est le *Coregonus clupeaformis* (Mitchell), grand corégone, tous deux représentés dans le *Codex*, Pl. LIX, fig. 76.1, sous la désignation «le petit poisson blanc» et Pl. LX, fig. 77, sous la désignation «atticamec Le gran poisson blanc». Sainte-Marie, 164 signale que la pêche à l'«atticamek» est également représentée dans le *Codex*, Pl. XV, fig. 19, avec la légende suivante : «La pesche des sauvages passinassiouek Je déscris cette pesche ailleur qui est une des choses tres merveilleusses touchand La Pesche». Boucher le mentionne (Rousseau 1964, 333).

tres sont rougeâtres, à la graine de même couleur. D'autres nations ne vivent presque que de poissons. Les Kiristinons ne mangent ordinairement que de la viande fraîche et boucanée demi-cuite; tantôt* elle est demi-pourrie et pleine de vers. On ne sait parmi ces sortes de gens ce que c'est que le pain, ni le vin; on n'a point du sel. Les Indiens sont presque toujours tout nus, excepté les femmes qui sont toujours fort décemment vêtues depuis le col jusqu'aux genoux. Ces barbares sont toujours exposés, comme les bêtes, à toutes les injures de temps. Ils sont chasseurs, pêcheurs, grands navigateurs, hardis guerriers, voyageurs infatigables, etc. On peut juger de là quelles souffrances sont obligés de supporter ceux qui ont la charité de suivre ces errants pour leur apprendre à connaître Dieu dans des voyages redoublés de mille ou de douze cents lieues tout d'une traite en allant ou venant, la rame éternellement à la main comme des forçats, étant nu-pieds dans des portages, chargés de bagage, comme des crocheteurs*, les raquettes aux pieds pendant l'hiver sur les neiges à tirer une traîne sur laquelle est tout le bagage d'habits, de vivres, de tout ce qu'il faut pour dire la messe, exposés sans nulle retraite* ni nulle maison à toutes les injures de l'air, à la pluie, au vent, aux naufrages, au froid, au chaud, aux neiges, aux glaces, aux grêles, aux frimas, aux brouillards et aux gelées si vives que très souvent il se forme au bout des cheveux et sur la barbe des gros glaçons, aussi bien que sur les paupières et sur les sourcils et par tout le visage, avec une très grande incommodité coucher toujours vêtu et sur la dure. Que si enfin, au milieu de toutes ces misères, on est pris de quelque maladie, on est plus misérable qu'un chien.

Dans telles rencontres*, un morceau de poisson blanc sert de consommé, bouilli dans l'eau claire ou rôti au bout d'un bâton.

Ce poisson blanc se prend en toute saison dans les lacs à trente ou quarante brasses de profondeur, et quelquefois à trois ou quatre, selon les lieux et selon la saison.

J'ai vu très souvent des sauvages qui jetaient leurs filets à trente brasses de fond sous les glaces dans la mer Tracy. Voici comment.

[f. 179] Environ* les fêtes de la Noël, lorsque les glaces sont fortes, on va se promener sur les mêmes glaces à deux ou trois lieues au large du lac, là où l'on sait que la pêche est bonne. L'on fait un trou à coups de hache sur la glace. Le trou étant fait, on sonde la profondeur du lac, et l'ayant découverte, l'on continue à faire autant de trous que le filet qu'on veut tendre a de longueur. Les trous sont de quatre ou de cinq en cinq pas* en droite ligne. On passe le filet de trou en trou sous les glaces avec une longue perche qu'un homme tire d'un trou à l'autre, à mesure qu'un autre lui tend la perche au bout de laquelle le filet est attaché. Lorsqu'on a tendu tout le filet, on jette deux ancres, un à chaque bout du filet, pour faire couler à fond le filet. Et pour le tenir tendu en hauteur, on attache deux cordes sur les glaces à deux chevilles qu'on a plantées pour ce sujet* dans la glace, qu'on a soudées avec de l'eau qui se gèle contre, à même temps qu'on la verse autour de la cheville. Au lieu de plomb dont on se sert en France, l'on use là de petits cailloux ronds attachés avec de l'écorce de bois blanc. Et au lieu qu'on se sert de liège en Europe pour soutenir le filet, nos pêcheurs se servent de lames de bois de cèdre faites en forme de lames d'épée qu'on attache aussi, tout le long du haut du filet, d'espace en espace, avec de la même écorce de bois blanc pour le soutenir.

Le filet étant ainsi tendu et les trous des deux extrémités bouchés, de peur qu'ils ne règlent, les pêcheurs se retirent jusqu'au lendemain de bon matin, pour revenir avec un autre filet tout sec et pour le remettre à la place de celui qu'ils avaient tendu le jour auparavant pour pêcher du poisson blanc. Ils tirent leur filet si chargé de ce poisson, et la chose est d'autant plus agréable qu'ils trouvent dans leurs filets, pêle et mêle avec le poisson blanc, des gros brochets de deux ou trois pieds de long, des truites qui pèsent jusqu'à quarante ou cinquante livres. Souvent l'esturgeon s'est mêlé dans le filet.

C'est à dessein que j'ai voulu dire ici un mot de cette différente prise de poisson, puisqu'il est vrai que ce n'est que par hasard qu'on trouve toutes ces sortes de poissons pris ensemble, car ordinairement chacun de ces poissons se prend en temps et en lieux différents, mais de la même manière. Ainsi, lorsque je parlerai des autres poissons en particulier, comme je fais ici du poisson blanc, je ne serai pas obligé de redire l'admirable invention que les sauvages ont trouvée pour prendre les poissons.

Voilà une façon de pêcher qui est assez spirituelle*. En voici d'autres manières qui ne le sont pas moins, que je vais [f. 180] décrire après vous avoir dépeint le grand poisson blanc qui a du moins* deux pieds de long et un de large. Tout est excellent dans ce poisson, et sans autre façon* on n'a qu'à le jeter dans l'eau et le faire bouillir quelque peu de temps pour le manger très bon s'il est cuit à propos*. La chair en est fort savoureuse, ferme et blanche comme du lait, sans arête, entrelardée d'une graisse si douce qu'elle se résout* facilement en une sorte d'huile très belle, claire, jaune comme de l'or et fort douce, excellente à brûler, à fricasser, et particulière* pour passer* les peaux à l'huile. Elle n'a nulle mauvaise odeur.

Cet admirable poisson blanc n'a qu'une arête qui tient plutôt du cartilage que de ce qu'on appelle *arête* dans le poisson. Cette arête est entourée d'une longe de graisse qui court depuis le museau du poisson jusqu'au commencement de sa queue. Cette graisse est si douce et si succulente qu'elle réjouit merveilleusement* le cœur en se fondant auparavant sur la langue comme fait le sucre. L'eau où ce poisson a bouilli devient fort blanche et fait un très bon bouillon. L'écaille du poisson est grande comme un denier*. Elle n'est point trop rude, non plus que toutes ses nageoires, ni le bout de sa queue. Et quand par plaisir on veut manger du poisson réduit en gelée aussi blanche que de la neige, on n'a qu'à faire bouillir un peu longtemps le poisson tout entier qui se réduit tout en bouillie sans qu'il reste nulle apparence de poisson.

Ce même poisson est très bon séché à la fumée, mais s'il est rôti et cuit dans sa graisse et par sa graisse qui le pénètre de tous côtés, il est excellent. Étant rôti, on ne l'appelle plus *atikamek*, qui veut dire poisson blanc, mais les Sauteurs sauvages lui donnent un autre nom, l'appelant *nametté*; étant simplement bouilli, son premier nom lui demeure; étant séché à la fumée, on lui donne un troisième nom, à savoir *apoualak*.

On trouve dans le ventre de ce poisson ce qui ne se voit point dans nul autre. C'est un nœud gros comme deux œufs, fort blanc et d'un goût ravissant et tout particulier. C'est un morceau de capitaine, disent les sauvages : *unkima–oumitchin*, le manger de celui qui gouverne. Par là, ils veulent exprimer la bonté d'une viande dont on fait des festins dont on donne les meilleurs morceaux aux capitaines.

Ce grand poisson blanc se plaît à nager à la grande eau claire et dans des rudes bouillons d'eau au milieu des grands rapides.

C'est ici que je puis dire que j'ai vu une infinité de fois la plus belle et la plus féconde pêche qu'on puisse jamais voir à travers les horribles élévations d'eau de la décharge du grand lac Supérieur qu'on nomme à présent la *mer Tracy*, et sa décharge le saut Sainte-Marie, distant de Québec de trois cents lieues [f. 181] sous le 46e degré de hauteur polaire, au milieu duquel saut deux sauvages s'en vont montés sur un canot dans lequel ils ont deux sortes de perches de quatre brasses de long chacune. L'une leur sert pour piquer contre terre et pour se raidir contre l'effroyable impétuosité des bouillons, des courants et des rapides épouvantables au milieu desquels ces argonautes poussent avec violence leur canot pour les surmonter, jusqu'à ce qu'ils soient arrivés à des endroits où ils savent qu'il y a tant de ces gros poissons blancs que tout le fond de l'eau en est comme pavé, ou plutôt entassé l'un sur l'autre en telle

quantité qu'ils n'ont qu'à laisser couler en bas leur seconde perche au bout de laquelle il y a un filet en forme de cône ou de capuchon, d'où à chaque fois qu'ils le relèvent – ce qui se fait prestement – , ils amènent cinq ou six gros poissons blancs. Je donne la figure* du filet dans mes figures. Dès qu'ils ont vidé leur filet dans le canot, ils le relancent successivement* dans l'eau, et à chaque fois, ils puisent, comme la force de leur mot sauvage le porte, autre cinq ou six poissons, et cela va si vite qu'il n'y a point de canot qui ne revienne, dans moins d'une heure, chargé de cent ou de six-vingts* de ces poissons. Le même canot ayant déchargé son poisson à terre, il n'a qu'à retourner au milieu du rapide. Il revient chargé comme la première fois. Ce n'est guère pêcher si cent canots ne sont remplis tous les jours que les sauvages se veulent attacher à la pêche qui dure près de six mois tous les ans, ou du moins trois infailliblement.

La merveille de cette sorte de pêche est d'autant plus rare et plus remarquable que les sauvages sauteurs y sont si accoutumés qu'ils ne font nulle difficulté de se hasarder* au milieu de ces épouvantables courants d'eau et de ces bouillons qui font tourner la tête à ceux qui les regardent de loin. Ils vont, dis-je, pendant que la lune luit, se jeter au milieu de ces précipices effroyables. Et s'il arrive, par le défaut* d'un coup de perche ou d'un coup de rame donné mal à propos, que le canot tourne, comme ils sont tout nus et qu'ils savent nager comme des poissons, ils ne s'en mettent guère en peine, se voyant portés dans un moment à plus de sept ou huit cents pas au pied du rapide, où ils vont reprendre leur canot à plus de huit piques* de hauteur du fond de l'eau pour se remettre dedans, se goguenardant* et se riant l'un de l'autre d'avoir perdu leur poisson et de leur aventure, ayant aussi perdu leur *koûbahagan*, qui est leur cuiller à pot, à ce qu'ils disent, avec laquelle ils puisaient le poisson comme dans un pot. En effet, ce mot est bien conforme à celui qu'ils disent lorsqu'ils vont à cette pêche, disant qu'ils vont puiser du poisson : «Nikakoûabahoûa», disent-ils (je puiserai du poisson), quand ils vont à cette sorte de pêche. Ce mot est bien différent du *Vado piscari* du grand saint Pierre.

Ce poisson est si commun dans le camp qu'il en faut jeter. Et c'est pour cette raison qu'on n'en prend souvent que pour en manger ce qui est nécessaire.

[f. 182] On chargerait aisément des grands vaisseaux dans peu de temps de ces poissons. Dans les deux saisons du printemps et de l'automne, cette pêche attire force sauvages tout autour de ce saut, ou plutôt de ce rapide majestueux qui fait la jonction de trois lacs si prodigieux que l'un n'a pas moins de cinq cents lieues, qu'on appelle la *mer Douce*; l'autre n'en a pas moins de

sept cents, et on le nomme le *lac Supérieur*, ou la *mer Tracy*; et l'autre enfin, en a mille quatre cents, sous le nom de *lac des Illinois*. Desquels lacs, il vient tant de monde jouir des avantages de la pêche des Sauteurs qu'on compte des bandes de deux ou trois mille personnes qui y vivent heureusement.

Que si nos messieurs les sauvages veulent quelquefois s'y divertir, faire des feux de joie et quelque manière de feux d'artifice, ils n'ont qu'à faire bouillir de leurs poissons blancs dans des chaudières rangées en diverses figures* et jeter tous / en même temps / du bouillon des chaudières dans chaque feu qui est dessous les chaudières : on voit en même temps mille différentes figures de feu s'élever de la hauteur d'une pique qui sortent toutes d'une même figure qu'on a fait dans la différente disposition des chaudières. Si elle est ronde, on voit sortir toutes ces différentes attitudes* (pour me servir de ce mot de peinture) d'un cercle de feu. Si les chaudières sont posées en figure de fleur de lys, on voit une fleur de lys qui enfante, pour ainsi dire, autant de figures différentes qu'on jette au feu de pleines cuillers de bouillon de poisson blanc, qui, étant mêlé avec la graisse fondue de ce poisson, s'évapore en flammes tournées d'une infinité de façons. Cet exercice est un jeu des Indiens qu'ils font assez souvent pour se divertir. Cette flamme est si subtile* et a si peu de corps qu'elle peut être considérée à peu près comme le feu* élémentaire.

[F. 183] TREIZIÈME LIVRE

Du brochet[351]

Le brochet que je prétends de décrire ici, n'ayant rien de différent qu'une grandeur extraordinaire du brochet commun de France, je n'en dirai rien autre chose. Je n'ai qu'à faire savoir la particulière façon* dont on se sert pour le pêcher. On l'embarrasse dans les filets comme j'ai dit; mais les sauvages ont l'adresse de le tuer à coups de dards et à coups de flèches avec beaucoup d'industrie* et avec tant de subtilité* qu'ils égalent en adresse les plus habiles tireurs à la volée. Et comme ceux-là poursuivent la caille et la perdrix sur la terre, ceux-ci vont après le brochet dans l'eau à peu près

comme les chiens vont quêtant* le gibier. Ils ont la vue si fine qu'ils voient le brochet dans l'eau au travers de mille embarras où ils le dardent*.

Pendant l'hiver, ils le prennent à l'hameçon ou avec le dard sous les glaces, sur lesquelles ils font des trous d'un pied et demi de diamètre qu'ils couvrent avec des robes de castor ou avec des branches d'arbres appuyées sur un petit arceau sous lequel les pêcheurs cachent leur tête. Ils tiennent à la main une fort longue perche au bout de laquelle il y a un harpon denté en forme de dard, et au bout du harpon, il y a un poisson ou sa figure qu'ils représentent adroitement. Ils remuent sans cesse cette perche pour faire remuer le poisson comme s'il nageait. Le brochet, qui est fort goulu et fort grand, ou la grosse truite, voyant ce poisson, viennent pour l'avaler, et le pêcheur prenant son temps lance son dard et accroche le poisson qui se trouve pris au bout d'une ficelle qui tient le harpon, laquelle est attachée à la perche que j'ai dit, aussi ronde et aussi bien polie que le manche d'une pique. Le pêcheur attire ainsi fort lentement le gros poisson pris, de peur qu'il ne s'échappe par quelque effort violent qu'il ferait si on le tirait de l'eau avec trop de vitesse.

C'est une chose merveilleuse de voir la constance du pêcheur demeurer les trois et les quatre heures, pendant les plus rudes journées, appuyé sur la glace et regardant toujours dans l'eau pour faire quelque nouvelle prise.

Des truites communes[352]

Ces truites ont la même figure que les nôtres; mais elles n'en ont pas le goût ni la couleur intérieure, ni extérieure. Leur chair est rouge presque comme celle du saumon; elle est plus sèche et plus ferme : c'est la cause* qu'elles sont d'un goût insipide. L'odeur même en est un peu forte et sauvage. Pour la peau, on ne peut rien voir de plus beau ni de mieux martelé* de rouge, de jaune, de gris, de blanc et de violet. On n'en voit guère de fort grosses.

Des truites moyennes et bigarrées[353]

La truite moyenne est assez grosse. C'est le plus beau poisson qu'on puisse voir sous la même figure que nos plus belles truites. Leurs taches et la figure des

351 *Esox lucius* (L.), grand brochet, représenté dans le *Codex*, Pl. LX, fig. 78 sous la désignation «Le grand Broché dune grosseur Extraordinaire et dune longuer surprenante». Boucher en parle dans les mêmes termes (Rousseau 1964, 331).

352 *Salvelinus fontinali* (Mitchell), omble de fontaine, re-

présentée dans le *Codex*, Pl. LX, fig. 78.1, sous la désignation «la truite comune». Boucher aussi mentionne les «truites», comme on l'a vu plus haut (Rousseau 1964, 328).

353 Il aurait pu s'agir d'*Oncorhyncus mykiss* Walbaum, truite arc-en-ciel, mais cette espèce, venue de l'ouest,

tavelures sont toutes différentes, et les couleurs infinies en sont si vives qu'on ne peut rien voir de plus rare. Ce poisson est fait à peindre. Il est d'un très bon goût.

Des grosses truites[354]
Cette espèce de poisson ne se trouve que dans les mers douces et dans la grande eau, de telle manière que, pour le prendre aux filets, il faut les jeter (ou des lignes qu'on tend pour cela) à vingt ou à [f. 184] vingt-cinq brasses* de profondeur, et bien souvent à plus de quarante.

Ce poisson est admirable en sa grosseur. On en voit de monstrueux, à la tête et à la gueule effroyable, capable d'avaler des enfants : on voit un million de dents dans leur gueule. Toute la tête est d'un royal manger : les yeux sont meilleurs que ceux du veau. Le ventre est d'un goût fin. L'estomac du poisson est prodigieusement grand et fort : les sauvages en font des sacs. Un seul de ces poissons donne à manger à plus de vingt hommes dans des festins dont on régale souvent de plusieurs tout un village ou tout un camp.

Les sauvages sont plaisants quand ils font la pêche de ce poisson de la même façon qu'ils prennent le brochet sous les glaces avec le harpon, comme j'ai dit : le pêcheur, couché sur la glace, tenant son dard à la main, siffle, chante et harangue la truite la conjurant de venir; il l'appelle sa grand-mère : «Viens, viens, ma grand-mère, dit-il, viens, viens çà*! Aie pitié de moi, viens, moi donner à manger. Ho! ho! ho! ajoute-t-il en sa langue. *Noûkoûmis pimatcha, pimatcha, chaouerimir, pimatcha achamir, nigaouikounké, nigaouikouaké*, je ferai festin, je ferai festin, *undachiiaien*, si tu viens çà».

Du poisson armé[355]
Ce nom a été très bien donné à ce poisson, car véritablement on peut dire qu'il est armé d'une manière surprenante de tête en queue. Son bec est presque aussi long que le reste de son corps, qui est couvert comme d'une très forte cotte de mailles, faite avec des écailles si fortes qu'à peine un gros dard de fer bien affilé peut

le percer. Le poisson a la queue extrêmement forte : d'un seul coup, il tuerait un homme et il brise tous les filets. Sa dent est très forte et pointue comme des aiguilles / les mieux / affilées. Il en a une infinité. Le poisson est dangereux. On ne le tue que par curiosité, n'étant guère bon à manger.

On en trouve qui ont dix ou douze pieds* de long, qui seraient aussi à craindre que le crocodile s'ils avaient quatre jambes et autant de pieds. / Ce poisson / dévore l'autre poisson et il chasse les oiseaux dont il vit ordinairement tout l'été. Voici comment. Comme ce poisson à la tête fort longue, et fendue comme un compas, il élève cette partie de son corps hors de l'eau et l'ouvre comme un compas au milieu des grandes joncquières*, où une infinité d'oiseaux de marine* vont se retirer, soit pour y chercher leur vie ou pour s'y mettre à l'abri. Et comme ces oiseaux courent deçà et delà, il en passe beaucoup au travers du bec du poisson armé qui, le serrant, plonge et avale sa prise sans la mâcher. Je dirai tantôt* que la grande morue en fait autant un peu différemment du poisson armé, qui se mâte* comme s'il était debout, là où la morue et les grosses truites de nos lacs nagent naturellement quand elles avalent des canards tout entiers qu'elles viennent prendre à fleur d'eau.

Il y a peu d'Indiens qui ne réservent fort soigneusement les têtes des poissons armés qu'ils tuent pour se guérir des maux de tête en s'y piquant avec les dents du poisson. Ils s'en servent aussi de lancette pour se saigner par tout le corps avec beaucoup d'adresse sans crainte d'offenser* leurs nerfs. Ils ne sont pas si scrupuleux que les habiles chirurgiens : ils piquent hardiment toutes leurs veines et s'ensanglantent si fort qu'ils semblent* à des hommes écorchés.

[f. 185] *Du petit esturgeon*[356]
J'ai remarqué trois sortes d'esturgeons, dont seulement deux espèces fréquentent nos grands lacs. Le petit n'a qu'environ deux pieds de long. Il est à cinq

n'a été introduite que récemment dans le Parc National des Laurentides, au Québec (Sainte-Marie, 169). Le *Codex*, Pl. LXI, fig. 79, a tout de même représenté une «Autre espece de truite».

354 *Salvelinus namaycush* (Walbaum), l'omble du Canada, ou truite grise, ou touladi, représentée dans le *Codex*, Pl. LXI, fig. 79.1, sous la désignation «la grosse et la grande truite». Claude Le Beau dans ses *Avantures de Sr C. Le Beau*, 1738 consacrera une illustration à la pêche de cette grosse truite (Sainte-Marie, 170).

355 *Lepisosteus osseus* (L.), lépisostée osseux, représenté dans le *Codex*, Pl. LXI, fig. 79.2, sous la désignation «chausarou ou poisson arme il a 12 pieds de long et six de contourd». Il a beaucoup excité la curiosité des pre-

miers voyageurs. Champlain en fournit une illustration sur sa carte de 1612; Sagard en parle en 1636; Du Creux en fournit une illustration, pl. I, face à la 50 dans son *Historiae canadensis seu Novae Franciae libri decem*, 1664. Boucher le décrit (Rousseau 1964, 333); Hennepin, 1698, les *Relations des Jésuites*, et Lahontan le mentionnent aussi (Sainte-Marie, 171–2).

356 On connaît cinq espèces d'esturgeons au Canada, dont deux au Québec : *Acipenser oxyrhyncus* (Mitchell), esturgeon de l'Atlantique, et *Acipenser fulvescens* (Rafinesque), esturgeon de lac, ou esturgeon jaune. Le premier est représenté dans le *Codex*, Pl. LXII, fig. 80.1, où l'on affirme que «le grand Eturgeon a douse pieds de long d'une grosseur proportionnée à sa longueur».

angles égaux. Il est délicat; il a la tête grosse, le museau pointu, la gueule en bas au milieu de la tête en forme d'une bourse qui s'ouvre et se ferme au gré du poisson. Sa couleur est grisâtre sur le dos et sur les flancs; le dessous est tout blanc. Il a sur sa peau quelques écailles fort dures tout le long des angles, et non pas ailleurs.

De l'esturgeon médiocre*

Je l'appelle médiocre quoiqu'il ait quatre ou cinq pieds de long ordinairement, pour le distinguer de ce prodigieux esturgeon qui en a sept ou huit, et quelquefois douze, sur une surprenante grosseur. Cet esturgeon médiocre est commun dans tout le pays. On le prend à la ligne, au filet et au dard* comme le brochet. On l'assomme avec des perches et on le lapide au pied des rapides. Ce poisson est excellent, fort charnu, bien nourrissant. Le bout de la queue a un pied* de long, est bien d'un goût plus délicat que la queue des meilleures morues. Le poisson bouilli extraordinairement se résout* et se fond comme de la graisse; et ce bouillon refroidi est épais comme la plus belle gelée. Il n'a point d'arête, mais quelque sorte de cartilage fort tendre qui se mange. Tout le dessous du ventre est d'un goût exquis. On ne voit point d'écaille sur la peau du poisson : on y découvre seulement sur le dos une vingtaine de marques comme autant de petits boucliers de la matière de l'écaille de tortue. Il a un million d'œufs dans le ventre, gros comme la graine de raiforts, dont les pêcheurs font une espèce de pain qui est puant, mais qu'on trouve bon par le défaut* de quelque chose de meilleur. / On dit que de toute cette grande quantité d'œufs il n'en éclôt qu'un : les sauvages l'assurent; il faut les en croire : ils sont fort naturalistes. Ce poisson est utile pour* l'huile fort douce et fort jaune qu'on en tire, propre* à brûler et à passer* les peaux. /

L'estomac du poisson est fort grand et fort épais, en forme de parchemin, dont on fait une colle très forte et très belle. Tous ces rares* bouquets et tous ces beaux images qu'on voit et qu'on dit être faits de colle de poisson le sont en effet puisqu'ils sont faits de l'estomac de ce poisson dont on fait de la colle, aussi bien que de l'estomac du grand esturgeon. Les sauvages se servent de cette colle pour garnir leurs flèches et pour armer leurs dards, au bout desquels ils attachent des pierres à fusil pour tuer leurs ennemis ou leurs grandes bêtes fauves.

Ce poisson a un gros nerf qui se produit* depuis le bout de la tête jusqu'au bout de la queue. On dirait à le voir que c'est un serpent blanc comme de la neige. Le faisant cuire, il est assez bon : il craque sous la dent comme les petites raves*. Ce nerf est plein d'une moelle de bon goût, et blanche comme de la neige.

Du gros esturgeon

Il n'y a rien de différent en cet esturgeon de celui que je viens de décrire qu'une prodigieuse grosseur et une longueur extraordinaire. Du reste, il n'y a rien de différent. Je n'en ai jamais vu qu'un de cette grande espèce, échoué sur la grève du grand fleuve. Je ne pouvais assez me satisfaire de considérer* ce beau poisson que la marée avait laissé à terre sèche. De bonne foi, il était plus gros qu'un muy*, et long à proportion. Mon malheur fut que je n'en pus pas profiter, étant déjà tout pourri.

[f. 186] Des morues[357]

Je n'aurais pas assez d'une main* de papier pour écrire tout ce que j'aurais à dire des morues; mais comme d'autres gens en ont parlé et que j'en ai dit un mot au commencement de mes mémoires, il me suffit de vous dire ici que ce poisson est si commun dans le fleuve de Saint-Laurent que depuis Tadoussac en bas, en revenant vers notre France jusqu'à l'île de Terre-Neuve, où est la belle et la fameuse anse de Plaisance, il y a une infinité de lieux où l'on fait la pêche des morues, et particulièrement sur les rives de Saint-Laurent. L'anse de Gaspé, l'île Percée, le Banc aux orphelins, le Banc à vers, tous les banquereaux, tout le tour de la grande île de Bacalos, le fameux grand Banc et une infinité d'autres lieux sont célèbres sans que j'entreprenne d'en parler davantage. Je dirai seulement que tous ces lieux sont des mines aussi riches que celles du Potosi, de l'Ophir et du Pérou, et que le seul Cap de Sable vaut presque tout cela puisqu'un seul homme dans peu d'heures y trouve de quoi nourrir plusieurs personnes fort longtemps, dans la prise qu'il y fait de plus belles, de plus

L'autre se trouve à la même page : «Le petit Eturgeon». On ne voit pas bien ce que Nicolas veut dire en parlant enfin de «médiocre eturgeon», à moins qu'il ne veuille désigner l'*Acipenser brevirostrum* (Lesueur), esturgeon à museau court. Lescarbot est le premier à en parler. Champlain l'a dessiné sur sa carte de 1612. Denys en fait une bonne description (Ganong, 216). Boucher le connaissait aussi (Rousseau 1964, 328). Sainte-Marie, 177, signale qu'à la page 19 du *Codex* on a représenté un

«chien qui traine un poisson quon appelle namé ou eturgeon».

357 *Gadus morhua* (L.), morue de l'Atlantique, représentée dans le *Codex*, Pl. LXIII, fig. 81, sous la désignation «Morue». Déjà dans *Delle Navigationi et Viaggi*, Giovanni Battista Ramusio avait représenté une morue en 1550. Champlain la représente aussi sur sa carte de 1612. Hennepin et Denys parlent de la pêche aux morues. On trouve également, dans *Il Gazzettiere Americano*, 1763

grosses et des plus grasses morues du monde. J'en donne la figure* fort recherchée*. Et comme elle a bien du rapport* à la truite et qu'on peut aisément juger de sa figure par ce qu'on en voit par toute la France, il est inutile d'en parler davantage.

Il faut seulement dire que la pêche des morues est une des plus belles raretés du monde, et si les seuls habitants des Terres Neuves faisaient ce grand commerce, on pourrait dire que la Nouvelle-France serait bientôt un fort riche et un fort puissant royaume. Tous les lieux que j'ai nommés sont aux portes du Canada, et le Canada même. Il y a tous les ans plus de quatre ou cinq cents navires des nations de l'Europe voisines de la mer Baltique qui vont faire la pêche des morues et recueillir un peu de cette manne inépuisable qui se prend avec un bout de corde qu'on appelle une ligne, au bout de laquelle on attache un aïn* chargé d'appâts, le tout proportionné à la gueule du poisson, sur lequel je n'ai guère remarqué de différence avec les grandes truites de nos lacs.

Du gelmon*[358]

Le gelmon est un gros poisson tout rond en long. Il semble avoir deux grandes ailes longues et tranchantes, quoique fort étroites. Elles ressemblent à des faux manchées* à l'envers. On prend ce poisson à la ligne sur le derrière des vaisseaux en pleine mer, lors même qu'on va à toutes voiles. Le poisson est beau et paraît couvert de toutes les couleurs comme le col du pigeon. Il n'a point d'écailles. Il est de bon goût.

Du flétan[359]

Le flétan est un poisson qui est prodigieusement grand. Il a presque la figure de la sole et de la raie. Sa chair est fort blanche, mais elle est bien grossière et s'enlève par grandes tranches, comme le gâteau feuilleté. Il est fort large, il a la gueule tournée en bas, proche du ventre et loin de la tête. À voir flotter ce poisson, il semble qu'on voit une table.

[f. 187] Sur la mer, il se prend à la ligne. Il se laisse aussi darder. Un soldat, voyant un de ces poissons qui dormait en flottant, lui lança sa pique sur le dos, et voyant que le poisson ne s'émouvait* pas de cela en emportant sa pique, il se jeta promptement dessus pour la ravoir sans éveiller le poisson.

Ce trait a quelque rapport à ce que disent de bons auteurs de quelques matelots, qui, croyant de voir quelque rocher en pleine mer, y descendirent dessus avec leur barque pour y aller faire bouillir leur chaudière. Et y ayant allumé du feu, et ce feu agissant éveilla un poisson qu'on avait pris pour un îlot de rocher, lequel plongeant, laissa ses mariniers bien en peine après la perte de tout leur équipage. Ils se jetèrent promptement à la nage dans leur chaloupe pour regagner au plus vite leur vaisseau.

Du marsouin gris, ou du petit porc de mer[360]

La couleur du marsouin gris tire un peu sur le noirâtre. On l'appelle / néanmoins / le marsouin gris pour le distinguer de ce beau marsouin blanc dont j'ai déjà dit un mot et duquel je dois parler encore, après avoir dit que le marsouin gris est ce pourceau de mer duquel on parle tant. En effet, il a quelque rapport à cet animal en tout son corps, quoiqu'il soit un poisson parfait*. Il est si gras qu'il semble* du lard dont assez souvent on surprend bien du monde lorsqu'en carême on leur met sur de la purée de pois une belle tranche de ce lard qui est fort bon et qui tire un peu sur le jaune.

Le poisson est rond, en long, et fort blanc sous le ventre. Son sang pris tout chaud fortifie les nerfs. Il est furieusement* denté. Tous ses intestins ont le goût du ventre du cochon. Il est fort ossé* et il est sans arêtes. La crête qui paraît sur son dos est délicate au goût, aussi bien que la queue. On en voit qui ont deux brasses de long. On le darde du bout de la proue des vaisseaux, où bien souvent on en voit passer de belles bandes.

Du marsouin blanc[361]

J'ai dit ailleurs par occasion* presque tout ce que je vais redire ici pour n'ôter pas ce beau poisson de son rang

une planche consacrée à la morue (Sainte-Marie, 178–9). Boucher la nomme la «moluë» (Rousseau 1964, 324–7).

358 *Thunnus alalunga* (Bonaterre), germon ou thon blanc. Commun en Méditerranée, mais très rare dans l'Atlantique occidental, le germon aura été plus familier à Nicolas que notre *Thunnus thynnus* (L.), thon rouge du nord. Le *Codex*, Pl. LXIII, fig. 81.1, représente «Le gelmon» de la Méditerranée.

359 *Hippoglossus hippoglossus* (L.), flétan de l'Atlantique, représenté dans le *Codex*, Pl. LXIV, fig.82, sous la désignation «le flectan». Mentionné par Champlain en 1604, par Lescarbot (Ganong, 217), et par Denys (Sainte-Marie, 181).

360 *Phocanea phocanea* (L.), marsouin commun, représenté dans le *Codex*, Pl. LXIV, fig. 82.1, sous la désignation «marsouin gris». Mais ce «marsouin gris» a le dos noir et le ventre blanc. Ramusio, 1550 le nomme *delfino* et ajoute que son nom français *marsouin* dérive de l'allemand *Meerschwein*, ce qui signifie en Italien *porco di mare*. Denys le connaît et sait le distinguer du bélouga (Sainte-Marie, 183–4).

361 *Delphinapterus leucas* (Pallas), béluga, représenté dans le *Codex*, Pl. LXIV, fig. 82.2, sous la désignation «Marsouin blanc». Il semble que Denys (Ganong, 224) et Boucher le connaissaient (Rousseau 1964, 315).

et pour ne pas donner la peine aux curieux d'avoir recours à mes premiers ouvrages.

[f. 188] J'ai dit que le marsouin blanc est un grand poisson long de dix-huit ou vingt pieds, d'une grosseur proportionnée à sa longueur. Il y en a qui ont plus de cinq pieds de diamètre.

Ce petit monstre marin a l'œil fort petit; il ressemble à celui du porc. Il a la tête grosse, une fort grande gueule garnie de terribles dents incisoires*, canines et molaires. Toute sa peau est fine et sans écailles, blanche comme du lait, épaisse d'un pouce*. Cet animal a trois ou quatre doigts de lard qui n'est propre qu'à faire de l'huile. On distingue le sexe comme entre le bœuf et la vache. Sa figure est ronde, en long. Il est beaucoup plus gros sur le train de devant que sur celui de la queue, qu'il a tournée autrement que le reste des poissons. Et comme il tient un peu de la baleine, il a la queue tournée de même.

Tout le fleuve de Saint-Laurent en paraît couvert à grandes bandes aux environs des côtes de Tadoussac. Ce poisson donne* sur l'anguille avec avidité, et il en avale tant qu'on en trouve jusqu'à cinq ou six cents dans son estomac.

Les petits, qui sortent du ventre de leur mère tout formés et en vie, s'attachent si fortement à leurs mamelles qu'on les voit très souvent comme s'ils y étaient liés.

Ce marsouin a un trou ou un éventail sur le milieu de la tête comme les baleines. Et on le voit et on l'entend respirer cent fois le jour. Il rejette même un peu de l'eau en forme d'une aigrette, de la hauteur d'une demi-pique*. Le moindre de ces poissons vaut et se vend cinquante écus*. J'en ai vu faire l'anatomie* par un capitaine hollandais qui commandait notre vaisseau et qui venait des côtes du nord où il en avait vu avec force lions* de mer. Deux baleines qu'il avait pris lui valurent dix mille écus.

Du requiem, que le vulgaire ignorant appelle* requien
Ce dangereux poisson peut passer pour un monstre marin. On en voit sur les côtes et en pleine mer, fort gros et fort longs; leur grosseur répond* à une longueur de dix-huit ou vingt pieds-de-roi.

La gueule de ce poisson est prodigieusement grande. Il a quatre ou cinq rangs de dents longues et grosses selon son âge. Ordinairement, elles ont deux ou trois pouces de long et un de large. Elles sont un peu en croc, elles tranchent et coupent comme un rasoir; elles sont fort dures. Le poisson est goulu autant qu'on pourrait dire : il se rassasie de tout. Il est hardi et furieux. Et quoiqu'il ait des dents, comme j'ai dit, il avale sans mâcher, même les hommes; et c'est pour cette raison qu'on le nomme [f. 189] le requiem. Il se jette quelquefois à sec* pour avaler les passants, et il mord quelquefois de rage les rames des barques quand il ne peut pas faire quelque coup.

Ce requiem est ce poisson qu'on voit ordinairement flotter autour des armées navales pour avaler les hommes morts qu'on jette en mer, où jamais il n'attaque une personne qui nage ou qui se remue beaucoup; mais si on s'arrête, il fait son coup aussi vite qu'un éclair, coupant ou brisant tout un membre s'il a manqué* d'avaler la personne toute entière. Il ne saurait manger qu'en se tournant sens dessus dessous, à cause* que son museau où sa mâchoire d'en haut est notablement plus longue que celle d'en bas.

Il n'a qu'un seul os tout le long de son corps divisé en vertèbres grosses et fort larges. La femelle jette* ses petits en vie, et elle est si féconde qu'elle en produit jusqu'à quinze.

Si ces petits sont prêts à sortir bientôt, quoiqu'on tue la mère, on en nourrit quelque temps dans des cuves pleines d'eau de la mer; ils sont bons à manger en cet âge, mais après on n'en mange point parce que leur chair est d'une odeur trop forte, et semblable à des étoupes.

La cervelle de ce poisson séchée soulage du mal de gravelle*, elle est fort blanche, selon l'âge du poisson, on tire jusqu'à trente ou quarante pots d'huile de son foie, et plusieurs autres de tous ses intestins. Sa couleur est noirâtre et violâtre fort rude. Etc.

Du balenon[362]
Il est très commun depuis l'embouchure du grand fleuve jusqu'à Tadoussac, il monte même jusqu'au parallèle de l'Échafaud aux Basques. On le voit au large du fleuve, et quelquefois à une portée du pistolet de terre ferme où il demeure en même place les heures entières. À le voir, il semble un îlet de roche. Il est de l'espèce de ceux qu'on pêche en Inde et sur les côtes de

362 Probablement *Eubalaena glacialis* (Müller), baleine franche de l'Atlantique Nord, car Nicolas déclare qu'elle a le museau noir. Elle est représentée dans le *Codex*, Pl. LXV, fig. 83.1, sous la désignation «La petite balene». Rousseau signale treize espèces de cétacés dans le Golfe du Saint-Laurent, au nord de la Nouvelle-Écosse, autour de Terre-Neuve et sur la côte du Labrador, dont notre *Eubalaena g.* Il est difficile de savoir lequel d'entre elles Boucher désigne en parlant de «baleneaux» ou de «grosses baleines» (Rousseau 1964, 315). On pourrait faire la même remarque à propos de la «ballaine» de la carte de 1612 de Champlain ou de celle qui paraît sur sa carte de l'île Sainte-Croix (Sainte-Marie, 191).

la Biscaye qui ont bien du moins* trente-six coudées* de long et huit ou dix d'épaisseur. L'ouverture de leur gueule n'a guère moins de dix-huit ou vingt pieds d'ouverture, le balenon n'est point denté; mais au lieu de dents, il a aux mâchoires deux grandes lames de corne noire qui se terminent en poil comme de la soie de cochon. Il y a quatre aunes* de distance d'un œil à l'autre. Lorsque l'animal est en vie, les yeux paraissent fort petits, mais étant arrachés, ils sont gros, chacun comme la tête d'un homme. Le balenon a comme deux grandes ailes aux côtés, qui lui servent de nageoire et de refuge pour ses petits, où il les cache et où il les porte.

[f. 190] La queue des balenons est si grande que, quand ils la remuent, elle émeut* si fort la mer dans une certaine circonférence qu'elle bouillonne d'une étrange manière tout autour, et il y aurait danger que des grosses barques, et même des brigantins* et des frégates ne fussent submergés; en un mot il ne fait guère bon auprès de ce monstre.

Le museau du balenon est court et abattu, et d'une couleur noire. Il a un trou au milieu de la tête pour rejeter de l'eau et pour respirer. Il fait du bruit comme un coup de canon, et sur mer on l'entend de plus loin.

La femelle fait ses petits en vie. Les os du balenon sont monstrueux : une seule côte a plus de vingt ou de vingt-cinq pieds de long; elles sont grosses comme un homme. On en voit de cette grosseur à La Tremblade, à La Rochelle, à Bayonne, et ailleurs où j'en ai vu et mesuré; à Frontignan, on en voit une sur la main gauche de l'église de la paroisse, pendue à la muraille assez haut, qui a dix-huit grands pieds de long, et si* elle n'est pas entière comme je l'ai remarqué.

L'Échaufaud aux Basques, dans l'Inde occidentale, montre encore aujourd'hui divers prodigieux ossements de balenons. On les voit au pied d'une fort haute montagne, où les Basques fondaient, autrefois, ces monstres pour en tirer l'huile de la graisse. La chair du baleineau, étant salée, est assez bonne. En divers pays, on fait des poutres des os du balenon et des clôtures. J'en ai vu à La Rochelle plantés aux coins de quelques maisons, comme des gardes pour empêcher le charroi* d'enlever des coins de maison.

De la grande et de la véritable baleine
Ce n'est pas bien loin des côtes de l'Amérique que l'on voit de fort grandes baleines, puisque même il y en a dans le golfe du Saint-Laurent. Quand ces grands monstres marins sont en amour, on les voit par bandes, on les entend souffler avec tant de force (rejetant l'eau qui entre dans leurs naseaux, de la hauteur de deux

piques) qu'on dirait qu'ils vont crever. Dans ce grand effort apparent à notre oreille, ces baleines font un certain bruit, qu'il semble qu'on entend venir de bien loin un meuglement sourd néanmoins fort élevé. Et lorsque deux ou trois mâles se rencontrent auprès d'une femelle, ils s'attaquent si furieusement, et ils se livrent de si rudes combats, se frappant étrangement* à coups d'ailerons et à coups de queue, qu'il semble qu'on entend deux vaisseaux de guerre de la première qui se foudroient à coups de canon.

[f. 191] Un certain brave homme qui a écrit de la grande baleine assure ce que je ne voudrais pas dire, n'ayant jamais vu de si grandes baleines comme celles qu'il décrit; je ne veux pas aussi l'improuver*, étant bien sûr qu'il y a des choses dans la nature presque incroyables, qu'il ne faut pas mécroire* pour ne les avoir pas vues.

Cet auteur dit qu'il se voit des baleines aussi grandes que quatre arpents* de terre en toute dimension, et il suppose que chaque arpent de terre a dix-neuf perches* de long sur chaque face, et chaque perche a neuf pieds de long, chaque pied douze pouces : cela veut dire que chacune de ces baleines peut couvrir une superficie de terre qui aura 1 444 pieds et 17 328 pouces.

Monsieur le Maréchal de Bassompierre dit, dans les mémoires de sa vie, qu'allant en ambassade en Espagne et passant à Bayonne, on lui fit voir un petit balenon qui était échoué sur la grève, qui avait cinquante pieds de long, et cependant les pêcheurs assuraient que ce monstre n'avait pas plus de huit jours.

Autant que je le peux conjecturer de ce que j'ai vu des baleines et de la mer, il ne faut pas trop croire à ce qu'écrit un espagnol nommé Garcie, qui dit que les sauvages de l'Amérique pêchent les baleines avec deux bouchons de bois et une massue pour les enfoncer dans leurs éventails et faire crever ainsi les baleines.

J'ai fait un trajet de près de 1 400 lieues avec un capitaine hollandais qui venait de la pêche aux baleines, qui m'a assuré que la baleine se prenait tout autrement que ne dit l'espagnol; et comme plusieurs personnes en ont écrit, je ne dirai seulement pas ce que j'ai vu sur ce point, n'y ayant rien de différent.

Je dirai seulement que la baleine est un animal très dangereux : en voici des preuves. Cet animal est si fort qu'il enlève aisément des grandes barques et les fait couler à fond. Il n'y a pas trop longtemps que ce malheur arriva sur les côtes de notre Amérique. Une baleine venant à heurter contre une barque, l'enleva hors de l'eau et fit périr presque tous ceux qui étaient dedans, la barque ayant été crevée. Il est vrai que la baleine se tua et rougit de son sang la mer plus de qua-

rante pas* de chaque côté de la barque, c'est-à-dire quatre-vingts pas de diamètre.

D'autres font tourner* des vaisseaux. Et il y a des baleines qui avalent tant d'eau que, venant à la rejeter par les trous qu'elles ont sur la tête, [elles] mettent des vaisseaux en danger de couler à fond. Et lorsqu'il y doit avoir, ou qu'en effet il y a quelque tempête manifeste*, comme l'on parle sur la mer, on les voit s'élever sur les vagues avec tant de vigueur que retombant sur l'eau elles agitent si fort l'endroit de la mer où elle replongent, qu'excitant* une double tempête elles font périr sans ressource* les plus gros bâtiments qui s'y trouvent enveloppés. Je puis assurer, par ce que j'ai vu auprès des écores* du grand banc, que la baleine [f. 192] est le plus terrible animal de toute la terre et de toutes les eaux. S'il ne passe qu'à vingt ou trente pas loin d'un vaisseau, on dirait que c'est un diable déchaîné qui y passe, si vite cela va. Le bruit et les bouillons qu'elle fait épouvantent tout le monde : il semble qu'on voit un terrible torrent ou une fort grande rivière débordée qui va aussi vite que la foudre.

Les Latins ont à mon avis bien rencontré* quand ils ont dit que la baleine était la bête de la mer à cause de sa démesurée grandeur : *Bellua marina*. Nos sauvages l'appellent *Matchi-Manitou-Kikoûns*, le méchant diable, ou le méchant génie de poisson; d'autres disent simplement : *mamistinga kikouns*, le grand poisson par excellence.

Il est si grand, en effet, que de sa seule langue on en remplit plus de trois muids*. La baleine vit ordinairement de petit poisson, et en ayant trop mangé, ou de telle autre chose, on l'entend crier et mugir d'une furieuse* façon de plus de deux lieues loin, en temps de calme.

Il y a quelque temps qu'on prit une si furieuse baleine, tout proche du cap de Frie dans le golfe de Guanabara (qui en notre langue veut dire le cap que je garde avec la vue) [que] personne n'osa jamais aborder* ce monstre qui s'était échoué qu'il ne fût mort. Et en se débattant avant que de mourir, pour regagner la haute mer, il faisait trembler la terre tout autour de son corps, et on entendait le bruit de son de battement et de ses mugissements à plus de deux lieues de là. Après que tous les sauvages et tous les Français de la côte voisine en eurent pris autant qu'ils en voulurent, il en resta encore sur la place plus de deux tiers. C'était un prodige de voir les os de cette montagne, pour ainsi dire, où il fallait monter avec des grandes échelles.

La queue de cet épouvantable monstre est faite en forme de divers croissants. Elle est si grande qu'elle ressemble à une voile d'un grand bâtiment. Son cuir est noirâtre, dur et épais, ferme et solide, sans poil et sans écailles; il est attaché sur l'épaisseur de plus d'un pied de graisse fort jaune dont on fait de l'huile pour plus de dix ou douze mille écus, si la baleine est de la première grandeur.

Ce poisson a des poumons, des reins, une vessie. On y remarque fort clairement la différence du sexe. La femelle jette son petit – ou tout au plus ses deux petits – en vie et tout formés. Elle les nourrit de lait et ils s'attachent avec ardeur aux mamelles de leurs mères qui les avalent quand elles ont peur et les revomissent après leur crainte.

En les ouvrant, les pêcheurs trouvent quelquefois dans leur ventre de l'ambre, de l'écume, de l'eau, de la mousse marine et de l'algue, qui est une herbe de la mer. On ne voit point souvent dans ce grand ventre [f. 193] aucune apparence* de poisson et jamais aucune sorte de chair, car la baleine n'en mange jamais.

Enfin cet animal est si prodigieux en tout, et particulièrement en grandeur, qu'il pourrait nourrir plus d'un jour une puissante armée. Les ignorants appellent *côte de baleine* ces arêtes d'ailerons dont on se sert pour les habits des femmes, mais ils sauront que les côtes des baleines étant deux ou trois fois plus grandes que celles des balenons, on ne s'en peut pas servir pour cet usage.

Il y a une autre sorte de baleine qui a quatre pieds bien griffés, au museau fort pointu et bien crochu, a deux grosses mamelles couvertes de grosses écailles, et qui a deux trous sur la tête comme les autres baleines, avec une toile fort grande sur le front qui lui sert de guide.

Ces sortes de baleines sont grandes comme des montagnes; elles coulent aisément à fond les plus grands vaisseaux qu'elles rencontrent, si on ne les détourne avec le bruit des tambours, le fanfare* des trompettes, et avec le tonnerre des coups de canons chargés à boulet. Et pour les amuser, on leur jette plusieurs barriques vides pendant qu'on fait chemin à pleines voiles sur les vastes mers de l'océan, où les matelots dont j'ai rapporté l'histoire allumèrent du feu sur une qui dormait. Si on est dans une crainte extrême voyant de ces monstres, on ne laisse pas d'avoir du plaisir de voir voler en l'air les barriques qu'on a jetées en mer lesquelles la baleine élance* fort haut avec le bout de son museau.

Quand on en pêche de cette grandeur et que la mer les a poussées sur le gravier, il faut avoir des fort grandes échelles pour monter dessus et des fort grosses haches bien affilées pour les dépecer. Il y a peu de temps qu'on en trouva une qui était morte sur les côtes de l'île de Faré.

Pour finir tout ce que j'ai à dire de la baleine, je rapporterai ici un prodige qui arriva à un vaisseau portugais qui allait dans l'Inde, qui se trouva un beau matin investi d'un monstre marin qui surpassait de beaucoup avec sa tête le plus haut lieu de la dunette (qui est toujours sur le derrière du vaisseau); et de sa queue, il investissait l'éperon du même vaisseau (l'éperon est le devant du navire). Cette queue était large comme une voile qui couvrait toute la mer de ce côté. Tout le monde fut dans l'épouvante et se crut perdu, et ne sachant que faire, se résolut à ne rien faire qu'à se disposer à la mort en priant Dieu, qui les délivra de ce danger dans peu de temps, la baleine se retirant d'une façon aussi douce qu'elle s'était attachée sans bruit à ce vaisseau. *Creavit Deus cete grandia.*

[f. 194] *De l'anguille*363
Ce n'est pas sans dessein que, contre mon ordinaire*, je finis ce traité de poissons, et mon 19e livre, par une des plus petites espèces; mais comme j'ai fait cette exception pour l'anguille, je m'en vais vous en dire quatre mots et finir au plus tôt toute mon histoire naturelle, pour entreprendre le narré*, dans six livres, de tout ce que j'ai remarqué de plus rare et de plus curieux dans les tours et dans les retours de plus de quinze ou seize mille lieues de chemin : vous y verrez des choses très divertissantes.

Le prodige surprenant qu'on voit au milieu des Indes occidentales et septentrionales, pour ce qui touche les anguilles, m'a fait résoudre de vous dire ici qu'il y en a tant que c'est un miracle, ou plutôt une merveilleuse providence de voir que, tous les ans, trois mois durant, on en voit prendre vingt ou trente mille pleines barriques où il y en a, de compte fait, cinq cents dans chacune, dans l'étendue seulement de quinze ou seize lieues de plage* de l'un et de l'autre bord du fleuve de Saint-Laurent.

L'anguille du pays a un goût bien meilleur que n'est celui des anguilles qu'on prend en France. Et elle est si commune qu'il y a des pêcheurs qui en ont trouvé dans leurs nasses en un seul jour les cinq ou six mille, qui sont très excellents. Et étant salées, elles sont de très bonne garde*. Cinq mille anguilles remplissent dix barriques ou dix poinçons*; chaque barrique où il y en a cinq cents se vend sur la grève et presque dans les nasses trente livres*. C'est une merveilleuse provision, en ce qu'elle est si grasse qu'on n'a que faire de nul as-

saisonnement : on la mange sans apprêt rôtie; et même étant bouillie, elle sert de beurre et de graisse pour faire le potage.

La pêche de cette espèce de poisson est admirable* : on commence à la faire au mois d'août et elle ne finit qu'après la Toussaint. Les pêcheurs tendent des claies et des nasses sur le bord du fleuve. Lorsque le reflux de la mer s'est retiré, la mer, revenant à monter, couvre toutes ces machines*, et revenant à descendre, laissant encore la grève à sec, nos pêcheurs trouvent une infinité d'anguilles dans leurs nasses, dans des coffres et dans divers parcs qu'ils dressent exprès. Le plus fort de la pêche se fait au déclin de la lune, du mois de septembre et du mois d'octobre, lorsque les nuits sont fort obscures. On en prend quelquefois tant que les pêcheurs sont obligés de les donner pour rien, et même d'en jeter des prodigieuses quantités quand le sel leur manque; on prend l'anguille dans les nasses avec des cendres qu'on leur jette dessus. C'est en ce temps qu'on voit un débattement horrible entre* ces anguilles, [f. 195] qui s'entortillant les unes avec les autres, on les prend à douzaines, et on les jette dans des sacs pour de là les porter dans des barriques qui sont sur le bord de la grève, où l'on les vide à pleins sacs pour leur jeter un peu de sel dessus, afin que, se remuant extraordinairement, elles achèvent de jeter* le limon et la bave qui est sur leur peau qui est extrêmement gluante. L'anguille, qui a la vie fort dure et qui vit les cinq ou six jours hors de l'eau quand elle n'est point blessée, meurt dans moins d'une heure après qu'on l'a saupiquée* de cendres et de sel, comme je viens de dire. Quelque temps après qu'elle est morte, on la lave fort proprement* sans l'éventrer. Et lorsque les anguilles sont sèches ou que l'eau s'est écoulée, on les range dans des poinçons bien nets, qu'on garde d'un an à l'autre pour cet effet*. On jette un lit de sel au fond et ensuite on met un rang d'anguilles, un rang de sel, un rang d'anguilles jusqu'à ce que le poinçon soit plein ou que du moins il y en ait cinq cents à chacun. Il faut remarquer ici que l'anguille du Canada est de beaucoup plus grosse que celle de France : ordinairement une en vaut trois.

On prend l'anguille d'une seconde façon : c'est avec le dard*. Et il n'y a que les sauvages qui s'appliquent à cette sorte de pêche, où ils vont la nuit avec des flambeaux. Ils ne demeurent guère à en darder des pleins canots à moins d'un demi-pied d'eau. Leur façon d'accommoder l'anguille est de les ouvrir par le dos et de

363 *Anguilla rostrata* (Lesueur), anguille d'Amérique, représentée dans le *Codex*, Pl. LXVI, fig. 84.2, sous la désignation «figure de Languille dont dans la colonie francoise on en prend plus de cinquante mille bariques dans trois mois tous les ans». Boucher aussi mentionne l'anguille (Rousseau 1964, 331).

les faire sécher à la fumée, et d'en faire des gros paquets quand elles sont assez boucanées*, car ces gens n'ont point l'usage du sel.

Mais pour vous donner une parfaite connaissance de l'anguille, je dirai que son nom d'anguille lui a été donné de la figure du serpent qu'elle porte : *anguilla*, disent les Latins, *quasi ab angue cuius speciem fert*.

Elle naît dans les eaux douces d'ordinaire, en France sur les côtes du Languedoc. Elle naît, vit et se prend dans l'eau salée. L'étang de Frontignan et celui de Maguelone en sont pleins dans la saison qu'elle donne. J'ai vu la célèbre pêche qu'on en fait aux portes de Frontignan / avec des filets de fil, là où nos Français les prennent avec des filets de buis /. Elles sont bien plus petites que dans les Indes. Je dirai par occasion* que j'ai vu au même lieu une autre pêche merveilleuse où le poisson se prend dans des filets hors de l'eau, lorsqu'on a bouché les passages pour empêcher une certaine espèce de poisson fort gros et fort bon dont le nom m'a échappé; ce poisson, ne trouvant point de sortie, saute de lui-même dans le filet.

Dans l'Inde occidentale, l'anguille naît, vit et se prend dans les lacs, dans les étangs et dans les rivières d'eau douce, et jamais ailleurs. Tous ceux qui ont vu et considéré* de l'anguille savent bien que c'est un poisson long, limoneux, sans écaille, glissant, armé de fort petites dents, qui s'écorche facilement. Les peaux sont de grand usage parmi les Français et parmi les sauvages. Les uns en font des liens pour leurs flaux*, etc. Les sauvages les passent* et en font des grandes tresses pour lier les cheveux des filles. Les passeuses* de peaux se servent de tous les intestins, et particulièrement du foie, pour adoucir les peaux et pour les blanchir.

[f. 196] L'anguille n'a que deux nageoires, des petits yeux, des oreilles rases. Sa queue est assez large, son nez affilé au bout duquel elle a deux trous. Elle ne vit que de limon. Elle a la tête grosse et plate. On connaît à la tête la distinction du mâle et de la femelle, qui l'a plus petite et moins large. Sa chair est grasse et huileuse.

L'anguille s'engendre de quelque pourriture comme les vers dans la terre. L'expérience en a été faite sur un cheval mort qu'on traîna dans l'étang de Maguelone, proche de Montpellier, lequel étant pourri, on trouva dessous et tout autour une infinité de petites anguilles. Quelqu'un a voulu dire que les anguilles se forment des vieilles anguilles mortes, et cela a beaucoup plus de vraisemblance.

Aristote a bien voulu assurer que l'anguille n'est point engendrée ni par le mâle ni par la femelle, comme l'ordinaire des animaux; et pour dire le vrai, je n'ai jamais remarqué dans l'infinité d'anguilles que j'ai ouvertes ou vu ouvrir, qu'il y eût aucun œuf, ni aucune marque de semence génitale dans leurs intestins.

Pour mon particulier*, je voudrais dire qu'il y a en l'anguille quelque secrète vertu* générative, que nous ne connaissons pas à l'extérieur, qu'elle laisse couler dans le limon ou dans le sable, lorsqu'on y en voit une infinité entortillées les unes avec les autres à gros monceaux. Cette semence extérieure, qui est attachée au dehors de la peau, venant à tomber, se convertit en limon, duquel enfin sort cette prodigieuse quantité d'anguilles que nous voyons sur les rives du fleuve de Saint-Laurent, à commencer au grand Cap de Tourmente, jusqu'au Mont-Royal, distants l'un de l'autre d'environ quatre-vingts lieues qui font tout l'espace de la colonie française, où l'on compte déjà près de vingt mille âmes.

Cette opinion n'est pas à mon avis trop à rejeter, puisque tous les savants conviennent que plusieurs animaux s'engendrent de la pourriture, comme le scorpion, le serpent et les souris même. Pourquoi ne pourra-t-on pas dire le même de l'anguille?

Mais qu'il en soit ce qu'il voudra, il nous est plus important de savoir qu'on prend et qu'on mange une infinité d'anguilles que de savoir ni d'où elles viennent ni comment elles se forment, ni si elles vont mourir dans l'eau salée du fleuve. Je m'en rapporte*, mais je ne l'ai jamais remarqué, et cela ne doit pas être, par une raison convaincante, car si cela était, notre fleuve, qui ne souffre point d'immondices dans son sein, les aurait bientôt rejetées sur ses bords à la première tempête ou même au premier coup de vent qui y souffle presque continuellement, ou du côté du midi, du septentrion, du couchant ou du levant, dans sa très vaste largeur. Après cela, il est temps que je finisse mon histoire naturelle, que je commence mes six derniers livres de l'état de plus de cent nations que j'ai fréquentées dans l'Inde, où vous allez voir mille raretés de ces vastes pays.

FIN

GLOSSAIRE

Pour la confection de ce glossaire, nous avons utilisé les dictionnaires de Nicot (1606), de Richelet (1680), de Furetière (1690 et 1727) et de l'Académie française (1694); nous avons aussi tiré profit de l'*Encyclopédie* (1751–65) de Diderot et d'Alembert, de Fr. Godefroy, *Dictionnaire de l'ancienne langue française et de tous ses dialectes du ix^e au xv^e siècle* (1881–1902); de J. Dubois, R. Lagane et A. Lerond, *Dictionnaire du français classique* (Paris, Belin, 2^e éd., 1960; Larousse, 1992), Larousse, *Grand Larousse universel* (1866–79), M. Lenoble-Pinson, *Poil et plume* (1989); É. Littré, *Dictionnaire de la langue française* (1863) et A. Rey, dir., *Dictionnaire historique de la langue française* (Paris, Dictionnaires Le Robert, 1992, 2 vols.).

abattre : diminuer
abatture : broussailles foulées par le cerf
abecher, abbacher, abecquer : nourrir
abois (tenir les) : résister, faire tête aux chiens
abord (d') : aussitôt, d'entrée de jeu
aborder : approcher
accident : hasard, coup du sort
accommodant : qui a l'art d'arranger ou de réparer les choses
accommoder : arranger, meubler, attacher, réparer, habiller
acharner : donner le goût de la chair à l'oiseau de proie pour augmenter son ardeur
actuel : effectif
actuellement : effectivement
admirer : considérer avec stupeur
admirable : étonnant
admiration : stupeur, étonnement
affaire : usage, embarras, travail
affaitage : dressage
affaiter : dresser, apprivoiser
affaiteur : dresseur, apprivoiseur
affection : zèle, goût
affoler : meurtrir, blesser
affranchir : assécher

affriandir : rendre gourmand, mettre en appétit
agreste : non cultivé
agriffer (s') : s'attacher avec les griffes
aiglure : petite tache de couleur rouge
aile (mettre sur l') : contraindre le gibier à prendre son vol
ailes (monter sur ses) : s'élever dans les airs
ailleurs (d') : par ailleurs
ain : hameçon
air (donner de l') : donner libre cours
aire : surface sur laquelle les oiseaux de proie bâtissent leur nid
airs (entre deux) : à moyenne hauteur
ais : planche, madrier
aise : content, contentement
albacorain : thon blanc
allant : gros chien de chasse
amant : qui aime et est habituellement payé de retour
amas : action d'amasser
Américain : Amérindien
anathème : victime immolée, offrande votive
anatomie : dissection, examen minutieux
andouillette : (l'adouiller), les bois de l'animal hachés: usage pharmaceutique

appareil : apprêt, préparatif

apparent : important, manifeste

apparence : vraisemblance, probabilité, trace

appeau : appel, sifflet utilisé pour attirer les oiseaux de chasse, oiseau utilisé pour attirer des oiseaux de même espèce

appendre : consacrer, suspendre selon les rites

apporter : porter, produire

apprendre : élever, apprivoiser

après : d'après, selon

après à : en train de

ardent : brûlant, incandescent

arpent : mesure de longueur valant 58,47 m : mesure de surface valant 3418, 8 m²

assurance : confiance, sécurité

assurer : rendre sûr, sécuritaire, affermir

attachement : ténacité, force

attirer : tirer

attitude : posture

aucun : quelque

aune : ancienne mesure de longueur valant 1884, m à Paris

aunier : aune

auparavant : avant

aussi : car, ainsi, à cause de cela

aussi … comme : aussi … que

avance : affirmation

avant : profondément

aventure (à toute) : au hasard

balancer : hésiter

bas : terne

bas (à) : par terre, près du sol

bas-de-chausse : bas

bâtonner : plier, recourber, façonner

batterie : partie de la grange où l'on bat le grain

bénéfice de ventre : flux de ventre

biberon : buveur

biscayenne : embarcation à voile ou à rame, effilée des deux bouts

blatte: bleuâtre

bois blanc: tilleul d'Amérique

bonté : qualité, excellence, saveur, bon goût

boucan : gril pour fumer les viandes et les poissons, chair cuite sur le gril

boucaner : fumer sur le gril, faire sécher à la fumée

bouillet: filet de pêche

bouline (être à la) : avoir les voiles placées pour recevoir le vent de côté

brancher : se percher sur les arbres

branle : lit de vaisseau

branler : remuer, agiter, hésiter

brasse : mesure de longueur valant environ 1,60 m

brave : excellent, fiable

brayer : culotte, caleçon

brayet : cul du faucon

brenache : bernache

brifau : chien de chasse

brigantin : vaisseau bas, à voile et à rames

brisées : branches cassées pour marquer les pistes du gibier

brout : jeunes pousses mangées par le gibier

brute : animal

buffle : justaucorps en peau de buffle

bure (couleur de) : brun

çà : ici

cabanage : lieu de campement

cabinet : petit lieu couvert dans un jardin

cachet: signe de distinction

cadran : cercle ou cylindre portant des divisions, comme une boussole

calebasse : grosse courge séchée et vidée

callus : callosité, durillon

canine (faim) : faim dévorante

canons (à) : creux

canton : région, partie d'une ville

caresse : démonstration d'amitié ou d'amour

carguer : pencher sur le côté en naviguant

carreau de foudre : foudre

casuel : fortuit, accidentel, imprévu

cause : raison

cause que (à) : parce que

céladon (vert) : vert tendre

célèbre : sompteux, solennel

cependant : pendant ce temps

cerne : cercle

chagrin : irritation, colère, humeur maussade

chaise : chaise à porteurs

change : bête substituée à l'animal de chasse

change (prendre le) : quitter la bête poursuivie pour une autre

chaperon : casque de cuir qui couvre la tête et les yeux de l'oiseau de proie

chaperonner : couvrir la tête et les yeux de l'oiseau de proie

chardonnette : cardon

charnure : qualité de la chair

charrier : transporter avec soi, poursuivre sa proie, emporter sa proie et revenir à la voix

charroi : transport par chariot, bourrasque

charvis : carvi

chaudière : chaudron, récipient en métal pour faire
 cuire les aliments
chaumine : petite chaumière
choquer : heurter
ciller : coudre les paupières d'un oiseau de proie pour
 le dresser
circuit : circonférence
climat : pays, contrée
cliquette : crécelle
clisser : entourer d'osier tressé
col : cou
col du pied : cou-de-pied
colleter : attaquer
colletin : courte veste protégeant le cou et les épaules
comme : comment, à peu près
commettre (se) : se risquer, se hasarder
commode : propre à, convenable
commun : répandu, courant, ordinaire
commun (le) : la généralité
compasser : mesurer, ajuster
condescendance : prévenance
conjoncture : situation, danger
considérable : important, précieux
considération (de) : important
considérer : examiner, estimer, faire cas de
constant : sûr
coq d'Inde : dindon
corme : fruit du cormier
corsage : taille
coudée : mesure de longueur valant 50 cm
coudrier : noisetier
couleuvrine : canon à tube long et effilé
coulis (vent) : courant d'air
couper : castrer
courant : chien qui court après les cerfs
cournau : chien de chasse
couvert : foncé
couverture : plumage couvrant l'oiseau du cou
 à la queue
crayon : esquisse, dessin
crocheteur : portefaix
croupir : tremper
cuissin : coussin, oreiller
cure : pilule composée de coton et de plumes servie
 à l'oiseau de proie
curée : part du gibier donnée aux chiens, moment
 où l'on donne le gibier aux chiens
curieux : minutieux

dard : javelot, pique
darder : frapper avec un javelot ou une flèche

débucher : faire sortir la bête du bois
décocher : fondre sur le gibier
déduit : divertissement, équipage de chasse
défaut : manque, besoin; le fait de perdre la voie
 du gibier
défiant : méfiant
défier (se) : prendre une attitude de défi
dégorger : se jeter, se verser, refluer, déborder
délibérer (sans) : immédiatement
délié : faible, menu, grêle
denier : pièce de cuivre valant 1/12 de sol (lequel vaut
 environ 1/25 de livre)
denrée : objet de première nécessité
dépiteux : arrogant
depuis (du) : à partir de ce moment
désoler : détruire, ravager
devant : avant
devoir : hommage; part réservée à l'oiseau du gibier
 qu'il a pris
différence : sorte, espèce
discours : traité, essai, exposé
donner dessus, sur : attaquer, charger
double : monnaie de cuivre valant deux deniers
doucine : rabot servant à fabriquer les moulures
douleur chaude ou froide : douleur accompagnée
 ou non de fièvre
drogue : remède

écarlate : lychnis
échange (en) : en contrepartie
économie : soin
écores : bords escarpés d'un cours d'eau ou de l'océan
écrouelles : scrofules
écu : pièce de monnaie valant trois livres
écumer : épier
effet : but, fin; efficacité; exécution, réalisation
effet (à, pour cet) : à cette fin
élancer : lancer
élévation : latitude
embéguiner : coiffer, recouvrir la tête
embonpoint : bonne mine, bonne santé
éminence : saillie, protubérance
émotion : mouvement, agitation
émouchoir : pièce de tissu ou réseau de cordelettes
 servant à chasser les mouches
émouvoir : mouvoir, mettre en mouvement, soulever
émouvoir (s') : réagir
emploi : occupation, charge
empiéter : saisir avec ses serres
émut : fiente
enduire : faire digérer

engager (s') : se prendre au piège

enlacer : prendre dans un collet, un nœud coulant

ennuyant : ennuyeux

énoncer (s') : s'exprimer

entendre : comprendre, savoir

enter : rattacher une penne d'oiseau rompue
 ou froissée

entêter : faire mal à la tête

entre : chez, parmi

envelopper : saisir

environ : vers

environner : entourer

épicerie : épices variées

éplan : éperlan

éploiement : déploiement

épreuve : expérience

éprouver : expérimenter, vérifier

équipage : ensemble des êtres et des objets nécessaires
 pour un voyage ou une entreprise

erres : traces

escarbot : coléoptère

escarre : ouverture

esquif : petite embarcation à rames

essor : envol de l'oiseau de proie

estime (faire de l') : apprécier

estomac : poitrine, cœur

étapé : broyé

état de (faire) : alléguer, faire mention de

étrange : extrême, excessif

étrangement : violemment, extrêmement

être : aller

exact : minutieux, fidèle

exciter à : porter, pousser à

exercice : occupation, activité; fatigue, souci

expédient : avantageux, utile

expérience : observation

expérimenter : observer

exprimer : extraire par pression

extrémité (à l') : au pis aller, en dernier recours

fâcheux : enragé, pénible, porté à se fâcher

façon : forme, apparence, manière, apprêt

faire : finir

familier : apprivoisé

familiariser : apprivoiser, domestiquer

fanfare : bruit ou concert d'instrument militaire

fantaisie : caprice, humeur bizarre

fau, feau : hêtre

fauconneau : petit canon

fauconner : apprivoiser

fauve : sauvage

ferré : garni

feu élémentaire : dans la physique ancienne, feu qui
 serait à l'origine de tous les autres

fiant : excréments

figure : aspect, forme; gravure, peinture

figurer : représenter par la peinture, le dessin

filière : ficelle attachée au pied de l'oiseau pour
 le dresser

flau : fléau

flegme : mucosité, sécrétion

fluer : suppurer

foit d'or : verge d'or

formidable : capable d'inspirer une grande crainte

fouetter : marquer de petites raies

fouler : fouler aux pieds

foulure : partie du sol piétinée par un animal

fourrer : garnir de fourrures

fourrure : plumage

fraisé : muni d'une bosse d'où sortira le bois
 de l'animal

franc : enté, greffé; cultivé

friand : gourmand, appétissant

frontau : bandeau

fumées : excréments des cerfs

furieusement : prodigieusement

furieux : violent; prodigieux, extraordinaire

gabarit : armature

gaine : petite truite

garancier : fruit du rosier

garde (de bonne) : qui se conserve bien

garder : observer; prendre garde

gare : cri poussé par le veneur quand le cerf quitte
 son lieu de repos

gelmon : thon blanc

gentillesse : grâce, joliesse

giboyer : chasser

gliron : loir

glu : matière visqueuse tirée de certains arbres pour
 prendre les oiseaux

goguenarder : taquiner

gorge chaude : chair des animaux vivants, ou tout
 juste tués qu'on donne aux oiseaux de proie

gorge froide : chair des animaux morts qu'on donne
 aux oiseaux de proie

goût (haut) : goût relevé

gouverner : traiter, se comporter avec

gravelle : maladie caractérisée par la présence de
 petits calculs rénaux

gridelin, gris de lin : gris couleur de lin

guidon : aileron d'oiseau

guindage : action de guinder

guinder : élever au moyen d'un engin de levage

habiller : apprêter; apprêter un animal pour la cuisson
habitant : colon
habitation : établissement agricole
hagard : farouche, difficile à apprivoiser
halbran : jeune canard sauvage
halebrener : rompre certaines plumes d'un oiseau
hardes : vêtements
hasarder (se) : se risquer
haut-de-chausse : culotte allant de la ceinture
　　aux genoux
haut mal : épilepsie
herbe à la reine : tabac
hère : nid
hièble : sureau à baies noires
hispide : hérissé, velu, âpre
hollander : passer le tuyau d'une plume à écrire dans
　　la cendre ou la lessive pour en enlever la graisse
　　et l'humidité
honnête : honorable, bienséant, décent, cultivé
horreur : effroi
houssine : branche de houx pour battre les tapis
　　ou mener un cheval
humeur : caractère; liquide produit par un corps
　　ou une plante

improuver : blâmer
incarnadin : de couleur plus pâle que l'incarnat
incident : difficulté imprévue
incisoire : incisive
Indien : Amérindien
industrie : habileté, soin
influer à : provoquer
injure : dommage
innocent : inoffensif
instruire : dresser
insulte : attaque, assaut

jaiet : jais
jardiner : égayer
jet : petite courroie passée au pied de l'oiseau et reliée
　　à la filière
jeter : mettre bas; pousser, produire; éliminer
jeunesse (la) : les jeunes gens
joindre : rejoindre, toucher à
joint à : ajouté à
joncquière : jonchère
jonglerie : cérémonie curative ou prophétique
jube : crinière

lacet : collet, lien, nœud coulant

lancer : poursuivre une bête, la faire sortir de son lieu
largue (vent de) : vent oblique
léser : endommager, blesser
leste : élégant
leurre : simulacre de proie tenu au bout d'une lanière
liard : pièce de bronze valant un quart de sou
lienterie : diarrhée
lier : saisir avec ses serres
lieu : place
lieue : mesure de distance valant plus ou moins 4 km
limier : chien dressé pour faire sortir les bêtes du bois
lion de mer : otarie
liqueur : liquide
lisse : femelle du chien de chasse
livre : monnaie valant 20 ou 25 sols; mesure de poids
　　valant 0,489 kg à Paris
livrée : vêtements aux couleurs d'un personnage
　　important
longe : lanière de cuir qui guide l'oiseau de chasse
　　lors du dressage
longtemps (de) : pendant longtemps
lopin : morceau de nourriture
louvre : lieu où demeure le roi

machine : outil, instrument, assemblage
macule : tache
madrer : tacheter, veiner
mai : arbre de mai
maille : tache
mailler : moucheter, tacheter
maillure : ensemble des taches
main : patte du faucon
maître : grosses pièces de bois formant les varangues
　　et la préceinte du navire
malin : mauvais, funeste, dangereux
mancher : munir d'un manche
manière : sorte, façon
manifeste : éclatant, violent
manquer de : ne pas arriver à
manteau : plumage couvrant le dos de l'oiseau
marcassite : sulfure de fer utilisé en bijouterie
marine : mer
marquer : indiquer, représenter
martelage : moucheture
marteler : moucheter, tacheter
massacre : action de tuer une grande quantité
　　de gibier; tête de l'animal chassé
massacrer : démembrer un cerf; tuer une grande
　　quantité de gibier
mâter (se) : se dresser verticalement
maussade : laid, sale
mécanique : vil, sans noblesse

méchant : mauvais, de mauvaise qualité

mécroire : refuser de croire

médiocre : moyen

ménage : biens meubles et animaux

ménager : économe

mener : amener, conduire, accompagner; se comporter

menterie : mensonge

mépris: dédain, indifférence

mépriser: dédaigner, être indifférent à

merrain: planche de chêne

merveilleusement : extrêmement

merveilleux : étonnant

métier : occupation

milliasses (à) : en grand nombre

minute : relevé précis

miraut : chien de chasse

misérable : malheureux, digne de pitié

mitridat : électuaire employé comme contre-poison

moins (du) : au moins

monosserot : licorne

mont (mettre à) : faire voler, faire partir de la main

motte (prendre) : prendre terre

motter : se cacher derrière des mottes de terre; prendre terre

moucle : moule

mue : cage où l'on renferme les oiseaux de proie pendant leur mue

muid, muit, muy : futaille dont la capacité variait considérablement selon les provinces

mulette : estomac des oiseaux de proie

multiplier : augmenter, se reproduire

narré : récit, description

naturalité : chose naturelle

naveau : navet

nécessité : besoin, ce qui est nécessaire pour vivre

neuf : non apprivoisé

nicotiane : tabac

noble (partie) : partie comme le cœur ou la tête

nul : quelque

occasion (dans l') : le cas échéant

occasion (par) : à l'occasion

occasion de (prendre) : profiter de la circonstance pour

offenser : blesser, attaquer

office : métier, charge

oiseleur : personne qui dresse les oiseaux de proie

oiselier : personne qui capture les oiseaux de proie

onde: veine

ondoyé: veiné

ordinaire : habituel

ordinaire (à, pour l') : habituellement

ossé: osseux

oublie: pâtisserie ronde cuite entre deux fers

ouïr : entendre

ouvrage : objet

paître : nourrir

palme : qui mesure la longueur de la main

parfait : complet

parquetage : ouvrage de parquet

particularité : détail, circonstance, caractéristique

particulier : remarquable; privé, personnel

particulier (pour mon) : selon moi

parures : plumage

pas : mesure de longueur valant environ 80 cm

passade : passage, bref séjour

passage : migration

passer : préparer, corroyer, monder, dépasser, outrepasser, migrer

passeur : corroyeur, apprêteur

passion : ardeur, emportement, désir violent

pays : contrée, région

pelamide : bonite

perche : mesure de longueur à Paris, mesure de longueur valant 5, 847 m; mesure de surface valant 34, 19 m²

pertuisane : arme munie d'un fer triangulaire garni d'oreillons

pétun : tabac

pichikiou : bison

pied : mesure de longueur valant 0,3048 m

pierre : calcul qui se forme dans la vessie, les reins ou la vésicule biliaire

pinte : mesure valant 0,93 l, ou deux chopines

pique : mesure de longueur valant environ 1,60 m

piqueur : homme à cheval qui conduit une meute de chiens

plage : terrain plat et découvert

plancher : recouvrir de planches

pleumache : plumage

pliage : action de plier les ailes

plutôt : plus tôt

poinçon : mesure de contenu variable d'une région à l'autre et valant environ un demi-tonneau

point (en si bon) : bonne mine, bonne santé

pointage : action de monter et de descendre rapidement

pointes : montées et descentes rapides de l'oiseau

poivrot : poireau

poli : élégant, cultivé

police : gouvernement, législation

policé : civilisé

politesse : civilisation; élégance, raffinement

porcelaine : coquille polie, verroterie; collier fait de verroterie

port (prendre) : s'arrêter

porter : transporter, amener; supporter

porter (se) : se rendre

portrait : tableau, description

pot : cuisine; mesure de capacité contenant d'une à deux pintes

pot et feu (à) : manger à la même table

pouce : mesure valant un douzième du pied, soit 2,54 cm

poule d'Inde : dinde

pour : par, à cause de, comme, en tant que

pourpre : maladie caractérisée par des taches ou des éruptions rouges

pratiquer : arranger

présent : qui agit rapidement

presser : serrer de près, attaquer vivement

priver : apprivoiser

produire (se) : se trouver

profiter : gagner, tirer un profit

propos (à) : soigneusement, opportunément

proposer : présenter, décrire

propre : convenable, approprié

proprement : bien, élégamment, de manière convenable

protester : affirmer solennellement

provenu : revenu

provigner : multiplier

quartier : région, pays; partie

que : à moins que, parce que, au point que, pour que, alors que, ce que, sans que, dont

quérir : chercher

quêter : poursuivre

raccommoder : réparer

ragoût : assaisonnement, mets

railler : plaisanter

raison (à) : à sa place

ramasser : regrouper, réunir

rang (hors de) : désordonné

ranger : dresser

rapeau : appel du fauconnier

rapine (oiseau de) : oiseau de proie

rapine : chasse des oiseaux de proie

rapport : ressemblance; témoignage d'autrui, ouï-dire

rapporter (s'en) : en convenir, en déférer au jugement de quelqu'un

rapporter : ressembler

rare : difficile à trouver ou à faire; précieux, extraordinaire, singulier

rareté : chose difficile à trouver ou à faire; chose précieuse, extraordinaire, singulière

ravage : sentier ou territoire forestier foulé par les cervidés pendant l'hiver

rave : variété de navet; nom populaire du radis

rechercher : poursuivre, étudier avec soin

réclame : cri dont on se sert pour appeler le faucon

réclamer : appeler; crier pour appeler le faucon

recommandation (en) : digne d'estime

recréer : vivifier

redonner : se remettre à la poursuite du gibier

régler : diriger, gouverner

reguinder : reprendre son essor

régulièrement : conformément aux règles

reluisant : brillant

rembucher : faire rentrer la bête dans le bois

remettre : s'assurer de l'endroit où l'animal est resté

remise : retard, repos

rencontre : occasion, événement, hasard

rencontrer : tomber juste, trouver

repart : action de repartir, réponse

répondre : correspondre

représenter : figurer, démontrer, rendre présent

reprise : recommencement

requiem : requin

réserve : provision

réserve de (à la) : excepté

réserver : conserver

résoudre (se) : fondre

ressauter : rebondir

ressource : moyen de se rétablir, de réparer ses pertes

restringent : astringent

retirer à : ressembler

retraite : refuge

retrancher à : borner à

rêverie : folie, idée étrange

révoquer en doute : mettre en doute, contester, rejeter

rhumb : chacune des trente-deux parties de la boussole d'où part l'un des trente-deux vents

rignosserot : rhinocéros

rude : pénible

saupiquer : assaisonner

saut : chute

savoir : apprendre, connaître

science : connaissance précise

sec (à) : hors de l'eau

sembler : ressembler à

semer : parsemer

sensible : évident, ressenti vivement

seulement : même

si : pourtant, mais

six-vingts : cent vingt

sol : monnaie valant 1/20ᵉ ou 1/25ᵉ de livre.

sor : rapace qui n'a pas encore mué

spéculation : observation poussée, pensée

spirituel : intelligent; qui s'attache aux choses
 de l'esprit

strèle : hirondelle de mer

subtil : adroit, rusé, ténu, léger

subtilité : adresse

successivement : continûment

sujet : motif, raison

sujet (pour ce) : à cause de cela

taille : voix qui se situe entre la haute-contre
 et la basse

tant comme : tant que

tantôt : bientôt

tartarot, taugarot : sorte d'épervier

temps (aller de beau) : se démener

terme : dernier stade

théâtre : estrade

tigre marin : phoque de grande taille

tillot : tilleul

tintimale : euphorbe

tirer : aller

tirer de long : se sauver au loin

tissu : tissé

tœuf : tuf

toise : mesure de longueur valant six pieds (1,80 m)

toise (voler à la) : s'envoler du poing à tire d'aile, tout
 près de sa proie

toucher : trouver

tourner : chavirer

tourteau : gâteau

trafic : commerce

trafiquer : commercer

train : tumulte, convoi

transporter : importer, apporter

traverse : voyage par mer

tremble-terre : tremblement de terre

triste : sombre, terrible

truchement : interprète

trousse : sac, poche

user de : utiliser, pratiquer, recourir à

ustensile : meuble, outil, objet domestique

vache sauvage : cervidé femelle

vacherie : troupeau de vaches

vain : frivole

varier : diversifier

vener : faisander

ventrée : portée

véritable : véridique, réel

vertu : force, pouvoir, efficacité, effet

vêtement : plumage

vêtu : couvert de plumes

vêture : plumage, peau

viande : nourriture

viander : brouter

viandis : pâture du cerf

vigonne : chapeau en laine de vigogne

vite : rapide

vol (de haut) : qui s'élève dans les hautes régions
 de l'air

volage (feu) : dartre

voler : chasser à l'aide d'oiseaux de proie

volerie : chasse à l'aide d'oiseaux de proie

volerie (basse) : chasse près du sol

volerie (haute) : chasse de haute volée

voyée : voie; pistes et odeur laissées par un animal

vulgaire (le) : le commun des humains

BIBLIOGRAPHY

Aelian, Claudius. *On Animals.* 3 vols. Translated by A.F. Scholfield. Cambridge, Massachusetts: Loeb Classical Library, 1958–59.

– *Aelian: On the Characteristics of the Animals*, A.F. Scholfield, ed. London, Loeb Classical, and Cambridge, Massachusetts, William Heinemann and Harvard University Press, 1959.

– *Histoires diverses.* Reprinted, translated and annotated by M. Dacier. Paris: Auguste Delalain, 1927.

Agamben, Giorgio. *Signatura rerum. Sur la méthode.* Translated by Joël Gayraud. Paris: Vrin, 2008.

Aldrovandi, Ulisse. *De quadrupedibus digitatis viviparis.* Bologna: Nicolai Tebaldini, 1637.

Allaire, J.-B.A., *Dictionnaire biographique du clergé canadien-français.* Montreal, 1910.

Alpers, Svetlana. *The Art of Describing: Dutch Art in the Seventeenth Century.* Chicago: University of Chicago Press, 1983.

Andrieux, Georges. *Importants livres et manuscrits relatifs aux Amériques et à la guerre d'Indépendance. Très précieux documents originaux.* Abbeville: Imprimerie F. Paillart, 1934.

Anonymous. *Histoire naturelle des Indes. The Drake Manuscript in the Pierpont Morgan Library.* Preface by Charles E. Pierce; foreword by Patrick O'Brian; introduction by Verlyn Klinkenborg, and translation by Ruth S. Kraemer. New York and London: W.W. Norton, 1996.

Anonymous. *A Concise Dictionary of the Ojibway Indian Language. Compiled and abridged from Larger Edition by English and French Authors.* Toronto: International Colportage Mission, 1903.

Anonymous. In John L. Russell, "Friday, January 9, 1857." *Proceedings of the Essex Institute.* Vol. 2. Salem, Massachusetts: 1856–60, 94–115.

– In John Josselyn, "New England's Rarities," *Proceedings of the Essex Institute.* Vol. 1. Salem, Massachusetts, 1848–56.

Arnaud, Antoine. *La morale pratique des Jésuites*, vol. 34 of *Œuvres.* Paris: Sigismond D'Arnay and Compagnie, 1780.

Aristotle. *On the Generation of Animals.* Translated by Arthur Pratt. Adelaide: University of Adelaide: eBooks@Adelaide, 2007.

– *Histoire des Animaux.* 3 vols. Edited and translated by Pierre Louis. Paris: Les Belles Lettres, 1964–69.

– *History of Animals.* Translated by D'Arcy Wentworth Thompson. Oxford: Clarendon Press, 1910.

– *The Works of Aristotle.* Translated by W.D. Ross. Oxford: Clarendon Press, 1925.

– *The Works of Aristotle Translated into English.* Edited by A.J. Smith and W.D. Ross. Oxford: Clarendon Press, 1965, 1966.

Arveiller, Raymond. *Contribution à l'étude des termes de voyage en français (1505–1722).* Paris: D'Artrey, 1963.

Atikamekw Sipi (Conseil de la Nation Atikamekw). *Notcimiw kekwan ka ici aitakok Atikamekw [Coup d'oeil sur les plantes et les animaux du territoire Atikamek].* Version préliminaire. La Tuque, Quebec: 1999.

Atkins, P.W. *Molecules.* New York: Scientific American Library, 1987.

Aubin, George F. *A Proto-Algonquian Dictionary.* Ottawa: National Museums of Canada, 1975.

Backer, Augustin de, and Aloys de Backer. *Bibliothèque des écrivains de la Compagnie de Jésus ou Notices*

bibliographiques de tous les ouvrages publiés par les membres de la Compagnie de Jésus. 7 vols. Liège: Grandmont-Donders, 1853–61. Reprint, Brussels: Lambert Marchant, 1960.

Bacon, Roger. *Opus maius*. Edited by John Henry Bridges. (Vols. 1 & 2, Oxford: Clarendon Press, 1897. Vol. 3 with corrections, London: Williams & Norgate, 1900). Reprint, Frankfurt Am Main: Minerva, 1964.

Banfield, A.W.F. *The Mammals of Canada*. Toronto: University of Toronto Press, 1974.

– *Les mammifères du Canada*. Edited by Norman J. Boudreau and Madeleine Choquette. Quebec: Presses de l'Université Laval, 2nd edition, 1977.

Bauhin, Johann. *De Plantis a divis sanctisve nomen habentibus*. Basle: Conrad Waldkirch, 1591.

– *Historia plantarum universalis*. 2 vols. Yverdon: Typographia Caldoriana, 1650–51.

Beauvais, Vincent de. *Speculum naturale*. Douay: Baltazar Bellerus, 1624. Reprinted, Graz, Austria: Akademische Druck-u. Verlagsanstalt, 1964.

Bécart de Granville, Charles. *Les raretés des Indes: "Codex Canadiensis": album manuscrit de la fin du XVIIᵉ siècle contenant 180 dessins concernant les indigènes, leurs coutumes, plus deux cartes; précédé d'un avant-propos par le Baron Marc de Villiers*. Paris: Librairie Maurice Chamonal, 1930.

Belon du Mans, Pierre. *De aquatilibus libri duo cum iconibus ad vivam ipsorum effigiem quoad ejus fieri potuit expressis*. Paris: Ch. Estienne, 1553.

– *La Nature et Diversité des poissons, avec leurs pourtraicts représentez au plus près du naturel*. Paris: Ch. Estienne, 1555.

Berman, Antoine *The Experience of the Foreign: Culture and Translation in Romantic Germany*. Translation by S. Heyvaert. Albany: State University of New York, 1992.

Blanc, Charles. *Le trésor de la curiosité*, 2 vols. Paris: Renouard, 1857.

Blunt, Wilfrid. *The Complete Naturalist: A Life of Linnaeus*. London: Collins, 1971.

Boivin, Bernard. "Quelques noms vernaculaires de plantes du Québec." *Le Naturaliste canadien*, 70, 1943, 145–62. *Contributions de l'Institut Botanique de l'Université de Montréal* 44 (1942): 3–9; 48 (1943): 3–20.

– "La flore du Canada en 1708. Étude du manuscrit de Michel Sarrazin et de Sébastien Vaillant." *Études littéraires*, 10: 1–2 (1977): 223–97.

Boucher, Pierre. *Histoire véritable et naturelle des mœurs et productions du pays de la Nouvelle-France vulgairement dite le Canada*. Paris: Florentin Lambert, 1664. Reprint with several essays: Société historique de Boucherville, 1964.

– *Canada in the Seventeenth Century: From the French of Pierre Boucher*. Translated by Edward Louis Montizambert. Montreal: Desbarats, 1883.

Brymner, Douglas. "Report of Douglas Brymner on Archives." In *Report to the Minister of Agriculture of the Dominion of Canada for the Calendar Year 1873*, Ottawa, 1874, 189: "Fonds étrangers."

Burt, W.H., and R.P. Grossenheider. *A Field Guide to the Mammals*. Boston: Houghton Mifflin Company, 1976.

Byrne, R. and J.H. McAndrews. "Pre-Columbian Purslane (*Portulaca oleracea* L.) in the New World." *Nature* 253 (1975): 726–7.

Calmann, Gerta. *Ehret: Flower Painter Extraordinary*. Boston: New York Graphic Society, 1977.

Campeau, Lucien. *Monumenta Novæ Franciæ. I. La première mission d'Acadie (1602–1616)*. Rome and Quebec: Presses de l'Université Laval, 1967.

Cartier, Jacques. *Relations*. Edited by Michel Bideaux. Montréal: Presses de l'Université de Montréal, 1986.

– *The Voyages*. Published from the originals with translations, notes and appendices by Henry Percival Biggar. Ottawa: F.A. Acland, Publications of the Public Archives of Canada, no. 11, 1924.

– *The Voyages of Jacques Cartier and a Collection of Documents relating to Jacques Cartier and Sieur de Roberval*. Edited by H.P. Biggar. Toronto: University of Toronto Press, 1993.

Catalogue restauré des Jésuites de la Nouvelle France, Archives of the Company of Jesus, Montreal, Quebec.

Chamberlain, A.F. "Algonquian Words in American English." *Journal of American Folklore* 15, no. 59 (1902): 240–67.

Champlain, Samuel de. *Les voyages du Sieur de Champlain*. Paris: Jean Berjon, 1613. Online: <http://gallica.bnf.fr/> and <http://www.canadiana.org>.

– *Voyages et descouvertures faites en la Nouvelle France, depuis l'année 1615 jusques à l'année 1618*. Paris: Claude Collet, 1619. Online: http://gallica.bnf.fr and http://www.canadiana.org.

– *Les voyages de la Nouvelle France occidentale, dicte Canada depuis l'an 1603 jusques en l'an 1629*. 2 vols. Paris: Claude Collet, 1632. Online: http://gallica.bnf.fr/ and http://www.canadiana.org.

– *Œuvres*. 6 vols. Edited by C.H. Laverdière. Quebec: Desbarats, 1870. Reprint, Éditions du Jour, Montreal, 1973, in 3 vol.

– *The Works*. 6 vols. Reprinted, translated, and annotated by six Canadian scholars [H.H. Langton, William Francis Ganong, John Home Cameron, John Squair, and William Dawson LeSueur] under the general editorship of H.P. Biggar. Toronto: Champlain Society, 1922–36.

Charbonneau, Hubert, and Jacques Légaré. *Répertoire des Actes de baptême, mariage, sépulture et des recensements du Québec ancien, le xvii^e siècle.* Montreal: Presses de l'Université de Montréal, 1980.

Charlevoix, Pierre François-Xavier. *Histoire et description générale de la Nouvelle-France.* 3 vols. Paris: Nyon Fils, 1744. Online: http://gallica.bnf.fr and http://www.canadiana.org.

– Critical edition of vol. iii, by Pierre Berthiaume: *Journal d'un voyage fait par ordre du Roi dans l'Amérique septentrionale.* 2 vols. Montréal: Presses de l'Université de Montréal, 1994.

Cicero. *Cicero: The Speeches, with an English Translation,* N.H. Watts, ed., London, William Heinemann, and New York, G.P. Putnam's Sons, 1931.

Cicéron. *Discours.* 17 vols. Texte établi et traduit par H. de La Ville de Mirmont. Paris: Les Belles Lettres, 1925.

Clément, Daniel. *La Zoologie des Montagnais.* Paris: Éditions Peeters, 1995.

Clusius, Carolus. *Rariorum plantarum historia.* Antwerp: Plantin, 1601.

Contant, Paul. *Le jardin et cabinet poétique de Paul Contant, apothicaire de Poitiers.* Poitiers: A. Mesnier, 1609.

Corbet, Gordon, and Denys Ovenden. *The Mammals of Britain and Europe.* London: Collins, 1980.

Cordus, Valerius. *Adnotationes in Dioscoridis de medica materia libri V.* Strasbourg: Conrad Gesner, ed., 1561. Online: http://visualiseur.bnf.fr/Visualiseur?Destination=Gallica&O=NUMM-098052

Cornut, Jacques-Philippe. *Canadensium plantarum, aliorumque nondum editarum historia cui adjectum est ad calcem enchiridion botanicum pariense.* Paris: Simon le Moyne, 1635. Reprint with an introduction by Jerry Stannard: New York and London, Johnson Reprint, 1966. Translated and annotated by André Daviault: thesis (D.E.S.), Quebec, Université Laval, 1967. Partial translation in Jacques Mathieu and André Daviault. *Le premier livre de plantes du Canada. Les enfants des bois du Canada au jardin du Roi à Paris en 1635.* Sainte-Foy: Presses de l'Université Laval, 1998.

Cristofolini, G., and U. Mossetti. "Interpretation of Plant Names in a Late Medieval Medical Treatise." *Taxon* 47 (1998): 305–19.

Dalechamps, Jacques. *Historia Generalis Plantarum, Pars Altera, Continens Reliquos Nouem Libros.* Lyon: Guillaume Rouillé, 1586.

– *Histoire générale des plantes.* 2 vols. Translated by Jean des Moulins. Lyon: Guillaume Rouillé, 1615.

Daviault, Diane. *L'algonquin au xvii^e siècle. Une édition critique, analysée et commentée de la grammaire algonquine du Père Louis Nicolas.* Sainte-Foy: Presses de l'Université du Québec, 1994.

Delaunay, Paul. *La zoologie au seizième siècle.* Paris: Hermann, 1997.

De Montespan, Françoise Athénaïs. *Mémoires de Madame la Marquise de Montespan.* Paris: Mame et Delaunay-Vallée Libraires, Paris, 1829; reprint by Elibron Classics Series, Adamant Media Corporation.

Denise, Louis. *Bibliographie historique et iconographique du Jardin des Plantes.* Paris: H. Daragon, 1903.

Denys, Nicolas. *Description geographique ethistorique des costes de l'Amerique septentrionale. Avec l'histoire naturelle du pays.* 2 vols. Paris: Claude Barbin, 1672. Reprint, with introduction, annotation and unpublished correspondance. Edited by Clarence-Joseph d'Entremont. Yarmouth (Nova Scotia): L'imprimerie Lescarbot, 1982.

– *The Description and Natural History of the Coasts of North America (Acadia).* Translated and edited, with a memoir of the author, collateral documents, and a reprint of the original, by William F. Ganong. Toronto: The Champlain Society, 1908.

De Rochemonteix, Camille. *Relation par lettres de l'Amérique Septentrionale (1709–1710).* Paris: Letouzey et Ané, 1904.

Descartes, René. "Le libraire au lecteur," *Méditations,* in *Œuvres complètes.* Edited by Charles Adam, and Paul Tannery. Vol. 9–1. Paris: Vrin, 1964.

– "Preface to the Reader," in *Meditations on First Philosophy* in *The Philosophical Works of Descartes Rendered into English,* edited by Elizabeth S. Haldane and G.R.T. Ross. London: Cambridge University Press (1911) 1973.

Devillers, Pierre, Henri Ouellet, et al. *Noms français des oiseaux du monde avec les équivalents latins et anglais.* Québec: Éditions MultiMondes, 1993.

Diderot, Denis, et al. *L'Encyclopédie ou Dictionnaire raisonné des sciences, des arts et des métiers.* Paris: Briasson, 1751–72; republished by Stuggart-Bad Canstatt, Friedrich Frommann Verlag, 1966.

Dièreville, *Relation du voyage du Port Royal de l'Acadie,* Rouen, Besonge, 1708. Online: http://gallica.bnf.fr/ and http://www.canadiana.org. Critical edition by Normand Doiron. Montreal: Presses de l'Université de Montréal, 1997.

Dioscoride, *Pedacii Dioscoridis Anazarbei de medicinali materia libri quinque. De virulentis animalibus, et venenis canerabioso, et corum notis, ac remediis libri quattuor.* Edited by Jean Ruel. Paris: Henri Estienne, 1516. Online: http://www.bium.univ-paris5.fr/histmed/medica/cote?00815.

– *De medica materia libri six.* Edited by Jean Ruel. Paris: Simon Colin, 1537.

Dodart, Denis, Nicolas Robert, and Abraham Bosse.

Mémoires pour servir à l'histoire des plantes. Paris: Imprimerie royale, 1676. Digital Library of the University of Paris, 2010. http://web2.bium.univ-paris5.fr/.

Dodoens van Joenckema, Rembert. *Stirpium historiae pemptades sex sive libri xxx.* Antwerp: Christopher Plantin, 1583. Digital Library of the Real Jardin Botánico, 2010. Online: http://bibdigital.rjb.csic.es/ing/Libro.php?Libro=1653.

Doyon, Pierre-Simon. *L'iconographie botanique en Amérique française du xvııᵉ au milieu du xvıııᵉ siècle.* PhD dissertation: Université de Montréal, 1993.

Dragon, Antonio. *Trente robes noires au Saguenay.* Chicoutimi: Société historique du Saguenay, no. 24. 1971.

Drapeau, Lynn. *Dictionnaire montagnais-français.* Sillery, Quebec: Presses de l'Université du Québec, 1991.

Du Creux, François. *Historiae Canadensis seu Novae Franciae Libri Decem.* Paris: S. Mabre-Cramoisy, 1664.

– *The History of Canada or New France by Father François Du Creux.* 2 vols. Edited by Percy J. Robinson and James B. Conacher. Toronto: The Champlain Society, 1951–52.

Dulong, Gaston. *Dictionnaire des canadianismes.* 2nd edition. Sillery (Quebec): Septentrion, 1999.

Dusenbery, David B. *Life at Small Scale: The Behavior of Microbes.* New York: Scientific American Library, 1996.

Ellis, Richard. *Monsters of the Sea.* New York: Alfred A. Knopf, 1994.

Fabvre, Bonaventure, Lorenzo Angers, and Gerard E. McNulty. *Racines montagnaises (compilées à Tadoussac avant 1695).* Université Laval, Centre d'Études Nordiques 29. Quebec: Université Laval, 1970.

Faribault, Marthe. "L'Apios tubéreux d'Amérique: histoires de mots." *Recherches amérindiennes au Québec* 21, no. 3 (1991), 65–75.

– "Les phytonymes de l'*Histoire naturelle des Indes occidentales* de Louis Nicolas: image du lexique botanique canadien à la fin du xvııᵉ siècle." In *Actes du quatrième Colloque international de Chicoutimi, Québec, 21–24 septembre 1994.* Edited by Thomas Lavoie and Pierre Larrivée. Tübingen: Max Niemeyer Verlag, 1996.

– "Phytonymes nord-américains: étude onomasiologique de la terminologie des racines alimentaires." In *Actes du xxᵉ Congrès International de Linguistique et Philologie Romanes,* University of Zürich April 6–11, 1992. Edited by Gerald Hilty. Vol. 4, sec. 6. Tübingen: Francke Verlag, 1993.

Feest, Christian F. "Mexico and South America in the European Wunderkammer." In O. Impey and A. McGregor, eds., *The Origins of Museums: The Cabinet of Curiosities in Sixteenth- and Seventeenth-Century Europe.* New York: Oxford University Press, 1985.

– "The Collection of American Indian Artifacts in Europe, 1493–1750." In Karen O. Kupperman ed., *America in European Consciousness 1493–1750.* Chapel Hill: University of North Carolina Press, 1995.

Feinbrun-Dothan, Naomi and Ruth Koppel. *Wild Plants in the Land of Israel.* Israel: Hakibbutz Hameuchad Publishing, 1968.

Ferret, Stéphane. *L'identité.* Paris: GF Flammarion, 1998.

Foucault, Michel. *Les Mots et les Choses. Une archéologie des sciences humaines.* Paris: Gallimard, 1966. Translated as *The Order of Things: An Archeology of the Human Sciences.* New York: Vintage Books, 1973.

Fournier, Georges. *Hydrographie, contenant la théorie et la pratique de toutes les parties de la navigation.* Paris: chez Soly, 1643.

French, Roger. *Ancient Natural History: Histories of Nature.* London and New York: Routledge, 1994.

Fuchs, Leonhart. *De Historia Stirpium Commentarii inignes.* Basel: Isingriniana, 1542.

– *The Great Herbal of Leonhart Fuchs: De Historia Stirpium Commentarii insignes.* Edited by Frederick G. Meyer, Emily Emmart Trueblood, and John L. Heller. Palo Alto, California: Stanford University Press, 1991.

Gagnon, François-Marc. "Portrait du castor. Analogies et représentation." In B. Beugnot, ed., *Voyages, récits et imaginaire, Biblio 17, Papers on French Seventeenth-Century Literature,* 199–214. Paris: 1964.

– "Ils se peignent le visage. Réaction européenne à un usage indien au xvıᵉ et au début du xvııᵉ siècles." *Revue d'histoire de l'Amérique française* 30, no. 3 (1976): 363–81.

– "L'expérience ethnographique de Louis Nicolas." *Recherches amérindiennes au Québec* 8, no. 4 (1979): 281–95.

– "Experientia est magistra rerum. Savoir empirique et culture savante chez les premiers voyageurs du Canada." *Questions de culture* 1 (1981): 47–61.

– "Le castor et ses signatures. Analyse d'une figure du *Codex canadiensis,* attribué au jésuite Louis Nicolas." *Quaderni del Seicento Francese* 6 (1983): 255–66.

– "Écrire sous l'image ou sur l'image." *Études françaises* 21, no. 1 (1985): 83–99.

– "Figures hors-texte. Note sur l'*Histoire naturelle des Indes occidentales* du Père Louis Nicolas, Jésuite." *Annales d'histoire de l'art canadien* 10 (1987): 1–15; *Journal of Canadian Art History* 10, no. 1 (1987): 1–15.

– "Fragment de bestiaire: La bête à grand' dent." *Cahiers des arts visuels au Québec* (winter 1982) 28.

– *Images du castor canadien, xvıᵉ–xvıııᵉ siècles.* Sillery: Septentrion, 1994.

Gagnon, François-Marc, and N. Cloutier, *Premiers peintres de la Nouvelle-France*. Quebec: Ministère des Affaires Culturelles, 1976.

Gagnon, François-Marc, and Denise Petel. *Hommes effarables et bestes sauvaiges*. Montreal: Boréal Express, 1986.

Ganong, William F. ed. "The Identity of the Animals and Plants mentioned by the Early Voyagers to Eastern Canada and Newfoundland." Ottawa: Transactions of the Royal Society of Canada, 3 (1909): 197–242.

Gatin, C.-L. *Dictionnaire de botanique*. Paris: Lechevalier, 1924. Reprint: Nendeln, Lichenstein, Kraus, 1973.

Gentil, Ambroise, *Dictionnaire étymologique de la flore française*. Paris: Lechevalier, 1923.

George, Wilma. "Alive or Dead: Zoological Collections in the Seventeenth Century." In O. Impey and A. McGregor, eds., *The Origins of Museums: The Cabinet of Curiosities in Sixteenth- and Seventeenth-Century Europe*. Oxford: Clarendon Press, 1985.

Gerarde, John, John Norton, Bonham Norton, Edmund Bollifant, and W. Pratt. *The Herball, or Generall Historie of Plantes*. London: John Norton, 1597.

– *The Herball, or General Historie of Plants, Gathered by John Gerarde of London Master in Chirurgie, Very much Enlarged and Amended by Thomas Johnson Citizen and Apothecarye of London*. London: Adam Islip, Joice Norton, and Richard Whitakers, 1663. Reprint, New York: Dover, 1975.

Gert Van Wijk, H.L. *A Dictionary of Plant Names (Latin, English, German, French, Dutch)*. 2 vols. The Hague: Nijhoff, 1909–16.

Gesner, Conrad. *Conradi Gesneri medici Tigurini Historiae animalium*. 5 vols. Vols 1–4, Zürich: Christoph Froschover, 1551, 1554, 1555, 1558; vol. 5, Zürich, Officina Froschouiana, 1587.

– *Icones Avium Omnium quae in Historia avium… describuntur, cum nomenclaturis singulorum*, Zurich, 1555.

– *Nomenclator Aquatilium Animantium. Icones Animalium Aquitilium in mari & dulcibus aquis degentium … per Conradum Gesnerum Tigurinum*. Zurich: Christophe Froschover, 1560.

– *Historiae Animalium, Liber III, qui est de Avium natura*. 2nd edition. Frankfurt: Cambieri, 1585; *Liber IV*, 1621.

– *Vingt lettres à Jean Bauhin, fils (1563–1565)*. Edited by Augustin Sabot and Claude Longeon. Saint-Étienne: Université Saint-Étienne, 1976.

– *Konrad Gesner. A Selection of 190 Sixteenth-Century Woodcuts from Gesner's and Topsell's Natural Histories*: New York, Dover Publications, 1971.

Gilstrap, Roger. *Algonkin Dialect Relationships in North Western Quebec*. Ottawa: National Museum of Canada, 1978.

Godfrey, W. Earl. *The Birds of Canada*. Revised Edition. Ottawa: National Museums of Natural Sciences, 1986. *Les Oiseaux du Canada*. Adaptation in French by Annie J. Ollivier. Montreal and Ottawa: Éditions Broquet et Musée national du Canada, 2nd ed., 1986.

Gombrich, Ernst H. *Art and Illusion: A Study in the Psychology of Pictorial Representation*. 1960. London: Phaidon Press, 1972.

Gosselin, Auguste. "Quelques observations à propos du voyage du P. Le Jeune au Canada en 1660 et du prétendu voyage de M. de Queylus en 1644." Ottawa: *Mémoires de la Société Royale du Canada* 2, 1896.

Goubert, Pierre. *Le Siècle de Louis XIV: Études*. Paris: Éditions de Fallois, 1996.

Grandtner, Miroslav M. *Elsevier's Dictionary of Trees*. Vol. 1: *North America*. With names in Latin, English, French, Spanish, and other languages. Amsterdam: Elsevier Science, 2005.

Guyot, Lucien, and Pierre Gibassier. *Les noms des fleurs*. Que sais-je? Paris: Presses Universitaires de France, 1960.

– *Les noms des plantes*. Que sais-je? Paris: Presses Universitaires de France, 1967.

Haas, Mary R. "A New Linguistic Relationship in North America: Algonquian and the Gulf Languages." *Southwestern Journal of Anthropology* 14 (1958): 231–64.

– "The Proto-Algonquian Word for 'Sun.'" Bulletin 214. Ottawa: National Museum of Canada, 1967.

Haies, Edward. "Sir Humphrey Gilbert's Voyage to Newfoundland." In *Voyages and Travels*. The Harvard Classics, 33. Edited by C.W. Eliot. New York: Collier, 1910.

Hanzeli, Victor Egon. *Missionary Linguistics of New France: A Study of Seventeenth- and Eighteenth-Century Descriptions of American Indian Languages*. The Hague and Paris: Mouton, 1969.

Harris, Tegwyn. *The Natural History of the Mediterranean*. London: Pelham Books, 1982.

Hatton, Richard G. *Handbook of Plant and Floral Ornament Selected from the Herbals of the Sixteenth Century, and Exhibiting the Finest Examples of Plant Drawing Found in Those Rare Works, Whether Executed in Wood-Cuts or in Copperplate Engravings, Arranged for the Use of the Decorator with Supplementary Illustrations and Some Remarks on the Use of Plant Form in Design*. New York: Dover, 1960. Originally published in 1909 under the title, *The Craftsman Plant Book*.

– *The Craftsman's Plant Book: or Figures of Plants: Selected from the Herbals of the Sixteenth Century …*

with Supplementary Illustrations and Some Remarks on the Use of Plant-Form in Design. London: Chapman and Hall, 1909

Heinzel, Herman, Richard Fitter, and John Parslow. *The Birds of Britain and Europe with North Africa and the Middle East.* 1972. London: Collins, 1979.

Hennepin, Louis, *Nouveau voyage d'un pais plus grand que l'Europe.* Utrecht, Antoine Schouten, 1698. Online: BNF, http://gallica.bnf.fr/ and http://www.canadiana.org.

Hérodote, *L'enquête.* Translated and annotated by Andrée Barguet, in *Hérodote-Thucydide, Oeuvres complètes.* Paris: Gallimard, "Bibliothèque de la Pléiade," 1964. 51–654.

Hewson, John. *A Computer-Generated Dictionary of Proto-Algonquian.* Hull: Canadian Museum of Civilization, 1993.

Hoffman, Bernard G. "The *Codex Canadiensis*: An Important Document for Great Lakes Ethnography." *Ethnohistory* 8, 4 (1962), 387.

Hollier, Robert. "Où se trouve le *Codex canadiensis*?" *Vie des arts* 8, no. 32 (1963).

Howard, R.C. "Guy de la Brosse and the Jardin des Plantes in Paris." In Harry Woolf, ed., *The Analytic Spirit: Essays in the History of Science in Honor of Henry Guerlac.* Ithaca: Cornell University Press, 1981.

Impey, Oliver, and Arthur McGregor, eds. *The Origins of Museums: The Cabinet of Curiosities in Sixteenth- and Seventeenth-Century Europe.* Oxford: Clarendon Press, 1985.

Jenkins, A.C. *The Naturalists: Pioneers of Natural History.* New York: Mayflower Books Inc., 1978.

The Jesuit Relations and Allied Documents. Travels and Explorations of the Jesuit Missionnaries in New France, 1610–1791. The Original French, Latin, and Italian Texts, with English Translation and Notes: Illustrated by Portraits, Maps, and Facsimiles, 73 vols., edited and translated by Reuben G. Thwaites. Cleveland: Burrows, 1896–1901. Reprint, New York: Pageant Book, 1959, 36 vols. Online: http://www.canadiana.org.

Josselyn, John. *New England's Rarities Discovered in Birds, Fishes, Serpents and Plants of that Country. Together with the Physical and Chyrurgical Remedies, Wherewith the Natives Constantly Use to Cure Distempers, Wounds & Sores, &c. &c.* London: Widdowes, 1672. Reprint: Berlin, W. Junk, 1926.

– *New England's Rarities Discovered in Birds, Beasts, Fishes, Serpents, and Plants of that Country.* London: Widdows, 1672. Reprinted with introduction and notes by Edward Tuckerman. Boston: William Veazie, 1865.

– *An Account of the Voyages to New England.* London: Widdows, 1674. Critical edition published by Paul J. Lindholdt. Hanover, New Hampshire, University Press of New England, 1988.

Le Journal des Jésuites. Quebec: Léger Brousseau, 1871.

Juel, H.O. "The French Apothecary's Plants in Burser's Herbarium." *Rhodora* 34 (1931): 177–9.

Julien, Charles-André. *Les voyages de découverte et les premiers établissements (xve et xvie siècles).* Paris: Presses Universitaires de France, 1948.

Juvénal. *Satires.* Edited and translated by Pierre de Labriolle et François Villeneuve. Paris: Les Belles Lettres, 1952.

Juvenal. *The Satires.* Translated by Niall Rudd. 2nd ed. Oxford and New York: Oxford University Press, 1992.

– *Satires, with the Satires of Persius.* H.J. Rose, W. Gifford, and J. Warrington, eds. New York: Dutton, 1954.

Kalm, Pehr. *Voyage de Pehr Kalm au Canada en 1749.* Edited by Jacques Rousseau, Guy Béthune, and Pierre Morisset. Montreal: Pierre Tisseyre, 1977.

Kappler, Claude. *Monstres, démons et merveilles à la fin du Moyen Âge.* Paris: Payot, 1980.

Kenseth, Joy. *The Age of the Marvelous.* Hanover, New Hampshire: Hood Museum of Art, Dartmouth College, 1991.

Kinietz, W. Vernon. *The Indians of the Western Great Lakes 1615–1760.* Ann Arbor: University of Michigan Press, (1940) 1965.

Kirk, Geoffrey S. *The Nature of Greek Myths.* 1974. Harmondsworth: Penguin Books, 1978.

Kupperman, Karen, ed., *America in European Consciousness 1493–1750. An International Conference on the Intellectual Discovery of the New World.* Providence, Rhode Island: The John Carter Brown Library, 1991.

La Brosse, Guy de. *Description du jardin royal des plantes médicinales établys par le roi Louis le Juste à Paris, contenant le catalogue des plantes qui y sont de présent cultivées, ensemble le plan du jardin.* Paris: Jean d'Estrées, 1636. Digital Library of the Bibliothèque Interuniversitaire de Médecine, 2010. www.bium.univ-paris5.fr/.

Lacroix, Laurier. "Le fonds de tableaux Desjardins: nature et influence." PhD dissertation: Quebec: Université Laval, 1996.

Lahontan. *Nouveaux voyages de mr. le baron de Lahontan, dans l'Amerique septentrionale,* and *Memoires de l'Amerique septentrionale, ou la suite des voyages de mr. le baron de Lahontan.* 2 vols. The Hague: Frères L'Honoré, 1703.

– *New Voyages to North America giving a full Account of the Customs, Commerce, Religion, and Strange Opinions of the Savages of that Country with political Remarks upon the Courts of Portugal and Denmark and the present State of the Commerce of those Countries.* 2 vols. London: Printed for H. Bonwicke, 1703. Online: http://www.canadiana.org.

– *Œuvres complètes.* 2 vols. Critical edition by Réal Ouellet and Alain Beaulieu. Montreal: Presses de l'Université de Montréal, 1990.

Lalonde, H. "Le rat musqué. Du trappage à votre porte." *Québec. Chasse et pêche* 2 (November 1972): 38.

Lamoureux, Gisèle, and Claude Allard. *Plantes sauvages printanières.* Montreal: Éditions France-Amérique, 1975.

Lamoureux, Gisèle, Lucette Durand, and France Morissette. *Plantes sauvages comestibles.* Saint-Cuthbert: Le Groupe Fleurbec, 1981.

Lanzara, Paola and Marietta Pizzetti. *Simon and Schuster's Guide to Trees.* Translated from Italian by Hugh Young. New York: Simon and Schuster, 1978.

La Roncière, Charles de. *Histoire de la découverte de la terre. Explorateurs et conquérants.* Paris: Larousse, 1938.

Le Beau. *Avantures du Sr C. Le Beau, avocat au Parlement, ou Voyage curieux et nouveau, parmi les Sauvages de l'Amérique septentrionale.* Amsterdam: Herman Uytwerf, 1738.

Leclercq, Chrestien. *Nouvelle relation de la Gaspésie.* Paris: Amable Auroy, 1691. Online: http://gallica.bnf.fr and http://www.canadiana.org. Critical edition by Réal Ouellet. Montreal: Presses de l'Université de Montréal, 1999.

– *New Relation of Gaspesia: With the Customs and Religion of the Gaspesian Indians.* Translated and edited with a reprint from the original, by William F. Ganong. Toronto: Champlain Society, 1910.

Léry, Jean de. *Histoire d'un voyage faict en la terre du Bresil.* 2nd edition, Geneva: Antoine Chuppin, 1580. Republished by Frank Lestringant: *Histoire d'un voyage en terre de Brésil.* Paris: Libraire générale française, coll. "Bibliothèque classique," 1994.

Lescarbot, Marc. *Histoire de la Nouvelle France*, 3 vols. Paris: Jean Milot, 1609. New editions: 1611 and 1617. Online (1609, http://gallica.bnf.fr/; 1617, http://gallica.bnf.fr/ and http://www.canadiana.org). Critical edition of books IV and VI by Marie-Christine Pioffet: *Voyages en Acadie (1604–1607), suivis de la description des mœurs souriquoises comparées à celles d'autres peuples.* Quebec: Presses de l'Université Laval, 2007.

– *The History of New France.* English translation, notes and appendices by W.L. Grant. Toronto: The Champlain Society, 1907–14.

Louis-Marie, Père. *Flore-manuel de la province de Québec.* Quebec: Institut agricole d'Oka, 1931.

Lowie, Robert. *Indians of the Plains.* New York: McGraw-Hill, 1954.

Mack, R.N. "Plant Naturalizations and Invasions in the Eastern United States: 1634–1860." *Annals of the Missouri Botanical Garden* 90 (2003): 77–90.

Magnol, Pierre. *Hortus Regius Monspeliensis.* Montpellier: Honoré Pech, 1697. Online: http://gallica.bnf.fr/.

Magnus, Albertus. *De Animalibus.* 2 vols. Edited by H. Stadler. Münster: Aschendorff, 1916–21.

Magnus, Olaus. *Historia de Gentibus Septentrionalibus.* Roma: Giovanni Maria Viotto, 1555.

– *Description des peuples du Nord.* Paris: Martin le Jeune, 1561.

Marie de l'Incarnation. *Correspondance, 1599–1672.* Edited by Guy Oury. Solesme: Abbaye Saint-Pierre, 1971.

– *Words from New France: The Selected Letters of Marie de l'Incarnation.* Translated and edited by Joyce Marshall. Toronto: Oxford University Press, 1967.

Marie-Victorin, Frère, Luc Brouillet, and Isabelle Goulet. *Flore laurentienne.* Presses de l'Université de Montréal. 1964. 3rd ed. Montreal: Gaëtan Morin Éditeur, 1995.

Marsy, François de. *Dictionnaire abrégé de peinture et d'architecture.* Paris: Barrois et Nyon, 1746.

Mathieu, Jacques. *Le commerce entre la Nouvelle-France et les Antilles au XVIIIe siècle.* Montreal: Fides, 1981.

– and André Daviault. *Le premier livre de plantes du Canada. Les enfants des bois du Canada au jardin du Roi à Paris en 1635.* Quebec: Presses de l'Université Laval, 1998.

Mattioli, Pier Andrea. *Commentarii in libros sex Pedacii Dioscorides Anazarbei, de Materia Medica, Adjectis quam plurimis plantarum & animalium imaginibus, eodem auctore.* Venice: Vincenzo Valgrisi, 1565. Translation by Jean des Moulins: *Commentaires sur les six livres de Ped. Dioscoride, […] de la matière médicinale […].* Mis en françois sur la derniere edition latine de l'autheur. Lyon: Guillaume Rouillé, 1572. Online: http://www.bium.univ-paris5.fr/histmed/medica/cote?00824.

– *De plantis Epitome utilissima,* Frankfort-on-Main: Calceolario, 1586. Online: www.bium.univ.paris5.fr/histmed/medica/cote?07755x01.

Mattiroto, Oreste. *L'opera botanica di Ulisse Aldrovandi.* Bologna: Merlani, 1897.

Mélançon, Claude. *Les poissons de nos eaux.* 4th edition revised and expanded. Montreal: Guérin, 2006, [1973].

Méthivier, Hubert. *Le siècle de Louis XIV*. Que sais-je? Paris: Presses Universitaires de France, 1968.

Michelin Guide. "Paris et sa proche banlieue." Paris: Services de Tourisme Michelin, 1965.

Molinet, Claude du. *Le Cabinet de la Bibliothèque Sainte-Geneviève*, Paris, 1692.

Mommsen, C. *Julie Solini Collectanea Rerum Mirabilium*. Berlin and Cologne: A. Raabe, 1958.

Montaigne, Michel de. *The Essays of Michel de Montaigne*. Translated and edited by M.A. Screech; introduction and notes by M.A. Screech. London: Penguin, 1991.

Nida, Eugene. *Toward a Science of Translating*. Leiden: E.J. Brill, 1964.

O'Brian, Patrick, Verlyn Klinkenborg, and Ruth S. Kraemer, *The Drake Manuscript in the Pierpont Morgan Library: Histoire Naturelle des Indes*. London: André Deutsch, 1996.

Ovid. *The Art of Love, and Other Poems*. Edited and translated by J.H. Mozley. Cambridge, Massachusetts: Loeb Classical Library, 1957.

– *Metamorphoses*. Edited and translated by F.J. Miller. London and Harvard University Press: William Heinemann, 1958.

Peterson, Roger Tory, Guy Mountfort, and P.A.D. Hollom. *A Field Guide to the Birds of Britain and Europe*. New York: Houghton Mifflin, 1993.

Piggott, G.L., and A. Grafstein. *An Ojibwa Lexicon*. Ottawa: National Museums of Canada, 1983.

Pline l'Ancien. *Histoire Naturelle*. Book 8. Edited and translated by Alfred Ernout. Paris: Belles Lettres, 1952.

Pliny the Elder. *Natural History* with an English Translation in ten Volumes. Vols 1–5, and 9 translated by H. Rackham; vols. 6–8 translated by W.H.S. Jones; vol. 10 translated by D.E. Eichholz. London: William Heinemann, and Cambridge, Massachusetts: Harvard University Press, 1938–62.

Pouliot, Léon. "Le Jeune, Paul." In *Dictionnaire biographique du Canada*. Vol. 1. Quebec: Presses de l'Université Laval, 1966. 464–9.

Reeves, Henry M., François-Marc Gagnon, and C. Stuart Houston. "*Codex canadiensis*, an Early Illustrated Manuscript of Canadian Natural History." *Archives of Natural History* 31, no. 1 (2004): 150–66.

Rhodes, Richard A. *Eastern-Ojibwa-Chippewa-Ottawa Dictionary*. Berlin: Mouton, 1985.

Robertson, F.W. "James Sutherland's *Hortus Medicus Edinburgensis*, 1683." *Garden History* 29 (2001): 121–51.

Rochemonteix, Camille de. *Les Jésuites et la Nouvelle-France au XVIIᵉ siècle, d'après beaucoup de documents inédits*. 3 vols. Paris: Letouzey & Ané, 1895–96.

– *Relation par lettres de l'Amérique Septentrionale (1709–1710)*. Paris: Letouzey & Ané, 1904.

Rondelet, Guillaume. *Libri de piscibus marinis, in quibus verae piscium effigies expressae sunt*. Lyon: Mathieu Bonhomme, 1554.

– *De l'histoire entière des poissons, composée premièrement en latin avec leurs portraits au naïf*. Translation by Laurent Joubert. Lyon: Mathieu Bonhomme, 1558.

Rousseau, Jacques. "La botanique canadienne à l'époque de Jacques Cartier." *Annales de l'ACFAS* 2 (1937): 151–236.

– "L'anneda et l'arbre de vie." *Revue d'histoire de l'Amérique française* 8 (1954): 171–212.

– *Les noms populaires des plantes au Canada français*. Mémoires du Jardin botanique de Montréal 43. Quebec: Presses Universitaires Laval, 1955.

– "Pierre Boucher, naturaliste et géographe." In *Histoire véritable et naturelle*, Société historique de Boucherville, 1964.

Rousseau, Jean-Jacques. *Les rêveries du promeneur solitaire*. Edited and annotated by Marcel Raymond. In *Œuvres complètes*. Vol. 1. Paris: Gallimard, "Bibliothèque de la Pléiade," 1959, 993–1099.

– *Les rêveries du promeneur solitaire*, Henri Rodier, ed., Paris, Classiques Garnier, 1960. *The Reveries of a Solitary Walker*. Translated by John Gould Fletcher. New York: Burt Franklin, 1971.

Ruel, J. *De natura stirpium libri tres*. Paris: Simon de Colines, 1536. Available at Fondos Digitalizados de la Universidad de Sevilla.

Sagard, Gabriel. *Le grand voyage du pays des Hurons*. Paris: Denys Moreau, 1632. Online: http://gallica.bnf.fr; http://www.canadiana.org.

– *Le grand voyage du pays des Hurons*. Critical edition by Jack Warwick. Montreal: Presses de l'Université de Montréal, 1998. Re-edition by R. Ouellet et J. Warwick. Montreal: Bibliothèque québécoise, coll. BQ, 2nd ed., 2007.

– *Dictionaire de la langue huronne necessaire à ceux qui n'ont l'intelligence d'icelle & ont à traiter avec les sauvages du pays*. Paris: Denys Moreau, 1632. Online: http://gallica.bnf.fr; http://www.canadiana.org.

– *The Long Journey to the Country of the Hurons*. Edited with an introduction by George M. Wrong, translated by H.H. Langton. Toronto: The Champlain Society, 1939. Reprint, New York: Greenwood Press, 1968.

Saineanu, Lazare. *L'histoire naturelle et les branches connexes dans l'œuvre de Rabelais*. Paris: Champion, 1921.

Sainte-Marie, Dorothée. "Les Raretés des Indes ou Co-

dex canadiensis: premier recueil illustré de la flore et de la faune de la Nouvelle-France." MA thesis. Montreal: Université de Montréal, 1980.

Sanecki, Kay N. *The Complete Book of Herbs.* London: MacDonald Futura Publishers, 1974.

Sayre, James K. *North American Bird Folknames and Names.* Foster City, California: Bottlebrush Press, 1996.

Schnapper, Antoine. *Le géant, la licorne et la tulipe. Collections et collectionneurs dans la France du XVII^e siècle.* Paris: Flammarion, 1988.

Schleiermacher, Friedrich. "On the Different Methods of Translating." In André Lefevere, *Translating Literature: The German Tradition from Luther to Rosenzweig.* Assen and Amsterdam: Van Gorcum, 1977.

Schwendener, Simon. "Die Flechten als Parisiten des Algen." *Verhandlungen der Naturforshenden Gesellschaft in Basel* 4 (2001): 527–50.

Scupbach, William. "Some Cabinets of Curiosities in European Academic Institutions." In O. Impey and A. McGregor, eds., *The Origins of Museums: The Cabinet of Curiosities in Sixteenth- and Seventeenth-Century Europe.* New York: Oxford University Press, 1985.

Seleskovitch, Danica and Marianne Lederer. *Interpréter pour traduire.* Paris: Didier, 1984.

Senior, Nancy. "On Whales and Savages: Reflections on Translating Louis Nicolas' *Histoire naturelle des Indes occidentales.*" *Meta: journal des traducteurs / Meta: Translators' Journal* 49: 3 (2004): 462–74.

Sève, Jacques Eustache de. *Nouveau dictionnaire de l'Histoire Naturelle, appliquée aux arts, à l'agriculture, à l'économie rurale & domestique.* Paris: Deterville, 1817.

Seville, Isidore of. *The Etymologies of Isidore of Seville.* Edited by W.M. Lindsay. Oxford: Oxford University Press, 1911.

Silvy, Antoine. *Dictionnaire montagnais-français (ca. 1674–84).* Transcribed by Lorenzo Angers, David E. Cooter, and Gerard McNulty. Montreal: Presses de l'Université du Québec, 1974.

Sioui, Anne-Marie. "Qui est l'auteur du *Codex canadiensis?*" *Recherches amérindiennes au Québec* 8:4 (1979): 271–9.

Sioui (Blouin), Anne-Marie, "Les onze portraits d'Indiens du *Codex canadiensis.*" *Recherches amérindiennes au Québec* 9:4 (1981): 281–96.

Stearn, William T. "Linnean Classification, Nomenclature and Method." In *The Complete Naturalist: A Life of Linnaeus.* Edited by W. Blunt. London: Collins, 1971.

– *Botanical Latin.* London: David & Charles, 1985.

Thevet, André. *Singularités de la France antarctique.* Paris: Maurice de la Porte, 1557.

– *La Cosmographie universelle d'André Thevet, cosmographe du Roy, illustrée de diverses figures des choses plus remarquables veuës par l'Auteur, & incogneuës de nos Anciens & Modernes.* Paris: Pierre L'Huillier and Guillaume Chaudière, 1575.

Topsell, Edward. *The History of Four-footed Beasts and serpents … Whereunto is now Added, The Theayter of Insects … By T. Muffet* [Moffet]. London: E. Cotes for G. Sawbridge, T. Williams et T. Johnson, 1658.

Tremblay, Guy. "Louis Nicolas: Sa vie et son œuvre. Les divers modes de transport des Indiens américains." MA thesis, Université de Montréal, July 1983.

Trigger, Bruce G. *The Children of Aataentsic: A History of the Huron People to 1660.* Montreal: McGill-Queen's University Press, 1976.

– *Handbook of North American Indians. Northeast,* vol. 15. Washington: Smithsonian Institution, 1978.

Ubrizsy A., and J. Heniger. "Carolus Clusius and American Plants." *Taxon* 32 (1983): 424–35.

Vachon, André. "Bécart de Granville et de Fonville, Charles." In *Dictionnaire biographique du Canada.* Vol 2 55–6. Toronto: University of Toronto Press/Université Laval, 1969.

Van der Donck, Adriaen. "Description of the New Netherlands, 1653." Edited by T. O'Donnell. Syracuse: Syracuse University Press, 1968. *American Journeys online database.* No. AJ-096. www.americanjourneys.org/.

Warkentin, Germaine, "Aristotle in New France: Louis Nicolas and the Making of the *Codex Canadensis.*" *French Colonial History* 2 (2010): 71–107.

White, James. *Handbook of Indians of Canada.* Appendix to the Tenth Report of the Geographic Board of Canada. Ottawa, 1913.

Wolvengrey, Arok. *Nēhiýawewin: itwēwina / Cree: Words /* ᐆᐦᐄᐧᐊᐦᐁᐧᐃᐧ: ᐃᐧᐆᐊᐧ Regina: Canadian Plains Research Center, 2001.

Wood, Casey A. and F. Marjorie Fyfe. *The Art of Falconry.* Palo Alto, California: Stanford University Press, 1943.

Zwinger, Theodor. *Theatrum Botanicum.* Basel: Jacob Bertsche, 1696.

INDEX

INDEX OF MAMMALS